IN PURSUIT OF BEAUTY

IN PURSUIT

AMERICANS AND THE

Doreen Bolger Burke, Jonathan Freedman, Alice Cooney Frelinghuysen, David A. Hanks,

Marilynn Johnson, James D. Kornwolf, Catherine Lynn, Roger B. Stein,

Jennifer Toher, and Catherine Hoover Voorsanger, with the assistance of Carrie Rebora

OF BEAUTY

AESTHETIC MOVEMENT

THE METROPOLITAN MUSEUM OF ART · RIZZOLI

NEW YORK

This volume has been published in conjunction with the exhibition *In Pursuit of Beauty: Americans and the Aesthetic Movement* held at The Metropolitan Museum of Art, New York, from October 23, 1986, to January 11, 1987.

The exhibition has been made possible by the generous support of Meredith Corporation.
Additional support has been received from the National Endowment for the Humanities. Additional funding for the publication was provided by grants from the William Cullen Bryant Fellows of The American Wing at The Metropolitan Museum of Art and the National Endowment for the Humanities.

Published by The Metropolitan Museum of Art, New York
Bradford D. Kelleher, *Publisher*
John P. O'Neill, *Editor in Chief*
Polly Cone, *Executive Editor*
Amy Horbar, *Editor,* with the assistance of Cynthia Clark, Sue Potter, and Mary-Alice Rogers, and with the bibliographic assistance of Jean Wagner and Laura Hawkins
Joseph B. Del Valle, *Designer*
Suzanne Bodden, *Production*

Library of Congress Cataloging-in-Publication Data

In pursuit of beauty.

Published to coincide with a major loan exhibition at the Metropolitan Museum of Art, Oct. 23, 1986 to Jan. 11, 1987.

Bibliography: p. 488
Includes index.

1. Art, American—Exhibitions. 2. Eclecticism in art—United States—Exhibitions. 3. Aesthetic movement (British art)—Influence—Exhibitions. 4. Arts and crafts movement—United States—Exhibitions. 5. Art, Modern—19th century—United States—Exhibitions. I. Burke, Doreen Bolger, 1949– . II. Metropolitan Museum of Art (New York, N.Y.)
N6510.5.E2515 1986 709'.73'07401471 86–16312
ISBN 0–87099–467–0
ISBN 0–87099–468–9 (pbk.)
ISBN 0–8478–0768–1 (Rizzoli)

All photographs in this volume not otherwise credited in the Photograph Credits were specially taken for this publication by David Allison.

Typeset in Bembo with Perpetua display by Graphic Composition, Inc., Athens, Georgia
Color separated by Chanticleer Company, Inc., New York
Printed and bound by Dai Nippon Printing Company, Ltd., Tokyo, Japan; Satin Kinfuji paper

COVER/JACKET: Detail of a cabinet (FIG. 5.3), design attributed to Frank Furness, manufacture attributed to Daniel Pabst. Philadelphia, ca. 1874–77. Walnut, maple, glass. The Metropolitan Museum of Art, New York, Friends of the American Wing Fund, 1985 (1985.116)

Contents

MEREDITH CORPORATION is pleased to sponsor *In Pursuit of Beauty: Americans and the Aesthetic Movement* at The Metropolitan Museum of Art.

As a Des Moines–based diversified media company with particular interest in the visual arts, we welcome this opportunity to celebrate New York and its cultural endeavors.

The Aesthetic movement cultivated a popular appreciation of art, bringing taste and beauty to nearly all facets of everyday life. Our sponsorship of the first American exhibition devoted to the Aesthetic movement is a particular pleasure, as it relates so closely to our long commitment to home and family.

Robert A. Burnett
President and Chief Executive Officer
Meredith Corporation
Des Moines, Iowa

Director's Foreword

THE PIONEERING exhibition *In Pursuit of Beauty: Americans and the Aesthetic Movement* and the accompanying publication demonstrate the continuing commitment of the Metropolitan Museum's American Wing to the study of the arts of the last century, exemplified by the landmark show *Nineteenth-Century America* (1970) and reaffirmed in such permanent installations as the Nineteenth-Century Arts Gallery, the Greek Revival Parlor, the John Henry Belter Rococo Revival Parlor, and the Renaissance Revival Parlor. The current project is the first comprehensive study of a phenomenon that not only dominated the American arts of the 1870s and 1880s but also helped set the course of such later developments in the United States as the Arts and Crafts movement, the indigenous interpretation of Art Nouveau, and even the rise of modernism. In fact, the early history of the Metropolitan—its founding, its sponsorship of a school of industrial design, and its display of decorative works—is inextricably tied to the Aesthetic movement and its educational goals.

In Pursuit of Beauty: Americans and the Aesthetic Movement comprises some 175 objects including furniture, metalwork, stained glass, ceramics, textiles, wallpaper, painting, and sculpture. Some of these have rarely been displayed in recent years; others, although familiar, are being shown in new and even startling contexts. The exhibition is arranged thematically to illustrate both the major styles of a visually rich movement and the ideas that generated its diversity.

The exhibition and the book that accompanies it are the result of a long collaboration between members of the Museum's staff and a team of consulting scholars. Alice Cooney Frelinghuysen, Assistant Curator in the Department of American Decorative Arts, has served most ably as project director, coordinating every aspect of this complex show. In her efforts she has been assisted by Doreen Bolger Burke, Associate Curator in the Department of American Paintings and Sculpture, who was the curator responsible for the publication; Catherine Hoover Voorsanger, Research Associate, who supervised the extensive research program undertaken for the preparation of the book and who assisted in the development of the exhibition; and Carrie Rebora, Coordinator of American Wing Documentation, who organized the photography and wrote the captions for the book. From the outset several other scholars have been instrumental in shaping this project: David A. Hanks with Jennifer Toher, Marilynn Johnson, and Catherine Lynn, all of whom have also contributed essays to this volume; and Martin Eidelberg, whose participation throughout the organizational stages of the show proved invaluable. Essays by Jonathan Freedman, James D. Kornwolf, and Roger B. Stein have provided a broad context for the Aesthetic movement, placing it in its cultural and social milieu and examining its implications for architecture and literature of the era. Both the exhibition and the publication have benefited from the involvement of consultants Richard H. Brodhead, Sarah Bradford Landau, William R. Leach, Carl E. Schorske, and the late Warren Sussman, whose suggestions helped expand and enrich the other participants' perspectives on the Aesthetic movement.

In the Museum's Editorial Department, Amy Horbar, Editor, organized the diverse aspects of this volume and edited it with tenacity and skill; John P. O'Neill, Editor in Chief and General Manager of Publications, and Polly Cone, Executive Editor, supervised the endeavor.

Such an ambitious exhibition could only be achieved through the unstinting cooperation of many private and public lenders, whose objects appear in the show and whose names appear elsewhere in this volume. The Museum is also indebted to David Harvey of the Metropolitan's Design Department, who is responsible for the installation.

The publication *In Pursuit of Beauty: Americans and the Aesthetic Movement* has been subsidized by the William Cullen Bryant Fellows of The American Wing, who helped defray the expense of research, writing, editing, and production. The book is one of a number of proposed publications that will accompany exhibitions in The American Wing devoted to the exploration of major themes in our national art, particularly those that reflect the integration of painting, sculpture, and the decorative arts.

The exhibition has been made possible by a generous grant from the Meredith Corporation. Additional support from the National Endowment for the Humanities was received for both the planning and the implementation of the project.

Philippe de Montebello
Director
The Metropolitan Museum of Art

Contributors

DOREEN BOLGER BURKE, Associate Curator in the Department of American Paintings and Sculpture at The Metropolitan Museum of Art, wrote the third volume of *American Paintings in the Metropolitan Museum of Art* (New York, 1980) and was a contributor to the second volume in the same series, published in 1985. Her most recent project was a monograph on the American Impressionist J. Alden Weir, published in 1983 to accompany the artist's retrospective exhibition held at the Museum.

JONATHAN FREEDMAN is Assistant Professor of English at Yale University, where his dissertation, "'The Quickened Consciousness': Aestheticism in Howells and James," received the Rockwell Field Dissertation Award. He is currently preparing for publication a book entitled *Henry James and British Aestheticism.*

ALICE COONEY FRELINGHUYSEN, Project Director for the exhibition that this book accompanies, is Assistant Curator in the Department of American Decorative Arts at The Metropolitan Museum of Art, where she is responsible for ceramics and glass, as well as for late nineteenth-century furniture. She has recently directed The American Wing's installation of the Renaissance Revival Parlor and is currently preparing a catalogue for the exhibition *American Porcelain, 1770–1920,* to be held in April 1989.

DAVID A. HANKS has contributed to a number of exhibitions and publications on late nineteenth- and early twentieth-century decorative arts: *The Arts and Crafts Movement in America, 1876–1916* (The Art Museum, Princeton University, N.J., 1972), *The Decorative Designs of Frank Lloyd Wright* (Renwick Gallery of the National Museum of American Art, Smithsonian Institution, Washington, D.C., 1977), and *High Styles: Twentieth-Century American Design* (Whitney Museum of American Art, New York, 1985). He has also published articles on the nineteenth-century cabinetmakers Daniel Pabst and Isaac Elwood Scott. Formerly Curator, Department of American Art, Philadelphia Museum of Art, he is now president of his own decorative-arts consulting firm, David A. Hanks and Associates, Inc., New York.

MARILYNN JOHNSON was previously Associate Curator in the Department of American Decorative Arts at The Metropolitan Museum of Art. She helped organize the Museum's major exhibition *Nineteenth-Century America,* held in 1970, and contributed to the catalogue. Formerly Curator, Gracie Mansion Conservancy, New York, Ms. Johnson is now Chairman, Department of Museum Studies, at the Fashion Institute of Technology, New York.

JAMES D. KORNWOLF, Professor of Fine Arts at the College of William and Mary, has written articles and books on nineteenth-century British and American architecture, among them *M. H. Baillie Scott and the Arts and Crafts Movement: Pioneers of Modern Design* (Baltimore and London, 1972). Most recently he was a contributor to and the editor of *Modernism in America, 1937–1941: A Catalog and Exhibition of Four Architectural Competitions* (Muscarelle Museum of Art, College of William and Mary, Williamsburg, Va., 1985). He is currently completing a study of American and Canadian Colonial architecture, to be published by Cambridge University Press.

CATHERINE LYNN was Assistant Curator in charge of the wallpaper collection at the Cooper-Hewitt Museum, The Smithsonian Institution's National Museum of Design, New York, for seven years and authored the award-winning book *Wallpaper in America: From the Seventeenth Century to World War I* (New York, 1980). More recently she has taught the history of decorative arts at Yale University, Columbia University, and the Fashion Institute of Technology, New York.

CARRIE REBORA, Coordinator of American Wing Documentation at The Metropolitan Museum of Art, was Guest Curator of the exhibition *Jasper Cropsey Watercolors* at the National Academy of Design, New York, in 1985. She is currently preparing catalogue entries on Cropsey's work for the Metropolitan's forthcoming publication *The Hudson River School: The Rise of American Landscape Painting,* as well as catalogue entries to accompany William H. Gerdts's essay for the exhibition *Henry Inman and His Portraits,* to be held at the National Portrait Gallery, Washington, D.C.

ROGER B. STEIN, Professor of Art History at the University of Virginia, is the author of such exhibition catalogues as *Seascape and the American Imagination* (Whitney Museum of American Art, New York, 1975) and *Susquehanna: Images of the Settled Landscape* (Roberson Center for the Arts and Sciences, Binghamton, N.Y., 1981). Among his many articles are those on the artists John Singleton Copley, Charles Willson Peale, and Thomas Smith. He also wrote the pioneering study *John Ruskin and Aesthetic Thought in America, 1840–1900* (Cambridge, Mass., 1967).

JENNIFER TOHER, Associate with David A. Hanks and Associates, Inc., New York, was the editor of and a contributor to the exhibition catalogue *Beyond the Plane: American Constructions, 1930–1965* (New Jersey State Museum, Trenton, 1983). Ms. Toher, with David A. Hanks, authored an essay for the book that accompanied the exhibition *High Styles: Twentieth-Century American Design* (Whitney Museum of American Art, New York, 1985).

CATHERINE HOOVER VOORSANGER, formerly Curator of Fine Arts and Exhibitions at the California Historical Society, San Francisco, is currently Research Associate in the Department of American Paintings and Sculpture at The Metropolitan Museum of Art. She is contributing an essay to the Museum's forthcoming exhibition catalogue *The Hudson River School: The Rise of American Landscape Painting,* to be published in 1987.

Lenders to the Exhibition

Mr. and Mrs. Arthur G. Altschul
The Art Institute of Chicago
The Athenaeum of Philadelphia
Avery Architectural and Fine Arts Library, Columbia University, New York
The Bennington Museum, Vermont
Berry-Hill Galleries, Inc., New York
Mrs. Carl Bieser
Sonia and Walter Bob
Geoffrey N. Bradfield
The Brooklyn Museum, New York
Virginia Guard Brooks
Bryn Mawr College Library, Maser Collection, Pennsylvania
Margaret B. Caldwell and Carlo M. Florentino
Calvary Church, New York
The Chrysler Museum, Norfolk, Virginia
Cincinnati Art Museum
Cincinnati Historical Society
The Cleveland Museum of Art
Cooper-Hewitt Museum, The Smithsonian Institution's National Museum of Design, New York
The Corning Museum of Glass, Corning, New York
The Currier Gallery of Art, Manchester, New Hampshire
Detroit Institute of Arts
R. A. Ellison
Mr. and Mrs. W. Roger Fry
The Glessner House, Chicago Architecture Foundation
Hallmark Historical Collection, Hallmark Cards, Inc., Kansas City, Missouri
Mrs. Casper Heeg Hamilton
High Museum of Art, Atlanta
Marilyn and Jerome J. Hoffman
Houghton Library, Harvard University, Cambridge, Massachusetts
Barbara Jacobson
The John G. Johnson Collection, Philadelphia
Margot Johnson
Mr. and Mrs. Jay Lewis
Los Angeles County Museum of Art
Louis H. Sullivan Architectural Ornament Collection, Southern Illinois University at Edwardsville
Mary Jean McLaughlin
Maine Women Writers Collection, Westbrook College, Portland
Richard and Gloria Manney
Mark Twain Memorial, Hartford, Connecticut
Moses Mesre
Mitchell Wolfson, Jr., Collection of Decorative and Propaganda Arts, Miami-Dade Community College

Mr. and Mrs. I. Wistar Morris III
The Morse Gallery of Art, Winter Park, Florida
Museum of Art, Carnegie Institute, Pittsburgh
Museum of Art, Rhode Island School of Design, Providence
Museum of The City of New York
Museum of Fine Arts, Boston
The Museum of Fine Arts, Houston
Museum of Fine Arts, Springfield, Massachusetts
John Nally
The National Arts Club, New York
National Museum of American Art, Smithsonian Institution, Washington, D.C.
The Newark Museum, New Jersey
The Newberry Library, Chicago
New Jersey State Museum, Trenton
New York State Office of Parks, Recreation and Historic Preservation, Bureau of Historic Sites, Olana State Historic Site, Taconic State Park Region
The Oakland Museum, California
Philadelphia Museum of Art
Paul Reeves
Mr. and Mrs. John Rooney
The Rothschild Collection, Ltd.
Saint-Gaudens National Historic Site, National Park Service, U.S. Department of the Interior, Cornish, New Hampshire
The Saint Louis Art Museum
J. S. M. Scott
Shelburne Museum, Inc., Vermont
S. J. Shrubsole, Corporation, New York
Society for the Preservation of New England Antiquities, Boston
Spencer Museum of Art, The University of Kansas, Lawrence
Stowe-Day Foundation, Hartford, Connecticut
The Strong Museum, Rochester, New York
Marco Polo Stufano
Sunworthy Wallcoverings Collection, Reed Decorative Products, Ltd., Brampton, Ontario
Trustees of the British Museum, London
Trustees of the Victoria and Albert Museum, London
United States Trust Company of New York
The University of Michigan, School of Art and College of Architecture and Urban Planning, Ann Arbor
Veterans of the Seventh Regiment Armory, New York
Wadsworth Atheneum, Hartford, Connecticut
Barrie and Deedee Wigmore
Graham Williford
Yale University Art Gallery, New Haven
James L. Yarnall and Stephen M. Lovette

Acknowledgments

THE EXHIBITION *In Pursuit of Beauty: Americans and the Aesthetic Movement* has a long and rather complicated history. It was first conceived of more than ten years ago by Marilynn Johnson, then Associate Curator in the Department of American Decorative Arts at the Metropolitan Museum, but owing to the construction and ongoing installation of the new American Wing, its scheduling was postponed indefinitely. In 1982, when Ms. Johnson, Martin Eidelberg, David A. Hanks, and Catherine Lynn reintroduced the idea for the exhibition, the staff of The American Wing responded enthusiastically: Alice Cooney Frelinghuysen was appointed project director, Doreen Bolger Burke joined the curatorial team, and Catherine Hoover Voorsanger began the extensive research on architects, artisans, artists, and manufacturers that resulted in the Dictionary that appears in this publication. At that time the exhibition was scheduled for more than one venue. We are grateful to the High Museum of Art, Atlanta, especially to Gudmund Vigtel, Director, and Donald C. Peirce, Curator of Decorative Arts, for their contributions and consideration of the exhibition during its early stages. The High Museum received a planning grant from the National Endowment for the Humanities; it was this grant that gave the curators of the exhibition the opportunity to explore its interdisciplinary themes and enabled them to travel for the purpose of locating objects for the show. For assisting us in the development of both this grant and the subsequent implementation grant awarded to the Metropolitan in 1984, we thank Gabriel P. Weisberg, Steve Mansbach, and Gail Capitol Weigl at the National Endowment. This financial support enabled the curators to benefit from the insights and advice of consultants Richard H. Brodhead, Martin Eidelberg, Sarah Bradford Landau, William R. Leach, Carl E. Schorske, and the late Warren Sussman and to invite Jonathan Freedman, James D. Kornwolf, and Roger B. Stein to write essays for the accompanying publication.

We would like to acknowledge the many Museum staff members who have contributed so generously to our progress over the past five years. John K. Howat, Lawrence A. Fleischman Chairman of the Departments of American Art, recognized the potential of the project from the outset and provided his support at every stage of its development. Lewis I. Sharp, Curator and Administrator of The American Wing, guided us around many an administrative obstacle, often with the help of his assistant, Emely Bramson. To all our curatorial colleagues in the Departments of American Decorative Arts and American Paintings and Sculpture we offer our gratitude for making *In Pursuit of Beauty* a priority, frequently at the expense of their own work. In the Department of American Decorative Arts, we are especially indebted to Morrison H. Heckscher, Curator, for his help with furniture and architecture; R. Craig Miller, Associate Curator, for his assistance on architecture; Amelia Peck, Curatorial Assistant, for her advice on

textiles and upholstery; and Frances Gruber Safford, Associate Curator, for sharing her knowledge about silver objects. Administrative Assistants Nancy Gillette, Pamela Hubbard, Barbara A. Whalen, and especially Ellin Rosenzweig performed essential tasks of all kinds. Our departmental technicians, George Asimakis, Gary Burnett, Don E. Templeton, and Jason J. Weller, have provided their usual able assistance, not only during the exhibition's installation but also during a long period of preparation, when many objects included in the show were being conserved, studied, and photographed. We are grateful as well to Kathleen Luhrs, Editor; Dale Johnson, Research Assistant; and Lauretta Dimmick, Chester Dale Fellow, for their interest in the project.

Catherine Hoover Voorsanger coordinated the research phase of this undertaking and directed the activities of a large corps of volunteers and interns, who gave selflessly of their time and expertise. We thank volunteers Barbara Ball Buff, Jo-Nelle Long, Ann-Louise Mitton, Elizabeth Quackenbush, Linda Shulsky, Miriam Stern, and Rebecca St. L. Tennen, as well as interns Mary Raymond Alenstein, who also aided Ms. Voorsanger in the preparation of the manuscript for the Dictionary, Mishoe Brennecke, Ruth Wilford Caccavale, Teresa A. Carbone, Maria Carruba, Alice Evarts, Elizabeth Frosch, Deborah Ann Goldberg, Merrill Halkerston, Diana Linden, Elizabeth Russell McClintock, Matthew J. Murray, Alice Pennisi, Christopher Reed, Gretchen Price Rude, and Nina R. Rutenberg. Ms. Carbone, Gail Stavitsky, and Carrie Rebora researched the many architects, artisans, artists, and manufacturers of works included in the show. Ms. Rebora continued as research assistant and performed myriad tasks both large and small to ensure that this ambitious project would become a reality.

Many individuals throughout the Museum have contributed their efforts to *In Pursuit of Beauty* and well deserve our thanks. Philippe de Montebello, Director, and James Pilgrim, Deputy Director, not only offered their support, but also demanded a sense of discipline that proved crucial in shaping the exhibition and publication. John K. McDonald, Assistant to the Director; Linden Havemeyer Wise, Assistant Secretary and Associate Counsel; and Jeanie M. James, Archivist, provided assistance in their special areas. Emily Kernan Rafferty, Vice President for Development, and her very competent staff, particularly Patricia White Maloney and Nina McNeely Diefenbach, worked tirelessly to secure funding for the exhibition. John Ross, Manager of Public Information, assisted by Daniel Schlenoff, coordinated press matters and public relations. Marilyn G. Jensen, Manager and Book Buyer, Trade and Book Buying, offered essential advice and enthusiastic support. Joanne Lyman, Manager, Objects Reproduction and Reproduction Studio, selected and supervised the production of objects made for sale in conjunction with the show. Bruce Wineberg oversaw the production of sales posters. John Buchanan, Registrar, with

Herbert M. Moscowitz and Laura Rutledge Grimes of his staff, made the many arrangements necessary for insurance, packing, and shipping of loans. The staff of all the Museum's conservation departments did important work for the exhibition: Dianne Dwyer in Paintings Conservation, Helen Otis and Margaret Lawson in Paper Conservation, Elena Phipps in Textile Conservation, and most especially the staff of Objects Conservation, in particular John Canonico, Rudolph Colban, Kathryn Gill, Hermes Knauer, Yale Kneeland, William Louché, Steven A. Weintraub, and Henry F. Wolcott, Jr., as well as supervising installer Jeffrey Perhacs. Arthur Femenella, Melville Greenland, and Mary Clerkin Higgins of the Greenland Studios, New York, helped with the conservation of stained glass. David Harvey, Designer, was responsible for the handsome installation, which so sympathetically displays the varied works of art in the exhibition. In the Department of Public Education, Meredith Johnson and Linda Lovell developed the educational programs for the show, and Peter Donhauser and Susan Mahoney coordinated the interns working on the project.

Because so many of the objects included in the exhibition represent cultures and periods outside those under the jurisdiction of The American Wing, we have drawn heavily on the collections and knowledge of other curatorial departments within the Museum. For help of this kind we thank James David Draper, Jessie McNab, and James Parker, as well as volunteer Carolyn Cassilly, of the Department of European Sculpture and Decorative Arts; Jean Mailey of the Textile Study Room; Barbara B. Ford, Marise Johnson, and Alfreda Murck of the Department of Far Eastern Art; Joan R. Mertens of the Department of Greek and Roman Art; Marilyn Jenkins of the Department of Islamic Art; and David W. Kiehl and Robert Luck of the Department of Prints and Photographs.

William B. Walker and the staff of the Thomas J. Watson Library deserve special notice; we particularly thank Katria Czerwoniak and Daphne G. Estwick, for securing the immense number of interlibrary loans that this project required, as well as Ljuba Backovsky, Patricia J. Barnett, Patrick F. Coman, Ilse M. Daniel, Philip A. D'Auria, Kathryn Deiss, Kenneth Dinin, Mindell Dubansky, Paula Frosch, Edith Galaska, Joan Glaser, Robert W. Hamilton, Ana Hofmann, Céline Palatsky, Doralynn Pines, Donya-Dobrila Schimansky, Albert Torres, David K. Turpin, and Edward K. Werner.

The authors extend their deepest gratitude to Amy Horbar, Editor, who coordinated and edited this publication. She skillfully oversaw every aspect involved in this complicated project and directed the efforts of her colleagues. John P. O'Neill, Editor, in Chief and General Manager of Publications, contributed his support to the undertaking from its inception, and Polly Cone, Executive Editor, offered valuable guidance. In the preparation of the enormous manuscript, Ms. Horbar was ably assisted by Sue Potter, who edited four of the essays, Mary-Alice Rogers, Editor of Bryant Fellows Publications, who edited the three contributed by The American Wing curators, and Cynthia Clark, who edited the Dictionary of Architects, Artisans, Artists, and Manufacturers. The monumental task of verifying notes, references in the Dictionary, and citations in the Selected Bibliography was the work of Jean Wagner, with Laura Hawkins. The authors are indebted to all these editors for their substantial contributions. Joseph B. Del Valle designed this sumptuous book; Maria Miller and Michael Harvey prepared the mechanicals. Suzanne Bodden, Production Associate, supervised the production. For the fine photography of many of the objects illustrated here, we are grateful to David Allison. Barbara Cavaliere, with Carol Saltus and Katherine Balch, proofread the galleys, and Elizabeth Finkelstein and Julie Rosenbaum performed countless helpful functions.

Many individuals outside the Museum contributed to the success of the project. Descendants of collectors, craftsmen, and designers and their families who have generously shared manuscript material, reminiscences, and objects with us include Mr. and Mrs. Albert R. Bennett and Mr. and Mrs. William Bennett on John Bennett; Mrs. Carl Bieser, Adelaide Ottenjohn, and Virginia Sterling on Emma Bepler; Arthur L. Bolton, Ann Bomann, Virginia Guard Brooks, Janet Cottier Cheney, Henry Guard, Joan Cottier Kennedy, and Joyce Stewart on Daniel Cottier; Mr. and Mrs. W. Roger Fry on Henry Lindley Fry and William Henry Fry; George G. Frelinghuysen, Adaline Havemeyer Rand, and J. Watson Webb, Jr., on Mr. and Mrs. Henry Osborne Havemeyer; Mrs. Henry La Farge on John La Farge; Barea Lamb Seeley on the J. and R. Lamb Studios; Mr. and Mrs. John Stewart and Mr. and Mrs. Richard Thompson on Adelaide Nourse Pitman and Benn Pitman; and Marian Ware Balch, Betty Ware Sly, Hilda Ware Sturges, Hugh Cabot Ware, and Cary Cabot Wright on Alice Cunningham Ware.

Many of the commercial firms important during the Aesthetic period continue in business today and have provided us with invaluable information about their histories and products. For their help we thank Paul W. Thurston of Bailey, Banks and Biddle; Audrey Wall of Elkington Mansill Booth Limited, Walsall, England; J. L. Kaswan, formerly of I. P. Frink; Jay Johnson, J. W. Madden, Edward Money, and Warren Thomas of Gorham Division of Textron Inc.; Carolyn Aram of Arthur Sanderson and Sons, Uxbridge, England; Janet Zapata of Tiffany and Company, as well as Amanda Austin, formerly of that firm. We are also grateful to Malcolm A. Cooper of Sunworthy Wallcoverings Collection, Reed Decorative Products, Ltd., Brampton, Ontario, for access to that company's extensive collection of wallpapers.

Several individuals furthered this project by graciously opening their homes to all or some of the authors, sharing with them their collections and expertise or, in some cases, period woodwork and decoration. For this we are grateful to Florence I. Balasny-Barnes, Mr. and Mrs. Robert Cavally, Bob Ellison, Jan Feld, Gilbert and George, Dr. and Mrs. Eric Glanzer, the late Allen Harriman, Betty and Bob Hut, David Jenks, Edward Judd, Emma and Jay Lewis, William and Carol Nagel, John Nally, Peter Rose, Bill Rubin, J. S. M. Scott, Mr. and Mrs. Richard Sellee, Marco Polo Stufano, Deedee and Barrie Wigmore, and Mrs. Stanley Woodward. We would also like to thank George H. Boynton, George H. Boynton, Jr., Mrs. Jackie Kornfeld, Mary McTamaney, and Mr. and Mrs. Albert Winslow, who kindly provided information about and served as guides to Tuxedo Park. Francis D. Bartow; Bruce Bradbury; the Reverend Stephen Garmey, Calvary Church; O. Aldon James, Jr., Hildegarde F. Smith, and Janet Sumner, The National Arts Club; Craig Littlewood; Craig Maue; Claire R. Smalley, whose father worked for D. F. Haynes and Company; Alice Van Straalen; Henry C. White; and Elise Wright also came to our aid.

Numerous scholars supplied unpublished information on architects, artists, designers, craftsmen, and manufacturers and their works. For their assistance in bringing works of art to our attention, for sharing their research, biographical data, and in some cases for reviewing and correcting biographical entries, we thank David Adams; Henry B. Adams, The Nelson-Atkins Museum; Diane L. Fagan Affleck, Museum of American Textile History; Elizabeth M. Aslin; Paul Atterbury; Martha Baron; E. Bernard; Jennifer A. Martin Bienenstock; Doris Bowman, National Museum of American Art, Smithsonian Institution; Mary Alice Heekin Burke; Shirley Bury, formerly of the Victoria and Albert Museum, London; Charles H. Carpenter, Jr.; Jan P. Christman; Michael Collins, The British Museum, London; Michael Darby, Victoria and Albert Museum, London; Ellen and Bert Denker; Ulysses G. Dietz, The Newark Museum; Michael Donnelly, The People's Palace, Glasgow; Samuel Dornsife; John H. Dryfhout, Saint-Gaudens National Historic Site; Stuart Durant, Kingston Polytechnic, Kingston upon Thames, England; Michael J. Ettema, National Museum of American History, Smithsonian Institution; Desmond Eyles; Betsy Fahlman, Old Dominion University; Wilson H. Faude, The Old State House Association, Hartford; Gail

Fenske; Jean A. Follett; John Crosby Freeman, American Life Foundation; William H. Gerdts, Graduate School and University Center, The City University of New York; Mark Girouard; Geoffrey A. Godden; Anne Castrodale Golovin, National Museum of American History, Smithsonian Institution; Lloyd Goodrich and the late Edith Havens Goodrich; Tammis Kane Groft, Albany Institute of History and Art; Jean D. Hamilton, Victoria and Albert Museum, London; Martin Harrison; Charles Hasbrook, New York Landmarks Preservation Commission; Susan Hobbs; Margaret H. Hobler; Louise Irvine, Royal Doulton International Collectors Club, London; Kresten Jespersen; Bruce R. Kahler, Purdue University; Joy Kestenbaum; Juliet Kinchin, Pollok House, Glasgow Art Gallery and Museum; Jean Callan King; Joseph Pell Lombardi; Kenneth S. Lord; Robert Irwin Lucas; Martha Crabill McClaugherty; Celia Betsky McGee; Sean M. McNally; Patricia C. F. Mandel; Jana Kaye Martin; Frank Matero, Columbia University; Laura Meixner, Cornell University; Nancy Merrill, The Chrysler Museum; Mary Alice Molloy; Barbara White Morse; Sarah Nichols, Museum of Art, Carnegie Institute; Richard Nylander, Society for the Preservation of New England Antiquities; Ruth O'Brien, New York Landmarks Preservation Commission; Morihiro Ogawa; Linda Parry, Victoria and Albert Museum, London; Donald C. Peirce, High Museum of Art; Lisa Peters; Ronald G. Pisano; David F. Ransom; Albert Christian Revi; Carlyn Crannell Romeyn; Rodris Roth, National Museum of American History, Smithsonian Institution; Judy Rudoe, The British Museum, London; James A. Ryan, Olana State Historic Site; Sophia Duckworth Schachter; Norris F. Schneider; Marvin D. Schwartz; Arlene Palmer Schwind; Beverley Sherry, University of Sydney, Australia; Wayne Smith; Regina Soria; Jane Shadel Spillman, The Corning Museum of Glass; Laura Fecych Sprague; Mary Ann Stankiewicz, University of Maine, Orono; Annie V. F. Storr, University of Delaware; Peter L. L. Strickland; James L. Sturm; Raymond T. Tatum; Edward Teitelman; Susan Tunick; Clive Wainwright, Victoria and Albert Museum, London; Karin M. Walton, City of Bristol Museum and Art Gallery, England; Bruce Weber, Norton Gallery and School of Art; H. Barbara Weinberg, Queens College of The City University of New York; Dr. Eugene E. Weise; Helen Weiss, The Willet Stained Glass Studios; Susan R. Williams, The Strong Museum; and James L. Yarnall. Our colleagues Anita J. Ellis, Cincinnati Art Museum; Elaine Harrington, Glessner House, Chicago Architecture Foundation; and Kenneth R. Trapp, The Oakland Museum, deserve special acknowledgment for their constant enthusiasm in the face of a multitude of queries, site visits, and photography requests.

Many museums, libraries, and historical societies assisted us by making their collections accessible, answering numerous inquiries, and offering useful suggestions. We would like to thank all our colleagues at the Engineer Society's Library, the Genealogical and Biographical Society of New York, The Library of Congress, The New-York Historical Society, The New York Public Library, The New York Society Library, and Yale University Library. We are particularly grateful to the following individuals and their institutions: Barbara R. Luck, Abby Aldrich Rockefeller Folk Art Center; Susan Safford, Albany Institute of History and Art; John Lancaster, Amherst College; Arleen Pancza, Archives of American Art; Susan Glover Godlewski and John Zukowsky, The Art Institute of Chicago; Lawrence Campbell, Art Students League; Roger W. Moss, The Athenaeum of Philadelphia; Mark A. Mastromarino, Baker Library, Harvard University; Kirk Nelson, The Bennington Museum; Jonathan P. Harding, Boston Athenaeum; Therese Cederholm, Boston Public Library; James Bettley and Ruth Kamen, The British Architectural Library, Royal Institute of British Architects, London; Elizabeth Ann Coleman, Dianne H. Pilgrim, Kevin Stayton, and Polly Willman, The Brooklyn Museum; Mary S. Leahy, Bryn Mawr College Library; Gerald Wright, California Historical Society; Ann M. Loyd, Carnegie Library of Pittsburgh; David Jones, Castle Museum, Norwich, England; Mark Davis and Andrew Zaremba, The Century Association; Ralph Pugh, Chicago Historical Society; Carolyn R. Shine, Cincinnati Art Museum; Laura Chase, Frances Forman, and Anne B. Shepherd, Cincinnati Historical Society; Emmeline Leary, City Museums and Art Gallery, Birmingham, England; J. Fraser Cocks III, Colby College; Herbert Mitchell and Janet Parks, Avery Architectural and Fine Arts Library, and Rudolph Ellenbogen, Rare Book and Manuscript Library, both at Columbia University; Carole Holmes, The Connecticut Historical Society; Elaine Evans Dee, Ann Dorfsman, Margaret Luchars, David Revere McFadden, Gillian Moss, and Milton Sonday, Cooper-Hewitt Museum, The Smithsonian Institution's National Museum of Design; Carol Abatelli, The Cooper Union for the Advancement of Science and Art; Katherine Kovacs, Corcoran Gallery of Art; Norma Jenkins, The Corning Museum of Glass Library; Karen A. Fordyce and Marilyn F. Hoffman, The Currier Gallery of Art; Electa Kane Tritsch, Dedham Historical Society; Alan Phipps Darr and Nancy Rivard Shaw, Detroit Institute of Arts; Marilynn Soules, Dundurn Castle, Hamilton, Ontario; Dorothy T. King, East Hampton Free Library; P. R. Hoare, The Edgehill Trust, Kent, England; Wesley L. Wilson, Enoch Pratt Free Library; Anne Farnum, Essex Institute; Marianne Promos, The Free Library of Philadelphia; Helen A. Harrison, Guild Hall Museum; Joanne Avant, The Haggin Museum; Glenys A. Waldman, The Historical Society of Pennsylvania; Joanne B. Moore, Historical Society of Western Pennsylvania; Nancy Finlay, Houghton Library, Harvard University; Margaret C. Conrads, formerly of the Hudson River Museum; Elsie Reinert, Ipswich Historical Society; Mary E. Carver, J. B. Speed Art Museum; Cynthia H. Sanford, Jersey City Museum; Robert M. Bartram, George Peabody Library of the Johns Hopkins University; David Fournier, Levi Heywood Memorial Library; Clara Lamers, The Long Island Historical Society; David C. Huntley, Louis H. Sullivan Architectural Ornament Collection, Southern Illinois University at Edwardsville; Mrs. Arvin Karterud, Lyman Allyn Museum; Jacqueline Beaudon-Ross, McCord Museum, Montreal; Dorothy Healy, Maine Women Writers Collection, Westbrook College; Marianne J. Curling and Wynn Lee, Mark Twain Memorial; Aaron Acker, Marshall Historical Society; Laurie A. Baty and Francis P. O'Neill, Maryland Historical Society; John D. Cushing, Massachusetts Historical Society; Richard B. Heath, Milton Historical Society; Stephen Greenguard, Mitchell Wolfson, Jr., Collection of Decorative and Propaganda Arts, Miami-Dade Community College; Thomas S. Michie and Christopher Monkhouse, Museum of Art, Rhode Island School of Design; John Carmichael, Jonathan Fairbanks, Helen Hall, Wendy Kaplan, and Cathie Zusy, Museum of Fine Arts, Boston; Katherine S. Howe, The Museum of Fine Arts, Houston; Ernest A. Levesque, The Nashua Historical Society; Abigail Booth Gerdts and Barbara Krulik, National Academy of Design; Everett Raymond Kinstler, The National Arts Club; Lenore Gershuny, George Gurney, Susan R. Gurney, and William H. Truettner, National Museum of American Art, Smithsonian Institution; Charles G. Berger and Carolyn Long, National Museum of American History, Smithsonian Institution; Valerie Ann Weinberger, Newark Public Library; Janie Chester Young, New Bedford Glass Museum; Ralph J. Crandall, New England Historic Genealogical Society; William N. Copeley, New Hampshire Historical Society; Susan Finkel and Kathleen Stavec, The New Jersey Historical Society; Suzanne Corlette Crilley and Maxine Friedman, New Jersey State Museum; John A. Cherol and Roxanne Hadfield Squibbs, Preservation Society of Newport County; Mary Jean Blasdale, Old Dartmouth Historical Society; Elizabeth Banks, Olmsted National Historical Site; Elizabeth Milroy, Pennsylvania Academy of the Fine Arts; Gail L. Davis, Philadelphia Museum of Art; Charlene B. Santos, Rhode Island Historical Society; Christina H. Nelson, The Saint Louis Art Museum; Martha Hassell,

Sandwich Glass Museum; Laura Luckey and Margaret L. Smith, Shelburne Museum, Inc.; Carolyn Hughes, Elizabeth Redmond, Ellie Reichlin, and Penny J. Sander, Society for the Preservation of New England Antiquities; Joan Severa, The State Historical Society of Wisconsin; Rebecca B. Colesar, State Library, State of New Jersey; Diana Royce and Joseph S. Van Why, Stowe-Day Foundation; Richard Edgcumbe, Philippa Glanville, and Andrew Hiskens, Victoria and Albert Museum, London; Mary Ann Carnado, Wadsworth Atheneum; William E. Jones, Wakefield Historical Society; and Eleanor McD. Thompson, Henry Francis du Pont Winterthur Museum.

A great number of individuals assisted us in obtaining photographs for the publication. We would like to thank especially Cindy Cannon, The Art Institute of Chicago; Michael Gotkin, Avery Architectural and Fine Arts Library, Columbia University; Philip Bergen, Bostonian Society; B. A. Martin, The British Museum, London; Glenda Galt, The Brooklyn Museum; Joy Payton, Cincinnati Art Museum; Sarah Seggerman, Cooper-Hewitt Museum, The Smithsonian Institution's National Museum of Design; Margaret Wong, Documents Collection, College of Environmental Design, University of California, Berkeley; Alice Nightingale, High Museum of Art; M. P. Naud, Hirschl and Adler Galleries, Inc.; Pamela Tippman, Los Angeles County Museum of Art; Eric Barnett, Louis H. Sullivan Ornament Collection, Southern Illinois University at Edwardsville; Allison M. Eckardt, *The Magazine Antiques;* Elizabeth I. Wade, Missouri Historical Society; Carol Alper, Mitchell Wolfson, Jr., Collection of Decorative and Propaganda Arts, Miami-Dade Community College; Jane Hankins and Janice Sorkow, Museum of Fine Arts, Boston; Bonnie Ray, The Museum of Fine Arts, Houston; Sarah Brown, National Monuments Record, London; Patricia Geeson and Kathy Wirtala, National Museum of American Art, Smithsonian Institution; Robert Harmon, Pennsylvania Academy of the Fine Arts; and Rita Eckartt, Tiffany and Company.

Among the auction houses and commercial art dealers who cooperated with our research, we thank in particular Alastair Duncan, Guy Jennings, Dan Klein, and Nancy McClelland, Christie, Manson and Woods International, Inc.; Thomas Colville; Roy Davis, Davis and Langdale; Richard Dennis, London; Eileen Dubrow; Mimi Findlay; Andrew McIntosh Patrick and Peyton Skipwith, The Fine Art Society Limited, London; Jack Feingold, Gem Antiques; Wendy M. Weaver, Graham Gallery; Michael Whiteway, Haslam and Whiteway Limited, London; Helen Hersch; Stuart P. Feld and Douglas Dreishpoon, Hirschl and Adler Galleries, Inc.; Margot Johnson; Beth Cathers, Victoria Garvin, Vance Jordan, Megan McKearny, and Todd Volpe, The Jordan-Volpe Gallery; Richard McGeehan; Bryce R. Bannatyne, Jr., P. G. Pugsley and Son; Barbara E. Deisroth, Sotheby's; Gary and Diana Stradling; and Anthony A. P. Stuempfig.

We would like to offer our thanks to colleagues who provided our consultant authors with assistance and support. Jonathan Freedman is grateful to Anne Badger, Richard H. Brodhead, Charles Feidelson, and Amelia Zurcher, all at Yale University; David A. Hanks and Jennifer Toher acknowledge the help of Ellen Davidson, Richard P. Goodbody, Robert Skelton, and especially Caroline E. Stern; and James D. Kornwolf is indebted to the Department of Fine Arts at the College of William and Mary, and to Georgiana W. Kornwolf, Peggy Miller, Nancy O'Brien, and Valentin Stalowir at that same institution.

We would like to extend our deep appreciation and thanks to all the lenders to *In Pursuit of Beauty,* who are listed separately and without whom the exhibition and book would not have been possible. The symposium on the American Aesthetic movement held at the Metropolitan Museum in conjunction with the show has been generously funded by Deedee and Barrie Wigmore.

Finally, Meredith Corporation deserves special acknowledgment for its generous sponsorship, which made the exhibition a reality. In particular, we thank Phillips van Dusen, Contributions Management, who helped bring Meredith and the Museum together, and all those at Meredith Corporation, especially Robert A. Burnett, President and Chief Executive Officer; Leo Armatis, Staff Vice President, Corporate Relations; Ken McDougall, Community Relations Director, and his successor, Gail Stilwill; Larry Riley, Manager, Corporate Information; and Rita Barnes, Eastern Public Relations Representative, for their enthusiastic support of the project.

The Authors

Explanatory Notes

Architects, artisans, artists, and manufacturers represented by works in the exhibition *In Pursuit of Beauty: Americans and the Aesthetic Movement* are included in the Dictionary in this publication, and their names appear in UPPERCASE letters at the first mention in each essay and Dictionary entry.

Dimensions: Height precedes width. Other dimensions are indicated where relevant.

Figures/Illustrations: Every work included in the exhibition is designated in this book as a figure (FIG.). Every supplementary work is referred to as an illustration (ILL.).

In Pursuit of Beauty

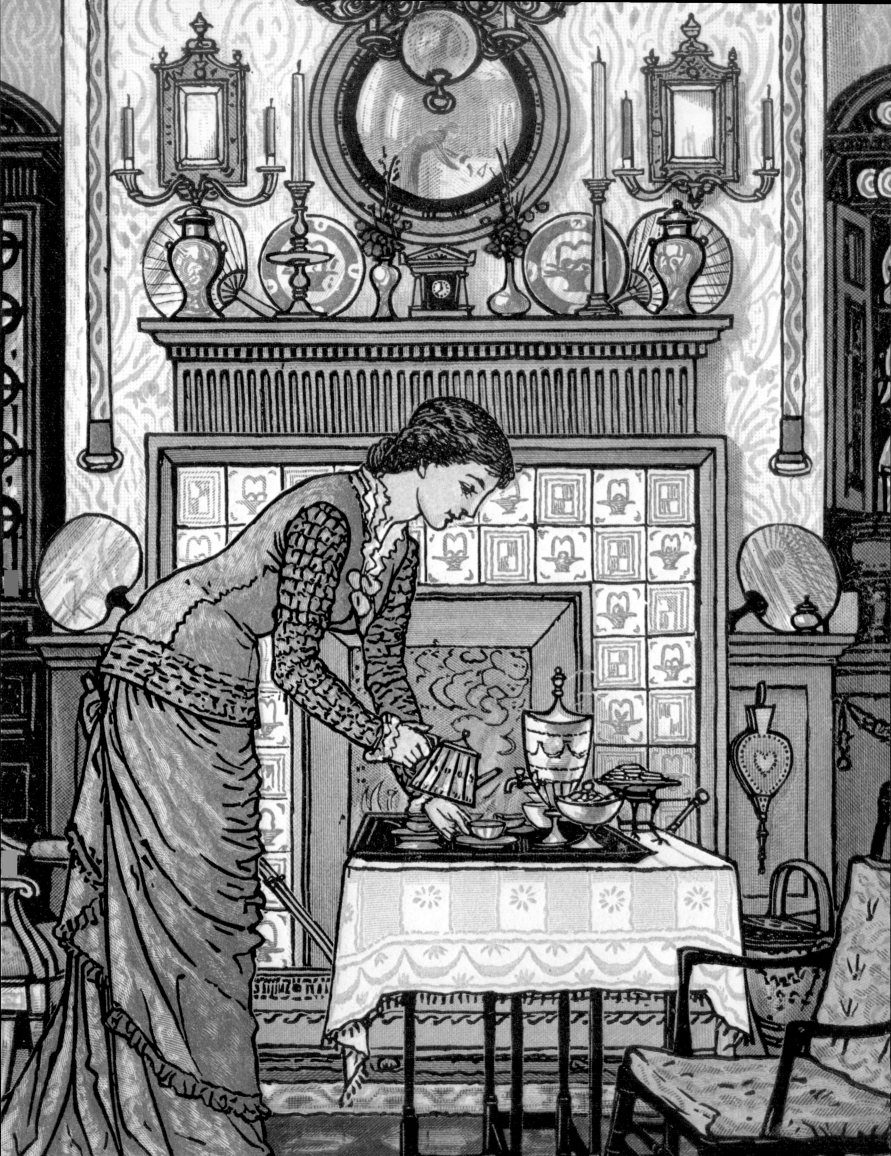

Preface

THE TERM "Aesthetic movement" refers to the introduction of principles that emphasized art in the production of furniture, metalwork, ceramics, stained glass, textiles, wallpapers, and books. During its height, from the mid-1870s through the mid-1880s, the Aesthetic movement affected all levels of society in America. The catalyst for its widespread popularity was the Philadelphia Centennial Exposition of 1876. There, in numerous displays, many Americans, artists and craftsmen as well as the general public, were exposed to art objects from a great variety of nations and periods.

A proliferation of art magazines, books, societies, clubs, and exhibitions followed in the wake of the Centennial. New periodicals, often profusely illustrated, extolled the beauties and benefits of art: the British publications *Magazine of Art* and *Art Journal* commenced editions in the United States, educating the American populace; *Art Amateur, Art Interchange,* and *Art Age* counseled their readers on how to decorate their homes and how to make their own aesthetic objects; and even general magazines, for example, *Scribner's Monthly* (later *Century Illustrated Monthly Magazine*), became more artistic in appearance and content, with articles that addressed issues of design. The covers, illustrations, and advertisements of these magazines were highly ornamental, with eccentric typography and stylized marginal decoration. The first of the best-selling books that proselytized innovative approaches to decoration, CHARLES LOCKE EASTLAKE's *Hints on Household Taste* (London, 1868), was reissued in at least eight American editions between 1872 and 1886. A number of American books were modeled on Eastlake's example, including *Art Education Applied to Industry* (1877) by GEORGE WARD NICHOLS, *The House Beautiful* (1878) by CLARENCE COOK, and *Art Decoration Applied to Furniture* (1878) by HARRIET PRESCOTT SPOFFORD.

Societies and clubs like the Society of Decorative Art, founded in New York in 1877, became commonplace across America, not only in major cities such as Cincinnati and San Francisco, but also in small towns. Painters and sculptors together explored decorative media, working outside the traditional academic program; in 1877 alone New York artists established the Tile Club, the Society of American Artists, and the New York Etching Club. Every international exposition and countless exhibitions and local fairs

Opposite: Detail of "My Lady's Chamber." Walter Crane. Clarence Cook, *The House Beautiful* (New York, 1878). Thomas J. Watson Library, The Metropolitan Museum of Art

displayed art and decorative objects, reinforcing and disseminating aesthetic ideas.

Another result of the Philadelphia celebration was an exaggerated enthusiasm for collecting artistic works. Cabinets and overmantel shelves became repositories for everything from fine art to bric-a-brac. Wealthy patrons, Mr. and Mrs. Henry Osborne Havemeyer and William H. Vanderbilt among them, assembled eclectic collections that included contemporary paintings, carpets from the Ottoman Empire, porcelains from China and Japan, and glass from Venice. Private mansions were occasionally opened to the public, and elaborately illustrated catalogues glorified prominent collections. Artists and craftsmen such as LOUIS COMFORT TIFFANY, JOHN LA FARGE, and EDWARD C. MOORE gathered decorative objects that served as inspiration for their own designs. For artists, as for patrons, the display of art became a form of self-aggrandizement. The artist's studio—that of WILLIAM MERRITT CHASE, for instance—became a showplace for its inhabitant's possessions as well as for his creations.

It was the interior, particularly the domestic interior, that best expressed the taste of the Aesthetic era. During these years the major decorators—HERTER BROTHERS, ASSOCIATED ARTISTS, and La Farge's Decorative Art Company—completed lavish interiors in consultation with their patrons and in collaboration with architects, craftsmen, and other artists. Examples of aesthetic decoration from the late 1870s and early 1880s include the apartment of Louis Comfort Tiffany, the mansion of Governor Samuel J. Tilden, the baronial residences of William H. Vanderbilt and his son Cornelius II, and the Seventh Regiment Armory, all in New York; the Pennsylvania Academy of the Fine Arts in Philadelphia; Mark Twain's house in Hartford; and the homes of Frederick L. Ames and Oliver Ames, Jr., in Boston.

Few of these interiors remain intact, and precious little survives to suggest their richness and beauty. They were photographed and illustrated in books like *Artistic Houses* (1883–84), but while period documents preserve the overall composition of the design schemes, they cannot possibly convey the ambience of each room. The layering and juxtaposition of many different patterns and the use of a subtle palette of colors closely related in value, hue, and tone demonstrated a heightened artistic consciousness on the part of the decorator and at the same time demanded a refined sensibility on the part of the visitor. Each object or detail deserved close attention, yet, like a mosaic, the whole became unified when seen from a distance.

The American Aesthetic movement evolved from British reform

ideas, which began to emerge as early as the 1830s and were concerned with principles that would improve contemporary design. London's Great Exhibition of 1851 made clear the objectionable qualities of manufactured goods, among them an affinity for curved, ponderous forms, and a horror vacui, or aversion to blank surfaces, which often led to a plethora of ornament that threatened to overwhelm an object and to obscure its use. As a result of what they saw at the 1851 fair, Henry Cole (1808–1882) and others redefined the goals of the industrial-training programs conducted throughout England in the Normal Schools of Design; in 1857 they founded the South Kensington Museum (now the Victoria and Albert Museum), a national museum of design, with Cole as its first director.

Even prior to the Great Exhibition, in the early 1840s Augustus Welby Northmore Pugin (1812–1852), champion of the Gothic style, originated two tenets of ornamentation that remained critical to reform theory throughout the century: the embellishment of "useful" forms with motifs from nature, and the decoration of flat surfaces with two-dimensional patterns. Following Pugin's lead, artists and architects associated with Cole's South Kensington circle helped formulate theories that were to give direction to the Aesthetic movement. OWEN JONES stated a series of "propositions" in his influential book The Grammar of Ornament (1856). He supported many of his points with examples from oriental art and admired Persian, Moorish, Egyptian, and other exotic styles, all of which would inform the aestheticism of the next three decades.

The legacy of Jones and his South Kensington colleagues may be found in the work of Eastlake, E. W. GODWIN, CHRISTOPHER DRESSER, and BRUCE J. TALBERT—individuals whose impact on the Aesthetic movement in America was crucial. In their pursuit of beauty these artists endeavored to alter radically the prevailing attitudes toward design. Talbert's furniture and interiors exemplified the rectilinear lines, honest construction, and conventionalized ornament that Eastlake recommended in Hints on Household Taste. Godwin's Anglo-Japanesque furniture of the 1870s expressed many of these same ideas. Dresser, a botanist and early in his career an assistant to Jones, advanced design theory further toward abstraction. His two-dimensional patterns, based on geometry and motifs from nature, were increasingly composed of compartmentalized elements of line, shape, and color. The Englishmen John Ruskin (1819–1900) and WILLIAM MORRIS also significantly influenced the course of the Aesthetic movement in America. Ruskin's greatest contribution was his crusade to elevate the decorative arts to the status of the fine arts. Like Ruskin, who held the utopian belief that a more artful environment could be morally uplifting, Morris argued that reform in art was a means of improving society. Morris carpets, wallpapers, and textiles were widely distributed in America during the 1880s.

During this era of expanded trade and easier travel, many British designers, artists, and craftsmen emigrated to America, lured by economic and creative opportunities. Ceramist JOHN BENNETT, glass stainer CHARLES BOOTH, and wood carver BENN PITMAN, to name only three, brought British art principles with them across the Atlantic. During his American lecture tour in 1882–83, Oscar Wilde's (1854–1900) arrogant posture and elitism were satirized by the press, promoting popular interest in aestheticism. During the Aesthetic period a great number of Americans, artists and manufacturers among them, visited Britain, where they were exposed to innovative designs and manufacturing techniques. At the same time, the British admired the work of American manufacturers, notably TIFFANY AND COMPANY and the J. AND J. G. LOW ART TILE WORKS.

Progressive design ideas found their earliest American expression in Modern Gothic furniture, which emphasized revealed construction and architectonic forms with shallow-carved and incised motifs. The work of Talbert, widely known through his book Gothic Forms Applied to Furniture, Metal Work, and Decoration for Do-

mestic Purposes (1867), inspired such American furniture makers as A. KIMBEL AND J. CABUS of New York and Mitchell and Rammelsberg of Cincinnati.

The search for pure beauty also led to classical Greece. Great collections of ancient archaeological finds, including those of Luigi Palma di Cesnola and Heinrich Schliemann, were amassed in the 1870s and 1880s and were made available to Americans in publications and newly founded museums. Decorative artists adapted Greek shapes and ornamentation in silver, earthenware, and glass, and replicated classical friezes on wallpaper borders. They selected those elements from antiquity that were sympathetic to Aesthetic-era concerns, particularly simplified, flattened, and stylized natural forms; rarely, however, did the aesthetic designer borrow from classical sources as literally as his contemporaries working in the Beaux-Arts tradition.

The Queen Anne style and the Regency revival in Britain, inspired by nostalgia for the past, were paralleled in America by similar trends. Americans' appreciation for native antiques and reproductions of them was awakened in large part by the Centennial, which stirred national pride. CHARLES ALLERTON COOLIDGE, FRANCIS H. BACON, Herter Brothers, and Wilson Eyre (1858–1944) were among those whose decorative work exhibited a respect for the Colonial and Federal eras.

The opening of trade between Japan and the Western world in 1854 provided a vital and previously inaccessible source of artistic ideas; by the early 1870s the enthusiasm for things Japanese was pervasive in America. Japanese shapes, surface treatments, materials, and techniques were interpreted in all the American decorative arts of the Aesthetic period: for example, in silver by Tiffany and Company and the GORHAM MANUFACTURING COMPANY, in porcelain by OTT AND BREWER and the GREENWOOD POTTERY, and in furniture by A. AND H. LEJAMBRE and Herter Brothers.

The Islamic world also enriched the vocabulary of aesthetic style. Sensual ornament and colorful forms associated with Turkish, Moorish, Persian, and Indian ways of life were used in the domestic milieu to suggest the moods and customs of these exotic cultures. Tastemakers of the day determined which foreign styles were most appropriate for specific rooms and decorative forms. The oriental and the Indian were particularly well suited to sitting rooms like the "Japanese" parlor in William H. Vanderbilt's palatial New York house and smoking rooms like the "Moorish" one in industrialist John D. Rockefeller's impressive New York mansion. The painter Frederic E. Church (1826–1900) carried exoticism to an extreme at Olana, his home and studio overlooking the Hudson River.

Aestheticism offered an unprecedented opportunity for collaboration among artists, some of whom entered the growing ranks of professional decorators. In 1879 Louis Comfort Tiffany joined forces with SAMUEL COLMAN, LOCKWOOD DE FOREST, and CANDACE WHEELER to found Associated Artists. Wheeler was in charge of textiles, de Forest supervised carvings and wood decoration, Colman was consulted for color and pattern, and Tiffany, who directed the firm, was responsible for stained glass. It is noteworthy that three of the four partners had begun their careers as painters. Indeed the participation of painters and sculptors in the decorative arts was a significant aspect of the Aesthetic movement. Painters no longer confined their brushwork to canvas. Rather, they could now embellish the walls of an interior, as JAMES ABBOTT MCNEILL WHISTLER did in his famed Peacock Room for the London home of Frederick Richards Leyland; decorate furniture, as Albert Pinkham Ryder did on screens and mirror frames; or ornament tiles, like those painted at meetings of the Tile Club. Architects, too, expanded their role, conceiving not only the elevations and the plans of a building, but also the interior scheme, designing furniture, metalwork, and other decorative elements: wrought iron and furniture by FRANK FURNESS and architectural ornament by LOUIS SULLIVAN are outstanding examples.

Just as established artists explored decorative media, many others—primarily women—applied their talents to china painting, needlework, and wood carving, which they pursued either as enlightened leisure activities or as a means of producing an independent income, albeit a modest one. The artistic commitment of Cincinnati women is a case in point. Instrumental in establishing a school of design and an art museum in their city, these women also carved furniture and decorated ceramics, eventually establishing a national reputation for their art pottery.

Within two decades of its inception, the Aesthetic movement began to evolve in different directions—most significantly those of the Art Nouveau and the Arts and Crafts movements. The geometry of aesthetic patterns yielded to the sensuous lines of Art Nouveau, and the use of asymmetry, derived from oriental art, became more pronounced. Arts and crafts doctrines shared the Aesthetic era's exaltation of craftsmanship, natural materials, and the integrated interior but rejected machine production and emphasized form and structure rather than surface ornament. The pursuit of beauty persisted well after the Aesthetic period ended. Through later movements aesthetic ideas became widely accepted, even ubiquitous.

The Authors

Overleaf: Detail of *Portrait of Miss Dora Wheeler* (FIG. 9.15)

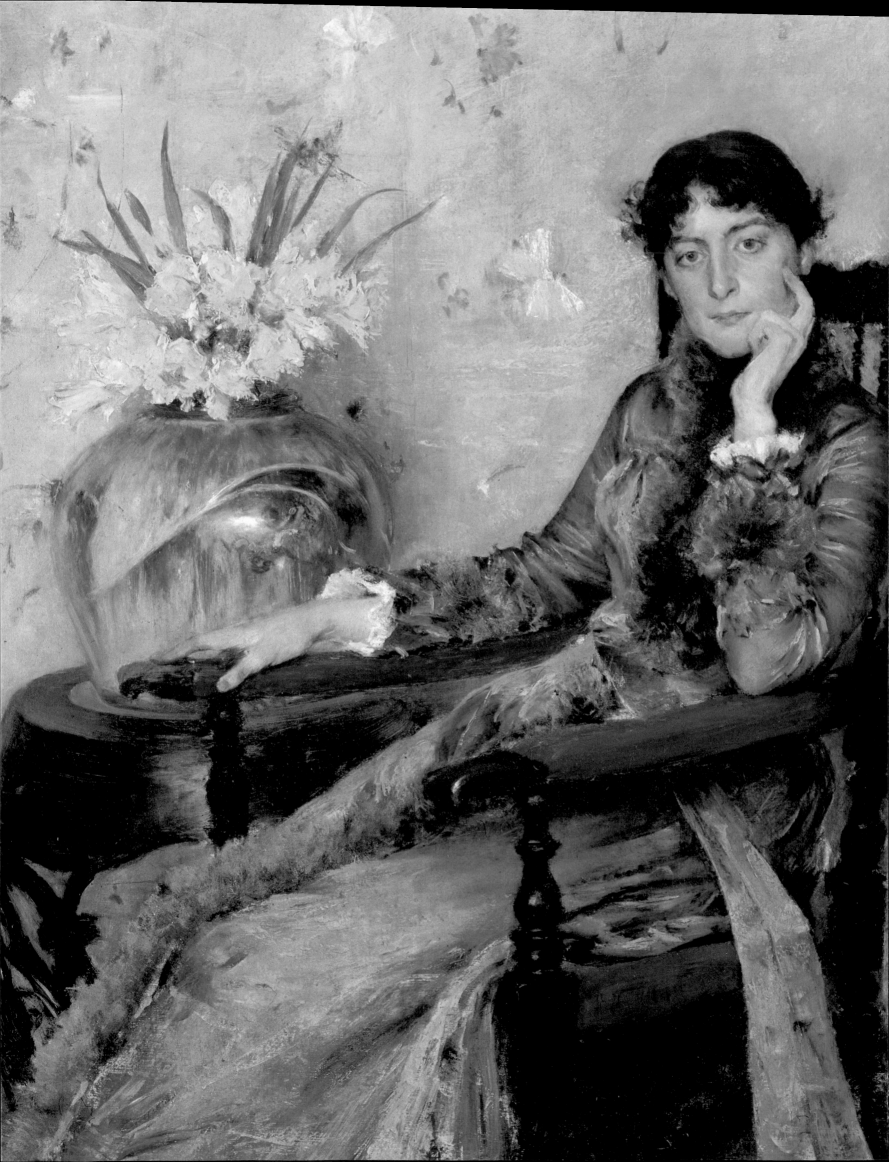

I

Artifact as Ideology:

The Aesthetic Movement in Its American Cultural Context

Roger B. Stein

THE TERM "AESTHETIC MOVEMENT" describes a period of extraordinarily rich artistic activity in the United States in the last third of the nineteenth century, centered in the decorative arts in the 1870s and 1880s but expressed as well in American painting, in architecture and planning, in public and private collecting, and in art education in schools, museums, and on the printed page. The work produced during these years is artistic achievement of a high order, ranging from unique objects fashioned for an exclusive elite to mass-produced goods and popular forms.

The essays that follow examine various types of art and locate them in the history of art making by individuals and—more significantly, perhaps—by groups. They point to sources in design theory and practice both in the United States and abroad, especially in Britain, where the American Aesthetic movement had its deepest roots. To understand the nature of the American achievement, it will be helpful to see it within its time and place in order to ask how the artifacts created gave expression to the culture of which they were a part. If we see these works as in some sense the aesthetic solutions or resolutions that artist-producers offered to their audiences of consumers and viewers, our task becomes one of asking what were the questions to which the objects were answers; what were the problems they sought to resolve; what induced late nineteenth-century men and women—considered individually and collectively, and as they were differentiated by gender—to shape them in particular ways; and toward what ends was aesthetic production directed? To phrase the questions thus offers a dynamic approach to these marvelously inventive artifacts, defining them not as static objects but as elements in the process of development and change, of challenge and response, that we call culture.

The last third of the nineteenth century was a period of especially rapid change in the United States. Industrial growth was massive, agriculture was capitalized through large-scale farming of the Midwest, and the Rocky Mountains and the Far West were fully opened to exploitation through railroad and governmental surveys. A transportation revolution created an international network for the distribution of goods, with implications for aesthetic commodities as well as for corn and wheat, iron and steel and coal. Facilities for marketing and financing within an expanding capitalist economy increased, particularly in the urban centers, whose populations swelled through immigration from abroad and relocation from rural areas.

Inevitably changes in the American economy and in ethnic and class relationships put a severe strain upon traditional American values. Shifts from rural to urban, from local and regional orientation to national and international, with a loss of authority on the part of local institutions (most notably the churches); expanding employment, including that of women seeking opportunities beyond the home; and frequently depressed wages all challenged the liberal ideology of an earlier rural America, which the post–Civil War generation often idealized as a simpler, innocent world, without conflict or stress.[1]

Although the 1876 Philadelphia Centennial Exposition stimulated a certain nostalgia and even a Colonial revival[2]—a belief that Americans could reinstate some of the forms and the supposed work habits of craftsmanship as well as the local and national loyalties associated with the founding fathers—the majority of Americans sought to come to terms with the new urbanized and industrialized society. The Aesthetic movement as a cultural phenomenon played an active role in the transformation of American life in the 1870s, 1880s, and early 1890s. It was a critique of previous modes of life and thought and both a response to and an expression of contemporary American culture, that is, the material conditions of late nineteenth-century America and the ideology—the system of values and beliefs—that supported, reinforced, and gave direction to certain patterns of life and work.

Ideologically the Aesthetic movement functioned most clearly in four major areas of cultural change. "Nature," which for Americans in the preceding generations had been an emblem of national geographic destiny, a spiritual resource and a sign of innocence, as well as the place for the family farm and the source of economic well-being, for many Americans no longer served these functions in the post–Civil War era.[3] The Aesthetic movement adapted the cultural language of natural forms to new purposes, more in keeping with the urban and industrial society of which it was a part.

Second, though religious values continued to be important to individuals and church attendance was up during the late nineteenth century, the laments in the periodical press of the era about the absence of a spiritual center were frequent and repetitive.[4] Some middle- and upper-class Americans were drawn to Christian Science, others to the religions of the Orient or to Christian Socialism, and immigrant groups brought with them Old World Catholic, Orthodox, and Jewish beliefs as alternatives to the previously dominant Protestant ideology. To this congerie of values the Aesthetic movement offered "art" as a counterbalance to materialism, though its adequacy as a religious remedy was in doubt.

Third, the instability of boom and bust cycles, of expanding opportunities and major strikes, led to questioning of the dominant American ideology. American political liberalism and laissez-faire capitalism had promised satisfaction to all who would work diligently in their calling, as the Protestant language expressed it,

but the conditions of work had changed significantly in the late nineteenth century. What role was art to play either in sustaining the older relationships of power or in altering them, in reorganizing society?[5] Because much Aesthetic-movement production was carried out by groups, it challenged, at least implicitly, a radically individualistic conception of creative selfhood. In class terms, the claim of the Aesthetic movement in America was meliorist and universal—that art would enhance and improve the lives of everyone. Yet its primary effect was upon the leisure class and to some degree the middle class, which led to a number of critiques in the 1890s and thereafter that illuminate the ultimately conservative character of the movement.

Finally, an area of change in which the Aesthetic movement was to have a profound effect was what the age called "the woman question." Women had been ideologically defined in American society as linked to nature and nurture and to spiritual values as the guardians of religion, especially within the home and family. As they increasingly either moved into the wage-labor force or sought to find meaningful roles as equals within their own "sphere," the Aesthetic movement responded by facilitating new possibilities for women's control over their own lives. Indeed in many respects the Aesthetic movement was a women's movement. Women were among the leading producers of aesthetic goods, and insofar as the movement was particularly directed toward the domestic realm, they were also its chief consumers. In what ways this occurred, and with what consequences, is a central question to any consideration of American aestheticism.[6]

The great achievement of the Aesthetic movement in the United States, from the point of view of ideology, lay in its ability to embody these changing circumstances and values, not merely in theoretical statements but in the production of artifacts and in the widespread marketing and consumption of both ideas and objects as well. The Aesthetic movement did not "reflect" these changes. It shaped them in specific directions; for works of art—the houses we build and inhabit, the spaces we choose to decorate, the ornamental objects we create, the books and articles we read—actively influence our lives.

Our task in what follows, thus, is to read through the aesthetic texts to their ideological subtexts in order to see how together they can help us understand the role of the Aesthetic movement in late nineteenth-century American culture. To accomplish this task we need to explore the sites of aesthetic transformation, the places where the new artistic activity was taking place, so that we may observe the dynamics of the Aesthetic movement in its impact upon the lives of Americans of the time. Let us begin up the Hudson River, past Sleepy Hollow and the romantic world of Rip Van Winkle, at Olana, near Hudson, New York, some thirty miles south of Albany.

The Experience of Olana

Perched high above a serpentine road that leads from the Hudson River valley through dense woods and into open fields punctuated with beautiful trees is Olana, the summer home and studio of the nineteenth-century American landscape painter Frederic E. Church (1826–1900). Enameled tiles frame the mosaic portal that greets the visitor, and rich exterior brickwork reaches up to a cornice once ornately stenciled in bright colors. Designed by Calvert Vaux (1824–1895) as a villa, the house was built under Church's supervision in the 1870s, with a new wing added in 1888–90. Both the design and the site make clear an allegiance to nature as a repository of national, picturesque, and spiritual values. The ogival windows and porches of the house open to the sublime and beautiful spaces of the natural world that Church captured in hundreds of paintings and sketches, from the 1840s when he studied with Thomas Cole (1801–1848), who lived across the river in Catskill,

New York, through the 1850s and 1860s, the heyday of Church's fame as the chief celebrant of untamed nature in American culture.[7]

The architectural design of the house is neither in the villa style typical of the work of Andrew Jackson Downing (1815–1852) nor is it a Gothic-style castle, favored by many during the previous decades. In its playful massing of large brick surfaces against windows, porches, towers, and balconies, accentuated with colorful tiles, Near Eastern in feeling but unlike any particular prototype, Olana defies stylistic categorizing. Upon entering the house, the dominant impression of the interior is in radical contrast to the view from the windows that frame America's most renowned nineteenth-century romantic landscape scenery. If we stand with our backs to the *ombra,* or inset porch, to the south, the vision into the central Court Hall (ILL. 1.1) epitomizes Church's achievement: the gently arched window filters the light through the patterned paper tracery—which imitates Moorish metalwork—bathing the space below in an amber glow; the floors are festooned with oriental rugs, which serve also as runners up the stairs and as portieres across a landing that heightens the impression that this interior space can become—and is—a stage set; and the upstairs hall has a large wardrobe containing costumes from many lands, used by the Churches for the entertainment of guests.

A sense of costume drama is a clue to the artifice of the whole. Egyptian ibis bracket the area; a highly polished brass Buddha sits in a quasi-Romanesque niche below the upper return of the staircase near a gathering of armor and brass bowls; tall vases stand on elaborately carved side tables; rondels in white alabaster by Erastus Dow Palmer (1817–1904) over doorways contrast to framed butterflies (iridescent emblems of immortality) on another narrow wall space; stylized mosarabic floral stenciling on the spandrels and across the interior of the arches is juxtaposed with equally flat Assyrian black figures on the risers of the lowest stairs; and a large blue-and-white china vase is strategically placed in a corner of the second landing of the staircase. It is an astonishing mélange of color, texture, and form brought into harmony and order by the overall patterning, the blending of hues and tones controlling the eye as it moves from object to object, ricocheting back and forth through artistic style and historical period and the spiritual connotations they suggest.[8]

What sense are we to make of this extraordinary spectacle? The rupture with the values of nature that drew Church to the location is important, but the interior of Olana is not hermetically sealed off, like the semi-Gothic solipsistic fantasy world that Edgar Allan Poe (1809–1849) created in "The Fall of the House of Usher" (1839). Church was hardly the withdrawn romantic genius (indeed few American artists were more responsive to their public than Church, who was a careful promoter of his own work); yet to attribute what we see solely to Church's individual enthusiasms for the art and archaeology of Latin America, Europe, and the Near East is to miss the general relevance of Olana to the major revolution in style and thinking that we term the Aesthetic movement.

The rural setting, sublime, beautiful, and picturesque vistas, and shaping of the fore- and middle-ground landscape to frame the view at Olana link it to the aesthetics not only of Vaux but also of Downing and of Frederick Law Olmsted (1822–1903), of Cole and of Asher B. Durand (1796–1886). The profusion of diverse religious imagery in the interior of the house suggests that the iconography is a kind of cross-cultural survey of the manifestations of spirituality in the worlds of nature and art. But in the internationalism of its religious language, in its stylistic borrowings and decorative conventionalizing of natural forms, in its dissociation of style from history, and in the ways in which Olana recombines disparate elements into a new artistic unity, it is an exemplary early product of the Aesthetic movement.

Our task is to understand the aesthetic impulses that find expression at Olana. As Church's home indicates, the Aesthetic

movement prided itself on the governing order that the eye and the act of seeing imposed upon experience. Further, Olana and the Aesthetic movement it betokens were not governed by an allegiance to the revival of a single past historical style, and certainly not to some notion of vernacular "American" style. Olana draws upon, indeed it ransacks, the high art forms of the Western and Eastern worlds with carefree abandon and with rich visual playfulness; and though it is "eclectic" in its use of various styles, that is not an adequate label to apply.[9]

At Olana dramatic juxtapositions of time, place, and style are harmoniously resolved through delicate adjustments of color, tone, and texture. Individual objects and their cultures are appropriated and recontextualized by the master—or, as frequently was the case during the Aesthetic era, the mistress—hand of the interior designer. Past and present meet in the Olana experience: older, collected objects coexist with newer ones, such as the intricate "Hindoo" carving designed by Mrs. Church's cousin LOCKWOOD DE FOREST (ILL. 1.2), as the aesthetic present asserts its hegemony over the historical past and an American interior actively reshapes the artistic wealth of the world.

The process of absorption and transformation of objects and styles from East and West that we observe at Olana was deeply indebted to current thought and practice coming from England, a nation with which Church had always had strong ties. His teacher Cole was English born. Church was an early disciple of the great English art critic and writer John Ruskin (1819–1900), from whom an entire generation of Americans learned that meticulous fidelity to specific natural forms could be not only a kind of national expression and a spiritual act but also a pictorial guide for artist and audience.[10] The special dialect of Olana was a variant of an essentially British aesthetic language of the preceding decades.

Ideological Sources: The English Reform Movement

The origins of the American Aesthetic movement lay in Britain in the 1850s and 1860s: in the writings of leading aesthetic and social critics, in the teaching in newly emerging schools of design, and in artifacts themselves. All of these were to make their way to American shores in the post–Civil War years via the rapidly increasing transatlantic traffic in persons, in books and periodicals, and in objects for exhibition and sale. The Aesthetic movement in Britain began as a reform impulse. It was part of a larger critique of the Industrial Revolution, which had radically altered Britain following the Napoleonic Wars, and it paralleled political events that had firmly established the power of the middle class with the Second Reform Bill of 1867. The costs of these social transformations were the subject of impassioned debate, in the aesthetic realm as elsewhere.

The British architect and theorist Augustus Welby Northmore Pugin (1812–1852) had been an early and savage critic of nineteenth-century culture. His *Contrasts, or a Parallel Between the Noble Edifices of the Fourteenth and Fifteenth Centuries and Similar Buildings of the Present Day* (1836) was a social as well as an aesthetic protest against the ugliness of the contemporary English cityscape. In religious terms, the Evangelical Ruskin was the antagonist of the Roman Catholic Pugin; but socially and aesthetically he extended Pugin's argument for the Gothic as a repository of spiritual values, combining it with his own lament for the loss of workmanship in industrial society. From early in his career, Ruskin was a spokesman for truth to nature, that is, the integrity of an unaltered, natural universe, which he saw as expressive of a divine plan in the realm of beauty. The blight on the English industrial landscape convinced Ruskin of the dependence of art on a healthy society. The famous chapter "The Nature of Gothic" in his *Stones of Venice*

(1851–53), as well as many of his later writings, assaulted the failure of modern society to make possible the necessary social conditions for artistic labor.[11]

In this sense Ruskin's indictment, which was indebted to the moral outrage of Thomas Carlyle (1795–1881) and which was to become central to the thinking of the younger WILLIAM MORRIS, paralleled the frontal attack on industrial relations that Karl Marx (1818–1883) and Friedrich Engels (1820–1895) were formulating in these same years on British soil. To Marx, only the man who is free from physical need "produces in accordance with the laws of beauty." The modern wage slave is alienated from his work, and goods produced are "fetishized," their significance defined by their exchange value rather than their expression of socially productive labor on the part of the maker, their display serving as a sign of wealth, what Thorstein Veblen (1857–1929) would later call "pecuniary canons of taste."[12] For Marx and Engels, social and aesthetic expression was embedded in entrenched relationships of power in capitalist society. They rejected reform as a solution and predicted inevitable revolution in the struggle between classes.

More palatable to British as well as American audiences was the reformist critique from within liberal ideology espoused by the English poet, essayist, and school inspector Matthew Arnold (1822–1888). In the essays collected in 1869 as *Culture and Anarchy*, Arnold argued the value of "Hellenism" over "Hebraism," which for him meant the triumph of "spontaneity of consciousness" over "strictness of conscience." He sweepingly attacked the "barbarian" aristocracy, the "Philistine" middle class who held economic and political control, and the "populace," thus dissolving the relationships of power in a cultural condemnation of all who live in terms of their own self-interest and the narrowest utilitarian morality. Nineteenth-century society had "fetishized" the mere accumulation of material goods, and Arnold called instead for "sweetness and light," an expansion of consciousness that would give people a fuller grasp of the ideal intellectual and aesthetic potential of the human spirit. Of the United States he said bluntly, "From Maine to Florida, and back again, all America Hebraizes."[13] The value of Arnold's voice in the ideological debates of the Aesthetic period lay in his reconciliation of the pursuit of beauty with larger social and moral ends, however vaguely defined. He offered a way of believing in the visual, in the power of feeling and of art to arrive somehow at ideal goals, without really challenging, as had Ruskin, Morris, and especially Marx and Engels, the structure of traditional capitalist work relationships.

That some in Britain would carry the general critique of Philistine culture to its extreme can be seen from Walter Pater (1839–1894) to Oscar Wilde (1854–1900) and JAMES ABBOTT MCNEILL WHISTLER, from the incipient heightening of aesthetic consciousness to art for art's sake, a scornful dissociation of art from ordinary life. Whistler's suit against Ruskin in London in 1878 was an impassioned defense of the aesthetic view and of the integrity of the picture as an independent visual statement, exaggerated because Whistler was under attack by the leading proponent of truth to nature. Art had traditionally been understood as a means toward some extrinsic end: the mimetic reproduction of the external world; the glorification of the state; the inculcation of a social or moral message; the praise of God. To a devoted aesthete like Whistler, such concerns were merely "literary"; art was independent of all extrinsic purposes, and subject matter was irrelevant.[14]

Wilde, Ruskin's student at Oxford and a friend of Whistler's, was the Aesthetic movement's most successful popularizer. Wilde brought the aesthetic gospel in flamboyantly theatrical form to the United States in his famous and well-reported lecture tour of 1882–83 (see ILL. 11.1). He denied that

> in its primary aspects has painting any more spiritual message for us than a blue tile from the walls of Damascus or a Hitzen vase. It is a beautifully-coloured surface, nothing

more, and affects us by no suggestion stolen from philosophy, no pathos pilfered from literature, no feeling filched from a poet, but by its own incommunicable artistic essence.

Wilde frequently coupled such rhetorically severe statements with appeals to Americans, based upon vaguely liberal political premises, to appreciate the natural forms abundantly present in the landscape and to reform the American urban and domestic environment; he called for "the union of Hellenism—with intense individualism, the passionate colour of the romantic spirit."[15]

To the extent that the committed aesthetes argued that art was the goal of life and that people should live *for* art, they were suspect in Britain—and especially suspect in the United States—as amoral (if not immoral) poseurs, self-indulgent and irresponsible. The general reaction to aestheticism was a series of parodies, and George Du Maurier's (1834–1896) satires in *Punch* were well known (see ILL. 11.9). Lampoons of aestheticism reached their apotheosis in the WORCESTER ROYAL PORCELAIN COMPANY's teapot of 1882 (FIG. 1.1), complete with lily, sunflower, yellow-green blouse, puce cap, and limp wrist serving as a spout. The base bears the inscription *FEARFUL CONSEQUENCES–/THROUGH THE LAWS OF NATURAL SELECTION/AND EVOLUTION–OF LIVING/UP TO ONE'S TEA-POT*, an aesthetically witty spoof, from a pseudo-Darwinian position, of the shibboleths of the Aesthetic movement. Gilbert and Sullivan's comic opera *Patience* of 1881, which had long runs in New York during Wilde's American tour, as well as in England, is the best known of all the lampoons of aestheticism,[16] but the figure of the aesthetic Oscar was played with by Americans in many ways (see ILLS. 11.2, 11.6). Wildean caricatures and aesthetic maidens

ILL. 1.1 Court Hall, Olana, Hudson, N.Y. Frederic E. Church, ca. 1872–74. New York State Office of Parks, Recreation and Historic Preservation, Bureau of Historic Sites, Olana State Historic Site, Taconic State Park Region

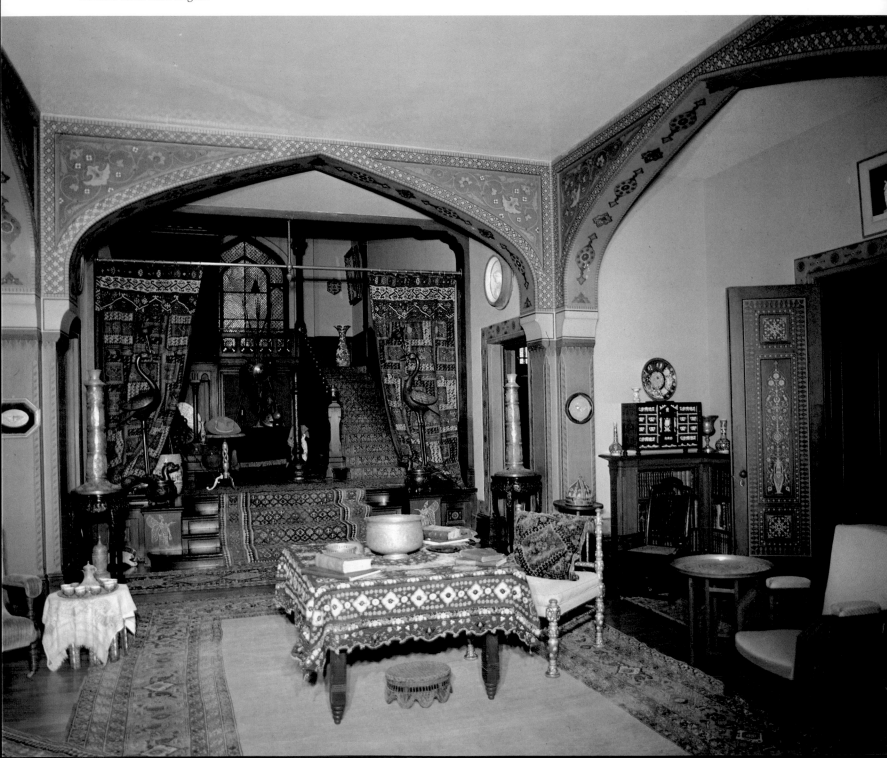

ILL. 1.2 "Hindoo" fireplace surround, Olana, the Frederic E. Church house, Hudson, N.Y. Designed by Lockwood de Forest, 1887, probably made in India. New York State Office of Parks, Recreation and Historic Preservation, Bureau of Historic Sites, Olana State Historic Site, Taconic State Park Region

orative styles, from "Savage" and Egyptian to Assyrian, Greek, Arabian, Moresque, Gothic, and Italian, were essentially a "grammar," the structure of a language that could be employed through the application of general principles. Jones reduced decorative expression to a series of thirty-seven "propositions." To attempt to work out a decorative style independent of the past would be "folly," Jones maintained, for the past was both inheritance and guide, though it should not be followed mechanically. Proposition 36 read: "The principles discoverable in the works of the past belong to us; not so the results. It is taking the end for the means."[18]

Jones's theory of decoration involved a "paradoxical attitude toward history," according to the critic John G. Rhodes, "simultaneously a rejection and a selective idealization" that arrived at a new concept of "authentic style" not by reviving any single mode from the past but by generating abstract propositions.[19] To this conception Dresser added a warning about trying to carry over the symbolic values of prior ornamental forms. The age of symbolic representation had passed, in Dresser's view, and there was no reason to hope that symbolism would again prevail. Instead, he advised designers of his day to appeal in their work to the common knowledge of people.[20]

The efforts of the reform designers clarify the ideological function of the Aesthetic movement in several ways. First, their stress on the availability to the present of a wide spectrum of past stylistic choices contributed to the dehistoricizing of decoration and made it "universally" accessible to artists of the late nineteenth century as an infinitely manipulable language for the trained eye. One need not know—or care—about how art functioned in past cultures to draw upon the decorative forms and patterns of those worlds. As Olana illustrates, the past loses something of its "pastness," its associative cultural values, when it is recontextualized for present use.

Second, the universalizing of stylistic choice may be seen ideologically as the aesthetic expression of Britain's experience as an imperial power during the nineteenth century. As goods from around the world came under the control of British markets, the designers of the Aesthetic movement justified the process, however unconsciously, by internationalizing the principles of style. The vocabulary of art for art's sake partially masked the degree to which this stylistic appropriation was indeed a form of cultural appropriation, particularly over the non-Western regions of the Near East and the Orient.[21] To Americans, who were now fully entering the international marketplace, the new language was a powerful one.

Third, design reform must be understood as a response to issues of gender. The schools established by the reformers in London and elsewhere in Britain had been especially directed toward women, for reasons that were made clear in an essay called "Women and Art," published in the London *Art Journal* in 1861. The author, Thomas Purnell, recognized that one of the great social challenges to British culture was the demand of women for equal rights, but his response was to assert flatly,

> Woman owes allegiance to the hearth. On this point there is a singular and complete unanimity, and none—not even the most zealous advocate for woman's rights, we presume—but will unhesitatingly concur in condemning her who would be guilty of transferring that allegiance elsewhere.

Purnell's anxiety is evident beneath the bullying tone of the statement; indeed he realized that the domestic ideals he advocated did not speak to the situation of an increasing pool of middle-class women whose failure in the marriage market left them without adequate means of support. The rich, he claimed, should be content with their lot, while the women of the "lowest classes" had inevitably to work for a living. The precarious position of middle-

were employed to sell soap, hosiery, sewing machines, and "aesthetic corsets" (FIG. 1.2). Artful parody depends of necessity upon the audience's knowledge and understanding of the subject under attack; if in the case of aestheticism it played in part to the Philistine sensibilities, it also asserted the triumph of style, aesthetic artifice, and the man-made world over mere nature.

In contrast to the aesthetes, another contingent of British reformers focused more particularly on the practical aspects of artistic work and style. This contingent was determined to transform the principles of design itself through the establishment of schools and curricula and through writings specifically directed toward the decorative arts. To this group, decorative beauty was not only an intrinsic good; it helped market commodities. William Morris, Henry Cole (1808–1882), OWEN JONES, CHRISTOPHER DRESSER, CHARLES LOCKE EASTLAKE, BRUCE J. TALBERT, and E. W. GODWIN were among those who both wrote and trained others in the reorientation of the design and production of artifacts at a variety of new institutions, the most important of which was the Normal School of Design in the South Kensington district of London.

South Kensington played a critical role in the debate with Ruskin over the degree to which natural forms should be conventionalized, and the impact of the school on design in all media, both in Britain and America, was far-reaching. Church's designs for the Court Hall at Olana, for example, would have been unthinkable without *The Grammar of Ornament* (1856) by Owen Jones, the doyen of South Kensington.[17] Jones taught his readers, especially through the 112 beautifully drawn and colored plates with text in three languages (see FIGS. 2.1, 2.2), that the various historical dec-

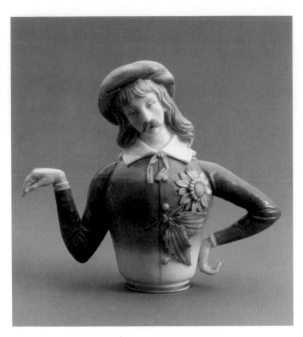

FIG. 1.1 Teapot. Worcester Royal Porcelain Company, Worcester, England, 1882. Porcelain, h. 6⅛ in. (15.5 cm), diam. 3 in. (7.5 cm). Inscribed: *FEARFUL CONSEQUENCES* – / *THROUGH THE LAWS OF NATURAL SELECTION* / *AND EVO-LUTION* – *OF LIVING* / *UP TO ONE'S TEAPOT* / *"Budge,"* marked: [registry mark] / [WRP mark]. Collection of Marilyn and Jerome J. Hoffman

class women was that they could not accept manual labor without losing their middle-class status (and thus their opportunity for a "proper" marriage); Purnell noted, however, that they "do possess unlucky appetites that ask to be fed, and backs for which nature has neglected to provide ready-made clothing." The heavy-handed irony bespeaks the author's discomfort with the hard truth of their situation, but he nevertheless insists that "'equality of the sexes' is a chimera."[22]

Art education was a solution to the dilemma of middle-class women. The occasion for Purnell's essay was the loss of public monies for the Female School of Design, which had been established by the British government in London in 1842. Purnell urged the restoration of funding on the grounds that the school provided training and employment for women, who had "natural" abilities in art, and he singled out "their quick perception of the laws of harmony and contrast of colour, their fineness of hand, their powers of arrangement, and their natural good taste."[23]

Purnell's arguments—and his specific language—are worth citing not because they are special but because they typify and clarify the gender ideology of the Aesthetic movement as a social phenomenon in both Britain and the United States. As a reform ideology, the Aesthetic movement was a sharp and often penetrating critique of the effects of a capitalist industrial society in its failure to rank the pursuit of beauty—"sweetness and light"—above or even on a par with the Philistine values of accumulation of money and goods, as well as in its debasement of the worker from a proud craftsman to an alienated operative. In terms of gender, however, the Aesthetic movement was more problematic: it offered opportunities for work—new creative outlets for social and aesthetic productivity—to middle-class women, but it did so without challenging traditional male hegemony. The "allegiance to the hearth" remained central, and women's aesthetic work was viewed as a concession to (hopefully) temporary necessity. Women's skills in art were declared to be an expression of their "natural" abilities, their female instincts. These would be developed, to be sure, through training in schools but as the fulfillment of essentially do-

mestic female roles. The legacy of this attitude in Britain and the ways in which the Arts and Crafts movement in the 1880s reproduced a sexual division of labor that continued to limit women and make equality of the sexes "a chimera" has been perceptively studied elsewhere.[24] Its importance to the American Aesthetic movement in its own pursuit of beauty is a critical part of our story.

The Lesson of the Centennial

Everything converged on Philadelphia in 1876. The international Centennial Exposition was an active agent in the transmitting of the ideas and artifacts of the British Aesthetic movement to American producers and consumers as well as a sign of American society in its transformed relationships of power. Attendance at the exposition exceeded ten million.[25] The great Corliss engine in the Machinery Hall was the most obvious symbol of an industrial, mechanical, and commercial might that was amply reported in the American press and in commentaries by foreign exhibitors.

The fine-arts display in Memorial Hall was on the whole conservative and frequently bombastic. Few nations sent their best art, either past or present, and the American works shown were on the whole a canonization of older ideal values rather than a risking of new ones. Yet it was clear that a narrow and defensive aesthetic nationalism (reasserted in the 1930s and thereafter as "the Americanness of American art") had given way in the presence of a great international bazaar. Church exhibited *Chimborazo* (1864; Private collection), which won a bronze medal, and *The Parthenon* (1871; The Metropolitan Museum of Art, New York). In a sense, both were nostalgic and retrospective paintings, for nature was no longer the compelling signifier of American national destiny.[26]

From our point of view, the most important quality of the Centennial was its stress on American participation as a strong but friendly competitor in the international marketplace, involved in "a generous and peaceful rivalry in the production of the excellent." This was "the lesson of the centennial," according to the art educator Walter Smith (1836–1886), a recent British arrival on American shores. The Centennial was also a triumph of the urban, the cosmopolitan, the man- (and even to a degree the woman-) made, as the industrial- and decorative-arts exhibitions made clear. Natural resources and raw materials were not enough to ensure the prosperity of a people, asserted Smith. "The transforming hand of man, skilled in the arts and sciences," was needed "to change these rich gifts of nature into products which satisfy the needs of civilized communities."[27]

The Centennial was the primary vehicle for the communication of British ideas, for the presentation of artifacts inspired by the work of the reformers, and for the publicizing of schools and organizations that gave pedagogic and institutional direction to the Aesthetic movement. Though British leadership was generally acknowledged, nascent American groups of decorative reformers also received recognition at the Centennial, in a display of student work from the Massachusetts Normal Art School, in an exhibition of Cincinnati wood carving and ceramics, and in the very existence of the Women's Pavilion. Despite the suspicion and even hostility of some critics, it was clear that in much of this work it was not the "transforming hand of man" but of women that was particularly impressive. The writer William Dean Howells (1837–1920) wondered why it was necessary to segregate female achievement, and he commented that women's skills could best be seen in the operation and superintendence of machinery, where woman "showed herself in the character of a worker of unsurpassed intelligence."[28] By contrast, Smith's own frequent touting of the accomplishments of the Royal Society of Art Needlework was linked to his hope that American women would follow the British example by flocking "to the studios" and leaving "the ballot-box alone." In a restatement of Purnell's fear, he underscored the con-

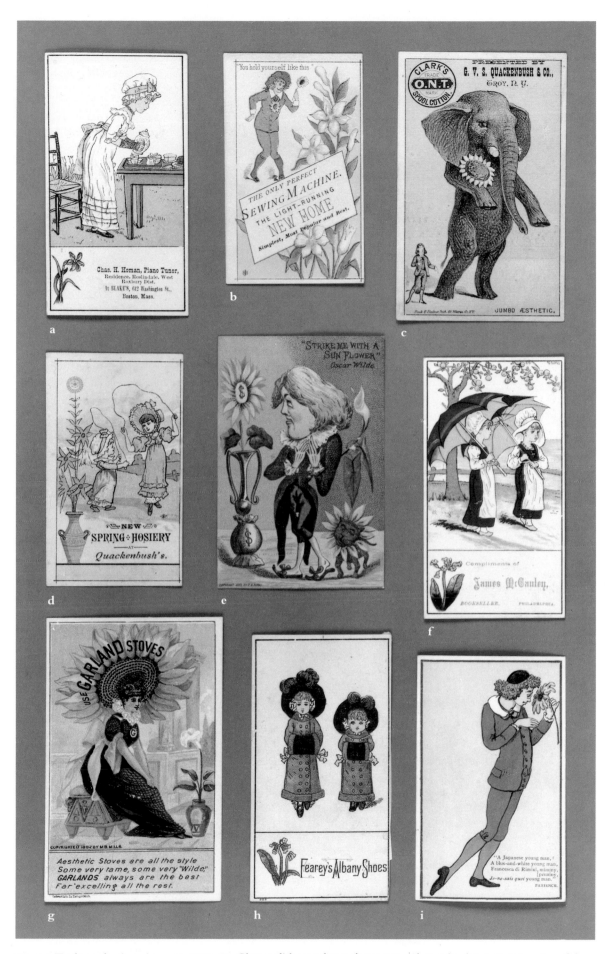

FIG. 1.2 Trade cards. American, ca. 1880–85. Chromolithographs; each approx. 4½ × 3 in. (11.4 × 7.6 cm). a, f, h: The Metropolitan Museum of Art, The Jefferson R. Burdick Collection, Gift of Jefferson R. Burdick; b, c, d, e, i: Private collection; g: The Metropolitan Museum of Art, Anonymous Gift, 1985 (1985.1110)

servative gender ideology of separate spheres. He believed that by allowing women to explore their "thoroughly feminine" aesthetic impulses, women's art would become a hedge against "woman's rights and radicalism," against women's drive to "unsex themselves" by seeking "to engage in men's affairs."[29]

In spite of such attempts to circumscribe the role of women, the Centennial did offer important models to aspiring females. The influence of the exposition upon CANDACE WHEELER, for example, was profound and direct, giving focus to her career as one of the subsequent leaders of the Aesthetic movement in the United States. The same was true for the female ceramics leaders from Cincinnati: M. LOUISE MCLAUGHLIN was inspired by the French Haviland Limoges exhibition of faience, MARIA LONGWORTH NICHOLS by the display of Japanese ceramics.[30]

Upon other American women the effects of the Centennial were more oblique. For the young writer Sarah Orne Jewett (1849–1909), a trip to the fair was a way to spend part of a summer vacation. Seventeen years later, after a visit to the World's Columbian Exposition in Chicago, Jewett reflected that "the Philadelphia exposition gave a new regard for our antiquities (our 'Centennial' chairs and plates!)."[31] Clearly this was the case, but Jewett's more profound understanding of the importance of the 1876 exhibition may be seen in her story "The Flight of Betsey Lane,"[32] which cuts against revivalist nostalgia in its description of an old woman who is trapped in a small-town New England poorhouse and rebels by running away to visit the Centennial. For Jewett the Philadelphia experience is an apt image of a woman's liberation, her breaking free from provincial restrictions to expand her psychological as well as geographic horizons through participation in the urban and international worlds that the Centennial symbolized.

The impact of the Philadelphia exposition may be measured both by its influence on particular decorative artists and by its long-term effects upon visitors like Jewett or the geologist-aesthete Clarence King (1842–1901). King journeyed to the exhibition from Washington, D.C., where he was organizing the scientific reports from his Fortieth Parallel Survey of the West. At the Centennial's popular Japanese display he acquired a Watanabé Seitei screen in an instance of the Ruskinian lover of mountain gloom and mountain glory balancing scientific dissection of nature against a developing impulse toward international collecting of "aesthetic" goods.[33] To examine the ways in which a wide range of Americans accommodated over time the theories and practice of the Aesthetic movement, we may now turn from Philadelphia to New England.

Sites of Transformation:
From Boston to Appledore

Boston's dominant role in American intellectual and religious life included an early and sustained interest in Ruskin's writings, though of a vigorous and argumentative kind.[34] Bostonians had brought back both ideas and inspiration from the Philadelphia Centennial. Howells reported in the *Atlantic Monthly* that the British exhibition was the most impressive in the entire exposition: "A whole world of varied arts and industries, among which the aesthetic observer would be most taken with the contributions from the Indian empire, and with that wide and beautiful expression of artistic feeling in household decoration in which England is now leading the world."[35] HUGH C. ROBERTSON of the CHELSEA KERAMIC ART WORKS was excited by the Japanese pottery, and his distinguished manufactures of the 1880s, along with those of the J. AND J. G. LOW ART TILE WORKS (founded in 1877) and other firms, made the Boston area a center of aesthetic ceramics production.[36]

Furthermore, Massachusetts had been experimenting with art education in public and private schools since before mid-century. Public-school training under the leadership of Horace Mann (1796–1859) had emphasized the practical advantages of industrial drawing as a means of social and economic mobility, while education of females and drawing from the antique had emphasized the more general aesthetic education of the middle class in the moral language of Ruskin. In 1870 Massachusetts passed an industrial-drawing act, the first state law making drawing a public-school required subject, and then hired South Kensington–trained Walter Smith as State Director of Art Education and as Director of Drawing for the Boston Public Schools. By 1873 these activities had spawned the Massachusetts Normal Art School, and in 1876 the school's teacher-training system was exhibited at the Centennial, where it received a diploma and a medal for excellence. In cooperation with the Boston lithographic firm of Louis Prang, Smith produced a series of textbooks that in some of their illustrative material were clearly modeled on the work of Jones and Dresser. Smith's stress on the practical application of drawing and his attempt to extend drawing curricula into the high schools were in conflict with the views of those more Ruskinian advocates of ideal aesthetic education, and by 1881 Smith had been dismissed from both of his administrative positions. The Boston educational experience suggests the underlying class and gender tensions within the American Aesthetic movement: Was art education a democratic means of training young men to rise within an industrial society, or was it intended to inculcate ideals, "Hellenizing" women and a leisure class to an appreciation of the beautiful?[37]

To Isaac Edwards Clarke, another leading proponent of technical instruction in art in the public schools, the Centennial had "taught the people of this country how beauty enriches all the appliances of life; the study of drawing in the common schools will teach . . . children how things are to be made beautiful and . . . thousands upon thousands of home missionaries of the beautiful, will create everywhere such a demand for the element of art in all manufactures," that either producers would comply or foreign goods would capture the market.[38] Clarke's language, in his 1886 U.S. Commissioner of Education Report, "The Democracy of Art," indicates how the call for beauty in domestic life could be both a "missionary" quest for the ideal and a market imperative. Clarke aimed to allay fears that the pursuit of the aesthetic was a form of immoral self-gratification, while showing Americans that commodity production could benefit from such a pursuit.

To experience the visual achievement of the Aesthetic movement in Boston, we need to explore the Back Bay area, filled land opened to real-estate development in the post–Civil War years, for the district was to become the aesthetic center of the city and a showplace for the new stylistic possibilities. The residential brownstones of Back Bay were French inspired, and other buildings of the day ranged from Arthur D. Gilman's (1821–1882) early, classical Arlington Street Church of 1859–61 to Richard Upjohn's (1802–1878) Modern Gothic to H. H. RICHARDSON's adventures in Romanesque. The new quarters of the Boston Natural History Society and the recently erected Massachusetts Institute of Technology, which offered training in architecture under William Robert Ware, were within a few blocks of one another. The Museum of Fine Arts, incorporated in 1870, moved from the pre-war, classical Athenaeum to a Modern Gothic building in 1876. The museum also housed a school of drawing and painting, which in its opening decade catered primarily to women. At right angles to the museum, in the space that in 1883 was to be designated Copley Square, stood the great mass of Richardson's Trinity Church, consecrated in 1877.[39]

Trinity Church is the greatest religious edifice of the Aesthetic movement and a stunning example of how Aesthetic-movement style on a monumental scale harmonized disparate elements to a common purpose through the cooperative efforts of architect, decorative artists, and their patron-minister, the Reverend Phillips

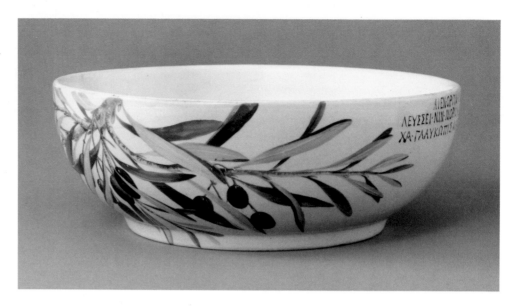

FIG. 1.3 Bowl. Decorated by Celia Thaxter, Appledore Island, Isles of Shoals, Maine, 1882, blank made by John Maddock and Sons, London. Glazed and painted earthenware, h. 3½ in. (8.9 cm), diam. 9½ in. (24.1 cm). Signed: *Celia Thaxter. / 1882.*, marked: ROYAL. SEMI. PORCELAIN / JOHN MADDOCK & SONS / ENGLAND. Maine Women Writers Collection, Westbrook College, Portland, Gift of Rosamond Thaxter

Brooks (1835–1893). Richardson's Auvergnat Romanesque style incorporated JOHN LA FARGE's suggestions for a tower based on the cathedral of Salamanca, Spain. Brooks's Low Church Episcopalian leadership emphasized the preaching function, and his notions of architecture were influenced by his visits to Hagia Sophia in Constantinople and to Saint Petersburg. The inner space of Trinity Church was consequently shaped to bring the word of God to parishioners not by sacerdotally distancing them but by making the structure what Richardson, Brooks, and La Farge agreed should be "a color church." Richardson himself seems to have been largely indifferent to the iconography that La Farge developed for the wall decoration. Though the deeply religious La Farge worked out his choice of figures and scenes typologically, dramatizing Old Testament prefigurations of the revelations of the New, it was "the effect of the figure painting," its relation to other ornamentation, and "the necessities of the composition" that controlled his choices. The harmonizing of color and pattern, of historical styles and iconographic content, modulated by the light filtering through La Farge's stained glass, created the overall interior design that makes Trinity Church a major expression of the Aesthetic movement.[40]

The aestheticizing of a church interior could raise problems, however. Henry Adams (1838–1918), a close friend of both Richardson's and La Farge's, used the decoration of Trinity as the source for the opening section of his 1884 novel, *Esther*,[41] juxtaposing a Trinitarian minister, the artist-designer of his new church (modeled on a combination of Richardson and La Farge), and a scientist (modeled on another friend of the author's, Clarence King). The conflict of spiritual, aesthetic, and scientific values is played out in the plot. Adams's description of the church in the opening scene suggests how La Farge's use of natural forms and the splendors of color have become problematic as a language of religion:

> Looking down the nave, one caught an effect of autumn gardens, a suggestion of chrysanthemums and geraniums, or of October woods, dashed with scarlet oaks and yellow maples. . . . The sun came in through the figure of St. John in his crimson and green garments of glass, and scattered more color where colors already rivaled the flowers of a prize show; while huge prophets and evangelists in flowing robes looked down from the red walls on a display of human vanities that would have called out a vehement Lamentation of Jeremiah or Song of Solomon, had these poets been present in flesh as they were in figure.[42]

The female protagonist of the novel, Esther, is an aesthetic young woman who participates in the decoration of the church and falls in love with the minister, but she cannot accept his faith. The sensuous and aesthetic appeal of art is insufficient to convert Esther's love into the specifically religious faith necessary for a successful marriage, which in the novel form traditionally signifies the establishment of social order. Adams's work thus acknowledges the importance of the aesthetic in creating a new, harmonious structure in the realm of beauty as well as its limitation as a substitute for either religious conviction or the social order of the married state.[43]

In New England as elsewhere, the Aesthetic movement was directed in large part toward women, educating them in the new taste through classes and public lectures, teaching them the new techniques of the decorative arts, and hoping to reshape their religious commitment in the new "color" churches. The experience of CELIA THAXTER as china painter dramatizes how the Aesthetic movement functioned on the small scale in the lives of women.

It is easy to dismiss the china-painting craze of the late 1870s and the 1880s as a fad, a pleasant aesthetic diversion for leisured ladies; and it is surely true that among those who took to china painting were amateurs who read the manuals that were published during these decades, attended classes at local art schools, and bought ceramic blanks for decoration based on patterns available in books. The Cincinnati women's exhibition at the Philadelphia Centennial offered fine examples of china painting. Still, the availability of techniques and materials to amateurs and especially the fact that china painting was primarily a domestic activity should not obscure its significance as a form of artistic expression. By privileging both the fine arts of architecture, painting, and sculpture and the lone professional artist-genius (who has full access to centers of training), artistic ideology has biased our notions of what constitutes art in favor of forms of creativity open primarily to men.[44] The Aesthetic movement not only proselytized the importance and status of the decorative arts but also facilitated the education of women. Yet its emphasis on *domestic* beauty tended, at least in part, to reinforce the location of women's work within the lower status confines of the home in a world where the criteria of success were still defined in terms of the male-dominated public sphere.

The functioning of aesthetic ideology is illuminated by the artistic life of Celia Thaxter, and particularly by the simple ceramic bowl of 1882 (FIG. 1.3) that she decorated with olive sprays and a Greek inscription, one of her modest contributions to the American Aesthetic movement. Thaxter's childhood and her summers as an adult were spent on the Isles of Shoals, rock outcrops off the

coast of Portsmouth, New Hampshire, where her family established Appledore House, a resort frequented by the Boston intelligentsia and artistic elite.[45] Thaxter's talents were notably literary. She was a welcome member of Boston salons when she was in town, and she was the lodestone who drew aesthetic guests to Appledore. There she served as hostess, as well as promoter and facilitator of the art of others, balancing her own artistic needs against the pressure not only to care for but also to help support her family financially, in an enlarged domestic sphere that included the hotel.

Thaxter's deepest creative springs flowed from her love of the special combination of brutal winter storm and delicate summer flower that characterize the ecology of the Isles of Shoals. Her vision of the world was a tough-minded and precise version of truth to nature—Ruskin tempered by a strong sense of Darwinian struggle. Her religion was an equally tough-minded negotiation between despair and hope, eventuating in a personal faith that depended upon no sectarian allegiance, though it drew upon classical, Christian, oriental, and Spiritualist sources in a way that was typical of the period. Her artistic task was to discover forms to give shape to her vision, but since her writing paid little, she needed to find other means of support.

In 1874 Thaxter turned to painting, copying from nature: "I want to paint everything I see," she wrote, "every leaf, stem, seed vessel, grass blade, rush and reed and flower has new charms."[46] The sustenance offered her by mimetic transformation of natural fact into pictorial image she channeled practically into the making of aesthetic commodities: as a painter of greeting cards for the lithographer Louis Prang, of panels for Chinese screens, and of decorative designs on china. Thaxter's aesthetic vocabulary expanded, and her productivity increased. In the winter of 1877, while she tended her dying mother, she turned out 114 objects for sale. The Appledore House clientele offered a market for her decorative art, as did her wide circle of friends.[47]

For one group of works in 1881–82 Thaxter devised an ornamental motif of vividly rendered olive sprays (based on her 1880 visit to San Miniato in Florence) coupled with a three-line inscription in Greek from Sophocles' *Oedipus at Colonus:* "Watched by the eye of olive-guarding Zeus and by gray-eyed Athena."[48] Her repeated use of this olive and inscription pattern suggests both that Hellenism was commercially viable—she also used it for a Prang greeting card—and that it tapped deeper personal needs, evoking a classical world of ordered nature and, as expressed in the Sophoclean quotation, of the sanctification of natural space for Oedipus, who dies during a moment of mystical transcendence beyond earthly strife.

Thaxter's china painting thus became a language through which one woman could give form to a life of struggling to meet the demands of the domestic. The aesthetic act brought her metaphysical despair under control and effected a reconciliation of the classical, the natural, and the spiritual worlds—without the large-scale public patronage, public space, public drama, and shared participation in worship within a traditional creed, enacted within the male-defined architecture of Trinity Church.

Trinity Church and Celia Thaxter's decorative work—two instances of the functioning of Aesthetic-movement ideas and educational patterns in New England—bracket the extremes of public and private, of art for monumental and for domestic space, and of the resources open to male and female creators and their audiences. To see the dynamics of work and gender in their more complex interaction, let us turn to another major center of aesthetic activity.

Work and Gender in the Queen City

Cincinnati, on the banks of the Ohio River, had been an urban trade center since its founding at the turn of the nineteenth century.

It was also the cultural, scientific, and publishing capital of the Midwest, as well as a locus of reform activities. The new aesthetic reform arrived early in Cincinnati in the person of three British immigrants who had come there in the 1850s. HENRY LINDLEY FRY, an intellectual disciple of Ruskin and Morris who had studied under the Gothic-revivalist architects Pugin and George Gilbert Scott (1811–1878), moved to Cincinnati with his son WILLIAM HENRY FRY. Both were wood carvers who received important early decorative commissions. BENN PITMAN first came to Cincinnati to lecture on phonography, the system of shorthand developed by his brother Isaac that would have important consequences for women's work in succeeding decades; but by the 1870s he, his first wife, JANE BRAGG, and their daughter, AGNES, were also doing wood carving. By 1872 Henry Fry was teaching a wood-carving class, and shortly thereafter Pitman was giving instruction in design, wood carving, and china painting at the University of Cincinnati School of Design.

The story of Cincinnati wood carving and aesthetic ceramics has been frequently told in recent years.[49] What is significant to the present discussion are the factors that made possible Cincinnati's impressive production of notable artifacts. The Aesthetic movement drew upon Cincinnati's tradition of cultural patronage; artists had gone there to study and had moved from that city through the generosity of Nicholas Longworth, eccentric land developer and horticulturist, and others to eastern art centers and abroad.[50] It was Longworth's son Joseph who offered Henry and William Fry the opportunity to decorate his mansion, Rookwood. This act of socially legitimizing the newest aesthetic trends was carried one step farther in the Frys' work on a house for Joseph's daughter, Maria Longworth Nichols, and her first husband, GEORGE WARD NICHOLS, carried out from 1868 to 1872. George Nichols became a collector and an author of books and articles. Maria, the illustrator of her husband's 1878 *Pottery: How It Is Made, Its Shape and Decoration* (see FIG. 7.30), became an artist in ceramics and the founder of the ROOKWOOD POTTERY.

Indeed to trace the network of relationships among patron and artist, teacher and pupil, publicist and theorist and consumer is to see the interconnectedness of Aesthetic-movement artistic production and the tastes of Cincinnati's manufacturing and professional leadership. The claim was that such production would upgrade the quality of manufactured goods generally in Cincinnati, and the instruction in woodworking and ceramics offered both privately and through the School of Design was available to all, male and female, working class as well as social elite. Yet the evidence seems clear that it was predominantly middle- and upper-class women who were drawn to the new schools and workshops and that they were not only the skilled producers of the decoration on chests and beds and cabinets, on bowls and vases and plaques, but frequently were also the consumers of their own work. The development of the Rookwood Pottery, with its national and international market, is an exception to this pattern, and characteristically, when its expansion occurred, men assumed the key roles as overseers of production and sales.[51]

Women's creativity was expressed both in the range of artifacts that they produced in aesthetic styles and in their experimentation with techniques—the underglazes used by McLaughlin, for example, or the bold patterning of decorative wood carving—as well as in their powerful promotional efforts. The Women's Art Museum Association, for instance, an outgrowth of the Cincinnati Women's Centennial Committee, spearheaded the drive for a city art museum.

The extraordinary creative outburst that Cincinnati made possible to women needs to be viewed in its complex ideological context. The functioning of ideology in Cincinnati is exemplified by one of the masterpieces of the Aesthetic movement in America: the carved bedstead (FIGS. 1.4, 1.5) for the Pitman residence, displayed at the Cincinnati Industrial Exhibition of 1883. Designed by Benn

Pitman; decorated with carving by ADELAIDE NOURSE (whom he married in 1882) and with painted panels by her sister ELIZABETH NOURSE; and constructed by an unnamed male joiner, it proclaims visually their achievement in harmonizing the aesthetic teachings of Ruskin, the ornamental principles of South Kensington, and the American version of romantic naturalism as articulated by Ralph Waldo Emerson (1803–1882), for whose writings Pitman had a special affinity.

Stylistically, the larger forms of the bedstead are Gothic, with two lancet panels framing a central trilobate arch, though the bracketed upper range with its classical balustrade, the modified bits of egg molding over the lancets, and other details make clear that this is "Modern Gothic," not some archaeologically precise copy of an earlier mode but a playful contemporary reinterpretation. The basic pattern of the headboard is distinctly ecclesiastical, derived from church windows, but the forms have been recontextualized, appropriated for secular domestic purposes. Instead of offering the viewer hieratic images of saints (interestingly, the Nourses were Roman Catholic), the "windows" open centrally to the natural world with a burst of swallows, a crescent moon, a flourish of hydrangeas, and the rather staid Gothic script reading "Good night, good rest." In the lancets are painted women's heads representing Night and Morning, surrounded by white azaleas and balloon vines; the spandrels, the decorative bands on the head- and the footboard, as well as the side panels incorporate recognizable images of asters, water lilies, geraniums, gladiolus, acanthuses, and maple and oak leaves. In this work the language of flowers symbolically suggests the generative and transformative powers of nature.

Many of the specific decorative patterns and forms of the Pitman-Nourse bedstead echo the carvings and the painted panels over fireplaces and on doorways in other rooms of the house (ILL. 1.3), so that one feels the unity of design. Without sacrificing energy and vitality, the "nature" of Ruskin has been drawn indoors and domesticated through a careful balancing of deep and shallow carving, of flat, painted surfaces sculpturally framed, and of Ruskinian naturalism combined with conventionalization of the type endorsed by Jones and Dresser. This mediation of nature by aesthetic artifice is emphasized in the architectonic elements of the bed and in the house itself, set upon a Cincinnati hill. Yet in a way that would have pleased both Ruskin and Emerson, Pitman and the Nourses have transformed the bed—an ultimate image of domesticity and of interior rest, of a space apart from active life in the world—into a quasi-religious celebration of natural life in its manifold forms.

A comparison of the Pitman-Nourse bedstead with a pair of illustrations from CLARENCE COOK's popular book *The House Beautiful* of 1878 (see FIG. 5.6) underlines the contrast between the willful exuberance of the former and the restrained carving of the middle-class ideal for which Cook was spokesman, with its emphasis on careful craftsmanship and simplicity of line and shape. Cook's plate 86 (FIG. 1.6), the caption of which proclaims, "A bed is the most delightful retreat known to man," shows a HERTER BROTHERS bed in a richly patterned aesthetic context of wallpaper, portiere, rug, parquet floor, and mirrored table. In gender terms the interior depicted creates a hospitable aesthetic domestic corner, away from and an implicit alternative to the man's world of business and commerce. The companion illustration in Cook's publication, plate 85 (FIG. 1.7), makes explicit the gender contrast. The lounging figure of a young woman is at once both sensuously available and innocently childlike. The image tantalizes and forbids, as the woman petulantly insists upon withdrawing again into sleep.

The Pitman-Nourse bedstead clearly defies such stereotyping. Its bold generative message is apparent, and its achievement a complex one that reconciles the conflicting and sometimes even contradictory values of the Aesthetic movement. As an artifact displayed in an urban industrial exhibition, it argued for nature and handicraft. To the business and commercial world, it presented the staunchly playful domesticity of the Pitman home. As the joint product of male and female labor, it redefined conventional work roles, though only in part. The Nourses had been a well-to-do family who had fallen upon hard times economically, and the artistic training of Adelaide and Elizabeth under Pitman and others was by no means an expression of genteel leisure but rather of a need for a financially supportive career. Adelaide "solved" her dilemma through marriage to Pitman. Elizabeth rejected both the search for a marriage partner and the opportunity to teach drawing in Cincinnati to pursue the difficult path of the woman painter; in 1887 she went to France to study and live.[52] In this sense the bed represents the possibility afforded to middle-class women of straitened circumstances that Purnell had noted in the London *Art Journal* in 1861 and that Calista Halsey repeated in her New York *Art Amateur* article on wood carving in 1879: that the hope of that art "or any other branch of artistic handwork" lay in its capacity to reach "the vast number of women who occupy the debatable land between housework and teaching, who will not do the one and who cannot do the other." For this group, said Halsey, aesthetic activity was "the ideal work."[53]

Benn Pitman's attitude toward women's work was ambivalent. While training, guiding, and cooperatively working with them in the decorative arts, he was also to some degree supervising the segregation of specific tasks by gender. A work like the bedstead discussed above was usually made by a male joiner from Pitman's designs, then "deconstructed" into its separate parts for decoration by the women artists, before being reassembled by the male joiner. Toward the end of his career, in a New Year's editorial in the *Cincinnati Post* in 1892, Pitman regretted his earlier formulation—"Let men construct and women decorate"—declaring, "How foolish! I now say let women construct or decorate or do anything else according to their ability or inclination," for after half a century as an art educator "it is with humiliation, I confess, that it has only been of late years I have seen the absurdity and injustice of any general discrimination against women."[54]

But the gender dynamics of Cincinnati and perhaps of the Aesthetic movement in America more generally incorporate both points of view. Pitman's ideology and that of his Cincinnati colleagues illuminate the double nature of women's achievement. On the one hand, through Pitman's and the Frys' teachings, by being trained and encouraged to see the creative potential of woodworking and other art forms, and through acting collaboratively on a multitude of projects (from a single table or cabinet to the scheme for the Pitman house or the huge organ for the Cincinnati Music Hall), women were empowered to express themselves, singly and collectively, as the decorators of objects rather than as the decorative objects in their husbands' homes. On the other hand, the objects they produced were by and large for domestic purposes, not unlike the quilts and braided rugs, mourning pictures and watercolors that women had done for at least a century. As such their work tended to reinforce the circumscription of their lives within the domestic sphere, not only in practice but in theory as well.

Pitman's younger colleague William Henry Fry, in an 1897 essay on wood carving, argued in modified Ruskinian cadences for the adaptation of natural forms. Fry spoke of the medieval stone carver at work on the tomb of the "chiseled warrior,"[55] before turning to the possibilities of contemporary art, "the newer dispensation, the Renaissance [*sic*] of the New World." In a key passage, he moved from nature to women:

> The flowers of the field, the waving palm, the wondrous
> birds, the ever-delightful tracery of branch and leaf; these
> become themes to be woven by our subtle imagination,
> to decorate and beautify. The expression, the charm, the
> molding of these by ideal conception comes intuitively to

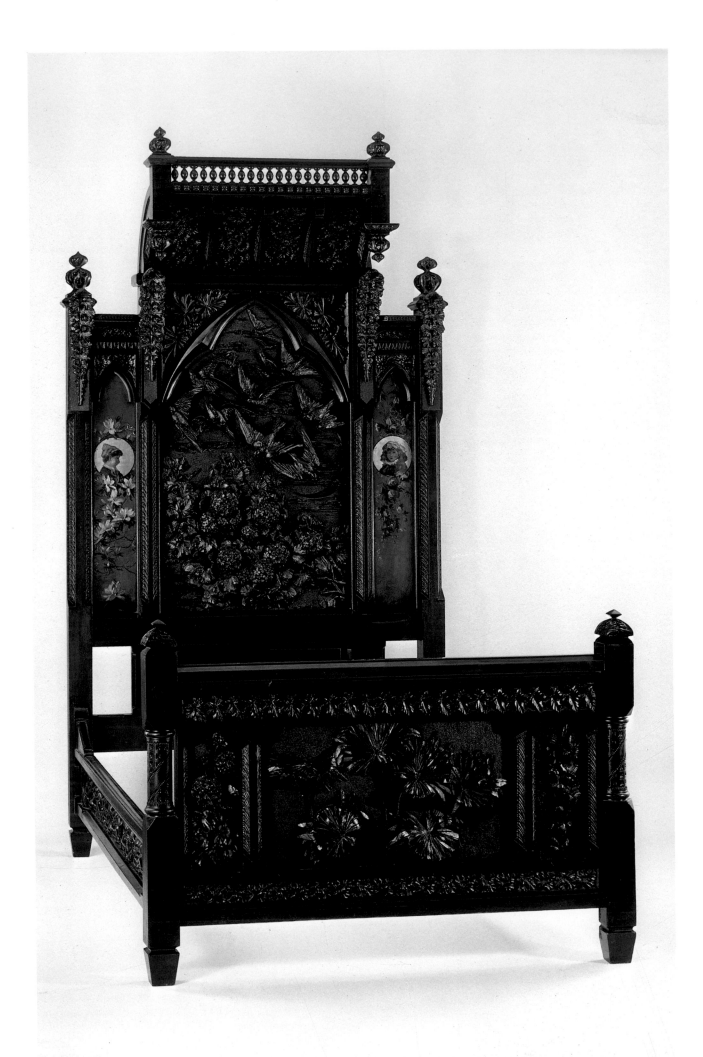

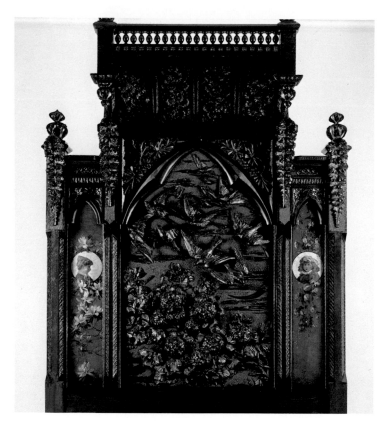

Above: FIG. 1.5 Detail of bedstead (FIG. 1.4)

Opposite: FIG. 1.4 Bedstead. Designed by Benn Pitman, carved by Adelaide Nourse Pitman, panels painted by Elizabeth Nourse, Cincinnati, ca. 1883. Mahogany, h. 9 ft. 2 in. (2.79 m), w. 3 ft. 7 in. (1.09 m), l. 7 ft. (2.13 m). Collection of Mrs. Casper Heeg Hamilton

the American woman. The nature endowed aptitude of most women makes them the ready exponents of the creed-beautiful, placing their loving labor upon the high plane that what is worth doing should be done the very best we have the power to do. And I draw my conclusions from actual experience, that decoration—the study of good lines—is essentially womanly work. All that is beautiful, all that is true in art, appeals to her very nature.[56]

The passage makes clear that Fry's praise of women's art flowed from his love of nature. As a teacher for many years, as Pitman's successor in 1893 as head of the wood-carving department at the Art Academy of Cincinnati (formerly the University of Cincinnati School of Design), and as father of the leading wood carver LAURA FRY, he knew and clearly respected the work that Cincinnati women had produced. Yet the effect of his praise, while it mentioned the need for "loving labor"—no achievement in America was without effort—still defined women's work as a kind of natural fulfillment. By stressing the relation between aesthetic work and the emotional life of its maker in an object destined for the home rather than an impersonal market, Fry's argument locates women's labor as "unalienated," in Marx's language, and thus is an implicit critique of capitalist modes of production.

In gender terms, however, men for Fry remained the "constructors" of American society, as in past societies they had been the soldiers, the chiselled warriors whose death the male artist commemorated. If women, by contrast, were associated with natural processes and with growth, they were only acting out their supposedly inherent proclivities. On some fundamental level, while praising the aesthetic achievement of the Cincinnati wood carvers, Fry, like male colleagues elsewhere, was arguing that women's biology was their destiny. This is the mixed legacy of the Aesthetic movement in Cincinnati and in the United States generally in this period: it empowered women to create beautiful work, expressed in a range of forms and media, while at the same time preserving and reinforcing the dominant ideology of separate male and female spheres.

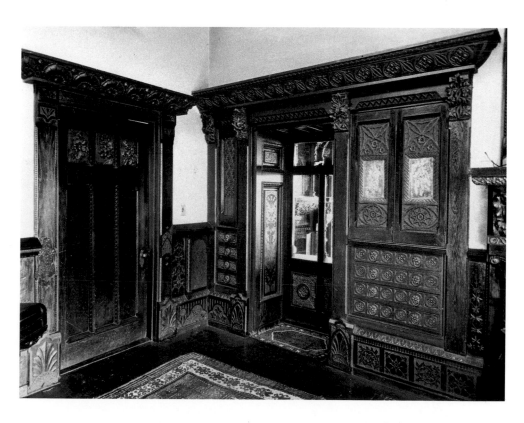

ILL. 1.3 Carved decoration, Pitman house, Cincinnati. Designed by Benn Pitman, carved by his students, ca. 1883–90

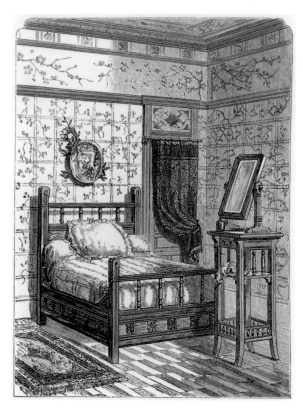

FIG. 1.6 "A Bed Is the Most Delightful Retreat Known to Man." Designed and drawn by Alexandre Sandier, Herter Brothers, New York. Clarence Cook, *The House Beautiful* (New York, 1878). Thomas J. Watson Library, The Metropolitan Museum of Art

The production and consumption of most Cincinnati aesthetic articles, before the Rookwood workshop was fully expanded, was the responsibility of a limited but extraordinarily dedicated group of women and men among the city's cultural and social elite. The local papers were, on the whole, strongly supportive of aesthetic activity. Local pride was enhanced by recognition of Cincinnati-made objects not only by the city's own publicists but also by national reviewers and through the exhibition of Cincinnati work at international fairs from Philadelphia in 1876 to others in Boston, Atlanta, Chicago, and elsewhere.

Occasionally an unfavorable note was sounded. The *Cincinnati Enquirer* in 1876 published criticism written by Judge Stallo, one of the University of Cincinnati's trustees, of the Cincinnati Room in the Women's Pavilion at the Philadelphia Centennial. According to Stallo, art education had not reached the working class, whom educators claimed they wished to serve, and the School of Design was "run for the accommodation of ladies, mostly the wives and daughters of our wealthy citizens, who go into rhapsodies over the 'Antique.'" Pitman, in contrast, believed that the decorative arts appealed "to people of average culture," whereas painting and sculpture were "as yet, for the rich; they mainly affect the favored few."[57]

Yet it was Pitman himself, in 1890–91 in the last of a course of decorative-arts lectures he delivered in Cincinnati at the Art Academy, who ultimately challenged the underlying premises of laissez-faire capitalist ideology as destructive to the growth of American art. The lectures were published as a pamphlet, and Pitman's decorative design for the cover (ILL. 1.4) was emblematic of his point of view. Stylized leaves and flowers encircled the title: *American Art—Its Future Dependent on Improved Social Conditions.* Around the leaves on the right-hand border curls a scroll with the names Plato, Ruskin, Bellamy, Gronlund, and Morris. Hellenic

idealism, Ruskin's indictment of commercial society, and Morris's extension of Ruskin toward socialism were now linked with two Americans: Edward Bellamy (1850–1898), whose utopian critique of contemporary society, the immensely popular *Looking Backward* (1888), had spawned Nationalist clubs around the country, and Laurence Gronlund (1846–1899), whose *Co-operative Commonwealth* (1884) drew more directly on Marx's ideas. Together the five frame Pitman's forthright attack on the inequalities of American life, the polarization of rich and poor, and his call for a breakup of the trusts and a nationalization of large-scale industry and utilities. In earlier ages, kings, priests, and nobles may have supported the arts, but, wrote Pitman,

> Such patronage exists for art workers no longer. Our modern oligarchy of wealth have neither inclination nor culture to encourage art, that is worthy of the name. Their means and energies are, for the most part, expended on finery that is wasteful, or frivolity that is sensuous and demoralizing. Art patronage and appreciation, in the future, must come from the general enlightenment and culture of the people, and I see no reason why we should not rejoice at the thought.[58]

Pitman recovered for his 1890s audience the radical reformist core of the Aesthetic movement, and if he unflinchingly asserted the necessity for social and economic changes as the basis for the growth of art, like Gronlund and the Bellamy Nationalists he seemed confident that this could be achieved through some vaguely benign process that would avoid outright class warfare or revolution. The social and ethical foundations of art must be reaffirmed, Pitman believed, with decorative concepts based on the reconstruction of a healthy society. The significance of Pitman's position in an evaluation of the Aesthetic movement in the United States can only be fully measured in the context of New York City.

Artistic Association and Class Conflict in New York City

For all the variety of achievement in New England in general and in Boston as the hub of regional artistic activity, or the special

FIG. 1.7 "You Have Waked Me Too Soon, I Must Slumber Again." Drawn by Alexandre Sandier. Bedstead designed by John Miller, made by Matthias Miller, New York. Clarence Cook, *The House Beautiful* (New York, 1878). Thomas J. Watson Library, The Metropolitan Museum of Art

ILL. 1.4 *American Art—Its Future Dependent on Improved Social Conditions* (Cincinnati, 1891). Benn Pitman. Cincinnati Historical Society, Gift of Melrose Pitman, 1970

contributions of Cincinnati and other cities, New York was clearly the aesthetic capital of the nation, as it was the nation's commercial and financial center. Both the old wealth and the new gravitated to New York as the great emporium where the latest goods could be purchased. Consequently it became the home of those whose great fortunes may have been made in land or transportation or steel but were maintained by the business of Wall Street. The majority of residences described in the lavish volumes of *Artistic Houses* (1883–84) were in New York City, and New York was likewise the location of the leading design firms that helped to shape aesthetic-style taste in the homes and clubs of the Vanderbilts, Havemeyers, Morgans, Villards, and others. Such families were among the great collectors of objects of art, accumulating works for their own homes and taking part in the organization and benefaction of The Metropolitan Museum of Art, founded in 1870.

The merchandising and display of the large New York dry-goods stores made an international array of aesthetic artifacts available to a broad, middle-class public.[59] Periodicals of national circulation, like *Scribner's Monthly*—later *Century Illustrated Monthly Magazine,* under the editorship of RICHARD WATSON GILDER, poet and husband of the artist HELENA DE KAY—communicated the latest aesthetic news, such as Clarence Cook's essays on furniture, with their practical hints on where artistic products could be

bought.[60] The artists to serve this public were numerous in New York City. They were drawn there by opportunities for study and exhibition not only at the long-established, conservative National Academy of Design (founded in 1826), but also at the Cooper Union for the Advancement of Science and Art (1859), which had a School of Design for Women, the Art Students League (1875), the Society of American Artists (1877), the Society of Decorative Art (1877), and the Metropolitan Museum Art School (1880). Art-oriented social clubs like the Century, the Lotos, and the Grolier brought artists, writers, and potential patrons together, and places like the Tenth Street Studio Building continued to provide forums for artistic exchange. In the late 1850s the Tenth Street Studio Building had been a meeting place for landscape and genre painters. In the early 1860s John La Farge shared with colleagues there his interest in Japanese prints. By 1878 WILLIAM MERRITT CHASE had taken over its exhibition space as his aesthetic-style studio.[61]

New York City's rich resources for artistic communication and collaboration highlight a critical quality of the Aesthetic movement more generally: that works of art, from design to execution, were most frequently the result of many hands, the product of ASSOCIATED ARTISTS, TIFFANY AND COMPANY, or Herter Brothers in New York, for example, the Rookwood Pottery in Cincinnati, or Louis Prang in Boston. Trinity Church in Boston, the most monumental joint effort, represented one extreme; the Tile Club in New York, a social gathering of painters and writers on ceramics holiday, the other; and in between existed a range of relationships, with the interior designer—a single figure or a firm—presiding over an entire undertaking. The early nineteenth-century romantic image of the artist as lone genius in an anti-poetic, hostile universe has had considerable staying power, but the Aesthetic movement made clear that this was a myth, strengthened the sense of artistic community, and moved the male—and to some degree the female—artist from a position of marginality to a more central status as designer, if not arbiter, of social space, whose task was to transform his or her Philistine clients into lovers of beauty.

William Merritt Chase was the archetypal male artist in this period: a debonair public personality, a painter and teacher, a mainstay of The Metropolitan Museum of Art, and a member of the best clubs who could hobnob with his wealthy clientele, as could John Singer Sargent (1856–1925) or Stanford White (1853–1906) or AUGUSTUS SAINT-GAUDENS. Painters like WINSLOW HOMER and especially Albert Pinkham Ryder (1847–1917), whom we tend to mythologize as loners or romantic hermits, are surprisingly social in the context of the Aesthetic movement.

Among the women artists in New York during this era the key figure was Candace Wheeler. She was taught the household arts of spinning, weaving, and knitting as a child in rural, upstate New York. After her marriage in 1844, she and her husband, Thomas, entertained such artists as Frederic E. Church, Eastman Johnson (1824–1906), and Albert Bierstadt (1830–1902). Wheeler studied painting in Europe in the 1860s, but it was the South Kensington displays at the Philadelphia Centennial that galvanized and focused her energies to organize the Society of Decorative Art in New York, modeled on London's Royal Society of Art Needlework. Her activities in subsequent years included collaborative endeavors as the textile designer on decorative projects such as the Mark Twain house in Hartford, Connecticut, the Seventh Regiment Armory in New York, and that greatest of American residences, the White House; work with exclusively female organizations to stimulate women's opportunities in the arts and crafts; and a steady outpouring of articles, pamphlets, and books on decorative subjects, which were forthright in their advocacy both of aesthetic tenets—the primacy of color as a harmonizing element in design, for example—and of the critical role of women as active shapers of their own environment.[62]

For aspiring professional women Wheeler offered a model of the active public life. For women more generally, her writings en-

couraged the belief that guiding principles for the decoration of the household interior and the garden were not arcane mysteries, but could be understood and implemented by the layperson. Wheeler's underlying assumption was that if the middle-class woman's life revolved around the home, she needed to control that space aesthetically, accommodating it to her own needs and the needs of her family and transforming the wealth of the family, whether great or modest, into beauty.[63]

New York in the 1870s and 1880s was the primary aesthetic meeting ground for artists and patrons. But it was also a city teeming with the "huddled masses yearning to breathe free," who had come through Castle Garden in immense numbers and whose poverty was visually evident if one stepped beyond the thresholds of the "artistic houses." Perhaps nowhere are the dynamics of New York aesthetic culture and its relationship to the larger social forces at work in the 1880s examined more astutely than in the self-consciously realist fiction of William Dean Howells. An Ohioan who had become in the 1870s and 1880s a critical spokesman for Boston as novelist and as editor of the *Atlantic Monthly,* Howells moved to New York in 1889 and used his experiences as the inspiration for his finest novel, *A Hazard of New Fortunes* (1890). The autobiographically based Basil March takes his family from Boston, with its Brahmin values, to New York to become editor of an aesthetic periodical underwritten by one Jacob Dryfoos, an Ohio farmer who in the urban environment has been isolated from his rural roots.[64] Dryfoos's fortune in natural gas has led him to the great national entrepôt so that he might become more directly involved in finance on Wall Street.

Howells is fully the urban novelist in *A Hazard of New Fortunes,* juxtaposing various character types to dramatize the social and aesthetic alternatives of life in New York in 1890. Dryfoos searches, for instance, for a "place" for his children in the city. Of symbolic importance, his son, Conrad, who longs for a career in the ministry to help the poor, is instead made the business manager of March's aesthetic periodical. Dryfoos's daughters are ensconced in a marble palace of lavish (but dubious) taste to qualify them for the marriage market. Howells permits the reader to share the other characters' judgments of the Philistinism of the Dryfooses by creating a full range of aesthetic possibilities. In contrast to the Dryfooses, for example, Howells depicts both the elitist Mrs. Horn and her niece Margaret Vance and the morally empty aestheticism of the artists and writers who frequent her salons, including young Beaton, the son of a stone carver (a Ruskinian-style artisan). Beaton's studio in New York is described in terms that suggest an impoverished version of the Tenth Street studio of William Merritt Chase. Howells reels off the canonical list of the mixed decor of its aesthetic style: a vaulted ceiling, casts, prints and sketches, "a strip of some faded mediaeval silk," a Japanese kimono and other costumes, rugs and skins. "These features," observes Howells, "one might notice anywhere."[65]

As the central consciousness of the novel, March tries to maintain his balance between the extremes of culture that New York presents. His hunt for an apartment involves classic descriptions of the middle-class options, which Clarence Cook's articles were trying to improve, and despite March's protest that the New York flat is spatially and socially the denial of the family ideal, the Marches do settle into an aesthetic interior, filled with "gim-crackery."[66]

Howells's brilliant ironic perspective on March recognizes the dilemma of an intellectual who uses a magazine to convey an aesthetic vision that is neither Philistinism nor amorality. When March and his wife enter Grace Church, they are responding in a sense to the issue raised by Adams in *Esther:* they have come, says March, not for religious reasons but "to gratify an aesthetic sense, to renew the faded pleasure of travel for a moment, to get back into the Europe of our youth. It was a purely pagan impulse."[67] Further, March tries to find the picturesqueness of poverty, and he

is repelled by the embittered anticapitalism of his old German teacher Lindau (whose rhetoric in attacking the system, according to March, sounds like Ruskin).[68]

A street-railway strike (based upon an actual incident of the 1880s) shatters the precarious equilibrium of March's aesthetic position, and though at the end he retains a shaky grip on his moral balance as well as on his periodical, it is not without Howells's—and the reader's—recognition of the social costs of such an achievement: the martyrdom of young Conrad Dryfoos, minister manqué, by an accidental shot during the strike and the consequential death of the principled radical Lindau; the emotional collapse of the elder Dryfoos, who takes his daughters to Europe; and the decision of Margaret Vance to become an Episcopalian nun and devote her life to the poor.

Howells is unwilling (or unable) in this novel to create social order and to regulate class conflict through the common strategy of marrying heroes to heroines. The one marriage that does take place in the course of the book involves Fulkerson, March's advertising manager, who makes clear that the New York culture being explored by Howells is dependent upon marketing and consumption—in this case, of an aesthetic magazine. The most eligible young woman in the novel, the artist-illustrator Alma Leighton, renounces love and marriage and rescues the aesthetic as a viable alternative, rather than merely as an escape from moral and social commitment.

The overriding importance of *A Hazard of New Fortunes* to the present discussion lies in the way in which Howells contextualizes the Aesthetic movement in New York. "There's only one city that belongs to the whole country, and that's New York,"[69] comments Fulkerson, and indeed the novel vividly dramatizes how a wide pool of available resources—Dryfoos's money, Fulkerson's marketing genius, and March's intellectual and editorial skills—is marshaled for aesthetic purposes. For the artists and writers in the book, New York serves not only as a place for study. It also offers a national market for creative talent, which means an aesthetic profession for a woman like Alma as well.

March's quandaries as an editor are those raised by the Aesthetic movement: Is it possible to be both aesthetically and socially responsible? Is art the captive of its capitalist financier, the luxury expenditure of the wealthy? Can art avoid both overt moralizing and social crusading without ignoring "how the other half lives"? (The social reformer Jacob Riis's famous exposé of New York poverty of that title was published in the same year as Howells's novel.) And is the pursuit of the aesthetic dependent upon the egoism of the artist and the callousness of an audience who insulate themselves in their "artistic houses," at least until a major calamity tragically breaks the spell? Howells offers his reader no solutions to the questions he poses. Though a lover of beauty and a sometime Ruskinian, as a realist his goal was to depict the problems of ordinary life, rather than to tie up plots with "happy endings." Howells had no clear answers, but it is the strength of *A Hazard of New Fortunes* that its vision, honest and precise, renders the unresolved ideological issues of the Aesthetic movement as they presented themselves in the nation's aesthetic capital.[70]

Aesthetic Style: The Design of Social Space

The ideological concerns voiced in Howells's *Hazard of New Fortunes* and in Benn Pitman's lectures of 1890–91—regarding social preconditions for art in the United States and related issues about women's work as both empowering and imprisoning—were a fundamental challenge to the Aesthetic movement in America and contributed to its transformation in the 1890s and thereafter. But before turning finally to that shift we need to capture the move-

ment in its greatest strength, which was to make accessible to artist and audience, aesthetic producer and consumer, a range of artifacts drawn from an international inventory.

In both theory and practice, the Aesthetic movement declared its freedom from the limitations of style as a historically embedded form of expression, the necessary language of a particular time or place. Sometimes wary, sometimes downright hostile toward narrative or associative values and iconographic intent in the name of universal notions of beauty, the Aesthetic movement set about deconstructing the unified artistic vision of earlier eras to make the art of the world more widely available, an aim facilitated by the international marketplace. The late 1860s, the 1870s, and the 1880s saw the founding of great major urban museums: the Metropolitan in New York, the Museum of Fine Arts in Boston, the Corcoran Gallery of Art in Washington, D.C., the Philadelphia Museum of Art, the Cincinnati Art Museum, and the Detroit Institute of Arts. These public institutions became great storehouses for the art of the world. American art lost its privileged position among patrons, and even though some rhetoric was expended on the special value and opportunities of the American experience, on the whole American products—wallpapers as well as landscape paintings, Rookwood pottery as well as Mission furniture—had to compete with foreign goods for aesthetic preeminence.

Particular period styles had their advocates and practitioners, and some collectors specialized in medieval manuscripts, Greek vases, Japanese screens or porcelains, even early American furniture. A William H. Vanderbilt (1821–1885) might designate one space in his New York City mansion a "Japanese" parlor, and a Henry Osborne Havemeyer (1847–1907) might combine Japanese objects with compatible contemporary Western paintings. But the Aesthetic movement had redefined the significance and decorative uses of style.

By liberating the artist, the decorator, the collector, and the perceiver more generally from a responsibility to the historical past and geographically distant cultures, by making artifacts available as individually beautiful objects for home consumption, the Aesthetic movement made possible a kind of creative play with form and color and texture that helped to revolutionize our ways of seeing and knowing. It focused attention on harmony and symmetry (or Japanesque asymmetry) and on arresting juxtapositions of works from different worlds, creating cumulative effects for the sake of sensuous and formal enjoyment and stressing the visual composition as a whole. The demands of narrative, associative, or symbolic meaning and the earlier belief that art was the servant of some extrinsic purpose were exchanged, at least in theory, for the pleasures of art for art's sake.

By concentrating on the supposedly intrinsic qualities of the visual and its compositional values rather than its referential functions, the Aesthetic movement takes us part way toward modernism. Early twentieth-century artists explored the dissolution not only of history, narrative, and the illusionist ideal but also of objects themselves; thus the African "primitive" tribal mask became a French pictorial or sculptural design, or objects fragmented in a continuous cubist present or recombined in a fully nonobjective absolute vision. The avant-garde of modernism created a rift between the public at large and an elite audience of collectors and the critics, dealers, and museums who catered to their taste.[71] Despite the Aesthetic movement's concern with the language of art and the grammar of ornament, it was by no means ready to effect modernism's extreme ruptures with the past and with the observable world. Though some spokesmen for art for art's sake scorned the Philistine public, in general the aim of the Aesthetic movement's chief apologists—though not always their achievement—was to reach a wide audience. Nevertheless, the overwhelming stress on visual values during the 1860s, 1870s, and 1880s can be seen, retrospectively at least, as a significant step in the development of the formalist discourse of the twentieth century.

In its own terms, however, the special challenge of the Aesthetic movement lay in the sensitive arrangement of beautiful objects within the domestic interior to arrive at an overall harmony. Thus Clarence Cook, in *The House Beautiful,* could isolate the Moorish gun rack from a French Salon painting by Regnault, *The Guardian of the Harem,* refer to the rack as "a bit of Regnault," and suggest it as "a most convenient hat and umbrella rack for an entry hall; and though its pleasantest use would be to support some choice arms on the rack, and vases, or casts, on the shelves," what was essential was "to get a little more color and cheerfulness into our rooms."[72] And fifteen years later, in 1893, Candace Wheeler emphasized that color "is the primary factor of beauty," that the key to a successful domestic interior may be found in "the principle of appropriateness, and the intelligent and instructive use of color."[73] A decade afterward, she claimed that to assist the amateur, one must teach her "the science of beauty, . . . how to make the interior aspect of her home perfect in its adaptation to her circumstances, and as harmonious in colour and arrangement as a song without words"—that is, without a controlling associative context. Wheeler insisted that design must be "appropriate" to the situation of women, and by 1903 she was pleased to note women's entry into politics, philanthropic work, and a variety of socially useful activities. When it came to aesthetic work within the domestic sphere, however, she was convinced of the abstract principles that women must learn: "laws of compensation and relation, which belong exclusively to the world of colour, and [though] unfortunately they are not so well formulated that they can be committed to memory like rules of grammar; yet all good colour-practice rests upon them as unquestionably as language rests upon grammatical construction."[74] Wheeler's own language suggests how well she had learned the lessons of Owen Jones and Christopher Dresser.

Aesthetic style had been effectively redefined as the international reorganization of artifacts in the American present for the delight of the beholder, lifting him or her to the contemplation of the beautiful. It is most clearly seen on the grand scale of Olana, Trinity Church, the William H. Vanderbilt mansion, the Seventh Regiment Armory, or the White House. These are the sites that challenged the energies of the most skillful professional decorators of the period and set the standard for what Thorstein Veblen called "emulation." The objects created for such places have been, on the whole, those recorded and preserved by later collectors and by museums that have recognized their value.

Our concern at this point is less with the individual decorative achievements, the masterpieces of the Aesthetic movement, than with understanding the process of redefinition, in theory and practice, and the social implications of that process. To observe this in the artifactual evidence, we may turn to the painters of the period, whose works educated Americans in the aesthetic vision. Paintings became sites, as it were, on which were enacted the redefinition of style—the appropriation of cultures of the past and their transformation into new expressions of "American" art. As such they actively participated in the redesigning of social space to meet the needs of a rising generation of art lovers.

The shift in attitude can be seen in a comparison of the paintings of EDWARD LAMSON HENRY and William Merritt Chase. Henry's *Old Clock on the Stairs* (FIG. 1.8), dated 1868, was in fact exhibited the year before at the Pennsylvania Academy of the Fine Arts, in 1869 at the National Academy of Design, and again at the Philadelphia Centennial in 1876. The painting was "made from nature," according to Henry, at the late eighteenth-century Spruce Street home of William Kulp, a Philadelphia antiquarian with whom he was to be involved in various projects for the architectural preservation of residences and public buildings (including Independence Hall). The vision of the work is nostalgic and retrospective, a meticulous record of the past and of classical order. The primary focus of the painting is the old clock, a symbol of past time, at the top

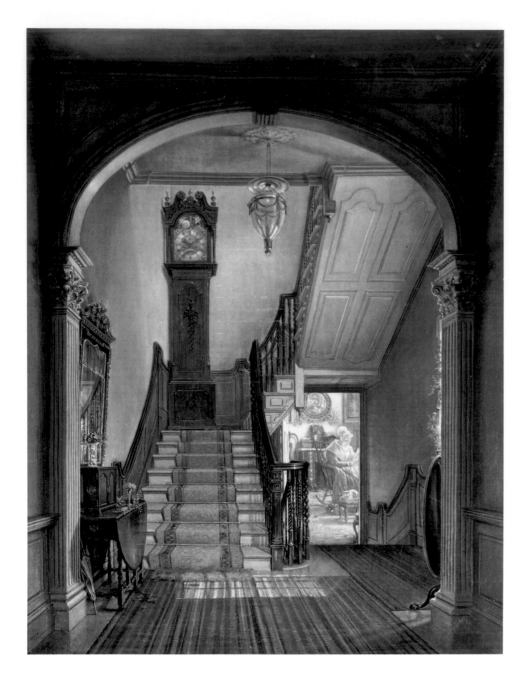

FIG. 1.8 *Old Clock on the Stairs*. Edward Lamson Henry, 1868. Oil on canvas, 20¾ × 16½ in. (52.7 × 41.9 cm). Signed: *E L Henry. / MDCCCLXVIII*. Shelburne Museum, Inc., Vt. (27.1.67)

of the stairs on the left. On the right the space is deeper, more constricted, leading to an elderly woman reading a newspaper in her sunlit back parlor. In temporal and spatial terms the aged figure represents a midpoint between the viewer in the present and the carefully defined classical stability of a bygone era that is "revolutionary" only in the chronological sense. One of many such images by Henry, this work is an antiquarian gesture, a quaint act of revivalism.[75]

A contrasting strategy, involving an aesthetic reorganization of the present, appears in the many versions that Chase painted of his Tenth Street studio, in the same building in which Henry had worked for more than twenty years.[76] Chase's sense of both time and pictorial space is entirely different from Henry's. *In the Studio* of about 1880 (FIG. 1.9) shows paintings, ceramics, textiles, an oriental rug, Japanese fans, and a Renaissance credenza filled with objets d'art—all artifacts that are included as color and tonal notes and as textural juxtapositions contributing to the elegance, sophistication, and artifice of the arranged decor. Though the objects displayed in Chase's studio were drawn from cultures East and West, past and present, in the picture they function as parts of a

visual ensemble, rather than as a coherent iconographic program. The viewer's eye is led into the open space, across the rug to a young woman (in old-fashioned costume) who looks at art. Her youthful beauty plays off against the centrally placed print of *Malle Babbe,* the mad old crone painted by Chase's most revered master, Frans Hals; the females are framed by the males, in portrait and sculptural head; the dark landscape painting is located between the palm in its elegant bowl and the fresh bouquets on the credenza, the dark sculptured forms of which are in turn balanced by the sheen of the gold silk hanging—the possibilities for aesthetic play are almost endless. Whereas *Old Clock on the Stairs* at once distances the viewer by insisting upon the pastness of the past and allows the viewer to step across the threshold into memory, *In the Studio* dissolves the complex pattern of historical styles of time and place into a present visual order on the surface of the canvas and emphasizes the artifice of the conjunction of such disparate objects. The luxuriousness of the space and the pleasure the viewer derives from the painting prepare him or her to be a connoisseur of art for art's sake as a formal experience.

Chase's studio was itself designed as a work of art in the new

style, a familiar gathering place for the aesthetic entertainment of artist and patron as well as Chase's students, who made their own versions of its interior.[77] The technical skill and bravura of Chase and his students should not divert us from the significance of their achievement: the deconstruction of the associative process, the loss of a strong sense of the iconographic value and the symbolic import of the individual artifacts depicted, and their resolution into pattern and style, a visual harmony that sacrifices particular origins to the grand cadence of Art. The Aesthetic movement proclaims the artistic vitality of the present as the transformer of near and far.

The process so evident in the Chase studio portraits, as well as in other paintings by this consummate artist in the aesthetic style, had begun some two decades before, in Whistler's art of the 1860s. *Purple and Rose: The Lange Leizen of the Six Marks* (1864, see FIG. 9.14) is an early instance of the new accommodation between East and West, between the Japanese style and the Western model, which Chase would utilize in a number of works in the 1880s.[78] The *Lange Leizen* and its progeny all employ Japanese decor—kimonos, screens and textiles, books and prints, bowls and vases—but Whistler's central female figure here is in no sense Japanese. She is at once the Western artist-decorator who in pose mimics the "long ladies" on the jar she is contemplating and the device through which the viewer also removes him- or herself in contemplating the picture as aesthetic object.[79] The aesthetic unity of the scheme militates against an intellectual response; yet there is an intellectual problem in the disjunction between the perceiver and the art and style being perceived. The woman provides the viewer with access to an exotic culture, but she is depersonalized in the process, serving as a mannequin for the display of the style of another time and place. Because she is herself not part of that time and place but an outsider, an actress playing a role in a dress-up costume, she is emotionally stripped, object-ified, decontextualized. Art drives a wedge between the viewer and the woman's identity as a person.[80]

This dynamic is evident even in the seascape painting of Winslow Homer, who though seemingly peripheral to the Aesthetic movement moved in these years toward the same kind of aesthetic objectification. His 1880 *Promenade on the Beach* (FIG. 1.10) shows two young women, one with floral gown and Japanese fan, in a stylized pose on the edge of a sea rendered as flat pattern. Homer had been depicting women at the seashore for twenty-five years in a variety of media and narrative situations: frolicking at Newport, Rhode Island; emerging from bathing at high tide; as lone figures on the beach at Marshfield, Massachusetts; or seated in the moonlight with a fan and a male companion.[81] In the late 1870s Homer experimented with informally posing a pair of women in the same stark setting as *Promenade* in both an oil sketch (Private collection) and a set of fireplace tiles (1878; Private collection). In 1880 he completed a small, stylized ceramic tile, *Woman on a Beach* (Addison Gallery of American Art, Andover, Mass.), which incorporates a Japanese fan and a verbal inscription, and the large oil *Promenade,* a Whistlerian harmony in blue and beige in which the abstract organization of the canvas, rather than some narrative or genre situation, controls the vision.[82]

It is not merely that Homer had learned from Japanese prints how to strengthen in *Promenade* the formal composition and design of his material, although there is ample evidence of this.[83] Rather, at this crucial "aesthetic moment" in Homer's career, following years of specifically American genre work often with a strong implicit narrative content, style as the abstract organizer of material from various cultures triumphs over the female subject, depersonalizing her and distancing the viewer, frustrating the search for some cultural meaning and resolving the experience of the picture only in aesthetic terms. That Homer in the immediately succeeding years, during his residence in the North Sea fishing community of Cullercoats, England, and thereafter on the Maine coast, would rediscover his subject as the stark conflict of natural forces is well

known. But it is his participation and sharing in the strategies of the Aesthetic movement that is important to the present discussion.

A similar process of dislocation and objectification is apparent in the glowing stained-glass idealized figures of John La Farge and in a stylized classical allegory such as *The Days* (1887, see FIGS. 9.18, 9.19) by THOMAS WILMER DEWING. One can see it also in the lounging figures in a landscape, gathered around an oversized ceramic fountain, in WILL H. LOW's four painted panels for an ebonized cherry cabinet (1882, FIG. 1.11), with its contrasting floral panels above—a striking Hellenistic alternative to the Modern Gothic version in the Pitman-Nourse bedstead (see FIGS. 1.4, 1.5), with its inset painted allegorical heads by Elizabeth Nourse.

The placement of women in relation to such self-conscious artistic style is equally apparent in two portraits of women artists. The subject of one, Chase's *Portrait of Miss Dora Wheeler* (1883, see FIG. 9.15), is the artist-designer daughter of Candace Wheeler, and the work establishes a tension between the formal orders of art and the personality of the sitter. Chase boldly emphasizes the reflective gold tones of the tapestry hanging and the daffodils (a play of art and nature) as well as the curves of the vase and the taboret; he contrasts these with the darker absorbent blues of Wheeler's dress and the rigid turned chair in which she sits, staring out at the viewer. Reversing the usual convention of the recessive background highlighting the figural subject, Chase makes Wheeler and the aesthetic artifacts with which she was creatively involved as designer equally the pictorial focus, in a delicate stylistic balance of human and artistic values.[84]

Perhaps the most profound and poignant treatment of this theme, wherein the relationship between the woman artist and the aesthetic opportunities of the period becomes part of the dynamics of picture making, appears in Thomas Eakins's (1844–1916) *Artist's Wife and His Setter Dog* (1884–88, ILL. 1.5), probably begun the year after Chase's *Dora Wheeler* was completed.[85] In this work the painter's wife, who was also his former student and fellow artist, is surrounded by stylistic alternatives of the Aesthetic era: Eakins's Hellenistic *Arcadia* relief displayed on the right, modern pictures on the left, an open book of Japanese prints in the sitter's hands, an oriental rug beneath her, and a muted, rich fabric drapery behind. Despite the harmony of the aesthetic interior (defined by the varying modulations of the warm red hues), the figure is thoroughly isolated in her chill blue dress, looking out at the painter and the viewer.

Whatever Eakins's canvas may have meant to artist and sitter, to us as students of the Aesthetic movement the work is an extraordinary example of a profusion of styles neither absorbing the self, as they do in Chase's *In the Studio,* nor leading into a reconstructed past, as in Henry's *Old Clock on the Stairs,* nor drawing the subject into some costume drama, as in one of Dewing's or Low's allegorical displays. The figure in the Eakins portrait is fundamentally alone in a present whose stylistic trappings cannot conceal her existential situation.

The tension that the Eakins portrait creates between the aesthetic interior and the female sitter thus underscores major concerns of the period: Was the woman a subject or an aesthetic object? Was the aesthetic interior the woman's domain, the place over which she exercised authority, as various theorists maintained, or was it the site of her isolation, her beautiful prison? Beneath the shimmering surfaces of the aesthetic interior lurked the central issue of women's control of their own lives.

Eastman Johnson's (1824–1906) *Not at Home* (about 1872–80, ILL. 1.6) sheds light on the issue from one angle, by dramatizing a woman's refusal to participate in social ritual through her withdrawal into the darkness at the left of the picture, up the stairs to the private family area. A portrait of a bearded man—possibly her husband or a male ancestor—hangs above her on the stair wall, and a child's carriage under a tall clock frames the scene in the

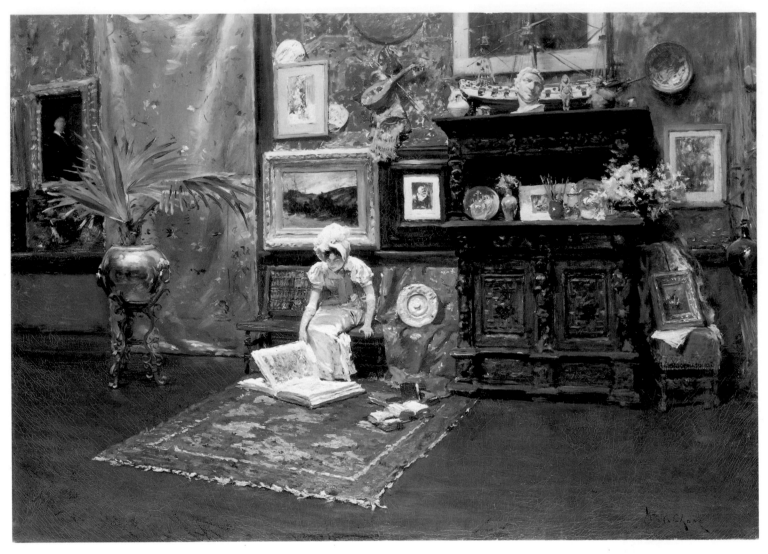

FIG. 1.9 *In the Studio*. William Merritt Chase, ca. 1880. Oil on canvas, 28½ × 40¹⁄₁₆ in.
(71.4 × 101.8 cm). Signed: *Wm M Chase*. The Brooklyn Museum, New York, Gift of Mrs. Carll H.
DeSilver, in memory of her husband (13.50)

darkness at the right. The viewer, like the visitor presumed to be at the door of the house, remains to gaze through the hall arch into the warmly lighted public space: the aesthetic parlor with its wall-paper dado, fill, and frieze, carved sideboard for the display of china, needlework pillows, and rugs. Paintings of farm women (reminiscent of those by Jean-François Millet) and a cast of the *Venus de Milo* serve as a kind of public-art commentary on the receding woman. Unlike Henry's *Old Clock on the Stairs,* where the elderly woman is doubly framed and distanced as one of a number of relics of the past, *Not at Home* is a problematic work that defines public participation within the contemporary aesthetic interior as but one alternative for the late nineteenth-century woman. Yet the design of the image, which locates the viewer in the transitional space of the entry hall, does not allow us (as outside visitors to pictorial space) to know what constitutes the woman's upstairs—her private, domestic, and inner worlds.

One may contrast the chiaroscuro of Johnson's urban interior with the brilliantly lighted, sun-filled image of Celia Thaxter's Appledore parlor, recorded in Childe Hassam's (1859–1935) *Room of Flowers* (1894, ILL. 1.7). His broken-brush technique dissolves the multitude of images that fill the walls, the sculpture and fan over the sideboard, the simpler forms of the rattan and Eastlake-style furniture, and the profusion of flowers from Thaxter's famous garden. It is a summer version of the more stylized studio

images conceived by Chase. The woman reading on the couch is barely discernible, merely a single element in the shimmering Impressionist design. However much Thaxter had struggled to create and organize space as mistress of her aesthetic salon, Hassam's rendition becomes, probably unconsciously, an ironic commentary on the woman's subordination as artist and aesthete, reduced pictorially to just one more note in the pattern of the whole.

Indeed the 1890s and thereafter saw the creation of a number of paintings, especially by such Boston-area artists as Edmund Tarbell, Robert Reid, William McGregor Paxton, and Frank Benson, of women in aesthetic interiors with arrays of Japanese porcelains, screens, or elegant fabrics. The paintings deny vitality to the subjects, who read or play the guitar or simply pose. The women hover on the borderline between being merely beautiful objects in elegant displays and being lonely human beings, lost in thought and isolated in space. Yet whether we see the women as objects or subjects, the pictorial ideology of the works is in marked contrast to the active lives of social concern and philanthropy that the Bostonians depicted frequently led. The aestheticizing of the female sitter in these images functioned to deny publicly the control that women were exercising over their own lives.[86]

That this visual system of signification was equally a language for writers of the period is apparent in two fictional renderings of the aesthetic interior during the 1890s. The first is a scene in Harold

Frederic's (1856–1898) *Damnation of Theron Ware* (1896). The novel has as its eponymous central figure a small-town Methodist minister who is caught in the philosophical cross fire between the sophisticated "higher criticism" of a Catholic priest and the atheist Darwinism of the priest's scientist friend. Ware is attracted to the beautiful young Catholic aesthete Celia Madden. In the central scene between them, Celia lures Ware, who is married, to her boudoir. Frederic renders with ironic particularity Celia's aesthetic interior, replete with stained-glass lighting fixtures, pictures "embedded" in stamped-leather walls painted in shades of peacock blue, parquet floors covered with rugs, and deep green portieres over the doorways. The paintings and statuary scattered about combine ancient Greek and Christian imagery. Ware reclines on an oriental couch as Celia proclaims her "Greek" allegiance—a somewhat exaggerated and erotic version of Arnoldian Hellenism that involves "absolute freedom from moral bugbears. . . . The recognition that beauty is the only thing in life that is worth while." While playing Chopin, Celia tells Ware that her gorgeous red hair is the key to the room's color scheme: "We make up what Whistler would call a symphony." A seduction does not take place—Ware is ultimately too naïve and "a bore"—and the novel closes with Ware's flight from both the spiritual and the aesthetic to the West Coast and a career as a land agent.[87]

That the Chicago aesthetic publishers of *The Damnation of Theron Ware,* Stone and Kimball, former art students of Charles Eliot Norton's (1827–1908) at Harvard, saw the sensuously aesthetic Celia as the key to attracting readers is evident in the poster that they commissioned from John H. Twachtman (1853–1902) to advertise the book (ILL. 1.8). As icon of the strong aesthetic woman in a Philistine world, Celia Madden is a fascinating figure. Frederic dramatizes in extreme form both the powerful appeal and the powerful threat of the Hellenized aesthetic, personified in Celia, to the small-town Hebraized innocent American male. In the process he illuminates the complexity of the several claims to sectarian and spiritual values that impinged upon the lives of Americans at the close of the nineteenth century.

Another perspective on the same issue was offered in January 1892, when the *New England Magazine* published a ten-page story entitled "The Yellow Wall-Paper." The author, Charlotte Perkins Stetson (1860–1935), was born of old New England stock, as a young woman had studied art at the newly founded Rhode Island School of Design (1877), and was the estranged wife of the Providence aesthetic painter Charles Walter Stetson (1858–1911). The story that she had recast from the agonies of her personal experience describes, from the point of view of her fictional alter ego, the onset of madness in a young wife, mother, and writer, who has been condemned to "rest" for three months in the barren attic of an old mansion on the New England coast, a cure prescribed for nervous disorder. The reader is drawn into the narrator's dislocation and loss of reason as her fantasies about the yellow wallpaper

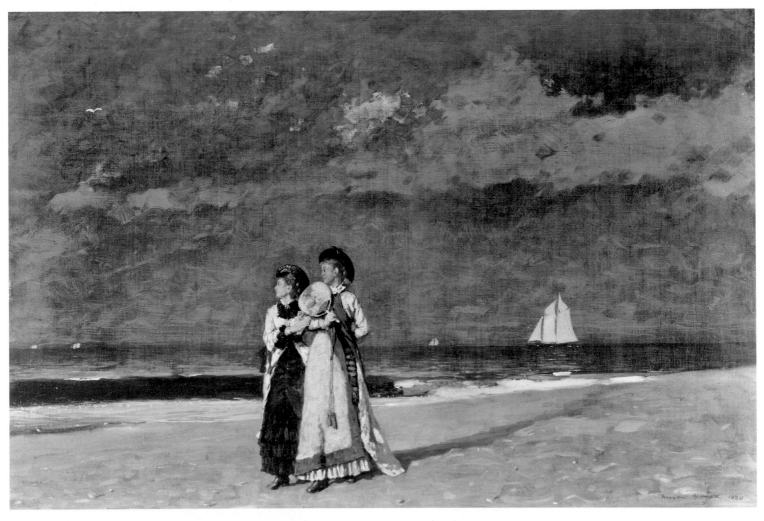

FIG. 1.10 *Promenade on the Beach.* Winslow Homer, 1880. Oil on canvas, 20 × 30⅛ in. (50.8 × 76.5 cm). Museum of Fine Arts, Springfield, Mass., Gift of the Misses Emily and Elizabeth Mills, in memory of their parents, Mr. and Mrs. Isaac Mills (36.06)

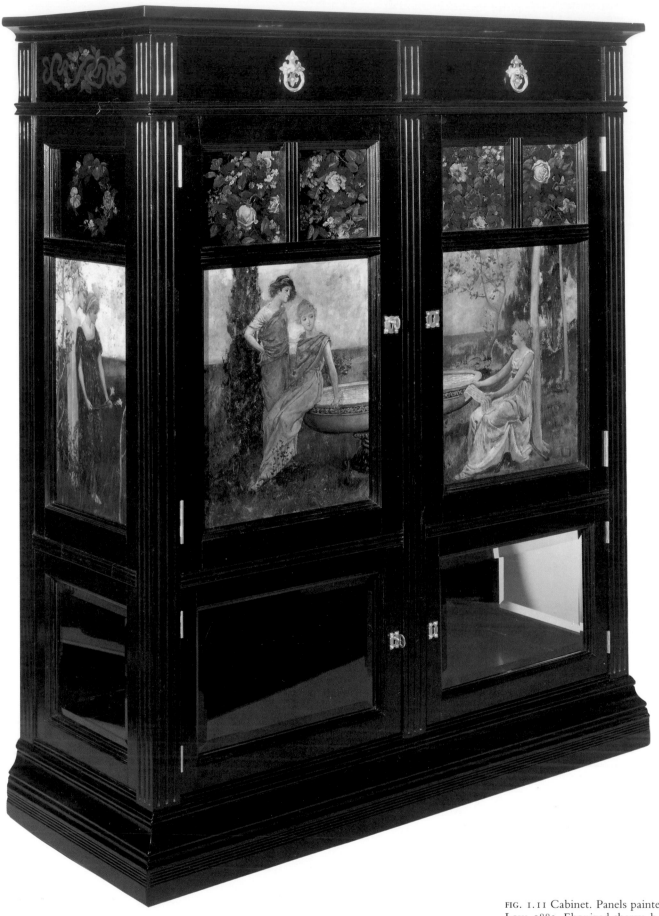

FIG. I.II Cabinet. Panels painted by Will H. Low, 1882. Ebonized cherry, h. 52 in. (132.1 cm), w. 42 in. (106.7 cm), d. 17½ in. (44.5 cm). Panel signed: *1882 Will H Low*. High Museum of Art, Atlanta, Virginia Carroll Crawford Collection (1982.320)

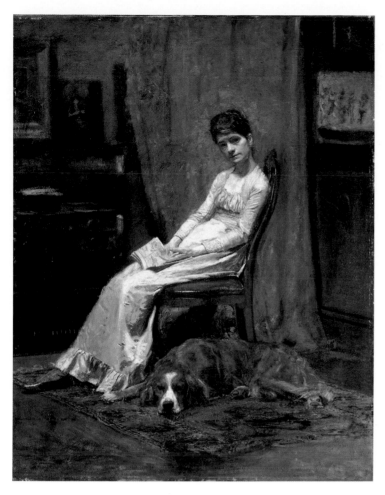

ILL. 1.5 *The Artist's Wife and His Setter Dog.* Thomas Eakins, 1884–88. Oil on canvas, 30 × 23 in. (76.2 × 58.4 cm). The Metropolitan Museum of Art, Fletcher Fund, 1923 (23.139)

in her room become projections of her terrifying entrapment.

The story had been rejected by the editor of the *Atlantic Monthly,* despite the characteristically courageous advocacy of William Dean Howells. In recent years "The Yellow Wall-Paper" has been revived by feminist scholars as a touchstone work by its now-famous author, better known by her later name of Charlotte Perkins Gilman, for the dramatic way in which it renders the situation of a late nineteenth-century American woman.[88] Dependent upon—indeed treated as a child by—her husband, the narrator's only resource is to withdraw inwardly. Her madness at the story's end is at once her defeat and her bold assertion of her identity as a woman, a self-destructive triumph over her husband and the imprisoning world he represents.

"The Yellow Wall-Paper" is the nightmare tale of the Aesthetic movement, a vivid protest, an outcry, drenched in the terms and the problems of the period. Confined to the home and forbidden meaningful work both as mother and as artist, the narrator, as teller of the story, persists in aesthetic activity. Though a grotesque parody of Arnoldian "spontaneity of consciousness," the narrative fragments create an aesthetic order, a verbal artifact. The sign of the protagonist's derangement is her preoccupation with the design of the wallpaper in her room: she tries first to understand it as pattern and then seeks to reinvent the decorative and conventional with meaning.

The theorists and practitioners of the Aesthetic movement had

offered the life of art, the concern especially with domestic beautification, as simultaneously a solution to the question of work for middle-class women and an incarnation of value. The home was to be an escape from industrial and commercial ugliness, bringing "sweetness and light" into the experience of Americans and providing in a newly ordered and harmoniously arranged setting a respite from the professional pursuit of gain in the lives of men. "The Yellow Wall-Paper" turns these ideals and practices on their head, uncovering their sinister side. The setting for the story is "a colonial mansion, a hereditary estate," rented for the summer, with seaward vistas of the New England coast as well as "a *delicious* garden."[89] Yet neither the old house nor the natural vista is a stabilizing force able to bring under control the terror of the interior worlds of both the house and the mind of the narrator.

The critic Clarence Cook had asked in the title of his 1880 pamphlet, *"What Shall We Do with Our Walls?"* (see FIG. 3.7), and the response of the aesthetic enthusiasts had been an outpouring of extraordinary wallpapers, inspired by MORRIS AND COMPANY's examples of the 1860s, 1870s, and later, which introduced new pattern into the homes of the well-to-do and the middle class.[90] The theories emanating from South Kensington had tried to separate decorative design from overtly symbolic and narrative meaning, to universalize pattern and rid it of its deeper cultural associations. But the vague, bulbous, threatening forms on the walls of Gilman's narrator's prison/room also become in the course of the story the bars that entrap her doppelgänger, who shakes them as she struggles for release. Flat pattern and decorative design are metaphorically transformed in "The Yellow Wall-Paper" into the three-dimensional cage that imprisons the self. Meaning is thereby reasserted. In her final mad gesture, the narrator tears the paper off the walls in huge strips; she may be seen symbolically as avenging herself on Cook and an entire generation of interior decorators whose injunctions seemed to restrict women within the domestic sphere.

The aesthetic notion of a harmonious interior achieved through color and tonal unity is further parodied in the sickly cast of the paper, which is "repellent, almost revolting; a smouldering unclean yellow, strangely faded by the slow-turning sunlight."[91] Here, in contrast to Church's Olana or Eastman Johnson's *Not at Home,* there is a failure to bring sunlight and color from the exterior world into play in the decorative interior. Candace Wheeler, the period's leading spokesperson for the centrality of color as the coordinating element in interior decoration, recognized the larger danger:

> Color is the beneficent angel or the malicious devil of the house. Properly understood and successfully entreated, it is the most powerful mental influence of the home; but if totally disregarded or ignorantly dealt with, it is able to introduce an element of unrest, to refuse healing to tired nerves and overtasked energies, to stir up anger and malice and all unseen enemies of household comfort—the enemies that lie in wait for the victims of weakness and fatigue.[92]

To read this passage in the context of "The Yellow Wall-Paper" is to locate the deepest psychological and social sources of Wheeler's language, her implicit recognition that the issues at stake in the Aesthetic movement could not merely be reduced to the superficial prettification of the homes of the wealthy. The interiors to be "decorated" by the period's designers were ultimately the social being, the very souls, of the inhabitants, male and especially female. For Ruskin, one of the movement's chief mentors, art had always been a spiritual concern. The Aesthetic movement had shifted the focus of art from sectarian religious concerns, but it still held that art could be spiritually uplifting and socially instructive. For Wheeler, it was requisite that the home be "harmonious in colour and ar-

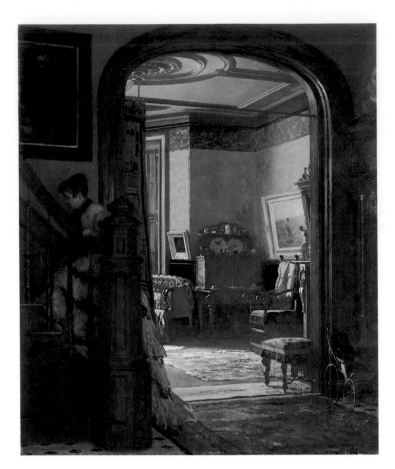

ILL. 1.6 *Not at Home*. Eastman Johnson, ca. 1872–80. Oil on academy board, 26½ × 22¼ in. (67.3 × 57.2 cm). The Brooklyn Museum, New York, Gift of Gwendolyn O. L. Conkling (40.60)

The shift in Gilman's work from "The Yellow Wall-Paper" to *Women and Economics* (1898), *The Home: Its Work and Influence* (1903), and other writings suggests a wider questioning that was occurring in the 1890s, one that grounded aesthetics more fully in the socioeconomic context of American life. Gilman joined with other feminists among the Bellamy Nationalists to explore means of socializing domestic household labor—not to deny woman's role in the home and family but to balance that role against her creative and productive potential in other areas.[94] Benn Pitman's insistence that the future of American art was "dependent upon improved social conditions" and Howells's presentation of the moral and social quandaries of the aesthetic editor Basil March in *A Hazard of New Fortunes* make it clear that art, the religion of beauty, could not, at least in the eyes of the period's most perceptive critics, resolve the dilemmas of class and economic power. Our reading of selected representative art objects and fiction of the Aesthetic movement indicates that it was equally clear from the point of view of gender that if the aesthetic interior as a social space reinforced men's social and economic dominance while illuminating women's isolation, powerlessness, and confinement within the domestic sphere, it would become a stultifying trap rather than a source of sustenance.

The critique in the 1890s of the Aesthetic movement focused on both the upper and lower reaches of the social ladder. The most sweeping condemnation flowed from the mordant pen of Thorstein Veblen in his ponderous parody of scientific sociology, *The Theory of the Leisure Class: An Economic Study of Institutions*

rangement as a song without words," the interior "perfect in its adaptation to [a woman's] circumstances."[93] Yet as Wheeler knew, the aesthetic process could go awry, and Gilman's "Yellow Wall-Paper" dramatizes precisely how. A forceful critique of the aspirations of Wheeler, Cook, and other aesthetic theorists and practitioners, the story clearly indicates the costs to a woman when the aesthetic is separated from its foundations in social being: beauty cut off from utility and power can destroy life, suggests Gilman, and isolating art and the artist from the productive work that sustains social values and human relationships leads to truly alienated labor—in this story the alienation takes its most extreme form, madness.

Charlotte Perkins Gilman never again reached the imaginative intensity in her clarification of women's situation that she achieved in "The Yellow Wall-Paper." Her language in subsequent works was more sociologically oriented, as she explored at length the problem of women and work. Yet in the fashioning of this story she appropriated the terms of the Aesthetic movement in order to define central ideological issues of the period, even as the specific patterns, the sulfurous colors, and the nightmarish realities of "The Yellow Wall-Paper" point toward the transmogrified versions of Aesthetic-movement ideas in their fin-de-siècle, Beardsleyesque, and Art Nouveau modes. Gilman's tale demonstrates once more the deep rootedness of aesthetic forms in their cultural context and examines them as both embodiments and critiques of social behavior and society's most cherished beliefs.

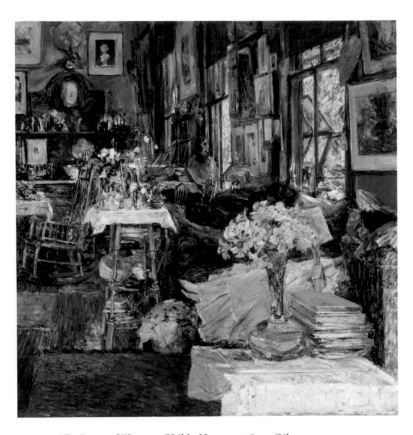

ILL. 1.7 *The Room of Flowers*. Childe Hassam, 1894. Oil on canvas, 34 × 34 in. (86.5 × 86.5 cm). Collection of Mr. and Mrs. Arthur G. Altschul

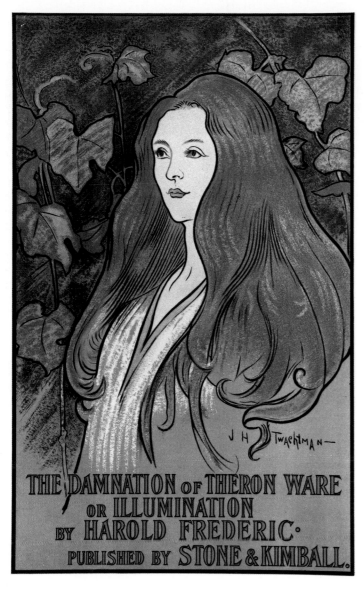

ILL. 1.8 Poster for *The Damnation of Theron Ware* by Harold Frederic. John H. Twachtman, 1896. Color lithograph, 20¹⁄₁₆ × 12 in. (51 × 30.5 cm). The Metropolitan Museum of Art, Museum Accession, 1957 (57.627.10[22])

(1899). Veblen's concern centered on the ways in which cultural behavior expressed or masked relationships of power. More specifically, he examined the various social rituals through which the wealthy maintained their ascendancy. The arts, like dress, the tending of a lawn, "devout observances," and a number of contemporary practices carried over from "barbarian" times (as Veblen's mock anthropology had it) all came under his withering analysis, as he probed their instrumental value. Veblen implicitly challenged the claims of the Aesthetic movement to the disinterested pursuit of beauty and to art for art's sake, since he denied such intrinsic goals. Ruskin's "Lamp of Sacrifice" in *The Seven Lamps of Architecture* (1849), which had distinguished architecture from building through the addition of "unnecessary" ornament over and beyond functional needs, and Arnold's Hellenistic striving for "spontaneity of consciousness" over the merely utilitarian calculus of money-getting were understood by Veblen as the strategies that a "barbarian" leadership used to maintain its economic position.

The theorists of the Aesthetic movement had stressed the uni-

versal values involved in decorative design, had decontextualized historical styles from their cultural matrix to make them generally available, and had singled out color as a potentially organizing and harmonizing principle. From Veblen's vantage point such aesthetic strategies were elaborate mystifications and reifications (to borrow Marx's terminology), which obscured underlying social interchanges. Thus his famous phrases "conspicuous consumption" and "conspicuous waste" indicated the social function of display. Dressing a woman in an aesthetic corset or a servant in livery,[95] acquiring a limited edition book from Morris's Kelmscott Press, and preferring a handmade silver spoon over an inexpensive aluminum copy were all forms of financial ostentation. In Veblen's terms, the "house beautiful" conveyed its owner's capacity to spend. Benefactions and bequests to the new museums, which were understood by others as a way of sharing with the public great personal wealth, were understood by Veblen as means of enhancing the "pecuniary reputability" of the donor. Not surprisingly, Veblen's view of the role of women was particularly ruthless, for he saw them as primary signifiers of the economic supremacy of their male "owners": women's "uselessness" a badge of merit and the domestic sphere a place where a woman could give passive expression to the "vicarious leisure and consumption" of the male head of the household, who might himself be more actively involved in the acquisitive process.[96]

In sum, Veblen's analysis uncovered the uses to which the aesthetic impulse had been put to strengthen the position of the wealthy within society. Yet Veblen also searched for those instances wherein a deeper human "instinct of workmanship" might be found, located not in an object of art but in the activity of the maker when he or she was not controlled by the values of the marketplace. In this sense Veblen is linked to Progressives who attempted to redefine the nature of work relationships during the 1890s and thereafter, though in the complex and witty argumentation of his books and essays he remained radically aloof.

Another critique of the intrinsic value of aestheticism came also from Chicago, where at the end of the nineteenth century Veblen was a professor at the newly founded University of Chicago. If Veblen directed his attack toward the leisure class, Jane Addams (1860–1935) and her colleagues at Hull-House asked whether the instinct of workmanship could find expression among the poor and the immigrant communities on the South Side of Chicago. Addams's experience exemplifies the reinterpretation of aesthetic concern. She was born to a prosperous middle-class family in Cedarville, Illinois, attended Rockford Seminary, and then went east to Women's Medical College in Philadelphia in 1881–82. Ill health cut off her medical studies.[97] By 1886 Addams was in Baltimore. There she read Ruskin, organized a women's art club, and wrote to her seminary friend, the artist Ellen Gates Starr (1860–1940), "Do you know anything of Russell Sturgis of New York? He gave a series of four lectures on Decorative Art at the Peabody, which were very fine."[98] The following year, during her second trip to Europe, she turned her attention to the London poor and the experiments in social work taking place at Toynbee Hall, where Ruskinian ideals had been put into practice. In 1889 Addams and Starr established Hull-House, and two years later the Chicago merchant Edward Butler donated $5,000 for the addition of an art gallery to its original building.

Given the backgrounds of Addams and Starr as college-educated young ladies with a drive to find an outlet for their energies in meaningful work—both chose not to marry—it should not be surprising that they included the arts as part of the life of Hull-House. What is remarkable is their changing perspective on the role that the arts were to play. At first they attempted to bring their middle-class culture to the life of the poor, to imbue life with beauty through exhibitions of art reproductions, trips to the World's Columbian Exposition in 1893 and to the Art Institute, and classes in drawing and sculpture as well as comparable activi-

ties in music and drama. But it rapidly became apparent to both women that such an approach was antithetical to their efforts to be responsive to the immigrants whom the settlement house served.

The pressing issues in the lives of the poor concerned work, and in a key essay entitled "Art and Labor," which appeared in an 1895 collection called *Hull-House Maps and Papers,* Starr made clear that art could not be separated from daily life. Lacing her analysis with quotations from Ruskin, Carlyle, and Morris, she insisted that "only a free man can express himself in his work. If he is doing slave's work under slavish conditions," it is doubtful that he will have either the thoughts or the creative capacity to produce art. Again and again she hammered home her message, saying, "Into the prison-houses of earth, its sweat-shops and underground lodging-houses, art cannot follow," and "The artist is not a product of spontaneous generation," and most powerfully, "The soul of man in the commercial and industrial struggle is in a state of siege. He is fighting for his life. It is merciful and necessary to pass in to him the things which sustain his courage and keep him alive, but the effectual thing is to raise the siege."[99] According to Starr, when the aesthetic impulse was merely a palliative[100] it had failed in its mission. Starr and Addams ultimately turned Hull-House art study away from infusions of high aesthetic culture and summer classes in the country, embracing instead the arts and cultures of the immigrants themselves in order to generate and sustain respect for the Old World arts of their homelands and help preserve those traditions in America. Style was thereby restored to its function as the expression of a particular culture in time and space.

Veblen and Hull-House thus bracket the achievement of the Aesthetic movement.[101] Where Veblen, the isolated male theorist, anatomized the economic function of leisure-class aesthetic activity as a way of maintaining and reinforcing the power of society's dominant group, Addams and Starr, fugitives from the genteel world, transformed their own lives as practical reformers by devoting themselves to the working class whom the Aesthetic movement had for the most part ignored. Hull-House became, in the words of the historian Rosalind Rosenberg, "a half-way house between domestic tradition and the political world from which women had been so long excluded."[102]

Starr and Addams were instrumental in organizing at Hull-House the Chicago Arts and Crafts Society in 1897, though the group's activities were gradually included within the Hull-House Labor Museum. Starr herself spent six months in 1900 studying bookbinding in England with T. J. Cobden-Sanderson, who was producing editions for the Kelmscott Press, and she brought those skills back to Hull-House. The appeal of craft is premonitory; for the Aesthetic movement survived the attacks of its radical critics both from within and from outside its ranks—Ruskin and Morris, Pitman and Howells, Frederic and Gilman, Veblen and Starr—not by altering its generally conservative defense of laissez-faire capitalism and of separate spheres for men and women but by being absorbed and transformed by the artists and publicists of the Arts and Crafts movement.

The path taken by the Arts and Crafts movement in America, especially in the late 1890s and after the turn of the twentieth century, is not part of our story here, but its direction can be suggested. If the Arts and Crafts movement could eventuate in the striking architectural achievements of Frank Lloyd Wright (1867–1959),[103] with worldwide consequences for the development of twentieth-century art, in other ways it retreated from the bold internationalism of the Aesthetic movement into regional and local workshops, frequently in quasi-agrarian settings like that enjoyed by Elbert Hubbard's (1856–1915) Roycrofters in East Aurora, New York.

The Arts and Crafts movement did extend the Aesthetic movement's call for the decoration and beautification of the domestic sphere. Gustav Stickley (1858–1942) and his brothers were making and marketing art furniture in Binghamton, New York, in the 1880s. The simple direction "art glass" appears in an 1871 Binghamton house design by Isaac Perry (1822–1904), and the tract of domestic residences constructed on that city's west side between 1885 and 1895 still contains many examples of such glass, commercially produced in simple, conventionalized floral patterns.

By the early 1890s, when Stickley relocated his furniture factory to Eastwood near Syracuse, the latter was already a center of artistic activity. The university there had opened the College of Fine Arts in 1873, the first such coeducational degree-granting institution in the United States. Its dean and professor was George Fiske Comfort, a founding trustee of the Metropolitan Museum in New York and an advocate of artistic education for women on the familiar grounds that "the feminine mind inclines naturally to the pursuit of aesthetic studies. A refined and cultivated taste is one of the most potent elements in inducing a healthy love of body and mind."[104] It was in this environment that Stickley founded the *Craftsman* magazine in 1901, with Professor Irene Sargent of Syracuse University contributing most of the writing in the opening issues. Articles on Morris, Ruskin, the Arts and Crafts guilds, color, Boston's Trinity Church, and the Cincinnati and Grueby potteries all continued to popularize the achievement of the Aesthetic movement of the previous decades. Yet while holding up Morris's accomplishments as a model for American craftsmen, the Arts and Crafts movement blunted the edge of his explicitly socialist critique of capitalism and used his artistic principles and practices to answer the needs of both Progressive liberalism and a nostalgic idealism based upon a return to a handicraft society.[105]

The Aesthetic movement had been bold in its acceptance of the challenges and potentialities of urban culture. Through its reinterpretation of an older American vocabulary rooted in nature and through the internationalism of its stylistic language, it offered Americans a visual ideology that accommodated the transformation of a rural, agricultural society in the last third of the nineteenth century and promoted a new concern with industrial design. Its claims for the primacy of the aesthetic as a universal ordering of social and domestic space liberated the artist from revivalist and historicist solutions to creative tasks, encouraging freer play with artistic forms. It sought to move the artist from a position of isolation and marginality to cooperative relationships near the centers of social power and prestige. And it offered to women greater possibilities to participate in the creative process: through training in the burgeoning art schools; through employment in the design and production of decorative artifacts; through a crucial role as consumers of aesthetic goods for use in the domestic environment as well as through expanded facilities for marketing such goods; and through an extensive literature, which guided women in the pursuit of beauty.

The limitations of the Aesthetic movement lay in the ways in which it functioned ideologically: rather than alter the fundamental relations of power in late nineteenth-century America, it reaffirmed the existing social structure. Despite its claims that beauty would change the lives of all Americans, the Aesthetic movement rarely reached immigrant groups or the poor. It facilitated the accumulation of the signs of wealth by a social elite, and it encouraged the emulation of an aspiring middle class to possess similar artistic tokens. If it increased opportunities for women, it also circumscribed them primarily within the domestic sphere and thus reinforced the dominant gender ideology. The accomplishments of the Aesthetic movement thus present to us not so much a mirror of American society or a plate-glass window onto it but a stained-glass window, through which are refracted the color and quality of American life in the late nineteenth century.

NOTES

1. Alan Trachtenberg, *The Incorporation of America: Culture and Society in the Gilded Age* (New York, 1982). The sense of pre–Civil War America as the "simpler age" is pervasive in Henry James, *Hawthorne* (1879), in Edmund Wilson, ed., *The Shock of Recognition* (New York, 1955); and Mark Twain, *Life on the Mississippi* (Boston, 1883). For the best recent study of the issues dealt with in this essay, see Eileen Cynthia Boris, *Art and Labor: Ruskin, Morris, and the Craftsman Ideal in America* (Philadelphia, 1986), originally the author's Ph.D. diss., Brown University, 1981.

2. For the fullest accounts, see William B. Rhoads, "The Colonial Revival," 2 vols. (Ph.D. diss., Princeton University, 1974); and Alan Axelrod, ed., *The Colonial Revival in America* (New York and London, 1985).

3. For a summary of these attitudes, see Barbara Novak, *Nature and Culture: American Landscape and Painting, 1825–1875* (New York, 1980); and, from a different point of view, Roberson Center for the Arts and Sciences, Binghamton, N.Y., *Susquehanna: Images of the Settled Landscape,* by Roger B. Stein (exhib. cat., 1981); for the shift in perspective, see National Collection of Fine Arts, Washington, D.C., *American Art in the Barbizon Mood,* by Peter Bermingham (exhib. cat., 1975).

4. It is clear that "Darwinism" is an inadequate label to account for the complex changes in older patterns of belief during this period. See Richard Hofstadter, *Social Darwinism in American Thought,* rev. ed. (Boston, 1955); T. J. Jackson Lears, *No Place of Grace: Antimodernism and the Transformation of American Culture, 1880–1920* (New York, 1981); and Rosalind Rosenberg, *Beyond Separate Spheres: Intellectual Roots of Modern Feminism* (New Haven, 1982).

5. On the relation of art to ideology, see the useful summary of the issues in Janet Wolff, *The Social Production of Art* (London, 1981), esp. pp. 49–70.

6. See Ann Douglas, *The Feminization of American Culture* (New York, 1977); Alice Kessler-Harris, *Out to Work: A History of Wage-earning Women in the United States* (New York, 1982); and William [R.] Leach, *True Love and Perfect Union: The Feminist Reform of Sex and Society* (New York, 1980).

7. See David C. Huntington, *The Landscapes of Frederic Church: Vision of an American Era* (New York, 1966); Peter L. Goss, "An Investigation of Olana, the Home of Frederic Edwin Church, Painter" (Ph.D. diss., Ohio University, 1973); and Clive Aslet, *Olana* (n.p., n.d.), printed by Friends of Olana, from two articles in *Country Life,* Sept. 1983.

8. See Huntington, *Landscapes of Frederic Church,* pp. 117–25; Goss, "Investigation of Olana"; and Aslet, *Olana.*

9. For an attempt at defining the architectural style of the period as eclectic, see Walter Kidney, *The Architecture of Choice: Eclecticism in America, 1880–1930* (New York, 1974). For a different view of the problem, see James D. Kornwolf, "American Architecture and the Aesthetic Movement," this publication.

10. It was in Church's New York studio in the winter of 1848–49 that the American painter and journalist William James Stillman (1828–1901) first read Ruskin; see Roger B. Stein, *John Ruskin and Aesthetic Thought in America, 1840–1900* (Cambridge, Mass., 1967), p. 104. For Church in an English context, see Gerald L. Carr, *Frederic Edwin Church: The Icebergs* (Dallas: Dallas Museum of Art, 1980), pp. 21–35, 80–107. Ruskin's praise of Church's paintings may have stimulated the English market for the American's work in the 1860s.

11. The standard early work on Ruskin's social thought is John A. Hobson, *John Ruskin, Social Reformer* (London, 1898); two recent and divergent views are presented in Peter Anthony, *John Ruskin's Labour: A Study of Ruskin's Social Theory* (Cambridge, Eng., 1983); and Jeffrey L. Spear, *Dream of an English Eden: Ruskin and His Tradition in Social Criticism* (New York, 1984).

12. For Morris's views on art, see "The Lesser Arts," in William Morris, *Hopes and Fears for Art: Lectures on Art and Industry* (1882), vol. 22 of *The Collected Works of William Morris,* ed. May Morris, 24 vols. (London, 1910–15), pp. 3–8. Friedrich Engels, *The Condition of the Working Class in England,* was published in German in 1845 and was translated into English (New York [1887?]) by Florence Kelley Wischewetzky, who was active a few years later at Hull-House in Chicago; for Marx's early views on art, see his *Early Writings,* intro. Lucio Colletti (Baltimore, 1975), p. 329; "The Fetishism of Commodities" appears in the first volume of Karl Marx, *Kapital,* chap. 1, pt. 4, published in 1867; for Veblen, see his *Theory of the Leisure Class: An Economic Study of Institutions* (1899; reprint New York, 1953), chap. 6.

13. See *Culture and Anarchy,* in vol. 5 of *The Complete Prose Works of Matthew Arnold,* ed. R. H. Super (Ann Arbor, 1965), pp. 216, 218, 243.

14. See James Abbott McNeill Whistler, *The Gentle Art of Making Enemies,* 2d ed. ([1892]; reprint New York, 1967), pp. 1–34, 127–28.

15. Oscar Wilde, quoted in Elizabeth Aslin, *The Aesthetic Movement: Prelude to Art Nouveau* (New York and Washington, D.C., 1969), p. 111; for a useful summary of Wilde's trip, see p. 110.

16. Ibid., pl. 101, pp. 112–28.

17. For the specific decorative sources, Church borrowed from Jules Bourgoin, *Les Arts arabes* (Paris, 1868), according to Goss, "Investigation of Olana," p. 103.

18. Owen Jones, *The Grammar of Ornament* (1856; 2d ed. 1864; reprint New York, 1972), pp. 2, 8.

19. John G. Rhodes, "Ornament and Ideology: A Study of Mid-Nineteenth-Century British Design Theory" (Ph.D. diss., Harvard University, 1983), p. 210.

20. Christopher Dresser, *The Art of Decorative Design* (1862; reprint Watkins Glen, N.Y., 1977), pp. 13–14, 168.

21. Edward W. Said, *Orientalism* (New York, 1978).

22. Thomas Purnell, "Women and Art," *Art Journal* (London), Apr. 1861, pp. 107, 108.

23. Ibid., p. 108.

24. See Anthea Callen, *Women Artists of the Arts and Crafts Movement, 1870–1914* (New York, 1979); and her "Sexual Division of Labor in the Arts and Crafts Movement," *Women's Art Journal* 5 (Fall / Winter 1984–85), pp. 1–7.

25. Joseph M. Wilson, *History, Mechanics, Science,* vol. 3 of *The Masterpieces of the Centennial International Exhibition,* 3 vols. (Philadelphia, copr. 1875 [1877?]; reprint New York, 1977), p. clxxxvi.

26. See Edward Strahan [Earl Shinn], *Fine Art,* vol. 1 of *Masterpieces of the Centennial.* For other views of art at the Centennial, see David C. Huntington et al., in Detroit Institute of Arts, *The Quest for Unity: American Art Between World's Fairs, 1876–1893* (exhib. cat., 1983), pp. 13–18, 47–82; and National Collection of Fine Arts, Washington, D.C., *1876: American Art of the Centennial,* by Susan Hobbs (exhib. cat., 1976). The broader achievement of the Centennial in other areas is perceptively assessed in National Museum of History and Technology, Washington, D.C., *1876: A Centennial Exhibition* (exhib. cat., 1976).

27. Walter Smith, *Industrial Art,* vol. 2 of *Masterpieces of the Centennial,* pp. 505, 499–500.

28. William Dean Howells, "A Sennight of the Centennial," *Atlantic Monthly* 38 (July 1876), p. 101.

29. Smith, *Industrial Art,* pp. 95–96, 280.

30. For Wheeler, see below; for Cincinnati, see note 49 below.

31. Sarah Orne Jewett, *Letters,* ed. Richard Cary, rev. ed. (Waterville, Maine, 1967), p. 81.

32. The story first appeared in *Scribner's Magazine* 14 (Aug. 1893), pp. 213–25, and was subsequently collected in Sarah Orne Jewett, *A Native of Winby and Other Tales* (Boston, 1893).

33. In later years King traveled in Europe collecting bric-a-brac in the aesthetic manner, sometimes dressed in a green velvet suit in the style of Oscar Wilde; see Thurman Wilkins, *Clarence King: A Biography* (New York, 1958), p. 292; and Stein, *John Ruskin,* pp. 168–77. For a description of King's collection at his death, see American Art Association, New York, *Catalogue of the Art and Literary Property Collected by the Late Clarence King and William H. Fuller* (sale cat., Mar. 10, 1903), and p. 37 (no. 181) for the Watanabé Seitei screen.

34. Stein, *John Ruskin,* pp. 240–54; Susan P. Casteras, "The 1857–58 Exhibition of English Art in America and Critical Responses to Pre-Raphaelitism," in Brooklyn Museum, *The New Path: Ruskin and the American Pre-Raphaelites,* by Linda S. Ferber and William H. Gerdts (exhib. cat., 1985), pp. 108–33, 284–87; Lears, *No Place of Grace,* pp. 191–92; and Jonathan Freedman, "An Aestheticism of Our Own: American Writers and the Aesthetic Movement," this publication.

35. Howells, "Sennight," p. 99.

36. See Alice Cooney Frelinghuysen, "Aesthetic Forms in Ceramics and Glass," this publication.

37. For the Massachusetts story, see Henry Green, "Walter Smith: The Forgotten Man," *Art Education* 19 (Jan. 1966), pp. 3–9; and Arthur D. Efland, "Art and Education for Women in Nineteenth Century Boston," *Studies in Art Education* 26 (Spring 1985), pp. 133–40. For the impact of Massachusetts art education on the lives of a New Hampshire family of artists and a perceptive assessment of the Centennial and Smith's role, see Diana Korzenik, *Drawn to Art: A Nineteenth-Century American Dream* (Hanover, N.H., 1985), esp. pp. 143–230. For the influence of Ruskin, see Mary Ann Stankiewicz, "'The Eye Is a Nobler Organ': Ruskin and American Art Education," *Journal of Aesthetic Education* 18 (Summer 1984), pp. 51–64. I am indebted to Professor Stankiewicz for stimulating perspectives on the question of art education, particularly as it affected women; see Enid Zimmerman and Mary Ann Stankiewicz, eds., *Women Art Educators,* 2 vols. (Bloomington, Ind., 1982–85).

38. Isaac Edwards Clarke, "The Democracy of Art," p. 137, quoted in James B. Gilbert, *Work Without Salvation: America's Intellectuals and Industrial Alienation, 1880–1910* (Baltimore, 1977), p. 99.

39. Walter Muir Whitehill, *Boston: A Topographical History,* 2d ed. (Cambridge, Mass., 1968), pp. 158–73; Bernice Kramer Leader, "The Boston Lady as a Work of Art: Painting by the Boston School at the Turn of the Century" (Ph.D. diss., Columbia University, 1980), pp. 24, 126 (n. 97).

40. For the best discussion of the church from a decorative point of view, see H. Barbara Weinberg, "John La Farge and the Decoration of Trinity Church, Boston," *Journal of the Society of Architectural Historians* 33 (Dec. 1974), pp. 323–53; the quoted phrases are on p. 347.

41. For the documentation of the relation to Trinity Church, see ibid., p. 345 (n. 126).

42. Frances Snow Compton [Henry Adams], *Esther: A Novel* (New York, 1884), pp. 1–2.

43. In this respect *Esther* is not unusual in the fiction of the period. The problem of aestheticizing the churches was a live one for the ministry of the period; see, for example, the lament of the Reverend W. Strobel, in *Quarterly Review of the Evangelical Lutheran Church* 9 (Apr. 1879), p. 171: "Was the moral equal to the aesthetic effect, or was the former para-

lyzed and overshadowed by the latter . . . was the worship spiritual or simply dramatic?"

44. For a good summary of this issue, see Rozsika Parker and Griselda Pollock, *Old Mistresses: Women, Art, and Ideology* (New York, 1981), pp. 50–81.

45. For biographical material on Thaxter, see A[nnie] F[ields] and R[ose] L[amb], eds., *Letters of Celia Thaxter* (Boston and New York, 1895); Rosamond Thaxter, *Sandpiper: The Life and Letters of Celia Thaxter* (1963; reprint Hampton, N.H., 1982); and Jane E. Vallier, *Poet on Demand: The Life, Letters, and Works of Celia Thaxter* (Camden, Maine, 1982). See also University Art Galleries, University of New Hampshire, Durham, *A Stern and Lovely Scene: A Visual History of the Isles of Shoals* (exhib. cat., 1978).

46. Fields and Lamb, *Letters of Celia Thaxter,* pp. 58, 59.

47. Rosamond Thaxter, *Sandpiper,* p. 14. Celia Thaxter also wrote poetic texts for the painter ELIHU VEDDER; see Regina Soria, *Elihu Vedder: American Visionary Artist in Rome (1836–1923)* (Rutherford, N.J., 1970), pp. 154–55. Thaxter's granddaughter reported that as the years went on, her china painting and illustrating of her own poetry "brought her a tidy income" (Rosamond Thaxter, *Sandpiper,* p. 117).

48. Fields and Lamb, *Letters of Celia Thaxter,* pp. 125–26, give the Sophoclean source. It is probably significant that the quotation invokes male and female deities. Thaxter believed in both and wore the crescent moon of Diana in her hair during these years. The other source of Thaxter's Greek usage lies in her association with Annie Fields, a classical scholar whose collection of poetry and plays, *Under the Olive,* was published in 1880. The person responsible for the olive-spray design on the cover of Fields's book—possibly Thaxter herself—is unknown. See Sarah Sherman, "Victorian and Matriarchal Mythology: A Source for Mrs. Todd," *Colby Library Quarterly* 22 (Mar. 1986), pp. 63–74, for the availability and importance of ancient matriarchal mythology during the Aesthetic era.

49. See Cincinnati Art Museum, *The Ladies, God Bless 'Em: The Women's Art Movement in Cincinnati in the Nineteenth Century,* by Anita J. Ellis (exhib. cat., 1976); Kenneth R. Trapp, "Toward a Correct Taste: Women and the Rise of the Design Reform Movement in Cincinnati, 1874–1880," in Cincinnati Art Museum, *Celebrate Cincinnati Art: In Honor of the 100th Anniversary of the Cincinnati Art Museum, 1881–1981,* ed. Kenneth R. Trapp (exhib. cat., 1982), pp. 48–70; idem, "'To Beautify the Useful': Benn Pitman and the Women's Woodcarving Movement in Cincinnati in the Late Nineteenth Century," in *Victorian Furniture: Essays from a Victorian Society Autumn Symposium,* ed. Kenneth L. Ames (Philadelphia, 1982), pp. 174–92; Anita J. Ellis, "Cincinnati Art Furniture," *Antiques* 121 (Apr. 1982), pp. 930–41; and idem, "Cincinnati Art Furniture: Woman as Beautifier," *Queen City Heritage* 42 (Winter 1984), pp. 19–26.

50. Among these artists were the sculptors Hiram Powers and Shobal Clevenger, the painters James Beard and Worthington Whittredge, the mulatto Robert Duncanson, and French-born Lilly Martin Spencer. The Western Art Union, founded in Cincinnati in 1847, made available studio space in its new building after 1848.

51. Denny Carter Young, "The Longworths: Three Generations of Art Patronage in Cincinnati," in Cincinnati Art Museum, *Celebrate Cincinnati Art,* pp. 28–47; see also the sources cited in note 49 above.

52. For a first-rate study of her life, see National Museum of American Art, Washington, D.C., *Elizabeth Nourse, 1859–1938: A Salon Career,* by Mary Alice Heekin Burke (exhib. cat., 1983).

53. Calista Halsey [Patchin], "Wood-carving for Women," quoted in Trapp, "To Beautify the Useful," p. 179. I am much indebted to the insights of-

fered by Trapp's essay.

54. I am grateful to Mary Alice Heekin Burke of Cincinnati, who is at work on a biography of Pitman, for this quotation and for sharing ideas on him. Inexplicably, it was Pitman's earlier formulation that went, unrevised, into the reprinted version of his teaching published in Cincinnati in 1895 as *A Plea for American Decorative Art.*

55. William H. Fry, *Wood-carving: A Short Paper* (Cincinnati, 1897), unpaged [p. 5]. The allusion to Ruskin is implicit; see *The Stones of Venice,* vol. 3, chap. 2, par. 48.

56. Fry, *Wood-carving* [p. 5].

57. Judge Stallo, quoted in Trapp, "To Beautify the Useful," p. 182; Pitman, *Plea for American Decorative Art,* p. 9.

58. Benn Pitman, *American Art—Its Future Dependent on Improved Social Conditions* (Cincinnati [1891]), p. 17.

59. See Susan Porter Benson, "Palace of Consumption and Machine for Selling: The American Department Store, 1880–1940," *Radical History Review* 21 (Fall 1979), pp. 199–221; and also William R. Leach, "Transformation in a Culture of Consumption: Women and Department Stores, 1890–1925," *Journal of American History* 71 (Sept. 1984), pp. 319–42.

60. Clarence Cook, *The House Beautiful: Essays on Beds and Tables, Stools and Candlesticks* (1878; reprint New York, 1980), pp. 1, 22, 23, 48, 49.

61. See Annette Blaugrund, "The Tenth Street Studio Building," in National Academy of Design, New York, *Next to Nature: Landscape Paintings from the National Academy of Design* (exhib. cat., 1980), pp. 18–22.

62. There is no full-scale study of Wheeler at present. For the existing literature, see Dictionary of Architects, Artisans, Artists, and Manufacturers, this publication.

63. See, for example, "The Color Scheme of a Room: A Talk with Mrs. T. M. Wheeler, Who States Her Principles on the Subject," *Art Amateur* 16 (Feb. 1887), p. 62; Candace Wheeler, "Art Education for Women," *Outlook* 55 (Jan. 2, 1897), pp. 81–87; and idem, *Principles of Home Decoration with Practical Examples* (New York, 1903), pp. 11–19.

64. William Dean Howells, *A Hazard of New Fortunes* (1890; reprint New York, 1965), pp. 201–2.

65. Ibid., pp. 103–4.

66. Ibid., pp. 58–59, 42–43.

67. Ibid., p. 47.

68. Ibid., p. 168.

69. Ibid., p. 12.

70. For the notion of "happy endings," see William Dean Howells, *Criticism and Fiction* (New York, 1891), pp. 85–86; and Henry James, "The Art of Fiction," in *The Future of the Novel: Essays on the Art of Fiction,* ed. Leon Edel (New York, 1956), p. 8. Like Benn Pitman, Howells was among those who were powerfully affected by their reading of Edward Bellamy's *Looking Backward* (Boston, 1888), the writings of Laurence Gronlund, and William Morris's *News from Nowhere, or an Epoch of Rest, Being Some Chapters from a Utopian Romance* (London, 1890), and Howells also turned briefly to writing utopian social fiction, publishing *A Traveler from Altruria* in 1894; see Dolores Hayden, *The Grand Domestic Revolution: A History of Feminist Designs for American Homes, Neighborhoods, and Cities* (Cambridge, Mass., 1981), pp. 135, 137.

71. Benjamin H. D. Buchloh, Serge Guilbaut, and David Solkin, eds., *Modernism and Modernity: The Vancouver Conference Papers* (Halifax, Nova Scotia, Can., 1983); Francis Frascina and Charles Harrison, eds., *Modern Art and Modernism: A Critical Anthology* (New York, 1985); and Museum of Modern Art, New York, *Primitivism in Twentieth Century Art: Affinity of the Tribal and the Modern,* ed. William Rubin,

2 vols. (exhib. cat., 1984).

72. Cook, *House Beautiful,* pp. 30–31.

73. Candace Wheeler, ed., *Household Art* (New York, 1893), pp. 32, 33, a volume in the Distaff series of women's essays published by New York State women as a contribution to the exhibition of women's work at the Chicago World's Columbian Exposition.

74. Wheeler, *Principles of Home Decoration,* pp. 12–13, 14.

75. Elizabeth McCausland, "The Life and Work of Edward Lamson Henry, N.A., 1841–1919," *New York State Museum Bulletin* 339 (Sept. 1945), pp. 228, 49, 324, 307 (ill.).

76. For Henry's painting *The Old Sign on Tenth Street* (1877), see Blaugrund, "Tenth Street Studio Building," in National Academy of Design, *Next to Nature,* pp. 18–22.

77. See, for example, Irving Wiles's *Reverie* (1886), in Canajoharie Library and Art Gallery, N.Y., *Catalogue of the Permanent Collection of the Canajoharie Library and Art Gallery* (Canajoharie [1969]), no. 51; and Rosalie Gill's *New Model* (about 1884; The Baltimore Museum of Art), in Sona Johnston, ed., *American Paintings, 1750–1900, from the Collection of the Baltimore Museum of Art* (Baltimore, 1983), p. 69 (ill.). For a summary of the importance of the Chase studio, see Nicolai Cikovsky, Jr., "William Merritt Chase's Tenth Street Studio," *Archives of American Art Journal* 16, no. 2 (1976), pp. 2–14.

78. For examples, see Henry Art Gallery, University of Washington, Seattle, *Leading Spirit in American Art: William Merritt Chase, 1849–1916,* by Ronald G. Pisano (exhib. cat., 1983), pp. 68 (ill.), 69 (ill.), 136 (ill.), 138 (ill.).

79. Whistler's Dutch *Lange Leizen* distances us linguistically in another Western direction; see Andrew McLaren Young et al., eds., *The Paintings of James McNeill Whistler,* 2 vols. (New Haven, 1980), vol. 1, p. 25, which calls the work an "unexceptional Victorian genre subject," with oriental objects taken from Whistler's own collection.

80. Whistler was, of course, quite explicit about this as his artistic aim. A case in point is his painting *La Princesse du Pays de la Porcelaine* (1863–64; Freer Gallery of Art, Washington, D.C.), which depicts purely aesthetic royalty. When Whistler and THOMAS JECKYLL designed the Peacock Room (1876–77; now installed in the Freer Gallery of Art, Washington, D.C.) for the London home of Frederick Richards Leyland, they subordinated both the painting and its owner's collection of oriental objects to the requirements of pictorial design; see ibid., pp. 59–63, 26–27, 102–4.

81. See, for example, *The Bathe at Newport,* in *Harper's Weekly,* Sept. 4, 1858, p. 568 (ill.); *Eagle Head, Manchester, Massachusetts (High Tide)* (1870; The Metropolitan Museum of Art, New York); and two watercolors (Canajoharie Library and Art Gallery, N.Y.), in Gordon Hendricks, *The Life and Work of Winslow Homer* (New York, 1979), CL 508, CL 397, CL 385.

82. For the studies, see Hendricks, *Homer,* pp. 128 (fig. 195), 131 (fig. 201); and Albert Ten Eyck Gardner, *Winslow Homer, American Artist: His World and His Work* (New York, 1961), p. 230. Homer's letter to the purchaser is quoted in Hendricks, p. 141.

83. For a discussion of the early evidence, see Henry Adams, "John La Farge's Discovery of Japanese Art: A New Perspective on the Origins of Japonisme," *Art Bulletin* 67 (Sept. 1985), pp. 449–85, esp. p. 455 (n. 36). The Japanism in the later works is a standard subject for comment by most Homer critics.

84. For a full discussion of this painting, see Karal Ann Marling, "Portrait of the Artist as a Young Woman: Miss Dora Wheeler," *Bulletin of the Cleveland Museum of Art* 65 (Feb. 1978), pp. 47–57.

85. For the complex history of this painting, see Natalie Spassky et al., *American Paintings in the Metropolitan Museum of Art*, vol. 2, *A Catalogue of Works by Artists Born Between 1816 and 1845* (New York, 1985), pp. 613–19; and Ellwood C. Parry III, "The Thomas Eakins Portrait of Sue and Harry, or When Did the Artist Change His Mind," *Arts Magazine* 53 (May 1979), pp. 146–53; compare this work with Gill's *New Model*, cited in note 77 above.

86. See Bernice Kramer Leader, "Antifeminism in the Paintings of the Boston School," *Arts Magazine* 56 (Jan. 1982), pp. 112–19.

87. Harold Frederic, *The Damnation of Theron Ware* (1896; reprint New York, 1960), pp. 205, 197.

88. For feminist commentary, see Gail Parker, ed., *The Oven Birds: American Women on Womanhood, 1820–1920* (New York, 1972), pp. 50–56; and Elaine R. Hedges, Afterword, in *The Yellow Wallpaper*, by Charlotte Perkins Gilman (Old Westbury, N.Y., 1973), pp. 37–63.

89. Charlotte Perkins Stetson [Gilman], "The Yellow Wall-Paper," *New England Magazine* 11 (Jan. 1892), pp. 647, 648; in the initial illustration for the story, the protagonist is shown seated by the window—which is barred since it was previously a children's nursery—in a Windsor rocker.

90. Catherine Lynn, *Wallpaper in America: From the Seventeenth Century to World War I* (New York, 1980), pp. 367–443; and see idem, "Surface Ornament: Wallpapers, Carpets, Textiles, and Embroidery," this publication.

91. [Gilman], "Yellow Wall-Paper," pp. 651, 649.

92. Wheeler, *Household Art*, pp. 7–8; compare with Mariana Griswold Van Rensselaer, "The Competition in Wall-Paper Designs," *American Architect and Building News* 10 (Nov. 26, 1881), pp. 251–53, in which Candace Wheeler won first prize and her daughter Dora won fourth. Van Rensselaer notes that among the other designs submitted "were some entitled to the name of abnormal, almost pathological specimens of art" (p. 252). For an earlier image, entitled *Despair*, of a young woman confounded in her attempt to re-wallpaper a guest room, see Eugene C. Gardner, *Home Interiors* (Boston, 1878), pp. 18–19.

93. Wheeler, *Principles of Home Decoration*, pp. 12–13, 14.

94. See Hayden, *Grand Domestic Revolution*, pp. 182–277. For a sense of Gilman's dependence upon and adaptation of Aesthetic-movement ideas of decorative art, see Charlotte Perkins Gilman, "Domestic Art," in *The Home: Its Work and Influence* (New York, 1903).

95. Or as *Priam, the Nubian Ganymede*; see Chase's 1879 Tile Club painting of his black servant, hired for the club's 1879 canal trip, a notable instance of turning class and race relationships of power into a costume drama, in Henry Art Gallery, *William Merritt Chase*, pp. 50, 51 (ill.).

96. Veblen, *Theory of the Leisure Class*, p. 58.

97. The rest-cure treatment prescribed by Dr. S. Weir Mitchell did little for Addams, though its effects were not as devastating as they were upon Charlotte Perkins Gilman, whose own nervous collapse had formed the basis of her "Yellow Wall-Paper"; see Allen F. Davis, *American Heroine: The Life and Legend of Jane Addams* (New York, 1973), pp. 27–43.

98. Christopher Lasch, ed., *The Social Thought of Jane Addams* (Indianapolis, 1965), pp. 4, 6.

99. *Hull-House Maps and Papers: A Presentation of Nationalities and Wages in a Congested District of Chicago, Together with Comments and Essays on Problems Growing out of the Social Conditions* (New York, 1895), pp. 167, 175, 176, 178.

100. As Veblen realized, even the most abject poor practiced some form of conspicuous consumption; see Veblen, *Theory of the Leisure Class*, p. 70.

101. Jane Addams put *The Theory of the Leisure Class* on a reading list for an extension course; see John C. Farrell, *Beloved Lady: A History of Jane Addams' Ideas on Reform and Peace* (Baltimore, 1967), p. 84 (n. 10).

102. Rosenberg, *Beyond Separate Spheres*, p. 33.

103. Kornwolf, "American Architecture and the Aesthetic Movement," this publication, sees arts and crafts ideas as intimately linked with those of the Aesthetic movement.

104. George Fiske Comfort, quoted in Mary Ann Stankiewicz, "The Creative Sister: An Historical Look at Women, the Arts, and Higher Education," *Studies in Art Education* 23 (1982), p. 52; and see Stankiewicz, "The Eye Is a Nobler Organ," p. 59.

105. For the role of Sargent, see Cleota Reed Gabriel, "Irene Sargent: Rediscovering a Lost Legend," *Courier* (Syracuse University, N.Y.) 16 (Summer 1979), pp. 3–13; and Cleota Reed, "Irene Sargent: A Comprehensive Bibliography of Her Published Writings," *Courier* (Syracuse University, N.Y.) 18 (Spring 1981), pp. 9–24. For the analysis of the Arts and Crafts movement, see the essays by Edgar Kaufmann, Jr., Carl E. Schorske, and especially Robert W. Winter, "The Arts and Crafts as a Social Movement," in "Aspects of the Arts and Crafts Movement in America," ed. Robert Judson Clark, *Record of the Art Museum, Princeton University* 34, no. 2 (1975); Gilbert, *Work Without Salvation*, pp. 83–96, and Lears, *No Place of Grace*, pp. 59–96. For the arts and crafts achievement in New York State, see Gallery Association of New York State, *The Arts and Crafts Movement in New York State, 1890s–1920s*, by Coy L. Ludwig (exhib. cat., 1983).

Overleaf: Detail of "Mr. W. H. Vanderbilt's Bedroom" (ILL. 2.1)

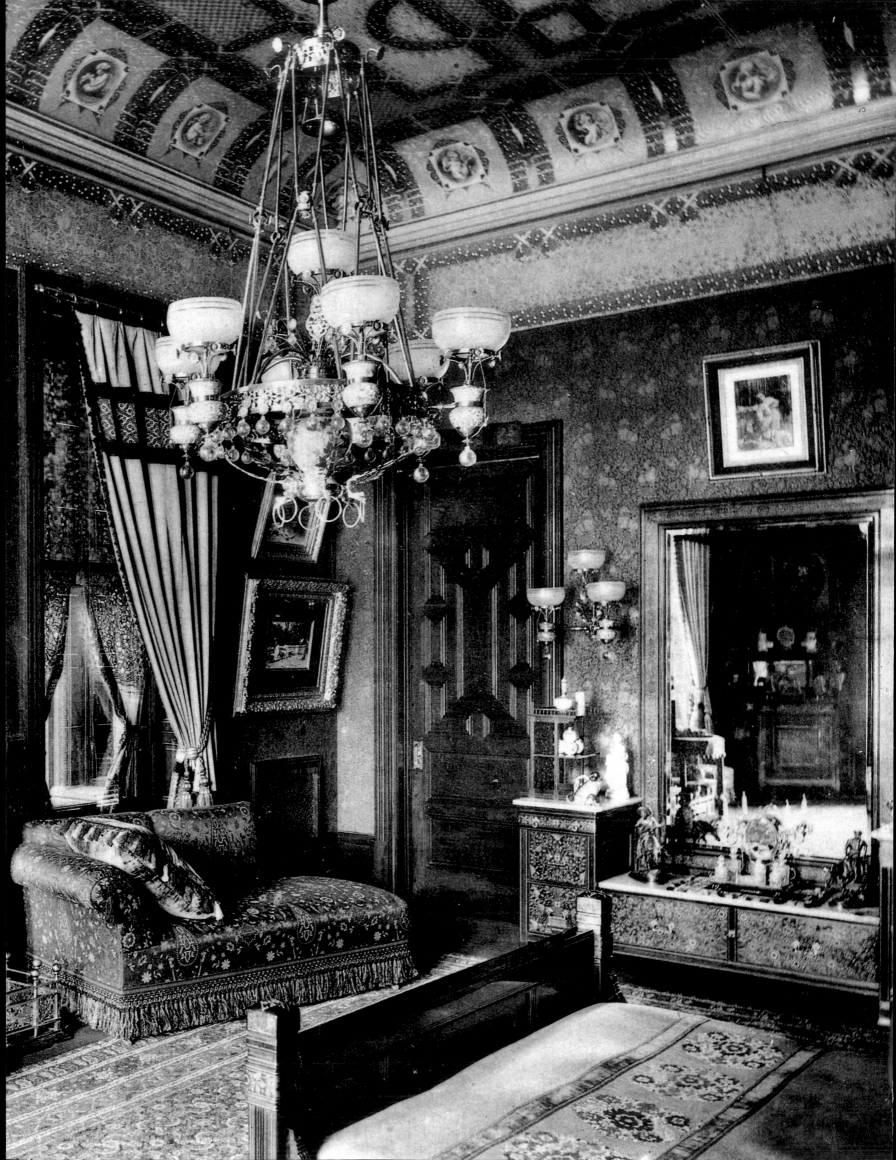

Decorating Surfaces:
Aesthetic Delight, Theoretical Dilemma

Catherine Lynn

SURFACE ORNAMENT, to use a term of the 1870s and 1880s,[1] seems to cover everything in American rooms deemed beautiful enough for immortalization by photographers of the period. Patterns on walls, ceilings, carpets, rugs, window draperies, portieres, pillows, and upholstery are likely to dominate much of the available space in any one of the room portraits interleaved in family albums from the Aesthetic era. Pictures so carefully preserved must have been important relics. Can they be dismissed as mere status symbols, records of accumulated wealth? Study of the surface ornament so dominant in the photographs suggests they should not be.

Why is there so much of this ornament? Its seeming omnipresence is something of a barrier to the most basic identification of objects in the pictures. Room shapes and furniture forms are hard to make out when every surface carries a thin veneer of ornament. The picture planes are so dense with imagery that empathetic entry into the rooms portrayed is difficult. Nor is it easy to keep the pictures in the mind's eye, to remember distinctions among them, when perusing a large collection like the 202 photographs gathered in *Artistic Houses,* the volume that presents the rooms judged the most beautiful in America during the early 1880s (ILL. 2.1; see also ILLS. 4.1, 4.8, 4.11, 4.12, 4.20, 9.12).[2]

Turn-of-the-century tastemakers were soon to reject that judgment, to react against the visual complexity in interior decoration to which the eccentric, creatively eclectic patterns of the previous decades had contributed so appreciably. In campaigning for the purity and authority of historical styles, architects such as Charles Follen McKim (1847–1909), William Rutherford Mead (1846–1928), and Stanford White (1853–1906) turned more obediently to models from the past.[3] Edith Wharton, in *The Decoration of Houses* (1897), and Elsie de Wolfe, in *The House in Good Taste* (1911), popularized and embellished upon their ideas.[4] For a long-lived generation de Wolfe effectively froze an understanding of "good taste" in using pattern, restricting it to discrete areas and objects. The relative simplifications of this group have subsequently dominated "traditional" interior decorating in America.

The ideas of their contemporaries who were attempting to create "modern" interiors have not come down to us in such unbroken succession, but they too preferred simpler ornamentation. The rooms of many arts and crafts enthusiasts look fairly Spartan when compared to those in *Artistic Houses.* The urge to express modernity in American terms, whether in the work of craftsmen before World War I or in that of industrial designers during the Great Depression, has favored the simplification or elimination of decoration. The more ornate twentieth-century styles, including Art

Nouveau as well as the Parisian- and Viennese-inspired "modernistic" styles of the 1920s, have enjoyed only limited popularity in the United States. Since the 1930s most self-proclaimed American modernists, especially those influenced by the International style, have pursued radical programs for stripping rooms of ornament and clearing them of the many objects they associated with Victorian clutter.[5] For the better part of a century now architects, decorators, industrial designers, domestic scientists, feminists, and engineers, in testing the theories peculiar to their callings, have persuaded successive generations to create simpler rooms, sparsely ornamented.[6]

For many years the role of surface ornament has been so unimportant that it has not been studied outside trade schools. But surface ornament was thoughtfully studied and created by the architects and artists of the Aesthetic era; the theoretical and popular literature of the period is filled with discussions of their work. Through those pages runs a lively argument about propriety in ornamental design. At the heart of the discussion is a fundamental disagreement about whether realistic, naturalistic imagery is acceptable as decoration, or whether all ornamental forms must be abstractly rendered. Both realistic and abstract patterns appear in photographs of rooms touched by aesthetic aspiration (see ILL. 4.1).[7] A decorator could have defended the artistic superiority of either type of pattern, or the propriety of using both within the same room, by quoting from revered texts of the day. Theoretical treatises and decorating guides, as well as columns in popular journals and even in newspapers, provided thoughtful, sometimes impassioned decorators with the inspiration to call almost any among a wide variety of patterns the only "aesthetic" or "art" patterns, or, conversely, to call the very same designs "Philistine," or even "immoral."

Most mid-twentieth-century artists and architects, preoccupied with problems of function, structural expression, and abstraction, dismissed such terms, as well as the notion that pattern and ornament—"superficialities"—were subjects worthy of discussion. Few of them produced wallpaper or textile patterns. Their attitudes, until very recent years, have encouraged us to see all patterned surfaces as pretty much the same. Indeed, our visual perception of any flat area on which several contrasting tones, colors, or hues are closely juxtaposed is very different from our perception of an area of solid color or of white. We quickly see a plain surface as a plane. A patterned surface gives the eye pause: light and dark areas seem to recede or come forward in relation to one another. We have to focus and think, to rectify illusion, in order to locate the surface in real space.

Expanses of ornament carried on tissues and in paint often have the effect of visually dematerializing the forms and surfaces they cover. Granted, our perception of this may be accidentally heightened when we look at photographs in which three dimensions have been reduced to two and multicolors to tones of sepia or gray. Some decorators of the late nineteenth century, however, deliberately used color and pattern to dematerialize, visually at least, material facts, such as the too-near presence of the surface of a wall. Those who enjoyed the illusory potential of pattern tended to view the designer as an artist who was privileged to preempt the virtuosity of a painter in ornamenting interiors. Others, influenced by contemporary architectural theory, deplored illusion in decorative contexts. They saw the designer as a member of a discrete profession, a trained expert who accorded precedence to the expression, rather than to the distortion, of the structural realities of architectural surfaces and volumes. Their concern for designing ornamentation that would not visually fracture a surface led, logically, to the twentieth-century modernists' banishment of ornament and pattern.

Wallpapers, carpets, textiles, and embroideries of the late nineteenth century serve as telling documents of the prolonged dispute about propriety in ornamental design that came to this twentieth-century pass. American-made examples as well as imported goods are considered in detail in chapter 3. But before we examine the printed, woven, and stitched ornaments that were demonstration pieces for the various theories, it seems worth trying to bridge some of the gap between our time-bound responses to ornament and pattern and those of the aesthetic enthusiasts. I will begin by suggesting some of the reasons home decorators might have had for wanting so much two-dimensional ornament around them, and then will review the argument about propriety in ornamental design.

The sheer quantity of ornament apparent in the sepia-toned room portraits cannot fully be explained as merely another expression of delight in what Thorstein Veblen, writing in the 1890s, was to call "conspicuous consumption."[8] During the 1870s and 1880s pride of possession was sometimes overshadowed by, and doubtless linked with, a conviction that the forms of material things were important because they had the power to influence human minds and even human souls. Decoration was important, not simply because it was attractive, but because it had a bearing on the formation of character; it was not a minor art, but part of the great unity of art.

A book by John Ruskin (1819–1900), *The Two Paths, Being Lectures on Art and Its Application to Decoration and Manufacture,* played a significant role in persuading Americans to think this way about decoration. This was the only book Ruskin ever devoted exclusively to decorative art. With its publication in 1859, the English critic of art and architecture most widely read and highly regarded in the United States became the most effective and persuasive of the English writers who contended that decoration merited the attention of the artist and that a good designer must be an artist. *The Two Paths* is theoretical, and we cannot quantify its impact on the visual character of papers, carpets, and textiles in America during the period. Its popularity in the United States, however, suggests that it decidedly affected designers' approaches to their work and consumers' evaluations of that work. Nineteen American printings of *The Two Paths* between 1859 and 1891 have been recorded, more than for any other book on the subject.[9]

In earlier works, especially *The Seven Lamps of Architecture* (1849), Ruskin had already focused his readers' attention on ornament, citing it as the feature that distinguished true architecture from mere building.[10] The stress Ruskin put on ornamentation dignified the finishing and furnishing of rooms and the work of pattern designers with the status of art making. In *The Two Paths* he charged his readers to "get rid, then, at once of any idea of Decorative art being a degraded or a separate kind of art."[11] The

taste for large quantities of surface ornament can be linked to Ruskin's equating of ornament with art, and to his arguing that art was a powerful tool of moral influence, so powerful that the way to reform society was to reform its art. This introduction of moral issues immediately complicates an understanding of the Aesthetic movement as art for art's sake. In the popularization of aesthetic enthusiasms in America, the moral justifications for them seem to have been prerequisite to their broad-based acceptance. The argument that art could be good for you and for your country contributed to the successful marketing of patterns advertised as "artful" or "aesthetic."

In the first of the five lectures in *The Two Paths,* which he called "The Deteriorative Power of Conventional Art over Nations," Ruskin asserted that the very forms of the decorations produced by a given people at once reflected and influenced their characters and souls. He focused on the "Hindoos" as sinful, perceiving evidence of their sins in the "geometry," "formula," and "legalism" of their ornament—or of their ornament as it had been presented in recently published English books, which omitted such features as representational sculpture on Indian buildings. According to Ruskin, in designing, the "Hindoos" had taken the wrong path, for the path of the geometrician, the conventionalizer, led only to the "Salt Sea" and to death. A vocal majority of English critics and designers had hailed Indian patterns as models of decorative accomplishment. To Ruskin these same patterns evinced the character of a race of people revealed as especially heinous by the atrocities they reportedly committed during the Mutiny of 1857. Judging the Indians devoid of "natural feeling," Ruskin found that quality in the Scots, a race he not coincidentally admired for their bravery in quelling the Mutiny. He felt that the proud Scots, even in their crude art, were on the right path to the "Olive mountains" and to life, because their art, like their lives, was in direct harmony with nature. The choice between the Scots model and the Indian one was a choice between life and death, Heaven and Hell.[12]

Ruskin's preoccupation with the moral qualities of design and with the power of form and visual imagery both to influence and to reflect the spirit was peculiarly compelling to women of the period. For half a century they had been the targets of increasing quantities of prescriptive literature arguing that the only power appropriate to their sex was influence, especially over their sons within the domestic sphere.[13] In *The Two Paths* Ruskin called for a reevaluation and nurturing of arts produced in and for the home. He inflated their importance when he identified the domestic realm as the preserve of the natural scale of life, contrasting it to the inhuman scale of monstrous new industrial structures.[14] He provided a rationale for viewing pattern and ornament, along with all interior decoration, as tools of moral influence. Perhaps the circumstances of women's lives made them overly eager to test the potential latent in ornamental forms, now viewed as art, for molding character. By Ruskinian lights, shopping itself was transformed: passive consumption became active art making. As society's chief consumers, women could find in Ruskin's pages justification for purchasing many ornamental embellishments: when they brought home new examples of "art," decorative or fine, they were increasing the possibilities that the truths inherent in the objects would be transmitted to the minds of the children who were to live among them.

Truth in art was one of Ruskin's most passionate concerns. Natural scale, natural form, natural materials—these were all elements he found essential to true art. He summarized the aim of his life's work as "to teach . . . to declare that whatever was great in human art was the expression of man's delight in God's work."[15] The patterns on textiles, carpets, and wallpapers had traditionally carried images of flowers and foliage, "God's work" in Ruskin's terms. His use of such terms, and his own enthusiasms, encouraged his readers to surround themselves with natural imagery and to regard it as "art" even in its most decorative contexts. *The Two Paths,*

then, intensified Ruskin's exhortation in *The Seven Lamps of Architecture* to make "our ordinary dwelling-houses . . . as rich and full of pleasantness as may be, within and without."[16] Surface ornament contributed to an effect "rich and full of pleasantness" for many nineteenth-century householders, and they could value it even more highly after Ruskin had taught them to appreciate decoration as an expression of delight in God's work, as a force for moral good, even as a sign of the goodness of those who designed and chose it. At least some of those who included portraits of their rooms in family albums must have done so because they believed that rooms and furnishings conveyed a sense of family character. In an era when amateurs of phrenology abounded, detailed study of the ornament in a family's home might have been expected to yield much the same sort of information about their minds and souls as might a study of their skull shapes and the bumps on their heads.

If Ruskin's book is paramount among those that suggest reasons for the popularity of pattern and ornament, it serves even more precisely to sharpen our understanding of the distinctions the era made among types of decorations. Most of Ruskin's opinions about the visual character of ornamental design were direct rebuttals of opinions that had prevailed in England for more than two decades. By the 1840s a group of designers, civil servants, critics, and businessmen had mustered the powers of the British Crown and bureaucracy in a program of mass education in design. The Normal School of Design had been established in London in 1837, and by 1849 there were sixteen branches throughout the country. The program was, in large part, a defensive campaign against French encroachments on the market for industrially produced English goods. Its prime mover was Henry Cole (1808–1882). Cole began his career in public work as a clerk in the Record Commission and rose to become the first director of the South Kensington Museum, which opened in 1857 when the collection of ornamental art and the design school were moved from Marlborough House to quarters in the South Kensington district of London. (Queen Victoria renamed the museum at South Kensington in 1899, and it has since been known as the Victoria and Albert Museum.) Prince Albert became an active supporter of Cole's efforts to inculcate what he considered good design in schools and museums through publications and exhibitions. It was Cole who first suggested to the prince that the Great Exhibition of 1851 should be of unprecedented international scale, so that it might serve as a public educational experience in which all of England could study the manufacture and design of all the earth. Cole had many other allies in key positions, among them the painter Richard Redgrave (1804–1888), who became headmaster of the schools of design in 1849 and until he retired at age seventy-two was often called the "Pope of South Kensington."[17] The architect Matthew Digby Wyatt (1820–1877), a critic and theorist of design who became the Slade Professor of Fine Arts at Cambridge University in 1869, also helped to formulate the principles of design that came to be identified with South Kensington.[18]

Although this British group, like Ruskin, focused on motifs found in nature as central concerns of the ornamentalist, they vilified the realistic depiction of these motifs in decorations. This was part of their war against the fondness of ordinary English people for French fabrics with lifelike portraits of flowers by the yard and for hand-printed French wallpapers that were inexpensive copies of great works of art adapted for merchants' overmantels. From the perspective of these would-be design reformers the taste for French products amounted to near treason in a trade war in which England was faring badly. English machines simply could not reproduce the painterly effects that French handcraftmanship had long since perfected and that French ingenuity was currently better able to adapt for mass production.

Recalling the propaganda of hotter wars is the exaggerated fervor with which Cole and his circle deplored the character of the very things the French made so well. Like Ruskin's followers, this British group introduced moral terms into their criticism, but for very different ends. They condemned infractions of visual logic, especially in the area of two-dimensional surface ornament. First, they cited illusionistic shading as illogical because it was inevitably at odds with natural lighting. Then the moral vocabulary took over. "Fraud" was their judgment when confronted with wallpaper pictures that seemed to recede into distant horizons or to protrude into the space of the viewer. They heaped epithets like "sham," "vicious," "false," and "meretricious" on gay little floral motifs that seemed to stand out from the textiles on which they were printed.[19] In state-supported classes all over England instructors trained at South Kensington used such terms to teach future designers and consumers a set of rules about ornament that opposed every feature of French accomplishment in making textiles, wallpapers, and carpets.

Those rules were conveniently condensed by OWEN JONES, an architect and designer, into a list of thirty-seven "propositions," which he published in 1856 as the introduction to his *Grammar of Ornament*. Jones followed the model of a scientist, collecting data, deducing natural laws, and invoking the certainties of mathematics. He gathered and analyzed samples of all the world's ornamental traditions, treating styles rather as if they were biological species, some growing healthily, others in decline. This work, he felt, revealed to him universal truths of good design. Among these truths, he and his disciples emphasized the one he offered as Proposition 8: "All ornament should be based upon a geometrical construction."[20] Jones and his colleagues also turned to science and mathematics for guidance in coloring ornament. Their study of contemporary color theory about the physical properties of light and pigment convinced them of the importance of including a mathematical balance of the primary colors to "harmonize" or "neutralize" one another in ornamentation. That balance might be achieved by the measured use of secondary and tertiary colors, but it was easier to get with primaries, and much of their work featured all three—or at least touches of bright red, blue, and yellow.[21]

A scientific approach to design had become a fixture in the

ILL. 2.1 "Mr. W. H. Vanderbilt's Bedroom." *Artistic Houses* (New York, 1883–84). Thomas J. Watson Library, The Metropolitan Museum of Art

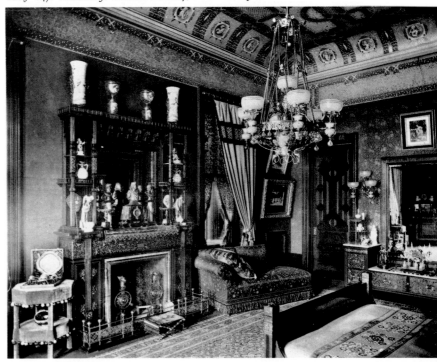

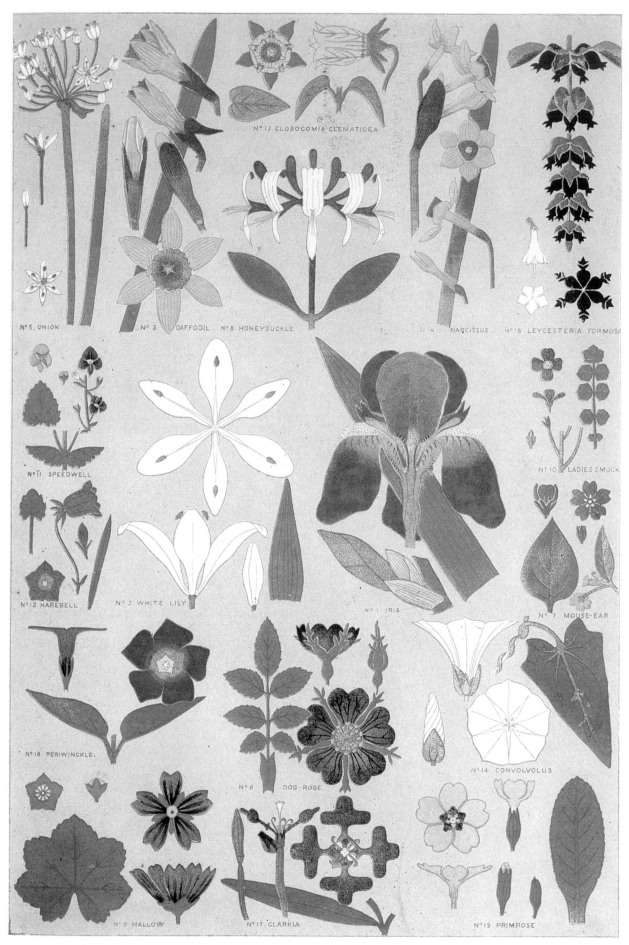

FIG. 2.1 Plate 98: "Leaves and Flowers from Nature No. 8." Christopher Dresser. Owen Jones, *The Grammar of Ornament* (London, 1856). Thomas J. Watson Library, The Metropolitan Museum of Art

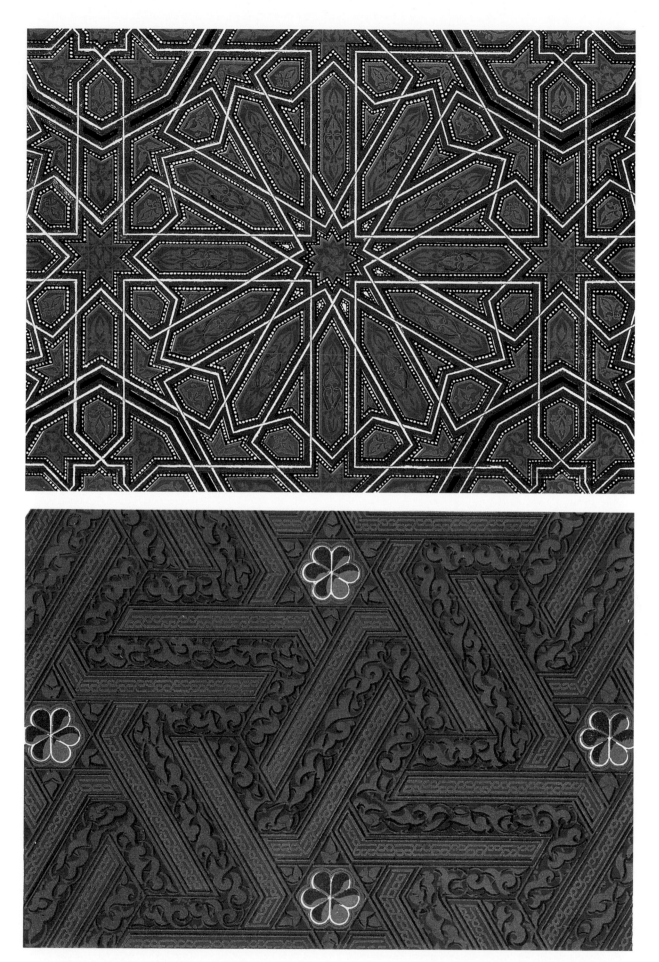

FIG. 2.2 Plate 42: "Moresque No. 4." Owen Jones, *The Grammar of Ornament* (London, 1856). Thomas J. Watson Library, The Metropolitan Museum of Art

ILL. 2.2 "Wild Rose." *Decorator and Furnisher* (June 1883). Art, Prints and Photographs Division, The New York Public Library, Astor, Lenox, Tilden Foundations

government-sponsored system of design education that had its central teachers' school and museum in South Kensington, and Jones's concise statements of principle were the best-known summaries of that approach. *The Grammar of Ornament* became a standard reference, both in England and in the United States. (The first American edition was published in New York in 1880, just as the momentum of the aesthetic enthusiasm was peaking.) Basic to the thinking at South Kensington was an understanding that ornamental design constituted a branch of study quite separate from the fine arts of painting and sculpture, and governed by an entirely different set of rules. One of the rules that most clearly distinguished the decorative from the fine arts was summarized in Jones's Proposition 13: "Flowers or other natural objects should not be used as ornaments, but conventional representations founded upon them sufficiently suggestive to convey the intended image to the mind, without destroying the unity of the object they are employed to decorate."[22] The distinction between ornamental flowers, so defined (FIG. 2.1), and painterly flowers, appropriate to the fine arts, was especially obvious at a time when painters' canvases revealed their continuing preoccupation with mimetic realism in depicting the natural world.

"Natural objects," as Jones called them, and especially flowers, "nature's ornaments," furnished the principal subject matter for nineteenth-century ornamentalists of many persuasions whose work had an impact in America. These designers, however, treated nature's forms in many different ways (ILL. 2.2). Their approaches can be visualized as shadings on a spectrum ranging from severe geometric abstraction on the left, through conventionalization, to mimetic realism on the right.[23] On this spectrum Jones's designs and theory fall left of center. Jones always insisted on some degree of abstraction from nature. Many of his patterns, and those he admired, were purely geometric (FIG. 2.2). In designing other ornaments he abstracted or simplified plant forms while retaining the identifying shapes of their species. In still others he adapted historical conventionalizations of plant motifs such as the anthemion of the ancient Greeks.

Far to the right on the spectrum stand the theories of the French, who endorsed the use in ornament of not only realistic floral and foliate imagery (ILL. 2.3) but also the full range of other subjects from the painter's repertory, including human figures. The painter Thomas Couture (1815–1879), for instance, felt it was the duty of French industry to make the work of great artists available to the many. He designed for manufacturers and encouraged other paint-

ers to do the same.[24] Couture's theories about decorative art, written in French, were not read by many Americans. John Ruskin's were.

Ruskin's ideas also stand far to the right on the spectrum of influential theories about the way nature should be used in ornament. Ruskin was no booster of machine production, but he agreed with Couture on two points relevant to this discussion: that realism was more than acceptable for decoration and that there should be no cleft between the fine and the decorative arts. In *The Two Paths* Ruskin rebutted the formulas of Jones, a man ten years his senior, and cast himself in the role of a brash younger reactionary in the design controversy. His book was in large part a frontal attack on South Kensington's effort to banish from decoration realistic depictions of nature's forms. As part of this attack, Ruskin criticized the government's program that separated the decorative from the fine arts. Instead of attending schools of design where they studied historical ornament and geometry, students who wanted to design for industry should attend art schools alongside future painters and sculptors. Like them, they should learn to draw directly from nature. "Depend upon it," Ruskin assured the students, " . . . good subordinate ornament has ever been rooted in a higher knowledge."[25] And the highest knowledge always came straight from God's own nature, not through authoritative interpreters. Conventional and even geometric ornaments had places in Ruskin's scheme, but they were to be created only by an artist who had first studied nature, *then* abstracted, not by someone trained to adapt historical motifs or to manipulate a compass and a ruler. He warned that "substitution of obedience to mathematical law for sympathy with observed life, is the first characteristic of the hopeless work of all ages."[26]

Ruskin, the greatest living art critic, scoffed at the Crown's appointed experts. In *The Two Paths* he characterized as "absurd" their insistence that "room decoration should be by flat patterns—by dead colours—by conventional monotonies, and I know not what." He went straight for the reductionism of South Kensington theory: "The principles on which you must work are likely to be false, in proportion as they are narrow; true, only as they are founded on a perception of the connection of all branches of art with each other."[27] In offering this broad vision, Ruskin bucked the tide of his contemporaries' efforts to improve design by training the many to respond to a very few principles, which were to be applied automatically in all cases.

For the people who were dedicated to improving and simpli-

fying decorative design, Ruskin's dismissal of the principle that limited choice in ornamentation to the geometric and conventional was vexing. Because it was a principle easily grasped and applied, it was dear to many—to the popularizers who wrote home-decorating guides and to the manufacturing and buying public who wanted assurance that their taste was correct. The simple dictum seemed a sure anchor in a bewildering sea of published advice on decoration. By complicating what seemed to have been so conveniently simplified by authorities, Ruskin reintroduced the possibilities for blunders that come with unlimited choice. He denied the prerogative of the experts to dictate, and to limit, a definition of good design. He gave back the choices to the artist. Ruskin believed that the great painters, not the graduates of design schools, were the ultimate decorators, and that "a great painter will always give you the natural art, safe or not." In illustrating his point he wrote a passage that bears quoting both for a taste of the rhetoric that was so compelling in its day and because a number of American decorating books of the Aesthetic era include pointed allusions to it:

> Correggio gets a commission to paint a room on the ground floor of a palace at Parma: any of our people—bred on our fine modern principles—would have covered it with a diaper, or with stripes or flourishes, or mosaic patterns. Not so Correggio: he paints a thick trellis of vine-leaves, with oval openings, and lovely children leaping through them into the room [ILL. 2.4]; and lovely children, depend upon it, are rather more desirable decorations than diaper, if you can do them—but they are not so easily done. . . . In all other cases whatever, the greatest decorative art is wholly unconventional—downright, pure, good painting and sculpture, but always fitted for its place.[28]

With such prose Ruskin inspired many British artists and architects to look with new interest at the possibilities inherent in decorating interiors. Among them, WILLIAM MORRIS was perhaps the most inspired and certainly the most gifted creator of ornamentation. Several of his patterns are discussed and illustrated in chapter 3. By Morris's own account, his reading of Ruskin played a large part in his decision to turn from architecture and painting to decorative design.[29] The succession of wallpapers and printed textiles he offered through the 1870s gives visual evidence that he took quite seriously Ruskin's injunction to go to nature for inspiration. In these printed patterns an initial comparatively rigid subservience to geometry gave way to more fluid and naturalistic lines and forms.[30] For woven textiles, including carpets, where he had to rely on coarse fibers and large rectilinear grids to carry his patterns, Morris continued to use conventional motifs, forms more responsive, as he observed, to the nature of the materials and the craft techniques. By pointedly identifying himself as an artist in the Ruskinian sense, Morris was asserting that all the options from realism to abstraction were equally open to him. His choices among these options were influenced not only by the variety of media in which he worked but also by his sense of propriety as he adjusted his patterns to the places they were to occupy in interiors.

The theory of Ruskin and the work of Morris admitted realism. The ideas of CHRISTOPHER DRESSER made no such admission. His theories and patterns fall far to the left of Morris's. Born in the same year, 1834, Morris and Dresser were the two most influential pattern designers of a younger generation, the two men who most effectively put into practice, questioned, and developed the theories of their elders. Both turned to decorative design after early accomplishment in other fields. But whereas Morris came to ornament as an artist and architect who responded with enthusiasm to Ruskinian ideas, Dresser came as a scientist, a trained botanist, and a pupil and apprentice of Owen Jones's.[31] His ideas and his

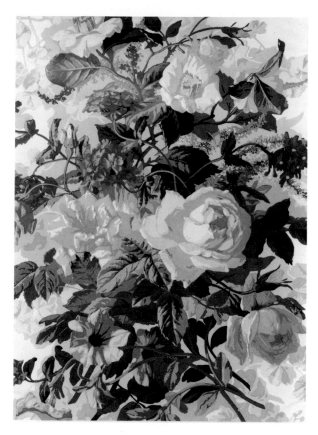

ILL. 2.3 "Dessin à fleurs. 18 couleurs." Jules Desfossé, *Note pour mm. présidents et membres du jury international concernant l'établissement de Jules Desfossé, fabricant de papiers peints, à Paris* (Paris [1855?]). Cooper-Hewitt Museum Library, The Smithsonian Institution's National Museum of Design, New York (M/748.4/D453N)

ILL. 2.4 East wall, Camera di S. Paolo, Parma. Antonio Allegri da Correggio, 1518–19

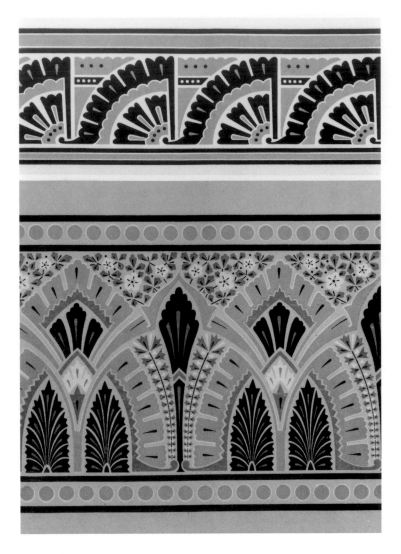

ILL. 2.5 Plate 5: "Border Ornaments of New Style." Christopher Dresser, *Studies in Design* (London, 1874–76). Thomas J. Watson Library, The Metropolitan Museum of Art

career were grounded in the design establishment.

In 1862, three years after Ruskin published his attack on Jones in *The Two Paths,* Dresser mounted a counterattack in *The Art of Decorative Design.* Branding Ruskin "the leader of the Natural School," Dresser found him dogmatic in his defense of the unity of art. He charged that although Ruskin seemed to have a "true feeling for pictorial art," he had "little knowledge of ornament."[32] Assuming the voice of a professional, a technically trained expert, Dresser then rehearsed the principles of the school at South Kensington and defended Jones's Thirty-seven Propositions. By presenting ornamental art in such concrete terms, by concocting expertise that could be tested, the South Kensington establishment drew on the same appeals to science and certainty that historians have identified with the rise of professionalism in many other realms of nineteenth-century endeavor. The school had given Dresser strong footing.

Dresser went beyond the school's teachings, however, beyond Jones's rules, beyond any idea that decorative designing was largely a matter of abstracting from the forms visible in nature to arrive at conventional forms. Rather, he proposed a new way to create ornament: the aspiring designer must first identify the underlying principles of natural growth, then abstract from those principles

using mathematics and the knowledge of a botanist to conceptualize structures not necessarily visible.[33] A great ornamental designer could create forms *never* seen in nature, purely imaginative forms designed in the ways that nature herself designs. The resulting ornaments would be supernatural, superconventional, ideal in the sense of being born of ideas in the mind, not of appearances in the visible world. In *The Art of Decorative Design* Dresser wrote, "Purely ideal ornament is that which is most exalted, it being wholly a creation of the soul; it is utterly an embodiment of mind in form, or an offspring of the inner man, and its origin and nature give to it its elevated character."[34] In "Ornamentation Considered as High Art," a paper he presented to the Royal Society of Arts in London in 1871, he told his audience:

> True ornamentation is of purely mental origin, and consists of symbolised imagination or emotion only. I therefore argue that ornamentation is not only fine art, but that it is high art, . . . even a higher art than that practised by the pictorial artist, as it is wholly of mental origin.[35]

In approaching nature analytically, not visually as Ruskin had, Dresser had again separated ornament from the art of the painter. Whether higher or lower, ornamental art as seen from the perspective of South Kensington continued to deny Ruskin's insistence on the unity of all art.

Dresser's most distinctive contribution to his higher art of ornamentation was a rich, bizarre, and personal vocabulary of forms (ILLS. 2.5, 2.6; see also ILL. 3.11, FIG. 7.11). His patterns and ornaments of the 1870s, sharp-edged, angular, imbued with a look of motion and dynamic growth, seem startlingly "modernistic" from a post-1930s perspective. He not only sold his patterns to manufacturers in England and the United States but also published them as illustrations in his many articles and books.[36] The practicality and concreteness of his lessons on design methodology made them appealing texts for commercial designers.

Dresser's published illustrations found their way to the drafting boards of some Americans with little alteration. No matter how enthusiastically one endorsed his theory that "true ornamentation is of purely mental origin," it was much easier to crib a Dresser design than to invent a new pattern. *Modern Surface Ornament,* a collection of ornamental plates published by CHARLES BOOTH in New York in 1877 (see ILL. 6.2), includes designs signed by little-known Americans whose direct debt to Dresser is sometimes all too apparent. Nevertheless, several of these designers showed themselves to be "imaginative" and to be working as Dresser prescribed, evolving a bestiary of creatures as strange as any invented by medieval illuminators and an array of angular plant forms never seen on this planet.[37]

The following year, 1878, similar plates appeared in a short-lived New York magazine, the *Art-Worker* (see ILL. 6.3). J. O'Kane, the publisher, offered his subscribers designs for furnishings and interiors, interspersed with pages of surface ornament. Each month he doled out a plate or two from the publications of major British designers, including F. E. Hulme (1841–1909), E. W. GODWIN, and J. MOYR SMITH. O'Kane punctuated these plates with ornamental designs by less familiar names, including four Americans whose work had also appeared in *Modern Surface Ornament* and eight other designers.[38] O'Kane himself signed eleven of the plates; on at least one of them (ILL. 2.7) his signature appears under a motif lifted directly from Dresser.[39] This might not have been quite the way Dresser envisioned influencing designers, but it is clear evidence that by the late 1870s he was having a visible impact on their work in the United States.

During the 1870s and 1880s the American trades that dealt in papers and "stuffs" for interior decoration hailed the patterns of both Dresser and Morris, and of their imitators, as examples of "English art decoration." Advertisers could count on the very

ILL. 2.6 Plate 54: "Ornaments to Be Used as 'Powderings' on Walls." Christopher Dresser, *Studies in Design* (London, 1874–76). Thomas J. Watson Library, The Metropolitan Museum of Art

names Dresser and Morris, which they sometimes used together in the same notice,[40] to signal "aesthetic" and "artistic" to perhaps distinct segments of a public persuaded by different bits they had read in the range of pronouncements about ornament. Depending on which English guide one had read most recently, any degree of abstraction, or its total absence, might seem artistically correct, as might any identifiable style, whether historical or in the manner of one of the newly published designers. American guides to designing and choosing surface ornament yielded equally conflicting instruction, since for the most part they were derived from English sources. American magazines such as the *Decorator and Furnisher* excerpted long passages from the writings of all the leading British theorists whose ideas have been presented here, and many of the British books were brought out in American editions.[41]

During the 1870s new American books offering guidance in the decorative arts tended to recapitulate the theories of the left in the English argument about surface ornament. Most American authors of home-decorating guides recognized the threat that Ruskin's opening up of possibilities represented to their campaign for simplifying and improving household taste. One of these authors, HARRIET PRESCOTT SPOFFORD, was a successful novelist who already commanded a respectful public when in 1878 she published *Art Decoration Applied to Furniture* (FIG. 2.3). Spofford brought the ideas of the "English renaissance in decorative art" to her American readers. Most of the English theory she had read, theory that had inspired the recent production of objects she thought beautiful, repeated the South Kensington dicta on ornamental design.

Siding with the school, refuting the mighty voice of John Ruskin, she wrote:

> Correggio, indeed, may paint his disputed wall surface of rosy children peeping through trellises, covered with blossoming vines; but only Correggio. The rest of us are wiser to avoid that sort of realism on our walls, for the simple reason, if for no nobler one, that it is absolutely impossible in decency to set the furniture against the picture it makes, or to hang one picture on another.[42]

Spofford's practical advice endorsed the South Kensington ap-

proach to ornament in tones that echo through many other American writings on decoration, such as the books Charles Wyllys Elliott (1817–1883) and Henry Hudson Holly (1834–1892) brought out in the late 1870s.[43] Such appeals to common sense encouraged American acceptance of a position left of center in the controversy in which abstraction was pitted against realism.

During the 1880s, however, Americans suffered some loss of their faith in the arguments of the left in this English design controversy. CLARENCE COOK, an influential New York art critic whose devotion to the principles of John Ruskin was of long standing, shook some of that American trust in South Kensington. In 1880 he noted that "we Americans . . . have blindly accepted the English dictum . . . and look upon . . . any but set conventional patterns and sombre colors, as vulgar." He reminded Americans that

> France makes no account of one of the prime articles in the creed of the modern English and American schools of Decorative Art, that natural representation, . . . imitations of all sorts, should be sedulously avoided. The French permit themselves full liberty in this matter, imitate any thing and every thing they can force into the service of decoration, and when they feel like it, paint flowers and fruits on wall-papers, or weave them into silks, or print them upon chintzes, with such grace and truth to nature, as to deceive the very elect.

Cook went on to hail a newfound choice between "a docile obe-

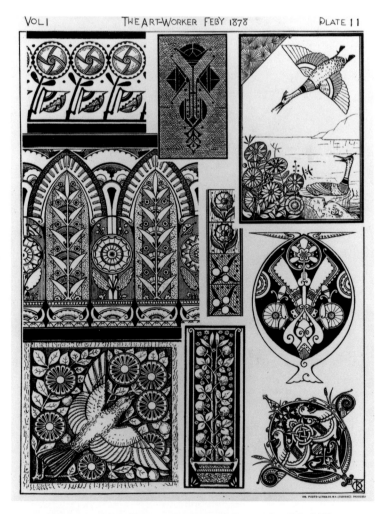

ILL. 2.7 Plate 11: "Miscellaneous Design and Decoration." J. O'Kane. *Art-Worker* (Feb. 1878). Thomas J. Watson Library, The Metropolitan Museum of Art

FIG. 2.3 *Art Decoration Applied to Furniture* (New York, 1878). Harriet Prescott Spofford. Cover: 9¼ × 7 in. (23.5 × 17.8 cm). The Metropolitan Museum of Art, Harris Brisbane Dick Fund, 1940 (40.31.7)

dience to certain formal rules" and a "revived freedom" to choose the naturalistic. He attributed this appreciation of freedom in ornamental design to the "revival" of the Queen Anne style and to the discovery of the "far more artistic art of the Japanese with freedom and naturalness equally its characteristics."[44] The old naturalism, the conservative forms of mid-century against which the English schools of design had aimed their every reforming effort, had emerged in Cook's thinking as essential to a new reform: the reclaiming of artistic freedom for ornamental design.

While Cook, as a critic and student of world art, emphasized historical precedents in his effort to inspire a reevaluation of theoretical restraints, CANDACE WHEELER, as a practicing decorative artist in the 1880s, was to assert that her mimetic depictions of nature on textiles represented original contributions to the arts of decoration. Wheeler's work, which is presented in chapter 3, is impressive both in its own right and because it inspired so many American women to take up brush or needle with a new high seriousness. It is also representative of the dilemma of many creative Americans who were torn between the attractions of English example and what they perceived as their duty to create an independent American art. Wheeler's high-spirited insistence on her own originality is touching, as is her will to lead a new American rebellion against English tyranny over an art to which she herself had turned only after the English had made it interesting to her.

English inspiration for American opinions about surface ornament during the Aesthetic era was inescapable. English notions had aroused the unprecedented interest in pattern and ornament in the first place. Right through the 1880s, and up to the effective end of the American Aesthetic era in the early 1890s,[45] the enthusiastic and earnest use of many patterns characterized aesthetic interior decoration. Also to the end, the argument about the principles of design appropriate for those patterns continued. The dilemma of choice remained a fresh and important one for the artistically aspiring American home decorator.

NOTES

1. The term furnished the title for a collection of ornamental plates published in 1877: [Charles Booth et al.], *Modern Surface Ornament* (New York, 1877); and Christopher Dresser, in *Principles of Decorative Design* (1873; reprint London, 1973), p. 73, used a near variant of it when he discussed the "principles involved in the decoration of surfaces, or in 'surface decoration,' as it is usually called."

2. *Artistic Houses, Being a Series of Interior Views of a Number of the Most Beautiful and Celebrated Homes in the United States,* 2 vols. in 4 pts. (1883–84; reprinted in 1 pt., New York, 1971).

3. For a thorough study of McKim, Mead and White, see Leland M. Roth, *McKim, Mead and White, Architects* (New York, 1983); for a study of their turn-of-the-century interiors, see Susan H. J. Harris, "McKim, Mead and White's Domestic Interiors, 1890–1909: A Catalogue of Decorative Treatment" (M.A. thesis, Columbia University, 1981).

4. Edith Wharton and Ogden Codman, *The Decoration of Houses* (1897; reprint New York, 1978); Elsie de Wolfe, *The House in Good Taste* (New York, 1911).

5. The book that was perhaps most important in bringing to America modernist ideas and images of white-walled interiors without ornament was Henry-Russell Hitchcock and Philip Johnson, *The International Style* (1932; reprint New York, 1966), esp. pp. 50–55, 69ff., and the illustrations of interiors.

6. For discussions of the programs for simplifying domestic interiors, see David P. Handlin, *The American Home: Architecture and Society, 1815–1915* (Boston and Toronto, 1979); Gwendolyn Wright, *Moralism and the Model Home* (Chicago, 1980); and Dolores Hayden, *The Grand Domestic Revolution: A History of Feminist Designs for American Homes, Neighborhoods, and Cities* (Cambridge, Mass., 1981).

7. For striking juxtapositions of abstract and realistic ornament within the same room, see *Artistic Houses,* vol. 1, pt. 1, ills. opp. pp. 20, 30, 35, 37, 54, 61, 62, 71; vol. 1, pt. 2, ills. opp. pp. 147, 158, 159; and vol. 2, pt. 1, ill. opp. p. 5.

8. Thorstein Veblen, *The Theory of the Leisure Class* (1899), in *The Portable Veblen,* ed. Max Lerner (New York, 1976), esp. pp. 111–40.

9. Henry-Russell Hitchcock, *American Architectural Books* (New York, 1976), pp. 85–92.

10. John Ruskin, *The Seven Lamps of Architecture* (1849), vol. 8 of *The Works of John Ruskin,* ed. E. T. Cook and Alexander Wedderburn [library ed.], 39 vols. (London and New York, 1903–12).

11. John Ruskin, *The Two Paths, Being Lectures on Art and Its Application to Decoration and Manufacture* (1859), vol. 16 of *Works of John Ruskin,* p. 320.

12. Ibid., pp. 254, 259–92, esp. pp. 261–63, 265, 268, 289. Christopher Dresser, who opposed Ruskin on many points, shared Ruskin's belief in the moral power of decorative art; in *Principles of Decorative Design,* p. 16, Dresser wrote that "decorative art . . . is a power for good or evil; that it is what will elevate or debase."

13. See Barbara Welter, "The Cult of True Womanhood, 1820–1860," *American Quarterly* 18 (Summer 1966), pp. 151–74. Nineteenth-century texts, especially sermons such as J. F. Stearns, "Female Influence, and the True Christian Mode of Its Exercise" (Newburyport, Mass., 1837), are specific about restricting the sphere of women's power to influence in the home. See also Nancy Cott, *The Bonds of Womanhood* (New Haven, 1977); and Ann Douglas, *The Feminization of American Culture* (New York, 1977). For late nineteenth-century evidence of the viability of the idea after the period studied by Cott, see "Home and Its Queen," *Scribner's Monthly* 1 (Feb. 1871), p. 752.

14. Ruskin, *Two Paths,* pp. 342–43, wrote, "For our own England, she will not, I believe, be blasted throughout with furnaces; nor will she be encumbered with palaces. I trust she will keep her green fields, her cottages, and her homes of middle life; but these ought to be, and I trust will be, enriched with a useful, truthful, substantial form of art. . . . And let these things we want . . . be scattered abroad and made accessible to all men."

15. Ibid., p. 290.

16. Ruskin, *Seven Lamps,* p. 228.

17. Elizabeth Bonython, *King Cole: A Picture Portrait of Sir Henry Cole, KCB, 1808–1882* (London, 1982), p. 26. Redgrave drew up the curriculum for the art schools, but a manual based on his writings and lectures, compiled by his son, was not published until 1876; see Gilbert R. Redgrave, *The Manual of Design, Compiled from the Writings and Addresses of*

Richard Redgrave (London and New York, 1876). For other accounts of the British efforts in design education, see Alf Bøe, *From Gothic Revival to Functional Form: A Study in Victorian Theories of Design* (Oslo and Oxford, 1957); Quentin Bell, *The Schools of Design* (London, 1963); and Janet Minihan, *The Nationalization of Culture* (New York, 1977).

18. Among his many books, see especially Matthew Digby Wyatt, *Fine Art: A Sketch of Its History, Theory, Practice, and Application to Industry, Being a Course Delivered at Cambridge in 1870* (London and New York, 1870).

19. The *Journal of Design and Manufacture,* a periodical published in London between 1849 and 1852, is especially rich in this vocabulary of vituperation. Charles Dickens parodied the teachings and methods of Cole's group in *Hard Times: For These Times* (1854; reprint New York, 1961), pp. 15–17.

20. Owen Jones, *The Grammar of Ornament* (1856; [3d ed.] London, 1868), p. 5.

21. Ibid., pp. 6–8 (Propositions 14–34).

22. Ibid., p. 6.

23. This spectrum is a purely visual and spatial construct used here to evoke a mental image of the relationships of particular ideas and forms in a theoretical controversy over design. Used in this context, the terms left and right have nothing, of course, to do with political stances. In fact, Ruskin and Morris, whose ideas about ornamental design place them to the right in this discussion, leaned decidedly to the left in their politics and were leaders in England's budding socialist movement.

24. Albert Boime, *Thomas Couture and the Eclectic Vision* (New Haven and London, 1980), pp. 63, 307–9.

25. Ruskin, *Two Paths,* p. 311, and see pp. 312, 326–30.

26. Ibid., p. 274.

27. Ibid., pp. 321, 319.

28. Ibid., pp. 321–22.

29. Paul Thompson, *The Work of William Morris* (New York, 1967), esp. pp. 5, 14–15.

30. For illustrations of Morris's patterns, see Andrew Melvin, *William Morris: Wallpapers and Designs* (London, 1971); Fiona Clark, *William Morris: Wallpapers and Chintzes* (New York and London, 1973); Birmingham Museums and Art Gallery, Eng., *Textiles by William Morris and Morris and Co., 1861–1940,* by Oliver Fairclough and Emmeline Leary (exhib. cat., 1981); and Linda Parry, *William Morris Textiles* (New York, 1983). For a discussion of development in his pattern designing, see Peter Floud, "The Wallpaper Designs of William Morris," *Penrose Annual* 54 (1960), pp. 41–45. Floud's emphasis on an increasing formalism in Morris's wallpaper patterns is only partially contradicted by my emphasis on the develop-

ing naturalism. My reading of the patterns is much closer to that of Denise McColgan, "Naturalism in the Wallpaper Designs of William Morris," *Arts Magazine* 56 (Sept. 1981), pp. 142–59, and to that of Thompson, *Work of William Morris.*

31. See the introduction to Fine Art Society Limited, London, *Christopher Dresser, 1834–1904,* by Stuart Durant et al. (exhib. cat., 1972), unpaged.

32. Christopher Dresser, *The Art of Decorative Design* (1862; reprint Watkins Glen, N.Y., 1977), pp. 146, 144.

33. Ibid., esp. pp. 39 (no. 18), 40 (no. 21), 49, 68–70.

34. Ibid., p. 40.

35. Quoted in "A Chronological Outline of the Life of Christopher Dresser," in Fine Art Society Limited, *Christopher Dresser.*

36. For a listing of Dresser's publications, see the bibliography, ibid.

37. Designers who contributed ornamental plates to [Booth et al.], *Modern Surface Ornament* included W. H. Wood ("architect, Newark, N.J."), H. E. Ficken ("architect, New York"), Charles Booth ("glass stainer, New York"), Charles Rollinson Lamb ("New York"), Arthur Halliday ("ornamentist"), Charles M. Jencks ("New York"), D. B. Peale, and Milton See.

38. Booth, Ficken, Halliday, and Lamb published plates in both *Modern Surface Ornament* and the one-volume *Art-Worker: A Journal of Design Devoted to Art-Industry* (Jan.–Dec. 1878). The eight others who contributed ornamental designs to the *Art-Worker* were Hall C. DeBaud, J. O'Kane, Bassett Jones, R. W. Rattray, all of New York, Adolph Rudolph of Chicago, Isaac E. Ditmars, and two Englishmen: A. Bedborough and Philip H. Ward.

39. The motif in the lower-right corner of the O'Kane plate in illustration 2.7 duplicates a design Dresser published in *Modern Ornamentation, Being a Series of Original Designs* (London, 1886); see Stuart Durant, *Victorian Ornamental Design* (London and New York, 1972), fig. 53.

40. See, for example, the advertisement of F. Andress and Company, Cincinnati, in *Illustrated Catalogue of the Art Department, Cincinnati Industrial Exposition, 1882* (Cincinnati, 1882), unpaged, 3d p. from end. Kenneth R. Trapp, The Oakland Museum, Calif., was kind enough to produce a photocopy of this catalogue for me. See also Catherine Lynn, *Wallpaper in America: From the Seventeenth Century to World War I* (New York, 1980), p. 388, for a New York advertisement listing wallpapers by Morris, Dresser, and CHARLES LOCKE EASTLAKE.

41. The lists of contributors published prominently in the *Decorator and Furnisher,* which was founded in 1882, were made up largely of British

authors of books on the decorative arts, including Mrs. M. E. Haweis, Robert W. Edis, Gilbert R. Redgrave, F. E. Hulme, Luther Hooper, and Lewis F. Day. Their writings were often cited in the magazine. As already noted, no fewer than nineteen American printings of Ruskin, *Two Paths* are recorded for the period 1859–91, and the first American edition of Jones, *Grammar of Ornament* was published in New York in 1880. Wyatt, *Fine Art* was published in London and New York in 1870. Redgrave, *Manual of Design* was brought out in New York in 1876, the same year it was first published in London. William Morris, *The Decorative Arts: Their Relation to Modern Life and Progress, an Address Delivered Before the Trades' Guild of Learning, of London* was published in London and Boston in 1878; the address was later included, under the title "The Lesser Arts," in a collection of five lectures Morris delivered between 1878 and 1881, *Hopes and Fears for Art: Lectures on Art and Industry,* published in London and Boston in 1882. Dresser, *Principles of Decorative Design* came out simultaneously in London, Paris, and New York in 1873 and 1882; the speeches Dresser gave in Philadelphia in 1876 were issued shortly thereafter as a monograph: Christopher Dresser, *General Principles of Art, Decorative and Pictorial, with Hints on Color, Its Harmonies and Contrasts* (Philadelphia, n.d.). Other figures in the British design establishment also had their books published in the United States. BRUCE J. TALBERT, *Gothic Forms Applied to Furniture, Metal Work, and Decoration for Domestic Purposes* (Birmingham, Eng., 1867) came out in Boston in 1873 and again in 1877; his *Examples of Ancient and Modern Furniture, Metal Work, Tapestries, Decorations, Etc.* (London, 1876) was issued in Boston in 1877. M[arianne M.] Alford, *Handbook of Embroidery* was published in New York in 1880, the same year it first appeared in London.

42. Harriet Prescott Spofford, *Art Decoration Applied to Furniture* (New York, 1878), p. 185. The essays in Spofford's book were originally published anonymously as a series of articles in *Harper's Bazar* and *Harper's New Monthly Magazine,* 1876–77; see Elizabeth K. Halbeisen, *Harriet Prescott Spofford: A Romantic Survival* (Philadelphia, 1935), p. 166.

43. Charles Wyllys Elliott, *The Book of American Interiors* (Boston, 1876); Henry Hudson Holly, *Modern Dwellings in Town and Country Adapted to American Wants and Climate with a Treatise on Furniture and Decoration* (New York, 1878).

44. Clarence Cook, *"What Shall We Do with Our Walls?"* (New York, 1880), pp. 15–17.

45. For example, in 1893 one architect spoke of "the aesthetic craze" as something decidedly in the past and lamented that the wallpaper patterns of that era—"much more than a craze at its best"—were no longer offered by the dealers; see Lynn, *Wallpaper,* p. 444.

Overleaf: Detail of portiere (FIG. 3.21)

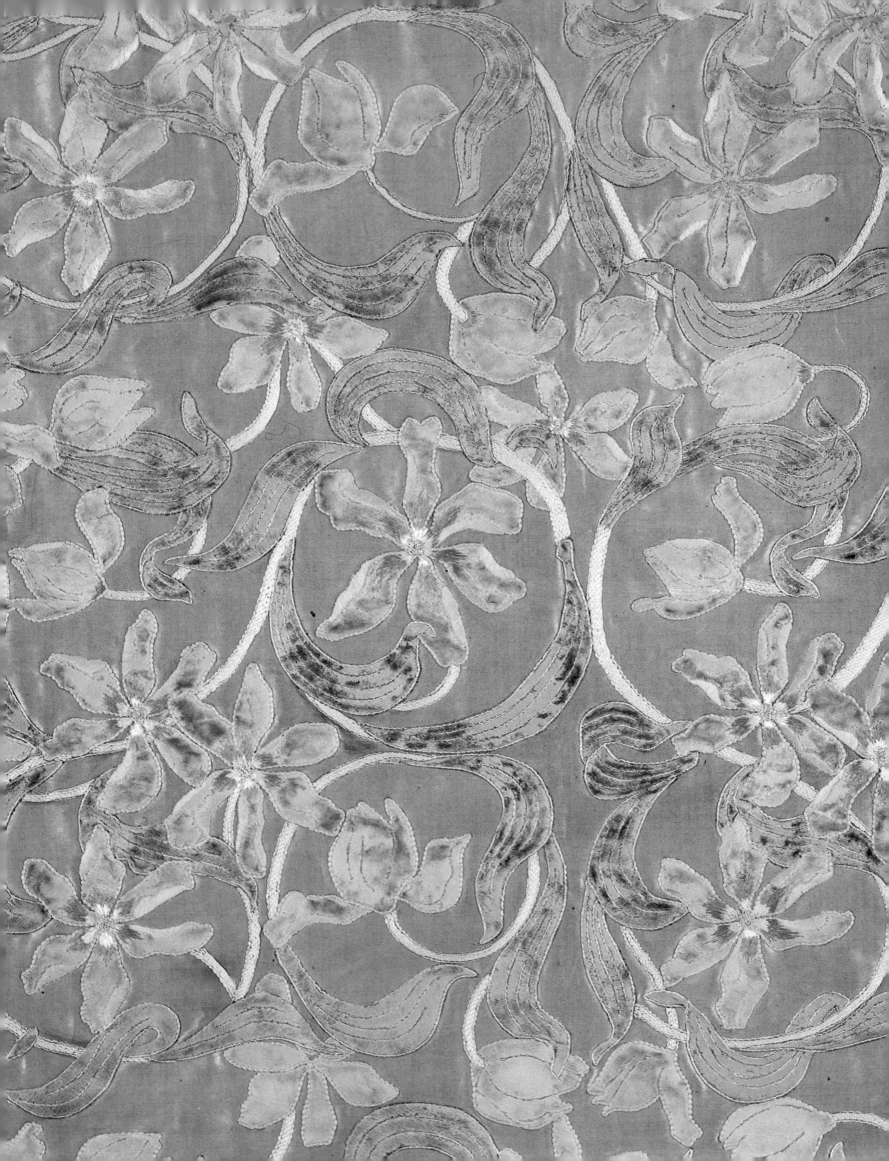

3

Surface Ornament:

Wallpapers, Carpets, Textiles, and Embroidery

Catherine Lynn

HEATED DEBATE about what constituted artful surface ornament continued throughout the Aesthetic era. From the 1870s to the early 1890s, American producers, consumers, and critics of the "stuffs" that covered most interior surfaces grappled with the practicalities of interpreting and reconciling English theories of design, with all their unresolved disputes (see chap. 2). In the wallpaper, carpet, and textile trades—which provided most of the surface ornament for American interiors—designers, manufacturers, and retailers used the words "aesthetic" and "art" with great freedom to describe their products. From trade to trade, the criteria for applying those labels varied considerably. Outside the commercial world, in the studios and amateur societies formed by embroiderers across the United States, contradictory notions about art in design also bred different standards for calling patterns aesthetic.

Nonetheless, there were some areas of consensus. The worlds of trade, amateur production, and connoisseurship generally granted the validity of labeling decorative work aesthetic if it was the product of a major artist or architect, or of a well-known designer who called it "art." Any ornamentation created by a "true" artist was a candidate for aesthetic veneration—whether the pattern was abstract, conventional, conforming to the theories of OWEN JONES, spokesman for the English design establishment centered in London's South Kensington district, or a realistic depiction of natural forms, judged acceptable on the grounds that John Ruskin (1819–1900) had cited realistic painting as the most admirable decoration. Ruskin, whose impassioned, sometimes inconsistent criticism of art, architecture, and decoration was widely heeded in England and America, was the most eminent proponent of artistic freedom for designers (see chap. 2). American manufacturers and shopkeepers of the 1870s and 1880s could be confident that patterns in the distinctive personal styles of much-publicized English designers, especially WILLIAM MORRIS and CHRISTOPHER DRESSER, would be recognized as aesthetic. No matter that the two men's patterns looked not at all alike and that their ideas often placed them on opposite sides in the design controversy: Morris with Ruskin, Dresser with Jones.

The adjective "aesthetic"—or alternatively, "art"—was also considered appropriate for certain traditional, or "exotic," styles and for modern adaptations of them. In all the American trades and crafts that printed, wove, stitched, and purveyed patterns on textiles and paper, traditional Japanese work and modern Anglo-Japanesque versions of it were most readily acknowledged to be carriers of the "art idea." Novelty was part of the appeal of Japanese art. Only since 1854, when Commodore Perry opened Japan to

trade with the West, had many Western artists and designers gained access to Japanese products. Appreciation for the newly revealed beauties of Japanese culture first nurtured in the art circles of Paris and London in the late 1850s soon spread to the larger world of commerce. Curio shops in Paris were offering Japanese objets d'art for sale by 1858. The Japanese displays at the London International Exhibition of 1862 excited an interest that continued to gather momentum in England over the next two decades. Much of the early success of Liberty and Company of London, founded in 1875 largely as an import house, can be attributed to its profitable catering to the growing demand for Japanese goods.[1] Many Americans were introduced to Japanese art at the Centennial Exposition in Philadelphia in 1876. By the time Gilbert and Sullivan's *Mikado* opened in London in March of 1885, the English and American fascination for things Japanese had been recognized as a "mania" for at least five years.

Japanese imports and styles had acquired some of this popular aesthetic prestige because they were associated with the tastes of famous artists. The enthusiasms of JAMES ABBOTT MCNEILL WHISTLER, who as an expatriate painter in Paris in the late 1850s had "discovered" Japanese prints, were soon rivaled by those of British artists and designers representing many camps in London's art world. Ruskin, Morris, and Dresser, as well as the painters Edward Burne-Jones (1833–1898) and Dante Gabriel Rossetti (1828–1882), his brother, the critic William Michael Rossetti (1829–1919), and the architects RICHARD NORMAN SHAW and E. W. GODWIN, all collected Japanese art. Among American collectors were the painters LOUIS COMFORT TIFFANY and SAMUEL COLMAN.[2] Some Japanese designs enjoyed special aesthetic status because they could serve as demonstration pieces for South Kensington principles.

Near Eastern art and ornamentation based on Arabian, Moorish, and Indian patterns garnered much the same regard, and on the same grounds. A taste for creative blendings of objects and decorations from these exotic cultures was cultivated by ASSOCIATED ARTISTS, the decorating firm Tiffany and Colman formed with LOCKWOOD DE FOREST and CANDACE WHEELER in 1879. For their wealthy clients the firm could provide whole rooms of intricately carved Indian woodwork made in a factory set up in Ahmadabad by de Forest.[3] For less extravagant home furnishers with aesthetic aspirations, American carpet, textile, and wallpaper factories turned out quantities of "exotic" patterns, either copying Near Eastern and Indian prototypes or freely combining motifs from several cultures.

Smaller numbers of goods made or sold in America during the

Aesthetic era carried the Greek and medieval motifs much valued in the artistic enclaves of London. Interest in Gothic architecture and decoration, which had inspired much of the mid-nineteenth-century English work produced with a zeal to reform design, was somewhat in abeyance by the 1870s, when the "English renaissance in decorative art" had its real impact in America. By then, most avant-garde English designers had turned to later models for their domestic architecture and furnishings. The rooms in English houses dating from the fifteenth through the eighteenth century, cozier and more comfortable than medieval halls, were appreciated as models more appropriate for modern interiors. Designs owing a debt to Tudor, Elizabethan, and later periods were sometimes called post-medieval, a term that revealed a concern for historical accuracy. In common and commercial parlance they usually bore the name Queen Anne, a confusing and (as Anne reigned for only twelve years, from 1702 to 1714) historically almost irrelevant label. The writings of John Ruskin played no small part in piquing a nostalgic sensitivity to the art inherent in the simple and vernacular objects of everyday life in the past.[4] Post-medieval or Queen Anne styles were almost always described as "quaint."

The English reevaluation of eras so recently past encouraged Americans to color their antiquarian studies with an appreciation of the artistic merits of Colonial furnishings, which generations just previous had dismissed as crude. As the centennial celebration approached, the reproduction and adaptation of styles that were thought to represent the tastes of eighteenth-century America became closely linked to the Aesthetic movement. Influenced by the English aesthetes' animating quest for beauty, wherever it might lead them, American printers, weavers, and embroiderers of the 1870s and 1880s revived and embellished upon Colonial renditions of eighteenth-century Baroque, Rococo, and Neoclassical patterns. The Colonial revival also sparked renewed interest in goods from India and China that had been imported to the United States during the eighteenth century. Elements from Indian chintzes and Chinese painted silks and wallpapers were blended with the trendier Japanese motifs in a vague "oriental" style that appealed to the art enthusiasts.

Whether modeled on the styles of Colonial America or of other places and times, most historical revival patterns of the Aesthetic era flaunt a disdain for studied authenticity and accurate reproduction. Old patterns had value because they could inspire modern and original creations. Perhaps it was that very rage to be original that led, ironically, to the development of some common mannerisms in the drawing and coloring of decorations, traits that lend a certain sameness of flavor to much of the ornamental work of the 1870s and 1880s. From the distance of a hundred years, the attenuation, the delicacy, of many of the decorative forms of the Aesthetic era is striking. Flowers are often slender and fragile, stems and foliage spindly. Such mannerisms, which mark even patterns not usually identified with the aesthetes' favorite styles, seem to embody the period's sense of artfulness.

The surfaces on which such delicate imagery is carried are often themselves made to look extremely thin and fragile. Many of the motifs are outlined in black or gold, and the coloring is flat, in solid tints as South Kensington instructed, to avoid any illusion of depth or projection. The much-favored gold and silver in patterns on walls and the sheen of silk on fabrics stretched across furnishings reflect light, increasing the impression that the two-dimensional plane of ornament is superficial, without supporting mass. Indeed, such details of drawing and coloring assured that in a fully patterned room of the 1880s there could emerge very little sense of architectural structure or weight. The artful eye savored the illusion that even the walls were fragile films of nothing more substantial than that precious, shimmering thing, ornament.

If such mannerisms can only generally be associated with some commercial goods and crafted work that passed for aesthetic in America, and if such visual qualities often elude the classifier, certain motifs, however they might have been drawn, became virtual stigmata of the Aesthetic movement: sunflowers, lilies, bulrushes or cattails, cranes, fans, artists' palettes, and peacock feathers. All were featured in novelty prints and needlework patterns of the period, often introduced within the most inhospitable of decorative contexts.

Some specific styles and motifs, therefore, as well as the work of certain artists, were recognized as "aesthetic" in all the trades and crafts that dealt in wallpapers, carpets, textiles, and needlework. In the different contexts of factory, studio, and home, however, the diverse persuasive powers of individuals dedicated to bringing art to commerce and fireside and the distinctive histories of the various decorative industries fostered the interpretation of aestheticism in myriad ways that preclude further generalization. In the pages that follow I explore the ways each of these related industries and crafts responded to contradictory English theories about ornament, comparing and contrasting how each construed the meaning of "art" as applied to its respective products.

I cannot pretend that the bases for my comparisons are as well balanced as might be wished. More information has been published, both during the period and since, about wallpapers and needlework[5] of the late nineteenth century than about manufactured textiles and carpets.[6] More samples of wallpaper and embroidery have survived as well, and the samples are more readily accessible—reflecting not necessarily the durability of the goods themselves but rather the interests of museums, private collectors, and scholars. Major collections of wallpapers used in the United States are available for study at the Cooper-Hewitt Museum, New York, and the Society for the Preservation of New England Antiquities, Boston. Among the many collections that preserve embroidery from this period I found those at The Metropolitan Museum of Art, New York, and the Mark Twain Memorial, Hartford, Connecticut, particularly useful. Quilts, treasured by those who made them by hand during an era increasingly wary of mechanization and lovingly preserved by those who inherited them, survive in especially large numbers. It is difficult to find a historical society in the United States without a bequest of quilts, and the National Museum of American History in Washington, D.C., has a large, rich, and varied collection.[7]

In contrast, very few machine-made American carpets reflecting aesthetic tastes have survived the intervening century of tramping feet, and only a small number of those have found their way to major museums. The Stowe-Day Foundation in Hartford has a collection of more than twenty remnants of mid- to late nineteenth-century carpeting from Hartford-area houses, but examples of complete rugs are extremely rare. In the absence of samples I have had to rely heavily on verbal descriptions, published illustrations, and designs for carpets registered in the Patents and Trademarks Office of the United States Department of Commerce. Although no recent studies exist, the major carpet-trade journals of the era, the *Carpet Trade* and the *Carpet Trade Review* (founded in 1868 and 1874, respectively, and consolidated into the *Carpet Trade and Review* in 1882), printed lectures and articles, only sometimes illustrated, by American carpet designers. The writers voiced their reactions to English theories about surface ornament and detailed their own schemes for bringing art to the masses through carpet patterns.

Consistent with most American museums' interest in more antique textiles and in the handmade rather than the mass-produced, few commercially manufactured textiles of the late nineteenth century are to be found in their collections. Very few of the samples are large enough to suggest their decorative effect, and fewer still qualify as specifically "aesthetic." Research on textiles is further complicated by the fact that the enormous, multifaceted textile industry, catering to the apparel as well as the decorating trades, with specialized branches for spinning, weaving, dyeing, and printing, could not be succinctly covered in a journal or two. Countless

swatches, most of them bound in books, have survived from the period, but no reliable survey of this material has yet been made. I have used one of the best-documented collections, from the COCHECO MANUFACTURING COMPANY, a New England mill, along with samplings from museums' holdings, to suggest the ways aesthetic tastes affected the American textile industry.

My broad assessments of the impact of the Aesthetic movement on wallpapers, carpets, textiles, and needlework in America remain suggestive at best. Lacking equivalent resources within these four areas of research, I have in some cases ventured to compare information and ideas derived strictly from reading written documents with information and ideas that came exclusively from visually assessing objects. The two kinds of evidence can differ immeasurably. As more factory records, artists' memoirs, and caches of old textiles and carpets come to light and are studied, and as the vast trade literature of the nineteenth century is more thoroughly digested, I hope this overview will suggest areas for more conclusive studies of late nineteenth-century pattern and ornament in America.

Wallpaper

From the early 1870s through the early 1890s, American wallpaper designers, manufacturers, and retailers, as well as their customers, seem to have been more generally convinced of the rightness of South Kensington theories than were their counterparts in the carpet and textile trades. In commercial contexts the term "art wallpapers" very often implied conformity, visual or theoretical, to a famous British designer's work. Indeed many of the art wallpapers sold in America were imported from England.

Although wallpaper had been the object of much of the reforming ardor of the bureaucrats, designers, and architects who campaigned for the improvement of English design during the middle decades of the nineteenth century, the papers of this early phase apparently enjoyed little commercial success in America. Many of the brightly colored, rather stiffly geometric patterns the would-be reformers endorsed were inspired by the Near Eastern and Moorish wall decorations Owen Jones featured in his *Grammar of Ornament* (1856).[8] Others were based on the medieval ornamentation studied by Augustus Welby Northmore Pugin (1812–1852), the pioneering crusader for the revival of Gothic architecture in England.[9] These English designs are not mentioned in the many mid-nineteenth-century advertisements I studied, nor are they to be found among the numerous surviving samples of wallpaper used in America during the 1850s and 1860s. There is copious evidence, however, that by the mid-1870s and for more than a decade thereafter most Americans who had any pretension to fashion were choosing either imported English designs or imitations of them when buying wallpaper. Such Anglophilia perhaps owed some debt to the example of a few rich Americans and their architects. It certainly was colored by the applications of South Kensington design theory that CHARLES LOCKE EASTLAKE spelled out in his *Hints on Household Taste,* which was first published in London in 1868 and came out in a Boston edition in 1872 (see FIG. 4.1).

For Château-sur-Mer, their Newport, Rhode Island, mansion, Mr. and Mrs. George Peabody Wetmore chose several new English papers and borders. The American architect Richard Morris Hunt (1827–1895) enlarged and updated the house over the course of nearly a decade beginning in 1869. During much of that time Mr. and Mrs. Wetmore were in England, and they could well have purchased the wallpapers there.[10] Among them was a wide border pattern on which snarling doglike creatures confront one another in pairs, their tails entwined with foliage (FIG. 3.1). The figures are conventionalized in a studied medieval manner and edged with quatrefoils. The designer of this paper was the well-known English architect WILLIAM BURGES, a fact we can only speculate might have been known to the Wetmores or to Hunt and influenced their choice. The motifs and the character of the drawing in this border are identifiably medieval and therefore stylistically different from the Japanism and conventionalized naturalism of the other English papers chosen for the house. All of the papers, however, conform to the canons of South Kensington. All are printed in flat, unshaded colors, boldly outlined to avoid any possible illusion of a third dimension, and each displays a degree of abstraction and a clear reliance on geometry in the placing and linking of the motifs, in the very drawing of the curves.

Geometry is not so important in the pattern chosen for the dining room (ILL. 3.1) in the house that a Hartford architect, Francis Goodwin, designed in 1871 for his father, Major James Goodwin. But the designer of the wallpaper (ILL. 3.2), again an important English architect, E. W. Godwin, conformed to most other South Kensington standards when he produced the Japanese pattern of bamboo in 1872.

In the wallpaper patterns of these two English architects, as in many others by their colleagues in England and the United States, we can see the working out of South Kensington principles that were especially congenial to architects. In *Hints on Household Taste,* Eastlake popularized these principles, explaining that "as a wall represents the flat surface of a solid material, which forms part of the construction of a house, it should be decorated after a manner which will belie neither its flatness nor solidity." He went on to

FIG. 3.1 Wallpaper frieze (remnant). William Burges, London, ca. 1875. Block printed in distemper on paper, 22⁷⁄₁₆ × 50 in. (57 × 127 cm). Cooper-Hewitt Museum, The Smithsonian Institution's National Museum of Design, New York, Gift of Edith and Maude Wetmore (1939.45.5)

banish "all shaded ornament" as well as any "appearance of relief" that might violate the sense of the physical reality of a wall. In his hint on handling "natural forms" in wall decoration, he applied some of Jones's formulas: natural forms "should be treated in a conventional manner, i.e. drawn in pure outline, and filled in with flat color, never rounded."[11] Eastlake followed his own advice in designing the wallpaper patterns that were illustrated on eight sheets of colored paper and tipped into the Boston edition of *Hints on Household Taste* (ILL. 3.3). Stencil-like in their simplicity, printed in one or two flat colors on a colored ground, the designs had been adapted from what Eastlake called "early" and "fifteenth- and sixteenth-century" Italian patterns.

P. B. WIGHT, an American architect, apparently followed similar advice when, about 1875, he designed wallpapers.[12] In the paper shown in figure 3.2, he superimposed conventionalized tiger lilies on a pattern derived from Gothic sources. Wight was a prominent and vocal disciple of Ruskin and attempted to demonstrate Ruskinian principles in his architectural commissions. Yet this design for wallpaper reveals his attraction to the same styles and manners of drawing that had dominated decorative work by English architects since Pugin—including the two-dimensionality, stylization, flat colors, and bold outlines that had come to be associated with South Kensington and with Eastlake. We do not know whether Wight agreed with Eastlake's acceptance of the South Kensington restrictions that limited the choices for wall decorations to such abstract forms. Nor do we know whether he accepted Eastlake's justification of these restrictions in moral terms. As a Ruskinian architect, he must have considered himself an artist who could defend both his choice of naturalistic carving for the capitals of columns flanking the doors of the National Academy of Design in New York and his decision to "descend," to use Ruskin's term, to more abstract forms for subordinate decorations within interiors. The fact that he designed wallpapers, as well as attended to countless other minor decorative details in his buildings, is evidence of the power of Ruskin's exhortations to move American architects of this era to such work.

Just when Wight was designing wallpapers in the mid-1870s, the budding design-world Anglophilia cherished by a limited number of architects, and by the cultural elite closely connected with them, was about to be transformed. It became a widespread middle-class Anglomania expressed in so many purchases of English and English-inspired wallpapers that to at least one observer

ILL. 3.1 Dining room, James Goodwin house, Hartford, Conn. Francis Goodwin. Photograph, 1873.
Philip Lippincott Goodwin, *Rooftrees, or the Architectural History of an American Family* (Philadelphia, 1933).
Stowe-Day Foundation, Hartford, Conn.

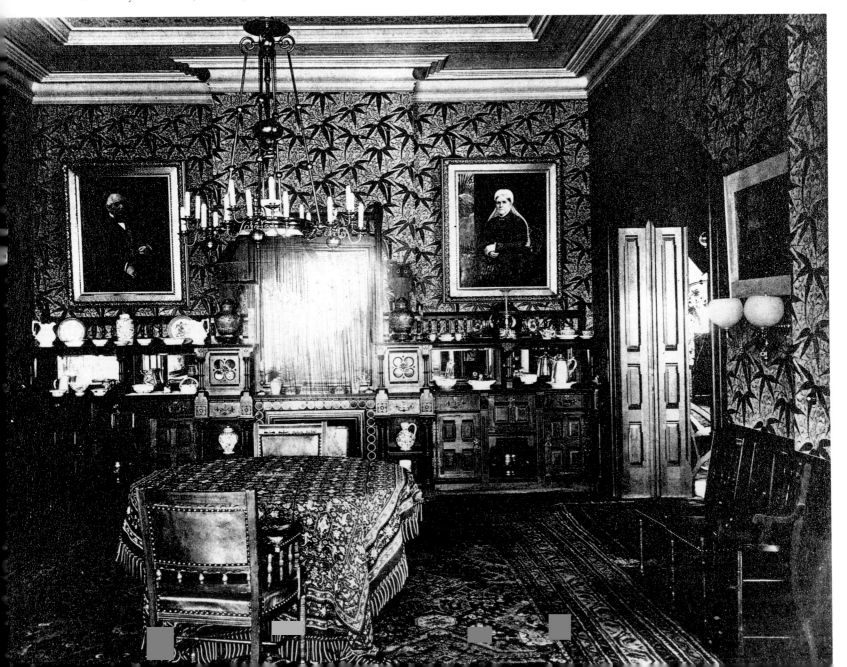

ILL. 3.2 Design for a wall decoration. E. W. Godwin, London, 1872. Watercolor on tracing paper, 20⅝ × 20⅝ in. (52.5 × 52.5 cm). Inscribed: *Wall Decoration November 1872.* Trustees of the Victoria and Albert Museum, London (E.515.1963)

ILL. 3.3 "Design for a Wallpaper Adapted by C. L. Eastlake from an Early Italian Pattern." Charles Locke Eastlake, *Hints on Household Taste* (1868; 1st Amer. ed. Boston, 1872). The Metropolitan Museum of Art, The Jefferson R. Burdick Collection, Gift of Jefferson R. Burdick (65.672.2)

the so-called Aesthetic movement was nothing more than "this wallpaper movement."[13]

Eastlake's book was certainly crucial in multiplying the numbers of American customers for English papers. But Eastlake mentioned only in passing William Morris, without whose work it is hard to imagine that wallpapers would have become so extraordinarily popular in the United States during the Aesthetic era. It seems unlikely that stiff conventionalization and relatively arcane references to bizarre historical and exotic styles would ever have had as broad an appeal as did Morris's graceful depictions of com-

mon flowers and leaves, rendered in mellow colors derived from his observations of nature and from his experiments with natural dyes. The monochromatic effects Morris preferred proved more useful to home decorators than the many hues in patterns colored according to the scientific theories taught by the design schools. A spokesman (perhaps Morris himself) for MORRIS AND COMPANY, the firm Morris founded in London in 1861, wrote in 1883 that "when all is done the result must be *color,* not colors."[14]

Morris began to experiment with wallpaper designs in 1862, but not until 1864 were his first three patterns—Pomegranate (or Fruit), Daisy, and Trellis—in production. Daisy, his second design (FIG. 3.3), was the first to be printed.[15] In creating Daisy, Morris approached nature by way of Ruskin's beloved Middle Ages, depicting growing tufts of conventionalized flowers like those in the edges and foregrounds of a great many medieval tapestries. Adhering to standards for wallpaper patterns sanctioned by South Kensington, he lined the tufts up in straight rows, spacing them to fall at geometrically determined intervals on the crossings of a diamond grid. Queen Anne (ILL. 3.4), based on an eighteenth-century textile at the South Kensington Museum (now the Victoria and Albert Museum), which had opened in 1857, represents another relatively early group of Morris papers. Morris and Company was offering Queen Anne for sale about 1870, around the same time Morris introduced Venetian and Indian.[16] These patterns give evidence that Morris shared the enthusiasm of contemporary architects for reviving post-medieval ornamentation. He used and supported the South Kensington group's new museum, and about 1871 he also seems to have experimented with their approach to decorative design when he added to his line two patterns of rather stiffly conventionalized foliage: Scroll and Branch.

Between 1872 and 1876 Morris created nine new patterns, including Willow of 1874 (ILL. 3.5), that displayed a marked independence from the prevailing styles and approaches to ornamental design.[17] In discovering his singular gift for interpreting the graceful curves of growing plants in lines that responded to the dictates of his eye, not of a compass, Morris seems to have followed Ruskin to nature. These new, more distinctive papers were shown along with Morris's earlier designs in the display of the London wallpaper manufacturer JEFFREY AND COMPANY at the Philadelphia Centennial Exposition in 1876. When Americans saw Morris's patterns, they seem to have responded to his interpretations of natural growth with much greater enthusiasm than they had to either the mimetically mirrored floral imagery of the French or the earnestly studied abstractions from nature of the English design schools.

Prior to the Centennial Morris's wallpapers had been appreciated only in relatively elitist circles in America. His papers sold especially well in Boston, the city perhaps most closely associated with aesthetic tastes.[18] According to a report presented to the United States Senate in 1885,

> it was in November, 1870 . . . that the first importation into Boston . . . of the artistic wall-papers designed and manufactured by the poet William Morris in England, was made by Mr. N. Willis Bumstead who, returning from a visit to England, sought to introduce the new English ideas in regard to the decoration of interiors. To effect this he fitted up some rooms in the English style and opened them for inspection in April 1871.[19]

J. M. Bumstead and Company was then acting as American agent for Morris and Company.

In 1873 William Dean Howells (1837–1920), editor of the *Atlantic Monthly,* the magazine that gave voice to Boston's literati, wrote to his friend Henry James (1843–1916), "We have done some aesthetic wall-papering, thanks to Wm. Morris whose wall-papers are so much better than his poems." He described a few other details of his interior decorating, and concluded, "I try not to be proud."[20]

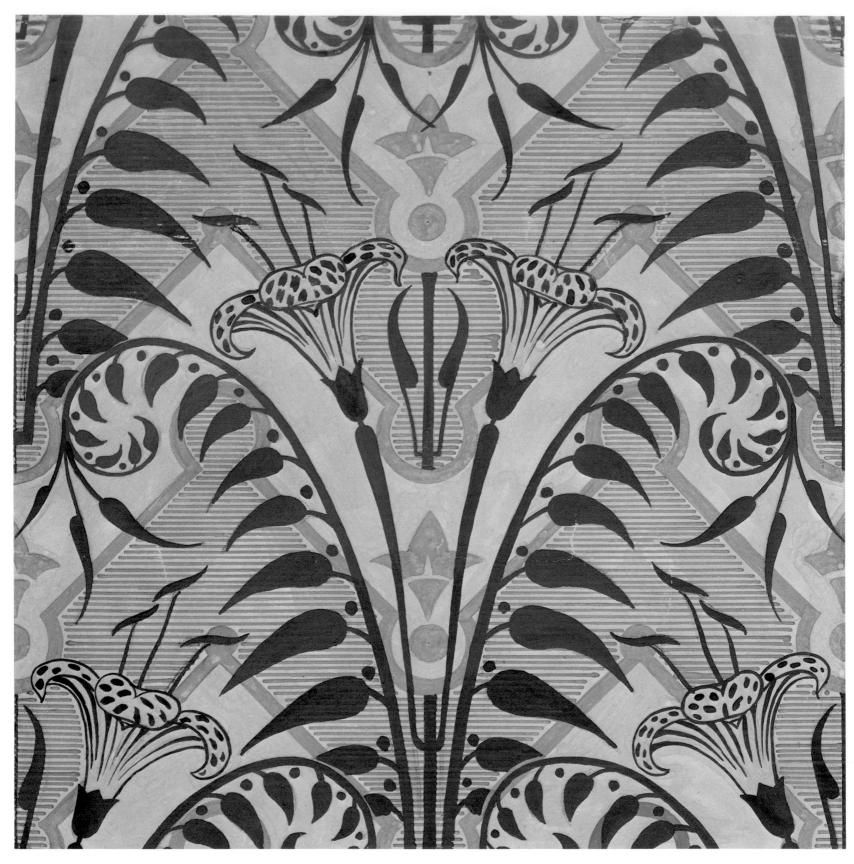

FIG. 3.2 Tiger Lilies (design for a wallpaper). P. B. Wight, Chicago, ca. 1875. Gouache on paper, 10½ × 10½ in. (26.7 × 26.7 cm). Signed: *PBW*. The Art Institute of Chicago

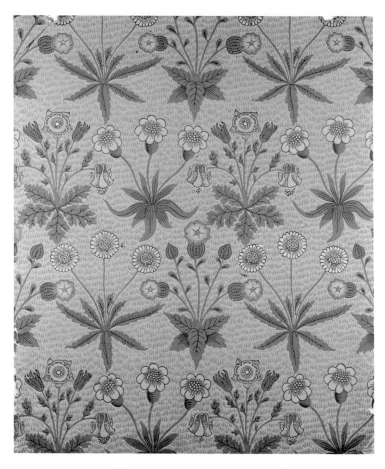

FIG. 3.3 Daisy wallpaper (sample). Designed by William Morris, made by Jeffrey and Company, London, 1864. Block printed in distemper on paper, 31 × 23 in. (78.7 × 58.4 cm). Trustees of the Victoria and Albert Museum, London

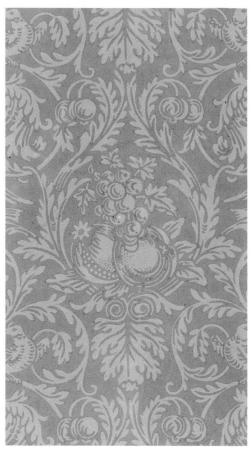

ILL. 3.4 Queen Anne wallpaper (sample). Designed by William Morris, made by Jeffrey and Company, London, ca. 1868–70. Block printed in distemper on paper, 36 × 22 in. (91.5 × 56 cm). Whitworth Art Gallery, University of Manchester, England

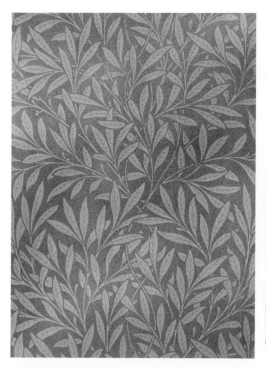

ILL. 3.5 Willow wallpaper (sample). Designed by William Morris, made by Jeffrey and Company, London, 1874. Block printed in distemper on paper, 31 × 23 in. (78.7 × 58.4 cm). Trustees of the Victoria and Albert Museum, London

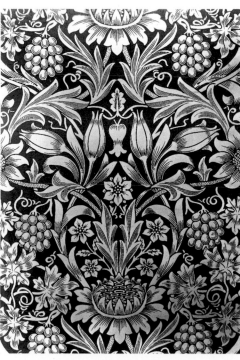

ILL. 3.6 Sunflower wallpaper (sample). Designed by William Morris, made by Jeffrey and Company, London, 1879. Machine printed on paper, 27 × 21 in. (68.5 × 53.3 cm). Trustees of the Victoria and Albert Museum, London

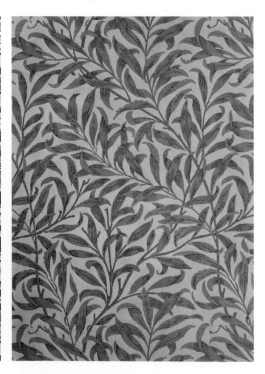

ILL. 3.7 Willow Bough wallpaper (sample). Designed by William Morris, made by Jeffrey and Company, London, 1887. Machine printed on paper, 27 × 21 in. (68.5 × 53.3 cm). Trustees of the Victoria and Albert Museum, London

Yet two years later Howells's flush of housepride had subsided. He seemed quite tired of it all when he wrote an unfavorable review of Morris's new volume of poems, comparing them to "looking through a modern house . . . adorned with tiles, and painted in the Pompeian style, or hung with Mr. Morris' own admirable wall-papers; it is all very pretty indeed; charming; but . . . it is so well aware of its quaintness, that, on the whole, one would rather not live in it."[21]

The quaintness of Morris's wallpapers may have become cloying as early as 1875 in the circles Howells frequented, but the era of their real popularity in America had not begun. Nor had all of Boston's intellectual and social elite seen too much of them: Charles Wyllys Elliott (1817–1883), Boston's most active entrepreneur of products of the "English renaissance," included a photo-graph of a Harvard College study with a frieze papered in Morris's Daisy pattern in his *Book of American Interiors,* which appeared in 1876, the same year Morris's papers were exhibited at the Centennial fair.[22] After that most public of showings, enthusiasm for Morris wallpapers, both the originals and much cheaper American imitations of them, was expressed in sales far beyond the confines of Boston. American decorating guides endorsed and intensified this enthusiasm. In *Art Decoration Applied to Furniture,* published in 1878 (see FIG. 2.3), HARRIET PRESCOTT SPOFFORD analyzed and detailed "the merit of conventionalized treatment" in Morris's Jasmine paper, "where the tints were more suggestively and conventionally treated than the shapes."[23]

Morris's early conformity to the standards of South Kensington may have furnished the basis for Spofford's appreciation of his pat-

Below: ILL. 3.8 Bedroom, John J. Glessner house, Chicago. Archival photograph, The Glessner House, Chicago Architecture Foundation

Opposite: ILL. 3.9 Alcestis, La Margarete, Lily and Dove (wallpaper set). Designed by Walter Crane, made by Jeffrey and Company, London, ca. 1875–76. Walter Smith, *Industrial Art,* vol. 2 of *The Masterpieces of the Centennial International Exhibition* (Philadelphia [1877?]). Thomas J. Watson Library, The Metropolitan Museum of Art

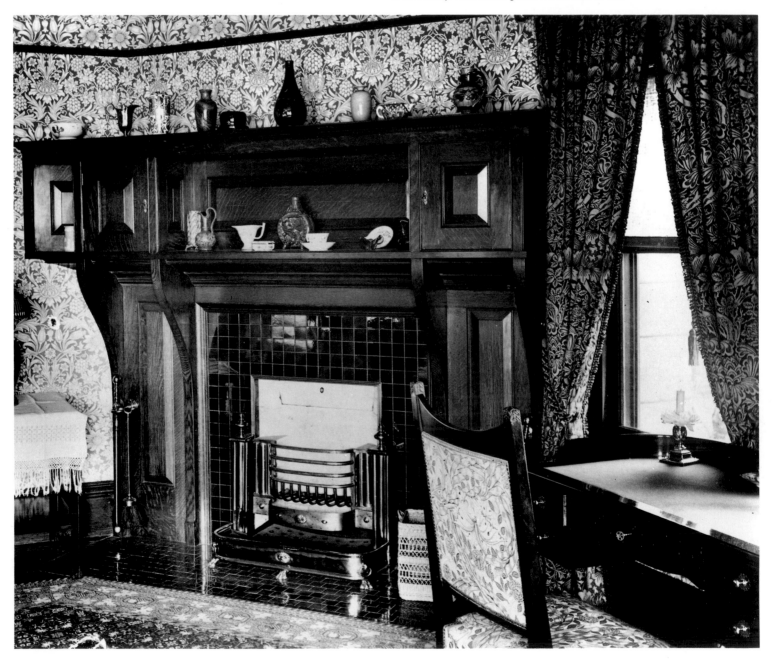

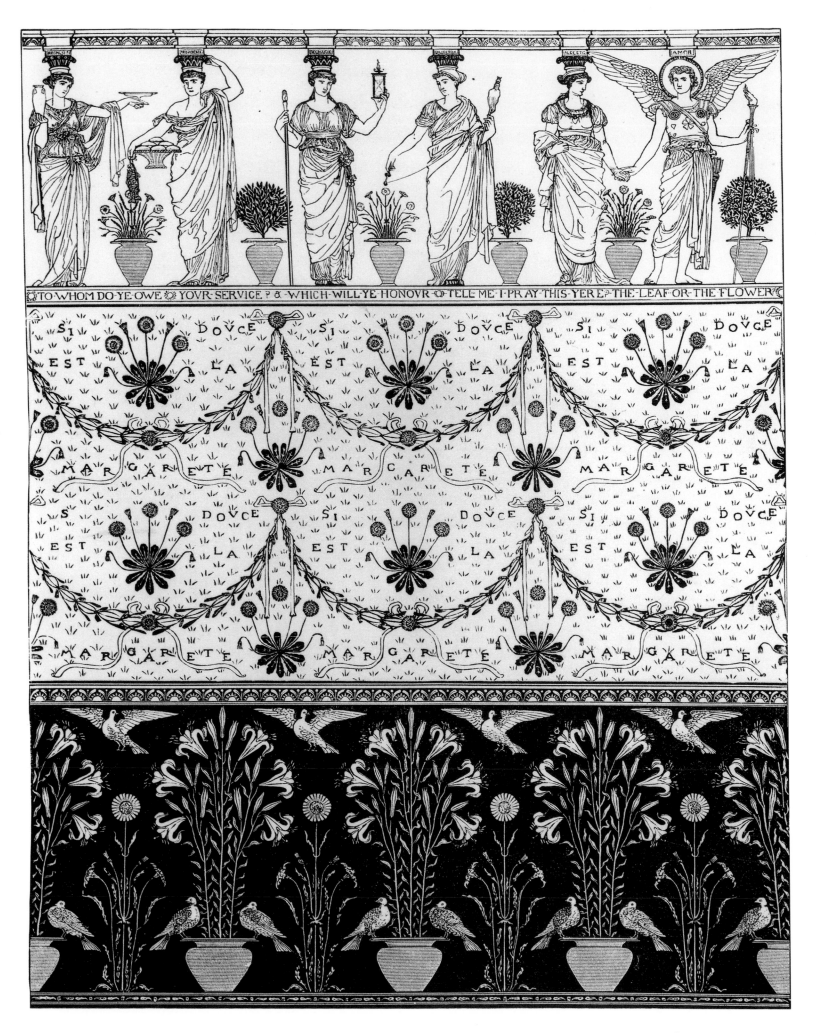

TO·WHOM·DO·YE·OWE · YOVR·SERVICE? & WHICH·WILL·YE·HONOVR · TELL·ME·I·PRAY·THIS·YERE · THE·LEAF·OR·THE·FLOWER

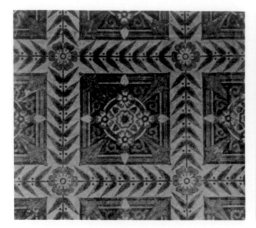

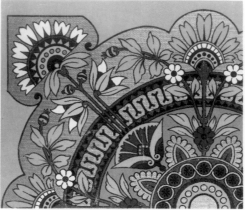

Far left: ILL. 3.10 Design Patent No. 9982 (wallpaper). Christopher Dresser, London, assignor to Wilson and Fenimore, Philadelphia, May 15, 1877. United States Patents and Trademarks Office, Washington, D.C.

Left: FIG. 3.4 Ceiling paper (remnant). American, ca. 1880–90. Machine printed on embossed paper, 20¼ × 18⅛ in. (51.4 × 46 cm). Society for the Preservation of New England Antiquities, Boston (1985.26.4)

Below: FIG. 3.5 Ceiling paper (remnant). American, ca. 1880. Machine printed on embossed paper, 8⅞ × 14¾ in. (22.5 × 37.5 cm). Society for the Preservation of New England Antiquities, Boston (1985.25.5)

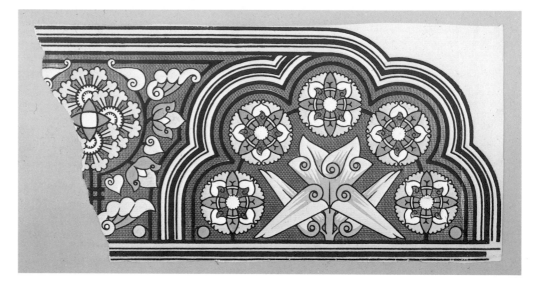

terns, but it was the naturalism in his designs, not the stylization, that was beginning to distinguish them from other English patterns she admired. This distinction was underlined, and American enthusiasm for Morris papers was encouraged, by American publication of Morris's thoughts on what he called "the lesser arts." In 1878 Robert Brothers of Boston issued as a monograph *The Decorative Arts: Their Relation to Modern Life and Progress.* In this, his first public lecture, delivered in London during the previous December, Morris professed that "at the root" he believed that "everything made by man's hands has a form, which must be either beautiful or ugly; beautiful if it is in accord with Nature, and helps her; ugly if it is discordant with Nature, and thwarts her."[24] American devotees of Ruskin who had perceived in Morris's patterns a sympathetic image of nature must have been reassured by this confirmation that Morris gave priority to firsthand observation of nature as Ruskin had demanded.

His relaxed confidence that naturalism was perfectly acceptable as decoration allowed Morris to portray identifiable plants and flowers such as the sunflower in his wallpaper pattern of 1879 (ILL. 3.6). Sunflower was one of about ten papers Morris designed between 1876 and 1883,[25] the year of the Boston Foreign Fair, the next major American exhibition of Morris papers for which records survive.[26] In 1883 Morris and Company reported that Sunflower was its biggest seller. The pattern's popularity was probably due largely to the current cult-object status of its central motif, but

Sunflower, like the other papers of these years, was also appealing because it demonstrated Morris's ability to "sharpen our dulled senses" of the alliance of decoration with nature.[27]

By the time he died in 1896 Morris had designed a total of more than fifty wallpaper patterns, many of them outstanding examples of what he recognized as "those wonders of intricate patterns . . . that men have so long delighted in . . . that do not necessarily imitate Nature, but in which the hand of the craftsman is guided to work in the way that she does."[28] The ease with which he could "mask the construction of our pattern enough to prevent people from counting the repeats," managing "to lull their curiosity to trace it out," distinguished this artist's work from the more mechanically plotted and measured configurations of pattern elements worked out under the influence of South Kensington.[29] With increasing frequency in his later wallpapers, Morris introduced illusionistic shading and a sense of depth, if no more than an inch or so.[30] His drawing sometimes also admitted depictions of the idiosyncratic turns and twists of individual, rather than idealized, plants. This can be seen most readily by comparing Willow of 1874 (see ILL. 3.5) with Willow Bough of 1887 (ILL. 3.7).

After 1876 the use of Morris wallpapers in America could almost be equated with aesthetic aspiration. In many photographs of rooms in the great, and lesser, houses of the Aesthetic era Morris papers cover the walls (ILL. 3.8).[31] The evidence also includes papers that survive in situ, though often in fragments, and countless

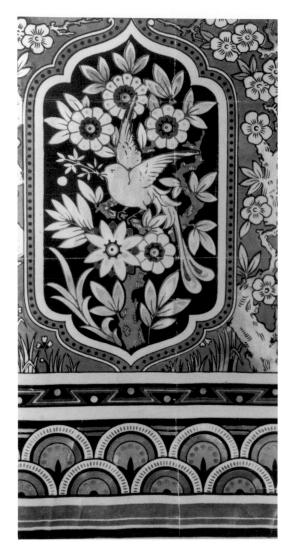

advertisements for Morris papers in every major city.[32] In fact, the Morris phenomenon introduced a new note in the infant American advertising business: the marketing of Morris's highly recognizable wallpapers proved to be one of the first experiments in promoting designer-labeled consumer products. There were innumerable references to Morris papers in American decorating guides, in popular fiction, and in jingles that poked fun at people who hung his wallpaper. In 1882 a writer for the *Critic,* a New York literary magazine, jested,

> And it happened that Mr. William Morris, an upholsterer, who had designed some tasteful wall-papers, had obtained a reputation as a poet of the Spenserian school. The combination of poetry and upholstery was so uncommon that many people were induced to buy his wall-papers. Having bought them, they were bound to find gimcracks that should match them. Their houses being thus furnished in a new style, they found it necessary to dress in harmony with the prevailing colors. Then the jokers said that they must not only dress but live up to their furniture. So a few wall-papers effected a revolution . . . and the result was pretty, simple, and picturesque.[33]

Above: ILL. 3.11 Wallpaper (fragment). Designed by Christopher Dresser, ca. 1877. Machine printed on paper, 29¾ × 15⅜ in. (75.5 × 39 cm). Marked: DR. DRESSER INV. Cooper-Hewitt Museum, The Smithsonian Institution's National Museum of Design, New York, Gift of Wilmer Moore (1941.17.1)

Right: FIG. 3.6 Lincrusta-Walton (remnant). British or American, 1880s. From the John D. Rockefeller house, New York. Embossed and gilded composition material, 22⅞ × 18½ in. (58 × 47 cm). Cooper-Hewitt Museum, The Smithsonian Institution's National Museum of Design, New York, Gift of John D. Rockefeller, Jr. (1937.57.3)

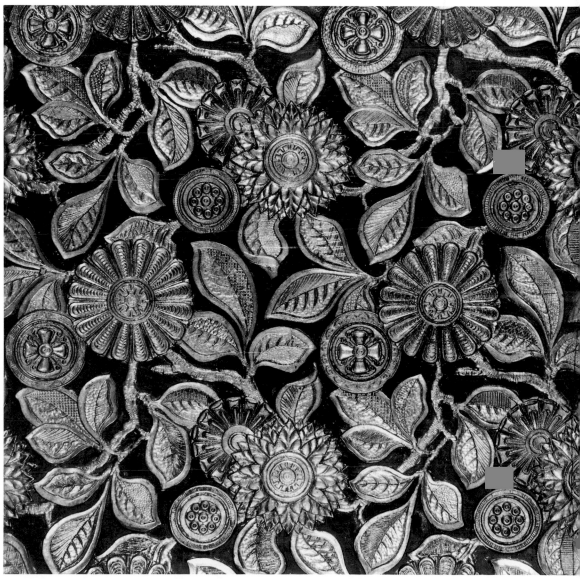

ILL. 3.12 "A Dado Designed by Mr. L. C. Tiffany." *Carpentry and Building* (Dec. 1880). Art, Prints and Photographs Division, The New York Public Library, Astor, Lenox, Tilden Foundations

The interest in both Morris papers and South Kensington ideas that had been mounting in the United States just prior to the Centennial apparently sharpened American interest in other English wallpapers that Jeffrey and Company showed at the Philadelphia exhibition. Of these, WALTER CRANE's ambitious allegorical set (ILL. 3.9), which included a wallpaper frieze (Alcestis), a fill (La Margarete), and a dado (Lily and Dove), was most often pictured in American books and articles about the exhibition and about decorating. Crane chose a literary theme: wifely virtue as it had been interpreted by Chaucer in his *Legend of Good Women*. Some criticized the choice of so lofty a subject for a mere wallpaper; an article in the *Furniture Gazette* in 1876 cited Crane's papers as "an instance of attempting too much with a paper" and of "putting too much meaning into a wall paper and thus obtruding it beyond its proper place as a decorative background."[34] But Crane clearly recognized no limit to his ambition to bring art and its attributes to commercial products. The central figure in the frieze is the virtuous Alcestis, wife of Admetus, King of Thessaly. When Alcestis willingly died in her husband's stead, Hercules wrestled Death to bring her back from the underworld. Crane has depicted her in classical garb, her hand held fast by the winged god of love, and surrounded her with the allegorical attendants of the ideal wife: Diligence, Order, Providence, and Hospitality. The marguerite in the fill paper, medieval in character and closely based on Morris's Daisy (see FIG. 3.3), symbolizes innocence; the lily and dove in the dado stand for purity. By intermingling classical and medieval themes, Crane was responding to contemporary literary and artistic preoccupations. Hellenism—the aesthetic taste for Greek culture, colored by misty romanticism rather than studied with archaeological rigor—is well represented in this set of wallpapers. Crane approached a classical theme through the veil of medieval graphic stylization and the sensibilities of Chaucer, whose poetry is worked into the frieze and fill patterns. This vagueness and mingling of times and styles is very different from the sharp antiquarian focus on diligently studied Greek palmettes and frets of other phases of classical revival.

Creating horizontal wall divisions with a frieze, a fill, and a dado became the favored way to handle wallpaper during the decade following the Centennial. In 1873 Christopher Dresser had commended this way of using wallpaper in *Principles of Decorative Design*. He urged the decorator to "proceed as an artist, and not as a mere workman," by selecting several patterns for any given wall and arranging them thoughtfully.[35] In 1875 Jeffrey and Company simplified the problem of choosing artistic combinations of patterns by having their artists design matching frieze, fill, dado, and ceiling papers. Though in fact such sets had been standard fare in

the French wallpaper trade in the early nineteenth century, MET-FORD WARNER of Jeffrey and Company claimed that his firm was the first to introduce them.[36] The precedent they set was quickly taken up by American wallpaper manufacturers (see ILLS. 3.13, 3.14, 3.17).

Dresser's impact on the design and use of wallpaper in America rivaled, but did not quite match, Morris's influence during the late 1870s and all through the 1880s. Although Morris and Ruskin inspired artists to design wallpapers and designers to study nature, unlike Dresser they neither explained nor illustrated just how one went about preparing patterns for manufacturers. Although Morris's writings were more widely known to the American public than were Dresser's, and although Morris's papers were imported and imitated by American firms, Morris himself never came to the United States, nor did he design for American manufacturers. Dresser did both. He visited the Centennial Exposition in 1876, and while he was in Philadelphia he lectured on design at the Pennsylvania Museum and School of Industrial Art.[37] The next year the Philadelphia wallpaper manufacturers Wilson and Fenimore registered in the United States Patents Office thirteen designs by "Christopher Dresser of London" (ILL. 3.10).[38] No printed papers that correspond to these patterns have yet come to light, but wallpapers do survive from the period that appear to be American-made and that look very much like Dresser's. Among seven such papers at the Society for the Preservation of New England Antiquities are some that are plays on vaguely Near Eastern and rather specifically Egyptian models (FIG. 3.4) and others that feature more imaginative, supernatural forms (FIG. 3.5). These may be Dresser's own work, or they may be derivations from it by commercial designers. Dresser himself designed the paper shown in illustration 3.11, one of his exercises in the Japanesque;[39] his name is printed in the margin. There is no evidence, however, that this paper was printed by an American firm. It could well have been manufactured by one of the several English firms for whom Dresser designed wallpapers.

Dresser was among many of his generation who found that the principles of design they valued had been worked out in the most interesting ways in Japanese patterns. Japanesque wallpapers by Godwin (see ILL. 3.2) and by BRUCE J. TALBERT, another major British architect, were reproduced in American magazines. A pattern in the manner of Talbert, or perhaps his own design, survives in a piece of Lincrusta-Walton taken from the dining room of the John D. Rockefeller house in New York, where it was hung during the 1880s (FIG. 3.6). Lincrusta-Walton is the brand name of the most widely advertised of several composition materials that were

patented in response to a demand for ornamentation in high relief. As in this example, wall coverings with raised patterning were often gilded. During the Aesthetic era many wallpaper dealers offered Lincrusta-Walton alongside embossed imitation-leather papers made in Japan.[40] Especially when gilded, they were reminiscent of leather wall coverings of the seventeenth century and must have been appealing to those attracted to that many-faceted style, the Queen Anne.

Japanesque patterns, Modern Gothic designs by Talbert and others, and the more idiosyncratic papers by Dresser were very probably among the ones described as "Quaint, Rare and Curious Papers by Eminent Decorative Artists" in an advertisement for wallpapers published in New York in 1883.[41] Innovations in the manner of treatment, whether of historical motifs or natural objects, were closely associated with the "artistic." The freedom designers took with styles was valued more than were faithful renditions of them, at least by enough of the artistically inclined to encourage the advertiser to use the word "curious" in his copy.

Other American advertisers indulged in name-dropping. In 1877 an interior-decorating company in Pittsburgh published a handbill announcing, "In addition to Owen Jones, and Morris— after Eastlake—we have the designs of Dr. Dresser, (at present lecturing on Household Art in this country)." American retailers often coupled the names Morris and Dresser in their advertisements. The differences in the approaches to nature that separated the two were not significant enough to prevent a wallpaper dealer in Cincinnati from citing the imported designs of both Morris and Dresser, along with those of Eastlake, as "Modern Art in Paper Hangings" for 1882.[42] The decorating guides also linked the names of the two famous English designers. Their very different papers were equally valued by writers such as Constance Cary Harrison (1843–1920). In *Woman's Handiwork in Modern Homes* Harrison noted as part of her proud assessment of the improvement in American taste during the years preceding 1881 that the wallpapers "of Dresser and of Morris, are familiar in our houses."[43]

The sale of English art wallpapers contributed dramatically to the growth of the American wallpaper trade through the 1870s and 1880s. The use of the imports in large part constituted aestheticism as the word was popularly and commercially applied to wallpaper in the United States. In 1879, "to show the progress made in the designing of wall-papers of late years," the Chicago firm of John J. McGrath sponsored an exhibition that featured work by the major British designers. Three hundred papers were shown, many of them framed like works of art, others displayed in a series of room vignettes. The opening was covered in the *American Architect and Building News,* whose reviewer noted papers by "J. Moyr Smith, B. J. Talbert, Dr. Dresser, Walter Crane, William Morris . . . and the late E. W. Pugin and Owen Jones," as well as by French manufacturers, describing several in great detail. This lengthy account was reprinted in the *Scientific American Supplement* in April of 1879. McGrath was one of a few American wallpaper manufacturers who attempted to "aestheticize" their products by imitating English designs and also, again following English precedent, by hiring "eminent" artists. During the 1870s McGrath printed wallpaper patterns created for the firm by American architects, including P. B. Wight, Russell Sturgis (1836–1909), and John Wellborn Root (1850–1891).[44]

By 1880 a New York firm, WARREN, FULLER AND COMPANY, was manufacturing wallpapers designed by the painters Louis Comfort Tiffany and Samuel Colman.[45] The papers were frequently advertised and sometimes illustrated in the magazines, where a Japanesque dado pattern by Tiffany (ILL. 3.12) appeared most often. By juxtaposing rectangles of various sizes and filling them with many separate elements Tiffany created a collage-like, almost patchwork effect. This way of putting together unrelated motifs is derived from Japanese sources, as are some of the motifs in the pattern, including the Prunus branch and the pine bough. The bizarre styl-

ization of plant forms in some of the narrow bandings that edge the dado follows examples from the South Kensington texts.

In 1880 Warren, Fuller and Company published a small promotional book entitled *"What Shall We Do with Our Walls?"* (FIG. 3.7). The well-known New York art critic CLARENCE COOK wrote the text, which he illustrated with five plates showing wallpaper designs by Tiffany and Colman. Both of the Tiffany designs are for ceiling papers, one a pattern of snowflakes, the other of clematis and spider webs Japanesque in feeling. One of Colman's designs, also for a ceiling paper, is a pattern of stylized butterflies, rigidly aligned, alternating with squares in a grid. In each of his two other designs Colman detailed a full array of frieze, fill, and dado patterns, with the requisite borders separating the major elements. The same dado—conventionalized tufts of flowers and foliage set within the bold structure of a modified scale pattern— appears in both of these plates, but the multiple borders and the frieze and fill patterns vary. The thick, curvaceous tangle of one fill pattern (ILL. 3.13) seems to owe some debt to Morris. The other fill pattern, the dado, the friezes, and all the borders are more stiffly conventionalized in the manner of the English schools of design. The leaves on the frieze and borders in illustration 3.13 bear resemblances too striking to be entirely coincidental to drawings of horse-chestnut and ivy leaves in Jones's *Grammar of Ornament.*[46]

FIG. 3.7 *"What Shall We Do with Our Walls?"* (New York, 1880). Clarence Cook. Cover: 9⅜ × 7¹/₁₆ in. (23.8 × 17.9 cm). Private collection

ILL. 3.13 "Parlor Decoration Designed by Mr. Samuel Colman." Clarence Cook, *What Shall We Do with Our Walls?*" (New York, 1880). Private collection

ILL. 3.14 "$1000 Prize Design by Mrs. C. Wheeler." 1881. Clarence Cook, *What Shall We Do with Our Walls?*" (2d ed. New York, 1883). Art, Prints and Photographs Division, The New York Public Library, Astor, Lenox, Tilden Foundations

FIG. 3.8 Wallpaper (fragment). Designed by Candace Wheeler, 1881, made by Warren, Fuller and Company, New York, 1882. Machine printed on paper, 9½ × 20¼ in. (24.1 × 51.4 cm). Sunworthy Wall Coverings Collection, Reed Decorative Products, Ltd., Brampton, Ontario, Canada

Above: FIG. 3.10 Wallpaper border (fragment). American, ca. 1880–90. Machine printed on paper, 19¾ × 24⅝ in. (50.2 × 62.5 cm). Society for the Preservation of New England Antiquities, Boston (1985.26.6)

Left: FIG. 3.9 Wallpaper (fragment). Probably American, 1860–70. From the Norton house, Suffield, Conn. Machine printed on embossed paper, 11 × 9 in. (27.9 × 22.9 cm). Stowe-Day Foundation, Hartford, Conn.

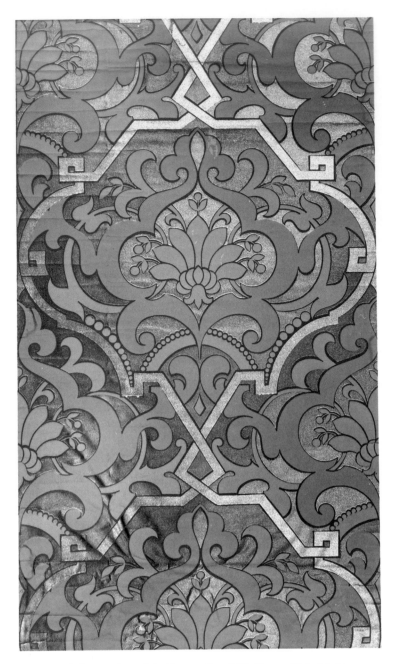

ILL. 3.15 Wallpaper (sample). Cresswell and Washburn, Philadelphia, ca. 1880–90. From the Dearborn-Woodbury house, Wakefield, Mass. Machine printed on paper, 33¾ × 19½ in. (85.7 × 49.5 cm). Society for the Preservation of New England Antiquities, Boston (1969.557.1)

Lockwood de Forest, who based his patterns on Indian sources, also designed papers for Warren, Fuller and Company.[47] In 1882 Candace Wheeler became yet another of the Associated Artists who furnished patterns for the wallpapers printed by this manufacturer. Her entry in a competition sponsored by Warren, Fuller and Company in 1881 had won the thousand-dollar first prize.[48] The prize-winning design was illustrated in an edition of *"What Shall We Do with Our Walls?"* that appeared in 1883 (ILL. 3.14). Hives among clover fill the dado, a few stray bees buzzing between circles of clover make up the frieze, and a honeycomb serves as background for the fill pattern of bees swarming in clover. A tiny fragment of the fill pattern, the only known surviving bit of this

paper, is shown in figure 3.8.

The drawing in Wheeler's set of wallpapers is slightly more realistic than the designs by Colman and Tiffany, but it gives only the faintest hint that she delighted in the potential for creating artistic illusions offered by the prospect of decorating a wall. As an artist working with her fellow artists to bring art to decoration, she prized the power of artifice. "To be constantly reminded of the wall as a wall, as a solid piece of masonry," she wrote in an article published in 1895, "is what we must avoid."[49] Her words have the ring of phrases set down in conscious reaction to the advice from Eastlake's *Hints on Household Taste* that was quoted at the beginning of this section. Wheeler recognized no separation of design from art, no limitation of her choices. In tailoring designs to meet the fashionable criteria of the judges in Warren, Fuller and Company's competition she perhaps avoided the illusionistic only because she knew that to the ambitious firm "art wallpapers" meant conventional and two-dimensional patterns.

Evidence that the term meant pretty much the same to the American manufacturers who made less costly papers exists in the form of numerous samples of their products in museum collections and manufacturers' archives, as well as on the walls of both modest and grand houses.[50] These machine-printed papers from the Aesthetic era reinforce the impression given by the late nineteenth-century trade magazines, that making imitations of English art patterns was an important part of the business of major American wallpaper factories. The samples include Modern Gothic designs (FIG. 3.9) and patterns in which Japanese themes are varied by the addition of Gothic motifs such as quatrefoils (FIG. 3.10), as well as Near Eastern patterns (ILL. 3.15), printed in muted pastel shades rather than in the primary colors that had been favored at mid-century.

Artful naturalism dominates many of these American wallpapers of the Aesthetic era, both machine prints and more expensive block prints (FIG. 3.11). The trellis in figure 3.11, which is indebted both to Japanese sources and to one of Morris's first patterns, Trellis,[51] represents a favorite wallpaper theme of the 1870s and 1880s. The paper in illustration 3.16, an ingenious derivation from Morris's Willow pattern (see ILL. 3.5) to which Japanesque flowers have been added, suggests the way distinctive styles were blended in some prints. Imitations of Morris's designs and of Japanese textile patterns interpreted in an Anglo-Japanesque manner (FIG. 3.12) are often found among inexpensive American-made papers of the period. These papers are evidence of the beneficial effects artists and architects had on the design of decorative products, even when their efforts were only reflected in imitations on this most commercial level. During the late 1870s more American architects and artists turned to wallpaper manufacturers than to carpet and textile firms as allies in their artistic mission.

Larger numbers of surviving papers demonstrate the way most American manufacturers responded to the enthusiasm for Japanese asymmetry. In an era when making scrapbooks was considered an artful pastime, many of these wallpapers looked rather like scrapbook pages, paste-ups of framed pictures or most any other snippets of imagery, often overlapping one another. Designers arranged the elements in configurations as random as the demands of the mechanical repeats of printing rollers would allow. Some brought to the asymmetrical format a discordant array of novel motifs, such as the views of Niagara Falls and the Brooklyn Bridge juxtaposed with Japanese vases in one paper (FIG. 3.13). Others were more faithful to their Japanese sources in choosing motifs and to English design-school principles in maintaining two-dimensionality.[52]

For ordinary Japanese-inspired papers, most American manufacturers adopted a palette featuring olive greens, maroons, pale creamy yellow, black, and metallic gold. This comparatively drab color scheme seems to have been derived from the subdued colorings in designs by Morris and the subtle combinations of pale

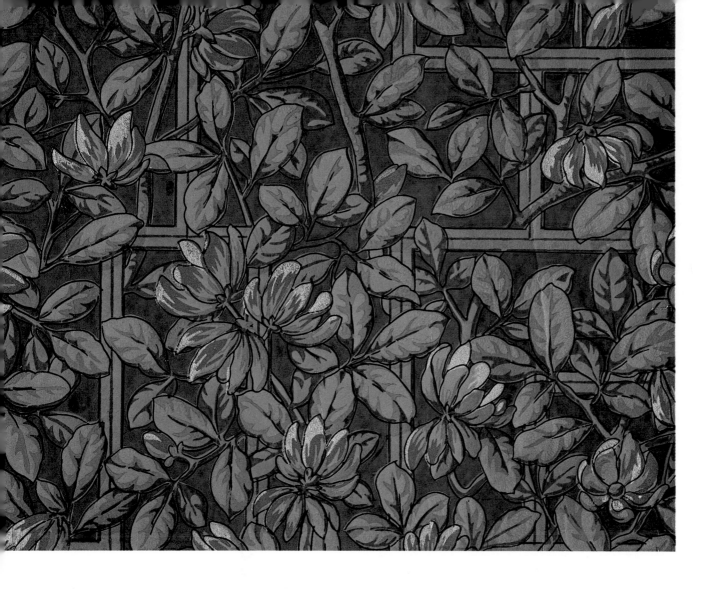

Above: FIG. 3.11 Wallpaper (remnant). American, 1875–85. From the Bush house, Salem, Oreg. Block printed on paper, 13¹⁵⁄₁₆ × 18 in. (35.3 × 45.7 cm). Cooper-Hewitt Museum, The Smithsonian Institution's National Museum of Design, New York, Gift of the Salem Art Association, Oreg. (1972.21.5)

Right: FIG. 3.12 Wallpaper (remnant). American, 1880–90. From the Manse, Deerfield, Mass. Machine printed on paper, 22 × 19⅝ in. (56 × 50.3 cm). Cooper-Hewitt Museum, The Smithsonian Institution's National Museum of Design, New York, Gift of Deerfield Academy (1972.51.3)

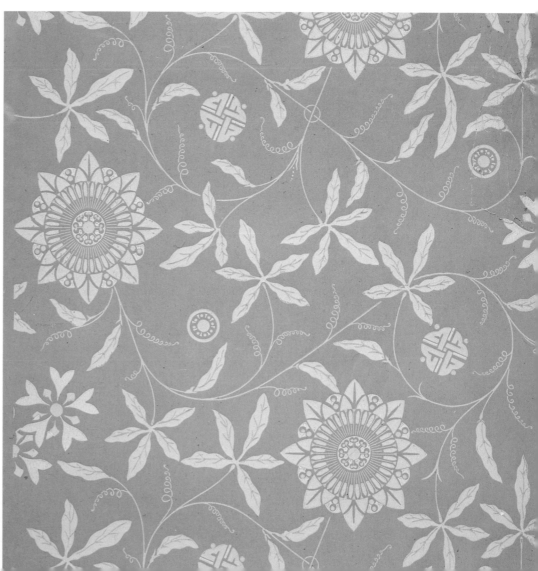

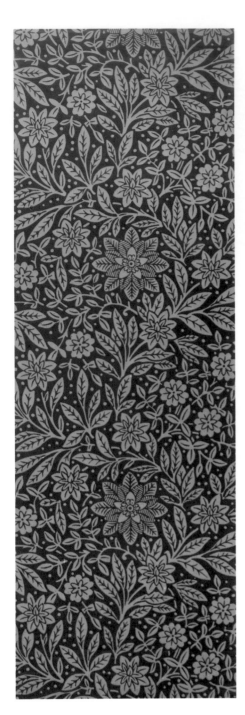

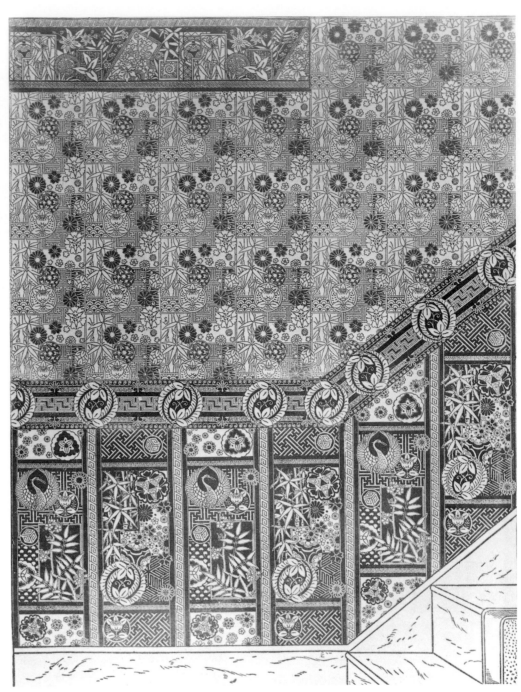

hues, strong accent colors, and gold in Japanese prints and textiles. The large American factories applied variations of the scheme not only to "art wallpapers" but also to patterns of every description. The bulk of the commercial wallpaper produced in America in the 1880s was printed in relatively dull, muted shades, markedly different from the light, bright, clear colors favored in French-inspired papers of mid-century. The drab colors in papers of every description were by-products of aestheticism that changed the look of many rooms otherwise untouched by the new English styles.

A proliferation of borders was another such by-product. It is easy to imagine that the artful might have appreciated the way borders set off walls and ceilings in much the same way frames did paintings. American wallpaper manufacturers produced large quantities of inexpensive borders: both narrow paper edgings to accent larger borders (friezes and dados) and borders to frame ceil-

ings.[53] During the 1880s combinations of borders became standard finishes for nearly every wall, no matter how far removed from the Aesthetic movement a home furnisher might have remained (ILL. 3.17).

All the elements for wallpaper design, and sometimes whole patterns, were freely borrowed from English sources by American manufacturers. The cheaper American copies were based on "originals"—English art wallpapers as well as ambitious patterns by major American artists—which were the least expensive products of the leaders of the Aesthetic movement. Wallpapers were the first examples of the new art decoration available to many Americans, and the papers carried aesthetic themes to broad audiences. In many American homes wallpaper served as a harbinger of the Aesthetic movement, and the generous use of wallpaper was to remain closely identified with the movement itself.

Opposite left: ILL. 3.16 Wallpaper (remnant). American, 1880s. From Carolina, R.I. Block printed on paper, 39 × 22½ in. (100 × 57 cm). Cooper-Hewitt Museum, The Smithsonian Institution's National Museum of Design, New York, Gift of Elizabeth Albro (1972.39.3)

Opposite right: ILL. 3.17 Wallpaper combination. H. J. Goth and Brother, *A Few Suggestions for Interior Decoration* (Bethlehem, Pa., 1884). Avery Architectural and Fine Arts Library, Columbia University, New York

Right: FIG. 3.13 Wallpaper (remnant). American, 1880s. From the Bixby house, Salem, Mass. Machine printed on paper, 29⁹⁄₁₆ × 19½ in. (75 × 49.5 cm). Cooper-Hewitt Museum, The Smithsonian Institution's National Museum of Design, New York, Gift of Grace Temple Lincoln (1938.62.18)

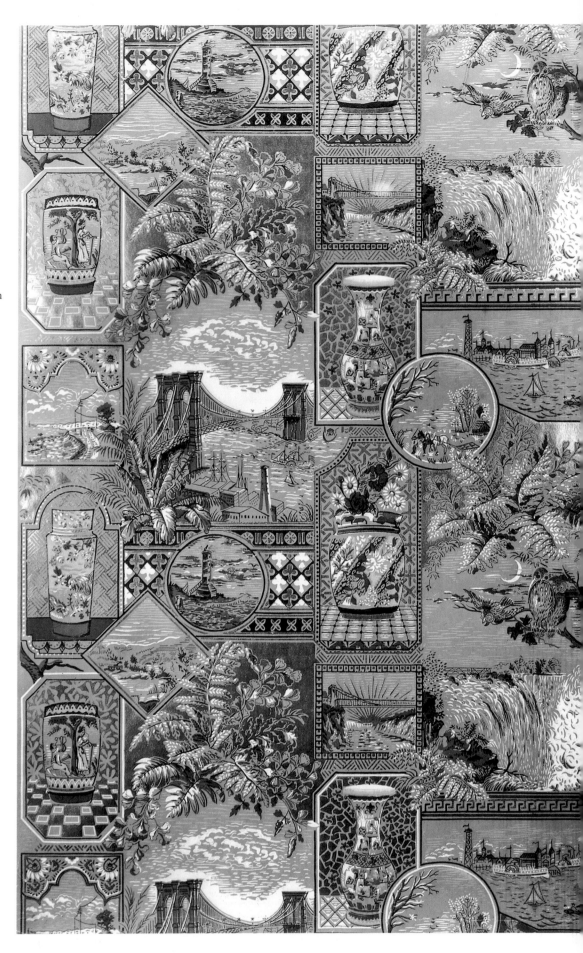

Carpets

Rugs imported from Turkey, Persia, India, and elsewhere in the East were prized and collected as works of art during the Aesthetic period. They were associated with aestheticism to the exclusion of most carpets made in the United States and England. Writers of guides for interior decorating from Eastlake to Cook popularized reverence for Eastern geometry and handwork in rugs. They spurned the wall-to-wall carpets made on Western machines, preferring the orientals, surrounded by expanses of polished wood floors.[54]

Trade in these imports, the most valued "art carpets" of the day, flourished both in stores offering a general range of home furnishings and in newly opened specialized rug shops. During the 1870s several such shops opened in New York on "Ladies' Mile"— Broadway from Fourteenth to Twenty-third Street. Major retailers regularly took out full-page advertisements in the carpet-trade magazines to list Persian, Moorish, Turkish, and other oriental rugs; in 1880, for example, W. and J. Sloane of New York advertised rugs "selected with much care by their own agent in the East."[55]

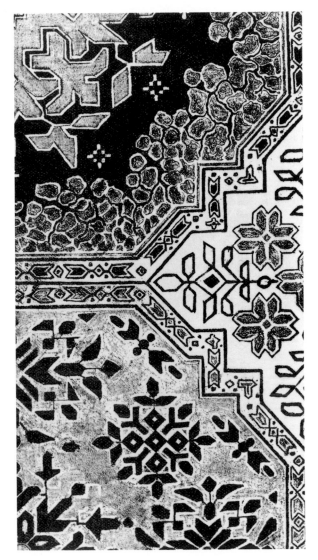

ILL. 3.18 "Pioneer Persian Three-Ply No. 3776." Hartford Carpet Company, Conn. *Carpet Trade and Review* (Oct. 1883). Art, Prints and Photographs Division, The New York Public Library, Astor, Lenox, Tilden Foundations

From the East as well, American carpet merchants imported mattings. Mattings had long been standard offerings in the carpet business, but Americans' interest in them was fueled by reports in the press that Whistler and Godwin used mats both in their own homes and in rooms they decorated for exhibitions.[56] An article in the *Carpet Trade Review* in November 1880 described the actress Sarah Bernhardt's Paris apartment as "in Japanese style," with "matting of a musty color, enlivened here and there by curious specimens of fancy straw mats."[57] The *Mikado* craze also boosted sales. The advertising pages in the trade magazines of the 1880s suggest a brisk business in mattings, both plain and in a variety of colors and patterns.

Although most of the decorating literature dismissed machine-woven American imitations of handwoven oriental rugs as poor substitutes for the real things, "Persians" had sold well for years. They were listed season after season in the lines of all the major American manufacturers of the 1880s. In 1883 the Hartford Carpet Company published with pride an illustration of its "Pioneer Persian Three-Ply" (ILL. 3.18), reporting that the pattern "was brought to this country by the late William Sloane, who had secured it in Scotland . . . in 1863, and was at once put in work."[58] Carpet makers appropriated exotic names for the methods they developed to approximate oriental craft techniques. The term "Smyrna," for instance, was applied to a special category of Ax-minsters (seamless carpets knotted in imitation of orientals) that were made with chenille wools to produce fabrics with two faces.[59] In *Woman's Handiwork in Modern Homes,* Harrison praised "American Smyrna" or "Merzapore" carpets "recently made in Philadelphia," finding them, compared to genuine orientals, "as admirable in color and design—and they are sold at a smaller price, have the additional advantage of being reversible, and are expected to wear as well." She commented that oriental carpets "are so generously used, and have been bought so cheap at recent sales, that almost every American home contains one or more of them."[60] A great many people who wanted at least a semblance of the much-admired abstract and geometric patterning on their floors, but were unable or unwilling to pay the prices that real oriental rugs commanded, bought these machine-woven American "Persians."

Most other carpets made in America during this period were not so closely associated with aestheticism. There is no record of major American architects and artists designing for the large carpet factories, as they did for wallpaper firms, and the American carpet industry was less dramatically affected by English design theory than was the wallpaper trade. Carpet manufacturers' resistance to the English theories and to the simplified, two-dimensional designs they favored doubtless reflected the difficulties of redirecting the momentum of a relatively new industry that had only just developed commercially successful design theories of its own. Not until the 1820s had the infant American carpet industry, first centered in Philadelphia, made much impact on interior decorating in the United States. In 1839 Erastus B. Bigelow (1814–1879) patented power-driven looms for making ingrain carpets, and during the 1850s he developed power-driven looms for Brussels carpets at his Bigelow Carpet Company in Clinton, Massachusetts. Much of the industry moved to New England, and American-made carpets became more widely available. Unprecedented growth during the 1850s and 1860s was followed, according to industry statistics, by a 180 percent increase in carpet production in the decade between 1870 and 1880.[61]

By the 1870s a corps of well-paid professional carpet designers had a vested interest in perpetuating methods and principles learned from the French. In 1879 an observer of the industry estimated that it paid at least $100,000 each year to "regularly-employed artists for carpet designs."[62] Most of these designers were entrenched in the studios of large carpet factories, where through a painstaking course of apprenticeship they had refined their skills for translating the intricacies of painterly floral patterns

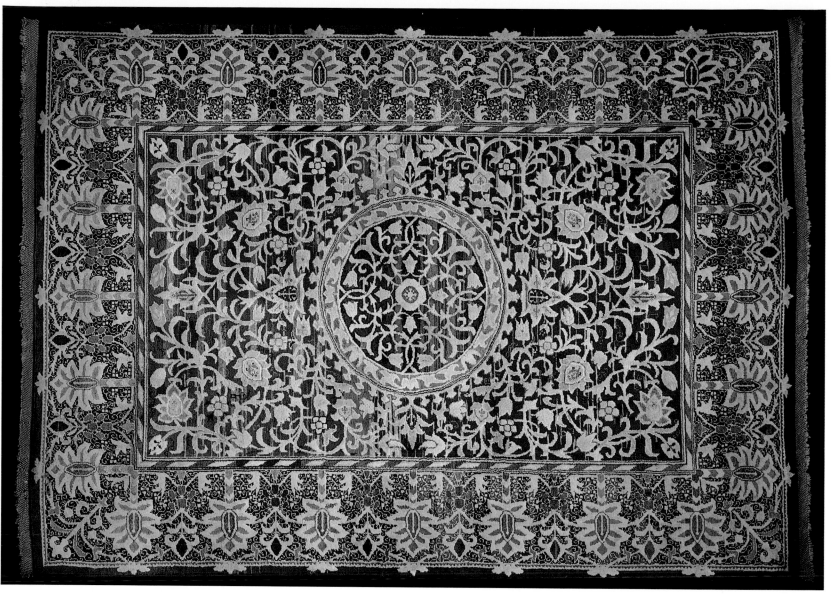

ILL. 3.21 Hammersmith carpet. Designed by William Morris, London, early 1880s. From the John J. Glessner house, Chicago. Wool and cotton, 11 ft. 9¼ in. × 15 ft. (3.33 × 4.72 m). The Art Institute of Chicago, Gift of Mrs. Charles F. Batchelder (1974.524)

based on complex French prototypes into diagrams directing the workings of carpet looms. These skills were their art.

The trade did not fail to capitalize, however, on the excitement about art in decoration. In the advertisements of American manufacturers, "art carpet" often meant that the carpet looked like a picture. Ingrain carpets woven in one width of three or four yards were advertised as "art squares" in the 1880s, even when they carried no pictures—the rationale probably being that since they were not woven in strips and pieced together like most other carpets, they were especially well suited to imitating large paintings.[63] In 1887 the Crompton Loom Works of Worcester, Massachusetts, advertised an "art square loom" with a jacquard machine that presumably could be programmed like a protocomputer to weave the oversized pictures.[64]

While the wallpaper trade was scorning French floral imagery, its artistic merits were defended on the pages of carpet-trade magazines. In 1880 an article on "Good Taste" in the *Carpet Trade* reported with approval that "flowers . . . still form a prominent feature in the ornamentation of coverings for the floors of the family and business temples of mankind."[65] Two years later an unnamed

American carpet designer explained his admiration for just the sorts of French carpets that most English theoreticians had been trying for forty years to discredit: "The charm of French floral designs is that their flowers are not labored. . . . They endeavor to produce in their sketches the first impression that flowers convey to the eye in a rapid glance . . . so that their floral patterns are always decided, clear and crisp."[66] Such assessments implied criticism of the laborious process of conventionalization taught in the English schools of design. Defenders of painterly, impressionistic, and mimetic art in floral carpet designs invoked the name of Ruskin and paraphrased his *Two Paths* (1859) to identify their imagery as the "outward and visible sign of the delight man takes in the work of his Creator."[67]

As the collection of carpets at the Stowe-Day Foundation bears out, even carpets with realistic floral patterns based on French models were standardly colored in a palette derived from English sources. The choice of colors was doubtless a response, in some degree, to the need for carpets to blend with or match the wallpapers that were so much in demand. For the paler creams and metallic golds of the papers, carpet manufacturers substituted a

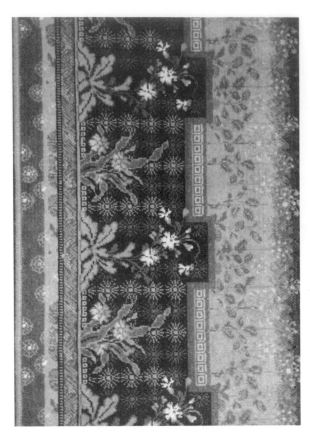

ILL. 3.19 Wilton carpet. Bigelow Carpet Company, Clinton, Mass., 1883. From Honolulu House, Marshall, Mich. Marshall Historical Society (C3035 48)

ILL. 3.20 Carpet design. Bigelow Carpet Company, Clinton, Mass. *Carpet Trade Review* (Oct. 1880). Art, Prints and Photographs Division, The New York Public Library, Astor, Lenox, Tilden Foundations

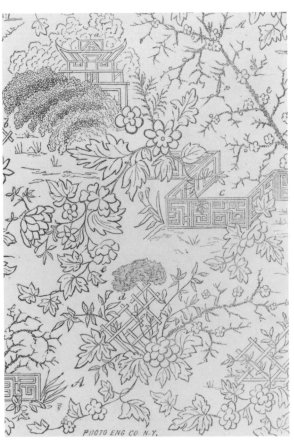

range of mustard shades less vulnerable to muddy feet. Their combinations of maroons, olive greens, mustards, and accents of black also bore some resemblance to the colors of natural dyes in faded handwoven oriental rugs.

Commercial carpets of the 1870s and 1880s were almost always manufactured with wide matching borders banded by narrow edgings that gave them an emphatically linear finish, a frame, as it were. One of these elaborately bordered carpets, from Honolulu House, built in 1860 in Marshall, Michigan, is shown in illustration 3.19; others survive in place in the Alfred E. Cohen house, which was built in 1883 at 1440 Twenty-ninth Avenue in Oakland, California. Although borders had long been important in making carpets, during this era their design and placement became something of an art in its own right. Laying these bordered rugs in irregularly shaped rooms and around hearths required great skill and ingenuity.

Beginning about 1878, "Japanese designs" began to figure prominently in the long, long listings of manufacturers' current offerings that American carpet-trade magazines published each season. Very different from true oriental rugs, these novelty designs were variously described as "damask effects," "landscape effects," and "pagoda patterns." By the spring of 1879 every major American manufacturer had some of these carpets, in bright as well as drab colors, in its line.[68] A Japanesque carpet from the Bigelow Carpet Company was illustrated in the *Carpet Trade Review* in 1880 (ILL. 3.20). This and the few other illustrations that appeared in the trade literature suggest that, like inexpensive Japanesque wallpapers, these carpets incorporated conglomerations of oriental motifs and scenes, arranged to play down as much as possible the symmetries created by the repeats of machine production. As admixtures of Chinese and Japanese motifs became more numerous, "oriental" was used more and more frequently in a vague way to suggest carpet styles.

Although English "art patterns" and English theories about them were not so wholeheartedly accepted in the carpet industry as they were in the wallpaper trade, the English made their mark on American carpets. For American carpet design, as for wallpapers, the most influential English models and ideas came from Morris and Dresser.[69] The two were more nearly in agreement about carpet design, however, than about wallpaper. Morris felt that the nature of the materials of carpets, and especially the angular geometry built into the large scale of web and woof and of most piles, dictated the use of geometric and conventional forms of the kind Dresser favored for all ornamentation. Both men admired the geometric carpets of the Near East.

American carpet designers who defended realistic French flowers on the pages of their trade journals also attacked the designs and ideas of both Morris and Dresser. One critic deemed Morris's carpet designs "cold" and "meaningless."[70] Dresser was the target of especially vindictive prose in the trade's press after he called American taste in carpets the worst in the world. In 1873, in *Principles of Decorative Design,* he observed, "Judging from the carpets which they order, I imagine that nowhere on earth is taste in matters of decorative art so depraved as it is in America. . . . Let the pattern be 'loud' and inharmoniously coloured, and the chances of its sale in the American market are great."[71] Writers in the American carpet-trade journals referred repeatedly to these lines during the 1870s and 1880s. Some angrily refuted Dresser's assessment; others used it as a goad to improve taste and looked back to 1873 as a point in time from which to chart progress.[72]

Nevertheless, American designers imitated Morris's and Dresser's carpets, if for no better reason than to recapture for American manufacturers the customers who were beginning to buy imported English carpets. In 1873, the year Morris first began to design Kidderminster carpets (three-ply, flat-woven ingrains made by machine), Bumstead and Company was selling them in Boston.[73] In 1880, when Morris introduced his more expensive hand-knotted

Hammersmiths (ILL. 3.21) "to make England independent of the East for carpets which may claim to be considered as independent works of art,"[74] these too were promptly offered for sale in Boston, by Goldthwaite and Company.[75] Even before that, by 1879, imitations of Morris carpets could be bought "of almost any upholsterer at half Morris' price," according to New York's *Art Interchange*.[76] A remnant of a Kidderminster from the home of the writer Sarah Orne Jewett (1849–1909) in South Berwick, Maine, could well be one of these.[77]

American manufacturers also adopted the names Morris and Dresser as descriptive adjectives. In 1879 Boyd, White and Company, makers of floorcloths, called some of their products "Morris designs" and complemented these with specimens of "Dresser designs."[78] One writer of 1880 recognized a "Dresseresque" style in American carpets that represented "fernery and leaves coloured in autumn hues . . . the outgrowth of one of Mr. Dresser's pet fancies—the 'flat character in decorative art.'"[79] Other catchwords for the interests of aesthetic enthusiasts, words like "Eastlake" and "Queen Anne," appear occasionally in the lists of carpet patterns offered each season from the late 1870s through the 1880s.[80] Unfortunately, without illustrations the words actually tell us very little. Eastlake extravagantly admired the handmade rugs of Persia, Turkey, and India, and he also passed as acceptable conventional and geometric patterns in machine-made Western carpets, if they were kept simple and small in scale.[81] Are such designs the ones to which American carpet manufacturers were assigning his name? The absence of an illustration of a "Queen Anne" carpet is especially lamentable. Late nineteenth-century use of that single term covered so many periods for which we now recognize distinctive styles that it is difficult to imagine what was meant by "Queen Anne."

"Morris," "Dresser," "Eastlake," and "Queen Anne" occur much less frequently on these long lists, however, than do "Japanese" and "Persian," which in turn are nearly lost among the large number of listings for a wide variety of other designs with names such as "scroll pattern," "chintz," and "medallion," or, more often, "landscape" or, even more frequently, simply "floral." The lists corroborate the evidence given in articles in the trade magazines: "Aestheticism in Carpets," as one of those articles was entitled, certainly existed, but it played a less important role than did aestheticism in wallpapers.[82]

Textiles

This section focuses on patterning and decoration on textiles associated with the Aesthetic movement in America, a narrow slice from a broader subject. Questions such as which weaves, fibers, or finishes were appreciated as artful are not broached here. These and many other questions this introduction suggests could be answered only by exhaustive study of all American records of textile design, production, and sale during the Aesthetic period. In this discussion of imported textiles, American-made textiles, and embroidery, I have emphasized the different effects that artistic ideals and theories had on the people who designed, made, and sold goods in these three categories. The disparate roles played by artists are particularly telling. Major English artists designed patterns that were prized by artful American decorators, and some well-known American artists designed expensive textiles, but none of these artists seems to have designed for the large American mills that printed inexpensive cloth, or so the omission of any mention of their having done so in the major decorating-trade journals during a publicity-conscious era would indicate. In contrast, American artists and architects turned their hands to art embroidering in several well-publicized instances.

For textile imports, as for wallpapers, the trade in goods from Morris and Company of London is the best documented. That trade made available to Americans the printed chintzes that Morris began designing in 1868, six years after he designed his first wallpaper, as well as the more expensive silks and woolens with woven patterning that he began to produce in 1872.[83] During the 1870s and 1880s Morris textiles were sold in the American outlets for Morris wallpapers, including decorating firms, and they were also carried by merchants who dealt exclusively in yard goods.[84]

Some of Morris's chintz patterns duplicated his wallpapers; others were more vertical and narrow, to fall gracefully in folds when draped. Some, such as Jasmine Trellis of 1868–70, were naturalistic; others, such as Iris of 1876, were more geometric. The patterns Morris designed for double- and triple-woven woolen cloths tended, like his carpet designs, to be more abstract. For both rugs and woven textiles he preferred what he called "weavers' flowers," simpler forms he worked into more rigidly geometric configurations because he felt that the materials and techniques of the crafts dictated such handling.[85] Morris's heavy, handsome woolens were of a weight that Eastlake deemed appropriate for curtains, which, he reminded his readers, "were originally hung across a window or door, not for the sake of ornament alone, but to exclude cold and draughts." He recommended suspending the hangings "by little rings . . . over a stout metal rod."[86] Stylish American home furnishers also used rings and rods to hang Morris chintzes, such as the Rose and Thistle pattern of 1882, which was used for window curtains in a bedroom in the John J. Glessner house in Chicago (see ILL. 3.8).

While many Americans prized the artistry they felt Morris's textiles brought to their rooms and were willing to pay relatively large sums to own them, American artists do not seem to have been inspired during this period to follow his example of personal experimentation with dyeing yarns and weaving on a handloom. A resurgence of interest in handweaving came to America only toward the turn of the twentieth century, when arts and crafts processes, rather than products, captured the imaginations of many Americans.

Documentation for the sale in the United States during the 1870s and 1880s of textiles designed by other major British figures, such as Dresser and Talbert, is more elusive. Applying the same principles of surface ornament they had followed in creating the wallpapers admired by customers in both England and the United States, these well-known British designers furnished patterns for cloth mills. Dresser sold designs to at least seven English textile firms.[87] Talbert's designs include the silk brocade used in the portiere in figure 3.14.[88] American merchants undoubtedly offered such textiles to the affluent people who bought wallpapers by the same British designers.

Exotic goods from the East also had tremendous appeal for Americans with aesthetic goals in dress and decoration. The South Kensington circle's admiration of Near Eastern and Indian patterning lent new interest to woolen shawls from Kashmir and the imitations of them that were the specialty of the town of Paisley, Scotland. A synthesis of Indian, Persian, and European motifs that had evolved through centuries of trade between India and the West is equally apparent in the shawls woven by hand in the East and those made in Europe on drawlooms or more mechanized, power-driven jacquard looms.[89] Whether the genuine handwoven articles or clever Scottish imitations made on machines, whether old or new, Paisley shawls found new roles in the 1870s and 1880s: rather than warming stylish ladies' shoulders as they had in mid-century, the shawls more often decorated their pianos and mantelpieces.

Textiles imported from Japan had even more stylish cachet. Antique examples (FIG. 3.15) were treasured by collectors. Less expensive textiles were among the goods advertised by the Japanese warehouses and permanent bazaars that opened in several major

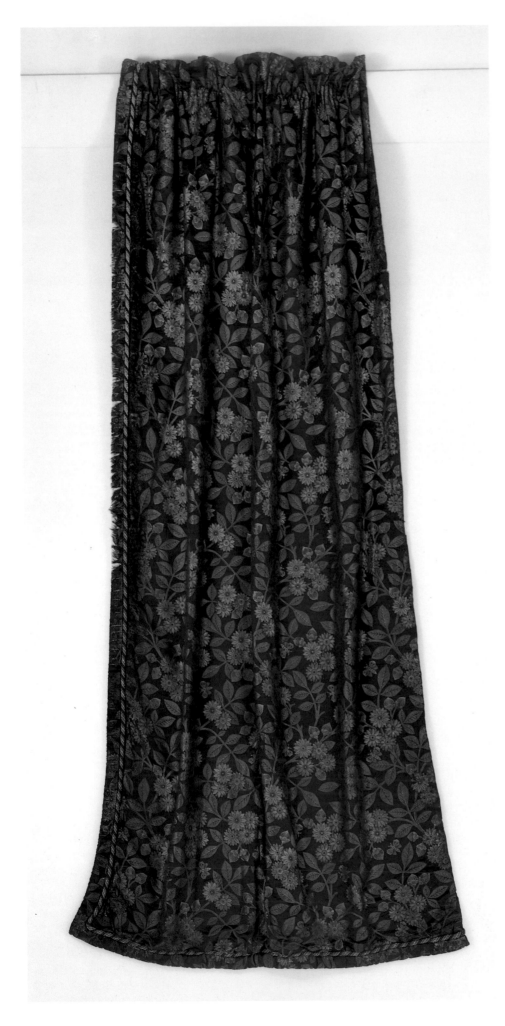

Left: FIG. 3.14 Portiere in the Hatton pattern (one of a pair). Designed by Bruce J. Talbert, made by Warner and Company, London, ca. 1875. Silk brocade, 8 ft. 8 in. × 4 ft. 2 in. (2.64 × 1.27 m). Collection of John Nally

Opposite: FIG. 3.15 Textile (fragment). Japanese, late 18th or early 19th century. Silk, paper gold, 26½ × 50 in. (67.3 × 127.6 cm). The Metropolitan Museum of Art, Edward C. Moore Collection, Bequest of Edward C. Moore, 1891 (91.1.21a)

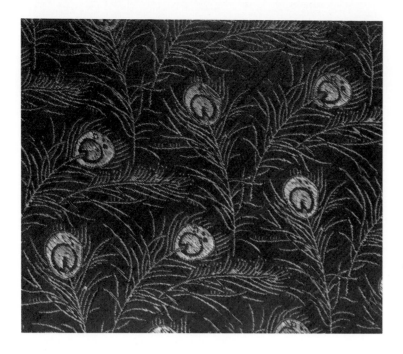

American cities during the 1870s. Among the first sales outlets for Japanese imports in the United States, and the most widely publicized, was the Japanese Bazaar at the Philadelphia Centennial in 1876. The same year, George Turner Marsh established his Japanese emporium in San Francisco, and Rowland Johnson's and A. A. Vantine's Japanese shops opened in New York (Johnson's on Beaver Street, Vantine's on Broadway).[90] Advertisements for other firms, such as the Asian Trading Company and the First Japanese Manufacturing and Trading Company, are prominent in magazines and newspapers of the 1880s.[91] During the winter of 1885–86 Madison Square Garden in New York was the scene of a "Japanese" or "Mikado" village where Japanese goods were sold and Japanese artisans demonstrated crafts, including silk weaving.[92] In March of 1886 the magazine *Dixie,* published in Atlanta, Georgia, included a report on the "Mikado Village" and also announced that the J. P. Stevens Company of Atlanta was offering Japanese silk embroideries for sale.[93] TIFFANY AND COMPANY of New York had been selling Japanese silk embroideries at least since 1875,[94] and in the early 1880s the Nippon Company, located on Broadway in New York, frequently advertised Japanese "High Art Goods," including "wall hangings," in the *Art Amateur.*

AMERICAN-MADE TEXTILES

The sale of fabrics imported from Europe and the East impinged on the American domestic textile trade, skimming off customers for "aesthetic" goods. In the competition for this segment of the market, a few American makers of expensive textiles enlisted the participation of American artists. CHENEY BROTHERS of Manchester, Connecticut, who specialized in silks and about whose products we know the most, employed Candace Wheeler as a designer.[95] A number of silks, linens, and cottons that Wheeler herself saved as representative of her work are now in The Metropolitan Museum of Art and the Mark Twain Memorial. Whether all of these were actually produced by Cheney Brothers or whether all of the designs actually came from Wheeler's own hand is not clear. Worked into the patterning on several of the textiles are the letters *AA,* the signatory initials for an exclusively female organization to which Wheeler took the name Associated Artists in 1883, after the dissolution of her partnership with Tiffany, Colman, and de Forest.

Although the patterns of these fabrics demonstrate a wide range of approaches to design, the work could well all be Wheeler's own: the variation could be interpreted as expressive of the Ruskinian attitude that held that when an artist decorated, any choice from the naturalistic to the conventional was equally valid. Many of the patterns draw on English and Japanese precedents. One of the floral patterns is conventionalized and two-dimensional; others are more naturalistic, like the daffodil print in illustration 3.22, which may have been influenced by the curvaceous forms of Morris prints. The lily motif chosen for another swirling print, as well as for a vertical border, was associated with English Pre-Raphaelite painting and with English decorative work (such as Crane's wallpapers; see ILL. 3.9). The lily's status as cult flower of Oscar Wilde (1854–1900), the aesthetic apostle, may also have influenced the choice. The combination of seashells and ribbons in one pattern suggests a determined effort to handle motifs in original ways. Japanese sources furnished novel subject matter for other designs, including a pattern depicting nets and rings that may be bubbles, another (FIG. 3.16) of fish and rings that are more clearly bubbles, a design with emblematic mountains and waves, and yet another (FIG. 3.17) showing bees over a honeycomb in a woven pattern closely related to the wallpaper Wheeler designed for the Warren, Fuller and Company competition in 1881 (see ILL. 3.14, FIG. 3.8).

Insects owing a clear debt to Japanese sources were also woven into the elegant fabric that HERTER BROTHERS furnished for portieres hung about 1882 in the John Sloane house in New York (FIG. 3.18).[96] Dragonflies are worked into borders that frame large panels, and they float among the woven renditions of watery motion and lily pads in one of the panels. In another panel, water bugs flit across stylized water lilies. CHRISTIAN HERTER, who took over Herter Brothers in 1870 and built it into one of the most important decorating firms of the era, may well have designed this pattern, which appears in photographs of other rooms decorated by his company. In the drawing room of the Oliver Ames, Jr., house on Commonwealth Avenue in Boston, it was used as upholstery on chairs and sofa pillows (ILL. 3.23).[97]

ILL. 3.23 Drawing room, Oliver Ames, Jr., house, Boston. Herter Brothers, New York. Photograph, ca. 1883. The Bostonian Society, Old State House

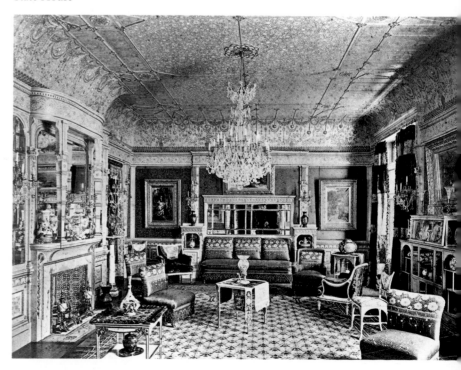

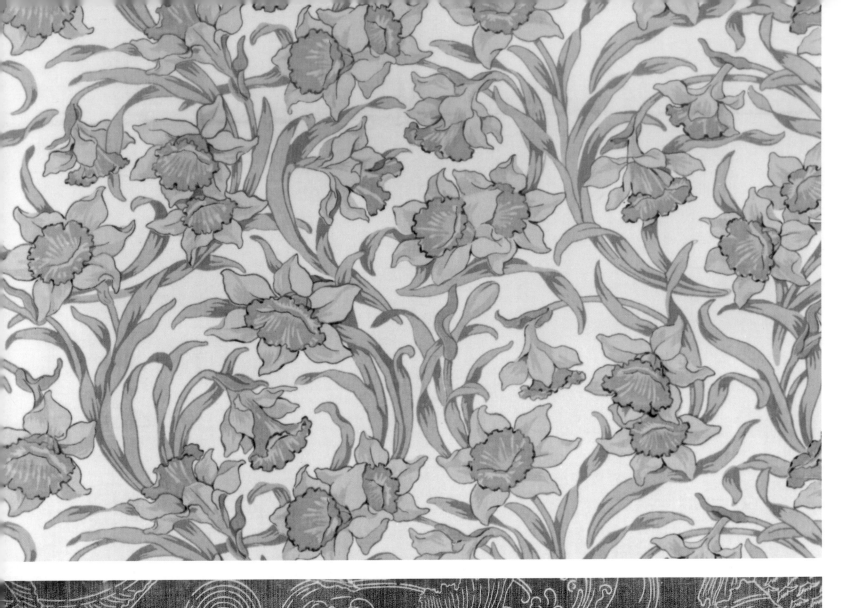

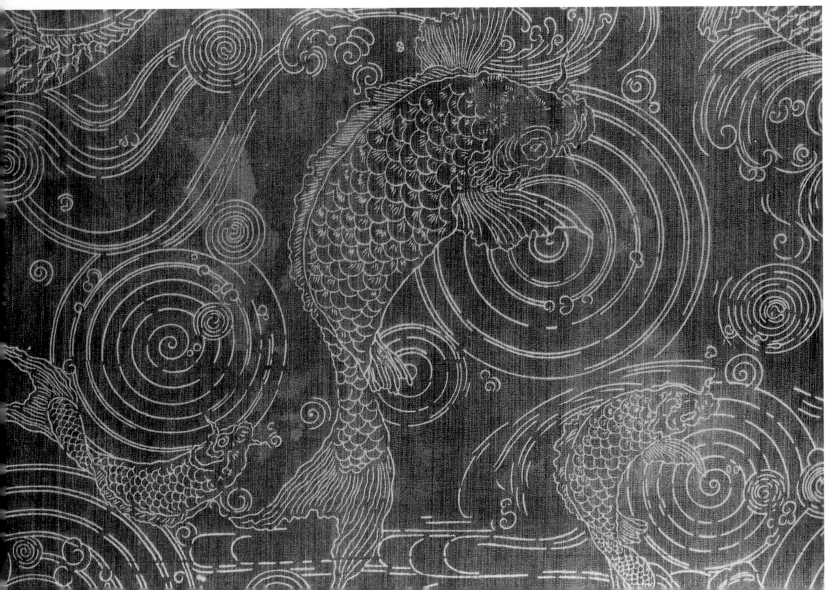

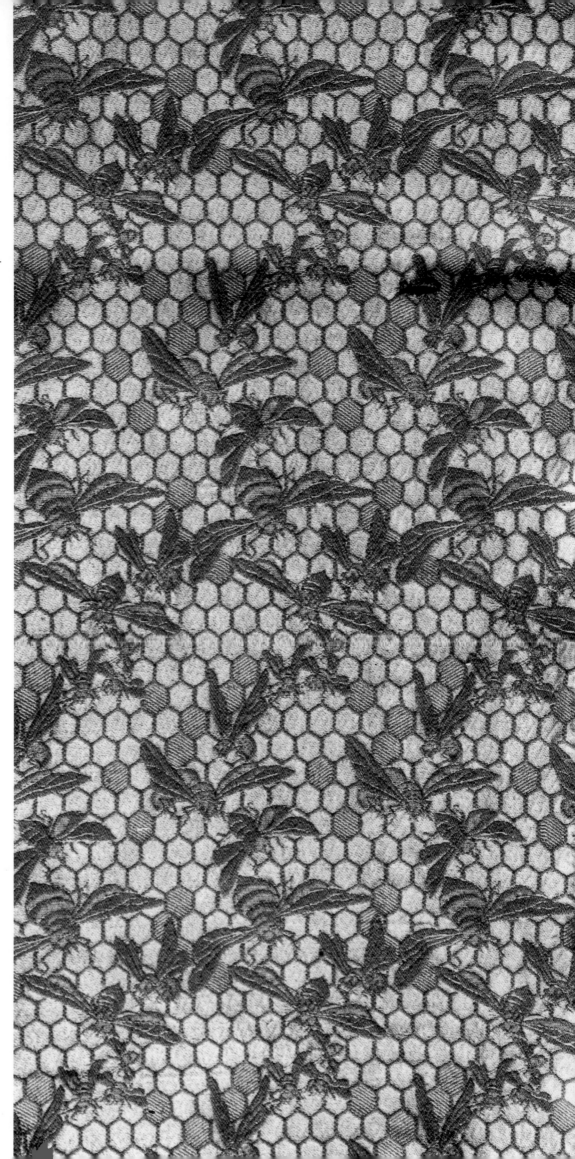

Opposite top: ILL. 3.22 Textile (sample). Designed by Candace Wheeler, made by Cheney Brothers, Hartford, Conn., ca. 1885. Printed cotton velveteen, 32½ × 37 in. (82.6 × 94 cm). Marked: *AA* [monogram] / *ASSOCIATED ARTISTS* / *115 East Twenty-Third St., New York.* The Metropolitan Museum of Art, Gift of Mrs. Boudinot Keith, 1928 (28.70.25)

Opposite bottom: FIG. 3.16 Textile (sample). Designed by Candace Wheeler, ca. 1885–95, probably made by Cheney Brothers, Hartford, Conn. Printed denim, 53⁷⁄₁₆ × 19⅞ in. (135.7 × 50.5 cm). Mark Twain Memorial, Hartford, Conn.

Right: FIG. 3.17 Textile (fragment). Designed by Candace Wheeler, made by Cheney Brothers, Hartford, Conn., ca. 1885. Silk and wool, 26¾ × 12¼ in. (67.9 × 31.1 cm). The Metropolitan Museum of Art, Gift of Mrs. Boudinot Keith, 1928 (28.70.4)

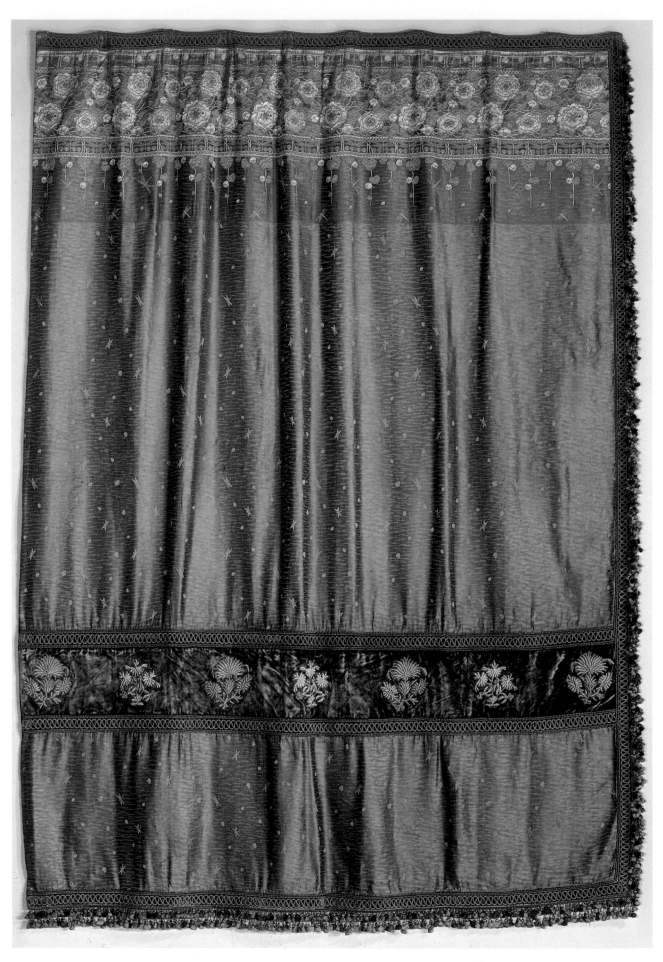

FIG. 3.18 Portiere. Herter Brothers, New York, 1882, for the John Sloane house, New York. Silk
brocade, metallic thread, 8 ft. 7¼ in. × 5 ft. 7 in. (2.62 × 1.7 m). The Brooklyn Museum, New York,
Gift of Mrs. William E. S. Griswold in memory of her father John Sloane (41.980)

For the American factories that produced less expensive textiles no record has yet been found of major artists designing patterns. Rather, patterns for their printing rollers probably came from their own design studios. If the printed cottons of the Cocheco Manufacturing Company can be taken as representative, only a small portion of the overall production of these factories appears to have been tailored to suit aesthetic tastes. A remarkably complete and well-documented collection of samples from this mill in Dover, New Hampshire, survives at the Museum of American Textile History in North Andover, Massachusetts.[98]

The sample cards that document all of Cocheco's production between 1880 and 1890 include only one pattern derived from Morris's designs: a cotton upholstery print of fluid blossoms and leaves (ILL. 3.24) that is very much the exception to the ordinary run of this mill. Conventionalized, strictly two-dimensional leaves, rather rigidly worked out with a strong emphasis on geometry, perhaps derived from South Kensington, appear in a very few patterns. Replications of Japanese motifs, as in the printed cotton "satines" in illustration 3.25, were more common, for both upholstery and dress fabrics. Cocheco also produced a fairly large number of paisley prints. They perhaps worked well with Near Eastern decorative schemes, but by the 1880s paisleys, a fashion standard since mid-century, hardly represented a new influence of English aestheticism.[99]

Realistic depictions of flowers and foliage and of vignetted landscapes and figure groups made up the bulk of Cocheco's prints. Some of the landscapes and figures are oriental, more in the whimsical manner of the chinoiserie of the eighteenth century than in studied imitation of the heraldic Japanese textiles so much admired during the late nineteenth. Again, differentiations between Japanese and Chinese sources were casually blurred and elements from virtually any other decorative tradition were introduced in the "oriental" style. Many examples among Cocheco's realistic prints should perhaps be identified with a catering to devotees of the American Colonial-revival version of the Queen Anne style. For this last group Cocheco also reproduced eighteenth-century Rococo and Neoclassical motifs.

Much more blatant responses to aestheticism are a few novelty prints that Cocheco produced between 1880 and 1890. The cotton print used for an apron found in a house in Warren, Rhode Island (FIG. 3.19), was evidently designed to trade on the popularity of both quilts and *The Mikado*. A pristine sample of this pattern, a six-color print of 1886, survives in the Cocheco collection. The drab color scheme, dominated by maroon, can be more tenuously linked to aesthetic influence. A number of Cocheco fabrics were printed in similarly dull shades, but bright colors are also plentiful in the mill's products of the 1880s.

Among Cocheco's furnishing prints from these years are surprisingly few that suggest the importance of borders so apparent in commercial aesthetic wallpapers and carpets. The unknown maker of the panel of printed cotton in illustration 3.26 seems to have been more mindful of artistic predilections. The print features not only artful bordering but a rather realistically rendered version of the much-used sunflower motif. This piece was found in the United States, but it could have been made in either England or America. The coloring—maroon and mustard yellows on a creamy, off-white ground—is closely related to the commercialized American aesthetic palette for wallpapers and carpets, suggesting an American attribution.

ILL. 3.25 Salesman's sample card. Cocheco Manufacturing Company, Dover, N.H., ca. 1889. Cardboard, machine-printed cotton, 29¼ × 9¾ in. (74.3 × 24.8 cm). Museum of American Textile History, North Andover, Mass.

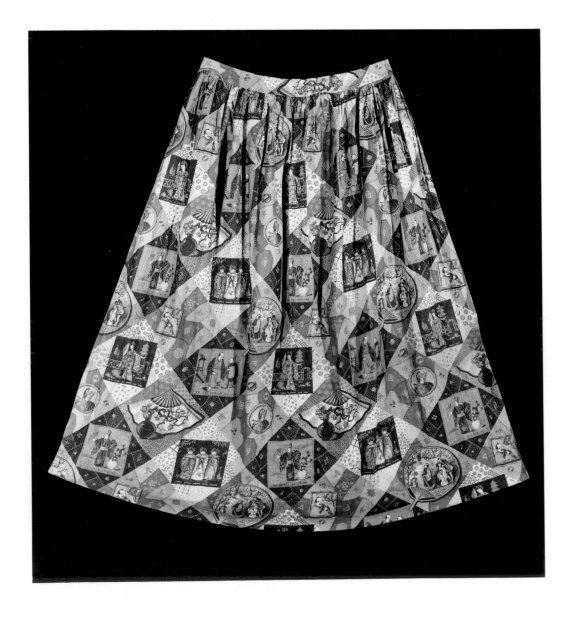

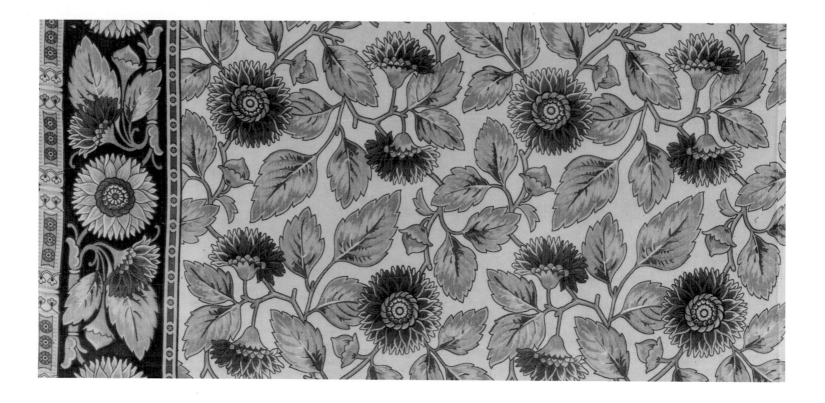

EMBROIDERY

Textiles, whether imported, expensively made by specialized firms, or cheaply churned out by large mills, were often transformed into objects deemed artful and aesthetic because they were embroidered or pieced together in creative ways. In the United States the textile art most radically affected by English theory and example was embroidery. It was among embroiderers that the widely diffused aesthetic enthusiasm of the 1870s and 1880s perhaps came closest to becoming an organized national Aesthetic movement.

The chief agent of this organizational feat was Candace Wheeler. In 1877, at age fifty, with no more formal preparation than any other society matron of a generation in which embroidery was a necessary "accomplishment," Wheeler, with four other women, founded the Society of Decorative Art in New York.[100] The society was the model for similar groups soon founded in Boston, Philadelphia, Baltimore, Chicago, San Francisco, and smaller towns throughout the country.[101] It functioned as a school with a lending library, as a center for studying and experimenting with the art of embroidery, as a workroom for executing commissions, as a sponsor of numerous exhibitions, and as a salesroom for the work of its members and a store where embroidery tools, materials, and literature could be purchased. The New York society fostered other crafts as well, particularly china painting (see chap. 7).

Wheeler's leadership promoted national cohesion, but so too did the presence in each of the societies of certified teachers from the school of the Royal Society of Art Needlework in London,[102] often called the South Kensington School after the location of its classes and the source of the principles of design to which it ad-

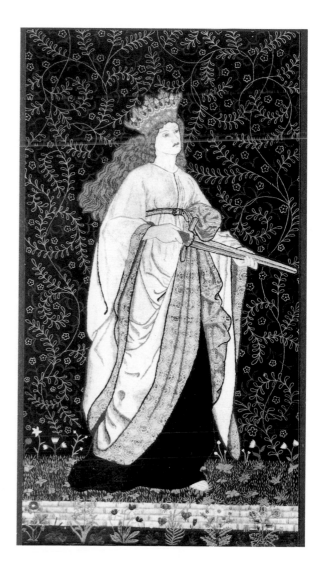

ILL. 3.27 "Woman with a Sword" (panel from a screen). Designed by William Morris, embroidered by Jane Morris and Elizabeth Burden, London, early 1860s. Wool, silk, and gold thread on linen, 53½ × 28 in. (136 × 71 cm). The Castle Howard Collection, York, England

hered. The curriculum and the products of the London embroidery school, organized in 1872, were ultimately inspired by William Morris. As early as 1855, after studying medieval embroidery, Morris had begun to experiment with the possibilities of the needle, using woolen threads. Pleased with the results he achieved, he taught the women of his family and acquaintance. Together they revived the art of crewel embroidery, designing original patterns, emulating old stitches, and dyeing wools with natural pigments. Morris incorporated embroidery into the decorative commissions of Morris and Company. Ambitious figural panels by Edward Burne-Jones, Dante Gabriel Rossetti, and Morris himself (ILL. 3.27), as well as floral and foliate panels, were executed by a staff of embroiderers or, in some cases, by the women who lived in houses decorated by the firm.[103] Morris and Company also sold patterns, tools, threads, and other embroidery supplies, exporting many to retailers in America.[104] The pillow with a rose-tree motif in illustration 3.28 was one of many smaller, less expensive Morris embroidery designs that were available either ready-made or as kits for women to work themselves.

The new embroidery, with its many different stitches and creative approach to design, intrigued stylish London women. It offered freedom from the mechanical tasks of Berlin woolwork, which involved copying picture patterns from squared paper onto a canvas grid, working only in tent or cross stitches. Berlin woolwork, with its realistic puppy dogs, cabbage roses, and biblical scenes, remained the most popular embroidery of the Victorian era, but the artistically enlightened scorned it. They preferred sim-

pler, more stylized needlework motifs based on some of Morris's exercises and the soft colors, in limited palettes, of the natural dyes he used. These colors were considered particularly beautiful in contrast to the vivid rainbow of hues that had dominated commercial embroidery patterns at mid-century.[105]

Although the leaders of the Royal Society of Art Needlework were inspired by Morris's example, and although they enlisted Morris, along with other renowned English decorative artists, including Walter Crane and G. F. Bodley (1827–1907), to teach and furnish designs to be executed at their school,[106] they rejected the manner of Morris's more ambitiously representational art embroideries and all the more pictorial possibilities for needlework. The South Kensington embroidery style and the complex institution established in London to foster it were intricately interlocked products of late nineteenth-century social mores oddly allied with notions of art, charity, and self-improvement. The society was not just a school, but also a sheltered workshop with a salesroom and an exhibition program, all supported by an elite organization of aristocratic ladies. The objects of the society's charity were "ladies," as the American writer Mary Gay Humphreys described them in 1884 in an article in the *Art Amateur*, " . . . in the English sense of the word, who [were] forced to earn their incomes wholly or in part." Humphreys went on to explain that the society was "so ordered that this [work] may be done without exposing their needs."[107] She did not have to comment on the reticence, dictated by Victorian social custom, on the part of women of any social standing to reveal a need to work. The richer matrons, the bene-

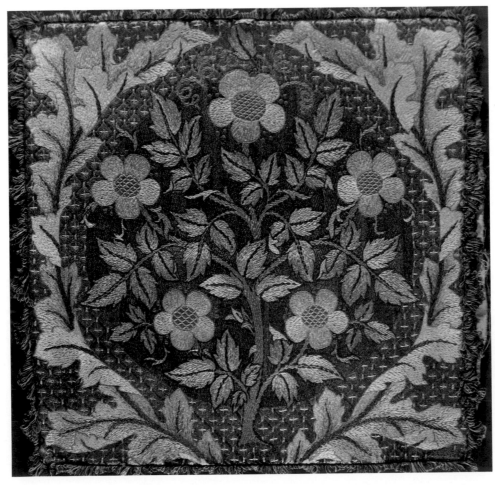

ILL. 3.28 Pillow. Design attributed to William Morris, London, n.d. Cotton thread on cotton, 22 × 22 in. (55.9 × 55.9 cm). Cooper-Hewitt Museum, The Smithsonian Institution's National Museum of Design, New York, Gift of Miss Annie May Hegeman (1944.71.6)

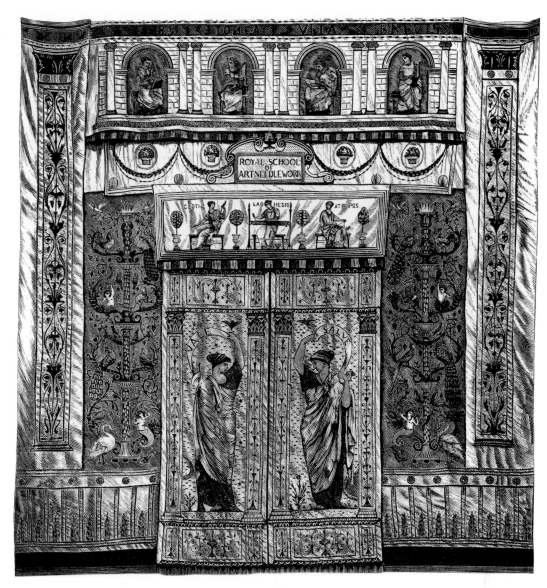

ILL. 3.29 "Curtain-Door" (part of a set). Designed by Walter Crane, executed by students at the Royal School of Art Needlework, London, ca. 1875–76. Walter Smith, *Industrial Art,* vol. 2 of *The Masterpieces of the Centennial International Exhibition* (Philadelphia [1877?]). Thomas J. Watson Library, The Metropolitan Museum of Art

factors, were equally reluctant to impose heavy, drudging work on gentlewomen. They could console themselves with the knowledge that the poverty-stricken ladies who anonymously plied their needles for bread also did it for Art, and therefore, as any reader of Ruskin would have known, expressed their joy in such work.

The benefactors also studied at the school and exhibited their work in its rooms. They both adopted and helped to mold the school's methods and the distinct style it fostered. The most dogmatic strictures of those who limited decoration to abstract and conventional forms found perhaps their most obedient adherents among these members of an aristocracy long renowned for its flaunting of rules. Some of these women expounded on the school's teachings in print. The most prolific, thorough, and ambitious of them was Lady Marianne Margaret Compton Cust, Viscountess Alford (1817–1888), who was often quoted in American magazines. In 1880 Lady Alford edited a small *Handbook of Art Needlework for the Royal School, South Kensington.* Her *Needlework as Art* was published in 1886. In this, her major book, she applied to embroidery strict rules for design, citing the authority of Owen Jones and of Richard Redgrave (1804–1888), also a key figure in the English design establishment.[108] Believing that "all attempts at pictorial art are a mistake in textiles," Lady Alford instructed that

"design must follow the scientific laws of art, and shape the variations of traditional forms from which we cannot escape. In our present search after these inner truths . . . we have nothing to do with the rules of painting, sculpture, and architecture."[109] In her article in the *Art Amateur,* Humphreys described the work of the Royal Society's needlework school as "conventional and decorative. . . . The treatment suggests principally three influences—those of mediaeval, Renaissance, and Japanese art."[110]

The embroideries the Royal Society of Art Needlework exhibited at the Centennial Exposition in Philadelphia, including the screen shown in figure 3.20, were demonstration pieces for the views Lady Alford committed to print.[111] The society's work was loquaciously admired in virtually every publication that dealt with decorative arts at the exhibition. In his popular volume on the fair's industrial art, Walter Smith (1836–1886) cited the embroideries, and the school itself, as models for emulation by American women. "Give our American women the same art facilities as their European sisters," he wrote, "and they will flock to the studios and let the ballot-box alone."[112] He included ten plates illustrating fifteen specimens of the society's work, ranging from pincushions, through the screen in figure 3.20, to an elaborate set of hangings (ILL. 3.29) that Crane designed especially for the occasion. Crane's

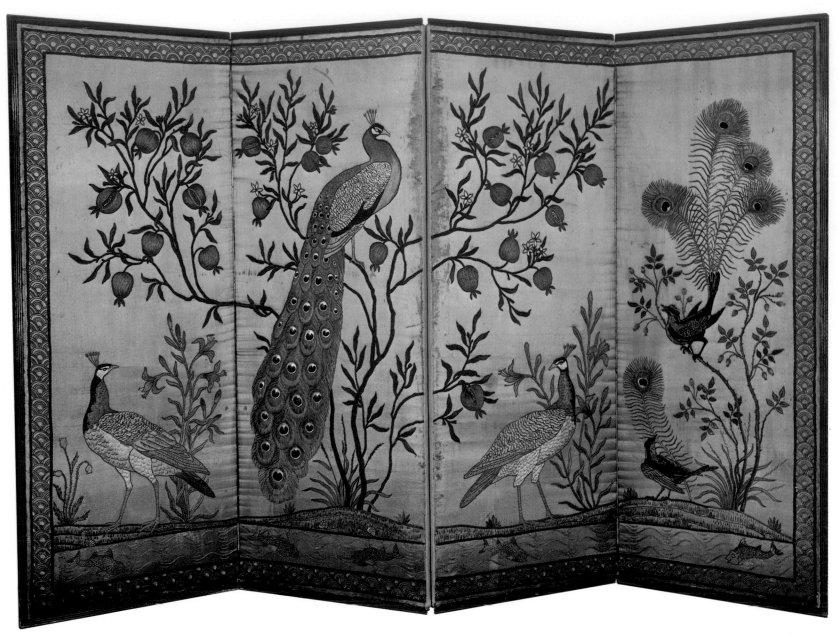

Above: FIG. 3.20 Screen. Design attributed to Walter Crane, executed by students at the Royal School of Art Needlework, London, ca. 1875–76. Wool thread on cotton and silk, h. 59½ in. (151.1 cm), w. 23½ in. (59.7 cm), d. 4 in. (10.2 cm). Collection of Paul Reeves

Opposite: FIG. 3.21 Portiere. Designed by Candace Wheeler, fabric made by Cheney Brothers, Hartford, Conn., ca. 1884. Silk-velvet appliqué on embroidered silk and metallic-thread fabric, 74 × 50½ in. (188 × 128.3 cm). The Metropolitan Museum of Art, Gift of the family of Mrs. Candace Wheeler, 1928 (28.34.2)

hangings, with their allegorical figures set in a framework of classical architecture, were the featured work in the Royal Society's pavilion. Only twelve feet square, the pavilion was a major attraction for women visitors to the fair, who were drawn by the reputations of the famous English designers whose work was displayed and, even more so, by the glamour of the society's associations with the English aristocracy. Included in the display was "The Queen's Curtain," with a border of sunflowers designed by Her Gracious Majesty. Smith commended the example thus set for women "to employ their leisure in refining and elevating pursuits."[113]

The American woman visitor who acted most effectively on what she saw at the Royal Society's booth was Candace Wheeler.

Struck with the notion that the English had discovered "the subject of suitable occupation for women who could not become mere laborers," which she regarded as "a pressing necessity of the time," she spearheaded the establishment in New York of the Society of Decorative Art. Wheeler freely acknowledged her debt to the Royal Society of Art Needlework and its school, but only as the germ of her idea. The organization of the New York society, she wrote, "was as different from its English prototype, The Kensington, as a republic is from a monarchy."[114] She perhaps exaggerated the differences, for the Society of Decorative Art modeled its school, its sheltered workshop, its exhibition gallery, and its sales outlet on the London precedents.

If New York could provide no titled aristocracy to patronize

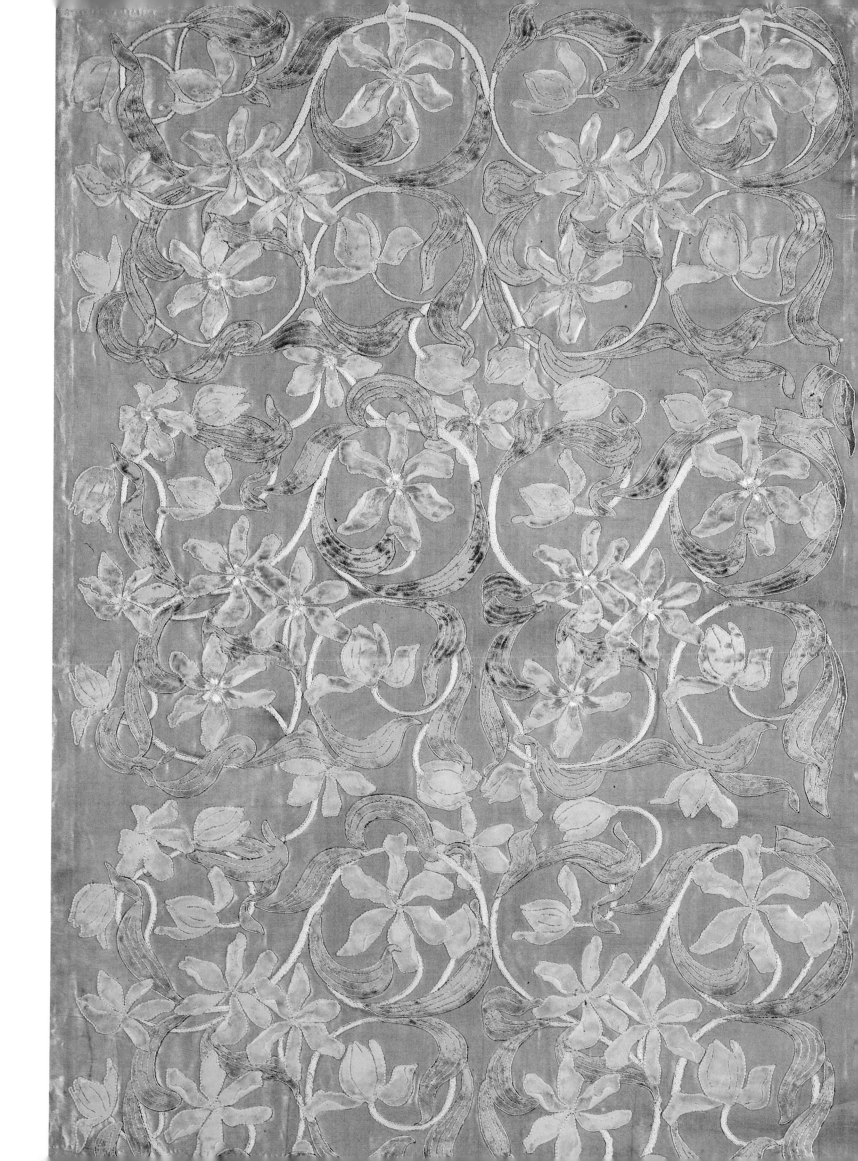

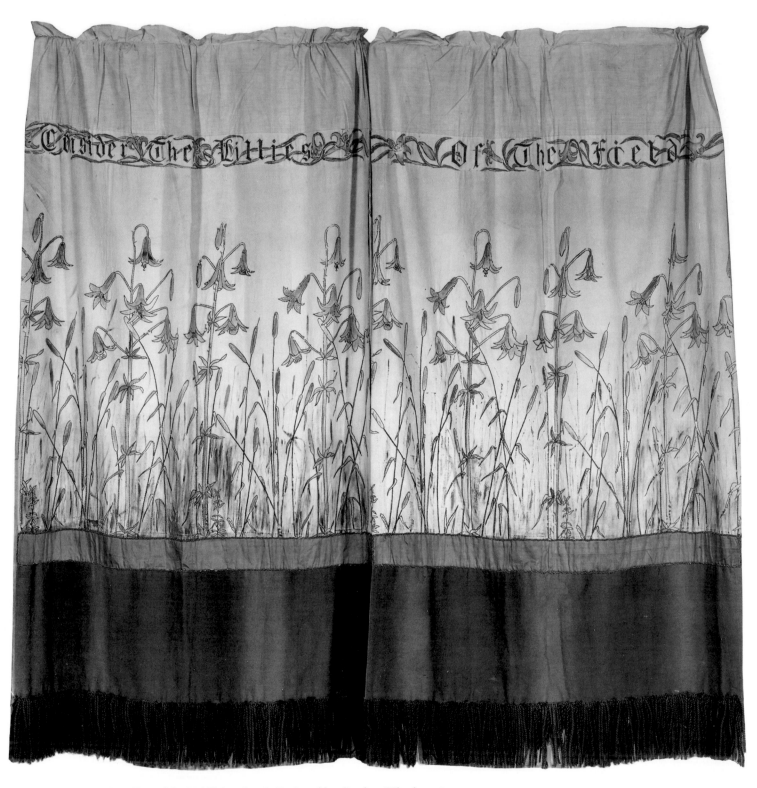

ILL. 3.30 "Consider the Lillies of the Field" (portieres). Designed by Candace Wheeler, 1879.
Embroidered and painted cotton, serge, wool fringe; each 73 × 41½ in. (185.4 × 105.4 cm).
Mark Twain Memorial, Hartford, Conn.

Wheeler's cause, it did have the wives of a financial and political elite. The president of the society, Mrs. David Lane, enlisted the support of Mrs. Cyrus W. Field, Mrs. Abram S. Hewitt, Mrs. August Belmont, Mrs. William Astor, and Mrs. Hamilton Fish, to name a few. General Custer's widow was bold enough to accept the paid position of assistant secretary.[115] Leading New York artists, like their London counterparts, were persuaded to design and teach for the society. Tiffany, Colman, and de Forest were especially active. Wheeler was also proud of the society's nationwide affiliations, and she credited part of its success to the immediate support it received from other groups all across the country. These were, in almost every case, the old sewing circles familiar in every community, traditional women's gatherings that underwent a dramatic and instantaneous metamorphosis just after the centennial.[116]

Wheeler defied social convention when in 1879 she entered into a professional partnership with the same artists, Tiffany, Colman, and de Forest, whose help she had enlisted for her amateur charity work. Wheeler was chief of textile design for Associated Artists. She made an arrangement with the board of managers of the Society of Decorative Art by which her new business became the sole agent for the sale of "beautiful embroideries" designed by the firm and executed by the society under her supervision. When the partnership dissolved in 1883 and Wheeler took the name Associated Artists to her firm of women who proposed to profit from the textile arts, she launched an even bolder professional enterprise. She directed the company until the turn of the century, when she turned it over to one of her sons, who kept it in operation until 1907.[117]

Although Wheeler's choice of a medium for most of her amateur and professional ventures was inspired by the South Kensington school, most of her embroideries bore little resemblance to the English work. For the two-dimensional, conventional designs of the English embroideries, she often substituted landscapes and figures. For Lady Alford's dicta that "all attempts at pictorial art are a mistake in textiles" and that embroiderers "have nothing to do with the rules of painting, sculpture, and architecture," Wheeler substituted a conviction that any subject or technique appropriate for the painter's canvas was equally appropriate for her textile surfaces. A self-conscious attempt to Americanize her work, to differentiate it from its English antecedents, is a recurring theme in her later writings. In 1894 she was still asserting that the American revival in art needlework "was only at first an exact reflection of English methods. . . . The American needlewoman boldly took to the representation of vivid and graceful groups of natural flowers, following the lead of Moravian practice and of flower painting, rather than that of decorative design."[118]

Among the surviving samples of Wheeler's embroideries, however, are some exercises in conventionalized ornament that seem derived from English examples. These include a pair of portieres (ILL. 3.30) decorated with simplified lilies and, in Gothic script, the legend "Consider the Lillies [sic] of the Field." The work on these portieres, combining elementary outline stitches with areas of painted color, seems studied in its simplicity. The dull woolen threads sparsely outlining the lilies offer a marked contrast to the luxuriously rich silken threads, thick-sewn on shimmering velvet, in other embroidered panels by Wheeler. The portiere illustrated in figure 3.21 reveals an interest in the geometry of patterned structure characteristic of South Kensington work. Yet the drawing admits the idiosyncrasies of individual tulips and their leaves: the flowers are shown not at the idealized moment of fresh bloom, but overblown and disheveled, observed in their visual reality as are flowers in paintings. The clumps of irises on another panel (ILL. 3.31) are again geometrically spaced, but each is shaded in a more painterly manner than a South Kensington class mistress would have permitted.

Ironically, very little has survived of Wheeler's most ambitious work—the embroidered hangings with landscapes and figures ren-

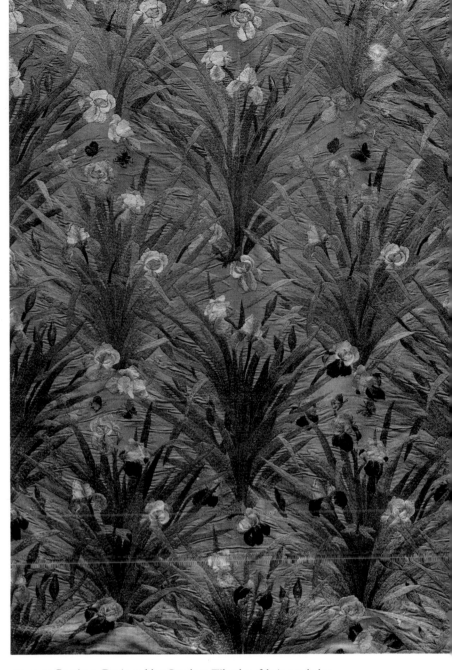

ILL. 3.31 Portiere. Designed by Candace Wheeler, fabric made by Cheney Brothers, Hartford, Conn., ca. 1884. Embroidered silk, sequins, glass beads, 93 × 58¾ in. (236.2 × 149.2 cm). The Metropolitan Museum of Art, Gift of the family of Mrs. Candace Wheeler, 1928 (28.34.1)

dered in painterly fashion that she executed as curtains for a major New York theater and as draperies and portieres for the houses of the rich or famous, including Cornelius Vanderbilt II of New York, Mrs. Potter Palmer of Chicago, and Lillie Langtry, the English actress.[119] The irony is particularly sharp since these hangings were the ones Wheeler herself valued most, and of all her work they were most often illustrated and described in the press. Only an occasional critic complained of the weakness of the figure drawing or questioned the appropriateness of the subjects to the medium. Also much published during the 1880s was a tapestry-like hanging on which Wheeler had her workers render Raphael's cartoon *The Miraculous Draught of Fishes* (about 1519). Her interest in

tapestries, or in imitations of them, led her in 1883 to patent an "American tapestry" method, in which embroidery techniques were combined with weaving on a heavy jacquard-woven silk canvas carrying the colors of the design in the woof.

Wheeler's press was large and for the most part favorable. A regular section of the *Art Amateur,* "Art Needlework," frequently reported on commissions that Wheeler's studios executed for Associated Artists; in May 1881 it was noted that "one of the handsomest portieres yet produced by the Associated Artists . . . is in tapestry stitch and appliqué on the new material manufactured for their service. . . . [It] is a reproduction of the picture of 'Titian's Daughter.'" Materials, colors, and stitches were subsequently detailed, and the "effect" was assessed as "indescribably rich."[120] The anonymous author of an article on the Society of Decorative Art in *Scribner's Monthly* in 1881 was more reserved and critical of Wheeler's work and of the society, whose accomplishments were "to be measured by comparative, rather than absolute standards."[121] Constance Cary Harrison, however, devoted much of *Woman's Handiwork in Modern Homes* to praise of Wheeler's achievements, which she admired further in an article in *Harper's New Monthly Magazine* in 1884.[122]

The publicity Wheeler received not only helped further her own career but also assisted her campaign to have her daughter Dora's needlework designs recognized as true works of art. As Karal Ann Marling has recently pointed out, the virtually untrained amateur mother, whose professional work was circumscribed by "the restraints of cautious amateurism and piecemeal instruction," was determined to assure her daughter's complete freedom from such restraints.[123] Wheeler sought the best fully professional and thorough training in art for Dora. She persuaded her friend the painter WILLIAM MERRITT CHASE (see FIG. 9.15) to instruct Dora and Dora's friend Rosina Emmet. She then delighted in executing her daughter's figural compositions in embroidery (ILL. 3.32). To Wheeler, this work signaled a refusal to accept the limitations placed on embroidery design and the lesser status assigned to it by the South Kensington school.

Although they were mentioned in the press less often than Wheeler, there were other American women who did comparable work. Mary Elizabeth Tillinghast (1845–1912) collaborated with the painter JOHN LA FARGE on textiles for his decorating commissions. A particularly celebrated group of embroidered panels, described as "tapestries," were made by La Farge and Tillinghast in 1883 for Cornelius Vanderbilt II (1843–1899). Some of the panels were described as decorative and conventional, but one, it was reported, related "in embroidery the story of Aeneas' Carthaginian adventures, copied from Raphael's cartoons."[124] The decorative work of MARIA OAKEY DEWING, who during the 1870s studied painting with La Farge and, in Paris, with Thomas Couture (1815–1879), was never widely publicized, perhaps by her own choice. A pair of velvet panels (see FIGS. 9.2, 9.3), embroidered and appliquéd with flowers reminiscent of the still lifes that won her critical acclaim as a painter, are among the few examples of her essays in the decorative arts to survive.[125]

Mrs. Oliver Wendell Holmes, one of the most active members of Boston's Society of Decorative Art, shared Wheeler's opinion that embroiderers might use their needles as painters did their brushes. Her landscapes and marine scenes, demonstrating that she, like Wheeler, held "enlarged views as to the legitimate scope of embroidery,"[126] were exhibited at the New York society. In 1881 a critic for *Scribner's Monthly* judged Mrs. Holmes not as an embroiderer but as "one of the most sensitive colorists among American artists."[127] Mary Gay Humphreys, however, writing in the *Art Amateur* that same year, found her work "but little more than curious entertainment" and concluded that "the effects sought for are those which belong to the palette and brush, and can be much better achieved by them."[128]

Disagreement over the proper character of "art" as applied to

ILL. 3.32 *Alice Pyncheon.* Designed by Dora Wheeler, embroidered by Candace Wheeler, 1887. Embroidered cotton, 74 × 50½ in. (188 × 128.3 cm). Signed: *AA / 1887, DW.* The Cleveland Museum of Art, Gift of Mrs. Boudinot Keith

embroidery ran through the pages of the *Art Amateur,* the *Art Interchange, Godey's Lady's Book,* and other popular magazines during the 1880s. Some writers described as "art embroidery" the painterly creations of Wheeler, Tillinghast, and Holmes, as well as similar work by a Mrs. Weld of Boston and a Miss Carolina Townshend of Albany.[129] Others disparaged such work and applied the term only to the conventional South Kensington embroidery. Many magazine writers rehearsed South Kensington theories and promptly reviewed new books associated with the English embroidery school, often printing long excerpts from them.[130] The writers sometimes mentioned a "Kensington stitch," which was simply the currently stylish name for a quite ordinary backstitch that was particularly useful for outlining.[131] Most of the motifs printed as embroidery patterns in the magazines were in the stylized manner of South Kensington. The embroiderer of the swirling design of cattails on the mantle in figure 3.22 could well have relied on one of these patterns. The subdued, monochromatic effect of the browns on khaki was especially associated with work of the school of the Royal Society of Art Needlework.[132] The motifs themselves suggest Japanese sources, whereas the swirling forms perhaps derive from patterns by Morris.

The focus on "art embroidery" encouraged the production of ambitious, large-scale wall hangings, portieres, and screens. A heightened awareness of the possibilities the medium offered, combined with the fact that it was handwork, helped interest American artists in embroidery. Not only was handwork revered by followers of Ruskin and Morris, but executing embroidery de-

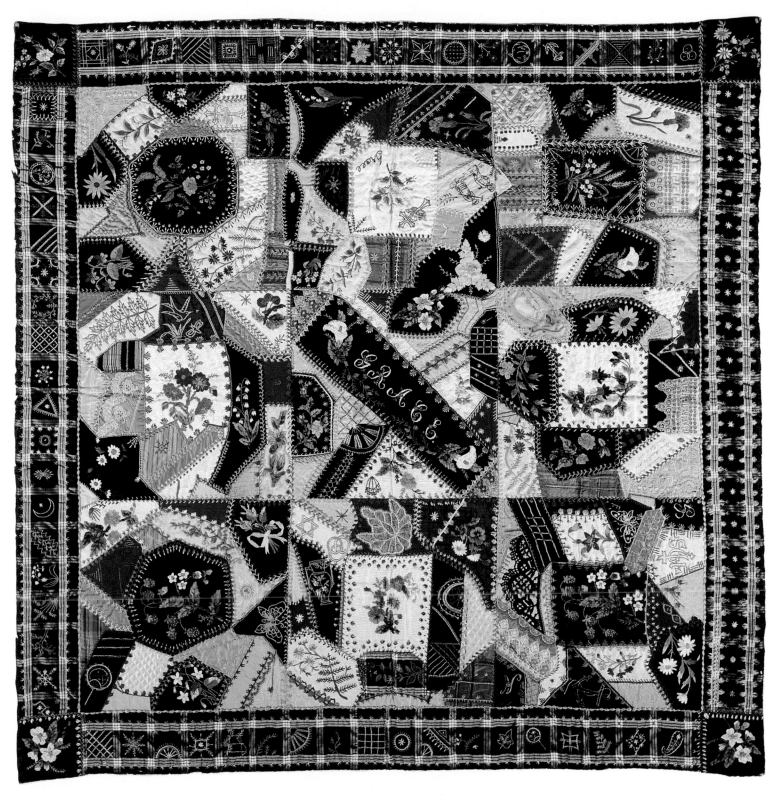

FIG. 3.23 Memorial crazy quilt. Tamar North, North's Landing, Ind., ca. 1877. Embroidered silk, wool, cotton, 54 × 54 in. (137.2 × 137.2 cm). The Metropolitan Museum of Art, Gift of Mr. and Mrs. John S. Cooper, 1983 (1983.349)

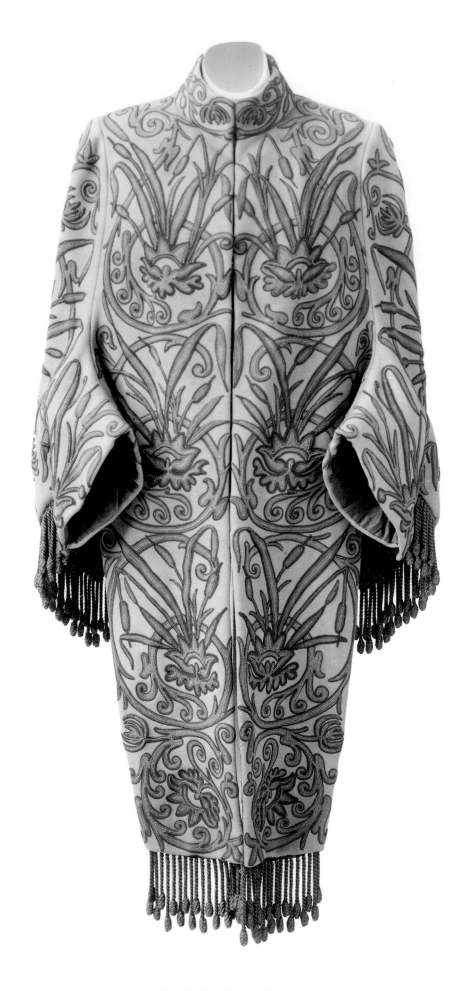

FIG. 3.22 Mantle. American, ca. 1885. Embroidered melton, l. at center back 45 in. (114.3 cm). Museum of Art, Rhode Island School of Design, Providence, Gift of the Society for the Preservation of New England Antiquities (S.83.185.39)

signs, or having them executed, was much simpler than arranging for the manufacture of patterns for machine-printed or -woven textiles. In addition to the American artists who have already been mentioned, at least one well-known American architect designed embroidery. The catalogue for an exhibition of the Boston Society of Decorative Art in 1879 lists "Sunflowers, Panel of Screen: Worked by Mr. Arthur Little" and "Apples Worked by Mr. Arthur Little." Little (1852–1925), an architect who worked in the Shingle style, was also an officer of the Boston society.[133]

If embroidery was the textile medium most favored by American artists, it was also the one to which women with no pretense to the status of artist most often applied their talents. During the late 1870s many American women began applying those talents to the making of "crazy quilts." The taste for things Japanese first cultivated by aesthetes in Paris and London was probably more widely popularized by crazy quilts than by any other textile medium. The magazines were recognizing a crazy quilt "mania" by 1882, when a piece in the *Art Amateur* recounted, "When the present favorite style of quilt was introduced it was called the Japanese, but the national sense of humor has been too keen, and the Japanese is now generally known as the 'crazy' quilt."[134] Although these patchwork quilts seemed comical to Americans, they were based on a quite ancient and serious Japanese tradition: *kirihame,* a technique whose complex effects, achieved with both appliqué and patchwork, were prized in Japan as early as the sixteenth century. An elegant robe preserved in the Uesugi Shrine, Yamagata Prefecture, Japan, exhibits many of the basic elements of *kirihame.* The robe, made about 1560 for a samurai, is a patchwork of the finest silks, many of them from outside Japan and prized for their rarity. Angular patches of various sizes form wide, straight-edged strips that are sewn together to give a striped effect. Sharp diagonals, jagged and randomly placed, cross the strips of patches at odd angles, marking the seams between contrasting fabrics.[135]

Kirihame techniques were still being employed in the nineteenth century and must have been used in some of the Japanese trade goods sold in American shops. They probably inspired women accustomed to patching cottons together in symmetrical arrangements to break with the old rigidity. In any case, these crazy quilts, heavily embellished with an artful array of decorative stitches along every seam, appear to have been made in America before they were in England, which makes them an exception to the general rule that Japanesque styles arrived in the United States by way of England, or at least after they had become the fashion there.[136] The crazy quilt shown in figure 3.23 is but one of hundreds that survive from the Aesthetic era. Like their Japanese models, many of these quilts incorporated treasured fabrics, usually silks and velvets, from favorite dresses, worn-out upholstery, or even men's ties. Tamar North of North's Landing, Indiana, made the quilt shown here in memory of her only daughter, Grace, who died in 1877 at the age of twenty-one. The embroidered motifs depict an array of naturalistically rendered flowers, including calla lilies and sunflowers, as well as Japanese fans and vases and figures of children like those pictured in books written and illustrated by the English author Kate Greenaway (1846–1901). They might well have been based on the patterns for just this sort of work that late nineteenth-century magazines published in great numbers.

A crazy quilt seems a fitting object with which to end a survey of the impact of the Aesthetic movement on surface ornament in wallpapers, carpets, and textiles used and made in America. It represents one of the most popular, and in some ways the most trivialized, American spin-offs from the English-born movement, yet as a form it is free from direct English precedent. It incorporates a great many symbols and materials that personalize and localize it. It suggests the way the pursuit of beauty in America brought together motifs from nature and from many cultures, then rendered them in styles that range from the painterly and pictorial, through the conventional, to the geometric. Behind the apparent haphazardness in this juxtaposition of many ways of rendering imagery lies a surprisingly coherent dispute about the methodology appropriate to ornamental design. In crazy quilts as in the rooms covered in surface ornament with which chapter 2 begins, the dilution and reconciliation of divergent ideas, in forms that have come through the filters of commerce, popularization, and sentimentalization, have left weakened images of the models that inspired them. The images have often been rendered in a manner directly and knowingly linked with theoretical, even moral, justifications. Before a popular press published theories about ornament and suggested, both in words and in illustrations, how to apply those theories, embroiderers and home decorators had probably never had such links called to their attention.

During the Aesthetic era major designers, and even the anonymous creators of the most inexpensive or amateur ornamentation for home furnishings, paid homage in their products to theories of design. Concern for the moral issues raised in the nineteenth-century design literature is foreign indeed to the thinking of decorative artists of most other periods. Journalists, advertisers, and tastemakers introduced unprecedented numbers of decorators, paperhangers, and stitchers to design theories and convinced creators and consumers alike that they should care about these ideas.

Like the furnishers of so many rooms of the 1880s whose twisted interpretation of Ruskin's ideas emerged as a faith in the power of ever more "art" images and objects to render ever more good, the woman who created this quilt, so laden with ornamental imagery, perhaps overread the favorite theories of the day. Against such overreading the succeeding generation now appears to have been overreacting in its rush to demonstrate that less is more. Vestiges of reaction against the excesses of the late nineteenth century still linger. But a century later, as we begin to recover from a multiple series of overreadings and overreactions, we can once again share some of the delight the Aesthetic era took in its rooms and objects. Among the many, many patterns and ornaments of the 1870s and 1880s some endure as things of lasting beauty, the products of unprecedented and subsequently unmatched thinking and debating about principles of ornamental design.

NOTES

1. Perry's first expedition had arrived in Japan in July 1853. According to Elizabeth Aslin, *The Aesthetic Movement: Prelude to Art Nouveau* (New York and Washington, D.C., 1969), p. 80, in 1854 an exhibition of Japanese applied art was mounted "in the gallery of the Old Water Colour Society in Pall Mall East," and from that exhibition Richard Redgrave and Henry Cole made purchases for their Science and Art Department; see also Catherine Lynn, "Decorating Surfaces: Aesthetic Delight, Theoretical Dilemma," this publication. Martin Eidelberg and

William R. Johnston, "Japonisme and French Decorative Art," in Cleveland Museum of Art, *Japonisme: Japanese Influence on French Art, 1854–1910* (exhib. cat., 1975), p. 143, refer to La Porte Chinoise, which had been founded as a tea-importing house in 1826, as an important Parisian source for Japanese curios in the late 1850s. They cite the Japanese government's exhibition at the Exposition Universelle in Paris in 1867 as a major catalyst in stirring Western interest in Japanese goods. Alison Adburgham, *Liberty's: A Biography of a Shop* (London, 1975), pp. 19–26, chronicles the early years of Liberty and Company.

2. See Aslin, *Aesthetic Movement,* p. 81; and Julia

Meech-Pekarik, "Early Collectors of Japanese Prints and the Metropolitan Museum of Art," *Metropolitan Museum Journal* 17 (1982), pp. 93–118. For accounts of other American collectors of oriental objects, see T. J. Jackson Lears, *No Place of Grace: Antimodernism and the Transformation of American Culture, 1880–1920* (New York, 1981), esp. pp. 186–90, 225, 228.

3. Wilson H. Faude, "Associated Artists and the American Renaissance in Decorative Arts," *Winterthur Portfolio* 10 (1975), p. 102. See also Constance Cary Harrison, *Woman's Handiwork in Modern Homes* (New York, 1881), ill. opp. p. 58, for a portiere designed by Tiffany. The pattern on the portiere is

formed by regular divisions of hexagons, as were many "Arabian" and "Persian" ornaments illustrated in Owen Jones, *The Grammar of Ornament* (1856; [3d ed.] London, 1868).

4. Among his many books, see John Ruskin, *The Seven Lamps of Architecture* (1849), vol. 8 of *The Works of John Ruskin,* ed. E. T. Cook and Alexander Wedderburn [library ed.], 39 vols. (London and New York, 1903–12); and idem, *The Two Paths, Being Lectures on Art and Its Application to Decoration and Manufacture* (1859), vol. 16 of *Works of John Ruskin.*

5. For discussion and illustrations of English wallpapers and embroideries of this period, see Aslin, *Aesthetic Movement.* For discussion of English studies of the influence of aestheticism on embroidery, see Barbara Morris, *Victorian Embroidery* (New York, 1962), pp. 113–42; and Joan Edwards, *Crewel Embroidery in England* (New York, 1975), pp. 160ff. For related American work, see Georgiana Brown Harbeson, *American Needlework* (New York, 1938), pp. 159–65. For English wallpapers of the mid- and late nineteenth century, see Brenda Greysmith, *Wallpaper* (New York, 1976), pp. 128–61; and Jean [D.] Hamilton, "British Wallpapers from the Later Nineteenth Century to the Present Day," in Charles C. Oman and Jean [D.] Hamilton, *Wallpapers: A History and Illustrated Catalogue of the Collection of the Victoria and Albert Museum* (London, 1982), pp. 63–67. For American wallpapers of the period, see Samuel J. Dornsife, "Wallpaper," in *The Encyclopaedia of Victoriana,* ed. Harriet Bridgeman and Elizabeth Drury (New York, 1975); Catherine Lynn, *Wallpaper in America: From the Seventeenth Century to World War I* (New York, 1980); and Richard C. Nylander, Elizabeth Redmond, and Penny J. Sander, *Wallpaper in New England* (Boston, 1986).

6. For studies of American textiles, see Florence H. Pettit, *America's Printed and Painted Fabrics, 1800–1900* (New York, 1970); Jane C. Nylander, *Fabrics for Historic Buildings* (Washington, D.C., 1980); Edgar de Noailles Mayhew and Minor Myers, Jr., *A Documentary History of American Interiors: From the Colonial Era to 1915* (New York, 1980), pp. 193–310; and Florence M. Montgomery, *Textiles in America, 1650–1870* (New York, 1983). For carpets in America, see Anthony N. Landreau, *America Underfoot: A History of Floor Coverings from Colonial Times to the Present* (Washington, D.C., 1976); and Helene von Rosensteil, *American Rugs and Carpets: From the Seventeenth Century to Modern Times* (New York, 1978).

7. To the enormous recent body of literature on quilts has been added a slim, colorful volume on quilts of the type introduced in the 1870s, Penny McMorris, *Crazy Quilts* (New York, 1984).

8. Jones, *Grammar of Ornament,* pls. 31–48. For illustrations of thirteen wallpapers by Jones, see Oman and Hamilton, *Wallpapers,* pp. 346–50.

9. For the purest examples of Pugin's two-dimensional ornamental work, see A. W. N. Pugin, *Floriated Ornament: A Series of Thirty-one Designs* (London, 1849). For illustrations of four of the many wallpaper patterns he designed for the houses of Parliament between 1848 and 1859, see Oman and Hamilton, *Wallpapers,* nos. 1116, 1118, 1123, 1125. Pugin's papers, made by Samuel Scott for J. G. Crace, were perhaps the best-known wallpapers in mid-nineteenth-century England.

10. John A. Cherol, "Château-sur-Mer in Newport, Rhode Island," in Elizabeth Donaghy Garrett, *The Antiques Book of Victorian Interiors* (New York, 1981), pp. 124–29.

11. Charles Locke Eastlake, *Hints on Household Taste in Furniture, Upholstery, and Other Details* (1868; reprinted from the 2d London ed., intro. and notes by Charles C. Perkins, Boston, 1872), p. 116.

12. Most of the factual information given here about Wight's life and loyalties has been taken from Art Institute of Chicago, *P. B. Wight: Architect, Contractor, and Critic, 1838–1925,* by Sarah Bradford Landau (exhib. cat., 1981).

13. "Mr. Wilde and His Gospel," *Critic* 2 (Jan. 14, 1882), p. 14.

14. Morris and Company, *The Morris Exhibit at the Foreign Fair, 1883–84* (Boston, 1883). Color is discussed at length in this booklet.

15. Oman and Hamilton, *Wallpapers,* pp. 363, 369, 381.

16. According to Paul Thompson, *The Work of William Morris* (New York, 1967), p. 91, Indian and Venetian, along with a pattern called Diapers [sic], were issued in 1871. Oman and Hamilton, *Wallpapers,* give about 1868–70 as the date for these three patterns, and for Queen Anne, on p. 381; but on p. 371 they say Diaper was issued about 1870, and on p. 377 they give about 1870 as a date for Queen Anne and about 1871 for Diaper and Venetian.

17. The eight other patterns—Jasmine, Lily, Vine, Powdered, Larkspur, Acanthus, Pimpernel, and Wreath—are illustrated in Oman and Hamilton, *Wallpapers,* pp. 370–72.

18. Boston's reputation prompted the author of "Household Art," *Carpet Trade Review* 4 (Apr. 1877), p. 45, to remark that "vulgarity, on the whole, seems preferable to sham 'culture' of the Charles River Order," and to refer to Beacon Street as a center of the "sham crusade against sham."

19. Isaac Edwards Clarke, *Art and Industry: Education in the Industrial and Fine Arts in the United States,* pt. 1, *Drawing in the Public Schools* (Washington, D.C., 1885), p. ccxvii. This report is U.S. Senate exec. doc. 209, ser. no.1888, 46th Congress, 2d sess.

20. William Dean Howells to Henry James, Aug. 26, 1873, in *W. D. Howells: Selected Letters,* ed. George Arms and Christoph K. Lohmann (Boston, 1979), vol. 2, p. 34, quoted in Eileen Cynthia Boris, "Art and Labor: John Ruskin, William Morris, and the Craftsman Ideal in America, 1876–1915" (Ph.D. diss., Brown University, 1981), p. 121.

21. William Dean Howells, in *Atlantic Monthly* 35 (Aug. 1875), p. 243, quoted in Clara Marburg Kirk, *W. D. Howells and Art in His Time* (New Brunswick, N.J.), 1965), p. 187.

22. Elliott himself designed the study; see Charles Wyllys Elliott, *The Book of American Interiors* (Boston, 1876), p. 107.

23. Harriet Prescott Spofford, *Art Decoration Applied to Furniture* (New York, 1878), p. 184. The essays in this book were originally published anonymously as a series of articles in *Harper's Bazar* and *Harper's New Monthly Magazine,* 1876–77; see Elizabeth K. Halbeisen, *Harriet Prescott Spofford: A Romantic Survival* (Philadelphia, 1935), p. 166.

24. William Morris, *The Decorative Arts: Their Relation to Modern Life and Progress, an Address Delivered Before the Trades' Guild of Learning, of London* (London and Boston, 1878), p. 6. This address was later included, under the title "The Lesser Arts," in William Morris, *Hopes and Fears for Art: Lectures on Art and Industry* (1882), vol. 22 of *The Collected Works of William Morris,* ed. May Morris, 24 vols. (London, 1910–15), pp. 3–27.

25. The other patterns include Rose, Bower, Chrysanthemum, Apple, Acorn, Poppy, Saint James, Wreath, and Grafton; all are illustrated in Oman and Hamilton, *Wallpapers,* pp. 373–74.

26. See Morris and Company, *Morris Exhibit.*

27. Morris, *Decorative Arts,* p. 7. See also Luther Hooper, "The Sunflower: A Botanical, Historical, and Esthetic Account of the Favorite Flower," pts. 1, 2, *Decorator and Furnisher* 1 (Oct. 1882), p. 17; (Nov. 1882), p. 50. Significantly, these were the first two issues of the magazine.

28. Morris, *Decorative Arts,* p. 7.

29. William Morris, *Some Hints on Pattern Designing: A Lecture Delivered at the Working Men's College, London, on December 10, 1881* (London, 1899), p. 24.

30. An observation of Thompson, *Work of William Morris,* p. 91.

31. For period photographs of rooms decorated with Morris papers, see Lynn, *Wallpaper,* pp. 383–91, 413, 457, 471. For further documentation of their popularity in America, see Boris, "Art and Labor," pp. 120–29.

32. In 1871 J. M. Bumstead and Company of Boston was serving as Morris's authorized agent for wallpapers, tiles, stamped and unstamped velvets, curtain stuffs, carpets, and laces; see Clarke, *Art and Industry,* p. ccxvii. In 1873 Bumstead and Company of Boston was mentioned as American agent for Morris and Company in "Culture and Progress: The William Morris Window," *Scribner's Monthly* 6 (June 1873), p. 245. By September 1882 Elliot and Goodwin of New York was advertising that it was American agent for Morris and Company; see *Art Interchange* 9 (Sept. 28, 1882), p. 68. The firm sold Morris wallpapers, chintzes, tapestries, furniture, silks, crewels, carpets, velvets, serges, tiles, and embroidery silks. A successor firm, Elliot and Bulkley, became Morris's agent in 1883, according to Boris, "Art and Labor," p. 122. In 1885 yet another successor firm, A. E. Bulkley, 14 East Fourteenth Street, New York, advertised on the front cover of the *Decorator and Furnisher* 7 (Nov. 1885) that it was "The Sole Agent in America" for Morris and Company, whose goods could be bought from its authorized agents: A. H. DAVENPORT AND COMPANY, Boston; W. F. Spingler, Newport, R.I.; B. W. Wooster Furniture Company, Albany, N.Y.; J. L. Earll and Company, Utica, N.Y.; Warner and Jennings, Buffalo, N.Y.; Bradstreet Thurber and Company, Minneapolis, Minn.; John J. McGrath, Chicago; the Robert Mitchell Furniture Company, Cincinnati; P. Hanson Hiss and Company, Baltimore; and C. B. Scott and Company, Philadelphia. Each of these companies in turn placed advertisements in local publications.

33. "Mr. Wilde and His Gospel," p. 14.

34. "Modern Wallpapers," *Furniture Gazette* 4 (May 13, 1876), p. 302.

35. Christopher Dresser, *Principles of Decorative Design* (1873; reprint London, 1973), p. 87.

36. Metford Warner, "The Notebooks of Metford Warner," manuscript, n.d., Library of the Victoria and Albert Museum, London. The set Warner cites as the first Jeffrey and Company produced was designed by Brightwen Binyon; it is described and illustrated in Oman and Hamilton, *Wallpapers,* p. 284 (nos. 772, 773). The frieze from this set was used at Château-sur-Mer in Newport, R.I.; see Lynn, *Wallpaper,* pp. 348–49.

37. Dresser's lectures were printed in *Penn Monthly,* Jan.–Mar. 1877, pp. 15–16; see David A. Hanks, *The Decorative Designs of Frank Lloyd Wright* (New York, 1979), pp. 3–5. The lectures were mentioned in Walter Smith, *Examples of Household Taste* (New York, copr. 1875 [1880?]), p. 473, also issued as Walter Smith, *Industrial Art,* vol. 2 of *The Masterpieces of the Centennial International Exhibition* (Philadelphia, copr. 1875 [1877?]).

38. The design patents bear the numbers 9,975–87; see Lynn, *Wallpaper,* pp. 396–97.

39. See also Christopher Dresser, *Japan: Its Architecture, Art, and Art Manufactures* (London and New York, 1882).

40. For a description of Lincrusta-Walton, a wall covering with a linseed-oil base, and of other wall coverings with patterning in relief, see Lynn, *Wallpaper,* pp. 432–43.

41. Advertisement of H. Bartholomae and Company, New York, makers and importers of wallpapers, in *New York Life* 2 (Sept. 27, 1883), p. ii.

42. Handbill of DeZouche and Co., 101 Fifth Avenue, Pittsburgh, with the heading "Pittsburgh, February, 1877," in the Strong Museum, Rochester, N.Y. I thank Rodris Roth, National Museum of American History, Washington, D.C., for sending

me a photocopy of this advertisement; Roth in turn credits Susan Myers of the Strong Museum for calling it to her attention. See also the advertisement of F. Andress and Company, Cincinnati, in *Illustrated Catalogue of the Art Department, Cincinnati Industrial Exposition, 1882* (Cincinnati, 1882), unpaged, 3d p. from end. Kenneth R. Trapp, The Oakland Museum, Calif., was kind enough to produce a copy of this catalogue for me. For a New York advertisement also listing papers "after Morris, Dresser, Eastlake," see Lynn, *Wallpaper*, p. 388.

43. Harrison, *Woman's Handiwork*, p. 136.

44. W., "An Exhibition of Wall-Papers," *Scientific American Supplement* 7 (Apr. 12, 1879), p. 2718, reprinted from *American Architect and Building News*. One of Root's designs for McGrath was described in "Art Notes," *Inland Architect and Builder* 1 (Nov. 1883), unpaged, as "a dado and border, a wallpaper and frieze . . . characteristic, bold, and artistic."

45. *Carpentry and Building* 2 (Dec. 1880), pp. 221–24; Lynn, *Wallpaper*, pp. 387–88, 398, 412.

46. Compare Clarence Cook, *"What Shall We Do with Our Walls?"* (New York, 1880), pl. opp. p. 24 (see ILL. 3.13), with Jones, *Grammar of Ornament*, pl. 91.

47. "Unique India Designs of Lockwood de Forest" were advertised by Warren, Fuller and Lange in *Art Amateur* 12 (Mar. 1885), back cover. The advertisement is illustrated in Faude, "Associated Artists," p. 127.

48. M. G. Van Rensselaer, "The Competition in Wall-Paper Designs," *American Architect and Building News* 10 (Nov. 26, 1881), pp. 251–52.

49. Candace Wheeler, "Decoration of Walls," *Outlook: A Weekly Newspaper*, Nov. 2, 1895, p. 706, quoted in Faude, "Associated Artists," p. 127.

50. For examples, see Lynn, *Wallpaper*, pp. 392, 414–15, 423, 433–34, 436–38.

51. Trellis is illustrated in Oman and Hamilton, *Wallpapers*, p. 363.

52. For examples of American patterns borrowed more faithfully from Japanese and high-style Anglo-Japanesque sources, see Lynn, *Wallpaper*, pp. 392, 437.

53. See "The Aesthetic in Wallpaper Manufacture," *Frank Leslie's Illustrated Newspaper* 54 (May 27, 1882), p. 219; "Philadelphia Letter," *Decorator and Furnisher* 1 (Oct. 1882), p. 20; and R. H. Pratt, "Dados," *Decorator and Furnisher* 4 (July 1884), p. 139.

54. Eastlake, *Hints on Household Taste*, pp. 109–10, 113–14; Clarence Cook, *The House Beautiful: Essays on Beds and Tables, Stools and Candlesticks* (1878; reprint New York, 1980), pp. 49–56.

55. *Carpet Trade* 11 (Oct. 1880), p. 7.

56. Aslin, *Aesthetic Movement*, p. 65, quotes contemporary descriptions of Godwin's designs.

57. "Sarah Bernhardt's Fancy," *Carpet Trade Review* 7 (Nov. 1880), p. 220.

58. "In Active Service: Veteran Carpet Patterns at the Front. Pioneer Persian Three-Plys—Designs Which Have Reached Their Twentieth Year and Are Still Selling—Points about Popular Taste," *Carpet Trade and Review* 14 (Oct. 1, 1883), p. 26. Another, similar pattern, designed for the Hartford Carpet Company in 1864 by Levi G. Malkin, was also illustrated as "A Home Production" still selling well.

59. This description is derived from the definition of "Smyrna carpet or rug" in *History and Manufacture of Floor Coverings* (New York, 1899), p. 94.

60. Harrison, *Woman's Handiwork*, p. 138.

61. The name of Bigelow's firm and its location changed several times during the nineteenth and early twentieth centuries. I use here the corporate name that appeared in George Wallis, *New York International Exhibition: Special Report to the House of Commons . . . February 6, 1854* (London, 1854), p. 32. Wallis wrote, "The most interesting carpet manufac-

tory in the United States is without doubt, that of the Bigelow Carpet Company, Clinton, Massachusetts. In this establishment the manufacture of Brussels carpets by power is fully and completely carried out, and a fabric manufactured, which . . . is of exceptional character." The industry statistics are taken from "Our Carpet Mills," *Carpet Trade* 11 (Jan. 1880), pp. 11–13.

62. "The Spring Styles," *Carpet Trade* 10 (Jan. 1879), p. 17.

63. Advertisements for "art squares" were placed by Thomas Leedom and Company, Philadelphia, in *Carpet Trade and Review* 17 (Apr. 15, 1886), p. 5; Hemphill, Hamlin and Company, New York, *Carpet Trade and Review* 17 (May 15, 1886), p. 1; and the Hyatt Company, New York, *Carpet Trade and Review* 18 (July 1, 1887), p. 64. I can only speculate that the "Kensington art squares" advertised by Joseph Wild and Company, New York, in *Carpet Trade and Review* 17 (Aug. 15, 1886), p. 20, and Boyd, White and Company, Philadelphia, *Carpet Trade and Review* 17 (Apr. 15, 1886), p. 16, might have been conventionalized patterns woven in seamless ingrain carpets three or four yards wide.

64. *Carpet Trade and Review* 18 (July 1, 1887), p. 128.

65. "Good Taste," *Carpet Trade* 11 (Aug. 1880), p. 11.

66. A Well-known Brussels Designer, "Floral Brussels Designs," *Carpet Trade* 13 (Feb. 1882), pp. 25–26.

67. H. Kuenemann, "Nature in Industrial Design," *Carpet Trade and Review* 18 (Aug. 15, 1887), p. 36, paraphrasing Ruskin, *Two Paths*, p. 290.

68. "The Spring Styles," *Carpet Trade* 10 (Jan. 1879), pp. 17–22. Henry Davis, "Styles in Art," *Carpet Trade Review* 9 (Apr. 1882), p. 30, referred to "the Japanese ornament [that] has also, within the last four years, been largely applied to designs for carpets." In "A Matter of Taste," *Carpet Trade and Review* 15 (Feb. 15, 1884), p. 39, a "veteran carpet dealer" wrote that "Japanese designs and realistic patterns seem to have had their day, and are virtually laid aside for a time."

69. Among the many articles by, on, and quoting from Morris and Dresser in the press of the carpet trade the following are of interest: William Morris, "Historical Development of Pattern Designing," *Carpet Trade* 10 (June 1879), pp. 19–20; "Harmony of Colors," *Carpet Trade* 11 (Feb. 1880), pp. 16–17; "A Few Words to Mr. Dresser," *Carpet Trade Review* 7 (Sept. 1880), p. 172; "The Decay of Eastern Art" [excerpts from Morris's lecture "The Lesser Arts"; see note 24 above], *Carpet Trade and Review* 13 (July 1882), p. 25; "Arraigning Mr. William Morris," *Carpet Trade and Review* 15 (Nov. 1, 1884), p. 47; and "Dr. Dresser on Carpet Design," *Carpet Trade and Review* 16 (Jan. 15, 1885), pp. 33–34.

70. Kuenemann, "Nature in Industrial Design," p. 36.

71. Dresser, *Principles of Decorative Design*, p. 104.

72. The anonymous author of "The Power to Design a Source of National Wealth and Prosperity," *Carpet Trade* 10 (Aug. 1879), pp. 13–14, wrote, "We have made vast strides in the right direction since Mr. Dresser so coolly judged us." The author of "Are We Progressive?" *Carpet Trade Review* 7 (Sept. 1880), p. 170, noted that "Mr. Dresser's onslaught upon American taste in carpets has awakened considerable discussion." F. E. Fryatt, "Domestic Designing," *Carpet Trade* 12 (July 1881), pp. 13–14, remarked that "Mr. Dresser so strongly denounced . . . our depraved taste. Up to a certain time America . . . had not given much consideration to the luxuries that call for the employment of decorative art. . . . The true tendency is now toward the development of a purely American school of art in carpet design." Fryatt went on to laud the founding of a school of carpet design in New York as the nucleus of that development.

Fryatt was referring to the New York Institute of Technical Design for Women, which opened at 351 West Twenty-fourth Street on October 27, 1881. According to "Women Carpet Designers," *Carpet Trade* 9 (May 1879), p. 12, the principal of the institute, Mrs. Florence E. Cory, "a practical carpet designer" from Oswego, N.Y., had been a teacher of the normal class at the Cooper Union for the Advancement of Science and Art in New York. In the *Carpet Trade* 12 (Oct. 1881), p. 13, Cory was lavishly praised as "an energetic and enterprising young lady" who had been "accorded well-merited patronage by many of the most prominent of our carpet manufacturers." Her stated intention, printed in the *Carpet Trade and Review* 13 (Oct. 1882), p. 25, was to give "advantages to ladies which they cannot otherwise obtain, leaving to the sterner sex the opportunities that have always been theirs." Mary Gay Humphreys, "Instruction in Carpet Designing," *Art Amateur* 6 (Apr. 1882), p. 100, is an admiring and detailed account of Cory's school. Through the mid-1880s and into the 1890s the *Carpet Trade and Review* published articles and letters to the editor discussing the merits and dangers of training women in technical design, as well as the more general question of the validity of teaching carpet design in technical schools. The magazine featured the activities of Cory and her pupils and published their designs. It also gave accounts of a rival Woman's Institute of Technical Design (which was opened in New York in 1882 by Cory's former partner, Mrs. Florence A. Densmore) and reported on activities at the School of Design for Women at the Cooper Union in New York, and at the technical and design schools in Philadelphia, Boston, and Lowell, Mass. Writers in the magazine discussed teaching methodology and appropriate curricula, and they also argued rather fiercely about the role of women in designing carpets. In "Industrial Designs and Decorative Art," *Carpet Trade and Review* 16 (May 15, 1885), p. 38, one writer observed that "while many women study decorative design for pleasure, a large class have learned it as well as a means of support." The realization that this was the case brought some enthusiastic endorsements, but it also provoked acrimonious objections to women's working in the carpet profession because, as the author of "Among the Studios," *Carpet Trade Review* 9 (Jan. 1882), p. 51, put it, women were "merely using it as a means of getting a livelihood until the inevitable husband comes along."

73. *Scribner's Monthly* 6 (June 1873), p. 245.

74. William Morris, quoted in Birmingham Museums and Art Gallery, Eng., *Textiles by William Morris and Morris and Co., 1861–1940*, by Oliver Fairclough and Emmeline Leary (exhib. cat., 1981), p. 51.

75. "A New Manufacture," *Carpet Trade Review* 7 (Aug. 1880), p. 149. The introduction of Hammersmiths was also noted in "Mr. Morris Makes a Move," *Carpet Trade* 11 (Aug. 18, 1880), p. 22.

76. "Carpet Decoration," *Carpet Trade* 10 (Apr. 1879), p. 18, reprinted from *Art Interchange*. The author of this article observed, "Morris was the first to abandon Brussels carpets and their miserable imitations called 'tapestry'—those with the patterns merely printed on. He brought out . . . a Kidderminster carpet of stout make, of designs of his own and of coloring peculiar to his own style of decoration. . . . In Morris' hands the despised Kidderminster, which up to that time was used only for bedrooms, or housekeepers' rooms, became a thing of beauty. . . . The idea in all was much the same as in his wallpapers—the use of tertiary shades and the absence of relief."

77. The design on the remnant, which is now at the Society for the Preservation of New England Antiquities, Boston, is a close variant of a Morris pattern. The words "private pattern" are woven into its backing. In the American carpet industry this phrase was used to mark special-order work; see "In

Active Service," *Carpet Trade and Review* 14 (Oct. 1, 1883), p. 26. But whether it was also used in England is not clear to me. Whether made in America or not, the remnant is a remarkably unfaded example of a type of machine-made carpeting that was acceptable to American decorators in the 1870s and 1880s. The pattern is currently being reproduced for installation in the Sarah Orne Jewett house. For a near duplicate of this carpet, see Birmingham Museums and Art Gallery, *Textiles by William Morris*, p. 102 (no. C11A).

78. See "Spring Carpet Styles," *Carpet Trade* 9 (Jan. 1878), p. 18, the Philadelphia firm of Boyd, White and Company's showing of floor oilcloths by R. H. and B. C. Reeve. Nos. 116, 118, 196 are "Morris" designs; no. 129 is a "Dresser" pattern.

79. "Parisian Fancies," *Carpet Trade Review* 7 (Nov. 1880), p. 223.

80. See especially "Spring Carpet Styles," *Carpet Trade* 9 (Jan. 1878), pp. 15–19; and "The Spring Styles," *Carpet Trade* 10 (Jan. 1879), pp. 17–22.

81. Eastlake, *Hints on Household Taste*, pp. 112–15.

82. "Aestheticism in Carpets," *Carpet Trade* 13 (May 1882), pp. 27–28.

83. Birmingham Museums and Art Gallery, *Textiles by William Morris*, pp. 92, 99.

84. For the "authorized agents" of Morris and Company from 1871 to 1885, see note 32 above. The list is far from complete. In Boston in 1879, for example, E. H. Bradbrook was offering "all colors of Silk and Wool, Wool and Cotton Fabrics from 'MORRIS' and from the English and French Manufactories," according to their advertisement in Boston Society of Decorative Art, *Catalogue of a Loan Exhibition in Aid of the Boston Society of Decorative Art, January 1879* (exhib. cat., 1879), p. 2. A. H. Davenport and Company had evidently taken over Bradbrook by 1881.

85. Morris coined the term "weavers' flowers," which he used in 1881 in *Some Hints on Pattern Designing*, p. 27.

86. Eastlake, *Hints on Household Taste*, p. 95.

87. Fine Art Society Limited, London, *Christopher Dresser, 1834–1904*, by Stuart Durant et al. (exhib. cat., 1972), unpaged, 3d p. from end.

88. For other Talbert textiles, see Aslin, *Aesthetic Movement*, pp. 117–18.

89. Yale University Art Gallery, New Haven, *The Kashmir Shawl*, by Sarah Buie Pauly (exhib. cat., 1975), pp. 30–35.

90. Clay Lancaster, *The Japanese Influence in America* (New York, 1963), p. 217.

91. See, for example, the advertisement of the First Japanese Manufacturing and Trading Company, *New York Times*, Dec. 13, 1880.

92. "Japan in Miniature," *Carpet Trade and Review* 16 (Dec. 15, 1885), p. 35.

93. *Dixie*, Mar. 1886, p. 128.

94. *Appleton's Journal, a Magazine of General Literature* 14 (July 24, 1875), p. 121.

95. Madeleine Stern, *We the Women: Career Firsts of Nineteenth-Century America* (New York, 1963), p. 189; see also Candace Wheeler, *Yesterdays in a Busy Life* (New York and London, 1918).

96. For more information about the John Sloane house and its decoration, see Dianne H. Pilgrim, "Decorative Art: The Domestic Environment," in Brooklyn Museum, *The American Renaissance, 1876–1917* (exhib. cat., 1979), pp. 143–45.

97. The room is also illustrated in William Seale, *The Tasteful Interlude: American Interiors Through the Camera's Eye, 1860–1917* (New York, 1975), pp. 74–75. I thank Ann Coleman, The Brooklyn Museum, for pointing this out. The chances that Christian Herter himself might have designed textile patterns are enhanced by the fact that in 1878 he registered in the U.S. Patents Office twelve designs for wallpaper

patterns; see Lynn, *Wallpaper*, pp. 385–97.

98. An exhibition drawn from this collection, *Just New from the Mills: Printed Cottons in Victorian America*, was mounted in 1984 by Diane L. Fagan Affleck, Museum of American Textile History, North Andover, Mass., which at that time was called the Merrimack Valley Textile Museum. Lawrence and Company of Boston, New York, and Philadelphia, whose name appears on all the sample cards, were the sales representatives for Cocheco.

99. See Yale University Art Gallery, *Kashmir Shawl*.

100. Stern, *We the Women*, p. 277.

101. Arachne [pseud.], "Propriety in Needlework Decoration," *Art Amateur* 10 (Mar. 1884), pp. 90–91, mentions the New York, Philadelphia, Boston, Chicago, and San Francisco societies. The society in Rochester, N.Y., is noted in "Amateur Decorative Societies," *Carpet Trade and Review* 13 (Aug. 1882), p. 34; the one in Saratoga, N.Y., in *American Architect and Building News* 3 (Mar. 30, 1878), p. 109; the one in Baltimore in *Crockery and Glass Journal* 10 (Dec. 18, 1879), p. 26, and in "Decorative Exhibition," *Carpet Trade and Review* 14 (June 15, 1883), p. 42.

102. Arachne, "Propriety in Needlework Decoration," p. 90. In Candace Wheeler's lengthiest account of her society, *The Development of Embroidery in America* (New York and London, 1921), p. 110, she recalled that "graduates from the Kensington School were employed as teachers in nearly all of the different societies, and in this way every city became the center of this new-old form of embroidery."

103. Birmingham Museums and Art Gallery, *Textiles by William Morris*, pp. 21, 28.

104. Elliot and Goodwin of New York were selling Morris crewels in 1882, according to "Materials for Decorative Work," *Art Interchange* 7 (June 8, 1882), p. 136; see also notes 32, 84 above.

105. Morris, *Victorian Embroidery*, pp. 19–31. M[arianne M.] Alford, *Needlework as Art* (London, 1886), pp. 49–50 (n. 1), appreciated Morris's color, its "sobriety and tenderness."

106. Morris, *Victorian Embroidery*, p. 115.

107. Mary Gay Humphreys, "The Royal School of Art Needlework," *Art Amateur* 11 (Sept. 1884), p. 88.

108. See Gilbert R. Redgrave, *The Manual of Design, Compiled from the Writings and Addresses of Richard Redgrave* (London and New York, 1876). Richard Redgrave was one of the leaders in the English campaign to reform design education, which is discussed in Lynn, "Decorating Surfaces," this publication.

109. Alford, *Needlework as Art*, pp. 77, 69.

110. Humphreys, "Royal School," p. 88.

111. Although the design for this screen has been assigned to Crane by the Royal School of Art Needlework based on drawings attributed to him, it could also have been designed by another of the artists who did work for the school. Walter Smith, in *Examples of Household Taste*, did not credit Crane with the design, even though elsewhere in his book he noted him as the designer of work executed at the school. (On p. 172, for instance, Smith discussed the portiere shown in illustration 3.29 as "the most elaborate piece of work in the exhibit of the Royal School of Art Needlework," part of "a complete set of room-hangings designed by the well-known artist, Mr. Walter Crane.") On p. 255 Smith described the screen, which he illustrated on p. 249, as "another of the charming pieces of work designed and executed under the auspices of the Royal School of Art Needlework. . . . The design was doubtless made by one of the artists employed by that institution." In addition, Spofford used a photograph of this same screen as the frontispiece to her *Art Decoration Applied to Furniture* without crediting Crane, and Isabel Spencer makes no mention of this design in her monograph on Crane's work, *Walter Crane* (New

York, 1975).

112. Smith, *Examples of Household Taste*, p. 96.

113. Ibid., p. 203. For a description of the Royal Society's pavilion, see Morris, *Victorian Embroidery*, p. 115.

114. Candace Wheeler, "Art Education for Women," *Outlook: A Weekly Newspaper* 55 (Jan. 2, 1897), p. 85.

115. Stern, *We the Women*, p. 279.

116. Wheeler, "Art Education for Women," p. 85, wrote that "our first efforts were given to the encouragement of innumerable auxiliaries all over the country." The metamorphosis of the sewing circle apparently amused Shirley Dare, "Boston Decorative Art," *Art Amateur* 4 (May 1881), p. 121, who noted, "The Boston Society shares with every small-art club . . . [that it has] changed its style and title from the old-fashioned sewing circle, and plagues Christian eyes with sunflower curtains instead of worrying heathen with flannel bandages."

117. Stern, *We the Women*, pp. 282, 300–301.

118. Wheeler, *Development of Embroidery*, p. 111. Wheeler also noted her preference for silk threads, while the English preferred crewels (woolen threads).

119. Illustrations derived from drawings of four of the hangings are reproduced in Faude, "Associated Artists," pp. 105, 108, 112, 130; seven more appear in Karal Ann Marling, "Portrait of the Artist as a Young Woman: Miss Dora Wheeler," *Bulletin of the Cleveland Museum of Art* 65 (Feb. 1978), pp. 50, 52–54.

120. "Art Needlework," *Art Amateur* 4 (May 1881), p. 127.

121. "The Society of Decorative Art (New York)," *Scribner's Monthly* 22 (Sept. 1881), pp. 697–709.

122. Constance Cary Harrison, "Some Work of the 'Associated Artists,' " *Harper's New Monthly Magazine* 69 (Aug. 1884), pp. 343–51.

123. Marling, "Portrait of the Artist," p. 50.

124. "The Vanderbilt Tapestries," *Carpet Trade and Review* 14 (July 1, 1883), p. 57, reported that "the daily papers have lately been extensively describing the justly celebrated Vanderbilt tapestries."

125. See Jennifer A. Martin [Bienenstock], "The Rediscovery of Maria Oakey Dewing," *Feminist Art Journal* 5 (Summer 1976), pp. 24–27, 44; and idem, "Portraits of Flowers: The Out-of-Door Still-Life Paintings of Maria Oakey Dewing," *American Art Review* (Los Angeles) 4 (Dec. 1977), pp. 48–55, 114–18.

126. "The Associated Artists," *Art Amateur* 12 (Jan. 1885), p. 40.

127. "Society of Decorative Art," p. 708.

128. Mary Gay Humphreys, "Mrs. Holmes' Art Embroideries," *Art Amateur* 4 (May 1881), p. 127.

129. Wheeler, *Development of Embroidery*, p. 115, reminisced about the work of these embroiderers and about that of a Mrs. Dewey of New York (perhaps this represents a misprinting of Maria Oakey Dewing's last name?). See also "Society of Decorative Art," p. 697, where work by Miss Townshend and "Mr. Maynard's allegorical panels" are discussed.

130. For instance, excerpts from M. S. Lockwood and E[lizabeth] Glaister, *Art Embroidery* (London, 1878) and from Elizabeth Glaister, *Needlework* (London, 1880) were printed in "Curtains, Mantel-Hangings, and Piano Fronts," *Art Amateur* 3 (July 1880), pp. 38–39; "Door-Curtains," *Art Amateur* 3 (Sept. 1880), p. 78; and "Needlework Screens," *Art Amateur* 4 (Dec. 1880), p. 9.

131. See, for example, Jane Weaver, "Kensington-Stitch for Outline Embroidery," *Peterson's Magazine* 83 (Jan. 1883), p. 8. I thank Diane L. Fagan Affleck, Museum of American Textile History, North Andover, Mass., for this reference. Humphreys, "Royal School," p. 88, described the South Kensington

stitch as "only the varied use of the stem-stitch, which is common to the embroideries of all nations."

132. Humphreys, "Royal School," p. 88, reported that "what are understood as antique tints are almost exclusively used [at the Royal School of Art Needlework]. Antique tints are simply the result of time and the action of the air on colors which we would not call antique. . . . The finest pieces of color, however, at the Royal School are in different tints of the same hue, using a ground of the deepest shade as the starting point."

133. Boston Society of Decorative Art, *Loan Exhibition,* nos. 48, 54. See also Dare, "Boston Decorative Art," p. 122, for a description of "the large portiere, designed by Mr. Arthur Little, after old English work," which "draws attention from its size and quaint pattern." Little also served on the board of managers of the School for Art Needlework at the Museum of Fine Arts, Boston; see Harbeson, *American Needlework,* p. 118.

134. "'Crazy' Quilts," *Art Amateur* 7 (Oct. 1882), p. 108.

135. Seiroku Noma, *Japanese Costume and Textile Arts* (New York and Tokyo, 1974), fig. 36. On p. 157 Noma notes that "the true purpose of *kirihame* is to achieve a complex effect by combining several simpler designs," and that "the *kirihame* method . . . stretches back to the Heian period, when it was known as *zogan.*" Noma discusses "the preciousness of the cloths used and the great care taken in the way the curves, rectangles, triangles and other motifs are combined in these compositions" on p. 120.

136. McMorris, *Crazy Quilts,* p. 21.

Overleaf: Detail of carved panel (FIG. 4.5)

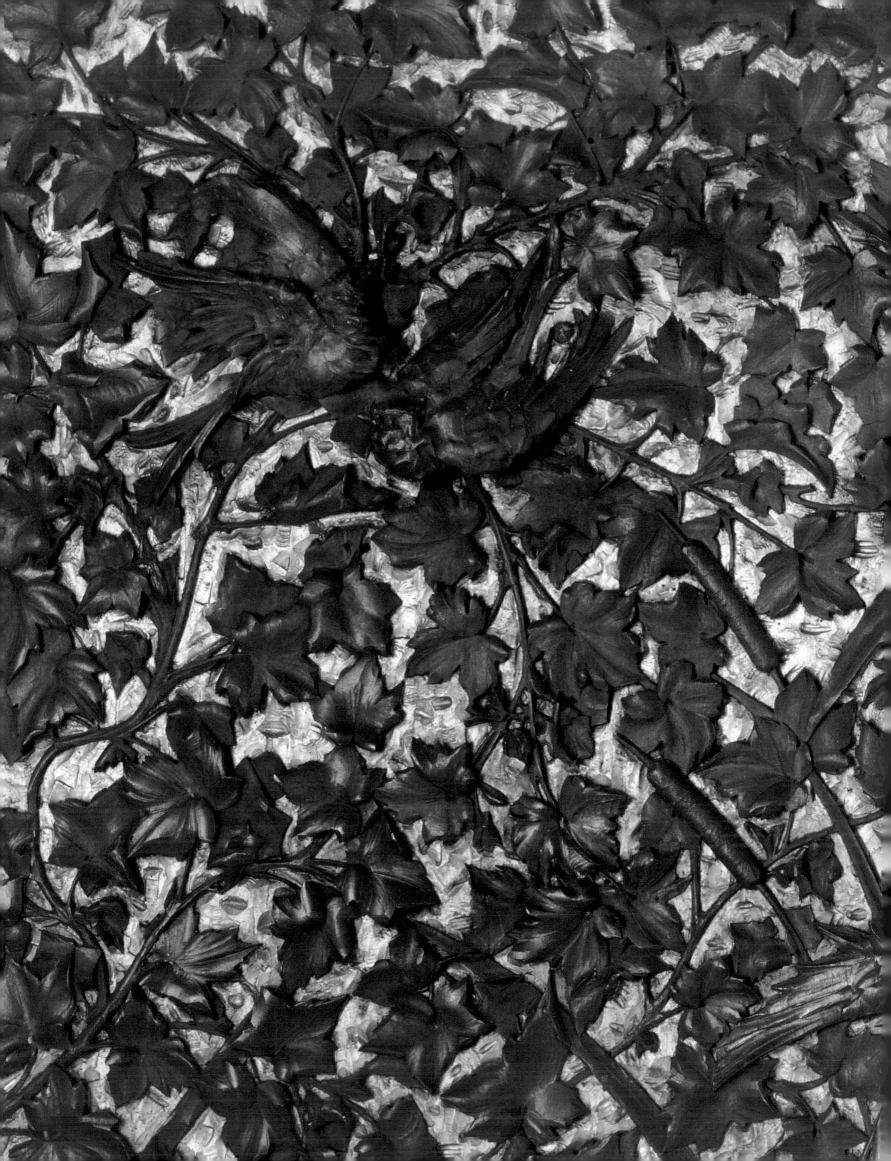

4

The Artful Interior

Marilynn Johnson

I<small>N THE SPOKEN</small> language and popular writings of any age there are a few words that appear to have captured the imagination of the many. Repeated so often that they cease to have precise meaning, they nevertheless reveal the preoccupations of the period. In England and America in the 1870s and 1880s the names, terms, and phrases in the air and on the printed page included artistic and tasteful, beautiful and useful, medieval, Renaissance and Japanese, blue and white, lily and sunflower, style, ornament and design, aesthetic, and most of all, over and over again with ever a different shade of meaning, art.

There was art furniture and art decoration, industrial art and household art. In a world in which technology made possible a dazzling spectrum of product choice, art demanded the attention of even the Philistine, justified a rapacious acquisitiveness, and led to the formation of a tastemaking elite. Wending its way from a small cult of devotees to the constantly widening circle of those wishing to be cultured, it left forever the rarefied domain of privilege and entered the house of the common man and woman.

There, art was visible not only upon the walls but also upon the velvet-covered shelves of mantels and cabinets. One could sit upon art in the form of an elegant chair of ebonized finish and spindly frame, and one could even walk upon it in the form of a Persian carpet. Art fluttered in Japanese fans arranged with studied carelessness. It was evident, too, in peacock feathers on piano scarves, or even in stuffed peacocks, eternally preening upon newel-post perches.

The importance of art in the home resulted from a complex set of precepts. Chief among these was the sanctity of one's dwelling. An inviolable part of Victorian life, the home was perceived by many as the microcosm of the nation's culture. As for the individual, he too was judged by his residence in this era when a man's home was his castle and also his museum of other cultures, his temple of the visually uplifting, and his school for the inculcation of proper principles. It was the badge of his social standing, the proof of his financial success, and the reward for his moral rectitude. For many a woman, it was the entire sphere of her world. A beautiful home was a worthy home, for the quality of surroundings could affect the quality of life. Pleasing decoration and objects had the power to inspire, the householder was constantly admonished by writers, while the ugly would degrade and defile.

The elevation of everyday objects to the status of art was not without its problems. While satirists spoke lightly of living up to one's blue-and-white teapot (see ILL. 11.9), householders felt the oppressive weight of proper taste. Moreover, an infallible ability to recognize and to create the beautiful and the true seemed limited to a select few. Small wonder, then, that men and women alike agonized over issues of home decoration. "*What Shall We Do with Our Walls?*"— a question CLARENCE COOK addressed in his 1880 booklet of that title (see FIG. 3.7)— posed a dilemma of more than casual significance. Each choice of furnishing, each placement of an object, became imbued with meaning. Never had so heavy a burden rested upon frail table and chair.

The use of the word art with decoration or furniture originated in England in the 1840s, became popular in the late 1860s, and reached America by the 1870s. It indicated a reaction to prevailing Victorian taste and to poorly designed or executed products of the Industrial Revolution. Exponents of art decoration generally emphasized individual preferences, handcrafted as opposed to mass-produced objects, subtle colors rather than the harsh hues characteristic of mid-nineteenth-century synthetic dyes, and the display of miscellaneous collections, which gave evidence of an owner's cultivation.

As the art-decoration movement became increasingly widespread, there developed a need for tastemakers, who could guide the average person to make appropriate decisions. Chief among the tastemakers were authors of books and articles that set forth rules for well-chosen decoration and professional designers who could create a total and harmonious interior. One of the earliest and most influential books of the movement was CHARLES LOCKE EASTLAKE's *Hints on Household Taste* (FIG. 4.1), originally published in England in 1868 and subsequently republished in at least three editions there and in at least eight editions in the United States, the first appearing in 1872 and the last in 1886.[1] To this work can be traced, perhaps, the popularization of the word art in conjunction with furniture, as well as many of the governing precepts of taste that were to be reiterated for the next two decades, including the desirability of eliminating superfluous ornament and the notion that beauty results from an object's fitness for its purpose. Eastlake may probably also be credited for coining the term household art— first used in the Aesthetic period and still with us today—a term that refers to art in the context of everyman's home. "Household art" covers a broad range of design, from painted panels to clay pots, indicating the magnitude of choices available to the homeowner who wished to create an artistic environment.

One way to make acceptable choices was to repeat tried and true styles of the past, thus affirming the constancy of principles of art, which once studied and comprehended could be applied to the present. A second, somewhat riskier way was to emulate an exotic foreign culture that had found acceptance among the acknowledged cognoscenti. If the homeowner or his decorator found

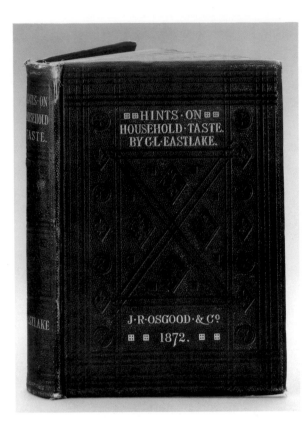

FIG. 4.1 *Hints on Household Taste* (1868; 1st Amer. ed. Boston, 1872). Charles Locke Eastlake. Cover: 8½ × 6⅛ in. (21.5 × 15.7 cm). The Metropolitan Museum of Art, The Jefferson R. Burdick Collection, Gift of Jefferson R. Burdick (65.672.2)

houses set apart for the pleasures of idleness. . . . Happily, the notion that such a room is absolutely necessary to every respectable family is no longer so prevalent. . . . They are useless and out of place in the houses of nine-tenths of our Americans.[3]

His words indicated changing social structures as well as new living patterns, particularly in the homes of the rising middle class. By the early 1880s the term living room was commonplace. In the *Decorator and Furnisher* of January 1883 it appeared in two articles, one of which described a builder's row where "every house has a 'living-room.'"[4] In the other, the author, Mary Gay Humphreys, bewailed the fetish of the prominent drawing room, while "in cities the sitting and living rooms is [*sic*] usually in the rear of the house." She proposed that the hall "serve some of the purpose of the sitting room," an idea reflected in the living halls that were becoming prominent in published architectural plans of American homes.[5]

If the designation and character of sitting room and hall were changing, so were those of other spaces. New rooms that were accorded attention during the 1870s and 1880s included the conservatory, the billiard room, and the smoking room. Even such a man of the people as Mark Twain (1835–1910) included a conservatory (ILL. 4.2) in his residence at Nook Farm in Hartford, Connecticut.[6] This sort of luxury, known to the rich in England in the seventeenth and eighteenth centuries, by the 1870s in America could be considered not ostentation, but rather an expression of interest in the natural world and thus an expression of culture. Twain's conservatory was on the first floor of the rambling Stick-style house that Edward Tuckerman Potter (1831–1904) designed for him in 1874. It opened off the principal family room, or library, which had an ornate carved mantelpiece and overmantel from Scotland, a tasteful scattering of oriental rugs on polished floors, and comfortable, deeply cushioned chairs. On the third floor of the house, under the eaves, was the billiard room; Twain indicated the dual purpose it served for him when he remarked, "Where do I write? In the billiard room, the very most satisfactory study that ever was."[7] Having been distracted in his second-floor study by the views, Twain preferred in his attic retreat merely to gaze at the walls, which had been decorated, by an unknown hand, with billiard symbols. On the first floor, the wall decorations and the plans for the main rooms were designed, in 1881, by LOUIS COMFORT TIFFANY and ASSOCIATED ARTISTS, a group founded in 1879 by Tiffany, in collaboration with LOCKWOOD DE FOREST, SAMUEL COLMAN, and CANDACE WHEELER.

Far grander in scale than Twain's picturesque house was a Newport, Rhode Island, mansion called Château-sur-Mer. In 1870 its owners, George Peabody Wetmore and his bride, Edith, embarked on an extended European trip, leaving the remodeling of their future home in the hands of the noted architect Richard Morris Hunt (1827–1895). During the next ten years Château-sur-Mer was completely transformed in terms of its spatial qualities, room arrangement and designation, and decorative detailing.[8] One of the first areas to exhibit the new aesthetic taste was a morning room (ILL. 4.3) of approximately one thousand square feet, remodeled in 1873 by Hunt as a meeting place and an auxiliary library for Wetmore. White-oak woodwork and a massive Modern Gothic mantel formed a background for furniture in the same style, which was being popularized at that time by British tastemakers such as Eastlake and BRUCE J. TALBERT. The fireplace surround was made of MINTON AND COMPANY tiles with patterns of cattails, water lilies, and insects, and the fireplace lining, also of Minton tiles, displayed the Four Seasons pattern designed by WALTER CRANE. Since George and Edith Wetmore spent their overseas sojourn in England, locating aesthetic tiles, wallpapers, fabrics, and furniture was not difficult for them. If the decorative features of their house owe much to the owners' awareness and taste, the innovative plan and

the bewilderment of possibilities too vast, he could choose a different theme for each room. David L. Einstein, for example, whose New York town house was illustrated in the lavish publication *Artistic Houses* (1883–84), settled on distinct styles for every room: the hall was decorated in early English Renaissance, the library in Louis XIII (ILL. 4.1), the dining room in Henry IV, the sitting room in Anglo-Japanesque, the reception room in Chinese, the parlor in Louis XVI, and so forth.[2]

Such choices were not without precedent. For much of the nineteenth century, and even before, certain modes had been considered appropriate to certain rooms. Gothic, or early English, for instance, with its connotations of scholarly monasticism, was deemed proper for a library. Formal reception rooms had long been thought the place to display furnishings in the French taste—Louis XIV, Louis XV, or Louis XVI.

What was peculiar to the Aesthetic period was not the application of different styles to different spaces, but rather the abundance of styles from which one could acceptably choose. Furthermore, in the homes of the prosperous there was a proliferation of rooms to which these styles could be applied. In the above description of Einstein's house, three rooms are cited that fulfill basically the same function: the sitting room, the reception room, and the parlor. In other houses, areas almost analogous to these were sometimes called by the essentially British terms drawing or morning room or, in the late 1870s, by the newly favored and less formal American nomenclature, living room.

As early as 1875 Clarence Cook noted, "I use the word 'Living-Room' instead of 'Parlor,' because I am not intending to have anything to say about parlors." He added,

None but rich people can afford to have a room in their

architectural character indicate Hunt's familiarity with current English and French interiors.

A tour-de-force hall was created by Hunt from the space given in 1851–52 to the original staircase and dining room. Unified with the adjoining morning room and Hunt's boldly conceived grand staircase by white-oak woodwork, the hall soars three levels and forty-five feet to a stained-glass skylight that was at one time back-lighted by sixty gas jets. On the first floor the ceiling of the light-well surround is painted to resemble woven matting; on the second and third levels it is frescoed in trompe-l'oeil trellises laden with grapevines. This dematerializing of the ceiling plane is echoed on the ceiling of the grand staircase, where trellises support even lusher foliage and the onlooker's eye, like the painted bird above, wheels off into the endless space of artifice.

Swallow-like birds evoking patterns from Japanese prints also flit across the wallpaper frieze of George Wetmore's bedroom (ILL. 4.4). The frieze and the willow-pattern paper of the bed alcove were designed by WILLIAM MORRIS. The bed itself was made in London in 1876 by Gregory and Company, part of a four-piece suite with matching chimney breast that, along with the paneled and patterned walls and the bordered and patterned ceiling, creates as excellent a simulation of an English aesthetic room as existed in America in this period.

During the mid-1870s, when Hunt was redesigning Château-sur-Mer (a project he undertook in 1869 and worked on for nearly a decade), another residence, vastly different though curiously analogous to the Wetmores', was rising on a plot just across the street (see ILLS. 10.9, 10.10). In contrast to the formidable gray granite of its neighbor, this second house had an exterior polychromed and textured in a variety of materials: irregular pink-granite ashlar with brownstone trim for the ground-story masonry, half-timbering and plaster with painted decoration for the front gable, bands of glass in the grouped casement windows, oddly shaped decorative shingles for the high roofs, and red brick for the massive chimneys. This irregularity and yet unity, this richness and yet seeming simplicity existed inside as well. Although the sources for the house were clearly English and lay particularly in the work of RICHARD NORMAN SHAW, the creators were American: H. H. RICHARDSON, its architect; Stanford White (1853–1906), Richardson's assistant from 1872 to 1878 and the house's principal interior designer; and its owners, William Watts Sherman and his young wife, Anne Derby Wetmore Sherman, sister of George Peabody Wetmore. Whereas at Château-sur-Mer the concepts of Queen Anne architecture and the British Aesthetic movement were only partially assimilated, in the W. Watts Sherman house they found their first complex yet cohesive American expression.

The core of the W. Watts Sherman residence was a hall that stretched from front to back, but unlike Hunt's spectacular hall in Château-sur-Mer, which was conceived as a place to view and to pass through, this one was regarded as a living space. Opening off a vestibule and staircase, it both linked and extended the principal rooms of the first story: the drawing room and the library on one side, the dining room on the other. Doorways opening into these areas were wide, giving a spatial continuity within the structure, while window walls at the front and back incorporating stained glass provided light and a feeling of space.

Perhaps the best evocation of the hall as it appeared originally is a sketch (ILL. 4.5), attributed to Stanford White, published in May 1875 in the *New-York Sketch-Book of Architecture*. Although inaccurate in the sense that no vantage point existed that allowed such a view of the vestibule and the staircase, the drawing vividly depicts a fully developed and integrated early aesthetic interior, with its massive central fireplace bordered with tiles, its dado paneling in squares, its patterned walls and frieze, and its boldly beamed ceiling.

Not visible in the illustration are some of the most interesting decorative details of the hall. Blue-and-white Dutch tiles facing the

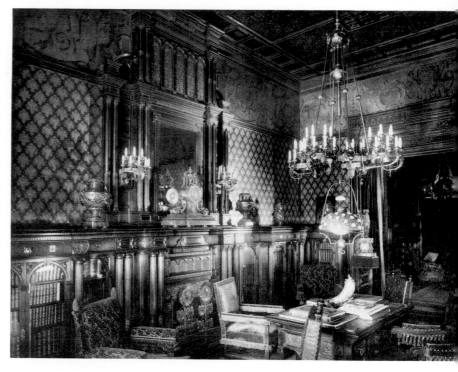

ILL. 4.1 "Mr. David L. Einstein's Library." *Artistic Houses* (New York, 1883–84). Thomas J. Watson Library, The Metropolitan Museum of Art

ILL. 4.2 Library and conservatory, Mark Twain house, Hartford, Conn. Designed by Edward Tuckerman Potter, 1874, decorated by Associated Artists, New York, 1881. Mark Twain Memorial, Hartford, Conn.

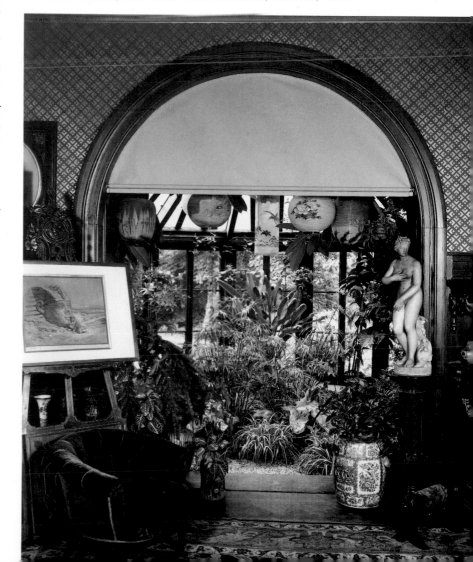

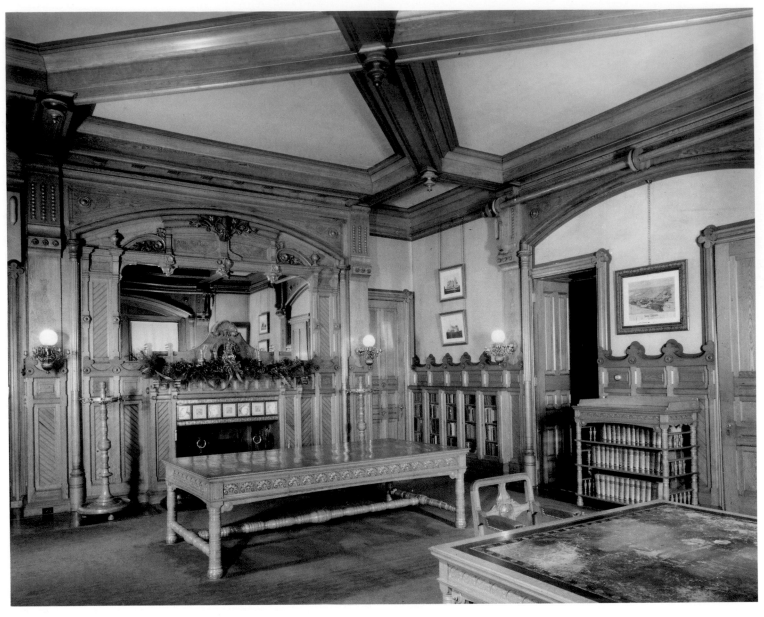

Above: ILL. 4.3 Morning room, Château-sur-Mer, Newport, R.I. Designed by Seth Bradford, 1851–52, remodeled by Richard Morris Hunt, 1871–78, for George Peabody Wetmore. The Preservation Society of Newport County, Newport, R.I.

Opposite: ILL. 4.4 Bedroom, Château-sur-Mer, Newport, R.I. Designed by Seth Bradford, 1851–52, remodeled by Richard Morris Hunt, 1871–78, for George Peabody Wetmore. The Preservation Society of Newport County, Newport, R.I.

fireplace and recalling the Colonial period were probably one of White's decorative choices. Stained-glass panels in a flower-and-lattice pattern (see FIG. 6.5) by JOHN LA FARGE might have been the preference of either Richardson or White, or of both in concert. A colleague of Richardson's, La Farge had also been a counselor to White, recommending that he renounce the artist's brush for a more lucrative profession. In part because of La Farge's advice, White entered Richardson's office in 1872, the same year that Richardson began designing Trinity Church in Boston, which later was decorated with stained glass and murals by La Farge and others. If the W. Watts Sherman house owes most of its architectural coherence to Richardson, it owes much of its color and charm to the painterly strokes of White.

Before 1880 White had further extended his influence on the W. Watts Sherman interiors by converting the original drawing room into a library. In keeping with the changing tastes of the

1870s, the lingering Gothicism that had characterized British architecture of the 1860s and early 1870s was replaced with classicism. Colonial-revival details were prominent in the paneling, which also skillfully incorporated Hispano-Moresque and Japanesque motifs. Gilded lines, some in the whiplash curve that would in the 1890s signal Art Nouveau, embellished the deep green background. Fretwork and screen effects suggested the East, to which wealthy Newport merchants had once sent vessels, while great carved scallop shells evoked Newport's own illustrious eighteenth-century furniture and architecture.

Since many of the most important British furniture and interior designs of the Aesthetic movement were the work of architects, one might be tempted to view White's role in the W. Watts Sherman house as that of the architect functioning as interior decorator. In fact, although White is now remembered as an architect, he had no training in that field prior to his apprenticeship with Richard-

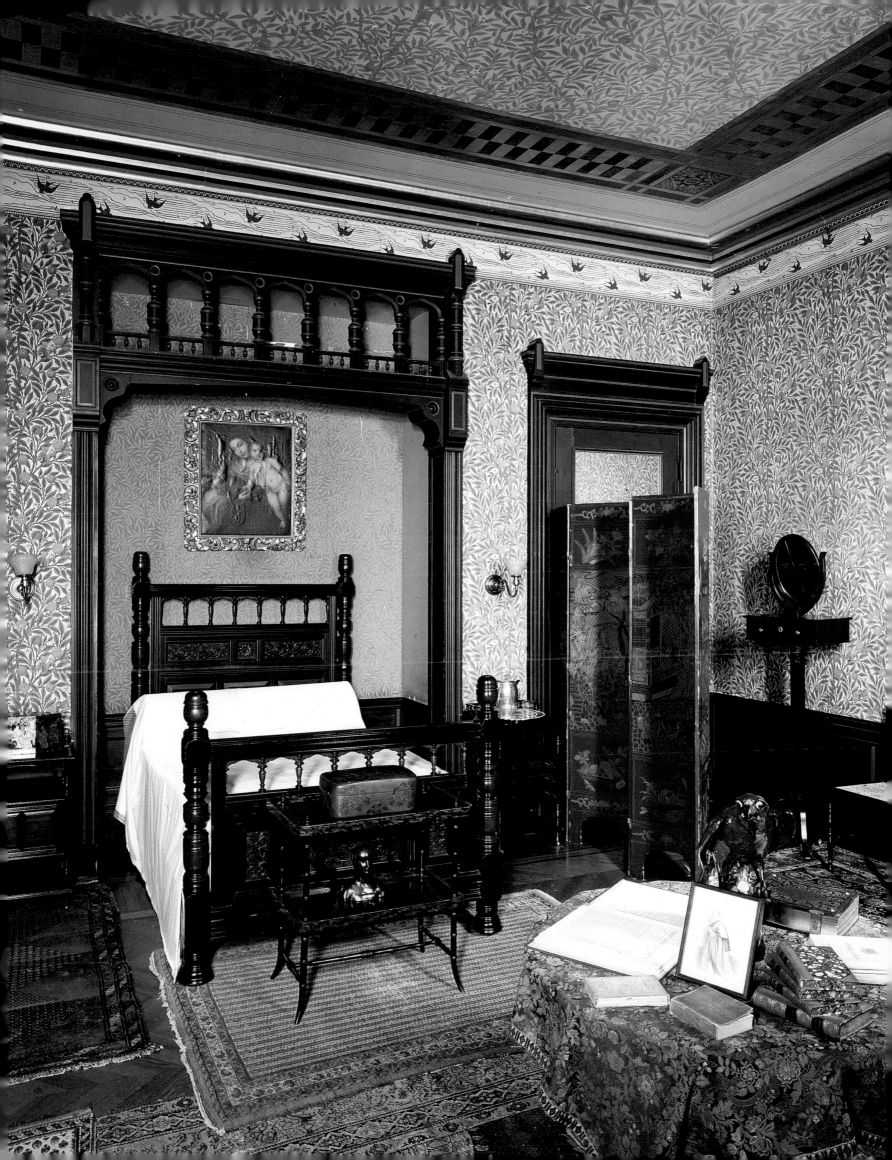

son. His part in the W. Watts Sherman project and in other early schemes might therefore just as accurately be seen as that of the artist-designer serving as architect.

To some extent replacing the traditional role of the architect as the developer of the unified interior, the artist-designer remained prominent throughout the Aesthetic movement. Preeminence was also enjoyed by another new figure, that of the interior decorator. Although the concept of the interior decorator existed prior to the 1870s and 1880s, the term came into common usage during those decades, having made its first significant appearance in New York and other American city directories in the 1870s.[9] Most firms or decorators listed were furniture manufacturers who had expanded their services to include the design and execution of interior wood-work as well as furniture, the stocking of fabrics for draperies, portieres, and upholstery, and in many cases, the display of a range of accessories and bibelots, often from foreign sources, to complete a room and give it character. Large furniture firms were no longer simply cabinetmakers employing skilled carvers, turners, and workers in inlay, but were also upholsterers, retailers, and arbiters of taste—that is, decorators.

An 1871 volume with photographs and descriptions of the factory of the Pottier and Stymus Manufacturing Company, which had begun as cabinetmakers, indicates how many specialties were by that time carried out under one roof. In 1876 *The Golden Book of Celebrated Manufacturers and Merchants in the United States* amplified the information supplied in the earlier publication. As *The Golden Book* explained, one workroom contained "panels with graceful frescoes, and sketches for carpets which are to be manufactured at Aubusson." Another department specialized in the finishing and gilding of bronze, while yet a third produced the locks and moldings for case goods and interior work. The cabinetmak-

ing division was on the second floor, where a "large part of [the] room [was] devoted to the manufacture of ceilings for dining rooms." In this area veneering was done, as well as chair upholstery and the making of tapestries, hangings, and trimmings.[10]

In *Art Decoration Applied to Furniture* (1878, see FIG. 2.3) the writer HARRIET PRESCOTT SPOFFORD, suggesting ways to create an artistic interior, recommended the services of professional decorators if one could afford them:

> They will enter at the moment the masons leave, and they will not only attend to every detail, but will render those details into a homogeneous whole. The frescoes of the ceilings, the colors of the carpet and curtains and furniture covers, the wood-work of the furniture and of the walls, will be designed exactly to correspond with each other; doors and fireplaces, windows and mirrors, will be part of the picture.[11]

In the Aesthetic period the New York firms considered most capable of such achievements included HERTER BROTHERS; A. KIMBEL AND J. CABUS; L. Marcotte and Company; Herts Brothers; Pottier and Stymus Manufacturing Company; and Roux and Company, all evolving from furniture-making firms; COTTIER AND COMPANY, whose Scottish founder began as a manufacturer of stained glass; and Sypher and Company, which produced furniture, particularly in the Colonial-revival style, but also dealt extensively in antiques and in decorative accessories. Though firms in other cities proclaimed their abilities to create artistic interiors, the leading New York companies were those generally chosen to decorate the houses of the prominent and wealthy across the country.

From New York and Boston on the East Coast, to Cincinnati,

ILL. 4.5 "Staircase and Hall in Cottage for W. Watts Sherman, Esq., Newport." Designed by H. H. Richardson, drawing attributed to Stanford White, 1874. *New-York Sketch-Book of Architecture* (May 1875). Art, Prints and Photographs Division, The New York Public Library, Astor, Lenox, Tilden Foundations

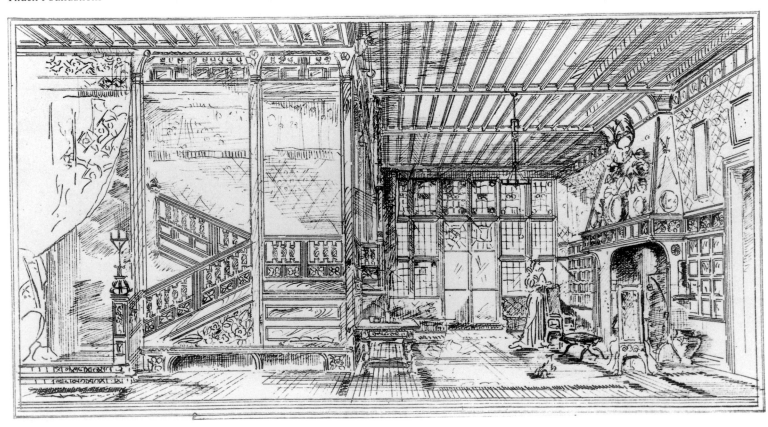

Minneapolis, and Chicago in the Midwest, to San Francisco and its suburb Menlo Park on the West Coast, the newly rich ensured both tasteful and elegant interiors when they entrusted the decorating of their homes to Herter Brothers. The two siblings to whom the firm owed its name were GUSTAVE HERTER and his younger half brother, CHRISTIAN, both born in Stuttgart, Germany, and trained in Europe before emigrating to the United States. Each was a talented designer; it was Christian, however, who led the company during its art-furniture period and made Herter Brothers a name synonymous with the finest and most costly American interiors of the 1870s and early 1880s.

A contemporary description of the Herter showrooms indicates that by the mid-1870s the firm had become far more than a cabinetmaking shop. To the anonymous *Scribner's Monthly* writer, whose style suggests that of Clarence Cook, Herter Brothers had "that quiet atmosphere that pervades picture galleries," making it one of those "museums of household art" that had sprung up "in our great cities." He continued,

> The first and most noticeable feature of the place is the free use of drapery, and the subdued colors employed everywhere . . . chandeliers, Newell lights, wall papers, hanging and covering stuffs, bronzes and vases, each have their department. In papers, only the best and most artistic, in stuffs, everything that loom can make. . . . The bronze ornaments and the vases and articles of virtu make in themselves a museum of unusual variety and value. . . . Besides these is the furniture of every material and style.[12]

The reviewer rhapsodized further about the Herter showroom textiles, emphasizing their "cosmopolitan wealth of design. It seems as if the world had been laid under contribution for the beautiful national types, the Persian, the Indian, Moorish, Chinese, Japanese, Venetian."[13] A year later, in 1877, the *American Architect and Building News* printed some of the critical comments of Frédéric-Auguste Bartholdi (1834–1904), the French artist, designer, and sculptor of *Liberty Enlightening the World* (1885, unveiled 1886). Evaluating American cabinetmaking, Bartholdi cited particularly the happy combination of French and American ideas produced in the work of such houses as Marcotte, Pottier and Stymus, and Herter, as well as "the great influence for good produced in this country by the decorative movement in England." The writer who reported Bartholdi's remarks added that "the use of Japanese motifs in furniture and ceiling decorations of Herter . . . marks an era in household work of the highest class."[14] Herter advertisements of the period also emphasized the cosmopolitan character of their stock. An 1878 notice called attention to recent importations of "Fine French and English Paper Hangings, Rich Japanese Silk Brocades, Rare Oriental Embroideries, [and] French Moquette Carpets."[15]

The wide-ranging geographic sources of Herter Brothers furniture and decorations were almost matched by the widespread market to which they appealed. On the West Coast major Herter clients included Senator Milton Slocum Latham, briefly governor of California, and financial and railroad magnates such as Darius Ogden Mills, Collis Potter Huntington, and Mark Hopkins.[16] Although Herter's wealthiest and most famed patrons were primarily in California or New York, shopping at Herter Brothers, or even commissioning a room or a total house, was not unknown to affluent and informed midwesterners. A former resident of Prairie Avenue, Chicago, writing her memoirs of a childhood home, stated, "All the woodwork in the library as well as the center table, which I still have, were made by the original Huerter [sic] of New York."[17]

Across from the writer's house on Prairie Avenue, one of the great monuments of American domestic architecture had been commissioned in 1885 by John J. Glessner and his wife, Frances,

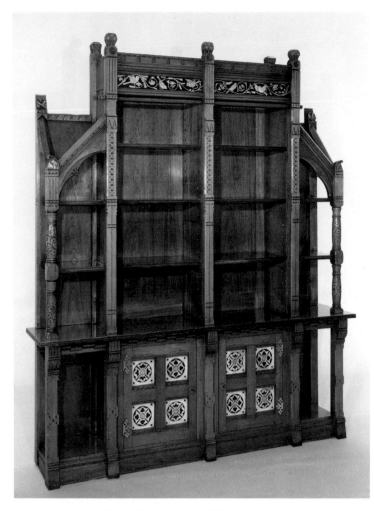

ILL. 4.6 Bookcase. Isaac Elwood Scott, Chicago, 1876, for Mr. and Mrs. John J. Glessner. Walnut, inlaid woods, h. 86 in. (218.4 cm), w. 70 in. (177.8 cm), d. 14½ in. (36.8 cm). The Glessner House, Chicago Architecture Foundation, Gift of Mrs. Charles F. Batchelder

who were well aware of current trends in England. The architect was Richardson, who also designed the interior paneling, which was complemented by Morris wallpapers. Some of the art furniture was by the Glessners' friend and favorite designer, ISAAC ELWOOD SCOTT (ILL. 4.6). The Glessners also purchased Herter furniture. As early as 1879, according to Glessner family journals, Mr. Glessner "while in New York bought watch chain for Mrs. G, two chairs from Herter Bros." Several years later, on September 24, 1882, an entry in the journals noted, "After lunch went to Herters and ordered a lounge for our Chicago house. By invitation of Mr. Getz we crossed the street and saw Herters men making stained glass windows and plaster and mosaic work."[18]

While in Chicago, Richardson reputedly visited the most imposing house in the city, the baronial dwelling of Potter Palmer, and pronounced the mosaic floor of the hall "the handsomest in the country." He also "spoke warmly in praise of the woodwork, the carvings and the glass-enameled Venetian mosaic of the walls."[19] The hall, as well as the dining room of the Potter Palmer mansion, was decorated by Herter Brothers.[20]

The exoticism of the Moorish style seems to have had a particular fascination for midwesterners, who may have traveled no farther east than to the bazaars of New York. A restrained but imposing art-furniture cabinet with Moorish arches on its facade and sides is documented as the work of Herter Brothers by a

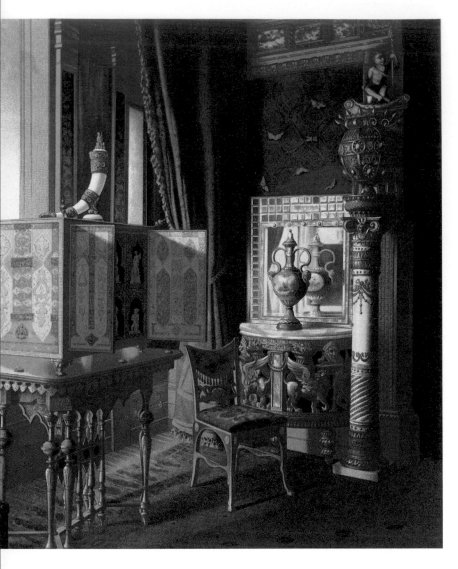

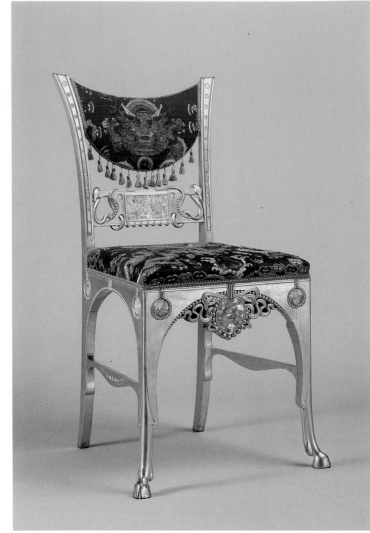

June 24, 1884, bill of sale to the then-governor of Minnesota, W. D. Washburn.[21] Listed on the third page of the invoice, the cabinet was part of the furnishings of Washburn's Minneapolis house, which was illustrated and discussed in George William Sheldon's *Artistic Country-Seats* (1886). The rosewood and inlaid brass of its structure matched the woodwork of the Herter-decorated drawing room in which it stood. Sheldon described the room as "in light Louis XIV style, its wall in tapestry silks, its ceilings in blue and gold, its mantel of onyx, its wood-work of rosewood relieved with fine lines of gilt and inlaid."[22]

In 1886 the dining room of the West Hotel in Minneapolis was completed. It was "96 feet long, 47 feet wide, 26 feet high, of a strictly Moresque character."[23] A contemporary illustration shows a room of extraordinary fantasy with paneled wainscoting typical of the period and "walls and ceiling appropriately frescoed."[24] Although the interiors were designed by the noted architect of the building, Leroy S. Buffington (1847–1931) of Minneapolis, and the woodwork and marble were by companies in Minneapolis and in nearby Illinois, the frescoes and stained glass were by Herter Brothers.

A project engaging several designers, such as that for the West Hotel, was not unusual in the 1870s and 1880s. Generally, however, one designer oversaw the unity of the work. In 1883–84 a compendium of some of the most admired domestic rooms of the era appeared under the title *Artistic Houses*. Published in four parts, *Artistic Houses* depicted the high-style interiors of urban dwellings.

Above: FIG. 4.2 Side chair. Herter Brothers, New York, ca. 1882, for the William H. Vanderbilt house, New York. Gilded maple, inlaid mother-of-pearl, h. 34½ in. (87.6 cm), w. 18¾ in. (47.6 cm), d. 18 in. (45.7 cm). Museum of Art, Carnegie Institute, Pittsburgh (83.36)

Above left: ILL. 4.7 "The Drawing Room." M. Gaulard. Edward Strahan [Earl Shinn], *Mr. Vanderbilt's House and Collection* (New York, 1883–84). Thomas J. Watson Library, The Metropolitan Museum of Art

Opposite top: FIG. 4.4 Detail of library table (FIG. 4.3)

Opposite bottom: FIG. 4.3 Library table. Herter Brothers, New York, 1882, for the William H. Vanderbilt house, New York. Rosewood, inlaid brass and mother-of-pearl, h. 31¼ in. (80.6 cm), w. 60 in. (152.4 cm), d. 35¾ in. (88.3 cm). The Metropolitan Museum of Art, Purchase, Gift of Mrs. Russell Sage, by exchange, 1972 (1972.47)

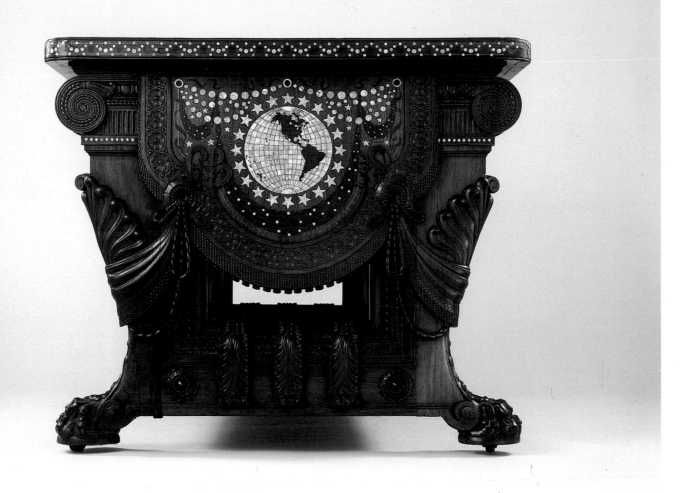

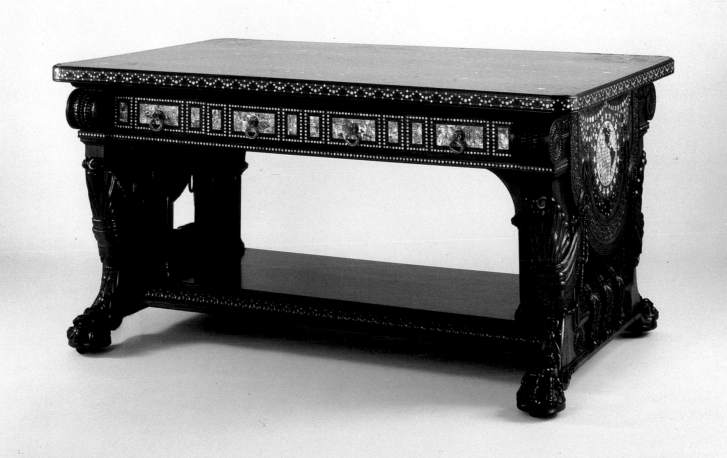

The text accompanying the photographs revealed the major role played by the professional designer, who was in some cases an interior decorator, in others an architect, and in still others an artist.

In *Artistic Houses,* particularly notable in the category of interior decorator was the firm of Herter Brothers, to whom were credited the New York homes of J. Pierpont Morgan, Jacob Ruppert, Mrs. Robert Leighton Stuart, and most famous of all, the residence accorded more space than any other, that of William H. Vanderbilt (1821–1885) (see ILL. 2.1). In addition, furniture so closely related to marked Herter pieces as to warrant a Herter attribution appeared in photographs of interiors not always credited to the firm.

Few houses of the age were so profusely lauded and so copiously documented as were the almost twin brownstone mansions designed, constructed, and decorated between 1879 and 1882 at Fifth Avenue and Fifty-first Street in New York, the first for Vanderbilt himself and the second for his sons-in-law, Messrs. Shepard

and Sloane. In addition to the eleven photographs and seventeen pages of text allocated in *Artistic Houses,* the contents of the house were published in a two-volume work entitled *Mr. Vanderbilt's House and Collection,* written in 1883–84 by Earl Shinn (1837–1886) under the pseudonym Edward Strahan. To Shinn the house was "a typical American residence, seized at the moment when the nation began to have a taste of its own," a moment when wealth was "first consenting to act the Medicean part in America" and when Americans had begun "to re-invent everything . . . especially the House."[25]

For the reinvention of the house of the Medicean William H. Vanderbilt, no expense or pains were spared. Christian Herter was responsible for all the ornamental details, and although professional architects John B. Snook and Charles B. Atwood worked with him, Herter was considered both architect and decorator. Perhaps this explains why the house resembled nothing quite so much as a beautifully tooled and embellished jewel box inflated to inor-

Below: ILL. 4.8 "Mr. W. H. Vanderbilt's Library." *Artistic Houses* (New York, 1883–84). Thomas J. Watson Library, The Metropolitan Museum of Art

Opposite: ILL. 4.9 "The Japanese Parlor." Edward Strahan [Earl Shinn], *Mr. Vanderbilt's House and Collection* (New York, 1883–84). Thomas J. Watson Library, The Metropolitan Museum of Art

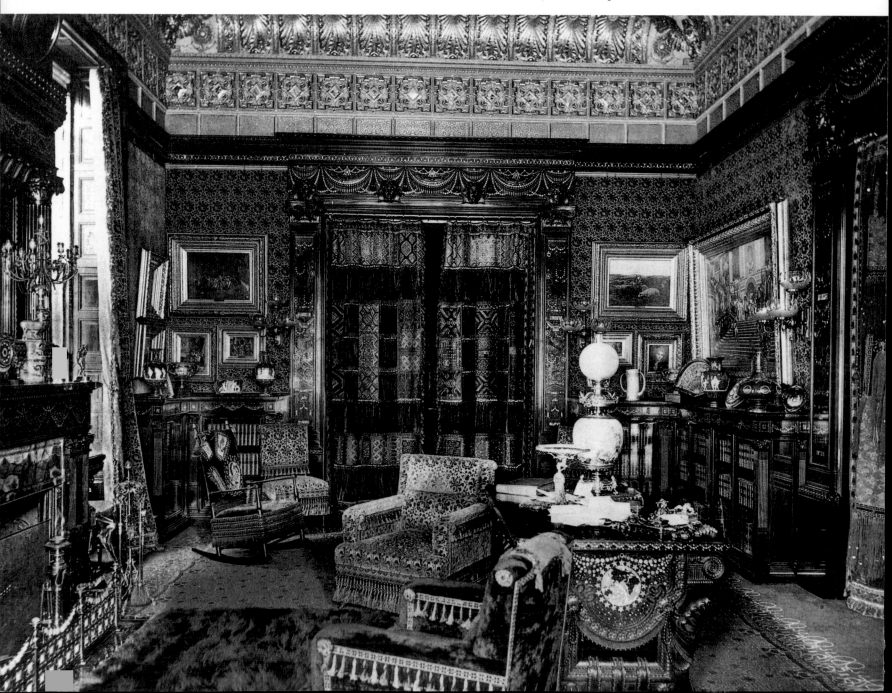

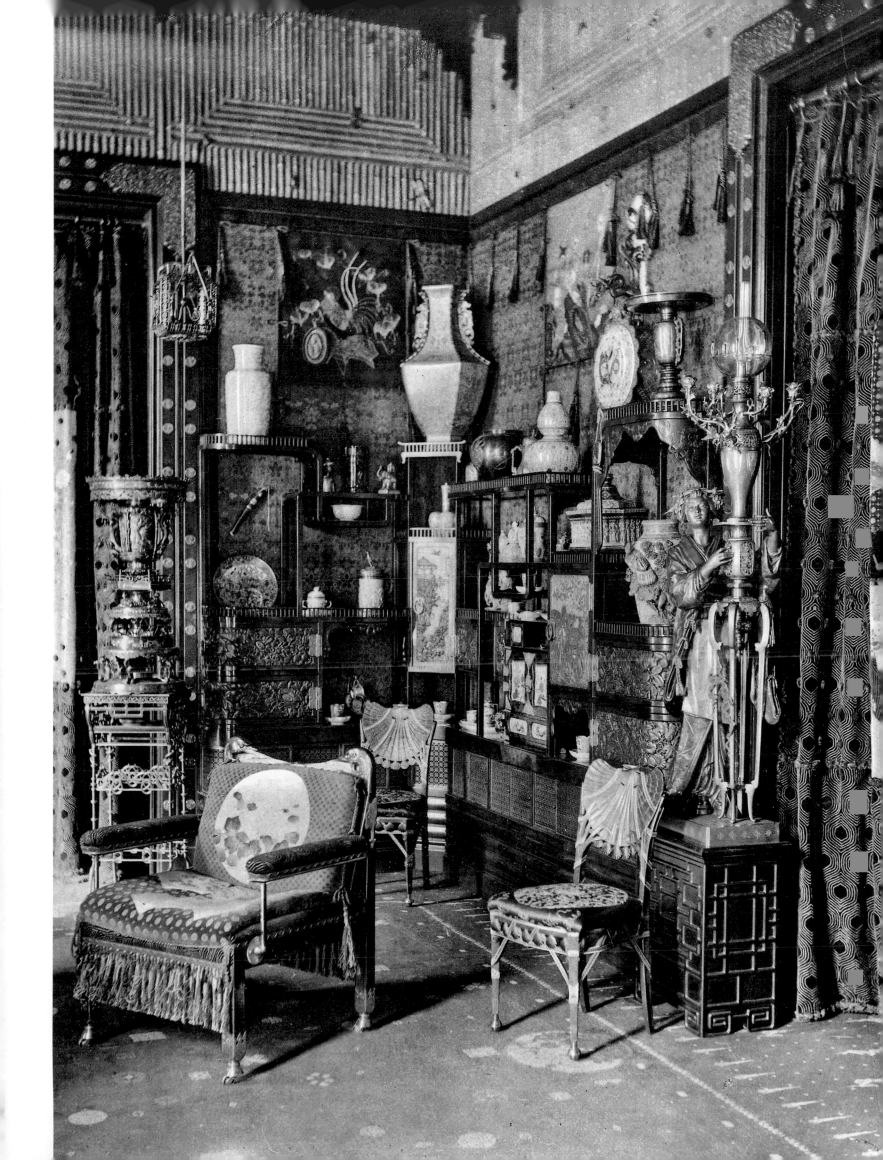

dinate proportions.[26] The analogy becomes even more appropriate when one considers the objects and interiors of the house, from the towering malachite Demidoff vase of the atrium to the Barbedienne gilt-bronze copy of Lorenzo Ghiberti's *Gates of Paradise* and the Pompeian-style vestibule of marble and mosaic. In the "brilliantly decorated" drawing room (ILL. 4.7), according to *Artistic Houses,* "everything sparkles and flashes with gold and color—with mother-of-pearl, with marbles, with jewel-effects in glass . . . every surface . . . weighted, with ornament: the walls, with carnation-red velvet . . . [and] gilt *appliqué* work . . . [of] trees whose flowers are made of jewels, and from whose branches hang festoons of gold-thread."[27] Gilded chairs (FIG. 4.2) with graceful lines and lavish embroideries echoed the gilding on the walls. Mother-of-pearl inlay glittered on the stay rail of one hoof-footed chair, on panels of two cabinets, and on the tops of two stands, and also formed the entire six-by-four-foot top of the center table. The writer in *Artistic Houses* commented, "Especially affluent and striking is the use of mother-of-pearl; very rarely, if ever, in the history of house-decoration has this material been used so

generously."[28] Mr. Vanderbilt's library (ILL. 4.8), paneled with rosewood inlaid with brass and mother-of-pearl, contained an extraordinary table (FIG. 4.3), its top embellished with a mother-of-pearl celestial field, while the sweeping rosewood lambrequins of each end featured an inlaid mother-of-pearl terrestrial globe (FIG. 4.4).

A forty-eight-by-thirty-two-foot picture gallery, thirty feet high, housed Vanderbilt's picture collection. Of even greater interest from a decorative viewpoint, however, was the "Japanese" parlor (ILL. 4.9), with brilliant ornamental glass by La Farge, red-lacquer beams against a bamboo frieze, walls hung with gold brocade, and innumerable lacquered cabinets and shelves to hold "the rarest objects of *bijouterie* and *vertu*."[29] Reminiscent of the Peacock Room (1876–77; now installed in the Freer Gallery of Art, Washington, D.C.), designed by JAMES ABBOTT MCNEILL WHISTLER and THOMAS JECKYLL as the dining room in the London home of Frederick Richards Leyland (ILL. 4.10), Herter's "Japanese" parlor for Vanderbilt was the ultimate collector's cabinet.

If Vanderbilt's choice of designer for the adjoining residences he

ILL. 4.10 *Harmony in Blue and Gold: The Peacock Room.* James Abbott McNeill Whistler and Thomas Jeckyll, 1876–77, for Frederick Richards Leyland, London. Photograph, 1892. Room now in the Freer Gallery of Art, Washington, D.C.

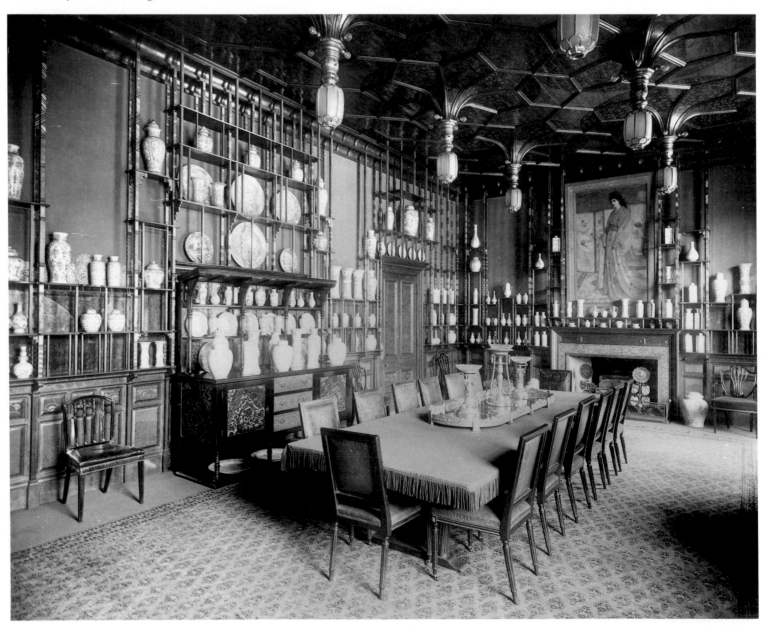

FIG. 4.5 Carved panel. Attributed to Ellin and Kitson, New York, ca. 1880–84, for the dining room, Samuel J. Tilden house, New York. Gilded and stained satinwood, 48½ × 47¼ in. (123.2 × 121 cm). The National Arts Club, New York

commissioned was an interior decorator who could also function as architect, Governor Samuel J. Tilden's preference was a prominent architect, Calvert Vaux (1824–1895), who not only transformed the exterior of two already-existing New York brownstones into one facade but also modified and unified their interiors. The outside of Tilden's city residence at 14 and 15 Gramercy Park was described in *Artistic Houses* as "a free adaptation of the Gothic style."[30] The inside, however, bore little resemblance to homes of the period done in the Modern Gothic style. Still, in keeping with aesthetic principles, the library, the dining room, and a few of the bedrooms were "entirely reconstructed in their woodwork and decorations" and possessed the carved details, tiles, and stained glass requisite for the sophisticated home. In the governor's library a dome of stained glass represented the work of Donald MacDonald of Boston, while the "opalescent, pearly, and variegated tones" of the inner vestibule doors were the work of La Farge and to the writer were a part of "this later American Renaissance,

which our painters, turned decorators, are creating."[31] The same author reserved the longest description and the most effusive praise for the dining room (ILL. 4.11). There the architect's addition of satinwood to the existing black-walnut woodwork produced "an effect of great richness and perfect unity."[32] Turquoise blue tiles by the J. AND J. G. LOW ART TILE WORKS of Chelsea, Massachusetts, were set into satinwood frames and covered the ceiling; they also formed a horizontal band around the room between the walnut wainscoting and the satinwood decorative panels of the midwall (FIG. 4.5). Skillfully carved in low relief with such natural forms as birds, leaves, and branches against a stippled and gilded background, the panels were probably the work of ELLIN AND KITSON of New York. Perceived in 1883 as one of the great glories of the Tilden interior, the bird panels are the only major element of the dining room known to survive today.[33]

The third type of interior designer prominent in the early 1880s is represented in *Artistic Houses* by the firm of Louis C. Tiffany and

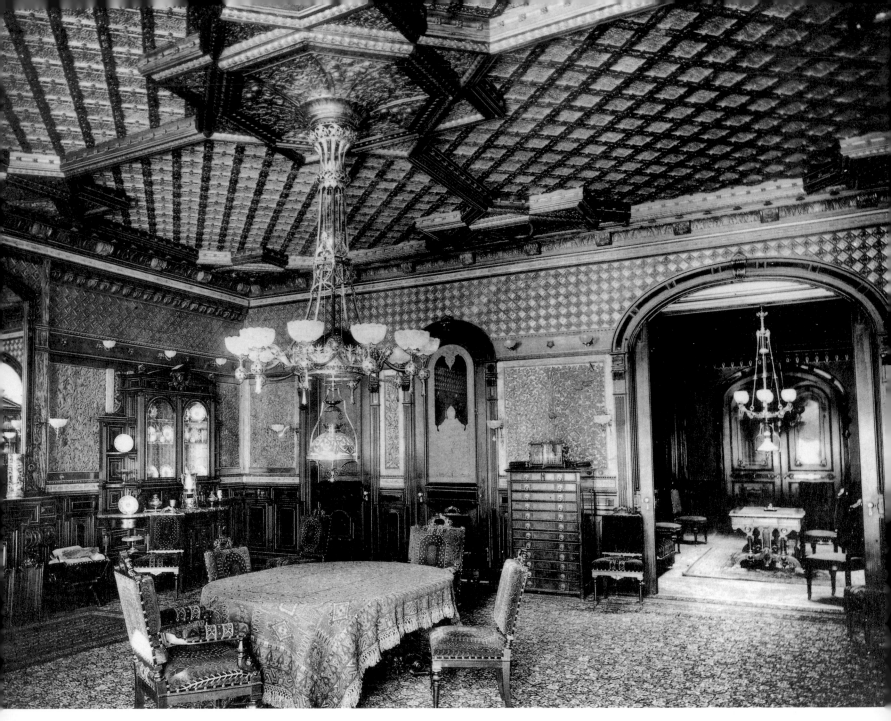

ILL. 4.11 "Governor Tilden's Dining Room." *Artistic Houses* (New York, 1883–84). Thomas J. Watson Library, The Metropolitan Museum of Art

Company, from 1879 to 1883 called Associated Artists.[34] The latter name is itself meaningful, indicating the seriousness of interior decoration and the willingness of artists to undertake ornamental projects. Three of the firm's four original members—Tiffany, Colman, and de Forest—were painters who in the 1870s began turning their talents in other directions. Even before the founding of Associated Artists, Tiffany had begun experiments with stained glass, which was to become his favored medium. De Forest developed an interest in the design of carved woodwork and furniture, for which he established a shop in Ahmadabad, India, in 1881. Colman preoccupied himself with the study of color and with the design of flat patterns, particularly those suited to walls and ceilings. Wheeler, the fourth founding associate, was a specialist in textile design and art embroidery, having been inspired by London's Royal Society of Art Needlework, which exhibited at the Centennial Exposition in Philadelphia in 1876.

Perhaps significantly, *Artistic Houses* commences with the library and the dining room that Tiffany designed for himself in 1878 (ILL. 4.12; see also ILL. 9.12) in the Bella Apartments on East Twenty-sixth Street in New York, work that, according to the text, led the artist to "the systematic study of the principles of the profession which he is now practicing."[35] Much of what characterizes Tiffany's accomplishments of the Aesthetic period appeared in these rooms: a use of exotic "Moorish" decor suggested by the Near East, with East Indian and Japanesque detailing; a delineation of different rooms through different decorative characters and changes in light; a profusion of pattern on walls and ceilings; a display of collections, particularly of pottery and porcelains; a feeling for textures, with deliberate contrasts of smooth and rough; occasional panels of stained glass; and an integration of paintings into the overall scheme of the walls on which they were hung. Many of these same characteristics existed in the New York houses

of George Kemp, John Taylor Johnston, and Dr. William T. Lusk, in the Newport home of Colman (which was particularly praised for its owner's sensitivity to color), and in the W. S. Kimball house in Rochester, New York.[36] All except the Colman residence were cited as the work of "Messrs. Louis C. Tiffany and Company," as was a redecoration of the White House carried out in the winter of 1882–83. In the nation's first dwelling, as in other Tiffany projects, screens of opalescent glass, patterned ceilings, mosaics and fireplace tiles of glass, accents of gilding and of gold tracery along with flashes of brass and silver, rich colors, and dramatic lighting were combined to transform the decor of an earlier era into a fashionable and artistic house.[37] Nothing remains today of the White House in its Tiffany years, nor does much survive of the majority of the other Associated Artists collaborations.

Associated Artists designed interiors for clubs, theaters, and, of

particular importance both because they were published in their time and because they are still extant, the cavernous Veterans' Room (ILL. 4.13) and Library of 1879–80 in the Seventh Regiment Armory on Park Avenue at Sixty-seventh Street, New York.[38] An 1881 *Scribner's Monthly* article by William C. Brownell on the decoration of the Veterans' Room found "no part . . . so interesting as . . . what might be called the circumstances of its authorship," that is, the cooperative effort of artists, each having his own specialty. Tiffany was cited as conceiving the "general character and scope of the decoration," preparing the basic sketch or idea, and then turning over the details to his associates: White for architectural work, Colman for ornamental detailing and color harmonies, Wheeler for embroidered "stuffs," the painters Frank Millet (1846–1912) and George Henry Yewell (1830–1923) for the decorative frieze. Neither White nor Millet nor Yewell was a member of As-

ILL. 4.12 "Mr. Louis C. Tiffany's Library." *Artistic Houses* (New York, 1883–84). Thomas J. Watson Library, The Metropolitan Museum of Art

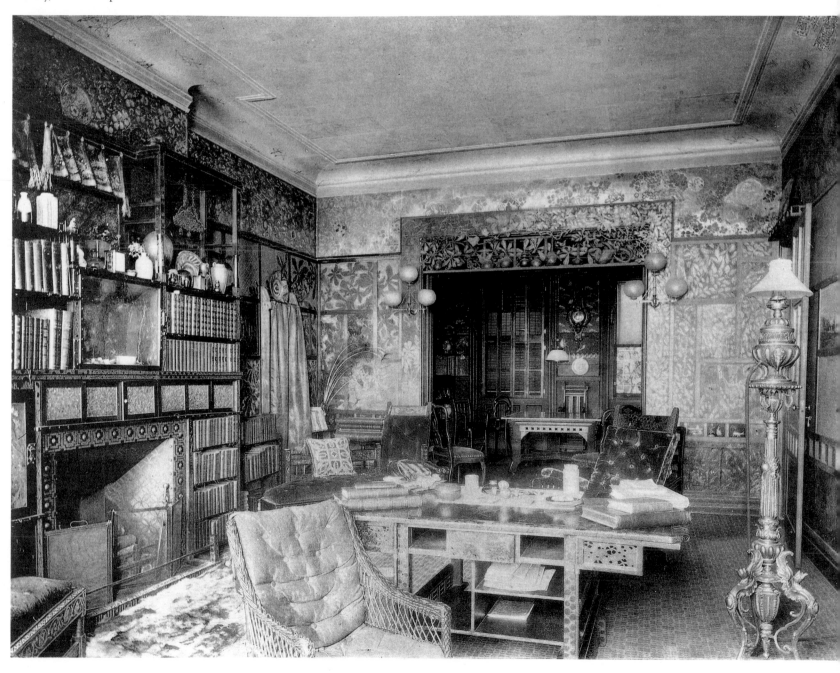

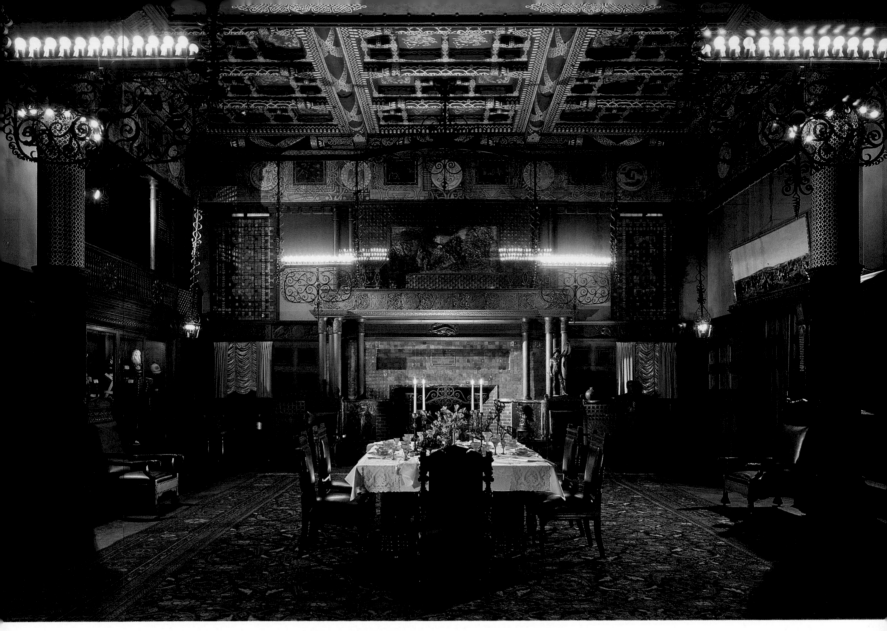

ILL. 4.13. Veterans' Room, Seventh Regiment Armory, New York. Associated Artists with Stanford White, New York, 1879–80

sociated Artists. That nonmembers worked for the firm is further indicated by the following description of the ateliers, on Fourth Avenue in New York,

> where, in perfect accord with each other, Mr. [Augustus] Saint-Gaudens designs graceful compositions for low reliefs, Mr. Maitland Armstrong arranges mosaics in glass, Mrs. and Miss [Dora] Wheeler occupy themselves with rich stuffs and delicate embroideries, Mr. White invents circumventions of that evil genius conventionality, Mr. Colman traces oriental arabesques, and Mr. Tiffany presides rather as a harmonious influence than as a director.[39]

The Veterans' Room remains a major achievement of its era. It is of its age in its resemblance to other rooms of the period, yet it is also a strong and individual expression of aesthetic sensibility. Still, Brownell's praise was not unqualified. He only grudgingly acknowledged the suggestive powers of the decorative symbolism, which conceptually, at least, was in the Victorian mainstream rather than in a reform current, and he referred to the overall interior scheme as "mechanical and trivial."[40] His descriptions of the

space, however, coupled with numerous drawings and photographs (ILL. 4.14), give a clear picture of the room as it appeared when it was first executed and before its surfaces darkened: the high wainscot of oak with its band of grotesque carving; the surface varied by recessed iron tiles resembling plates of armor; the walls a light yellow with painted linked copper and silver rings; and the frieze, a silvery sequence of shields and circular allegories representing the chronological progress of the art of war. The light yellow color of the ceiling was broken up by red beams and crossbeams.[41] The entire room was stenciled in silver arabesques.

The focal point of the walls was a large fireplace at the north end with brownish red brick flanked by pieces of red marble, in the angles of which were seats. The ledge of the mantel was elaborately carved, and the opening below it was framed with blue glass tiles. Above was a painted stucco relief of an eagle swooping down upon a dragon, lighted by two Gothicized wrought candelabra (see FIG. 8.25). Great columns were wound with studded chains and "ochred into the semblance of rust."[42] There were five stained-glass windows, primarily colored opaline and olive. Portieres in the room were embroidered with buttons and crewels, and iron nailheads on the furniture echoed the iron tiles of the

wainscot and the buttoned embroidery. The very richness and symbolism of the decorations that occasioned critical praise also raised critical questions. In the eyes of some contemporary reviewers, the room's design might have profited from the overriding vision of a single architect.

Perhaps no designer of the Aesthetic period better demonstrated an ability for creating the total interior than did Stanford White. Whether in partnership with Charles Follen McKim (1847–1909) and William Rutherford Mead (1846–1928) or working on his own, White consistently experimented with spatial flow and exhibited a talent for decorative detail. Two Newport dwellings that are close in date to the Veterans' Room reveal White's sure hand. The Isaac Bell, Jr., house of 1882–83 (see ILLS. 10.20, 10.21), done in collaboration with McKim and Mead, features an expansive first-floor plan in which the hall (or more appropriately the living hall), the drawing room, the reception room, and the dining room are all connected by oversized doors that when open contribute to the impression of a vast, continuous space.[43] Highly visible wheel-like devices on the sliding doors, which White may have modeled after New England barn doors, have their philosophical basis in reform concepts of revealed, that is, honest, construction.[44] If such a moral quality stems from the Gothic revival, the home's open spaces owe a debt to Japanism.

More startling for its period and more obviously Japanesque is the dining room that White designed and supervised in 1880–81 as an addition to Kingscote, the residence of David King III, originally designed by Richard Upjohn (1802–1878) in 1839–41.[45] In the Kingscote dining room (ILL. 4.15) a high horizontal band across the window wall continues along the fireplace wall. An evocation of a *kamoi*—the beam above Japanese sliding screens—it serves

here as a plate rail for the display of objects.[46] Despite the solid walls, the rhythm of the three contiguous windows and the light reflecting from the Tiffany glass tiles flanking the flat marble mantelpiece give the effect of an open Japanese interior. A built-in sideboard (ILL. 4.16) and a matching table and chairs suggest no trace of Japanism, however, but rather an interest in Queen Anne furniture and the Colonial revival. Other original furnishings of the dining room evince an eclecticism typical of the 1880s. With its richly varied materials and play of textures, its flat planes and intricate balancing of components, the room achieves both serenity and simplicity. As much as any American room of its age, this one fulfills the canon of the aesthetic interior.

Aesthetic decoration, which derived a great deal from the spatial qualities and restraint of Japanism, seems to have been more a concept than a reality. Rarely described by tastemakers, though sometimes caricatured by cartoonists such as the Englishman George Du Maurier (1834–1896), an aesthetic interior was apparently envisioned as having simple walls and floor coverings, subtle harmonies based on tertiary colors, and frail, rectilinear furniture. Perhaps the only rooms that could meet the most rigid principles of aestheticism were those designed by the English architect E. W. GODWIN, whom the noted essayist Max Beerbohm (1872–1956) called "the greatest aesthete of them all."[47] From the prevailing taste for the classical world, an interest in the medieval, and a grand passion for the arts of Japan, Godwin fashioned furniture and rooms that were often strikingly original. The majority of his contemporaries, however, were content to draw upon the same and other sources in more conventional ways, creating interiors that were generally termed artistic rather than aesthetic.

In the United States, the character of an artistic home of the

ILL. 4.14 Veterans' Room, Seventh Regiment Armory, New York. Associated Artists with Stanford White, New York, 1879–80. Archival photograph, The New-York Historical Society

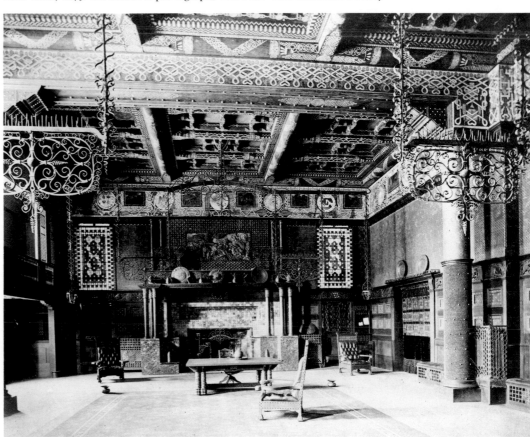

Aesthetic period had much to do with questions of financial standing and social class. While history may view the newly rich American entrepreneurs of the Gilded Age as "robber barons," they saw themselves as latter-day Medicis, patrons of the arts who elevated the masses through an appreciation of the best that other cultures and eras could offer. Striving to establish a superiority not only within society generally but also within their own peer group, they favored interiors of extraordinary elaboration. A successful application of such conspicuous consumption could be achieved solely through the services of professional designers able to unify complex elements: elegant art furniture mixed with genuine antiques; sumptuous textiles, often with intricate embroideries or patterns; collections of fine-art objects such as ivories, jade, and porcelains; as well as collections of paintings and sculpture. All of these were arranged in rooms that were themselves works of art, with inlaid or carved woodwork, ceilings and friezes painted by major artists, panels of jewel-like stained glass, and floors patterned in fine wood or marble.

Filtering down the social strata, the tastes of the rich and prominent were reflected in similar precepts but simpler examples by a comfortable middle class. The household-art movement, essentially a middle-class phenomenon, found expression in countless books and periodicals. Unlike *Artistic Houses* and *Artistic Country-Seats,* or an even more blatantly vanity publication such as *Mr. Vanderbilt's House and Collection,* these works were filled with practical advice aimed at the individual householder and thus helped establish an entire category of amateur but enthusiastic decorators.

Material for studying and evaluating the interiors of the 1870s and 1880s abounds: period photographs, drawings, and paintings; records of individual design, decorating, or architectural firms; household-art books; pattern books of furniture designers or makers; women's magazines; the then-new "art" periodicals, including architectural journals and newspapers; and even contemporary descriptions in letters, diaries, and novels. Because of the very wealth of material, as well as the socioeconomic differences in application of ideas and the continuing emphasis throughout the era on the importance of individual taste, delineating broad yet accurate outlines of period interiors is extremely difficult.

Nevertheless, there were certain traits that appeared in virtually every room of the time. Two of the most evident were a horror vacui, or aversion to blank surfaces, and a rigid compartmentalization of decorated areas, usually into horizontal bands or square or rectangular panels, with rich ornamentation. Both of these characteristics were evident in many, and sometimes all, areas of a room's framework—floor, walls, ceiling; in architectural features such as doors and windows, mantelpieces and built-in cabinets; in upholstery and hangings; as well as in the design of furniture and decorative-art objects within the room.[48]

Despite a continual emphasis upon the role of individual choice, definite rules governed each area. No longer were floors covered wall to wall as they had been in fashionable homes for much of the century. Strip carpeting of Brussels or Wilton weave in vivid colors and bold floral patterns was considered passé for the parlor. In its place came the room-size rug, preferably from an area of the exotic Near East, such as Turkey, Caucasia, or Persia, or from a region of Asia, such as India or China. Indian or Japanese straw matting, though found wall to wall on the second floor (the British first floor) of the ultra-aesthetic London interior that Godwin had designed in 1873–74 for his own use, in the average home more often became a covering for the dado. Like the handwoven oriental rug, woven matting bore the moral implications of traditional, honest craftsmanship. It lacked, however, other qualities that made oriental rugs highly acceptable to prevailing aesthetic tastes. These included both a stylized flat pattern related to that found in the work of contemporary reform designers, and the soft coloration of the natural dyes used in non-Western cultures, as opposed to the aniline dyes favored in industrializing countries.

In an 1886 issue of the *Decorator and Furnisher,* the architect-writer Ralph Adams Cram (1863–1942) deplored civilization's "ruining forever the foundation head of this last art supply" (that is, oriental art). "One must be," he stated, "as careful in buying a piece of alleged Oriental stuff as in buying a frankly home-made piece of work. Of course a true or carefully trained eye will not hesitate a moment, an analine [sic] dye being evident at once." (At this point Cram's readers were undoubtedly meant to reflect upon their own ignorance and sigh wistfully for the skills of the true connoisseur.) With a Gothicist's eye-for-an-eye integrity, Cram continued, "Contemporary Persian work is remarkably pure. It is said that the Shah has ordered brought him the hands of any man using analine [sic] dyes in the manufacture of rugs and stuffs of any kind. It is greatly to be hoped this is true, and that his practice may extend to civilized countries."[49] One is left with a sense of Cram as the perfect Lord High Executioner. If the sin was great, the punishment should fit the crime. A man's hands were, quite literally as well as figuratively, a small price to pay for an aesthetic floor covering.

It was, of course, possible to obtain aesthetic floor coverings that were not of oriental origin but were manufactured by English or American firms. Probably the most desirable of these were the group termed Kensington carpets, not after their manufacturers but rather after the precepts of the design and needlework schools located in the South Kensington area of London (see chaps. 2, 3). Various writings in American household periodicals recommended "a Kensington rug" as an appropriate floor covering,[50] and an 1882 article in the *Art Amateur* said of the Bigelow Carpet Company, "In its employ are men who have been trained under South Kensington and other excellent English influences."[51]

An article of two years earlier in the same publication had been based on the principles of design set forth by CHRISTOPHER DRESSER. American carpet manufacturers were familiar with these principles and approved of them, asserted the writer, who expressed, in addition, a sentiment that was to become common in the next century: "Unfortunately the public taste is shockingly bad, the . . . manufacturers have to make what will sell." The article concluded with eight rules of design for carpets, drawn from Dresser's work. The last of them stated that "every carpet, however small, should have a border, which is as necessary to it as a frame is to a picture."[52] A carpet used in a town house in Philadelphia, also featured in the July 1880 *Art Amateur,* fulfilled some of Dresser's aesthetic criteria. It was made in "the colors and style of a Persian mat," though it was "good Brussels for all that, with a border of warm colors and outer filling of dark-red plain carpet."[53]

Just as the fashionable and nonaniline oriental or oriental-style rug had a contrasting border, so too the hardwood floor upon which it was laid was bordered, often elaborately. At times the field, or central portion of the floor, was stained warm brown and covered with scatter rugs.[54] Floors with intricately inlaid fields, usually of oak with insets of other woods, were called "wood carpets" and were meant to be left uncovered in warm weather.[55] The same page of the *Decorator and Furnisher* that bore Cram's diatribe on the corruption of oriental art illustrated a "Design for Inlaid Floor, Suitable for a City House" (ILL. 4.17), drawn by R. C. Mead, its field a bold geometric pattern of chevron squares centered with a dazzling optical cross.[56] Framing the entire design were a half-dozen lines of contrasting woods to create the border. If a room-size rug was used, it was meant to extend to the edge of the border parquet. Since parquetry was expensive, in simpler homes a border was sometimes painted on the floor, a treatment that was also used to demonstrate the artistic talents of the more sophisticated homeowner.[57] For example, the Japanesque reception-room floor in the New York home of Mrs. John A. Zerega featured a "beautiful border . . . not a parquetry, but . . . painted in stencil after designs furnished by the hostess."[58]

The border effect of the floor was complemented by the wall

and ceiling treatment, which usually had at least three horizontal divisions: the wainscot, or dado; the fill, or upper wall; and the partial entablature of the cornice and sometimes a frieze. Although decoration of these areas differed according to the individual room as well as the wealth of the inhabitant, rules and proportions were still relatively well defined. Tastemakers generally advocated a tripartite arrangement for rooms of eleven feet or more in height. The dado served a functional as well as an ornamental purpose in the dining room, where the chair rail, or molding, was "above two feet nine inches from the floor, to prevent the chairs from damaging the paint." In rooms less than eleven feet high it was permissible to omit one section and "carry up the dado for about two-thirds of the height of the wall, letting the upper third form a deep frieze." Similarly, the proportion of the dado could be changed for a drawing room, "since there is generally more furniture standing against the walls, and . . . a good piece of furniture always looks best when the ground behind it is unbroken."[59]

The materials employed for each of the various sections were as limitless as the imagination of the era. The dado area could be paneled with wood, or a combination of wood and tile or wood and marble; in an entry hall it could be tiled only. The dado might be covered with a stamped composition wall covering known as Lincrusta-Walton (see FIG. 3.6), Indian or Japanese matting, or canvas painted or stenciled with designs. It could be wallpapered to complement the pattern of fill and frieze or have panels lined with fabric in the high-fashion French manner, though the latter was deplored by many tastemakers, who considered it both costly and dirty.

The use of panels set off by moldings, which was one of the most popular treatments of dado or wainscot, was common in other areas of the room as well, particularly the doors. Although here, too, the decorating experts sometimes warned of the danger of excess ornamentation, door panels, like those for walls or furniture, were perceived as a place for painted designs. A writer for the *Decorator and Furnisher,* James Thomson, complained, "It is impossible for people to see a plain surface without wishing to decorate it."[60] The renowned English designer Lewis F. Day (1845–1910) stated, "It is mainly . . . in the panels of the doors that there is room for ornament . . . one cannot well load the stiles with details without overdoing it." Thus the stiles and moldings became frames for the picture surface of the panels. Day felt that "stenciling is scarcely enough" and advocated freehand painting. "Flower and figure panels are often introduced into drawing room doors," he noted, adding that these were acceptable only if they possessed restraint, simplicity, and architectural character and were not "tawdry things on gold grounds."[61] Would he have found pleasing, one wonders, David L. Einstein's town house, with its Anglo-Japanesque second-floor sitting room where the "inside panels of the door recount the story of Orpheus in delicate line work of gold upon ground of neutral blue,"[62] or the "cosy little cottage in New England" that was "suggested by, yet not patterned upon the prevalent Queen Anne style in architecture." In the latter home each door panel was "decorated in oils by the occupant of the house [a woman who built it from the proceeds of her literary work] with suitable design—game, fruit and vegetables appearing on dining-room and kitchen doors, and flowers, birds, butterflies, grasses and autumn leaves on other portals."[63] Tastemaker Ella Rodman Church (b. 1831) offered color schemes for country-house door panels to complement the walls. She recommended "cream-colored paper with blue morning-glories" for a sunny blue bedroom, but if not available, the paper should instead be of "pale terra cotta and gold, with a frieze of blue and golden brown; blue morning-glories painted on the doors." Furthermore, according to the same author, a green bedroom should have "sprays of beautiful green leaves, and golden catkins of the tree, painted over the door panels."[64] Decorative motifs from nature were perhaps the most common type and could be found not only in homes where door

panels were painted, but also in places where they were carved, as in the house of BENN PITMAN in Cincinnati (see FIGS. 1.4, 1.5, ILL. 1.3).

In the Aesthetic period, door-panel paintings were considered worthy of the attention of the cognoscenti, even though they were executed predominantly by unknown amateurs. The noted English artist, collector, and aesthete Edward Linley Sambourne (1844–1910) in 1874 decorated the panels of his dining-room doors at 18 Stafford Terrace, London, with *faux* blue-and-white porcelain vases, which held trompe-l'oeil branches to fill the vertical panels and echoed the real blue-and-white porcelains that lined the walls.[65] In 1880 the American artist CHARLES CARYL COLEMAN, perhaps aware of the Sambourne precedent, produced panels painted on canvas and "destined to be placed in a double door." One of these showed a bronze vessel, the other "a richly carved Majolica jar, made to hold a branch of light, graceful blossoms."[66]

Branches were a highly favored motif in door-panel decoration. In 1880 the *Art Amateur* featured an illustration (ILL. 4.18) by Lewis F. Day in an article that urged the proper construction of doors to allow for decorative adornment. In England, Day's design had been executed in muted aesthetic shades of grayish green upon greenish gray, with the birds painted in gray and "soft white" and the flowers in "soft white and pale yellow." The American tastemaker who penned the *Art Amateur* piece advocated a livelier and more experimental palette, commented upon the "peculiarly Japanese character of the design," and remarked upon the trompe-l'oeil aspects of "this mode of decoration," where "the idea to be conveyed . . . is that we are looking at the tree through the frame of the door."[67]

Decorative painting was generally recommended for door panels, but other types of embellishment more closely allied to the era's collecting craze were also used. "Pictorial tapestry work is highly ornamental when used for panels of dados and doors,"[68] noted one anonymous author. And Day wrote, "I know a room in which the doors are actually filled with old German panel paintings that once formed part of fifteenth century altar pieces." While he seemed to find this use acceptable, he was less approving of "drawing rooms . . . in which water colors have been let into the door panels with delicate effect, but scarcely with due regard to the value of the paintings themselves."[69]

The concept of ornamented panels and moldings not only on doors but also on walls or furniture was part of a general tendency to blur the distinctions between decorative painting and so-called fine art. Whereas decorative panels could be made prominent with moldings that served as frames, fine art could in like manner be de-emphasized by incorporating it into a total scheme. Nowhere was this more evident than in Tiffany's rooms in New York (see ILLS. 4.12, 9.12), which were described in *Artistic Houses:*

> The walls are paneled with Japanese matting, the panels being small—say, three feet by two—some of them painted by hand, while others show the plain matting, or serve as frames for pictures. A notable marine sketch by Samuel Colman fills one of these places. . . . The frame is nothing but the narrow molding used to tack the matting to the wall. . . . Here the yellow tone of the walls helps to keep the picture flat, and make it look like a part of the whole side of the room.[70]

A unified artistic interior depended upon the intricate balancing of all components so that no one element would be visually dominant. Art for the walls became part of the decorating program, unless, as in the homes of many of the wealthy, a separate picture gallery existed to display the owner's connoisseurship.

In many rooms, if any one part of the wall area was viewed as the most important, it was the fireplace. The typical fireplace mantel was large, even imposing, but its character generally allowed it

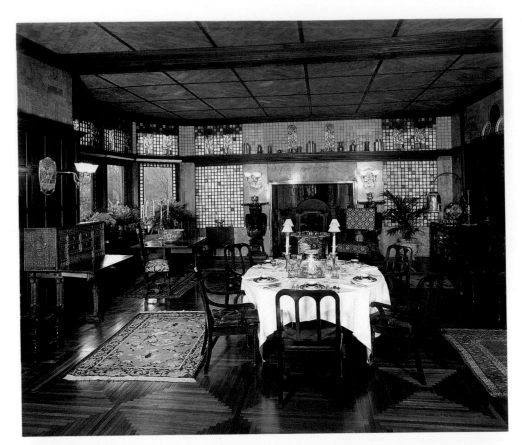

ILL. 4.15 Dining room, Kingscote, Newport, R.I. Stanford White, 1880–81, for David King III. The Preservation Society of Newport County, Newport, R.I.

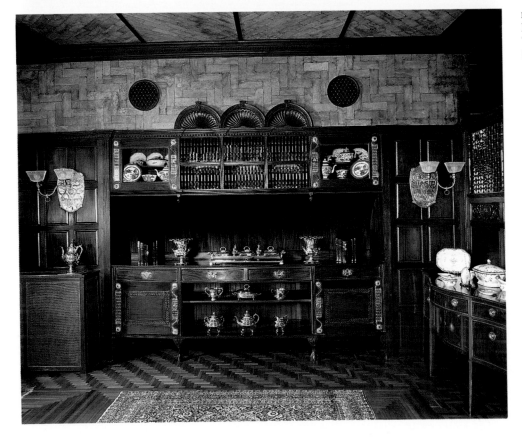

ILL. 4.16 Dining room, Kingscote, Newport, R.I. Stanford White, 1880–81, for David King III. The Preservation Society of Newport County, Newport, R.I.

to blend with its environment. Over and over again writers of the Aesthetic period stressed the significance of the fireplace, imbuing it with a mystical, quasi-religious meaning. Many sought in history both timeless principles and justification for current beliefs.

Thus the Reverend O. D. Miller theorized in 1882 on "The Divinity of the Hearth," a place that "constituted the focus of the most ancient civilization."[71] Similarly, Mary Gay Humphreys noted, "The fireplace is really the domestic altar, the true rallying point

ILL. 4.17 "Design for Inlaid Floor, Suitable for a City House."
R. C. Mead. *Decorator and Furnisher* (June 1886). Art, Prints
and Photographs Division, The New York Public Library,
Astor, Lenox, Tilden Foundations

ILL. 4.18 "Design for a Painted Door." Lewis F.
Day. *Art Amateur* (Dec. 1880). Thomas J. Watson Library, The Metropolitan Museum of Art

of the household."[72] Another columnist proclaimed that "if there were no other thing in the esthetic renaissance to be thankful for, its restoration of fireplaces to our homes would entitle it to respectful consideration. Open fires have a more than esthetic influence. As centres for the home circle—it may be claimed that they serve an ethic [sic] purpose."[73]

One of the favored treatments of the mantel was to make it a place of display surrounded or surmounted by countless shelves for a variety of objects (ILLS. 4.19, 4.20). In *Hints on Household Taste,* Eastlake featured a design for mantelpiece shelves intended for use in a library: "For specimens of old china, etc. the plates should be placed upright on their edges . . . a little museum may thus be formed."[74] The concept of the mantel museum was adopted by numerous followers, and as late as 1900 writers were still echoing Eastlake's advice. In the *Decoration and Furniture of Town Houses* (1881), for example, a drawing by the Englishman Robert W. Edis (1839–1927) of his own dining room (ILL. 4.21) shows fireplace walls with the usual dado and fill, all densely hung with pictures, a broad frieze with both central mural and printed mottoes, and a simple mantelpiece covered with a draw-drapery arrangement and surmounted by "a cluster of shelves specially made to take blue and white china." In another design, termed "an example of simple treatment for wall decoration," Edis created a large surround and molded frame for the restrained fireplace opening. He called this superstructure an étagère, and in its recesses he illustrated tasteful glass and ceramic plates and vessels.[75] Cabinets, standing as well as hanging, were prominent in the artistic interior, though they took second place to the cabinet overmantel: "For a

picturesque display of artistic porcelain, pottery, and glass, of bronze and knickknacks of any kind, over-mantels are certainly the most suitable arrangement. They bring the ornaments in a convenient line with the eyes, and avoid the marring effect of mirage from the glass panes of a cabinet."[76] One American householder who took this advice to heart achieved a breadth of display seldom paralleled. Praised in *Artistic Houses,* his second-floor sitting room had

> an immense ebony mantel, with cabinets containing *bric-à-brac* of varied and fine interest—an ivory snuff-box of Louis XIV's, a miniature Italian guitar enriched with marquetry, old Nuremburg samplers embroidered with exquisite grace, an old Geneva watch, a French harp-clock— an ebony writing-case, fitted up to be a thing of use as well as of beauty, a corner cabinet laden with specimens of Dresden, Royal Worcester, and enamels.

To assemble this truly extraordinary grouping, the owner ostensibly "ransacked the ends of the earth for *objets d'art*."[77]

By the 1880s the American collector abroad often included in his travel itinerary swift visits to antique dealers and flea markets, Parisian ateliers and Near Eastern bazaars, for his social standing might depend upon his acquisition of artistic objects. Though the rage to collect and display objects continued throughout the decade, by 1885 there was some attempt to modify the idea of the mantel museum. "In design," wrote a commentator on fashionable mantels, "the present taste seems a little more for plain, substantial

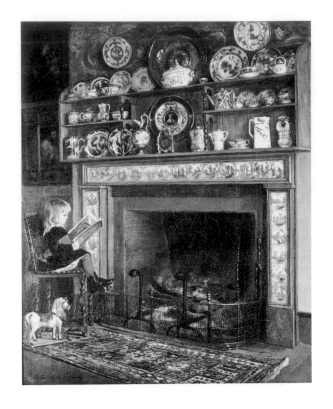

Right: ILL. 4.19 *The Chimney Corner.* D. Maitland Armstrong, 1878. Oil on canvas, 21½ × 16½ in. (54.6 × 41.9 cm). The Preservation Society of Newport County, Newport, R.I.

Below: ILL. 4.20 "Mr. H. G. Marquand's Dining-Room." *Artistic Houses* (New York, 1883–84). Thomas J. Watson Library, The Metropolitan Museum of Art

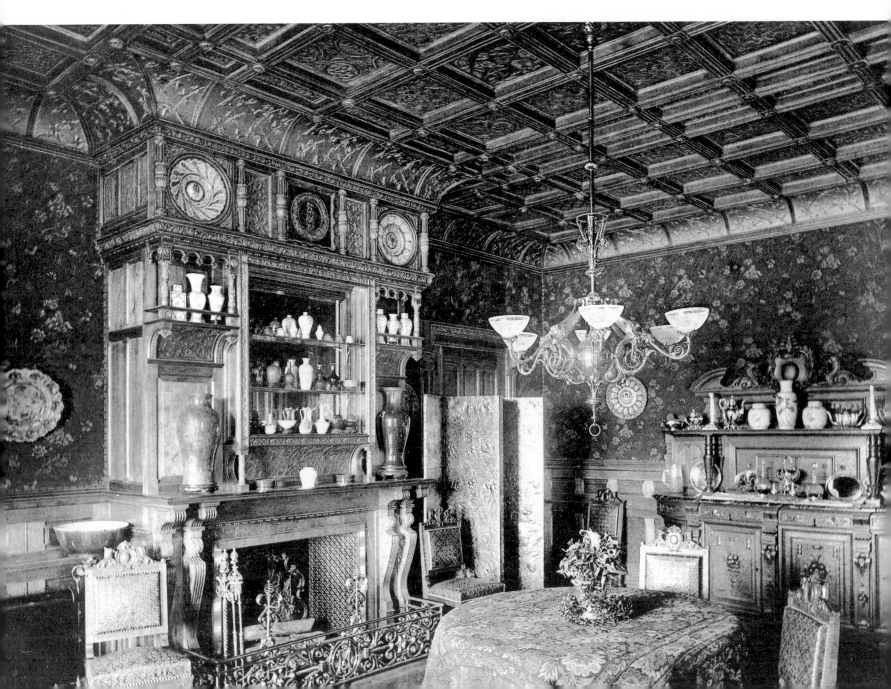

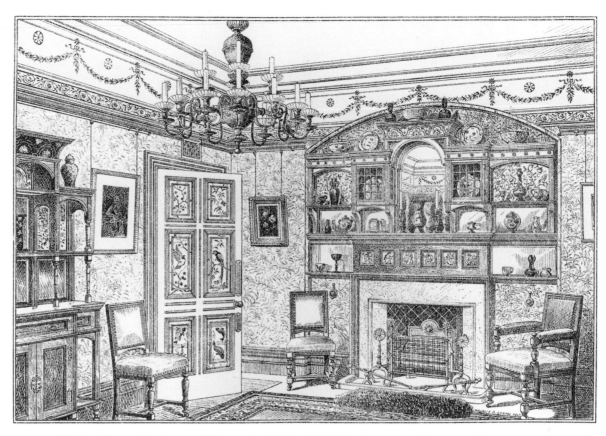

ILL. 4.21 "Dining Room. Furniture and Decoration." Robert W. Edis, *Decoration and Furniture of Town Houses* (New York and London, 1881). Thomas J. Watson Library, The Metropolitan Museum of Art

work, . . . in place of . . . nests of shelves for the display of bric-a-brac." The fireplace, however, was still perceived as "the central attraction—the focus of the room," and therefore "no pains seem to be spared by our designers and makers in adding to its beauty and grace."[78]

All aspects of this household "altar" were apparently considered worthy of serious attention. A dramatic and highly aesthetic advertisement for "Artistic Fire Place Linings" in iron, bronze, and antique brass announced that the objects were "from the Designs of Lockwood deForest [sic]," while the general agent was CARYL COLEMAN, brother of Charles Caryl Coleman.[79] In 1884 a full-page advertisement for a Boston stove company not only promoted an "exceedingly artistic" book on heating, but also one on "The Open Fire Place and Its Surroundings, containing illustrations of the finest series of Fire Place Linings ever offered, including designs by Elihu Vedder and other artists."[80] The center of the page bore a three-part lining with rays of light mingled with flowers and radiating from the head of a woman, conceived by ELIHU VEDDER and in other works by him aesthetically entitled *The Soul of the Sunflower* (see ILL. 9.4, FIG. 9.5).

By the 1880s aesthetic fireplace designs by British artists and architects had long been known. Perhaps the most important of these were Thomas Jeckyll's sunflower andirons for BARNARD, BISHOP AND BARNARDS of Norwich (see FIG. 8.29), the pattern of which was featured prominently at the 1876 Philadelphia Centennial Exposition. The andirons had been used in a number of noted English interiors, including Jeckyll's and Whistler's famed Peacock Room. Within a short time andirons with the same pattern found their way into fashionable American interiors as well, as documented, for example, by a period photograph in which a pair of them dominates the fireplace in the library of David L. Einstein's

New York town house (see ILL. 4.1).

Prosperous New Yorkers, clearly cognizant of current fashions, provided a ready market for British goods. During the late 1870s and the 1880s the showroom of Cottier and Company displayed English-designed fireplace accouterments, including grates by MORRIS AND COMPANY and pictorial tiles by Minton.[81] Almost equally desirable for American fireplace facings were the tiles manufactured by such firms as the J. and J. G. Low Art Tile Works (see FIGS. 7.39–7.41) and the INTERNATIONAL TILE AND TRIM COMPANY of Brooklyn, New York (see FIG. 7.36). So popular were tiles in American decorative schemes that a group of eminent artists in New York formed the Tile Club, and member WINSLOW HOMER executed a fireplace facing that featured a continuous figural design of shepherd on one side, shepherdess on the other (see FIG. 9.8).[82]

In addition to the mantelpiece, another area thought worthy of the attention of the serious artist was the ceiling. Throughout history, with encouragement from the proper patron, the ceiling has been considered a suitable canvas for the artist's brush, and during the late nineteenth century a number of American painters—notably Colman, Tiffany, La Farge, Francis Lathrop (1849–1909), and THOMAS WILMER DEWING—concerned themselves with a range of ornamental plans for this surface. Painted ceilings of the era ranged from those based upon historical conventions, including trompe-l'oeil skies, to more stylized and geometric concepts, such as Moorish or Japanesque overall patterns, and allegorical or symbolic representations. In the category of exotic patterns was the ceiling of oriental design on mummy cloth executed by La Farge for the reception room of Henry G. Marquand's Newport house. Bordered by a "delicately carved frame of mahogany embellished with pearl and holly" and overlaid with elaborate fretwork, also of mahogany, the La Farge ceiling resembled the work of both Col-

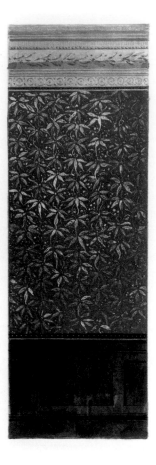

FIG. 4.6 Design for a wall and ceiling. Vincent Stiepevich, New York, ca. 1875–85. Watercolor, gouache, metallic paint on board, 12½ × 10⅜ in. (31.8 × 26.3 cm). The Metropolitan Museum of Art, Harris Brisbane Dick and Rogers Funds, The Elisha Whittelsey Collection, The Elisha Whittelsey Fund, and Gift of John Size, by exchange, 1958 (58.635.5[2])

FIG. 4.7 Design for a ceiling. Vincent Stiepevich, New York, ca. 1875–85. Watercolor and metallic paint on paper, 8¹/₁₆ × 7¹³/₁₆ in. (20.5 × 19.8 cm). Inscribed: *Sitting-Room.Anglo.Japanese.Style.* The Metropolitan Museum of Art, Harris Brisbane Dick and Rogers Funds, The Elisha Whittelsey Collection, The Elisha Whittelsey Fund, and Gift of John Size, by exchange, 1958 (58.635.5[6])

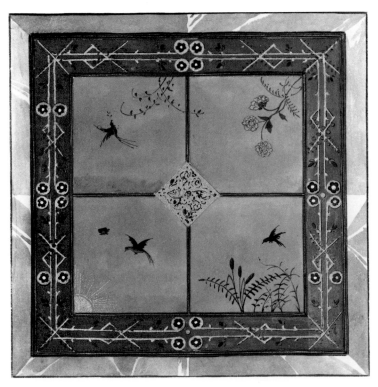

man and Tiffany.[83] Typical of an allegorical aesthetic ceiling was Lathrop's design for the dining room of the Henry Villard house on Madison Avenue and Fiftieth Street in New York, which featured painted heads of mythological characters.[84] Lathrop was most renowned, however, for yet another type of ceiling, one consisting of ornament "modeled in composition," which may seem outside the province of the painter except that it was "done with the brush and overlaid with color."[85] Whereas prominent artists worked principally from their own designs, lesser-known artisans might work from the designs of a decorative painter like VINCENT STIEPEVICH (FIGS. 4.6, 4.7) or an architect like P. B. WIGHT (FIG. 4.8).

When the ceiling of a fashionable home was not decorated by hand with a custom design, it was permissible to cover it with a material deemed appropriate, such as Lincrusta-Walton. Perhaps the simplest patterned ceiling decoration was paper, often made to complement the wall covering. Ceiling paper was used extensively by the middle class; its acceptability in a more sophisticated artistic house was dependent upon both its rarity and the fame of its designer. Such was the case in the picture gallery of the Brooklyn home of John T. Martin, where one of Dresser's papers was used to cover an area extending from the cove of the ceiling to the borders of the skylight.[86]

Mass-produced papers were readily available to the average homemaker and were perhaps the most favored ornamental treatment when their cost was not too great. If a decorated or papered ceiling could not be managed, color was emphasized instead. Throughout the Aesthetic period writers on household taste deplored white ceilings as cold, advocating instead tinting any such surface that was to remain relatively plain. Cream and gray blue were the preferred shades, meant to harmonize with woodwork.[87] A blank ceiling without hue, like an undecorated white doorway, was viewed as a jarring note in an overall design. One writer summed up the prevailing taste, using the analogy of a room as a work of art: "The decoration of a room, like a picture, will be judged as a whole, and as a whole it is incomplete, until the ceiling space has been so utilized that it may contribute its full share to the color gradations of the general scheme."[88]

The importance of color to a total decorating scheme was widely acknowledged in the 1870s and 1880s. Over the course of time, however, fashions in color combinations came and went. In the mid-1870s the soft, aesthetic tones popular in England were also the vogue in America. Clarence Cook enumerated them in *Scribner's Monthly* when he began his series of decorating articles in June 1875:

> Cottier & Co. have serges in colors whose delightfulness we all recognize in the pictures that [Lawrence] Alma Tadema, and Morris, and [Edward] Burne-Jones and [Dante Gabriel] Rossetti paint, . . . the mistletoe green, the blue-green, the ducks-egg, the rose-amber, the pomegranate-flower, and so forth . . . colors which we owe to the English poet-artists who are oddly lumped together as the pre-Raphaelites, and who made the new rainbow.[89]

Although the names of the colors in the new rainbow were sometimes too poetic to permit clear identification, it is apparent that the hues were tertiary. They retained their importance for much of the 1880s and continued to be associated with English designers. In an 1879 article describing the interior of the new Union Club in New York, Edgar Fawcett had remarked that the furniture of one of the rooms in particular was "especially odd. It is of some velvety material, and its changeable greenish-brown color doubtless represents one of those peculiar shadings recently brought to notice by William Morris, the English poet." "Drab" was a color much favored for backgrounds, whether of paint, paper, or fabric, while peacock blue was one of the few strong tones considered acceptable as an accent. In advising upon color choices

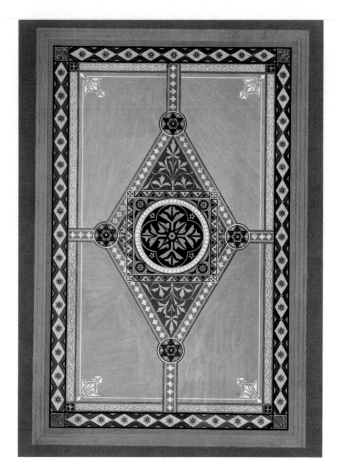

FIG. 4.8 Decoration for a vestibule ceiling. P. B. Wight, 1869, probably for the Brooklyn Mercantile Library, New York. Pencil and gouache on paper, 17¾ × 13⅜ in. (45.1 × 34.6 cm). Labeled: *Executed 1869*. The Art Institute of Chicago

for curtains, Fawcett stated, "We may choose peacock from the deepest to the coldest tint, golden and russet browns, sage greens, dull brick-reds, and in fact all unobtrusive tints."[90]

Another tastemaker, writing four years later, recommended similarly subtle shades for rooms: "A deep, rich brown, umber or dark bronze-green may be used for a skirting, the dado of greenish gray, with the ornamental band above it in brown, gray or sage green, with scroll work upon it in a darker shade of the ground color of the dado. The wall could be painted pink, gray, or stone color." The color scheme advanced by this author not only followed the aesthetic taste for soft backgrounds, but also obeyed the popular precept that hues should lighten as they ascend: "The skirting should invariably be the darkest, the dado next in depth of color and harmonizing approximately with the woodwork, then the walls in a comparatively light tone."[91] Thus the room followed the example of nature; it was anchored by the floor, analogous to the ground, with walls that directed a viewer's eye to the ceiling, the equivalent of sky, which was never so dark as to intrude into the space below. Almost universally, nature was considered a model to be emulated, since no discord could exist between colors joined and juxtaposed in the natural world.

Nature could, of course, be perceived quite variably by different people. In 1881 the *Art Amateur* extracted portions of an article on a model back parlor, originally written by H. J. Cooper for the periodical the *Artist*. Defending the use of primary colors—red, blue, and yellow—Cooper expressed a prejudice against "your muddy half-tints, 'tertiaries,' so called." Like Ruskin, the author said, he himself viewed tertiaries as "colors chiefly to be found associated with the more ignoble species of creation—the serpent,

the toad, and the like." Although generally approving of Cooper's color scheme, in closing the piece the unnamed *Art Amateur* editor cautioned his readers "against accepting such sweeping generalizations. Tertiaries are invaluable in their place in decoration, and it is as foolish to condemn their use because they are associated with 'the serpent, the toad, and the like,' as it would be to condemn the primary colors because they are to be seen in the berries and flowers of many poisonous plants."[92]

Still, the use of primaries continued to have its supporters, among them an anonymous contributor of an 1885 article for the *Decorator and Furnisher* who used entire passages of Cooper's work word for word. Only the closing that the author penned was original, with its condescending class snobbery and smug assumption of aesthetic progress. The writer's aim was to present a lesson, "though of course the term 'primary' is here only comparative—none of the colors used being pure. This would be impossible in any bulk, except for a savage or a middle class American thirty years ago."[93] The implication of the article, despite the slur, was that by the mid-1880s even the American middle class had learned to appreciate the more subtle aesthetic colors.

Earlier in the same decade, in 1881, Mary Gay Humphreys had begun a lengthy commentary on household art by saying that "the love of color is inherent and there is no form that color takes which appeals more powerfully to the senses than in glass."[94] The author reviewed the work of the New York stained-glass makers of the day, J. and R. Lamb, William Gibson's Sons, Tiffany, and La Farge, and she provided detailed suggestions for how stained glass could be employed in home decoration. It was especially desirable for library windows, where medieval costumes and heraldic arms and devices were most appropriate; it was useful, too, for vestibules, hall windows, stair landings, fan lights, and doors of bookcases and cabinets. Panels in drawing-room doors could be removed and replaced with stained glass, and bathroom doors could benefit from translucent panes. Stained-glass fire screens were also attractive, for through them one could glimpse the glow of a burning fire.

Even more important than these purely decorative functions was the reliance on stained glass for problem windows. One writer announced, "The dull and depressing outlook of street windows in a great town call [*sic*] for the use of stained glass."[95] Stained glass could take the place of "swathing draperies, neither wholesome [n]or beautiful,"[96] or, in combination with muslin curtains at the lower sash, it could form the upper sash and veil the prospect of a lifeless wall. Sometimes both stained glass and draperies were used for effects of color and richness. In the library/dining room of a "beautiful" town house in Philadelphia, the long windows had

curtains of coffee-colored canvas, with bands of appliqué embroidery of the Kensington school, in lotos-bells and green rushes on red-brown velvet, drawn in full folds away from the window-screens of amber and wine-red Dutch glass, which tempers the light to the hues of the rest of the room.[97]

The use of both draperies or curtains and stained glass appears to have been unusual. However, it was not uncommon to hang heavy curtains over others of thinner material, and household writers suggested "lace with velvet and silk," for example, or "ecru lace and peachy Morris curtains."[98] Dressing a window elegantly could be as expensive as purchasing a piece of fine furniture, as indicated by an 1882 invoice of Herter Brothers to John Sloane. For the drawing room of Sloane's residence on Fifth Avenue in New York, two pairs of curtains made of "velours richly trimmed with silk" cost $900, while lace curtains to be used with them were $600. Gilt-bronze poles and brackets for installing the double curtains in bay windows cost $75, and the total figure came to $1,575.[99]

If one could afford such fashionable luxury, one had to make a choice

between the innumerable stuffs and artistic colors everywhere exhibited. There are velvet, plush, brocade, satin, waste silks, Oriental fabrics, heavy carpet-like textures interwoven with gold thread, damask, and satin cloth, besides serge that drapes so beautifully, reps, moreens, camel-hair cloths, charity blankets, oatmeal cloth, etc. In lighter textures, cretonnes have almost replaced the old-fashioned glazed chintzes. . . . Crash, Bolton and workhouse sheeting look charming, as do also hop-sacking, unbleached linen, twill, and lava canvas without mentioning the numerous kinds of white and colored muslin, lace, and guipere [sic]; and the more homely ones in knitting, netting, and crochet.[100]

These were by no means all the fabrics available, and choosing among them did not bring to an end the decision-making process. Once a cloth was settled upon the homemaker needed to select a decorative treatment. Bandings of contrasting textiles were favored trims, as were embroidered strips or allover patterns, or the scatterings of embroidered flowers recommended by the English author Elizabeth Glaister.[101] Rules for the placement of bandings and trimmings were well defined. According to a writer in the *Art Amateur* in 1879, when required for an edge finish, "The trimming borders the sides alone, or the sides and hem; in other arrangements it crosses the curtain at a distance of six or eight inches from the top and lower part." If the curtain was to have a border of another material or color, its depth would relate to the depth of the dado of the walls. For one curtain design, a deep dado of three bands was specified: "A sage-green serge has a 25-in or 27-in dado of peacock-blue velvet plush. . . . Above is a space of about eight inches, adorned with embroidery, and surmounting this an equally broad band of the plush."[102] Repeatedly during the Aesthetic era the concept of borders was discussed in advice on window dressings. Suggestions offered in an article of 1880 included "curtains of canvas silk, edged with deep bands of mahogany-colored brocade or satin" and artistic, colored sheetings "that could be worked, bordered, and ornamented."[103]

A deep border was apparently also often the rule for the doorway curtain, or portiere (see FIG. 3.18), and portieres were customary for artistic interiors. "Doors should be discarded from the interior of houses, except for bedrooms or other private apartments," proclaimed one "hint" in the *Decorator and Furnisher* of May 1883. "All reception rooms, dining and drawing rooms, libraries, picture galleries, etc., should have their entrances graced by portieres."[104] The original source of this advice, not surprisingly, was the *Carpet Trade and Review*. The words expressed a sentiment that was also pervasive in *Artistic Houses*. For example, in the dining room of the New York residence of W. G. Dominick, "Turkoman portieres" covered the entrance to the butler's pantry; in Tiffany's apartment the drawing room was separated from the hall by a screen with Moorish columns, between which were curtains of "old Japanese stuffs"; the embroidered portiere of David L. Einstein's house was "made piece by piece out of old silk robes imported for the purpose."[105] While exotic fabrics were preferred by many of the most privileged homeowners, textiles by noted designers and artists were also sanctioned. In an article of 1880 Colman was mentioned as "superintending the execution of some portieres from his own designs, in the work-rooms of the [New York] Society of Decorative Art" and was lauded for his "original effects, without any of the affectation or oddity of misplaced quaintness that is so common."[106] La Farge found curtains as suitable for his talents as stained glass and painted ceilings. For the New York home of Mrs. John A. Zerega he designed portieres, inspired by a Japanese picture, for a room in which the window curtains were of "variegated old Japanese priests' robes." For the drawing room of the same house La Farge conceived a portiere depicting a "sunset landscape . . . somewhat in the style of the embroideries recently exhibited in New York by Mrs. Oliver Wendell Holmes, Jr." The design was derived from a pencil drawing by Mrs. Zerega herself, and the needlework was done by "the ladies of Miss Tillinghast's studio."[107] The result was a cooperative effort of amateur, artist-designer, and artisan that fulfilled the best expectations of the era.[108]

In such affluent homes the opulence of window hangings and portieres was enhanced by choice upholstery fabrics. Patterns and colors for furniture, however, differed slightly from one piece to the next. As one writer instructed, "It is not considered necessary that the curtains should match the coverings of the furniture of the rooms; indeed it is in better taste when they do not. . . . Sofas, ottomans, and settees are not covered 'en suite' as heretofore, except in large rooms . . . used for receptions only." The ideal, as the writer of these rules expressed it, was "harmony in place of monotony, agreeable contrasts instead of dreary sameness."[109] Most fabrics were inspired by European prototypes—"French copies of tapestry effects of fifteenth century cretonnes," "designs in old English style"[110]—or by more exotic motifs from the Near and the Far East. French upholstery imitating old Flemish and French handwrought tapestries might have patterns of Indian designs with palms, flowers, birds, and foliage; Persian flora; Renaissance scrolls; and large flower forms. Sometimes an entire room was Moorish (also called Turkish), such as the smoking parlor of about 1880 (ILL. 4.22; now installed in the Brooklyn Museum, New York) in the house of John D. Rockefeller at 4 West Fifty-fourth Street in New York. "Turkoman" curtains could command as much as $100 a pair, and rich fringes for furniture covering were sometimes supplied in Turkish tassels.[111]

In opposition to exotic influences was the work of reform designers, such as the firm of Morris and Company, which by 1881 had a New York agent, Elliot and Goodwin of Union Square. Morris wallpapers, already available through C. H. George and J. M. Bumstead and Company of Boston, were supplemented by carpets, tapestries, fabrics, and hangings.[112]

Fabrics were essential not only for traditional uses such as upholstery, curtain, or drapery material but also for myriad new applications. Despite the writings of Eastlake and other reformers, neither before nor since the Aesthetic period have rooms been so swathed in textiles. Lengths of fabric tented above a space created corners for intimate conversation or reading. Even pieces of furniture or frames of pictures could not escape decorators' impulses to drape. In 1883 the *Decorator and Furnisher* admonished its readers that "cabinets are now to be covered with plush, the drawer fronts 'swagged,' and the material wrapped or wound about the legs."[113] The *Decorator and Furnisher* also advocated the use of pink mosquito net over pictures or mirrors, looped back and fastened on each side with a bow of pink ribbon. This sort of treatment, it was said, furnished a "pretty and inexpensive protection" for gilded frames.[114]

In a principal room such as the parlor the two focal points were usually the mantelpiece and the piano. Both were accorded the extra importance that fabric imparted. The mantelpiece often had a lambrequin, or valance, and the fireplace opening sometimes had curtains as well. The latter could be fashioned from "cloth of gold, satin, velvet, brocade, and painted or embroidered Indian muslin. The Oriental style being now so popular, Persian needlework harmonizes perfectly with the quaint chimney-piece decoration, and utilizes to advantage any carefully stored specimens too short for window curtains, yet too entire for scattering about on small cushions and chair seats."[115] More elaborate was the painted silk valance with matching curtains, which might be artfully installed with "trails of either real or artificial flowers and ferns, sometimes with the addition of lace and muslin."[116] While this was clearly a seasonal

dressing, the mantel lambrequin was suitable year-round, and its design and trim were of considered significance. A drawing-room mantel lambrequin might be of "Pompeian red plush, the square corners adorned with inset appliques of Turkish embroidery, the finish a fringe of ecru cotton strands, edging an insertion of ecru lace, heavily worked with silks."[117]

Like the mantel, the piano could be draped, and the novel practice of situating a piano in the middle of a room made it necessary to cover the back. Alternatively, oriental embroidered stuffs or Indian shawls and chintzes might be used in the same way.[118] More unusual by far than the practice of draping pianos with fabric was the "pretty fashion of taking out the meaningless fretwork in the fronts of upright pianos and putting in a piece of embroidery"; an *Art Amateur* article of 1880, quoting the indefatigable art embroiderer Elizabeth Glaister, advised, "The piano front should be in fine materials, fine linen, silk or satin; velvet is too heavy, and would deaden the sound."[119] One has visions of pianos across the land sprouting morning glories or perhaps poppies and lilies on their somber facades.

Positioning a piano out in the room was indicative of a new approach to the arrangement of furniture in general. During the first half of the nineteenth century, the furnishings in the principal sitting room or parlor were usually of the same style, or even en suite, and were placed both against the wall and parallel to it, never extending into the central space. Beginning in the 1830s and continuing through the 1860s, a matched set of seating furniture—whether classical, Gothic, Rococo, Louis XVI, or Renaissance revival—might customarily include a pair of sofas, several large and several slightly smaller upholstered armchairs, a number of side chairs, and perhaps even window benches or ottomans. All of these had nearly identical wood frames, and all were covered in the same fabric, which was duplicated or sympathetically evoked in the window treatments. Extra occasional chairs, also upholstered in the same fabric, echoed the style of the suite, as did tables and case pieces. The prevailing atmosphere was thus one not simply of decorum but also of rigid control. A cool formality was often conveyed by a white marble mantelpiece or by the marble top of a pier table, situated between the windows, and of a center table, unfailingly placed beneath the chandelier.

By the early 1870s, the beginning of the Aesthetic period in America, less strict furnishing layouts, in keeping with a concurrent architectural opening up of interior spaces, began to appear. American tastemakers, writing from the mid-1870s on, stressed comfort as well as taste. The principal room in the house, as connoted by a new name, was now for living, rather than merely receiving, and other rooms also reflected more relaxed living patterns.

Periodicals and decorating handbooks from the mid-1870s and later emphasized both a deliberate mixing of styles and a studied informality in the placing of furniture. "Chairs, like after-dinner coffee-cups, seem to be selected nowadays with a view to their harlequin effect," observed Constance Cary Harrison (1843–1920) in 1881. She continued,

> One sees the little Louis XV gilt beauties, their satin seats powdered with embroidered flowers, drawn confidingly up to the arm of a square "Cromwell" in oak, severely plain save for its dark cushion in maroon plush. Gilt wicker, flaunted with bows like a bed of poppies, confronts the rigid dignity of a Tudor or Eastlake specimen in *solid* wood, while India teak and Wakefield rattan hobnob most cordially.[120]

Such a combination of modes and periods, although thought out and balanced, was meant to look casual and unplanned, as indicated by an illustration done by Francis Lathrop for Clarence Cook's *House Beautiful* (1878, see FIG. 5.6). Depicting a choice cor-

ner grouping of Cromwellian chair, Queen Anne mirrored sconce, Chinese stand, and Japanese scroll, set off by a Near Eastern rug and a voluminous hanging, the drawing was nevertheless captioned "We Met by Chance."[121]

If Aesthetic-period assemblages of furniture were intended to convey the variegated beauty of different styles, forms, and colors, individual pieces assumed personal significance: chairs for friendly conversations became "gossip" chairs, and tables small or light enough to be carried about as need dictated—to serve perhaps as private worktables in the morning, tea tables by the fire in the late afternoon—were termed "gypsy" tables. Whether a gossip chair or a gypsy table acted as the primary element in an arrangement of furniture, the ultimate purpose was to break up a single large formal interior into several more manageable and personal areas.

One other means of simultaneously achieving a feeling of both open space and intimate groupings was through the use of screens. Fixed architectural screens of fretwork, basket weave, or turned spindles were often employed to separate areas linked architecturally but intended for different functions, such as the staircase, corridor, and seating section of a living hall.[122] Movable screens might conceal undesirable views, set off a collection of artistic objects, or define areas for social activities. "A Chapter on Screens," printed in November 1878 in *Art Interchange,* quoted a Mme de Girardin, writing forty years earlier but with a sensibility attractive to the 1870s. Her advice was to transform a long and uninterrupted parlor into a series of small artistic areas: "Gather there easy chairs and foot stools, lounges strewn with pillows, stands, writing tables, jardinières, screens indispensably screens." The result, she concluded, would be "a sort of society bazaar where delicious mysteries may be confidentially discussed."[123]

Photographs of interiors of the 1870s and 1880s show a remarkable number of screens, indicating the efficacy of the tastemakers' admonitions. They also clearly illustrate the emphasis on numerous seating arrangements spotted about a room. At times intimate seating was not introduced by a decorator but was part of the architecture itself. These same decades produced both the built-in cozy corner, a conversation area replete with cushions and drapery, and the inglenook,[124] usually created with padded benches near a fireplace. Bay windows and alcoves were also favored locations for built-in seating, which was occasionally installed in quite unexpected places, such as a very small sitting room or turret off a stair landing.

If a room had no inglenook, a personal space could be established in a novel way—described in an article in the *Decorator and Furnisher* of September 1886—by using a Japanese parasol, "an important item in the decoration of homes of taste and cultivation where artistic effects are sought after." The writer of the article explained that an amateur artist had fitted a jointed section of pipe to one of the gas brackets on either side of a chimney. To this the artist had attached a Japanese umbrella "of about nine feet spread. The joints are so arranged that when not required the parasol can be closed and will hang at the side of the chimney." When in use, however, the parasol floated above a table, an easy chair, and a footstool, with a revolving bookcase nearby. The author for the *Decorator and Furnisher* concluded that "a more delightful retreat after the cares of the day could scarcely be imagined."[125] This cozy corner for one person (they were usually for two) was so appealing, in fact, that the entire description of it was repeated almost verbatim in the October 1886 issue of *Art Age*.[126]

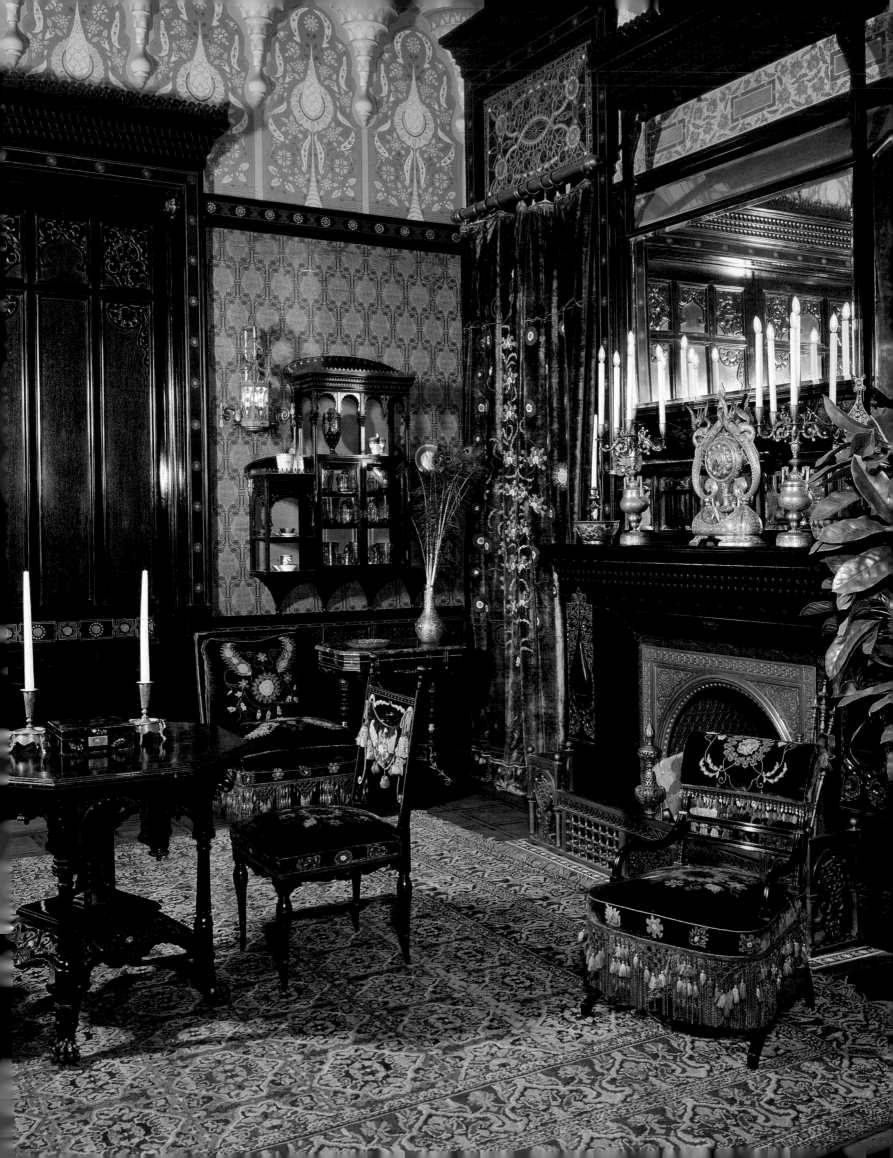

Such an application of a Japanese umbrella undoubtedly strikes a twentieth-century sensibility as a curious conceit, though it aptly reflects the Aesthetic movement's exploration of the unusual. To be artistic, it seems, one was expected to broaden the conventional boundaries of art. A notable example of experimentation with decoration could be found in the Japanesque reception room of Mrs. John A. Zerega, which was published in *Artistic Houses,* with the author drawing attention to "two objects fastened on the walls in a fashion daring if not defiant." One of the two items was "an immense Japanese fan, opened to its full extent and six feet wide, painted by hand, and imported in a case as big as a coffin"; the other was a "bill of lading covered with mysterious Japanese characters, and inviting the visitor to ask the hostess (who, by the way, saw it in some debris of a fancy-goods establishment, and carried the trophy off . . .) 'Won't you tell me a story about that?'"[127] If the rescuing of artistic embellishment from the rubbish bin presages twentieth-century interests in "found art," and the storytelling evocation is in a general Victorian tradition, the whimsy of the exaggerated scale and the exoticism of the decorative options are typical of the Aesthetic movement.

Seldom if ever has an age provided so many guidelines for the decoration of houses as the Aesthetic period did; seldom if ever have there been so many contradictions and questions as a result. Since leading critics of the time frequently disagreed, it is small wonder that average men and women constantly found themselves asking whether the important arbiter of taste was the individual or the tastemaker. Moreover, in a world where distinctions between the arts were deliberately being blurred, what was the role of the artist? the architect? the artisan? the decorator? the amateur? And what was the status of craft? In this context, one may well recall the woman who told William Morris that she would not mind her son's being a furniture maker if he would create art furniture,[128] or the words of Dr. William A. Hammond, quoted in *Artistic Houses:* "If I wasn't a physician, I should be an upholsterer."[129] These comments suggest an ennobling of the craft tradition and an assertion of the dignity of hand labor, but do they not also suggest something of a Marie-Antoinette playing milkmaid? Such role playing might have prompted even aesthetic wit to proclaim "the importance of being earnest."

A hundred years ago, the word more often used for an interior was artistic rather than aesthetic. Looking back across a century of de-sign trends, in the midst of an age once again intrigued by historical form, pattern and ornament, complexity and contrast, the postmodern critic might prefer to call those same interiors "artful." If in this term there are seemingly negative connotations of contrivance and artifice, there are positive connotations as well. Above all, the interior of the Aesthetic movement was artful in the literal sense of the word—that is, filled with art—and such artfulness expressed striking oppositions: exuberant and restrained, tasteful and tacky, moral and meaningless, serious and playful. In keeping with the high seriousness of the Aesthetic period was the belief that an artistic interior could influence the character of its occupants; consistent with the era's playfulness was the idea that one could exercise a great deal of choice in achieving an artistic and therefore an edifying and spiritually uplifting interior. For designers, tastemakers, and consumers, the Aesthetic movement broadened the concept of art so that no one could continue to view objects as they had been viewed before or regard interiors as areas to be designed without careful consideration.

The artful interior has sustained its mark throughout a century of change. The ultimate artistic room was clearly one where "anything goes." The logical early modernist reaction to Aesthetic-period design was the interior where everything literally went, a functional space, stripped not only of pattern and ornament, but of aestheticism's allusions to other cultures and ages as well. The modernist interior of the teens and twenties served not as an extension of man, human and imperfect, intricate and controversial, but rather as a well-constructed machine. As the stringent functionalism of the Bauhaus gave way after World War II to a still-spare but less mechanical version of the International style, a range of art objects once again appeared in the home; folk art, African masks, and—by the late 1950s and the 1960s—Tiffany art glass were all carefully selected and displayed. The owners of such objects unwittingly paid homage to the concepts of the Aesthetic movement—its preoccupation with a variety of cultures, its emphasis on personal taste, and its widening of earlier boundaries of art. Today, the postmodern period has designers turning with approbation to interiors of the 1870s and 1880s, finding in them a complexity fascinating to the eye and the mind. Nevertheless, art decoration, the principal legacy of the Aesthetic movement, bequeaths a whispering doubt to designer, critic, and everyman alike: If art is everywhere, is it nowhere?

NOTES

1. For a complete bibliography of *Hints on Household Taste* editions, see Charles Locke Eastlake, in Dictionary of Architects, Artisans, Artists, and Manufacturers, this publication.

2. *Artistic Houses, Being a Series of Interior Views of a Number of the Most Beautiful and Celebrated Homes in the United States,* 2 vols. in 4 pts. (1883–84; reprinted in 1 pt., New York, 1971), vol. 1, pt. 1, p. 28, ill. opp. p. 31.

3. Clarence Cook, "Beds and Tables, Stools and Candlesticks [1]: Some Chapters on House-Furnishing," *Scribner's Monthly* 10 (June 1875), pp. 172–73.

4. Ralph Adams Cram, "The Reception Room," *Decorator and Furnisher* 1 (Jan. 1883), pp. 119–20.

5. Mary Gay Humphreys, "Our Halls," *Decorator and Furnisher* 1 (Jan. 1883), p. 115.

6. See Wilson H. Faude, "The Conservatory," in *The Renaissance of Mark Twain's House* (Larchmont, N.Y., 1977), pp. 64–70. For fine color reproductions of these interiors, see Henry Darbee, ed., *Mark Twain's House* (Hartford, Conn., 1977).

7. Quoted in Faude, *Renaissance of Mark Twain's House,* p. 90.

8. John A. Cherol, "Chateau-sur-Mer in Newport, Rhode Island," *Antiques* 118 (Dec. 1980), pp. 1220–25.

9. B. W., "Correspondence: American Decorative Art and Artist Decorators," *American Architect and Building News* 7 (Feb. 14, 1880), pp. 58–59. The artists mentioned in the article include La Farge, William Morris Hunt, Tiffany, de Forest, H. M. Lawrence, and Charles Caryl Coleman. For information on the rise of the decorator, see Dianne H. Pilgrim, "Decorative Art: The Domestic Environment," in Brooklyn Museum, *The American Renaissance, 1876–1917* (exhib. cat., 1979), pp. 110–51, esp. pp. 114–15.

10. A red leather volume in the possession of the Museum of the City of New York has the title *Pottier and Stymus Manufacturing Co., New York* (New York, 1871). Apparently prepared for purposes of fire insurance, it contains pictures of the exterior and of the second- through sixth-floor workrooms, accompanied by brief commentary. For references to and analyses of this volume, see *The Golden Book of Celebrated Manufacturers and Merchants in the United States* (New York, 1876); David [A.] Hanks, "Pottier and Stymus Mfg. Co.: Artistic Furniture and Decorations," *Art and Antiques* 7 (Sept.–Oct. 1982), p. 90; and idem, Introduction, in Geoffrey N. Bradfield and Connie LeGendre, *Great New York Interiors: Seventh Regiment Armory* (New York, 1983).

11. Harriet Prescott Spofford, *Art Decoration Applied to Furniture* (New York, 1878), p. 232, originally published anonymously as a series of essays in *Harper's Bazar* and *Harper's New Monthly Magazine,* 1876–77.

12. "Concerning Furniture," *Scribner's Monthly* 11 (Nov. 1875–Apr. 1876), Scribner's Miscellany [bound in at back], p. 9.

13. Ibid., p. 10.

14. Quoted in "A Frenchman's Ideas upon American Cabinet Work," *American Architect and Building News* 2 (Sept. 1, 1877), p. 278.

15. *Art Interchange* 1 (Sept. 18, 1878), p. 8.

16. M. B. H., "Herter, Christian," in *Dictionary of American Biography,* vol. 8 (New York, 1932), pp. 596–97.

17. Addie Hibbard Gregory, *A Great-Grandmother Remembers* (Chicago, 1940), p. 29.

18. Glessner family diaries, quoted in letter of

David A. Hanks to the author, Aug. 15, 1971. For a photograph showing a pair of Herter-type armchairs from the Glessner House, see David T. Van Zanten, "H. H. Richardson's Glessner house, Chicago, 1886–87," *Journal of the Society of Architectural Historians* 23 (May 1964), p. 111.

19. Thomas E. Tallmadge, *Architecture in Old Chicago* (Chicago, 1941), p. 185. See also [George William Sheldon], *Artistic Country-Seats: Types of Recent American Villa and Cottage Architecture, with Instances of Country Club-Houses,* 2 vols. in 5 pts. (New York, 1886).

20. It is interesting to note that Mrs. Potter Palmer's bedroom, intricately detailed in the Moorish style, was decorated by R. W. Bates of Chicago, the same Bates who along with Herter had been praised in "Decorative Fine-Art Work at Philadelphia: American Furniture," pt. 3, *American Architect and Building News* 2 (Jan. 13, 1877), p. 13, for his work in the Queen Anne style.

21. Photocopy of bill of sale in possession of the author, courtesy of Margot Johnson, Inc. This cabinet is in the collection of the Museum of Art, Carnegie Institute, Pittsburgh.

22. [Sheldon], *Artistic Country-Seats.*

23. Caption to [Illustration of the dining room, West Hotel, Minneapolis], *Decorator and Furnisher* 7 (Jan. 1886), p. 116.

24. Ibid.

25. Edward Strahan [Earl Shinn], *Mr. Vanderbilt's House and Collection,* 2 vols. (Boston, New York, and Philadelphia, 1883–84), vol. 1, pp. v, vi.

26. Ibid., p. 10. Shinn remarked, "This house is a box, if you will, but there is a finish and a style about it that shows it is a jewel-box."

27. *Artistic Houses,* vol. 1, pt. 2, p. 113, ill. opp. p. 114.

28. Ibid., p. 114, ill. opp. p. 118.

29. *Artistic Houses,* vol. 1, pt. 2, p. 115, ill. opp. p. 121; H. Barbara Weinberg, "The Decorative Work of John La Farge" (Ph.D. diss., Columbia University, 1972), pp. 271–72.

30. *Artistic Houses,* vol. 2, pt. 1, p. 61.

31. Ibid., p. 62.

32. Ibid., pp. 63, 60 (ill.).

33. Although the facade of the Tilden house (now the National Arts Club) has been painstakingly restored and much of the interior aesthetic detailing including paneling, stained glass, and tiles still exists, the Tilden dining room was dismantled to provide space for an art gallery. At the same time the club added a studio building.

34. References in *Artistic Houses* are to Louis C. Tiffany and Company, but references elsewhere are to Associated Artists.

35. *Artistic Houses,* vol. 1, pt. 1, p. 1, ills. opp. pp. 3, 4.

36. For Kemp, see ibid., pp. 53–56; for Johnston, see vol. 2, pt. 2, pp. 152–53; for Lusk, see vol. 2, pt. 2, pp. 154–55; for Colman, see vol. 2, pt. 1, pp. 71–74; and for Kimball, see vol. 2, pt. 2, pp. 158–60.

37. Ibid., vol. 2, pt. 1, pp. 97–100.

38. For information on the Seventh Regiment Armory interiors, see [William C. Brownell], "Decoration in the Seventh Regiment Armory," *Scribner's Monthly* 22 (July 1881), pp. 370–80; Wilson H. Faude, "Associated Artists and the American Renaissance in the Decorative Arts," *Winterthur Portfolio* 10 (1975), pp. 101–30; Bradfield and LeGendre, *Great New York Interiors;* Sophia Duckworth Schacter, "The Seventh Regiment Armory of New York City: A History of Its Construction and Decoration" (M.A. thesis, Columbia University, 1985).

39. [Brownell], "Seventh Regiment Armory," pp. 370–71.

40. Ibid., p. 375.

41. This is a color scheme used by E. W. Godwin for his own house; see Elizabeth Aslin, *The Aesthetic Movement: Prelude to Art Nouveau* (New York and Washington, D.C., 1969), p. 65.

42. [Brownell], "Seventh Regiment Armory," p. 375.

43. For a view of the living hall of the Isaac Bell, Jr., house, see Vincent J. Scully, Jr., *The Shingle Style: Architectural Theory and Design from Richardson to the Origins of Wright* (New Haven, 1955), figs. 129, 130, 131. See also [Sheldon], *Artistic Country-Seats,* pt. 1, pp. 23–27, and pt. 3, pl. 7.

44. Tiffany used the same wheel-like devices for the drawing-room doors in his own residence in the Bella Apartments; see Hugh F. McKean, *The "Lost" Treasures of Louis Comfort Tiffany* (New York, 1980), p. 102.

45. See John A. Cherol, "Kingscote in Newport, Rhode Island," *Antiques* 118 (Sept. 1980), pp. 476–85.

46. For a reference to the *kamoi* published in America in the 1880s, see Edward S. Morse, *Japanese Homes and Their Surroundings* (Boston, 1886), pp. 125–26.

47. Quoted in Dudley Harbron, *The Conscious Stone: The Life of Edward William Godwin* (London, 1949), p. xiii.

48. See Martha Crabill McClaugherty, "Household Art: Creating the Artistic Home, 1868–1893" (M.A. thesis, University of Virginia, 1981), and her "Household Art: Creating the Artistic Home, 1868–1893," *Winterthur Portfolio* 18 (Spring 1983), pp. 1–26.

49. Ralph Adams Cram, "Interior Decoration of City Houses: A Smoking Alcove," *Decorator and Furnisher* 8 (June 1886), p. 78.

50. Ella Rodman Church, "What to Do with a Country House," *Decorator and Furnisher* 7 (Dec. 1885), p. 73.

51. Mary Gay Humphreys, "Instruction in Carpet Designing," *Art Amateur* 6 (Apr. 1882), p. 100.

52. "The Principles of Design in Carpets: Industrial Art," *Art Amateur* 3 (July 1880), p. 40.

53. Shirley Dare, "Decoration and Furniture: A Beautiful Town Home," *Art Amateur* 3 (July 1880), p. 35.

54. For M. E. James's comments on decoration of the floor, see "Walls and Ceilings from Well-known Authors," *Decorator and Furnisher* 1 (Jan. 1883), p. 24.

55. The term wood carpet appears in period advertisements and articles. See, for example, Cook, "Beds and Tables, Stools and Candlesticks [1]," p. 177.

56. *Decorator and Furnisher* 8 (June 1886), p. 78 (ill.).

57. R. B. Preston, "Modern Houses: Their Style and Decoration," *Decorator and Furnisher* 1 (Jan. 1883), pp. 111–12, originally published in *British Architect.* Preston, p. 112, notes, "The floor should have stained and varnished margins, about two or three feet wide, but if the floor boards are not good enough for this, they may be painted or varnished."

58. *Artistic Houses,* vol. 1, pt. 1, p. 63.

59. Preston, "Modern Houses," p. 112.

60. James Thomson, "Ancient and Modern Furniture, 2," *Decorator and Furnisher* 3 (Jan. 1884), p. 130.

61. Lewis F. Day, "Door Decoration," *Decorator and Furnisher* 1 (Jan. 1883), p. 108.

62. *Artistic Houses,* vol. 1, pt. 1, p. 32.

63. Charles M. Skinner, "Economy in Decoration," *Decorator and Furnisher* 1 (Jan. 1883), p. 120.

64. Ella Rodman Church, "What to Do with a Country House," p. 73.

65. Aslin, *Aesthetic Movement,* p. 73 (ill.).

66. B. W., "American Decorative Art and Artist Decorators," p. 59.

67. "Door Decoration," *Art Amateur* 4 (Dec. 1880), p. 18.

68. "Decorative Notes and Suggestions," *Art Age* 4 (Oct. 1886), p. 31.

69. Day, "Door Decoration," *Decorator and Furnisher* 1 (Jan. 1883), p. 108.

70. *Artistic Houses,* vol. 1, pt. 1, pp. 4–5.

71. O. D. Miller, "The Divinity of the Hearth," *American Antiquarian* 4 (Apr.–July 1882), p. 179. Less religious in its content and far more concerned with technical advances is J. Pickering Putnam, *The Open Fire-place in All Ages* (Boston, 1881). Portions of Putnam's book were published in various places, most notably in two series on fireplace technology, "The Open Fire-place" and "The Ventilating Fire-place," which appeared monthly during 1880 in the *American Architect and Building News. Art Amateur* 4 (Jan. 1881), pp. 34–37, featured a review of Putnam's book, accompanied by illustrations of fireplaces through the ages.

72. Humphreys, "Our Halls," p. 115.

73. "Odds and Ends: With Pen and Pencil," *Decorator and Furnisher* 3 (Oct. 1883), p. 24.

74. *Artistic Houses,* vol. 2, pt. 1, ill. opp. p. 86; Charles Locke Eastlake, *Hints on Household Taste in Furniture, Upholstery, and Other Details* (London, 1868), p. 121.

75. Robert W. Edis, *Decoration and Furniture of Town Houses* (New York and London, 1881), pp. 171–72, pls. 11, 16.

76. "Overmantels," *Art Amateur* 2 (Apr. 1880), p. 104.

77. *Artistic Houses,* vol. 1, pt. 1, pp. 32–33. The householder referred to was David L. Einstein.

78. "Artistic and Fashionable Mantels," *Decorator and Furnisher* 7 (Dec. 1885), p. 93.

79. Advertisement for a catalogue of "Artistic Fire Place Linings from the Designs of Lockwood deForest [sic]" [source unknown, n.d.], photocopy in the scholarship files, Department of American Decorative Arts, The Metropolitan Museum of Art, New York.

80. Smith and Anthony Stove Company, Boston [advertisement], in Boston Art Club, *The Seventh Annual Exhibition of the Paint and Clay Club* (exhib. cat., 1888), unpaged.

81. Mark Girouard, *Sweetness and Light: The "Queen Anne" Movement, 1860–1900* (Oxford, 1977), p. 211; Clarence Cook, "Beds and Tables, Stools and Candlesticks, 2: More about the Living-Room," *Scribner's Monthly* 11 (Dec. 1875), pp. 349–50.

82. See Alice Cooney Frelinghuysen, "Aesthetic Forms in Ceramics and Glass," and Doreen Bolger Burke, "Painters and Sculptors in a Decorative Age," this publication.

83. *Artistic Houses,* vol. 2, pt. 1, p. 85.

84. Ibid., vol. 2, pt. 2, p. 163.

85. "Decorative Notes," *Art Age* 2 (Jan. 1885), p. 81. The article also states that in the country house of Charles J. Osborne in Mamaroneck, N.Y., Lathrop created "effloriated scroll work placed in panels," probably an independent design. Lathrop is known to have painted ceilings in homes decorated by Herter Brothers. Some indication of the importance in the Aesthetic period of ceiling ornamentation to a total scheme, and its cost when executed by a decorating firm, is provided by an 1882 invoice from Herter Brothers to New Yorker John Sloane. For the drawing room of Sloane's new residence, Herter Brothers used "ceiling and cove of ornamental plaster richly decorated in distemper and gold according to special design [$]1500." The original invoice, dated March 21, 1882, is in the collection of the Brooklyn Museum, New York, which also has in its possession the interior woodwork and some of the furnishings of the room.

86. *Artistic Houses,* vol. 1, pt. 2, pp. 138 (ill.), 139.

87. "Ceiling Decoration," *Art Amateur* 6 (Jan. 1882), p. 40.

88. Ibid., p. 39.

89. Cook, "Beds and Tables, Stools and Candlesticks [1]," p. 179.

90. Edgar Fawcett, "The Union Club," *Art Amateur* 1 (June 1879), pp. 9, 11.

91. "Colorings," *Decorator and Furnisher* 1 (Jan. 1883), p. 118.

92. "Practical Room Decoration, 2: Suggestions for Small Apartments," *Art Amateur* 4 (Apr. 1881), p. 105.

93. "A Summer House," *Decorator and Furnisher* 6 (Aug. 1885), p. 142.

94. Mary Gay Humphreys, "Colored Glass for Home Decoration," *Art Amateur* 5 (June 1881), p. 14.

95. "Hints for Home Decoration," *Art Amateur* 1 (July 1879), p. 34.

96. Humphreys, "Colored Glass," pp. 14–15.

97. Dare, "Beautiful Town Home," p. 35.

98. "Home Upholstery, 1: Curtains," *Art Amateur* 1 (June 1879), p. 11; "A Home-Like House," *Art Amateur* 1 (Nov. 1879), p. 123.

99. Herter Brothers, invoice to John Sloane, Mar. 21, 1882, Brooklyn Museum.

100. "Home Upholstery, 1: Curtains," p. 11.

101. Elizabeth Glaister, cited in "Curtains, Mantel-Hangings, and Piano Fronts," *Art Amateur* 3 (July 1880), pp. 38–39.

102. "Home Upholstery, 1: Curtains," p. 11.

103. "Curtains and Hangings," *Art Amateur* 3 (Aug. 1880), p. 64.

104. "Hints and Notions," *Decorator and Furnisher* 2 (May 1883), p. 67.

105. *Artistic Houses,* vol. 1, pt. 1; for Dominick, see p. 72; for Tiffany, see p. 2; and for Einstein, see p. 27.

106. B. W., "American Decorative Art and Artist Decorators," p. 58.

107. *Artistic Houses,* vol. 1, pt. 1, p. 62. Mary Elizabeth Tillinghast (1845–1912) collaborated with La Farge on textiles for his decorating commissions.

108. Less satisfactory but still eminently acceptable was the choice of many affluent city dwellers to leave all detailing to a top firm of decorators. The cost of such certainty in taste was never inconsequential. John Sloane's 1882 invoice from Herter Brothers listed a portiere for the drawing-room door to the library at $600 and one for the drawing-room door to the dining room at $500, both of embroidered silk plush; a portiere for the library door to the drawing room at $475 and another for the library door to the hall at $400, with four gilt-bronze poles at a total of $100. The overall cost was $2,075. See Herter Brothers invoice, Brooklyn Museum.

109. "Drawing-Room Fashions," *Art Amateur* 2 (Dec. 1879), p. 18.

110. "Upholstery Textiles," *Decorator and Furnisher* 5 (Feb. 1885), p. 176.

111. Ibid.

112. "Morris Art in Decoration," *Art Amateur* 4 (Feb. 1881), p. 66.

113. "Hints and Notions," *Decorator and Furnisher* 1 (Jan. 1883), p. 130.

114. "Seasonable Draperies," *Decorator and Furnisher* 8 (June 1886), p. 83.

115. "Home Upholstery, 1: Curtains," p. 11.

116. "Painted Silk Mantel Hangings," *Art Amateur* 3 (July 1880), p. 37.

117. "Hints and Notions," *Decorator and Furnisher* 3 (Oct. 1883), p. 28.

118. "Piano-Back Decoration," *Art Amateur* 2 (Mar. 1880), p. 80.

119. "Curtains, Mantel-Hangings, and Piano Fronts," pp. 38–39; "Embroidered Piano-Fronts," *Art Amateur* 3 (Sept. 1880), p. 78.

120. Constance Cary Harrison, *Woman's Handiwork in Modern Homes* (New York, 1881), pp. 190–91.

121. Clarence Cook, *The House Beautiful: Essays on Beds and Tables, Stools and Candlesticks* (1878; reprint New York, 1980), p. 184.

122. "Hall Screen of Sawn and Turned Wood," *Art Age* 4 (Oct. 1886), p. 32.

123. "A Chapter on Screens," *Art Interchange* 1 (Nov. 27, 1878), p. 41. See also Yale University Art Gallery, New Haven, *The Folding Image: Screens by Western Artists of the Nineteenth and Twentieth Centuries,* by Michael Komanecky and Virginia Butera (exhib. cat., 1984).

124. *The Compact Edition of the Oxford English Dictionary,* 2 vols. (Oxford, 1971), vol. 1, p. 1435, defines inglenook as "the nook or corner beside the 'ingle'; chimney-corner."

125. "A Few Suggestions: Japanese Parasols," *Decorator and Furnisher* 8 (Sept. 1886), p. 166.

126. "Decoration Notes and Suggestions: A Novel Use of the Japanese Parasol," *Art Age* 4 (Oct. 1886), p. 31.

127. *Artistic Houses,* vol. 1, pt. 1, p. 62.

128. William Morris, *Art, Wealth, and Riches,* cited in Nikolaus Pevsner, "Art Furniture of the Eighteen-Seventies," *Architectural Review* 111 (Jan. 1952), p. 43.

129. *Artistic Houses,* vol. 1, pt. 2, p. 92.

Overleaf: Detail of cabinet (FIG. 5.3)

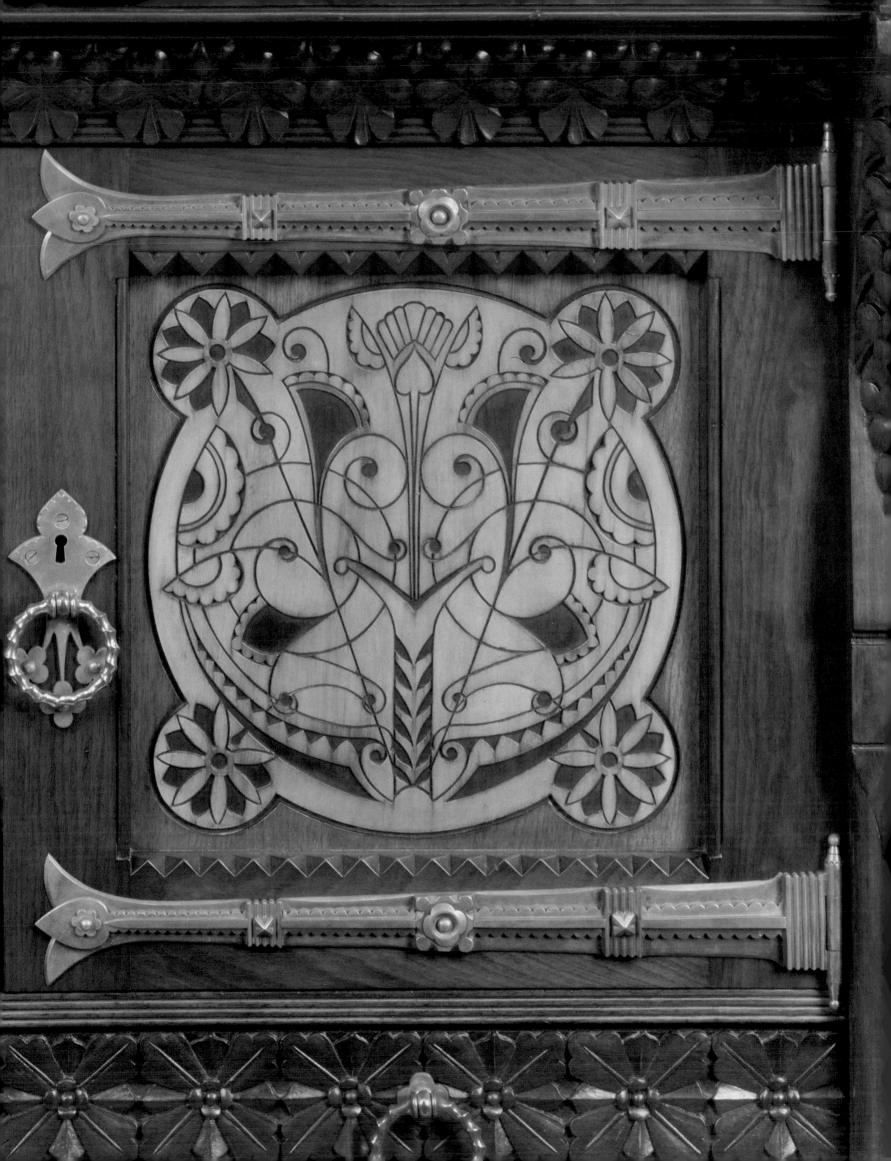

5

Art Furniture:

Wedding the Beautiful to the Useful

Marilynn Johnson

To REUNITE THE beautiful and the useful was a primary concern of late nineteenth-century critics, designers, and collectors alike:

> Of all the materials used in daily life, none more common, none so powerful for artistic purpose, and none so little considered, as furniture. A carpet is a floor covering, tables to hold things, chairs to sit upon. The idea that table, chair or carpet may be a work of art, is foreign to the thought of their users. Pictures are made by artists. Chairs come from the mill. Fortunately, owing to a better education, our more intelligent people now recognize the fact that furniture may be useful and yet artistic. Attention has been much turned of late to domestic art, and the expectant householder now casts about to see if it be not possible to buy chairs that are beautiful as well as comfortable, and to procure tables and sideboards that will mean something, as well as hold plate.[1]

These words, published anonymously in *Scribner's Monthly* in the mid-1870s, may have been written by CLARENCE COOK, the American critic and tastemaker who was a frequent contributor to the magazine. Cook, along with many other British and American leaders of the Aesthetic movement, struggled to elevate once more the "decorative" arts and to repair what art historian Nikolaus Pevsner has called the "split which occurred during the second third of the nineteenth century between art and craft, and between art and manufacture."[2]

Like the nineteenth century itself, the reasons behind this separation of the fine and the applied arts were complex and often contradictory. The Industrial Revolution had transformed the social structure of England and America, creating both a new class of manufacturers and a new class of consumers to buy the proliferation of objects the rise of technology made possible. Also contributing to the schism was the romantic movement of the early 1800s, which fostered radically new attitudes toward the character and role of art and the artist. The romantics saw artists as lonely, misunderstood geniuses who awaited inspiration on a pinnacle above the masses, hoping to translate that inspiration into works of art in stone or paint. Marble sculptures to grace grand halls or paintings on canvas to adorn elegant salons were fitting expressions of genius. Vessels of clay or furniture of wood were not.

The terms used today to describe furniture, silver, glass, pottery, and porcelain as "minor" or even "decorative" or "applied" art are in large part a persistence of nineteenth-century attitudes. As writers on household art in the 1870s and 1880s were fully aware, the arts had not always been divided into "higher" and "lesser" forms. "To the Greeks there was no gulf between the useful and the beautiful," wrote one American author. "Useful things were beautiful, and beauty went hand-in-hand with use."[3] British architect and designer E. W. GODWIN reminded his contemporaries in 1877 that decorative art continued to be a valid art form during the Renaissance, an age dominated by the rigorous regulations of the guild system. "The Institute of Painters at Venice," he recalled, "included casket-makers, gilders, and varnishers. At the very dawn, too, of the Renaissance, we find that Dello, a Florentine painter of note, was not content to wait idly or dreamily for commissions to paint easel pictures. . . . He filled up the whole of his time for some years in painting and decorating furniture, seats, beds, caskets, &c. His work was not only well done, but the well-doing was much appreciated."[4]

Godwin's examples hint at yet another problem that perplexed many Victorian theorists: the relationship between an object and its embellishment. If a painter like Dello applied art to furniture, then art and decoration were essentially the same thing. It followed logically to many early Victorian manufacturers and consumers that the more a product was decorated, the more it became a work of art. To turn a phrase, they believed that more was more. As one historian has observed, "It was easier to apply decoration than principles of proportion and form, and anyway, the former satisfied the demand for 'art' and 'poetry.' Decoration was a kind of ersatz art, cheaper, readily available (it could literally be bought by the yard), and lavishly applied."[5]

The artists and educators who attempted in the 1840s and early 1850s to improve British standards of industrial design and thereby reduce England's dependence on foreign trade shared this passion for ornament. In effect, by working to ensure that objects were embellished with appropriately symbolic decoration befitting their quality and character, the crusaders might be said to have caused "a reform of the art of ornamentation more than of design."[6] One of the most fervent of the British reformers was Henry Cole (1808–1882), a civil servant who wrote handbooks on historical monuments under the pseudonym Felix Summerly. Cole also turned his hand to designing. Among his creations was a tea service with comparatively simple forms and sparse decoration that could be mass-produced at a reasonable cost. The lack of decoration was not an indication of Cole's lack of interest in elaboration. Rather, according to Cole, it was an attempt "to obtain as much beauty and ornament as is commensurate with cheapness."[7] In this respect, Cole was a man of mid-century. In many other ways, however, he was ahead of his time. Cole's tea set won a prize at the

annual exhibition of the Royal Society of Arts in 1846, the year he became a member. Thus encouraged, in 1847 he founded Summerly's Art-Manufactures for the express purpose of improving public taste and reviving "the good old practice of connecting the best Art with familiar objects in daily use," as the pamphlet announcing his venture proclaimed. Just as Godwin would thirty years later, Cole strengthened his plea by speaking of days past when artists lent their talents to the enrichment of humbler everyday life. Giotto, Leonardo, Holbein, and Reynolds, he reminded his readers, had all worked in the decorative arts.[8]

Cole was joined in his endeavor to create an alliance between manufacturing and the fine arts by teachers and administrators in the schools of design that had been established under the aegis of the British government during the late 1830s and the 1840s. He also found allies among his colleagues at Summerly's Art-Manufactures and among fellow members of the Society of Arts, which was led from 1845 by no less a figure than Prince Albert himself. It was Cole, however, who was most instrumental in

turning the society's annual exhibition into something of significance: the first World Exhibition held in London in 1851, called in its own time the Great Exhibition and often referred to subsequently as the Crystal Palace Exhibition for the striking iron and glass building that Joseph Paxton (1801–1865) designed to house it.

The name of virtually every major figure of mid-century design reform appears on the list of those intimately involved with the design, administration, construction, judging, and criticism of the Great Exhibition. The list includes architect and ornamentalist OWEN JONES; architect and critic Matthew Digby Wyatt (1820–1877); painter William Dyce (1806–1864), director of the government school of design in London from 1840 to 1843 and professor of fine arts at King's College, London, from 1844; Richard Redgrave (1804–1888), also a painter, appointed headmaster of the school of design in 1849; and German architect Gottfried Semper (1803–1879). British architect Augustus Welby Northmore Pugin (1812–1852), who organized the Medieval Court, was already widely known and enormously respected because of his work on such projects as the houses of Parliament and Scarisbrick Hall as well as through his writings, including *Contrasts* (1836) and *The True Principles of Pointed or Christian Architecture* (1841). Pugin loathed sprawling Rococo and all sham. His reverence for medieval craftsmanship, drawn largely from his devout Catholicism, led him to pronounce the Gothic the only true and Christian style. His philosophy enlarged the perceptions of his colleagues and continued to influence reform thinkers for the remainder of the nineteenth century and well into the twentieth.

English Art Furniture

Throughout the 1850s the Gothic style continued to prevail in attempts at design reform. John Ruskin (1819–1900) laid the theoretical foundation in *The Stones of Venice* (1851–53), and his chapter "The Nature of Gothic" became a touchstone for the British architects who were to change the look not only of buildings but also of furniture in the 1850s and 1860s, among them William Butterfield (1814–1900), George Edmund Street (1824–1881), J. P. Seddon (1827–1906), Charles Bevan (active 1865–1883), Alfred Waterhouse (1830–1905), WILLIAM BURGES, RICHARD NORMAN SHAW, and PHILIP WEBB.[9]

These designers produced essentially two types of Gothic-inspired furniture. From the late 1850s through the early 1860s Butterfield, Street, Webb, and the English painter Ford Madox Brown (1821–1893) created a few pieces of rationally designed furniture so stripped of superfluous detail or ornament as to be without pronounced reference to historical period or style. Webb's and Brown's plain tables and stands, for example, though substantial and even massive, relied for their effect on balanced proportions and the honest construction Pugin had advocated. They convey a timeless elegance and simplicity that compares with the best furniture of the mature Arts and Crafts movement of almost half a century later. The second type of furniture, the dominant trend, was characterized by its decorative qualities as well as its Gothicized structure. Also rectilinear and sometimes massive, these designs were often embellished with Gothic pointed arches, crockets, finials, and panels with polychrome "medieval" decoration. Early pieces in this style were generally painted with figural scenes. A relatively simple cabinet (ILL. 5.1) that Webb designed in 1861, with a depiction of *The Backgammon Players* painted by Edward Burne-Jones (1822–1898), is typical.

With the organization of Morris, Marshall, Faulkner and Company (later MORRIS AND COMPANY) in London in 1861 there existed a group of both furniture designers and decorators to work in this painted Gothic style. WILLIAM MORRIS himself scarcely ever designed furniture, but his short apprenticeship in Street's offices in

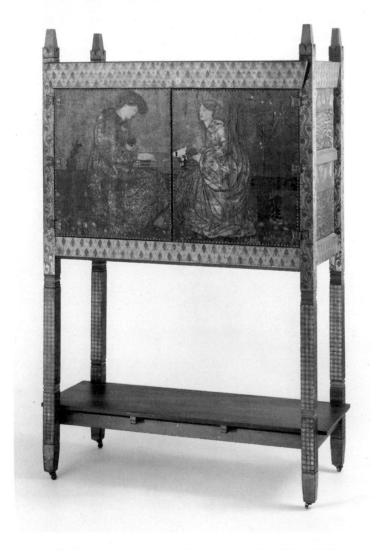

ILL. 5.1 *The Backgammon Players* cabinet. Designed by Philip Webb, panels painted by Edward Burne-Jones, made by Morris, Marshall, Faulkner and Company, London, 1861. Wood, oil paint, leather panels, h. 73 in. (185.4 cm), w. 45 in. (115.3 cm), d. 21 in. (53.3 cm). The Metropolitan Museum of Art, Rogers Fund, 1926 (26.54)

FIG. 5.1 *Gothic Forms Applied to Furniture, Metal Work, and Decoration for Domestic Purposes* (1867; 1st Amer. ed. Boston, 1873). Bruce J. Talbert. Cover: 17 × 12 in. (43.2 × 30.5 cm). The Athenaeum of Philadelphia, Gift of William C. Scheetz, Jr.

inset tiles, by marquetry or shallowly carved designs abstracted from nature, or even by molded composition pictures featuring medieval or classical figures. Large strap hinges in brass or steel, sometimes nickelplated, became important components of the design, as did keyhole escutcheons and rows of turned spindles.

In the late 1860s two British publications popularized the reform Gothic style, which was termed Modern Gothic. The first was a book of designs by British architect BRUCE J. TALBERT entitled *Gothic Forms Applied to Furniture, Metal Work, and Decoration for Domestic Purposes* (FIG. 5.1), published in Birmingham in 1867. The second, CHARLES LOCKE EASTLAKE's *Hints on Household Taste* (see FIG. 4.1), appeared in London a year later. The design of a wall cupboard (FIG. 5.2) from Talbert's *Gothic Forms* displays many of the characteristics of English Modern Gothic furniture of the late 1860s and early 1870s. Highly architectural, the cabinet conveys a feeling of substance and even of grandeur that belies its small scale. As on numerous other Modern Gothic cabinets, the pediment resembles a sloping roof, and columns with stylized leaf capitals flank the recess below the pediment. Large strap hinges decorate the cupboard doors, each of which is also embellished with a rectangular panel containing a Gothic beast within a lozenge. The spandrels filled with radiating sunflower petals evoke the decorative work of Owen Jones and CHRISTOPHER DRESSER.

The style of furniture that Talbert championed is also well illustrated by several existing objects known to have been executed from his designs. One of the most important of these, a rectilinear sideboard (ILL. 5.2) made by the London firm Holland and Sons and recorded in their daybook for 1867, won a medal at the Paris

1856 had given him an appreciation of interior and furniture design. It was also at Street's that Morris met Webb, with whom he formed a lasting friendship and professional relationship. The prospectus for Morris and Company proclaimed that "the Growth of Decorative Art in this country, owing to the efforts of English Architects, has now reached a point at which it seems desirable that artists of reputation should devote their time to it."[10] A number of "artists of reputation"—including Morris himself, Brown, Burne-Jones, and Dante Gabriel Rossetti (1828–1882)—devoted their time to painting panels for furniture designed for the firm by Webb and Seddon. Morris and Company exhibited Gothic cabinets incorporating the work of these designers and artists at the London International Exhibition of 1862. A painted Gothic bookcase by Shaw and a whimsical cabinet, painted by E. J. Poynter, that Burges had designed in 1858 appeared in other displays at the exhibition. Also shown was Burges's towering Gothic bookcase, the so-called Great Bookcase of 1859–62, an elaborate gilded structure decorated with scenes painted by Rossetti, Burne-Jones, Poynter, Simeon Solomon, Albert Moore, H. Stacy Marks, and others.[11] Once again, furniture was deemed worthy of panel paintings by artists of note.

Within a few years manufacturers had translated the Gothic forms and panel decorations of these highly individual and finely crafted architect-designed pieces into more affordable furniture for the general public. Gothic details continued to be a part of the structure, but hand-painted panels by known artists no longer formed the rich surface ornament. Instead, panels were created by

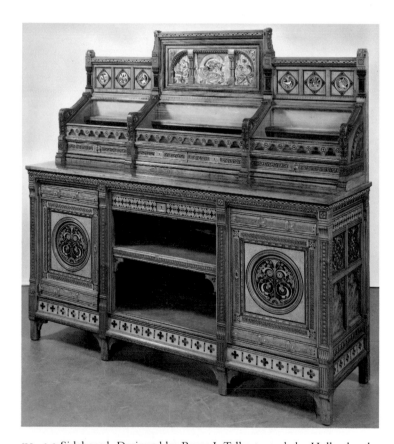

ILL. 5.2 Sideboard. Designed by Bruce J. Talbert, made by Holland and Sons, London, 1867. Walnut, inlaid woods, polychrome enamel plaques, metal reliefs, h. 55½ in. (141 cm), w. 58½ in. (148.6 cm), d. 17 in. (43.2 cm). Trustees of the Victoria and Albert Museum, London (286.1955)

Exposition Universelle that year. The sideboard displays the rich surface ornament of the era. Talbert used moldings to create square and rectangular panels on the cabinet's surface. In the upper section polychrome enamel bird plaques flank three inset panels illustrating the Sleeping Beauty from Alfred, Lord Tennyson's poem *Daydream*.[12] In the base the doors on either side of the recess are elaborately inlaid in figured wood and abstract pattern. An apron of pierced quatrefoils shows the continuing Gothic influence. Before he became an architect Talbert apprenticed as a wood carver, and his emphasis on carved detail in both this sideboard and the design for the wall cupboard may reflect that early training.

The most successful American interpretations of the Talbert style of Modern Gothic furniture were apparently the result of a collaboration between a highly skilled Philadelphia cabinetmaker and carver, DANIEL PABST, and FRANK FURNESS, a Philadelphia architect. Furniture believed to have been produced by Pabst and Furness includes a desk that was handed down in the Furness family, at least two suites of furniture owned by Theodore Roosevelt, and, most impressive of all, a cabinet that has only recently come to light (FIGS. 5.3, 5.4).[13] Its rooflike pediment, angular base, chamfered edges, truncated columns, elaborate strap hinges, and decorated door panels all link this cabinet to the Modern Gothic

furniture of British architect-designers such as Burges. The scrolling, finely carved brackets, however, specifically suggest the form of Talbert's wall cupboard, and the cutaway pattern of stylized flowers on the upper doors is reminiscent of the decoration on a sideboard that relates closely to the Holland and Sons sideboard of 1867 and is illustrated as number 20 in *Gothic Forms*. Talbert's work may well have been the source for the design of the cabinet. *Gothic Forms* was reprinted in Boston in 1873 and again in 1877; and another of his books, *Examples of Ancient and Modern Furniture, Metal Work, Tapestries, Decorations, Etc.* (published in London in 1876), came out in Boston in 1877.

Pabst and his Philadelphia colleagues were unquestionably familiar with English aesthetic design. A Modern Gothic buffet that Pabst made about 1877 for Glenview, John Bond Trevor's house in Yonkers, New York, contains panels adroitly carved with a rendering of Aesop's fable of the fox and the crane. An illustration of embroidered portieres in Eastlake's *Hints on Household Taste* furnished the design.[14]

Eastlake's compendium, which before it was published in book form in 1868 had appeared as a series of articles in several British periodicals, including the *Queen* and the *London Review,* was not a design book like Talbert's. Rather, Eastlake's aim was to present "some fixed principles of taste for the popular guidance of those who are not accustomed to hear such principles defined."[15] *Hints on Household Taste* was thus the first major work of what was to be a vast outpouring of publications on taste in household art. As had Talbert's designs, Eastlake's advice met with considerable success in America as well as in England. *Hints on Household Taste* was published four times in England between 1868 and 1878, and there were at least eight Boston editions of it during the 1870s and 1880s. Not surprisingly, in America particularly, "Eastlake" became synonymous with the Modern Gothic style.

American writer and tastemaker Charles Wyllys Elliott (1817–1883) objected to the use of Eastlake's name as a designation for furniture that was an "attempt to express a useful purpose, with fine lines, with modest decoration, and with honest construction. . . . What style do you call this? . . . Is it a copy of the Medieval, the Gothic, the Roman, or what? Is it Eastlake? It is none of these." Elliott's alternative proved his statement that "it is not easy to invent a name." For furniture designed not to provide "ostentation or luxury, but to help to make the home-life beautiful," he

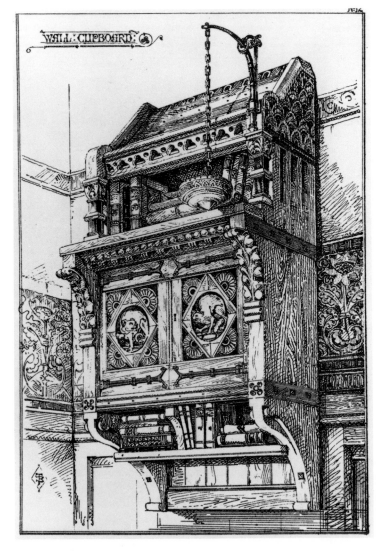

FIG. 5.2 Plate 12: "Wall-Cupboard." Bruce J. Talbert, *Gothic Forms Applied to Furniture, Metal Work, and Decoration for Domestic Purposes* (1867; 1st Amer. ed. Boston, 1873). Thomas J. Watson Library, The Metropolitan Museum of Art

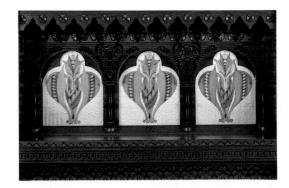

Above: FIG. 5.4 Detail of cabinet (FIG. 5.3)

Opposite: FIG. 5.3 Cabinet. Design attributed to Frank Furness, manufacture attributed to Daniel Pabst, Philadelphia, ca. 1874–77. Walnut, maple, glass, h. 96 in. (243.8 cm), w. 42 in. (106.7 cm), d. 20 in. (50.8 cm). The Metropolitan Museum of Art, Friends of the American Wing Fund, 1985 (1985.116)

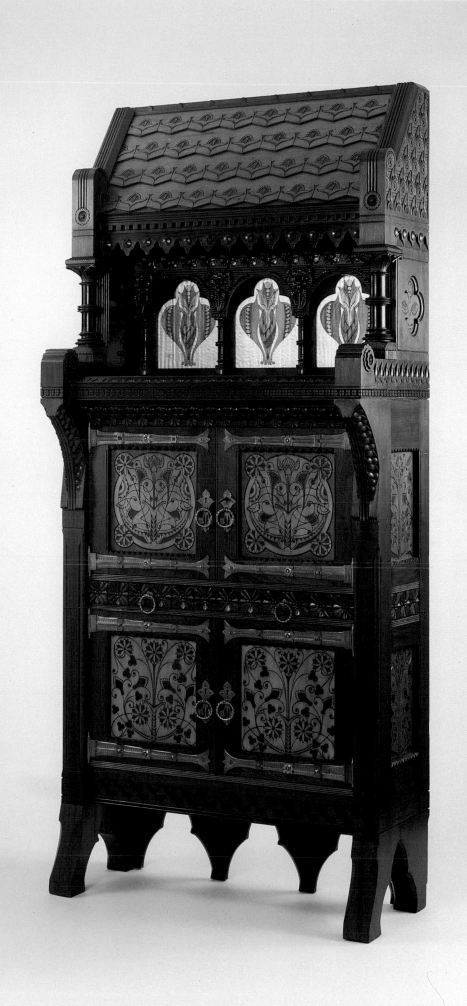

ILL. 5.3 Sideboard. Designed by E. W. Godwin, ca. 1867, made by William Watt, London, ca. 1876. Ebonized wood, embossed paper panels, silverplated fittings, h. 5 ft. 11½ in. (1.8 m), w. 8 ft. 6⅜ in. (2.59 m), d. 1 ft. 10⅟₁₆ in. (.56 m). Trustees of the Victoria and Albert Museum, London (Circ.38.1953)

suggested "The Homelike Style."[16] Presented with such an amorphous mouthful, public and press alike continued to prefer the name Eastlake, and if one read any of the rapidly proliferating art periodicals one was bound to come across it. The reviewer of a Boston decorative-arts exhibition in 1875 deplored the "deficiency of native design in most of the departments," explaining that "the popular demand for improvement having risen so recently . . . it will still be long before men educated to supply our wants can be found here." He ascribed the recent change to "an echo in this country of the reaction in England against the thoughtless and unintelligent work of past years," but lamented that one of the just effects had been "imitation, and a fashion for anything called after Morris, Eastlake, or other teachers of decorative construction."[17]

Other writers were more kind. If imitation amounting to plagiarism is the sincerest flattery, American architect Henry Hudson Holly (1834–1892) greatly complimented Eastlake in "Modern Dwellings: Their Construction, Decoration, and Furniture," a series of articles he wrote for *Harper's New Monthly Magazine* in 1876. Holly mentioned Eastlake's name only twice, once in a paragraph condemning pedestal tables, and again in the description of a bedroom suite "of medieval design, commonly known in this country as Eastlake style." Nevertheless, he appropriated not only Eastlake's principles but even his exact words, repeating whole passages from *Hints on Household Taste*.[18] Two years later, however, when the articles were published in his book *Modern Dwellings in Town and Country Adapted to American Wants and Climate with a Treatise on Furniture and Decoration,* Holly redressed his wrongs. He dropped the plagiarized passages and acknowledged that he had "profited considerably by the writings of Eastlake and others."[19]

In 1876 Clarence Cook commented that "Eastlake furniture must not . . . be judged by what is made in this country, and sold under that name. I have seen very few pieces of this that were either well designed or well made. None of the cheaper sort is ever

either."[20] Curmudgeon though he might sometimes have been, Cook had put his finger on the problem. By the mid-1870s cheap, factory-produced "Eastlake" furniture had become so prevalent that Eastlake himself felt called upon to comment. In 1878, in his introduction to the fourth revised British edition of *Hints on Household Taste,* he repudiated what American tradesmen were "pleased to call 'Eastlake' furniture, with the production of which I have had nothing whatsoever to do, and for the taste of which I should be very sorry to be considered responsible."[21]

Eastlake made clear that a new taste had arisen for designs rooted in the seventeenth and eighteenth centuries rather than the Middle Ages. He noted that many a student who began as "an earnest advocate for Gothic is now a follower of what is commonly called the 'Queen Anne' school."[22] Styles might change but enduring principles did not, and Eastlake made no revision in his basic precepts. In 1878, the same year the fourth British edition of Eastlake's book appeared, the American writer HARRIET PRESCOTT SPOFFORD published *Art Decoration Applied to Furniture* (see FIG. 2.3). The book, an expanded version of the articles Spofford published anonymously in *Harper's Bazar* and *Harper's New Monthly Magazine* in 1876–77, contained an entire chapter on "The Eastlake." Like other writers of the era, Spofford had echoed Eastlake in her articles, but in her book she gave due credit to the historical significance of *Hints on Household Taste,* which had "occasioned a great awakening, questioning, and study in the matter of household furnishing. Presently there arose a demand for furniture in the 'Eastlake Style.'"[23] The demand for high-style Eastlake or "modern" furniture was at its peak in the early to mid-1870s, but factory-made "Eastlake" furniture continued to be popular in America well into the 1880s, long after the term Modern Gothic had ceased to be used.

Just before the Philadelphia Centennial Exposition of 1876 a new style of art furniture had begun to supplant the medieval- and

Jacobean-inspired forms that had been fashionable in England from the late 1850s through the early 1870s. Although their shapes were still rectilinear, with surfaces divided into decorated panels, case pieces such as cabinets and sideboards were less angular and massive than their Modern Gothic counterparts. The forms of chairs and tables were often lighter, the ornament was simpler, and the legs were sometimes delicately saber shaped or turned rather than carved. Slender spindles or fine fretwork was often used in the designs. Although a number of British designers were working in this mode from about 1870 on, the new art furniture owed much to one man, E. W. Godwin, who virtually invented the style called Anglo-Japanesque.

As had so many of his colleagues, Godwin began his career as a medievalist. Both he and his close friend William Burges were impressed by the Japanese display at the London International Exhibition of 1862. "To realize the real Middle Ages," Burges said, one "must visit the Japanese Court."[24] Godwin, however, saw in Japanese art and architecture not only the traditions of the medieval craftsman but also a fresh artistic vision. Like many other British and American artists and architects of the Aesthetic era, Godwin collected Japanese prints, fans, and porcelains. He decorated his London home in Japanese fashion, with sparse furnishing, and straw matting on the walls and some of the floors, which in other rooms were oiled or waxed and left bare. He persuaded Ellen Terry (1847–1928), the famed English actress with whom he lived for many years, to dress their children in kimonos, and he chose a Japanese conjurer as their special entertainment treat.[25] But Godwin's love for things Japanese went far deeper than the affectation of an exotic lifestyle. More than any of his contemporaries, he absorbed and incorporated into his own designs the very principles of Japanese architecture and three-dimensional art: straight lines and gentle curves, restrained ornament and taut surfaces free of superfluous moldings and carvings, and an interplay of solid and void.

Godwin began to design furniture in 1867, the year he moved his architectural practice from Bristol to London. This was also the year he began work on Dromore Castle in County Limerick. Godwin designed the external structure of the castle, which was completed in 1869, in the then-popular French Gothic style modeled on thirteenth-century buildings, but in the interiors he combined Gothic and Japanese design.[26] The simplicity and elegance of the furniture he created for Dromore are also apparent in an Anglo-Japanesque sideboard of about 1867 that was to become his most famous furniture design and was subsequently produced in a number of versions (ILL. 5.3). With its strict geometry and balanced massing, the sideboard is visible proof that Godwin had achieved the aims he set for himself. "When I came to furniture," he wrote, "I found that hardly anything could be bought ready made that was at all suitable to the requirements of the case. I therefore set to work and designed a lot of furniture. . . . There were no mouldings, no ornamental work, and no carving. Such effect as I wanted, I endeavored to gain as in economical building, by the grouping of solid and void and by more or less broken outline."[27] In a period when even the most prominent design reformers were preoccupied with decoration and ornament, Godwin's concept seems extraordinary.

Godwin also produced designs for well-known British furniture makers, including William Watt and COLLINSON AND LOCK. Frank Collinson and George Lock established their firm in 1870 in a "quaint building in Fleet Street" with a facade redesigned by the architect THOMAS EDWARD COLLCUTT.[28] Collcutt designed furniture for the firm as well. Many of the pieces illustrated in Sketches of Artistic Furniture, the catalogue Collinson and Lock issued in 1871, were by Collcutt. Critics were quick to appreciate the commercial possibilities of the newly fashionable "artistic furniture." As one reviewer put it, "The cabinets do not look like miniature cathedrals nor Brobdingnagian reliquaries."[29] Most of the furniture in the

Collinson and Lock catalogue can be classified as modified Modern Gothic, but not all the designs echo Eastlake and Talbert. A few of the cabinets evince many of the qualities of the lighter art-furniture style then coming into vogue, and one design for a side chair with a curule base incorporates Roman forms like those Godwin studied and used. Two other chairs have the slender proportions and simplicity of some of Godwin's work, but neither has the exaggeration and attenuation so typical of his furniture.[30] None of these Collinson and Lock pieces displays the remarkable stylization of Godwin's best Anglo-Japanesque designs.

Nevertheless, Godwin did design for the firm, as his ledgers, office diaries, and annotated sketches in notebooks attest.[31] Moreover, in the Collinson and Lock section at the Philadelphia Centennial Exposition in 1876 there appeared several pieces of furniture, including an Anglo-Japanesque cabinet, that were clearly after the designs of Godwin.[32] Also in the display was a slender, stylish side chair like the one pictured in figure 5.5, a design that Collinson and Lock had begun to produce in 1873 or 1874 and that became one of their stock items.[33] LOUIS COMFORT TIFFANY may well have been among the American visitors who admired Collinson and Lock's wares in Philadelphia in 1876. A few years later a side chair identical to the one shown at the Centennial turned up in a picture of a room designed by Tiffany and ASSOCIATED ARTISTS that Constance Cary Harrison (1843–1920) chose as the frontispiece for

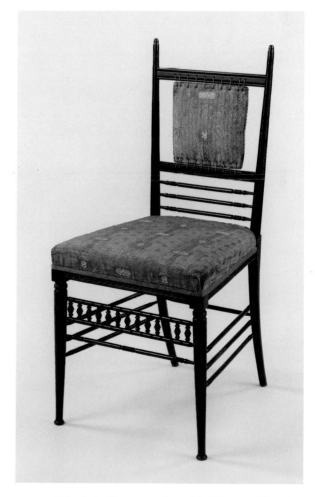

FIG. 5.5 Side chair. Design attributed to Thomas Edward Collcutt or E. W. Godwin, ca. 1873–75, made by Collinson and Lock, London, ca. 1880–87. Rosewood, h. 34½ in. (87.6 cm), w. 15½ in. (39.4 cm), d. 15½ in. (39.4 cm). Marked: *Collinson & Lock / London / of Dawson Jan 30 188[] / 7750 / Collinson & Lock[?] / London.* Collection of Mr. and Mrs. I. Wistar Morris III

her *Woman's Handiwork in Modern Homes*, published in New York in 1881.

Godwin's work became readily available for emulation with the publication in 1877 of *Art Furniture, from Designs by E. W. Godwin, F.S.A., and Others, with Hints and Suggestions on Domestic Furniture and Decoration by William Watt*, a catalogue with a layout and cover resembling Collinson and Lock's 1871 book of sketches, but containing designs of a very different character that ranged from the eccentric to the familiar, from the elaborate to the simple. In addition, some of Godwin's designs were published in the American periodical the *Art-Worker* in 1878.[34] Ample evidence exists, however, that his furniture was known and copied in the United States at least two or three years earlier. One has only to turn to the pages of Cook's *House Beautiful* (1878, FIG. 5.6), which was first published in serial form as "Beds and Tables, Stools and Candlesticks" in *Scribner's Monthly* from June 1875 to May 1877.

For example, Cook attributed "Much in Little Space" (FIG. 5.7), an engraving of a room of art furniture with many of the characteristics of Godwin's Anglo-Japanesque style, to ALEXANDRE SANDIER, who allegedly "made his drawing from the original, which he designed for Mr. Herter." A design for a hanging shelf and cabinet in another illustration, which Cook said was "by Cottier & Co.," bears all the earmarks of Godwin's furniture in its use of a shelving superstructure composed of angular struts and frets. Cook described "a cupboard of to-day" (FIG. 5.8) as "made by Cottier & Co. after their own design, mainly to serve as a frame

to the two painted panels in the doors with which Mr. Lathrop enriched it."[35] It is interesting to compare this corner cabinet with one that Godwin designed for Collinson and Lock in 1873 (FIG. 5.9), a cabinet commonly known as the Lucretia cabinet after the figure in the central panel, which was painted by Charles Fairfax Murray.[36] Godwin's Anglo-Japanism is strongly reflected in both pieces. The question arises, Did Godwin design for the London-based firm of COTTIER AND COMPANY (who had a branch in New York), as he did for Collinson and Lock and William Watt, or was his style so well known by the mid-1870s that it was being extensively mimicked by other manufacturers? Of the two possibilities, the latter seems more probable.

For further evidence that Godwin's Anglo-Japanesque furniture designs had spread to America, one need only examine an illustration in *The House Beautiful* that had originally appeared in Cook's first article for *Scribner's Monthly* in 1875. There, pictured standing on what appears to be rush matting, against a backdrop of South Kensington–type fabric, is a "coffee-table with chair, both of black wood" (FIG. 5.10). The chair is unmistakably a variation on Morris's Sussex chair, and should any doubt have existed about its origin, Cook stated that it was "introduced here by the Messrs. Bumstead of Boston," a firm known as the American agent for Morris and Company. "The originals were of English make," Cook continued, "but those we get now are all made in Boston."[37]

The coffee table Cook illustrated was without doubt Godwin's design. It was in fact the very coffee table Godwin described in a

FIG. 5.6 *The House Beautiful: Essays on Beds and Tables, Stools and Candlesticks* (New York, 1878). Clarence Cook. Binding designed by Daniel Cottier. Cover: 10 × 8⅛ in. (25.4 × 20.6 cm). The Metropolitan Museum of Art, Gift of Elizabeth and Katharine Beebe, 1942 (42.50.1)

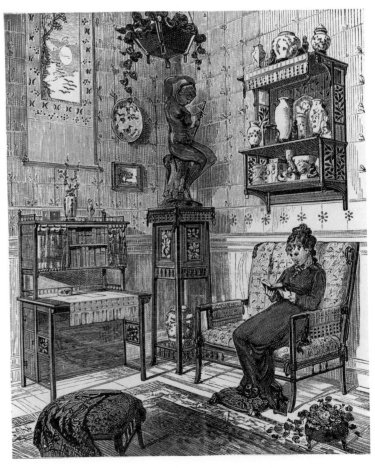

FIG. 5.7 "Much in Little Space." Designed and drawn by Alexandre Sandier, Herter Brothers, New York. Clarence Cook, *The House Beautiful* (New York, 1878). Thomas J. Watson Library, The Metropolitan Museum of Art

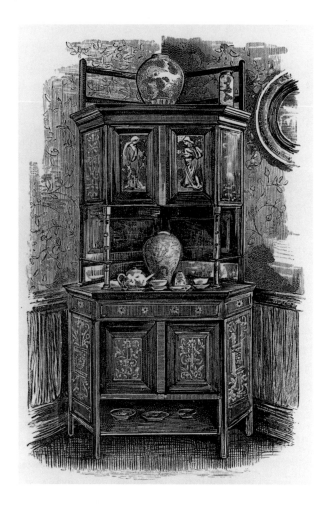

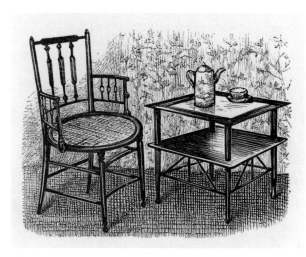

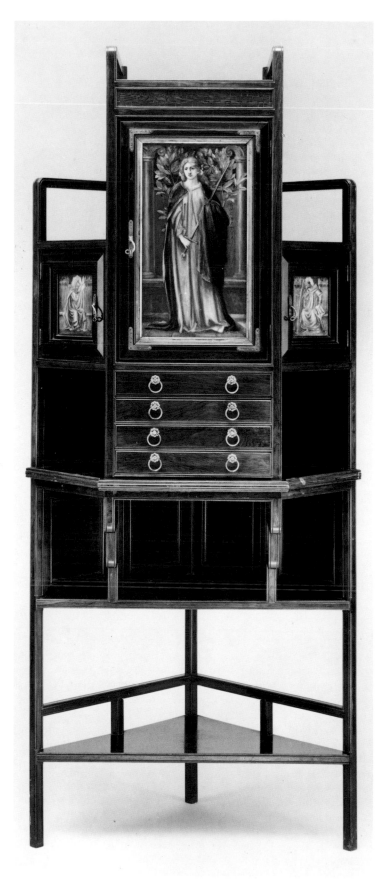

Top: FIG. 5.8 "A Cupboard of To-Day." Drawn by Francis Lathrop. Cupboard by Cottier and Company, panels painted by Francis Lathrop, New York. Clarence Cook, *The House Beautiful* (New York, 1878). Thomas J. Watson Library, The Metropolitan Museum of Art

Bottom: FIG. 5.10 "Coffee-Table with Chair, Both of Black Wood." Drawn by Francis Lathrop. Clarence Cook, *The House Beautiful* (New York, 1878). Thomas J. Watson Library, The Metropolitan Museum of Art

FIG. 5.9 "Lucretia" corner cabinet. Designed by E. W. Godwin, panels painted by Charles Fairfax Murray, made by Collinson and Lock, London, 1873. Rosewood, painted panels, brass, h. 75 in. (190.5 cm), w. 32 in. (81.3 cm), d. 23 in. (58.4 cm). Marked: *COLLINSON & LOCK / EDWARDS & ROBERTS,* panel signed: *CFM.* Detroit Institute of Arts, Founders Society Purchase, European Decorative Arts Fund, Honorarium and Memorial Gifts Fund (1985.1)

letter printed as the preface to *Art Furniture* in 1877. Indicating how pleased he was with the catalogue, Godwin told Watt that he hoped it might

> lead intending purchasers to come to you direct for things that I have designed for you, and which . . . have unfortunately been travestied, even caricatured, in the process. A marked example of this is the square coffee table you first made for me, nine or ten years ago. The lines and dimensions of the different parts of what seems to be a very simple bit of furniture constitute its beauty and its art—if it has any. But I have seen the lines changed, the proportions altered, until that which I had regarded as a beauty became to me an offence and an eyesore. I should not have alluded to this but for the large sale the table in question commands, and but for the fact of my meeting it almost wherever I go,—in private houses, in showrooms, in pictures, and in books, very prominently in the frontispiece of Miss Garrett's "Suggestions for House Decoration."[38]

Godwin's comments help to date the design of the Anglo-Japanesque coffee table to approximately 1867, a decade earlier than its publication in Watt's catalogue. They also firmly establish Godwin as the originator of the popular design, which was recognized as commercial at the time and was therefore paid the dubious compliment, as were many others of Godwin's creations, of being widely copied and interpreted. That the authors of the books (one of the most popular of which was Rhoda and Agnes Garrett's *Suggestions for House Decoration in Painting, Woodwork, and Furniture* of 1876) in the Art at Home series Macmillan and Company brought out in London between 1876 and 1880 lifted illustrations from Cook's *Scribner's Monthly* articles has been cited as an example of reverse cultural influence.[39] That Cook himself reproduced Godwin's famous coffee table and Godwin-type designs from the stock of Cottier and Company without proper acknowledgment would also seem worth noting.

Art Furniture at the Philadelphia Centennial

Although a few well-read and well-traveled artists and designers were in 1876 already aware of the reforming influence of English design, the ordered simplicity of Japanese art, and the exotic drama of Moorish decorative objects, for most Americans the displays at the Philadelphia Centennial Exposition were a first glimpse of foreign cultures.

At noon on May 10, 1876, in front of the newly completed Memorial Hall in Philadelphia, President Ulysses S. Grant declared the Centennial Exposition officially open. The president's words were remarkably terse, but if his speech seemed momentary, its implications were not. Grant told his fellow citizens that the exhibitions would inspire in them a "profound respect for the skill and taste of our friends from other nations" as well as a sense of satisfaction over "the attainments made by our own people during the past one hundred years."[40] Universal friendship and unceasing progress were the fundamental ideals not only of the 1876 Centennial but also of all eleven world's fairs held between 1851 and the turn of the century.[41] The Centennial was a midpoint, the sixth world's fair after the London Crystal Palace Exhibition of 1851. Like all those that preceded and followed it, the Philadelphia fair was more than an occasion for chauvinism and showmanship. It was a major force in the acceptance and dissemination of the new, the foreign, the unfamiliar. Across the 384-acre Centennial park the air was charged not simply with the humming whir of the powerful Corliss engine and countless other machines but also

with the living current of ideas that Matthew Arnold had seen as a necessity of culture. Public and critic alike sensed the electricity.

Pride in the past, belief in the present, hope for the future—this was the emotional climate of the age. Much of what was written about the Philadelphia Exposition, as well as the exhibitions themselves, reflected these feelings. In addition to finding satisfaction in their own attainments, Americans who visited the Centennial demonstrated a new breadth of interest in other cultures. Long bound culturally to England and France, Americans learned at the fair the fascination of the East. The Turkish bazaar was a favorite meeting place. Although the Japanese workmen who built their country's exhibition at first "brought many a burst of laughter from the bystanders" with their "uncouth mechanical operations," the Japanese pavilion became a primary object of praise. The building was, said one reviewer, "as nicely put together as a piece of cabinet-work."[42]

The analogy indicated more than a new approbation for the Japanese; it also suggested the respect accorded in this period to fine craftsmanship. Actual examples of cabinetwork from all over the world were among the most elaborate and popular displays in the Main Building. Indeed, virtually every theme, style, and idea connected with fine furniture in the Aesthetic era had its place at the Centennial. Only a few of the displays actually commemorated American life a hundred years earlier. A replica of an eighteenth-century New England kitchen complete with a spinning wheel drew considerable crowds, and scattered through the exhibition buildings, sometimes in unlikely places, were actual pieces of eighteenth-century furniture. Very little, if any, of what is today called Centennial furniture—nineteenth-century versions of eighteenth-century American Colonial styles—was in evidence.[43] In the furniture displays at Philadelphia, belief in the present overshadowed pride in America's past.

If American exhibitors were generally ranked first in the mechanical and technological aspects of furniture manufacture, the British were given highest marks for their artistic and imaginative designs. One writer lauded the British decorative arts and furniture as "possibly the most striking collections among the European exhibits."[44] The British exhibition space was arranged as a suite of rooms decorated in different styles, principally, according to George Titus Ferris, author of the copiously illustrated *Gems of the Centennial Exhibition* (1877), "highly-artistic studies from the Jacobean, Queen Anne, and Georgian periods." Only one display suggested the Eastlake, or Modern Gothic, school of design.[45] Probably the single most influential object in the British furniture section was a cabinet designed by Collcutt for Collinson and Lock (ILL. 5.4). One of several versions of a design first shown in 1871 at the London International Exhibition, the cabinet featured all the vocabulary of the new art furniture: ebonized finish, crisply turned balusters, rectangular panels, cupboard sections and open shelves, Gothic detailing, coved cornice, beveled mirror, and elaborate surface decoration with shallowly incised lines, some of them emphasized with gilding.[46]

Chagrined, perhaps, at the English decorative arts and furniture being pronounced superior, as a whole, to that of any other country, the author of a review published in the *American Architect and Building News* (hereafter the *American Architect*) in January 1877 defended American accomplishments:

> The Queen Anne work of Herter Brothers of New York has already been referred to. . . . It is to be regretted that this firm did not make an exhibit of some of the beautiful work with which the house has been credited during a few years past. Had the work of their able designer Mr. A. Sandier been seen in comparison with that of the English exhibitors, it would have been less easy to concede to them the superiority which their designs in the main portrayed.[47]

The writer was obviously well aware of current styles in England; by 1876 the term Queen Anne was increasingly being used, somewhat inaccurately, to describe any art furniture that was not Modern Gothic, including pieces that might also be called Anglo-Japanesque. Although HERTER BROTHERS, the leading American furniture and decorating firm of the 1870s, did not mount a display of its own, its work was indeed represented at Philadelphia. According to the first part of the *American Architect's* review, published in December 1876, "The Queen Anne style had but one exponent in Robert Ellin & Co. of New York, unless we may add the name of Herter Brothers of New York, whose cases for Reed & Barton and the Whiting Paper Company were worthy of special notice as much as the works of any exhibitor, and were freely rendered and original designs in that style."[48] Herter Brothers' designs also appeared in the exhibition of American pianos and organs, "one of the chief ornaments of the Main Building," reported *Frank Leslie's Historical Register of the Centennial Exhibition* in 1877.[49] The display, which included parlor organs by Mason and Hamlin and the Estey Organ Company in the newly popular Modern Gothic style and a piano with a rosewood case elaborately carved by a student at the University of Cincinnati School of Design, was reviewed in the *American Architect* in 1877. Among the pianos with inlays or painting, the critic commented, "the finest were the pianos of ebonized wood, decorated with artistic inlay work in bright-colored woods, exhibited by Albert Weber of New York. We understood that these cases were designed and made by Herter Brothers."[50]

Although critics lamented the inferiority of American furniture design, the foreign displays did not completely overshadow the examples of skilled American cabinetmaking at the Centennial. *Frank Leslie's Historical Register* proclaimed the amount of furniture shown by American firms "enormous," comprising "every imaginable article of this class."[51] The 177 domestic exhibitors represented more than half the states. Moreover, two prominent American furniture makers, Mitchell and Rammelsberg of Cincinnati and A. KIMBEL AND J. CABUS of New York, displayed art furniture that reflected the influence of both Talbert and Eastlake.

An oak hall stand and sideboard (ILL. 5.5) exhibited by Mitchell and Rammelsberg were described in *Gems of the Centennial Exhibition* as designed "rigidly after the canons of Eastlake."[52] The success of the display in Philadelphia apparently had profitable consequences for the company's business in the following years. Within a short time variations on the hall stand and the sideboard became commercially available. For instance, among the several pieces of furniture Abram Gaar purchased from Mitchell and Rammelsberg in May 1877 for his new home near Richmond, Indiana, was a "walnut Eastlake hall rack with bronze double pins and blue tile." The hall stand, still in the house that Gaar furnished, is nearly identical to the stand exhibited at Philadelphia in 1876, with a few minor changes. It is made of walnut rather than oak, its turned supports are fitted with bronze hooks, and both the surface of the shelf and the sides of the base are embellished with turquoise and black tiles illustrating biblical scenes. A "walnut Eastlake sideboard [with] bronze trimmings" custom-made for Gaar by Mitchell and Rammelsberg at a cost of $325 had the same general plan as the Centennial sideboard, with a central cabinet surmounted by a crocket and finials. In details such as the arrangement of open shelves and enclosed cabinet spaces and the character of the decoration and hinges, however, it was quite different. The sideboard was the most impressive piece of a dining set that included an extension table and ten "Eastlake" dining chairs, an armchair, and an "Eastlake" tea chair all upholstered in red embossed leather with black velvet trim. The Gaars also owned a carved and inlaid table like one Mitchell and Rammelsberg showed at the Centennial; quite possibly Gaar himself attended the fair and chose his hall stand and dining set from the Mitchell and Rammelsberg display.[53]

Further capitalizing on the success of their British-inspired furniture, about 1879 Mitchell and Rammelsberg "brought over from England an artist in household decoration . . . [who] supervised the fitting up in the store of three rooms illustrative of the dispensation of aestheticism." By 1883 a Cincinnati newspaper could claim, "That innocent suite of rooms quietly revolutionized the interior decoration of the homes of wealth in the valley of Ohio."[54]

The Kimbel and Cabus display space at the Centennial was not simply filled with articles of furniture but arranged as an entire integrated room, an image appropriate to the new role the firm had assumed in 1872, when they first listed themselves in New York directories as "furn., cabinetmakers & decorators."[55] Surviving pieces of furniture bearing Kimbel and Cabus's label indicate

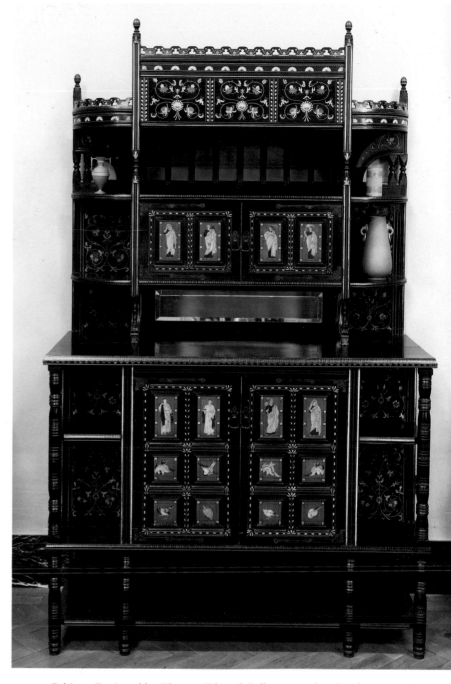

ILL. 5.4 Cabinet. Designed by Thomas Edward Collcutt, panels painted by Albert Moore, made by Collinson and Lock, London, 1871. Ebonized wood, painted panels, h. 94 in. (239.2 cm), w. 45 in. (114.3 cm). Trustees of the Victoria and Albert Museum, London (Misc.127.1921)

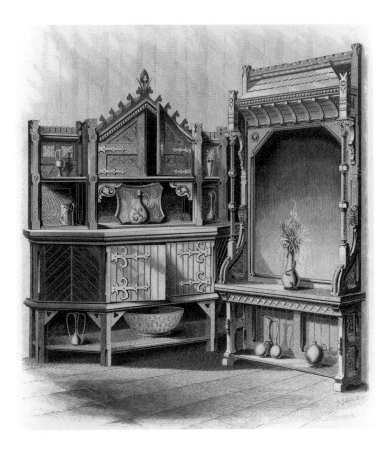

that the firm worked extensively in both Renaissance and Modern Gothic styles, as do the photographs in a two-volume album, now in the Cooper-Hewitt Museum, New York, that Kimbel and Cabus compiled from the 1870s to the 1890s. Significantly, however, they chose Modern Gothic furniture for the illustration on their trade card (see ILL. 8.3) and to represent their work at the Centennial. One critic judged the Kimbel and Cabus display, a room all in the Modern Gothic style, "rich and tasteful enough to rank it among the very best of the American exhibits in household art."[56] The much-admired room was illustrated in July 1876 in the *American Architect* and again in 1878 in Spofford's *Art Decoration Applied to Furniture* (FIG. 5.11).[57] Kimbel and Cabus decorated their model drawing room with a fashionable bordered rug and wallpaper in the typical tripartite arrangement: a dado with Gothic diagonal panels, a fill in the kind of flat pattern favored by the English reform designers, and a broad pictorial frieze. An intricately detailed mantel and overmantel dominated the left wall. The mantel's structure featured the turned columns, deep coves, and projecting entablature of the Modern Gothic style, and the ornamental detailing included carved animals' heads, quatrefoils, Gothic arches, and incised linear decoration. A pair of elaborate, tied-back portieres framed the doorway centered on the rear wall. Although the portieres were hung on a rod with rings, as Eastlake advocated for simplicity and cleanliness, a deeply fringed lambrequin surmounted them, and above the door a gallery of turned spindles provided not only further elaboration but also an approved place for the artistic householder to display objects, should he or she desire.

Above: ILL. 5.5 "Furniture from Cincinnati." Mitchell and Rammelsberg, Cincinnati, ca. 1876. [George Titus Ferris], *Gems of the Centennial Exhibition: Consisting of Illustrated Descriptions of Objects of an Artistic Character, in the Exhibits of the United States, Great Britain, France . . .* (New York, 1877). Thomas J. Watson Library, The Metropolitan Museum of Art

Below: FIG. 5.11 "Drawing-Room in Modern Gothic." A. Kimbel and J. Cabus, New York. Harriet Prescott Spofford, *Art Decoration Applied to Furniture* (New York, 1878). Thomas J. Watson Library, The Metropolitan Museum of Art

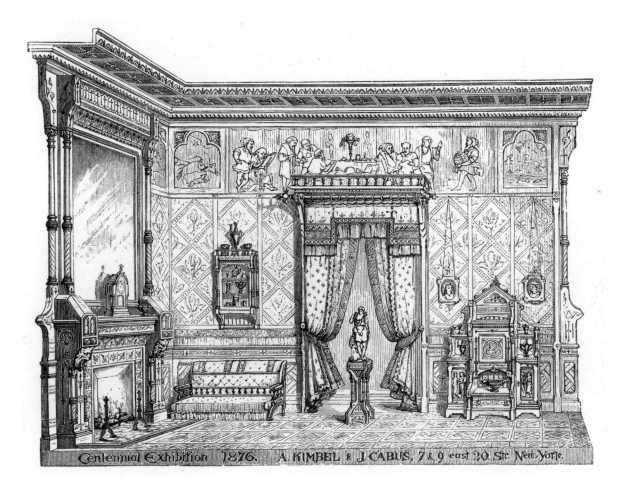

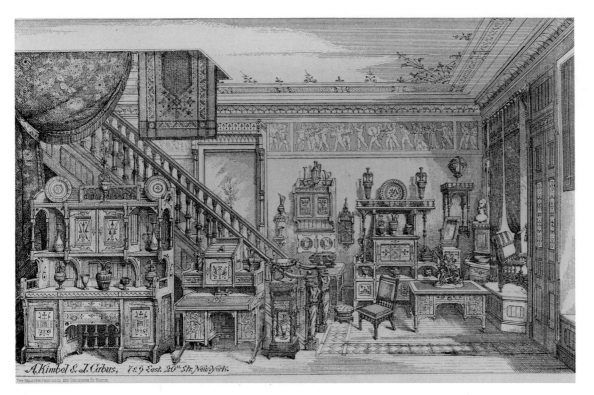

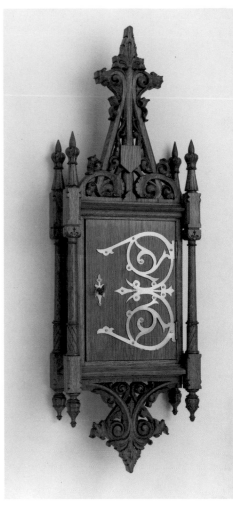

Above: ILL. 5.6 "A. Kimbel and J. Cabus, 7 and 9 East 20th Str. New-York." *American Architect and Building News* (Feb. 24, 1877). Thomas J. Watson Library, The Metropolitan Museum of Art

Right: FIG. 5.12 Hanging key cabinet. A. Kimbel and J. Cabus, New York, ca. 1877. Oak, nickel-silver fittings, h. 41¾ in. (106 cm), w. 12⅞ in. (32.7 cm), d. 5½ in. (14 cm). The Metropolitan Museum of Art, Sansbury-Mills Fund, 1981 (1981.211)

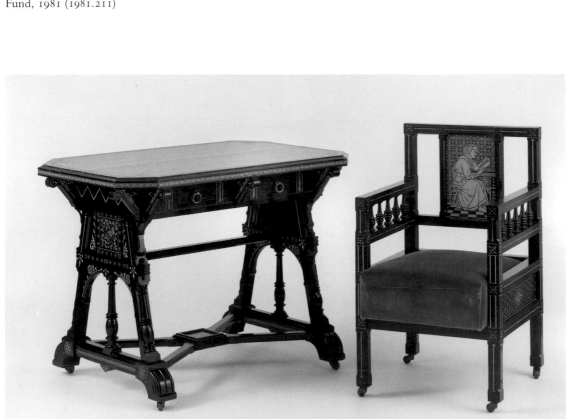

FIG. 5.13 Table and armchair. A. Kimbel and J. Cabus, New York, 1875–85. Ebonized wood, incised and gilded decoration, paper panels; table: h. 31 in. (78.7 cm), w. 42 in. (106.7 cm), d. 27 in. (68.6 cm), chair: h. 35 in. (88.9 cm), w. 20¼ in. (51.4 cm), d. 24 in. (61.6 cm). Collection of Barrie and Deedee Wigmore

A pedestal identical to the one in front of the doorway in the Kimbel and Cabus Centennial room appears in the firm's photograph album. The large cabinet against the right wall is a variation of one pictured in the album. Both cabinets have the same basic structure and central pointed gable surmounted by a crocket and finials, but on the album version a large central cabinet with a mirrored door has replaced the recessed shelf and small cabinet with a paneled, decorated door.[58] Interchangeable parts appear to have been an important component of Kimbel and Cabus's production. For furniture in the Modern Gothic style, Kimbel and Cabus used such embellishments for two basic groups of designs. One group, represented by a hanging key cabinet (FIG. 5.12) that also appeared in an illustration of a Kimbel and Cabus interior published in the *American Architect* in 1877 (ILL. 5.6), was more florid. Usually made from oak, ash, or walnut, these pieces often incorporated carved architectural elements or motifs traditionally considered Gothic: turned and carved columns, flying buttresses, crockets and finials, scrolling leafage, and so on. The decorative elements were superimposed so that they could be produced in quantities and affixed to different types of furniture.

On a second group of furniture Kimbel and Cabus used mass-produced paper or composition borders and panels, sometimes with elaborate floral, animal, or figural representations. The table and armchair pictured in figure 5.13 typify this furniture, which was angular, rectilinear, and often made of ebonized cherry decorated with incised and gilded patterns rather than carving.[59] The panels that provide the most striking embellishment on the armchair and table appear on numerous other pieces of furniture in the Kimbel and Cabus album. As in the case of the hanging key cabinet, the sources for the designs of this table and chair can be found in the Modern Gothic furniture of both Eastlake and Talbert. Two figural panels on a massive sideboard illustrated in Talbert's *Gothic Forms* may have been the inspiration for innumerable similar pieces in the Kimbel and Cabus repertoire.[60]

New York in the 1870s was considered the style center of America. In its fashionable emporiums the householder aspiring to good taste could find the full range of aesthetic decorations and furniture. Kimbel and Cabus kept a large stock of Modern Gothic furniture on hand to satisfy their customers, and other New York firms such as Pottier and Stymus and Herter Brothers filled their showrooms with a more eclectic range of styles, including Anglo-Japanesque and Queen Anne. But New Yorkers were not alone in their rapid assimilation of the English reform styles. As the displays at the Centennial Exposition proved, merchants and manufacturers in several other American cities could boast that they carried the new styles. In one of those cities, Cincinnati, an unusual set of circumstances had created a major center of aestheticism in the Midwest.

Cincinnati Carved Furniture

"Cincinnati is a remarkable place," began a brief article in *Scribner's Monthly* in August 1875. The unidentified author vividly described the young city's horrors: the number of hogs killed, the yellow drinking water, and the buildings blackened by soot. "But Cincinnati, with all its drawbacks," the writer continued, "is intellectually and artistically alive. . . . She has the nucleus of a gallery of art. She has an art school, to which one citizen has given fifty thousand dollars. The ladies in large numbers are carving wood under a competent instructor. Others are painting porcelain, with remarkable results. She has an annual exposition of art and industry."[61]

The phrase "art and industry" once more evokes the basic mid-century design schism: the Cincinnati industrial exhibitions held annually starting in 1870 were yet another attempt to bridge the split. The art school mentioned was the University of Cincinnati

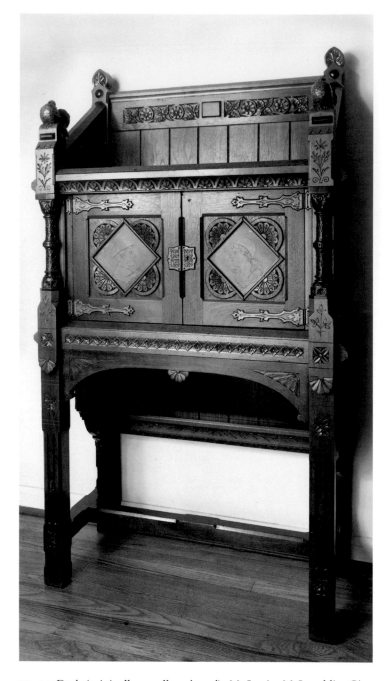

ILL. 5.7 Desk (originally a wall cupboard). M. Louise McLaughlin, Cincinnati, 1876. Walnut and ebony, h. 59⅜ in. (151 cm), w. 35 in. (88.9 cm). Marked: ANNO DOMINI 1876 / L MCL / 1877. Collection of Don Burke

School of Design (later the Art Academy of Cincinnati); its patron, Joseph Longworth. The competent instructor of carving the article referred to could have been either HENRY LINDLEY FRY or BENN PITMAN.

Born in England and trained in the offices of the illustrious architects Augustus Welby Northmore Pugin and George Gilbert Scott (1811–1878), Henry Fry was well grounded in both the art of Gothic design and the craft of carving. Fry came to Cincinnati in 1851, and over the next two decades he and his son, WILLIAM HENRY FRY, were hired by several local churches and prominent Ohio residents not only to carve individual pieces of furniture but also to decorate entire rooms. The private classes in wood carving the Frys began offering in the early 1870s were the result of widespread admiration for the skill they demonstrated in the woodwork in the house Joseph Longworth had built for his daughter, MARIA LONGWORTH NICHOLS, before her marriage to GEORGE WARD NICHOLS in 1868.[62] The same skill is evident in the impressive carved mantelpiece (FIG. 5.14) that adorned the Frys' own house, called Sunflower Cottage. The Frys used a traditional rectangular form for their mantelpiece, rather than the hooded Modern Gothic shape Talbert favored. On one side of the fireplace opening they carved a calla lily and on the other a sunflower. To aesthetes the lily connoted not only purity but "precious loveliness," and the sunflower, one of the symbols of the Aesthetic movement, conveyed "leonine beauty."[63] The dramatic, carefully detailed sunflower blossoms in the square blocks above the full-length flowers are linked by a ribbon banner interlaced with vine and foliage. In a tradition stretching back to Red House (1859, see ILL. 10.1), the home of Morris (whom Henry Fry often cited as a favorite author), the banner bears a motto: "I will give beauty for ashes and the oil of joy for mourning." A repeat pattern of foliated palmettes incised and abstracted in the Modern Gothic manner connects the pair of heraldic shields on the backboard above the mantelpiece shelf.

In 1872, about the same time the Frys began offering their private classes, their rival in wood carving, Benn Pitman, along with his wife, JANE BRAGG, and their daughter, AGNES PITMAN, showed examples of their carved furniture, doors, and baseboards at the Third Annual Cincinnati Industrial Exhibition.[64] Pitman and his daughter began teaching in 1873 in the wood-carving department he helped establish that year in the School of Design. Like Henry Fry, Benn Pitman was born in England and had trained as an architect. He, too, had an allegiance to the Gothic, "a style of decoration peculiarly restful [that] forms an admirable contrast to the life and vigor of natural decoration; it never tires, and is always suggestive of the wonderful religious structures of medieval Europe."[65] He owned a copy of Gothic Ornaments (1831) by Augustus-Charles Pugin (1762–1832), father of Augustus Welby Northmore Pugin, and he sometimes turned to it for design motifs. In addition, Pitman named Ruskin, William Beckford (1760–1844), and Ralph Waldo Emerson (1803–1882) as major influences on his thinking. The philosophy of design he derived from this wide range of sources centered on fidelity to natural animal and plant forms and a belief in the Gothic as the only proper style.

An extraordinary carved bedstead (see FIGS. 1.4, 1.5) that Pitman, his second wife, ADELAIDE NOURSE, and her sister ELIZABETH NOURSE created and displayed at the 1883 Cincinnati Industrial Exhibition is the culmination of his philosophy. In basic form the bed appears to follow art-furniture precepts of straight line and paneled surfaces, as well as the fashion for Gothic arches, shortened columns and chamfered edges, and rows of spindles. Yet no Modern Gothic bed, even in the most imaginative work of Burges, ever equaled the towering fantasy, awesome grandeur, and intricate iconography of this tour de force. Nor did the flat surfaces of English art furniture ever sprout such verdant splendor and writhing fecundity of leaf and flower.

Through the Frys and the Pitmans, Cincinnati design and dec-

orative arts were known in other cities even before the Philadelphia Centennial Exposition of 1876. It was at the Centennial, however, that these efforts first reached a wide audience. The city's extensive participation in the fair was no doubt encouraged by Alfred T. Goshorn (1833–1902), citizen of Cincinnati and instigator of the first Cincinnati Industrial Exhibition, who was director general of the Centennial Exposition.[66] Local women organized the Women's Centennial Committee of Cincinnati in 1874 "to secure a creditable representation of women's work" and "to bear the expense of its transportation and exposition." Goshorn suggested that women pay for the Women's Pavilion at the fair. Although some members objected to the "injustice of putting women on a different footing from other exhibitors," the committee agreed to contribute $5,000, and a section of the Women's Pavilion was reserved for an exhibition from Cincinnati.[67]

According to an 1876 catalogue list from the School of Design, some sixty-five women students exhibited more than two hundred pieces of furniture and decorative objects at the Centennial. Eight women who studied with the Frys also showed furniture, architectural elements, and art objects.[68] Despite this broad representation, only two pieces of Cincinnati carved furniture that were shown at the Centennial are known today: a chest of drawers (now in the Cincinnati Art Museum) by Agnes Pitman and a standing desk (ILL. 5.7) that was originally made as a hanging cabinet by M. LOUISE MCLAUGHLIN, one of the Frys' students.[69] In "Women as Wood-Carvers," a glowing review the American Architect published in March 1877, McLaughlin's cabinet was described as "in the style of B. J. Talbert." Recognizing the importance of the display, the American Architect reviewer lauded the Cincinnati movement and

FIG. 5.14 Mantelpiece. Henry Lindley Fry and William Henry Fry, Cincinnati, 1875. Walnut, h. 58 in. (147.3 cm), w. 60 in. (152.4 cm), d. 10 in. (25.4 cm). Collection of Mr. and Mrs. W. Roger Fry

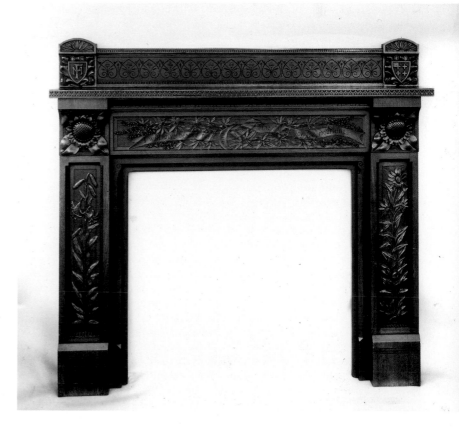

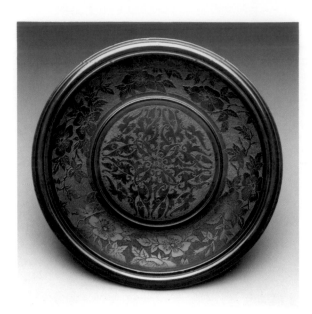

FIG. 5.15 Fruit plate. Emma Bepler, Cincinnati, ca. 1886–94. Cherry, diam. 12 in. (30.6 cm). Collection of Mrs. Carl Bieser

to the belief that nature was the great teacher and that after nature the lessons of history should furnish inspiration.

The continuation of the Cincinnati tradition can be seen in a fruit plate (FIG. 5.15) carved in cherry by EMMA BEPLER, who studied first under Pitman and later under William Fry at the Art Academy of Cincinnati. The motifs on the plate's well are Near Eastern; the shallowly carved leaves and flowers on its flange, like those on the chest of drawers Agnes Pitman showed at the Philadelphia Centennial, recall the sketches from nature that Pitman required of his students.

Even wood carvers who had not studied under Pitman or the Frys came to know their work through reproductions and exhibitions, most notably in the Cincinnati Room of the Women's Building at the Chicago World's Columbian Exposition of 1893, the year Pitman retired and handed his post at the Art Academy to William Fry. Pitman lived until 1910. William Fry died in 1929, having served as head of the wood-carving department and taught classes at the Art Academy until 1926. By the turn of the century, however, the energy of the Cincinnati wood-carving movement was spent. Rather than fulfilling the promise of its first decade, it remained a regional phenomenon in which affluent amateurs carved furniture for their own amusement. In a broad sense, the movement failed to develop artistically, never moving beyond the ideas and styles of its early years. Although it emphasized handwork, it offered no regular paid employment for women, and it never became a part of the Arts and Crafts and social-reform movements of the last decades of the nineteenth century and the first years of the twentieth. Nor was the widespread market that would have ensured the movement's economic survival ever sought. Its carvers were also its consumers, and although in the late nineteenth century Cincinnati carved furniture was nationally exhibited and known, most of the thousands of pieces produced remained in Cincinnati. Nevertheless, as a regional expression of aesthetic ideals in America, the Cincinnati movement remains unparalleled.

American Art Furniture after the Centennial

Modern Gothic furniture by Talbert or Eastlake, and American interpretations of it by Pabst in Philadelphia or by Pitman and Fry in Cincinnati, had relatively clear-cut characteristics and can usually be easily categorized. Not so with much of the other art furniture of the Aesthetic era. The imprecise style terms used today for furniture of the 1870s and 1880s—Queen Anne, Anglo-Japanesque, and Moorish, also often called Persian or Near Eastern—mirror the confused terminology of the period itself.

A large cabinet designed by Godwin that was made by William Watt and illustrated in *Art Furniture* in 1877 demonstrates the problems of period nomenclature. Although with its straight lines and simple facade the cabinet closely resembles Godwin's Anglo-Japanesque cabinets and sideboards, the catalogue lists it as "a cabinet in the Queen Anne style."[75] Only the broken pediment at the top, reminiscent of the pediments on eighteenth-century English woodwork and furniture, seems to justify the designation. With leading designers themselves unclear about predominant style, the confusion of period reviewers and critics is understandable.

Just as Modern Gothic furniture had paralleled High Victorian architecture, Queen Anne furniture evinced the same eclecticism and embodied many of the contradictions of the Queen Anne style of British architecture. Like the Modern Gothic, the Queen Anne possessed an inherent dualism. It was at once a historical revival based loosely on seventeenth- and eighteenth-century styles and a creative expression that assimilated romantic rationalist theory as well as a broad variety of visual influences, including motifs borrowed from Eastern art.

That designers of the 1870s and 1880s often mingled period styles and exotic motifs exacerbates the difficulty of classifying art

urged American artisans and decorators to follow its example. He did, however, comment on the Cincinnati carvers' tendency to "cover all plain surfaces with niggling ornament," and he encouraged them to work instead on "things which were beautiful in themselves."[70]

Just after the Centennial, in 1877–78, the Pitmans and the Frys collaborated on the most ambitious wood-carving project to come out of Cincinnati, the decoration of the grand organ in the Cincinnati Music Hall. Well over one hundred women carved the decorative designs, which were all based on natural forms. Pitman and his students completed the greater portion of the screen, including ten of the fifteen symbolic panels dedicated to individual composers; the Frys and their students carved the remaining five panels, as well as the towers and the ornament between them. The results inspired generations of American wood carvers.[71]

Throughout the 1880s and into the 1890s the wood-carving movement in Cincinnati remained strong. During these years Benn Pitman contributed numerous articles to the *Art Amateur*. The *Art Amateur* had reviewed Cincinnati wood carving in 1879, its first year of publication, and other periodicals, such as the *Art Interchange* and the *Decorator and Furnisher*, also helped popularize the movement.[72] In 1883 the Pitmans opened the workrooms in their home to private instruction, and their students assisted them in the monumental task of carving the interior elements for their new house, begun that year (see ILL. 1.3).[73] Pitman published illustrations of that work in 1895 in *A Plea for American Decorative Art,* a pamphlet reiterating his theory of design. Acceptable decoration, he wrote, is "the correct and appropriate representation of the facts and forms of nature, combined with the intelligent employment of the decorative forms bequeathed to us by the art workers of the past. . . . The all-pervading lesson of nature seems to be, that the useful should be made beautiful. Adornment—decoration—is the expression of the beautiful as applied to the useful." He declared that careful digestion of nature and history might help artists to assert their nationality and "produce a true American decorative art."[74] Thus did Pitman express his debt to mid-Victorian thought,

FIG. 5.17 Detail of table (FIG. 5.16)

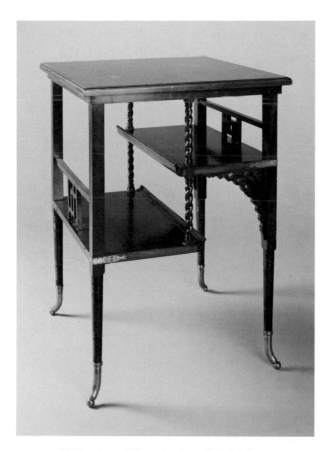

FIG. 5.16 Table. A. and H. Lejambre, Philadelphia, ca. 1880. Mahogany, inlaid copper and mother-of-pearl, brass, h. 27 in. (68.5 cm), w. 20 in. (50.8 cm), d. 20 in. (50.8 cm). Stamped: *LEJAMBRE*. The Saint Louis Art Museum (13.1982)

furniture by one style name. The same table or chair may sometimes be called Queen Anne, sometimes Anglo-Japanesque, the term usually used for English designs flavored with Japanese asymmetry, delicate line, lightness of scale, a balance of solid with void, and a play of plain surface against ornament—thin struts, fretwork, or patterns adapted from Japanese prints, screens, fans, or porcelains. A fine example of the Anglo-Japanesque style of furniture is a small occasional table (FIGS. 5.16, 5.17) of about 1880 that bears the mark of A. AND H. LEJAMBRE, Philadelphia furniture makers. Inlaid on the plain field of the table's mahogany top are a small, restrained Japanesque beetle and butterfly. If the border of double stringing recalls the border mania of the Aesthetic period, the lack of other patterning indicates how much Japanism contributed to the demise of the era's horror vacui. The fretwork, the asymmetrical arrangement of the shelving, and the delicacy of the turned legs, with their curving brass ferrules, all indicate a clear debt to Godwin. Yet the spiral twists that support parts of the shelving probably derived from seventeenth-century Jacobean furniture, and the scalloped brackets at the legs create from the void a Moorish arch. If one were to categorize first by form and then by ornament, this table would be considered Anglo-Japanesque art furniture with Moorish and Jacobean influences.

The contrasts and deliberate blending of styles so characteristic of the Aesthetic period encouraged an imaginative use of materials other than conventional furniture woods. At times art furniture was created from materials thought to evoke foreign cultures: wicker, cane, bamboo, and pseudobamboo. Perceived today as porch furniture, chairs and settees in wicker and bamboo were in the last third of the nineteenth century prominent in bedroom, parlor, and living hall. Wicker furniture was not only portable, befitting the freer room arrangements of the late 1870s and the 1880s, but with its airy weave and easily cleaned surface it was also hygienic.[76] A rectilinear wicker settee (FIG. 5.18) bearing the label of the WAKEFIELD RATTAN COMPANY and the date April 1880 illustrates how often the style of an object was delineated by only one or two salient decorative elements. A whimsical pagoda-like cresting is all that earns this sofa the label Anglo-Japanesque. In its adaptation of material to function, as well as its straight lines and basic simplicity, the design follows the reform precepts of the Aesthetic movement.

On an armchair (FIG. 5.19) he designed about 1886, Boston manufacturer JAMES E. WALL used real bamboo for a structure with the straight lines of art furniture. A similar chair was featured in the December 1886 issue of the *Decorator and Furnisher* as an example of Wall's "extremely odd and pretty" furniture (ILL. 5.8).[77] The arms terminate "honestly" in handholds naturally shaped by the root of the plant. Rows of long, tightly spaced cane spindles form the backrest, and shorter bamboo rounds shape part of an asymmetrical cresting. Only the irregular quality of this cresting, with its overhanging bamboo root and lacquer panel, proclaims the chair to be not simply art furniture but Anglo-Japanesque art furniture.

At first glance Moorish influence seems to predominate in a mahogany side chair (FIG. 5.20) from Olana, the Persian palace that American artist Frederic E. Church (1826–1900) created for himself in the 1870s on a hilltop overlooking the Hudson River near the town of Hudson, New York (see ILLS. 1.1, 1.2). On close examination, however, one can see in this chair all the traits of conventional art furniture of the 1870s and 1880s: square back, straight legs and seat-rail, and rows of spindles at the cresting and front stretcher, as well as surface ornament of shallow carving. Scrolling lines on carved panels could be interpreted as either Near Eastern or Anglo-Japanesque. The shaping of the void hints at Moorish forms, but here too, in the concept of sculptural solid and void, the debt is to Japan rather than the Near East.

More clearly Moorish is a satinwood desk (FIG. 5.21) probably made by Associated Artists in the 1880s for the home of Henry G.

Marquand in New York, as part of a library interior said to have been designed by the architect Manly Cutter. Keyhole-shaped arches and spindle screens in the base conjure up images of mosques, while delicate inlays bring to mind the patterning of Persian carpets and pottery. The Marquands' eclectic tastes reflected the mood of the times. Four bird's-eye maple pieces from a bedroom suite from their home represent styles ranging from the Neoclassicism of the Renaissance to the Anglo-Japanism of Godwin. A cupid, a classical urn, and paterae adorn the masterfully carved bedstead (FIG. 5.22); the slender proportions and Japanesque detailing of the chairs and the table (FIG. 5.23) recall Godwin's designs.

A survival of the exotic Near Eastern tradition in art furniture can be seen in a table and chair (FIGS. 5.24, 5.25) produced in 1890–91 by Louis Comfort Tiffany and SAMUEL COLMAN for the Henry Osborne Havemeyer house in New York. Again, forms are based on straight lines and rows of elongated spindles, and shallowly carved plants and flowers embellish the flat surfaces. These pieces suggest that although Tiffany and Colman's work may have matured in the decade after their interior designs were illustrated in *Artistic Houses* in 1883–84, their overriding artistic vision, a product of the aestheticism of the 1870s, was little changed.

The various companies formed by Tiffany and his colleagues, particularly the original Associated Artists that existed from 1879 to 1883, illustrated the importance of the aesthetic viewpoint in American design during the last three decades of the nineteenth century. No one decorating company, however, not even Tiffany's, can match Herter Brothers of New York in demonstrating the wide range and high quality of the furniture made in the United States during the Aesthetic era. Herter Brothers was founded in the 1850s by GUSTAVE HERTER as a furniture-making company, but by the 1870s, after Gustave's half brother CHRISTIAN HERTER assumed control, the firm had become much more than a cabinet-making shop (see chap. 4).

One of the styles Herter Brothers offered its clients was Modern Gothic. Although little Herter furniture of this type is known at present, the firm's designs in the "Eastlake style"—"tile-covered beds, tables severely plain, and book-cases at once mediaeval and not wholly antique"—were lauded in *Scribner's Monthly* in the mid-1870s as "not so severe as to be disagreeable, and . . . more independent of real fashion." Moreover, the critic (whose style suggests Cook's) continued, it was honest furniture, "really beautiful," for it still showed "the 'chisel marks' of those old laborious fellows, who were satisfied to make two sideboards a year; and, with care, it will outlast even their work." It would seem that Herter Modern Gothic met all the criteria for furniture of the age: it was not only beautiful and useful, it was sincere, and it was not a slavish copy but rather a free interpretation of an antique style. Showing adaptation to American ideas and wants, it was "at once truthful, rational and artistic."[78]

In 1877 a writer in the *American Architect* commented that the use of Japanese motifs in the furniture and ceiling decorations of Herter marked "an era in household work of the highest class."[79] Although contemporary photographs and published comments indicate that Herter Brothers worked in all the styles then in vogue, the Anglo-Japanesque is the style for which the firm has become justly famed. The slender proportions and attenuated stiles of a Herter side chair (FIG. 5.26) of ebonized wood proclaim the influence of Godwin's designs; the rectangular panels of pierced floral carving and graceful leaf marquetry of lighter wood bespeak the masterful skill of Herter Brothers' European craftsmen. Part of a bedroom suite once owned by the Carter family of Philadelphia, the chair is one of many pieces of ebonized and inlaid art furniture either stamped with the name Herter Brothers or authoritatively documented as having been made by the firm.

Herter Brothers repeated many furniture forms with only minor variations. A less Godwinesque but still demonstrably Anglo-Japanesque chair (ILL. 5.9) with a fretwork back now in the Cleveland Museum of Art is identical in basic shape to chairs purchased, for example, by the Goodwins of Hartford, Connecticut, and by William H. Vanderbilt of New York.[80] Only the decorative detailing and the marquetry panels differ from chair to chair. The inlays on some of the chairs are tight, allover flower-and-leaf patterns much like those used on contemporary English textiles and wallpapers. Others are as spare as the patterns on Japanese porcelains and textiles.

One object stands supreme among all the fine furniture created in the Herter Brothers workrooms: a wardrobe (FIG. 5.27) dating to between 1880 and 1885 that was once owned by the actress Lillian Russell, the toast of Broadway in the 1880s. Like the house that Christian Herter designed for William H. Vanderbilt in New York in 1879–82, the wardrobe is a box saved from monotony by a balanced play of decorated against plain surfaces. But whereas the carving on the facade of the Vanderbilt house was contained in static panels, the ornament on the wardrobe is alive. Oriental-style branches appear to grow from the corners of the cornice, and flowers and leaves seem actually to flutter down the doors.

The apparent simplicity of the wardrobe provides a vivid foil to an equally striking but totally different Anglo-Japanesque cabinet (FIG. 5.28), perhaps a sherry cabinet, made by Herter Brothers about 1880.[81] With its carved dog's-head finials, pierced and gilded foliate and floral panels, op-art checkerboards and framing lines, and dazzling central panel intricately inlaid with an urn surrounded by cranes, butterflies, and plants, this cabinet is the Herter "vocabulary" piece. Both the quality of the workmanship and the concept of the design make it a masterpiece of art furniture.

A screen with oriental-style fretwork (FIG. 5.29), also from about 1880, has a pierced and carved floral panel similar to the one on the cabinet. On the ebonized cherry cabinet Herter Brothers used a combination of inlays and gilded decoration. The screen, however, is entirely gilded, as were numerous pieces of furniture made for wealthier clients. This screen has a history of having been owned in California, and it may have been purchased for the home of either Milton Slocum Latham (onetime governor of California) in Menlo Park or financier Mark Hopkins in San Francisco. Details typical of Herter Brothers work abound on this magnificent object: carved paw feet, an overlapping scale pattern on the stiles, and a finely carved classical swag between two sculpturally carved bird finials at the cresting. One side of the screen displays a dramatic Anglo-Japanesque flowering branch and golden pheasant, the other a more traditional floral motif. Here is yet another example of a piece of furniture that might be called either Anglo-Japanesque or Queen Anne.

By the time of the Centennial the Queen Anne style was the latest rage from England. As an article in the *American Architect* noted in January 1877, the Gothic revival in America was commenced "under the inspiration of Viollet-le-Duc and the contemporaneous works of the English architects. It has found its imitators among the furniture-manufacturers, who only give us part of the shell and none of the kernel of the nut. This has proved so disgusting to people of taste and judgment, that a very few of the conscientious manufacturers like Herter of New York . . . have taken up the Queen Anne style, freely treated, and worked on constructive principles."[82] Although the Queen Anne in England continued many of the philosophical precepts of the Modern Gothic, particularly the search for an appropriate national style creatively drawn from the past, it is clear from contemporary writings that in the 1870s Queen Anne was viewed in both England and America as a repudiation of and replacement for Modern Gothic.

It is not surprising then that Herter Brothers, whose designers were apparently completely aware of the changing currents of English taste, seem to have begun abandoning the Modern Gothic late in 1876 or early in 1877, at exactly the same time the more

avant-garde American architects were eschewing High Victorian Gothic and embracing the free classicism of Queen Anne. The concurrent movement in architecture, however, had other implications; it led from an adaptation of the manorial houses of Richard Norman Shaw to the picturesque cottages of the 1880s, with their open plans and Colonial-revival details. There is as yet no evidence that Herter Brothers produced any furniture in the late 1870s and the 1880s with an American Colonial character. Rather, the Herter productions that contemporary reviewers considered Queen Anne were undoubtedly furniture designs freely rendered from the styles of England, and to some degree France, of the eighteenth and early nineteenth centuries.

Elegant chairs that evoke the English Regency (FIG. 5.30), a delicate cabinet vaguely reminiscent of the Neoclassical designs of British architect-designer Robert Adam (1728–1792) and of Louis XVI furniture from France (FIG. 5.31), an étagère cabinet embellished with gilded and painted floral motifs, carved elephants' heads, and embossed composition panels of Prunus blossoms (FIG. 5.32)—any or all of these might have been called Queen Anne in America in the late 1870s and early 1880s.

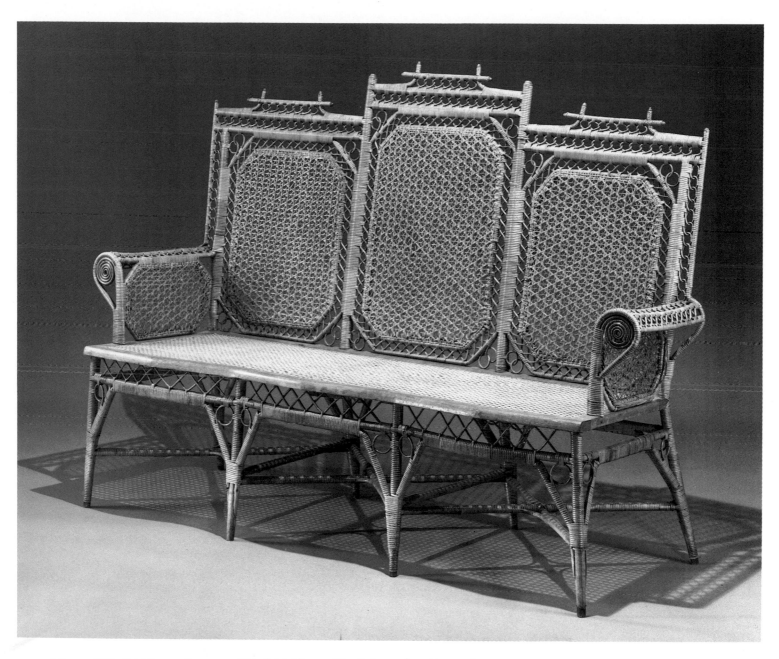

FIG. 5.18 Settee. Wakefield Rattan Company, Wakefield, Mass., 1880. Oak, maple, rattan, caning, h. 48 in. (121.9 cm), w. 72 in. (182.9 cm), d. 23 in. (58.4 cm). Marked: *Apr 1880,* labeled: [maker's mark]. Collection of Mary Jean McLaughlin

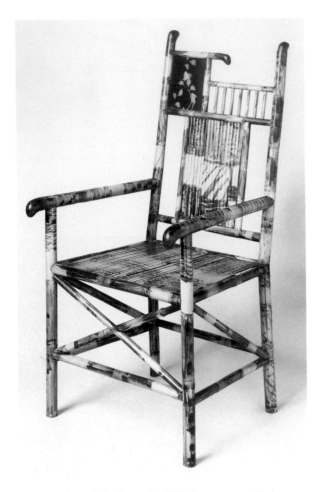

FIG. 5.19 Armchair. James E. Wall, Boston, ca. 1886. Bamboo, lacquer panel, h. 45⅜ in. (115.3 cm), w. 22 in. (55.9 cm), d. 25 in. (63.5 cm). Museum of Art, Rhode Island School of Design, Providence, Anonymous Gift (82.111.1)

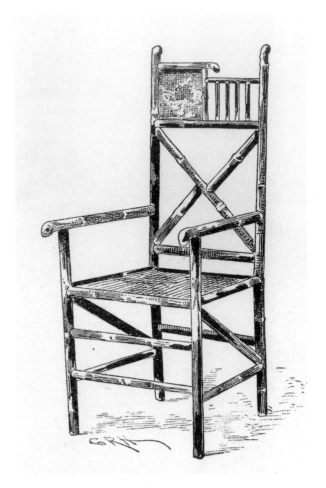

ILL. 5.8 "Bamboo Chair, Made by James E. Wall, Boston." *Decorator and Furnisher* (Dec. 1886). Art, Prints and Photographs Division, The New York Public Library, Astor, Lenox, Tilden Foundations

The Colonial Revival: Collecting, Copying, Creating

The artistic powers of furniture had been debated endlessly during the 1870s and 1880s. Finding artful chairs and honest tables could be difficult, however, for the "expectant householder." To solve the dilemma, Clarence Cook suggested that if one could not find desirable, affordable art furniture, one could meet the canons of current taste by searching for furniture with an acceptable patina of age. "In the suburbs of Boston," he told his readers in 1876, "the best places in which to look for Jacobean sideboards and cupboards that came over in the 'Mayflower' are found to be the henyards. . . . Several handsome oak cupboards that now adorn pretty Boston dining-rooms had to be feathered and singed before they could be made presentable." Being "given over in fee-simple to the fowl," far from damaging these sturdy relics of America's past, had given them "a good healthy color, and their angles are enough rubbed down to take away the disagreeable newness which troubles us in things just out of the shop."[83]

Cook approved wholeheartedly of the burgeoning demand for the furniture of "by-gone times in America," a mania, as it was called by the scoffers, that was "one of the best signs of returning good taste in a community that has long been the victim to the whims and impositions of foreign fashions." Owning a chest with a *Mayflower* pedigree or a Federal card table inlaid with an Amer-

ican seal expressed normal pride in an admirable past. If one was not so fortunate as to have had a grandfather who had owned such treasures, Cook, ever practical, recommended that one "scour our own back country" or visit the dealers. "Things we come upon in our own country are soon at home in our houses, because they were used by our own ancestors or our own people. They were to the manor born. They neither look affected, nor strange, nor pretentious, but native and natural."[84]

Americans' newfound passion for antiques grew also from the nineteenth-century notion that through careful study of the past one could find the true and enduring principles of art: tables, chairs, and candlesticks might serve as visual touchstones even as the works of great writers served as literary ones. Writers on household art provided further justification of the old-is-better concept. When Ella Rodman Church (b. 1831), author of *How to Furnish a Home* (1881), opened the deep, narrow side drawers of a "richly hued old mahogany" sideboard she sensed an aroma, not of the henyard, but of "foreign wines and sweetmeats."[85] As so often in the 1870s and 1880s, romance and nostalgia joined a sense of history. Antiques were valued not simply for their educational uses and eternal truths but also because they conjured up romantic pictures of a better age, when life was simple, straightforward, even Arcadian.[86]

Moreover, as Cook put it, "the furniture which was in use in this country in the time of our grandfathers . . . was almost always well designed and perfectly fitted for the uses it was to be put to."[87]

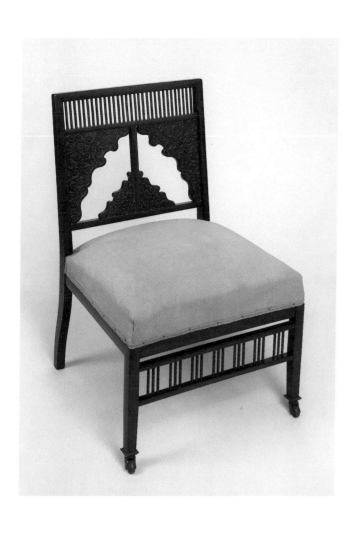

As Eastlake had lauded art furniture for its "fitness of purpose," Cook was now declaring that old furniture was better because it was better designed, better made, and better suited to its purpose. Church carried Cook's reasoning even further, finding the sideboard of fifty or a hundred years ago "more attractive in its plainness, and perhaps positive ugliness, because of its better fitness to the use for which it was intended."[88] The syllogism was transformed: "Beautiful plus Useful equals Art" had become "Useful equals Beautiful." And whereas usefulness was a clearly demonstrable quality, beauty was another matter. Beautiful, plain, or positively ugly—in whose eyes? Even the leading arbiters of taste seldom agreed.

The tastemakers, and the consumers who heeded their advice, did agree that just about anything from the American past, whether it was actually from the Colonial period or not, was a desirable possession. The so-called Colonial revival encompassed not only early American clothing, eighteenth-century recipes, and mementos of the founding fathers, but also piano stools and china from the early nineteenth century. These things were special simply because they had been used by "our own ancestors." Little

Left: FIG. 5.20 Side chair (one of a set of eight). American, late 19th century. From Olana, the Frederic E. Church house, Hudson, N.Y. Mahogany, h. 31⅜ in. (79.7 cm), w. 20½ in. (52.1 cm), d. 19½ in. (49.5 cm). New York State Office of Parks, Recreation and Historic Preservation, Bureau of Historic Sites, Olana State Historic Site, Taconic State Park Region (OL.1979.27.1)

Below: FIG. 5.21 Desk. Attributed to Associated Artists, New York, 1880s. From the Henry G. Marquand house, New York. Satinwood, inlaid metals, leather, h. 25⅝ in. (75.2 cm), w. 36 in. (91.4 cm), d. 24⅜ in. (61.9 cm). Collection of Margaret B. Caldwell and Carlo M. Florentino

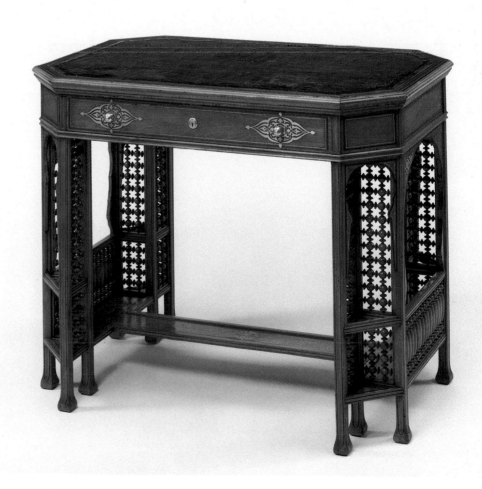

matter that only a small percent of antique American objects had actually been "to the manor born"; in a period of changing social structure antiques in one's home had the power to connote both status and class. Likewise, the Colonial revival lent cachet to any design thought to reflect Revolutionary-era taste. An authentic eighteenth-century American Chippendale armchair (FIG. 5.33) was no doubt given a place of pride in the Verplanck home about 1880, when the seat was reupholstered with needlework in a Morrisian pattern. CHARLES ALLERTON COOLIDGE used a Windsor chair as inspiration for the oak armchair (FIG. 5.34) he designed for Mr. and Mrs. John J. Glessner of Chicago in 1887. For those who found rifling through attics or henhouses for antiques distasteful, such creative adaptations of vernacular "Colonial" furniture were an attractive alternative.

The Colonial revival started even before the Centennial, and an interest in American antiques was by no means new in the mid-1870s.[89] In a period of only half a dozen or so years, however, the market for antiques apparently changed radically. Just as the 1870s saw the rise of the professional architect and the professional decorator, these years were also the beginnings of the antique trade. In August 1874 the "Culture and Progress" column in *Scribner's Monthly* described Sypher's, a store established in 1867, as "the only real bric-a-brac magazine we have in New York." Two years later Sypher and Company was listing itself as a dealer in "antique furniture."[90] Sypher's trade card from the period (ILL. 5.10) advertised their wide range of offerings with an engraving of an Amer-

ican scene. A man and woman in Colonial dress flank a fireplace with a lining of Delft tiles and a carved Federal mantelpiece featuring a classical urn, swags, and fluted pilasters. The andirons are also classical, the mantel garniture is either Chinese export porcelain or Delft, and the hearth rug is oriental. A corner chair, a card table, and an armchair are all in the Chippendale style; a graceful candlestand and a girandole looking glass surmounted by an eagle represent the Federal period. Small wonder that such "Broadway bazaars," as Ella Rodman Church called them, were not for everyone.[91]

Over and over again in books and magazines of the 1870s writers equated owning American antiques with having "taste." Possession of the antique suggested not only learning and background but a special talent, a refined eye that set one apart. Money was important—one could, after all, hire advice. But only the man or woman with taste possessed an instinct for the treasure hidden amid trash, and so joined those select, or better yet elect, few who were destined to walk with the apostles of the new aestheticism.

In America during the Aesthetic era one of the leading apostles of taste was the Bostonian Charles Wyllys Elliott. Descendant of prominent New England families, student of antiquities, proponent of honest furniture, Elliott passionately hailed the design millennium he foresaw: "The revolt from the vulgar, the meretricious, and the commonplace, which have long affected us, will resolve itself . . . when, in every house, the Beautiful married to

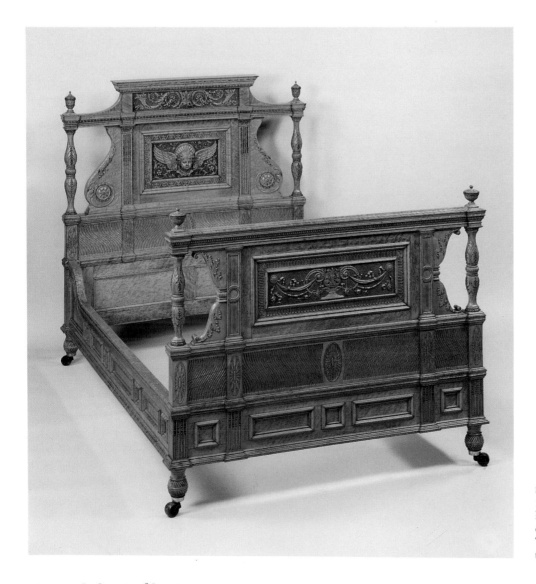

FIG. 5.22 Bedstead (from a suite). New York, ca. 1878–84. From the Henry G. Marquand house, New York. Bird's-eye maple, h. 51½ in. (130.8 cm), w. 49¼ in. (125.1 cm), l. 80 in. (203.2 cm). The Metropolitan Museum of Art, Friends of the American Wing Fund, 1986 (1986.47.1)

Right: FIG. 5.24 Table. Louis Comfort Tiffany with Samuel Colman, New York, 1890–91, for the Henry Osborne Havemeyer house, New York. Ash, h. 27 in. (68.6 cm), w. 24 in. (61.6 cm), d. 28 in. (71.1 cm). Shelburne Museum, Inc., Vt.

Below: FIG. 5.23 Table and chairs (from a bedroom suite). New York, ca. 1878–84. From the Henry G. Marquand house, New York. Bird's-eye maple; table: h. 30¼ in. (76.8 cm), diam. 28 in. (71.1 cm), each chair: h. 34¾ in. (88.3 cm), w. 16¾ in. (42.6 cm), d. 16¾ in. (42.6 cm). The Metropolitan Museum of Art, Friends of the American Wing Fund, 1986 (1986.47.2–4)

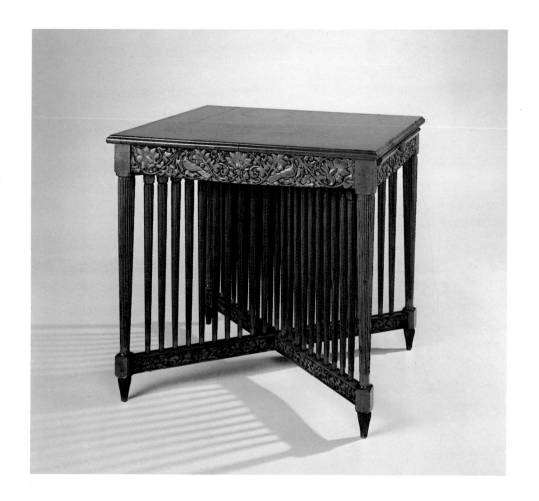

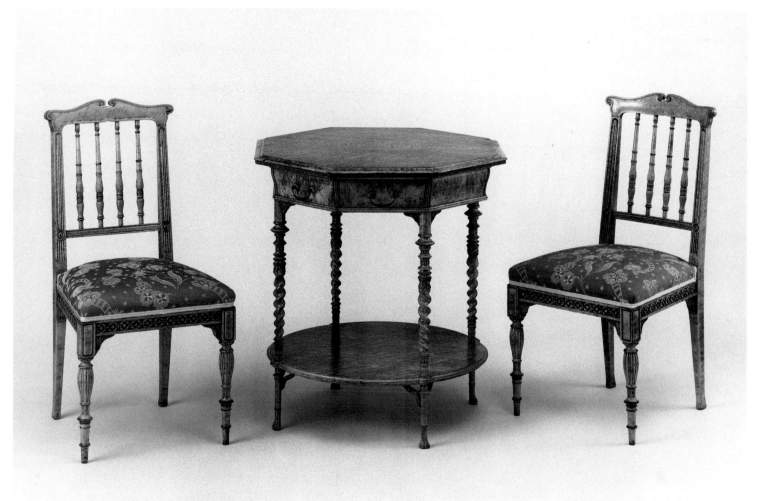

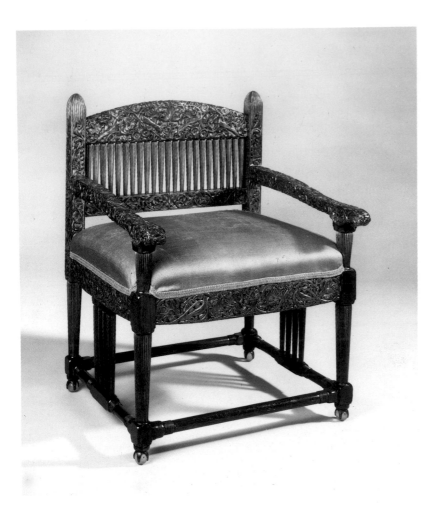

Left: FIG. 5.25 Chair. Louis Comfort Tiffany with Samuel Colman, New York, 1890–91, for the Henry Osborne Havemeyer house, New York. Ash, satinwood, mahogany, h. 33½ in. (85.1 cm), w. 25 in. (63.5 cm), d. 20½ in. (52.1 cm). Shelburne Museum, Inc., Vt.

Below left: FIG. 5.26 Side chair. Herter Brothers, New York, ca. 1880. Ebonized cherry, incised and gilded carving, inlaid woods, h. 37⅜ in. (94.9 cm), w. 17¼ in. (43.3 cm), d. 16½ in. (41.9 cm). Philadelphia Museum of Art, Gift of Mrs. William T. Carter ('28.121.1e)

Below right: ILL. 5.9 Side chair. Herter Brothers, New York, ca. 1880. Ebonized cherry, incised and gilded carving, inlaid woods, h. 33¼ in. (84.5 cm), w. 16 in. (40.7 cm), d. 18½ in. (46 cm). The Cleveland Museum of Art, Norman O. Stone and Ella A. Stone Memorial Fund (82.5)

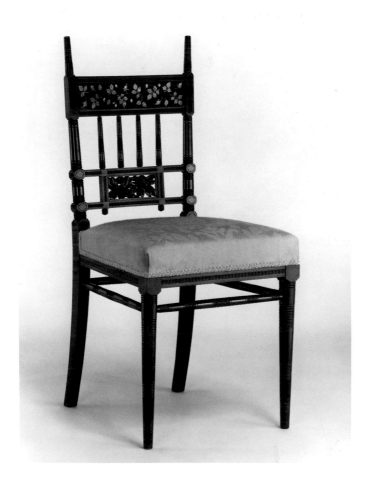

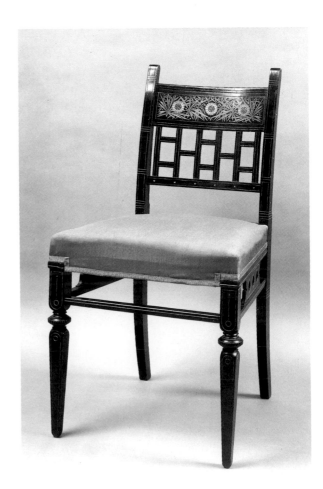

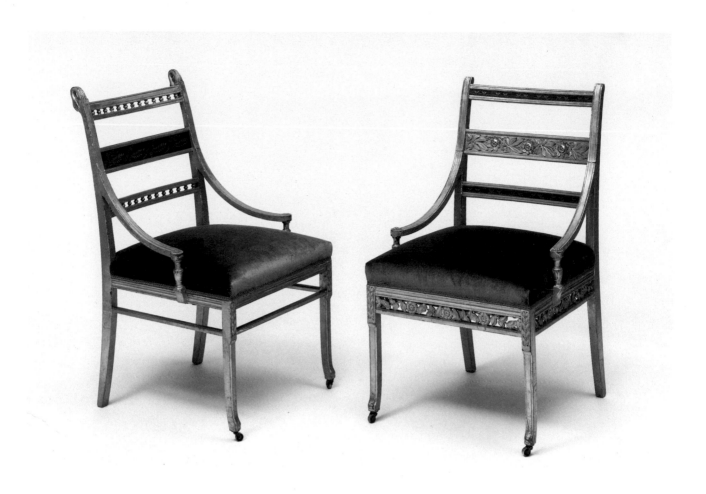

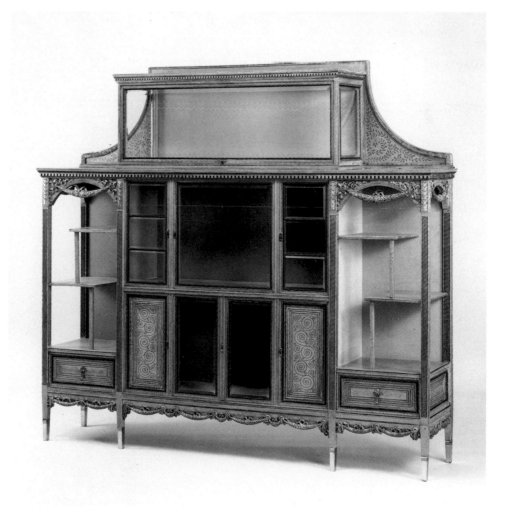

Above: FIG. 5.30 Armchairs. Attributed to Herter Brothers, New York, ca. 1880. Gilded maple, inlaid woods and brass; each: h. 34½ in. (87.6 cm), w. 22 in. (55.9 cm), d. 19¼ in. (48.9 cm). Collection of John Nally

Right: FIG. 5.31 Cabinet. Herter Brothers, New York, ca. 1880. Gilded maple, h. 66 in. (168.2 cm), w. 60½ in. (152.4 cm), d. 15 in. (38.1 cm). Marked: *HERTER BRO'S.* United States Trust Company of New York

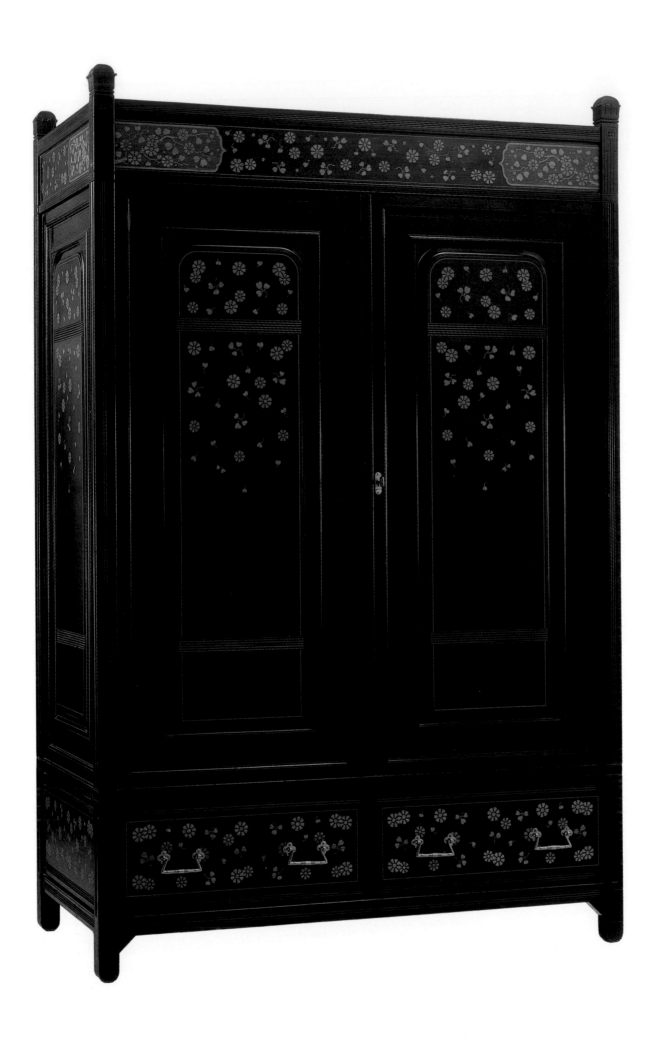

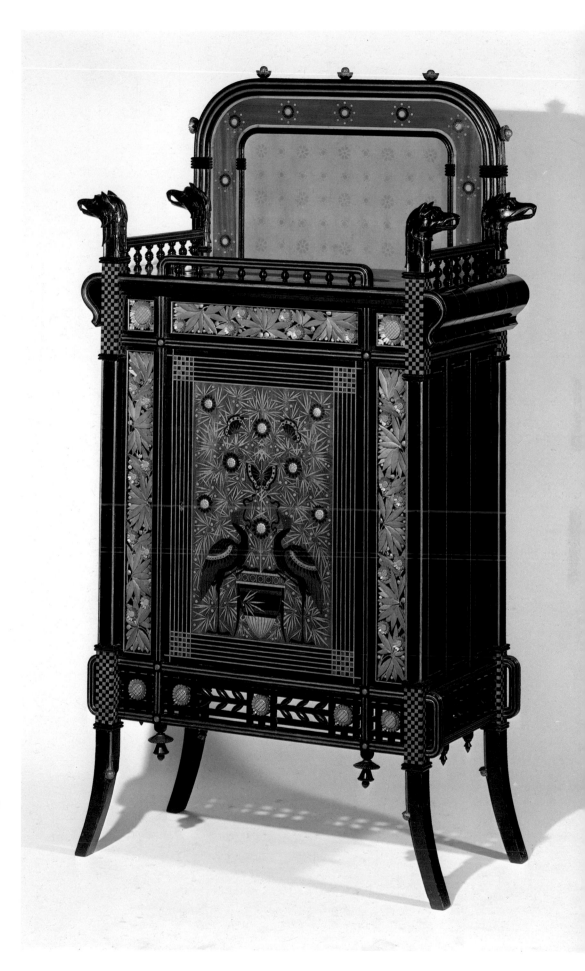

Opposite: FIG. 5.27 Wardrobe. Herter Brothers, New York, 1880–85. Ebonized cherry, inlaid woods, h. 78½ in. (199.4 cm), w. 49½ in. (125.7 cm), d. 26 in. (66 cm). The Metropolitan Museum of Art, Gift of Kenneth O. Smith, 1969 (69.140)

Right: FIG. 5.28 Cabinet. Herter Brothers, New York, ca. 1880. Ebonized cherry, inlaid and gilded woods, h. 60 in. (152.4 cm), w. 33 in. (83.8 cm), d. 16¼ in. (41.3 cm). High Museum of Art, Atlanta, Virginia Carroll Crawford Collection (1981.1000.51)

FIG. 5.33 Armchair with needlework seat. New York, 1750–70, for the Verplanck family, needlework, ca. 1880. Mahogany, wool, h. 39½ in. (100.3 cm), w. 30 in. (76.2 cm), d. 23½ in. (59.7 cm). The Metropolitan Museum of Art, Bequest of Barbara Bradley Manice, 1984 (1984.2.87)

FIG. 5.34 Armchair. Designed by Charles Allerton Coolidge, manufacture attributed to A. H. Davenport and Company, Boston, 1887, for the John J. Glessner house, Chicago. Oak, h. 39¼ in. (99.7 cm), w. 26 in. (66 cm), d. 21 in. (53.3 cm). The Glessner House, Chicago Architecture Foundation, Gift of Mrs. Charles F. Batchelder

the Useful shall make life truer, finer, happier."[92] Elliott's words were rooted in four decades of theory, in a long-standing tradition of thought traceable through the works of Henry Cole, Richard Redgrave, and other early Victorian design reformers whose ideas Owen Jones summarized in a list of thirty-seven "propositions" published as the introduction to his *Grammar of Ornament* in 1856. Jones's theories blended the structural and ethical themes of the Gothic revival. His first proposition stated that "the Decorative Arts arise from, and should be properly attendant upon, Architecture." His fifth declared, "Construction should be decorated. Decoration should never be purposely constructed. That which is beautiful is true; that which is true must be beautiful."[93]

In the 1880s, while he was editor of the *Furniture Gazette* in London, Christopher Dresser applied Jones's philosophy to correct principles in furniture: "Construction is the first thing to be considered, for, however costly may be the materials employed, and however lavish the ornamentation, a piece of furniture which is ill-constructed can neither be useful nor beautiful." A plain piece of furniture, when it is "thoroughly adapted to its purpose, and has all its parts in due proportion, . . . is an object upon which the cultivated eye rests with great satisfaction, and a very slight amount of ornamentation will render it an object of beauty. When the decoration is carried farther it becomes an object of art."[94] Thus did Dresser, the great theorist of ornament who was also a masterful designer of pure unadorned forms, pay continuing obeisance to the earlier Victorian concept wherein structure conveyed utility and ornament art.

The Gothic revival and the British reform theorists also helped shape the thinking of a young architect from the Midwest who was to become the leading figure of the Arts and Crafts movement in the United States. In *An Autobiography* (1932) Frank Lloyd Wright (1867–1959) recalled finding a reprint of Jones's *Grammar of Ornament* in the library of All Souls College, Oxford University, in 1887: "I read the 'propositions' and the first five were dead right."[95]

Wright and other leaders of the Arts and Crafts movement, preoccupied with ideas of utility, honesty, and craftsmanship, were at the opposite pole from their contemporaries who were less concerned with structure than with decorative detailing and visual content, or style. In the late nineteenth century two visually and ideologically antithetical phenomena coexisted. Art Nouveau, the new mannerism of the 1890s that nevertheless owed a debt to the whiplash line of Japanism, purported to represent a break with the then-current tendency toward historicism. It was, however, a style, and not, as were the Gothic revival and the Arts and Crafts, an embodiment of a philosophical movement. Proponents of the Art Nouveau viewpoint might have concurred with that most articulate and often self-contradictory aesthete, Oscar Wilde (1854–1900), spokesman for art for art's sake. Wilde once declared, with his customary impunity, that "in matters of grave importance, style, not sincerity, is the vital thing."[96]

Finding the moralism of the Arts and Crafts movement somewhat unpalatable, designers of the 1970s and 1980s have seized more upon the visual and have embraced "style." As in Clarence Cook's day, descriptions of furniture still convey something not only of the technology but also of the underlying interests and assumptions of the age. If furniture today is seldom called "beau-

tiful," it is virtually never described as "honest." One would, after all, be hard put to find truthful construction in an inflatable chair, or sincerity in a cardboard chest of drawers. Furniture of the 1980s is sometimes characterized as "amusing," "eccentric," "brash," "witty," or even "outrageous," suggesting reactions from pleasurable humor to shock. It may be "charming," "childlike," or "whimsical," offering the escapism of nostalgia or fantasy. Today's furniture might be "glamorous," "rare," "costly," or "opulent," signifying money and power. Or it might be "novel" or "daring," suggesting an obsession with the new, with change, speed, and essential obsolescence. Furniture called "energetic," "high tech," or "innovative" may glorify a society's technological progress, even as other pieces that are "incongruous," "irreverent," or "pop" may question that society's values and parody its culture. How far we seem from the world of a century ago and the Victorians' search for a single enduring truth rooted in the past. Yet is the gap so great as it seems? In a 1985 essay called "Total Style" the writer speaks of "two recent phenomena: the resurgence of architect-designed objects for domestic use, and the increasing number of visual artists who have 'crossed over' into the design field, turning their attention to functional objects."[97] Recent phenomena, or echoes of the past?

In the 1930s England's time-honored architect Edwin Lutyens (1869–1944) perceived the long, continuing thread of the theme of the beautiful and the useful, which flowered first, appropriately, in the great glass conservatory that was the Crystal Palace:

The 1851 exhibition awakened the idea of utility as the basis of art. All that was necessary for daily life could and ought to be made beautiful. This utilitarian principle began to be put into practice when William Burges, E. W. Godwin, A. H. Mackmurdo, Bodley and others regarded nothing in or outside the home as too small to deserve their careful consideration. So we find Burges designing water taps and hair brushes, Godwin and Mackmurdo furniture, Bodley, like Pugin, fabrics and wallpapers.[98]

Having perused newspapers and periodicals of a hundred years ago, I cannot help but feel a jolt of recognition, a sense of déjà vu, when I read on the front page of the *New York Times* "Home" section for March 6, 1986, "It's not art over here and you over there; the idea is to make your life connected with art, from what you sit on, to what you wear, to the places you go and the things you do." The speaker is identified as the owner of Art et Industrie, a downtown gallery that specializes in art furniture.[99] Still with us, it would seem, is the great schism of the nineteenth century: art and industry. So too is "art furniture," although it could today mean anything from the finely crafted woodworking of artisans like Wendell Castle to the more intellectual designs of architects like Ettore Sottsass, with his madcap Memphis. In the work of both schools, curiously enough, the tenets of the Aesthetic movement endure. Art furniture, it would seem, remains an answer. It is the questions that have changed.

ILL. 5.10 Trade card. Sypher and Company, New York, ca. 1872–75. Lithograph, 3⁷⁄₁₆ × 5 in. (8.7 × 12.7 cm). Collection of Marilynn Johnson

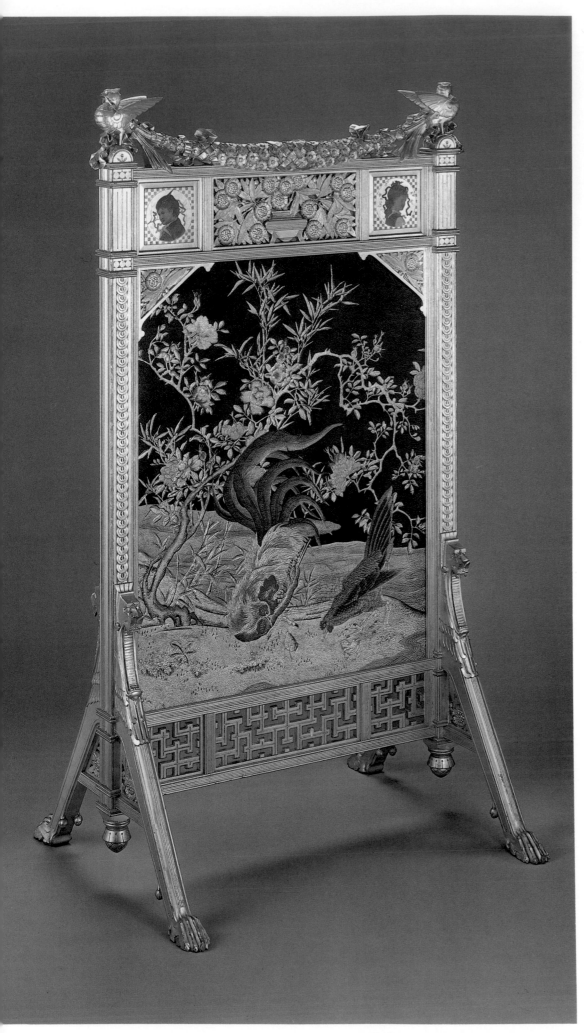

Left: FIG. 5.29 Screen. Herter Brothers, New York, ca. 1880. Gilded and painted wood, embroidered silk, embossed leather(?), h. 53 in. (134.6 cm), w. 29¾ in. (75.6 cm). Collection of Margot Johnson

Opposite: FIG. 5.32 Cabinet. Herter Brothers, New York, ca. 1880. Rosewood, inlaid woods, painted and gilded panels, embossed composition material, h. 80 in. (203.2 cm), w. 64 in. (163.2 cm), d. 17¾ in. (45.1 cm). Collection of John Nally and Marco Polo Stufano

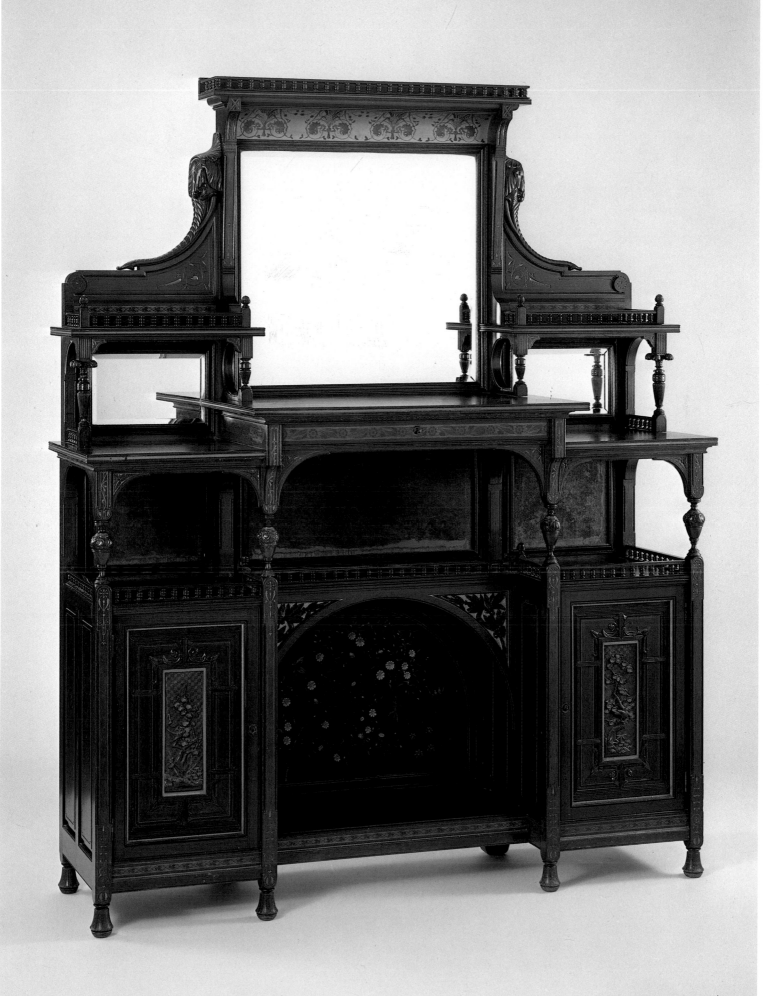

1. "Concerning Furniture," *Scribner's Monthly* 11 (Nov. 1875–Apr. 1876), Scribner's Miscellany [bound in at back], p. 9.

2. Nikolaus Pevsner, "Art Furniture of the Eighteen-Seventies," *Architectural Review* 111 (Jan. 1952), p. 43.

3. *Artistic Houses, Being a Series of Interior Views of a Number of the Most Beautiful and Celebrated Homes in the United States*, 2 vols. in 4 pts. (1883–84; reprinted in 1 pt., New York, 1971), vol. 1, pt. 1, p. 75.

4. Letter from E. W. Godwin to William Watt, Jan. 1, 1877, in *Art Furniture, from Designs by E. W. Godwin, F.S.A., and Others, with Hints and Suggestions on Domestic Furniture and Decoration, by William Watt . . .* (London, 1877), reprinted in E. W. Godwin, *Art Furniture and Artistic Conservatories* (New York and London, 1978), p. iii.

5. Herwin Schaefer, *Nineteenth Century Modern: The Functional Tradition in Victorian Design* (New York, 1970), p. 111. Although Schaefer espouses the twentieth-century functionalist view of ornament, which assumes that the bare form is always preferable to the decorated one and that ornament or decoration by its nature obscures form, he has nonetheless accurately evaluated the way decoration was seen during much of the early and mid-Victorian period.

6. Alf Bøe, *From Gothic Revival to Functional Form: A Study in Victorian Theories of Design* (Oslo and Oxford, 1957), p. 45. Bøe's book is an excellent study of the design-reform movement in England. See also Charles Handley-Read, "England, 1830–1901," in *World Furniture*, ed. Helena Hayward (London, 1965), pp. 218–26.

7. Quoted in Bøe, *Gothic Revival*, p. 47.

8. Ibid., p. 49.

9. See Fine Art Society Limited, London, *Architect-Designers: Pugin to Mackintosh*, by Clive Wainwright and Charlotte Gere (exhib. cat., 1981).

10. Quoted in Pevsner, "Art Furniture," p. 44.

11. For information on the British painted furniture at the London International Exhibition of 1862, see N. Cromey-Hawke, "William Morris and Victorian Painted Furniture," *Connoisseur* 191 (Jan. 1976), pp. 32–43. Shaw's bookcase (1861; Victoria and Albert Museum, London) is also discussed and illustrated in Andrew Saint, *Richard Norman Shaw* (New Haven and London, 1976), p. 21, fig. 11. Burges's cabinet and his bookcase are discussed and illustrated in J. Mordaunt Crook, *William Burges and the High Victorian Dream* (Chicago and London, 1981), pp. 296–97, 321, col. pls. 7, 8.

12. Cataloguing information, Victoria and Albert Museum, London. See also Victoria and Albert Museum, *English Cabinets* (London, 1972), no. 36.

13. See David A. Hanks and Page Talbott, "Daniel Pabst, Philadelphia Cabinetmaker," *Philadelphia Museum of Art Bulletin* 73 (Apr. 1977), pp. 4–24, esp. nos. 15, 16; and David [A.] Hanks, "Daniel Pabst, Philadelphia Cabinetmaker," *Art and Antiques* 3 (Jan.–Feb. 1980), pp. 94–101, which includes a photograph of the dining room in the Roosevelt house at 6 West Fifty-seventh Street, New York. Pabst and Furness are believed to have collaborated on the furniture for the house, which also included a bedroom suite that is now at Sagamore Hill National Historic Site, Oyster Bay, N.Y.; two pieces from that suite, as well as a massive settee in the same style, are illustrated in Hudson River Museum, Yonkers, N.Y., *Eastlake-Influenced American Furniture, 1870–1890*, by Mary Jean Smith Madigan (exhib. cat., 1973), nos. 10, 11, 12.

14. Charles Locke Eastlake, *Hints on Household Taste in Furniture, Upholstery, and Other Details* (1868; reprinted from the 2d London ed., intro. and notes by Charles C. Perkins, Boston, 1872), ill. opp. p.

90; see Hudson River Museum, *Eastlake-Influenced American Furniture*, no. 7.

15. Eastlake, *Hints on Household Taste*, preface.

16. Charles Wyllys Elliott, "Household Art, 6: The Dining-Room," *Art Journal* (Appleton's) 2 (June 1876), p. 183.

17. "Culture and Progress: An Exhibition of Decorative Art," *Scribner's Monthly* 10 (Aug. 1875), p. 518.

18. Henry Hudson Holly, "Modern Dwellings: Their Construction, Decoration, and Furniture," *Harper's New Monthly Magazine* 53 (July 1876), pp. 217, 225–26, 357, quoted in Mary Jean Smith Madigan, "The Influence of Charles Locke Eastlake on American Furniture Manufacture, 1870–90," *Winterthur Portfolio* 10 (1975), pp. 6–7.

19. Henry Hudson Holly, *Modern Dwellings in Town and Country Adapted to American Wants and Climate with a Treatise on Furniture and Decoration* (New York, 1878), preface, quoted in Madigan, "Influence of Charles Locke Eastlake," p. 7.

20. Clarence Cook, "Beds and Tables, Stools and Candlesticks," pt. 6, *Scribner's Monthly* 12 (Sept. 1876), p. 802.

21. Quoted in Madigan, "Influence of Charles Locke Eastlake," p. 12.

22. Ibid.

23. Harriet Prescott Spofford, *Art Decoration Applied to Furniture* (New York, 1878), p. 147. For information on Spofford's 1876–77 essays, see Elizabeth K. Halbeisen, *Harriet Prescott Spofford: A Romantic Survival* (Philadelphia, 1935), p. 166.

24. Quoted in Crook, *William Burges*, p. 52.

25. See Dudley Harbron, *The Conscious Stone: The Life of Edward William Godwin* (London, 1949), p. 95; and Elizabeth Aslin, *The Aesthetic Movement: Prelude to Art Nouveau* (New York and Washington, D.C., 1969), p. 65.

26. Several of the Dromore Castle dining chairs are now in the Victoria and Albert Museum, London; see Elizabeth Aslin, "The Furniture Designs of E. W. Godwin," *Victoria and Albert Bulletin* 3 (Oct. 1967), pp. 147–49, fig. 5.

27. Quoted in ibid., p. 145. That Godwin's designs showed "a great advance" was noted by Hermann Muthesius, *Das Englische Haus*, 3 vols. (Berlin, 1904–5); see idem, *The English House*, ed. Dennis Sharp, abridged from the 2d ed., 3 vols. in 1 (New York, 1979), pp. 31, 156–58. See also Edgar Kaufmann, Jr., "Makers of Tradition: Godwin and Dresser," *Interiors* 118 (Oct. 1958), pp. 162–65.

28. *Furniture Gazette*, quoted in Juliet Kinchin, "Collinson and Lock, Manufacturers of Artistic Furniture," *Connoisseur* 201 (May 1979), p. 47. Kinchin provides the most thorough historical and stylistic commentary available on the firm.

29. *House Furnisher* 1 (Oct. 1881), p. 139, quoted in Kinchin, "Collinson and Lock," p. 47.

30. Collinson and Lock, *Sketches of Artistic Furniture* (London, 1871), pp. 5, 6, 17 (bottom), 19 (left).

31. Letter from Elizabeth Aslin to Catherine Hoover Voorsanger, Department of American Decorative Arts, The Metropolitan Museum of Art, New York, May 16, 1985. Aslin acquired the Godwin papers for the collection of the Victoria and Albert Museum, London, in the early 1950s.

32. The dated design for the Anglo-Japanesque cabinet is in the Godwin papers, Victoria and Albert Museum, London.

33. Letter from Juliet Kinchin to Catherine Hoover Voorsanger, Department of American Decorative Arts, The Metropolitan Museum of Art, New York, Mar. 7, 1985.

34. *Art-Worker: A Journal of Design Devoted to Art-Industry* 1 (Jan.–Dec. 1878), pls. 13, 14, 22, 30, 37, 46, 53, 60, 69, 76.

35. Clarence Cook, *The House Beautiful: Essays on*

Beds and Tables, Stools and Candlesticks (1878; reprint New York, 1980), pp. 107, 100, 106. These comments originally appeared in Clarence Cook, "Beds and Tables, Stools and Candlesticks," pt. 4, *Scribner's Monthly* 11 (Apr. 1876), pp. 809–22. For a listing of the other ten parts in the series, see Dictionary of Architects, Artisans, Artists, and Manufacturers, this publication. Alexandre Sandier worked at Herter Brothers of New York during the 1870s. His designs epitomized the firm's unique approach to cosmopolitan art furniture. Sandier was born and educated in France, where Christian Herter may have met him in the late 1860s or early 1870s. Sandier eventually returned to his homeland, where he became the head of the art department at the Sèvres porcelain factory. Correspondence between Tamara Préaud and Marilynn Johnson Bordes; see Marcelle Brunet and Tamara Préaud, *Sèvres: Des origines à nos jours* (Paris, 1978), p. 274, n. 17. "Mr. Lathrop" is American painter Francis Lathrop (1849–1909); see also Marilynn Johnson, "The Artful Interior," this publication.

36. Collinson and Lock's records for November 17, 1873, document a payment to Godwin for a design for a cabinet with panels painted by Murray. The cabinet may have been exhibited at the Paris Exposition Universelle in 1878. Detroit Art Registration and Information System, May 31, 1985, courtesy of Alan Darr, Detroit Institute of Arts. See also Kinchin, "Collinson and Lock," p. 51.

37. Cook, *House Beautiful*, p. 70.

38. Letter from Godwin to Watt, in Godwin, *Art Furniture and Artistic Conservatories*, p. iii. The coffee table is illustrated in pl. 15.

39. See Mark Girouard, *Sweetness and Light: The "Queen Anne" Movement, 1860–1900* (Oxford, 1977), pp. 210–11. On p. 241 (n. 16) Girouard notes that "since Agnes and Rhoda Garrett, who . . . were connected by marriage to J. W. Loftie [editor of the series], had studied under Cottier in London, the plagiarism may have been by agreement." See also Martha Crabill McClaugherty, "Household Art: Creating the Artistic Home, 1868–1893" (M.A. thesis, University of Virginia, 1981), pp. 115–18.

40. Frank H. Norton, ed., *Frank Leslie's Historical Register of the United States Centennial Exposition, 1876* (New York, 1877), p. 77.

41. World's fairs were held in London in 1851, Paris in 1855, London in 1862, Paris in 1867, London in 1871, Vienna in 1873, Philadelphia in 1876, Paris in 1878 and 1889, Chicago in 1893, and Paris in 1900.

42. "Japanese Work at the Centennial Grounds," *American Architect and Building News* [hereafter abbreviated as *American Architect*] 1 (Feb. 12, 1876), pp. 55–56; Thompson Westcott, *Centennial Portfolio: A Souvenir of the International Exhibition at Philadelphia* (Philadelphia, 1876), p. 22, quoted in Clay Lancaster, *The Japanese Influence in America* (New York, 1963), p. 48.

43. For information on the New England kitchen, see Norton, *Frank Leslie's Historical Register*, pp. 87, 90; and James D. McCabe, *The Illustrated History of the Centennial Exhibition* (1876; reprint Philadelphia, 1975), pp. 645–46. See also Rodris Roth, "The New England, or 'Olde Tyme,' Kitchen Exhibit at the Nineteenth-Century Fairs," in *The Colonial Revival in America*, ed. Alan Axelrod (New York and London, 1985), pp. 159–83; and Christopher Monkhouse, "The Spinning Wheel as Artifact, Symbol, and Source of Design," in *Victorian Furniture: Essays from a Victorian Society Autumn Symposium*, ed. Kenneth L. Ames (Philadelphia, 1983), pp. 155–72. Although "Centennial" furniture is probably a twentieth-century misnomer and the Colonial revival started before 1876, the exhibitions at the fair did strengthen the focus on America's past; see Rodris Roth, "American Art: The Colonial Revival and 'Centennial Furniture,'" *Art Quarterly* 27, no. 1 (1964), pp. 57–81.

44. Norton, *Frank Leslie's Historical Register*, p. 220.

45. [George Titus Ferris], *Gems of the Centennial Exhibition: Consisting of Illustrated Descriptions of Objects of an Artistic Character, in the Exhibits of the United States, Great Britain, France . . .* (New York, 1877), p. 89.

46. For an illustration of the cabinet exhibited at the Centennial, see Walter Smith, *Industrial Art*, vol. 2 of *The Masterpieces of the Centennial International Exhibition* (Philadelphia, copr. 1875 [1877?]), p. 168.

47. "Decorative Fine-Art Work at Philadelphia: American Furniture," pt. 2, *American Architect* 2 (Jan. 6, 1877), p. 3.

48. "Decorative Fine-Art Work at Philadelphia: American Furniture," pt. 1, *American Architect* 1 (Dec. 23, 1876), p. 412.

49. Norton, *Frank Leslie's Historical Register*, p. 264.

50. "Decorative Fine-Art Work at Philadelphia: American Furniture," pt. 3, *American Architect* 2 (Jan. 13, 1877), p. 12.

51. Norton, *Frank Leslie's Historical Register*, p. 261.

52. [Ferris], *Gems of the Centennial Exhibition*, p. 133.

53. Mitchell and Rammelsberg's bill of sale to Gaar is in the possession of his great-granddaughter, Mrs. Joanna H. Mikesell; see Columbus Museum of Art, *Made in Ohio: Furniture, 1788–1888*, by E. Jane Connell and Charles R. Muller (exhib. cat., 1984), p. 61. See also Donald C. Peirce, "Mitchell and Rammelsberg, Cincinnati Furniture Manufacturers, 1847–1881," *Winterthur Portfolio* 13 (1978), pp. 222–29.

54. Cincinnati *Week: Illustrated*, Dec. 15, 1883, p. 242, quoted in Peirce, "Mitchell and Rammelsberg," p. 229.

55. Directory run on Kimbel and Cabus, the scholarship files, Department of American Decorative Arts, The Metropolitan Museum of Art, New York.

56. [Ferris], *Gems of the Centennial Exhibition*, p. 140.

57. [Illustration of Kimbel and Cabus display at the Centennial], *American Architect* 1 (July 22, 1876).

58. A. Kimbel and Sons, "Albums of Furniture, New York," 2 vols. of mounted photographs, n.d., Rare Book Collection, Cooper-Hewitt Museum, New York, nos. 330 (pedestal), 363 (cabinet). These elaborate numbered albums may also have served as order books from which clients could select the ornamental variations they preferred.

59. The table and chair are listed as nos. 400 and 401 in the Kimbel and Cabus album.

60. B[ruce] J. Talbert, *Gothic Forms Applied to Furniture, Metal Work, and Decoration for Domestic Purposes* (1867; reprint Boston, 1873), no. 7.

61. "Topics of the Time: Cincinnati," *Scribner's Monthly* 10 (Aug. 1875), pp. 510–11.

62. For further information on the Frys and their classes, see Anita J. Ellis, "Cincinnati Art Furniture," *Antiques* 121 (Apr. 1982), pp. 930–41.

63. See Robin Spencer, *The Aesthetic Movement* (London and New York, 1972), pp. 97–98; and Ellis, "Cincinnati Art Furniture," p. 933.

64. Cincinnati Art Museum, *The Ladies, God Bless 'Em: The Women's Art Movement in Cincinnati in the Nineteenth Century*, by Anita J. Ellis (exhib. cat., 1976), p. 15.

65. Benn Pitman, "Practical Wood-carving and Designing," pt. 9, *Art Amateur* 18 (Dec. 1888), p. 18. Pitman's copy of Augustus [Charles] Pugin, *Gothic Ornaments, Selected from Various Buildings, Both in England and France . . .* (London, 1831), is in the Cincinnati Art Museum; see Ellis, "Cincinnati Art Furniture," p. 934.

66. See Cincinnati Art Museum, *The Ladies, God Bless 'Em*, pp. 8, 15.

67. [Elizabeth W. Perry], *A Sketch of the Women's Art Museum Association of Cincinnati, 1877–1886* (Cincinnati, 1886), p. 24, quoted in Kenneth R. Trapp, "'To Beautify the Useful': Benn Pitman and the Women's Woodcarving Movement in Cincinnati in the Late Nineteenth Century," in *Victorian Furniture*, p. 182. See also Carol Macht, in Cincinnati Art Museum, *The Ladies, God Bless 'Em*, p. 8.

68. Trapp, "To Beautify the Useful," pp. 182–83.

69. For an illustration of the Pitman chest of drawers, see ibid., p. 181.

70. "Women as Wood-Carvers: The Movement in Cincinnati," *American Architect* 2 (Mar. 31, 1877), pp. 100–101.

71. See George Ward Nichols, ed., *The Cincinnati Organ: With a Brief Description of the Cincinnati Music Hall* (Cincinnati, 1878), a copy of which is in the Cincinnati Art Museum; and Trapp, "To Beautify the Useful," pp. 184–85.

72. Lilian Whiting, "The Cincinnati Exposition," *Art Amateur* 1 (Nov. 1879), pp. 119–20. For a listing of Pitman's articles for the *Art Amateur*, see Dictionary of Architects, Artisans, Artists, and Manufacturers, this publication.

73. See Trapp, "To Beautify the Useful," p. 187.

74. Benn Pitman, *A Plea for American Decorative Art*, Cincinnati Souvenir, Cotton States and International Exposition, Atlanta, Ga. (Cincinnati, 1895), pp. 7, 5, 8. "It is humiliating, and a national disgrace," Pitman wrote, "that rich Americans should build palaces and spend millions of dollars on adornment, all upon foreign ideas and skill." To his cry for a national art he added a second kind of chauvinism, which he had elsewhere repudiated: "To whom shall we look for the adornment of our homes? To girls and women most assuredly! Let men construct and women decorate"; see ibid., p. 13; and Roger B. Stein, "Artifact as Ideology: The Aesthetic Movement in Its American Cultural Context," this publication, note 54.

75. Godwin, *Art Furniture and Artistic Conservatories*, pl. 12. See also Pevsner, "Art Furniture," fig. 24.

76. See Johnson, "Artful Interior," this publication, note 120 and accompanying text.

77. [Bamboo furniture], *Decorator and Furnisher* 9 (Dec. 1886), pp. 107–8.

78. "Concerning Furniture," *Scribner's Monthly* 11 (Nov. 1875–Apr. 1876), Scribner's Miscellany [bound in at back], p. 10. A few pieces of Herter Brothers' Modern Gothic furniture have surfaced at dealers, but their present locations are unknown.

79. "A Frenchman's Ideas upon American Cabinet-Work" [Frédéric-Auguste Bartholdi], *American Architect* 2 (Sept. 1, 1877), p. 278.

80. Henry [H.] Hawley, "Four Pieces of American Furniture," *Bulletin of the Cleveland Museum of Art* 69 (Dec. 1982), pp. 330–32. The parlor from the James Goodwin house, including a version of the Herter chair, is now installed in the Wadsworth Atheneum, Hartford, Conn. The Vanderbilt chair appears in Edward Strahan [Earl Shinn], *Mr. Vanderbilt's House and Collection*, 2 vols. (Boston, New York, and Philadelphia, 1883–84), vol. 2, p. 109.

81. Two versions of this cabinet exist; the second is now at the Sagamore Hill National Historic Site, Oyster Bay, N.Y.

82. "Decorative Fine-Art Work at Philadelphia," pt. 3, p. 13.

83. Cook, "Beds and Tables," pt. 4, p. 813.

84. Ibid., pp. 813–14.

85. Ella Rodman Church, *How to Furnish a Home* (New York, 1881), p. 35.

86. See Vincent J. Scully, Jr., *The Shingle Style and the Stick Style: Architectural Theory and Design from Downing to the Origins of Wright* (1955; rev. ed. New Haven, 1971), pp. 19–33; and Girouard, *Sweetness and Light*, pp. 208–9.

87. Cook, "Beds and Tables," pt. 4, p. 814.

88. Church, *How to Furnish a Home*, p. 35.

89. See Richard Saunders, "Collecting American Decorative Arts in New England, Part 1: 1793–1876," *Antiques* 109 (May 1976), pp. 996–1003; and Axelrod, *Colonial Revival in America*.

90. "Culture and Progress," *Scribner's Monthly* 8 (Aug. 1874), p. 500. See also directory run on Sypher and Company, the scholarship files, Department of American Decorative Arts, The Metropolitan Museum of Art, New York.

91. Church, *How to Furnish a Home*, pp. 38–39, wrote that picking up treasures was no longer easy, "now that . . . the little second-hand furniture-dealer's humble shop in a crowded down-town street, where one could always be sure of finding a bargain, has blossomed out into the Broadway bazaar, filled with antiques and supercilious clerks." Even before Sypher's called itself "the American House of Antique Furniture" in 1875–76, it was far from humble; "Culture and Progress," *Scribner's Monthly* 8 (Aug. 1874), p. 500, described it as a place for those "with money and taste in equal quantities."

92. Charles Wyllys Elliott, *The Book of American Interiors* (Boston, 1876), p. 6.

93. Owen Jones, *The Grammar of Ornament* (1856; [3d ed.] London, 1868), p. 5.

94. Quoted in "Correct Principles in Furniture," *Art Amateur* 6 (Jan. 1882), p. 37. Dresser echoed the thoughts of earlier writers such as Richard Redgrave, who believed that "ornament should arise out of construction" and "not . . . be *applied* to the object"; see Gilbert R. Redgrave, *The Manual of Design, Compiled from the Writings and Addresses of Richard Redgrave* (London and New York, 1876), p. 88. Redgrave's son incorporated in the manual documents his father had written between 1851 and 1871. The copy in The Metropolitan Museum of Art, New York, bears the signature of its owner, John Taylor Johnston (1820–1893), first president of the Museum.

95. Frank Lloyd Wright, *An Autobiography* (1932; 2d ed. New York, 1943), p. 75, quoted in Scully, *Shingle Style*, p. 162.

96. Quoted in Lisa Phillips, "Total Style," in Whitney Museum of American Art, New York, *High Styles: Twentieth-Century American Design* (exhib. cat., 1985), p. 192.

97. Ibid.

98. Edwin Lutyens, in *Architectural Review* (1931), quoted in Clive Wainwright, "The Architect and the Decorative Arts," in Fine Art Society Limited, *Architect-Designers*, p. 6.

99. Joseph Giovannini, "Day-glo Esthetics: The New Downtown Style," *New York Times*, Mar. 6, 1986, p. C1.

Overleaf: Detail of window (FIG. 6.5)

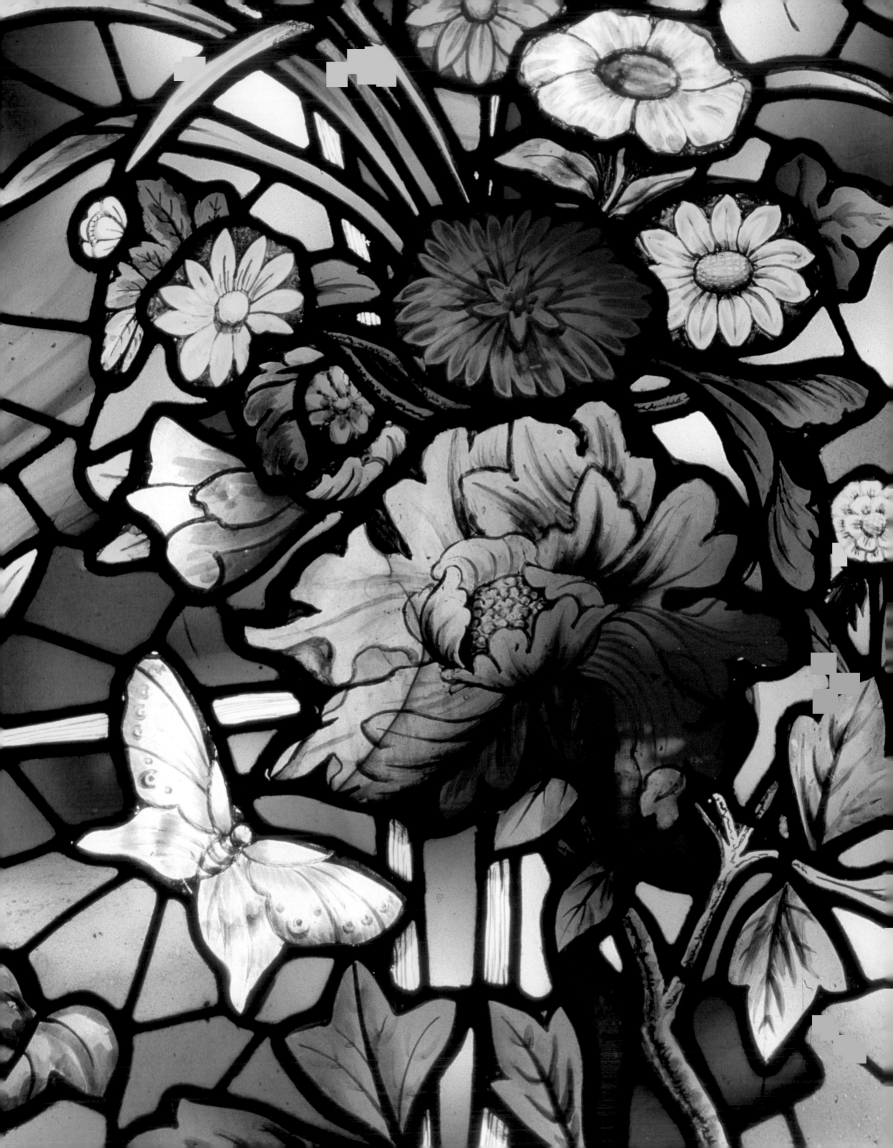

A New Renaissance:

Stained Glass in the Aesthetic Period

Alice Cooney Frelinghuysen

The great aesthetic wave, which has carried taste
and beauty into the adornment
of the modern home, has borne colored glass upon its crest.

THAT COMMENT, made by an unknown journalist in the *Boston Herald* during the Aesthetic period,[1] acknowledged the far-reaching American interest in stained glass, which in the 1870s was widely available from abroad for the first time and was also coming out of numerous urban workshops across the country.[2] In the New York area alone, approximately two thousand people were employed by 1884 in the design and manufacture of stained-glass windows,[3] an enterprise "driving the ugly plate-glass window out of existence," as one critic put it.[4]

The medieval art form, revived in England in the 1860s, created a thriving industry that would flourish for at least six decades. With techniques from the Middle Ages reevaluated and refined, windows acquired a totally new appearance. These new examples of a very old art, greeted in the United States with unprecedented enthusiasm, inspired native-born artists to create novel kinds of glass and to experiment with increasingly innovative methods of production. The efforts of JOHN LA FARGE and LOUIS COMFORT TIFFANY, America's most illustrious artists in glass, gained them and their work worldwide renown.

Stained Glass in Ecclesiastical Use

Before the Gothic revival in architecture brought with it a resurgent interest in stained glass, the art of working it had been neglected in Europe for two centuries. In England, the Gothic designs of Augustus Welby Northmore Pugin (1812–1852), together with the windows he produced in collaboration with various artist-glaziers—John Hardman (1811–1867) of Birmingham, for one—laid the foundation for a new tradition of English stained glass that craftsmen across the Atlantic would follow in the early years of its tenure in America.

Prior to the resumption of the old methods, craftsmen had approached the medium in much the same way that an artist does a canvas: they painted on its surface in opaque enamels that destroyed its transparency. Instead of working with stiff lines of lead to contain the varicolored components of the image they were building, they executed their designs on a single large pane, thereby negating the essential quality that accounts for the glory of the medieval achievement. John Ruskin (1819–1900) and others of like mind who advocated the return to the twelfth- and thirteenth-century art form cited the translucence and pure color of pot-metal glass (that colored in its molten state by means of metallic oxides) as one of their principal reasons. They also preached the use of lead to separate the colors, since its strong linear elements served so well to emphasize the design. With painting on stained glass confined to outlines and shadows, the aesthetic was altered from the one then in use—based on imitations of famous religious works by the great masters—into a "flatter, more legitimate style of painting."[5]

A period of prosperity in both England and America led to the building of new churches, usually in the favored Gothic-revival style of the era. These called for stained-glass windows, thousands of which, made primarily in England in the 1860s and 1870s, were being installed in churches all over the Western world. America experienced a similar phenomenon during the late nineteenth century: more than four thousand churches of different denominations were under construction by 1888.[6] The majority would boast windows of colored and stained glass, although only in the previous decade had such ecclesiastical decoration become almost a requirement. While some local craftsmen were working in stained glass during the third quarter of the nineteenth century,[7] Americans generally preferred imported windows, the greatest number of them produced in England by firms such as Clayton and Bell or Heaton, Butler and Bayne.

The Gothic style of English windows, preferred by Episcopalian and other Anglo-Protestant denominations in the early years of the Aesthetic movement in America and surviving in many examples, can still be seen in New York. In several windows in Grace Church, on Broadway at East Tenth Street, for instance, the style, characterized by vibrant reds and blues, by biblical figures clad in rich folds of drapery, and by compositions displaying the architectural motifs of the Middle Ages, is clearly illustrated. Also surviving from the same period are a smaller number of Continental windows, painted in the tradition of the Italian Renaissance and generally created for Roman Catholic churches,[8] though in 1878 the vestry of Trinity Church in Boston commissioned three from the Paris studio of Eugène Stanislas Oudinot (1827–1889).

The Gothic revival fired the imagination of WILLIAM MORRIS, who was responsible for a bounteous production of stained-glass windows, some of which his English firm made for American clients.[9] Morris designed few of them himself, preferring instead to supervise the realization of concepts by other designers—chiefly Edward Burne-Jones (1833–1898) and Ford Madox Brown (1821–1893)—and to apply the medieval techniques of stained-glass production to a new figural style on a floral background that was an extension of Pre-Raphaelitism. The resulting windows, exported to the United States, established an unprecedented fashion in stained-glass decoration. The earliest known MORRIS AND COMPANY example in America is a memorial window designed by Morris, Burne-Jones, and Brown[10] and installed in 1874 in Trinity

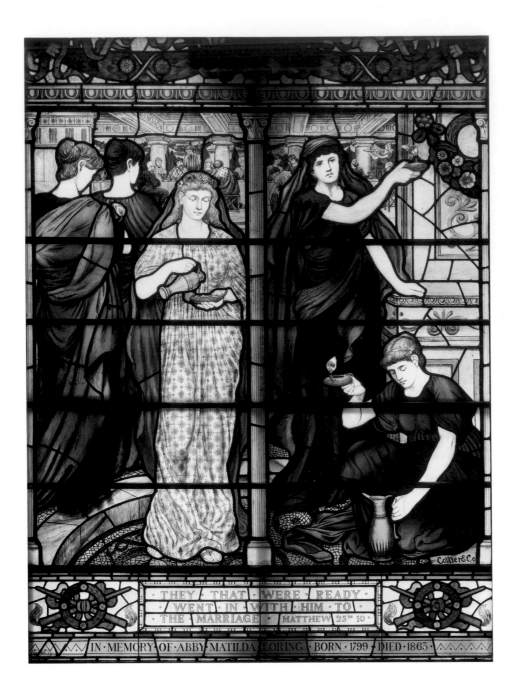

Church, Saugerties-on-Hudson, New York.[11] Instead of the typical Gothic-revival, architectural arrangement—narrow vertical lancets terminating in a trefoil arch—the Saugerties window is a large vertical rectangle surrounded by fourteen smaller rectangles. All fifteen spaces are similarly decorated with a central figure set against a delicate background of vines and clusters of grapes not unlike the patterns of some of Morris's fabrics and wallpapers. The shift from the old, formal mode to decorative, Pre-Raphaelite imagery is demonstrated in the languid, classical elegance of the subjects. Further, the designers have rejected the former combinations of jewel-like blues, reds, and greens in favor of subtle, subdued color harmonies.

The same characteristics were adhered to by another British stained-glass artist and decorator of note, the Scotsman DANIEL COTTIER, harbinger of aestheticism in America and a profound influence on American decoration. Cottier's interest in the fine and decorative arts had been kindled in London in the 1850s through lectures he heard by Ruskin, Brown, and Dante Gabriel Rossetti (1828–1882),[12] and his early career had been strongly affected by Morris and his circle. Among the many other designers and artists

closely associated with the Aesthetic movement with whom Cottier later became acquainted were Albert Moore (1841–1893), JAMES ABBOTT MCNEILL WHISTLER, J. MOYR SMITH, and BRUCE J. TALBERT.[13]

After a seven-year stint as a glass stainer in Glasgow, Cottier returned to London in 1869, the year that marked the beginning of his mature aesthetic style, which was to prevail at least through the mid-1880s. His windows (FIG. 6.1),[14] like those of Morris, represent a departure from the domination of the Gothic revival—rigid figural compositions replaced with large, clearly articulated subjects, usually female, wearing loose Hellenistic gowns. Also noteworthy is the change in his quarries (the small, geometric panes surrounding the central subject): borders of diamond-shaped glass, often filled with stenciled Gothic devices such as quatrefoils, fleurs-de-lis, or ivy leaves, are supplanted by rectangular or square shapes pale yellow in color and patterned in new motifs of delicate, conventionalized leaves and flowers that include the sunflower or the lily.

Cottier's London activities extended well beyond the area of stained glass. In 1870, at a time when painters, architects, and dec-

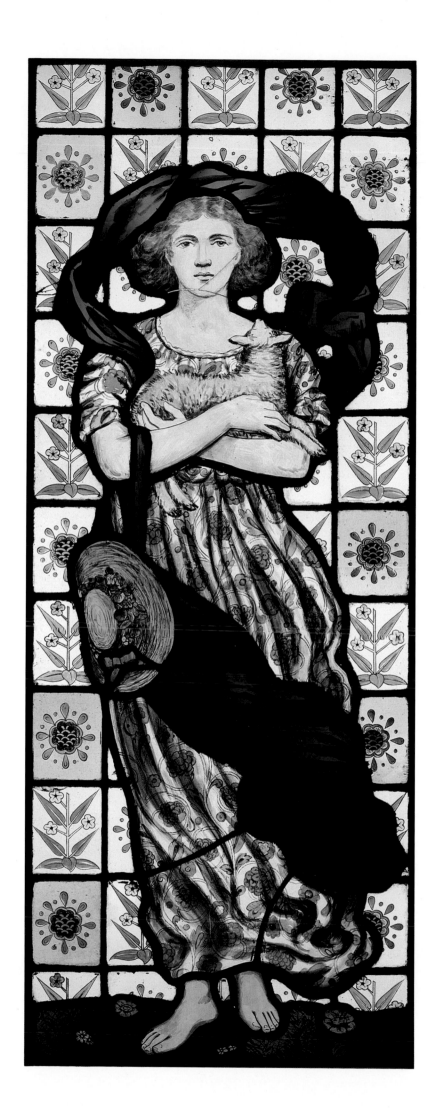

orative artists were collaborating on unified interiors in which most of the decorative media were intermingled, Talbert, architect John McKean Brydon (1840–1901), designer William Wallace (1801–1866), and Cottier formed the partnership "Cottier & Co., Art Furniture Makers, Glass and Tile Painters."[15] Encouraged by the firm's immediate success, Cottier came to the United States to seek new markets, and in 1873 he opened a workshop in New York under the name "Cottier & Co., Upholsterers, Fine Cabinet Makers, Glass Stainers, etc., Art Rooms, No. 144 Fifth Avenue."[16] He accepted commissions for decoration of all kinds, supplying his services to a growing clientele of distinguished Americans.

With his English experience—his knowledge of contemporary styles in stained glass in particular—Cottier was uniquely qualified to serve as a link between the expanding artistic ideas of England and those of an America just beginning its pursuit of aestheticism. In 1878–79, for Trinity Church in Boston (the building that brought architect H. H. RICHARDSON to national recognition), in addition to acting as technical adviser on windows that John La Farge was contributing,[17] Cottier designed four of his own (ILL. 6.1) in the south transept.[18] (Other English stained-glass designers working for Richardson were Henry Holiday [1839–1927], Morris, Burne–Jones, and the firm of Clayton and Bell.) Cottier windows are also to be found in several New York Episcopal churches,

including the Church of the Incarnation, on Madison Avenue, and Calvary Church, on Gramercy Park.

Through their interpretations of the Pre-Raphaelite and aesthetic styles, Morris and Cottier introduced into the churches of late nineteenth-century America a new subject matter not explicitly religious. Local artists were quick to follow suit, adding to the standard window repertoire of scenes from the Old Testament and from the life of Christ a whole assortment of historical and pictorial subjects. These ranged from charming floral and figural vignettes to lush river and mountain scenes in textural landscapes exploding with color.

CHARLES BOOTH, a stained-glass artist from Liverpool, came to work in the United States by 1875, bringing with him the English aesthetic design principles espoused by CHRISTOPHER DRESSER and thereby adding a certain abstraction, a totally different dimension, to the window form.[19] Dresser, in an entire chapter devoted to stained glass in his influential *Principles of Decorative Design* (1873), dealt thoroughly with the schematic possibilities of windows, though he himself is known to have designed only one. Discovering that the flat areas of color bounded by dark lead lines coincided with his artistic tenets, he decreed that a window "never appear as a picture with parts treated in light and shade,"[20] that is, that it be composed as a two-dimensional pattern. Even a design drawn

Left: ILL. 6.2 Plate 1: "Original Designs by Charles Booth, Glass Stainer." *Modern Surface Ornament* (New York, 1877). Art, Prints and Photographs Division, The New York Public Library, Astor, Lenox, Tilden Foundations

Opposite: ILL. 6.3 Plate 8: "Examples of Stained Glass Etc." Charles Booth. *Art-Worker* (Feb. 1878). Thomas J. Watson Library, The Metropolitan Museum of Art

from nature was to be flattened and to show no trace of shading, foreshortening, or perspective, he proclaimed. Compositional subjects "should be treated very simply, and drawn in bold outline without shading, and the parts should be separated from each other by varying their colors."[21] The "bold outline" he referred to was that achieved by the leading.

Booth adhered remarkably closely to Dresser's advice, his work dominated by Dresser's principles governing two-dimensionality of design and simplification of ornamental forms. Shortly after arriving in America, Booth issued a promotional pamphlet in which he suggested how various types of stained-glass windows could be suited to different types of buildings, his determination "to rely . . . on decision and purity of outline"[22] echoing Dresser's teachings. Moreover, the schemes he delineated in two subsequent publications, *Modern Surface Ornament* (1877) and the *Art-Worker*

(1878), both including concepts by other artists, follow Dresser's novel theories on conventionalized ornament (ILLS. 6.2, 6.3).[23]

Booth's published designs, which consist solely of outline, are abstract formal patterns of rigidly symmetrical flowers and leaves. In some cases the original plant shape has been flattened, simplified, and formalized until it appears only as halves or quarters; it has then been reassembled, emerging barely recognizable. Booth also conventionalized individual parts of the plant—leaves, petals, roots—to heighten the decorative effect. While several of his designs are so complex that how they could be applied to glass is difficult to imagine, others are clearly placed within a geometric framework of lead lines. For motifs Booth drew on medieval ornament—flowering plants in a stylized vase or, in one example, a griffin holding a shield bearing Booth's own monogram—yet the fans, butterflies, cranes, Prunus blossoms, and pine trees that ap-

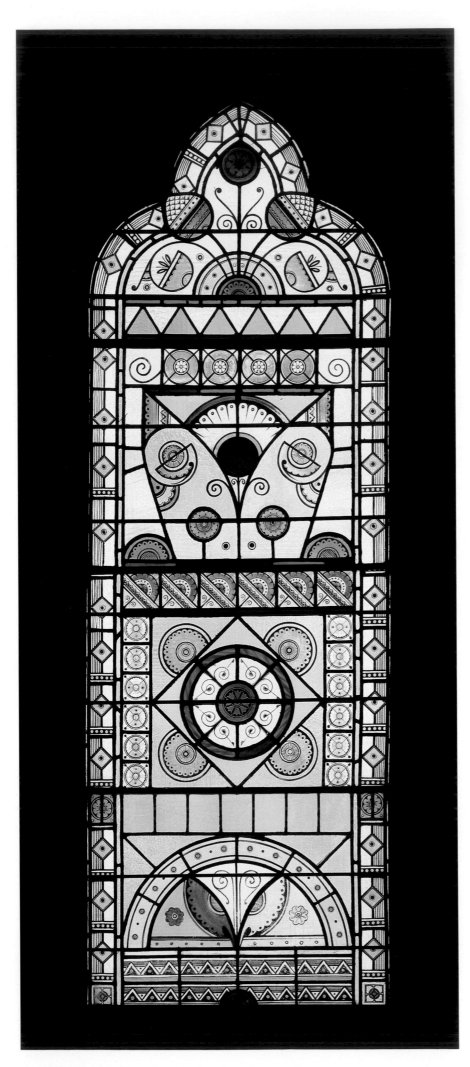

Left: ILL. 6.4 Window. Attributed to Charles Booth, New York, ca. 1877. From the Jefferson Market Courthouse, New York. Leaded and stained glass. The New York Public Library, Jefferson Market Regional Library

Opposite: FIG. 6.2 Window. Attributed to Charles Booth, New York, ca. 1878. Leaded and stained glass, 60½ × 37½ in. (153.7 × 95.3 cm). Calvary Church, New York

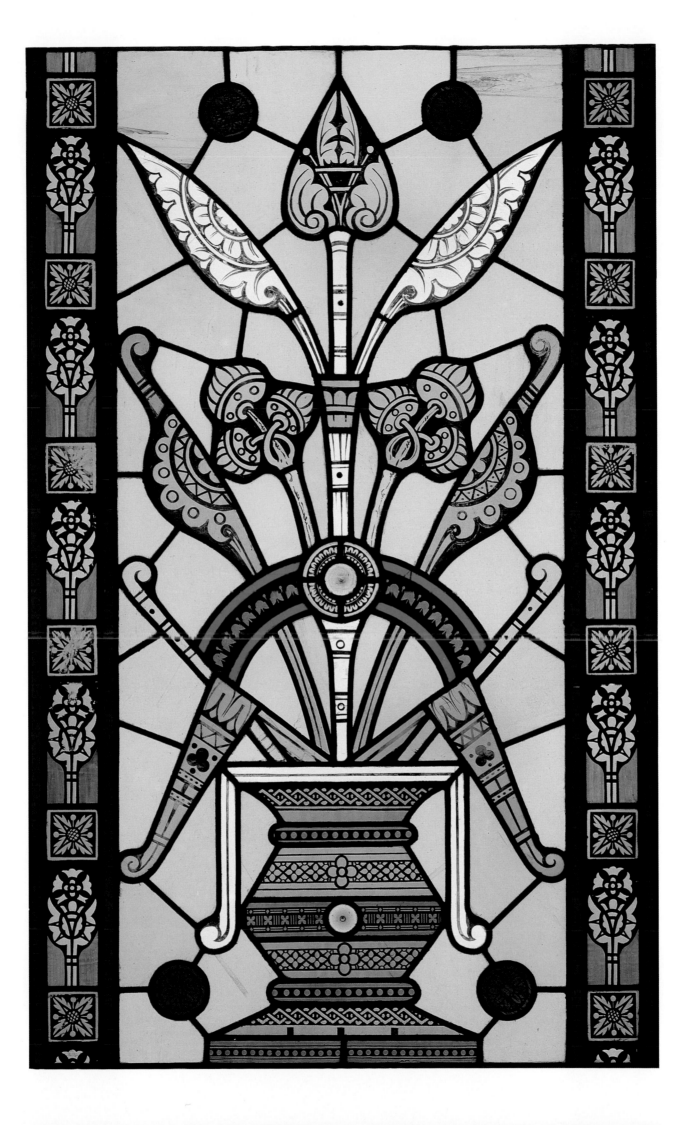

pear throughout much of his published work show that he was greatly inspired by Japanese art. He also used the sunflower motif frequently. Several of the windows that still light the Jefferson Market Courthouse, a building designed by Frederick Clarke Withers (1828–1901) and built between 1874 and 1877 at West Tenth Street and Sixth Avenue in New York,[24] can be attributed to Booth on the basis of their close similarity to designs he published (ILL. 6.4; see also ILL. 6.3, upper right). Their decoration, made up of stylized yet whimsical twists and turns of flowers, stems, and leaves, matches the fanciful late nineteenth-century architectural style of the nonecclesiastical structure that houses them.

Booth's palette, though consistent with the prevailing aesthetic style, is lighter and fresher, the earth tones of the Pre-Raphaelites replaced by shades of aquamarine, amethyst, pink, and light yellow. These colors can be seen in the large program of windows (FIG. 6.2) attributed to Booth and probably installed about 1878 at Calvary Church in New York, which had been erected some three decades earlier.[25] By effectively exploiting the transparent property of the glass, the artist has caused the Gothic-style church to be filled with gentle, pellucid light. The highly decorative effect of the leaded and stenciled outlines against the pale colors of the glass creates the type of strong linear pattern advocated by Dresser. The hues provide a striking contrast not only to the rich colors of Gothic-revival windows but also to the more somber tones that characterize those of Morris and Cottier.[26]

The extent of Booth's influence during the decade he spent in New York is not yet fully studied: except for his published designs his only known creations are the windows in a handful of buildings, both ecclesiastical and public, situated close to his 47 Lafayette Place studio—Grace Church, Calvary Church, and the Jefferson Market Courthouse. Though few in number, Booth's stained-glass windows are splendid examples of the importance of English prototypes and theories of design for Americans during the Aesthetic period.

Stained Glass in Secular Use

One of the major achievements of the Aesthetic movement was to release stained glass from its traditional religious milieu and bring it into the lavish private residences and august public buildings being built in the 1870s and 1880s. Stained glass could also be found in modest houses (to incorporate an element of the church into a household design was thought to endow the home with a hallowed quality), and it was employed commercially as well, in such unexpected places as newly built department stores or Pullman cars on the railroads then crisscrossing the continent.[27]

The use of stained glass in secular settings, generated in England, first appeared in America in the Gothic-revival houses of the mid-nineteenth century, although often just as overdoor lights or sidelights made of unadorned colored panes usually arranged in simple geometric patterns. CHARLES LOCKE EASTLAKE, who lauded the pure hues of windows in old Gothic churches and considered colored glass an appropriate element for household decoration, was quoted in an 1879 article as finding it "ornament conducive to instruction."[28]

Americans too found stained glass eminently suitable for use in the home. In 1885 Roger Riordan (d. 1904), then the leading American authority on the medium, wrote, "Now, everybody is familiar with [its] appearance. . . . It is to be seen in doors, windows and skylights of private houses . . . and in every variety of design."[29] As an essential element of the aesthetic interior, stained glass fulfilled a variety of needs, both practical and decorative. It provided privacy and, by depicting an idealized scene, perhaps a wooded landscape, it could change an unpleasant view into an entirely fresh prospect. It was used to embellish virtually every interior surface, especially the windows, since it was a means not

only of controlling the level and quality of light but also the color of the room. As a reporter for the *Crockery and Glass Journal* wrote in 1882, "Many years ago . . . stained glass windows would have suggested to the vulgar mind a dim religious light, but modern fashion decides that light transmitted through color is pleasanter and more artistic than the full glare of the white light of the day, and so . . . handsome houses today all are more or less decorated in it."[30]

The growth of cities during the Aesthetic period and the concurrent increase in the number and size of urban dwellings created new challenges for architects and designers. Many windows in densely populated areas gave onto unsightly alleys or neighboring buildings, eyesores that could be ameliorated through the use of colored and patterned glass. In 1876 Donald G. Mitchell, chairman of the judges of industrial and architectural designs at the Philadelphia Centennial Exposition, observed, "This style of glazing is full of suggestion to those living in cities whose rear windows look upon neglected or dingy areas or courts, where the equipment of a window with rich design would be a perpetual delight."[31] Booth, in the promotional pamphlet he circulated that same year, pointed out that his product not only afforded "a rich adornment for the windows of halls, corridors, staircases, libraries, dining rooms, bathrooms, &c.," but also screened "the objectionable sights in the back of the house."[32]

Stained glass in awkward windows could serve as a substitute for draperies. As the prolific writer on household art Mary Gay Humphreys noted in an 1881 issue of the *Art Amateur*, there were often "odd windows, cut by the caprice of some owner or another that are a source of annoyance to the present occupants. These can often be transformed by colored glass decoration."[33]

Tinted glass successfully modulated interior spaces and gave warmth to otherwise barren areas, a particularly efficacious means of treating hall windows and those on stair landings, which, according to Humphreys, "only need colored glass to throw a charm over the entire interior, the depth of hall giving that vista which so appropriately terminates in the play of light and color."[34] In the door or overdoor of a vestibule, for instance, colored glass lighted and extended that confined space, suffusing the hall beyond with soft illumination.

In the same way that certain styles and types of furniture and decoration were considered appropriate to specific types of Aesthetic-period rooms, so too were different kinds of windows. Humphreys was among the arbiters of household taste who professed a preference for stained glass in libraries, where "its subdued light is particularly grateful to the student."[35] Further, historical and literary subject matter, such as medieval costumes or heraldic arms and devices, could supply a library or a study with "an antiquarian interest."[36] Decoration in a room of images from the past or likenesses of important personages was meant to inspire its habitué. For instance, set into the library windows of a house in Saratoga, New York, were roundels in which portraits of Dante, Shakespeare, and Milton were painted.[37] In 1878 the trustees of the New York Society Library commissioned Cottier's company to provide a reading alcove with a stained-glass window. Its subjects—the figures of Knowledge and Prudence, with a medallion representing Homer, Virgil, Dante, or Petrarch in each of the four corners—enhanced the literary atmosphere of the space.[38] As for dining rooms, they could be adorned with fruit and vegetable designs such as the eggplant and squash motifs (FIG. 6.3) that Tiffany selected in 1879 to use in his own dining-room window and in the one he designed for the house of George Kemp on Fifth Avenue in New York the following year.

Stained glass contributed to the all-consuming interest in ornament characteristic of a period when every surface was covered with decoration. Even if a family could not afford costly painted and leaded glass, their windows could demonstrate fashionable aesthetic qualities through other, less expensive means: for ex-

ILL. 6.5 Design for sandblasted glass decoration. Signed:
T.D. / 86. *Matthews Catalogue of Decorative Glass and
Transparent Signs, as Executed by the Tilghman Sandblast and
Other Patented Processes* (New York, 1886). The Corning
Museum of Glass, Corning, N.Y.

ample, sandblasting, a newly invented technique whereby glass
could be decorated by applying a stencil to its surface and then
subjecting it to the high-velocity projection of a fine stream of
sand. The result would be a series of matte, or frosted, forms
against a clear background. The effect could be reversed by mask-
ing not the surface but the pattern, which would then stand out
flat and unshaded against a frosted background. The process was
particularly popular for vestibule doors and trade signs. Innumer-
able patterns, many aesthetic in character, could be ordered
through the catalogues in which they were advertised; in 1886 that
of a New York firm offered several designs (ILL. 6.5) inspired by
Japanese art in both composition and subject matter, the latter
dominated by cranes, flowers, and bamboo.[39]

Other, still cheaper alternatives to stained glass were less satis-
factory, since they could not withstand the rigors of use. These
were mainly transfer designs,[40] reflecting current styles, which
were widely marketed, or the less common paper cutouts, notably
those created by Frederic E. Church (1826–1900) for Olana, his
extraordinary, somewhat eccentric house built between 1870 and
1876 and overlooking the Hudson River. Decorative patterns and
borders of paper transfers and cutouts could be adjusted to fit panes
of any size, making stained-glass designs available to great num-
bers of American houses. Although the ready-made patterns al-
lowed for little creativity, their installation was considered "a pleas-
ing occupation for ladies and gentlemen."[41]

The increased popularity of the various uses of stained glass
during the 1880s and 1890s was a logical outgrowth of the Aes-
thetic movement and its emphasis on the integration of all the arts
in a single setting. As early as the 1870s components of glass were
used to embellish objects in a variety of media—for example, the
reverse-painted panels of abstracted, conventionalized, and sym-
metrical leaf-and-flower forms (recalling Dresser's patterns) exe-
cuted on a Philadelphia cabinet (see FIGS. 5.3, 5.4) designed by
FRANK FURNESS. According to the *American Architect and Building
News,* Furness had invented the unusual, tilelike sort of decorated
glass[42] in order to provide furniture with bright and colorful pat-
terns of stylized floral ornament. Furness's glass panels also ap-
peared on the exteriors of several buildings he designed about
1876, including the Pennsylvania Academy of the Fine Arts in Phil-
adelphia and the Brazilian Pavilion at the Centennial Exposition.[43]
The panels' glistening effect was obtained by placing a layer of gold
foil behind the glass and its painted decoration, thus imbuing both
with a lustrous glow. The color green so treated was described in
1876 as "a good imitation of the green on a beetle's wing";[44] blues,
yellows, and reds could be made to gleam in the same manner.

Bookcases traditionally fitted only with clear panes could be
considerably enlivened by geometric patterns of colored glass.[45]
Fire screens exhibiting yet another novel use of the medium pre-
served "the glow and beauty of the fire in its passage through the
many-colored barrier."[46] Although few survive, glass fire screens
were made by every prominent stained-glass artist of the day, in-
cluding La Farge and Tiffany. In a particularly imaginative burst of
creativity, Tiffany once added leaded panels patterned with Japa-
nesque flowers to the cherry case, carved in low relief with similar
oriental-style flowers, of a tall clock (FIG. 6.4).

American Opalescent Glass

As the decoration of churches and houses with English and En-
glish-style stained-glass windows was gaining favor in the United
States, La Farge and Tiffany were working on a thoroughly inno-
vative idea. The adaptation of opalescent glass to windows, as-
cribed to La Farge, was one of the greatest contributions to the
stained-glass repertoire since the Middle Ages, for with it the flat,
color-filled windows relying on outline for delineation could be
replaced by new ones possessing startlingly different properties,

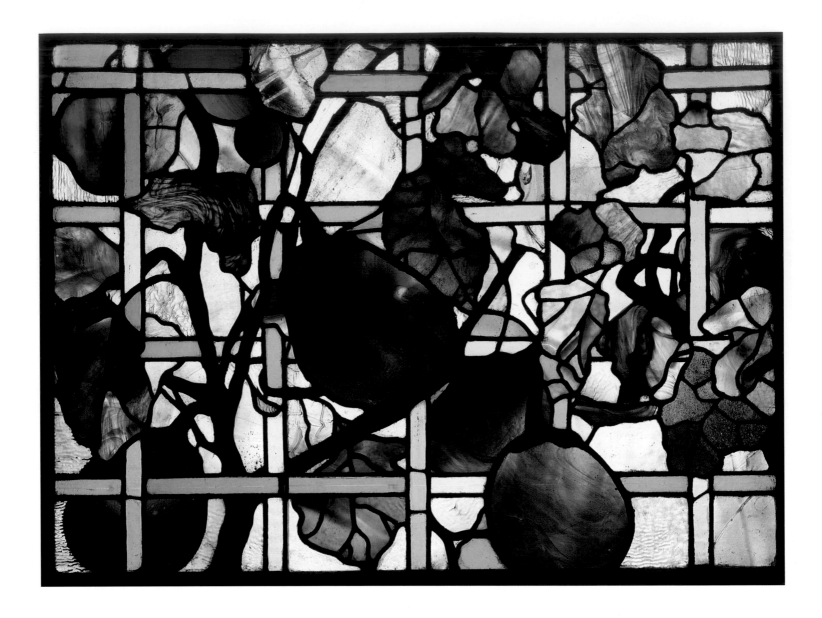

qualities, and textures. A whole opalescent-glass world opened to artists, offering an unprecedented opportunity for creative expression in light, color, form, and dimension.

La Farge's interest in the arts can be traced to 1856, when on a trip to France he encountered members of the artistic society then flourishing in Paris. Shortly after he came back to the United States, La Farge altered his course; originally intending to practice law, he now decided to pursue a career in art. On a second trip he made to Europe, in 1873, his visits to French churches and his admiration of medieval architecture led to his growing awareness of stained glass as an artistic medium,[47] but only on his return to America did he become seriously interested in decorative work. The pivotal point in that stage of his development occurred in 1876, when Richardson invited him to participate in the decoration of Trinity Church in Boston.[48] La Farge's duties included extensive painted decoration and, perhaps more important, designs for windows, a number of which were to be in grisaille (in the vocabulary of stained glass, the term refers to an allover geometric pattern). These were to be made of light, neutral-colored glass, which La Farge thought would harmonize with the painted decoration of the walls. Unfortunately, the vestry and the wardens of the church chose instead to install English figural windows by London firms, including Clayton and Bell, and by Cottier's New York company.[49] However disappointed La Farge may have been, his careful work still served a useful purpose. It marked the beginning of what would be lifelong crusades: to destroy forever the traditional prejudice that kept a serious painter from participating in any decorative medium and to unite all the decorative media into an integrated whole.

La Farge's earliest work in stained glass displays an English sensibility that is no doubt the result of his acquaintance with Burne-Jones and Rossetti. Though his first stained-glass designs were never actually executed, one of his earliest surviving windows, made about 1877 for the main hall of the Newport, Rhode Island, house of William Watts Sherman (1842–1912) and composed of three vertical panels surmounted by three transoms (FIG. 6.5), suggests an English derivation.[50] The glass was imported from England, and La Farge's limited color range—dominated by green, brown, and yellow—is evocative of that in the Pre-Raphaelite windows supervised by Morris. Nevertheless, the concern for materials manifested in La Farge's realization of the window was uniquely his own. It was to be one of his enduring characteristics. Unlike his English colleagues, who merely ordered their glass from suppliers, La Farge carefully examined the manufacturers' available stock, often choosing sheets that were streaked or of slightly imperfect texture, for glass that was flawed could be to

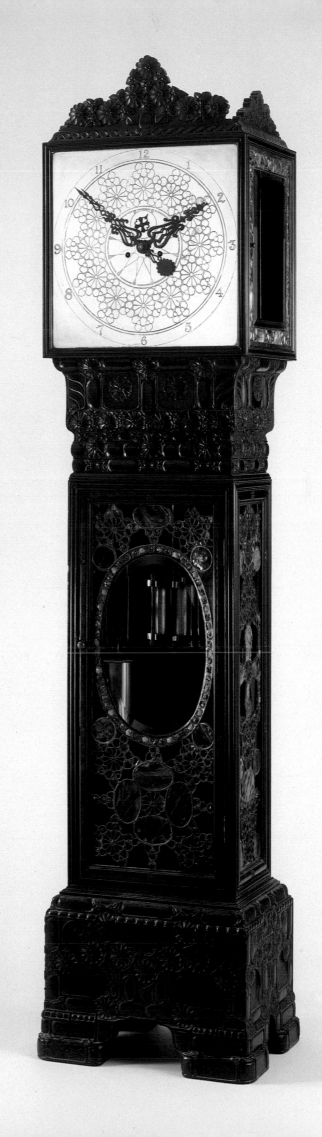

Opposite: FIG. 6.3 *Eggplants* (window screen). Louis Comfort Tiffany, 1879, for his apartment, New York. Leaded glass, 28¼ × 38⅜ in. (71.8 × 98.4 cm). Private collection

Right: FIG. 6.4 Clock. Attributed to Associated Artists, leaded-glass panels attributed to Louis Comfort Tiffany, New York, ca. 1879–83. Cherry, leaded glass, h. 97 in. (246.4 cm), w. 20⅞ in. (53 cm), d. 20⅞ in. (53 cm). The Rothschild Collection, Ltd.

him a vehicle for achieving a desired effect. In addition, though he utilized the full range of English glass techniques of painting, acid treatment, and staining, and created a decorative floral pattern reminiscent of Morris's wallpapers, the stiffness associated with English glass painting—the result of laborious tracing from an artist's cartoon—is totally absent.

The W. Watts Sherman window, likened to "Japanese metal 'open-work'" by an early La Farge biographer,[51] is further distinguished from contemporary English stained glass by La Farge's departure from figural subject matter. His flat, decorative, and asymmetrical composition of morning glories, peonies, and other flowers, arranged on a bamboo lattice, relates closely to his deeply ingrained enthusiasm for Japanese prints,[52] which he had begun to acquire as early as 1856.[53] His interest in adapting oriental designs for use in stained-glass windows is first recorded in November 1875, when he requested the English wood engraver William J. Linton to borrow for him an illustrated Japanese book in the collection of the American geologist-explorer Raphael Pumpelly (1837–1923), who had spent three years in Japan.[54] (Pumpelly and La Farge had become acquainted in New York some years earlier.) On three casement windows[55] that survive from 1876, La Farge employed a transfer process to apply facsimiles of woodcuts from the *Manga* of Katsushika Hokusai (1760–1849), the first volume of which he had acquired two decades before, probably while in Paris.[56] In addition to prints, he went on to amass a large and important collection of Japanese objects: sword guards, silks, pottery and porcelains, lacquerwork, and paintings.[57] His interest in the art of Japan was to be expressed in his work throughout his career.

The W. Watts Sherman window points to a new direction that the artist was soon to follow: in its white blossoms he utilized opalescent glass.[58] He had been experimenting with the glass, previously in use only for small utilitarian jars and vessels, for some time. In commissioning suppliers to manufacture quantities of it to his order, he had changed and modified his specifications until he obtained the effects he sought. What resulted was a glowing white glass in which striations of all colors of the spectrum could be seen against transmitted light. In La Farge's own words, the glass possessed "that mysterious quality . . . of showing a golden yellow, associated with [the color] violet, a pink flush brought out on a ground of green."[59] (The same quality is present in a fire opal.) Opalescent glass, dubbed "American" by both critics and the general public and soon in widespread production, revolutionized the appearance of stained glass.

Unhappy with the flat texture and the limited color range of commercial pot-metal glass and seeking a vehicle with which to define form without the aid of paint, La Farge also began to test the effects of variegated and multiple layers of glass, or plating, in order to gain an increased sense of depth and a wider choice of hues.[60] The preoccupation with textures and surfaces that can be said to characterize objects in the Aesthetic era took on another dimension when both he and Tiffany began to express those qualities in glass. La Farge not only used a varying number of layers in different colors for his plating but also embedded in the surface a mélange of cast and cut jewels of glass. To simulate three-dimensionality in, say, a flower or a drapery, he used an outer layer that had been endowed with unusual textures during its manufacture, a method explained by a contemporary critic: "The hot glass, while at a red heat, is rolled with corrugated rollers, punched and pressed by various roughened tools, or is squeezed and pressed up into corrugations by lateral pressure, or is stamped by dies."[61]

The employing of new materials in diverse combinations intensified the luminescence of stained-glass windows and expanded their color possibilities to include refinements of shading, tone, and density never before imagined. Another advancement in window design was the use of several dimensions of leading, which could be shaped into irregular contours "so as to imitate the touch of the brush on the different widths of lines."[62] In the same way

that novel kinds of glass provided stained-glass artists with exciting creative possibilities, the iconography of traditional figural compositions—medieval and classical themes—was replaced by a fresh vocabulary consisting primarily of flowers and birds inspired by the exotic art of the Orient.

It had long been La Farge's contention that only through introducing previously untried and dramatic methods of production into the stained-glass medium would it cease to be considered secondary in importance to painting. To prove his point, in 1878 he began to design a series of windows, for some of the American Aesthetic period's most sumptuous houses, that represent a completely innovative approach in stained-glass artistry. The windows, numbering at least five and made for Henry G. Marquand (1819–1902) in Newport (FIG. 6.6), Frederick L. Ames (1835–1893) in Boston (his two now at the Saint Louis Art Museum and the National Museum of American Art, Washington, D.C.), Cornelius Vanderbilt II (1843–1899) in New York (known only through early illustrations), and Lawrence Alma-Tadema (1836–1912) in London (now at the Museum of Fine Arts, Boston), all contain white, pink, and red peony blossoms fashioned from thick, molded, opalescent glass and shown on an ornate background of brightly hued foliage. Smaller glass pieces, said to resemble "myriad points of flashing blue jewels . . . and garlands of topazes and amethysts,"[63] enrich the windows. The total effect is a pyrotechnic display of color, vitality, and texture.

La Farge's peony windows evolved largely from commissions that called for the collaboration of several artists and designers. La Farge joined the painters R. Swain Gifford and SAMUEL COLMAN in devising the decorative details of the Marquand house. *Peonies Blown in the Wind,* for one of the bedrooms, may have been what was described in *Artistic Houses* (1883–84) as "a gloriously effulgent window of stained glass, which is the admiration of all viewers."[64] That window and the others relating to it demonstrate La Farge's freedom in combining different styles: in the Ames and Vanderbilt windows, an architectural border based on Renaissance designs frames a central scheme of oriental inspiration. The treatment of the Ames windows was described by a contemporary critic as "Japanesque . . . carried far beyond mere suggestions."[65] The critic went on to speak of the technique employed in the molded opalescent glass blossoms, "which leaves them in intaglio, and the translucence gives them a perspective which seems the result of brushwork, although no paint is used in the windows."[66] His remarks may be applied to the peony windows in all four houses.

At the same time that La Farge was developing a style and technique divorced from the influence of English stained-glass methods, he was also doing away with the working procedures followed in both England and the United States. He once observed that the glassmaking method employed by English artists of the Aesthetic period was "all that was known."[67] He was referring to the practice that required an artist to prepare only a window's design. Instead of executing it, alone or with the aid of shop assistants, the artist sent the design to a commercial studio for completion. With the artist-designer thus separated from the finished work, the concomitant loss of some of his original intent was inevitable. La Farge had "noticed . . . of the English artists in stained glass that [their work] had ceased improving, and it seemed . . . that the cause of this was mainly because the designer had become separated from the men who made the actual windows."[68] Regarding the frustration and discontent that Burne-Jones had constantly experienced over the production of his windows, La Farge commented, "When he sent in his elaborated final and pretty drawing to the glass makers . . . *their* part began, and they gradually stamped their commercial British mark on his final work."[69] La Farge wisely avoided that pitfall by personally taking his designs to the stained-glass studio and watching over every detail until they were finished to his satisfaction.

Louis Comfort Tiffany was La Farge's chief rival for supremacy

in the stained-glass medium. Tiffany, who began his artistic career studying landscape painting with George Inness (1825–1894), was the son of Charles L. Tiffany (1812–1902), founder of the silver and jewelry company that still caters to the New York carriage trade. EDWARD C. MOORE, chief designer at TIFFANY AND COMPANY from 1868 until 1891, and Samuel Colman, who worked with both L. C. Tiffany and La Farge and who had a deep commitment to the decorative arts, exerted considerable influence over Tiffany and may have encouraged him to develop his obvious talents rather than enter the family business. Tiffany began to travel abroad at an early age and continued to do so throughout his career, visiting the major artistic centers of Europe and venturing into the legendary regions of North Africa. Of great importance to his ensuing work were the twelfth- and thirteenth-century stained-glass windows at Chartres Cathedral and the early Christian mosaics in Ravenna; through the architecture of North Africa and Spain he developed a fascination with African, Islamic, and Moorish motifs that was to find expression in many of his subsequent decorative concepts. Through Colman and Moore he learned about the Far East and its arts, which were also to have a profound effect on his oeuvre.

The careers of La Farge and Tiffany had much in common. Like La Farge, Tiffany started out as a painter and worked outside the traditional medium of oil on canvas, concentrating instead on watercolor, whose "luminous qualities" he later translated into glass.[70] He made his first attempts in stained glass at about the same time as La Farge did, and he too was an early champion of the use of opalescent glass, though he exploited its properties to greater commercial success than did La Farge and with perhaps a more lasting impression on the public consciousness. He also concurred with La Farge's belief that an artist should be responsible for his windows from inception to completion, an undertaking that included everything from supervising the making of the glass to directing the glazier in its cutting and arrangement.[71] Irregularities in glass and adaptability in the leading were as important to him as they were to La Farge. A splendid exemplar of Tiffany's artistic philosophy is the *Eggplants* window screen (see FIG. 6.3) that he made for his New York apartment. The disparate widths of the leading simulate the thick stalks of the vine; the thin, uneven veins of the leaves; and the straight, uniform outlines of the latticework (this last the same device used by La Farge in the W. Watts Sherman window), while the vegetables and leaves derive their three-dimensionality and illusion of modeling from the variations in color and tone in the glass. In describing the work in 1881, Roger Riordan wrote that "when the sunlight streams in through such a window the effect is as if the real object, rendered transparent in all its tissues by some unwonted intensity, filled the space."[72]

La Farge's exploration of the decorative possibilities of glass was largely restricted to windows, but Tiffany's dazzling bravura impelled him to a fuller and more daring penetration into the medium's potential, leading to the creation of a bewildering range of objects from exquisite vases and lamps to mosaics and lambent windows drenched in color. Tiffany's large-scale participation in the realm of decoration began in 1879, when with Colman, LOCKWOOD DE FOREST, and CANDACE WHEELER he founded a partnership that was known as ASSOCIATED ARTISTS. The firm concerned itself with every aspect of the interior decoration of a house: the treatment of ceilings, walls, and floors; the design of the furniture, lighting, and windows; the advice to a client as to which art objects would be appropriate for him to collect. Each of the partners had an artistic specialty: Colman's was color and pattern; de Forest's, decoration and wood carvings; Wheeler's, textiles; and Tiffany's, of course, glass. One of the firm's earliest commissions was for George Kemp's New York house, where Tiffany's stained-glass windows created a special effect by modulating and varying the quality and hue of the transmitted light. Of a bay window of colored and opalescent glass in the drawing room, it was said that

the shimmering expanse was "reflected not only on the ceiling but in the deep stillness of the mirror on the opposite side of the room."[73]

The most important interior space that retains to this day the decorations devised in 1879–80 by Associated Artists is the Veterans' Room of the Seventh Regiment Armory on Park Avenue in New York (see ILLS. 4.13, 4.14). Here Tiffany freely borrowed Celtic, Moorish, and Japanese motifs, combining them in a richly patterned scheme that is at once unified, masculine, and exotic. The use of glass, though kept to a minimum, has been skillfully manipulated either to blend with or to highlight the other ornamental and architectural elements. In one instance, the nonpictorial windows Tiffany made for the room reveal an abstraction found in stained glass virtually for the first time. The patterns, their muted colors of opalescent white, amber, and olive green yielding a soft, warm light, are purely geometric arrangements that echo the wood latticework, this inspired by Islamic screens, elsewhere in the room. In another instance Tiffany covered the fireplace facing with glittering glass tiles in peacock blue, complementing the elaborate woodwork that surrounds it.

Tiffany's work in interior design, which encompassed every possible use of glass, was primarily concentrated in the four-year existence of Associated Artists, a period during which he added to his fascination with the possibilities of glass and his dedication to the integrity of interiors the designing of books, wallpaper, and furniture. He then abandoned these aspects of his career to see to the formation of a series of art-glass studios, though he later decorated two houses, the first of which offered him unlimited freedom in the expression of his talents. In the New York residence of Mr. and Mrs. Henry Osborne Havemeyer, devoted patrons of his, Tiffany met his greatest challenge. A description of what he accomplished there best exemplifies his sublime virtuosity.

The Havemeyer house, built between 1890 and 1891, when the influence of the Aesthetic movement was on the wane, was Tiffany's last interior-decorating commission. Working with the assistance of Colman, through whom he had made the Havemeyers' acquaintance and who was by that time a close friend,[74] Tiffany revealed in every facet of the design his delight in ornament. In all the elements of the interior—lighting fixtures, walls, floors, windows, draperies, and furniture—he was able to render a vivid illustration of his inspired imagination. He gave full rein to his masterly sense of color and his love of luxury, and he indulged to the fullest his keen sensitivity to the expressive potential and textural qualities of glass. The finished scheme, heavily influenced by Eastern art, was a summation of many aesthetic principles and proclaimed the philosophical ideal—the integration of all the arts—in this case by the hand of a single man.

The main entrance hall (ILL. 6.6), in its blending of pattern, texture, color, and light, epitomized Tiffany's sophisticated taste and provided a fitting introduction to the artistic splendors in the rooms and passageways that lay beyond. It was entered through an extraordinary pair of doors (ILL. 6.7) faced with gray-and-white marbleized glass and framed by intricately coiled leading studded with large, translucent, beach-worn stones. The hall, though sparsely furnished, was wondrous, for Tiffany used colored glass wherever he could: in windows, mosaics, lighting fixtures, or, as was said, "in any place that he could provide a rationale for its sparkle,"[75] every surface pressed into service to achieve "an air of gleaming opulence."[76]

In a manifestation of the resurgence of interest in mosaic during the Aesthetic period,[77] the floor was paved with more than a million Hispano-Moresque tiles;[78] each wall was completely covered in sparkling glass-mosaic panels that artfully broke up a large expanse into smaller rectangles; and the hall was encircled by a mosaic frieze of repeated stylized leaves of Near Eastern derivation (FIG. 6.7). At the right side of the entrance hall, the main stairway, its casing glittering with glass mosaics like those in the wall panels,

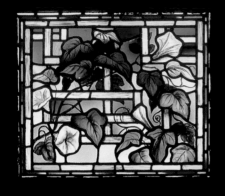
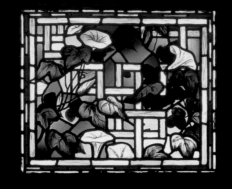
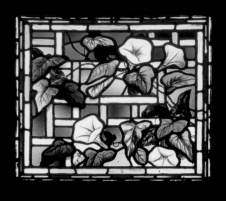
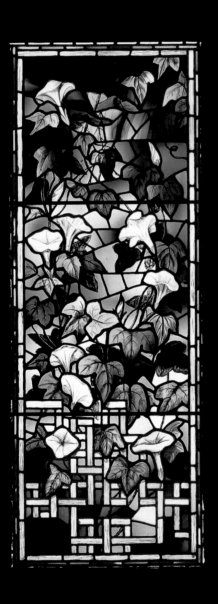
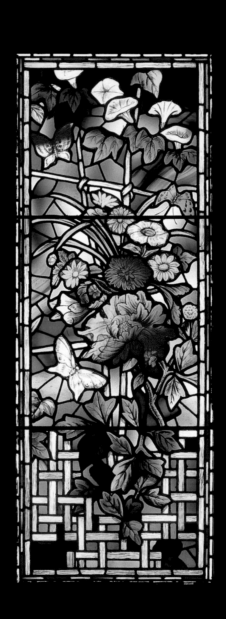
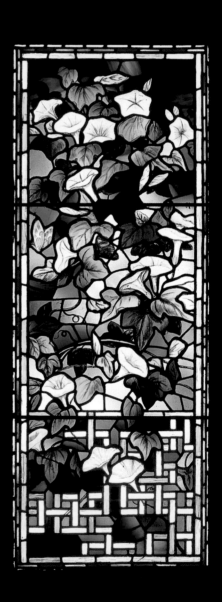

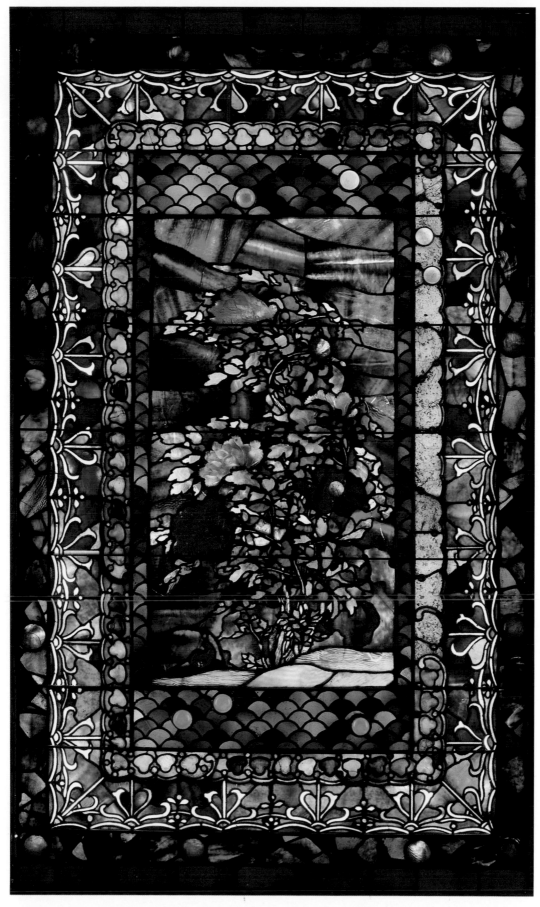

Above: FIG. *6.6 Peonies Blown in the Wind* (window). John La Farge, ca. 1880, for the Henry G. Marquand house, Newport, R.I. Leaded glass, 75 × 45 in. (190.5 × 113.7 cm). Marked: *JOHN LA FARGE PATnd 1880 / JN. LA FARGE PATd. 1880 / J. La Farge / Pat / 1880.* The Metropolitan Museum of Art, Gift of Susan Dwight Bliss, 1930 (30.50)

Opposite: FIG. *6.5* Six-panel window. John La Farge, ca. 1877, for the William Watts Sherman house, Newport, R.I. Leaded and stained glass, 86½ × 72 in. (220.1 × 182.9 cm). Museum of Fine Arts, Boston, Gift of James F. and Jean Baer O'Gorman (1974.498)

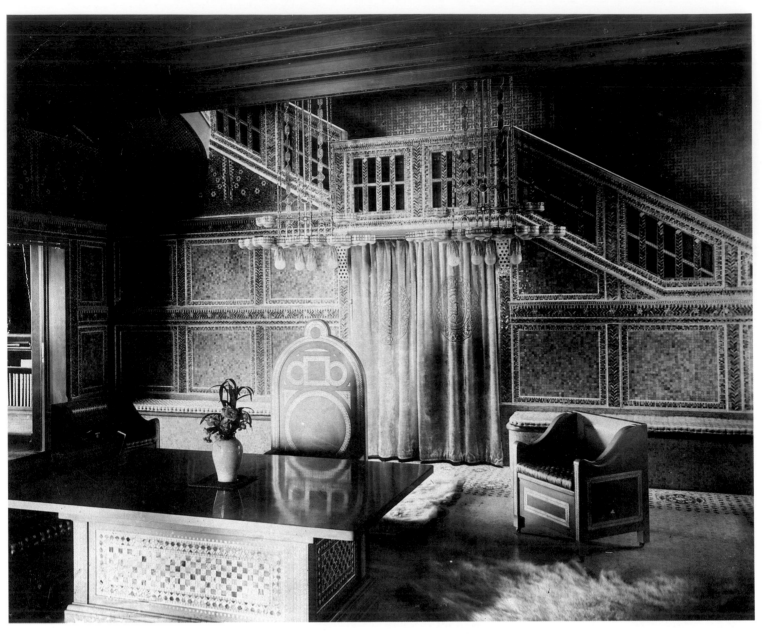

ILL. 6.6 Entrance hall and staircase, Henry Osborne Havemeyer house, New York. Louis Comfort Tiffany with Samuel Colman, New York, 1890–91. Archival photograph, The Metropolitan Museum of Art

conjured up visions of the one in the Doges' Palace in Venice (which had inspired its form). The Parisian art critic and dealer S. Bing (1838–1905), one of the first visitors to the house, was particularly impressed by the walls, from which he said "gleamed a rich variety of subtle shading, sober, chalky whites surmounted by polychromed friezes, diapered with the thousand details of woven cashmere."[79]

The focal point of the hall was the superb overmantel mosaic (FIG. 6.8) of two peacocks (a popular motif with Tiffany and other designers of the period), their iridescent feathers captured in shimmering glass. The screen for the fireplace opening (FIG. 6.9) was in the form of a lattice, its vertical members of amethyst-colored glass rods joined by delicate, twisted gilt metalwork. The impression conveyed was of an enormous piece of complex, handmade jewelry from India encrusted with an array of gems made of opalescent and amber glass. In the passageway adjoining the main hall, ten polygonal columns of black marble with glass mosaics in a peacock-feather design completed the theme.[80]

The last house that Tiffany designed, this one his own, was completed in 1904. Laurelton Hall, in Oyster Bay, New York, situated on a hill overlooking Long Island Sound, was a compendium of several of the ideas he had successfully integrated in the Havemeyer residence. To provide a sympathetic setting for his multitudinous collections, Tiffany made lavish use of his own stained-glass windows and lighting fixtures as well as the mosaics he had gathered on his travels. For years he had avidly pursued the acquisition of Japanese prints, Chinese pottery and porcelains, oriental rugs, Roman glass from antiquity, and American Indian basketry, all of which were displayed in his palatial home. He had also accumulated a great number of other oriental art objects, and these too he featured throughout the house: he embellished the walls and the mantelpiece of the smoking room, for instance, with many of the four thousand Japanese sword guards in his possession.

Tiffany's love of the outdoors had always been evident in his windows and paintings. Now, working with a real landscape, he enlarged his creative sphere in designs for hanging gardens of trop-

ical plants punctuated by waterfalls and fountains. The gardens and the entrance to the house converged at the terrace loggia (now installed in The American Wing of The Metropolitan Museum of Art), which was supported by columns whose capitals were ornamented with flowers—stems of green glass crowned by lotuses, dahlias, poppies, and magnolias, in various stages of bloom.

Tiffany's visionary ideals came full circle at Laurelton Hall: in much the same way that great masters have always passed along their knowledge to those who came after them, Tiffany established there in 1918 a foundation for art education. His aim was to provide young artists who were beginning their own creative quests with instruction in "both art appreciation and production, within the scope of the industrial as well as the fine arts."[81] He arranged to have students invited to his home, usually during the summer months, when the gardens were at their peak, for he felt that anyone who lived in the ideal world he had made could not fail to gain immeasurably from the experience. He could not have foreseen that the stock-market crash of 1929 and America's altered priorities would force the foundation to sell the house and Tiffany's collections in 1946 or that Laurelton Hall would be destroyed by fire eleven years after that. Extraordinary achievements, however, frequently have a life of their own, and those of Tiffany, having with-

stood the vicissitudes of fortune, still exist to attest to his incandescent genius.

Tiffany's glass was elevated to an international plane through his association with S. Bing, which began in the early 1890s and continued into this century. Bing commissioned stained-glass windows from Tiffany, among them several interpretations of designs by some of France's leading artists, including Edouard Vuillard (1868–1940), Pierre Bonnard (1867–1947), and Henri de Toulouse-Lautrec (1864–1901). Experiments that Tiffany had undertaken in 1892 led to his remarkable blown-glass vases, and Bing sold the sinuous vessels—their forms mostly derived from plants and flowers—in his Paris establishment. These works, an extension of aestheticism (they offer some of the best examples of the American Art Nouveau style), were still made in the spirit of the Aesthetic movement, that is, with the purpose of providing the American public with usable objects whose beauty would enrich the lives of all beholders.

In touching remarks he made in 1916, at the celebration of his sixty-eighth birthday, Tiffany summed up his lifelong quest. No matter what medium he was working in, he said, his most important consideration had always been the "pursuit of beauty."[82]

ILL. 6.7 Entrance hall, Henry Osborne Havemeyer house, New York. Louis Comfort Tiffany with Samuel Colman, New York, 1890–91. Archival photograph, The Metropolitan Museum of Art

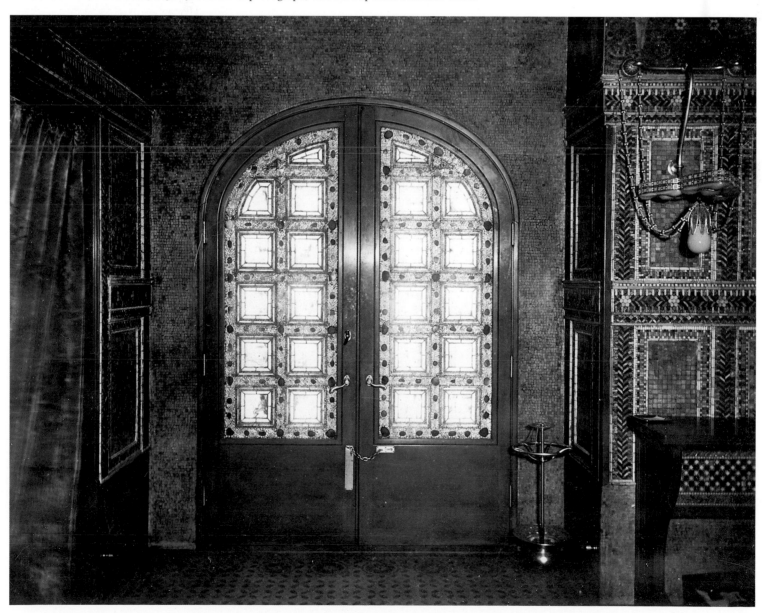

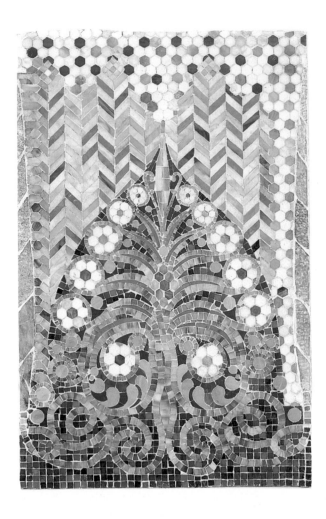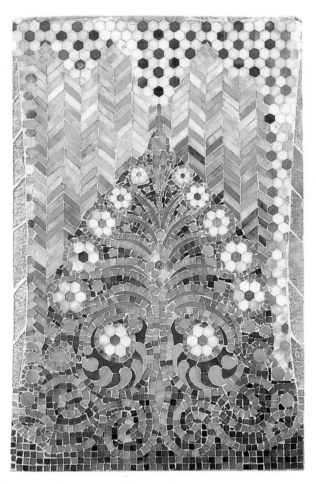

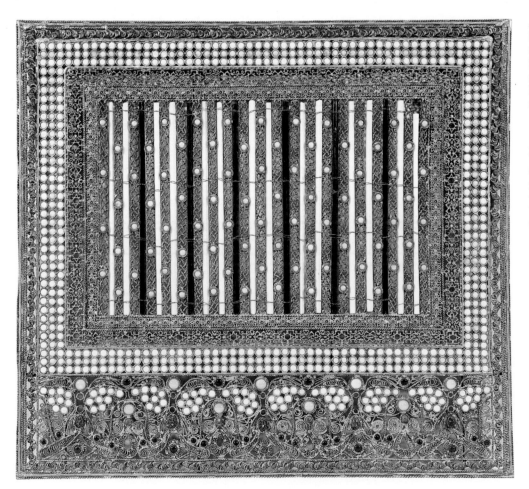

Above: FIG. 6.7 Mosaic frieze (two elements). Louis Comfort Tiffany, New York, 1890–91, for the Henry Osborne Havemeyer house, New York. Glass, plaster; each 34 × 22 in. (86.4 × 55.9 cm). The University of Michigan, School of Art and College of Architecture and Urban Planning, Ann Arbor

Left: FIG. 6.9 Fire screen. Louis Comfort Tiffany, New York, 1890–91, for the Henry Osborne Havemeyer house, New York. Gilt iron and bronze, glass, h. 40 in. (101.6 cm), w. 44 in. (111.8 cm), d. 2 in. (5.1 cm). The University of Michigan, School of Art and College of Architecture and Urban Planning, Ann Arbor

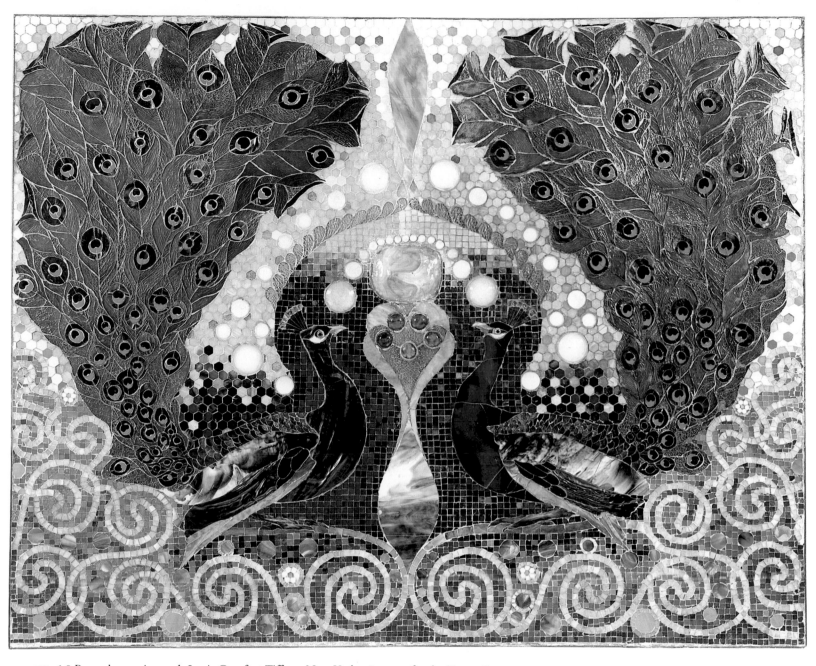

FIG. 6.8 Peacock mosaic panel. Louis Comfort Tiffany, New York, 1890–91, for the Henry Osborne Havemeyer house, New York. Glass, plaster, 52 × 64 in. (132.5 × 163.2 cm). The University of Michigan, School of Art and College of Architecture and Urban Planning, Ann Arbor

1. "Costly Tints in Glass," *Boston Herald* [date unknown], Doc. 20:7, Corning Museum of Glass Library, N.Y.

2. For example, Alfred Godwin and Company, J. and G. H. Gibson, Gillinder and Sons, and R. S. Groves and Steil are but four stained-glass studios active in Philadelphia in the 1880s. A surviving Groves and Steil catalogue illustrates many patterns that clearly demonstrate reliance on contemporary English stained glass; see R. S. Groves and Steil, *Catalogue of Art Stained Glass: Groups, Figures, Ornamental, Geometric, and Plain Windows for Churches and Dwellings* (Philadelphia, 1888), microfilm in the Corning Museum of Glass Library, N.Y., original at Eleutherian Mills Historical Library, Wilmington, Del. In Cincinnati William Coulter and Sons were advertising by 1886; see "Stained Glass Art Works," *Art Amateur* 8 (Aug. 1886), p. 156. Berry and Company and Glenny Brothers and Sutter were two of the leading firms in Saint Louis who offered to execute ornamental glass; see "St. Louis Trade Reports," *Crockery and Glass Journal* 11 (May 20, 1880), p. 12. For stained glass in Chicago in the 1870s and 1880s, see Sharon S. Darling, *Chicago Ceramics and Glass* (Chicago, 1979), pp. 101–19. For stained glass in Denver, Col., see Carolyn C. Stark, "Stained Glass in the Denver Area" (M.A. thesis, University of Denver, 1970).

3. "America's Stained-Glass Interest," *American Architect and Building News* 15 (May 17, 1884), p. 235.

4. Roger Riordan, "The Use of Stained Glass," *Art Amateur* 12 (May 1885), p. 130.

5. International Exhibition of 1862, *The Illustrated Catalogue of the Industrial Department, British Division Class 34*, 4 vols. (London, 1862), vol. 2, p. 67.

6. Will H. Low, "Old Glass in New Windows," *Scribner's Magazine* 4 (Dec. 1888), p. 675.

7. In New York City William Gibson started one of the earliest stained-glass firms in 1833. The business was carried on by his sons under the name William Gibson's Sons. The firm of J. and R. Lamb, established in 1857, also in New York, was one, though their earliest surviving windows date from the opalescent period and were made by the next generation of the family.

8. By far the most prolific of the Continental firms working in America was that of Franz Meyer of Munich. The firm, which continues today, has produced innumerable windows for American churches over a long period of time. See Jane Hayward, "Stained Glass Windows in America" (paper presented at the annual conference of the Association for Preservation Technology, Banff, Alberta, Can., Oct. 22–24, 1982).

9. For more information on Morris's stained glass, see A. Charles Sewter, *The Stained Glass of William Morris and His Circle*, 2 vols. (New Haven, 1974). For additional information on Morris's windows in America, see Marilyn Ibach, *Morris and Company Stained Glass in North America* (New York, 1983); and Catherine Hall Lipke, "The Stained Glass Windows of Morris and Company in the United States of America" (M.A. thesis, State University of New York, Binghamton, 1973).

10. Sewter, *Stained Glass of William Morris*, vol. 2, pl. 478, pp. 225–26.

11. *Pearl* (Saugerties-on-Hudson, N.Y.), 1875, p. 96, cited in Lipke, "Stained Glass Windows of Morris and Company," p. 16.

12. Michael Donnelly, *Glasgow Stained Glass: A Preliminary Study* (Glasgow, 1981), p. 8.

13. Ibid., pp. 10–11.

14. Michael Donnelly, The People's Palace, Glasgow, has suggested that the design of the window is Cottier's own and that the subject is Spring; see correspondence, July 9, 1984. Although it is unsigned and its original location is unknown, the window descended in Cottier's family. Its yellow silver-stain quarries of conventionalized plants also appear on another Cottier window made in memory of Watts Sherman II for Saint John's Episcopal Church in Canandaigua, N.Y. It is probable that that window, signed *Cottier / New York London* and depicting figural panels after John Everett Millais's *Parables of Our Lord* (one of Millais's illustrations originally published in the magazine *Good Words* [1863] and then issued in volume form by the Dalzell Brothers [1864]), was ordered by William Watts Sherman in memory of his father. I am grateful to Helen Zakin for bringing the Canandaigua window to my attention. Cottier may have been introduced to W. Watts Sherman through H. H. Richardson, who designed W. Watts Sherman's Newport house in 1874–75. John La Farge supplied a six-panel window (see FIG. 6.5) for the entrance hall of the house in about 1877.

15. Donnelly, *Glasgow Stained Glass*, p. 11.

16. "The Metropolis Today" [unknown source], p. 283, photocopy in the scholarship files, Department of American Decorative Arts, The Metropolitan Museum of Art, New York.

17. Clarence Cook, "Recent Church Decoration," *Scribner's Monthly* 15 (Feb. 1878), p. 571. In a March 1878 letter to Stanford White, Augustus Saint-Gaudens wrote: "I don't think, or at least I don't see, what La Farge would have done without him [Cottier] in the mixing of colors, direction of men, &c. &c., and all the practical part"; see Homer Saint-Gaudens, ed., *The Reminiscences of Augustus Saint-Gaudens*, 2 vols. (New York, 1913), vol. 1, p. 257.

18. The windows depict the following subjects: The Sower and the Reaper, The Five Wise Virgins, The Angel Troubling the Pool, and Storm on the Lake; see Edgar D. Romig, *The Story of Trinity Church in the City of Boston*, rev. ed. (Boston, 1964), p. 48.

19. Booth's stained glass has been virtually ignored. A brief mention of his American shop is made in Martin Harrison, *Victorian Stained Glass* (London, 1980), p. 57. One window is illustrated in James L. Sturm, *Stained Glass from Medieval Times to the Present: Treasures to Be Seen in New York* (New York, 1982), p. 95, figs. 96, 97. The window, *The Heavenly Hosts* (about 1884), is at Grace Church, Broadway and East Tenth Street, New York.

20. Christopher Dresser, *Principles of Decorative Design* (1873; reprint London, 1973), pp. 153–54.

21. Ibid.

22. Charles Booth, *Hints on Church and Domestic Windows, Plain and Decorated* (Orange, N.J., 1876), p. 14.

23. [Charles Booth et al.], *Modern Surface Ornament* (New York, 1877); *Art-Worker: A Journal of Design Devoted to Art-Industry* 1 (Jan. 1878), pl. 1; (Feb. 1878), pl. 8; (June 1878), pl. 39; (Aug. 1878), pl. 55.

24. For a detailed discussion of the design and construction of the Jefferson Market Courthouse, see Francis R. Kowsky, *The Architecture of Frederick Clarke Withers and the Progress of the Gothic Revival in America after 1850* (Middletown, Conn., 1980), pp. 109–16.

25. The attribution to Booth of the program of windows at Calvary Church, 60 Gramercy Park, New York, is based on their close stylistic similarity to thirteen windows at Grace Church, New York, which are documented to Booth and date from 1884–86. Although as yet no evidence has turned up relating to the Calvary Church windows, the vestry voted a large sum of money ($11,000) in 1878 for refurbishing the church, which may have included the installation of new stained-glass windows. I am grateful to the Reverend Stephen Garmey of Calvary Church for providing me with this information.

26. This comparison can be made at Calvary Church, where Booth windows can be seen alongside a stunning window by Cottier.

27. When John Wanamaker of Philadelphia had his department store, the Grand Depot, rebuilt in 1885, he had two stained-glass windows installed, one depicting Robert Morris, the other depicting Stephen Girard, both notable Philadelphia bankers; see Herbert Adams Gibbons, *John Wanamaker* (New York, 1926), p. 235. I am grateful to William R. Leach, New York Institute for the Humanities, New York University, for bringing this to my attention.

28. Charles Locke Eastlake, quoted in "Painted Glass in Household Decoration," *Crockery and Glass Journal* 10 (Oct. 2, 1879), p. 19.

29. Riordan, "Use of Stained Glass," p. 130.

30. "Stained Glass in Houses," *Crockery and Glass Journal* 16 (Nov. 23, 1882), p. 18.

31. Donald G. Mitchell, "Industrial and Architectural Designs; Interior Decorations; Artistic Hardware; Mosaics; Inlaid-Work in Wood and Metal; Stained Glass," in "General Report of the Judges of Group 27," in U.S. Centennial Commission, *International Exhibition, 1876: Reports and Awards*, 9 vols. (Washington, D.C., 1880), vol. 7, p. 651.

32. Booth, *Hints on Church and Domestic Windows*, p. 19.

33. Mary Gay Humphreys, "Colored Glass for Home Decoration," *Art Amateur* 5 (June 1881), p. 15.

34. Ibid.

35. Ibid., p. 14.

36. Ibid., p. 15.

37. Ibid.

38. "Architecture: Green Memorial Alcove," *Art Interchange* 1 (Nov. 13, 1878), p. 39. There is no such window in the New York Society Library today. The present location of the Cottier window is unknown.

39. John Matthews, *The Matthews Catalogue of Decorative Glass and Transparent Signs, as Executed by the Tilghman Sand-Blast and Other Patented Processes* (New York, 1886), Corning Museum of Glass Library, N.Y.

40. The most popular process, called "diaphanie," was developed in France. The transfer, a kind of chromolithograph in transparent colors that could be applied to any kind of window, fire screen, or lampshade, was laid over glass whose surface had been prepared with a special varnish. After the varnish had hardened, incorporating the pattern, another coat of varnish was applied.

41. Charles Moller and Company, *Stained Glass by the Improved Process of Diaphanie, for Church, Hall, Conservatory, Staircase, and Other Windows, Which May Be Easily Performed at a Small Cost, to Which Is Added Brief Instructions for Transparency Painting* (New York, 1881), unpaged [p. 3], Corning Museum of Glass Library, N.Y.

42. "Notes and Clippings" [Centennial notes], *American Architect and Building News* 1 (May 13, 1876), p. 160.

43. The Centennial National Bank in Philadelphia was also ornamented with "brilliant glass tiles, sparkling with gold and color"; see "The Centennial National Bank Building," *American Architect and Building News* 1 (Dec. 23, 1876), p. 414. See also Philadelphia Museum of Art, *The Architecture of Frank Furness*, by James F. O'Gorman (exhib. cat., 1973), pp. 43–44.

44. "Notes and Clippings" [Centennial notes], p. 160.

45. Humphreys, "Colored Glass," p. 15.

46. Ibid., p. 14.

47. See H. Barbara Weinberg, "The Early Stained Glass Work of John La Farge (1835–1910)," *Stained Glass* 67 (Summer 1972), pp. 7–10.

48. For an extensive analysis of La Farge's decorative work for Trinity Church, Boston, see H. Bar-

bara Weinberg, "The Decorative Work of John La Farge" (Ph.D. diss., Columbia University, 1972), pp. 75–144, 343–47.

49. Ibid., p. 344.

50. H. H. Richardson designed the W. Watts Sherman house, which was completed by 1878, but the paneled main hall was probably designed by Richardson's associate Stanford White. The window marks an early collaboration of La Farge with Richardson and White. The attribution of this window to La Farge is discussed in great detail and confirmed by H. Barbara Weinberg. See Weinberg, "Early Stained Glass Work," pp. 11–12. The precise dating of the window has also been the subject of much discussion. However, Sean McNally has convincingly proved that by at least June 1877 La Farge had provided designs and selected glass for the window; see Sean McNally, "The Watts Sherman Window," manuscript, n.d., p. 2.

51. Cecilia Waern, John La Farge, Artist and Writer (New York and London, 1896), p. 68.

52. Henry Adams has suggested that a Hiroshige wood-block print, Insects and Morning Glories, acquired by La Farge about 1860, was the source for the window. See Henry Adams, "The Stained Glass of John La Farge," American Art Review (Los Angeles) 2 (July–Aug. 1975), pp. 53–54 (n. 15).

53. See Henry Adams, "John La Farge's Discovery of Japanese Art: A New Perspective on the Origins of Japonisme," Art Bulletin 67 (Sept. 1985), pp. 449–85.

54. Two letters from John La Farge to William J. Linton, Nov. 24 and 27, 1875, W. J. Linton Papers, Collection of American Literature, The Beinecke Rare Book and Manuscript Library, Yale University, New Haven, quoted in Henry La Farge, [Catalogue raisonné of John La Farge], manuscript entry G76.1/1, Henry La Farge Papers, New Canaan, Conn., Mar. 1985 draft, courtesy of James L. Yarnall.

55. La Farge, [Catalogue raisonné], where these windows, now in the Walter Hunnewell house in Wellesley, Mass., have been attributed to La Farge. It is unclear whether the windows were originally made for Hunnewell's house in Boston or the one in Wellesley, which was designed by H. H. Richardson. La Farge originally made three windows for

Hunnewell, one of which has been broken beyond repair.

56. Adams, "La Farge's Discovery of Japanese Art," p. 459.

57. American Art Galleries, New York, Catalogue of the Art Property and Other Objects Belonging to the Estate of the Late John La Farge, N.A. (sale cat., 1911).

58. This may have been referred to by La Farge in describing a window "made mostly of English glass, some of the pieces of which I had taken out, to be replaced at will by the opalescent"; see John La Farge, The American Art of Glass, to Be Read in Connection with Mr. Louis C. Tiffany's Paper in the July Number of the "Forum," 1893 [New York, 1893], p. 14.

59. Ibid., p. 13.

60. See Weinberg, "Early Stained Glass Work," p. 6, where an excellent analysis is given of La Farge's earliest stained-glass commission (1874–75) for Memorial Hall, Harvard University, Cambridge, Mass., in which he struggled with the limitations of the medium.

61. "The World's Work: American Progress in the Manufacture of Stained Glass," Scribner's Monthly 21 (Jan. 1881), p. 486.

62. La Farge, American Art of Glass, p. 14.

63. Mary Gay Humphreys, "John La Farge, Artist and Decorator," Art Amateur 9 (June 1883), p. 14.

64. Artistic Houses, Being a Series of Interior Views of a Number of the Most Beautiful and Celebrated Homes in the United States, 2 vols. in 4 pts. (1883–84; reprinted in 1 pt., New York, 1971), vol. 2, pt. 1, p. 85.

65. "Some Notable Windows," Art Amateur 8 (Feb. 1883), p. 70.

66. Ibid.

67. John La Farge, "Bing," a response to "the questions asked by Mr. [S.] Bing regarding my work and my ideas so as to include a notice of the same in his report to the French Government," typescript [Jan. 1894?], p. 4, La Farge Papers, Collection of American Literature, The Beinecke Rare Book and Manuscript Library, Yale University, New Haven, quoted in Weinberg, "Early Stained Glass Work," p. 5.

68. Ibid.

69. Letter from La Farge to N. E. Montross, Oct. 31 [year unknown], quoted in Weinberg, Decorative Work of John La Farge, p. 341.

70. Grey Art Gallery and Study Center, New York, Louis Comfort Tiffany: The Paintings, by Gary A. Reynolds and Robert Littman (exhib. cat., 1979), p. 21.

71. Louis C. Tiffany, "American Art Supreme in Colored Glass," Forum 15 (July 1893), p. 624.

72. Roger Riordan, "American Stained Glass," pt. 1, American Art Review (Boston) 2, no. 1 (1881), p. 234.

73. Artistic Houses, vol. 1, pt. 1, p. 53.

74. Samuel Colman accompanied Mr. Havemeyer to the Philadelphia Exposition, where both men became particularly interested in the Japanese exhibits; see Louisine Waldren Havemeyer, Sixteen to Sixty: Memoirs of a Collector (New York, 1961), pp. 19–20.

75. S. Bing, "Artistic America," trans. from the 1895 French version ("La Culture artistique en Amérique") by Benita Eisler, in Artistic America, Tiffany Glass, and Art Nouveau, intro. Robert Koch (Cambridge, Mass., and London, 1970), p. 141.

76. Ibid., p. 107.

77. The use of mosaics in decoration increased steadily during the Aesthetic period. By 1890 it was reported that there were eight firms in New York City alone making mosaics "giving employment to fifty mosaic workers and double that number of helpers and masons"; see "Mosaics in Interior Decoration," Art Amateur 22 (Apr. 1890), pp. 104–5.

78. "Decorating the Havemeyer House," New York Times, Nov. 8, 1891, p. 16. I am grateful to Fran Weitzenhoffer for bringing this to my attention.

79. Bing, "Artistic America," p. 141.

80. American Art Association, New York, Furnishings and Decorations from the Estate of Mrs. H. O. Havemeyer (sale cat., Apr. 22, 1930), p. 14.

81. The official charter of the Louis Comfort Tiffany Foundation, cited in Hugh F. McKean, The "Lost" Treasures of Louis Comfort Tiffany (New York, 1980), p. 265.

82. "Louis C. Tiffany" [Tiffany's comments on the question, "What is the Quest for Beauty?"], International Studio 58 (Apr. 1916), p. lxiii.

Overleaf: Detail of vase (FIG. 7.21)

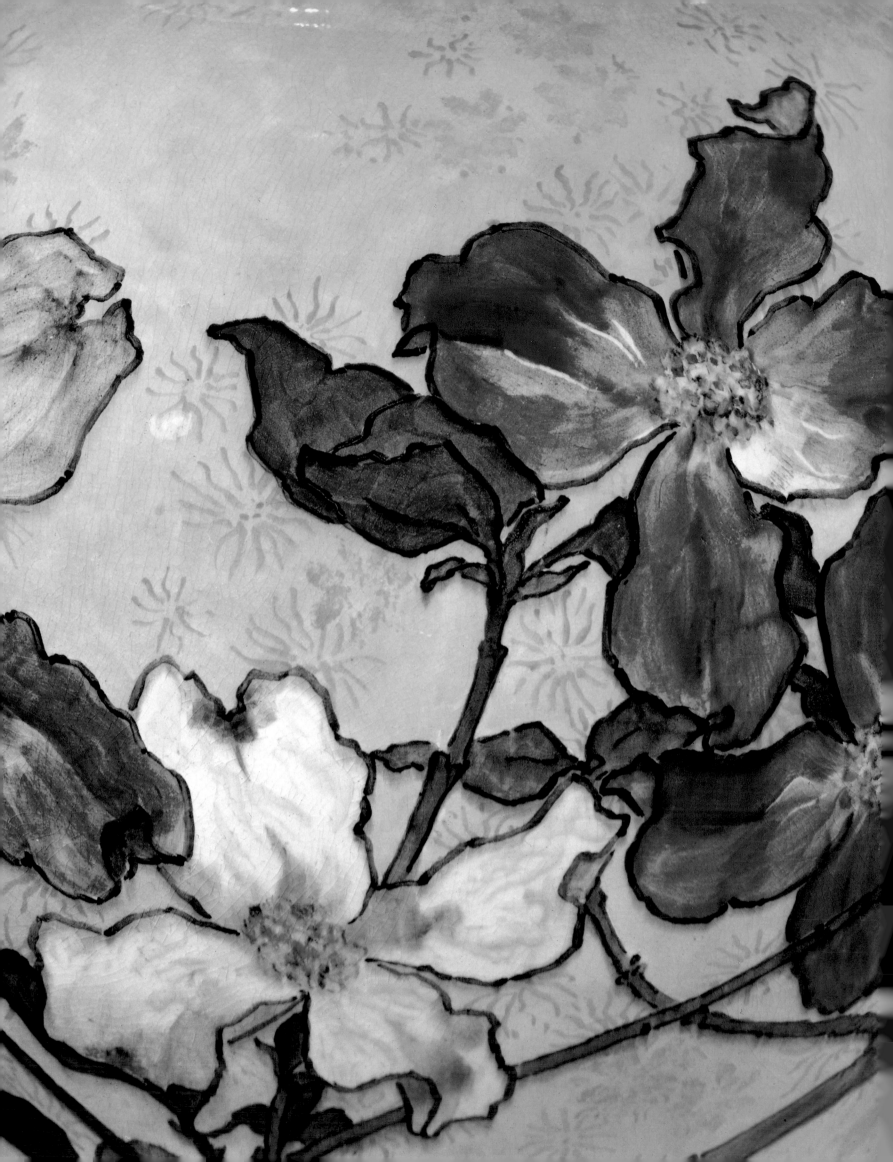

7

Aesthetic Forms in Ceramics and Glass

Alice Cooney Frelinghuysen

THE MANUFACTURE of art pottery, art tiles, and art glass developed from about 1875 to about 1885, a decade that marked the peak of the Aesthetic movement in America. Implicit in the term "art" was an aesthetic quality, which, as defined by the new decorative vocabulary of the time, denoted objects of superior character. An art object made in the Aesthetic era, therefore, was not merely of utilitarian value but of aesthetic value as well; an art pottery so designated was one that attempted to produce ceramics based on the new ideas of artistic design. The artists, designers, and factories that had their beginnings during the Aesthetic movement laid the groundwork for the fully developed art potteries, tileworks, and glassworks that flourished in the United States until the third decade of the twentieth century.

Ceramics

The remarkable surge of interest in ceramics of all kinds during the last quarter of the nineteenth century is virtually unparalleled in any other period in history. By the 1860s in England and the 1870s in America people were avidly collecting, painting, producing, and writing about ceramics, a medium that encompassed everything from the red- and black-figured vases of ancient Greece to the porcelains of the Orient, from Persian lusterwares to French porcelains. Even modest wares such as blue-and-white Chinese Nankeen, Japanese Satsuma, and, especially in America, historical blue transfer-printed Staffordshire pottery found admirers.

The late nineteenth-century popularity of ceramics collecting in Europe and America was part of the revival of interest in the decorative arts known as the Aesthetic movement. In ceramics, ancient Greek pottery and oriental porcelains were the most favored among collectors and potters; individuals and firms followed suit by making reproductions of those forms and by adapting their motifs, shapes, and glazes. Though the aesthetic style in ceramics was defined by the adaptation of the formal qualities of Greek and oriental objects and was determined by the theories of the leading nineteenth-century English designers OWEN JONES and CHRISTOPHER DRESSER, creativity in the field would never have reached such a pinnacle of accomplishment if makers had not been inspired both by the prototypes themselves and by their presence in the great collections of the time.

Several factors gave rise to the fever of collecting. The growth of nineteenth-century trade, travel, and international expositions created a universal fascination with exotic lands, and the personal fortunes then being amassed enabled individuals to spend huge sums of money on the works of art that in turn elevated their owner's status and self-esteem. That attitude represented a shift from earlier, eighteenth-century patterns, when collectors, motivated in large part by scientific curiosity, eagerly accumulated specimen plants, insects, and minerals. In an era when interiors were decorated to simulate foreign environments, one could achieve a similar effect by surrounding oneself with ceramics and other decorative objects from diverse cultures.[1] William H. Vanderbilt (1821–1885), in the most extravagant private display in America, virtually "papered" the walls of his "Japanese" parlor (see ILL. 4.9) with priceless oriental porcelains.[2] Even families of moderate means could keep pace with the trend by featuring on the walls, in the cabinets, and on the mantelshelves of their homes a wide selection of pottery. In William C. Prime's *Pottery and Porcelain of All Times and Nations,* published in 1878, the frontispiece, entitled "Home Decoration" (ILL. 7.1), shows a fireplace surrounded by quaint Delft tiles and a mantel adorned with Chinese porcelain bottles, a pair of Sèvres cups, and an Italian *maiolica* drug vase, surmounted by blue-and-white Chinese and Japanese plates hung on the wall.[3]

Perhaps the most altruistic aspect of great collections of art is that they instruct the average viewer and elevate his taste. The collections formed and exhibited by museums and by private individuals during the period of the Aesthetic movement improved standards of design and decoration by making the best achievements of past and present cultures accessible for study to interested persons. Artists and manufacturers who began looking at the unfamiliar objects that were clearly valued at the highest educational, social, and commercial levels ultimately became dependent on their styles. The field of ceramics was as fertile a ground for collectors as any art medium during the Aesthetic period.[4]

The Philadelphia Centennial Exposition of 1876 introduced many Americans for the first time to objects from exotic cultures. The vast and varied ceramics displays, nearly four hundred of which were foreign, were viewed by thousands of visitors (ILL. 7.2) and kindled an enthusiasm for ceramics in collectors, ceramists, and the general public that was international in scale. Among European displays, the English stoneware and painted faience of Henry Doulton and Company were notable, as was the work of the WORCESTER ROYAL PORCELAIN COMPANY and MINTON AND COMPANY; the French Haviland exhibition was also admired. Visitors flocked to the Japanese sections to see their extensive showings, which one critic went so far as to say surpassed "in beauty of forms and ornamentation the combined exhibit of every other nation in the building."[5] The Philadelphia judges too singled out the impor-

tant contribution made by the Japanese, commenting that their "blue and white porcelain alone would place the Japanese exhibition in a foremost place."[6] The curious shapes, the simple compositions painted with meticulously detailed decorations—perhaps only a single leaf or flower spray "thrown on the surface of the piece at the fancy of the artist"[7]—delighted all who beheld them and exerted a profound influence in the United States on art and commercial potteries alike.

Though numerous American factories participated in the Centennial, their contributions were praised more for the quality of the materials and decoration than for the originality of the designs. In keeping with American tradition and the centennial spirit, the larger firms, such as the UNION PORCELAIN WORKS of Greenpoint in Brooklyn, New York, and the OTT AND BREWER company of Trenton, New Jersey—which had both hired professional sculptors to design their exhibition pieces—exploited patriotic images in their decoration. That many of these firms were being exposed for the first time to a wide variety of international cultures at the fair opened the door onto wholly new sources for American design.

The nation's Centennial celebration and the other great international exhibitions of the second half of the nineteenth century gave fresh impetus to the collection and production of ceramics and signified a new era in the dissemination of these goods to the masses. At the same time, they stimulated the acquisitive urge in many of the great collectors, including William T. Walters (1820–1894) of Baltimore and Henry Osborne Havemeyer (1847–1907) of New York. In the ensuing years the number of collectors grew,

and the "china mania" or "rage for old china" that spread across the nation became the object of many a barbed witticism. American journals often reprinted amusing cartoons by George Du Maurier (1834–1896) and Edward Linley Sambourne (1844–1910) from England's *Punch*. A particularly satiric English view of the collecting craze was "Chinamania Made Useful at Last!" (ILL. 7.3), an illustration of a lady who, carrying her enthusiasm for porcelain to excess, applied plates to her gown and a teapot to her head.[8] An American cartoon of 1877 (ILL. 7.4), appearing in the widely circulated *Scribner's Monthly*, depicts "Arabella's reception-room" looking like a museum gallery or a china-shop showroom. The caption explains the seeming dichotomy by claiming Arabella to be "slightly touched with the fashion for old china."[9]

The pottery and porcelains from ancient Greece and the Orient that of all ceramics traditions were most attractive to collectors also inspired greater numbers of both European and American ceramists. Informed awareness of Greek pottery among collectors, scholars, and the public was not entirely new: it was heralded in London in 1772 with the British Museum's acquisition of William Hamilton's famous holdings of Attic vases. By the mid-1800s, when systematic excavations in Italy and Greece were uncovering large quantities of similar pottery, they became a major component of most art collections.

The great period of American collecting, however, did not begin until the last third of the nineteenth century,[10] an era in which it was not unusual for some men of wealth to acquire classical art to serve as decoration for their great houses. For others it was a more serious passion. By the late 1870s Luigi Palma di Cesnola

ILL. 7.1 "Home Decoration." William C. Prime, *Pottery and Porcelain of All Times and Nations* (New York, 1878). Thomas J. Watson Library, The Metropolitan Museum of Art

ILL. 7.2 "Character Sketches in Memorial Hall and the Annex: Visitors Taking Notes." Frank H. Norton, ed., *Frank Leslie's Historical Register of the United States Centennial Exposition, 1876* (New York, 1877). Thomas J. Watson Library, The Metropolitan Museum of Art

(1832–1904), who had zealously excavated in Cyprus, and the noted German archaeologist Dr. Heinrich Schliemann (1822–1890) had accumulated sizable collections of ancient pottery. Between 1874 and 1876, Cesnola sold a large portion of his Cypriot antiquities to the newly founded Metropolitan Museum of Art in New York. Those collections were then among the most commonly discussed subjects in art, ceramics, and popular magazines. Their subsequent exhibition and reviews created widespread enthusiasm, with certain of the objects eventually serving as models for reproductions of antique pottery.

Reproductions are one manifestation of the tremendous interest in collecting. Though pottery based on classical models had been made for decades in England, it was the Danes—the Copenhagen factory of Madame Ipsen, for one—who were among the first to produce actual imitations of Greek vessels (ILL. 7.5). The Danish terracotta vases, their hand-painted decoration described by one critic as "Greek figures and clear-cut conventional foliage"[11] in red or black on a black or buff ground, were strict reproductions of antique objects copied from specimens at the Thorvaldsens Museum. Madame Ipsen's copies, part of the Danish display at the Philadelphia Exposition, impressed American visitors and may have planted the idea of reproductions in manufacturers' minds.

CHARLES LOCKE EASTLAKE and Christopher Dresser, Englishmen who exerted considerable influence on American decoration, were among the first designers to admire the simple, conventionalized designs of classical pottery and to advocate their use in contemporary objects. Eastlake articulated those principles in *Hints on Household Taste,* first published in London in 1868:

> The Greeks . . . contented themselves, as we find on all antique vessels, with representing the human figure and other objects in one flat color, red . . . on a black ground, or *vice versa*. The folds of drapery, the action of limbs, etc., were expressed by lines. There was no shading, no pictorial effect. The design was simply decorative, and depended for its beauty on exquisite drawing, correct symmetry of general form, and refinement of execution.[12]

"Greek Painted Vases," an article that appeared in the *American Art Amateur* in 1882—a time when the vogue for these reproductions was beginning to wane—quotes Dresser's remarks on the lesson to be learned from ancient models: "Whatever ornament is placed around a cup, or vase . . . should be such as will not suffer in perspective, for there is scarcely any portion of the ornament that can be seen otherwise than foreshortened. Let simplicity be the ruling principle in the decoration of all rounded objects."[13] Design characteristics adopted from Greek pottery, among which flat, stylized decoration with a minimum of modeling or shading was especially prized, resulted in the simplified designs that helped to characterize aesthetic pottery. Facsimiles of Greek terracotta vessels were some of the earliest artistic ceramics produced in America. The first known reference to an "artware line" appeared in 1872, when "the Beverly Pottery at the request of Boston ladies began to copy beautiful forms of ancient vases to order."[14] Charles A. Lawrence, the superintendent of that Massachusetts factory, intentionally limited his production of imitation Greek pottery, for he feared that if it became common it would depreciate in value. He therefore sold it only in small lots to his "artistic" friends for their own private collections.[15]

In East Cambridge, Massachusetts, the firm of Albert H. Hews branched out at the same time from making standard horticultural vessels and began to fabricate antique wares, replicating some of the pottery found by Schliemann during his excavations on what was the site of ancient Troy. An account of the Hews factory in 1876 describes the quantity of "antique art pottery" produced by the firm: "acres of space piled high with every form and variety of wares, from the coarsest to the most delicate, and in size

CHINAMANIA MADE USEFUL AT LAST!
"Hand-painted china is all the rage as a trimming for Ladies' Dresses."—*Paris Fashions.*

ILL. 7.3 "Chinamania Made Useful at Last!" *Punch's Almanack for 1880* (Dec. 12, 1879). Private collection

ILL. 7.4 "Arabella's Reception-Room." *Scribner's Monthly* (May 1877). The New York Society Library

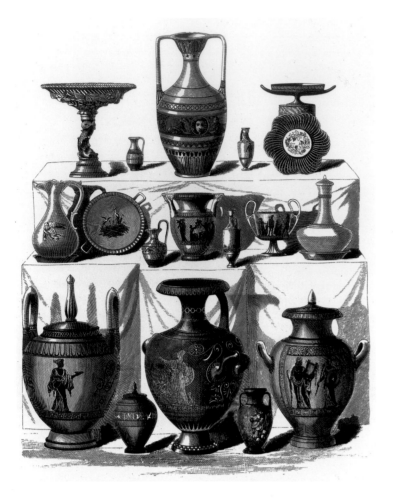

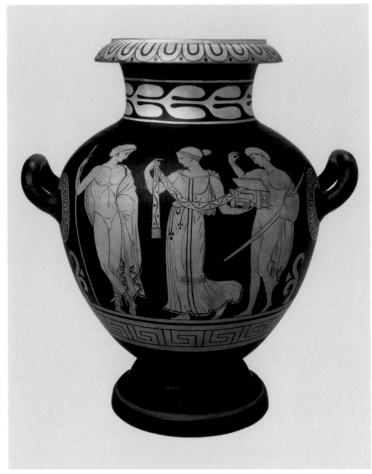

Above: FIG. 7.1 Hydria. Decorated by John Gardner Low, made by Chelsea Keramic Art Works, Chelsea, Mass., ca. 1877. Painted unglazed terracotta, h. 13⅛ in. (33.3 cm), diam. 9¼ in. (23.5 cm). Museum of Fine Arts, Boston, Gift of James Robertson and Sons (77.248)

Above left: ILL. 7.5 "Danish Pottery." [George Titus Ferris], *Gems of the Centennial Exhibition: Consisting of Illustrated Descriptions of Objects of an Artistic Character, in the Exhibits of the United States, Great Britain, France* . . . (New York, 1877). Thomas J. Watson Library, The Metropolitan Museum of Art

Left: ILL. 7.6 Pottery forms for sale by Albert H. Hews and Company, East Cambridge, Mass. *Designs and Instructions for Decorating Pottery in Imitation of Greek, Roman, Egyptian, and Other Styles of Vases* (Boston, 1877). Private collection

from the most minute to the great jugs in imitation of the most ancient forms known."[16] In Hews's 1877 illustrated catalogue, some seventy-eight facsimiles of undecorated antique red pottery (ILL. 7.6) offered for sale included what they claimed were exact replicas of some vessels found by Schliemann and some discovered by Cesnola in ancient Cypriot tombs.[17]

In Chelsea, Massachusetts, the CHELSEA KERAMIC ART WORKS had been in operation since the mid-1860s with a production that consisted largely of plain and fancy flowerpots and other utilitarian forms. By 1873 the firm, one of the most influential potteries of the Aesthetic movement in America, had established a line of antique reproductions that successfully rivaled those of the Hews factory. The vases, tazzas, and hydriae it "reproduced with remarkable fidelity" were to be praised as the best copies ever made in America.[18]

JOHN GARDNER LOW,[19] who was a decorator at the firm in 1876 and 1877 and who went on to found the J. AND J. G. LOW ART TILE WORKS, designed and painted one of the few extant examples of Chelsea's Greek-inspired terracottas. His large red earthenware vase (FIG. 7.1) closely resembles a red-figured hydria in the 1848 catalogue of vases owned by Henry Englefield, a noted early collector of antiquities.[20] Englefield's catalogue was probably widely known in Boston: a book on china painting published in that city in 1877 illustrated the vase and, as an example of advanced Greek decoration, a detail of three figures on its body.[21] Low's version simplifies the faces, hairstyles, and drapery of the figures and eliminates some of the detail, thus emphasizing the silhouettes. When Low's vase is compared with the illustration of the original, it appears that he also enlarged the size of the decorative borders: around the neck, the laurel leaves (which he reversed); below the figural scene, the Greek meander band; and on the lip and around the handles, the egg-and-dart pattern.

Interest in reproducing ancient vases was increasing well beyond Boston and its environs.[22] In Philadelphia, in 1876, the firm of GALLOWAY AND GRAFF, also inspired by Madame Ipsen's exhibitions of pottery facsimiles of classical red and black terracotta, added to the horticultural forms for which it was known a line of art pottery that it described as "truthful copies of some of the finest specimens from the Antique, old Greek and Roman productions."[23] The firm sold many simple, unpainted classical vessels (FIG. 7.2); others of its forms, such as the amphora (FIG. 7.3), featured stylized red-and-black painted decoration in classical patterns. No specific Greek prototype for the amphora illustrated is known, but its simplified, nonfigural ornamentation derives from the plant forms commonly found on ancient examples. The arrangement of horizontal patterned bands, each made up of crisp, stylized, repeating elements, is characteristic of ornamentation popular for the ceramics of the Aesthetic era.

Terracotta, a fragile, low-fired medium, has a poor survival rate. Because few terracotta vases were marked, only a handful of documented examples exist. Though the taste for vases in the style of ancient Greece was short-lived, the wares that survive demonstrate the direct influence the collecting of Greek vases effected on American pottery produced during the 1870s.

At the same time that collections of classical antiquities were being assembled, oriental art was beginning to attract its own share of interest. Some of the large collections formed during the late nineteenth century were eventually to join the holdings of such institutions as the Museum of Fine Arts in Boston, The Metropolitan Museum of Art in New York, and the Walters Art Gallery in Baltimore, where they are still being studied today. In the first half of the century oriental objects had been accumulated as part of the thriving trade that existed between China and America, especially New England. By the 1870s, however, a direct interest in

FIG. 7.2 Kylix and pedestal. Galloway and Graff, Philadelphia, 1876–82. Unglazed terracotta, h. 7 in. (17.8 cm), diam. 12 in. (30.5 cm). Marked: *Galloway, Graff & Co. / 1725 Market St. / Philadelphia*. Cincinnati Art Museum, Gift of the Women's Art Museum Association (1881.168, .169)

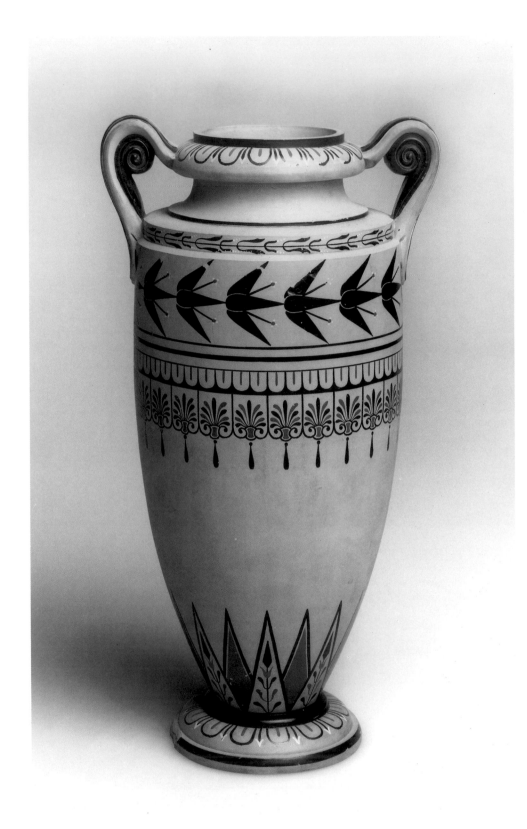

FIG. 7.3 Amphora. Galloway and Graff, Philadelphia, 1876–82. Painted unglazed terracotta, h. 13½ in. (34.3 cm), diam. 5¾ in. (14.6 cm). Marked: *Galloway & Graff, Philadelphia.* Cincinnati Art Museum, Gift of the Women's Art Museum Association (1881.160)

Far Eastern art emerged, a result of the expeditions to Japan inaugurated by Matthew Calbraith Perry two decades earlier. Commodore Perry and those who came after him opened the door to a civilization and a way of life previously almost unknown in the West.

Americans gained further insight into Far Eastern cultures at the great international exhibitions in the later years of the century. The first major display of Japanese art and artifacts—bronzes, ceramics, fans, lacquerwork, and textiles—was at the London International Exhibition of 1862. The effect was sensational. James Jackson Jarves (1818–1888), a Boston collector whose fame derives from his later writings on art, first saw examples of Japanese art in 1867 at the Exposition Universelle in Paris. Perhaps because of its tradition of early trade with the Orient, New England was home to several of the first systematic collectors of Far Eastern art: Jarves, Edward S. Morse (1838–1925), Ernest F. Fenollosa (1853–1908),

and William Sturgis Bigelow (1850–1926), whose collections were later to enrich the oriental holdings of the Museum of Fine Arts in Boston.[24]

While some men collected because of their intellectual interest in Far Eastern civilizations, others began to amass their collections in order to surround themselves with objets d'art, assiduously acquiring Chinese, Japanese, and Islamic artifacts that included not only ceramics (FIG. 7.4) but also jade, metalwork, lacquerwork (ILL. 7.7), textiles, painting, and sculpture. Many collectors, such as Walters and Havemeyer, were inspired by the great exhibitions. Walters, who by his own account began to collect oriental works of art after attending the London International Exhibition of 1862, found his interest deepening at subsequent expositions.[25] Havemeyer had been introduced to oriental art by the artist SAMUEL COLMAN, a close friend of his, at the 1876 Philadelphia Exposition.[26] There he began his extraordinary collection and, on Colman's advice, bought Japanese silks of "lustrous gold and silver and rich blues, reds and greens,"[27] with which he later decorated the library ceiling of his New York mansion and lined the cabinets that housed his porcelain and glass.

Oriental works of art also found favor with the designers and artists of the day—notably Dresser in England, and, in America, JOHN LA FARGE, HUGH C. ROBERTSON, MARIA LONGWORTH NICHOLS, and EDWARD C. MOORE, to name but a few—and numerous articles in contemporary art, crafts, and general periodicals covered all aspects of Far Eastern culture. Because Americans had fully embraced the craze for Japanism that infected Europe during the 1860s and 1870s, oriental collections were being exhibited in the decorative-arts societies, art schools, and industrial fairs popular by the centennial year. The widespread visibility of Far Eastern art provided designers and manufacturers with a wealth of resources from which they drew the same artistic inspiration they had first found in the great collections of ancient Greek pottery. While these works were not as slavishly copied as the vessels from antiquity had been, they were used by designers as a source of new decorative ideas. Rather than concentrating on ceramic objects, however, designers adopted ideas from objects in as many media as possible, so that in both shape and decoration the ceramics of the Aesthetic period were inspired by Japanese metalwork, ivories, lacquerwork, and even prints and textiles. As the new Japanese style appeared in increasingly varied forms, often mixed with styles from other countries, the eclecticism that characterizes much late nineteenth-century design began to emerge.

English manufacturers such as Minton, Doulton, and Royal Worcester, freely drawing on the oriental principle of asymmetrical design, produced rich and elaborate wares that either directly imitated Japanese porcelains or adapted other Japanese media, including Satsuma, cloisonné, lacquerwork, or bronze, to the ceramics produced at their own English factories. In America, many an object of seemingly pure Japanese derivation was actually borrowed from English (and sometimes French) adaptations of Japanese designs.

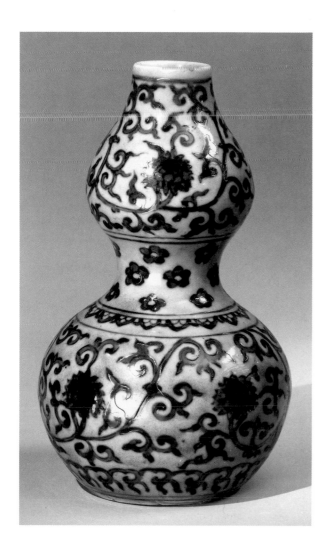

Above: ILL. 7.7 *Shikishi-bako* (box for writing paper). Japanese, Tokugawa period, 18th century. Lacquer, inlaid mother-of-pearl, h. 1½ in. (3.8 cm), w. 9 in. (22.9 cm), l. 8 in. (20.3 cm). The Metropolitan Museum of Art, Bequest of Mrs. H. O. Havemeyer, 1929, H. O. Havemeyer Collection (29.100.674)

Left: FIG. 7.4 Vase. Chinese, Ming dynasty, 1522–66. Porcelain, h. 6 in. (15.2 cm). The Metropolitan Museum of Art, Edward C. Moore Collection, Bequest of Edward C. Moore, 1891 (91.1.379)

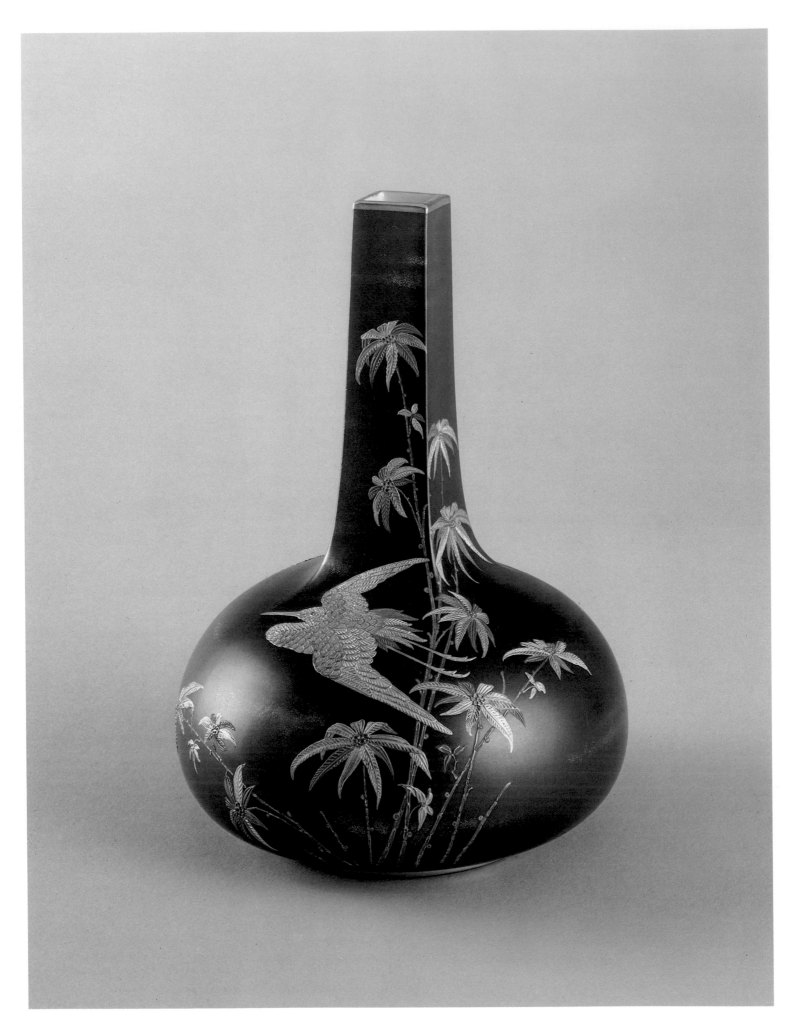

Opposite: FIG. 7.5 Vase. Ott and Brewer, Trenton, N.J., ca. 1883. Gilding and enamel on porcelain, h. 9¾ in. (24.8 cm), diam. 7 in. (17.8 cm). Marked: *BELLEEK* / *O & B* / [crescent moon]. Collection of Mr. and Mrs. Jay Lewis

Right: FIG. 7.6 Pitcher. Ott and Brewer, Trenton, N.J., ca. 1883. Gilding and enamel on porcelain, h. 13¼ in. (33.7 cm), diam. 6⅝ in. (16.8 cm). Marked: *BELLEEK* / [crown and sword] / *O & B*. High Museum of Art, Atlanta, Virginia Carroll Crawford Collection (1984.140)

Below: FIG. 7.7 Pair of vases. Greenwood Pottery, Trenton, N.J., 1883–86. Gilding and enamel on porcelain; each: h. 8½ in. (21.6 cm), w. 3⅜ in. (8.6 cm). New Jersey State Museum, Trenton, Gift of Mrs. Arthur K. Twitchell and Anne Yard Tams in memory of their grandfather William Henry Tams and their father James Elmore Moffett Tams (79.1.20)

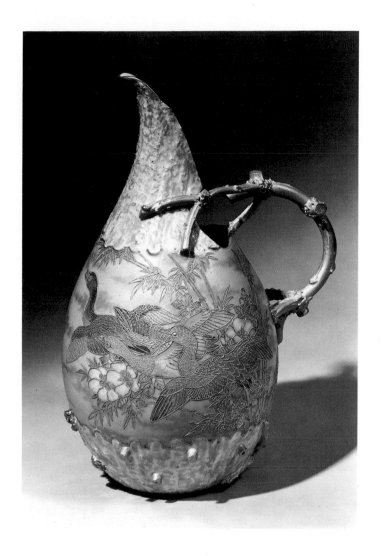

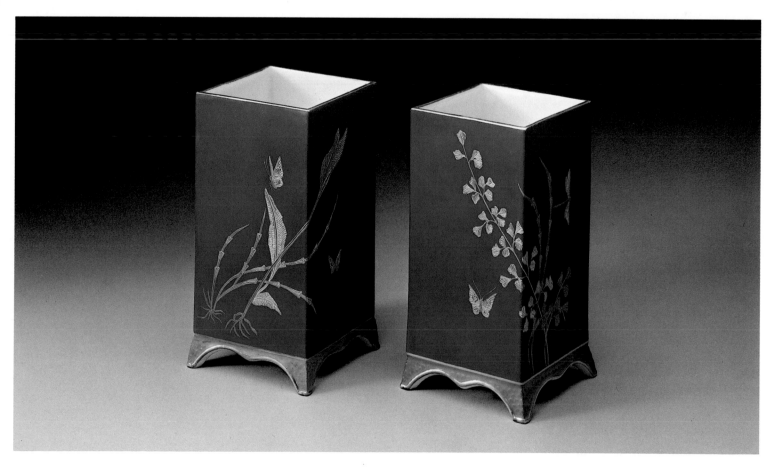

American commercial potteries in Trenton and Baltimore were quick to capitalize on the popularity of the profusely decorated Japanese-style wares imported from England. Trenton, where the potteries modeled themselves on English factories and tried to rival the products of Royal Worcester in England and Belleek in Ireland, primarily their Japanese-inspired wares, had by the mid-1870s become one of the most important centers in America for ceramics production on a large commercial scale and in 1880 had at least thirty factories in operation.

Trenton manufacturers soon recognized the value of using exhibitions, publications, and collections to review ceramics traditions from all over the world, which their designers and potters could then study. In 1878 New Jersey Governor George B. McClellan encouraged the continuing education of potters by deciding to send a representative of the Trenton ceramics industry to Paris to study entries at that year's Exposition Universelle and to report on them to the profession on his return.[28] After a much-publicized selection process, ISAAC BROOME, whom the Ott and Brewer firm had hired at the time of the Centennial, was chosen. The governor also allocated the sum of two thousand dollars to purchase for the state library a collection of books on the medium that would be available to artists and designers.[29] The books consisted of the most important works on ceramics history, including *Description méthodique du Musée Céramique de la Manufacture Royale de Porcelaine de Sèvres* (1845), by Alexandre Brongniart and Denis Riocreux, and *Keramic Art of Japan* (1875), by George Ashdown Audsley and James Lord Bowes, as well as many illustrated works on style and design, such as Owen Jones's *Grammar of Ornament* (1856).[30] William C. Prime (1825–1905), noted ceramics historian and collector of the period, considered the library to be the best of its kind in the country.[31]

With the encouragement of the Trenton Potters' Association, Governor McClellan began by the summer of 1879 to discuss the establishment of a school of industrial design dedicated to elevating the standard of excellence in pottery production. The school opened in Trenton later that year "with the idea of cultivating the youth of the potteries in the arts of design and decoration."[32] Representatives of industry were exploring at the same time the possibility of establishing a small collection or museum of specimens of pottery and porcelain to serve as models for study.[33]

A number of companies were now setting out to improve the quality of their wares. By the early 1880s several Trenton potteries had developed a fine porcelain comparable to that of their competitors in the British Isles. The product—hard, thin, and translucent, with a smooth, shiny surface—was especially suited to elegant overglaze decoration in jewel-like enamels, as well as in silver and gold relief.

By about 1883 the firm of Ott and Brewer had succeeded in perfecting a type of eggshell porcelain (a delicate ivory-colored clay body covered with a transparent, colorless glaze) similar to that produced at the Belleek factory. With it they began to make objects whose raised-relief designs, largely inspired by Japanese decoration and applied by the firm's highly skilled artisans, consisted of chased dragonflies, butterflies, cranes, and floral motifs in varying shades of silver and gold. By this juxtaposition of metallic colors on porcelain the firm could achieve the same effects for which Japanese Satsuma, metalwork, and lacquerwork were greatly esteemed.

An Ott and Brewer vase (FIG. 7.5) and a pitcher (FIG. 7.6) are two of the more opulently decorated examples of American Belleek porcelain made during the 1880s. The extravagant use of chased gilding demonstrated in the Japanese-style cranes on the richly colored background of the pitcher and in the golden clouds and flying crane on the green background of the vase impart to these objects a distinctly exotic appearance. With their lavish surface decoration and their elaborate materials and texture, they are clearly intended as pure decoration.

The GREENWOOD POTTERY, in Trenton, also emulated Anglo-Japanesque porcelains. After adding an art department in order to be able to branch out from its production of white granite and semiporcelain utilitarian tableware, Greenwood became one of Ott and Brewer's chief competitors. In a finer line consisting of vases, plaques, and other ornamental forms, Greenwood copied the artistic porcelain wares of the Royal Worcester factory, which had achieved considerable popularity during the early 1880s. In July 1883 the Greenwood Pottery hired from the Royal Worcester works a man named Jones to decorate their special pieces,[34] which borrowed the Japanese designs featured on the Worcester porcelains. As a contemporary description of the Greenwood Pottery noted, "The character of the work is relief gold and enameled decorations in the Japanesque style with European modifications. Many of the pieces have been especially modeled to receive the design of the decoration and are decidedly handsome."[35]

Greenwood products, like those of Ott and Brewer, bear a more direct relation to their English counterparts than to those of the Japanese; in some cases, an unmarked Greenwood vase would be difficult to distinguish from one made by the Royal Worcester factory. Recognizably similar to the Worcester artistry and indeed often mistaken for their superb achievement, Greenwood's raised ornament in shades of gold and bronze was admired in its own day for "forming the richest possible combination of metals that can be imagined."[36] The chief reason for the close similarity in the works of the two potteries is that the Greenwood factory hired more than one artist directly from the Royal Worcester works.[37]

A pair of vases with gilded decoration on a lacquer red ground (FIG. 7.7) demonstrates a striking resemblance to Royal Worcester vases both in form and style of decoration. Vases of this type not only display motifs and techniques of varicolored metallic decoration borrowed from Japanese objects but also adopt Japanese design characteristics, notably a closely detailed depiction of nature portrayed in a spare and asymmetrical composition. Ornamental vessels such as these, decorated with butterflies and trailing plants in raised metallic work, were in vogue through the mid-1880s.

The Royal Worcester style was just one of the different types of decoration advertised in 1886 by the FAIENCE MANUFACTURING COMPANY of Greenpoint, in Brooklyn.[38] Many of that factory's products, using raised gold decoration over an ivory-colored or rich cobalt blue background, recall Royal Worcester prototypes. In 1887 a reporter described such a piece, a large, tall, bottle-shaped vase (FIG. 7.8) with a bulbous base and an attenuated neck, as decorated "by a continuous spray pattern of flowers [chrysanthemums interspersed with butterflies] in the characteristic low-tone golds so familiar in Royal Worcester."[39] Encircling the vase, which is crowned with a dome-shaped cover in gilded arabesque openwork, is a broad band of mazarine blue powdered with gold. Below the band, the same blue is covered with a vermicular pattern in burnished gold as far as the base. The piece was probably made after 1884, when EDWARD LYCETT, an Englishman from Staffordshire who since 1861 had run a china-decorating business in New York, painting and gilding imported wares, was superintendent and chief decorator at the Faience works.

When DAVID FRANCIS HAYNES acquired the CHESAPEAKE POTTERY in Baltimore, in 1882, that firm also developed varieties of pottery having decoration similar to that on English artwares. While Chesapeake's products initially consisted of several kinds of earthenware selling for relatively modest prices, Haynes, with high aspirations "to make pottery the art of arts,"[40] set out to combine art and industry in his ceramics. In April of 1882 Haynes began to expand his business by hiring FREDERICK HACKNEY, an English potter, and putting him in charge of "artistic production."[41] By August of 1883 Hackney had developed "Calvert ware" (FIG. 7.9), predominantly cylindrical forms—mugs, pitchers, and vases—characterized by geometric ornament in horizontal bands, the pieces covered with a blue or green glaze.[42] The decoration recalls that on Rhenish

stoneware, also copied by the Doulton pottery, dating to the latter part of the Middle Ages.

To decorate his Chesapeake products Haynes began to hire art students, mainly women, from the Maryland Institute School of Design in Baltimore.[43] The most refined of the various ceramics produced by the Chesapeake Pottery was called "Severn" or "Severn ware." Vessels formed of a fine-grained grayish brown or grayish green clay, often made in shapes borrowed from medieval sources, included a "pilgrim" bottle (FIG. 7.10), a form recalling stoneware vases of the sixteenth century that was being made in both England and America during the late 1870s and early 1880s. Its popularity may have owed in part to the flat surface on front and back, which offered space suitable for artistic expression in modeled, incised, or painted decoration. The ornamentation on this example—Prunus blossoms and trailing vines—closely resembles plant forms of Japanese origin. The Severn line was adorned with varicolored raised metalwork similar to that appearing on the delicate porcelain vessels made in England at the Royal Worcester factory and in America at the Ott and Brewer and Greenwood potteries. As William C. Prime remarked, "No one who is interested in the art of pottery can fail to note this ware as marking an era in the history of American ceramics."[44]

The Aesthetic era is known not only for the high quality of commercially produced objects but also for the artistic aspirations of the manufacturers who made them. For the first time, pottery was considered not just as a functional, marketable necessity but as an appropriate medium for the expression of art; the art objects fashioned by the American ceramics industry were meant to be displayed, exhibited, and collected.

In order to take advantage of the growing interest in art, the commercial potteries in both England and America developed new lines of ceramics, employing art students, industrial designers, and professional artists for their finer work instead of relying on their in-house decorators. The success of such ventures convinced the proprietors to shift their commercial production entirely to art manufacture. For example, beginning in the mid-1860s, JOSIAH WEDGWOOD AND SONS, LIMITED, hired outside artists to contribute designs to be used by the firm. Among the most influential of these were WALTER CRANE and Christopher Dresser,[45] the latter publishing his views on art and design and creating designs for almost every decorative medium. One of the earliest dated examples of a Dresser design in ceramics, registered in 1867, is a cylindrical vase (FIG. 7.11) with ring handles having a printed pattern of a highly geometric floral motif on a buff-colored, unglazed body. The dynamic, angular style of plant forms treated in an excessively conventional manner typifies Dresser's approach to nature. Although

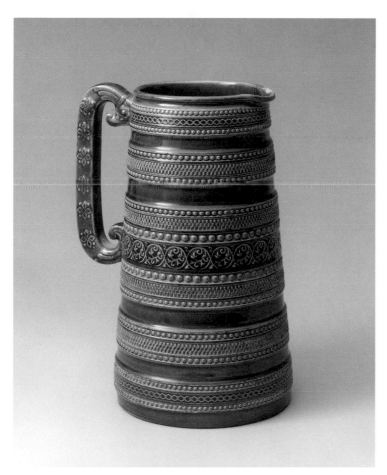

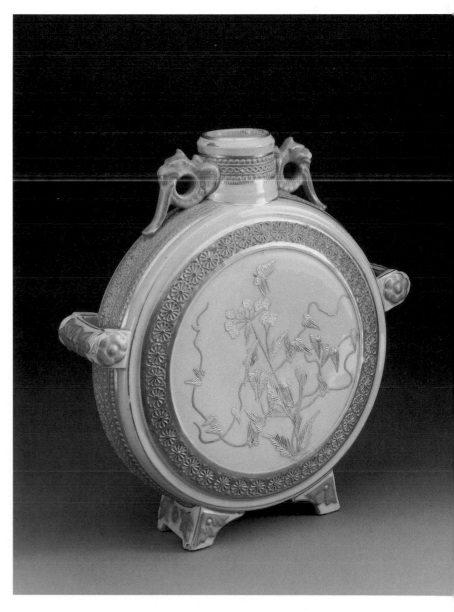

Above: FIG. 7.9 Pitcher. D. F. Haynes and Company, Baltimore, 1883–85. Glazed earthenware, h. 7¾ in. (19.7 cm), diam. 4¼ in. (11.4 cm). Collection of John Nally

Right: FIG. 7.10 Pilgrim bottle. D. F. Haynes and Company, Baltimore, 1883–85. Gilding on glazed earthenware, h. 9 in. (22.9 cm), w. 8¼ in. (21 cm). The Metropolitan Museum of Art, Gift of Florence I. Balasny-Barnes, in memory of her sister, Yvette B. Gould, 1984 (1984.443.3)

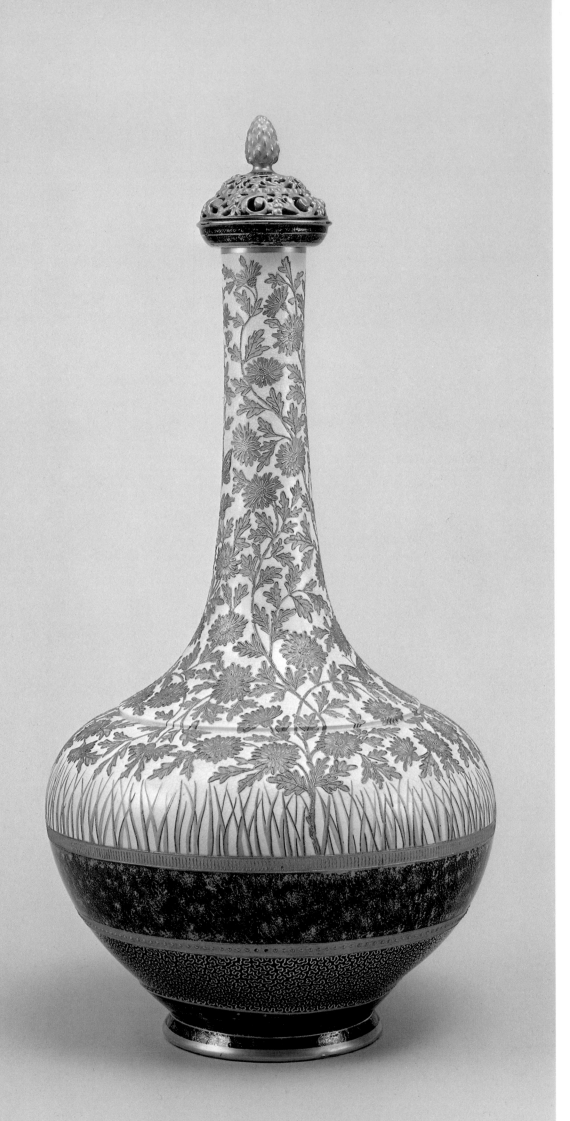

Left: FIG. 7.8 Covered vase. Probably decorated by Edward Lycett, made by Faience Manufacturing Company, Greenpoint, Brooklyn, New York, 1884–87. Gilding and enamel on glazed earthenware, h. 27 in. (68.6 cm), diam. 14½ in. (36.8 cm). The Metropolitan Museum of Art, Gift of Todd Michael Volpe, 1986 (1986.57)

Opposite: FIG. 7.11 Two-handled vase. Designed by Christopher Dresser, made by Josiah Wedgwood and Sons, Limited, Burslem, Staffordshire, England, Mar. 20, 1867. Unglazed earthenware, transfer printed, h. 10 in. (25.4 cm), diam. 7½ in. (19.1 cm). Marked: *Wedgwood.* Private collection

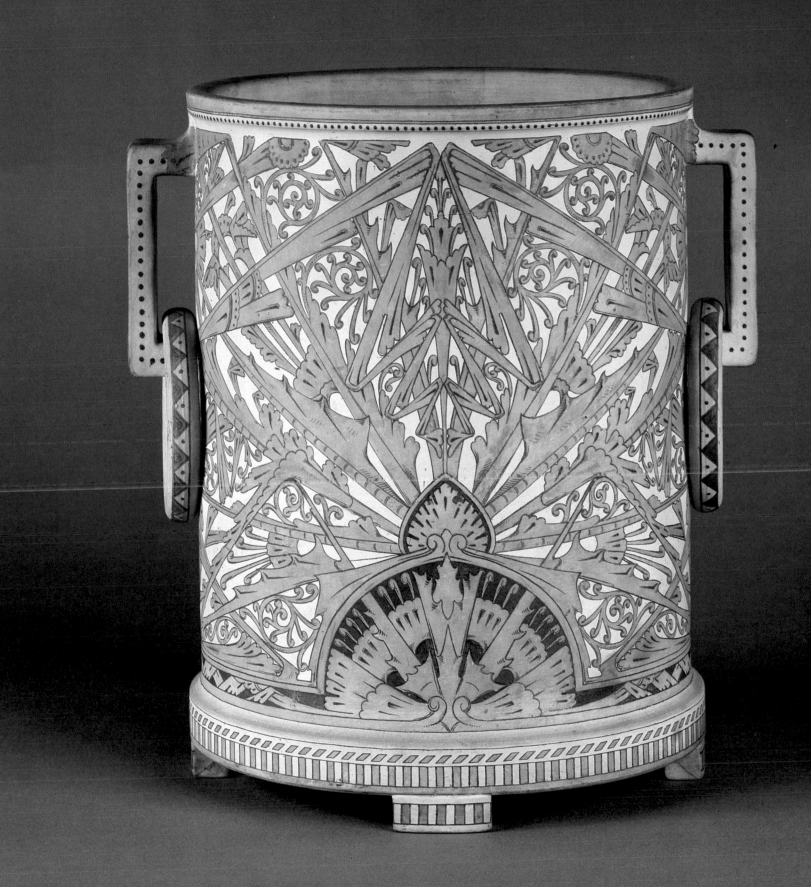

the vase may not have been known by American ceramists, its design would have become familiar through its later publication, captioned "Design Exemplifying Power," which appeared in Dresser's *Principles of Decorative Design* (1873).[46]

Doulton, with the Lambeth School of Art, and Minton, with the South Kensington Museum and Schools of Design, were among the English potteries that began in the late 1860s to establish ties with new schools opened for the training of artisans. The Minton Art Pottery Studio in South Kensington opened in 1871 as a result of such a connection and thereby produced and influenced production of aesthetic patterns often reflecting the current interest in Hellenism, medievalism, and Japanism by such artists as WILLIAM S. COLEMAN and J. MOYR SMITH. "The Rose," for example, a decorated plate (FIG. 7.12) from Smith's *Anacreon* series, features a woman attired in classical drapery lounging on a Grecian couch, the entire central scene framed by a gilded border of waves and stylized blossoms of Japanese derivation.

In Chelsea, Massachusetts, JAMES ROBERTSON AND SONS, which in 1872 began using the name Chelsea Keramic Art Works, exemplified the idea of an American "art pottery."[47] As a contemporary critic stated, "They may possibly have reached the conviction that Chelsea is to be numbered among the places where artists value their work solely according to its truth, excellence, and beauty. Without affecting to disregard commercial considerations, they succeed in giving their art the precedence."[48] Whereas some English commercial potteries had aligned themselves with an art school or studio, the American Chelsea pottery was described in an 1876 report as "a practical art school, where the study of artistic forms and groupings goes hand in hand with artistic work."[49] John Gardner Low and Hugh Robertson, at the time the firm's principal designers, Francis X. Dengler (1853–1879), William Rimmer (1816–1879),[50] and GEORGE W. FENETY[51] were prominent artists known to have designed for the Chelsea pottery. Rather than serving as nameless decorators in large industrial factories and producing designs severely limited to commercial standards, the Chelsea men specified the shape, finish or glaze, and

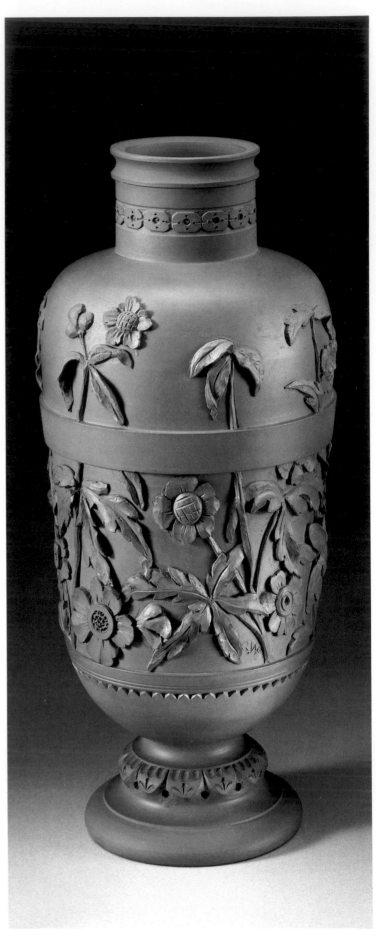

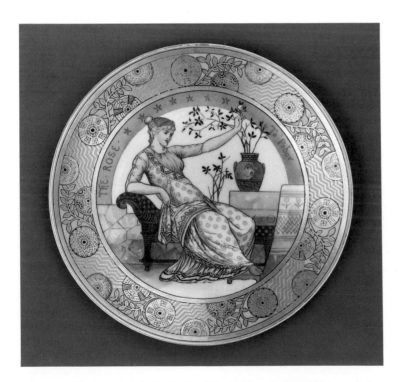

FIG. 7.12 "The Rose" (plate). Designed by J. Moyr Smith, blank made by Minton and Company, Stoke-on-Trent, Staffordshire, England, ca. 1878. Gilding and enamel on porcelain, diam. 10 in. (25.4 cm). Marked: *MINTONS* / *T.GOODE & CO* / *LONDON, MINTONS*. Collection of John Nally

FIG. 7.13 Vase. George W. Fenety, made at Chelsea Keramic Art Works, Chelsea, Mass., ca. 1876–79. Unglazed terracotta, h. 14 in. (35.6 cm), diam. 6 in. (15.2 cm). Signed: *GWF*, marked: *CHELSEA KERAMIC ART WORKS* / *ROBER . . .* / *C* / *KA* / *W*. Collection of R. A. Ellison

surface decoration of the vases for which they were individually responsible. The artist was no longer anonymous; instead, Robertson, Dengler, Fenety, and others often added their own signatures or cyphers to their works along with the mark of the company. One Chelsea vase (FIG. 7.13), signed with the initials of Fenety, features incised and carved surface decoration of simplified and stylized buttercup-like flowers. In the same unglazed terracotta that the Chelsea pottery had used in its earlier years for garden earthenware, Fenety's vase, divided into three broad horizontal bands of a floral pattern, is reminiscent of sixteenth-century stoneware.

ISAAC ELWOOD SCOTT, a designer whose various projects included furniture, architecture, and interiors, created two pairs of vases in 1879 for his devoted collector-patrons Mr. and Mrs. John J. Glessner of Chicago.[52] The vases, in the popular pilgrim-bottle form—one pair covered in a green glaze and the other unglazed—were executed at the Chelsea works. On one of the unglazed pair, the decoration in high relief (FIG. 7.14), grotesque birds and animals, possibly derived from the Japanese woodcuts and illustrated books that also captured the imagination of potters in England (the Martin brothers, famed for their products of bizarre animal forms, among them) may have been Scott's inspiration.

Largely because Hugh Robertson, in 1880 directing the activities of the firm after the death of his father, James, had developed an interest in oriental ceramics undoubtedly generated by the Chinese and Japanese displays he had seen at the Philadelphia Exposition, the Chelsea pottery began in late 1876 to produce glazed pottery with low- and high-relief decoration. That preoccupation with glazes was to obsess Robertson for the rest of his career. He must also have known about the great Boston collections of Far Eastern art that Jarves, Morse, Fenollosa, and Bigelow had acquired, since the highly developed wares his pottery produced attest to a keen familiarity with oriental prints, ceramics, and metalwork.

In Robertson's works, oriental art objects inspired not the piece's surface decoration, such as that also found on the richly ornamented porcelains and earthenwares of the Trenton and Baltimore potteries, but, rather, its general shape, color, and surface

FIG. 7.14 Pilgrim bottle. Isaac Elwood Scott, made at Chelsea Keramic Art Works, Chelsea, Mass., 1879. Unglazed earthenware, h. 14½ in. (36.8 cm), w. 10¾ in. (27.3 cm). Signed: *Scott / 79,* marked: *To John J. Glessner / of Chicago / from Scott . . . / Oct. 25 1879, C / KA / W.* The Glessner House, Chicago Architecture Foundation, Gift of Mrs. Charles F. Batchelder

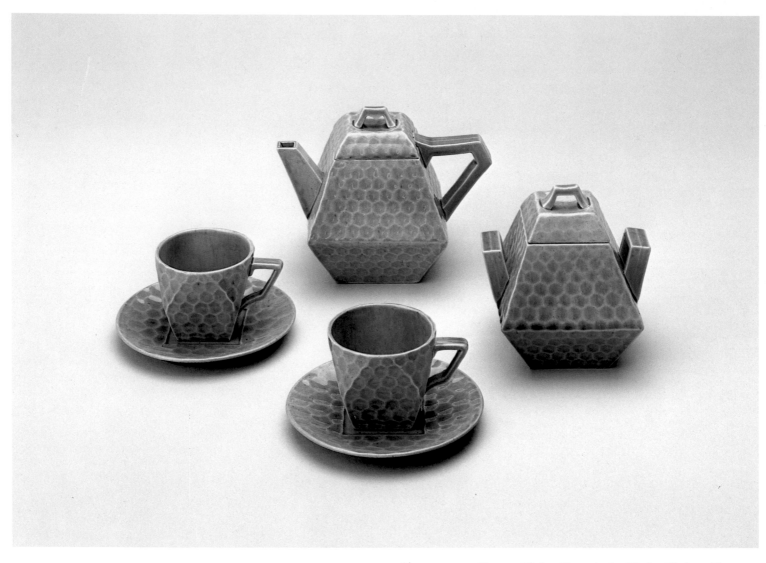

Above: FIG. 7.15 Tea set. Chelsea Keramic Art Works, Chelsea, Mass., 1879–83. Glazed earthenware; teapot: h. 4¾ in. (12.1 cm), w. 3¾ in. (9.5 cm), sugar bowl: h. 4½ in. (11.4 cm), w. 3½ in. (8.9 cm), each teacup: h. 2½ in. (6.4 cm), diam. 3⅜ in. (8.6 cm), each saucer: diam. 4¾ in. (12.1 cm). Each marked: *CHELSEA KERAMIC / ART WORKS / ROBERTSON & SONS,* saucers also marked: *C / KA / W.* The Metropolitan Museum of Art, Gift of Mr. and Mrs. I. Wistar Morris III, 1982 (1982.440.1–4)

Opposite top: FIG. 7.16 Vases. Chelsea Keramic Art Works, Chelsea, Mass., 1880–83. Glazed earthenware; left: h. 9¼ in. (23.5 cm), diam. 4½ in. (11.4 cm), right: h. 8 in. (20.3 cm), diam. 3¾ in. (9.5 cm). Each marked: *C / KA / W.* Collection of R. A. Ellison

Opposite bottom: FIG. 7.17 Vases. Chelsea Keramic Art Works, Chelsea, Mass., 1880–83. Glazed earthenware; left to right: h. 9½ in. (24.1 cm), diam. 4¼ in. (10.8 cm); h. 5½ in. (14 cm), diam. 2½ in. (6.4 cm); h. 8¾ in. (22.2 cm), diam. 4 in. (10.2 cm); h. 7⅞ in. (20 cm), diam. 3½ in. (8.9 cm). Each marked: *C / KA / W,* far right also labeled: *M.F.A. / H. Robertson / Chelsea / No.17.* Collection of R. A. Ellison

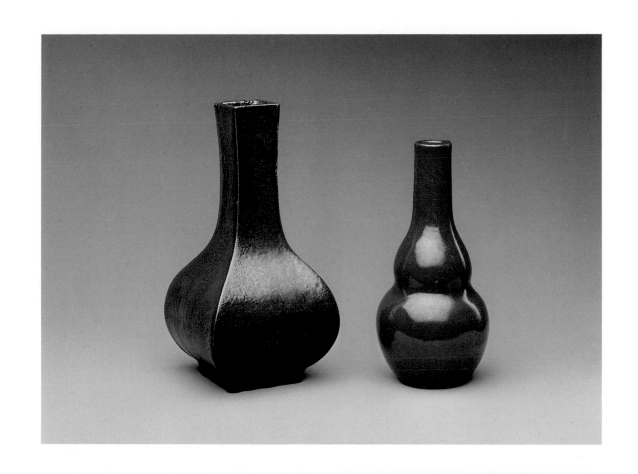

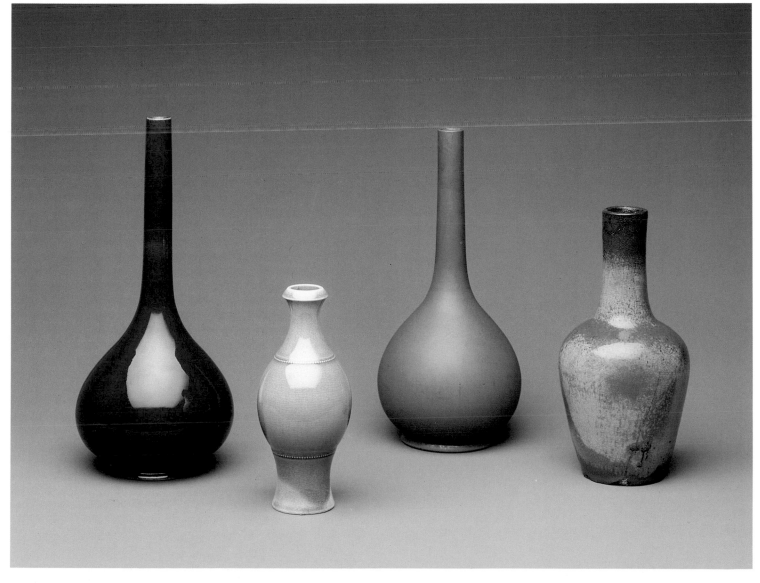

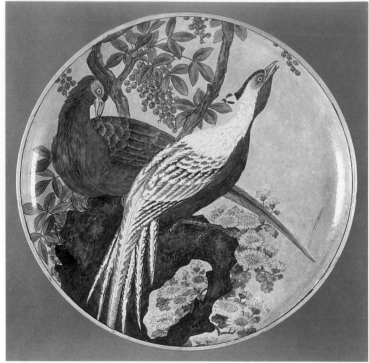

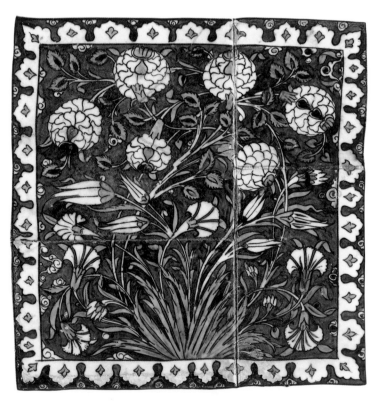

texture. An allover surface treatment resembling hand hammering, which produced a low-relief honeycomb pattern, was used by the Chelsea firm on a variety of forms: on a delicate tea set (FIG. 7.15) the surface and the angular planes recall Japanese ceramics and metalwork. Not surprisingly, the tea set is remarkably similar to metalwork designs by Dresser, himself strongly influenced by Japanese art. By 1876 Dresser had amassed a considerable collection of Japanese art objects for TIFFANY AND COMPANY of New York, which sold it at auction in 1877.[53]

The focus on surface decoration and form that characterized Chelsea production during the mid-1870s had shifted by the end of the decade to glazes, oriental ones in particular. Soft, cool blue-green glazes resembling Chinese celadon were introduced during the late 1870s, a period in which Hugh Robertson became almost totally consumed by his desire to simulate the Chinese sang-de-boeuf, also known as dragon's-blood, glaze. His numerous experiments finally resulted in successful deep, rich, and lustrous finishes, which his firm used for simple oriental vase shapes (FIG. 7.16). During the course of its experiments to obtain the blood red glaze, the Chelsea firm also perfected various others, these in Chinese-like colors of deep blue, apple green, mustard yellow, and peach bloom (FIG. 7.17). Faithful imitations of Japanese crackleware were also achieved through Robertson's efforts. Though collectors had been interested in the pottery's wares from the beginning, Robertson's single-minded devotion to art, combined with his total inattention to commercial details, caused his company to founder. In 1889, nearly penniless from his costly experiments with the sang-de-boeuf glaze, Robertson closed the Chelsea Keramic Art Works.[54]

Unlike the products of the Chelsea Keramic Art Works, which relied primarily on surface texture and glazes for their decorative effect, the ceramics designs of Charles Volkmar (1841–1914) and JOHN BENNETT in New York and M. LOUISE MCLAUGHLIN and Maria Longworth Nichols in Cincinnati were painted directly onto the form. Although the tradition of painted pottery had its roots in sixteenth-century Italian *maiolica,* the interest of all four ceramists reflects the late nineteenth-century revival of the craft. In England, the London firm of Howell and James specialized in the production

ILL. 7.10 Bottle. Iranian, second half 17th century. Glazed earthenware, h. 11¾ in. (29.8 cm). The Metropolitan Museum of Art, Theodore M. Davis Collection, Bequest of Theodore M. Davis, 1915 (30.95.157)

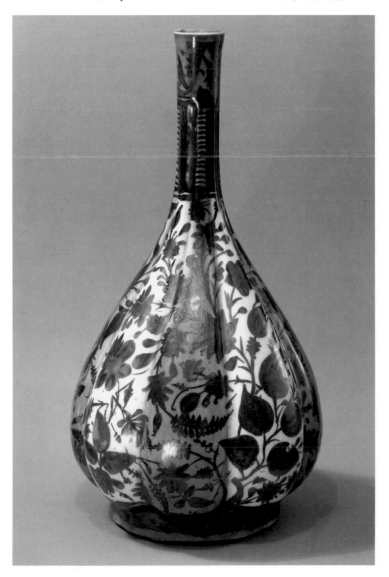

and retailing of "art manufactures" and also organized competitions for painting on porcelain that resulted in entries that were much admired in displays at the Paris Exposition Universelle of 1878. Biscuit-pottery vases and plaques for exhibition and for commercial distribution were being painted by both men and women artists (though mostly women). A striking example of such work is the head of a Japanese woman (ILL. 7.8) framed by Prunus blossoms, which was painted on a Minton blank probably by DANIEL COTTIER or by one of the designers in his employ at the New York gallery that he opened in 1873.

In keeping with the Aesthetic-movement practice of combining art and education at the manufacturing level was the collaboration between the Doulton factory and the Lambeth School of Art. Growing out of Henry Doulton's association with John Sparkes, the head of the school, the joint effort began in the 1860s when Doulton decided to revive the production of a type of pottery from medieval times known as glazed stoneware, but this time in artistic interpretations. At the urging of John Bennett, an artist who had studied china painting in Staffordshire and who may have been hired by Doulton at Sparkes's suggestion, Doulton established a painted faience, or earthenware, department supervised by Bennett to educate students, principally women trained at the Lambeth School of Art, in underglaze decoration. A plaque dated 1873 (ILL. 7.9), its form ideally suited to its underglaze decoration of a painted peacock, is one of the earliest known examples of Bennett's work in Doulton's newly established faience department.

Bennett's technique of underglaze decoration—the design painted in thin, richly colored slip onto the surface of a vessel before a coating of clear, shiny glaze is applied—was one he worked to perfect throughout his career. His efforts were greeted with adulation by critics of the day, and the process, which was emulated by Bennett's art-potter contemporaries, came to be dubbed "Bennett ware." When examples of his work and that of other artists appeared in the impressive Doulton displays at the Philadelphia Centennial, they proved an irresistible inducement for collectors to begin to acquire the pottery and porcelain of their own time. American praise lavished on the Doulton wares encouraged Bennett in 1877 to move to New York, where he hoped to gain full recognition for his work.[55] The influence on Bennett of the combined decorative elements of sixteenth- and seventeenth-century Islamic wares (FIG. 7.18) and contemporary English copies of them, notably those by William De Morgan (1839–1917), is highly visible in a vase (FIG. 7.19) that is one of the earliest examples of Bennett's New York oeuvre. Its bulbous body and attenuated form echo the shape of seventeenth-century Islamic water bottles (ILL. 7.10); the carnations, tulips, and leaves that decorate it are painted in colors—cobalt blue, turquoise, green, and a thickly applied red—found on the so-called Rhodian pottery made at Isnik, in what is now Turkey, where some of Islam's finest ceramics originated. The vase may have been inspired both by the painter Frederick Leighton's (1830–1896) famous collection of pottery, which Bennett had seen in Leighton's London home before he left for New York,[56] and by the walls of the house, which were lined with tiles created by De Morgan in varying hues of purple, blue, and green, in imitation of Islamic designs.

Bennett's style of painting and his choice of subject matter had much in common with that of the English reform designers De Morgan and WILLIAM MORRIS. Like their work, Bennett's is dominated by flowers and fruit: natural forms stylized into flat, two-dimensional patterns akin to those of Morris's wallpapers. The special Bennett effect stems from the contrast of crisp dark outlines on blossoms, leaves, and fruit against light, mottled background colors. The shape of a covered vase (FIG. 7.20) was one he apparently favored, to judge by the number of similar examples that survive. It provided Bennett with a form on which he could organize his designs into three horizontal sections, in much the same manner that aesthetic wallpaper was divided (the foot, body, and

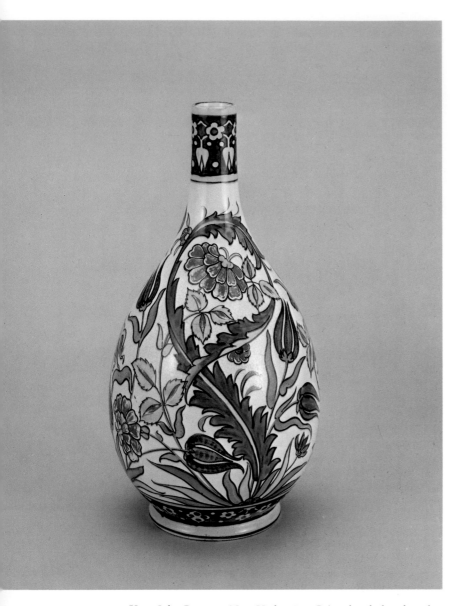

FIG. 7.19 Vase. John Bennett, New York, 1878. Painted and glazed earthenware, h. 13¼ in. (33.7 cm), diam. 6½ in. (16.5 cm). Marked: *BENNETT / 101 Lex. Ave / N.Y. 1878.* The Metropolitan Museum of Art, Gift of Mr. and Mrs. I. Wistar Morris III, 1984 (1984.448.3)

lid of the vase correspond to the dado, fill, and frieze), with the same motif in all three divisions, though treated differently in each. The body, or "fill," of Bennett's vase depicts oranges and olive green foliage in a stylized though recognizably naturalistic manner, but the oranges and blossoms on the foot and the lid are purely geometric, their naturalism sacrificed for ornamental effect.

Numerous exhibitions of Bennett's work, sponsored by decorative-arts societies in Boston, New York, Cincinnati, San Francisco, and elsewhere, made it well known across America. His colors—an early palette of somber earth tones in velvety greens, rich browns tinged with red, and deep blues reminiscent of English textiles, replaced in the beginning of the 1880s by a brighter range of brilliant yellows, reds, turquoises, and mazarine blues[57]—were universally praised in the decorative-arts journals of the day. One such vase (FIG. 7.21), dated 1882, features pink-and-white dogwood blossoms on a bright chrome yellow background randomly scattered with spriglike elements of slightly darker tone, an effect resembling a patterned paper. The rim of the vase is glazed in mottled blue, green, and brown, perhaps to suggest a semiprecious stone. On another vase (ILL. 7.11) made in the same year, vivid magnolia blossoms in white tinged with pink stand out sharply against a background of a green so deep as to appear almost black. One of the largest Bennett vases known, it is more than two feet in height. Through the critical acclaim he received, and through displays of his work in public exhibitions and in the showrooms of the country's best china dealers—Tiffany and Collamore in New York; Abram French and Company in Boston, all of which placed Bennett ware on their shelves alongside Haviland faience from Limoges and other European art pottery—his ornamental vases were soon attracting the attention of dealers, collectors, and museums alike.[58]

Decorative-arts societies played a key role in fostering widespread interest in ceramics; they sponsored exhibitions, and they also arranged for experienced potters and artists to provide instruction in china painting. In 1878 Bennett was the first artist to offer classes in pottery decoration at New York's recently founded Society of Decorative Art, though he taught there for only one year. Organized to promote "decorative work of any description done by women,"[59] the society established instruction in china painting, along with needlework and wood carving, as a primary activity. Bennett was greatly in demand as a teacher: the persistent and unsuccessful attempts of a group of Cincinnati china painters to lure him away from New York is evidence of the high esteem in which he was held.[60]

In America, because of his work and his teaching, Bennett was a primary conduit for conveying English aesthetic principles, particularly those of the Doulton pottery. His distinctive style and technique, renowned nationwide, fostered a broad acceptance of stylized forms in underglaze decoration. Though it is hard to imagine why the reputation he enjoyed was of such comparatively brief duration, in 1883, just as the art-pottery movement was gaining momentum in America, he retired to New Jersey. He continued his painting and potting there, but in relative obscurity. He never regained his former prestige.

In 1879 Bennett was succeeded at New York's Society of Decorative Art by Charles Volkmar, another painter who turned to ceramics.[61] Although Bennett and Volkmar worked in the same city during the same years and often displayed their wares at the same exhibitions, their styles were markedly different. Bennett's chief influence came from England, but Volkmar's came from France, where while studying landscape painting he had developed an interest in ceramics, particularly the "Limoges" method of underglaze slip painting he espoused. An underglaze design can achieve considerable depth according to the thickness of the slip with which it is executed. Volkmar's work is as different from Bennett's as oil painting is from watercolor: whereas Bennett's effect derives from his preference for a thinly applied slip and glaze,

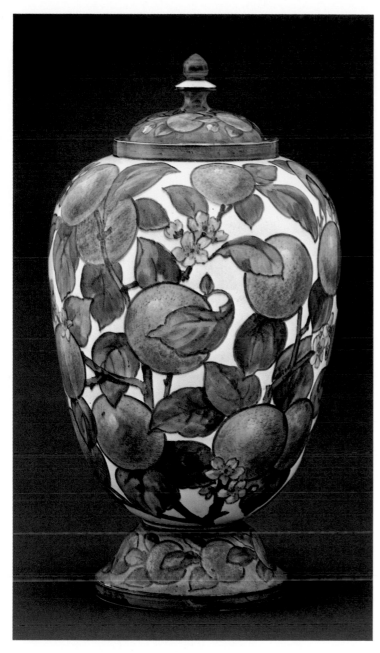

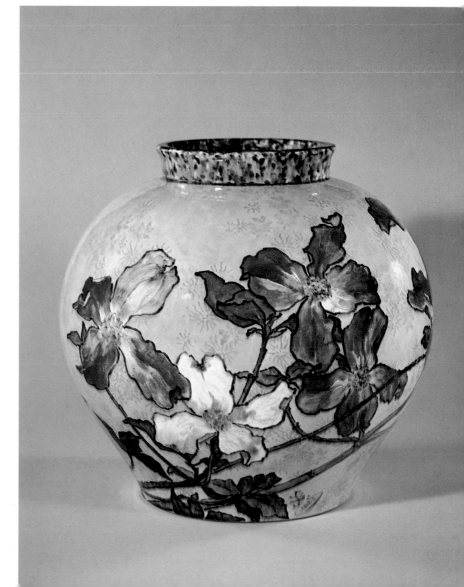

Above: FIG. 7.20 Covered vase. John Bennett, New York, 1877–78. Painted and glazed earthenware, h. 12¼ in. (31.1 cm), diam. 6⅜ in. (16.2 cm). Marked: *BENNETT / 101 Lex. Ave. N.Y.* High Museum of Art, Atlanta, Virginia Carroll Crawford Collection (1982.287)

Right: FIG. 7.21 Vase. John Bennett, New York, 1882. Painted and glazed earthenware, h. 11 in. (27.9 cm), diam. 11 in. (27.9 cm). Signed: *JB* [monogram] / *1882,* marked: *JBENNETT / NEW YORK. / 1882.* The Metropolitan Museum of Art, Friends of the American Wing Fund, 1984 (1984.425)

Volkmar's designs are so thickly painted as to appear in relief.[62]

Volkmar's advice to his students, to "treat the clay as one would a canvas,"[63] is carried out in his own work. His textures and finishes, closely resembling canvases painted with heavy impasto, reveal the strong influence of his serious artistic training. The pottery shapes he chose—flat-sided vases and plaques—provided a canvas-like surface on which he could paint. The landscapes with ducks or animals that are his usual subject matter recall the work of the Barbizon painters, though he departed from that formula in the plaque (ILL. 7.12) he decorated with a woman's portrait. With her laurel wreath he alludes to classical Greece; with her costume, to Elizabethan England; with her long, light reddish brown hair, to the Pre-Raphaelites. Volkmar's and Bennett's serious interest in ceramics, and especially china painting, communicated itself to the art-conscious public and soon became the rage. China painting was taught in decorative-arts societies and clubs in countless cities and towns throughout North America, with the New York Society of Decorative Art maintaining classes in it as an integral part of its curriculum at least through 1885.[64]

Across the country, the growth of American art potteries was matched by the increasing interest in china painting. The tradition of china painting in the United States, begun during the late 1870s and by 1893 engaging more than 25,000 women artisans, was to continue until well after World War I, particularly on an amateur level.[65] Art clubs and art societies sprang up everywhere to give instruction in the skill, and many advertisements in newspapers and magazines offered both lessons in china painting and services for firing the finished wares. As an activity often performed in organized groups, it was a pursuit that had a social as well as a creative function. It was popular with amateur painters, who found it a suitable leisure activity, and with professional artists, who sold their wares to supplement their income—a reasonably simple means of profitable artistic endeavor.

In New England, CELIA THAXTER, an essayist and poet by profession, was part of a circle that included Childe Hassam (1859–1935) and William Morris Hunt (1824–1879), artist friends who may have encouraged her to paint the picturesque surroundings of the Isles of Shoals, off the coast of New Hampshire, where she

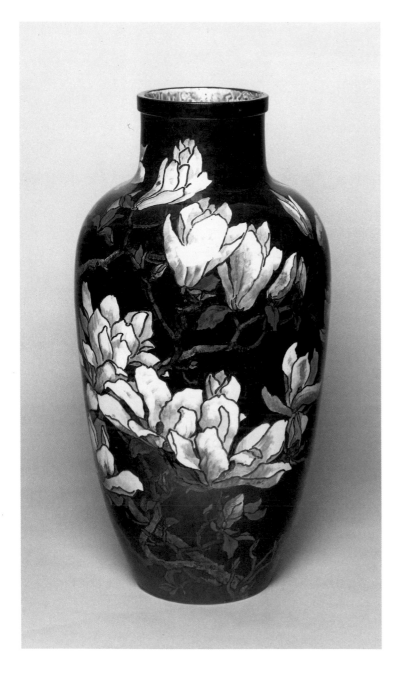

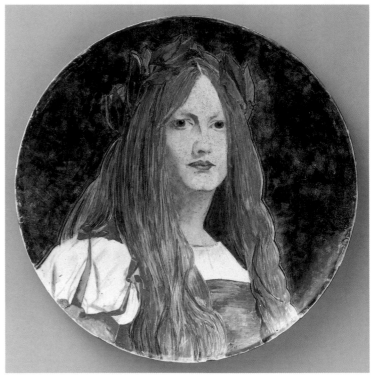

Above: ILL. 7.12 Plaque. Charles Volkmar, New York, ca. 1880. Painted and glazed earthenware, diam. 11⅛ in. (28.3 cm). Marked: *VOLKMAR.* Collection of R. A. Ellison

Left: ILL. 7.11 Vase. John Bennett, New York, 1882. Painted and glazed earthenware, h. 25⅞ in. (65.7 cm), diam. 13½ in. (34.3 cm). Signed: *JB* [monogram] / *1882* / *NY,* marked: *BENNETT / 412 E 24 / NEW YORK / 1882.* Museum of Art, Carnegie Institute, Pittsburgh, Mr. and Mrs. George R. Gibbons Fund, 1984 (84.58)

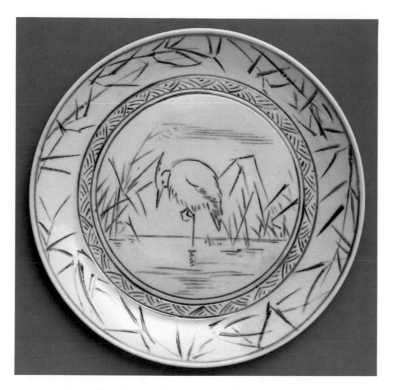

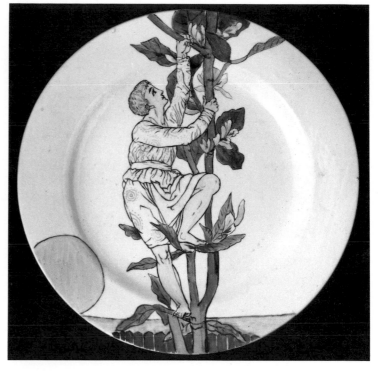

FIG. 7.22 Plate. Alice Cunningham Ware, Milton, Mass., 1876. Incised and glazed earthenware, diam. 7½ in. (19.1 cm). Marked: ACH [monogram], labeled: *Turned on a Potters Wheel, Impressed and Painted by Alice H. Cunningham, Mrs. Wm. R. Ware of Milton, Massachusetts, 1876 / Given to H. A. G. by her / no. 176.* Collection of Sonia and Walter Bob

FIG. 7.24 Plate. Decorated by Helen Metcalf, Providence, R.I., ca. 1885, after a design by Walter Crane for *Jack and the Beanstalk* (London, 1874), blank made in China. Painted porcelain, diam. 7⅞ in. (20 cm). Museum of Art, Rhode Island School of Design, Providence, Gift of Murray S. Danforth (36.155)

lived. Unlike the many china decorators who did not have to rely on their painting for their livelihood, Thaxter's interest in the skill may have grown out of a need to supplement her modest income.[66] Although she began in 1874, she first mentioned her new interest in a letter dated 1876: "I am painting on china now. It is most exquisite work, fit for fairies."[67] Whether Thaxter received formal instruction or where she fired her work is not known, but she may have used the kilns at the Boston Society of Decorative Art, and if so, possibly through her friendship with WILLIAM ROTCH WARE, who taught there. Her early work derived from Japanese art, as she described it in a letter of 1877: "Plates, tinted just pale sea-green, and a Japanese lady . . . in the middle of each, with birds, or butterflies or bats or turtles, swallows, dragon-flies, lizards, beetles, any and everything, on the border, with flowers and grasses or leaves, all copied from the Japanese."[68] In the decade following an 1880 trip through Italy, Thaxter's work shows new subject matter, usually designs of olives and olive branches (see FIG. 1.3) rendered in a naturalistic fashion and depicted in a palette limited to deep purple for the fruit and varying tones of green for the leaves, frequently accompanied by a painted inscription in ancient Greek.

ALICE CUNNINGHAM WARE, an artist and poet also from New England and widely admired in her own time, is today almost forgotten.[69] Her interests included all the decorative arts—wood carving, mural painting, book illustrating, and china decorating.[70] She showed some of her work in china painting at the Centennial Exposition's Women's Pavilion, where the majority of the exhibitors were from Massachusetts.[71] What she displayed there is not recorded, but it may have been in the nature of a plate (FIG. 7.22) she did that year which has sgraffito, or incised, decoration highlighted with cobalt blue, a characteristic of some wares made in the early years of art-pottery production at the Doulton factory. On the plate, the simple design of a heron standing on one leg is framed by a border derived from oriental patterns. Alice Ware may also have been one of the "two young ladies from Boston" who at

the 1877–78 exhibition of the Society of Decorative Art in New York entered what the catalogue described as a small pitcher, "blue-grey in tone," having a "design of field grasses and clover leaves, finished with delicate lines of beading,"[72] and sounding remarkably similar in technique and style to the known example by Ware.

HELEN TANNER BRODT, an artist trained in the East, settled in Oakland, California, where she taught china painting in the early 1880s. She brought her own work in that genre to such a high level that at the World's Industrial and Cotton Centennial Exposition in New Orleans (1884–85), it won an award. A plate she decorated in 1881 (FIG. 7.23), using an imported porcelain blank, combines some of the more universal aspects associated with the Aesthetic movement. Brodt has bestowed on it a random, collage-like arrangement of irregularly shaped motifs—Japanese fans, butterflies, field flowers, birds, and peacock feathers—roughly bordering a central vignette that might have come from the pages of a child's book: a sprite seated on a toadstool among fiddlehead ferns.

In a similar vein, about 1885 HELEN METCALF painted a set of china plates drawn from Walter Crane's illustrations in popular children's books of the period, including *Jack and the Beanstalk* (1874) (FIG. 7.24) and *The Baby's Opera* (1877). Metcalf's subject and her painting style, true to the decorative mode of the day, rely heavily on book illustration, especially in the flat areas of color bordered by dark outlines on a white ground. In her spare reorganization of the figures, which appears to owe a debt to Japanese art, her compositions deviate slightly from the original printed ones. Metcalf's apparently brief stint in china painting is only partial evidence of her steadfast commitment to the ideals of the Aesthetic movement: she had founded the Rhode Island School of Design in March of 1877 and continued to play an active role in it until her death, in 1895. The school not only provided instruction in design but also aimed at the "general advancement of public art education by the collection and exhibition of works of art."[73]

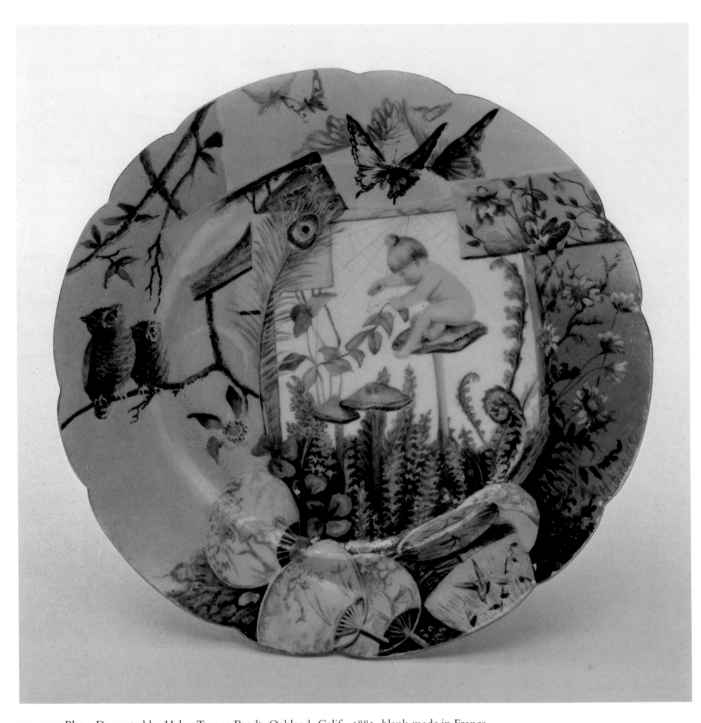

FIG. 7.23 Plate. Decorated by Helen Tanner Brodt, Oakland, Calif., 1881, blank made in France. Painted porcelain, diam. 8⅜ in. (21.3 cm). Signed: *Helen Brodt / Oakland 1881*. The Oakland Museum, Calif., Gift of Miss Virginia Perry Wilson (65.173.6)

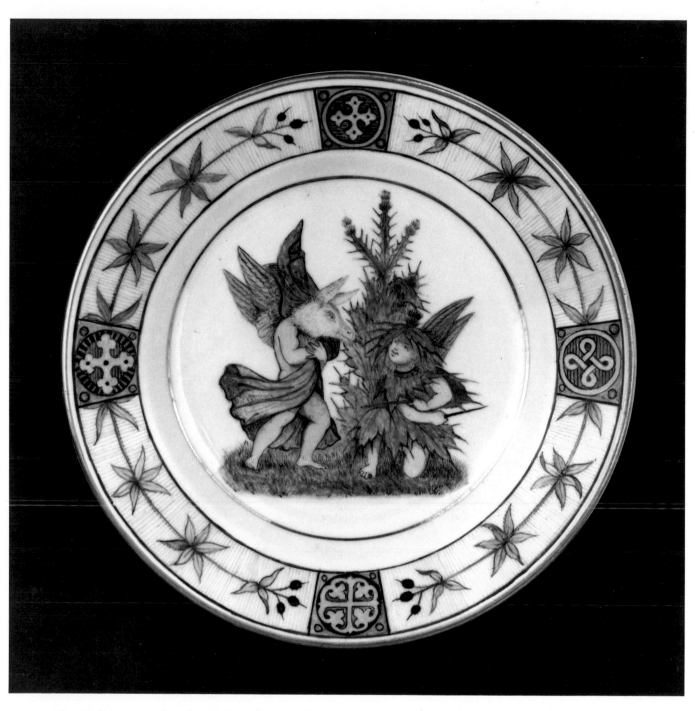

FIG. 7.25 Plate. Decoration attributed to Karl Mueller, made by Union Porcelain Works, Green-point, Brooklyn, New York, ca. 1876. Painted porcelain, diam. 9½ in. (24.1 cm). Marked: [eagle's head with S in beak]. Collection of John Nally

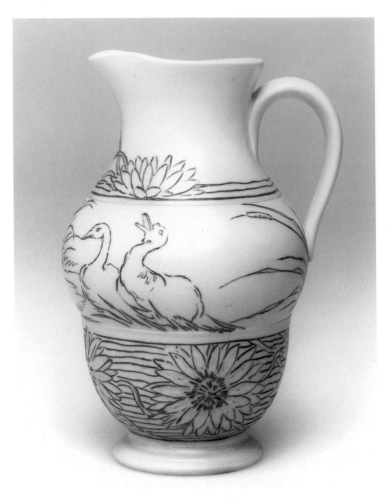

FIG. 7.27 Pitcher. Decorated by Laura Fry, made by Rookwood Pottery, Cincinnati, 1881. Incised and glazed earthenware, h. 8⅝ in. (22 cm), diam. 6⅛ in. (15.6 cm). Marked: *LAF* [monogram] / *1881* / *Cin. Pottery Club*. Cincinnati Art Museum, Gift of the Women's Art Museum Association (1881.48)

FIG. 7.28 *Pottery Decoration under the Glaze* (Cincinnati, 1880). M. Louise McLaughlin. Cover: 7⅜ × 5⅞ in. (18.7 × 14.9 cm). Cincinnati Art Museum, Gift of Mr. Gest's Office (no. 14166)

A book illustration was undoubtedly also the source for KARL MUELLER's design on a plate (FIG. 7.25)[74] made by the Union Porcelain Works, the factory that employed him. The firm had a thriving production of utilitarian white porcelain that had begun in the mid-1860s, but its proprietors had turned to more artistic pursuits, particularly in the field of decorated porcelain, by the early 1870s. In 1874 they hired Mueller, an artist trained in his native Germany, to work on the firm's special exhibition pieces for the 1876 Philadelphia Exposition. The painted border of his plate is characteristically aesthetic in style, though it derives more from the Gothic mode than from the Japanese. Four different Gothic ornaments divide the border into four parts, each containing a stylized plant, the Indian cucumber root (*Medeola virginiana*), in a symmetrical and almost geometric arrangement.[75]

Of all the cities where china painting flourished, nowhere was it more eagerly absorbed or did it have a more lasting effect than in Cincinnati, where BENN PITMAN, an Englishman active in the revival of all handcrafted arts, stimulated local interest in it. What was to become a major center for pottery manufacture and decoration began modestly in 1874, when Pitman's wood-carving class of Cincinnati women, which he had established the previous year, met informally to learn the art of china painting, applying to ceramics some of the skills and designs they had mastered while working with wood. Through "careful observation, and patient delineation of the constantly changing aspects of nature . . . all the

way from strictest conventionalism to purist realism,"[76] Pitman provided his students with an artistic philosophy that could be traced directly to the edicts of John Ruskin (1819–1900). The achievements of Cincinnati women in pottery decoration were soon to receive national attention, making them models for similar activity elsewhere in America. A redware vase (FIG. 7.26) by AGNES PITMAN, one of Benn's daughters, resembles her work in wood carving, in which she was greatly talented. On the vase, naturalistic chrysanthemums appear in juxtaposition with elements derived from them but geometric in form (a decorative device found on many pieces of furniture designed by her father). The flattened, naturalistic blossoms around the lower half of the clay vase are carved in low relief, as if in wood.[77] Above them, a horizontal band contains their elements halved and quartered, simplified and denatured to a bare outline that recalls the design theories published by Dresser. At the top, a pattern of very small stamped and gilded hexagons completes the decoration.

In 1879 twelve of Pitman's women students, fortified by his introduction to china decorating, formed the Cincinnati Pottery Club, with M. Louise McLaughlin as president. The association was to have a far-reaching influence on American ceramics. Three years before, the women, led by McLaughlin, had visited the exhibitions at the Philadelphia Centennial, where they were among the thousands of fairgoers impressed by the English, French, and Japanese ceramics displays. The vases, jugs, and plaques that the

Right: FIG. 7.30 *Pottery: How It Is Made, Its Shape and Decoration* (New York, 1878). George Ward Nichols. Illustrated by Maria Longworth Nichols. Cover: 7½ × 5⅜ in. (19.1 × 13.7 cm). The Strong Museum, Rochester, N.Y.

Below left: FIG. 7.31 Vase. Decorated by Maria Longworth Nichols, made by Rookwood Pottery, Cincinnati, ca. 1880. Painted and glazed earthenware, h. 17½ in. (44.5 cm), diam. 8½ in. (21.6 cm). Marked: *MLN* [monogram]. High Museum of Art, Atlanta, Virginia Carroll Crawford Collection (1984.127)

Below right: FIG. 7.32 Vase. Decorated by Maria Longworth Nichols, made by Rookwood Pottery, Cincinnati, 1882. Painted and glazed earthenware, h. 9½ in. (24.1 cm), diam. 4¼ in. (10.8 cm). Marked: *M.L.N. 1882, ROOKWOOD / 1882 / G 102*. Collection of R. A. Ellison

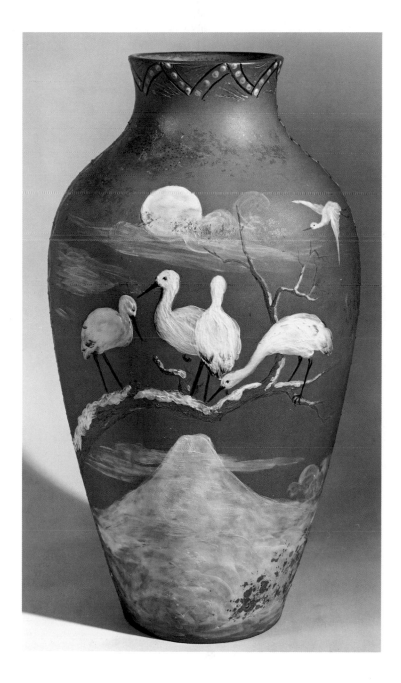

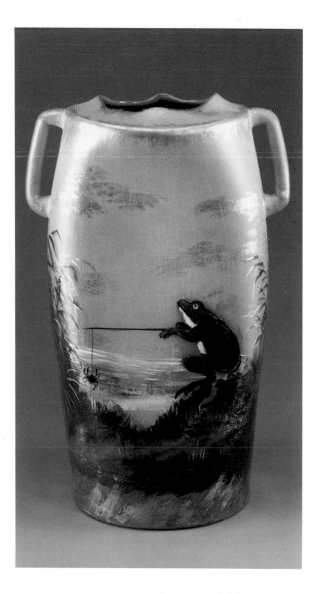

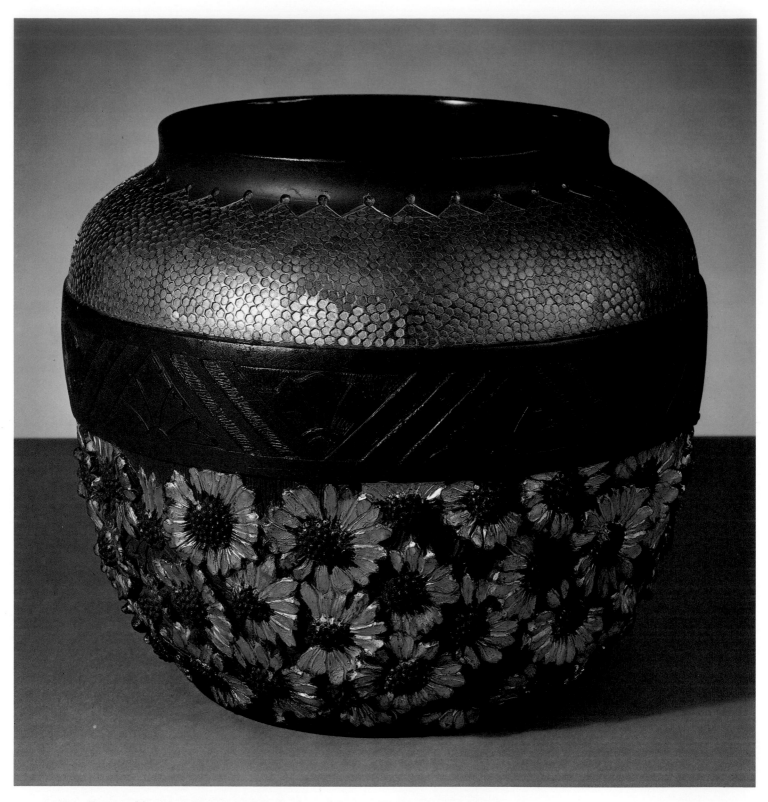

FIG. 7.26 Vase. Decorated by Agnes Pitman, made by Rookwood Pottery, Cincinnati, 1885. Glazed and gilded earthenware, h. 10¼ in. (26 cm), diam. 11½ in. (29.2 cm). Marked: *1885 / R.* Cincinnati Historical Society, Gift of Melrose Pitman

FIG. 7.29 Vase. M. Louise McLaughlin, Cincin-
nati, 1880. Painted and glazed earthenware, h.
39⅜ in. (100 cm), diam. 16¼ in. (41.3 cm). Pri-
vate collection

women decorated during the Pottery Club's early years suggest what they had seen in Philadelphia, especially English examples from the Doulton works in Lambeth and French pieces from the Haviland pottery in Limoges.

LAURA FRY, whose father, WILLIAM HENRY FRY, and grandfather HENRY LINDLEY FRY were wood carvers, excelled in Pitman's wood-carving class and went on to become a successful decorator of pottery. She produced some superb work with incised designs after the popular Doulton method of sgraffito used by Hannah Barlow and her sisters, Florence and Lucy, all of whom were decorators at Doulton. An 1881 pitcher (FIG. 7.27) embellished by Fry according to the Barlow technique was an early acquisition of the newly founded Cincinnati Art Museum.[78] Its design features grasses, water lilies, and swimming ducks, but Fry has transformed the natural subjects into simple, incised outlines heightened in cobalt blue. Like Bennett, Fenety, and others, Fry has organized the composition into three horizontal bands, with a resulting flat, linear, decorative pattern that is highly successful.

Incising or carving was not as extensively practiced on Cincinnati pottery as was slip-painted underglaze decoration. McLaughlin so admired the French examples she saw in Philadelphia that in the year following the Centennial she developed a method that replicated the effect of the French slip-painting underglaze technique. Unlike Volkmar, who claimed that he could achieve better and more controlled results by adding the decoration only after a piece had completely dried, McLaughlin specified that an object should be painted in its "green," or moist, state. In 1880 she published a complete practical description of her procedure in a book entitled *Pottery Decoration under the Glaze* (FIG. 7.28).

During the Pottery Club's early years, the members used both incised and slip-painted underglaze techniques. In 1880, a year after its founding, the organization held its first exhibition of members' work for the edification of the "fashionable and artistic world of Cincinnati."[79] Of thirty-six pieces shown by McLaughlin, the most impressive was the "Ali Baba" vase, more than three feet high—a prodigious accomplishment by virtue of its size alone—which she boasted was the largest made in America.[80] She also exhibited another vase (FIG. 7.29), identical in shape and size but decorated in a "ground tint of rich deep blue with calla blossoms and leaves," the entire background enriched by an irregular network in gold.[81] The calla lily, a device dearly cherished by the Pre-Raphaelites, was, with the sunflower, an attribute of Oscar Wilde (1854–1900), England's leading aesthete, who prized both flowers as examples of perfect natural beauty.[82] (Wilde, the lily, and the sunflower were all worked into the decorative design of an English aesthetic teapot [see FIG. 1.1].)

The Pottery Club exhibition was well attended, for many prominent Cincinnati citizens supported the revival of the decorative arts. They included Alfred T. Goshorn (1833–1902), who had been director general of the Centennial Exposition and whose widely known collection of ceramics was subsequently acquired by the Cincinnati Art Museum; Mrs. Aaron F. Perry (1823–1914), president of the Women's Art Museum Association, founded in 1877 to encourage the establishment of an art museum and art-training school in Cincinnati; as well as GEORGE WARD NICHOLS, Benn Pitman, and William Henry Fry and his father, Henry, all art educators active in Cincinnati.[83]

Though most of the decorative techniques practiced by the Cincinnati women originated in England and France, the designs they used for their vases derived largely from their studies of Japanese prints. The knowledge of those prints acquired by McLaughlin's rival Maria Longworth Nichols dated from the mid-1870s; in 1875 Nichols had obtained in England what she referred to as "some little Japanese books of design [which were] almost my first acquaintance with Japanese Art of the imaginative and suggestive kind. [They] prepared me for the wonderful beauty of the Japanese exhibit at the Philadelphia Centennial Exhibit of 1876."[84] The

books were probably from Katsushika Hokusai's (1760–1849) *Manga,* a series of volumes consisting of Japanese stories and legends, with profuse illustrations of details of Japanese figures, flora, and fauna.[85] In 1878 Nichols made drawings all but copied from the pages of the *Manga* that were used for the cover and for five plates of suggested decorative designs in a book written by her first husband, George Ward Nichols, under the title *Pottery: How It Is Made, Its Shape and Decoration* (FIG. 7.30). The book offered practical advice on the medium and its handling, singling out Japanese and ancient Greek examples to be studied as ideal models for ornament.[86]

Maria Nichols's ceramic work, which she took up in earnest in 1879, is clearly inspired by the influence of Japanism, a dependence attested to by a large earthenware vase (FIG. 7.31). Her composition, printlike in derivation, shows on one side small Japanese figures against a landscape dominated by a snow-covered mountain that could be Mount Fuji. On the opposite side, bordered by vertical bands of a geometric pattern oriental in spirit, white cranes perch on a barren branch against a mountain landscape complete with full moon. A small rectangle at the upper rim contains three Japanesque characters, a device often found on early Rookwood pottery.

The intense interest in the art of Japan, so important to aestheticism in general and in the late 1870s so much a part of the Aesthetic movement in the United States, was not overlooked by Cincinnati collectors, who, like their counterparts on the East Coast, avidly sought examples to add to their holdings. In 1878 the Women's Art Museum Association sponsored a loan exhibition of Japanese art from private Cincinnati collections, offering the public a look at a wide variety of ceramics, bronzes, lacquerwork, cloisonné, and musical instruments that included sixteen objects from the extensive holdings of Maria and George Ward Nichols.[87] Among the major sales of Japanese art held in Cincinnati,[88] one in May 1880 offered countless ceramics, some described in the sale catalogue as having decoration of flowers, foliage, bamboo stalks, birds in flight, and delicate blue clouds—all motifs that are found on most of the pottery made in that city in the 1880s.[89]

The influence of Japanism affected not just the surface decoration of Cincinnati-made pottery, but its contour as well. When Maria Nichols founded the ROOKWOOD POTTERY, one of the most successful and long-lasting art potteries in the United States, she employed modelers and decorators to create works commissioned by a growing number of clients. The hundreds of shapes the factory produced, each accompanied by notations specifying the origin of the vessel it copied, were recorded in a ledger referred to as the Rookwood Shape Book.[90] While the majority of the entries derived from Japanese prototypes, others copied antique forms from Persia, Turkey, and Greece, and still others, contemporary examples from the Chelsea Keramic Art Works, Royal Worcester, and Limoges.[91] Many of the shapes had been borrowed by Rookwood designers from porcelain and bronze objects they had seen in notable private collections, including those of Walters of Baltimore; Morse of Cambridge, Massachusetts; and the Nicholses of Cincinnati.[92] They also drew on their acquaintance with models in New York's Metropolitan Museum of Art, in Boston's Museum of Fine Arts, or in the factory's own pottery collection, which was later given to the Cincinnati Art Museum. Several vases of a pattern called Nancy that appeared to be Japanesque in shape were actually based on the work of Emile Gallé (1846–1904), a French potter from Nancy—hence the name.[93] A vase (FIG. 7.32) whose sides appear almost crushed in and whose decoration evokes thoughts of Japanese prints was one of several copying an example made by Gallé and owned by R. H. Galbraith, a local retailer. With Rookwood's unparalleled economic success and productivity, Cincinnati became one of America's leading centers of art-pottery manufacture.

Collections of Japanese art bolstered the opening of a school and

museum to further the education of Cincinnati artists and connoisseurs. The publicly expressed concern for art education through museums and in the schools led to prolific creativity that resulted in carved furnishings and decorated ceramics going on to receive national and international acclaim. Indeed all branches of the arts found the city a fertile ground in which to burgeon.

During the 1880s, when art pottery made at Rookwood and elsewhere was being acquired by enthusiastic patrons of the arts, another kind of painted earthenware, called majolica, was finding its way into nearly every middle-class American household. Majolica, with precedents in the decorative *maiolica* plates, plaques, and apothecary jars of the Italian Renaissance, had been revived during the mid-nineteenth century in England by the Minton and Wedgwood potteries. By the 1880s numerous factories in both England and America (including the Chesapeake Pottery) began to add to their regular production objects for everyday use made of

majolica, which is distinguished by its various designs in low relief, the raised part delineated by shiny, colorful, painted glazes in blue, yellow, pink, and green. GRIFFEN, SMITH AND COMPANY of Phoenixville, Pennsylvania—one of the largest American producers of majolica—made it their specialty from 1879 to 1889. The majority of their patterns relied heavily on current English prototypes, some direct copies of them. Both the English and American examples drew upon the recognizable aesthetic vocabulary: a saucer (FIG. 7.33), for example, made in the form of a sunflower blossom. Japanese influence was strong in the majolica production at Griffen, Smith and Company, as well as at other firms such as the EUREKA POTTERY COMPANY of Trenton, New Jersey, with popular patterns including bamboo, fans, and butterflies (FIG. 7.34). These wares, all utilizing advanced technical production methods that enabled them to be turned out in large quantities at low cost, became one means for the Aesthetic movement to enter popular culture.

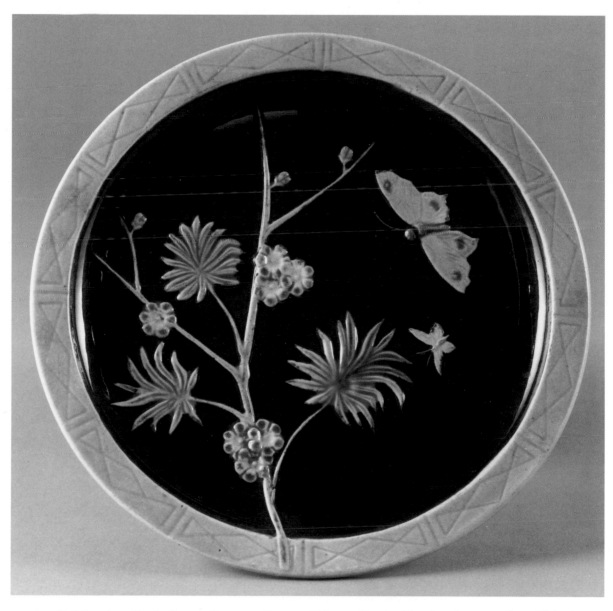

FIG. 7.34 Majolica plate. Eureka Pottery Company, Trenton, N.J., ca. 1883–84. Glazed earthenware, diam. 8⅝ in. (21.9 cm). Marked: *EUREKA POTTERY / TRENTON*. The Newark Museum, N.J., Sophronia Anderson Bequest Fund, 1985 (85.2.89)

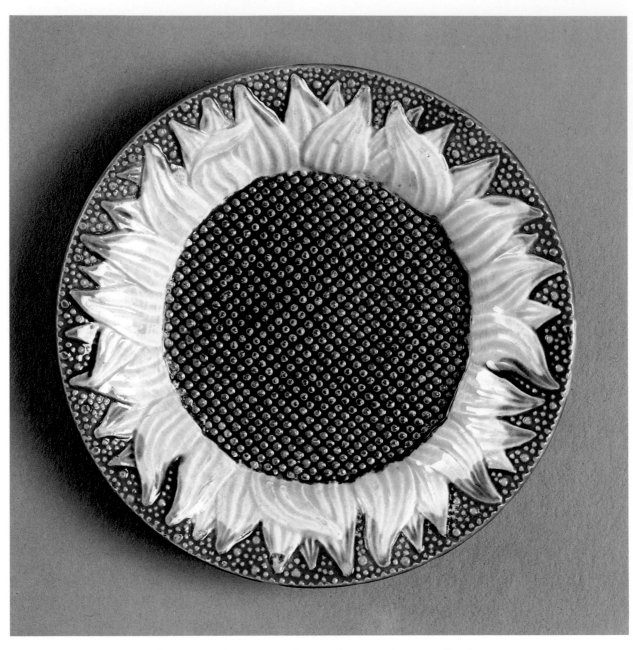

FIG. 7.33 Majolica saucer. Griffen, Smith and Company, Phoenixville, Pa., early 1880s. Glazed earthenware, diam. 5¹⁄₁₆ in. (12.9 cm). Marked: ETRUSCAN / GSH [monogram] / MAJOLICA. Collection of Barbara Jacobson

Tiles

Of all ceramic forms, tiles are perhaps the best suited to painted decoration, for a blank tile is essentially a two-dimensional, ceramic canvas. By the 1870s tiles had gained considerable favor for home decorating in America, and John Bennett, Charles Volkmar, and Alice Cunningham Ware were among many ceramists who painted them in styles made popular in other forms. Because tiles were so easy to obtain, they engaged the interest of a variety of artists, especially such established figures as WINSLOW HOMER (see FIG. 9.8) and members of the Tile Club in New York, which was founded in 1877 by a group of luminaries that included AUGUSTUS SAINT-GAUDENS, J. Alden Weir (1852–1919), Stanford White (1853–1906), Edwin Austin Abbey (1852–1911), Charles S. Reinhart (1844–1896; see ILL. 9.1), and Walter Paris (1842–1906; see ILL 9.2).[94] The club was more of a social organization than one devoted to improving the quality of the decorative arts, but the men probably enjoyed the discipline required of them in adapting their usual rhythms to the ornamental and stylized manner befitting the unfamiliar medium, one that required a limited palette, often confined to blue, and a small-scale composition reduced to simple outlines with minimal shading.

Fireplaces in American homes had been adorned with blue-and-white tin-glazed earthenware tiles from Holland and England since the beginning of the eighteenth century.[95] Now, early in the Aesthetic period, decorative tiles became almost a requirement in stylish households, throughout the 1870s and 1880s enriching foyers, floors, and fireplaces (and also inset into sideboards or cabinets, stoves, trivets, and even clocks). Arbiters of home decoration strongly recommended their use; one commentator went as far as to say that "no other like material presents better opportunities for gratifying the desire to embellish and beautify our homes."[96] Many techniques were utilized for such tiles: they were painted, transfer printed, encaustic, glazed, and modeled. In England, where the industry was flourishing by 1870, factories that included Doulton, Minton, Hollins, and T. AND R. BOOTE were exporting large quantities of tiles to America; moreover, all the important English tile manufacturers had sales representatives in every major American city. American tile production mushroomed in the years following the nation's centennial. The designs and mouth-watering colors of the English wall and floor tiles at the Philadelphia Exposition awakened Americans to their own inadequacy in the field,[97] and at least fifty companies were founded between 1875 and 1920 to capitalize on a ready market,[98] most of them large commercial potteries specializing in tile production. Americans found the English domination of the industry difficult to challenge and continued to turn out products that relied on English styles and necessitated the hiring of many English workers. An early kind of tile being made in both countries as a result of the renaissance of the form was the encaustic (unglazed, and with an inlaid pattern of colored clay, used principally on floors),[99] originally developed by monastic potters of the Middle Ages for use in churches. The technique was revived in the nineteenth century by English Gothicists, those devotees of the Modern Gothic style who borrowed motifs—trefoils, quatrefoils, fleurs-de-lis—and patterns from medieval sources.

A major American pottery center in the second half of the nineteenth century was Zanesville, Ohio, home to two of the largest producers of encaustic tiles in the country: the United States Encaustic Tile Company and the AMERICAN ENCAUSTIC TILING COMPANY, the latter, founded in 1875, producing only examples inlaid with Gothic patterns (FIG. 7.35, ILL. 7.13) until 1880, when it began to make simple glazed and printed products. In 1877 the company installed in Zanesville's Muskinghum County Courthouse one of the earliest surviving encaustic-tile floors.[100] The building's large area gave full scope for a highly decorative effect created by combining tiles of different geometric patterns in natural clay colors of

FIG. 7.35 Encaustic tile. American Encaustic Tiling Company, Zanesville, Ohio, 1875–80. Unglazed earthenware, 6 × 6 in. (15.2 × 15.2 cm). Marked: *THE AMERICAN / ENCAUSTIC TILE CO. / "LIMITED."* Private collection

ILL. 7.13 Encaustic tile. American Encaustic Tiling Company, Zanesville, Ohio, 1875–80. Unglazed earthenware, 4⁵⁄₁₆ × 4⁵⁄₁₆ in. (12.5 × 12.5 cm). Marked: *THE AMERICAN / ENCAUSTIC TILE CO. / "LIMITED."* The Metropolitan Museum of Art, Gift of Florence I. Balasny-Barnes, in memory of her sister, Yvette B. Gould, 1984 (1984.443.8)

buff, brown, and red. Encaustic tiles saw increasing use in domestic settings, principally in hallways. Their practicality caused tastemaker Charles Locke Eastlake to recommend them as "the best mode of treating a hall-floor, whether in town or country . . . a means of decoration which for beauty of effect, durability, and cheapness, has scarcely a parallel."[101]

The vast majority of English decorative tiles were transfer printed, a laborsaving method that produced hundreds of different designs and was the ideal vehicle for bringing Aesthetic-movement themes to popular attention; subjects included sunflowers, lilies, butterflies, and many different Japanese motifs, all in keeping with the prevailing mood of the period. The same themes were widely used in the United States: a tile (FIG. 7.36) made by the INTERNATIONAL TILE AND TRIM COMPANY of Brooklyn, New York, is decorated with a blue transfer-printed scene in which the personification of Industry, wearing classical robes, is framed by a border of Japanese Prunus blossoms. That it is remarkably similar to popular English examples is hardly surprising: the firm's backers were English, as were some of the workers.[102]

Many English companies mass-produced tiles bearing illustrations by Kate Greenaway (1846–1901) and Walter Crane. The American vogue for the two artists' work may have derived as much from their tiles, which have an undeniable charm, as from their printed illustrations.[103] The fireplace in a parlor redecorated in the early 1880s in Richmond, Virginia, was graced by Crane tiles made by T. and R. Boote and by Minton (FIG. 7.37).[104] The warm American welcome accorded not only Crane's many English tiles but Crane himself during his tour of the country in 1891 may have inspired the American Encaustic Tiling Company's manufacture of a series decorated with some of his best-loved illustrations from *The Baby's Opera* (1877) and *The Baby's Own Aesop* (1887), the latter consisting of Aesop's fables condensed into nursery

rhymes. The tiles, which include "Fortune and the Boy" and "The Peacock's Complaint" (FIG. 7.38), reproduce Crane's drawings and the title and verse of each tale. The two illustrated also depict classically garbed figures, a subject matter found on tiles massproduced by the company and sold at a modest price well into the twentieth century.[105] That the illustrations in Greenaway's and Crane's publications, reprinted many times in both England and America, continue to this day to be popular is perhaps the most enduring reminder of the Aesthetic movement.

Encaustic, printed, or simple glazed tiles constituted the majority of examples made in the United States during the last quarter of the nineteenth century, though making them did not interest John Gardner Low. The J. and J. G. Low Art Tile Works, despite its use of some standard methods of manufacture for creating many of its products, is distinguished from its commercial counterparts by Low's artistic ideals. Low, who was born in Boston, began his career in 1858, when he went to Paris to study landscape painting, along with his fellow Americans CHARLES CARYL COLEMAN and Frank Howland (active 1854–1868), in the ateliers of Thomas Couture (1815–1879) and Constant Troyon (1810–1865).[106] After his return to America in 1861, Low found work painting decorative wall murals, a pursuit that led him to become interested in decorating ceramics and, eventually, tiles, in which he was to specialize. Low's important role as principal decorator at the Chelsea Keramic Art Works began in 1876, three years after the plant began production of art pottery, and continued until 1878, when with the backing of his father, JOHN LOW, he established his own company and started making tiles that were heavily influenced by the glazes and relief patterns of the Robertsons' firm.

Low's pottery in Chelsea, Massachusetts, was not far from the site of his former employment. For his office he bought a one-room house adjoining the factory and decorated it to the aesthetic

FIG. 7.38 "Fortune and the Boy" and "The Peacock's Complaint" (tiles illustrating *The Baby's Own Aesop* by Walter Crane). Designed by Walter Crane, made by American Encaustic Tiling Company, Zanesville, Ohio, ca. 1891. Glazed earthenware, decalcomania decoration; each 6 × 6 in. (15.2 × 15.2 cm). Each signed: *c* [monogram], each marked: AETCO. Collection of Moses Mesre

FIG. 7.39 Tile. Design attributed to John Gardner Low, J. and J. G. Low Art Tile Works, Chelsea, Mass., 1879–81. Glazed earthenware, 6 × 6 in. (15.2 × 15.2 cm). Marked: *J. & J. G. Low* / [crossed keys] / *PATENT ART TILE* / *WORKS* / *CHELSEA MASS.* The Brooklyn Museum, New York, The Arthur W. Clement Collection (43.128.64)

taste. It was singled out by one of the firm's chroniclers as a "piece of estheticism," its interior "a sloping room with dull red walls, a sage-green dado, and [an] orange ceiling with many-paned, broad windows in early English style."[107] Above the windows were galleried shelves. In the manner of the day, the mantel held various pottery vases, jugs, and plates of diverse origins.[108] Rather than follow "the beaten paths of foreign manufacturers—least of all, of manufacturing printed tiles in black or color, which are so common and so generally unsatisfactory to lovers of art,"[109] Low struck out on his own. Wanting to produce patterns in relief on tile, Low sought the help of ARTHUR OSBORNE, an Englishman and South Kensington graduate who has been described as "unquestionably a genius in plastic art . . . doing work of rare excellence in clay."[110]

Low and Osborne, experimenting with different techniques, developed the so-called natural process, an unusual decorative method by which it was "possible to take the imprint of any natural object," such as a leaf, down to its tiniest veins, and "permit it to be readily lifted from the clay."[111] In a tile demonstrating this technique (FIG. 7.39), the primary indentation of a fan serves as the base for secondary impressions of a circular piece of fabric and some field grasses. The subtle beauty of the object lies in the simple composition of the three carefully contrasted and positioned elements. The exquisite components all suggest Japanese influence, as do many of Low's relief tiles. In one series (FIGS. 7.40, 7.41) the decoration consists of intricate patterns taken from Japanese textiles in which distinct individual devices—latticework, overlapped scallops, stylized flowers within adjoining hexagons or rectangles—are obliquely placed. In each tile of the series the designer

has first made in one corner a fan-shaped or circular depression, then, in higher relief, has neatly fitted into it two or three swallows or a flying crane. The glazes Low used on his art tiles were similar to those he had become acquainted with at the Chelsea Keramic Art Works: soft, monochromatic tones of blue and green not unlike the celadon glazes on Chinese porcelain or, in keeping with the current fashion in interior decoration, earth tones of golden ocher, amber, and brown.

With Osborne creating most of the tiles at the works,[112] Low, in an unusual instance, began to collaborate with his friend the artist ELIHU VEDDER[113] to produce a tile Vedder designed in 1882 to commemorate the 150th performance of the play *Esmeralda* at the Madison Square Theatre in New York. Vedder, who was also exploring the different uses of tiles and their commercial possibilities, devised a method for using them in the manufacture of chair backs and bottoms.[114] Although Low could not raise the financial support needed for that endeavor, he did achieve success for other projects featuring new applications of tiles, principally those in combination with ornamental metalwork in stoves (see ILL. 8.23) and clocks (see FIG. 8.30).[115]

Shortly after the founding of Low's firm, an exhibition of his tiles mounted by the Household Art Company of Boston brought him his first public recognition.[116] Through the support of that concern he soon developed a keen sense of marketing, advertising his products widely and distributing them throughout the United States and Canada.[117] Between 1881 and 1884, to further his firm's exposure to the public and to facilitate the ordering of his wares, he published illustrated catalogues; in 1887 he brought out a deluxe portfolio of forty-seven tile designs in photogravure.[118] The catalogues offered many choices of patterns for individual tiles and for sets of them incorporating a single composition over an entire series, complete with names clearly bestowed in order to point up the range of popular styles the line encompassed. The names, all evocative of English aestheticism—"Jacobean," "Queen Anne," "Persian Rose," "Ithaca Frieze," and "Japanese Quince"—may owe a debt to the English-trained Osborne.

The Low works went on to produce a staggering variety of artistic tiles that were to be installed in countless houses being built across the United States during the 1880s. The cost of the products ranged from ten dollars, for a set with a simple geometric design for a fireplace surround or a hearth, to more than a thousand dollars for the most elaborate examples.[119] In Chicago, "Chelsea tiles of Moorish pattern" lined the walls of Mr. S. M. Nickerson's house.[120] The New York residence of Governor Samuel J. Tilden, on Gramercy Park, featured an unusual use of Low creations, the dining-room ceiling completely covered with turquoise glazed tiles. The result, as one observer described it in 1884, was "almost a mirror effect, and produces the great charm of changing, shifting tones."[121] Even the sumptuous house that Cornelius Vanderbilt II (1843–1899) built in New York was fitted up with Low tiles.[122]

From the firm's first days of existence Low exhibited at a number of industrial-arts fairs, domestic and international, where the favorable publicity showered on the company and its products culminated in several magazine articles and reviews. In 1879, the year Low fired his first successful tiles, his entries at the Cincinnati Industrial Exposition won a silver medal against strong competition; Low also received accolades from showings in Boston, Saint Louis, and New York.[123] His greatest honor, however, was at an international exhibition held in Crewe, England, where over several far better established pottery manufacturers from the United Kingdom he was awarded a gold medal for the "finest display of artistically executed tiles in relief or intaglio."[124] During its thirty-year lifetime, Low's firm, among the first in America to produce the relief tiles that continued in popularity through the early years of the twentieth century, combined art with industrialization in products that surpassed those of his many competitors in both design and execution.

FIG. 7.40 Tile. Design attributed to Arthur Osborne, J. and J. G. Low Art Tile Works, Chelsea, Mass., 1881–84. Glazed earthenware, 6 × 6 in. (15.2 × 15.2 cm). Marked: *J. & J. G. Low* / [crossed keys] / *PATENT ART TILE / WORKS / CHELSEA MASS.* The Metropolitan Museum of Art, Lent by Mr. and Mrs. I. Wistar Morris III (L.1982.131)

FIG. 7.41 Tile. Design attributed to Arthur Osborne, J. and J. G. Low Art Tile Works, Chelsea, Mass., 1881–84. Glazed earthenware, 6⅛ × 6⅛ in. (15.6 × 15.6 cm). Marked: *J. & J. G. Low* / [crossed keys] / *PATENT ART TILE / WORKS / CHELSEA MASS.* Museum of Fine Arts, Boston, Gift of Professor Emeritus F. H. Norton and the Department of Metallurgy at the Massachusetts Institute of Technology, 1971 (1971.458)

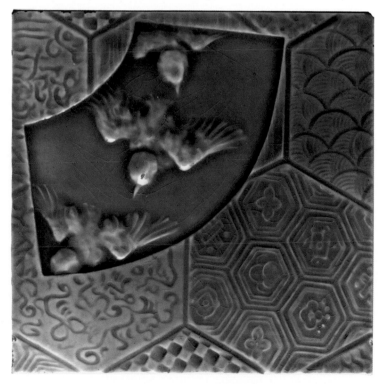

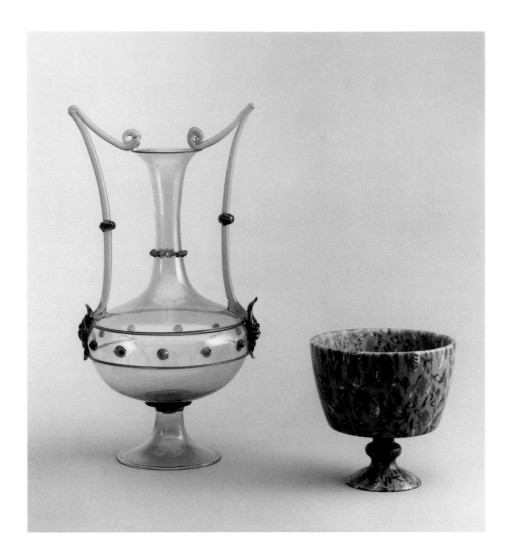

FIG. 7.42 Cups. Venice; left: 19th century, right: 17th century. Glass; left: h. 12¾ in. (32.4 cm), diam. 6¾ in. (17.1 cm); right: h. 4¾ in. (12.1 cm), diam. 4⅞ in. (12.4 cm). The Metropolitan Museum of Art, Gift of James Jackson Jarves, 1881 (81.8.31, .281)

Glass

The glass industry of the Aesthetic period had much in common with its sister industry, art pottery. The concentration on collecting that profoundly affected the production of ceramics in both England and America carried over into glassmaking, with manufacturers of each medium making artistic vessels in addition to utilitarian tableware. The influences on both were also the same, except that in addition to the sources they had in common—oriental, classical, and Islamic art—glassmakers had the added inspiration of Venice. Perhaps following the old Venetian example, they experimented with untried techniques in manufacturing and in surface decoration that led them to develop wholly new colors and textures; they also revived certain of the old methods in order to fabricate objects that resembled earlier styles of foreign glass. They then turned their attention to the surface, embellishing it with applied gilding and enamels in ever more dazzling patterns and effects.

The Aesthetic movement laid the groundwork for the emergence of an "art glass" production in much the same way that it provided the stimulus for "art pottery." Despite the many similarities in the two fields, there is one outstanding difference: with art pottery, though some of it may have been crafted by hand, most of it was decorated by individuals who were relatively unskilled technically; by contrast, those working in art glass were of necessity highly accomplished scientists or technicians. Throughout the nineteenth century and the first half of the twentieth, virtually all art glass was made in an industrial context akin to the Trenton potteries or to a factory such as the American Encaustic Tiling Company.

Though the acquisition of glass objects never absorbed most collectors to the level of their zest for ceramics, connoisseurs were far from oblivious to their charms. Vessels of foreign glass, greatly prized in many fine collections, eventually found a place on the mantels and shelves of a number of houses, first those of the well-to-do and ultimately those of families with lesser incomes. Treasures from Venice, the Islamic world, and ancient Rome stimulated public interest in novel forms, colors, and decorations, and glassmakers copied them all in an attempt to cater to the increasing public demand.

Perhaps the most important factor in the widespread interest in colored glass and the new decorative effects it could achieve was the revival that began by the 1850s of traditional Venetian techniques, especially as practiced on the island of Murano. Conceived in an antiquarian and nostalgic spirit but soon attaining a solid commercial footing, the revival gained worldwide attention and was the primary impetus for the avid collecting of Venetian glass in the late nineteenth century.

Though Apsley Pellatt, in his *Curiosities of Glass-Making* (1849), a book that was to become a standard reference for English and American glassmakers, had been in the vanguard of nineteenth-century champions of Venetian techniques, the credit for awakening the English-speaking world to the wonders of Venice must be accorded Ruskin. Ruskin lived in that Italian city for two years while he prepared his three-volume treatise *The Stones of Venice*

(1851–53), in which he dwelt at some length on the unique Venetian achievements in glassmaking:

> But of all the arts, the working of glass is that in which we ought to keep these principles [the workman's reverence for his materials] most vigorously in mind. . . . In glass . . . no delicate outlines are to be attempted, but only such fantastic and fickle grace as the mind of the workman can conceive and execute on the instant. No material is so adapted for giving full play to the imagination.[125]

Other notable English critics of the reform era—Eastlake and Morris, for example—echoed Ruskin's sentiments. Eastlake, whose writings were highly influential in America, regarded the glass produced in Venice from the fifteenth through the seventeenth century, and now again in his own time, as the ideal. In his chapter "Table Glass," in *Hints on Household Taste* (1868), he praised the vessels then being made on Murano by Antonio Salviati, who was chiefly responsible for the revival: "If fair color, free grace of form, and artistic quality of material, constitute excellence in such manufacture, this is the best modern table glass."[126] In 1882 Morris, whose ideology helped shape the Aesthetic movement, gave a lecture called "The Lesser Arts of Life," in which he praised the genius of the seventeenth-century Venetians, saying, "This glass of Venice and Murano is most delicate in form, and was certainly meant quite as much for ornament as use."[127]

In the 1860s Venetian manufacturers began to export to England a steady flow of their gaily colored wares, copiously besprinkled with gold dust and formed into intricate (though not always graceful) shapes.[128] During the same era the public had the opportunity to admire specimens of old and new Venetian glass at the great international exhibitions and at urban decorative-arts fairs that started with the 1851 Crystal Palace extravaganza in London and gained momentum after the Philadelphia Exposition of 1876. In Britain in the 1820s, the noted collector Felix Slade (1790–1868), one of the first to acquire an interest in Venetian glass, began to add it to his considerable holdings of coins, medals, and prints. A large number of his "fragile beauties," as he called them, were first put on public view in London in 1850 at the Society of Arts exhibition of ancient and medieval art.[129] The British Museum acquired Slade's collection as a bequest in 1868, just about the time that London's South Kensington Museum (now the Victoria and Albert Museum) was beginning its Venetian collection.

In America, the glass of Venice could generally be found alongside ceramics from the Near and Far East in the display cabinets and étagères of many of the new and expensive houses of the Aesthetic era. Though Salviati did not exhibit at Philadelphia's Centennial celebration, many of his English imitators did, giving Americans their first glimpse of Venetian-inspired marvels. The island city's exhibition at the 1878 Exposition Universelle in Paris received unanimous acclaim; in America, in the smaller industrial- or applied-arts fairs, the exquisite vessels were displayed as an example to be studied by artists and designers. The loan exhibition organized in Cincinnati by the Women's Art Museum Association in 1878 provided a wide assortment of Venetian glass, both antique and modern—marbled, frosted, and filigreed—drawn from local collections for the public to enjoy.[130] In New York, the delicate wares of Venice were being offered for sale by such dealers as Daniel Cottier, whose shop was just one of the venues for the examination of treasures that included the costly "jugs of dark, opaque, streaked glass [that resembled] marble in its mottled coloring," from Salviati's factory.[131]

In 1880 James Jackson Jarves, who in addition to being a passionate spokesman for the cause of art contributed to the founding of museums, undertook to amass a substantial "study" collection of about 280 examples of antique and contemporary Venetian glass

(FIG. 7.42) to honor the memory of Deming Jarves, his father, "the first man in America to establish the manufacture of this beautiful article on a large scale."[132] He gave the collection to the Metropolitan Museum the following year. In his letter of donation Jarves noted that the array "of a beautiful article of art-industry of past and present invention" constituted a remarkably complete range of glass—colored, frosted or crackled, aventurine, murrhine, and millefiori—representing techniques developed in Venice through centuries of accomplishment.[133]

Critics praised the resurgence of Venetian glassmaking largely because it restored to a world preoccupied with fussy, overly ornate objects a former elegance and simplicity of form. Because the contemporary products relied heavily on models from the past,

FIG. 7.43 Lemonade glass (one of a pair). Attributed to Boston and Sandwich Glass Company, Sandwich, Mass., ca. 1880. Threaded and engraved glass, h. 5½ in. (14 cm), diam. 2⁵⁄₁₆ in. (5.9 cm). Museum of Art, Rhode Island School of Design, Providence, Gift of Mrs. Pierre Brunschwig (85.035)

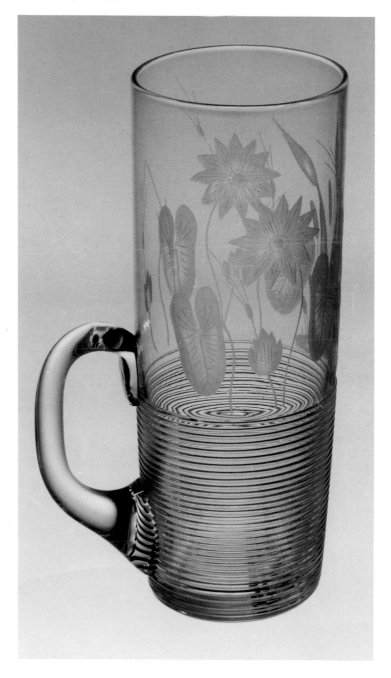

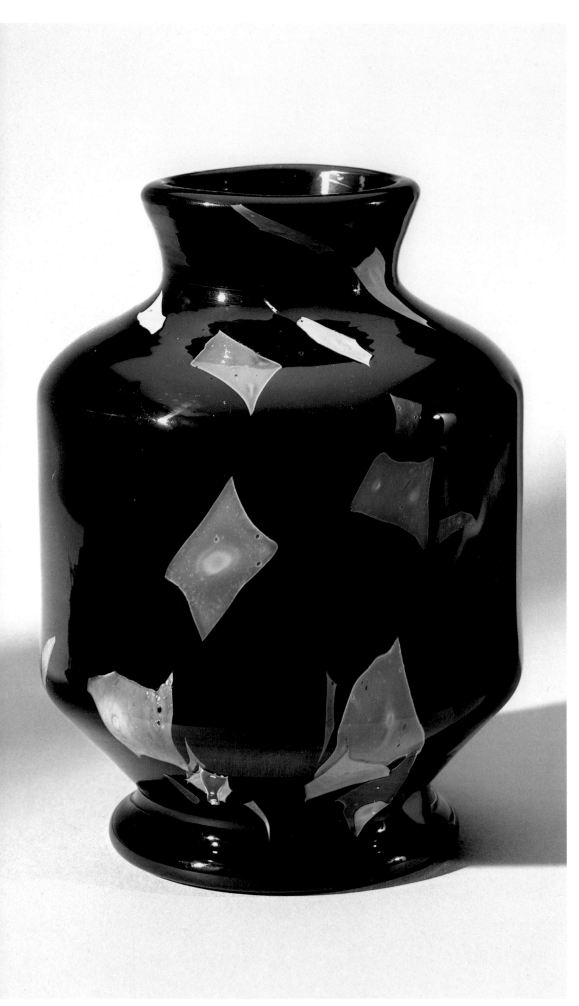

Left: FIG. 7.45 Vase. Designed by Frederick S. Shirley, Mount Washington Glass Company, New Bedford, Mass., ca. 1878. Sicilian glass, h. 6½ in. (16.5 cm), diam. 4⅜ in. (11.8 cm). Labeled: *SICILIAN / PATd. / MAY 28 '78 NO. 204384.* The Metropolitan Museum of Art, Friends of the American Wing Fund, 1984 (1984.67)

Opposite: FIG. 7.46 Pitcher. Hobbs, Brockunier and Company, Wheeling, W.Va., 1884–87. Spangled glass, h. 8 in. (20.3 cm), diam. 4 in. (10.2 cm). The Metropolitan Museum of Art, Friends of the American Wing Fund, 1984 (1984.218.1)

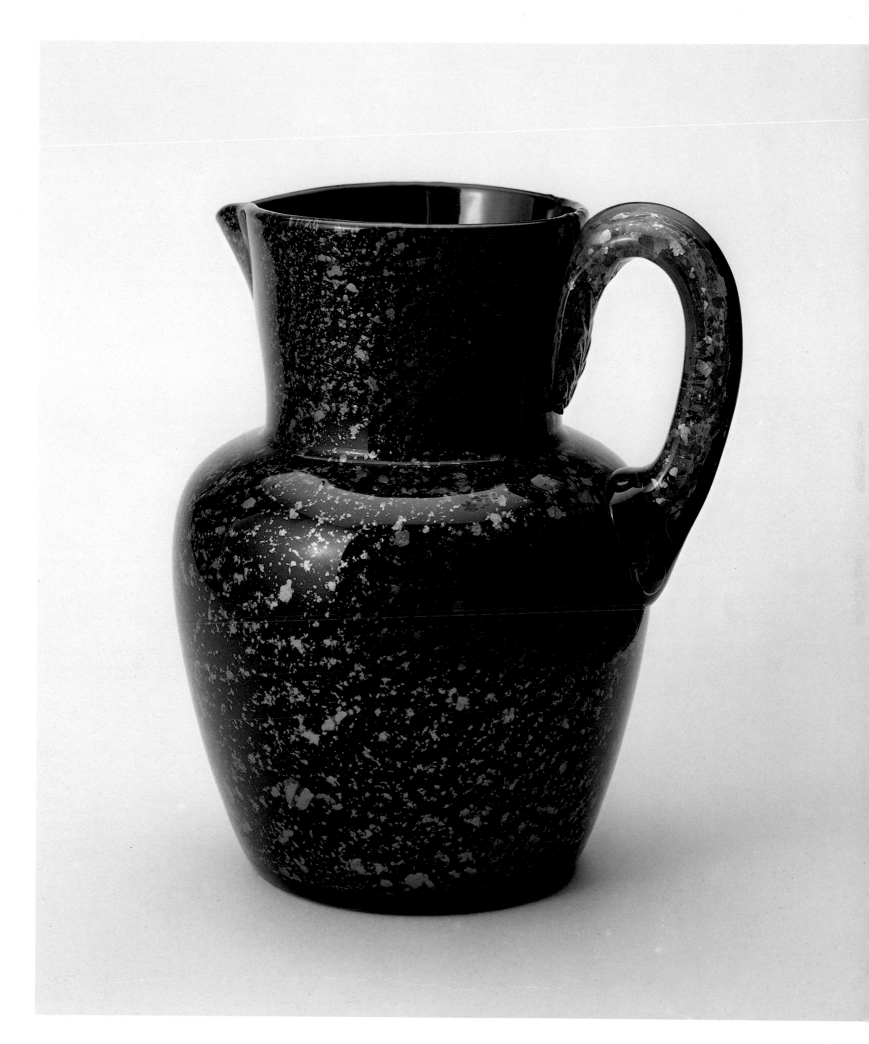

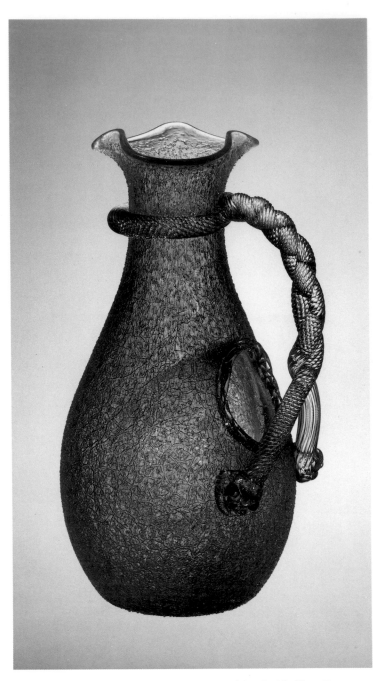

FIG. 7.44 Ice pitcher. Attributed to Boston and Sandwich Glass Company, Sandwich, Mass., 1877–85. Frosted glass, h. 11 in. (28 cm). The Corning Museum of Glass, Corning, N.Y. (74.4.115)

their appeal was to persons with a fairly informed antiquarian taste. Further, they provided a welcome relief from the excessively cut and laboriously engraved table glass in vogue in the mid- to late nineteenth century, for they relied on decoration—achieved while the form was hot and still being worked—that consisted of particles of glass or metal embedded in the colored body or of pulverized particles or fine threads of glass applied to its surface.

In the late 1860s the Venetian technique of horizontal close trailing, or threading, reached England, where it enjoyed wide popularity through the next decade. The development in London of a machine patented in 1876, which produced and applied a continuous thread of molten glass to a vessel it was simultaneously rotating, greatly facilitated this means of decoration, previously accomplished only by hand.[134] As a rule, threading was applied to the lower part of a vessel, with the upper part often ornamented with delicately engraved or acid-etched lotus blossoms or grasses. In America by 1888, the BOSTON AND SANDWICH GLASS COMPANY was announcing its production of glass threaded in ruby and turquoise, which yielded "bright and rich effects,"[135] and in both England and America many factories were making threaded glassware, which was much in demand.[136] Threaded decoration, soon available to an eager public in many hues, was most effective on tall, attenuated forms such as lemonade pitchers and glasses attributed to the Sandwich factory (FIG. 7.43).

In his *Curiosities of Glass-Making,* Pellatt had described several Venetian techniques, which in the absence of records or documentation he had attempted to reconstruct. One, which he termed "old Venetian frosted glass," also called "ice-glass," had surface crackles resulting from dipping hot glass into water and then reheating it so it expanded further, the cracks thereby widened into fissures.[137] Modern glassmakers gained the same effect by embedding minute particles of crushed glass over an entire surface, sometimes in a contrasting color. This textured ice-glass, also known as "craquelle" and "overshot," enjoyed great favor during the last quarter of the nineteenth century, with many factories from Massachusetts to West Virginia advertising it in a variety of colors, "rose, sapphire, old gold, and marine green" among them (FIG. 7.44).[138]

Makers also tried to replicate murrhine, an ancient Greek and Roman glass that imitated semiprecious stones such as gold-speckled lapis lazuli. They could see bottles and bowls, both originals and copies from the sixteenth century, in the cases that contained the Metropolitan Museum's murrhine-glass collections,[139] and, using the Museum's examples as their models, they developed new techniques to re-create the old effects. Tiny flakes of gold, silver, and other metals permeated glass whose brilliant colors could have been borrowed from the "plumage of tropical birds."[140] "Vasa murrhina," "spangled glass," or "spatter glass," as it was variously called, seemed to sparkle when light was refracted from the shiny metallic flakes and the colorful, jewel-like glass particles set into it.[141]

"Sicilian ware" may have been the forerunner of the vasamurrhina type of American glass. First patented in 1878 by FREDERICK S. SHIRLEY of the MOUNT WASHINGTON GLASS COMPANY, this new ware (FIG. 7.45), which can be considered the earliest art glass made in America, achieved its decorative effect by a seemingly haphazard arrangement of irregularly shaped mosaics in shocking colors—bright pink, blue, yellow, green—inlaid in an object's contrasting surface, this usually black. According to some accounts in the *Crockery and Glass Journal* shortly after the material was introduced, the finish of Sicilian ware ranged from a soft, porphyry-like material to a brilliant mosaic.[142]

Several English makers registered patents for the revived vasamurrhina technique as early as 1878, with the Americans following suit by the early 1880s. In 1882 the Farrall Venetian Art Glass Manufacturing Company in New York exhibited specimens of vasa murrhina, which they claimed reproduced examples in the collections of the British Museum.[143] The glittering, colorful glass be-

came so much in demand in America that makers hastened to put it into production. The newly founded Vasa Murrhina Art Glass Company of Sandwich, Massachusetts, produced it in a wide variety of forms that were enthusiastically received when the company introduced them to the public at the New England Mechanics Institute exhibition in the fall of 1883. The Farrall company recommended its version of vasa-murrhina glass for ceiling and wall panels "in the old Roman fashion."[144] Myriad ways of incorporating vasa murrhina into architectural decoration came into being, from reliefs and plaques to ceiling and wall inlays,[145] with the Massachusetts firm adding columns and tiles to the vases, lamps, and shades it had exhibited in Boston.[146] James Jackson Jarves said of these objects that "in brilliancy of metallic and mineral coloring, variety and perfect fusion and combination of tints, [they rivaled] the most precious colors and effects of the natural world."[147] He was particularly impressed with their opulence, which he termed "an Arabian Night's magnificence," and he praised the reproductions as "simply marvelous even after intimate acquaintance with the most successful modern efforts of Murano."[148]

To a list of art glass that already included craquelle and Venetian, HOBBS, BROCKUNIER AND COMPANY of Wheeling, West Virginia, had by 1884 added their version of vasa murrhina, called spangled glass (FIG. 7.46). The firm adapted that sumptuous material to its standard utilitarian table forms, calling the new metallic-studded colors "turquoise," "ormolu," and "lazuline."[149] Unfortunately, the juxtaposition was not felicitous, although the similarity of spangled glass to precious stones did make it desirable for architectural uses.

By the early 1880s the emphasis in glassmaking in both England and the United States had shifted from manipulated effects to experiments with color. A process was developed whereby one vessel of different hues could be created: as the vessel was exposed to heat, minute particles of a foreign element mixed in varying degrees of density into the colored glass of which it was formed caused the color gradually to shade into another. Such glass, put into production on both sides of the Atlantic at almost the same time, was endowed with names as exotic as the colors themselves: "amberina," for one; "Burmese," for another.

Although the technique used in producing shaded glass had been noted earlier in the century by Pellatt in his *Curiosities,* the kind known as amberina (also called "rose amber") was first patented in America in 1883 by JOSEPH LOCKE, an Englishman working in East Cambridge, Massachusetts, at the NEW ENGLAND GLASS COMPANY. A transparent glass shading from light amber to deep ruby and most effective with a patterned surface, amberina met with immediate public success. Locke, who shared the current interest in Far Eastern art, designed a small, square, pressed amberina vase (FIG. 7.47) whose form recalls the shape of Japanese brush pots and whose decoration consists of a stork standing on one leg amid field grasses, a popular Japanese motif.

Almost a decade before shaded glass was put into production, opaque or semi-opaque white "opal" glass was being exploited for its resemblance to alabaster. When it was coated with a layer of transparent color, plain or shaded, it assumed a different quality: the core of opacity now overlaid with a coat of amberina, the impression conveyed was that of glazed porcelain (FIG. 7.48). The extraordinary publicity that ensued when a Chinese vase of "peach blow," or "peach bloom," porcelain (the name derived from the vase's shaded coloring, which resembled that of the skin of a peach) was sold at auction on March 8, 1886, for $18,000 precipitated the manufacture of reproductions of the peachblow coloring in pottery and glass. The small, slender-necked vase described in the sale catalogue as an "ovoid peach-blow vase, 8 inches high,"[150] part of the superb collection of Japanese and Chinese porcelains belonging to Mrs. Mary J. Morgan of Baltimore, had been bought by W. T. Walters at the highest price recorded at the sale.

The glassmaking industry rushed to capitalize on the appeal

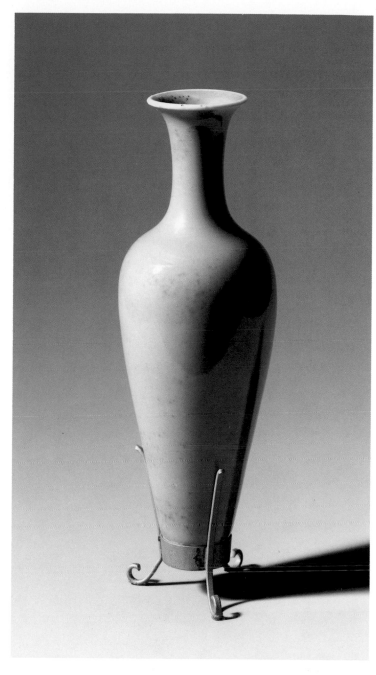

FIG. 7.48 Vase. Chinese, K'ang-hsi period, 1662–1722. Porcelain, h. 6⅛ in. (15.6 cm), diam. 2⅛ in. (5.4 cm). Marked: [K'ang-hsi] in Chinese. The Metropolitan Museum of Art, Bequest of Mrs. H. O. Havemeyer, 1929, H. O. Havemeyer Collection (29.100.327)

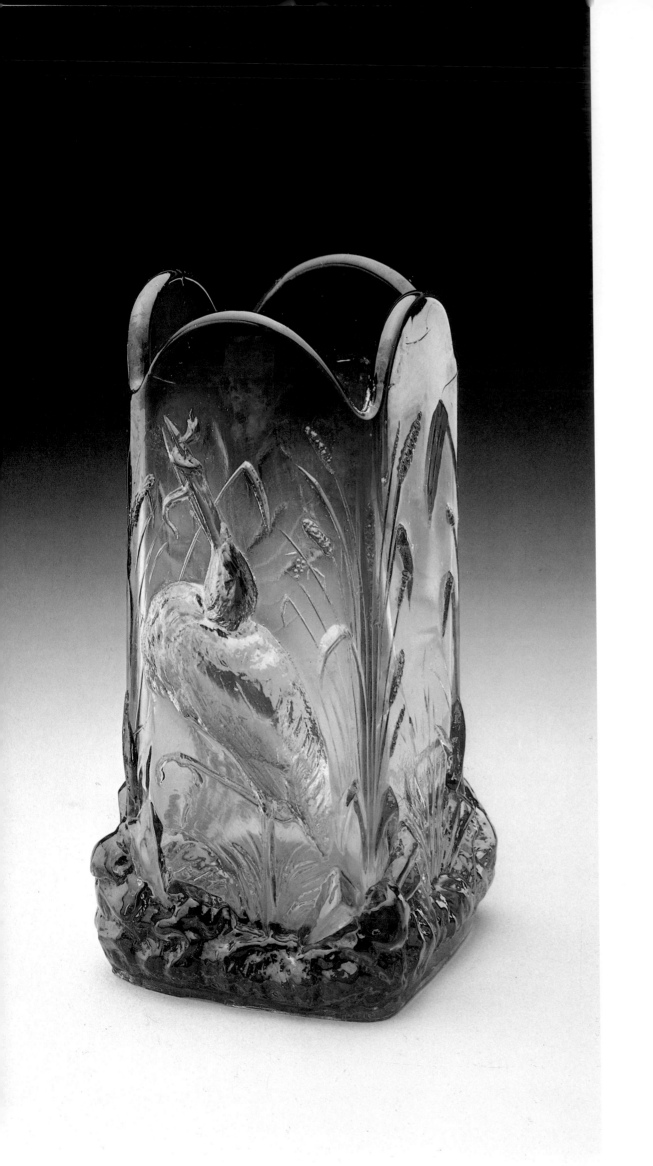

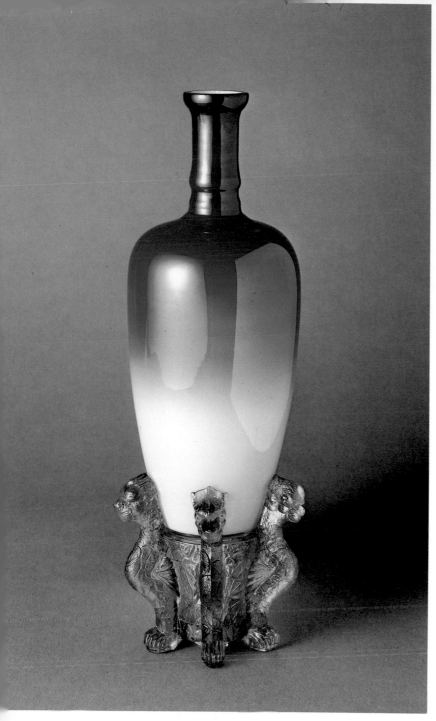

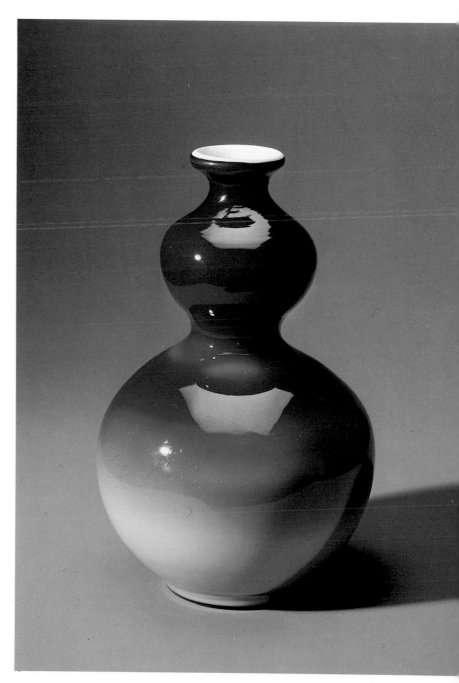

Above: FIG. 7.49 "Morgan" vase and stand. Hobbs, Brockunier and Company, Wheeling, W.Va., ca. 1886. Vase: blown peachblow glass, stand: amber pressed glass, h. 10 in. (25.4 cm), diam. 3¾ in. (9.5 cm). High Museum of Art, Atlanta, Virginia Carroll Crawford Collection (1984.163)

Right: FIG. 7.50 Vase. Hobbs, Brockunier and Company, Wheeling, W.Va., ca. 1886. Blown peachblow glass, h. 7⅛ in. (18.1 cm), diam. 4⅜ in. (11.1 cm). The Metropolitan Museum of Art, Gift of Emily Winthrop Miles, 1946 (46.140.761)

Opposite: FIG. 7.47 Vase. Designed by Joseph Locke, New England Glass Company, East Cambridge, Mass., 1883–87. Pressed amberina glass, h. 4½ in. (11.4 cm), w. 2¼ in. (5.7 cm). The Bennington Museum, Vt., Gift of Joseph W. and May K. Limric (76.155)

of the peachblow hue to the public imagination. The sensation spread to other commercial enterprises as well: cosmeticians, for instance, immediately marketed a rouge under the trade name Peach Blow.[151] The Hobbs, Brockunier company was the first to take advantage of the publicity, introducing in April 1886 what it called a "Fac-simile-Morgan ($18,000) vase and stand," which copied the small Chinese porcelain vase in glass (FIG. 7.49). The Hobbs firm interpreted the stand, bronze in the original, in amber pressed glass extended into the head and forequarters of four stylized oriental animals that held the vase in place.[152] The achievement was masterly: the amber base supported a vase endowed with color that began at the bottom as pale yellow, flowed subtly into rose at the

middle, and ended at the rim in deep cherry red. Hobbs sold their "Morgan" vase with either a shiny or a matte finish, which they called "lusterless," and used their peachblow glass for a variety of graceful oriental forms (ILL. 7.14, FIG. 7.50). The clever marketing ploy reaped great commercial rewards; by late November the firm could report that the demand for their "peach blow . . . is beyond expectations, and keeps up remarkably well."[153]

The commercial success of amberina is said to have prompted Frederick Shirley, Locke's rival, to apply to semi-opaque opal glass the same manufacturing techniques used in making peachblow, which resulted in his invention of Burmese, a kind of glass shading from lemon yellow to light rosy pink. Burmese glass, with a surface that could either be left shiny or rendered matte by a wash of acid, was made in a large number of shapes and forms, often following classical vessels such as a two-handled urn (FIG. 7.51). Though most Burmese and peachblow objects relied for their effect on delicate shading, they could also be embellished with all manner of enameled and gilded decoration: a gold-colored fern painted on one example (FIG. 7.52) is yet another use of a popular Japanese-inspired motif.

The surface decoration that characterized many of the decorative media of the Aesthetic movement—inlaid or painted on furniture, chased or applied on silverware, or painted, incised, or modeled in ceramics—was equally apparent on aesthetic glass. Venetian, Bohemian, and other European glassmakers had long decorated the surfaces of their vessels with applied gold and polychrome enamels and, employing increasingly complex designs, continued to do so throughout the nineteenth century. In England and America, the preferred decoration on opal, Burmese, peachblow, and colorless glass consisted of the ubiquitous themes of the Aesthetic period: naturalistic flowers and vines; ferns, either gilded or engraved; nymphs and sprites familiar from nursery tales; and Japanesque motifs, all of which were explored to the fullest extent by factory artists and independent decorators alike.

While the major American glassmaking centers advertised gilded and enamel-decorated glass, firms in New England—the Mount Washington Glass Company, in particular, and the SMITH BROTHERS partnership in New Bedford, Massachusetts—made it their specialty. Smith Brothers, in the years from 1875 to 1895 the largest firm of its kind in the United States, was the only American glassmaker to display its extensive array of enamel-decorated wares at the Centennial Exposition. Smith Brothers added adornment to plain tableware and lamps, either imported from Europe or made at the neighboring Mount Washington Glass Company, where the Smiths had run the decorating shop before establishing their own partnership. The Smiths' Japanesque patterns included herons or storks portrayed in marshy grasses, as well as spiky Prunus blossoms that form the background of a vase (FIG. 7.53) overlaid with naturalistically painted circular vignettes of a swallow and a landscape.

The painted vases and lamps of the Smiths' company appear simple in comparison with the gilded and enameled vases lavishly decorated by Joseph Locke at the New England Glass Company or by the staff decorators at the Mount Washington Glass Company. One example of Locke's work is a vase (FIG. 7.54) signed by him and dated 1887, which is completely covered with his characteristically intricate patterns—geometric designs, flowers, cranes, and butterflies—enameled in pink, red, yellow, and blue, and highlighted with gold to give it a distinctly exotic appearance. Locke's interest in surface-decorated glass extended to acid-etched, cut, and engraved motifs as well.

The Mount Washington Glass Company, the largest producer of decorated art glass, for which they were celebrated, retained their supremacy for about ten years beginning in the mid-1880s. The firm gave names—"Crown Milano," "Royal Flemish," "Napoli"—to evoke the opulence of the wares that bore them. In some, such as Crown Milano, the colors of the enamels were the

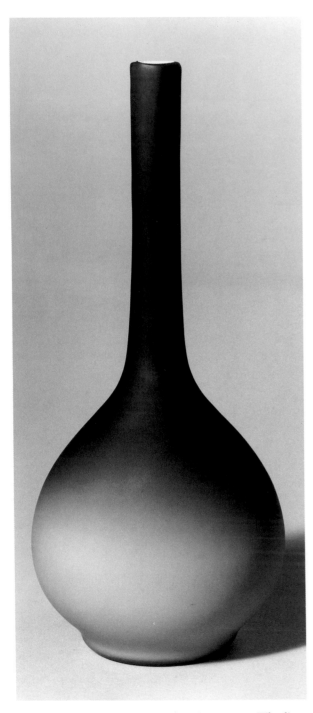

ILL. 7.14 Vase. Hobbs, Brockunier and Company, Wheeling, W.Va., ca. 1886. Blown and acid-treated peachblow glass, h. 8⅜ in. (21.3 cm), diam. 2⅛ in. (5.4 cm). The Chrysler Museum, Norfolk, Va., Institute of Glass, Gift of Walter P. Chrysler, Jr.

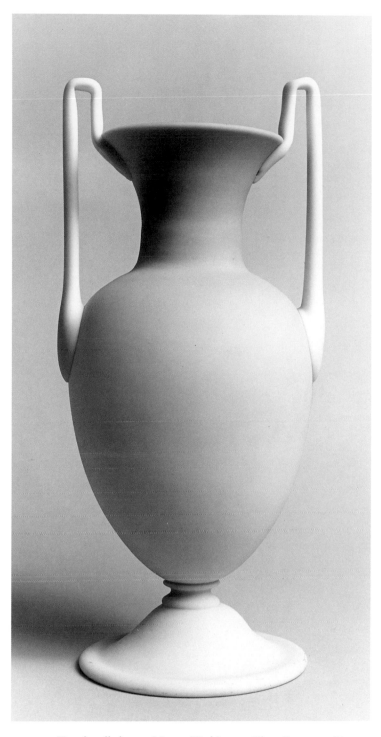

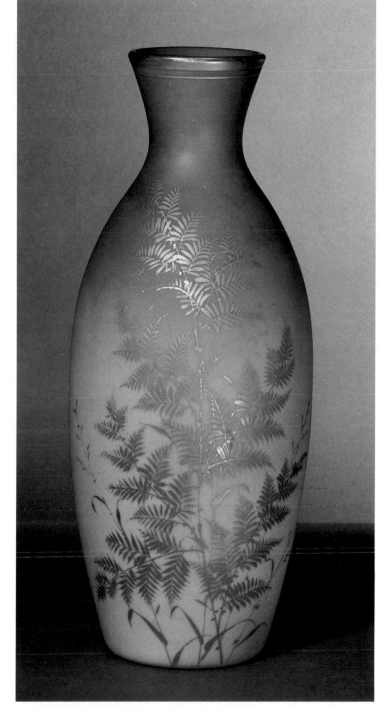

FIG. 7.51 Two-handled vase. Mount Washington Glass Company, New Bedford, Mass., ca. 1885. Blown and acid-treated Burmese glass, h. 13¼ in. (33.7 cm), diam. 4⅛ in. (10.5 cm). The Chrysler Museum, Norfolk, Va., Institute of Glass, Gift of Walter P. Chrysler, Jr.

FIG. 7.52 Vase. New England Glass Company, East Cambridge, Mass., 1886–90. Blown and gilded peachblow ("Wild Rose") glass, h. 7¾ in. (19.7 cm), diam. 3 in. (7.6 cm). The Metropolitan Museum of Art, Rogers Fund, 1973 (1973.16)

muted tones of the aesthetic palette—green, pink, rust, and beige—thinly applied to a surface that had already been treated with acid, resulting in a matte background; others, notably Royal Flemish, displayed more jewel-like colors. Raised lines in heavy enamel or gilding bordered the colored areas to create an effect similar to stained-glass leading or plique-a-jour. An elaborate example (FIG. 7.55) is decorated with a peacock roosting in a flowery tree whose branches form an irregular background. Gems of enamel, heavy gold outlines, and blues in varying shades further enrich the piece. The attenuated neck and the general shape of the vase recall Islamic forms, not surprising in view of the influence of

Islamic art on late nineteenth-century ceramics, furniture, and textiles. That this mode was more evident in art glass than any other non-Western tradition may be partly accounted for by the copies of fourteenth-century Islamic enameled glass that Philippe-Joseph Brocard (active 1867–1890) of France was making during the early 1870s. His vases and mosque lamps, ornately decorated with arabesques and rosettes in gorgeous red, blue, and gold enamels, were known through their display at international exhibitions and almost concurrently in America through the New York art dealer Samuel P. Avery (1822–1904).[154] The patterns that typified much of the Mount Washington Glass Company's decorated products of

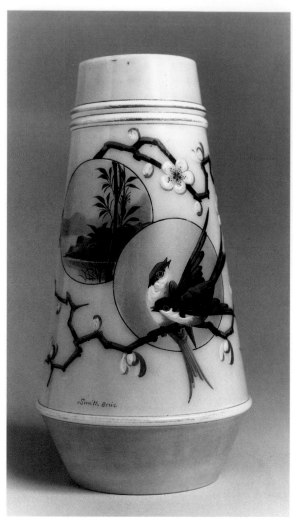

FIG. 7.53 Vase. Smith Brothers, New Bedford, Mass., ca. 1880–90. Blown and enameled opal glass, h. 7⅞ in. (20 cm), diam. 2¼ in. (5.7 cm). Marked: *Smith Bros.* The Chrysler Museum, Norfolk, Va., Institute of Glass, Gift of Walter P. Chrysler, Jr.

mond, copied from conservative forms of cut glass—others used floral, bird, and nursery-rhyme themes. These patterns were in keeping with the tenor of the Aesthetic movement, as were some of the names bestowed on them: "Queen Anne," "Pinafore," and "Lily," each referring to an aesthetic theme.[155] Still other patterns, such as that used for a cream pitcher (FIG. 7.57), showed Japanese influence in their incorporation of fans, bamboo shoots, and parasols. A pattern similar to this one, entitled Grace, was created in 1881 by a designer especially hired by Richards and Hartley of Tarentum, Pennsylvania, then among America's largest producers of pressed glass; it was used for a four-piece set consisting of sugar bowl, cream pitcher, spoon holder, and covered butter dish, praised by one critic for its "novel and beautiful decorations."[156] The motifs that encircled each piece included "Japanese fans of different styles," a Japanese sailing vessel, oriental grasses, and a "comical scene."[157] Such sets of pressed table glass in aesthetic patterns, sold for modest sums, served as a simple means of bringing the Aesthetic movement into every home in America.

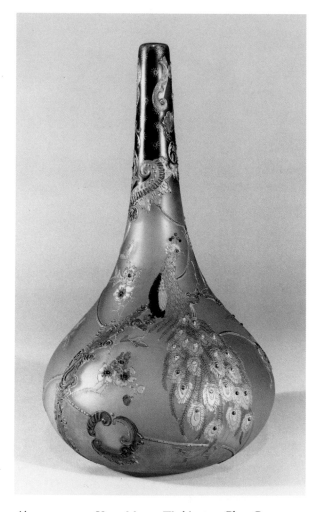

Above: FIG. 7.55 Vase. Mount Washington Glass Company, New Bedford, Mass., ca. 1894. Gilded and enameled blown glass, h. 12¾ in. (32.4 cm), diam. 3½ in. (8.9 cm). Marked: [Royal Flemish monogram] *594.* The Chrysler Museum, Norfolk, Va., Institute of Glass, Gift of Walter P. Chrysler, Jr.

Opposite: FIG. 7.54 Vase. Decorated by Joseph Locke, New England Glass Company, East Cambridge, Mass., 1887. Gilded and enameled blown glass, h. 5⅛ in. (13 cm), diam. 5¾ in. (14.6 cm). Signed: *BY / J LOCKE / 1887.* High Museum of Art, Atlanta, Virginia Carroll Crawford Collection (1984.169)

the Aesthetic period can be seen in the firm's Napoli glass, in which an overall, weblike pattern of raised gold enamel covers the surface. On one vase (FIG. 7.56), the webbing, again reminiscent of leading on stained-glass windows, combines with the yellow and green chrysanthemum-and-leaf pattern painted on the inside of the object to impart to it a hint of oriental exoticism.

The vogue for enamel-decorated glass, both the elaborate kind turned out by the Mount Washington Glass Company and the more popular products of the Smith Brothers firm, had waned by the mid-1890s, to be replaced in fashionable circles mainly by heavy clear and colorless glass with elaborate, brilliant-cut decoration that was made in large quantities until about 1920.

Because Venetian glass (the standard by which all aesthetic glass was measured), imitations of it, and richly enameled and gilded glass were too expensive and too fragile for the average household, pressed glass, already in production by the late 1820s, presented an alternative within the reach of the general public. Pressed-glass tableware was offered at moderate prices in a bewildering array of aesthetic patterns and often in stylish colors: opal, turquoise, and amber shading to ruby.

In an attempt to corner the profitable market for pressed glass, manufacturers across America created large numbers of different patterns. While most were far from innovative—ribbed and dia-

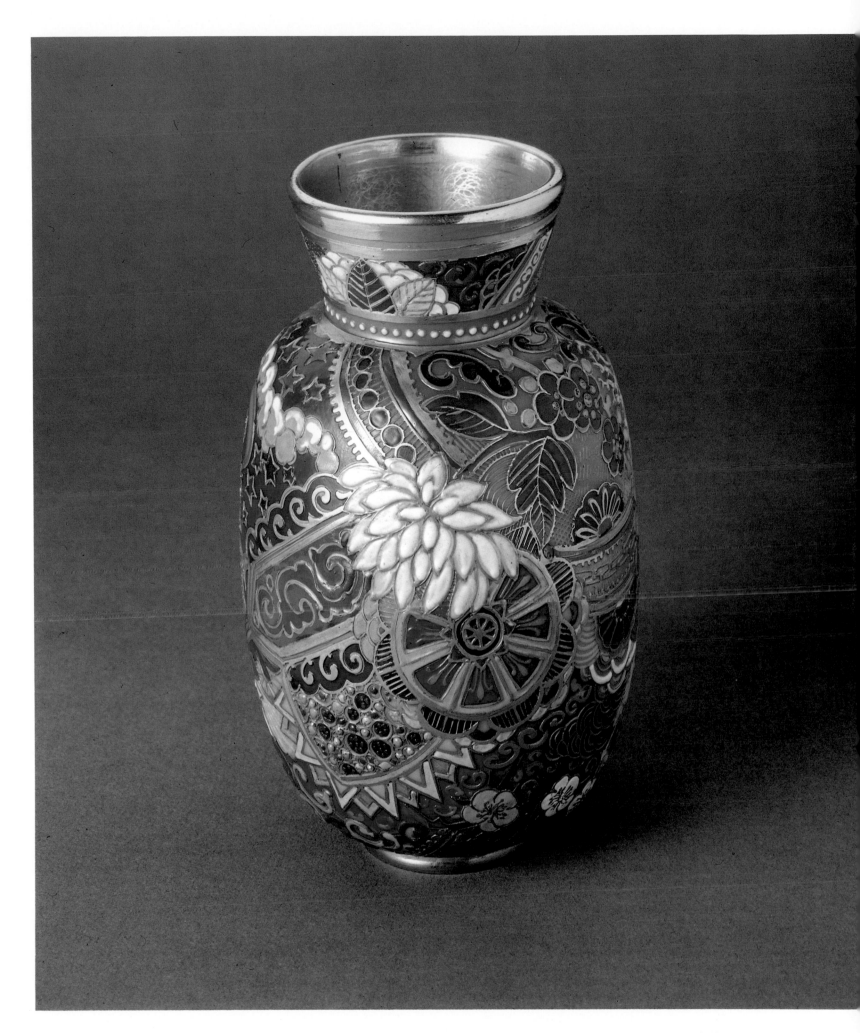

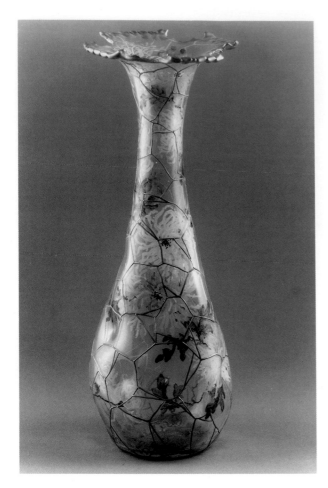

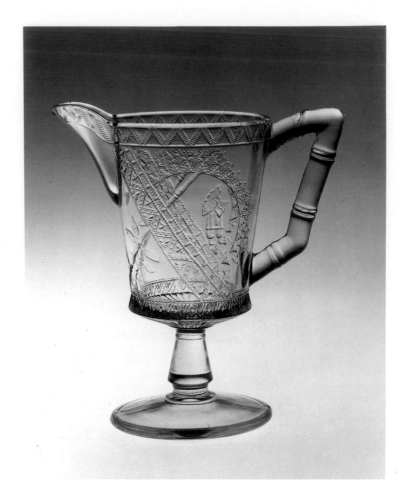

FIG. 7.56 Vase. Mount Washington Glass Company, New Bedford, Mass., ca. 1894. Gilded and enameled blown glass, h. 15½ in. (39.4 cm), diam. 5¾ in. (14.6 cm). Marked: *Napoli / 829.* The Chrysler Museum, Norfolk, Va., Institute of Glass, Gift of Walter P. Chrysler, Jr.

FIG. 7.57 Cream pitcher. American, probably midwestern, early 1880s. Pressed glass, h. 6¼ in. (15.9 cm), diam. 3 in. (7.6 cm). The Chrysler Museum, Norfolk, Va., Institute of Glass, Gift of Walter P. Chrysler, Jr.

NOTES

1. See Marilynn Johnson, "The Artful Interior," this publication.

2. For a complete description of William H. Vanderbilt's "Japanese" parlor, see Edward Strahan [Earl Shinn], *Mr. Vanderbilt's House and Collection,* 2 vols. (Boston, New York, and Philadelphia, 1883–84), pp. 59–73.

3. William C. Prime, *Pottery and Porcelain of All Times and Nations* (New York, 1878), p. 420.

4. Important ceramics sales had attracted attention in America by the mid-1870s. William C. Prime, in his chapter "Collectors and Collecting in America," cited three major ceramics sales in London: Philip P. Cother (1875), A. Morse (1876), and Dr. F. Gibson (1877). Prime, *Pottery and Porcelain,* pp. 425–29.

5. James D. McCabe, *The Illustrated History of the Centennial Exhibition . . .* (1876; reprint Philadelphia, 1975), p. 415.

6. Hector Tyndale, "Pottery, Porcelains, Bricks, Clays, Cements, and Their Materials, Etc.," in "General Report of the Judges of Group 2," in U.S. Centennial Commission, *International Exhibition, 1876: Reports and Awards,* 9 vols. (Washington, D.C., 1880), vol. 3, p. 499.

7. Walter Smith, *Examples of Household Taste* (New York, copr. 1875 [1880?]), pp. 292–93. Also issued as his *Industrial Art,* vol. 2 of *The Masterpieces of the Centennial International Exhibition* (Philadelphia, copr. 1875 [1877?]).

8. "Chinamania Made Useful at Last!" *Punch's Almanack for 1880* [unpaged supplement bound in at front of] *Punch* 78 (1880).

9. "This Is Not a Museum . . . ," *Scribner's Monthly* 14 (May 1877), p. 128 (ill.).

10. For further discussion on the history of collecting classical art in America, particularly in the last decade of the nineteenth century, see Dietrich von Bothmer, "Notes on Collectors of Vases," in Kimball Art Museum, Fort Worth, Tex., *Wealth of the Ancient World: The Nelson Bunker Hunt and William Herbert Hunt Collections* (exhib. cat., 1983), pp. 37–44.

11. Smith, *Examples of Household Taste,* p. 27.

12. Charles Locke Eastlake, *Hints on Household Taste in Furniture, Upholstery, and Other Details* (London, 1868), p. 208. The book was published in at least eight American editions; the first was printed in Boston in 1872 from the second London edition, with notes and introduction by Charles C. Perkins.

13. Christopher Dresser, quoted in "Greek Painted Vases," *Art Amateur* 6 (Mar. 1882), p. 82.

14. *North Shore* (1872), quoted in Lura Woodside Watkins, *Early New England Potters and Their Wares* (Cambridge, Mass., 1950), p. 222.

15. "Massachusetts Art Potteries," *Crockery and Glass Journal* 7 (Apr. 18, 1878), p. 19.

16. "Boston," *Crockery and Glass Journal* 4 (Oct. 19, 1876), p. 16.

17. A. H. Hews and Company [trade cat.], reproduced in *Designs and Instructions for Decorating Pottery in Imitation of Greek, Roman, Egyptian, and Other Styles of Vases* (Boston, 1877); A. H. Hews and Company [advertisement], *Crockery and Glass Journal* 5 (Jan. 18, 1877), p. 28.

18. "Boston," *Crockery and Glass Journal* 4 (Nov. 2, 1876), p. 15.

19. John Gardner Low's name first appeared in conjunction with the Chelsea Keramic Art Works in an advertisement the firm published, "Chelsea Keramic Works," *Crockery and Glass Journal* 4 (Nov. 16, 1876), p. 11.

20. A fully illustrated catalogue of the Englefield collection was posthumously published in 1848; see *Ancient Vases from the Collection of Sir Henry Englefield, Bart,* drawn and engraved by Henry Moses (London, 1848), esp. pls. 15, 16. On November 7, 1876, the Chelsea firm announced their intention to reproduce "the celebrated collection of Sir Henry Englefield entire"; see "Boston," *Crockery and Glass Journal* 4 (Nov. 2, 1876), p. 15. The present whereabouts of the vase illustrated in plates 15 and 16 in the Englefield collection is unknown. I am grateful to Joan R. Mertens, Department of Greek and Roman Art, The Metropolitan Museum of Art, New York, for her help in attempting to locate this vase.

21. The vase illustrated in *Ancient Vases,* plates 15

and 16, was copied in *Designs and Instructions,* pp. 31–32, but the artist omitted the handles and the painted decoration around the handles that appear on the Chelsea vase.

22. For example, the Portland Stoneware Company in Portland, Maine, advertised "all kinds of terra-cotta goods; art pottery for decoration, made from originals exhumed from Pompeii and Troy," in *Crockery and Glass Journal* 5 (Mar. 8, 1877), p. 11; a red terracotta vase with amateur decoration, marked by the Halm Art Pottery Company of Sandy Hill, N.Y., is in the collection of the Smithsonian Institution's Museum of American History (acc. no. 75.73); the Coultry Pottery of Cincinnati produced yellow ware and antique cream-colored pottery in Egyptian, Greek, Etruscan, and Roman forms, illustrating a profile of a "Hebe pitcher" in their advertisement for "Artistic Pottery," *American Pottery and Glassware Reporter* 1 (Sept. 11, 1879), p. 10.

23. Galloway and Graff, *Art and Horticultural Terra Cotta* (Philadelphia [1876]), unpaged, Collection of the Library Company of Philadelphia.

24. No one had a greater impact on the collections of oriental art at the Museum of Fine Arts, Boston, than did Morse. He was a highly systematic collector in his chosen field of Japanese ceramics, and by the time he finished his collection, it numbered well over five thousand pieces. The museum acquired his large holdings of Japanese pottery in 1892. Morse was also influential in inspiring others, Fenollosa and Bigelow among them, to visit Japan and to study its art and culture. Both Fenollosa and Bigelow collected Japanese art avidly. Bigelow's sizable collection came to the Museum of Fine Arts in 1889. Bigelow was also responsible for seeing that Fenollosa's collection went to the museum by persuading his friend Charles Goddard Weld to buy it in its entirety in 1886, with the understanding that it was to be given to the Museum of Fine Arts. See Jan Fontein, "Museum of Fine Arts, Boston, Department of Asiatic Art," *Oriental Art* 16 (Summer 1970), pp. 193–96; and Dorothy G. Wayman, *Edward Sylvester Morse: A Biography* (Cambridge, Mass., 1942), pp. 555–59.

25. Walters was an active buyer at most of the important European expositions, not just in London in 1862, but in Paris in 1867 and 1878, and in Vienna in 1873. He acquired the major part of his collection of oriental porcelains at the Vienna exhibition and at the Centennial Exposition in Philadelphia. See "Forward: The Founders of the Collection," *Journal of the Walters Art Gallery* 1 (1938), pp. 9–10.

26. Louisine Waldren Havemeyer, *Sixteen to Sixty: Memoirs of a Collector* (New York, 1961), pp. 15–16.

27. Ibid., p. 16.

28. Governor McClellan appropriated $1,500 for this endeavor; see "New Jersey Pottery and Glass Interests," *Crockery and Glass Journal* 9 (Jan. 23, 1879), p. 18.

29. "Trenton's Pottery Industry," *Crockery and Glass Journal* 9 (Mar. 30, 1879), p. 19.

30. "New Jersey Pottery and Glass Interests," p. 18; "Trenton Potteries," *Crockery and Glass Journal* 11 (Apr. 27, 1880), p. 20. A preliminary check through the card catalogue of the New Jersey State Library showed that the library includes extensive holdings on the history of ceramics in England, France, China, and Japan, which were presumably acquired by Isaac Broome in 1878–79. I am grateful to Ellen Denker for her help in reviewing the State Library holdings.

31. "Trenton Potteries," *Crockery and Glass Journal* 10 (July 24, 1879), p. 21.

32. It has generally been assumed that the first school of industrial design in Trenton aimed at the education of potters was founded in 1898, and was known as the School of Industrial Arts, or "The Trenton Academy." However, the Trenton Art School opened for professionals and amateurs in September 1879, where both modeling and painting

on china were taught. See [Trenton Art School], *Crockery and Glass Journal* 10 (Oct. 9, 1879), p. 16; and "Trenton Potteries," *Crockery and Glass Journal* 12 (Sept. 9, 1880), p. 19.

33. "New Jersey Pottery and Glass Interests," p. 18. There is no evidence that such a museum was ever established.

34. "The Potteries: Trenton," *Crockery and Glass Journal* 18 (July 19, 1883), p. 38.

35. "The Potteries: Trenton," *Crockery and Glass Journal* 18 (Aug. 2, 1883), p. 20.

36. "The Potteries: Trenton," *Crockery and Glass Journal* 18 (Sept. 6, 1883), p. 18.

37. "The Potteries: Trenton," *Crockery and Glass Journal* 20 (Oct. 2, 1884), p. 10.

38. "Faience Mfg. Co." [advertisement], *Decorator and Furnisher* 7 (July 1886), supplement, p. 121.

39. "Decorative Novelties," *Art Interchange* 19 (July 2, 1887), p. 4. This may well be one of a pair of vases made by the Faience Manufacturing Company for historian/collector Edwin AtLee Barber. It matches the description for lot 540 in the sale catalogue of Barber's collection at auction in 1917, where it had been catalogued per Barber's manuscript notes as "the most Artistic Faience Ever Produced in America." See Samuel T. Freeman and Company, Philadelphia, [*The Collection of*] *the Late Edwin AtLee Barber, A.M., PH. D.: Illustrated Catalogue of China, Pottery, Porcelains, and Glass . . .* (sale cat., Dec. 10 and 11, 1917), p. 83.

40. "Baltimore Reports," *Crockery and Glass Journal* 15 (Apr. 13, 1882), p. 24.

41. "Baltimore Reports," *Crockery and Glass Journal* 18 (Aug. 16, 1883), p. 38.

42. Ibid.

43. In November 1882, the *Crockery and Glass Journal* reported that about thirty ladies from the Maryland Institute School of Design were at work on the wares produced at D. F. Haynes Pottery. "Baltimore Reports," *Crockery and Glass Journal* 16 (Nov. 23, 1882), p. 28.

44. Quoted in Edwin AtLee Barber, *The Pottery and Porcelain of the United States,* 3d ed. (1909; reprint New York, 1976), p. 45.

45. Dresser designed for a number of different potteries throughout the late nineteenth century, including Minton, Stoke-on-Trent; Linthorpe Art Pottery, Middlesborough; Ault Pottery, Derbyshire; Old Hall Earthenware Company, Limited, Hanley; and Watcombe Pottery Company, Devon. For more information, see Camden Arts Centre, London, *Christopher Dresser, 1834–1904,* by Michael Collins (exhib. cat., 1979), pp. 31–44.

46. The design appeared in fig. 12, p. 18, of Christopher Dresser, *Principles of Decorative Design* (1873; reprint London, 1973), which was originally published as a series of articles in Cassell's *Technical Educator* (London, 1870–73). See Camden Arts Centre, *Christopher Dresser,* p. 31.

47. In recent years the term "art pottery" has been used loosely to describe many different kinds of pottery made in the late nineteenth and early twentieth centuries.

48. Jennie J. Young, *The Ceramic Art: A Compendium of the History and Manufacture of Pottery and Porcelain* (New York, 1879), p. 469.

49. "Boston," *Crockery and Glass Journal* 4 (Nov. 2, 1876), p. 15.

50. An unglazed red earthenware vase dating from 1877 displaying nearly three-dimensional putti carrying a ribbon in high relief was sculpted by Franz Dengler and is in the collection of the Worcester Art Museum, Mass.; a small, green-glazed vase in a private collection bears a relief design on each side of a woman's head and is signed and dated *W. Rimmer / 1879.*

51. Little is known about Fenety. By 1901 he is

listed in the *American Art Annual* as being a designer and a member of the Boston Society of Arts and Crafts, which was founded in 1897. For additional information, see his biography in Dictionary of Architects, Artisans, Artists, and Manufacturers, this publication.

52. On October 27, 1879, Mrs. Glessner recorded in her journal that "Mr. Scott was making pottery for us in Boston." Quoted in "Notes Taken from the Glessner Journals of 1874 thru 1880," in correspondence from Mary Alice Molloy, Chicago Architecture Foundation, Jan. 18–19, 1986. The vase illustrated here may have been Scott's most inspired, made specifically for his forward-thinking clients, for it is not only signed *Scott / 79* on the front in addition to the impressed factory mark of Chelsea Keramic Art Works, but on the opposite side it bears the inscription *To John J. Glessner / of Chicago / from Scott . . . / Oct. 25 1879.*

53. George A. Leavitt and Company, New York, *The Dresser Collection of Japanese Curios and Articles Selected for Messrs. Tiffany and Co.* (sale cat., June 18, 1877).

54. The pottery was able to reopen only when the commercial Dedham-type ware was introduced in 1891; see Paul Evans, *Art Pottery of the United States: An Encyclopedia of Producers and Their Marks* (New York, 1974), p. 50.

55. The date of Bennett's arrival in America is confirmed in a letter to the editors of *Art Amateur,* 1885, in which Bennett refuted that he was a "graduate of Doulton's" by saying, "The entire department of faience pottery was introduced, and all the pupils instructed by me up to 1877, when I came to this country." *Art Amateur* 12 (Apr. 1885), p. 117.

56. Letter of introduction from an acquaintance of Frederick Leighton to Leighton on behalf of John Bennett, London, June 21, 1877: "He is an enthusiastic admirer of Persian (Washani, Rhodian) faience and a very successful imitator. He would be much pleased to see your collection and I have no doubt you will be pleased to show your treasures to him." Courtesy of Mr. and Mrs. Albert R. Bennett, and Mr. and Mrs. William Bennett.

57. "Among the Dealers" [John Bennett], *Art Amateur* 8 (Jan. 1883), p. 43.

58. Numerous advertisements for Bennett faience by Davis Collamore and Company (or Gilman Collamore and Company) appeared in *Art Amateur* beginning in 1879. Abram French and Company was Bennett's exclusive agent in Boston. See "Bennett Faience in Boston," *Art Amateur* 2 (Mar. 1880), p. 88. In 1881 the women of Cincinnati wished to acquire Bennett's work for their new museum. In a letter of April 19, 1881, Mrs. Aaron F. Perry, president of the Women's Art Museum Association of Cincinnati, wrote Bennett expressing her personal wish "to secure a representation of your [Bennett's] work for our Museum that is to be." She went on to specify that she wanted "two specimens of Bennett faience, large and imposing, . . . not a *pair* in size and shape—but different—and say 3 ft. high." Much correspondence regarding this matter continued through 1882, yet the vases Bennett sent to the Women's Art Museum Association for approval were not equal to their expectations and therefore not accepted. In fact, the Cincinnati Art Museum acquired their first Bennett vase in 1984. Women's Art Museum Association of Cincinnati Collection, Box 1, Folder 8, Letters, 1881; Box 2, Folder 9, Letters, 1882, Cincinnati Historical Society. I am grateful to Kenneth R. Trapp, The Oakland Museum, Calif., for bringing this and other references regarding the Women's Art Museum Association and Cincinnati ceramics to my attention.

59. "The New Society of Decorative Art," *New York Times,* June 16, 1877, p. 4.

60. A lengthy correspondence between Mrs. Perry and Bennett took place from 1878 through 1881 with

regard to china-painting lessons in Cincinnati. Women's Art Museum Association of Cincinnati Collection, Box 1, Folders 5–8, Letters, 1878–81, Cincinnati Historical Society.

61. "General Notes," *Crockery and Glass Journal* 10 (Nov. 6, 1879), p. 28. For further information on Charles Volkmar, see Mary Gay Humphreys, "Volkmar Faience," *Art Amateur* 8 (Jan. 1883), p. 43; William Walton, "Charles Volkmar, Potter," *International Studio* 36 (Jan. 1909), pp. 75–81; Barber, *Pottery and Porcelain of the United States,* pp. 377–81, 517; and Evans, *Art Pottery of the United States,* pp. 310–15.

62. A reporter in 1878 described the difference between Bennett (or Lambeth) faience and "Limoges" style decoration. "Cincinnati Ceramics," *Cincinnati Enquirer,* Nov. 27, 1878. Women's Art Museum Association of Cincinnati Collection Scrapbooks, Cincinnati Historical Society.

63. Humphreys, "Volkmar Faience," p. 43.

64. *Annual Report[s] of the New York Society of Decorative Art,* 1877–85.

65. Jeanne M. Weimann, *The Fair Women* (Chicago, 1981), p. 416. I am grateful to Cynthia Brandimarte, Harris County Heritage Society, Houston, for bringing this reference to my attention.

66. For further discussion of Celia Thaxter, see Roger B. Stein, "Artifact as Ideology: The Aesthetic Movement in Its American Cultural Context," this publication.

67. Letter from Celia Thaxter to Richard H. Derby, Isles of Shoals, Maine, Dec. 11, 1876, in *Letters of Celia Thaxter,* ed. A[nnie] F[ields] and R[ose] L[amb] (Boston and New York, 1895), pp. 59, 81. I am grateful to Laura Fecych Sprague for bringing this and other Thaxter material to my attention.

68. Letter from Celia Thaxter to Annie Fields, Isles of Shoals, Maine, 1877, in ibid., p. 86.

69. For the most complete information on Alice Cunningham Ware, see Dictionary of Architects, Artisans, Artists, and Manufacturers, this publication. Cunningham married the noted Boston architect William Rotch Ware in 1877.

70. According to her granddaughters, Alice Cunningham Ware not only painted china, tiles, plates, teacups, and saucers, but she also carved wood, especially frames for panels and screens, and painted murals, notably scenes of fairies and sprites, in her home, down the stairway and in the nursery. She also illustrated storybooks. Marian Ware Balch, correspondence, Oct. 7, 1984; Betty Ware Sly, correspondence, Nov. 5, 1984.

71. "General Report of the Judges of Group 2," in U.S. Centennial Commission, *International Exhibition, 1876: Reports and Awards,* 9 vols. (Washington, D.C., 1880), vol. 3, pp. 595–96.

72. *Annual Report of the New York Society of Decorative Art,* 1877, p. 28.

73. Carla Mathes Woodward, "Acquisition, Preservation, and Education: A History of the Museum," in *A Handbook of the Museum of Art, Rhode Island School of Design* (Providence, 1985), p. 11.

74. The source for this decoration has not been identified. It has been suggested that it might be a scene from Shakespeare's *A Midsummer Night's Dream.* However, it may just as easily be from an English or German children's tale.

75. The *Medeola virginiana* plant is native to America. The identification of this plant was generously provided by Marco Polo Stufano and John Nally, Wave Hill, Riverdale, N.Y.

76. Benn Pitman, *A Plea for American Decorative Art,* Cincinnati Souvenir, Cotton States and International Exposition, Atlanta, Ga. (Cincinnati, 1895), p. 11.

77. Agnes Pitman's half sister, Melrose, gave the vase to the Cincinnati Historical Society in 1961. In an early (undated) photograph of Benn Pitman's Cincinnati home, this vase can be seen on the mantelshelf in the dining room. Pitman Collection, Box 1, Cincinnati Historical Society. It was also exhibited in 1893 at the World's Columbian Exposition in Chicago in the Cincinnati Room, which Agnes Pitman decorated. It is illustrated in situ in Maud Howe Elliott, *The Illustrated Art and Handicraft in the Women's Building* (Chicago, 1893), p. 112.

78. The pitcher, dated 1881, was made for the Cincinnati Pottery Club but was probably made at the Rookwood Pottery. The Pottery Club began to use the Rookwood facilities in 1881. Cincinnati Art Museum, *The Ladies, God Bless 'Em: The Women's Art Movement in Cincinnati in the Nineteenth Century,* by Anita J. Ellis (exhib. cat., 1976), p. 44.

79. Lilian Whiting, "The Cincinnati Pottery Club," *Art Amateur* 3 (June 1880), p. 11.

80. "The Ali Baba Vase," *Art Amateur* 2 (Mar. 1880), p. 79.

81. Whiting, "Cincinnati Pottery Club," p. 11.

82. Martin Fido, *Oscar Wilde* (New York, 1973), p. 33.

83. "Pottery Club Reception: A Brilliant Reception Given by the Pottery Club, Attended by the Elite of Cincinnati," *Cincinnati Commercial,* May 6, 1880, Women's Art Museum Association of Cincinnati Collection Scrapbooks, Box 4, Cincinnati Historical Society.

84. Rose G. Kingsley, "Rookwood Pottery," *Art Journal* (London), Dec. 1897, p. 342.

85. For further study of the influence of Japanese art on Rookwood pottery, see Kenneth R. Trapp, "Rookwood and the Japanese Mania in Cincinnati," *Cincinnati Historical Society Bulletin* 39 (Spring 1981), pp. 51–75, and his "Japanese Influence in Early Rookwood Pottery," *Antiques* 103 (Jan. 1973), pp. 193–97.

86. George Ward Nichols, *Pottery: How It Is Made, Its Shape and Decoration, Practical Instructions for Painting on Porcelain and All Kinds of Pottery with Vitrifiable and Common Oil Colors* (New York, 1878).

87. See Women's Art Museum Association of Cincinnati, *Loan Collection Exhibition* (exhib. cat., 1878).

88. A large exhibition and sale of 433 works of Japanese art took place in Cincinnati. See Jacob Graff and Company, Cincinnati, *Catalogue of the Yedo-Nausau Collection of the Choicest Japanese Works of Art* (sale cat., May 13, 1878), Cincinnati Historical Society, cited in Trapp, "Rookwood and the Japanese Mania," p. 54.

89. *Exhibition of Japanese Art Treasures, Ceramics of the Orient* (sale cat., 1880), Cincinnati Historical Society, cited in Trapp, "Rookwood and the Japanese Mania," p. 54.

90. I am grateful to Kenneth R. Trapp for bringing the Rookwood Shape Book to my attention. It is an immensely valuable document for the study of early Rookwood. William Watts Taylor, Rookwood's president, entered each shape design into the ledger, accompanied either by a small photograph or a sketch. Other recorded details include written descriptions of the source of the shape, its decorator(s), method of manufacture, and sales record. Collection, Cincinnati Historical Society.

91. It is interesting to note that the Schliemann collection of ancient vases is specified in two cases dating from 1887 and 1891. Two shapes copied examples of the Chelsea Keramic Art Works "from vase of Hugh Robertson." Rookwood Shape Book.

92. No. 664, copied a "Chinese vase in W. T. Walters' Collection" in 1892. The Morse and Nichols collections furnished numerous prototypes. For further information on Morse's relationship to Cincinnati, see Trapp, "Rookwood and the Japanese Mania," pp. 63–64. According to Trapp, while Morse was lecturing on Japanese subjects in Cincinnati in 1886, he also made suggestions for vase shapes based on Japanese examples. At that time, Maria Longworth Nichols purchased 670 pieces of Japanese pottery, duplicates from Morse's collection. Nichols's collection influenced numerous Rookwood designs such as "42. Japanese crock after model furnished by MLN, 1884"; "244. pressed bowl, 1885 (after cast) by William Watts Taylor From Mrs. Nichols Japanese wallpaper"; and "192. After Japanese bottle belonging to M. L. N., 1882." Rookwood Shape Book.

93. For a discussion of Gallé's influence on Rookwood Pottery, see Trapp, "Rookwood and the Japanese Mania," pp. 59–60.

94. For a thorough discussion of the Tile Club, see Doreen Bolger Burke, "Painters and Sculptors in a Decorative Age," this publication. For further information, see Lyman Allyn Museum, New London, Conn., *A Catalogue of Work in Many Media by Men of the Tile Club,* intro. William Douglas, essay by Dorothy Weir Young (exhib. cat., 1945); Ronnie Rubin, "The Tile Club, 1877–1887" (M.A. thesis, New York University, 1967); and Mahonri Sharp Young, "The Tile Club Revisited," *American Art Journal* 2 (Fall 1970), pp. 81–91.

95. Suzanne C. Hamilton, "Decorative Fireplace Tiles Used in America," *Antiques* 121 (Feb. 1982), pp. 468–75.

96. Almon C. Varney, *Our Homes and Their Adornments, or How to Build, Finish, Furnish, and Adorn a Home . . .* (Detroit, 1882), p. 355.

97. Edwin AtLee Barber, "Recent Advances in the Pottery Industry," *Popular Science Monthly* 40 (Jan. 1892), p. 307.

98. E. Stanley Wires, "Decorative Tiles, Part 3: Their Contribution to Architecture and Ceramic Art," *New England Architect and Builder Illustrated* 2 (Mar. 1960), p. 15.

99. The first patent for encaustic tiles was granted to English potter Samuel Wright. Herbert Minton purchased a share in the patent and perfected the technique. The patent describes the process as follows: ". . . ornamenting them [tiles] in various colors and with various patterns similar to the patterns on a carpet, etc., by impressing them with the patterns and filling up the impressions with clay, etc., coloured with metal oxides." Llewellynn Jewitt, *Ceramic Art of Great Britain,* 2 vols. (London, 1878), vol. 2, p. 195.

100. E. Stanley Wires, Norris F. Schneider, and Moses Mesre, *Zanesville Decorative Tiles* (Zanesville, Ohio, 1972), pp. 3–4.

101. Eastlake, *Hints on Household Taste,* p. 44.

102. Julian Barnard, *Victorian Ceramic Tiles* (Greenwich, Conn., 1972), pp. 39, 109–10.

103. In America during the 1880s, Greenaway subjects and "Greenaway-style" subjects were also popular on both English- and American-made commercially decorated tableware for children. The *Crockery and Glass Journal* reported that Jesse Dean had produced "a line of bread and milk sets, which are decorated in the brightest and prettiest way by illustrations from Kate Greenaway's 'Under the Willow'"; see "Trenton Potteries," *Crockery and Glass Journal* 12 (Aug. 5, 1880), p. 20.

104. I am grateful to Mrs. Wesley Wright, Jr., of Richmond, Va., for bringing these tiles to my attention. They were originally installed in the Archer Anderson house in Richmond, when it was redecorated in the early 1880s under the direction of local architect M. J. Dimmock.

105. There is some confusion about the dating of American Encaustic Tiling Company's tiles with Walter Crane illustrations. According to Chester Davis, "The AETCO Tiles of Walter Crane," *Spinning Wheel* 29 (June 1973), pp. 18–20, the American Encaustic Tiling Company reached an agreement with Edmund Evans, Crane's English publisher, to use illustrations from *The Baby's Opera* and *The Baby's Own Aesop* on a series of tiles for the American market, which the company produced from Crane's

original plates during the 1890s. However, there is also some evidence that Frederick Hurton Rhead, while working at the American Encaustic Tiling Company during the 1920s, worked on Crane designs for tiles.

106. "Charles C. Coleman," *Art Amateur* 2 (Feb. 1880), p. 46.

107. [Amanda B. Harris], "Fire-place Stories," *Wide Awake* 22 (Dec. 1885), pp. 46–47.

108. See ibid., p. 48, for Childe Hassam's illustration of a detailed view of the interior complete with a Windsor chair and a tall clock.

109. "American Tiles," *Crockery and Glass Journal* 10 (July 31, 1879), p. 30.

110. Ibid.

111. Frank D. Millet, "Some American Tiles," *Century Illustrated Monthly Magazine* 23 (Apr. 1882), p. 898.

112. Ibid., p. 903.

113. For more information on Low's collaboration with Vedder, see Regina Soria, *Elihu Vedder: American Visionary Artist in Rome (1836–1923)* (Rutherford, N.J., 1970), pp. 162–63; and Barbara White Morse, "John G. Low and Elihu Vedder: As Artist Dreamers," *Spinning Wheel* 32 (May 1976), pp. 24–27.

114. Soria, *Elihu Vedder*, p. 163.

115. See David A. Hanks with Jennifer Toher, "Metalwork: An Eclectic Aesthetic," this publication. See also Barbara White Morse, "Buying a Low Art Tile Stove," pts. 1, 2, *Spinning Wheel* 26 (Nov. 1970), pp. 28–31; (Dec. 1970), pp. 12–15.

116. Millet, "Some American Tiles," p. 899.

117. According to Barbara White Morse, correspondence, Mar. 23, 1985, Low had thirty-four agents in twenty-four cities in the United States and Canada. In the United States his tiles retailed on the West Coast in Los Angeles and San Francisco, in the Midwest from Chicago to Omaha, and in the East in Philadelphia and New York, to name just a few cities. Some of the agents and their locations are listed in the advertisement of J. G. and J. F. Low's Art Tile Works in Architectural League of New York, *Catalogue of the Third Annual Exhibition* (exhib. cat., 1887), [advertisements], p. 57. CARYL COLEMAN, brother of the artist Charles Caryl Coleman, was Low's agent in New York City.

118. J. and J. G. Low, *Art Tiles* (Chelsea, Mass., 1881); J. and J. G. Low, *Illustrated Catalogue of Art Tiles* (Chelsea, Mass., 1881–82); J. G. and J. F. Low, *Illustrated Catalogue of Art Tiles* (Chelsea, Mass. [1884?]); J. G. and J. F. Low, *Plastic Sketches* (Boston, 1887).

119. Harris, "Fire-place Stories," p. 47.

120. *Artistic Houses, Being a Series of Interior Views of a Number of the Most Beautiful and Celebrated Homes in the United States,* 2 vols. in 4 pts. (1883–84; reprinted in 1 pt., New York, 1971), vol. 2, pt. 1, p. 50.

121. Ibid., pp. 64–65.

122. A letter from Elihu Vedder to his wife, in 1881, describes a visit to the Cornelius Vanderbilt II house. Quoted in Soria, *Elihu Vedder,* p. 160.

123. J. G. and J. F. Low, *Illustrated Catalogue of Art Tiles* (Chelsea, Mass. [1884?]), p. 1.

124. "American Tiles in England," *American Art Review* (Boston) 1, pt. 2 (1881), p. 552.

125. John Ruskin, *The Stones of Venice,* 3 vols. (1851–53; 4th ed. Orpington, Eng., 1886), vol. 2, p. 392.

126. Eastlake, *Hints on Household Taste,* p. 227.

127. William Morris, "The Lesser Arts of Life," in *Lectures on Art Delivered in Support of the Society for the Protection of Ancient Buildings* (London, 1882), p. 197.

128. Ada Polak, *Glass: Its Tradition and Its Makers* (New York, 1975), p. 202.

129. Hugh Tait, *The Golden Age of Venetian Glass* (London, 1979), pp. 7–8.

130. Women's Art Museum Association of Cincinnati, *Loan Collection Exhibition,* pp. 38–40.

131. "Excellent Specimens of American Work," *Crockery Journal* 1 (May 13, 1875), p. 4.

132. Letter from James Jackson Jarves to Luigi Palma di Cesnola, Mar. 30, 1881, Archives, The Metropolitan Museum of Art, New York. Deming Jarves had an impressive reputation in the American glass industry during the nineteenth century, counting the founding of the Boston and Sandwich Glass Company in Sandwich, Mass., among his numerous achievements.

133. Letter from James Jackson Jarves to Luigi Palma di Cesnola, July 3, 1881, Archives, The Metropolitan Museum of Art, New York.

134. W. J. Hodgetts of Hodgetts, Richardson and Son of Stourbridge took out a patent for a glass-threading machine in 1876 and another was taken by Stevens and Williams also of Stourbridge in 1877; see Robert J. Charleston, *English Glass and the Glass Used in England, circa 400–1940* (London, 1984), p. 218; and Hugh Wakefield, *Nineteenth Century British Glass,* rev. ed. (London, 1981), p. 113.

135. This is the first reference to American-made threaded glass. See [Sandwich threaded glass], *Crockery and Glass Journal* 11 (Feb. 12, 1880), p. 13.

136. In 1886 the Phoenix Glass Company of Water Cure, Pa., offered threaded wares under the name "Venetian Threaded." See Albert Christian Revi, *Nineteenth Century Glass: Its Genesis and Development,* rev. ed. (Exton, Pa., 1967), p. 125.

137. Apsley Pellatt, *Curiosities of Glass Making* (London, 1849), pp. 116–17.

138. The earliest mention of American-made frosted glassware appears in the *Crockery and Glass Journal* 5 (May 3, 1877), pp. 14–15, referring to wares made by the Boston and Sandwich Glass Company. It was also produced at Hobbs, Brockunier and Company of Wheeling, W. Va., the Reading Artistic Glass Works established by Lewis Kremp in Reading, Pa., in 1884, George Duncan and Sons in Philadelphia, and undoubtedly many other factories. See Revi, *Nineteenth Century Glass,* p. 62; "Pittsburgh Trade Reports," *Crockery and Glass Journal* 11 (Jan. 1, 1880), p. 10; and Hobbs, Brockunier and Company [advertisement], *Crockery and Glass Journal* 18 (Oct. 4, 1883), p. 17.

139. James Jackson Jarves, "Lost Art: Restoration of the Vasa-Murrhina Glass," *Boston Evening Transcript,* Sept. 14, 1883, clipping from the Corning Museum of Glass Library, N.Y.

140. "A Lost Art Revived: Polychrome Glass in Endless Variety," *Daily Evening Traveler,* Sept. 15, 1883, p. 1.

141. According to John Charles DeVoy's patent for the Vasa Murrhina Art Glass Company, Sandwich, Mass., this was actually made by coating sheets of mica with silver, gold, copper, or nickel, and incorporating those mica flakes into the colored glass, which was then formed into a vessel. Patent specification filed with the U.S. Patents Office on Oct. 3, 1883, reprinted in Raymond E. Barlow and Joan E. Kaiser, *The Glass Industry in Sandwich,* vol. 4 (Windham, N.H., 1983), p. 136.

142. "Aetna and Its Lava Streams," *Crockery and Glass Journal* 8 (Dec. 12, 1878), quoted in Revi, *Nineteenth Century Glass,* p. 235.

143. [Farrall Venetian Art Glass Manufacturing Company], *Crockery and Glass Journal* 16 (July 6, 1882), p. 22.

144. Ibid.

145. Jarves, "Lost Art."

146. "Boston Trade Reports," *Crockery and Glass Journal* 18 (Aug. 9, 1883), p. 34.

147. Jarves, "Lost Art."

148. Ibid.

149. Hobbs, Brockunier and Company [advertisement], *Crockery and Glass Journal* 18 (Oct. 4, 1883), p. 17.

150. American Art Galleries, New York, *Catalogue of the Art Collection Formed by the Late Mrs. Mary J. Morgan* (sale cat., Mar. 8, 1886), p. 101 (lot 341). The vase, "peach blow" or "crushed strawberry" in color, was described in the catalogue as "of graceful ovoid shape with slender neck, slightly spreading at top, perfection in form, color and texture. . . . [The vase], from the private collection of I Wang-ye, a Mandarin prince, has a world-wide reputation as being the finest specimen of its class in existence."

151. According to Revi, *Nineteenth Century Glass,* p. 46, B. D. Baldwin and Company, Chicago, introduced a line of lipstick and rouge called "Peach Blow."

152. Hobbs, Brockunier and Company [trade cat.] (Wheeling, W.Va., n.d.), Fenton Art Glass Company, Ohio.

153. *Crockery and Glass Journal* 24 (Nov. 25, 1886), quoted in Revi, *Nineteenth Century Glass,* p. 45.

154. Katherine Morrison McClinton, "Brocard and the Islamic Revival," *Connoisseur* 205 (Dec. 1980), p. 279.

155. La Belle Glass Company [advertisement for "Queen Anne" pattern], *Crockery and Glass Journal* 10 (Dec. 26, 1879), p. 22; "Pittsburgh Glass Factories," *Crockery and Glass Journal* 10 (Sept. 18, 1879), p. 30.

156. This is an unusual instance where the designer for a particular pressed-glass pattern has been identified. Mr. A. Withmar, of Withmar, Gray and Kaminsky, Saint Louis, designed the Grace pattern for Richards and Hartley of Tarentum, Pa. He also designed the Queen Anne pattern. "New Designs in Glassware," *Crockery and Glass Journal* 13 (Feb. 17, 1881), p. 8.

157. Ibid.

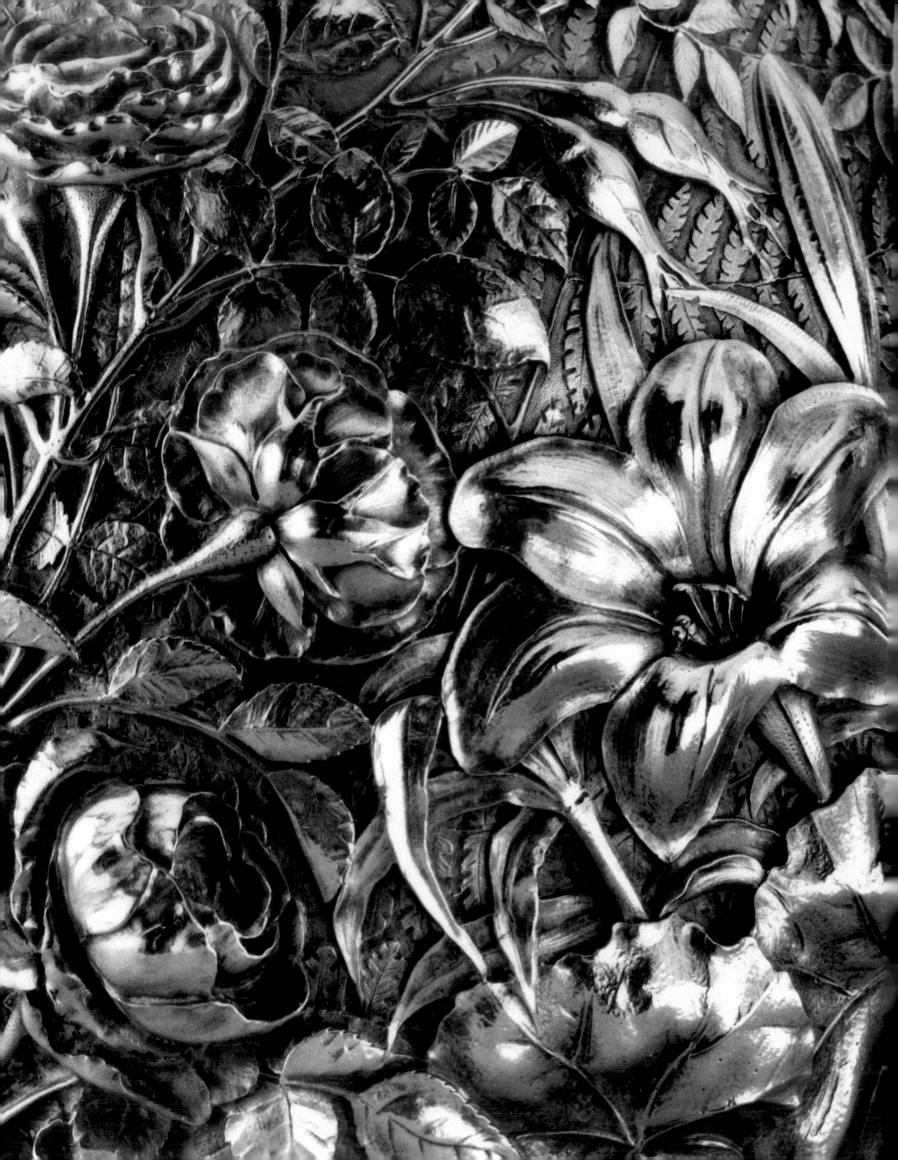

Metalwork: An Eclectic Aesthetic

David A. Hanks
with Jennifer Toher

ETALWORK of the Aesthetic movement often recalls the numerous styles available to designers of the period. In reaction to the ornate furnishings and interiors of the early nineteenth century, many American designers of the Aesthetic era sought inspiration from foreign sources, especially England and Japan, which frequently provided models based on principles of function and simplicity. Despite earnest attempts at reform, most metalwares produced during the Aesthetic era were imaginative interpretations that bore little or no relationship to original prototypes, combining elements from many historical styles. Although aesthetic ornament appeared in metalwork of various media, including brass, bronze, cast iron, wrought iron, copper, and gold, it found its most important expression in silver.

Silver and Other Precious Metals

"No branch of our American Art-manufacturers has made such rapid progress during the past twenty-five years as that devoted to the production of designs for household use in the precious metals," proclaimed a writer in the *Art Journal* in 1875.[1] This progress is evident in a good deal of American silver manufactured during the 1870s and 1880s, when the industry was undergoing technological changes in the production processes.[2] Factories of hundreds of workers had long replaced the small-scale shops of the eighteenth century, which had employed master craftsmen, journeymen, and apprentices. Division of labor, spurred on by greater output, flourished during the Industrial Revolution and widened the separation between design and execution. Along with an increased supply of metal, division of labor facilitating the ease of production helped reduce the price of silver products and thereby made it accessible to a larger consumer public. In contrast with the 1700s, when craftsmen tended to sell their own goods, during the 1880s the distribution of merchandise through non-manufacturing retailers, such as department stores and jewelers, grew.

Whereas silver objects were made in many cities on the eastern seaboard of the United States in the eighteenth century, by the second half of the nineteenth most major manufacturing centers were in New York City and New England. Three of the major silver firms that were to play an important role in the Aesthetic movement illustrate this point: TIFFANY AND COMPANY of New York, the GORHAM MANUFACTURING COMPANY of Providence, Rhode Island, and the WHITING MANUFACTURING COMPANY of North Attleboro, Massachusetts, and New York.[3] These concerns produced the greatest number of original silver designs of the 1870s and 1880s in America.

The eclectic nature of late nineteenth-century American silver makes it difficult to identify individual styles in many pieces. The predominant taste in the United States throughout the second half of the nineteenth century was for objects using historical modes such as Renaissance and Egyptian revival, evidenced by both the European and the American silver displayed at the Philadelphia Centennial Exposition in 1876. There Tiffany and Company exhibited approximately 125 pieces of silver that combined historical revivals with other styles, such as the Anglo-Japanesque and the Modern Gothic, which were popular during the Aesthetic period.[4] Both of these styles appealed to the reforming sensibilities of the aesthetes: the simple lines and derivation from nature typical of the Anglo-Japanesque were particularly suited to aesthetic principles, and the Modern Gothic, by invoking the medieval guild tradition of handicraft, allowed designers of the time to fashion objects of beauty with care and precision.

Tiffany's Bryant Vase (FIG. 8.1), designed in 1875 by JAMES HORTON WHITEHOUSE, illustrates late nineteenth-century eclecticism in its mixture of historicism and aestheticism. Whereas its classical form and lyre-shaped handles, as well as its Renaissance medallions, produce balance and symmetry, an asymmetrical arrangement of Japanese motifs embellishes the handles, and stylized flowers are incorporated about the body, typically aesthetic elements.[5]

The Whiting Manufacturing Company produced outstanding hollow ware, exemplified by a small vase (FIG. 8.2) with eclectic decorative groupings. The lower register of the object incorporates naturalistically depicted flora in repoussé consisting of lilies, roses, and other flowers in an asymmetrical composition. In addition, a band of conventionalized pseudo-Egyptian lotus plants appears at the neck.[6] The juxtaposition of naturalistic and stylized elements reflects an ongoing late nineteenth-century debate concerning the use of nature as a source of ornamentation (see chap. 2). The vase has an incised inscription, *LG SCULP,* on the side near the base and the signature *LGoerak*[?] *chaser.* The signature, clearly visible, was an unusual addition to a silver object, which ordinarily was stamped on the bottom with the manufacturer's name alone; during the late 1800s it was common for the individual designer or artisan to remain anonymous. The inclusion of the signature on the Whiting vase is indicative of the changing attitude toward the treatment of design from one of strict pragmatism to one that included artistic considerations.

At least one work displayed by Tiffany and Company at the Centennial could be described as representative of the reform movement—a silver pitcher designed in 1876 (FIG. 8.3) is an example in contour and decoration of the Modern Gothic style.[7] Quatrefoil-shaped in section, it has alternating bands of silver and

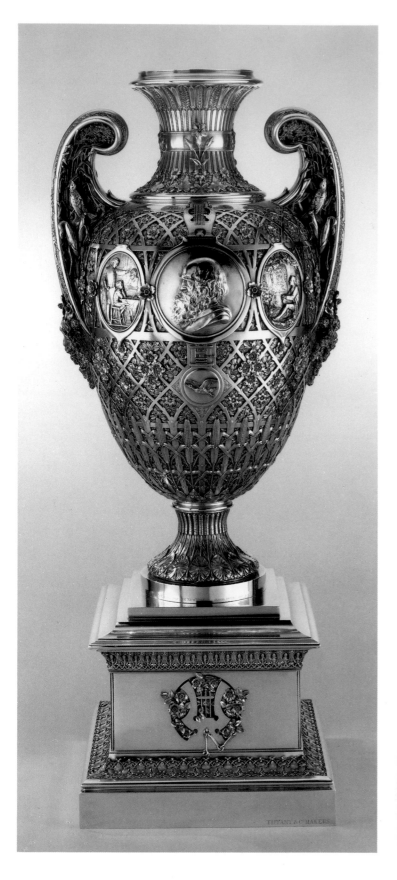

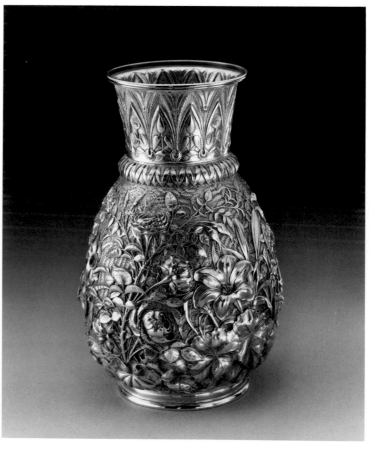

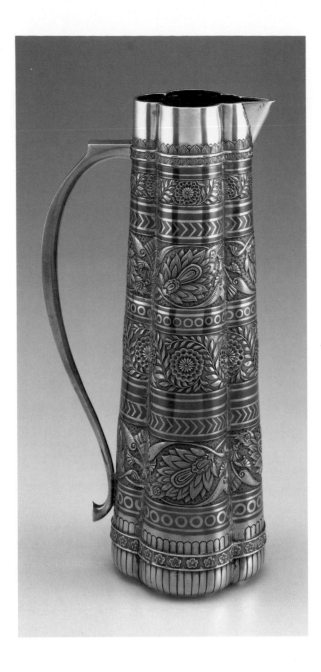

and 1880s. The Anglo-Japanesque prevailed as the major reform mode during those decades.[9] The presentation of bronze and lacquerwork in the Japanese section of the Centennial Exposition (ILL. 8.2) influenced American designers of metalwork and stirred enthusiasm among consumers. According to one account, never before had Americans seen such a variety of fine bronzes exhibited: "The sight of the Japanese display at Philadelphia filled us with amazed excitement, and we demanded of ourselves how these people had attained their Art, and what processes of mind and conditions of society must be passed through by us."[10] For designers at Tiffany and Company it confirmed a direction already established, as the firm had produced hollow ware with Japanese decoration as early as 1873.[11] One assumes that the display in Philadelphia fostered public interest in Tiffany's Anglo-Japanesque objects and helped to develop a popular taste for Japanese technical achievements, among them the use of mixed metals.

The origin of a Japanese sensibility in American metalwork can in part be traced to English manufacturers and designers. ELKINGTON AND COMPANY of Birmingham was among the first English firms to manufacture silver objects in the Japanese manner, which presumably were available in the United States. The company's experiments with enamelwork in the Japanese style date as early as the 1860s.[12] A silver and parcel-gilt jug and two beakers are impressive examples of the firm's Anglo-Japanesque work;[13] in the jug, Eastern elements such as bamboo shoots, Prunus trees, birds, and butterflies are asymmetrically arranged on a traditional Western form with a narrow neck. Among Elkington's successful aesthetic pieces is a parcel-gilt tray of 1879 (FIG. 8.4) on which naturally depicted birds are shown flying among leaves and branches. Although the motifs are Japanese, they are composed with a balance and a symmetry that are Western.

Dresser's visits to America in 1876 and 1877 served as a catalyst for the influence of Japanese art on American manufacturers and designers of metalwork. During his first trip the Englishman lectured at the newly formed Pennsylvania Museum and School of Industrial Art, and he worked with several American wallpaper manufacturers (see chap. 3). That Dresser's books and metalwares were known in America is indicated by a trade card for the New York firm of A. KIMBEL AND J. CABUS dating from about 1876, showing a Modern Gothic cabinet (ILL. 8.3) in which a sugar bowl (ILL. 8.4) designed by him has been placed; an illustration of this bowl also appears in figure 50 of Dresser's *Principles of Decorative Design* (1873).[14] The tenets that Dresser learned from Japanese art are evident in the radical simplicity expressed in his soup tureen (ILL. 8.5), manufactured by Hukin and Heath of Sheffield, England, about 1880, which incorporates his progressive design concepts. The ornamentation of the tureen is not applied. Rather, the functional elements remain exposed, serving as the only decoration. In their simplicity Dresser's functional objects provided exemplary models of reform design suitable for mass production, which would be further developed in the twentieth century.[15]

Dresser advocated the use of decoration derived from nature but not directly copying it: "If plants are employed as ornaments they must not be treated imitatively, but must be conventionally treated, or rendered into ornaments."[16] Dresser used both forms and decorations that were visual manifestations of his precepts, but it was his penchant for stylized ornament and not his preference for unadorned shapes that influenced American designers. For example, the Gorham Manufacturing Company produced a silver vase dating from 1877 (FIG. 8.5) with a polychromed enamel band of repetitive, stylized flowers surrounding the body. This conventionalized decoration, as well as the simplicity of the form, illustrates Dresser's principles. The tall, static row of flowers is reminiscent of the South Kensington style of design.

Following his visit to the Philadelphia Centennial in 1876, Dresser traveled to Japan for Tiffany and Company and other firms. During his stay he collected typically Japanese ceramics and

copper with engraved and chased conventionalized leaves and flowers, such as chrysanthemums, that graduate in size as they approach the top. Such motifs are similar to those by the renowned British designers OWEN JONES and CHRISTOPHER DRESSER, illustrated in plates of their books and employed in English silver. Plate 35 in Dresser's *Modern Ornamentation, Being a Series of Original Designs* (1886),[8] for example, shows a comparable banding of an alternating design of stylized flowers and geometric sections. The graceful, elongated S-scroll handle of the Tiffany pitcher contrasts with the compartmentalized body. Although small in scale, the object achieves an architectonic quality through its Gothic-inspired form and motifs. Its shape and decoration are related to medieval ecclesiastical prototypes: the quatrefoil plan to medieval chalices and the contour of the handle to altar cruets. The origin of the design of the Tiffany and Company pitcher can be found in Gothic-revival British metalwork, particularly that of BRUCE J. TALBERT, who was influenced by the English pioneer of the Gothic revival, Augustus Welby Northmore Pugin (1812–1852). Talbert's ewer (ILL. 8.1) is divided into horizontal banding in a similar manner to the Tiffany creation.

The superb Tiffany pitcher notwithstanding, American silver in the Modern Gothic syle occurred infrequently during the 1870s

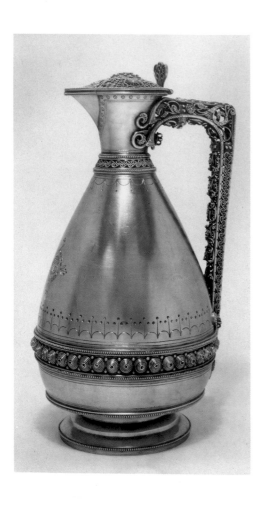

metalwares for Tiffany in order to provide design and technical suggestions for its craftsmen. According to a contemporary newspaper account, "Messrs. Tiffany & Co. gave Dr. Dresser *carte blanche* to select the vast quantity of goods they now offer for sale, and he has brought to them every variety of Japanese works, from the most splendid and costly to the simplest and cheapest."[17] A handwritten list of the collection purchased by Dresser is annotated "Bought for Patterns."[18] Dresser's role in the evolution of the company's involvement with the Japanese style is apparent in the extensive collection he established for them, publicly auctioned on June 18, 1877; he may also be credited with the employment of Japanese craftsmen at Tiffany.[19]

While EDWARD C. MOORE held the post of chief designer at Tiffany and Company (from 1868 to 1891), he was responsible for much of their Anglo-Japanesque work, and his collection of oriental pottery, metal, and glass provided prototypes for the firm. Use of oriental wares for patterns may be seen, for example, in a

Left: ILL. 8.1 Ewer. Designed by Bruce J. Talbert, made by Skidmore Art Manufactures Company, London, 1866–67. Parcel-gilt silver, h. 11½ in. (29.3 cm), diam. 4 1/16 in. (10.3 cm). Trustees of the Victoria and Albert Museum, London (M.208.1925)

Below: ILL. 8.2 "The Centennial—Bronze and Lacquer Work in the Japanese Department, Main Building." *Harper's Weekly* (Aug. 12, 1876)

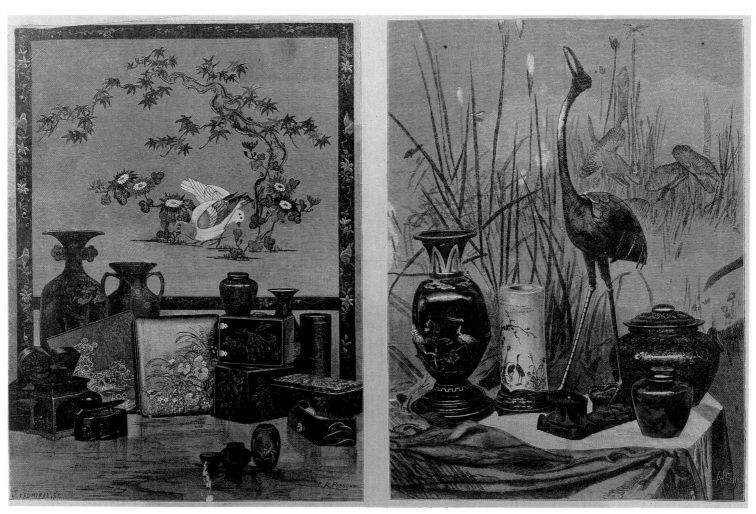

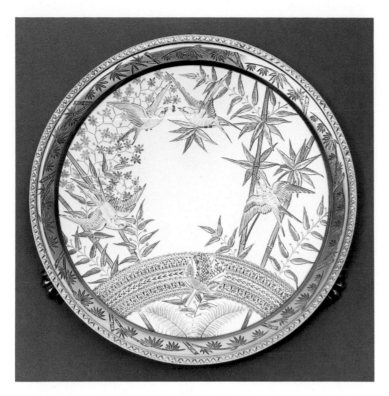

FIG. 8.4 Waiter. Elkington and Company, London, 1879. Parcel-gilt silver, diam. 8½ in. (21.6 cm). Marked: [maker's mark]. S. J. Shrubsole, Corporation, New York

vase (FIG. 8.6) with a spider-web design that is based upon a Japanese brush holder of identical form with the same motif (FIG. 8.7), once owned by Tiffany and Company and bequeathed in 1891 by Moore (along with the rest of his large and diverse collection of books and art objects) to The Metropolitan Museum of Art, New York.[20] According to Moore's son, his father was interested in the arts applied to industries and was anxious to make his holdings useful to workers in artistic crafts.[21] His personal art collection was strong not only in Japanese objects but also in Saracenic metalwork of the fourteenth century, which provided Tiffany with additional models.

Collecting Japanese metalwork was akin to collecting oriental prints and ceramics. Even before the Philadelphia Centennial, American collectors were fascinated with Japanese wares, which directly influenced American design. Such objects as Moore's Japanese sword guards (FIG. 8.8), the knife handles (FIG. 8.9) and pommel (ILL. 8.6) now in the H. O. Havemeyer Collection in the Met-

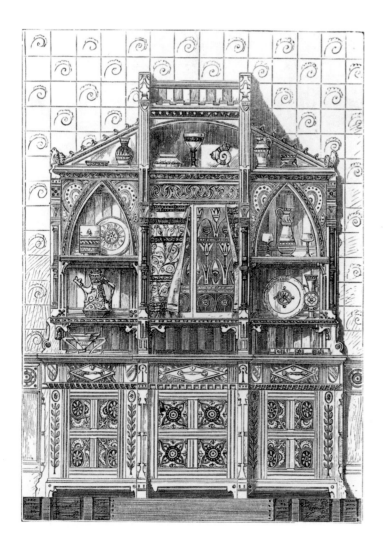

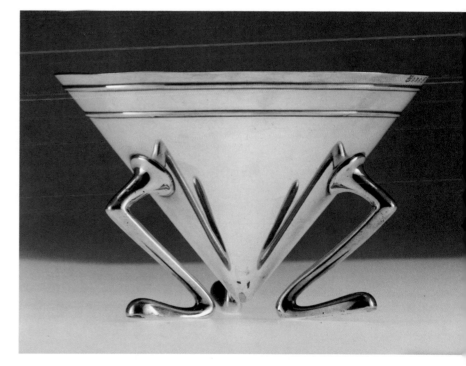

Above: ILL. 8.4 Sugar bowl. Designed by Christopher Dresser, ca. 1873, made by Elkington and Company, Birmingham, England, ca. 1885. Electroplated silver, h. 3 in. (7.6 cm), diam. 5 in. (12.7 cm). Marked: *Elkington & Co. / E. & Co.* Mitchell Wolfson, Jr., Collection of Decorative and Propaganda Arts, Miami-Dade Community College

Left: ILL. 8.3 "Kimbel and Cabus, 7 and 9 East 20th St. New York. Cabinet Manufacturers and Decorators" (trade card). The New-York Historical Society, Bella C. Landauer Collection

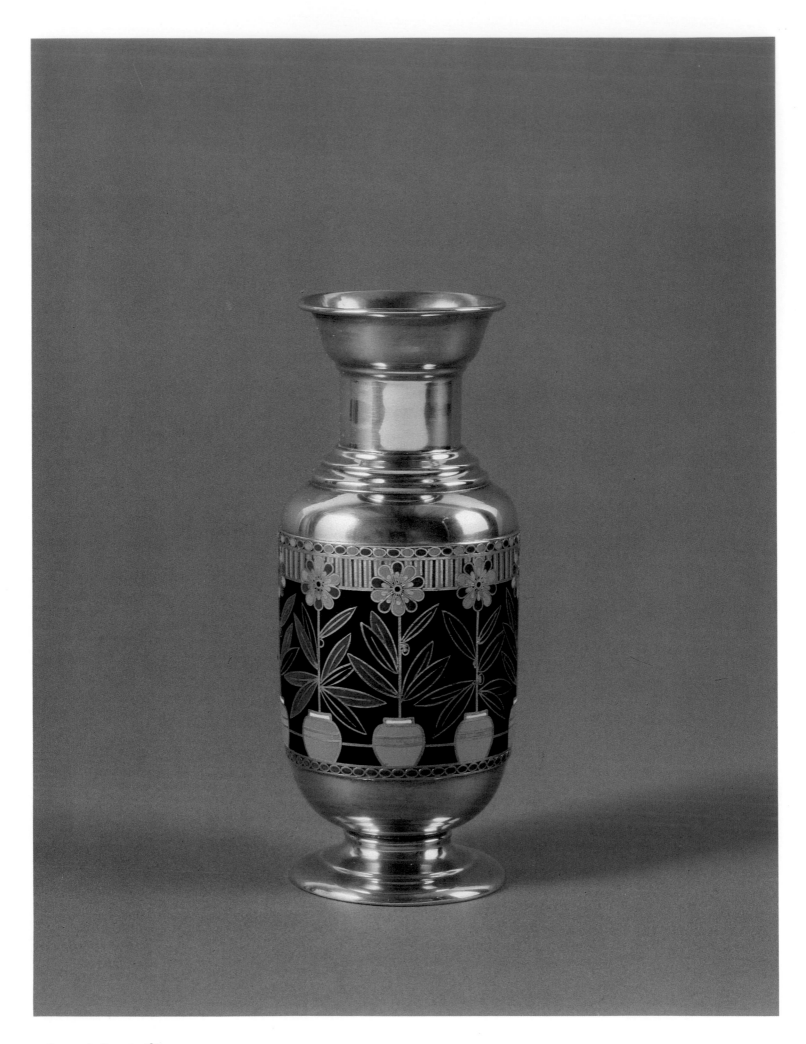

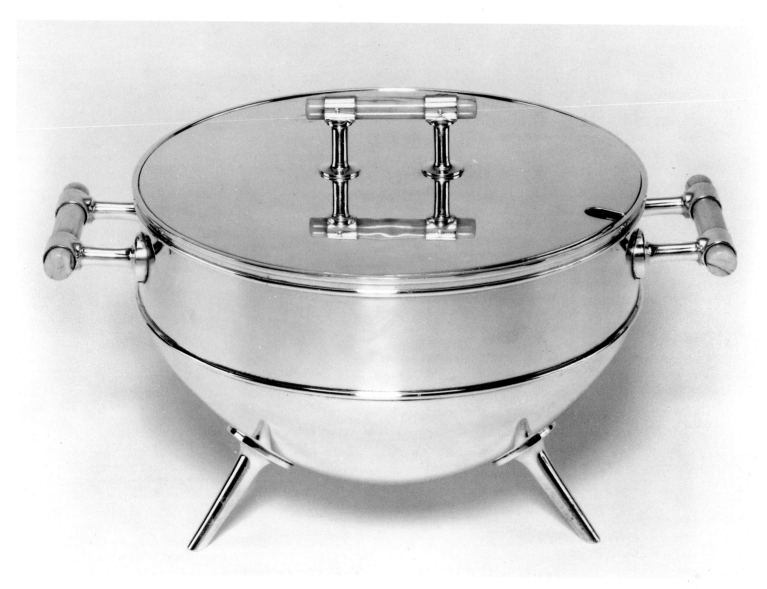

Above: ILL. 8.5 Soup tureen. Designed by Christopher Dresser, made by Hukin and Heath, Sheffield, England, ca. 1880. Electroplated silver, ivory, diam. 9¼ in. (23.5 cm). Trustees of the British Museum, London

Opposite: FIG. 8.5 Vase. Gorham Manufacturing Company, Providence, R.I., 1877. Gilt silver, polychrome enamel, h. 5½ in. (14 cm), diam. 2¼ in. (5.7 cm). The Newark Museum, N.J. (84.334)

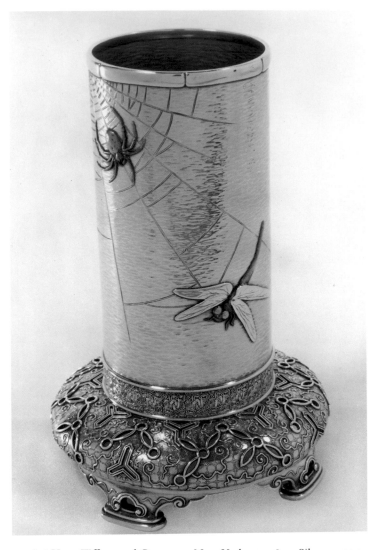

FIG. 8.6 Vase. Tiffany and Company, New York, ca. 1873. Silver, copper, gold, h. 9½ in. (24.1 cm), diam. 8½ in. (21.6 cm). Stamped: *Tiffany & Co. L991 / Makers 9295 / Sterling Silver 925–1000 M / [] 103 27/05.* The Brooklyn Museum, New York, H. Randolph Lever Fund (82.18)

ropolitan Museum, or the Indian box (ILL. 8.7) from the holdings of LOCKWOOD DE FOREST were greatly admired.

Among the pieces in Moore's holdings that especially inspired him were the sword guards, which in technique relate to Tiffany and Company's innovative mixed-metal Anglo-Japanesque pieces (see FIGS. 8.10–8.14).[22] It was probably Dresser who first prompted the firm to experiment with this medium, revived in America by Moore, in which various metals are soldered together in layers that are folded and hammered repeatedly to the desired thinness. A strengthening sterling-silver backing is added to the layers, the top of which are cut away to expose those at the bottom. The metal is then hammered into its desired shape, and the result is a smooth, polychromed surface.[23] Moore also employed the mixed-metal appliqué process, in which small, decorative elements of assorted metals are affixed to the surface of an object. This was viewed by one writer as "the most important step in artistic metalwork" taken by an American designer.[24] Thus, Tiffany and Company's tall, bulbous shapes, derived from Persian, Chinese, and Japanese sources, were achieved by blending silver with gold and with base metals such as copper. British assay laws regulating silvermaking prohibited manufacturers from combining these metals, but such regulations did not exist in the United States, enabling Tiffany to create some of the most unusual hollow ware and flatware pieces in late nineteenth-century metal design.

Tiffany's daring mixed-metal forms were well represented in the firm's display at the 1878 Paris Exposition Universelle, where Anglo-Japanesque pieces predominated, in contrast with the abundance of Renaissance-revival silver exhibited by the company at the Philadelphia Centennial two years earlier.[25] At the Exposition Universelle the firm won numerous awards, including the first prize for work in silver, a gold medal for jewelry, and six other honors.[26] According to S. Bing (1838–1905), a Parisian connoisseur and dealer of Japanese objets d'art, the American silver exhibited in Paris was of extraordinary quality. While acknowledging America's dependence on Japanese principles of design and technique, Bing noted that "the borrowed elements were so ingeniously transposed to serve their new function as to become the equivalent of new discoveries."[27]

Illustrations of objects shown in the Paris exposition demonstrate why Tiffany's display was considered so radical in comparison with the primarily conservative historical styles represented by other manufacturers.[28] Critics admired the unorthodox designs and the novel manipulation of metal to produce color effects that were impossible before. According to one commentator, "These developments mark what may well be styled an American Renaissance which ignored the prevailing conventions of Europe."[29] Dresser was delighted with the Tiffany exhibition in Paris, which he had encouraged, and he wrote enthusiastically to the firm, "No silversmith, that I know, has made the progress in art as applied to their industry in the last few years, that you have—indeed, the rapidity of your advancement has astonished many of my art friends . . . you occupy the proud position of being the first silversmith of the world."[30]

One of the objects exhibited, a coffeepot made with the mixed-metal appliqué process (FIG. 8.10), is an outstanding example of the Anglo-Japanesque style in its hand-hammered surface, as well as in its decoration, which consists of vines with leaves and gourds, butterflies, dragonflies, and other insects.[31] A sugar bowl, for which a preliminary design drawing exists (ILL. 8.8), and a creamer from another coffee service (FIG. 8.11) illustrate additional forms, as does a tray (FIG. 8.12).

The dramatic and difficult combination of copper and silver is seen in a graceful Tiffany and Company chocolate pot made in 1879 (FIG. 8.13). The form of this piece is Western, yet it is covered with a reddish patina and decorated with sea-life motifs, suggesting Japanese print sources. Crabs and lobsters cast in silver are affixed to the copper surface, which has been soldered and ham-

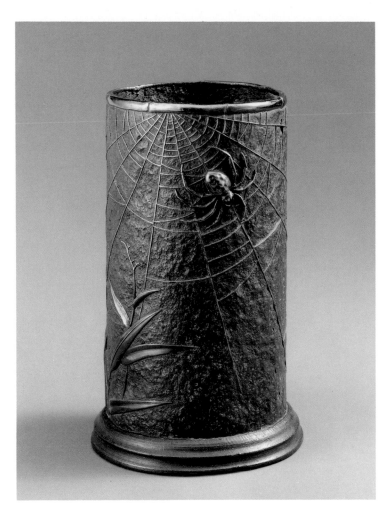

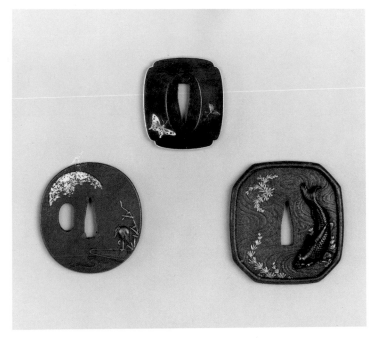

FIG. 8.8 Sword guards. Japanese, 19th century. Bronze, inlaid gold and silver; left to right: 2⅞ × 2⁹⁄₁₆ in. (7.3 × 6.5 cm), 2⅜ × 2⅛ in. (6 × 5.4 cm), 3⁷⁄₁₆ × 3 in. (8.7 × 7.6 cm). The Metropolitan Museum of Art, Edward C. Moore Collection, Bequest of Edward C. Moore, 1891 (91.1.759, .787, .838)

FIG. 8.7 Brush holder. Japanese, 19th century. Iron, inlaid gold, silver, and brass, h. 6¾ in. (17.1 cm), diam. 3½ in. (8.9 cm). The Metropolitan Museum of Art, Edward C. Moore Collection, Bequest of Edward C. Moore, 1891 (91.1.617)

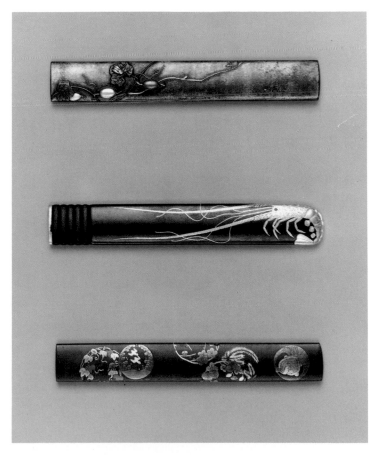

FIG. 8.9 Knife handles. Japanese, n.d. Bronze, inlaid gold and silver; each: l. 3¾ in. (9.5 cm). The Metropolitan Museum of Art, Bequest of Mrs. H. O. Havemeyer, 1929, H. O. Havemeyer Collection (29.100.1259, .1169, .1154)

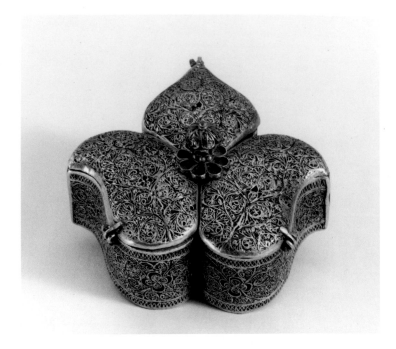

ILL. 8.6 *Fuchi-kashira* (sword decoration and pommel). Japanese, n.d. Bronze, inlaid gold and silver; top: l. 1½ in. (3.8 cm); bottom: l. 1⁵⁄₁₆ in. (3.3 cm). The Metropolitan Museum of Art, Bequest of Mrs. H. O. Havemeyer, 1929, H. O. Havemeyer Collection (29.100.1344ab)

ILL. 8.7 Betel-nut box. Indian, 19th century. Silver, h. 2¼ in. (5.7 cm), w. 3⅜ in. (8.6 cm), l. 3½ in. (8.9 cm). The Metropolitan Museum of Art, John Stewart Kennedy Fund, 1915 (15.95.12)

mered to the silver body of the pot. Brass and silver Paulownia leaves relating to the insignia of the Japanese imperial family are placed around the neck.[32] Other objects, such as a vase (FIG. 8.14), also used both copper and silver in the mixed-metal appliqué process. In addition, a working drawing for a pitcher (ILL. 8.9) shows how certain elements—polliwogs, seaweed, and dragonflies—were accentuated in order to clarify which motifs were to be attached to the surface.

Anglo-Japanesque works, like their Japanese prototypes, might be "matched" in the oriental style. The concept of "matching" refers to the combination of a variety of shapes and patterns in a group of objects that do not, to the Western eye, correspond to one another. The coffeepot in figure 8.10 was once part of a set that would have been matched in the Japanese style. A Tiffany archival photograph (ILL. 8.10) illustrates this adventurous mixing of forms.[33]

Despite the prevailing taste during the Aesthetic era for traditional English flatware in such shapes as the fiddleback, Tiffany and Company's mixed-metal designs were admired in the United States and abroad. In the set of flatware specially ordered for Mrs. H. O. Havemeyer, each piece varies in composition and theme (FIG. 8.15). Mrs. Havemeyer noted, "The hammered silver set . . . was made for me by Tiffany['s] 'Moore' who adopted it from the Japanese."[34] Various sea creatures and insects are depicted in exquisite cast details and arranged asymmetrically. The hammered surface was created by chasing a hollow form filled with pitch, so that the entire surface was impressed with the dents of the hammer, which were left exposed. According to a writer for the *International Review,* "This unique finish imparts to the body an appearance not unlike that possessed in Japanese 'crackle' pottery."[35] In its fine craftsmanship and reliance upon Japanese design motifs and principles, this flatware embodies some of the major aspects of the philosophy of the Aesthetic movement.

The Anglo-Japanesque was not always expressed in rounded forms with hammered surfaces. A geometric vase (FIG. 8.16) made

by Tiffany and Company has a planished surface against which the appliquéd and engraved design is set. The asymmetrical composition is similar to that in the drawing for a pitcher shown in illustration 8.9.

The Anglo-Japanesque mode is also seen in Tiffany and Company's jewelry, few pieces of which have been acquired by museums. The delicate gold-filigree necklace (FIG. 8.17) may be the work of the firm. Unmarked and without archival evidence, this piece may be attributed only speculatively to Tiffany and Company. A fan brooch (FIG. 8.17), also in the Japanese style, is marked by the firm.

The influence of Tiffany and Company's use of the Anglo-Japanesque style can be seen in the work of other manufacturers and merchants, including DOMINICK AND HAFF of New York, who produced a six-piece tea and coffee service (FIG. 8.18) stamped by the Philadelphia retailer Bailey, Banks and Biddle. Here an overall surface decoration combines Japanese naturalism with a stylized design.[36] Each piece is embellished with a repeating motif of repoussé leaves and berries against a chased background of overlapping foliage. These naturalistic motifs are not rendered as three-dimensionally as the more sculptural decoration of the Whiting vase (see FIG. 8.2), and the two-dimensionality of the stylized flowers at the base of the teakettle does not contrast sharply with the rest of the design, as is the case in the Whiting vase. The basic form of each piece in the Dominick and Haff set is a cube, with rounded corners by the handles and spouts. In a tea set of a later date, Dresser used the same simple geometric arrangement, which provided an appropriate setting for stylized floral ornamentation.[37] Both Dresser's set and that by Dominick and Haff are based on Japanese prototypes.

Because the Tiffany and Company Archives are extensive, much is known about the firm's design process. This is particularly evident in a Modern Gothic tea set produced by the firm in the late 1860s.[38] The Gothic detailing is apparent in the incised, interlaced patterns on the body of the creamer (ILL. 8.11) and in the tendrils,

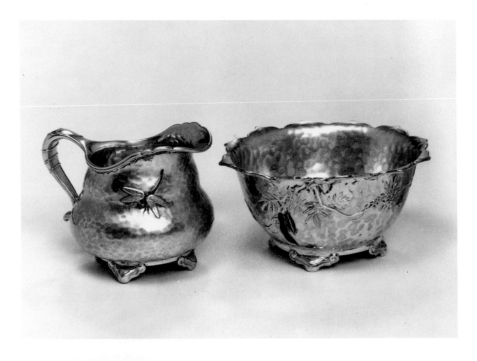

Above: FIG. 8.11 Sugar and creamer (from a three-piece coffee service). Tiffany and Company, New York, ca. 1877. Silver, copper, gold; sugar: h. 2½ in. (6.4 cm), diam. 4⅜ in. (11.1 cm), creamer: h. 2¾ in. (7 cm), diam. 3½ in. (8.9 cm). Each stamped: *TIFFANY & CO. / 4759 M 438 / STERLING SILVER / AND OTHER METALS.* Trustees of the Victoria and Albert Museum, London

Left: FIG. 8.10 Coffeepot. Tiffany and Company, New York, ca. 1878. Silver, copper, brass, h. 10¾ in. (27.3 cm), w. 8 in. (20 cm). Marked: *TIFFANY & CO. / 4872 M 5983 / STERLING SILVER.* Yale University Art Gallery, New Haven, Mrs. Alfred E. Bissell, Mr. and Mrs. Samuel Schwartz, Mr. and Mrs. E. Martin Wunsch and the American Arts Anonymous Purchase Funds (1981.98)

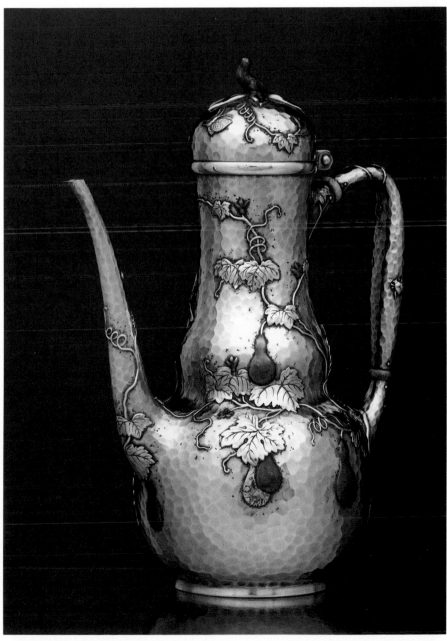

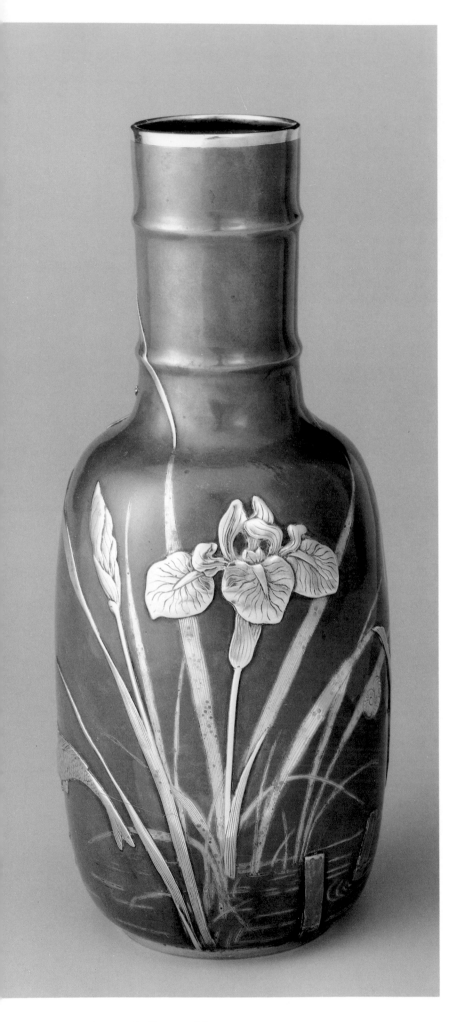

FIG. 8.14 Vase. Tiffany and Company, New York, ca. 1880. Copper, inlaid silver, h. 11 in. (27.9 cm), diam. 4¾ in. (12.1 cm). Marked: *Tiffany & Co. / 3622 M 151 / Sterling-silver-and-other Metals / 753.* The Morse Gallery of Art, Winter Park, Fla., through the courtesy of Charles Hosmer Morse Foundation

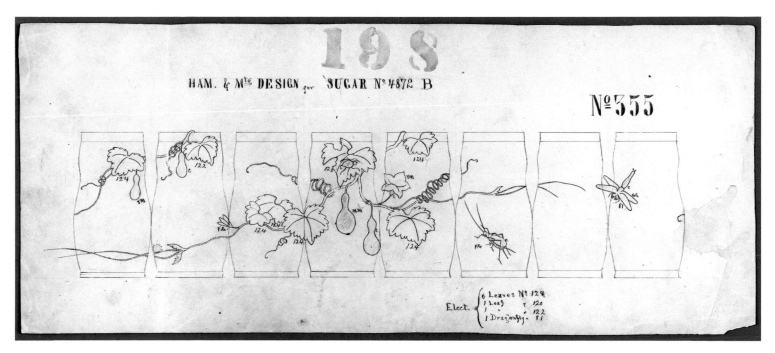

ILL. 8.8 "Hammer and Mounting Design for Sugar No. 4872 B." Tiffany and Company, New York, n.d. Pen and ink on paper, 8¼ × 19½ in. (21 × 49.5 cm). Tiffany and Company, New York

ILL. 8.9 "Hammer and Mounting Design for Pitcher No. 4834." Tiffany and Company, New York, n.d. Pen and ink on paper, 11¼ × 20⅜ in. (28.6 × 51.8 cm). Tiffany and Company, New York

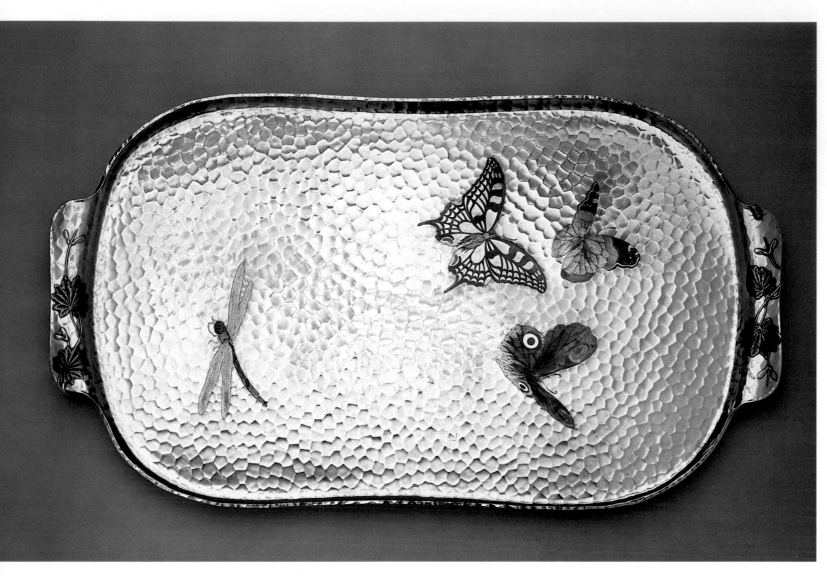

FIG. 8.12 Tray. Tiffany and Company, New York, ca. 1873–80. Silver, inlaid varicolored metals,
w. 13 in. (33 cm), l. 23 in. (58.4 cm). Private collection

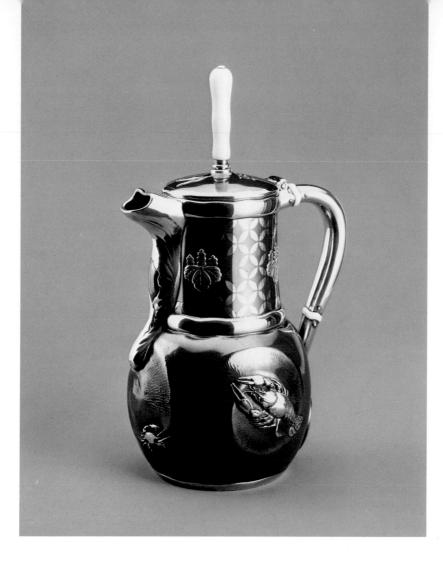

Left: FIG. 8.13 Chocolate pot. Tiffany and Company, New York, 1879. Silver, copper, ivory, brass, h. 11¾ in. (29.8 cm), diam. 6 in. (15.2 cm). Collection of Mr. and Mrs. Jay Lewis

Below: FIG. 8.15 Flatware (from a sixty-two-piece service). Tiffany and Company, New York, ca. 1883. Silver, copper, brass; right to left: l. 10½ in. (26.7 cm), l. 8¾ in. (22.2 cm), l. 8⅛ in. (20.6 cm), l. 6 in. (15.2 cm), l. 4¾ in. (12.1 cm), salad spoon: l. 11½ in. (29.2 cm), salad fork: l. 11¼ in. (28.6 cm). Marked: *TIFFANY & CO. / STERLING SILVER / AND OTHER METALS PAT. 1880; LWE* [monogram]. Private collection

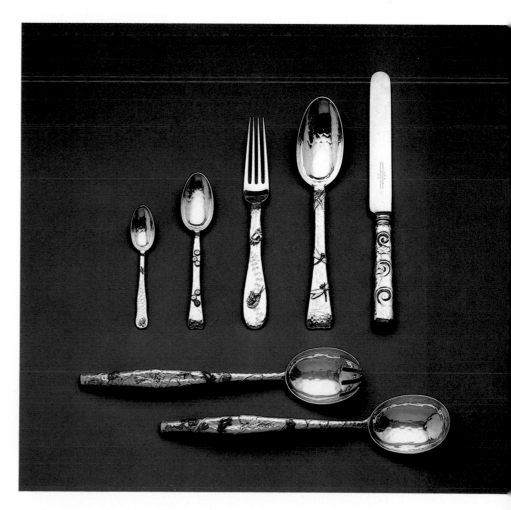

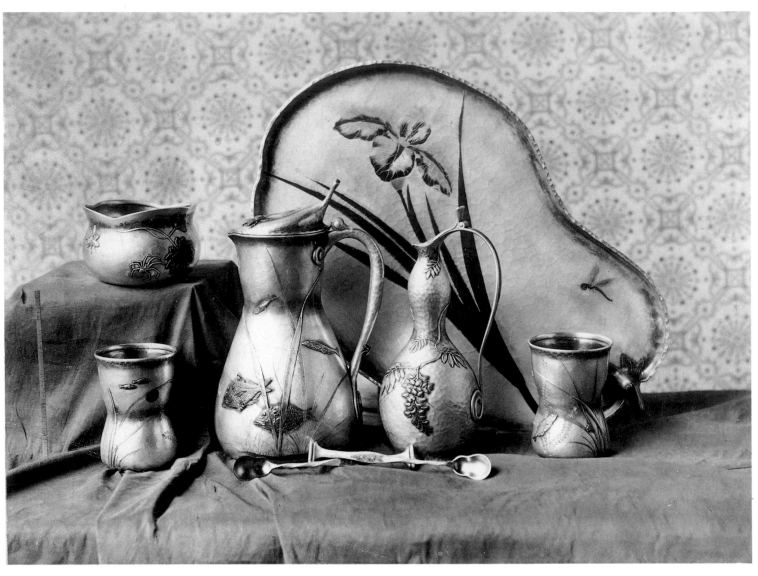

ILL. 8.10 Coffee service. Tiffany and Company, New York, ca. 1878. Silver. Archival photograph, Tiffany and Company, New York

which terminate in points on the handles. The curvilinear handles, which flare outward, relate to Modern Gothic furniture of the period. A drawing from Moore's sketchbook, dated November 1865, shows the handle of the creamer. Japanese objects serving as models were developed into working sketches by Moore and were then ultimately used by artisans in the design department as the bases for fashioning actual pieces. The same pattern would be employed for every order of a given object, although individualized results could be achieved by combining elements from two or more patterns.

Although much information has been ascertained from archival sketches and from contemporary articles regarding Moore's role in the development of design at Tiffany, little is known about a specific counterpart at Gorham. The introduction, for instance, of the Anglo-Japanesque style at Gorham cannot be identified with any single person. THOMAS J. PAIRPOINT, who was apprenticed in Paris and worked for the London firm of Lambert and Rawlings before serving as a designer and modeler for Gorham from 1868 to 1877, is credited with the firm's Renaissance-revival and classicizing designs of the 1870s,[39] including the immense Century Vase, the company's major showpiece at the Philadelphia Centennial.[40]

However, there is no evidence that Pairpoint was responsible for any of the Anglo-Japanesque designs that were introduced during his employment with Gorham.[41]

The Gorham Manufacturing Company utilized Japanese prints, books, and art objects as sources for its silver. The firm's library contains Japanese books that were acquired during the 1860s and 1870s, such as six of the fifteen volumes of the *Manga* (1814–78), a collection of woodcuts by Katsushika Hokusai (1760–1849); one of the volumes owned by Gorham bears the company's date stamp of October 16, 1871,[42] an indication of the firm's early interest in Japanese motifs. Gorham had already produced four parcel-gilt bowls with engraved Japanesque decoration by 1869,[43] predating the earliest surviving analogous example by Tiffany and Company by four years.

The parcel-gilt bowls of 1869 represent the beginning of Gorham's experimentation with the Anglo-Japanesque style, and the company later produced a significant quantity of pieces in this mode. The firm's output, however, never reached the creative pinnacle achieved by Tiffany and Company. Nevertheless, Gorham's Anglo-Japanesque silver was admired during the Aesthetic period. As one critic commented in 1886, "Of late years the influence of

FIG. 8.16 Vase. Tiffany and Company, New York, ca. 1873–75. Silver, h. 8½ in. (21.6 cm), w. 4½ in. (11.4 cm). Marked: *TIFFANY & CO / 2978 MAKERS / 6453 / STERLING-SILVER / 925–1000 / M.* The Metropolitan Museum of Art, Purchase, Mr. and Mrs. H. O. H. Frelinghuysen Gift, 1982 (1982.349)

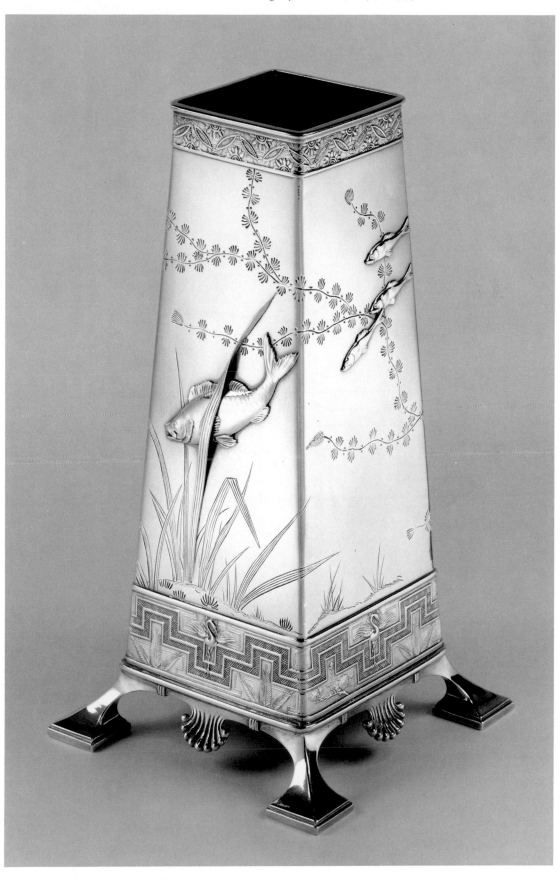

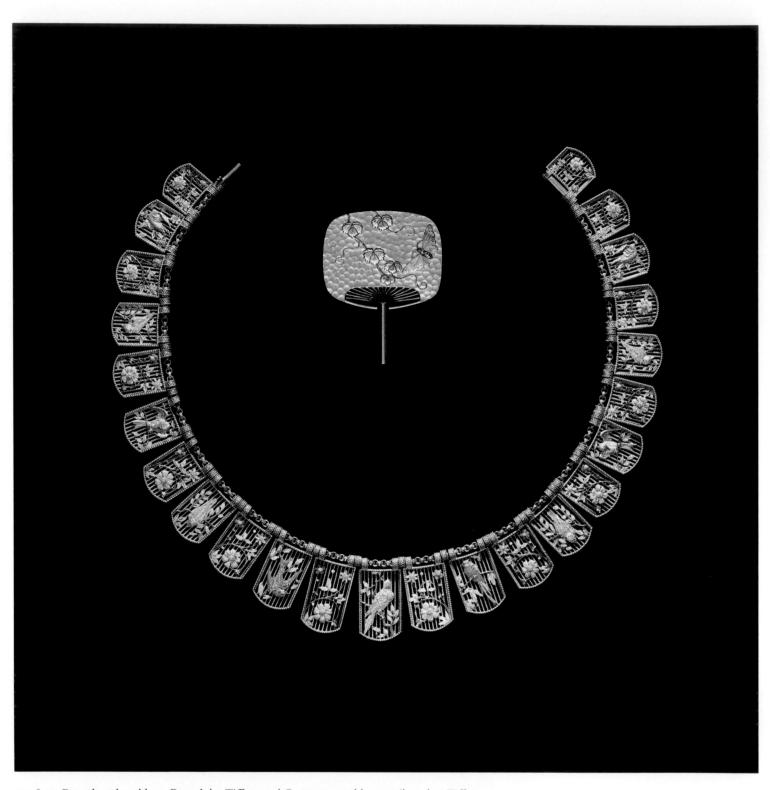

FIG. 8.17 Brooch and necklace. Brooch by Tiffany and Company, necklace attributed to Tiffany and Company, New York, ca. 1880. Brooch: gold, 1¹⁵⁄₁₆ × 1½ in. (4.9 × 3.9 cm), necklace: gold, l. 13⅜ in. (34 cm), w. ⁹⁄₁₆ in. (1.4 cm). Brooch marked: *TCo*. Trustees of the British Museum, London

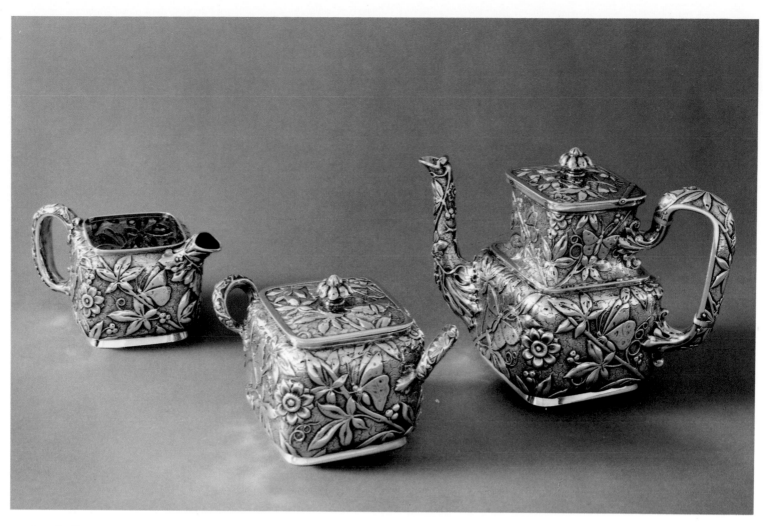

FIG. 8.18 Coffeepot, sugar bowl, creamer (from a six-piece tea and coffee service). Made by Dominick and Haff, New York, for Bailey, Banks and Biddle, Philadelphia, ca. 1881. Silver; coffeepot: h. 7¼ in. (18.4 cm), w. 5½ in. (14 cm), sugar bowl: h. 4½ in. (11.4 cm), w. 4¼ in. (10.8 cm), creamer: h. 3½ in. (8.9 cm), w. 4½ in. (11.4 cm). Cooper-Hewitt Museum, The Smithsonian Institution's National Museum of Design, New York, Gift of Mrs. Norris W. Harkness (1980.20.3, .4, .5)

Eastern art, especially that of Japan, has been very apparent in Western design, and this has perhaps been more particularly so in America. It can be traced very distinctly in many of the Gorham Company's patterns, but there is nothing slavish in the ready adoption of an idea."[44] Japanese metalwork frequently supplied models for the decoration and in some cases for the form of an object. Like Tiffany, Gorham made hammered wares, demonstrating further Japanese influence. Gorham also employed mixed-metal combinations, using copper and iron, as well as exotic materials such as ivory.

One of the most exuberant examples of Gorham's Anglo-Japanesque silver is a monumental punch bowl (FIG. 8.19), ornately decorated in repoussé and chasework, with oriental motifs that include a violent serpent in a turbulent sea. The waves and the various types of sea life—shells and crabs, among other creatures—cover the surface to create a rippling, dynamic effect, in contrast with more subtle aesthetic themes of abstract floral designs.

The Whiting Manufacturing Company also produced highly imaginative Anglo-Japanesque silver objects. Although basically a Western form, the firm's covered soup tureen (FIG. 8.20) is decorated with Japanese motifs, a swimming turtle on one side and a flying crane against a clouded sky on the other. Pea pods and floral reliefs are used on the base and the cover.

Despite the popularity of the Anglo-Japanesque style, other

modes—Hellenism, for example—were utilized in silver as a means of introducing design reform. As with furniture, the occurrence of Hellenism in American silver was relatively uncommon when compared with Japanism and was usually restricted to small, decorative details such as banding. As interpreted by American designers, Hellenism often incorporated lavishly ornamented banding with contrasting, severe, unadorned surfaces reminiscent of ancient Greek or Japanese simplicity. Hellenism could also be combined with the Anglo-Japanesque or the Modern Gothic. An examination of museum collections and the Tiffany and Gorham records indicates that Hellenistic silver objects were made by both companies during the 1880s. A Gorham Company archival photograph illustrates an elegant centerpiece from 1881 (ILL. 8.12) that reflects the influence of Hellenism in its decoration of elaborate classical friezes of chariots and equestrian figures. Yet a Japanese sensibility is evident in the cast, conventionalized sunflower in the center of the foot, as well as in the plain surfaces, and the whole is indicative of the overriding eclecticism of the Aesthetic period. A Gorham hot-water kettle (FIG. 8.21) from a tea and coffee service also demonstrates this mixing of Hellenism with other styles. The classical friezes contrast with the unembellished surfaces, and the forms of the set are predominantly Japanesque in inspiration, particularly apparent in the handle of the kettle.

A large vase (FIG. 8.22) made as a special order by Tiffany and Company in November 1877 is one of the most important ex-

amples of the Hellenistic style. It was presented to Reuben R. Springer in honor of his generous financial support for a new music hall in Cincinnati. The amphora shape of the vase recalls ancient Greek ceramics. The lyres, laurel leaves, and hanging masks are not only of classical derivation, but they are also in keeping with the iconography of a concert hall, since they are emblematic of music, poetry, and other arts. The Springer vase also demonstrates the Anglo-Japanesque; its hand-hammered body and neck and the employment of stylized chrysanthemums are typical of the oriental mode as interpreted by American designers. Interestingly, the vase, combining Hellenistic and Japanesque features, was designed to commemorate the gift of a major Modern Gothic building; it illustrates the concurrent viability of a variety of modes during the Aesthetic era.[45]

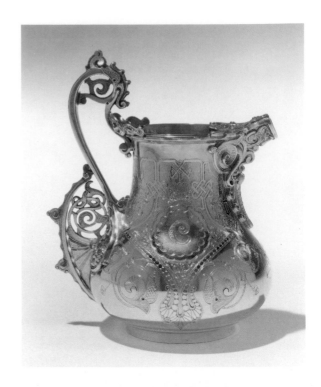

Right: ILL. 8.11 Creamer (from a three-piece coffee service). Designed by Edward C. Moore, made by Tiffany and Company, New York, 1866–67. Parcel-gilt silver, h. 7 in. (17.6 cm). Marked: *No. 11 (1770/4189).* Philadelphia Museum of Art (73.94.8c)

Below: FIG. 8.19 Punch bowl and ladle. Gorham Manufacturing Company, Providence, R.I., 1885. Silver; bowl: h. 10⅛ in. (25.7 cm), diam. 15¾ in. (40 cm), ladle: l. 14 in. (35.6 cm), w. 3⅞ in. (9.8 cm). Marked: *1885.* Museum of Fine Arts, Boston, Edwin E. Jack Fund (1980.383–4)

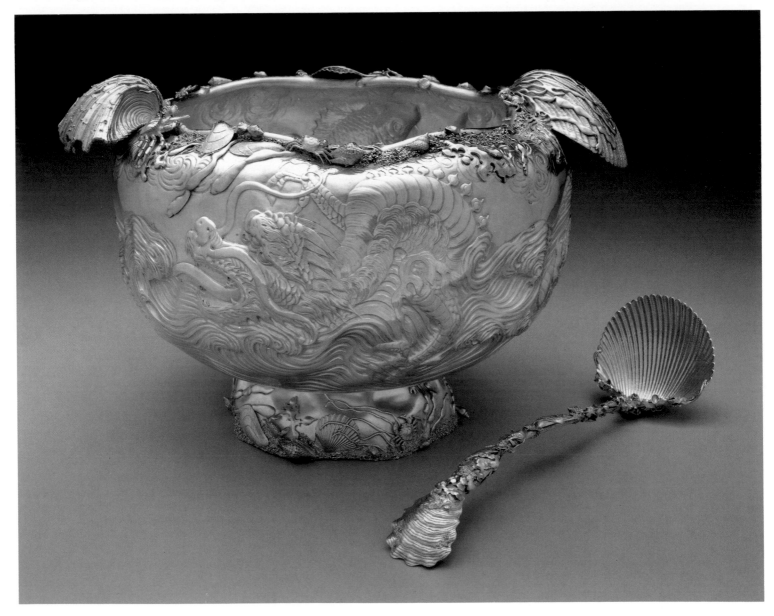

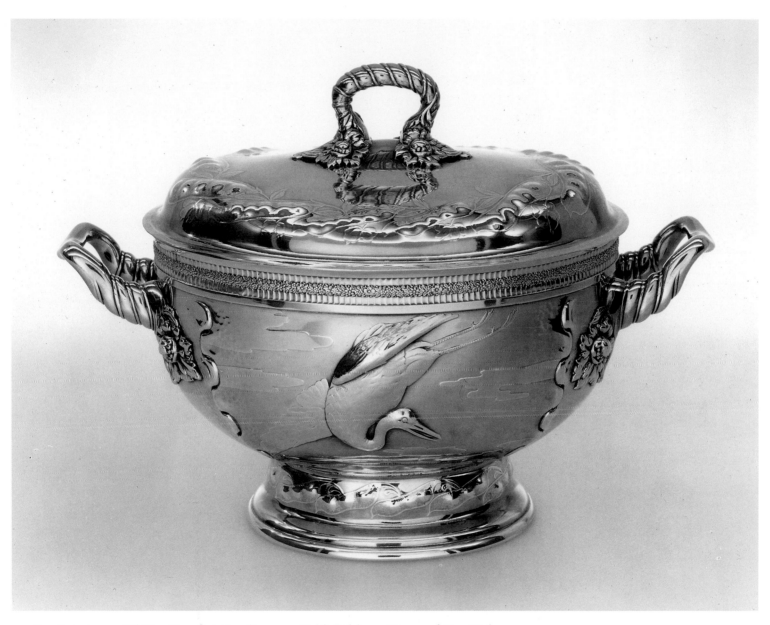

FIG. 8.20 Soup tureen. Whiting Manufacturing Company, North Attleboro, Mass., and New York, ca. 1880. Silver, h. 10 in. (25.4 cm), diam. 12 in. (30.5 cm). The Currier Gallery of Art, Manchester, N.H. (1985.3)

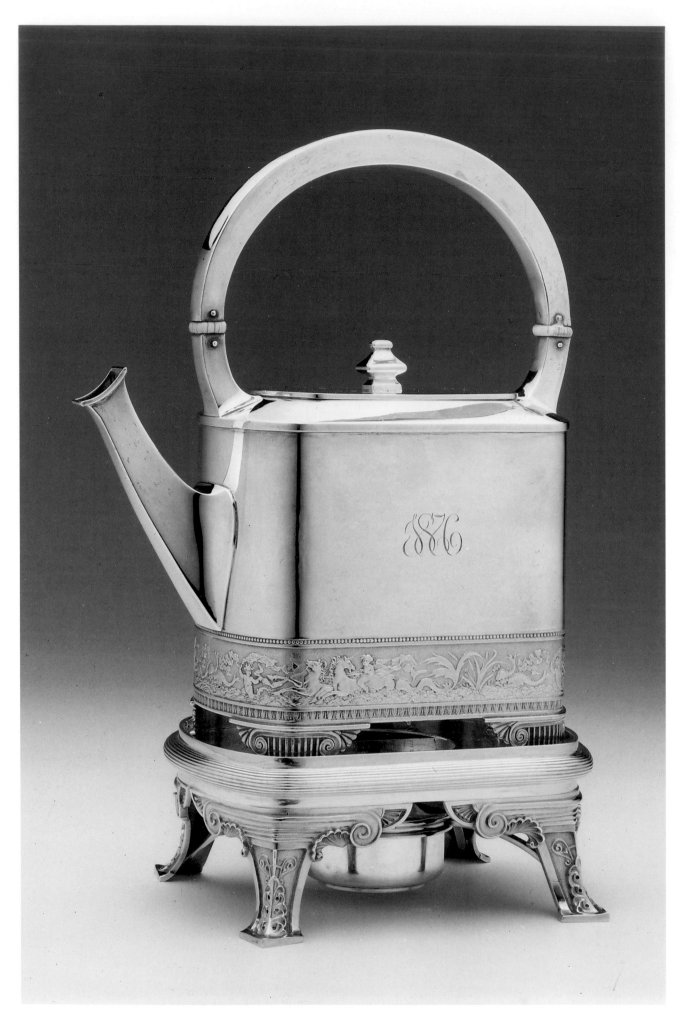

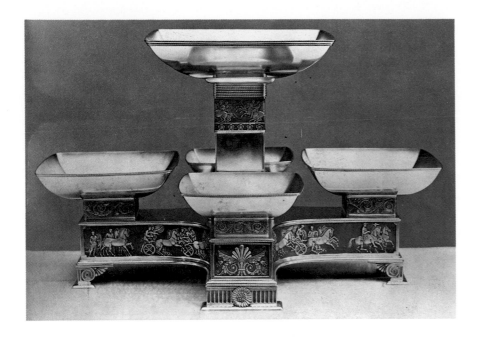

Electroplating

In electroplating, an electrical current is introduced to decompose a metallic solution into its constituents, depositing a precious metal on a base-metal surface prepared to receive it.[46] Because one of the primary objectives of artists of the Aesthetic movement was to introduce art into daily life in order to enhance the surroundings of the average person, several important firms became interested in electroplated wares, which served the middle-class household by providing objects that had the lasting quality of sterling silver without the expense. Made to appeal to a broad range of tastes, these wares often brought together an amalgam of styles in a single object. It is therefore not surprising to discover popular aesthetic patterns on widely available electroplated silver. After the Civil War, plated silver became part of almost every American household,[47] and catalogues such as one dated 1886–87 for the MERIDEN BRITANNIA COMPANY illustrated a number of pieces in aesthetic styles following European prototypes. Although plated silver was not costly, it was by no means purchased only by the less affluent, and its high artistic caliber frequently attracted a wealthier and sometimes more discriminating clientele, as well as the middle-class consumer. According to a note in the *Jewelers' Circular and Horological Review* of April 1886:

> The reasonable prices at which the best plated ware is now put on the market brings it within the reach of the popular trade, while the artistic forms and attractive finish with which it is presented, appeals to many who can afford the luxury of sterling silver. Indeed, in many cases, the solid silver service is in some safe deposit down-town while the family are dining up-town off plated ware.[48]

Although many improvements in electroplating were made by Americans, the process was an English invention credited to Elkington and Company, who exhibited at the Philadelphia Centennial. Elkington's silverplated hollow ware was technically and stylistically inventive, and at least one American company was directly influenced by their work and their methods. In 1852 John Gorham, of the Gorham Manufacturing Company, traveled to England and learned from Elkington the process of electroplating. During the same trip he worked for James Dixon and Sons of

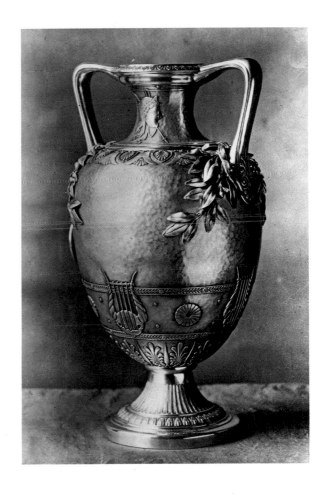

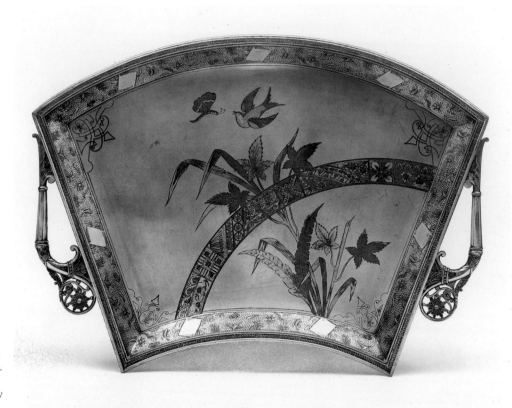

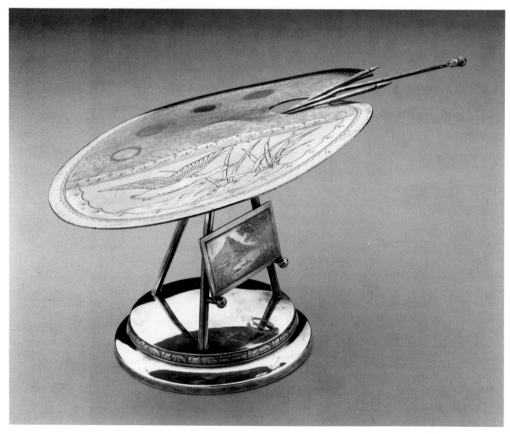

FIG. 8.23 Tray. Derby Silver Company, Derby, Conn., ca. 1880–83. Silverplate, h. 19½ in. (49.5 cm), w. 28¾ in. (73 cm). Marked: *DERBY SILVER*. Mitchell Wolfson, Jr., Collection of Decorative and Propaganda Arts, Miami-Dade Community College

FIG. 8.24 Card receiver. Meriden Britannia Company, Meriden, Conn., ca. 1885. Silverplate, h. 7 in. (17.8 cm), w. 9⅞ in. (25 cm). The Strong Museum, Rochester, N.Y.

Sheffield, where he became acquainted with white-metal hollow ware. In 1854, shortly after his return to the United States, GEORGE WILKINSON, an English silversmith working for the Ames Manufacturing Company of Chicopee, Massachusetts, joined the Gorham Company to supervise their silverplating.[49]

By the 1870s, many of the large American silverplate manufacturers, such as the Meriden Britannia Company and the DERBY SILVER COMPANY, were producing aesthetic wares. The latter firm was located in Derby, Connecticut—an industrial suburb known by the nickname "Birmingham." A large, fan-shaped tray (FIG.

8.23), an example of Derby electroplated ware, incorporates an oriental form and an asymmetrical arrangement of Japanese motifs in its configuration of birds and flora. In combination with these elements are those of the Modern Gothic, evident in the curvilinear handles with intricate, small leaves and scrollwork. According to its marking, the Derby tray was quadruple plated.[50]

Technological strides in plated wares by American companies offered new artistic opportunities. Mechanical advances enabled manufacturers to create more attractive lines, as well as a wider range of objects of better quality. For example, it was discovered that by applying the cooling principle used in ice houses, pitchers could be made "with double walls or shells enclosing an air chamber" that would preserve the temperature of liquid contents. An improvement was realized by adding a "thin iron lining, covered, while at a white heat, with pure porcelain."[51] The iron prevented cracking or breakage of the porcelain, and the ceramic medium preserved the purity of the pitcher's liquid contents. The artistic results of integrating these two media were rewarding: the polychromed smooth outer ceramic surface, or sleeve, provided contrast with the engraved, cast, and stamped ornamental, yet monochromatic silver. An example of this innovative technique may be seen in the silverplated tilting water set (ILL. 8.13) by Simpson, Hall, Miller and Company of Wallingford, Connecticut, which

was one of three versions, related in form and decoration, advertised in the firm's 1891 catalogue. The object was designed to rest in a supporting framework that facilitated pouring.[52] The embellishment on the electroplated framework is eclectic, combining a variety of elements. Camels, palm trees, sphinxes, and pyramids enliven the borders. Figures of fish form the handle and spout, possibly reflecting a Japanese influence. Partially draped female figures adorn each side of the stand. Despite this stylistic hybridization, the set is a harmonious combination of decoration and shapes.

Although electroplated objects were sometimes well designed, the majority were overly elaborate, untouched by aestheticism's reforming principles. There was no American equal in electroplated metalwork to Dresser, who understood the machine and its artistic possibilities and who created simple, unadorned forms particularly suited to the technology (see ILLS. 8.4, 8.5). In the eclectic decorative schemes of many American and British electroplated wares, Anglo-Japanesque themes—so intelligently worked out by Tiffany and Company—were haphazardly combined to appeal to popular taste.[53] For example, the card receiver manufactured by the Meriden Britannia Company about 1885 is in the shape of an artist's palette (FIG. 8.24). Significant items in their day, such holders received visitors' cards and served as a symbol of their owners' hospitality.

ILL. 8.13 Tilting water set. Simpson, Hall, Miller and Company, Wallingford, Conn., ca. 1891. Silverplate, porcelain, h. 23¾ in. (60.3 cm). Yale University Art Gallery, New Haven, Millicent Todd Bingham Fund (1978.57A–C)

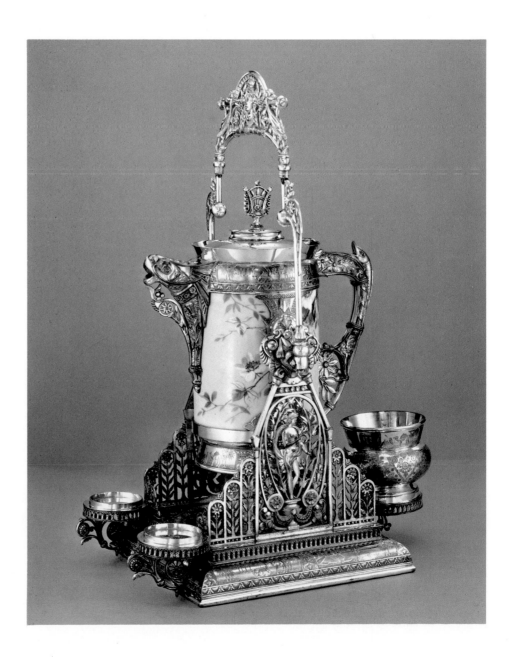

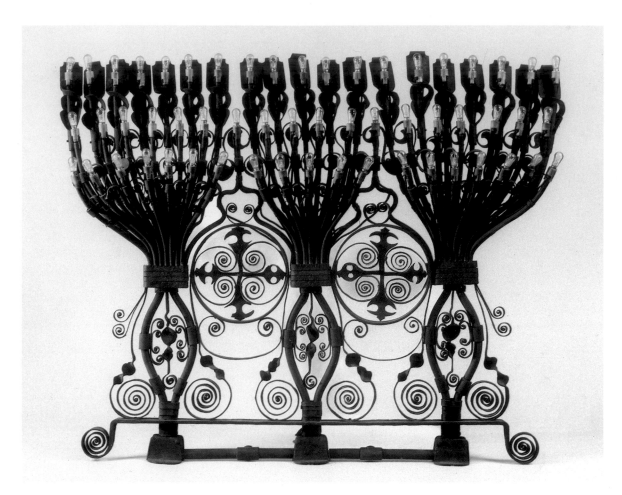

FIG. 8.25 Candelabrum (one of a pair). Associated Artists, New York, 1879–80, for the Veterans' Room, Seventh Regiment Armory, New York. Wrought iron, h. 35 in. (88.9 cm), w. 44½ in. (113 cm). Veterans of the Seventh Regiment Armory, New York

Metalwork and the Aesthetic Interior

Photographs of aesthetic dining rooms seldom show either sterling, which was usually stored in vaults for protection, or plated wares in use. However, metals other than silver are often visible. After the 1876 Philadelphia Centennial metalwork became, to a greater extent than before, an important part of the aesthetic interior, as can be seen in the Veterans' Room of the Seventh Regiment Armory in New York (see ILLS. 4.13, 4.14) of 1879–80, which utilized wrought iron throughout as a feature of the ornamental scheme. This ASSOCIATED ARTISTS commission, in which a variety of historical styles was employed, was under the general direction of LOUIS COMFORT TIFFANY, who may have been responsible for the wrought-iron designs.[54] The large scale and the heaviness of the wrought-iron chandelier (see ILLS. 4.13, 4.14), fireplace equipment, and candelabra (FIG. 8.25) were appropriate for the military theme of the room, and the metal itself symbolically conveyed the notions of war, weapons, and defense.

Plates from *Artistic Houses* (1883–84) also exhibit the use of metalwork in the aesthetic interior. For example, a combination of metal and mahogany was employed in the desk in the drawing room of the Hamilton Fish house in New York (ILL. 8.14). Here wrought-copper hinges and trimmings contrast with the dark mahogany wood, producing a pleasing juxtaposition.[55] An illustration from the *Decorator and Furnisher* of March 1886 shows how abundantly metal might be utilized in an interior during the

1880s.[56] Sheet-metal medallions might be introduced into the decoration of ceilings; in fact, entire sheet-metal ceilings became increasingly popular.[57] Metal was used for fireplace surrounds, firebacks, and guards. Free-standing pieces—lamps and vases, for example—might be made of metal, and so might end tables and wall plaques. As in previous centuries, brass pulls and escutcheons were common, but during the 1870s and 1880s art furniture included additional metal elements. Lavish brass or bronze hardware was incorporated into doors in the form of hinges, escutcheons, plates, and locks. An especially elaborate Anglo-Japanesque door handle and escutcheon (FIG. 8.26) with finely cast ornamentation are marked by the NASHUA LOCK COMPANY of Nashua, New Hampshire. Their size suggests the scale of interiors, both residential and commercial, of the 1880s. This doorplate and lock were illustrated in the Nashua catalogue of 1886 (ILL. 8.15), which shows the proper mounting for the pieces.

In many cases the increased use of metal in aesthetic interiors may be attributed to the rage for things Japanese. For instance, metal arm supports are evident in the Anglo-Japanesque side chair (see FIG. 4.2) designed for the William H. Vanderbilt house in New York. Philadelphian Dr. Edward H. Williams, inspired by the Centennial Exposition, visited the Far East and in 1882 furnished his library in the Japanese style; four Anglo-Japanesque brass lanterns hung beneath a blue ceiling decorated with flying storks.[58] A frieze of bronze panels depicting a dragon, from a Japanese temple, also adorned the room.[59]

Although wood and upholstery continued to be the predominant elements in furniture during the last quarter of the nineteenth century, the introduction of metal added a richness to the designer's vocabulary and often provided a structural function. Brass in particular offered a dimension to the aesthetic interior that cannot always be perceived in black-and-white photographs. Often, pieces of furniture were produced using brass almost exclusively, for example, the Modern Gothic plant stand in the Newark Museum (FIG. 8.27), which points up a dialogue between conventionalized and naturalistic approaches to materials. The former is evident in the cast- and perforated-brass parts, while the latter is apparent in the handling of the ceramic elements. The angular, easily reproduced features indicate machine production—a process to be further explored after the Aesthetic era. The stand demonstrates the influence of English design in the United States during the Aesthetic period. Although it is unmarked, it was probably made in Connecticut; it incorporates an English tile manufactured by MINTON AND COMPANY but bearing the label of the Meriden Flint

ILL. 8.14 "Hon. Hamilton Fish's Drawing-Room." *Artistic Houses* (New York, 1883–84). Thomas J. Watson Library, The Metropolitan Museum of Art

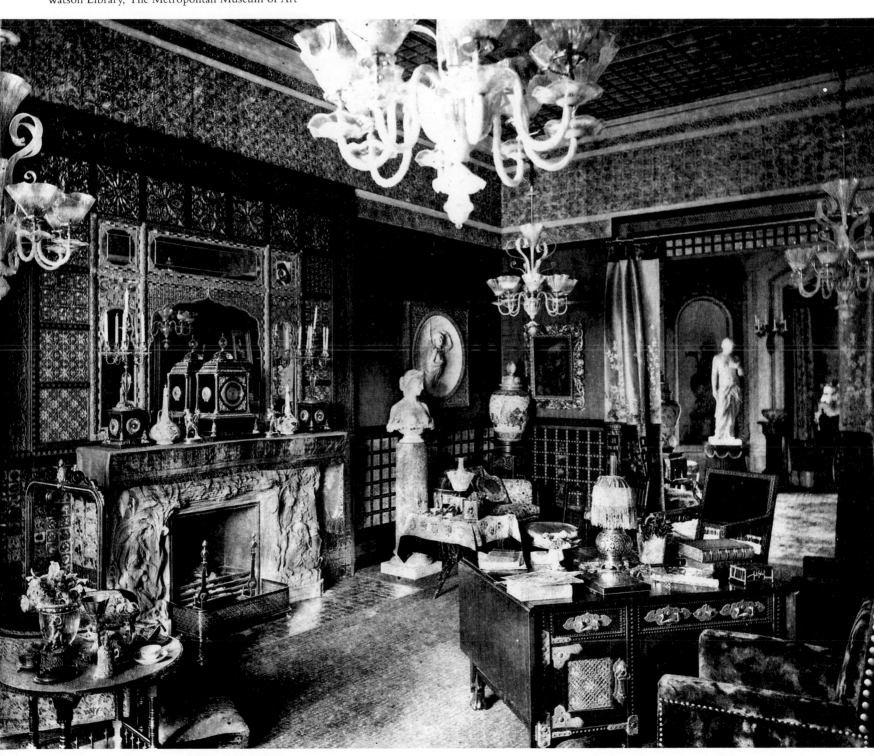

ILL. 8.15 "Ornamental Bronze Metal Store Door Handles and Escutcheons." Nashua Lock Company, *Illustrated and Descriptive Catalogue and Price List of Hardware, Tools, Etc.* (Boston, 1886). Avery Architectural and Fine Arts Library, Columbia University, New York

ILL. 8.16 "Household Brass Goods." Manhattan Brass Company, New York. *Decorator and Furnisher* (Oct. 1883). Art, Prints and Photographs Division, The New York Public Library, Astor, Lenox, Tilden Foundations

Glass Company, the American firm that most likely was the retailer of the piece.[60]

Brass filigree and marquetry of copper and pewter might be employed in furniture, as in the sumptuously embellished cabinet by HERTER BROTHERS (see FIG. 5.28). Likewise, brass was employed for the corner hinges, as terminals for each of the feet, and as stringing, or borders of decorative inlay, on the surface of the delicate table (see FIGS. 5.16, 5.17) stamped by the firm of A. AND H. LEJAMBRE. Discrete Anglo-Japanesque metal marquetry was also used, for the ornamentation of the top.

Brass furniture became ever-more important for the "artistic" household and, together with brass accessories such as clocks, chandeliers, sconces, and lamps, added warmth and color to a room. An advertisement (ILL. 8.16) for the Manhattan Brass Company in an 1883 issue of the *Decorator and Furnisher* illustrates a room that shows the multitudinous purposes of brass; the company manufactured interior decorations consisting of "Fenders, Fire Sets, Andirons, Fire Place Frames, Coal Hods, Grate Trimmings, ETC., Screens, Parlor Easels, Banner Stands, ETC., ETC."[61]

The most common type of brass chandelier in the 1860s and 1870s was in the Renaissance-revival style, and an example in this mode was illustrated in the *Art Journal* in August 1875.[62] Designed by Charles C. Perring for Mitchell, Vance and Company of New York, the fixture consists of a central shaft divided into two main sections: the lower portion is decorated with a medallion containing a nude figure of a woman in bas-relief; above this is a Greek-revival amphora adorned with garlands and laurel wreaths. From the shaft are suspended eight lights with griffins. Surrounding the shaft are four Corinthian columns that support a canopy of winged, mythical animals.

By the 1880s, brass chandeliers in a variety of styles were invariably found in "artistic" houses. The reform mode of the Anglo-Japanesque was often employed for these objects, even as the Renaissance-revival style continued to be popular. The American critic CLARENCE COOK, in *The House Beautiful* (1878, see FIG. 5.6), denounced the ornate Renaissance-revival lighting fixtures of the 1860s and 1870s, calling for uncomplicated forms:

> The makers of gas fixtures have played upon our love of ingenuity until they have made us accept the most monstrous and complicated gas machines for the decoration of our rooms. . . . No more do we want statuettes or intricate ornaments upon our gasoliers. Beauty and utility are served best by a combination in shining metal (not dull bronze), carved and twisted branches through which fluent gas shall really make its way.[63]

As Cook compared the arms of the chandelier to branches of a tree, so too had the Englishman CHARLES LOCKE EASTLAKE, in his *Hints on Household Taste* (1868, see FIG. 4.1), encouraged a style

Below left: FIG. 8.26 Door handle and escutcheon. Nashua Lock Company, Nashua, N.H., ca. 1886. Bronze, 9½ × 2½ in. (24.1 × 6.4 cm). Marked: NASHUA / LOCK / CO. Collection of Margot Johnson

Below right: FIG. 8.27 Plant stand. Probably made in Meriden, Conn., tile made by Minton and Company, Stoke-on-Trent, Staffordshire, England, probably retailed by Meriden Flint Glass Company, 1880–85. Cast brass, painted and glazed earthenware, h. 33⅝ in. (85.4 cm), w. 13⅜ in. (34 cm), d. 13⅜ in (34 cm). The Newark Museum, N.J. (78.214)

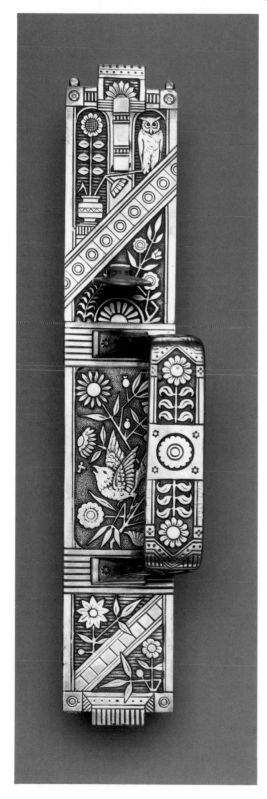

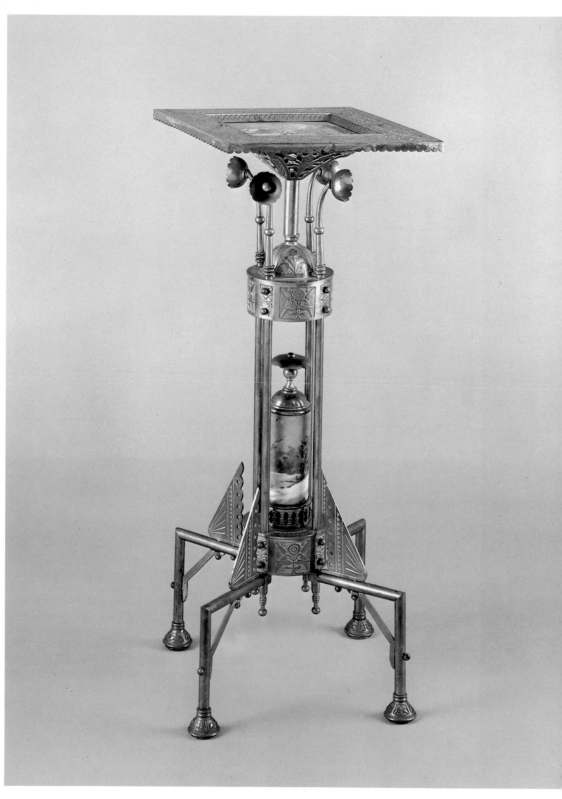

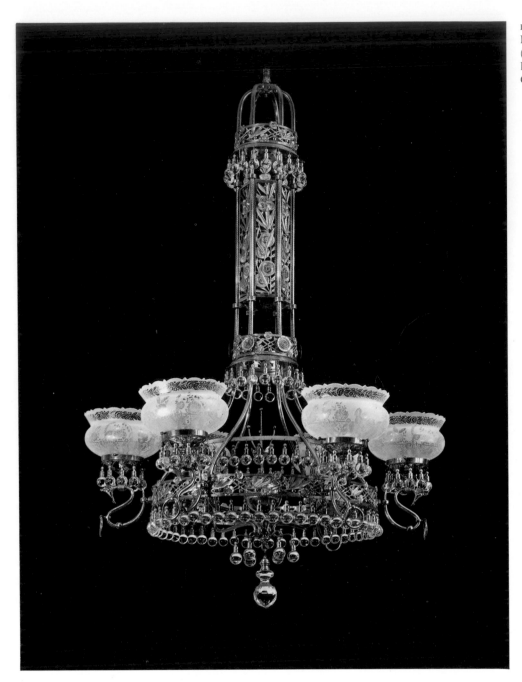

FIG. 8.28 Chandelier. Attributed to I. P. Frink, New York, ca. 1882–83. Bronze, glass, h. 54¾ in. (139.1 cm). The Metropolitan Museum of Art, Purchase, The Edgar J. Kaufmann Foundation Gift, 1969 (69.92)

based on nature: "Many valuable hints for the designing of such objects as gasoliers and lamps may be obtained from antique candelabra, whose ground principle of construction is for the most part that of the tree."[64] Eastlake's advocacy of conventionalized nature was inspired by the Japanese style. A six-light bronze chandelier (FIG. 8.28) attributed to I. P. FRINK of New York that originally hung in the Dubuque, Iowa, dining room of a prosperous meat-packer, William Ryan, exemplifies Anglo-Japanesque treatment. According to Ryan family history, the dining room was redecorated in the early 1880s, complete with WILLIAM MORRIS wallpaper, and aesthetic taste was particularly evident in the chandelier, whose flat, chrysanthemum pattern in brass panels and simplified, elegant design were characteristic of the Anglo-Japanesque style.[65]

Despite the prevalence of brass chandeliers, one critic condemned them as part of "metropolitan vulgarity," complaining about the "sham simplicity" advocated by popular household-art books.[66] JOHN LA FARGE was reported by this anonymous critic to have felt that brass chandeliers were inappropriate for his mellow, rich interior of Trinity Church in Boston, but popular demand insisted on them, even though their effect was "violently vile."[67] Although most interiors illustrated in *Artistic Houses* had prominent, often large, brass chandeliers as part of the ornamental scheme, there were some notable exceptions, among them J. Pierpont Morgan's New York residence, decorated by CHRISTIAN HERTER. This was "distinguished for being the first private dwelling in New York City into which the Edison electric light," invented in 1879, had been successfully introduced.[68] Such electric lights were used on their own without elaborate fixtures.

More common even than chandeliers during the Aesthetic period were brass lamps manufactured in numerous styles. An awkward assemblage of Japanese motifs is apparent in a kerosene lamp (ILL. 8.17) produced by Gorham about 1875–85. The enameled globe of the lamp displays an asymmetrical grouping of twigs on

which a bird is perched, treated in a stiff Western manner, rather than in an Eastern mode of spontaneous activity. Further evidence of the awkward handling of Japanese prototypes may be seen in the unnatural juxtaposition of a bird, a rectangle, and a circle containing a landscape scene. The base incorporates an amalgam of motifs, including two handles that take the form of a face and applied, cast-bronze claw feet out of which a symmetrical floral arrangement grows. The classical frieze around the neck is made of filtered bronze.

From the 1880s brass beds became increasingly fashionable. In 1883 the manufacturer W. T. Mersereau and Company of New York City advertised a brass bed that is uncomplicated in design.[69] The straight lines and simple knobs contrasted with other, highly ornamented beds of the late nineteenth century. According to the announcement, "These goods . . . are recommended by the leading Physicians and Medical Journals as being healthier and cleaner than those made of wood. . . . They are appreciated by all who desire to furnish in good taste."[70] The trend toward simplification in brass beds may be attributable to Japanese influence. Dr. William A. Hammond's Anglo-Japanesque bedroom, pictured in *Artistic Houses,* shows a plain bed frame consisting of vertical strips of metal,[71] appropriate for an aesthetic interior.

A superb example of furniture in the Anglo-Japanesque style is the brass magazine rack (ILL. 8.18) manufactured by W. T.

Mersereau about 1885. The engraved designs at the bottom derive from Japanese print sources, possibly via English objects that used oriental motifs, and the delicate form is evocative of art furniture by E. W. GODWIN. The piece, which sold for twenty-eight dollars and dates from 1883–89, is a rare example of documented American brass furniture.[72]

Among the essential elements of the aesthetic interior were reproductions of works of art made of iron, bronze, and other metals. Iron founding had reached such a remarkable degree of perfection by the 1880s that cast iron could be applied to bronze, silver, and brass reproductions of art objects. The bronze-founding industry had become vast by the time of the Philadelphia Centennial, with large departments devoted to it within such companies as Elkington and Gorham. In 1881 the *Art Amateur* reported that the tile manufacturer JOHN GARDNER LOW had undertaken art castings in iron with bronze effects, which had astonished everyone who saw them.[73] By means of artistic reproductions, the homeowner could surround himself with objects of beauty, in keeping with the tenets of the Aesthetic movement.

Andirons, one element of the interior today taken for granted, assumed prominence during the Aesthetic period. English prototypes inspired a new artistic interpretation of these functional objects. Perhaps one of the most important creations of Anglo-Japanesque metalwork is a pair of bronze sunflower andirons (FIG.

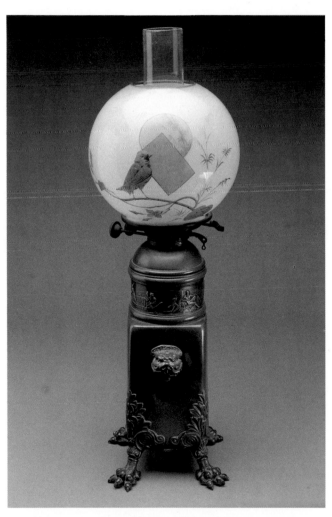

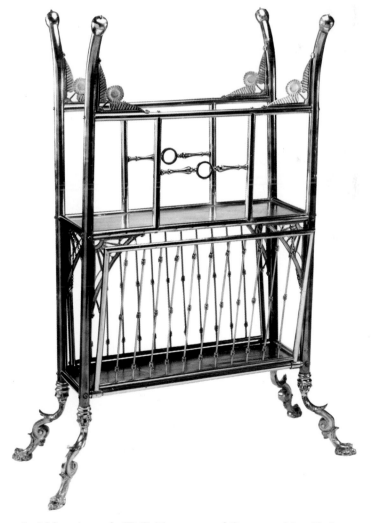

ILL. 8.17 Kerosene lamp. Gorham Manufacturing Company, Providence, R.I., 1875–85. Patinated bronze, painted glass, h. 23⅜ in. (59.3 cm). The Strong Museum, Rochester, N.Y. (80.560)

ILL. 8.18 Magazine rack. W. T. Mersereau and Company, New York, ca. 1885. Brass, h. 36 in. (91.4 cm), w. 19½ in. (49.5 cm). National Museum of American History, Division of Domestic Life, Smithsonian Institution, Washington, D.C., Gift of Charles and Rosanna Batchelor Memorial, Inc. (61.1078)

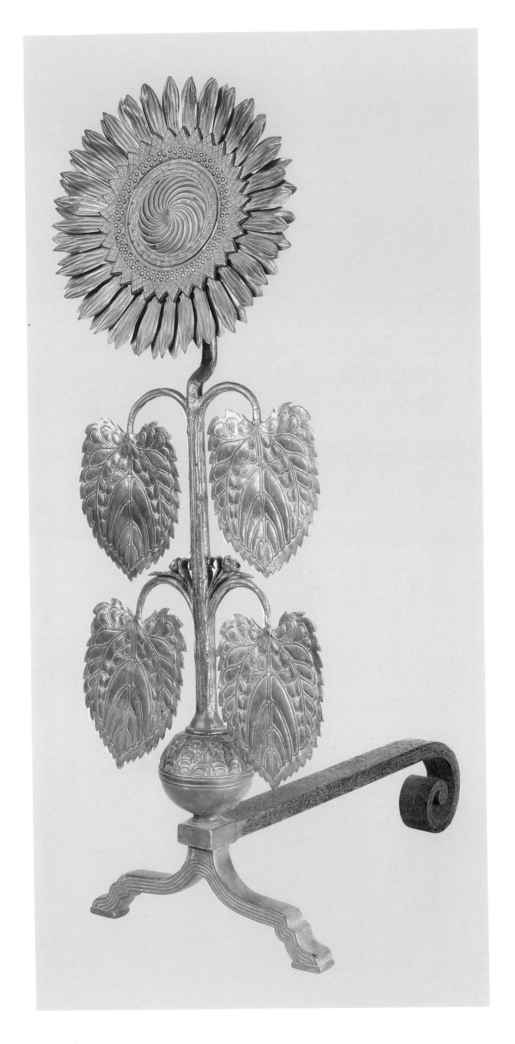

FIG. 8.29 Andiron (one of a pair). Designed by Thomas Jeckyll, made by Barnard, Bishop and Barnards, Norwich, Norfolk, England, ca. 1876. Gilt bronze, h. 33 in. (83.8 cm), w. 12 in. (30.5 cm), d. 21 in. (53.3 cm). Private collection

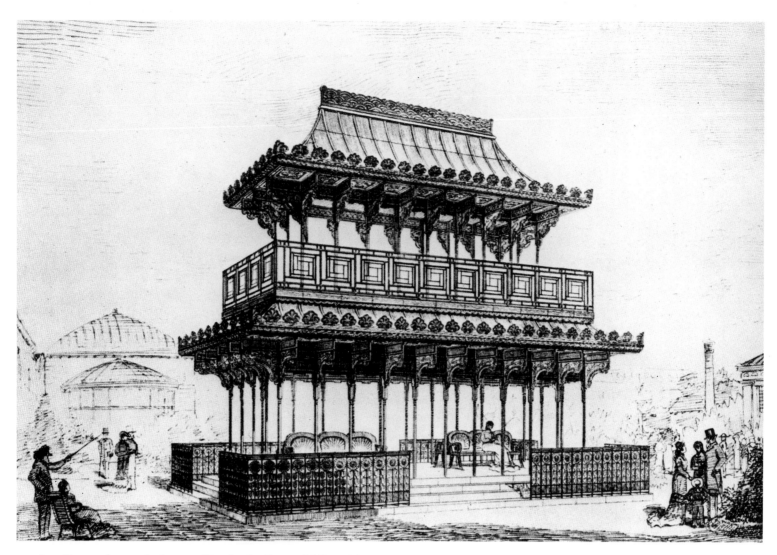

ILL. 8.19 Cast- and wrought-iron pavilion for the Centennial Exposition, Philadelphia. Designed by Thomas Jeckyll, made by Barnard, Bishop and Barnards, Norwich, Norfolk, England, ca. 1875–76. *British Architect and Northern Engineer* (Nov. 1, 1878). Art, Prints and Photographs Division, The New York Public Library, Astor, Lenox, Tilden Foundations

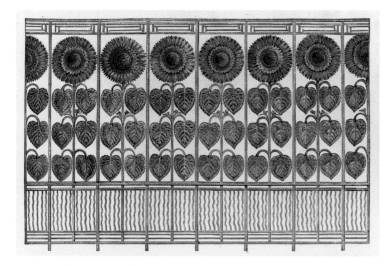

ILL. 8.20 Cast- and wrought-iron pavilion for the Centennial Exposition, Philadelphia (detail). Designed by Thomas Jeckyll, made by Barnard, Bishop and Barnards, Norwich, Norfolk, England, ca. 1875–76. Walter Smith, *Industrial Art*, vol. 2 of *The Masterpieces of the Centennial International Exhibition* (Philadelphia [1877?]). Thomas J. Watson Library, The Metropolitan Museum of Art

8.29) designed by THOMAS JECKYLL and manufactured by BARNARD, BISHOP AND BARNARDS of Norwich, England, about 1876.[74] Although not produced in great quantity, they were undoubtedly shown in the cast- and wrought-iron pavilion (ILLS. 8.19, 8.20), conceived by Jeckyll for the Centennial, that was also adorned with railings of sunflower motifs.[75] Certainly the andirons were used in America, for a pair of them can be seen in a contemporary photograph of David L. Einstein's library in New York (see ILL. 4.1), published in *Artistic Houses*, and a variation of the Jeckyll design is evident in a photograph of the hall in the Long Island residence of Samuel P. Hinckley, reproduced in the same publication.[76] The sunflower, incorporated as part of an overall flat ornamental pattern, is again the dominant motif for an iron-and-brass fireplace made by the J. L. Mott Iron Works of New York and known through a line drawing (ILL. 8.21).

Jeckyll also designed a number of fireplace surrounds in the Japanese style for Barnard, Bishop and Barnards. A cast-brass surround (ILL. 8.22) employs a number of Japanese motifs in a creative design.

Among the cast-iron firebacks in the Anglo-Japanesque style manufactured by American companies was one designed by Lockwood de Forest that appeared in an advertisement for "Artistic Fire

Place Linings" made of iron, bronze, and antique brass.[77] Here decorative, two-dimensional caning is interspersed with flowers. The caning, however, is not placed at the customary right angle to the frame; rather, it is turned askew. This asymmetrical quality is typically Japanesque. In fact, the entire advertisement reflects oriental influence, as stylized letters are combined with abstract wave motifs. FRANK FURNESS also designed two remarkable firebacks, dated 1887,[78] as part of his architectural commission for the William Winsor house in Ardmore, Pennsylvania. One uses a repeti-

tive arrangement of vertical sunflowers, the leaves of which are reduced to a two-dimensional, conventionalized pattern.

Some of the most extraordinary firebacks that incorporate a variation upon the Anglo-Japanesque sunflower motif were originated by a well-known American painter, ELIHU VEDDER. From December 1881 to January 1882, shortly after arriving in New York following art studies abroad, Vedder designed a group of firebacks that were put into limited production and retailed by the J. AND J. G. LOW ART TILE WORKS of Chelsea, Massachusetts.[79]

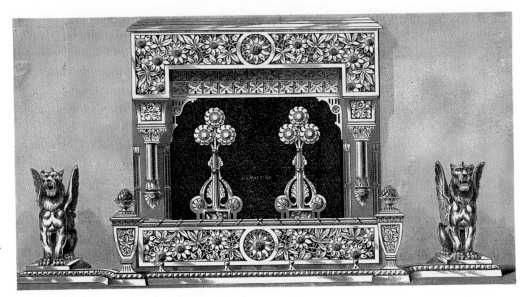

ILL. 8.21 "Specimens of American Factory Work." J. L. Mott Iron Works, New York. *Decorator and Furnisher* (Oct. 1882). Art, Prints and Photographs Division, The New York Public Library, Astor, Lenox, Tilden Foundations

ILL. 8.22 Fireplace surround. Designed by Thomas Jeckyll, made by Barnard, Bishop and Barnards, Norwich, Norfolk, England, after 1873. Brass, 36 × 36⅜ in. (91.4 × 92.4 cm). Marked: *BBB* / [registry mark]. Mitchell Wolfson, Jr., Collection of Decorative and Propaganda Arts, Miami-Dade Community College

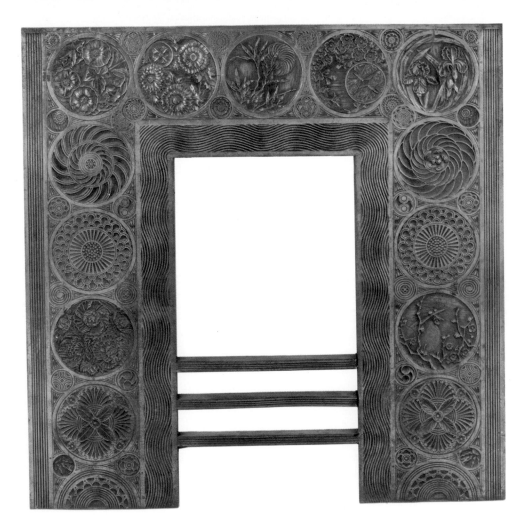

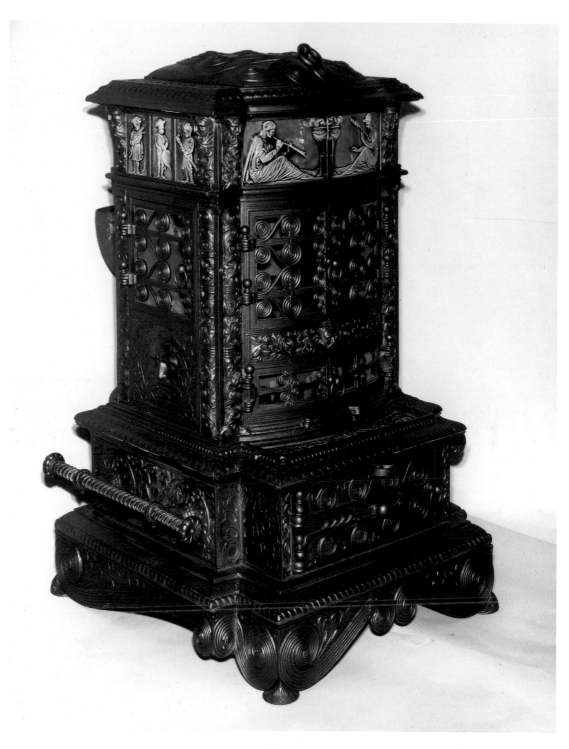

ILL. 8.23 Art Westminster stove. Rathbone, Sard and Company, Albany, N.Y., tiles made by J. and J. G. Low Art Tile Works, Chelsea, Mass., 1885. Cast iron, glazed earthenware, h. 38 in. (96.5 cm), w. 30 in. (76.2 cm), d. 36 in. (91.4 cm). Marked: *1885*. Private collection

These included one entitled *The Soul of the Sunflower* (see FIG. 9.5), made in 1882. The motif of a face surrounded by swirling rays closely resembles a drawing by Vedder dating from 1868 (see ILL. 9.4). The enigmatic mood and the floating head are strongly evocative of the art of the Pre-Raphaelite painters, particularly Simeon Solomon, with whom Vedder became acquainted while in London in 1869.[80] Vedder's concern with symbols and his highly individualized style place him outside the predominant modes associated with aestheticism, such as the Anglo-Japanesque and the Modern Gothic, though he shared the movement's philosophical attitudes and spirit of reform.

The far-reaching effects of the Anglo-Japanesque mode of the Aesthetic era can be seen in its employment in cast-iron stoves. At least one late nineteenth-century author criticized contemporary styles, such as the Renaissance revival, that were used in stoves. He judged the average stove of the day to be unsightly (American manufacturers, unlike their European counterparts, did not ordinarily employ artists to make beautiful models), though he deemed simple, early American stoves inoffensive. The author questioned whether glazed tiles would enhance the appearance of "hopelessly vulgarized stoves" and invoked as a prototype a seventeenth-century example with an "architectural appearance," its unattrac-

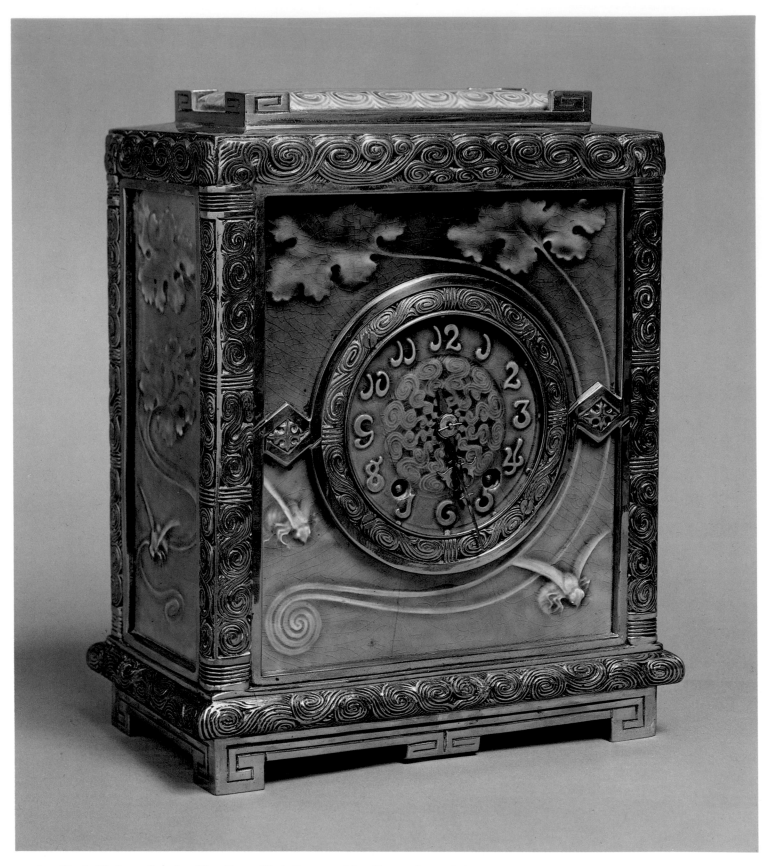

FIG. 8.30 Clock. Works attributed to New Haven Clock Company, New Haven, tiles made by
J. and J. G. Low Art Tile Works, Chelsea, Mass., ca. 1884. Brass, glazed earthenware,
h. 12 1/16 in. (30.6 cm), w. 9¾ in. (24.5 cm), d. 5⅞ in. (15 cm). Marked: *J & J. G. Low,* / PATENT /
ART TILE WORKS, / CHELSEA, / MASS., U.S.A. / COPYRIGHT 1884, / *By J. G. & J. E. Low.* The Museum
of Fine Arts, Houston, Purchase with funds provided by Dr. and Mrs. John R. Kelsey (82.15)

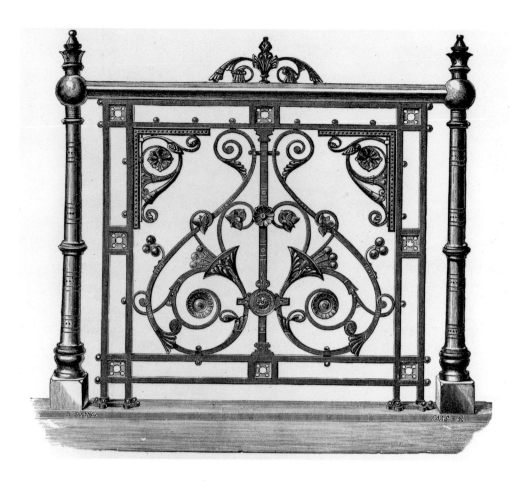

tive iron case covered with tiles.[81] Some American designers heeded such suggestions and created reinterpreted forms. In 1884 the Magee Furnace Company of Boston advertised a cast-iron stove that included tiles decorated with conventionalized, two-dimensional flowers, asymmetrically arranged in a Japanese fashion. The cast-iron ornament is in the Japanese style as well, juxtaposing decorative flora against curvilinear, wavelike motifs.[82] Another example is referred to in an 1882 advertisement by the Open Stove Ventilating Company for a cast-iron stove that was adorned with a sunflower on the side panel.[83]

While the American stove was praised for its technical ingenuity and was considered "peerless for its useful qualities," its artistic aspects were often neglected.[84] Artists and manufacturers strove to develop aesthetic American stoves, achieved by embellishment with ceramic tiles and decoration of the metal casing. One result was the stove (ILL. 8.23) called Art Westminster, made in 1885 by Rathbone, Sard and Company of Albany, New York.[85] Here cast-iron decorative scrollwork is surmounted by a ceramic frieze by the J. and J. G. Low Art Tile Works. The subdued green color of the tiles subtly complements the black of the cast iron.

During the Aesthetic era ornamental objects for the home in the Anglo-Japanesque style often combined metal with ceramic tiles to produce a rich effect. A mantel clock (FIG. 8.30) of about 1884 incorporates tiles by J. and J. G. Low within a brass frame. The tiles and the brass case employed on this entirely Western device reflect an Eastern influence, and the floral-and-insect design is typically Japanesque in that it is a pattern derived from nature. The asymmetrical motifs and the spiraling wave decoration of the brass case echo the swirling, linear decoration of the tiles. The key pattern of the frets, which are situated at the top and bottom of the clock, is also quintessentially Japanese. The lower fret acts as a base for the object and is reminiscent of the decorative stand that commonly supports a Japanese vase.[86]

Japanesque themes of a spider web and overlapping daisies are exquisitely rendered on a copper bowl (FIG. 8.31) cast and chased in 1884 by M. LOUISE MCLAUGHLIN of Cincinnati. (The overlapping daisy motif is often seen in Cincinnati wood carving.) The signature of the artist, *L MCL,* and the date, *1884,* are inscribed visibly on the side of the bowl, elevating this functional object, like the Whiting vase (see FIG. 8.2), to a work of art. Although known primarily as a ceramist, McLaughlin was also adept in the media of metalwork and wood carving and displayed the multifaceted abilities typical of the Cincinnati school. However, few examples of her metalwork are known. In addition to her bowl, two other copper pieces by McLaughlin in the Cincinnati Art Museum incorporate the Anglo-Japanesque style, including a plaque signed and dated 1884, engraved with snowballs, and a plate signed and dated 1887, engraved with a self-portrait within a Japanesque gilt frame.

Architectural Metalwork

During the Aesthetic movement as throughout the nineteenth century, metalwork was commonly employed as architectural ornamentation. A survey of contemporary periodicals and journals reveals that the Modern Gothic style, evinced infrequently in American silver, was a popular reform mode for American architects. English designs of the 1860s provided the inspiration for works by American iron manufacturers throughout the Aesthetic period. Characteristic English designs—including the rigid symmetry, emphatic two-dimensionality, twisting vines, and trefoil-shaped leaves associated with the Gothic—are displayed in a grille and a guardrail illustrated in the *Art Journal* in 1861.[87]

American architects such as Frank Furness and LOUIS SULLIVAN adapted the English Modern Gothic style to create individual or-

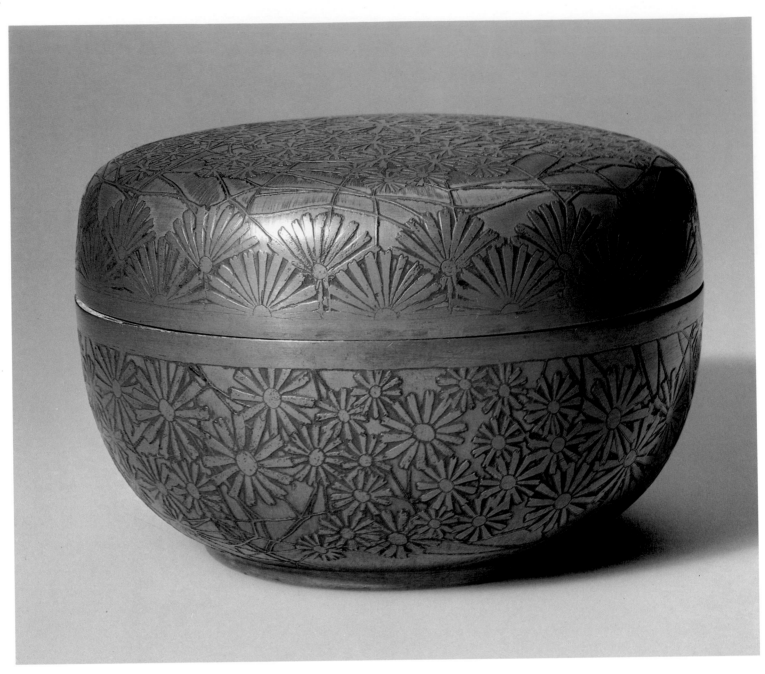

FIG. 8.31 Covered bowl. Decorated by M. Louise McLaughlin, Cincinnati, 1884. Copper, h. 5¼ in. (13.4 cm), diam. 7¾ in. (19.7 cm). Signed: *L MCL / 1884*. Cincinnati Art Museum, Gift of Mary Louise McLaughlin (1937.13)

naments for their buildings of the 1870s. A wrought-iron grille designed by Furness in 1873, now in the Philadelphia Museum of Art, was removed from an exterior window of the Guarantee Trust and Safe Deposit Company at 316–320 Chestnut Street in Philadelphia.[88] Here the continuous pattern of entwined flower blossoms with pointed ends resembles the interlaced motifs of medieval manuscript paintings. The conventionalized decoration on the cast-iron facade of the Rothschild Building on West Monroe Street in Chicago, designed by Adler and Sullivan in 1880–81, is also a striking illustration of Modern Gothic architectural adornment.[89] The cast-iron sections across the frieze of the building contain a repetitive pattern of stylized flowers with interlocking stems and leaves.

Brass and bronze, like iron, were employed for structural and

ornamental purposes. A brass gate (ILL. 8.24) by Mitchell, Vance and Company is an elaborate example of the ornamental railings that were manufactured, usually in brass or iron, in the Modern Gothic style for American buildings of the 1870s and 1880s.[90] When the gate was exhibited at the Centennial Exposition, one critic wrote, "Use has been considered before ornament in its construction, and we see how true excellence in the former can be allied with simplicity."[91] Such considerations of simplified design are characteristic of aestheticism. In the case of the gate, strips of metal fill the frame with curving, interconnected vines and tendrils. Leaves and stylized flowers terminate in graceful points in the fashion of the medieval periods.

Mitchell, Vance and Company also produced a bronze railing that is clearly rendered in the Modern Gothic mode.[92] Twisting,

vinelike elements end with decorative tendrils in the central portion. To either side, circular ornamentation, recollective of a Gothic stained-glass rose window, enhances the beauty of the object. Trefoil punctures further embellish the work.

The Anglo-Japanesque sunflower motif that appeared frequently in American metalwork of the 1880s was often employed for architectural ornamentation as well. Cast-iron sunflowers were used discreetly on the exteriors of several New York buildings. For example, the cast-iron railing of repeated, interlaced sunflowers from the Chelsea Hotel of 1883 was manufactured by the J. B. Cornell Foundry of New York. The iron sections contrast with the red brick of the Chelsea exterior, creating a decorative effect.[93] The two-dimensional, flat character of the railing conforms with the basic features of aesthetic architectural ornament.

The Philadelphia Centennial Exposition of 1876 made it clear to many American designers and manufacturers that the ornate styles of the mid- to late nineteenth century, exemplified by the Renaissance revival, should be modified and a new, simple approach developed. Thus, a number of designers looked to models that offered relief from the elaborate treatments displayed at the fair. Japanese objects provided one source of inspiration during the Aesthetic era, and because much American metalwork derived from English products, the Modern Gothic style also played an important role.

It was through the international expositions, particularly those held in Paris in 1878 and 1889, that Americans received widespread recognition for their metalwork, and by the time of the Philadelphia Centennial Tiffany and Company had already emerged as a leader in silver design. At these events, Americans were able to compare their designs with the avant-garde styles being generated in Europe, and European critics often lavished praise upon the American wares.

Despite the arbitrary assignment of stylistic labels to aesthetic metalwork, which was not manufactured in great quantity, certain conclusions can be drawn. That the Anglo-Japanesque mode appeared primarily in silver and that the Modern Gothic predominated in cast- and wrought-iron architectural ornament is apparent. However, it was typical for hybrid motifs to exist simultaneously in a single piece, which often incorporated traditional historical as well as reform styles. It was highly unusual for a room to be decorated exclusively in one mode; rather, an amalgam was ordinarily employed.

Although the Aesthetic movement occurred during a relatively short period of time, its effects were far-reaching and long-lasting. Its emphasis upon simplicity and unified design integrated with architectural surroundings persisted well into the early twentieth century, particularly in the Arts and Crafts movement, and in fact, it was not until that later period that the reforming ideas of the Aesthetic movement were fully realized.

NOTES

1. "American Art-Work in Silver," *Art Journal* (Appleton's) 1 (Dec. 1875), p. 371.

2. For a general discussion of American silver of this period, see Katherine Morrison McClinton, *Collecting American Nineteenth Century Silver* (New York, 1968).

3. Two archival sources of silver manufacturers provide opportunities for precise documentation of sources, styles, and the design process of American silver made after the Philadelphia Centennial Exposition of 1876. The extensive records of the Gorham Corporation in Providence, R.I., and of Tiffany and Company in Parsippany, N.J., contain working drawings, account books, and scrapbooks, which preserve the kind of information that was frequently destroyed when late nineteenth-century manufacturers went out of business. From surviving company archives, marked pieces can be matched with extant records and drawings, thus providing us with information such as a precise year of manufacture. While silver is normally marked, other categories of metalwork, including cast iron, silverplate, and brass, are not necessarily as well documented. Brasswork is seldom marked and consequently requires extensive research in catalogues and illustrated advertisements (extant brass objects can be matched with printed images). A number of New York brass-manufacturing firms advertised in such periodicals as the *Decorator and Furnisher,* and much of the unmarked elaborate Modern Gothic and Anglo-Japanesque furniture in this medium may be of American origin, but it is difficult to distinguish it from similar English work, which was produced in greater quantity.

4. Some of these pieces are illustrated in Walter Smith, *Industrial Art,* vol. 2 of *The Masterpieces of the Centennial International Exhibition* (Philadelphia, copr. 1875 [1877?]). See also Charles H. Carpenter, Jr., and Mary Grace Carpenter, *Tiffany Silver* (New York, 1978), pp. 36–37.

5. The Bryant Vase, made by Tiffany and Company to honor the poet William Cullen Bryant (1794–1878), is marked with the design patent date May 1875. Like Tiffany and Company, the Gorham Manufacturing Company exhibited Renaissance-revival pieces at the Philadelphia Centennial, the most notable example being their imposing Century Vase. Both the Bryant Vase and the Century Vase are illustrated in Smith, *Industrial Art,* pp. 52, 276.

6. For a design source for the Whiting vase, see Owen Jones, *The Grammar of Ornament* (1856; [3d ed.] London, 1868), pl. 7; and Christopher Dresser, *Principles of Decorative Design* (1873; reprint London, 1973), p. 5, fig. 3.

7. After the exhibition the pitcher was the first object acquired by the Decorative Arts Department of the Boston Museum of Fine Arts; see Carpenter and Carpenter, *Tiffany Silver,* p. 37. A drawing in the Tiffany and Company Archives, Parsippany, N.J., of this pattern (No. 4065) in elevation and plan is inscribed April 29, 1875, which helps to date the pitcher. Other manufacturers may have exhibited silver in reform styles, but this object is the only documented example known to survive. Even though it is not illustrated in the Centennial catalogues, it was purchased from the Centennial Exposition display.

8. Christopher Dresser, *Modern Ornamentation, Being a Series of Original Designs* (1886; reprint New York, 1978), pl. 35.

9. This style was contemporaneously described as "Anglo-Japanese," or, alternatively, "American-Japanese," terms that are often confused. "Anglo-Japanese" usually refers to the work of E. W. Godwin and the English interpretation of Japanese designs. Clearly "Anglo-Japanese" and "American-Japanese" both refer to the Japanesque, or those objects showing any resemblance to Japanese products.

10. S[usan] N. C[arter], "Brass and Bronze Work at the Centennial Exhibition," *Art Journal* (Appleton's) 2 (Nov. 1876), p. 348.

11. According to the Carpenters' research in the firm's daybook records, in 1873 Tiffany and Company produced its first piece of hollow ware in the Japanese style, a tea caddy with a lid, now in the collection of the Preservation Society of Newport

County, R.I.; see Carpenter and Carpenter, *Tiffany Silver,* p. 190. For a summary of the company's silver in the Japanese style, see Henry H. Hawley, "Tiffany's Silver in the Japanese Taste," *Bulletin of the Cleveland Museum of Art* 63 (Oct. 1976), pp. 236–45.

12. Royal Academy of Arts, London, *Victorian and Edwardian Decorative Art: The Handley-Read Collection* (exhib. cat., 1972), p. 76. For a short discussion of Elkington Anglo-Japanesque silver and illustrations of it, see Fine Art Society Limited, London, *The Aesthetic Movement and the Cult of Japan,* by Robin Spencer et al. (exhib. cat., 1972), pp. 35–40.

13. Royal Academy of Arts, *Victorian and Edwardian Decorative Art,* p. 76.

14. This information was kindly provided by Michael Collins, The British Museum, London, whose article is forthcoming in *Burlington Magazine.*

15. Like Dresser, his contemporary William Arthur Smith Benson, of W. A. S. Benson and Company, produced innovative metalwork that could be adapted easily to machine-manufacturing techniques. For a short discussion of Benson metalware, see Royal Academy of Arts, *Victorian and Edwardian Decorative Art,* pp. 93–94.

16. Dresser, *Principles of Decorative Design,* p. 24. For an article on Dresser's metalwork, see Ann Duman, "Victorian Modern: The Metalwork Designs of Christopher Dresser, C. R. Ashbee, and Archibald Knox, 1880–1910," *Antiques* 127 (June 1985), pp. 1342–51.

17. "Tiffany's Great Sale of Japanese Curiosities," Philadelphia *Evening Bulletin,* June 9, 1877, p. 4, clipping from Tiffany and Company scrapbook, Tiffany and Company Archives, Parsippany, N.J. A copy of the auction catalogue, George A. Leavitt and Company, New York, *The Dresser Collection of Japanese Curios and Articles Selected for Messrs. Tiffany and Co.* (sale cat., June 18, 1877), is also in the archives of Tiffany and Company.

18. This information was kindly provided by Amanda Austin, former archivist for Tiffany and Company, Parsippany, N.J.

19. Hawley, "Tiffany's Silver in the Japanese

"Taste," pp. 236–45.

20. Carpenter and Carpenter, *Tiffany Silver*, p. 185 (ills. 252, 253).

21. Edward C. Moore, Jr., to Edward Robinson, Assistant Director, The Metropolitan Museum of Art, New York, correspondence, July 9, 1907.

22. C. H., "The Edward C. Moore Collection," *Bulletin of the Metropolitan Museum of Art* 2 (June 1907), pp. 105–6. A study of Edward C. Moore's library, now in the Thomas J. Watson Library, The Metropolitan Museum of Art, New York, is being prepared by Kenneth Dinin, a member of the library's staff.

23. Carpenter and Carpenter, *Tiffany Silver*, p. 240.

24. "Silver in Art," *International Review* 5 (1878), p. 244.

25. At the time of the 1889 Paris Exposition Universelle, Tiffany and Company again displayed silver in the Japanese style.

26. Carpenter and Carpenter, *Tiffany Silver*, p. 38.

27. S. Bing, "Artistic America," trans. from the 1895 French version ("La Culture artistique en Amérique"), by Benita Eisler, in *Artistic America, Tiffany Glass, and Art Nouveau*, intro. Robert Koch (Cambridge, Mass., and London, 1970), p. 121.

28. "Illustrated Catalogue of the Paris International Exhibition," pt. 4, *Art Journal* (Appleton's) 4 (Aug. 1878), pp. 237–48.

29. Edwin C. Taylor, "Metal Work of All Ages," *National Repository* 6 (Nov. 1879), pp. 404–5.

30. Christopher Dresser to "Messrs. Tiffany and Co.," correspondence, July 25, 1878, Tiffany and Company Archives, Parsippany, N.J.

31. An identical coffeepot is illustrated in Emile Bergerat, *Les Chefs d'oeuvre d'art à l'Exposition Universelle*, 12 vols. (Paris, 1878), p. 123. Since subtle differences exist between the illustration and the other known coffeepots in the same design, the example in the Yale University Art Gallery, New Haven (see FIG. 8.10), may have been the one exhibited in Paris in 1878. The Yale coffeepot is illustrated in Taylor, "Metal Work of All Ages," p. 404. The working drawing for the form, "Coffee Pot No. 4872," in the Tiffany and Company Archives, Parsippany, N.J., indicates a possible seam at midpoint where the two bulbous shapes would have been joined. A drawing entitled "Hammering Design for Coffee or Tea Set No. 4872" shows elevations in eight sections for the complex decoration. The authors are grateful to Pat Kane and David Barquist for bringing this information to their attention.

32. The ledger in the Tiffany and Company Archives, Parsippany, N.J., indicates a date of 1879, and there is only one work order listed for the piece. Furthermore, the design drawing for No. 5461 is stamped February 15, 1879. For a discussion of Paulownia leaves and the Japanese imperial family, see James W. Peterson, *Orders and Medals of Japan and Associated States* (Chicago, 1967), p. 21.

33. In a child's flatware set by Gorham, formerly in the collection of Fred Heintz, New York, each piece was of a different form and decoration. A printed notice in the fitted case states that although the ornamentation of the pieces varied, the set was matched in the Japanese style.

34. Louisine Waldren Havemeyer, "Notes to Her Children," typescript, n.d., Thomas J. Watson Library, The Metropolitan Museum of Art, New York.

35. "Silver in Art," p. 245.

36. The firm of Bailey, Banks and Biddle was founded in 1878. From 1843 the company was known as Bailey and Kitchen, and from 1849 until 1878 as Bailey and Company. Bailey and Company was considered the leading jeweler and silversmith of Philadelphia; see Philadelphia Museum of Art, *Philadelphia: Three Centuries of American Art*, by Darrel Sewell et al. (exhib. cat., 1976), p. 326.

37. For an illustration of a tea kettle with a square base from this set, see Kunstgewerbe Museum, Cologne, *Christopher Dresser: Ein Viktorianischer Designer, 1834–1904* (exhib. cat., 1981), pl. 93.

38. A photograph from 1869 in the Tiffany and Company Archives, Parsippany, N.J., shows the entire tea and coffee service of six pieces, three of which are owned by the Philadelphia Museum of Art.

39. Carpenter and Carpenter, *Tiffany Silver*, p. 68.

40. For an explanation of the elaborate symbolism of this object, see Alexander Farnum, *The Century Vase* (Providence, R.I., 1876).

41. "Thomas J. Pairpoint" [obituary], *Providence Daily Journal*, Aug. 30, 1902, p. 3.

42. Charles H. Carpenter, Jr., *Gorham Silver, 1831–1981* (New York, 1982), p. 95. Company libraries retain books that provide evidence of design sources other than Japanese; for example, a copy of Owen Jones's *Grammar of Ornament*, which illustrates Persian and Egyptian sources, among others, is also in Gorham's holdings.

43. Ibid., p. 103.

44. A. St. Johnston, "American Silver-Work," *Magazine of Art* 9 (1886), p. 16.

45. For further information on the Springer vase, see Anita J. Ellis, "Cincinnati Music Hall Presentation Vase," *Silver Magazine* 18 (Mar.–Apr. 1985), pp. 8–11.

46. J. U. Urquhart, *Electro-plating: A Practical Handbook* (London, 1888), p. 1. This nineteenth-century account explains the process in detail.

47. For a full account of the development of electroplating, see Dorothy T. Rainwater and H. Ivan Rainwater, *American Silverplate* (Nashville, Tenn., and Hanover, Pa., 1968).

48. Elsie Bee, "Fashions in Jewelry," *Jewelers' Circular and Horological Review* 17 (Apr. 1886), p. 97.

49. Rainwater and Rainwater, *American Silverplate*, pp. 31–32.

50. Although the 1883 catalogue of the Derby Silver Company does not illustrate this tray, it does show two other similar objects. One, a small tray, or waiter (no. 62), of identical form was available in "assorted styles of Chasing to match Tea Sets." The chased design with "Niello Gold" (see p. 112 of the Derby catalogue) displays an alternative to the design on the tray illustrated here. A pair of quail are posed in a fighting stance; hence the title, *Warfare*. Another waiter, with a complementary six-piece tea set, was also illustrated in the Derby catalogue. For a discussion of the Derby trays, see *Victorian Silverplated Holloware* (Princeton, N.J., 1972), p. 109.

51. John W. Miles, "Electro-Gold and Silver Plate," *Jewelers' Circular and Horological Review* 14 (May 1883), p. 104.

52. Yale University Art Gallery, New Haven, *Silver in American Life: Selections from the Mabel Brady Garvan and Other Collections at Yale University*, ed. Barbara McLean Ward and Gerald W. R. Ward (exhib. cat., 1979), p. 82.

53. This is evident from illustrations in electroplating trade catalogues. For example, see Meriden Britannia Company, *The Meriden Britannia Silver-Plate Treasury: The Complete Catalogue of 1886–7* (1886; reprint New York, 1982), nos. 1024, 1040, 1047.

54. See Marilynn Johnson, "The Artful Interior," this publication.

55. For an illustration, see *Artistic Houses, Being a Series of Interior Views of a Number of the Most Beautiful and Celebrated Homes in the United States*, 2 vols. in 4 pts. (1883–84; reprinted in 1 pt., New York, 1971), vol. 2, pt. 1, p. 94 (ill.). The object is discussed on p. 95.

56. *Decorator and Furnisher* 7 (Mar. 1886), p. 179 (ill.).

57. "Sheet-Metal Center-Pieces," *Carpentry and Building* 10 (Apr. 1888), p. 82; "Kinnear's Metallic Ceilings," *Carpentry and Building* 10 (Nov. 1888), pp. 229–30.

58. *Artistic Houses*, vol. 1, pt. 2, p. 172 (ill.).

59. "In the Japanese Library of Dr. Edward H. Williams in Philadelphia," *Decorator and Furnisher* 5 (Dec. 1884), pp. 78–79.

60. For a similar table, see Charles Eugene Banks, *American Home Culture and Correct Customs of Polite Society* (Chicago [1902?]), ill. Another example of the same piece is in a private collection. This information was kindly provided by Ulysses G. Dietz, The Newark Museum, N.J.

61. [Advertisement], *Decorator and Furnisher* 3 (Oct. 1883), p. 34.

62. "American Art-Manufactures," *Art Journal* (Appleton's) 1 (Aug. 1875), p. 248 (ill.); the medium of the chandelier is not discussed. A Modern Gothic chandelier, also typical of the Aesthetic period, is illustrated in the November 1877 issue of the *Art Journal*. This Modern Gothic fixture, again designed by Charles C. Perring, was hand wrought, nickelplated, and gold grit. It included four clusters of three lights springing from thin, tendril-like elements. These elements were attached to a lower band with a perforated design of interlaced decoration. The bank was suspended by four rods, which supported a canopy adorned with trefoil-pointed arches punctuated with laced patterns in the Gothic style. See "American Art-Manufactures," *Art Journal* (Appleton's) 3 (Nov. 1877), p. 343. COTTIER AND COMPANY, the important glass manufacturer, also designed lighting fixtures, including an immense Flemish-style brass chandelier for the main hall of the F. W. Stevens house in New York, where Flemish woodwork had been installed; see *Artistic Houses*, vol. 1, pt. 2, pp. 100 (ill.), 108.

63. Clarence Cook, *The House Beautiful: Essays on Beds and Tables, Stools and Candlesticks* (1878; reprint New York, 1980), pp. 219–20.

64. Charles Locke Eastlake, *Hints on Household Taste in Furniture, Upholstery, and Other Details* (1868; reprinted from the 2d London ed., intro. and notes by Charles C. Perkins, Boston, 1872), p. 150.

65. Denys Peter Myers, *Gaslighting in America: A Guide for Historic Preservation* (Washington, D.C., 1978), p. 205. According to Myers, the chrysanthemum pattern resembles the design on a chandelier, no. 720, in the I. P. Frink catalogues of 1882 and 1883, as well as that on the Thackera chandelier, pl. 97, *Gaslighting in America*.

66. "Household Art," *Carpet Trade Review* 4 (Apr. 1877), pp. 45–46.

67. Ibid., p. 45.

68. *Artistic Houses*, vol. 1, pt. 1, p. 80.

69. [Advertisement], *Decorator and Furnisher* 1 (Jan. 1883), p. 131.

70. Ibid.

71. *Artistic Houses*, vol. 1, pt. 2, ill. opp. p. 89.

72. An identical magazine rack dating from 1883–89 was illustrated in W. T. Mersereau and Company, *Catalogue of Brass Bedsteads and Furniture Manufactured by W. T. Mersereau and Co., No. 321 Broadway, N.Y.* ([New York], n.d.), p. 181 (no. 673). A rack of the same configuration with sunflower and sunburst brackets was shown in the catalogue. The rack does not have spindle sides and paw feet, but these features appeared elsewhere in the publication. This information was kindly provided by Rodris Roth and Michael Ettema, correspondence, Mar. 13, 1985.

73. "New Metal Castings," *Art Amateur* 5 (June 1881), p. 12.

74. These andirons were illustrated in the company's catalogue of 1884, nos. 880, 884. They were available in wrought iron and polished wrought brass. The firm was founded in 1826 by Charles Barnard as an ironmongery and oil business. Eventually

the concern specialized in ornamental ironwork, exhibiting at the 1851 Great Exhibition in Hyde Park, London, a wrought-iron hinge that won a medal. It is not known exactly when Jeckyll began working with Barnard, Bishop and Barnards, but it was as early as 1862, and his association with the company ended in 1877. See "Barnards Have Led the Way Since 1826," Norwich, Eng., *Eastern Evening News,* Nov. 18, 1976, p. 13; and Roy Bridgen and Michael Day, unpublished lecture notes, n.d. This information was kindly provided by David Jones, Castle Museum, Norwich, Eng.

75. [George Titus Ferris], *Gems of the Centennial Exhibition: Consisting of Illustrated Descriptions of Objects of an Artistic Character, in the Exhibits of the United States, Great Britain, France . . .* (New York, 1877), p. 10. The Victoria and Albert Museum, London, has preserved two drawings by Jeckyll for his Philadelphia pavilion: one for a bracket incorporating a sunflower motif identical to the one used on the andirons, the other for a single iron sunflower that was originally part of a set of railings.

Jeckyll's andirons were again exhibited, with a grate by Barnard, Bishop and Barnards, at the 1878 Paris Exposition Universelle; see "The Paris Universal Exhibition," pt. 6, *Magazine of Art* 1 (1878), p. 167 (ill.). For two other Anglo-Japanesque grates of the Aesthetic period, see J. Moyr Smith, *Ornamental Interiors, Ancient and Modern* (London, 1887), pp. 206–7. Duplicate examples of Jeckyll metalwork were purchased by the South Kensington Museum (now the Victoria and Albert Museum); see James D. McCabe, *The Illustrated History of the Centennial Exhibition . . .* (1876; reprint Philadelphia, 1975), p. 367. The Victoria and Albert today, however (according to information kindly provided by their Department of Metalwork, Aug. 1984), has only a single wrought- and cast-iron sunflower from the railing of the Philadelphia Centennial pavilion. Past museum inventories indicate that duplicate objects by Jeckyll included in the Philadelphia exhibition were never owned by the Victoria and Albert.

The Peacock Room (1876–77, see ILL. 4.10), designed by Jeckyll and decorated by JAMES ABBOTT MCNEILL WHISTLER, originally contained a pair of sunflower andirons; see Peter Ferriday, "Peacock Room," *Architectural Review* 125 (June 1959), pp. 411–12. Ferriday states that the Peacock Room andirons were two of the sunflowers from the Philadelphia pavilion. The andirons, like the freestanding furniture, were not acquired with the woodwork;

they have been replaced with an identical pair.

76. *Artistic Houses,* vol. 2, pt. 1, p. 90 (ill.).

77. Advertisement for a catalogue of "Artistic Fire Place Linings from the Designs of Lockwood de-Forest [*sic*]" [source unknown, n.d.], photocopy in the scholarship files, Department of American Decorative Arts, The Metropolitan Museum of Art, New York. For a discussion of de Forest, see Marilynn Johnson, "The Artful Interior," this publication.

78. For examples, see Philadelphia Museum of Art, *The Architecture of Frank Furness,* by James F. O'Gorman (exhib. cat., 1973), pp. 162, 174.

79. Regina Soria, *Elihu Vedder: American Visionary Artist in Rome (1836–1923)* (Rutherford, N.J., 1970), pp. 160–61.

80. Ibid., pp. 17–19.

81. "The Art Possibilities of Stoves," *Art Amateur* 7 (Nov. 1882), p. 125.

82. For an illustration, see "Stove Architecture," *Brick, Tile, and Metal Review* 4 (Sept. 1884), p. 1. The Magee Furnace Company operated in Boston from 1868 until 1885 and had a factory in Chelsea, Mass. An *Art Amateur* article, "New Decorative Metal Castings," of June 1881 (vol. 5), p. 12, mentions a Magee Art Castings Company of Chelsea, Mass., in conjunction with the J. and J. G. Low Art Tile Works.

83. [Advertisement], *American Architect and Building News* 12 (Nov. 4, 1882), unpaged advertising supplement.

84. S[ylvester] R[osa] Koehler, "American Art Industries, 1: Heating Apparatus," *Magazine of Art* 8 (1885), p. 38.

85. Ibid., p. 39 (ill.).

86. John Gardner Low received a patent for the invention of this clock case on January 5, 1886; see John G. Low, application for patent of clock case (Washington, D.C., U.S. Patents Office, Jan. 5, 1886), no. 333873.

87. "Gothic Metal Work," pt. 2, *Art Journal* (London), Nov. 1861, p. 333 (ills.). Here tendrils ending with leafy blossoms twist and curve upward along a central rod. There is a distinctive variety among the blossoms—some are depicted as folded leaves and some as stylized trefoils, while others are completely open to reveal a sunflower-like pattern. The whole design is contained within a pointed arch, typical of the medieval period. The use of brass as a medium

for the Modern Gothic style had its precedents in England. During the early 1860s English designers such as T. Peard produced a variety of brass objects in this mode. Peard's gas bracket, reading desk, bell lever, and door lock with handle all display the Gothic elements popular in England at the time, including spiraling tendrils and trefoil-shaped leaves with an emphatic tendency toward two-dimensionality. For a further discussion of English Modern Gothic metalwork, see "Gothic Metal Work," pt. 1, *Art Journal* (London), Sept. 1861, pp. 281–84.

88. Philadelphia Museum of Art, *Frank Furness,* p. 85. For an illustration of the Guarantee Trust and Safe Deposit Company and for Furness's use of metal ornament as a fanciful weather vane and cornice grille, as well as for interior railings, see p. 91. A color lithograph by Bunk and McFetridge in the Historical Society of Pennsylvania, Philadelphia, shows the Guarantee Trust and Safe Deposit Company grilles in situ.

89. For a discussion of this building, see Hugh Morrison, *Louis Sullivan, Prophet of Modern Architecture* (New York, 1935), p. 295. A section of the frieze is preserved in the Art Institute of Chicago; see David [A.] Hanks, "Louis Sullivan—Drawings and Architectural Fragments from the Collection," *Bulletin of the Art Institute of Chicago* 68 (Jan.–Feb. 1974), pp. 6–7. Similar in style are Sullivan's fresco designs of 1873 in the Louis Sullivan Collection at the Avery Architectural and Fine Arts Library, Columbia University, New York; the conventionalized flowers are clearly visible, and their flat, two-dimensional rendering is typical of the Aesthetic movement. Sullivan's early ornament was derived from Furness, for whom he worked.

90. Smith, *Industrial Art,* p. 331 (ill.).

91. Ibid., p. 331.

92. See Maurice Maukis, "The Iron-Smith," pts. 1, 2, *Art Journal* (Appleton's) 5 (July 1879), pp. 202–8; (Aug. 1879), pp. 228–35.

93. The interior included a dramatic cast-iron stairway, now enclosed. Located at 222 West Twenty-third Street, in New York's Chelsea area, during the late nineteenth century the hotel was within a short distance of retail outlets for Gorham, Tiffany, and other metal manufacturers, as well as the homes of the clientele that patronized the wares of the Aesthetic movement.

Overleaf: Detail of *Japanese Still Life* (FIG. 9.16)

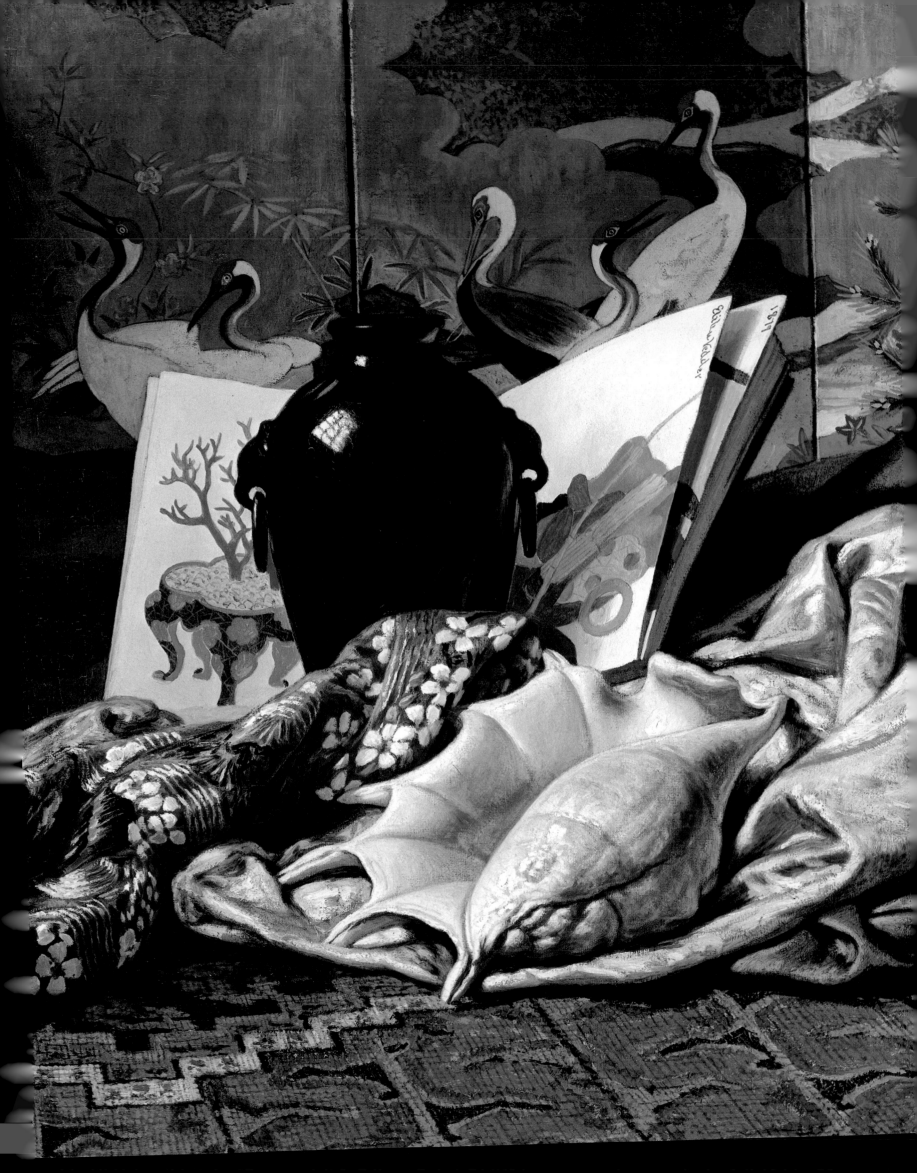

Painters and Sculptors in a Decorative Age

Doreen Bolger Burke

THE AESTHETIC MOVEMENT was manifested most overtly in the art community by a new enthusiasm for the decorative arts, both in projects undertaken by painters and sculptors and in easel paintings, where objects assumed a greater importance as subjects and decorative pictorial qualities—the effects of line, color, and shape—became central issues. Greater care was taken in the framing and display of works of art. The artist's studio, long a haven of creativity, became a more public space, not just for the exhibition of work by its resident but also for displaying his collection of objets d'art and works by other artists.

The movement, however, had more subtle ramifications. Its emphasis on decorative work posed a strong challenge to the academic conventions of America's art establishment, fostering a new informality of subject matter and a revival of the so-called secondary media—watercolor and printmaking in particular. The young artists who participated, some ardently and others only cursorily, in what could be described as the American Aesthetic movement were by and large the same ones who in the decade following the 1876 Philadelphia Centennial Exposition were leading the revolt against the traditional bastions of art in this country. Trained abroad, mainly in Paris and Munich, these painters and sculptors sought to replace the style and philosophy of established American painters with the new ideas they had assimilated in Europe. They founded new art organizations, displayed their work nationwide in annual exhibitions and industrial fairs, and, through a growing number of museums and a burgeoning field of art periodicals and illustrated magazines, reached a wider audience. In this context of change and expansion the American artist's role was extended into new areas: he became an organizer, a tastemaker, and a decorator.

The American artist who executed decorative work during the Aesthetic period was inspired by European precedents. In the decorative arts, the Aesthetic movement found its roots in Britain, in the writings of John Ruskin (1819–1900) and in the designs of such figures as BRUCE J. TALBERT, CHRISTOPHER DRESSER, and WALTER CRANE, but in the fine arts the lines were less clearly drawn. Though English painters such as Edward Burne-Jones (1833–1898) and George Watts (1817–1904) did influence American painters during the 1870s, 1880s, and 1890s, it was nevertheless French training and French art that determined the course of American painting. Even JAMES ABBOTT MCNEILL WHISTLER, the Aesthetic movement's leading painter and a longtime resident of London, had spent his formative years in Paris and maintained close ties with French artists and writers throughout his career. By 1879, when the Ecole des Beaux-Arts in Paris was clearly the most important training ground for American painters and sculptors, its

academic program emphasized the unity of all the arts. Four years later, the *cours simultané des trois arts* (a course embracing the study of painting, sculpture, and architecture) was added to the formal curriculum. The students enrolled in the course were required to study and practice in all three branches. Many Americans supplemented studies at the Ecole and in independent studios with work at the Ecole Gratuite de Dessin, usually called the Petite Ecole, which trained young artists in linear design and ornamental drawing suitable for decorative projects.[1] Moreover, French painters were as interested in decorative work as were their English contemporaries: for example, Thomas Couture (1815–1879) and Jean-Léon Gérôme (1824–1904), two of the most important French teachers of the period, did decorative work and may have encouraged their students to follow their example. Couture, who had studied at the Petite Ecole, executed designs for manufacturers of wallpaper and furniture.[2] His American students William Morris Hunt (1824–1879) and JOHN LA FARGE both returned to their native land to do important decorative work—Hunt, murals at the New York state capitol in Albany; La Farge, a myriad of projects from mural paintings to stained-glass windows to elaborate decorative schemes for entire interiors. Gérôme, then perhaps the most popular teacher in France, engaged in several decorative projects during his career, among them a number of murals and the frieze on a large Sèvres vase, and worked not only as a painter but also as a sculptor.[3] His American students demonstrated a similar willingness to experiment with more than one medium and to attempt decorative work. WILL H. LOW[4] painted murals and executed panels for furniture as well, including those for an ebonized cabinet (1882, see FIG. 1.11), and Thomas Eakins (1844–1916) produced reliefs for use as chimneypieces. When the decorative work done by native painters or sculptors during the period is assessed, it must be within the context of both the British designers and theoreticians usually associated with the movement and the French artists who trained so many of the Americans.

Painters and Sculptors as Decorative Artists

The American artists who became involved with decorative arts were inspired by a wide variety of motives. Some began casually, experimenting with new materials and styles in their own studios and in informal groups of their peers. For the painters and sculptors who participated in the Aesthetic movement only on this level, decorative work was a means of recreation and entertainment. (Even so, it had an unexpected dimension, for it contributed to the

Far left: ILL. 9.1 Tile. Painted by Charles S. Reinhart, ca. 1879, blank made by Minton and Company, Stoke-on-Trent, Staffordshire, England. Painted and glazed earthenware, 8 × 8 in. (20.3 × 20.3 cm). Guild Hall Museum, East Hampton, N.Y., Gift of the David Tyson Foundation, Carolyn Tyson and Edith Frankel, supplemented by the Guild Hall Purchase Fund (81.17.6)

Left: ILL. 9.2 Tile. Painted by Walter Paris, 1879, blank made by Minton and Company, Stoke-on-Trent, Staffordshire, England. Painted and glazed earthenware, 8 × 8 in. (20.3 × 20.3 cm). Guild Hall Museum, East Hampton, N.Y., Gift of the David Tyson Foundation, Carolyn Tyson and Edith Frankel, supplemented by the Guild Hall Purchase Fund (81.17.5)

breaking down of traditional academic values then underway.) For others, decorative work offered a ready source of income, since they could use their artistic abilities to make or design something commercially desirable. As the American artist's commitment to the decorative arts deepened, his perception of his own work altered commensurately: he valued more highly the importance of craftsmanship and acknowledged that a decorative object could not be isolated from its setting. A new type of artist, the artist-decorator, emerged, soon to become active beyond his own specialized milieu. In order to promote the decorative arts, this new breed organized clubs, societies, and firms; lectured; published books and articles; and sought new avenues for the display of the decorative work in which they took great pride.

The china-painting craze that swept America beginning in the 1870s captured the fancy of artists and amateurs alike. The medium, which for artists began as a light flirtation with the decorative arts, was taken up by one group of them—the Tile Club—as a form of recreation. From 1877, the members met regularly for almost ten years to decorate tiles and to socialize and occasionally to make excursions together.[5] The fun-loving spirit of the group is suggested by an animated conversation, undoubtedly embellished in the telling, which supposedly took place when the Tile Club was first established.

> "This is a decorative age," said an artist. "We should do something decorative, if we would not be behind the times."
>
> "Stuff!" said another. "It will be over soon. It is only a temporary craze. . . . Of course it has interfered with the sale of our pictures. I don't dispute that; but would you have us make old brass fenders and andirons, or paste paper jimcracks on old ginger-jars?"
>
> "Or turn carpenter," added a third, "and make Eastlakey things?"
>
> "Your allusions to brass," said the first speaker, gravely, "are irrelevant, and that remark about ginger-jars is an uncalled-for aspersion upon the crude, incipient struggles of the female of our species to be decorative. The popular interest in all matters that pertain to decoration, domestic and otherwise, is a healthy outgrowth of the artistic tendency of our time, and an encouraging evidence of the growing influence of our methods of art education and of the public disposition to take an active, practical interest in things that are more or less nearly allied to art itself."
>
> "Admirable!" said a person of an ironical turn. "Spoken like a furniture man, keenly alive to a sense of the

beautiful in his 'umble profession, but 'opeful of its future helevation to a 'igher plane——"

"Silence!" said the advocate of modern principles, with a becoming glance of reproof. "It is just this disposition to shallow, ignorant, and captious criticism among persons who call themselves artists that misleads people of ordinarily wholesome tendencies."[6]

Frivolous though this dialogue may be, it reveals many of the issues that concerned established artists as they moved into decorative work. Was popular interest in the field indeed "only a temporary craze," or did it point to future developments in America? Was it the domain of female amateurs, or could a so-called serious artist also find in it a means of expression? Since the popularity of decorative objects seemed to affect the sale of pictures, could an artist benefit financially by working in decorative media? Finally, what decorative projects were they willing and able to undertake? Membership in a group like the Tile Club offered painters and sculptors an opportunity to raise these questions and discuss them in a relaxed atmosphere.

There were originally twelve artists and writers in the Tile Club, WINSLOW HOMER, Edwin Austin Abbey, F. Hopkinson Smith, J. Alden Weir, Arthur Quartley, William Mackay Laffan, and Earl Shinn among them. Each member was dubbed with an amusing sobriquet: for example, Weir was called "Cadmium" because he preferred that particular shade of yellow; Quartley, "Marine," because he specialized in painting seascapes. There were also four honorary members, among them the musician Gustav Kobbé (1857–1918). As various members lost interest in the group or moved away to pursue their careers, they were replaced by other enthusiasts. The club's membership was eventually raised to thirty. Later additions included WILLIAM MERRITT CHASE, ELIHU VEDDER, AUGUSTUS SAINT-GAUDENS, John H. Twachtman, Frank Millet, and Stanford White.

At first the club met weekly in one or another's studio, the host providing materials, food, even entertainment, in exchange for retaining that night's production of tiles.[7] The members generally painted in blue pigment on white tiles eight inches square. Their choice of such a limited color scheme was reportedly dictated by practical considerations: because they met at night and worked by artificial light, it was difficult to use a wider range of colors effectively.[8] The blue-and-white coloration of their tiles may also have been inspired by the old Dutch examples that would have been so familiar to them all. Among the few early tiles by club members that survive are a dozen (Guild Hall Museum, East Hampton, New York) that differ widely in style and subject, reflecting the varying talents and styles of their creators.[9] Charles S. Reinhart painted a

classical head (about 1879, ILL. 9.1) in a realistic academic style, and Walter Paris portrayed a branch of leaves and fruit (1879, ILL. 9.2) in a far more decorative manner, with simplified forms strongly contoured and silhouetted against the flat white ground. As William Mackay Laffan, a well-known art collector and journalist of the day, explained, "It was not at any time prescribed what manner of tiles should be produced. Each member of the club proceeded just as his fancy dictated, and it was very seldom that any one did anything that was premeditated or studied in its character."[10] By the winter of 1878–79 the Tilers had already produced an abundance of tiles and had moved on to plaques.[11] "From plaques the Club proceeded to matters more promiscuous," Laffan reported. "Its Wednesday night table would be covered with drawing-boards, blocks of water-color paper, small canvases, charcoal and pencil paper, tiles and plaques and brushes, paints, 'turps' and materials of all kinds; each guest of the evening did what he pleased."[12]

Tile Club members, by publishing articles that described and illustrated their activities, helped to make tile painting widely popular. During its early years the club sponsored summer jaunts into the country to sketch from nature. Three—a sketching tour of Long Island in 1878, a three-week canal-boat trip up the Hudson River and the Northern Canal to Lake Champlain the following year, and an excursion to *The Two Sisters,* a ship that had been wrecked on the eastern shore of Long Island, in 1880—are recorded in illustrated magazine articles by club members.[13] These, however, were only a few of their many travels; they even visited the J. AND J. G. LOW ART TILE WORKS in Chelsea, Massachusetts, where they were permitted to paint and fire tiles. In 1882, under Laffan's leadership, club members collaborated on a special Christmas issue for Harper's, and in 1886 they wrote and illustrated *A Book of the Tile Club,* an account of their ten-year exploits and artistic accomplishments.[14]

In its early years the Tile Club had provided a sanctuary for its members, who mostly were unrecognized young men propounding radical ideas espoused during years of study abroad. By 1887 most of the Tilers had achieved critical recognition and some financial success: they had grown older, married, and become members of New York's art establishment. They no longer needed the security the club had afforded them, and it seems likely that the membership simply dwindled until it disappeared. In the best years

of its existence the Tile Club had made a major contribution to the contemporary art scene. It had provided its members with a forum in which to experiment and to benefit from the immediate reaction of their fellows. It had enabled them to expose one another to new materials, more informal subjects, and less academic compositions as their work progressed from tiles and plaques to a wider range of media.[15] Their diverse activities unquestionably fostered interest in media other than oil—etching, monotype, watercolor, and pastel—and gave rise to a whole generation of American illustrators. The club's liberating influence on its members freed many of them to practice outdoor sketching on their excursions, an experience that would have made them receptive to the growing influence of Impressionism in the ensuing decade.

The same spirit of fun and friendship that characterized the Tile Club inspired several impromptu groups of artists to undertake any number of efforts throughout the Aesthetic period. Unlike more serious decorative projects that were planned and executed as a unified whole, those collaborative projects were often a random assemblage of individual parts, executed in the same format but by different artists in different styles and with different subjects and compositions. In 1880, each of twelve artists, including SAMUEL COLMAN and Tile Club members Arthur Quartley, R. Swain Gifford, and Frederick Dielman, contributed a painted triangular panel for the top of a round table (about 1880, ILL. 9.3) exhibited at a fair to benefit the Homeopathic Hospital in New York. While some of the panels, particularly those of still-life and figure subjects, showed a sensitivity to the compositional problem of relating each segment to the whole, most are simply conceived as easel paintings and applied to a decorative purpose.[16] In 1882, on a transatlantic crossing, American artists working together produced another decorative project: they painted panels in the ladies' salon of the ship, an effort described archly as representing "a new principle in aesthetics: 'Art for the sake of the ladies' cabin.'"[17]

Another form that attracted artists experimenting with decoration was the fan. Fans enjoyed a revival in both Europe and America during the Aesthetic period; they were featured in exhibitions and, Japanese examples in particular, were used to decorate interiors.[18] Especially popular was the lamellar fan, which consisted of separate blades, often painted by several individual artists. Twenty "eminent" artists worked on such a fan (present location unknown) displayed at the New York Seventh Regiment Armory

ILL. 9.3 "Top of a Table of Twelve Panels and Centre Painted for the Hahnemann Fair." Designed by Mrs. Thomas Lord, panels by Arthur Quartley, A. D. Abbatt, J. Francis Murphy, Samuel Colman, James D. Smillie, Mrs. J. L. Raymond, M. Sartain, George H. Smillie, R. Swain Gifford, V. Nehlig, W. S. Macy, Frederick Dielman, Mr. Ludovici. *Art Amateur* (June 1880). Thomas J. Watson Library, The Metropolitan Museum of Art

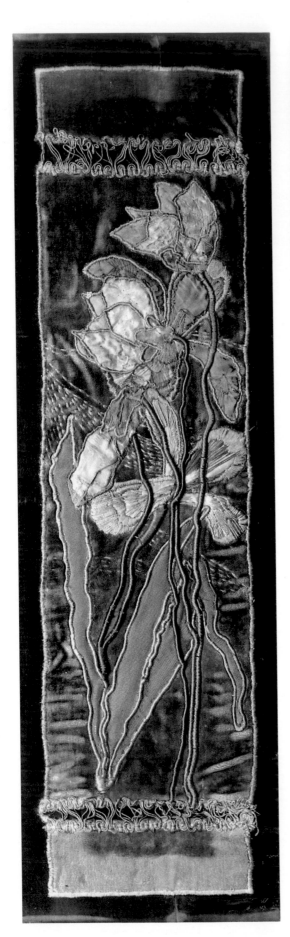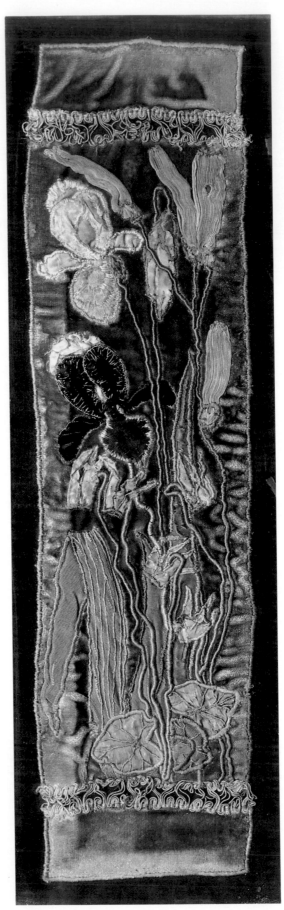

FIGS. 9.2, 9.3 Needlework panels. Maria Oakey Dewing, n.d. Embroidery and appliqué on velvet; each 27 × 9 in. (68.6 × 22.9 cm). Collection of Mr. and Mrs. John Rooney

Fair in 1879.[19] A twelve-blade fan (about 1883, FIG. 9.1) was painted by a group of artists then living in the Sherwood Studio Building at 58 West Fifty-seventh Street. Among the contributors were several older painters—Jasper F. Cropsey, a leading painter of the Hudson River School, Theodore E. Pine, a conventional portrait painter, and Granville Perkins, a landscape and marine painter—as well as the younger-generation artists Robert Blum, J. Carroll Beckwith, and Bruce Crane.[20] Each painted a vignette that appears unrelated either visually or thematically to any of the others. It has been postulated that the motifs suggest various aspects of marriage and that the fan may have been done as a wedding present.[21] Since there is little evidence to support that idea, it is more likely that the fan, like other whimsical decorative projects, was made either for display or simply to commemorate an artistic camaraderie.

Apart from these lighthearted experiments, artists who aspired to careers as major sculptors or easel painters sometimes approached decorative work with hesitation. For some, decoration represented a clear and not wholly desirable alternative to the fine arts. Their ambivalence is demonstrated by comments made by MARIA OAKEY DEWING,[22] a painter of floral still lifes, on the needlework she began during the 1880s. When Oscar Wilde (1854–1900) praised her work and asked her, "Why don't you go into decoration & wipe them all out?" Mrs. Dewing responded, "Because I must paint pictures or die." That statement and her later admission that she rarely let "these passing attacks have the least publicity" reveal that she may have considered her occasional sorties into the art of the needle less meaningful than her work as a painter in oils and, perhaps, even threatening to her standing as a serious artist.[23] Mrs. Dewing nevertheless lavished careful attention on her embroidery and published widely on the decorative arts, suggesting that she had considered the intellectual issues surrounding the subject. A pair of her panels (FIGS. 9.2, 9.3), both closeup views of flowers not unlike those of her oil paintings, are appliquéd on velvet and surrounded with embroidery that lends a three-dimensional vitality to their surfaces. Her choice of a color scheme, originally yellow and gold with a purple flower added to one panel, is explained by comments in her book on decoration *Beauty in the Household*

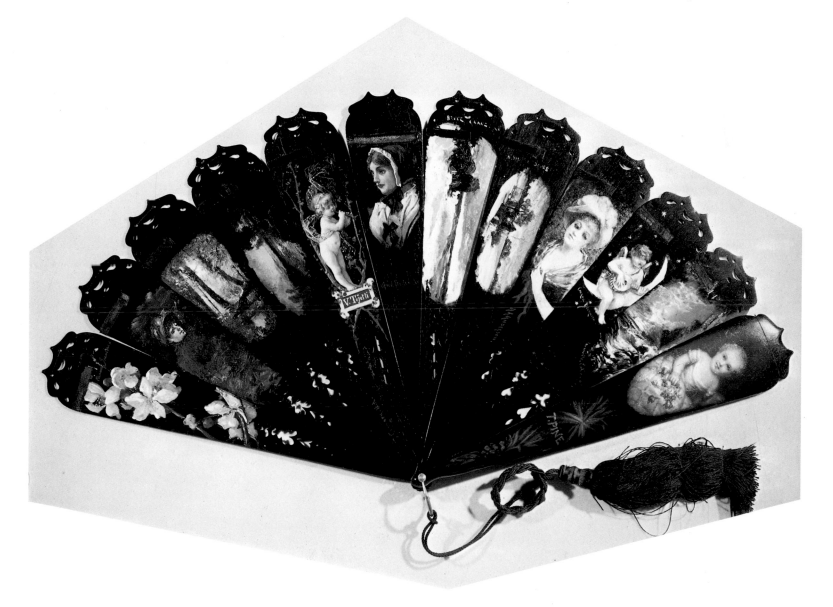

FIG. 9.1 Fan. Painted by Eleanor Greatorex, Robert Blum, Roswell Morse Shurtleff, Jasper F. Cropsey, Virgilio Tojetti, Alfred Fredericks, Bruce Crane, Hugh Bolton Jones, Abraham Archibald Anderson, J. Carroll Beckwith, Granville Perkins, Theodore E. Pine, ca. 1883. Oil on lacquer; each blade 12 × 2¾ in. (30.5 × 7 cm). Collection of Richard and Gloria Manney

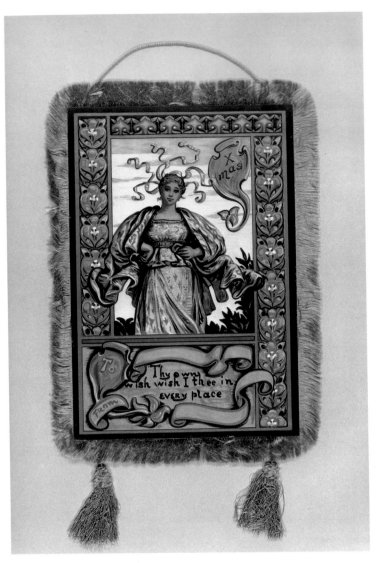

FIG. 9.4 Christmas card. Designed by Elihu Vedder, published by Louis Prang and Company, Boston, 1881. Chromolithograph, 8⅞ × 6¹⁄₁₆ in. (22.5 × 15.4 cm). Hallmark Historical Collection, Hallmark Cards, Inc., Kansas City, Mo.

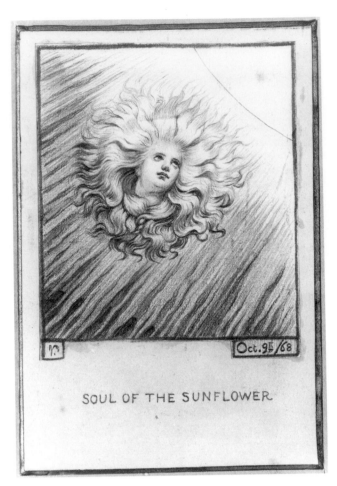

SOUL OF THE SUNFLOWER

ILL. 9.4 *The Soul of the Sunflower*. Elihu Vedder, 1868. Pencil on paper mounted on paperboard, 3⁷⁄₁₆ × 2¹³⁄₁₆ in. (8.7 × 7.1 cm). Inscribed: *v. Oct. 9th / 68 / SOUL OF THE SUNFLOWER*. The Love Collection

(1882). "Yellow is, in truth, warmth itself. . . . [It is] a color that can be contrasted with various shades of itself more unerringly than any other color."[24] She continued, "A dark purple that is almost blue is rich and beautiful with gold color; and yellow contrasted with a purplish brown is most harmonious."[25]

Some artists merely used decorative work as a convenient means of supporting themselves during their student years and abandoned it as soon as their reputations as painters were established. ELIZABETH NOURSE, best known for her academic paintings of peasant mothers and children, followed that course. In her first years of study, at the University of Cincinnati School of Design, Nourse benefited from the climate that city had established for the pursuit of fine craftsmanship in the decorative arts. She studied china painting with Maria Eggers and wood carving with BENN PITMAN, who, deeply influenced by the design-reform movement in his native England, had introduced instruction in both skills into the school. Nourse soon supported herself by painting decorative wall panels for Pitman, who had recently married her sister ADELAIDE NOURSE PITMAN. She also executed painted decoration for furniture carved by Adelaide and by Louise, another sister. Adelaide carved an elaborate bedstead (about 1883, see FIGS. I.4, I.5) after her husband's design, with Elizabeth contributing two panels for the head-

board. On each panel was a gold disk containing a bust portrait of a woman: on one, Night, on the other, Morning, each surrounded by painted white azaleas and balloon vines. The painted panels, a somewhat awkward combination of realism and decoration, relate to the rest of the bed, which combines areas of stylized ornament and naturalistic modeling. Although Elizabeth Nourse was an accomplished decorative artist and had ready access to commissions through her brother-in-law, she abandoned that kind of work after she went to Paris to pursue her career as a fine artist.

Other artists, more secure in their reputations, enthusiastically embraced decorative work, even that of a commercial nature. Elihu Vedder, an artist best known for his literary paintings and illustrations, undertook a number of commercial projects between 1881 and 1883, during his second sojourn in America. His friends and family were horrified. As the art critic William Davies observed, "Vedder has now fairly inaugurated a very high reputation as a painter. . . . What an error it would be to waste his powers for a fortune that *may* not come."[26]

Vedder entered a design for a Christmas card (1881, FIG. 9.4) in a competition sponsored in 1881 by the lithographer Louis Prang, who later produced it commercially.[27] In 1882, at Stanford White's suggestion, Vedder designed covers for the *Century Illustrated*

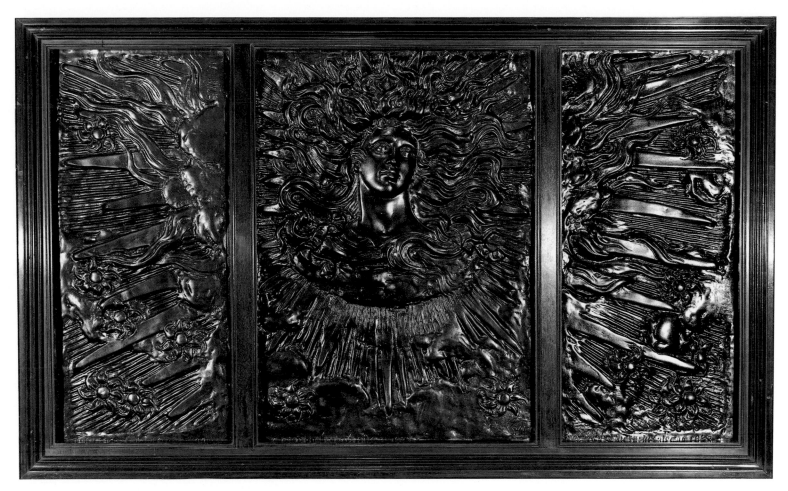

FIG. 9.5 *The Soul of the Sunflower* (fireback). Elihu Vedder, 1882. Cast iron, 35 × 58¼ in.
(88.9 × 147.6 cm). Signed: *Elihu Vedder,* marked: *Copyrighted by Caryl Coleman, 1882.* Spencer
Museum of Art, The University of Kansas, Lawrence, Gift in honor of Henry C. and Marjorie
Wildgren by their sons Patrick, Paul, Maurice, and Michael, 1981 (81.105)

ILL. 9.5 *Apollo.* Augustus Saint-Gaudens, after a design by John La Farge, ca. 1881–82, for the din-
ing room, Cornelius Vanderbilt II house, New York. Mahogany, bronze, colored marbles, mother-
of-pearl, abalone, ivory, 27⅝ × 63½ in. (70.2 × 161.3 cm). Hirschl and Adler Galleries, Inc.,
New York

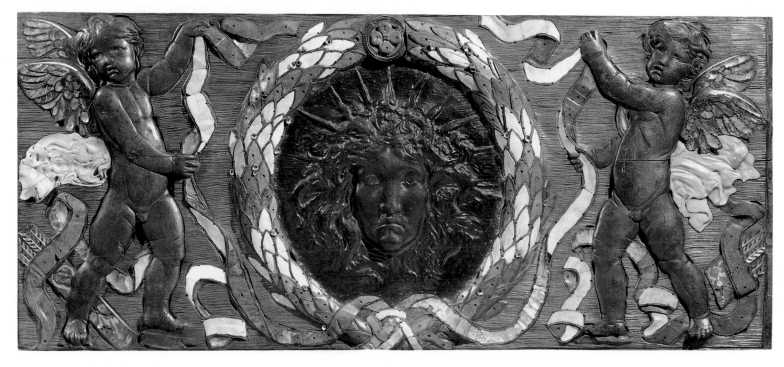

Monthly Magazine and an illustration for Harper's Christmas supplement.[28] He also attempted to market several schemes to be used in decorative work. He developed a method of forming a screen by means of a system of rings holding pieces of glass of various shapes and colors. He attempted to patent the idea in 1882, only to discover that LOUIS COMFORT TIFFANY had done so the year before. Vedder's use of flanges to hold the ringwork in place represented an advance over Tiffany's technique, however, and for five years the better-known decorator paid him a royalty of ten percent.[29] Through his friendship with one of the proprietors of the J. and J. G. Low Art Tile Works, Vedder developed and patented a metal frame that could be attached to a tile after it was fired, an improvement over the traditional practice of firing frame and tile together. He believed that the device would simplify the manufacture of decorative chair backs and seats, features that appeared occasionally on furniture of the period. Though the frames were never produced commercially, the Chelsea firm did make a very popular tile from Vedder's design, one depicting the actress Anne Russell as Esmeralda.[30]

Vedder had great hopes of profiting from the sale of four firebacks he designed during the 1880s, but they cost so much to produce that his royalties amounted to a mere two dollars for each one sold.[31] Appropriately, Vedder's firebacks, all representing themes of fire, warmth, and friendship, reflect the emphasis during the Aesthetic era on the hearth as the focal point of the home. Vedder described *Faces in the Fire,* a fireback he made in 1887, as "filled with a mass of heads . . . that lighted by the flames or the flickering light of the dying fire or the glow of the embers . . . would seem alive and recall lost or absent friends."[32] In another (1882, FIG. 9.5), Vedder selected the motif of a head encircled by the rays of the sun, a fireback traditionally called *The Soul of the Sunflower,* probably because it closely resembles an earlier drawing (1868, ILL. 9.4) of the same title.[33] Its original title may have been

Apollo, for it appears under that name in a Low catalogue as early as 1881–82, and a fireback called *The Sun God* is recorded in the Vedder literature.[34] Moreover, Vedder's treatment of the head, with its flowing hair and aureole of sun rays, is not unlike that of the *Apollo* (about 1881–82, ILL. 9.5) La Farge and Saint-Gaudens created for the dining room in the New York residence of Cornelius Vanderbilt II (1843–1899).[35] Vedder, who visited the Vanderbilt mansion while it was under construction, may well have known that decorative sculpture.[36]

Decoration was not just a question of profit or pleasure but was often eagerly undertaken with serious artistic purpose. Artists' conversion to what had previously been regarded as the domain of the artisan was justified by theoreticians such as John Ruskin, who praised the decorative arts and proclaimed that the best decoration was the work not of designers but of painters and sculptors.[37] Ruskin's assertion was echoed in America by the etcher and publisher Sylvester Rosa Koehler (1837–1900), who in 1884 thus attributed the recent advances in American decorative arts: "Several leading artists have interested themselves in decorative work, so that it is no longer left, at least in its most sumptuous forms, to the professional decorator. The great decorators of past ages were also great artists in other departments, who had studied something more than geometrical ornament and conventionalized plant-forms."[38]

During the 1880s an increasing number of American painters and sculptors, even those with extensive academic training, began to work in decorative modes. A prime example is Thomas Eakins. Through the architect Theophilus P. Chandler, probably in early 1883, Eakins was commissioned by a James P. Scott of Philadelphia to create chimneypieces that turned out to be the artist's first independent sculptures.[39] As a result, Eakins created two oval reliefs, *Spinning* (1883, ILL. 9.6) and *Knitting* (1883, ILL. 9.7), historical subjects that may have been inspired by the nostalgia, prevalent for a time after the 1876 Philadelphia Centennial Exposition, for life

ILL. 9.6 *Spinning.* Thomas Eakins, 1883 (cast 1930). Bronze, 20½ × 16½ in. (52.1 × 41.9 cm). The Pennsylvania Academy of the Fine Arts, Philadelphia, Gift of Edward H. Coates (1887.2.2)

ILL. 9.7 *Knitting.* Thomas Eakins, 1883 (cast 1930). Bronze, 20½ × 16½ in. (52.1 × 41.9 cm). The Pennsylvania Academy of the Fine Arts, Philadelphia, Gift of Edward H. Coates (1887.2.1)

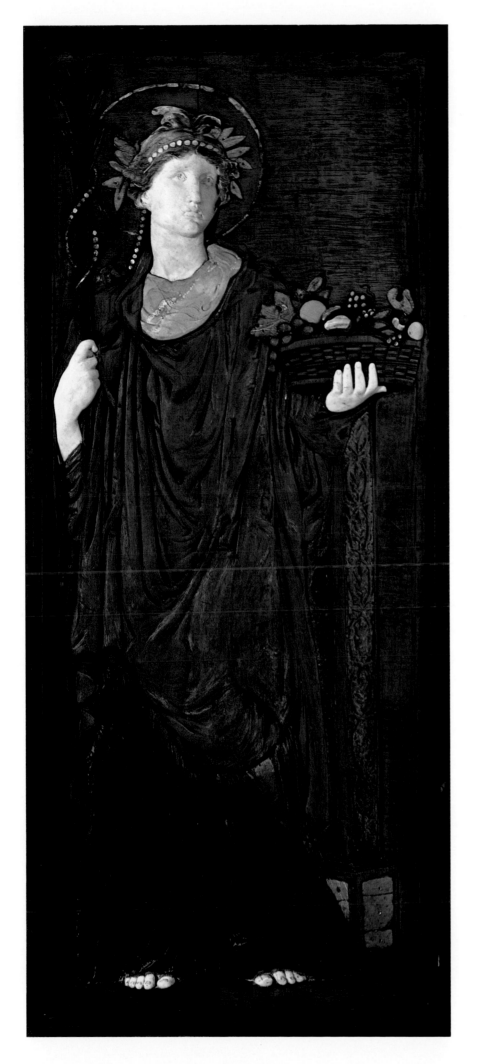

Above: ILL. 9.8 *Cérès.* Henri Roux and Louis Barré, *Herculanum et Pompéi* (Paris, 1870). Thomas J. Watson Library, The Metropolitan Museum of Art

Left: FIG. 9.6 *Ceres.* Augustus Saint-Gaudens, after a design by John La Farge, ca. 1881–82, for the dining room, Cornelius Vanderbilt II house, New York. Mahogany, holly, marble, bronze, ivory, mother-of-pearl, coral, 62¾ × 25¼ in. (159.4 × 64.1 cm). Saint-Gaudens National Historic Site, National Park Service, U.S. Department of the Interior, Cornish, N.H., Gift of the Trustees of the Saint-Gaudens Memorial, 1979

in the Colonial period. The reliefs show women in early nine-teenth-century dress, with accessories—a tilt-top table and a spinning wheel—that recall the craftsmanly achievements of an earlier age. Eakins modeled the works in clay and then cast them in plaster, intending to finish them himself after they had been cast in iron or bronze and then rough-carved in stone using a copying machine. Unfortunately, that plan resulted in a confrontation between artist and patron. Scott was displeased when he saw the plasters and questioned the artist's charge for them.[40] Eakins's response reveals the thoughtfulness and complexity of his working process as well as his regard for the artistic worth of his decorative work. He wrote to Scott in a letter of June 18, 1883:

I have taken great pains to do my work well. I did not stint myself in the use of models, or of anything that might improve it.

. . . My remuneration is not great for professional work.

Nor am I an obscure artist.

Relief work too has always been considered the most difficult composition and the one requiring the most learning. . . .

My interest in my work does not terminate with the receipt of my bill. Thus, I have heard with dismay that a stone cutter had offered to finish those panels each in a week's time.

I have been twenty years studying the naked figure, modelling, painting, drawing, dissecting, teaching.

How can any stone cutter unacquainted with the nude, follow my lines?[41]

Eakins brought his academic training, acquired at the Ecole des Beaux-Arts under Jean-Léon Gérôme and Augustin-Alexandre Dumont, to the resolution of a decorative problem clearly deemed simple by his patron. In his endeavors, he chose to emulate not the ornamental sculptors of his own generation but the greatest masters of the past. "The frieze of the Parthenon by Phidias is the highest perfection of relief," he commented in a lecture. "Those things by Phidias, with very little imagination you feel they stand out full."[42] As for his recalcitrant patron, Eakins urged him to visit the Pennsylvania Academy of the Fine Arts and study casts after the Parthenon.[43]

For the small but influential group of painters and sculptors who devoted themselves to decoration, it was far more than a recreation, a source of income, or an infrequent experiment. These were the men who applied the lessons of their academic training to this new, adventurous field. Among the artists who did their most imaginative work in innovative, ornamental projects were La Farge, who formed his own company in the early 1880s, and Tiffany, who in 1879 joined with Samuel Colman, LOCKWOOD DE FOREST, and CANDACE WHEELER to found ASSOCIATED ARTISTS, possibly the most important design firm of the period. Artist-decorators concentrated their efforts on elaborate, coordinated schemes for interiors—whole rooms or entire buildings and their contents—primarily for the wealthy and prominent but occasionally for clients among their fellow artists or for members of the intelligentsia.

Of all the artists who worked as decorators, La Farge was perhaps the most articulate in discussing the decorative arts and their relation to the fine arts. Like Ruskin, La Farge advocated that artists should be responsible for decoration. "When the commercial decorator can challenge the artist in any other line, he may have a right to lead, but not before," he said.[44] He found reason to lament that painting and sculpture had been separated from decorative art. This he viewed as a diminution of the artist's function. "We have been seeing the artist (I have to use this special term), as more and more separated from the artisan (another term which is also disagreeable to me because it helps to keep up this absurd artificial classing)," La Farge noted in 1906. "Instead of lifting the artist, this has degraded him . . . he sought to make his pictures by recalling stories, or subjects or intentions, or using studies from nature, and polishing them out of their natural appearance, instead of carrying all these things out through the physical qualities and advantages of his art."[45]

La Farge himself maintained unity between the imaginative and craftsmanly aspects of his work, which he accomplished by immersing himself in both the conception of his decorative projects and their execution. His intensity of purpose and its corollary—the avoidance of commercialism—while inevitably limiting his production, raised his decorative work to a level rarely achieved by his contemporaries. La Farge believed that the need for expression in art and decoration prohibited the artist and artisan from simply repeating a successful motif for commercial gain. In a public lecture he related a story about a Japanese artist-monk who grudgingly and for a hundred pieces of gold reproduced one of his compositions for a soldier to present to his ruler. The soldier found something lacking in the second painting. The monk explained the essential difference between the two versions of the work: "The first was a painting made from my heart; *the second was an excellent painting worth exactly 100 pieces of gold.*"[46]

Because of La Farge's conviction that successful decoration went beyond the mere repetition of designs and patterns, he proclaimed that decorative motifs had to be re-created each time they were used "as if never done by man before." As he said, "Intellectually and artistically, the excuse for a pattern of ornament is to give a chance to the person who makes it, or rather works from it, to express himself. I mean by that, to express his appreciation of and delight in the *ideal* of that pattern."[47] To illustrate his point, La Farge cited examples from classical Greece and Japan, the arts of which he greatly admired. In discussing a fragment of ornamental Greek molding, which had been restored by a plasterer who repeated its pattern "while the original had no duplicated surface anywhere,"[48] La Farge pointed out that the original Greek craftsman would have carefully shaped each separate curve, which though seemingly accomplished by rote, actually gave him an opportunity to express himself and the character of his tradition. Never was it a question of mere copying or repetition. La Farge held that a Japanese artist observed the same principle, for his work showed what his tradition must have taught him: "When you draw a branch, you must feel as though you were that branch yourself."[49] Further, because the ideal of a pattern or design was so deeply felt by the true craftsman, the form of a pattern might be identical in more than one country and from one age to another, but its ideal or expression remained individual: "So . . . the Greek could go on and copy that pattern over and over again, and make it perpetually new, indefinitely for centuries."[50]

That accomplishment so highly valued by La Farge was not limited to great artists and artisans of the past. In an eclectic age that drew constantly on what had gone before, the notion that a historical style could be resurrected by modern artists and craftsmen was a popular one. For example, as described in an account published in the early 1880s, the Moorish-style decoration Tiffany created for the drawing room of his home on East Twenty-sixth Street in New York was not considered a direct copy of authentic precedents but, rather, "a simple suggestion of the ancient Moorish style, the artist believing that an entire rendering of it . . . would have belittled him, besides being impossible; for something of its spirit would necessarily have escaped him in these later days, when his environment is so different from that of the Moorish decorator himself."[51]

La Farge could find this potential for reinterpreting the accomplishments of the past in the work of a dozen of his contemporaries—Saint-Gaudens and Herbert Adams, to name just two.[52] Cer-

tainly La Farge exercised the principle in his own work. His design for *Ceres* (about 1881–82, FIG. 9.6), a decorative panel for the dining room in the house of Cornelius Vanderbilt II, is a modern version of a Roman wall painting in the House of Castor and Pollux in Pompeii.[53] The figure's pose, costume, and accessories were drawn almost directly from an illustration (about 1870, ILL. 9.8) in a book in La Farge's library, but the inspired use of materials—a rich conglomeration of wood, ivory, marble, and bronze, chosen to harmonize with decorative elements throughout the room— makes this relief a creative achievement rather than a mere copy.

It was perhaps in his stained-glass work that La Farge was best able to apply his decorative principles. He criticized the current standards for stained-glass windows, which he found "artistic in their intention and somewhat commonplace in their execution. . . . The drawings made by these artists for their windows, look so much better than the windows. . . . This is the converse of what ought to be; it is as if the written score should be superior to the music played from it, the pencil sketch be richer, more full of material and wealth of execution than the finished pictures."[54] He overcame the disparity between conception and execution by entering into every aspect of the production of a window and by working with a small group of craftsmen who understood his standards and his objectives. Accordingly, even the earliest examples

of his stained glass display tremendous originality when compared to contemporary windows. While working on a memorial window (now destroyed) for Harvard University, he achieved the effect he wanted with "almost every variety of glass that could serve, and even metal, stones, such as amethysts, and the like, and I began to represent effects of light and modulations of shadow by using the streaked glass, the glass of several colors blended, and a glass wrinkled into forms, as well as glass cast into shapes, or blown into forms."[55]

The aesthetic quality and technical innovation revealed in this and other of his windows resulted from La Farge's constant participation in their production. The artist was later to recall, "I was obliged to give all my time absolutely to the making of the windows from designs and first sketches to the final completion. For nearly ten years I was obliged to give up painting."[56] Tiffany's statement about the decorative arts was even stronger. In 1879 he told Candace Wheeler, "I have been thinking a great deal about decorative work, and I am going into it as a profession. I believe there is more in it than in painting pictures."[57] That artists of La Farge's and Tiffany's ability and reputation would relinquish, or at least restrict, their pursuits in the fine arts in order to do decorative work suggests the importance of that type of activity to artists of the period.

ILL. 9.9 Dining room, Charles Freeland house, Boston. Henry Van Brunt, 1865

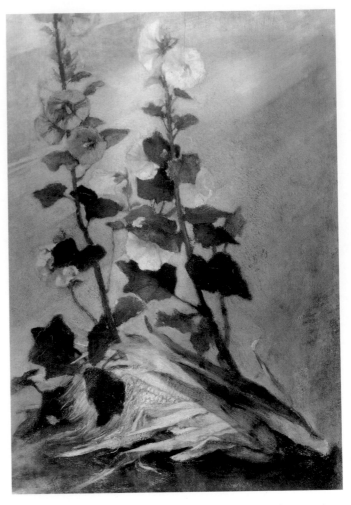

ILL. 9.10 *Fish*. John La Farge, 1865. Oil on panel, 23⅜ × 17⅜ in. (60 × 44 cm). Fogg Art Museum, Harvard University, Cambridge, Mass., Grenville L. Winthrop Bequest (1943.138)

ILL. 9.11 *Hollyhocks and Corn*. John La Farge, 1865. Oil on panel, 23½ × 16½ in. (59.7 × 41.9 cm). Museum of Fine Arts, Boston, Gift of Dr. William Sturgis Bigelow (21.1442)

The Decorative Work of Art and Its Setting

Whatever their creators' motivations—recreation, profit, artistic expression—the paintings and sculptures made for installation in specific interiors were carefully thought out to ensure their being integrally linked with their settings. Unlike independent easel paintings or freestanding pieces of sculpture, decorative works of art were executed as a part of a larger, integrated scheme that determined their style, scale, materials, and subject matter.

In a series of works created for installation in dining rooms one can see a growing sensitivity to the relation of the individual component of decoration to the rest of the interior. The first was La Farge's commission from the architect Henry Van Brunt for paintings for the dining room (ILL. 9.9) of Charles Freeland, a prosperous Boston builder.[58] La Farge executed the paintings in 1865, during the early years of his career and after his studies with Thomas Couture in Paris and with William Morris Hunt, whom he worked with in Hunt's Newport, Rhode Island, studio. Illness prevented La Farge from completing the project (it was turned over to Albion Bicknell, a less accomplished artist), but he did finish three pictures from which some idea of his decorative intentions can be inferred. In the surviving panels, *Fish* (1865, ILL. 9.10), *Hollyhocks and Corn* (1865, ILL. 9.11), and *Still Life with Eggplant and Flowers* (1865, FIG. 9.7), La Farge selected still-life subjects suitable for a dining room. As Henry Adams has pointed out in a 1980 article, the compositions of the three paintings were consciously

related to one another and to their proposed setting.[59] *Hollyhocks and Corn* and *Still Life with Eggplant and Flowers,* which were to have been placed side by side or on opposite sides of the Freeland dining room, are particularly complementary. In both, the humble vegetable in the foreground appears more elegant by the artist's addition of tall flowers to the background. Brilliant light, in each case from an opposite direction, streams in from the side, presumably replicating the actual lighting effect of the room. Nevertheless, the paintings would hardly have been fully integrated with their setting. Their Japanesque style, with asymmetrical compositions and shimmering, flat backgrounds, would have looked slightly alien in Van Brunt's conventional Renaissance-revival interior.

Works of art created for decorative projects of the Aesthetic era reflect a concern not only for the selection of an appropriate subject but also for the choice of style. The rooms created by Tiffany and his Associated Artists partners demonstrate these concerns. During its brief existence, from 1879 to 1883, Associated Artists received a number of major commissions for which they selected motifs and a decorative style suited to the function of a room and the taste of its inhabitants. For one of the windows in his own New York dining room (ILL. 9.12), which the firm decorated, Tiffany designed *Eggplants* (1879, see FIG. 6.3), a stained-glass screen.[60] Like the fish, vegetables, and flowers La Farge chose for his painted panels, Tiffany's subject—growing vines of eggplant—is related to the room's function; so too was the theme (an outdoor

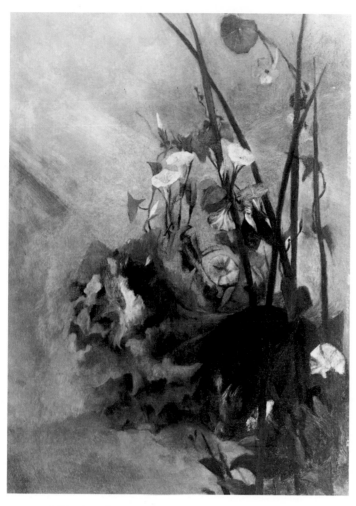

FIG. 9.7 *Still Life with Eggplant and Flowers*. John La Farge, 1865. Oil on panel, 24 × 17 in. (61.6 × 43.2 cm). The Chrysler Museum, Norfolk, Va., Gift of Walter P. Chrysler, Jr. (71.2721)

harvest scene showing a turkey, pumpkin, and corn) of a still life Tiffany painted and set inside narrow moldings above the dining-room fireplace. The window screen relates closely in style to the decorative features of the rest of the room, which were oriental in derivation. The walls were divided into horizontal registers and covered with embroidered cloth and "Japanese mushroom wall-paper," the ceiling was ornamented with blue circular plaques, and oriental porcelains were displayed on the walls, on the mantel, and on shelves about the room.[61] The stained-glass window screen reflects the same aesthetic. The brilliant yellow latticework on which Tiffany has arranged the curving forms of the eggplant, vine, and leaves is a Japanese design motif. Its elements create a pattern that in its treatment of line and color approaches abstraction. Uneven areas of color and irregularities in the glass have been utilized in the eggplants, each varied in hue, to suggest modeling. Translucent glass represents their smooth, glistening skins; opaque glass, the tendrils; streaked glass more intense in color, the leaves.

The decorative setting of an Aesthetic-period work often governed the materials in which it was executed as well as its subject and style. The decoration of Cornelius Vanderbilt II's New York dining room (ILL. 9.13), directed by La Farge from 1881 to 1882, is a case in point. *Ceres* (see FIG. 9.6), a relief created by La Farge and Saint-Gaudens for the project, is the only extant example of the four figural panels made for the room's ceiling. Because the others are known from photographs, descriptions, and preliminary studies, and because a photograph of the actual room exists,

it is possible to appreciate its character and to understand *Ceres's* place in the general scheme. The subjects of the four reliefs are not just appropriate for a dining room, they are appropriate for a *grand* dining room, which this one certainly was. Each relief represented some aspect of food or drink personified as a classical god, goddess, or mythological figure: Ceres, the goddess of grain; Pomona, the goddess of fruit and the spring; Bacchus, the god of wine; and Actaeon, the hunter (this panel sometimes called Vertumnus). The compositions of all four are vertical, each showing a figure with its attributes—in Ceres's case, a basket of fruit. A wide variety of materials has been combined in the relief: the wood panel has been inlaid with marble, mother-of-pearl, ivory, coral, and repoussé bronze, all of which correspond with the decoration used by La Farge in the rest of the room. Other sculptural panels made for the room—*Apollo* (see ILL. 9.5), for example—combine similar materials. The side walls were wainscoted in paneled oak surmounted by brown embossed leather, and mother-of-pearl was set into the panels of the fireplace. The coffered ceiling was divided into twenty panels by oak beams also inlaid with mother-of-pearl. Six of the panels were filled with opalescent glass; the remaining fourteen were "of mahogany, carved, inlaid, and overlaid, as the design and color scheme require."[62] *Ceres* and each of the other three figural panels were surrounded with wreaths of hammered bronze in dull iridescent tones, these framed in a heavy egg-and-dart molding of old oak that led up to the beams. The intention, of course, was to include all the panels in the general color scheme.

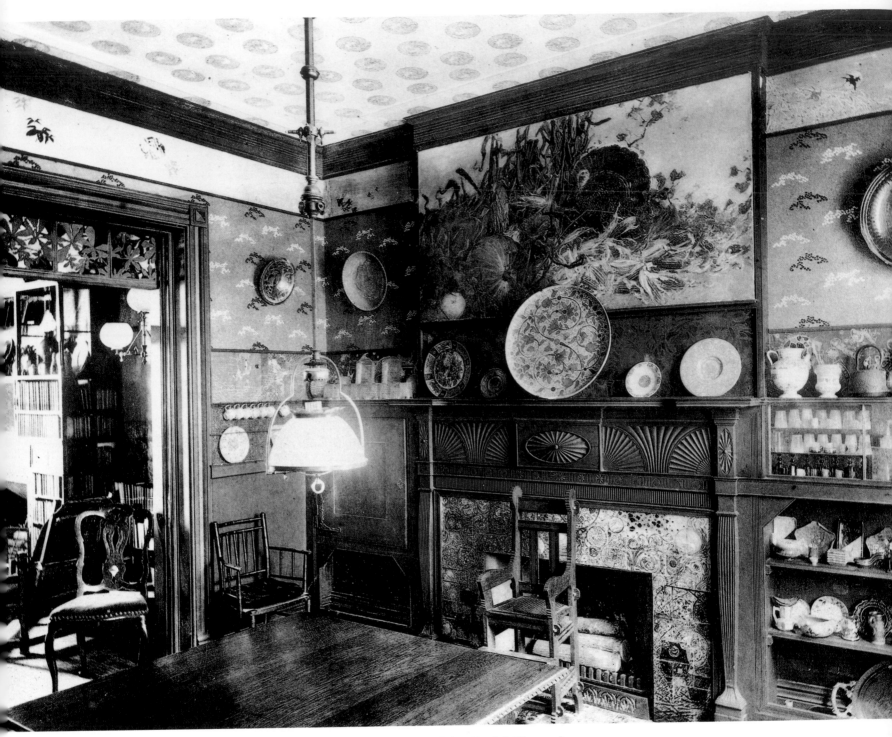

ILL. 9.12 "Mr. Louis C. Tiffany's Dining-Room." *Artistic Houses* (New York, 1883–84). Thomas J. Watson Library, The Metropolitan Museum of Art

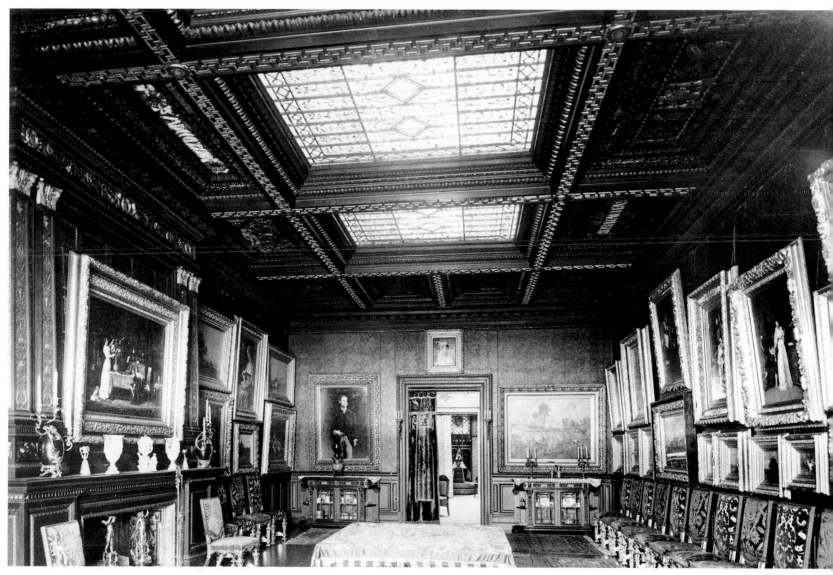

ILL. 9.13 Dining room, Cornelius Vanderbilt II house, New York. Designed by George B. Post, decorated by John La Farge, Will H. Low, and Augustus Saint-Gaudens, 1881–82. Photograph, ca. 1883

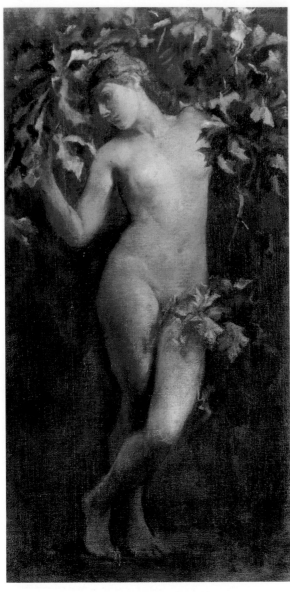

ILL. 9.14 *The Sense of Smell.* John La Farge, ca. 1881–82.
Oil on canvas, 21½ × 11 in. (54.6 × 27.9 cm). Museum
of Fine Arts, Boston, Bequest of Dr. William Sturgis
Bigelow (26.769)

The same principle is carried out more subtly in the painted decoration La Farge devised for Vanderbilt's Water-Color Room, where a wide range of materials and media were unified by a common use of color. A mural, *The Sense of Smell,* known today in photographs and in an exquisite oil study (about 1881–82, ILL. 9.14), reflected in its golden tones effects La Farge also achieved in the room's ceiling. "It is impossible to describe the color of these paintings in detail," said Mary Gay Humphreys in 1883. "The keynote is struck in the yellow tones of the marble and wall hangings, and a warmer, more varied tone is given in the ceiling, mingled with the reds, blues, and greens of the draperies and foliage in soft harmonizing tints."[63]

The innovative combination of materials in decorative work strongly influenced contemporary artists and craftsmen, who often translated the styles, components, and techniques of one medium for use in another. The rich elements inlaid in the *Ceres* panel must also have been inspired by La Farge's astonishingly original work in stained-glass windows, where in addition to his use of glass of all kinds, textures, and hues, he often incorporated glass cabochons resembling huge emerald, topaz, and amethyst jewels.[64] The linearity of the *Ceres* carving, particularly in the folds of the drapery, also recalls La Farge's windows, this time the fluid leading. (The *Ceres* figure was used again by La Farge in a stained-glass window for the home of D. O. Mills in Menlo Park, California. The two figures and their accessories are virtually identical, but in the Mills window the goddess stands in an ornate trompe-l'oeil niche.)[65] The facile transmutation of an artistic concept from one medium to another must have contributed to the artist's growing awareness of the particular character of each and how best to exploit it.

The *Ceres* panel highlights another important aspect of Aesthetic-period decorative works: they usually represent a cooperation, if not an actual collaboration, among the contributing artists. The extent of a collaboration and the degree of responsibility assumed by each participant are not always easily determined. While Saint-Gaudens is usually credited with the modeling, and sometimes the actual execution, of the Vanderbilt panels, it is clear that they, and indeed the entire room, were conceived and designed by La Farge, who had been retained by architect George B. Post to decorate three rooms in the Vanderbilt house.[66] It was La Farge who executed drawings and paintings in preparation for the reliefs,[67] and he also enlisted the collaboration of Saint-Gaudens and the painters Theodore Robinson and Will H. Low. For some of the sculptures, La Farge may even have modeled plaster maquettes from which Saint-Gaudens then worked, but with the *Ceres* it was probably Saint-Gaudens, working from La Farge's studies and under his direction, who modeled the plaster and then carved or supervised the carving of the finished relief.[68] Whatever Saint-Gaudens's responsibility for translating the idea into three-dimensional form, *Ceres* remains La Farge's concept: the figure, heavily endowed with classical draperies, is in his characteristic style, and the materials used in the piece are consistent with the character of his decorative design.

If the role played by each artistic contributor in executing a decorative object was not always clearly documented, neither was the role of the person whose patronage generated a collaborative effort. The decorative work of Albert Pinkham Ryder (1847–1917), an artist best known for his romantic landscapes and seascapes, is a cogent example. Ryder worked as a decorative painter in the late 1870s and early 1880s, mainly for COTTIER AND COMPANY, deriving a secure income by decorating mirror frames, cabinet panels, and screens. Of three mirror frames he is said to have painted, only one (early 1880s, ILL. 9.15) is known today.[69] (The wood frame, produced under the direction of DANIEL COTTIER, was reportedly designed by Stanford White.) The object was made for Ryder's friend Charles De Kay, who commissioned it for his mother. De Kay, the brother of HELENA DE KAY, was the art critic who, under the pseudonym Henry Eckford, wrote the first major article on

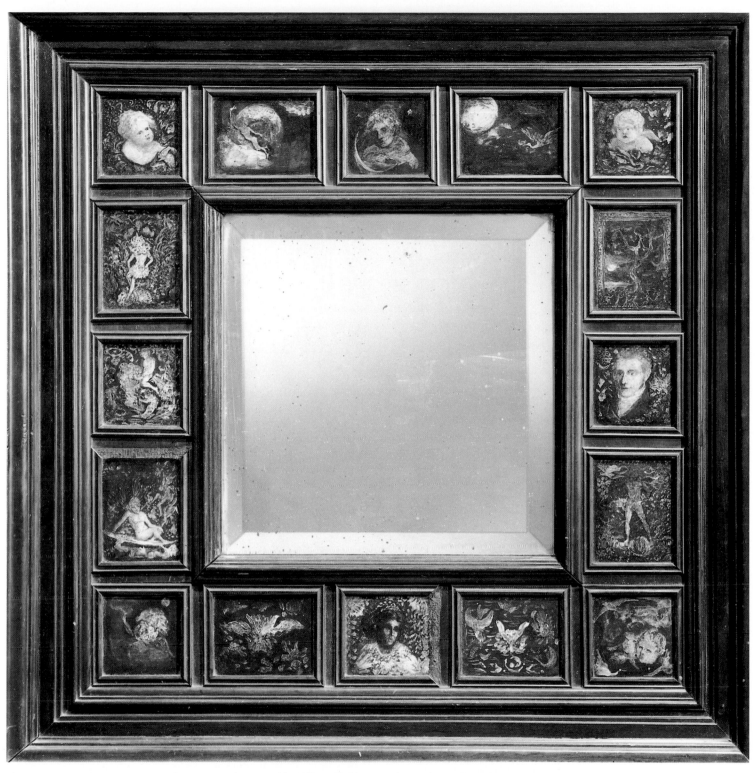

ILL. 9.15 *The Culprit Fay* (mirror frame). Panels painted by Albert Pinkham Ryder, early 1880s. Oil on wood, 20¼ × 20¼ in. (51.4 × 51.4 cm). Whitney Museum of American Art, New York, Bequest of Joan Whitney Payson (76.13)

Ryder. The frame consists of four screenlike wood sides that support sixteen panels whose subject matter clearly reflects the interests of its eventual possessor. The panels show scenes from the poem "The Culprit Fay," by Joseph Rodman Drake, Mrs. De Kay's father. Drake, who wrote the poem after a moonlight party on the Hudson River, was attempting to demonstrate that an American scene could inspire fanciful poetry as easily as the picturesque rivers and mountains of Europe. Family members are depicted in two of the panels—in the middle one at the bottom, Helena, as Earthly Love; in the middle one on the right side, Drake. Who selected the themes for Ryder's panels is not recorded,

nor is it known how closely the patron worked with the designer and the painter to determine the frame's final appearance.

Works of art executed as part of a decorative project are often separated from their setting and displayed independently. If an artist working on aesthetic decorative pieces did not sign his work, or if the work is not well documented, the creator's identity is difficult to establish. Moreover, an artist whose individual style in one medium is unmistakable could adopt a dramatically different one when he ventured into the decorative mode. Ryder's panels for screens are an excellent case in point. They are actually fragmentary parts of a larger whole; none have survived in the wood frames

forms and the leaves of the fruit bough. The style he used in decorative projects such as this suggests that he was aware of Japanese art, Japanese screens in particular, which may have inspired his use of gilding, his constricted, flattened treatment of space, and, perhaps, his sensitive handling of plants and other floral accessories.

Just how much an artist's decorative style can differ from that of his usual painting style is demonstrated by Winslow Homer's *Pastoral* (1878, FIG. 9.8), a tile fireplace surround. The Tile Club, of which Homer was a member, occasionally undertook such ambitious projects as this.[71] Homer's extant paintings on ceramics (six single tiles, those of two fireplace surrounds, and one round plaque, all varying dramatically in style and quality) were done between 1878 and 1880, with most dating from 1878.[72] Homer seems to have been proud of his tiles, for he exhibited them at the Century Club and in his studio, where he invited friends and patrons to view them.[73] *Pastoral*, one of the two fireplace surrounds,[74] consists of twelve tiles depicting a shepherd and shepherdess, who stand on opposite sides of the fireplace. The two figures are carefully matched and balanced: wearing similar decorative costumes and facing outward, each holds a crook in one hand and gestures with the other. The twelve tiles of the surround are united by the landscape setting; behind each figure is the side of a hill that reaches its greatest height at the middle of the fireplace, where Homer has painted two trees. The theme typifies a brief phase of his work. As early as 1877 he had begun to depict rural women in old-fashioned costumes, but by the following year, when he spent more time at Houghton Farm, in Mountainville, New York, the bucolic theme had become a major subject in his work.[75] The style of these tiles, however, is alien to the powerful realism usually associated with Homer's paintings. The artist has flattened the figures by simplifying or eliminating the modeling and by using dark, regularized contour lines. All the details—the weave of the straw hats, the delineation of the hair, even elements of the costumes—have been stylized. Linearity is enhanced by Homer's treatment of the cloud-filled sky behind the figures and by the delicate flowers at their feet. (A realistic sketch, *Shepherdess* [1878, ILL. 9.17], one of two known preparatory drawings he executed before he began painting the tiles,[76] is more in keeping with sketches he made for his characteristic work and scarcely prepares the viewer for what resulted from Homer's adventures in an unfamiliar medium.) The decorative style of *Pastoral* and even its composition were obviously inspired by the illustrations and painted tiles of the British artist Walter Crane, whose Shilling Toy Books gained international popularity during the 1870s.[77]

Decorative works of art, then, pose special problems both for the viewer and the scholar. By and large, these objects from the Aesthetic era are today separated from the contexts for which they were created and thus seem to lack some sense of visual orientation. Every aspect of a decorative work—its style, subject, and materials—was so integral a part of its purpose and setting that to evaluate, even to interpret, these paintings and sculptures as independent works of art is all but futile.

The So-called Secondary Media

The consequences of the Aesthetic movement extended far beyond the creation of decorative objects by painters and sculptors. As the activities of the Tile Club suggest, the enthusiasm then current for decorative arts undoubtedly spread to include the so-called secondary media—watercolor, printmaking (both etching and wood engraving), pastel, illustration, and book design. This interest, most intense between 1877 and 1882, featured a similar cast of characters—Tiffany, Colman, and La Farge, to name but a few. Many new art clubs were established to promote these media and to facilitate the exchange of ideas among the artists who worked in them.

ILL. 9.16 *Children Playing with a Rabbit* (panel for a screen). Albert Pinkham Ryder, 1876–78. Oil on leather, 38½ × 20¼ in. (97.8 × 51.4 cm). National Museum of American Art, Smithsonian Institution, Washington, D.C., Gift of John Gellatly (1929.6.106a)

that originally supported them. Of a number of Ryder's extant paintings on gilded leather, probably executed for similar commissions, only two sets can be documented. *Children Playing with a Rabbit* (1876–78, ILL. 9.16), one of three panels from a screen Ryder made for Mrs. William C. Banning, illustrates some of the characteristics of Ryder's decorative style.[70] Unlike his diminutive easel paintings, which he worked and reworked to create a thick, rich paint surface, the surface of this larger decorative panel is relatively thin. The pigments have been lightly applied over gilding, which is sometimes allowed to show through the paint—in the babies' bodies, for example, where the gold color lends an overall warmth to their skin. In his easel paintings Ryder often simplifies detail and features bold shapes, but here he relies more heavily on delicate linear effects, carefully outlining the babies'

Right: ILL. 9.17 *Shepherdess.* Winslow Homer, 1878. Charcoal and chalk on paper, 24½ × 12¼ in. (62.2 × 31.1 cm). Hirschl and Adler Galleries, Inc., New York

Below: FIG. 9.8 *Pastoral* (fireplace tiles). Winslow Homer, 1878. Glazed and painted earthenware; each tile 8 × 8 in. (20.3 × 20.3 cm). Signed: *Copyright, 1878, by* WINSLOW HOMER. Collection of Mr. and Mrs. Arthur G. Altschul

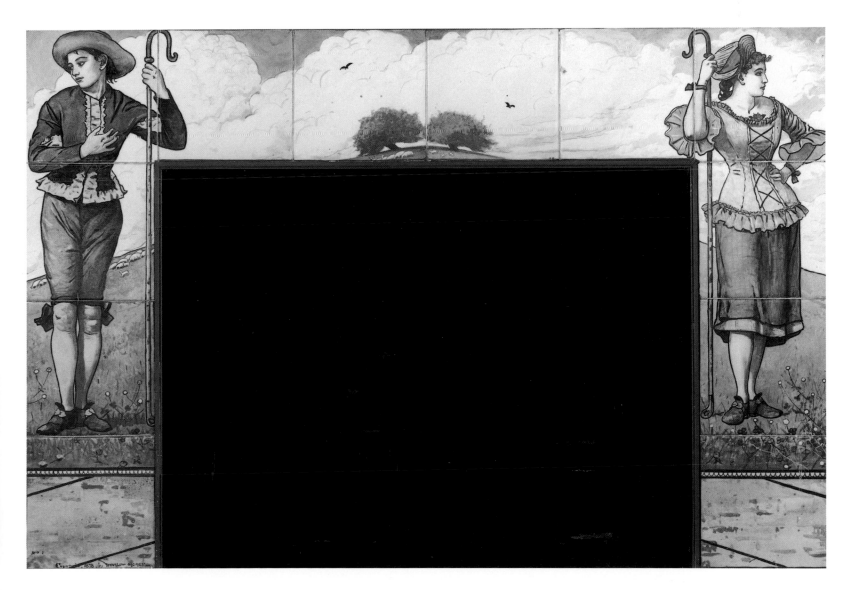

ILL. 9.18 *A Nocturne.* John La Farge, ca. 1885. Watercolor on paper, 8¼ × 7 in. (21 × 17.8 cm). The Metropolitan Museum of Art, Bequest of Louise Veltin, 1937 (37.104)

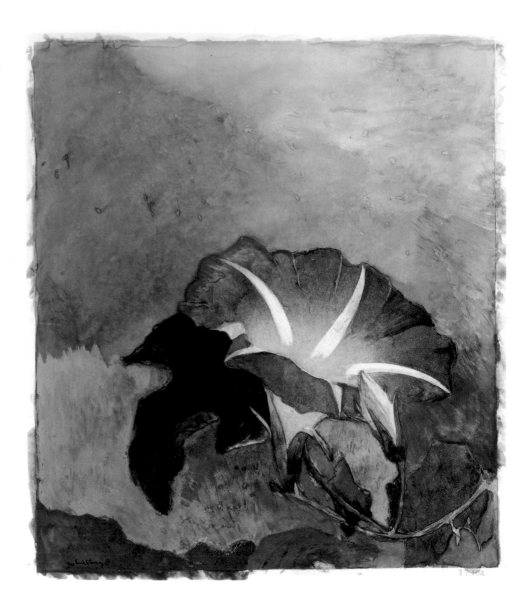

Earlier in the century printmaking had ceased to be the domain of the artist and was relegated to commercial production. Pastel and watercolor had fallen into disrepute: they had become the tools of the amateur and were used by professional artists only for making preliminary sketches rarely regarded as independent, exhibitable works of art. Several factors caused their revival and elevation in status. They were media eminently suited to the exploration of ideas that were then being tested by the rising generation of painters. Young American artists trained in Munich and Paris during the 1870s and 1880s were not fully committed to the high finish that had been a hallmark of the preceding generation. As revealed in the early exhibitions of the Society of American Artists, the sketch had achieved a new level of acceptance: the artistic process—concept, technique, and materials—was no longer concealed. Watercolors, pastels, and even etchings could be used in an informal manner to capture the ephemeral effects of light, air, and weather. A more individual, intimate choice of subject replaced the earlier, constricted academic vocabulary: simple, everyday landscapes supplanted the grandeur of the Hudson River School; the bounteous representations of fruit and vegetables popular at mid-century gave way to expressive floral still lifes; the narrative scenes common in American genre painting yielded to moody, contemplative figure studies. These new priorities, alien to the established academic tenets, thus found early expression in media other than oil and in works exhibited outside the traditional annuals of the National Academy of Design in New York. Like the decorative-arts move-

ment among artists, the revival of the "secondary" media spawned an experimental, nonacademic attitude among its participants. As Kathleen A. Foster has suggested, it also prompted "a free-flowing democratic integration of professional and amateur, 'fine' and 'popular' artistic endeavors."[78] Just as the Tile Club had inspired its members to consider the aesthetic issues implicit in their new form of expression, the organizations promoting secondary media did much to kindle an awareness of new ideas. Too, there are economic factors that deserve consideration: watercolors, prints, pastels, and illustrations put the artists in touch with yet another audience, one to whom they could offer more reasonably priced (and so more marketable) pieces.[79]

Watercolor painting, unquestionably the first of the media to be revived, has perhaps the closest relationship with the decorative arts. Throughout the period, watercolor remained the preferred medium for renderings by architects and designers. Watercolor was taught universally in schools of industrial design and was favored by the many female amateurs who aspired to "artistic" homes.[80] For some painter-decorators, such as VINCENT STIEPEVICH (see FIGS. 4.6, 4.7), watercolor work remained pedestrian, having value only as a document of taste, not as a work of art. Others became facile in the use of watercolor while working on decorative projects but found it transcending their immediate need for recording ideas. Painter-decorators such as John La Farge went on to produce in it beautiful and independent works of art (about 1885, ILL. 9.18).

The American Watercolor Society, founded in 1866 and still in existence, is the longest-enduring organization dedicated to the promotion of a medium other than oil.[81] One of its four organizers and its first president—serving from 1866 to 1870—was Samuel Colman, who later played a major role as a decorative artist. The society held its first annual exhibition in 1867 and, after weathering a certain flagging interest among its members, held ambitious shows in 1872 and 1873. By 1874 a number of important American artists had taken up watercolor and exhibited with the society— Edwin Austin Abbey, Winslow Homer, Thomas Eakins, and Will H. Low, as well as the illustrators Frederick S. Church and Charles S. Reinhart. That was the year that Whistler made his debut with the group. In 1876 the American Watercolor Society displayed its members' work at the Philadelphia Centennial Exposition. The society's annuals soon attracted the participation of younger artists, many of whom had become disillusioned with the National Academy of Design. An increasing number of artists became interested in watercolor and submitted their work for display with the society, where they were welcomed by the tolerant, open-minded group.

Etching preoccupied American artists anew during the late 1870s.[82] The chronology and character of the etching revival corresponded closely to the resurgence of watercolor. In 1866 the Parisian art dealer Alphonse Cadart (1828–1875) brought a group of French etchings to New York, a display that inspired the Americans Colman and Charles Henry Miller, among others, to try their hand at the medium.[83] Discouraged by the lack of public interest and with limited access to presses, they soon abandoned their efforts. During the following decade, etchings by French artists, often Barbizon painters, were included in some prominent exhibitions, most notably those of the American Watercolor Society in 1875, 1876, and 1877, and at the Philadelphia Centennial in 1876. The vogue for etching began to spread: in 1877 seventeen artists

joined together to establish the New York Etching Club. The club promoted appreciation for the medium by sponsoring annual exhibitions and for the next ten years determined the development of American etching, which was by then displaying new subject matter and an entirely new appearance. Whereas earlier etchings— reproductions of paintings, mostly—had resembled wood engravings in their high finish and hard, precise lines, etchings in the late 1870s and in the 1880s, more often original landscape subjects, were sketchier and more expressive. The stylistic change was inspired by French etchers and by British etchers and writers. Whistler, who exhibited at the New York Etching Club's annuals, exerted perhaps the strongest influence on his American contemporaries. His works—*Nocturne* (1879–80, ILL. 9.19), for one—with their delicate lines and fragmentary compositions, typified the new aesthetic. More important for the development of the medium in America, however, was his personal association with the painter Frank Duveneck and a group of his American students, who met Whistler in Venice in 1879 and 1880 and subsequently began to etch. *Sotto Portico del Traghetto* (1880, ILL. 9.20), by George Edward Hopkins, one of Duveneck's students, is typical of the works produced during the 1880s reflecting Whistler's influence. Whistler's brother-in-law, Francis Seymour Haden, himself an amateur etcher, wrote extensively on the subject, and in 1882 and 1883 traveled and lectured in the United States to promote interest in it.[84] Haden's work was especially praised in *Etching and Etchers* (an American edition of this 1868 book was published in 1876), an influential book by the English painter and writer Philip Gilbert Hamerton, editor of *Portfolio,* a London magazine dedicated to the art of etching.

America soon had its own periodical devoted to etching, *American Art Review* (1879–81), edited by Sylvester Rosa Koehler. Koehler became the principal spokesman for the American etching movement, urging his readers to work directly from nature and

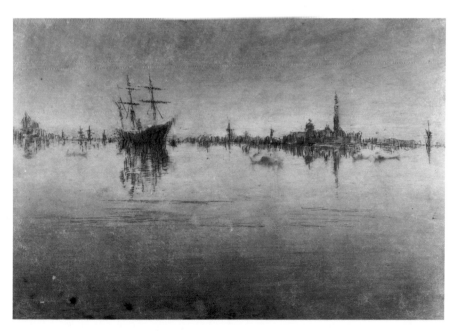

Above: ILL. 9.19 *Nocturne.* James Abbott McNeill Whistler, 1879–80. Etching and drypoint on paper, 8½ × 11¾ in. (21.6 × 29.8 cm). The Metropolitan Museum of Art, Harris Brisbane Dick Fund, 1917 (17.3.86)

Right: ILL. 9.20 *Sotto Portico del Traghetto.* George Edward Hopkins, 1880. Etching on paper, 9½ × 6⅛ in. (24.3 × 15.7 cm). Signed: *G. E. Hopkins / Venice 1880.* Museum of Fine Arts, Boston, Sylvester Rosa Koehler Collection

praising the medium for the freedom of line and warmth and variety of tone it afforded.[85] The informality and nonacademic character of etching made it an area in which experimentation and innovation were common. Like watercolor, it was a medium available to the average buyer because of its moderate costs, all the more so because it could be produced in multiples.

Illustrations and Book Design

Illustrations and book design displayed new vigor during the Aesthetic period. Both general-interest and art magazines enjoyed wider circulation as technical reproduction improved and became less expensive. This advancement hastened the spread of the Aesthetic movement by bringing illustrations of furniture and other decorative objects into more American homes, many of them outside major East Coast design centers, and by inspiring an entire generation of American painters to undertake more original and more ambitious illustrations. The engravings in Appleton's *Art Journal* and in the *Art Amateur* were surpassed by the art especially commissioned by *Harper's Weekly, Harper's New Monthly Magazine, Scribner's Monthly* (later *Century Illustrated Monthly Magazine*), and *Scribner's Magazine,* which attracted such talents as Edwin Austin Abbey, John White Alexander, and Robert Blum. Illustrations by these men were reproduced by a new school of wood engravers that included Timothy Cole, Frederick Juengling, and Gustav Kruell.[86] Technical advances, mainly the photographing of artists' drawings, greatly affected the illustrator-artist. His work, which he could now execute in any medium, including charcoal, watercolor, or oil, was presented more faithfully; moreover, since it was not destroyed during the process, it could be exhibited and sold to a collector.[87] As a result, increasing numbers of artists turned to illustrations, which, now expressions of individual creativity, were more highly regarded.

As did tile painters and watercolorists, illustrators too had an organization, theirs called the Salmagundi Club.[88] Founded in New York in 1871, the club met in the studio of the sculptor Jon-

FIG. 9.9 *Shipwrecked*. Engraved by Henry Marsh, after John La Farge, 1864. Wood engraving, 3^{15}/₁₆ × 4 in. (10 × 10.2 cm). Alfred, Lord Tennyson, *Enoch Arden* (Boston, 1865). Collection of James L. Yarnall and Stephen M. Lovette

athan Scott Hartley. Each Saturday night its members, who included Howard Pyle, A. B. Frost, and Frederick S. Church, displayed sketches illustrating a subject that had been selected the previous week. The Salmagundi suffered a decline in the early 1870s and was just reconvening about 1877, when the Tile Club and the New York Etching Club were being established.

One of the most original illustrators of the late nineteenth century was John La Farge. By the 1860s he was applying the principles of Japanese design to his illustration work. *Shipwrecked* (1864, FIG. 9.9), engraved by Henry Marsh, was La Farge's illustration for the poem *Enoch Arden* (1865) by Alfred, Lord Tennyson; it shows how closely La Farge had been studying oriental art. The drawing is based directly on *Mount Fuji Seen over Ocean,* from Katsushika Hokusai's (1760–1849) series *One Hundred Views of Fuji* (about 1830).[89] A drowning figure, surrounded by waves, clings to a floating object. The crests of two of the waves form sweeping curves, one of which divides the composition diagonally. As Henry Adams has convincingly demonstrated, La Farge's interest in Japanese art was not merely borrowed from his European contemporaries; rather, "his use of Japanese motifs was consistently earlier, more daring, and more inventive than anything comparable in France and England" before the mid-1860s.[90]

At the height of the Aesthetic period, artists were participating more frequently and more fully in the design of books. Typical of the era's creativity in this field is Helena De Kay's contribution to *The New Day: A Poem in Songs and Sonnets* (1876), the first collection of poems by her husband, RICHARD WATSON GILDER. The small volume, containing poems inspired by the Gilders' courtship,[91] was illustrated by Helena in drawings that were then engraved by Henry Marsh. The small, pocketable format and the simple, uncluttered binding are characteristic of aestheticism. The cover (about 1876, FIG. 9.10) takes its motif from the British aesthetes, who made a cult of the peacock and its feathers, but transforms it into a personal symbol. A simple blue ground decorated with the eye of a gold peacock feather represents the rising sun and the youthful optimism of the Gilders' relationship.[92] The flattened treatment of the feather, its asymmetrical placement in the lower-right corner of the cover, and the use of gilding lend a Japanesque flavor to the binding.

With interest in book design quickening among De Kay's contemporaries, artists became responsible not just for covers or single illustrations but for entire publications as well. This new approach, which emphasized the unity of all elements of the work, was a decided reaction against the eclecticism and, at times, the disorder of contemporary book design. Abbey, Pyle, Will H. Low, and Elihu Vedder were among the many American artists who contributed to such projects.[93] A number of artists collaborated on *A Book of the Tile Club,* a lavish publication that appeared in 1886.[94] Written by Edward Strahan (a pseudonym for Earl Shinn) and F. Hopkinson Smith, it was designed and illustrated by club members. Stanford White's binding of white cloth is stamped with an intricate pattern of gold and ornamented with metal corners (1886, ILL. 9.21). The endpapers (1886, ILL. 9.22), designed by George Maynard, feature a strapwork pattern with the club's monogram alternating vertically with round pseudocrests. The pseudocrests represent the sobriquets of the various members of the club—Vedder, the Pagan; Saint-Gaudens, the Saint; and R. Swain Gifford, the Griffin, to name but a few. White also contributed the title page and Vedder did the Riverside pressmark. The body of the book is illustrated with phototype plates and line drawings by club members. Several features show a new concern for the aesthetics of book design: the restrained use of color, confined to pale orange on the title page; the wide margins and white space around text and illustrations; and the general layout, which establishes a delicate balance between the two.

Just as the interior decorator brought a sense of unity to a room, the artistic book designer created a visual harmony among all the

FIG. 9.10 *The New Day* (New York, 1876). Richard Watson Gilder. Binding designed by Helena De Kay. Cover: 7 × 5⁵⁄₁₆ in. (17.8 × 13.5 cm). Bryn Mawr College Library, Maser Collection, Pa.

Right: ILL. 9.21 *A Book of the Tile Club* (Boston and New York, 1886; cover date, 1887). Edward Strahan [Earl Shinn] and F. Hopkinson Smith. Cover designed by Stanford White. Cover: 15¼ × 13 in. (38.7 × 33 cm). Private collection

Below: ILL. 9.22 Endpapers for *A Book of the Tile Club* (Boston and New York, 1886). Edward Strahan [Earl Shinn] and F. Hopkinson Smith. Endpapers designed by George Maynard. Machine printed on paper, 15¼ × 26 in. (38.7 × 66 cm). Private collection

FIG. 9.11 Drawing for the cover of *Rubáiyát of Omar Khayyám*. Elihu Vedder, 1883–84. Chalk, pencil, watercolor on paper, 15¹⁵/₁₆ × 11¾ in. (38.9 × 29.8 cm). Signed: *v*. National Museum of American Art, Smithsonian Institution, Washington, D.C., Museum Purchase and Gift from Elizabeth W. Henderson in memory of her husband Francis Tracy Henderson (1978.108.1)

FIG. 9.12 *The Cup of Death* (illustration for verse 49 of *Rubáiyát of Omar Khayyám*). Elihu Vedder, 1883–84. Chalk, pencil, ink on paper, 19⅜ × 14⅞ in. (49.2 × 37.8 cm). Signed: *v*. National Museum of American Art, Smithsonian Institution, Washington, D.C., Museum Purchase and Gift from Elizabeth W. Henderson in memory of her husband Francis Tracy Henderson (1978.108.25)

parts of a book. Elihu Vedder's work on the *Rubáiyát of Omar Khayyám,* published by Houghton Mifflin and Company in 1884, was one of the first efforts of this kind. "I have planned the whole thing, page by page," Vedder wrote to his friend Joseph B. Millet. "Evidently this will be the most important record I shall ever leave of myself."⁹⁵ Vedder was indeed responsible for every aspect of the book: he selected the paper and drew the lettering; he designed the cover and the endpapers; he recommended the photomechanical process used to reproduce his illustrations, even contributing interpretative notes on them. In his endeavors, Vedder aimed for "an evenness of work neither growing weaker or stronger toward the close." To that end, he placed his more important designs at "culminating points" throughout the book.⁹⁶ He achieved unity by repeating certain design features—for example, the binding, a gold design on a dark field, is dominated by a series of swirling lines (1883–84, FIG. 9.11). These represent, as Vedder explained, "the gradual concentration of the elements that combine to form life; the sudden pause through the reverse of the movement which marks the instant of life and then the gradual, ever-widening dispersion again of these elements into space."⁹⁷

The swirling motif reappears often in the book's illustrations: on the title page, in *Omar's Emblem,* where it forms a stream behind a singing bird perched on a skull, and in a number of the illustrations for Omar's verses, among them *The Cup of Despair.*⁹⁸ The cover's stylized motifs—sparkling stars, a curling vine, and a double-handled vase—are repeated throughout the pages. Vedder obviously had English precedents in mind when he began work on the book. He described its format as "about the size of Walter

Crane's *Pan Pipes,* only wider, square."⁹⁹ Vedder had known Crane for years; they had met in Rome during the early 1870s. Through Crane, who visited Italy again in 1880, Vedder may have learned that Omar's manuscript had been illuminated by WILLIAM MORRIS, Edward Burne-Jones, and Charles Fairfax Murray almost a decade earlier.¹⁰⁰

Indeed, Vedder's illustrations for the *Rubáiyát* may owe a great debt to Burne-Jones, both in the choice of languid, sensuous figures and in the stylized treatment of them. In *The Cup of Death* (1883–84, FIG. 9.12), for example, Vedder portrays a somnolent woman locked in an embrace with "the Angel of the darker Drink." The rippling draperies, the angel's wings, the surrounding foliage, and the rays of the setting sun enhance the decorative effect of the figures, who are pressed close to the picture plane. The incorporation of the text within the illustration serves as a reminder that the world Vedder depicts is the one existing only in Omar's imagination.

Another area of illustration, one with commercial overtones, was the poster, which increased in importance during the 1880s and reached its peak during the following decade. Large, dramatic posters were designed to promote the sale of books and magazines. One, created by John H. Twachtman (1853–1902) to advertise Harold Frederic's novel *The Damnation of Theron Ware* (1896, see ILL. 1.8), depicts the woman who tempts the book's hero. In the poster, Twachtman modifies the subtle style of the landscapes for which he is known, using the same strong sense of design but reducing his composition to clear outlines and simple, flat shapes of color easily read at a distance.

Framing and Display

During the Aesthetic period, as numbers of artists began to realize that the frame was an extension of the art it contained, they began to design frames for their own works. At the same time, decorators began to use pictorial decoration more extensively, integrating it into the total scheme of a room. Both artists and decorators came to realize that framed easel paintings would not just be viewed in relation to the space they occupied but would also affect how that space would be perceived. The unity of the interior, so strongly emphasized in aesthetic rooms,[101] inevitably extended to the framing and display of pictures. The walls of an aesthetic-style room were often divided into clear horizontal bands by relatively flat rectilinear moldings that framed surfaces covered by paper, textiles, or paint. Projecting picture frames with elaborate, three-dimensional decoration would have disturbed the total effect of that backdrop. While heavy, ornate frames remained popular throughout the period, particularly for academic European paintings, a new standard for frames evolved. Louis Comfort Tiffany, Stanford White, Elihu Vedder, and CHARLES CARYL COLEMAN were some of the forward-thinking designers, architects, and painters who devised frames that were more harmonious with the new interiors. Reflecting an admiration for Japanese design and Italian Renaissance models and inspired by frames designed by the Pre-Raphaelites, aesthetic-style frames were wider, flatter, and more rectilinear, with restrained ornamentation that was often only two-dimensional.

These reforms found a limited audience, however, and the 1890s saw a revival of heavy, sculptural frames, especially among such American artists as Theodore Robinson and William Merritt Chase. "Fashions change rapidly nowadays," one frame maker commented in an 1890 interview. "It took nearly thirty years to get from the old style curvilinear frames to the modern straight and flat ones; but we have got back again in two seasons."[102]

Tiffany's innovations in this area exemplify the close relation of the frame to the interior in which it hung. A watercolor in Tiffany's own apartment, enclosed in a wide, low-relief frame, prompted one writer to comment, "The artist has tried to keep the whole work, frame and picture, flat, as part of the wall, and, by so doing, to prevent the picture from disturbing the line or color scheme of that part of the room."[103]

In his sitting room, which was paneled with Japanese matting, Tiffany carried this concept to the extreme, treating the two-by-three-foot panels in various ways. Some were left blank, some were painted with decoration, and still others were used for the display of pictures, among them a sketch by Tiffany's friend and colleague Samuel Colman that had no frame at all other than the narrow molding used to attach the matting directly to the wall. The author of *Artistic Houses* (1883–84) remarked:

> The usual heavy gilt inclosure would have shut off this picture from all share in "the graceful ease and sweetness void of pride" of its surroundings, and acted as a hindrance, not only to Mr. Colman's charming and self-restrained sketch, but also to the general influence of the apartment. Here the yellow tone of the walls helps to keep the picture flat, and make it look like a part of the whole side of the room.[104]

Some designers preferred more traditional frames, principally the architectural ones derived from Renaissance models. Charles Caryl Coleman created a frame for his *Still Life with Peach Blossoms* (1877, FIG. 9.13) that shows a dependence on Renaissance design. The flat surface is heavily ornamented, but with shallow carving that is contained by prominent vertical and horizontal moldings. Each corner is punctuated by a rosette in a square surround. Like

the painting it encloses, the frame is heavily patterned and strongly colored: gilded, and with blue paint for accents on the corners and in the center of each side. The artist, who exhibits an eclecticism typical of the period, used exotic elements in his still life—a Turkish carpet and a Japanese fan—so that both the painting and the frame are intensely patterned.

Stanford White was more conservative in the frames he designed for his artist friends THOMAS WILMER DEWING, Augustus Saint-Gaudens, Abbott Thayer, and Kenyon Cox. Some of the frames, like the one he conceived for Saint-Gaudens's relief portrait of Mrs. White (1884; The Metropolitan Museum of Art, New York), are highly architectural and present the work as an object for admiration, even veneration, much in the manner of a shrine or an altarpiece. More directly related to the Aesthetic movement are the simpler frames that White later devised, which were produced by the Newcomb-Macklin Company. Like Whistler's frames and those used by Tiffany, White's were rectilinear and had regularized patterns contained by delicate moldings and repeated in shallow relief on the gently curved flats.[105]

In the America of the 1870s and 1880s, much of the impetus for reform in the framing and hanging of works of art came from England, first from the Pre-Raphaelite Dante Gabriel Rossetti (1828–1882) and then from the Anglo-American Whistler. The decorative effect of Rossetti's paintings was enhanced by the frames he began to design in the 1850s—these often relatively wide, with gilded flats decorated with bold moldings and inset round or square ornaments and with inscriptions related to the painting's subject.[106]

Whistler's frames followed in the tradition established by the Pre-Raphaelites, but also reflected his assimilation of other visual sources—seventeenth-century Dutch frames, Japanese ceramics, the furniture and interiors of THOMAS JECKYLL, and the patterns reproduced in OWEN JONES's *Grammar of Ornament* (1856).[107] Whistler's early frames, done during the 1860s, have wide flats surrounded by flat strips of molding; their gilded surfaces are incised with linear overall patterns, and oriental characters are carved in the corners and sometimes at the vertical and horizontal midpoints. The gilded frame Whistler designed for his *Purple and Rose: The Lange Leizen of the Six Marks* (1864, FIG. 9.14) has an outer molding decorated with rectangular Chinese motifs and flats embellished with Chinese characters and rows of spirals. Whistler copied these characters from a piece of blue-and-white porcelain seemingly without knowledge or concern for their meaning.[108] During the 1870s he favored simpler reeded frames inspired by Rossetti's use of that pattern and by moldings in such Jeckyll interiors as the Peacock Room (see ILL. 4.10), which combined areas of reeded and unadorned molding. They are generally more sculptural than his earlier frames, although they still appear relatively flat when compared to the heavier frames of the late nineteenth century.[109] One of Whistler's primary concerns was the coloring of his simple frames, which he deliberately keyed to the palette of the pictures they were intended for. Even in the 1880s, a decade preoccupied with the decorative effect of color, Whistler's approach was considered unusual. As Percy Fitzgerald noted in 1886:

> A clever eccentric . . . striving to portray the general *tone* of a scene without regard to details, has attempted to carry out his effect by the aid of the frame, which is either

Opposite: FIG. 9.13 *Still Life with Peach Blossoms*. Charles Caryl Coleman, 1877. Oil on canvas, 71½ × 25¼ in. (180.3 × 64.1 cm). Signed: CCC [monogram] *Roma 1877*, frame inscribed: *Roma 1877* / CCC [monogram] / ACD [monogram] / WAD [monogram]. Berry-Hill Galleries, Inc., New York

silvered or tinted in some greenish metal. This is in truth carrying on the picture into the frame, and the careful proprietor of such a work of art is driven to the absurdity of having a frame outside to protect the frame.[110]

By the 1870s and 1880s Whistler's concern for unity between the picture and its frame extended to the galleries in which his works of art were publicly displayed.[111] None of these interiors survive, but their character is suggested by such paintings of Whistler's as *Harmony in Grey and Green: Miss Cicely Alexander* (1872–73, ILL. 9.23) and by contemporaneous descriptions. The galleries were austerely decorated with plain, rectilinear moldings and flat, solidly colored walls that were sometimes ornamented with a stencil of Whistler's butterfly monogram. Rejecting the crowded impression usually conveyed in exhibitions, the artist prepared the gallery to enhance the display of his carefully chosen paintings and etchings. At his first one-man show, at London's Flemish Gallery in 1874, he painted the walls gray and placed about the room palms and flowers, porcelains, and bronzes. His actual works, though sparsely hung, benefited from the immense consideration he had given to their placement and interrelationship.[112]

The picture gallery, a separate room for the display of works of art, enjoyed a new popularity in commercial establishments and institutions and also in the homes of the wealthy Americans who, during the final quarter of the nineteenth century, were amassing large and important collections, mainly of European paintings. As one writer noted in 1882, "We see no reason . . . why the possessor of pictures, who has a separate apartment for his books, and a conservatory for his flowers, should not also have a gallery with a suitable light for the proper display of pictures."[113]

Most of these private galleries and the collections they held revived Renaissance practice, for American collectors, newly rich men of commerce, were indeed perceived as merchant-princes.[114] Their large galleries were often remarkably similar in layout and decoration: frequently situated off the drawing room, and occasionally off the library, they were illuminated by skylights during the day and gaslight by night. As a rule, the pictures were hung edge to edge on a simple background, usually of fabric, above the dado and beneath the cornice, filling much of the wall surface. For the display area, textiles in olive green and maroon or another shade of dark red were most often recommended.[115] Some attempt was made at an "artistic" layout, with large paintings placed in the center of each wall flanked by smaller paintings of comparable size in order to achieve a balanced effect. Additional paintings were often displayed on easels or simply on the floor, leaning against the dado.[116] The preponderance of these cluttered arrangements notwithstanding, many writers of the period cautioned against crowding pictures and recommended placing them along one low line instead of "skying" them, that is, aligning them on the wall well above a comfortable viewing level.[117] Art books, objets d'art, and prints were sometimes stored in glass cases in front of the dado.[118] The wall surface above the cornice and extending to the skylights was richly decorated, either with wallpaper (one of Christopher Dresser's designs in the gallery of Mrs. John T. Martin's Brooklyn house, for example) or with painted ornament, such as portrait medallions depicting European or American painters, as in Mrs. A. T. Stewart's New York home, and the "unobtrusive arabesque designs" in William H. Vanderbilt's (1821–1885) Fifth Avenue residence.[119]

The restrained displays advocated by Whistler did not alter most of the Aesthetic period's private picture galleries or public exhibition spaces. Paintings were usually shown in galleries where works were cluttered, skied, and arranged with little consideration for the effect that they had on their neighbors. The concern for framing and display engendered by the Aesthetic movement, however, ultimately influenced the appearance of American exhibitions. In 1898, the Ten American Painters, a group of prominent Impres-

sionists, held their first exhibition, partly in protest of the Society of American Artists' crowded and chaotic hanging practices. The simple elegance of their installations followed Whistler's example. They painted the walls of the gallery red, probably a deep terracotta color, and then covered the painted surface with cheesecloth to create a matte surface of diffused color that harmonized effectively with their pictures. The seams of the cheesecloth were hidden by gilded batons, and the floor was covered with cocoa-colored straw matting. Each artist's work was exhibited in a separate group, sometimes with one major painting as a focal point.[120] These principles of design were more commonly observed after the beginning of the new century.

American artists became more concerned with the appearance of their studios during the Aesthetic period. The studio was now a meeting place, a salesroom, and a display area, as well as a workplace. "In the city [the artist] often yields to the temptation of a *show* studio, a museum of rare bric-a-brac and artful effects of interior decoration," wrote Lizzie W. Champney in 1885.[121] The studio became a reflection of the artist's taste and his means of connecting himself, through the objects he collected, to the great artistic accomplishments of the past. As Nicolai Cikovsky, Jr., has pointed out, the artistic enthusiasm for the studio corresponded with a basic aesthetic shift: whereas the mid-century American painter had found his inspiration outdoors, in nature, the painter of the 1880s allied himself with earlier artistic achievements—his art was represented, at least symbolically, in the interior of his studio.[122] Nowhere is the change better illustrated than in the case of William Merritt Chase, whose famous Tenth Street studio, the repository of a fabulous and sometimes bizarre collection of objects, became an important subject of its resident's art. His painting *In the Studio* (about 1880, see FIG. 1.9) shows some of the variety and visual opulence of the artist's surroundings. His interior contains a bewildering assortment of carved furniture, luxurious textiles hung on walls and draped on furniture, a gaily patterned oriental rug, glistening brass and porcelains, musical instruments and casts after sculpture, his own works, and reproductions of old-master paintings. The setting was described by Chase's contemporaries as "a shrine . . . entered with bated breath and deep humility," and as "the sanctum sanctorum of the aesthetic fraternity."[123] Studios had become temples of art. To quote Cikovsky: "They attracted the faithful (patrons), and housed its priests (artists) and acolytes (students), its treasury, votive objects, and cult images (represented by all the standard studio appurtenances)."[124]

Given the enhanced significance of the artist's studio, it is not surprising that Chase chose a similar setting for his *Portrait of Miss Dora Wheeler* (1883, FIG. 9.15).[125] The subject is Candace Wheeler's daughter, an artist who worked as a textile designer in her mother's interior-decorating company. She is seated in her new design studio in front of a hanging the color of a golden peach and presumably produced by the Wheeler company. The backdrop is oriental in inspiration: flowers, birds, and dragonflies are arranged asymmetrically on its surface; a colophon, visible in the upper left of the composition, represents a kitten chasing its own reflection in a pool. A Chinese taboret, a blue pottery bowl, and an Elizabethan-revival easy chair that Chase chose for Dora's accessories are typical of the far-ranging taste of the Aesthetic movement. The portrait, more psychologically penetrating than Chase's society commissions of the 1880s, shows an intelligent woman who meets the viewer's gaze forthrightly. The force of her personality dominates the visual delight of her setting.

With enthusiasm for collecting reaching epidemic proportions during the Aesthetic era, object-filled interiors became favorite subjects for American painters by the end of the nineteenth century. The popularity of these subjects, with objects and decoration overwhelming the figures and their activities, can be explained in part by the social changes taking place during the period. As Celia Betsky has noted, "Urbanization, with its physical and human

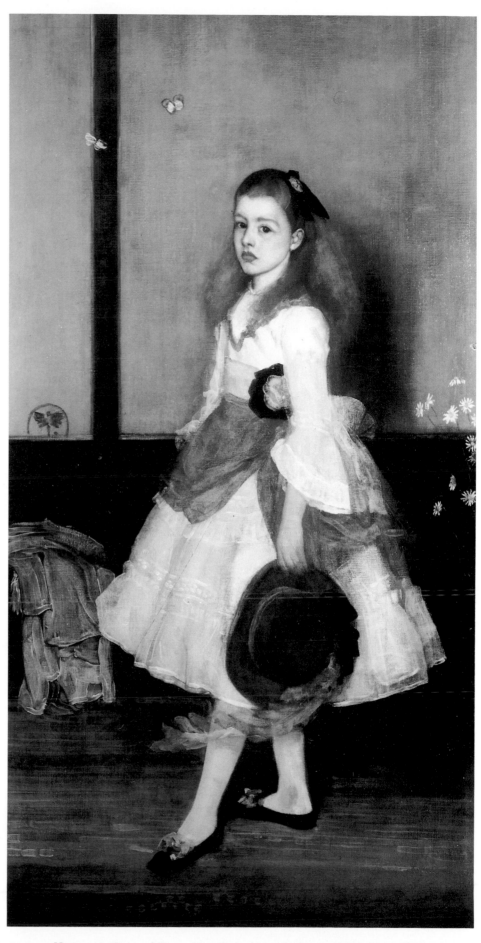

ILL. 9.23 *Harmony in Grey and Green: Miss Cicely Alexander.* James Abbott McNeill Whistler, 1872–73. Oil on canvas, 74¾ × 38½ in. (190 × 98 cm). Tate Gallery, London

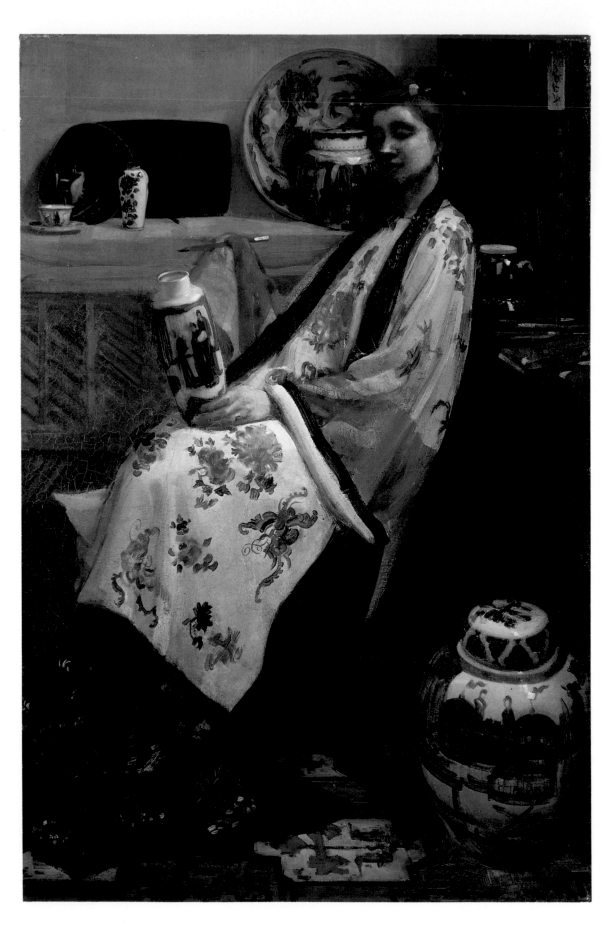

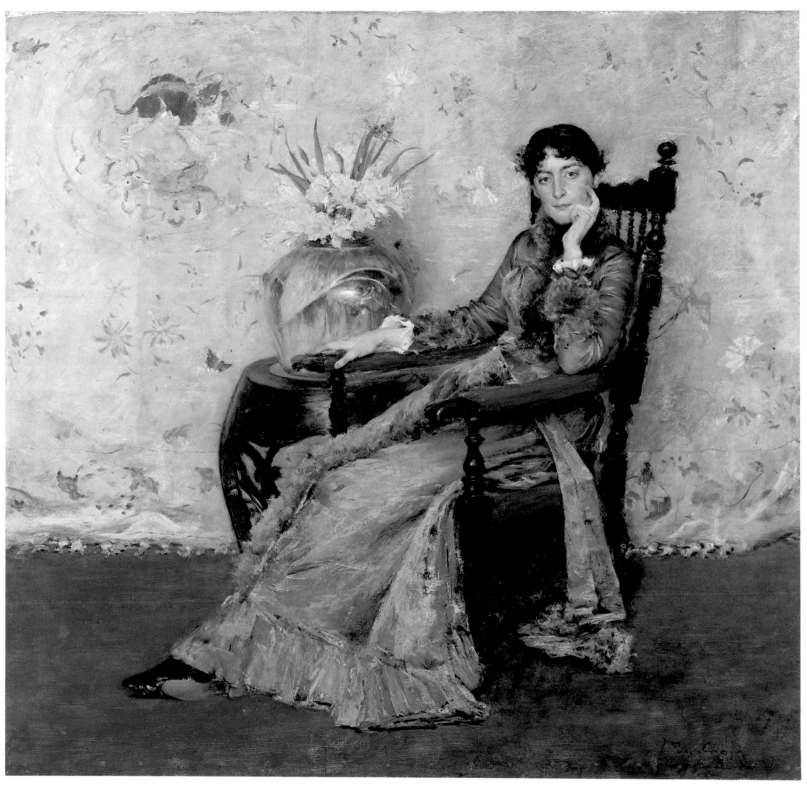

Above: FIG. 9.15 *Portrait of Miss Dora Wheeler.* William Merritt Chase, 1883. Oil on canvas, 62½ × 65¼ in. (158.8 × 165.7 cm). Signed: *Wm M. Chase.* The Cleveland Museum of Art, Gift of Mrs. Boudinot Keith, in memory of Mr. and Mrs. J. H. Wade (21.1239)

Opposite: FIG. 9.14 *Purple and Rose: The Lange Leizen of the Six Marks.* James Abbott McNeill Whistler, 1864. Oil on canvas, 36 × 24¼ in. (91.5 × 61.5 cm). The John G. Johnson Collection, Philadelphia (J.1112)

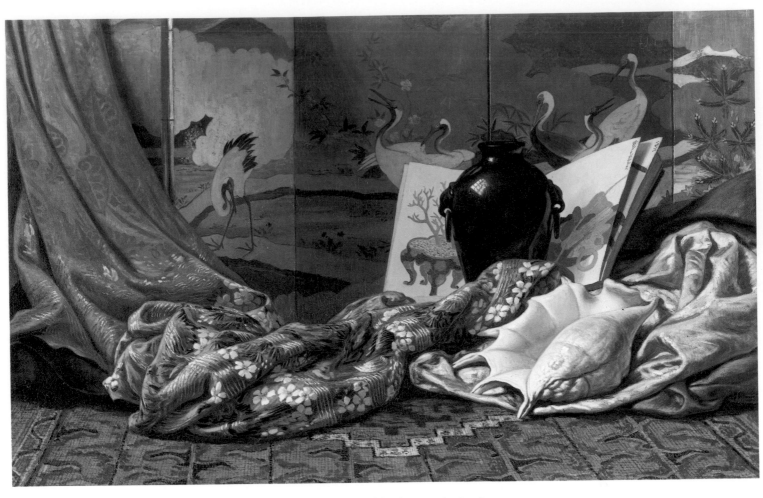

FIG. 9.16 *Japanese Still Life*. Elihu Vedder, 1879. Oil on canvas, 21½ × 34½ in. (54.6 × 87.6 cm).
Los Angeles County Museum of Art, Gift of the American Art Council (M.74.11)

squalor, and industrialization and its discontents caused much of American culture to move inside and turn inward."[126]

The new vogue for the bric-a-brac still life during the 1870s is a related development. Painters featured man-made objects more often—porcelains, glass, silver, old books, musical instruments, many of them antique, exotic, or rare[127]—in depictions that glorified their owner, establishing him as a person of taste, discernment, and, perhaps most important, wealth. Some of these paintings were simple documents of a collection. *Mrs. Stanford's Jewel Collection* (1898; Stanford University Museum and Art Gallery, California), by Ashley David Montague Cooper, is one example of a somewhat crass use of the genre.[128] Elihu Vedder's *Japanese Still Life* (1879, FIG. 9.16) includes characteristic components of the aesthetic taste: oriental textiles and a vase arranged in front of a painted Japanese screen. Art historian Joshua Taylor wrote of the canvas, "The painting is art admiring art, confusing the boundary between the representation and the objects shown, a double appeal to the sensuously triggered imagination."[129]

Art Education

By the 1870s the reform movement in industrial-art training that was transforming art education in Europe had reached the United States. The results of these reforms can be seen in several areas: in the general development of public education, in the increasing number of instructional articles appearing in art journals and popular periodicals, in the improved methods of training offered to artisans and industrial workers, in the tremendous growth of the number of museums and their collections, and, most momentous for the fine arts, in the dramatic changes in curricula at art schools and academies. In part, these developments in art education and its related spheres were accelerated in America by public disappointment in the nation's showing at the Centennial celebration in Philadelphia. The classes formed at the Pennsylvania Museum and School of Industrial Art and the art school at New York's Metropolitan Museum demonstrated American determination to see that native accomplishments could compete with those of foreign countries. Also instrumental for the improved educational opportunities was the arrival of several British instructors who helped make training in industrial design an important feature of the American art school: Benn Pitman, at the University of Cincinnati School of Design (later the Art Academy of Cincinnati); Walter Smith (1836–1886), at the Massachusetts Normal Art School, in Boston; and in New York, Thomas Charles Farrer, at the Cooper Union for the Advancement of Science and Art, and JOHN BENNETT, at the Society of Decorative Art. These organizations had responded to a situation where, to quote Candace Wheeler, young people had "nothing in view beyond a desire to become artists of some sort." She asserted, "There are many of the industrial arts in which a lesser degree of skill and knowledge may be turned to account; and it is to these that most of our art students must look for employment."[130] She was right: schools offering industrial training had a profound effect not just on artisans but also on painters and sculptors, many of whom received their initial training there.

The reforms in industrial-art education gradually spread to traditional art schools and academies, which expanded their programs in order to offer students more practical training in such skills as illustration and decorative painting. The process was relatively slow, however, with results mostly achieved long after the decline of the Aesthetic movement. The Boston Museum School seems to have been the first major art academy to offer instruction in decorative painting. In 1881 Frederic Crowninshield presented lectures there on the work of old masters, including Michelangelo and Raphael; he also encouraged students to make drawings after decorative objects in the school's collection, and he supervised as they decorated their lunchroom in what was described as the Egyptian style. Within three years the school was considering an experimental class in decorative painting. Instituted in 1885 under C. Howard Walker, the class became so successful that a regular three-year program in decoration was inaugurated in 1890.

Developments at other major art schools were slower. Students at the Pennsylvania Academy of the Fine Arts in Philadelphia decorated the lecture room in 1897, but that type of instruction remained outside the school's official program. In New York, only in 1915 did the National Academy of Design offer a class in mural painting, conducted by Edwin Blashfield, and a series of lectures by the architect James Monroe Hewlett. And so, even after the Aesthetic period had reached its height in America, many young artists still had to learn decorative painting by assisting more accomplished artists in their various projects. As for illustration, which enjoyed such a renaissance during the final two decades of the nineteenth century, it too entered the academic curriculum slowly. During the early 1890s lectures on illustration were presented at the National Academy and at the Pennsylvania Academy by W. Lewis Fraser, former art director for the *Century Illustrated Monthly Magazine,* but it was not until the twentieth century that a formal course on the subject was instituted.[131]

Easel Painting in the American Aesthetic Era

American painting of the last quarter of the nineteenth century unquestionably sought its inspiration in French art. Most American artists studied in Paris and brought the styles, ideas, and subjects of France home with them. Yet even artists whose training was exclusively French were nevertheless touched by the Aesthetic movement, an essentially English phenomenon. While the magnitude of the aesthetic influence nowhere approaches that of current French developments, it is still significant.

In America, as in England, the painting styles associated with the movement had their roots in the art and theories of the English Pre-Raphaelite Brotherhood. A group of artists and writers drawn together in London in 1848, the Brotherhood, which originally consisted of Dante Gabriel Rossetti, John Everett Millais, William Holman Hunt, Thomas Woolner, James Collinson, F. G. Stephens, and William Michael Rossetti, was determined to challenge the authority of the Royal Academy of Arts and to reestablish truth and morality in art. The principal tenet of the Brotherhood, as described by Hunt, was "the frank worship of Nature, kept in check by selection and directed by the spirit of imaginative purpose."[132] From 1848 to about 1865, the Pre-Raphaelites remained a cohesive group, producing figure paintings, still lifes, and landscapes characterized by a faithful imitation of nature and by an adherence to storytelling devices that enhanced the didactic, moralizing quality of their work. They sought their models in the great art of the past, adulating especially the early Italian painters, Fra Angelico among them, and asserting that only the painters preceding Raphael exemplified the principles the Brotherhood practiced. From the outset, despite their lofty ideals, there was conflict and contradiction within the group.[133] To cite a prime example: the

paintings of Dante Gabriel Rossetti were decidedly decorative, representing figures in a two-dimensional manner and without the exacting detail required in the imitation of natural effects. That as a result the viewer's attention was drawn to artistic considerations of line, color, and composition would seem somewhat opposed to the stated beliefs of the group. Moreover, Rossetti's treatment of subjects, particularly women, was far from chaste, often sensual—at times, downright erotic.

A number of artists not in the Brotherhood but working closely with its members espoused the Pre-Raphaelite standards. Two having the greatest import for the Aesthetic movement were Edward Burne-Jones and William Morris, who as students at Oxford in 1855 admired Rossetti's work, which soon exerted a strong influence on their own. In 1862 Whistler, who had moved to London three years earlier, met Rossetti and significantly changed the character of his own artistic approach. Judging from the tone of a letter he wrote to Henri Fantin-Latour (1836–1904) within five years' time, he had been able to reject his training and to dismiss the "damned realism" of Gustave Courbet (1819–1877), a major influence on his painting style during the previous decade.[134] Ford Madox Brown (1821–1893), whose artistic philosophy allied him with the more conservative elements within the Brotherhood, maintained that "art has beauties of its own, which neither impair nor contradict the beauties of nature; but which are not of nature, and yet are, inasmuch as art itself is but part of nature."[135] It was this aspect of Pre-Raphaelitism—one that pursued beauty rather than truth to nature—that ultimately spawned the Aesthetic movement beginning in England in the 1860s and in America a decade later.

The work and philosophy of the Pre-Raphaelites soon became well known in America, largely through the writings of John Ruskin, who was one of their early champions.[136] An exhibition of contemporary British painting traveling to major American cities in 1857 and 1858 featured important works by the Pre-Raphaelites, acquainting artists in the United States with their style.[137] In 1863 eight Americans—artists, architects, geologists, and lawyers—joined together to form the Association for the Advancement of Truth in Art, which, adhering without question to the emphasis on truth to nature, published *New Path,* a journal dedicated to the promotion of Pre-Raphaelite ideas. The increasing number of art-

ILL. 9.24 *The Squire of Low Degree: At Table.* Edwin Austin Abbey, 1897. Oil on canvas, 51½ × 66¾ in. (130.8 × 169.5 cm). Yale University Art Gallery, New Haven, Edwin Austin Abbey Memorial Collection (1937.2736)

ist-members of the group eventually included the expatriate Englishman Thomas C. Farrer and the Americans John Henry Hill and his son John William Hill, Charles Herbert Moore, Henry R. Newman, and William Trost Richards. These artists favored landscape and still-life subjects and, drawing directly from nature, painted with a brilliant palette works of high finish and exacting specificity. The group and its followers, in their dedication to Pre-Raphaelite ideals, exerted no little influence on contemporary American artists before suffering a decline after 1867 and becoming outmoded by 1870.

In *Art Thoughts* (1869), the critic James Jackson Jarves (1818–1888) called the artists of the association "exact literalists," noting that "their art thus far relies too much on its local truth of design and hue, and topographical exactitude of representation, and too little on the sentiment of nature or on the language of color, the strong points of the idealists."[138] It was those idealizing qualities (the formal aspects of art) ignored by the American Pre-Raphaelites that would preoccupy painters working in the aesthetic mode.

Despite the shortcomings of which it was accused, the American Pre-Raphaelite movement did much to prepare the way for its successors. It challenged established institutions with its anti-academic attitudes, it helped to make popular the more modest media of watercolor and etching, and it initiated the careers of several men—the painter and teacher Farrer and the critic CLARENCE COOK among them—who went on to participate in the American Aesthetic movement.

The American Aesthetic movement followed no such traceable course. There were no manifestos, no official publications, not even a unified, recognizable painting style. Rather, the effect it had on painters of the period is demonstrated in their enthusiasm for creating decorative works of art, in the revival of interest in etching and watercolor, and in a new concern for framing and display. In easel painting it can be seen in the striving for decorative results and in the emphasis on formal qualities of art inspired by the work of such diverse figures as Burne-Jones and Whistler, both of whom had been influenced by Rossetti in the early years of their careers.

ILL. 9.25 "Decorative Panel." Thomas Wilmer Dewing. *Harper's New Monthly Magazine* (Apr. 1882). The New York Society Library

FIG. 9.17 *Quince Blossoms*. Charles Caryl Coleman, 1878. Oil on canvas, 31¾ × 43⅝ in. (80.6 × 110.8 cm). Signed: *Roma 1878 / CCC* [monogram]. Collection of Graham Williford

American artists of the Aesthetic era were striving not so much for truth to nature as for beauty. They used the painter's "idealizing" tools—line, color, shape—in carefully arranged compositions that pointed up the distinction between the painted surface and the reality it represented.

This proclivity toward idealization, often combined almost indiscriminately with academic techniques, was common in decorative projects. Edwin Austin Abbey's (1852–1911) *Squire of Low Degree: At Table* (1897, ILL. 9.24), one of a series of paintings intended for his wife's dressing room, was inspired by Burne-Jones's mural cycle *The Briar Rose* (1870–90; Faringdon Collection Trust, Buscot Park, Faringdon, England), which Abbey saw in 1896. Abbey's canvas combines an ornamental scheme with a meticulous attention to detail in the faces and costumes of the figures. The painter has achieved flatness by reducing modeling and by using

an archaic perspective stressed through the highly patterned surfaces of the accessories and the setting. Linearity, brilliant coloring, and strong silhouetting of the figures serve to enhance the decorative appearance of the work, the realism of individual elements now overwhelmed.[139] A decade earlier, in a discussion of American decoration, the American architect ALEXANDER F. OAKEY, brother-in-law to the painter Thomas Wilmer Dewing, praised American artists for their adoption of "oriental conventionality while [adhering] in realism to the Greek and Italian ideal, at least so far as the portrayal of humanity is concerned."[140] As an example of that accomplishment he singled out a panel (ILL. 9.25) by Dewing. The composition shows three realistically treated women, perhaps representing three different epochs or cultures, absorbed in their labor on a piece of needlework. For Oakey, the painting "becomes a decorative panel suggesting a scheme of recurrence" through Dew-

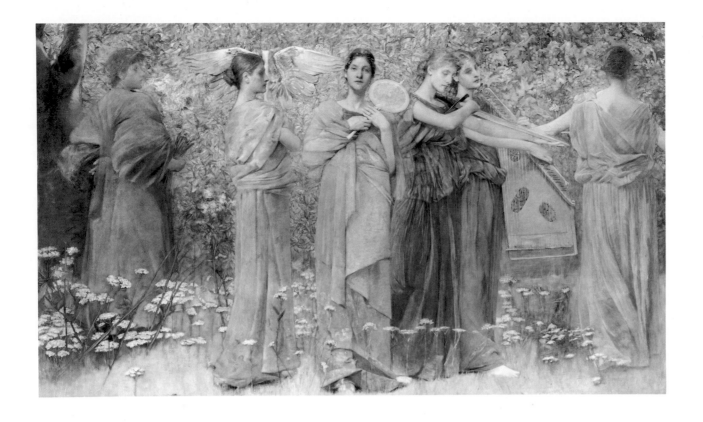

Above: FIG. 9.18 *The Days.* Thomas Wilmer Dewing, 1887. Oil on canvas, 43³⁄₁₆ × 72 in. (109.7 × 182.9 cm). Wadsworth Atheneum, Hartford, Conn., Gift from the Estates of Louise Cheney and Anne W. Cheney (1944.328)

Opposite: FIG. 9.19 Detail of *The Days* (FIG. 9.18)

Right: ILL. 9.26 *The Fates Gathering in the Stars.* Elihu Vedder, 1887. Oil on canvas, 44½ × 32¼ in. (113 × 81.9 cm). Dated: *1887.* The Art Institute of Chicago, Friends of American Art Collection (1919.1)

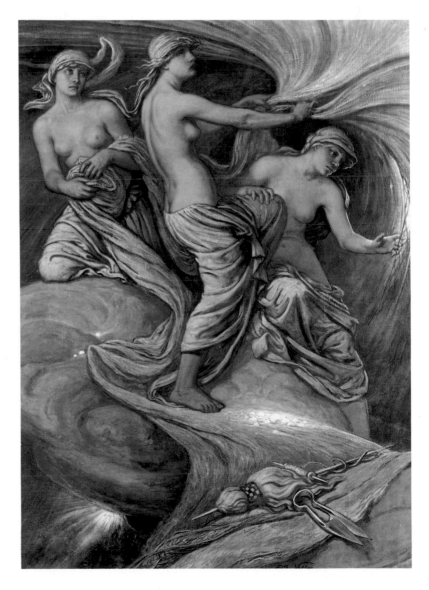

ILL. 9.27 *Arques-la-Bataille*. John H. Twachtman, 1885. Oil on canvas, 60 × 78⅞ in. (152.4 × 200.3 cm). Signed: *J. H. Twachtman / 1885 / Paris*. The Metropolitan Museum of Art, Morris K. Jessup Fund, 1968 (68.52)

ing's introduction of flowing lines on the backdrop and repetition of them below in the row of the women's hands.[141] (The lines are also reflected in the aligned curves of the women bending over their work and in the inclined stems of the flowers behind them.) The stylized arrangement is further intensified by the artist's use of a shallow foreground stage and an unarticulated backdrop, so eliminating the need for spatial recession and three-dimensionality. The same impression is perhaps more obviously conveyed in Charles Caryl Coleman's *Quince Blossoms* (1878, FIG. 9.17), a still life whose objects Coleman has arranged on a narrow ledge and rendered with almost photographic precision. The realism is nevertheless belied by the artist's handling of the backdrop and the tabletop. Three painted needlework bands run horizontally across the picture. Their gold color and flat treatment correspond to the surrounding frame Coleman designed (a rectilinear molding carved in low relief) and, the realistically treated models notwithstanding, reassert the two-dimensional character of the painting.

The tendency toward the combining of realism and decoration in a single composition can be seen in Dewing's easel paintings. Described in 1880 as "the Boston representative of the Burne-Jones school of English painters,"[142] Dewing had spent the years from 1876 to 1879 in Paris, where he studied with Jules Lefebvre and Gustave Boulanger at the Académie Julian. His figure paintings of the early 1880s appear to have been influenced by English precedents rather than French. As one critic observed,

> He seems to have been gradually lifted off the earth and wafted away from his hold on sublunary persons and things. His figures . . . have become thin and mysterious exhalations floating amid flying blossom-seeds through the ether on the wind of their own draperies or straining, bending, and yearning in all unimaginable sentimental agonies, if sitting or walking. . . . Each picture has been allegorical or illustrative of some unknown . . . rhapsody out of Swinburne or Rossetti, and unintelligible to the coarse unfeeling world for which the artist *must* paint.[143]

FIG. 9.20 *Nocturne: Blue and Gold—Southampton Water.* James Abbott McNeill Whistler, 1871–72. Oil on canvas, 19⅞ × 29¹⁵⁄₁₆ in. (50.5 × 76 cm). Signed: [butterfly] *187*[]. The Art Institute of Chicago, The Stickney Fund (1900.52)

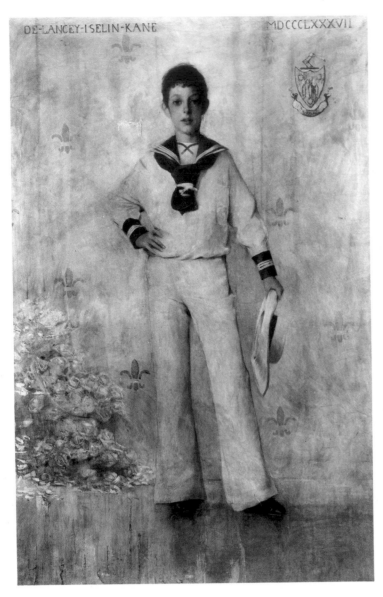

ILL. 9.28 *Portrait of Delancey Iselin Kane as a Boy*. Thomas Wilmer Dewing, 1887. Oil on canvas, 72 × 48½ in. (182.9 × 123.5 cm). Signed: *TW DEWING* / *MDCCCLXXXVII*. Museum of The City of New York, Gift of Miss Georgine Iselin (40.417)

The Days (1887, FIGS. 9.18, 9.19), whose subject Dewing drew from Emerson's similarly titled poem, brought the artist critical success when it won the coveted Clarke Prize for figure painting at the National Academy of Design in 1887. The work demonstrates Dewing's attempts to follow the example of Rossetti and other artists in reconciling the realistic figure style of his easel paintings with the pictorial effects he achieved as a decorator. His figures, while academically rendered, are once again confined to a shallow foreground stage; the view is otherwise blocked by a screen of foliage and flowers. The poses and gestures of the figures, even their placement within the composition, seem to have been dictated by Dewing's desire to create a pattern across the surface of the canvas. Here again the realism of individual parts is subsumed in the effect of the whole.

A still stronger decorative vein can be seen in the enigmatic compositions of Elihu Vedder. In his *Fates Gathering in the Stars* (1887, ILL. 9.26), the realistic figures, modestly attired in rippling garments, are unified by the lines of swirling cloth they draw in from the darkened sky. The flowing lines of these accessory elements, the strong contrasts of light and dark, and the pressing of the figures toward the picture plane heighten the ornamental character of the picture. As in his illustrations, Vedder is clearly working under the spell of such English artists as Rossetti, William Blake (1757–1827), and George Watts, whose London studio Vedder had visited in 1876.[144] In *Fates Gathering in the Stars* and in other works even more closely related to Watts precedents,[145] Vedder was striving for visible expression of his ideas. He obviously agreed with Watts's statement of intent: "I paint ideas, not things . . . my intention is . . . to suggest great thoughts which shall speak to the imagination."[146]

Whistler, who in the 1860s was closely associated with Rossetti, Burne-Jones, and Morris, took the central principle of aestheticism—the expression of beauty through the formal qualities of art—to its extreme. In early works such as *Purple and Rose: The Lange Leizen of the Six Marks* (see FIG. 9.14), his figure style had remained tied to the Pre-Raphaelites; even the porcelains, in spite of their highly patterned surfaces, were convincingly modeled. By the end of the 1860s, however, Whistler was attempting to create a new, ideal style, one that expressed his devotion to the art of Japan and Hellenistic Greece, the latter prompted by his friendship with Albert Moore (1841–1893). The new direction in his work was not simply an outgrowth of his English experience, but reflected the concerns of French artists and writers, including Théophile Gautier (1811–1872), who in 1864 had said, "The aim of art is not the exact reproduction of nature, but the creation, by means of the forms and colors it offers us, of a microcosm where may exist the dreams, sensations and ideas that are inspired by the view of the external world."[147]

Whistler's *Nocturne: Blue and Gold—Southampton Water* (1871–72, FIG. 9.20) and his other nocturnes of the 1870s renounce "exact reproduction" and instead use their landscape subjects as an opportunity to explore the effects of color and shape. In *Nocturne: Blue and Gold* the flattened ships, docks, and moonlit water are viewed through a delicate mist, its pale gray-blue color unifying those elements into a two-dimensional pattern on the surface of the canvas. The golden tone of the moon, repeated in the lights and reflections throughout the composition, follows the artist's dictum that "the same colour ought to appear in the picture continually here and there, in the same way that a thread appears in an embroidery."[148] If all the colors are repeated "more or less according to their importance . . . the whole will form a harmony."[149] It was this approach to painting that in 1877 caused Ruskin to describe Whistler as "a coxcomb . . . flinging a pot of paint in the public's face"[150] and that once and for all separated the artist from Ruskin and from his own Pre-Raphaelite sympathies. As Americans became familiar with Whistler and his work in the 1880s, the tonalist style inspired by his nocturnes of the previous decade found expression in American landscapes, John H. Twachtman's *Arques-la-Bataille* (1885, ILL. 9.27) for one.

Whistler's portraits and figure paintings, while strongly rooted in the tradition established by the seventeenth-century Spanish realist Diego Velázquez, also broke new ground. His sitters were recognizable and often shown in poses that captured their personalities and demeanor, but he achieved a more universal appeal through his thoughtful selection and disposition of accessories and elements of the setting. These titled arrangements of harmonies, no longer simple representations of the sitter's appearance, emerged as artistic statements. *Harmony in Grey and Green: Miss Cicely Alexander* (see ILL. 9.23), for example, shows a melancholy girl posed in an austerely decorated gray room, with delicate yellow touches introduced in her white dress and repeated in the butterflies and flowers around her. Whistler's compositions, which utilize blank spaces to powerful effect; his painting style, with its thin washes of pigment and light touches of color; and his insistence on harmony among his colors possibly did much to prevent

American painters from succumbing to the blandishments of society portraiture. Much of the starkness of Dewing's portrait of Delancey Iselin Kane (1887, ILL. 9.28), and certainly its unifying lavender tint, were prompted by Whistler's example. William Merritt Chase, who visited Whistler in London in 1885, adopted Whistler's principles in some of his figure paintings: *At Her Ease* (about 1885, ILL. 9.29) uses the profile composition so familiar from Whistler's portraits of his mother and of the writer Thomas Carlyle and emulates his working method, using thinly applied pigments diffused on an absorbent canvas. During the late 1890s, when Whistler moved back to Paris and conducted painting classes, admiration for his style was renewed among the American artistic community. John White Alexander (1856–1915), who knew him well during those Paris years, created a series of figure paintings, *Isabella and the Pot of Basil* (1897, ILL. 9.30) among them, that testify to Whistler's continued influence.

To summarize the significance of the Aesthetic movement for American painters and sculptors is still difficult, although by the 1890s it was evident in a wide range of artistic activities—book illustration and posters, watercolor, etching, and, when public architecture afforded the opportunity, mural decoration. In a sense, the Aesthetic movement was but one of a series of late nineteenth-century currents that liberated American artists from academic constraints. What seems to have set aestheticism apart, however, was that it fostered a spirit of experimentation in new media and styles and that it encouraged fine-art practitioners to delve into decoration and the aesthetic issues it generated. Perhaps the movement's greatest significance, however, was that it encouraged American artists to consider formal qualities—line, color, and shape—that then assumed new prominence in the work they produced. The awareness that informed the paintings of Whistler, whose nocturnes are harbingers of modernism, extended to painter-decorators such as Tiffany, who in his decorative work found the awareness quickening, particularly in the use of color, with immeasurable import for his accomplishments and his repu-

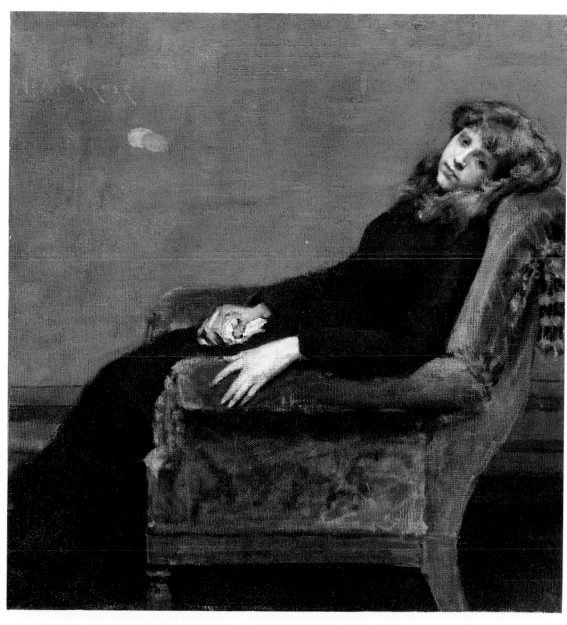

ILL. 9.29 *At Her Ease*. William Merritt Chase, ca. 1885. Oil on canvas, 44 × 42 in. (111.8 × 104.1 cm). Signed: *W. M. Chase*. National Academy of Design, New York

tation. "The sovereign importance of Color is only beginning to be realised in modern times," he wrote in 1917. "These light-vibrations have a subjective power and affect the mind and soul, producing feelings and ideas of their own."[151] It remained for the next generation of American artists, those exposed to the innovations of European modernism, to introduce Tiffany's abstract patterns of colors and shapes into their easel paintings.

Thus the true character of the Aesthetic movement slowly emerges: a bridge between the traditions of the nineteenth century and the fresh winds of the twentieth. Typically American is its assimilation into the mainstream of the nation's culture; typically American too is its ability to retain some measure of its own originality, integrity, and identity as the legacy of its principles strengthens and enriches the fabric of our daily lives.

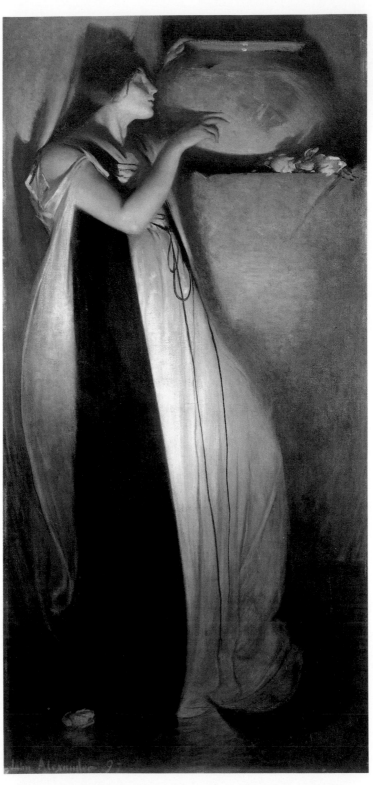

ILL. 9.30 *Isabella and the Pot of Basil*. John White Alexander, 1897. Oil on canvas, 75½ × 35¾ in. (191.8 × 90.8 cm). Signed: *John Alexander '97*. Museum of Fine Arts, Boston, Gift of Ernest Wadsworth Longfellow (98.181)

NOTES

1. For a discussion of the Ecole des Beaux-Arts and the unity of the arts, see Albert Boime, "The Teaching of Fine Art and the Avant-Garde in France During the Second Half of the Nineteenth Century," *Arts Magazine* 60 (Dec. 1985), p. 47. H. Barbara Weinberg kindly clarified information about the *cours simultané des trois arts*. For information on the Petite Ecole, see Anne M. Wagner, "Learning to Sculpt in the Nineteenth Century," in *The Romantics to Rodin*, ed. Peter Fusco and H. W. Janson (Los Angeles, 1980), pp. 10–11.

2. Albert Boime, *Thomas Couture and the Eclectic Vision* (New Haven and London, 1980), p. 63; for one of his wallpaper designs, see p. 308 (ill.).

3. Dayton Art Institute, Ohio, *Jean-Léon Gérôme (1824–1904)*, by Gerald M. Ackerman and Richard Ettinghausen (exhib. cat., 1977), pp. 10–11. For a discussion of Gérôme as a teacher, see H. Barbara Weinberg, *The American Pupils of Jean-Léon Gérôme*, The Anne Burnett Tandy Lectures in American Civilization, no. 5 (Fort Worth, Tex., 1984).

4. For my information on Low I am grateful to Laura L. Meixner, of Cornell University, who shared her then-unpublished research on the artist's early career; see her "Will Hicok Low (1853–1932): His Early Career and Barbizon Experience," *American Art Journal* 17 (Autumn 1985), pp. 51–70.

5. The literature on the Tile Club is extensive; see W[illiam] Mackay Laffan, "The Tile Club at Work," *Scribner's Monthly* 17 (Jan. 1879), pp. 401–9; W[illiam] Mackay Laffan and Edward Strahan [Earl Shinn], "The Tile Club at Play," *Scribner's Monthly* 17 (Feb. 1879), pp. 464–78; idem, "The Tile Club Afloat," *Scribner's Monthly* 19 (Mar. 1880), pp. 641–71; W[illiam] Mackay Laffan, "The Tile Club Ashore," *Century Illustrated Monthly Magazine* 23 (Feb. 1882), pp. 481–98; J. B. Millet, "The Tile Club," in *Julian Alden Weir: An Appreciation of His Life and Works* (New York, 1921), pp. 75–87; Lyman Allyn Museum, New London, Conn., *A Catalogue of Work in Many Media by Men of the Tile Club*, essay by Dorothy Weir Young (Mrs. Mahonri Young) (exhib. cat., 1945); Ronnie Rubin, "The Tile Club, 1877–1887" (M.A. thesis, New York University, 1967), the most complete treatment of the subject; and Mahonri Sharp Young, "The Tile Club Revisited," *American Art Journal* 2 (Fall 1970), pp. 81–91.

6. Laffan, "Tile Club at Work," p. 401.

7. The Tile Club met regularly at Walter Paris's studio and later in the photography gallery of Napoleon Sarony. Its final meeting place was at 58½ West Tenth Street, in a studio that Edwin Austin Abbey and Alfred Parsons had occupied in 1881. See Rubin, "Tile Club," pp. 18–19.

8. Rubin, "Tile Club," pp. 9–11, 12–15.

9. In addition to the two tiles illustrated here, other examples at Guild Hall include tiles by Arthur Quartley, F. Hopkinson Smith, R. Swain Gifford, Earl Shinn, Frederick Dielman, and J. Alden Weir. That so few tiles seem to have survived can be explained by their having been stored in a warehouse that burned in 1881. See Rubin, "Tile Club," p. 27.

10. Laffan, "Tile Club at Work," p. 405.

11. Rubin, "Tile Club," pp. 23–24. William Merritt Chase's blue-and-white plaque of a woman standing on the seashore (Baker–Pisano collection, New York) may well be one of them.

12. Laffan, "Tile Club Ashore," p. 482, quoted in Rubin, "Tile Club," p. 27.

13. Laffan and Strahan, "Tile Club at Play"; idem, "Tile Club Afloat"; Laffan, "Tile Club Ashore."

14. Rubin, "Tile Club," pp. 29–31.

15. The use of eight-by-eight-inch tiles by the club has been noted as a contributory cause to the popularity of the unconventional square canvas among American artists in the 1880s and 1890s by William H. Gerdts, "The Square Format and Proto-Modernism in American Painting," *Arts Magazine* 50 (June 1976), pp. 70–75.

16. "A Painted Table," *Art Amateur* 3 (June 1880), p. 4 (ill. of tabletop), pp. 5–8 (ills. of panels by Quartley, Dielman, J. D. Smillie, and W. S. Macy).

17. C. C. Buel, "Log of an Ocean Studio," *Century Illustrated Monthly Magazine* 27 (Jan. 1884), p. 356. The following summer, when these artists and three others were traveling from New York to Paris, they decided to repeat the project, this time in the captain's cabin (p. 358); for a discussion of the whole voyage and illustrations of the panels, see pp. 356–71. I am grateful to Ronald G. Pisano and Bruce Weber for bringing this article to my attention.

18. See "Exhibition of Fans at the Draper's Hall, London," *Art Journal* (Appleton's) 4 (Oct. 1878), pp. 315–16; and Evelyn M. Moore, "Fans and Their Makers," *Art Journal* (London), Apr. 1889, pp. 120–24.

19. "Decorative Art Notes," *Art Amateur* 1 (Nov. 1879), p. 123.

20. D[avid] [A.] H[anks] and N[ancy] R[ivard] S[haw], in Detroit Institute of Arts, *The Quest for Unity: American Art Between World's Fairs, 1876–1893* (exhib. cat., 1983), pp. 113–14 (no. 47, fan and collaborating artists discussed).

21. Ibid., p. 114.

22. For information on Maria Oakey Dewing's career, see Jennifer A. Martin [Bienenstock], "The Rediscovery of Maria Oakey Dewing," *Feminist Art Journal* 5 (Summer 1976), pp. 24–27, 44; and idem, "Portraits of Flowers: The Out-of-Door Still-Life Paintings of Maria Oakey Dewing," *American Art Review* (Los Angeles) 4 (Dec. 1977), pp. 48–55, 114–18.

23. Maria Oakey Dewing, letter to Royal Cortissoz, Feb. 20, 1921, Royal Cortissoz Papers, Collection of American Literature, The Beinecke Rare Book and Manuscript Library, Yale University, New Haven. I am grateful to Jennifer A. Martin Bienenstock for bringing this and other unpublished information about the artist's decorative work to my attention.

24. [Maria Oakey] Dewing, *Beauty in the Household* (New York, 1882), p. 31.

25. Ibid., p. 33.

26. Letter of Aug. 10, 1881, quoted in Regina Soria, *Elihu Vedder: American Visionary Artist in Rome (1836–1923)* (Rutherford, N.J., 1970), p. 159.

27. Soria, *Elihu Vedder*, pp. 151–55. The sketch for the card is illustrated in the National Collection of Fine Arts (now called the National Museum of American Art), Washington, D.C., *Perceptions and Evocations: The Art of Elihu Vedder* (exhib. cat., 1979), p. 176. I am grateful to Sharron Uhler, Hallmark Historical Collection, Hallmark Cards, Inc., Kansas City, Mo., whose unpublished research indicates that the card was issued for Christmas 1881, not in 1882 as previously assumed.

28. For illustrations, see Soria, *Elihu Vedder*, ills. 22, 23, 25; and National Collection of Fine Arts, *Elihu Vedder*, pp. 184, 185, 188.

29. For a discussion of the ringwork, see Soria, *Elihu Vedder*, pp. 159–62; Vedder's sketches for this idea are illustrated in National Collection of Fine Arts, *Elihu Vedder*, p. 182.

30. Soria, *Elihu Vedder*, pp. 162–63. For a further discussion of this tile, see Alice Cooney Frelinghuysen, "Aesthetic Forms in Ceramics and Glass," this publication.

31. Soria, *Elihu Vedder*, p. 161.

32. Ibid. For an illustration, see Hirschl and Adler Galleries, New York, *The Arts of the American Renaissance*, by Douglas Dreishpoon and Susan E. Menconi (exhib. cat., 1985), p. 111.

33. Jane Dillenberger, "Between Faith and Doubt: Subjects for Meditation," in National Collection of Fine Arts, *Elihu Vedder*, p. 117 (ill.).

34. J. and J. G. Low, *Illustrated Catalogue of Art Tiles* (Chelsea, Mass., 1881–82), pl. 16. I am grateful to Catherine Hoover Voorsanger for drawing my attention to this publication and for comparing its contents to photographs of known and attributed Vedder firebacks. For a discussion of *The Sun God*, see Soria, *Elihu Vedder*, p. 161.

35. For a full discussion of the La Farge–Saint-Gaudens *Apollo*, see Hirschl and Adler Galleries, *American Renaissance*, pp. 62–63.

36. Soria, *Elihu Vedder*, p. 160.

37. See Catherine Lynn, "Decorating Surfaces: Aesthetic Delight, Theoretical Dilemma," this publication.

38. S[ylvester] R[osa] Koehler, comp., *The United States Art Directory and Year-Book*, 2 vols. (New York, London, and Paris, 1882–84), vol. 2, pp. 9–10.

39. For a discussion of this commission, see Lloyd Goodrich, *Thomas Eakins*, 2 vols. (Cambridge, Mass., and London, 1982), vol. 1, pp. 213–19; Gordon Hendricks, *The Life and Work of Thomas Eakins* (New York, 1974), pp. 164–67; and Hirshhorn Museum and Sculpture Garden, Washington, D.C., *The Thomas Eakins Collection of the Hirshhorn Museum and Sculpture Garden*, by Phyllis D. Rosenzweig (exhib. cat., 1977), pp. 97–99.

40. Goodrich, *Thomas Eakins*, vol. 1, pp. 213, 215.

41. Ibid., pp. 216–17.

42. Ibid., p. 213.

43. Ibid., pp. 217–18.

44. John La Farge, "'Minor Arts' Lecture," typescript [1906?], La Farge Papers, Collection of American Literature, The Beinecke Rare Book and Manuscript Library, Yale University, New Haven, p. 11. For a thorough discussion of La Farge's major commissions for religious and secular mural paintings, as well as his contribution to the art of stained glass, see H. Barbara Weinberg, "The Decorative Work of John La Farge" (Ph.D. diss., Columbia University, 1972).

45. La Farge, "'Minor Arts' Lecture," p. 10.

46. Ibid., p. 25. La Farge occasionally succumbed to the temptations of commercialism. In 1880 he patented an undistinguished wood and glass screen (Chrysler Museum, Norfolk, Va.), which was produced for wide distribution.

47. La Farge, "'Minor Arts' Lecture," p. 14.

48. Ibid.

49. Ibid., pp. 14–15.

50. Ibid., p. 15.

51. *Artistic Houses, Being a Series of Interior Views of a Number of the Most Beautiful and Celebrated Homes in the United States*, 2 vols. in 4 pts. (1883–84; reprinted in 1 pt., New York, 1971), vol. 1, pt. 1, p. 1.

52. La Farge, "'Minor Arts' Lecture," p. 16.

53. Henry A. La Farge, "John La Farge's Work in the Vanderbilt Houses," *American Art Journal* 16 (Autumn 1984), pp. 46, 70 (n. 12). La Farge notes that the artist owned Henri Roux and Louis Barré, *Herculanum et Pompéi*, 4 vols. (Paris, 1870), but mistakenly cites vol. 4, pl. 5, as representing Ceres. Ceres is actually illustrated in vol. 4, pl. 50, and described on pp. 121–22.

54. La Farge, "'Minor Arts' Lecture," p. 10.

55. John La Farge, "Bing," a response to "the questions asked by Mr. [S.] Bing regarding my work and my ideas so as to include a notice of the same in his report to the French Government," typescript [Jan. 1894?], La Farge Papers, Collection of American Literature, The Beinecke Rare Book and Manuscript Library, Yale University, New Haven.

56. La Farge, "Bing." According to James L. Yarnall, who is preparing a catalogue raisonné of the artist's work, La Farge was exaggerating somewhat; conversation, June 1985. During the decade 1875 to

1885 he executed a number of major easel paintings and many watercolors.

57. Quoted in Robert Koch, *Louis C. Tiffany: Rebel in Glass* (New York, 1964), p. 11.

58. Henry Adams, "A Fish by John La Farge," *Art Bulletin* 62 (June 1980), pp. 269–80.

59. Ibid.

60. D[avid] [A.] H[anks], in Detroit Institute of Arts, *Quest for Unity*, p. 270. I am grateful to Mr. Hanks for sharing with me an article about the screen: Donald G. Mitchell, "From Lobby to Peak: Round about—Again," *Our Continent*, Mar. 29, 1882, p. 103.

61. Wilson H. Faude, "Associated Artists and the American Renaissance in the Decorative Arts," *Winterthur Portfolio* 10 (1975), p. 117 (ill.); *Artistic Houses*, vol. 1, pt. 1, ill. opp. p. 4.

62. Mary Gay Humphreys, "The Cornelius Vanderbilt House," *Art Amateur* 8 (May 1883), p. 135.

63. Ibid., p. 136.

64. For a discussion of La Farge's early work in stained glass, see Alice Cooney Frelinghuysen, "A New Renaissance: Stained Glass in the Aesthetic Period," this publication; Mary Gay Humphreys, "John La Farge, Artist and Decorator," *Art Amateur* 9 (June 1883), pp. 12–14; H. Barbara Weinberg, "The Early Stained Glass Work of John La Farge (1835–1910)," *Stained Glass* 67 (Summer 1972), pp. 4–16; idem, "John La Farge and the Invention of American Opalescent Windows," *Stained Glass* 67 (Autumn 1972), pp. 4–11; idem, "A Note on the Chronology of La Farge's Early Windows," *Stained Glass* 67 (Winter 1972–73), pp. 12–15; and Henry Adams, "Picture Windows," *Art and Antiques* 7 (Apr. 1984), pp. 94–103.

65. Mary Gay Humphreys, "The Progress of American Decorative Art," *Art Journal* (London), Jan. 1884, pp. 25 (ill.), 27.

66. For information on this decorative project, see Humphreys, "Vanderbilt House," pp. 135–36; Weinberg, "Chronology," pp. 12–15, esp. p. 15 (n. 4); John H. Dryfhout, "Augustus Saint-Gaudens' Actaeon and the Cornelius Vanderbilt II Mansion," *J. B. Speed Art Museum Bulletin* 31 (Sept. 1976), pp. 2–13; and La Farge, "La Farge's Work in the Vanderbilt Houses," pp. 30–70.

67. For information on and illustrations of these preliminary works, see Dryfhout, "Saint-Gaudens' Actaeon," p. 11, which mentions a watercolor study for *Pomona*, p. 12 (ill. of pencil drawings of Bacchus and Pomona); idem, *The Work of Augustus Saint-Gaudens* (Hanover, N.H., and London, 1982), p. 133 (ill. of watercolor of Pomona); La Farge, "La Farge's Work in the Vanderbilt Houses," p. 48 (ill. of watercolor study for *Pomona* and pencil drawing for *Bacchus*). In Museum of Fine Arts, Boston, *American Paintings in the Museum of Fine Arts, Boston*, 2 vols. (Boston, 1969), vol. 1, pp. 183–84, an oil is mistakenly identified as a study for *Ceres*. It is actually a study for *The Sense of Smell*, a mural decoration by La Farge, also for the Cornelius Vanderbilt II house; see La Farge, "La Farge's Work in the Vanderbilt Houses," pp. 54, 55, 57.

68. La Farge may have worked in plaster. His estate sale, held in 1911, included several models for the Vanderbilt project attributed to him by the sale's cataloguer, Grace Barnes, who was also La Farge's secretary in his later years. See American Art Association, New York, *Catalogue of the Art Property and Other Objects Belonging to the Estate of the Late John La Farge, N.A.* (sale cat., 1911), nos. 284, 285, 288, 289, 290, 291, 292. One of these, *Vertumnus (Actaeon)* (J. B. Speed Art Museum, Louisville, Ky.), may be the plaster relief currently attributed to Saint-Gaudens; see Dryfhout, "Saint-Gaudens' Actaeon," pp. 2–13. It is possibly the piece clearly described in La Farge's estate sale as "Designed and Modelled by Mr. John La Farge." No plaster for *Ceres* is mentioned in the La Farge sale; the gilded metal version

(ibid., no. 289) listed was "Designed by Mr. La Farge. Modelled by Mr. Saint-Gaudens." The actual work may have been done by Saint-Gaudens's assistants—his brother Louis, Philip Martiny, Frederick Kaldenberg, Réné de Quelin, and Frederick W. MacMonnies; see La Farge, "La Farge's Work in the Vanderbilt Houses," p. 47; and Dryfhout, *Work of Saint-Gaudens*, p. 131.

69. Henry Eckford [Charles De Kay], "A Modern Colorist: Albert Pinkham Ryder," *Century Illustrated Monthly Magazine* 40 (June 1890), p. 257. I am grateful to Lloyd Goodrich and the late Edith Havens Goodrich for providing unpublished information about the mirror frame; correspondence, Apr. 6, 1984.

70. The screen was mentioned specifically in early literature on the artist; see Eckford, "A Modern Colorist," p. 257.

71. See Rubin, "Tile Club," figs. 29, 30; and Laffan and Strahan, "Tile Club at Play," pp. 401, 407. The theme and composition of this fireplace surround resemble one by Edwin Austin Abbey, which shows a Puritan woman pointing to flying birds; see Laffan and Strahan, "Tile Club at Play," p. 401. Homer supposedly made this set of tiles for a fireplace in the house of his brother Charles Savage Homer, Jr., but its inscription, *Copyright by Winslow Homer*, suggests that the artist may have painted the set with an eye toward profit rather than friendship or recreation. Nevertheless, the set does not appear to have been reproduced commercially. Goodrich, correspondence, Apr. 6, 1984.

72. I am grateful to Lloyd Goodrich and the late Edith Havens Goodrich for providing extensive information on Homer's tiles; correspondence, Apr. 6, 1984.

73. Gordon Hendricks, *The Life and Work of Winslow Homer* (New York, 1979), p. 137.

74. The other set of fireplace tiles (1878) depicts a sea serpent on either side of the fireplace and two women on a beach above it. Ibid., p. 128 (ill.).

75. Ibid., pp. 133, 137. For examples of shepherdess themes, see p. 135 (ills.). At least one of these works, described by George Parsons Lathrop in the *Art Amateur* as "a Bo-peep shepherdess," hung in the Tile Club's headquarters at 58½ West Tenth Street. Quoted in Edward V. Lucas, *Edwin Austin Abbey*, 2 vols. (New York, 1921), vol. 1, p. 116; also quoted in Rubin, "Tile Club," p. 19. One of Homer's single tiles, *Shepherdess* (1878), treats a similar theme. See Young, "Tile Club Revisited," pp. 81–91.

76. Hendricks, *Homer*, p. 134 (ill.).

77. For Crane's illustrations and tiles, see Elizabeth Aslin, *The Aesthetic Movement: Prelude to Art Nouveau* (New York and Washington, D.C., 1969), pp. 152, 167; Chester Davis, "The AETCO Tiles of Walter Crane," *Spinning Wheel* 29 (June 1973), pp. 18–20; Rodney K. Engen, *Walter Crane as a Book Illustrator* (London, 1975); and Jill Austwick and Brian Austwick, *The Decorated Tile: An Illustrated History of English Tile-making and Design* (London, 1980), p. 34.

78. Kathleen Adair Foster, "Makers of the American Watercolor Movement, 1860–1890" (Ph.D. diss., Yale University, 1982), p. 268.

79. For a perceptive discussion of the relation of the watercolor revival to decorative work, illustration, etc., see ibid.

80. Ibid., pp. 6, 301.

81. Foster's introduction contains an excellent summary of this important art organization; ibid., pp. 1–38.

82. For a summary of the etching revival, with particular emphasis on its French sources, see Rona Schneider, "The American Etching Revival: Its French Sources and Early Years," *American Art Journal* 14 (Autumn 1982), pp. 40–65.

83. Ibid., p. 42; S[ylvester] R[osa] Koehler, "The Works of the American Etchers, 11: Samuel Col-

man," *American Art Review* (Boston) 1, pt. 2 (1881), pp. 387–88.

84. For information on Haden, see Schneider, "American Etching Revival," p. 41 (n. 2); and Allen Memorial Art Museum, Oberlin, Ohio, *The Stamp of Whistler*, by Robert H. Getscher and Allen Staley (exhib. cat., 1977), pp. 99–102.

85. Schneider, "American Etching Revival," pp. 56, 58.

86. For a discussion of the development of wood engraving in this period, see W. J. Linton, "The History of Wood-engraving in America, pts. 6, 7, 8," *American Art Review* (Boston) 1, pt. 2 (1881), pp. 431–38, 469–74, 515–23.

87. See F[rank] Weitenkampf, "Wood-engraving," and "The 'New School' of Wood-engraving," in *American Graphic Art* (New York, 1912), pp. 137–53, 154–70.

88. For information on the Salmagundi Club, see William Henry Shelton, *The History of the Salmagundi Club as It Appeared in the* New York Herald Magazine *on Sunday December Eighteenth Nineteen Twenty Seven* ([New York], 1927), and his *The Salmagundi Club* (Boston and New York, 1918).

89. Adams, "Fish by John La Farge," pp. 276–78.

90. Ibid., p. 278.

91. For information on *The New Day*, see Rosamond Gilder, ed., *Letters of Richard Watson Gilder* (Boston and New York, 1916), pp. 70–75; and Richard Watson Gilder, Scrapbook no. 2 [1875–], Richard Watson Gilder Papers, New York Public Library.

92. Gilder, *Letters*, p. 75.

93. For information on the Aesthetic movement and its influence on book design, see Susan Otis Thompson, *American Book Design and William Morris* (New York and London, 1977).

94. Lyman Allyn Museum, *Men of the Tile Club*, no. 186; Rubin, "The Tile Club," pp. 30–31.

95. Elihu Vedder, letter to Joseph B. Millet, June 28, 1883, Houghton Library, Harvard University, quoted in Soria, *Elihu Vedder*, p. 183. For a discussion of Vedder's work on this publication, see Soria, *Elihu Vedder*, pp. 183–97; Marjorie Reich, "The Imagination of Elihu Vedder—As Revealed in His Book Illustrations," *American Art Journal* 6 (May 1974), pp. 39–53; and Dillenberger, "Between Faith and Doubt," in National Collection of Fine Arts, *Elihu Vedder*, pp. 127–49.

96. Vedder, letter of June 28, 1883, quoted in Reich, "Imagination of Elihu Vedder," p. 51.

97. "Notes," in *Rubáiyát of Omar Khayyám, the Astronomer-Poet of Persia*, rendered into English verse by Edward Fitzgerald with an accompaniment of drawings by Elihu Vedder (Boston, 1884), unpaged.

98. See National Collection of Fine Arts, *Elihu Vedder*, pp. 132–33.

99. Vedder, letter of June 28, 1883, quoted in Soria, *Elihu Vedder*, p. 183. For information on Crane and the influence of his book illustrations in America, see Frederic Daniel Weinstein, "Walter Crane and the American Book Arts, 1880–1915" (Ph.D. diss., Columbia University, 1970).

100. Soria, *Elihu Vedder*, p. 191. These artists actually collaborated on two illuminated versions of this manuscript. Morris did the script for both; Burne-Jones did the miniatures on one occasion, Murray, on the other; see Martin Harrison and Bill Waters, *Burne-Jones* (London, 1973), p. 121.

101. See Marilynn Johnson, "The Artful Interior," this publication.

102. "A Talk about Picture-Frames," *Art Amateur* 22 (May 1890), pp. 125–26.

103. *Artistic Houses*, vol. 1, pt. 1, p. 2.

104. Ibid., pp. 4–5.

105. For information on Stanford White's frames, see Lawrence Grant White, *Sketches and Designs by*

Stanford White (New York, 1920), pls. 34–37; and Kathryn Greenthal, *Augustus Saint-Gaudens: Master Sculptor* (New York, 1985), pp. 122–24.

106. Alastair Grieve, "The Applied Art of D. G. Rossetti, 1: His Picture-Frames," *Burlington Magazine* 115 (Jan. 1973), p. 16.

107. Ira M. Horowitz, "Whistler's Frames," *Art Journal* (New York) 39 (Winter 1979–80), pp. 124–31; Freer Gallery of Art, Washington, D.C., *James McNeill Whistler at the Freer Gallery of Art,* by David Park Curry (exhib. cat., 1984), esp. pp. 157–59.

108. Horowitz, "Whistler's Frames," p. 124.

109. Ibid., pp. 126–27.

110. Percy Fitzgerald, "Picture Frames," *Art Journal* (London), Nov. 1886, p. 327.

111. David Park Curry, lecture, May 11, 1984, Freer Gallery of Art, Washington, D.C.

112. Denys Sutton, *Nocturne: The Art of James McNeill Whistler* (Philadelphia and New York, 1964), p. 88.

113. "Hanging and Framing," *Art Amateur* 6 (Jan. 1882), p. 39.

114. Mrs. A. T. Stewart's residence, which had a grand picture gallery, thirty by seventy-five feet with a fifty-foot ceiling, gave the visitor the impression that "he has been in the marble palace of a merchant-prince." *Artistic Houses,* vol. 1, pt. 1, p. 18.

115. "Hints about Picture Hanging," *Art Amateur* 7 (Aug. 1882), p. 61.

116. *Artistic Houses,* vol. 1, pt. 1, ills. opp. pp. 6, 140.

117. "Ruskin on Picture Galleries," *Art Amateur* 3 (Aug. 1880), p. 62.

118. See *Artistic Houses,* vol. 2, pt. 1, ill. opp. p. 87 for Mrs. Robert L. Stuart's gallery, p. 51 and ill. opp. p. 54 for Mr. S. M. Nickerson's gallery.

119. Ibid., vol. 1, pt. 2, ills. opp. pp. 139, 10, 119.

120. "Ten American Painters," *Collector* 9 (Apr. 15, 1899), p. 180.

121. Lizzie W. Champney, "The Summer Haunts of American Artists," *Century Illustrated Monthly Magazine* 8 (Oct. 1885), p. 846.

122. Nicolai Cikovsky, Jr., "William Merritt Chase's Tenth Street Studio," *Archives of American Art Journal* 16, no. 2 (1976), pp. 2–14. For a discussion of artists' studios during this period, see Celia Betsky, "In the

Artist's Studio," *Portfolio* 4 (Jan.–Feb. 1982), pp. 32–39.

123. Arthur Hoeber and Katherine M. Roof, quoted in Cikovsky, "Chase's Tenth Street Studio," p. 8.

124. Cikovsky, "Chase's Tenth Street Studio," p. 8.

125. For an excellent discussion of this painting, see Karal Ann Marling, "Portrait of the Artist as a Young Woman: Miss Dora Wheeler," *Bulletin of the Cleveland Museum of Art* 65 (Feb. 1978), pp. 47–57.

126. Celia Betsky, "Inside the Past: The Interior and the Colonial Revival in American Art and Literature, 1860–1914," in *The Colonial Revival in America,* ed. Alan Axelrod (New York and London, 1985), p. 242.

127. For a discussion of still life in this period, see William H. Gerdts, "The Bric-a-Brac Still Life," *Antiques* 100 (Nov. 1971), pp. 744–48.

128. Ibid., p. 746 (ill.).

129. Joshua Taylor, "Perceptions and Digressions," in National Collection of Fine Arts, *Elihu Vedder,* p. 109.

130. Candace Wheeler, quoted in "Art Study Practically Applied," *Art Amateur* 21 (July 1889), pp. 42–43.

131. Doreen Bolger [Burke], "The Education of the American Artist," in Pennsylvania Academy of the Fine Arts, Philadelphia, *In this Academy: The Pennsylvania Academy of the Fine Arts, 1805–1976* (exhib. cat., 1976), p. 73.

132. William Holman Hunt, *Pre-Raphaelitism and the Pre-Raphaelites,* 2 vols. (London, 1906), vol. 2, p. 451, quoted in Eugene Matthew Becker, "Whistler and the Aesthetic Movement" (Ph.D. diss., Princeton University, 1959), p. 38.

133. For an excellent study of the Pre-Raphaelite Brotherhood and its relationship to the Aesthetic movement and to the work of Whistler, see Becker, "Whistler."

134. Léonce Bénédite, "Artistes contemporains: Whistler," pt. 2, *Gazette des Beaux-Arts,* 3d ser. 34 (1905), p. 232, quoted in Becker, "Whistler," p. 23.

135. Ford Madox Brown, "On the Mechanism of a Historical Picture," pt. 1, *Germ* 1 (Feb. 1850), pp. 78–79, quoted in Becker, "Whistler," pp. 64–65.

136. For the history of Pre-Raphaelitism in America, see William H. Gerdts and Russell Burke, *Still-*

Life Painting in America (New York and London, 1971); and Brooklyn Museum, *The New Path: Ruskin and the American Pre-Raphaelites,* by Linda S. Ferber and William H. Gerdts (exhib. cat., 1985).

137. For a discussion of this exhibition, its content and influence, see Susan P. Casteras, "The 1857–58 Exhibition of English Art in America and Critical Responses to Pre-Raphaelitism," in Brooklyn Museum, *New Path,* pp. 109–33.

138. James Jackson Jarves, *Art Thoughts* (New York, 1869), pp. 294–95, quoted in William H. Gerdts, "Through a Glass Brightly: The American Pre-Raphaelites and Their Still Lifes and Nature Studies," in Brooklyn Museum, *New Path,* p. 40.

139. Kathleen Adair Foster, "The Paintings of Edwin Austin Abbey," in Yale University Art Gallery, New Haven, *Edwin Austin Abbey (1852–1911)* (exhib. cat., 1973), pp. 15, 46–47.

140. [Alexander F. Oakey], "A Trial Balance of Decoration," *Harper's New Monthly Magazine* 64 (Apr. 1882), p. 740.

141. Ibid.

142. Greta [pseud.], "Boston Correspondence," *Art Amateur* 2 (Mar. 1880), p. 75.

143. Ibid.

144. Soria, *Elihu Vedder,* p. 110.

145. Reich, "Imagination of Elihu Vedder," pp. 46–47.

146. Watts, quoted in Edward Lucie-Smith, *Symbolist Art* (New York, 1972), quoted in Reich, "Imagination of Elihu Vedder," p. 47.

147. *Moniteur,* Nov. 18, 1864, quoted in Sutton, *Nocturne,* p. 62.

148. James Abbott McNeill Whistler, letter of Sept. 30, 1868, Library of Congress, Washington, D.C., quoted in Sutton, *Nocturne,* p. 64.

149. Ibid.

150. John Ruskin, *Fors Clavigera* 79 (July 1877), quoted in Allen Staley, "Whistler and His World," in Wildenstein and Company, New York, *From Realism to Symbolism: Whistler and His World,* by Theodore Reff and Allen Staley (exhib. cat., 1971), p. 17.

151. Louis C. Tiffany, "Color and Its Kinship to Sound," *Art World* 2 (May 1917), p. 143, quoted in Robert Koch, "Tiffany's Abstractions in Glass," *Antiques* 105 (June 1974), p. 1291.

Overleaf: Detail of "Bits from the 'Berkshire'" (ILL. 10.26)

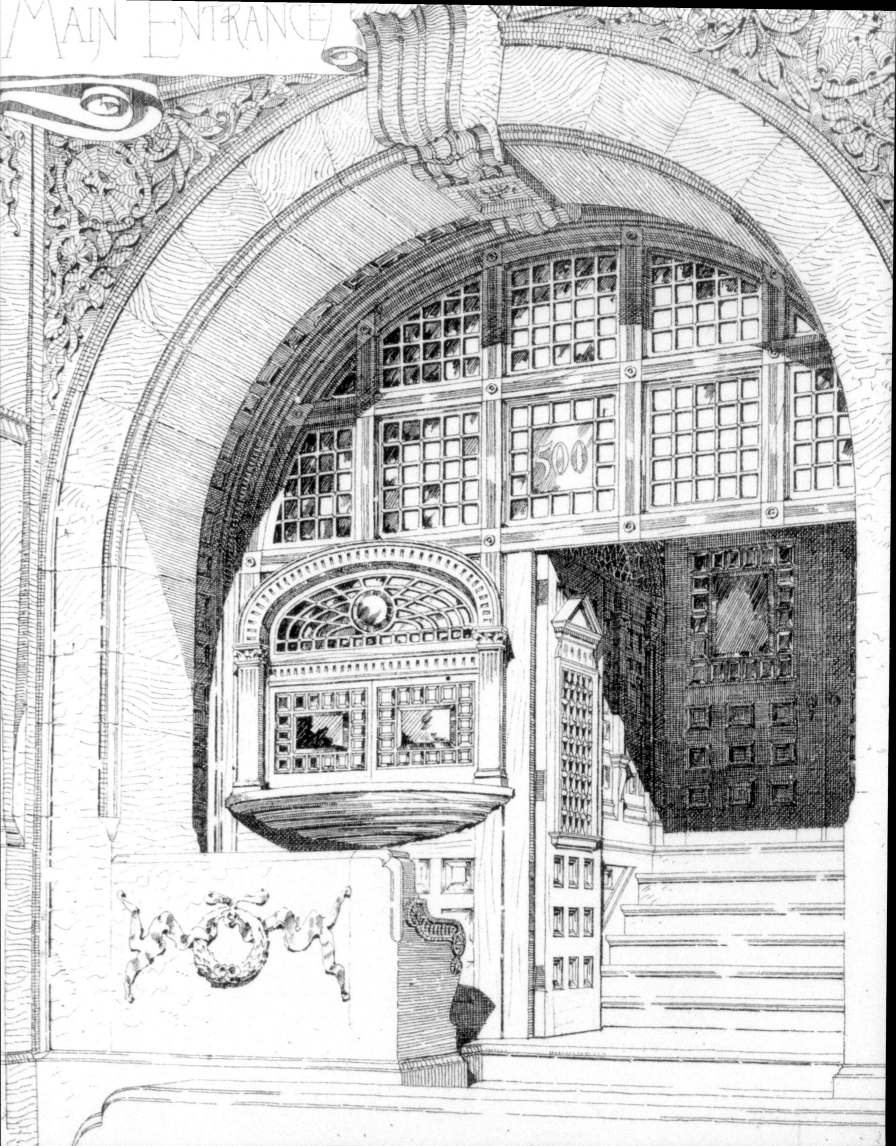

MAIN ENTRANCE

500

American Architecture
and the Aesthetic Movement

James D. Kornwolf

THE AESTHETIC MOVEMENT exerted a strong influence on American architecture, landscape, and town planning in the period 1870–90. The movement helped to direct architecture away from solely medieval, or Gothic, sources and drew anew from the classical inheritance, as well as from selected exotic traditions, especially the Japanese. The result was a thoroughly eclectic but very original architecture in which a number of diverse sources were subtly mixed.

Architects associated with the Aesthetic movement in England and America were in basic agreement about the directions their art ought to go. Domestic architecture was clearly the focal point of their efforts, yet the changes they wrought were felt not only in houses but in other building types as well. The most influential and enduring change—the particular achievement of the American movement from the late 1870s onward—was a new kind of open planning and a new way of massing volumes. Central to the Aesthetic movement in England and America was a closer relationship between architecture and ornament, between architecture and furniture, and between the fine and the applied arts in general. The British and American movements also shared a newfound respect for vernacular and indigenous architecture, which was appreciated for its relative simplicity and lack of pretension. In the United States the vernacular and indigenous were found not only in the early and widespread adaptation of the British Queen Anne mode but also in an important first look at Colonial architecture and a response to the highly individual designs of the American architect H. H. RICHARDSON. These combined sources produced an architecture that was to have a great influence on the next generation, in Europe as well as in the United States. The preservation and conservation movements in architecture and landscape were also an intrinsic part of aestheticism in America and in England, and significant changes in attitudes toward landscape design and town planning during this period gave rise to the first "garden suburbs" and "art cities."

Sources and Nature
of the New American Architecture

The American architects and works selected to illustrate the nature and extent of the influence of the Aesthetic movement are usually presented under other guises. Modern historians often separate American architecture of the late nineteenth century into a number of "schools" or "styles"—Queen Anne, Richardsonian Roman-esque, Shingle style, Chicago School, and so on—that isolate buildings by function, by type of construction, or by locale. While these terms may be useful as secondary classifications, they tend to obfuscate the national, indeed international, dimension of the changes that took place in the last third of the nineteenth century.[1] The works of these architects are much better seen, as they were during the period itself, as products of the Aesthetic and Arts and Crafts movements. The concept of the Aesthetic movement from 1870 to 1890, and of the Arts and Crafts after 1890, as the primary catalyst in American architecture brings an acceptable, noncontrived unity to the important developments of these years. Whether their designs were for houses, churches, or commercial buildings, executed in stone or wood, built in Boston, Chicago, or San Francisco, many American architects were profoundly affected by aesthetic and arts and crafts principles. Both movements are often seen as preludes to Art Nouveau, but the Arts and Crafts was more than that. It was to outlast both the aestheticism of the 1870s and 1880s and the enthusiasm for Art Nouveau that swept Europe and the United States during the 1890s.[2]

The Aesthetic movement had the same taproot as the Arts and Crafts—in WILLIAM MORRIS, John Ruskin (1819–1900), and the Pre-Raphaelite Brotherhood. No writings did more to affect how aesthetic and arts and crafts ideals were translated into architecture than Ruskin's before 1880 and Morris's afterward. The eclectic nature of the Aesthetic movement, however, was in sharp contrast to the dominant premises of the Arts and Crafts movement, whose proponents reinvigorated the vernacular and indigenous building traditions of the later Middle Ages. Moreover, the nascent Arts and Crafts movement before 1890 increasingly came to view the reform of society as a prerequisite to meaningful reform in art. As important as Ruskin and Morris were for the Aesthetic movement, they departed from it in emphasizing more the sociopolitical dimension of art than art itself.[3] Ruskin, Morris, and their followers saw ethics and aesthetics as inseparable; it was art for life's sake. Most adherents of the Aesthetic movement were less interested in moral and social matters. Some, such as the essayist and critic Walter Pater (1839–1894), wanted to disentangle ethics and aesthetics altogether; it was art for art's sake.[4] Pater was also among the most vociferous of those who challenged the hitherto preponderant taste for the medieval, owing much to Ruskin, and called new attention to classical and Renaissance art and architecture.

From the start the lines between the Aesthetic and Arts and Crafts movements often overlapped. Ruskin and Pater, though at considerable ideological odds, both admired the work of the Pre-Raphaelite painters Edward Burne-Jones (1833–1898) and Dante

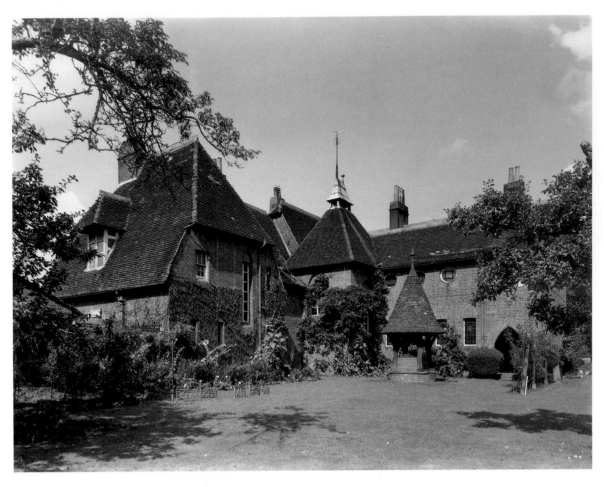

ILL. 10.1 Red House, Bexley Heath, Kent, England. Philip Webb and William Morris, 1859. Royal Commission on the Historical Monuments, London

Gabriel Rossetti (1828–1882). Oscar Wilde (1854–1900) epitomized the Aesthetic movement in the public eye in Britain and the United States, and he was caricatured as the aesthete Bunthorne in Gilbert and Sullivan's *Patience* in 1881. Nonetheless, Wilde was taken with Morrisian socialism in the 1890s, even while he parodied the Ruskin–Morris legacy in 1895 in *The Importance of Being Earnest*.[5] American architect Frank Lloyd Wright (1867–1959) affected an aesthetic air, with his long, flowing hair and cape and his precious collection of Japanese prints, while proposing many ideas far more ethical than aesthetic in nature. In short, a history of neither movement can be written without considering many of the same artists. The contradictions of the Aesthetic movement are perhaps most piquantly demonstrated in the libel suit the American expatriate painter JAMES ABBOTT MCNEILL WHISTLER brought against Ruskin in 1878, after Ruskin likened Whistler's *Nocturne in Black and Gold: Falling Rockets* (about 1875; Detroit Institute of Arts) to "flinging a pot of paint in the public's face."[6] As did nearly all the artists identified with the Aesthetic movement, Whistler owed a great debt to Ruskin, yet he could take him to court over a matter of aesthetic judgment.

Indigenous and vernacular traditions were more pronounced in architecture identified with the Arts and Crafts movement than with that of the Aesthetic movement, where more elaborate and eclectic features usually dominated. Yet again, the distinctions between the two movements were not clear-cut. Interiors and exteriors associated with either were quite plain in some instances, quite elaborate in others. Some architects developed very open planning; others did not. Nevertheless, whether they espoused aes-thetic or arts and crafts principles or both, the aim of many late nineteenth-century architects was the same. They believed that good design could be had by all, and they sought, as historian Dudley Harbron has put it, "to elevate the taste of their genera-tion."[7] The Aesthetic and Arts and Crafts movements were there-fore both distinct and indistinguishable, straightforward in some matters and circuitous in others, making Walter Kidney's view of the architecture of the period as being supremely "eclectic" quite acceptable and in harmony with the period's view of itself.[8]

Morris's own house, Red House, built at Bexley Heath, Kent, in 1859–60, and his forming of the decorating firm Morris, Mar-shall, Faulkner and Company (later MORRIS AND COMPANY) in Lon-don in 1861 marked the beginnings of both movements. Red House (ILL. 10.1) was designed by Morris and PHILIP WEBB. Its exterior, typical of Webb, is a muted combination of features from both medieval (for example, the pointed arch) and classical (the bull's-eye windows) architecture. The emphasis on materials and simple massing neutralizes any strong, obvious stylistic reference to particular periods. The house was a deliberate move away from High Victorian Gothic to what architectural historian Mark Girouard has called "a resolute attempt to obtain 'absence of style' combined with an increasing awareness of seventeenth- and eigh-teenth-century architecture."[9] Webb and Morris may also be cred-ited with the first interior that revealed the future direction of the Aesthetic as well as the Arts and Crafts movement: the Refresh-ment Room (ILL. 10.2) in the South Kensington Museum in Lon-don (now the Victoria and Albert Museum). The flat, intricate ornamental detailing—with rich surfaces but simple, rectilinear

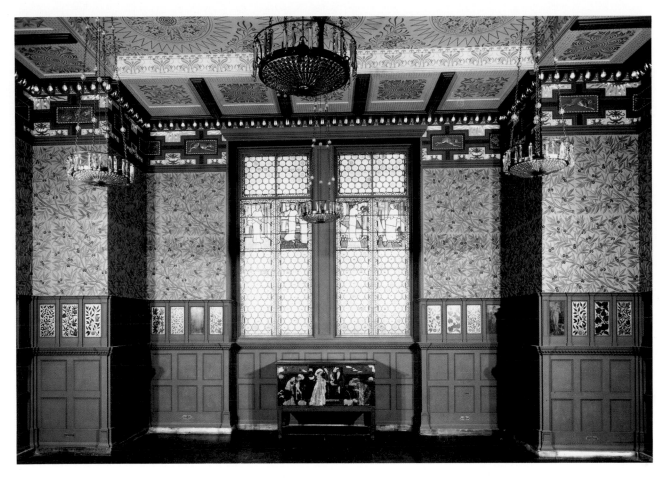

ILL. 10.2 Refreshment Room, Victoria and Albert Museum, London. Philip Webb and William Morris, 1867. Trustees of the Victoria and Albert Museum, London

proportions—of Morris and Webb's design, completed in 1867, was to become the hallmark of the aesthetic interior. Thirty years ago, when appreciating things Victorian was not so fashionable as it is today, Henry-Russell Hitchcock singled out the Refreshment Room as "a very original masterpiece of nineteenth-century decoration, hardly at all related to the contemporary High Victorian Gothic, yet reflecting the eighteenth century only as regards the treatment of the wainscoting and the door and window casings (which may be of eighteenth-century date)."[10]

In general, Morris and Webb preferred simple exteriors and more elaborate interiors. RICHARD NORMAN SHAW usually achieved the reverse.[11] By 1866–68, at Glen Andred, a Sussex country house that was more Tudor than it was Jacobean, Shaw had hit upon what would only later be called Queen Anne. More so than his better-known design for Leyswood (1866–69), also in Sussex, Glen Andred foreshadowed Shaw's later manner, which, like Webb's, showed a reliance on medieval traditions in massing volumes and on classical traditions in detailing. The source for Shaw's New Zealand Chambers in London (1872), with its exquisite banks of oriel windows, was Sparrowe's House in Ipswich, an early seventeenth-century building (remodeled in 1656) that anachronistically clings to "Englishness," to Elizabethan and Jacobean features that Inigo Jones (1573–1652), with his classicizing style, had meant to sweep away in the first decades of the seventeenth century.[12] Two years later, when Shaw designed his own house at 6 Ellerdale Road in Hampstead, London (ILL. 10.3), he further refined his ideas. The Ellerdale Road house, begun in 1874 and completed in 1876, is less derivative, intricate, and ornamental than the

New Zealand Chambers. The house's vertical proportion, the integrated bay of three oriel windows, and the irregular fenestration echoing the interior stairway and landings are Tudor or Elizabethan, but the use of red brick and some of the windows and detailing, whether Queen Anne or Georgian, are classical. Dozens of Shaw's designs were illustrated in the British periodicals the *Builder* and *Building News* throughout the 1870s; the design for the Ellerdale Road house was published in the *Builder* in 1876 and again in the *British Architect* in 1880, and Glen Andred appeared in *Building News* in 1881.[13] His work was also being appreciated in the United States by the late 1870s. In 1876, the year it was founded, the *American Architect and Building News* (hereafter the *American Architect*) published a report from England praising Shaw's design, "Queen Anne in style . . . with all the quaintness and picturesqueness he knows so well how to impart," for the house of Marcus Stone, a London artist.[14]

The architecture of the Aesthetic movement is best viewed, however, in the designs of E. W. GODWIN, whom English critic and caricaturist Max Beerbohm (1872–1956) once referred to as "that superb architect . . . the greatest aesthete of them all."[15] Godwin simplified both exteriors and interiors in many of his buildings. If Shaw's work represents the architecture of the British movement most broadly, Godwin's illustrates it at its most original. His designs for Whistler's studio and residence, called the White House, and, especially, for the house of the British painter Frank Miles in London's Chelsea district ought to figure more prominently in histories of modern architecture. The two facade studies for the Miles house show well the inherent complexities of the aesthetic,

ILL. 10.3 Richard Norman Shaw house, Hampstead, London. Richard Norman Shaw, 1874–76. Royal Commission on the Historical Monuments, London

ILL. 10.4 First design for the Frank Miles house, Chelsea, London. E. W. Godwin, 1878. Pen and ink on paper. Trustees of the Victoria and Albert Museum, London

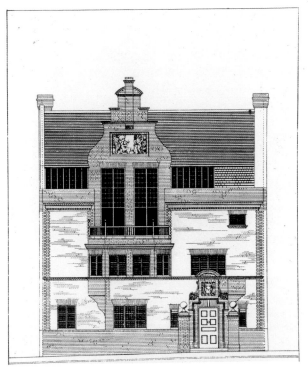

ILL. 10.5 Final design for the Frank Miles house, Chelsea, London. E. W. Godwin, 1878. Pen and ink on paper. Trustees of the Victoria and Albert Museum, London

Queen Anne mode. The first elevation (ILL. 10.4), for which the London Metropolitan Board refused to grant a construction license, is starkly abstract, proto-modernist,[16] far freer from period references than is Shaw's Ellerdale Road house (see ILL. 10.3). Japanese or Mediterranean vernacular architecture probably helped account for the design. The second elevation Godwin did for the Miles house (ILL. 10.5) is much more conventional, Jacobean, and ornate. Godwin's peers recognized his originality. In 1878 one critic thought the White House, which was completed that year, was "meant, perhaps, as a protest against the sudden popularity of Queen Anne fronts in red brick."[17]

It was not coincidental that Shaw and Godwin, two major proponents of the Aesthetic movement and the Queen Anne mode, both worked for Jonathan T. Carr, the developer, in designing Bedford Park, an aesthetic middle-class suburb built between 1876 and 1881 outside London (FIG. 10.1, ILL. 10.6). Godwin began the project, but Shaw succeeded him as consultant in 1877. Bedford Park was clearly the principal British example of the Aesthetic movement at work in landscape and urban design. It was also the precursor of the Garden City, the urban dimension of the Arts and Crafts movement in the period 1890–1914. Historian Robin Spencer maintains that Bedford Park went far in creating the Aesthetic movement's cultured middle-class elite. He also believes that Morris disapproved of Bedford Park because his social ideas were of a more down-to-earth kind.[18] Morris would equally have abhorred the stockbroker belt cuckoo-land that Bedford Park spawned in the twentieth century. Many of the leading architects and critics of the time did not agree with Morris. Boston architect Robert Swain

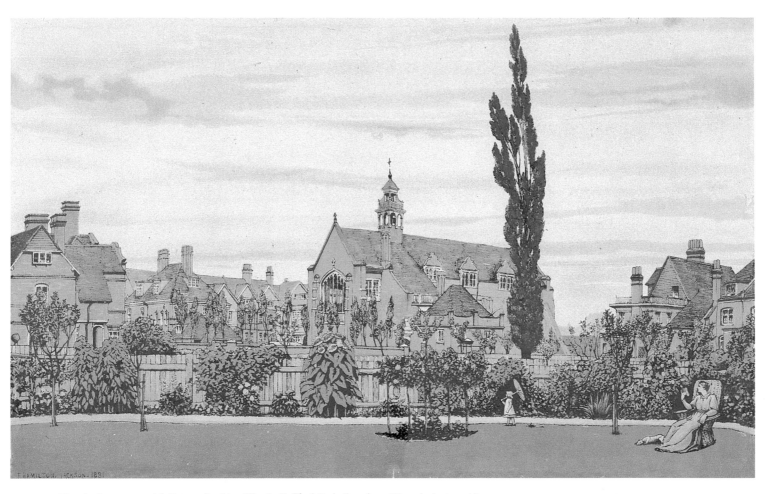

FIG. 10.1 *Church, Parsonage with Stores, Looking West in Bedford Park,* London. Church designed by
Richard Norman Shaw, 1879. Color lithograph by F. Hamilton Jackson, 1881. 8¾ × 14³⁄₁₆ in.
(22.2 × 36 cm). Avery Architectural and Fine Arts Library, Columbia University, New York

ILL. 10.6 *Tower House and Queen Anne's Grove in Bedford Park,* London. Tower House designed by
Richard Norman Shaw, 1878. Color lithograph by M. Trautschold, 1882. 8⅞ × 13¹⁵⁄₁₆ in.
(22.5 × 35.4 cm). Avery Architectural and Fine Arts Library, Columbia University, New York

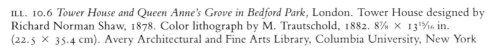
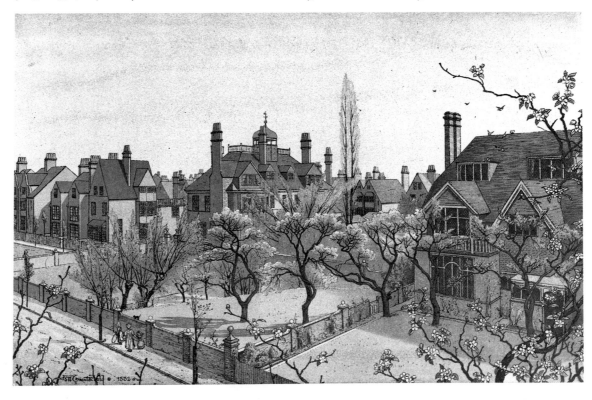

Peabody (1845–1917) published an appreciation of Queen Anne in the *American Architect* in 1877. In 1879 another American critic found Shaw's Queen Anne at Bedford Park "simply perfect," and John D. Sedding, a British architect, defended Queen Anne designs in the *American Architect* in 1885.[19]

Shaw's New Zealand Chambers was one of the first buildings to be called Queen Anne by contemporary critics, although the name was applied to furniture in the early 1860s. From the start the term posed a problem.[20] Anne reigned from 1702 to 1714. The new interest in the vernacular and indigenous ranged far wider, to encompass British architecture dating from the late fifteenth to the early nineteenth century. If one compares the majority of Shaw's buildings and those by Webb, Ernest George (1839–1922), and others working in the so-called Queen Anne mode with major examples of Tudor, Elizabethan, and Jacobean domestic architecture of the 1490s through the early 1600s, one finds most characteristics: oriel or bay windows, asymmetrical fenestration, vertical proportions, Flemish gables, beamed ceilings, and so on. Depending on the work in question, however, one can also find references to the designs of Christopher Wren (1632–1723) and to eighteenth-century English buildings of the Georgian period.[21] In addition, there are in the Queen Anne manner influences from Augustus Welby Northmore Pugin (1812–1852) and from earlier nineteenth-century British architecture not associated with the High Victorian Gothic; from Ruskin, Webb, and Morris, as well as from OWEN JONES and CHRISTOPHER DRESSER with regard to ornament and interior design; from the Japanese and other exotic cultures; and from a major renewal of the key tenets of the Picturesque, which dominated British architecture, landscape, and urban design from about 1780 to 1840. And these diverse sources do not take into account what is unique about Queen Anne, its innovative approach to planning and treating exteriors and interiors. Perhaps the ultimate definition of the aesthetic impulse in architecture as this affected Queen Anne is that direction toward a muted handling of an eclectic mix of period motifs and the effort to achieve no style. It was this that drew the best work from Shaw and Godwin in Britain and from Richardson and Stanford White (1853–1906) in the United States.

In the decade following America's centennial, Queen Anne, aestheticism, and "art" dominated architectural discussion in the United States. It is indeed a true measure of the impact of the Aesthetic movement on American architecture that so much attention could be afforded to this discussion when other more urgent problems were by comparison ignored. Unsuccessful efforts to define Queen Anne filled the pages of the *American Architect* from 1876 until at least 1884, when the Queen Anne mode was already regarded as "old fashioned."[22] Its supremely eclectic nature was noticed; one writer in an early issue of the magazine noted that "eclecticism is the rule."[23] It was accurately described, its source in Shaw's work was almost overly recognized, its turn from Victorian Gothic was appreciated, and its merits or lack of them were more intensely debated than any other architectural matter in these years. Theorists and critics took sides, but nearly all of them agreed with architect Henry Van Brunt (1832–1903) that Queen Anne was "improperly named."[24] They also realized, as did a writer in the *American Architect* in 1876, that "the restlessness which has led the English to jump in one century from Italian to Greek, from Greek to Gothic, from Gothic to Queen Anne, and is now tempting them back to Greek again, is not more likely to be exhausted in the next jump than in the last."[25]

The principles of Queen Anne eluded definition, but descriptions of its characteristics abounded. According to one critic the typical Queen Anne house contained "scroll-work panels, pedimented window-heads, small-lighted windows, barge-boards, false half-timber work, overhanging gables, marvelously shaped brackets and piazza-posts, and windows of all sorts, shapes, and sizes, in ordinary and untoward positions, most of these things

wrought in wood and all suggesting to those knowing in such matters the question of repair."[26] It is difficult to imagine what Wren, as England's leading architect during Queen Anne's reign, would have made of such a description or of the favored Queen Anne and aesthetic motif, the ubiquitous sunflower. For John Moser, a critic writing in the *American Architect* in 1878, "a big sunflower hewn out with a broad-axe [did] not express the national character of this great people." The following year another writer cautioned that "in our superficial age there seems to be some danger that the term 'decorative art' will come to be limited to the sunflowers in crewel and the vegetable forms on pottery that have sought its protection."[27]

WILLIAM ROTCH WARE, the first editor of the *American Architect,* called Queen Anne "a natural recoil or revolt of the artistic mind from the undue control exercised over it by Pugin and Ruskin and their followers in the interest of the mediaeval revival." To Ware, the Queen Anne evinced "a greater catholicity of spirit," a deliberate jab at Pugin's exclusivity and Catholicism.[28] Ware made these remarks at a monthly meeting of the Boston chapter of the American Institute of Architects (AIA) in 1878, when Queen Anne lectures were in vogue. These Boston meetings appear to have been the think tank of American architecture at the time. Boston was very much the center of American interest in Queen Anne and Colonial architecture in the 1870s; by 1880 New York, Philadelphia, and Chicago had also become important.

The debate over Queen Anne raged hottest in 1878 and 1879, the "season of the fever of that pseudo-style."[29] A note in the *American Architect* in 1878 declared that "Mr. Norman Shaw and his followers nearly make us believe that 'All the world's a stage, / And all the men and women merely players.' This is a new function for architecture."[30] The writer of a letter to the editor published a few months later found "almost comical" the Queen Anne's attempt "to trip up the old Gothic altogether on its own ground of picturesqueness, and to substitute Low Dutch."[31] Yet another writer the same year suggested that Queen Anne might be better understood as "the anonymous style" but doubted that the term would be considered "fancy" enough. He also agreed with the London Metropolitan Board's refusal to grant license for construction of Godwin's first elevation of the Miles house in Chelsea, for the design was "so plain and ugly."[32] Still another critic reasoned that if the term Queen Anne was to persist why not call the Jacobean the "King Jacob" and "complete the travesty."[33]

The Philadelphia Centennial Exposition of 1876 had drawn the attention of Americans not only to the Queen Anne but to their own cultural heritage and its roots in the Colonial period. The disruptions caused by the Civil War and an increasingly rampant process of urbanization and industrialization reinforced an interest in the simpler vernacular and indigenous traditions of the country's origins. This new interest is well documented in the *American Architect,* which, fittingly, began publication during the year of the centennial, with close associations with the AIA, which had been founded in 1857. Both Peabody, in an 1877 lecture on Queen Anne for the Boston chapter of the AIA, and Boston architect Arthur Little (1852–1925), in his book *Early New England Interiors* (1878), drew analogies between the British Queen Anne and the American Colonial with regard to period, style, and sound craftsmanship.[34] A writer in the *American Architect* in 1878, who impugned the Queen Anne as theatrically "histrionic," perceived that it needed "only a little more pushing of the 'Old Colonial' derivative in this country to bring about a corresponding form of revival here."[35]

In looking at their own seventeenth- and eighteenth-century buildings, American architects happily mixed medieval features of the earlier century with classical, Georgian features of the later one and generally sought that "absence of style" identified with Webb. Vincent J. Scully, Jr., whose 1955 survey represents the first definitive study of the American achievements in domestic architecture during the late nineteenth century, chose to de-emphasize stylistic

and historicist tendencies by selecting the term Shingle style to describe the innovative designs for wood-frame houses of the period.[36] A correspondent from London, writing in the *American Architect* in 1876, recognized that "the so-called 'Queen Anne' revival . . . is nothing more than good honest English building in brick and tile, ornamented with the materials under their architects' hands: this is as it should be, and is certainly a great advance on imitation palaces and villas in stucco. . . . [It is] an honest style of building."[37] The next year the American architect Henry Hudson Holly (1834–1892), in an article entitled "The American Style," spoke out strongly for looking afresh at New England Colonial methods of wood construction rather than at Colonial style:

> Why not recognize the fact that the germ of a vernacular style was planted here two hundred years ago, and instead of ruthlessly rooting it out, and substituting a Neo-Grec or Jacobean mansion, take the tender sapling from its withered trunk, and replant it in its parent soil, where, by nourishing it with the improvements which the fertility of science and art now furnish, it will develop to the present standard of excellence.[38]

Reinforcing the emphasis on materials and on the vernacular, and calling for a more straightforward approach, the author of "Red Brick in Architecture," an article published in the *American Architect* in 1880, avoided using any stylistic term and alluded to the picturesque qualities the Aesthetic movement reendorsed:

> One of the most prominent features in the town architecture of the last few years is the artistic use of the familiar red brick—a use which has . . . developed unsuspected sources of effect, and . . . has met with an almost universal approval. There must, indeed, be few . . . who have not found a new delight in those pleasant breaks in the "long unlovely street" which the buildings alluded to afford.[39]

He urged architects to heed Ruskin's injunctions against machine-made ornament and to learn a sense of craftsmanship from Colonial buildings. In 1885 another critic noted buildings that were "conceived in what is spoken of by the unprofessional American as the 'Queen Anne style,' that is, designs which depart from the vernacular."[40]

In their search for creative approaches to design, British and American architects also looked beyond their own borders. To the already rich and varied mix of sources were added exotic elements from other traditions: Byzantine, Islamic, and, in particular, Japanese. From the start the *American Architect* carried articles and reviews on the art and architecture of Japan: an article on Japanese houses appeared in the inaugural issue in January 1876. The Japanese exhibition buildings and garden (the first Japanese garden in the United States) at the Centennial Exposition in Philadelphia received considerable attention.[41] C. F. A. Voysey (1857–1941) in Britain and Wright in America both began to design houses in the late 1880s with simple rectangular forms and hipped roofs reminiscent of the main Japanese building at the Centennial fair and hardly typical of the Queen Anne or the Shingle style.[42]

No books explicitly treating and illustrating Japanese architecture appear to have been published in either England or the United States until the 1880s, by which time the "cult of Japan" had reached such proportions that Japan exported nearly four million fans, more than 132,000 umbrellas, and in excess of 16,000 screens to Europe in 1884 alone.[43] Through international exhibitions and depictions of buildings in Japanese prints, many British and American architects must therefore have been aware of the essential qualities of Japanese architecture and landscape design by the time Christopher Dresser's *Japan: Its Architecture, Art, and Art Manufac-*

tures, documenting his trip to Japan in 1876, appeared in London in 1882. The *American Architect* ran a three-part review of *Japan* in late 1882 and early 1883.[44] Dresser's illustrations of Japanese architectural details, such as the posts and lintels of the East Gate of the Temple Nishi-Hongwan-ji in Kyoto, appear to have influenced details of some of the buildings LOUIS SULLIVAN designed after 1885.[45] In 1886 the American zoologist and archaeologist Edward S. Morse (1838–1925), who had spent the years 1877–80 teaching at the Imperial University in Tokyo, published *Japanese Homes and Their Surroundings.* The drawings in Morse's book (ILL. 10.7) displayed a simplicity of line and a sense of proportion that soon came to be reflected in architecture of the Aesthetic movement and, later, in that associated with the Arts and Crafts movement and with modernism.

In his review in early 1886 of *Japanese Homes and Their Surroundings* for the *American Architect,* one of the most detailed reviews the magazine had so far published, Van Brunt agreed with Morse that Japanese domestic architecture and landscape design possessed nearly all the attributes progressive architects sought in their own work:

> In the planning, construction, furnishing and decoration of the humblest houses, in the laying-out, planting and enclosing of the little gardens which are always attached to them, there is a fundamental difference between our own methods and theirs, which indicates that these things are a growth out of, and an adaptation to, a simpler and more gentle life, and one of far greater natural refinement and innocence than that of the corresponding classes in our own country. These details will prove useful to us . . . because they show very clearly what may result when an industrious and ingenious people unconsciously develop . . . indigenous arts absolutely free from affectation or masquerade.[46]

The art and architecture of Japan, long isolated from other cultures, embodied many of the qualities the leaders of the Aesthetic movement wished to recapture in Western society. Vernacular and indigenous crafts and the decorative arts were inextricably linked to the fine, or "higher" arts in Japan, and Japanese art had a unity, consistency, and simplicity that had long since vanished in European and American culture.[47]

The negative impact industrialization and urbanization were exacting on the environment and the arts in England and America accounts for the period's virtual obsession with art and with the Aesthetic movement itself, an interest proven by the great quantity and quality of publications treating issues that were of concern to the movement. Greatly facilitating the rapid transmission of ideas and forms associated with aestheticism were the many books and magazines that had begun to appear in Britain and the United States in the 1860s. The increasing use of photographs permitted a more precise exchange of influences. The writings of Ruskin, Morris, Jones, and Dresser laid the foundations for the kind and extent of ornament architects in the movement used on exteriors of buildings, as well as in designs for interiors and for furniture. Robert Kerr, in *The English Gentleman's House* (1864), endorsed elegance without ostentation and English sources for English houses. Kerr's advocacy of a return to the use of the medieval great hall, as Scully has pointed out, helped produce the large, integrated interior spaces Richardson and others began to incorporate in their designs after 1870.[48] CHARLES LOCKE EASTLAKE's *Hints on Household Taste,* published in London in 1868 and brought out in an American edition in 1872 (see FIG. 4.1), had little influence on American architecture, and the so-called Eastlake style in furniture and interior design was earlier than and distinct from the Queen Anne and Aesthetic modes. The review the *American Architect* carried of *The Book of American Interiors* (1876), by Charles Wyllys Elliott (1817–

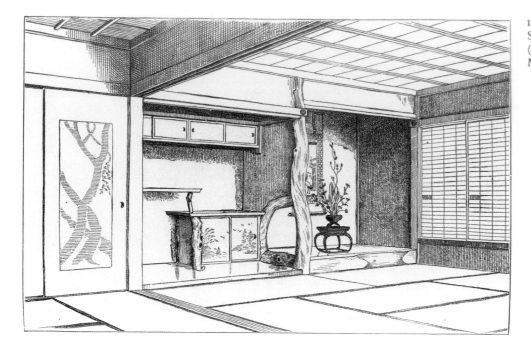

ILL. 10.7 "Guest-Room in Hachi-Ishi." Edward S. Morse, *Japanese Homes and Their Surroundings* (Boston, 1886). Thomas J. Watson Library, The Metropolitan Museum of Art

1883), noted that most of the furniture illustrated could be described as that "solid square style, which, since the publication of Mr. Charles Eastlake's book, is popularly called by that name." But by 1884 Eastlake and the Gothic were "things of the past."[49]

British architectural magazines, the *Architect*, the *Builder*, *Building News*, and especially the *British Architect*, founded in 1874, were widely subscribed to in the United States. Initially edited by Godwin, the *British Architect* was more sensitively and artfully designed than its older, more established rivals, and it published more articles extolling the Queen Anne manner. The appearance of the *American Architect and Building News* in 1876 marked a new American independence from British sources. The numerous competitions the *American Architect* sponsored from 1878 through the early 1880s—for interior designs, large houses, small houses, hotels, stables, and so on—stimulated the development and dissemination of the new mode, which was likely an intention of the editors. The photographs the magazine began publishing in 1877 (the first, of Richardson's Trinity Church in Boston, appeared in the February 3, 1877, issue) greatly assisted accurate emulation of designs. Numerous articles on and illustrations of works by Shaw, Morris, and other British artists appeared in the *American Architect*. The magazine was also a major voice in the preservation movement, and it focused on interior design as a distinct discipline and carried a number of "art in the household" articles and reviews.[50]

In March 1877 the *American Architect* favorably discussed the recently published Boston edition of British architect BRUCE J. TALBERT's *Examples of Ancient and Modern Furniture, Metal Work, Tapestries, Decorations, Etc.* (1876); the magazine reproduced two plates from Talbert's book, one of which, a design for a drawing room that had also appeared in the *Architect* in 1869, is shown in illustration 10.8. Holly's *Modern Dwellings in Town and Country*, which came out in New York in 1878, was also extensively reviewed, as was CLARENCE COOK's book of the same year, *The House Beautiful* (see FIG. 5.6).[51] The title of Cook's book—a title that survives still in the magazine William Gannett started in Chicago in 1896—symbolizes the main thrust of the Aesthetic movement in architecture: toward beauty and toward art for art's sake. (*The House Comfortable*, the title Agnes Bailey Ormsbee chose for the book she published in New York in 1892, perhaps in turn reflects the shift away from aesthetic imagery to the arts and crafts view-

point: art for life's sake.) So well known and so humorously debated were publications on aestheticism in some circles by 1882 that Walter Hamilton felt the need to defend the movement in *The Aesthetic Movement in England*, which appeared in London that year.

Having reached the level of an environmental movement with Bedford Park, aestheticism received its first clear polemic in landscape design in 1883 when William Robinson published *The English Flower Garden*, a vigorous rejection of the formalism of mid-Victorian gardens associated with Joseph Paxton (1801–1865) and the Crystal Palace he designed for the Great Exhibition of 1851 in London. Numerous editions of *The English Flower Garden* continued to appear in England and America well into the twentieth century; the book helped to produce a wholly new school of landscape design based on the Picturesque.[52] In the United States, Frederick Law Olmsted (1822–1903) worked and wrote with increasing vigor during the Aesthetic era on behalf of public parks, parklike development in urban and suburban spaces, and an aesthetic attitude toward landscape.

American architects' innovative designs were so apparent and plentiful by the early 1880s that the first of a number of sumptuously illustrated books on them, *Artistic Houses*, appeared in 1883–84. George William Sheldon's *Artistic Country-Seats* followed in 1886, and *Examples of American Domestic Architecture*, by John Calvin Stevens and Albert Winslow Cobb, came out in 1889. By 1892 the American accomplishment was complete enough that Montgomery Schuyler wrote its initial history in *American Architecture*, the earliest and quite appropriate use of that title. More exposure came the following year with *Homes in City and Country* by the American architect Russell Sturgis (1836–1909) and others.[53] Indeed, the achievements of architects in the United States from 1870 to 1890 were such that they were the first instances of American architecture influencing European, rather than the reverse.[54]

Stimulated by the outpouring of books and periodicals, the Aesthetic movement gathered momentum in England and the United States during the 1870s and 1880s. The Whistler–Ruskin fracas of 1878 may have been to little avail—Whistler won the case, but he was awarded just one farthing in damages and the suit left him in financial ruin—yet it too heightened public awareness of the movement and its goals.[55] That the *American Architect* was publishing articles with such titles as "New Interest in Art and How to Direct

It" and "Artists' Opinions Held to Be Facts" suggests that art was very much on American minds.[56] In 1879 a writer in the magazine could declare,

> The present age is, if anything, aesthetic. Art is the ruling craze. Unless a man would be set down as a mere Philistine, unfit to appear in the selecter circles, he must know, or pretend to know, something about aesthetics in one form or other, and be able to chatter about "tones" and "symphonies" and "arrangements," in the now fashionable gibberish.[57]

Most educated British and Americans would probably have agreed, though a few might have taken exception to the notion that discussing "arrangements" was necessarily "gibberish." Noting how art was prospering in education with the expansion of museums and offerings in schools and universities, another American critic the same year observed that "one of the curiosities of the political economy of the present time . . . is the rapid development which, in spite of long-continued business depression, has been given to the fine arts and the industries which are generated and fostered by their growth."[58]

By the 1880s the Aesthetic movement had so become the rage, with flowery figures like Whistler and Wilde, that it elicited some of the most extensive satire and parody ever to touch the arts. The alleged precious intricacies and excesses of the Queen Anne, the architectural corollary of the movement, did not escape enlightened critics' wit. In 1880 the *American Architect* illustrated "An Architectural Medley" that had been previously published in the *Builder*. The design, an obvious pun on the Picturesque and the Queen Anne, was intended as "a warning against the too free indulgence of individual whim, constituting, as it does, a gentle satire upon the designs, whereof it may be said 'Such labor'd nothings, in so strange a style, / Amaze the unlearn'd and make the learned smile.' "[59]

When Wilde embarked upon his ambitious coast-to-coast lecture tour of the United States and Canada in 1882, he addressed audiences in at least seventy-five cities, from Halifax, Nova Scotia, to San Antonio, Texas, who were generally well prepared for his celebration of art. After his lecture in New York City it was reported that a woman from Boston approached him and said, "Oh, Mr. Wilde, you have been adored in New York; in Boston you'll be worshiped." These were likely the same people whom Kenneth Clark thought had read Ruskin as "proof of the possession of a soul."[60]

Theory and Design of the New American Architecture

During the last three decades of the nineteenth century architects in the United States created a sophisticated style that remains one of the most original and American ever developed. In the United States, the Aesthetic and Arts and Crafts movements stimulated the development of a novel way of planning and of massing volumes, an unprecedented integration of architecture and interior design, and a new sense of the importance of domestic, vernacular, and indigenous architecture. This period also saw the birth of the conservation and preservation movements in architecture, landscape, and town planning, as well as the first signs of a conscious move toward aesthetic landscapes and towns.

ILL. 10.8 "A Study of Decorations and Furniture." Bruce J. Talbert. *Architect* (July 24, 1869). Art, Prints and Photographs Division, The New York Public Library, Astor, Lenox, Tilden Foundations

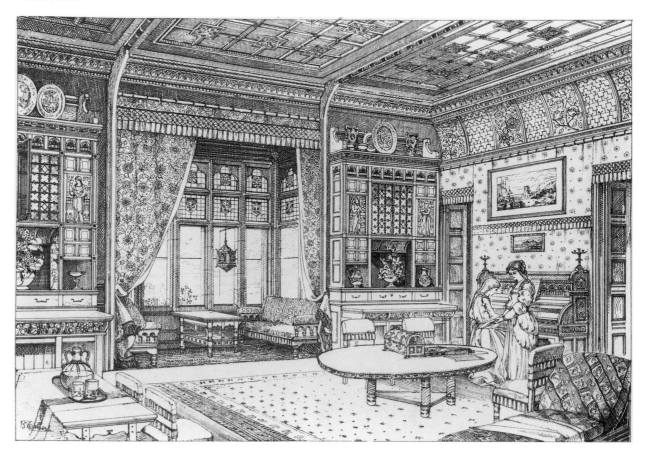

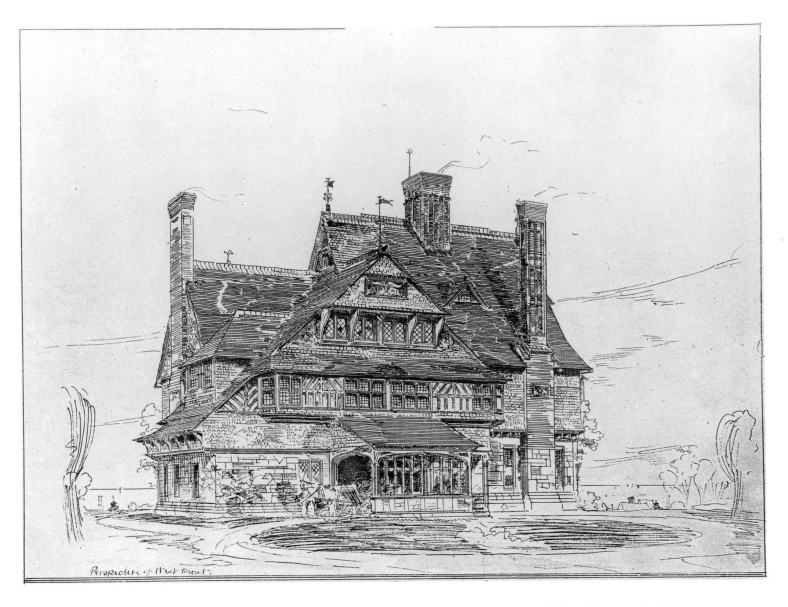

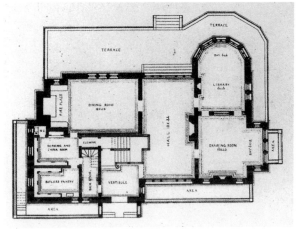

Above: ILL. 10.9 "Cottage at Newport for W. Watts Sherman, Esq." Designed by H. H. Richardson, drawing attributed to Stanford White, 1874. *New-York Sketch-Book of Architecture* (May 1875). Art, Prints and Photographs Division, The New York Public Library, Astor, Lenox, Tilden Foundations

Left: ILL. 10.10 William Watts Sherman house, Newport, R.I. (plan). H. H. Richardson, 1874. The Preservation Society of Newport County, Newport, R.I.

A NEW PLANNING AND MASSING OF VOLUMES

The most original contributions of American architecture of the Aesthetic era, seen especially well in the house, were a new open planning and a new way of massing volumes, the latter in part a consequence of the former. This change in the treatment of space and mass was what most greatly distinguished the American from the British movement, and its enormous effect on subsequent ar-

chitecture is still felt. It is also the characteristic of late nineteenth-century American architecture most difficult to account for. Open planning was certainly inspired by the English return to the medieval great hall in the 1860s, just as it was prompted by the relative openness of American seventeenth-century houses with the hall-parlor plan.[61] Perhaps the immediate stimuli were the houses Rich-

ardson began to design in the early 1870s, the open plan of the Chinese house (Fat Fau's house) illustrated by French architect Eugène Emmanuel Viollet-le-Duc (1814–1879) and reproduced in the *American Architect* in 1876,[62] and the open spaces of the Japanese and English buildings at the Philadelphia Centennial Exposition. The Froebelian building blocks Wright's mother acquired for him at the Centennial when he was a child supposedly provided the initial inspiration for the abstract qualities of his buildings. It is fitting that they came from the event that helped American architects discover the mode of planning and composing volumes without which Wright's architecture would have been inconceivable.

Americans were well aware of their achievements at the time. The reviewer of Holly's *Modern Dwellings in Town and Country* in 1878 considered the plans for his houses "nearly all ingenious— some of them exceptionally so . . . [with] large habitable halls well opened into the adjoining living rooms, stairs almost always very cleverly contrived with embayed and orielled landings. . . . [It is] a whole which is distinctly American and not English."[63] The term "living room" had not been in general use for long. Clarence Cook was among the first to use it in print. In 1875, in an article in *Scribner's Monthly,* he wrote, "I use the word 'Living-Room' instead of 'Parlor,' because I am not intending to have anything to say about parlors. As these chapters are not written for rich people's reading, and as none but rich people can afford to have a room in their houses set apart for the pleasures of idleness, nothing would be gained by talking about such rooms."[64] Living rooms soon replaced what had been called parlors and sitting rooms in the United States and Britain. By 1883 a majority of the architects submitting designs to the *American Architect*'s competitions were demarcating the largest space as the "living room." The term became universal in the $3,000-house competition during the summer of 1883 and from the pages of the *American Architect* traveled to Britain. Both the term and the spaces it was applied to suggest a desire for greater roominess and informality; that the term is still used is a tribute to the architects of the Aesthetic period.

By 1885 the quest for openness had reached such proportions that the American architect Ralph Adams Cram (1863–1942) felt the need to base an entire article on it. For Cram the revolution was "too vast."[65] He may also have considered the new style too "architectural." Critics in the 1880s were divided as to the merits of architects' being "archaeological," or governed by the forms of earlier work, versus their being "architectural" and seeking creative expression. Morris summarized the period's attraction to open interior spaces in *A Dream of John Ball* (1888):

The room we came into was indeed the house
For there was nothing on it but the ground floor
But a stairway in the corner led to the chamber or loft above.[66]

The new planning and massing of volumes eventually caused architects to think in terms of varying room heights and of levels rather than floors, areas rather than rooms, and movable partitions rather than walls. In addition, a new interrelationship between indoor and outdoor living spaces, enhanced by the use of exterior materials and features indoors, made a literal Colonial or Queen Anne revival impossible. Many of these characteristics are typical of Japanese houses and gardens, which must have influenced this development, possibly in part through the medium of the print. The generally complex volumes and masses produced by this open, free planning by area and level are not Japanese, but the horizontality the designs stressed—so different from the vertical emphasis of the High Victorian Gothic—might be. Rooms projected over porches; walls and roofs interlocked in amazing ways. Forms very much began to follow functions, and a variety of forms were used: circular, octagonal, and even irregular spaces joined more conventional squares and rectangles. One building might sport a combination of roof types, whether hipped, gable, or gambrel.

The architect who introduced these innovations in planning and massing, as well as other features of aestheticism in American architecture, was H. H. Richardson. The house Richardson designed for William Watts Sherman at Newport, Rhode Island, in 1874 (ILLS. 10.9, 10.10) is well recognized as the first clear indication of a quite new American style owing much to the British Queen Anne as well as to Stanford White, who was Richardson's assistant at the time and is credited with much of the interior design of the house (see ILL. 4.5). Richardson would have been familiar with works by Shaw and other British architects through his subscription to *Building News*. Kidney, who views Richardson as having been in "the forefront of the Aesthetic movement in America," considers the W. Watts Sherman house the American movement's "first Eclectic work."[67] Scully also agrees that this house "brought Queen Anne on American soil," but he sees it as Richardson's "only overtly Shavian house."[68] Richardson's reputation in his age is suggested by a poll conducted by the *American Architect* in 1885: voted among the ten finest buildings existing in the United States were five by Richardson, and his Trinity Church in Boston (1872–77) was ranked first, before the United States Capitol.[69]

The open plan of the W. Watts Sherman house and the non-Gothic horizontality of its complex exterior and interiors left their mark on the work of nearly every important American architect into the period of World War I. The pivotal location and monumental scale of the hall, with its masterful stair and hearth and exterior wall made almost entirely of glass, though probably indebted to Talbert, surpass Talbert's interior designs (see ILL. 10.8). The volumetrics of the exterior, though of the genre first used by Webb and Morris at Red House (see ILL. 10.1) and the result of a variety of stylistic influences, are an equal measure of Richardson's fresh and inventive approach. The W. Watts Sherman house also exhibits perfectly the new emphasis on the vernacular, on materials for their own sake, and on the integration of the fine and the decorative arts.[70]

The W. Watts Sherman house may be Shavian, but Richardson's Rectory of Trinity Church of 1879–80 (FIGS. 10.2–10.4, ILL. 10.11) is analogous to the comparatively simple and direct designs of Godwin. Its clean lines stand in sharp contrast to the relative busyness of the adjoining Victorian houses. Richardson masterfully overcame the narrow, tight site he was obliged to use for the Rectory as few High Victorian Gothic architects could have done. Only when one looks away from the house does one sense the narrowness of the lot. The gable treatment, the combined use of sash and casement windows, the embellishment of the hearths as expressed externally, and the bas-relief panels on the second floor identify the Rectory as a building of the period and of the Aesthetic movement. With such designs, Richardson, like Godwin, showed that the new manner was readily adaptable to buildings other than houses. Both the domestic and nondomestic idioms and both timber-frame and bearing-wall construction characterized the Aesthetic movement in American architecture.

With the impetus of Richardson's innovative work, the Centennial, and the many publications that appeared in the 1870s, the new style spread remarkably quickly. Until about 1875 Edward Clarke Cabot (1818–1901) and Francis W. Chandler (1844–1925) worked in a Victorian Gothic manner that Richardson never acquired. Inspired by aestheticism and Shaw's Leyswood, they began to abandon Victorian Gothic in 1876–77 for the Queen Anne. In their design of about 1877 for the H. A. Babbit house at Pomfret, Connecticut, they used a more open plan and Tudor detail. With the T. S. Perry house in Boston of about 1879 they fully embraced Queen Anne. One of the closest approximations attempted in the United States to Shaw's New Zealand Chambers was Cabot and Chandler's design of about 1880 for the offices of the Insurance Company of North America in Philadelphia (ILL. 10.12). Here

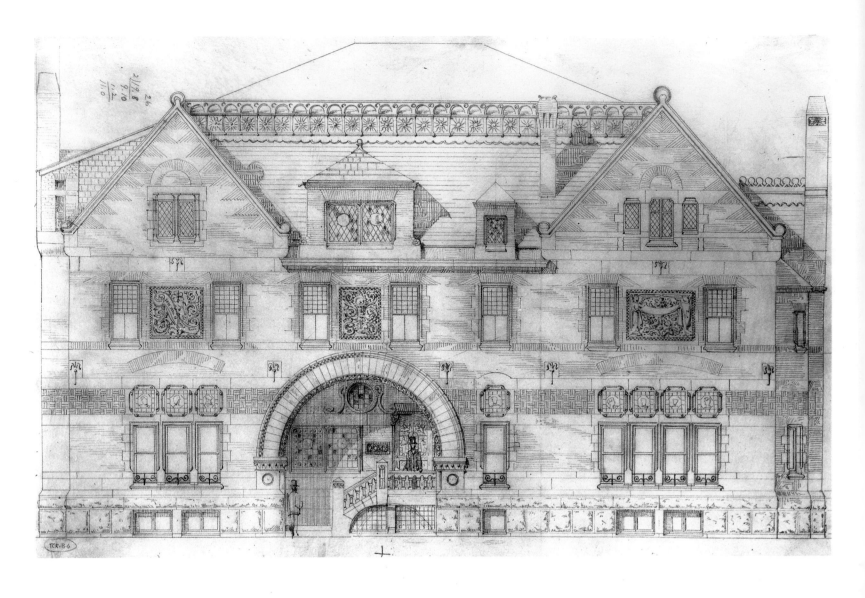

Above: FIG. 10.2 Study for Trinity Church Rectory, Boston. H. H. Richardson, 1879–80. Pencil on tissue, 13½ × 21 in. (34.3 × 53.3 cm). Houghton Library, Harvard University, Cambridge, Mass. (TCR. B–6)

Right: FIG. 10.3 "South Front Trinity Church Parsonage," Boston. H. H. Richardson, 1879–80. Ink on tracing cloth, 12½ × 10½ in. (31.8 × 26.7 cm). Houghton Library, Harvard University, Cambridge, Mass. (TCR. D–43)

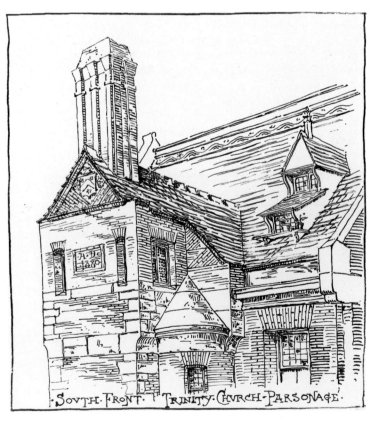

again is proof that the new mode was not confined to domestic or to wood architecture. The exterior perspective also shows Richardson's greater originality. Although competent, Cabot and Chandler's design has a certain Victorian Gothic heaviness and spottiness of detail. Nonetheless, the central motif of steep Queen Anne pediments and transomed bay windows with small panes dominates the facade.[71]

William Appleton Potter (1842–1909) and Robert H. Robertson (1849–1919), though younger than Richardson, like Cabot and Chandler retained a Victorian Gothic manner as late as 1876. The Victorian Gothic still prevailed in their designs for a hotel dormitory and seminary in Princeton, New Jersey, in 1876, but Robertson's design for a cottage at Seabright, New Jersey, the same year revealed some response to Queen Anne, and the tendency intensified in their commissions throughout 1877. In the C. H. Baldwin house they built at Newport in 1878, the strong imprint of the

Right: FIG. 10.4 "Study for Brick Panel–Rectory," Boston. H. H. Richardson, 1879–80. Ink on tracing cloth, 4 × 5 in. (10.2 × 12.7 cm). Houghton Library, Harvard University, Cambridge, Mass. (TCR. D–42)

Below: ILL. 10.11 "House on Clarendon St. Boston, Mass." (Trinity Church Rectory). H. H. Richardson, 1879–80. *American Architect and Building News* (May 3, 1884). Thomas J. Watson Library, The Metropolitan Museum of Art

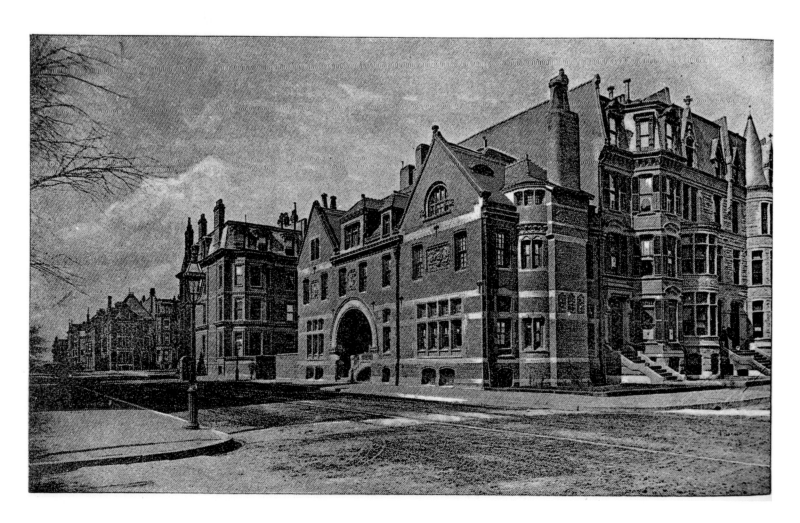

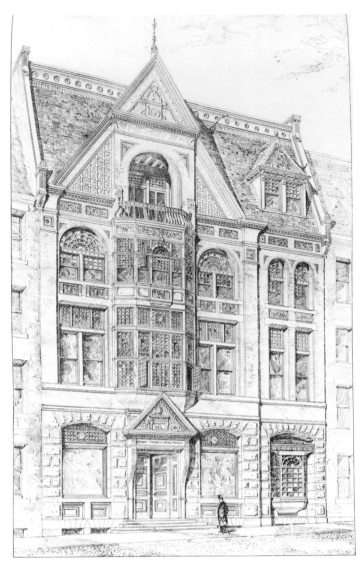

ILL. 10.12 "Design for New Offices for the Insurance Company of North America, Philadelphia, Pa." Edward Clarke Cabot and Francis W. Chandler. *American Architect and Building News* (July 31, 1880). Thomas J. Watson Library, The Metropolitan Museum of Art

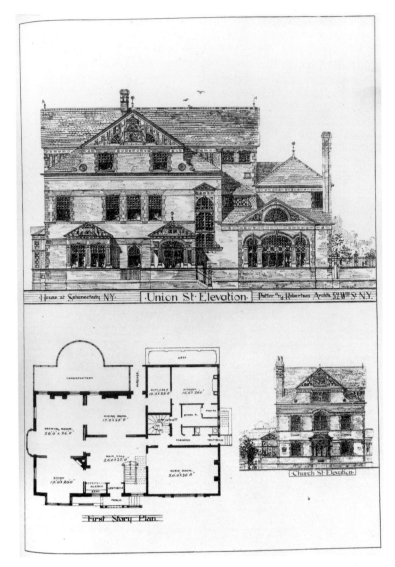

ILL. 10.13 "House at Schenectady, N.Y." William Appleton Potter and Robert H. Robertson. *American Architect and Building News* (Sept. 28, 1878). Thomas J. Watson Library, The Metropolitan Museum of Art

W. Watts Sherman house is unmistakable; this was perhaps the earliest American design to show both Queen Anne and Richardsonian influence.[72] Potter and Robertson emerged on their own terms, however, when they enlarged and redesigned a house in Schenectady, New York, in 1878 (ILL. 10.13). In the Schenectady house they incorporated Queen Anne features they might have seen earlier that year in a design submitted anonymously (as were all competition entries) in the *American Architect's* interior-decoration competition. "No. 2," as the design was called, appears to have been the most purely Queen Anne American design for a facade and interior the magazine had yet illustrated.[73] All the rooms on the first story of the Schenectady house open into one another and into the hall by means of broad sliding double doors, and the exterior, of red brick, is embellished with a steep, richly encrusted pediment, arched bays and porch, and a quintessentially Queen Anne tall, many-paned window on the stair landing, straight from Shaw. Though the facade by no means contradicts the plan, neither does it entirely reflect it: the bay in the study and the entry porch function and read differently on the plan but they are balanced on the elevation, and the slight projection of the music-room window

on the plan does not suggest the elaborate pedimented pavilion of the elevation.[74]

Like Potter and Robertson, Robert Swain Peabody and John Stearns (1843–1917) developed a Victorian Gothic mode, and they also worked in what Scully has called the Stick style.[75] Their commissions of early 1878, however, began to show a shift to a rather French version of the Queen Anne. Their admirable design for the Hemenway Gymnasium at Harvard University in 1878 brought Queen Anne to an American campus for the first time, not unexpectedly near Boston, where Queen Anne was best understood. Their design the next year for the Washington University School in Saint Louis (ILL. 10.14) carried the new manner a thousand miles westward. Both designs retain a vertical but somehow elegant proportion that is probably the result of Peabody's study at the Ecole des Beaux-Arts in Paris in the late 1860s. Neither reflects his intense interest at the time in American Georgian architecture.[76] Despite their sophistication, these two elevations, with their obvious Anglo-French overtones, make the overt period revivals of the late 1880s and the 1890s less a surprise.

The designs of William Ralph Emerson (1833–1917) represent

the American style of the 1870s better than those of any architect other than Richardson. Working largely in the Stick style before 1879, Emerson designed at least two houses that year in a Queen Anne mode: the T. R. Glover house in Milton, Massachusetts, and the C. J. Morrill house, Redwood, at Bar Harbor, Mount Desert, Maine (ILLS. 10.15, 10.16). Redwood is second only to the W. Watts Sherman house in manifesting the new manner before 1880, particularly with regard to the planning and massing of interior and exterior volumes. Its blend of Queen Anne, Colonial, and Shingle-style elements was approached after 1880 only by certain works of McKim, Mead and White and Wilson Eyre (1858–1944). Redwood also has the distinction of being one of the first buildings to be covered entirely with wood shingles, the American equivalent of British clay tiles. The uniform exterior material brings an added simplicity Richardson soon came to accept. The chamber above the porch recalls faintly similar seventeenth-century Colonial houses; the window at the stair landing perhaps resulted from Emerson's looking at Shaw's Ellerdale Road house (see ILL. 10.3). The interplay of volumes and of interior and exterior details in the hall, the most original feature of the house, reappears slightly later in the work of architects such as Eyre and Arthur Little. Emerson's

1881–82 design for the Boston Art Club (ILL. 10.17) shows a comparable ingenuity in massing that owes Richardson a debt but does not imitate him. Like Richardson's Trinity Church Rectory (see FIGS. 10.2–10.4, ILL. 10.11), the Art Club is neither Queen Anne nor Romanesque revival, but fully aesthetic: materials are employed for their own effect, and a number of stylistic traditions are muted and blended. One of the floral bas-reliefs on the facade is a particularly memorable instance of the use of the sunflower motif.[77]

By the late 1870s the aesthetic manner had matured in America. Charles Follen McKim (1847–1909), William Rutherford Mead (1846–1928), and Stanford White reveal this more clearly than any other architects of the period. McKim and White met in 1872 in Richardson's office in New York. McKim worked with Richardson from 1870 to 1872, when he left to form a loose partnership with Mead, also in New York, that William Bigelow joined soon after. White came to Richardson's firm in 1872. He played an important role in the design of the W. Watts Sherman house in 1874, and he may merit as much credit as Richardson for introducing Queen Anne in America. In 1878 White left for a year of travel in Europe. When he returned in 1879 the firm of McKim, Mead and

ILL. 10.14 "Sketch for Washington University School," Saint Louis. Robert Swain Peabody and John Stearns. *American Architect and Building News* (Sept. 6, 1879). Thomas J. Watson Library, The Metropolitan Museum of Art

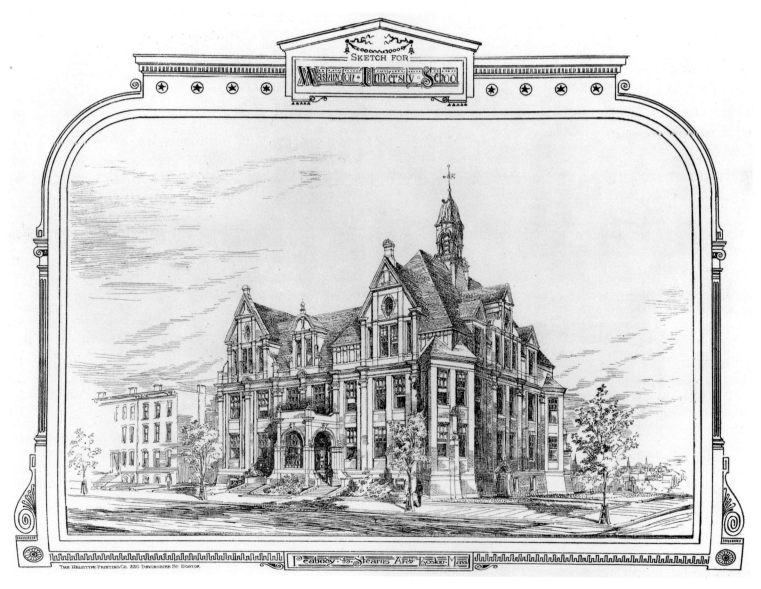

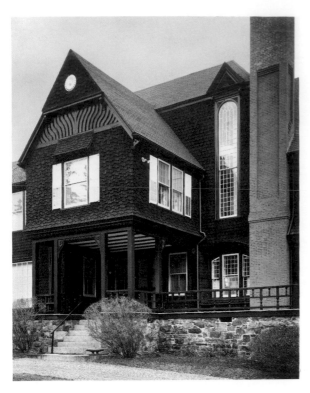

ILL. 10.15 Redwood, the C. J. Morrill house, Bar Harbor, Maine. William Ralph Emerson, 1879

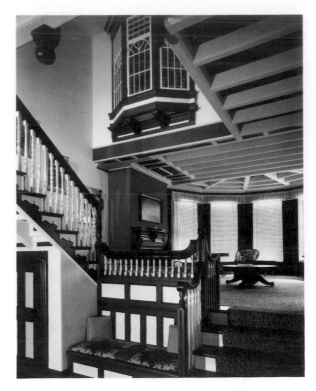

ILL. 10.16 Stairhall, Redwood, the C. J. Morrill house, Bar Harbor, Maine. William Ralph Emerson, 1879

White was established.[78]

The house McKim, Mead and Bigelow designed for Mrs. A. C. Alden on Fort Hill in Lloyd's Neck, New York (ILL. 10.18), shows how key the years 1878–79 were for developing a distinctly American manner. Overt Queen Anne features are much subdued, and there is nothing particularly Colonial about the elevations other than the simple, straightforward sense of massing derived from seventeenth-century houses such as those at Salem, Massachusetts. These American architects had truly attained an "absence of style." McKim, Mead and White's dashing Newport Casino, built between 1879 and 1881 (ILL. 10.19), shows that American architects had not only caught up with the British but overtaken them. The Casino should be compared to Shaw's Tabard Inn of the same date at Bedford Park. Girouard considers Shaw's Tabard group of old-fashioned inn, shop, and house in a row together "an extraordinarily clever design which sums up the essence of Bedford Park— its prettiness, its liveliness, and its preciosity."[79] Scully believes McKim, Mead and White's Casino to be "a remarkable building . . . [that] combines a sense of order by no means academic with a variety of experiments in picturesque massing and spatial articulation" and merges "Japanese and American stick-style sensitivities with that sweep of design which is typical of the shingle style."[80]

None of their contemporaries could match McKim, Mead and White's innovative employment of Queen Anne, Colonial, and Richardsonian features. And no house of the period surpassed the Isaac Bell, Jr., residence at Newport (ILLS. 10.20, 10.21) with regard to open, integrated interior planning. McKim, Mead and White designed the Bell house in 1882–83. A comparison of its plan with those of the W. Watts Sherman house (see ILL. 10.10) and Potter and Robertson's house in Schenectady (see ILL. 10.13) reveals the natural evolution toward more open, integrated planning.

The hall in the Bell house commands the plan both through its unrivaled spaciousness and through the superbly original and aesthetic handling of the mantel and surrounding paneling in the inglenook and adjoining stairway.

Designs by William A. Bates (1853–1922) show how the same type of open planning and ingenuity in massing volumes could be applied to a small row house in a town or to a hotel. In his 1880 design for a city house (ILL. 10.22) Bates eliminated the ubiquitous corridor for the sake of a library that not only extends the full width of the house but, with a semioctagonal corner bay window, projects beyond it. His design of about 1882 for a country hotel (ILL. 10.23), like McKim, Mead and White's Newport Casino, underscores the applicability of the new planning and massing, which was first evolved in single freestanding country houses, to types of buildings that the Gothic and classical revivals and utilitarian functionalism had stripped of all domestic allusions.[81]

This flexibility is even better demonstrated in some of the designs Carl Pfeiffer (1838–1888) created in the mid-1880s for large-scale apartment houses and hotels in New York City. The Berkshire at Madison Avenue and Fifty-second Street (ILLS. 10.24– 10.26) is a case in point. In a ten-story building, Pfeiffer cleverly retained all the accouterments of a house: open planning in individual apartments, integration of window bays and fireplaces by application of Queen Anne elements externally, and interior features readily traceable to Talbert. The scale of the undertaking, the originality of the planning, and the detailed thought given to the design of the interiors all bespeak an architect in fullest command of "total design" concepts.[82] Pfeiffer confirmed this in 1889 when he chose for the cover of his *American Mansions and Cottages* (ILL. 10.27) a series of well-painted vignettes in which members of the building trades perform their tasks, presumably with Morrisian joy.

Daniel H. Burnham (1846–1912), John Wellborn Root (1850–1891), and Louis Sullivan affirmed through their work that aesthetic impulses were not limited to architects practicing in the eastern United States. Burnham and Root, who formed their partnership in Chicago in 1873, worked in a Victorian Gothic mode until about 1882. That year, through influences from Richardson, the Queen Anne, and the Shingle style, a new manner emerged in their designs that was in advance of Sullivan's work at the time and can be credited mainly to Root, who was intensely interested in and knowledgeable about the arts and artists of the period. The Sidney Kent house of 1882–83 and the Edward A. Burdett house (ILL. 10.28) of 1885–86, both in Chicago, illustrate the change. The highly personal way he handled the Burdett facade is evidence of Root's thoroughgoing synthesis of Richardsonian and Queen Anne elements. The flat surfaces and crisp, taut lines eliminate blatant picturesqueness. Given the tight, restricted site, Burnham and Root's design of 1889–90 for Reginald de Koven's Chicago town house (ILL. 10.29) is a veritable tour de force of open planning. It is perhaps unrivaled in its openness and play of levels in so small a space. The entire first floor was really conceived as a single area as much defined by levels and partitions as by rooms.[83]

Sullivan did not entirely abandon the Victorian Gothic much before 1885. The Auditorium Building in Chicago (1887–89) and Sullivan's other later work probably owe as much to Root as to Richardson. His Saint Nicholas Hotel in Saint Louis (ILL. 10.30) reflects the Queen Anne idiom, though much less obviously than does the Berkshire by Pfeiffer. Indeed, both the Saint Nicholas and Sullivan's Masonic Temple in Chicago (1890–92) compare favorably with the Berkshire. Designed in 1892, two decades after Shaw's New Zealand Chambers—where it all began—the Saint Nicholas is a good index both of the continuing legacy of the Queen Anne and of the way in which Sullivan evolved his own individual style from it. Especially noteworthy is his use of bay windows to relieve the severity of the walls and to provide rooms with a variety of views as well as more air and light. The domestic parapeted gable roof is justified functionally by serving as a great hall complete with balconies. Sullivan's Wainwright Tomb in Saint Louis (1892) combines an ingenious medley of features tracing back to Roman and Palladian architecture and to the romantic-classical designs of German architect Karl Friedrich Schinkel (1781–1841) with the kind of ornamental "frosting" Owen Jones favored. Like Burnham and Root, Sullivan was not only a pioneer of modernism, he was also fully imbued with aesthetic eclecticism, wonderfully sublimated.[84]

ILL. 10.17 "Club House of the Boston Art Club." William Ralph Emerson. *American Architect and Building News* (June 3, 1882). Thomas J. Watson Library, The Metropolitan Museum of Art

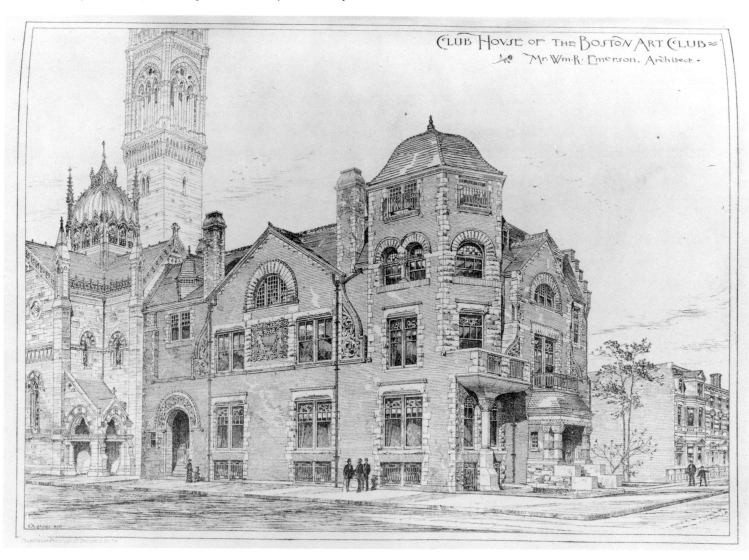

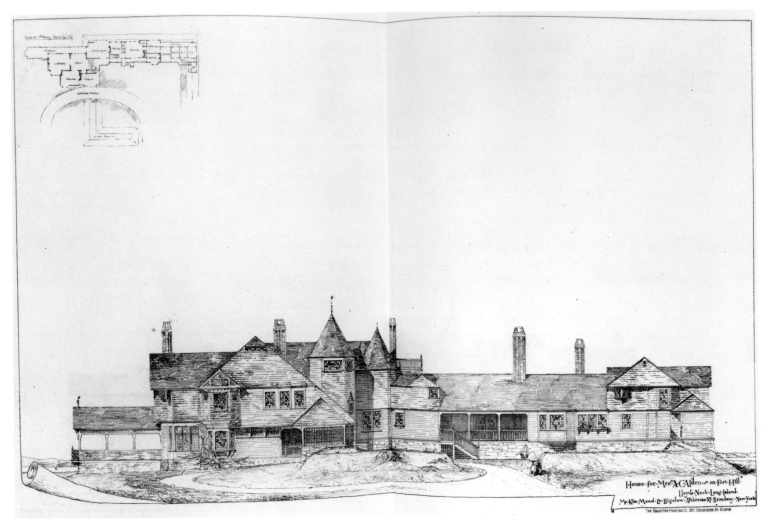

ILL. 10.18 "House for Mrs. A. C. Alden on Fort Hill, Lloyd's Neck, Long Island." McKim, Mead and Bigelow. *American Architect and Building News* (Aug. 30, 1879). Thomas J. Watson Library, The Metropolitan Museum of Art

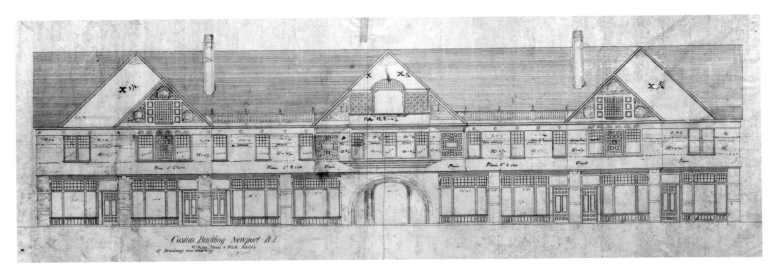

ILL. 10.19 "Casino Building, Newport, R.I." McKim, Mead and White, 1879–81. Ink and pencil on linen, 18¹/₁₆ × 54 in. (45.8 × 137.2 cm). International Tennis Foundation and Hall of Fame, Newport, R.I.

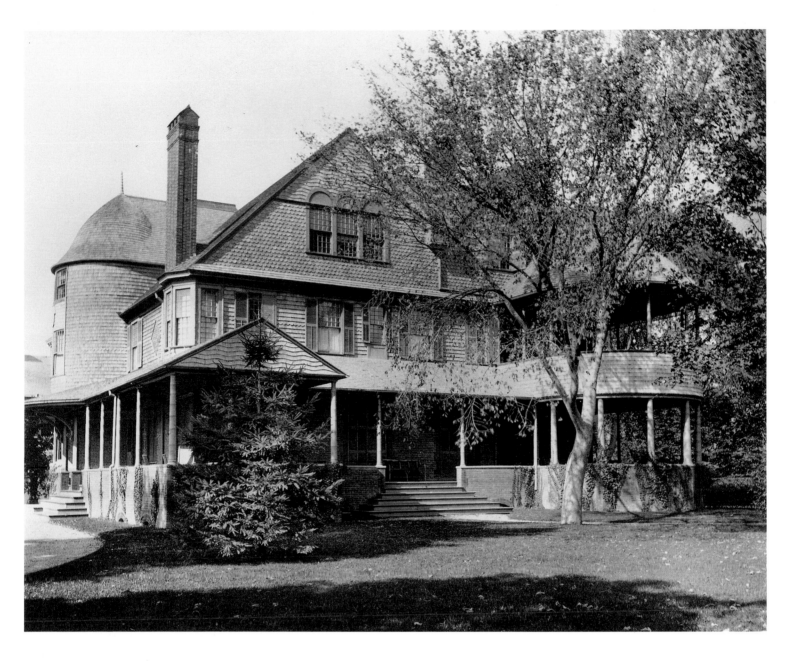

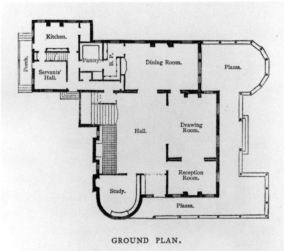

GROUND PLAN.

Above: ILL. 10.20 "Residence of Mr. Isaac Bell, Jr.," Newport, R.I. McKim, Mead and White, 1882–83. [George William Sheldon], *Artistic Country-Seats* (New York, 1886). Art, Prints and Photographs Division, The New York Public Library, Astor, Lenox, Tilden Foundations

Left: ILL. 10.21 "Residence of Mr. Isaac Bell, Jr.," Newport, R.I. (ground plan). McKim, Mead and White, 1882–83. [George William Sheldon], *Artistic Country-Seats* (New York, 1886). Art, Prints and Photographs Division, The New York Public Library, Astor, Lenox, Tilden Foundations

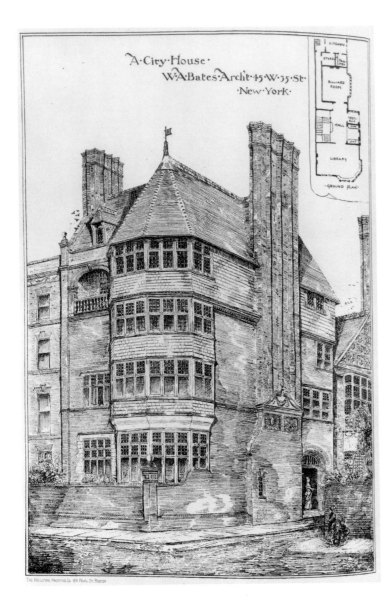

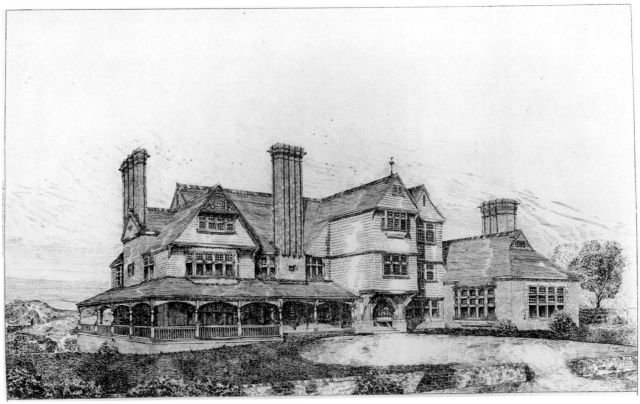

Inasmuch as many view the Aesthetic movement as having been primarily concerned with the decorative arts, the wish to increase the interrelationships between the fine and the applied arts and to elevate interior design to the status of a separate profession was intrinsic to the new architecture.[85] LOUIS COMFORT TIFFANY and ASSOCIATED ARTISTS, the decorating firm he formed in 1879 with CANDACE WHEELER and fellow painters SAMUEL COLMAN and LOCKWOOD DE FOREST, made tremendous contributions to the field in the United States, as did Stanford White and Wilson Eyre. In the decorative arts and interior design, however, Americans owed a great debt to the British, especially in the 1870s.

The American displays of home furnishings at the Centennial Exposition in Philadelphia in 1876 were severely indicted by many critics, who found them far from aesthetic. One reviewer pronounced some of the examples of American-made furniture so "contorted and agonized" he felt "like rushing away as from a nightmare." He preferred instead the simple Shaker chairs also shown at the fair, which were generically similar to Morris's Sussex chairs and to furniture designed by Godwin.[86] The critic who reviewed Holly's *Modern Dwellings in Town and Country* in the *American Architect* in 1878 found his sections on interior decoration and furniture meager. He considered HARRIET PRESCOTT SPOFFORD's *Art Decoration Applied to Furniture* (also published in 1878; see FIG. 2.3) the only American book that ranked with the superior works by the British, including Dresser, Talbert, and Eastlake.[87] When Talbert died in 1881 the *American Architect* carried a lengthy obituary in which he was called "a great man" and "the creator of an epoch" for his contribution to cabinetry and interior design beginning in the 1860s. "When young Talbert came to the front," the eulogy continued, "the only guiding star was Mr. Charles Eastlake's 'Hints on Household Taste,'—a volume theoretically useful, whilst practically unsatisfactory. . . . In designs by [Talbert] a fashion was set that for constructive correctness, beauty, and natural individuality, has not been equalled during this century."[88]

In an article defending Queen Anne design that the *American Architect* published in 1877, the British architect John McKean Brydon (1840–1901) wrote that in matters of interior decoration, "to no one . . . can greater honor belong than to the great art firm of Morris and Co."[89] From 1881 onward the *American Architect* regularly featured Morris's essays on the decorative arts. In introducing Morris's series of articles to readers the editor of the magazine called him "the greatest of living house decorators."[90] Morris, architectural student, painter, poet, scholar of Icelandic culture, perhaps left his greatest legacy in interior design. What he called for in interiors—exposed ceiling joists, naturally colored wood, "latticed" rather than plate-glass windows, rugs instead of carpets, and rich but controlled patterns on walls and furnishings—became hallmarks of the aesthetic house in Britain and the United States. "No room of the richest man," Morris warned, "should look grand enough to make a simple man shrink in, or luxurious enough to make a thoughtful man feel ashamed in."[91] Though imbued with Morris's socialist outlook, the statement speaks as strongly for visual restraint.

Influenced by Ruskin, Morris came to view ornament as the very soul of architecture. Yet in the hands of Morris and his contemporaries the decorative became constructive, the constructive decorative. Talbert's interior of 1869 (see ILL. 10.8) and White's drawing for the staircase and hall in the W. Watts Sherman house (see ILL. 4.5) exploit the new relationship: the intricately detailed windows, cabinetry, ceilings, and balustrades are as ornamental as they are functional. Van Brunt, in a series of articles entitled "Studies of Interior Decoration" that appeared in the *American Architect* in 1877, called attention to the "closeness of constructional and decorative work." Van Brunt reasoned that in order to obtain "perfect fitness" the decorative ought to proceed from the constructional. In *The Seven Lamps of Architecture* (1849) Ruskin had argued that the reverse was the case, but Van Brunt agreed with Ruskin that truth in construction was essential, that "the whole should constitute a unity," and that there should be "a harmony of forms and colors."[92]

The rooms designed by Morris and Webb (see ILL. 10.2) and by Talbert (see ILL. 10.8) in the 1860s were the first to show the impact of the Aesthetic movement. That they remained most representative of its effect is confirmed when one compares them with the interior of the W. Watts Sherman house (see ILL. 4.5), with Pfeiffer's designs for the apartments in the Berkshire (see ILL. 10.26), and with Potter and Robertson's dining room in the James A. Burden house, built in Troy, New York, about 1880 (ILL. 10.31). Particularly noteworthy in Potter and Robertson's design is the elaborate overmantel that unifies the fireplace wall, extending to surmount the doors that give access to twin inglenooks furnished with built-in benches and large "aesthetic" windows. This type of interior reached its apogee in 1880–81 when White designed the dining room in Kingscote, the Newport house of David King III (see ILLS. 4.15, 4.16). This masterpiece, with its Tiffany glass, is probably the finest interior created in the United States in the period. The room is purely a consequence of the Aesthetic movement, and it defies all other attempts at stylistic categorization. The sublime abstracting of architectural elements, such as ceiling beams, "mantelpiece," window mullions, and tilework, absolutely weds the decorative and the constructive. The "mantelpiece" sweeps around the room, integrating window and wall. A comparison of White's room with Morris and Webb's Refreshment Room (see ILL. 10.2) is instructive of the distance traveled.

Though owing much to the precedents set by Morris, Webb, and Talbert, the Kingscote dining room's proto-modernist character is unmistakable, influenced as it undoubtedly was by Japanese design. Its simplicity and the abstract lines of the design are rivaled only in certain interiors by Godwin. Generally devoid of the intricate, flat patterning covering most surfaces in the rooms already considered, Godwin's interiors were more in keeping with his first, more severe elevation for the Miles house (see ILL. 10.4). They reflect his admiration for Japanese rooms like those Morse illustrated in *Japanese Homes and Their Surroundings* (see ILL. 10.7). Although such "undecorated" interiors were rare in the late nineteenth century, they too were products of aestheticism. It was this second type of interior Shaw came to prefer to the more elaborate rooms Morris favored—a case of the architect, Shaw, asserting his hand over the decorator, Morris. In the eclectic and often contradictory Aesthetic movement there was not always consensus, even among its originators. Shaw and Morris may have shared artistic aims early on, but by 1880 they differed considerably as to what constituted good design.[93]

A possibly third type of aesthetic interior, also quite "architectural" but featuring period elements such as bay windows, is well viewed in those by Emerson. At Redwood, for example (see ILL. 10.16), Emerson demonstrated how ceiling beams, windows, balustrades, and paneling can in and of themselves supply a decorative quality to an interior without losing any of their architectural properties. Eyre managed a comparable effect about 1881 in the interior of Anglecot, the Charles A. Potter house in Chestnut Hill, Pennsylvania (see ILL. 10.38), but by the use of sideboards, cabinets, and other elements that read as furniture, not architecture. Also of this "architectural" genre is the powerful dining room Burnham and Root designed in 1885–86 for the E. E. Ayer house in Chicago (ILL. 10.32). Though it does not outshine White's brilliant design for the dining room in Kingscote, the Ayer room also ranks among the finest interiors produced by American architects sympathetic to the goals of the Aesthetic movement. It is as monumental, restrained, and reposeful as anything Richardson himself created; Morris's words had their effect more than his works. The handling of the ceiling beams is particularly original and aesthetic—are they

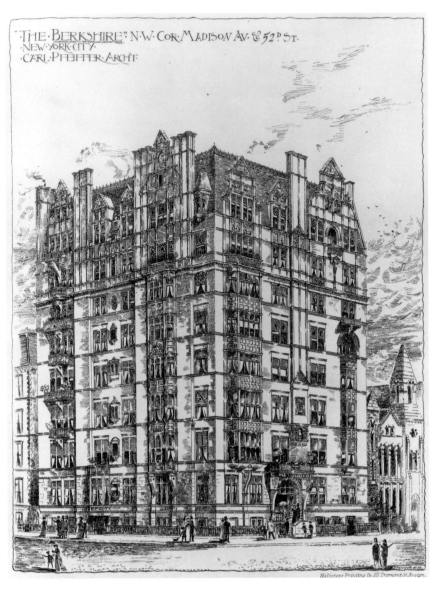

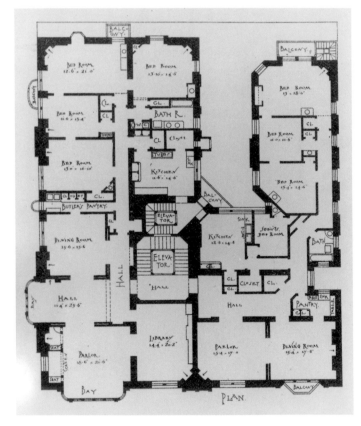

Above: ILL. 10.24 "'The Berkshire' New York City." Carl Pfeiffer. *American Architect and Building News* (Aug. 4, 1883). Thomas J. Watson Library, The Metropolitan Museum of Art

Right: ILL. 10.25 "One of the Corner Apartm'ts of 'The Berkshire,'" New York (plan). Carl Pfeiffer. *American Architect and Building News* (Aug. 4, 1883). Thomas J. Watson Library, The Metropolitan Museum of Art

structural, decorative, or both?

Features from all three of these types of aesthetic interiors, as well as from a fourth, usually associated with decorators rather than architects and embellished with Moorish, Indian, Japanese, or other exotic details, appear in the rooms decorated by Tiffany and Associated Artists. Like many other architects, artists, and designers of the aesthetic generation who moved from one discipline to another, Tiffany was drawn to the applied arts after an early career as a fine artist, turning from painting to interior design much as Morris had. In 1879 he told Candace Wheeler, "I have been think-ing a great deal about decorative work, and I am going into it as a profession. I believe there is more in it than in painting pictures."[94] Associated Artists' commission to decorate the state rooms in the White House in 1882 signaled the victory of the Aesthetic movement in the United States.

The parlor in Tiffany's own apartment in New York had a quite Japanese flavor, but the hall had a rusticity somewhat anticipating the buildings Bernard Maybeck (1862–1957) designed in California at the turn of the century. (Other rooms in Tiffany's apartment are shown in ILLS. 4.12, 9.12.) Some of the characteristics of the superb

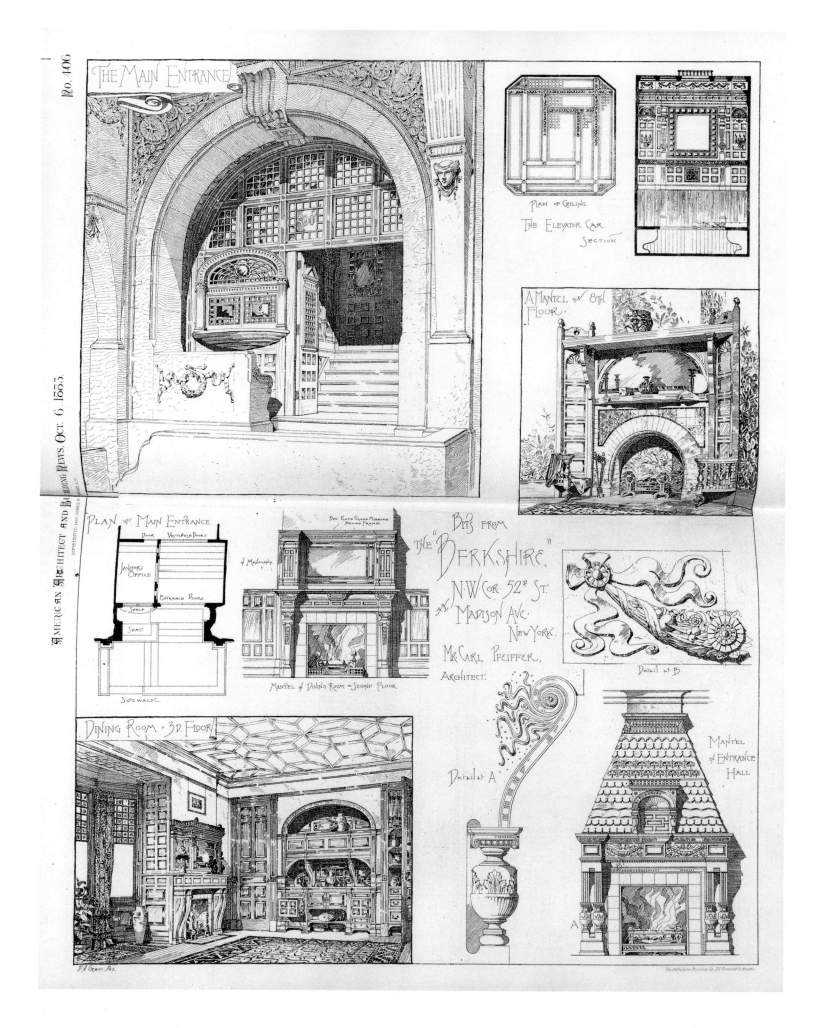

No. 406

THE MAIN ENTRANCE

PLAN OF CEILING

THE ELEVATOR CAR
SECTION

A MANTEL ON 8TH FLOOR.

AMERICAN ARCHITECT AND BUILDING NEWS. OCT. 6. 1883.

PLAN OF MAIN ENTRANCE

DOOR VESTIBULE DOORS

JANITOR'S
OFFICE

ENTRANCE DOORS

SHELF
SEAT

SIDEWALK

BEV. PLATE GLASS MIRROR
BRASS FRAME.

of Mahogany.

MANTEL of DINING ROOM ~ SECOND FLOOR

BITS FROM
THE "BERKSHIRE"
N.W. COR. 52d ST.
Madison Ave.
New York.
MR. CARL PFEIFFER,
ARCHITECT.

Detail at B.

DINING ROOM 3D FLOOR

Detail at A

MANTEL
in ENTRANCE
HALL

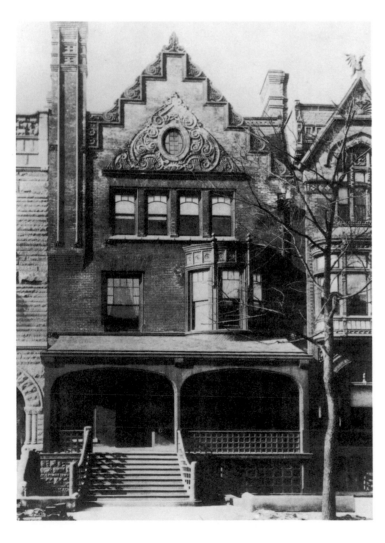

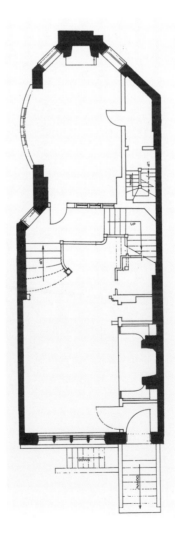

Left: ILL. 10.27 Cover design for *American Mansions and Cottages*. Carl Pfeiffer, 1889. Oil and pen and ink on paper, 28 × 22½ in. (71.1 × 57.2 cm). Avery Architectural and Fine Arts Library, Columbia University, New York

Below left: ILL. 10.28 Edward A. Burdett house, Chicago. Daniel H. Burnham and John Wellborn Root, 1885–86. Donald Hoffmann, *The Architecture of John Wellborn Root* (Baltimore, 1973)

Below right: ILL. 10.29 Reginald de Koven house, Chicago (plan). Daniel H. Burnham and John Wellborn Root, 1889–90. Donald Hoffmann, *The Architecture of John Wellborn Root* (Baltimore, 1973)

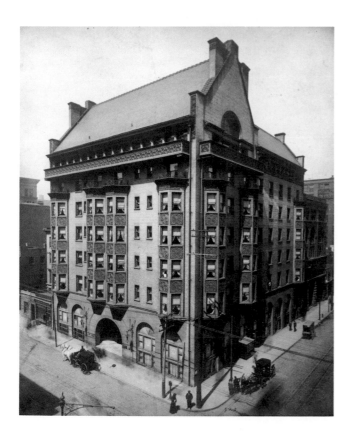

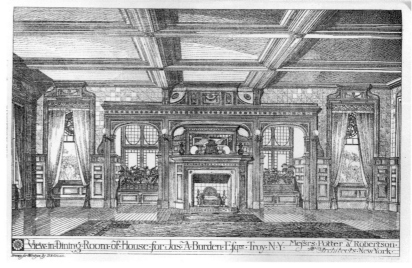

Above: ILL. 10.31 "View in Dining Room of House for Jas. A. Burden, Esqre., Troy, N.Y." William Appleton Potter and Robert H. Robertson. *American Architect and Building News* (Feb. 7, 1880). Thomas J. Watson Library, The Metropolitan Museum of Art

Left: ILL. 10.30 Saint Nicholas Hotel, Saint Louis. Louis Sullivan, 1892–93

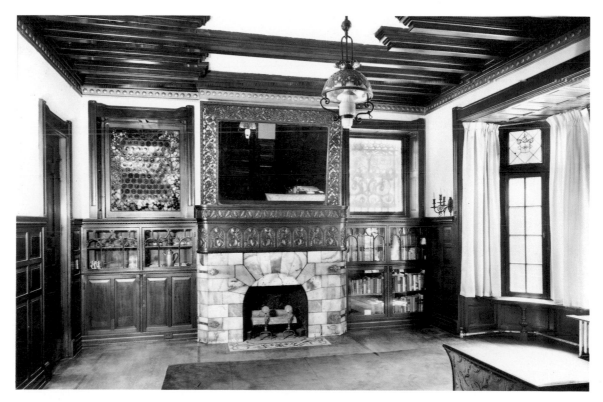

ILL. 10.32 Dining room, E. E. Ayer house, Chicago. Daniel H. Burnham and John Wellborn Root, 1885–86

library Tiffany designed for the Seventh Regiment Armory in New York in 1879–80 (see also ILLS. 4.13, 4.14) recall Morris and Webb's Refreshment Room. Eventually, Tiffany turned to architecture. With White he designed the Tiffany mansion in New York City (1884), an excellent example of the muted eclecticism of the architecture of the Aesthetic movement. The window in the gable, for instance, had a Palladian form but Tudor mullions, and Tiffany and White freely mingled Richardsonian, Queen Anne, Colonial, and Beaux-Arts features in their design, but the massive stonework overpowered all. In the dining room Tiffany created for Laurelton Hall, his own home in Oyster Bay, New York (1902–4), he carried forward the abstract, simplifying qualities of White's dining room in Kingscote. Laurelton Hall, which was destroyed by fire in 1957, was peerless as a late effort to achieve the aesthetic in the United States, with more analogies to the Palais Stoclet that Josef Hoffmann (1870–1956) designed in Brussels in 1905 and to German interest about 1900 in houses for *Kunstfreundes* (lovers of art) than to anything American.[95]

Many of the leading architects of the Aesthetic movement in America agreed with the author of "Red Brick in Architecture," published in the *American Architect* in 1880, who echoed Ruskin's and Morris's belief that ornament was essential to architecture but went on to say that ornament was "not well placed if in too great profusion."[96] The very emblems of aesthetic exteriors are those distinctive and carefully placed stone, plaster, or terracotta[97] bas-reliefs that grace Richardson's Trinity Church Rectory, Emerson's Boston Art Club, Bates's design for a town house, Burnham and Root's Burdett house, Eyre's Anglecot (see FIG. 10.4, ILLS. 10.17, 10.22, 10.28, 10.37), and myriad designs by Sullivan. Such reliefs are normally not possible on wood houses, where a variety of materials and colors offered another kind of rich embellishment. A house Emerson built at Bar Harbor "for a Baltimorean" was called "the house with the golden roof, the body of which looks like mahogany" and "a monument to mark the beginning of a new period in exterior house decoration" by a writer in the *American Architect* in 1881. "To Mr. Emerson," the writer professed, "we

FIG. 10.5 "Design No. 22. Street Scene." Hazelhurst and Huckel. Color lithograph, 11 × 14 in. (27.9 × 35.6 cm). Harrison Brothers and Company, *Practical Illustrations of Various Combinations of Harrisons' "Town and Country" Ready Mixed Paints* (Philadelphia, 1885/86). Avery Architectural and Fine Arts Library, Columbia University, New York

ILL. 10.33 Fresco design. Louis Sullivan, 1873. Ink on tracing paper, 6¾ × 6½ in. (17.1 × 16.5 cm). Avery Architectural and Fine Arts Library, Columbia University, New York

FIG. 10.6 Fresco border. Louis Sullivan, 1875. Ink on tracing paper, 10⅜ × 16⁵⁄₁₆ in. (26.4 × 41.4 cm). Signed: *Fresco border / Louis H. Sullivan to John H. Edelman / Paris April 1st 1875.* Avery Architectural and Fine Arts Library, Columbia University, New York

owe a great deal, not only for the introduction of the 'English Domestic' style . . . but because he has dared to use colors which required confidence and knowledge. . . . The new house at Bar Harbor . . . is covered with shingles of all shapes and lengths, and this is to be stained with . . . golden yellow melting itself into a citron, Vandyke brown, and burnt sienna, . . . an effect often seen in an artist's study of a brilliant sunset."[90] Books such as *Model Homes* (1878), *American Cottage Homes* (1878), and *New Cottage Homes and Details* (1887), all by George and Charles Palliser, popularized color schemes like the one Emerson used at Bar Harbor. The Pallisers recommended, for example, that one house be painted "green drab" on the first story and "old gold" on the second, with "sage green" and "Indian red" trim.[99] By 1885 the use of rich and varied colors on exteriors had become sufficiently fashionable that paint companies were employing architects to illustrate their trade catalogues. That year the Philadelphia architectural firm HAZELHURST AND HUCKEL created Bedford Park–like scenes to advertise Harrison Brothers and Company's "Town and Country" Ready Mixed Paints (FIG. 10.5). Each scene was repeated in the Harrison catalogue to show different combinations of "aesthetic" colors.

Though Sullivan embraced the new manner later than any other architect so far discussed, this possibly permitted him to take it farther, especially with regard to ornament, interior design, and furniture. Deeply rooted in the theories of Owen Jones, Ruskin, and Morris, Sullivan's ornamental designs are probably more extensive and more intensely personal than those of any other American architect associated with the Aesthetic movement. The five Sullivan designs illustrated here date from 1873 to about 1890 and span the course of the movement itself. They exemplify the dialogue between the mechanical and the organic that was the underlying theme in Sullivan's ornament, as in his architecture. The organic ultimately dominated in Sullivan's work, but the mechanical, or geometric, was rarely absent. His sketch of 1873, possibly for a fresco (ILL. 10.33), shows the linear stylization typical of his later designs and suggests his debt to Owen Jones and to Philadel-

phia architect FRANK FURNESS, with whom he worked for a few months in 1873. The flowers could well be sunflowers. Sullivan's tendency toward abstraction had intensified by 1875 when, in Paris, he designed a series of alternating plant forms (FIG. 10.6) so delicately linear and stylized they can be considered an early source for Art Nouveau. The larger motif may have been based on an Egyptian fresco showing papyrus; the smaller one may be a conventionalized flower, much farther removed from its botanical source than are the blossoms in the fresco design of two years before.[100]

By about 1882, when he did a study for the capital of a porch column (ILL. 10.34) for the Marx Wineman house in Chicago, Sullivan's style had matured, both intrinsically (the drawing is recognizably his) and extrinsically (his ornament is given concrete and classical architectural application). With the carved cherry door panel (FIG. 10.7) created about 1885 for the Samuel Stern house, also in Chicago, Sullivan had moved from ornamental studies to executed designs. The composition is more complex, and a new balance of the geometric and the organic is evident. The organic had begun to dominate, however, in the ornamental frame (FIG. 10.8) he designed about 1890 for the Seattle Opera House (a project that was never realized). Showing Tiffany's influence, the elaborate sculptural frame appears to have been conceived as a regular sequence of repeating geometric motifs that in the bottom corners metamorphose into organic forms. The sculpture is not simply a frame for the pastoral landscape it encloses, but an integral part of the composition. Such work established Sullivan as the archetype of the aesthetic architect as interior designer and inventor of ornament.[101]

DOMESTIC, VERNACULAR, AND INDIGENOUS ARCHITECTURE AND THE BIRTH OF THE PRESERVATION MOVEMENT

In his writings as in his work, Sullivan monumentalized themes of central concern to the aesthetic architect. Drawing on a tradition of anti-industrialist sentiment that can be traced back to the eco-

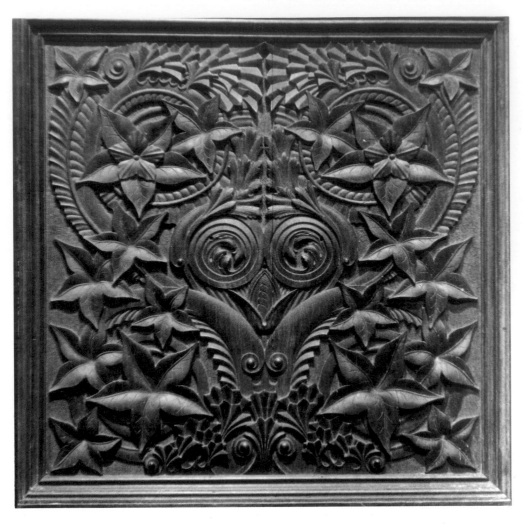

FIG. 10.7 Door panel. Louis Sullivan, ca. 1885, for the Samuel Stern house, Chicago. Cherry, 27¾ × 28 in. (70.5 × 71.1 cm). Louis H. Sullivan Architectural Ornament Collection, Southern Illinois University at Edwardsville

nomic, sociopolitical, and cultural revolutions of the late eighteenth century, he called for "a social fabric squarely resting on man's quality of virtue as a human being. Such a civilization shall endure, . . . for it shall have a valid moral foundation, understandable to all. . . . Work will be done with a living purpose, and the powers of mankind will be utilized to the full, hence there shall be no waste."[102]

A respect for domestic, vernacular, and indigenous architecture and a hope that good design could be had by all were natural outgrowths of the democratic societies that exponents of the Aesthetic and Arts and Crafts movements were attempting to enhance in England and America.[103] Ruskin and Morris expounded repeatedly on the vernacular and democratic themes; both preferred cottages to castles, and Morris liked barns more than he did cathedrals. "One art for the rich and another for the poor?" Morris once asked, and answered himself, "No it won't do."[104] A regular column in the *American Architect,* "American Vernacular Architecture," took note of the many books on modest houses that began to appear in the 1870s. S. B. Reed's *House-Plans for Everybody,* reviewed in 1878, was merely the "latest exposition of the Vernacular Architecture."[105] The reviewer who praised *Modern Dwellings in Town and Country* that same year remarked that even though Holly considered the Queen Anne "the only prospect of a healthy advance in our domestic architecture," he had managed to avoid its "pitfalls" and had produced designs that were "plainly a development of the vernacular."[106]

Seeking the commonplace and the unpretentious, Americans began to look, for the first time, at their earlier architecture, and it was in their Colonial inheritance that they found the requisite attributes. Nearly everyone who wrote on behalf of Colonial architecture in the *American Architect* urged its preservation and considered it a body of work that could be learned from: it was mainly domestic, vernacular, and indigenous, and it was well crafted and straightforward. Moreover, it was the only American architecture there was before the revivals of romanticism that began in the late eighteenth century. In 1878 Peabody praised Colonial buildings for their "disciplined and almost universal refinement and dignity, as well as the absence of vulgarity or eccentricity,"[107] the very qualities Kerr had advocated in 1864 in *The English Gentleman's House.*

Calling attention to the need to preserve American Colonial architecture was a main theme of the *American Architect* from the start. In its first twenty years the journal published more than two hundred articles, reviews, notes, and illustrations on the subject.[108] The campaign to preserve began, appropriately enough, in 1877 with an article by the British architect John J. Stevenson (1831–1908) entitled "Architectural Restoration: Its Principles."[109] The same year, in London, Morris, Webb, and others formed the Society for the Protection of Ancient Buildings (dubbed Anti-Scrape in England), the first such organization in an English-speaking

Above: ILL. 10.34 Design for a capital for a porch column. Louis Sullivan, ca. 1882, for the Marx Wineman house, Chicago. Pencil on drawing paper, 24⅞ × 28¹¹⁄₁₆ in. (63.2 × 72.9 cm). Avery Architectural and Fine Arts Library, Columbia University, New York

Right: FIG. 10.8 Design for an ornamental frame. Louis Sullivan, ca. 1890, for the Seattle Opera House. Pencil on tracing paper, 20⅞ × 19¾ in. (53 × 50.2 cm). Avery Architectural and Fine Arts Library, Columbia University, New York

country and the prototype for American groups like the Association for the Preservation of Virginia Antiquities and the Society for the Preservation of New England Antiquities, founded in 1889 and 1910, respectively. Morris was quoted in the *American Architect* on two occasions in 1879, on the debate in England over whether to restore churches and on the restoration of the cathedral of Saint Mark in Venice, the building that had so moved Ruskin in the 1850s. As did Ruskin, Morris strongly opposed efforts to restore; "protection" from restoration was his platform.[110] The AIA urged American architects to ferret out and record noteworthy early American buildings. The response came, and by 1881 the *American Architect* was regularly illustrating important Colonial buildings, such as the Jonathan Fairbanks house built in Dedham, Massachusetts, about 1638, with photographs and measured plans.[111]

William B. Rhoads has analyzed in great detail the awakening of interest in Colonial architecture and the initial view of it as the indigenous American equivalent of the British Queen Anne. He considers that Little "began the flow of Colonial design books" with *Early New England Interiors* in 1878.[112] Rhoads places more emphasis on the revival aspects of that interest, however, than on the efforts to preserve the Colonial and to use it as a stimulus for a new architecture. The Colonial revival only gained momentum in the late 1880s, when the influence of the Aesthetic movement had begun to wane and the Arts and Crafts movement had yet to mature in Britain and the United States. Nevertheless, the study and preservation of Colonial buildings were always entangled with a new appreciation of them, an appreciation that, as the authors of a report to the AIA noted in 1881, "led architects to apply to modern buildings [their] details and principles of construction." The same committee spoke out against outright revival of Colonial design:

> Let us therefore study the principles that shaped and guided the architecture of the colonial period and the first fifty years of American independence, not merely to find quaint details to copy in modern work and then unblushingly christen those works Queen Anne or Georgian . . . [but rather to] elicit data which . . . well sifted will reward us with an insight into the causes which led to the adoption of forms of construction which we now admire.[113]

Brydon agreed, and though his words might today be mistaken as a plea for revival, he was clearly encouraging Americans to preserve and study Colonial architecture rather than to revive or restore it: "If ever America is to become possessed of an historical style, it must spring from the work of the old colonists. You have good brick, you have splendid timber, you have the practice of timber-constructed houses; only waiting the artist's hand to carve out a style of your own. Preserve then your old colonial architecture, and it may yet bring forth fruit of which all the world of art may be proud."[114]

Richardson's house of 1874 for William Watts Sherman (see ILL. 10.9), as has already been noted, was probably the earliest American building to possess nearly all the essential features of the new style. This was especially true with regard to its domestic, vernacular, and indigenous character. It looks like what it is: a house, not an abbey or a temple. The rich variety and texture of the finely crafted materials overpower any stylistic allusions, the proportion and interplay of the gables are reminiscent of seventeenth-century Massachusetts houses, and it is difficult to find any overtly Queen Anne features. Emerson's Redwood (see ILL. 10.15), with its porch chamber and shingle-clad exterior, reinforced the Colonial connection and Americanness.

Indicative of the spread of the Aesthetic movement to the populace by the late 1870s were the builders' books that had by then embraced its principles. The books the Pallisers published between 1878 and 1888 were among the best, offering plans and elevations for skillfully designed houses (ILL. 10.35) in the vernacular mode Richardson had established with the W. Watts Sherman house. Whether for small, inexpensive cottages or town houses or for large, costly country homes, all of the Pallisers' designs were of comparable artistic and structural quality. Inspired perhaps by Bedford Park or by McKim, Mead and White's Newport Casino, the Pallisers often linked their houses together by means of porte cocheres and porches to create, in effect, multiple dwellings that were more adaptable to an urban setting. In 1884 the *American Architect* reported that the Pallisers had purchased the 150-acre Harriman estate in Irvington-on-Hudson, New York, to be laid out as a park with fifty stone mansions.[115]

Even more so than the Pallisers' designs, the semidetached houses Bruce Price (1845–1903) built at Mount Auburn near Cincinnati in 1885 (ILL. 10.36) showed how the idea of the aesthetic country house could be used successfully for town houses in the Bedford Park manner, but with allusions to seventeenth-century American vernacular architecture. Price practiced architecture from the early 1870s. He was about the same age as Potter and Robertson and Peabody and Stearns, but he did not entirely cast off his Victorian Gothic and Stick-style modes until the early 1880s. Price expressed his own keenly aesthetic goals when he observed that "this growing taste for country life, coupled with the increased knowledge and higher cultivation of our intelligent people in all matters pertaining to art, has given the architect of to-day a great opportunity to raise the structure of an American style."[116] With his designs for Tuxedo Park, New York, in 1885–90 (see ILL. 10.40) Price perhaps came closest of all the architects of his generation to shaping a vernacular, style-free mode of design. During the Aesthetic period he was for dropping the word "style" from architects' practice.[117]

Price, like McKim, Mead and White, abandoned the aesthetic mode after 1890 and turned his back on the effort to "raise an American style." In the work of Wilson Eyre the Aesthetic movement flowed naturally into the Arts and Crafts, carrying the new style into the period of World War I. Eyre, as Edward Teitelman has said, managed to merge "the simplicity and straightforward craftsmanship of the Pennsylvania farmhouse, the sometimes awkward Philadelphia Georgian, the Arts and Crafts, and the then current Anglo-American eclecticism with a personality and wit that was as extraordinary as his skill as a delineator and artist."[118] Eyre's numerous trips to Britain (where he often sketched English villages), his role in forming the T-Square Club in Philadelphia in 1883, and his forays into the applied arts with designs for furniture, wallpaper, and posters all evince his support for the tenets of the Aesthetic movement. Moreover, Eyre was perhaps the only architect of the period who fully matched McKim, Mead and White not only with his mastery of the vernacular and open planning but also with his highly personal designs for interiors. His many fine watercolors and drawings stand as works of art in their own right. Revealing yet another facet of his talents, he founded *House and Garden* in 1901 and served as editor of the magazine until 1905.

Basically self-taught, Eyre joined the firm of James P. Sims in Philadelphia in 1877. After Sims died in 1882 Eyre assumed control of the practice, and he ran it on his own until he was joined by John G. McIlvane in 1912. Eyre's distinctive style emerged full-blown about 1881 with Anglecot (ILLS. 10.37, 10.38). Anglecot and houses like the one Eyre created for Richard L. Ashurst in Overbrook, Pennsylvania, about 1885 affirm his unique blend of English and American elements. His town houses, including the Wistar house in Philadelphia (1891), show how subtle the "red brick" style became in his hands. The hotel (now destroyed) he built at Bay Head, New Jersey, in 1893 was unsurpassed for its complex, convoluted, but still successful use of the full gamut of shed and gabled dormers in the roof—the entire design unified by shingles.

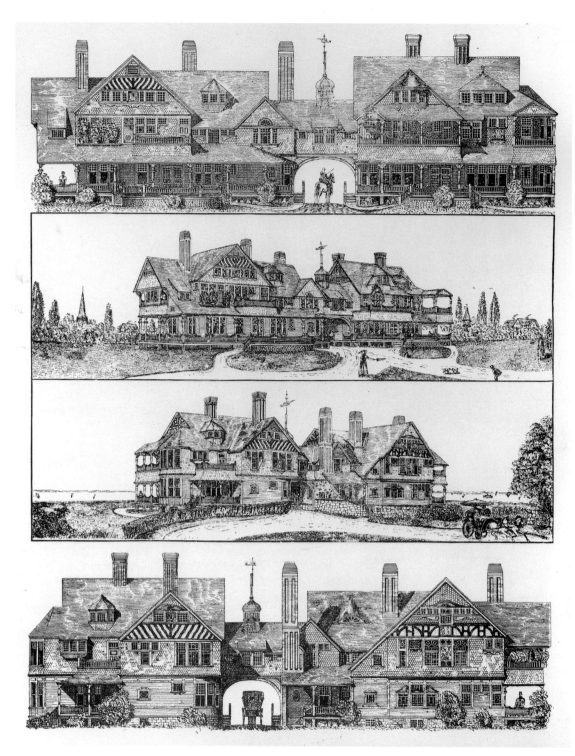

ILL. 10.35 "Designs 89 and 90." [George Palliser and Charles Palliser], *Palliser's New Cottage Homes and Details* (New York, 1887)

Few historians would dispute Eyre's influence on the so-called Philadelphia School, which included Edmund Gilchrist, Walter Mellor, Arthur Meigs, and the young George Howe. Beginning in the late 1880s Eyre's work and that of the other American architects discussed in this chapter also inspired a budding generation of British arts and crafts architects, among them Voysey, M. H. Baillie Scott (1865–1945), and Edwin Lutyens (1869–1944). The buildings these British architects created during the last years of the nineteenth century and the first years of the twentieth in turn

had an impact on Americans, including Eyre, Wright, and Charles Sumner Greene (1868–1957) and his brother Henry Mather Greene (1870–1954). Eyre is unique among American architects, however, for illustrating from 1880 through the 1910s a fusion of aesthetic and arts and crafts principles in a manner held together by its reliance on domestic, vernacular, and indigenous allusions.

The only architect who may have approached Eyre in his use of the aesthetic and arts and crafts modes of two generations was Harvey Ellis (1852–1904). The influence of Shaw and Richardson

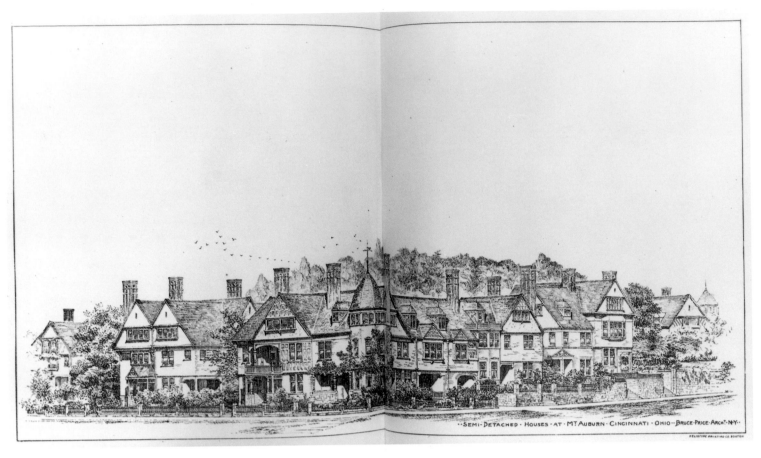

ILL. 10.36 "Semi-detached Houses at Mt. Auburn, Cincinnati, Ohio." Bruce Price. *American Architect and Building News* (Sept. 19, 1885). Thomas J. Watson Library, The Metropolitan Museum of Art

ILL. 10.37 "Residence of Mr. Charles A. Potter," Anglecot, Chestnut Hill, Pa. Wilson Eyre, 1881. [George William Sheldon], *Artistic Country-Seats* (New York, 1886). Art, Prints and Photographs Division, The New York Public Library, Astor, Lenox, Tilden Foundations

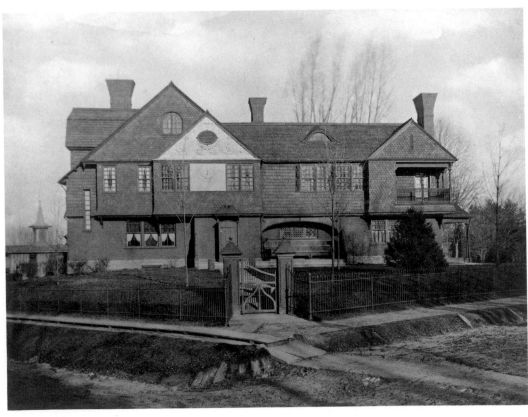

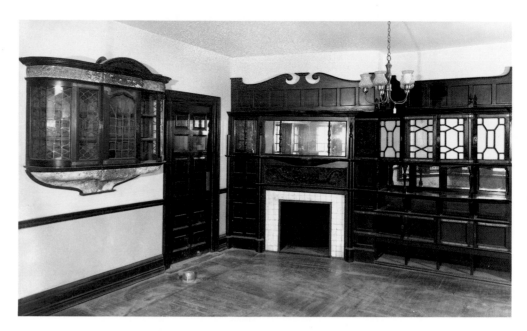

ILL. 10.38 Dining room, Anglecot, the Charles A. Potter house, Chestnut Hill, Pa. Wilson Eyre, 1881

is evident in Ellis's first houses, of about 1883. His design for Pillsbury Science Hall at the University of Minnesota (1887–89) was Richardsonian but with the sweep of the Japanese house at the Centennial Exposition. His project for a dormitory on the same campus in 1887 was a remarkably personal and muted example of the kind of simplification aesthetic architects wrought, and it anticipated the arts and crafts manner he adopted when he returned to his hometown, Rochester, New York, in 1895, after spending a decade working in Minneapolis and Saint Louis. The designs Ellis published in the *Craftsman* in 1902 and 1903 were intensely vernacular, and as typical of the British Arts and Crafts movement as the buildings of some other American architects had been of the Queen Anne.[119]

AESTHETIC LANDSCAPES AND TOWNS

Architects fired by aesthetic and arts and crafts ideals also envisioned an environment free of industrial blight. Bedford Park (see FIG. 10.1, ILL. 10.6), the initial manifestation of the Aesthetic movement in landscape and town, was also a model for the "garden cities" born of the Arts and Crafts movement after 1890. By 1881, some six years after ground was broken for the first houses at Bedford Park, the London suburb was well enough known to have become the brunt of satiric ditties in the *Saint James Gazette:*

> Now he who loves aesthetic cheer
> and does not mind the damp
> May come and read Rossetti here
> by a Japanese-y lamp
>
> While 'Arry' shouts to 'Hemmua':
> "Say, 'ere's a bloomin' lark,
> Thems the biled Lobster 'ouses
> as folks calls 'Bedford Park.'"[120]

Bedford Park also suffered financial difficulties, but it was, nonetheless, an oasis in the otherwise undifferentiated urban sprawl, and it was seen even at the time as a protest against the monotonous, unending bylaw streets and the uniform stucco villas of mid-century. The town was modeled on a traditional English village. A nucleus of shops and houses, in a variety of sizes and shapes, merged with landscape and streets into an inseparable relationship that took into account the terrain, existing buildings and landscaping, and the proximity of a railroad.[121] The bird's-eye perspective, the flat, intense colors, and the stylized lines of M. Trautschold's lithograph (see ILL. 10.6), one of a set of lithographs of Bedford Park scenes published in 1882, recall Japanese prints.

The picturesque principles Godwin and Shaw employed at Bedford Park received their first major reinstatement in landscape theory with Robinson's *English Flower Garden* in 1883. "There is nothing more melancholy," Robinson wrote, "than the walls, fountain basins, clipped trees, and long canals of places like the Crystal Palace, not only because they fail to satisfy the desire for beauty, but because they tell of wasted effort and riches worse than lost." He castigated carpet bedding, revival design, exotic plantings, and "sham picturesque" rock formations, cascades, and concocted undulations of ground and paths. As Andrew Jackson Downing (1815–1852) in America had before him, Robinson associated symmetrical gardens with tyranny because of the heavy maintenance they required. Informal cottage gardens, where variety and an easygoing, noncontrived picturesque governed, symbolized freedom. The ideal garden, for Robinson, preserved "the simple dignity of trees and the charm of turf."[122] His aesthetic views coincided with those of other critics of the period who deplored "the sinuosities of contorted and agonized woodwork" in furniture or, for that matter, similar effects in apparel.[123]

Designing landscapes, like decorating houses and working at wood carving, embroidery, and other crafts, was deemed an appropriate pursuit for women, an extension of their role as keepers and beautifiers of the home and its surroundings. Landscape architect Gertrude Jekyll (1843–1942), who studied with Robinson, was a pioneer in the field, and her theories and designs did much to shape the new Picturesque. Christopher Hussey considers Jekyll England's "greatest artist" in landscape design. The many books and articles she published from the late 1890s to 1914 were extremely influential in the United States; Beatrix Jones Farrand (1872–1959) was but one of the American landscape gardeners inspired by Jekyll.[124]

Frederick Law Olmsted, who dominated the landscape profes-

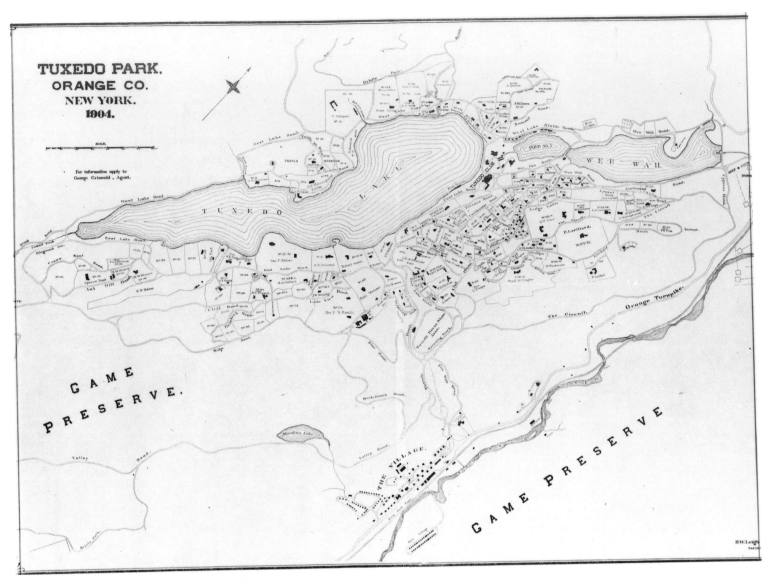

ILL. 10.39 "Tuxedo Park, Orange Co., New York, 1904." Tuxedo Park Association, Tuxedo Park, N.Y.

sion in America from the 1850s until his death in 1903, also rejected the anti-Picturesque extremes of designers like Paxton. One of Olmsted's biographers, Elizabeth Stevenson, describes him as a romantic who "saw in unspoiled nature and the simple life a great force for the rehabilitation and rejuvenation of the human spirit enervated by the pressures of civilized life."[125] Olmsted believed that all people needed access to public lands, and his Herculean efforts to make that possible are unmatched anywhere: he worked to ensure that areas of open land were left untouched near cities, he helped lay the foundation for a national park system, and he campaigned to save Niagara Falls, the redwoods of California, and other features of America's natural landscape from abuse and destruction.[126] His plans for parks in New York, Chicago, Washington, D.C., Detroit, Boston, and other cities reflect his conviction that a park should be not merely "vacant space, a dumping ground," but "a large ground scientifically and artistically prepared to provide . . . a poetic and tranquillizing influence on its people."[127]

Architects and landscape gardeners like Alexander Jackson Davis (1803–1892) and David Hotchkiss, a Saint Louis surveyor, shared Olmsted's romantic idealism. John Reps, in his history of city planning in the United States, considers Llewellyn Park, New Jersey, which Davis designed in 1855, the "first real romantic suburb" in America. Hotchkiss's plan for Lake Forest, Illinois, laid out in 1857, the same year Olmsted and Calvert Vaux (1824–1895) began their work on Central Park in New York, is remarkable for its naturalness and simplicity.[128] As precursors of Tuxedo Park and other planned new towns built in America in the 1880s and 1890s, these two suburbs were perhaps even more important than Olmsted's better-known designs for Berkeley, California (1866), and Riverside, Illinois (1869). At Riverside Olmsted sought to create "unfenced parks" with the "character of informal village greens," and he envisioned a six-mile-long parkway to take residents into Chicago.[129]

Olmsted's association with Harvard University professor and author Charles Eliot Norton (1827–1908) and with Richardson helped to establish landscape architecture as a profession and as a college discipline in the United States.[130] The arts of landscaping and architecture coalesced in influential and forceful ways when Olmsted and Richardson worked together on the F. L. Ames estate at North Easton, Massachusetts, between 1878 and 1886. In 1888 the American art critic Mariana G. Van Rensselaer (1851–1934)

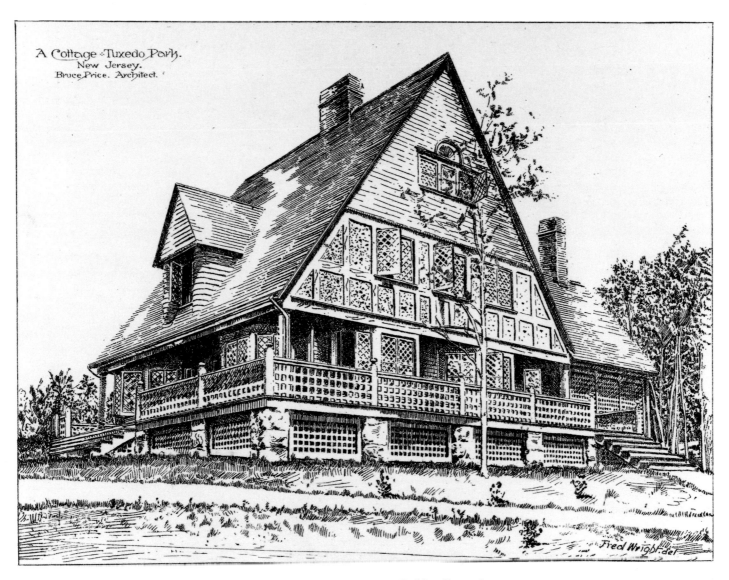

ILL. 10.40 "A Cottage: Tuxedo Park," (Chanler house). Bruce Price, 1885–86. *Building* (Sept. 18, 1886). Avery Architectural and Fine Arts Library, Columbia University, New York

wrote of the Richardson–Olmsted collaborations,

> Whenever we find ourselves considering what are the duties of the architect toward other artists . . . we find ourselves thinking of Mr. Richardson as a shining example of rectitude. He was constantly turning to Mr. Olmsted for advice. . . . The Town Hall at North Easton may be cited as one example of the extraordinary success which can spring from such cooperation, and Mr. Richardson was never tired of explaining how invaluable in this case had been Mr. Olmsted's assistance.[131]

Olmsted and Richardson achieved at North Easton an interlocking of landscape and buildings unequaled in Britain until Edwin Lutyens and Gertrude Jekyll cooperated on designs for houses and gardens around the turn of the century. It was this kind of integration of stone in nature and in architecture that Price strove to recreate at Tuxedo Park in the late 1880s. What Olmsted and Richardson accomplished also paved the way for similar collaborations between landscape architect Jens Jensen (1860–1951) and Wright and between Jensen and Sullivan, as well as for the Greene brothers' integral approach to house and garden in their work in California in the early 1900s.[132]

The movement for a new Picturesque in landscape and town planning greatly accelerated in the 1870s in Britain and the United States.[133] Bedford Park was the culmination of that effort. The American press took full notice of the project at Bedford Park, and by 1881 articles in the *American Architect* were pronouncing it "famous" and "one of the most interesting [enterprises] in the history of art."[134] Its impact on a theoretical level was immediate. The British *Court Circular* reported in 1881 that "the latest aesthetic idea is certainly a curious one, and it comes from America. It is said that an Art City is to be founded there, of which all the inhabitants shall be musicians, painters, sculptors, literary men and the like. . . . Behind the wild idea of an art-city, a sort of glorified Bedford Park, there is a background of solid sense."[135]

More than one art city was realized in the United States in the late nineteenth century.[136] There were also a number of efforts to create American Bedford Parks, the earliest of which appears to have been Short Hills, New Jersey, constructed in 1883–84. Short Hills was called "an American park" in the *American Architect* in 1884 by a writer who had visited Bedford Park and found "it was

not an Eden, although it was beautiful." Short Hills, he felt, had a much better chance of becoming a paradise, despite the almost cloying picturesqueness and quaintness of the houses being built there, many of which were by Hugh Lamb (1849–1903) and Charles A. Rich (1855–1943).[137] Short Hills, however, developed without the total design consciousness of Shaw and Carr at Bedford Park.

The first American town of the industrial era to fully incorporate the principle of the village nucleus used at Bedford Park was Tuxedo Park, New York. Tuxedo was the brainchild of Pierre Lorillard (1833–1901), a wealthy tobacco merchant who owned some 7,000 acres of undeveloped land in southeastern New York State.[138] In 1884, over lunch at the Union Club in New York City, Lorillard masterminded the Tuxedo Park Association, which was wholly owned by the Lorillard family until the 1920s, and the Tuxedo Club, which was limited to 200 members.[139] In 1885 he engaged Bruce Price and Boston engineer Ernest Bowditch to develop his 7,000-acre tract into a resort community that was simpler and more natural than Newport, where Lorillard already owned a house.

Before 1885 the Lorillards had used the tract in New York only for hunting. The hilly land, rising as much as 1,120 feet in some places, was wild except for a farm, a tavern, and the Continental Road, built under George Washington's direction in 1778, which ran along the eastern shore of the 291-acre Tuxedo Lake. Construction began in 1885 and proceeded with typical American zeal. Lorillard brought in some 1,800 Italian and Slovak workmen to build the complex, and two separate villages were created to house them and their families. When the Tuxedo Club opened on June 16, 1886, close to 5,000 acres had been planned, 30 miles of macadam roads had been built, and 40 buildings stood complete. These were soon joined by a boathouse, a school, a racetrack, a golf course (possibly the second oldest in the country), indoor tennis courts, a game preserve and breeding ponds, a swimming pool, an electrified toboggan run, 30 miles of bridle trails, and the first water, sewer, and telephone systems outside a major metropolis. Though it was originally intended as a resort to be used during the autumn hunting and spring fishing seasons, by 1900 Tuxedo Park could be called "the most luxurious forest home in the world."[140]

Tuxedo Park epitomized the aesthetes' quest for understatement and reserve. Its very name, of corrupted American Indian origin, was given to the simplified formal wear that was first worn by the future Edward VII of England but made its debut in America on Lorillard's son Griswold at a ball in Tuxedo Park in 1886.[141] Tuxedoites are also credited with making fashionable the game of bridge, and Price's daughter, Emily Post (1872–1960), who grew up in Tuxedo Park and later made her home there, became peerless in matters of etiquette. "As a beautiful place of permanent homes," Post once said, "Tuxedo is as nearly ideal as can be found," and she thought Tuxedoites much more likely to abstain from extremes than the so-called Smart Set of Newport.[142] Samuel Graybill, Jr., in his study of Price, calls Tuxedo "the first fully integrated romantic suburb in America," created for "conservative wealthy families who were trying to find a real solution to the problem of comfortable living."[143] In the 1890s William Waldorf Astor (1848–1919) declared that "with the exception of Tuxedo Park there was no fit place in America for a gentleman to live." And a current resident believes that "Tuxedo was originally built to be what the Aga Khan was striving for in Sardinia. A place where the rich could live simply."[144]

Tuxedo Park, unlike Bedford Park, was and remains restricted. An eight-foot-high barbed-wire enclosure created, in effect, "a world with a fence around it."[145] One enters through a gate lodge that Price based on the Ames gate lodge Richardson built at North Easton in 1880–81. Adjacent to the lodge are Saint Mary's-in-Tuxedo, designed by William Appleton Potter, and a cemetery with a remarkable rock-hewn mausoleum and low stone markers

that literally carry aesthetic restraint into the grave. The church was built over the objections of some of the residents, who thought it inappropriate to include any religious structures, or even a burial ground. As at Bedford Park, one was originally expected to arrive in Tuxedo by train, and the workers' villages, the shops, the inn, and the Association offices all cluster near the station. Price's plan for Tuxedo (ILL. 10.39) differed from all earlier towns, however, in that the focal point was not the station, or shops, or churches, but the Tuxedo Club, with a vast shingled frame built on a stone foundation.[146] The road patterns, the work of Price and Bowditch, follow the terrain in a loose, natural way and permit drainage into Tuxedo Lake, which supplies the town's water, and into the two smaller lakes that were created by a dam built in 1893.

Residential development spread southward out from the clubhouse along both shores of Tuxedo Lake and in the Tower Hill section. The Chanler cottage (ILL. 10.40), constructed in 1885–86, typifies Price's first houses at Tuxedo Park: small cottages with steep roofs and broad platforms of stone for porches and terraces. In all these designs there is a minimum of reference to period style, the word Price wanted to purge from the vocabulary. Lorillard's interest in Central American archaeology led him and Price to value monumental stonework and stairways. Lorillard cosponsored, with the French government, the expeditions of French archaeologist Claude-Joseph-Désiré Charnay (1828–1915) to Central America in 1880–83. Graybill thinks that Lorillard wanted a "kind of primitive Maya Renaissance" at Tuxedo and that other designs by Price were planned like the temples of Malta. These influences, combined with those from Olmsted and Richardson, produced what Price called his "megalithic" style.[147]

An article in *Art Age* in 1886 described the house Price built for Lorillard at Tuxedo as "a rambling structure, in the Colonial style, tinted in several shades of buff, ranging from a decided orange tint to a pale cream color. The clubhouse is treated in the same way."[148] Other residences at Tuxedo, as at Bedford Park, were in the Queen Anne mode.[149] When Price was asked in an interview in 1899 to state the essential principles of country-house design he responded, "Not going in opposition to nature." To a question about the elements of picturesque design his answer was, "Whatever is picturesque in design should be accomplished by the exigencies of the site rather than deliberately made. A picturesque effect should be the last thing to be thought of."[150]

"In beginning Tuxedo," Emily Post wrote in 1911, "the architect's idea was to fit buildings with the surrounding woods, and the gate-lodge and keep were built of graystone with as much moss and lichen as possible. The shingle cottages were stained the color of the woods—russets and grays and dull reds—ugly to the taste of a quarter century later, though this treatment did much to neutralize the newness of buildings—Old World and tradition-haunted as it looks, it is new, incredibly new."[151] Tuxedo Park was "incredibly new." Not only did it contribute to the development of an original American style that was to have an important effect on twentieth-century architecture, but it was also the first American town to be inspired by the simpler, less contrived landscape traditions of Japan, and its plan paid homage to the wildness of the natural terrain on a scale and to a degree that were unprecedented. As a writer in the *Tuxedo News* observed in 1900, it was at Tuxedo Park that "the Art of Landscape . . . began to show itself, and many of the most interesting houses are surrounded by, or have adjacent to them, excellent examples of this Art, and Art—by the way—of the greatest beauty, but the least understood and most commonly ignored by us."[152]

At Tuxedo, landscape dominated architecture. Indeed, land was cleared only where actual construction occurred, and large boulders were left in situ to add striking accents to the landscaping. Houses were built on or around rocks or around trees, in what a writer in the *American Architect* in 1880 had referred to as "a Japanese fashion."[153] According to historian Clay Lancaster, whereas

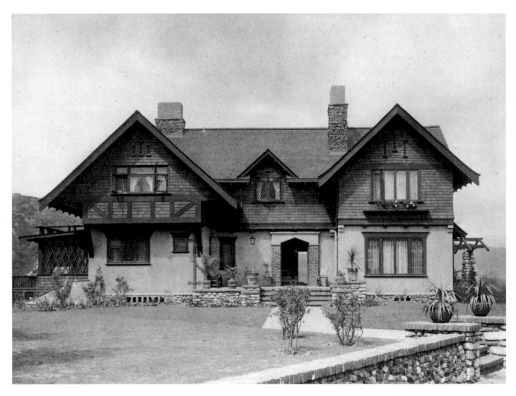

ILL. 10.41 James A. Culbertson house, Pasadena, Calif. Charles Sumner Greene and Henry Mather Greene, 1902

Llewellyn Park was influenced by the *jardin anglo-chinois,* at Tuxedo the source of inspiration for both the grounds and the buildings was largely Japanese.[154] Donald F. Clark, who prepared the National Register nomination form for Tuxedo Park in 1978, sees there "evidence of a new, limitless, and qualitatively different universe, containing mountain and lake, wood and hills. For antecedents, perhaps one must look more to the Oriental than to the Western World. Descriptions of old Chinese and Japanese parks echo the spontaneous spirit that seemed to be at work here . . . given a vitality of landscape that demanded certain original solutions."[155]

A number of the houses Price created for early Tuxedo residents also show the lessons he learned from the Japanese. Graybill has noted that the porch railing on the Henry house (1886) recalls similar details on Japanese buildings, and that the T plan Price used for other designs is "remindful of more primitive huts of New Guinea, Central and South America, and Japan."[156] By 1890 Price had designed the Glover house, which Tuxedoites called the "Japanese cottage." The Japanese taste that Price established continued at Tuxedo Park at least until World War I. Japanese gardens and teahouses graced several estates, among them the Walter Kroll house (later owned by Mary Scofield), designed about 1912 by the firm of Walker and Gillette in a Tudor manner. The house was given the name Sho-Chiku-Bai, and it boasted an authentic Japanese room and a Japanese garden with a ceremonial teahouse created by Takeo Shiota (1881–1946), a Japanese designer who emigrated to America in 1907.[157] Price's work at Tuxedo also had an effect on Wright. Their meaningful response to Japanese architectural traditions and the respect they shared for certain features of Precolumbian architecture make Price and Wright kindred spirits.[158]

After 1890 the buildings constructed in Tuxedo Park became increasingly more elaborate and derivative. Many American architects, including Price, had begun to abandon the fresher, simpler, and more eclectic style of the 1870s and 1880s for a new histori-

cism. The shift corresponded exactly with the demise of the Aesthetic movement in America.

The Aftermath

By the end of the 1880s what had begun in New England with Shaw's influence on Richardson had arrived in California. As David Gebhard and Harriette Von Breton point out in their survey of late nineteenth-century California architecture, on the West Coast the High Victorian Gothic and the Queen Anne became "concurrent . . . since a mixing of complexity and contradiction was the most direct means of realizing the picturesque."[159] The California version of the Queen Anne is perhaps best seen in the designs of Ernest Coxhead (1863–1933), who began his career in England in 1879 and emigrated to the United States in 1886.[160] In the English Lutheran Church in Los Angeles (1888) Coxhead merged Queen Anne with progressive Richardsonian features. After he moved to San Francisco in 1890 he designed a number of strikingly original houses that were as abstract and free of references to period styles as some of Godwin's buildings. The severity of Coxhead's designs and their lack of ornament also bring to mind Voysey's work; Voysey's influence is especially evident in the house Coxhead built for himself in San Francisco in the 1890s. A town house he designed in 1902 for a client is similarly abstract, with sublimated period references such as Palladian-Federal windows that relate it to the work of Sullivan and of Root.

Although Bernard Maybeck ultimately became wildly eclectic and worked in Roman, Gothic, Tudor, and Baroque modes, in the 1890s he introduced a new kind of wood architecture into the Bay Area. As a youth in New York City, Maybeck learned wood carving and cabinetry from his German father. In the early 1880s he studied at the Ecole des Beaux-Arts in Paris, and when he returned to the United States he spent a few years at the firm of John Merven Carrère (1858–1911) and Thomas Hastings (1860–1929) in New

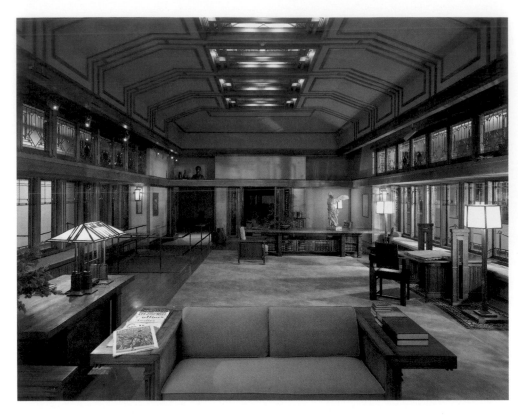

ILL. 10.42 Living room, Francis W. Little house, Wayzata, Minn. Frank Lloyd Wright, 1912–14. The Metropolitan Museum of Art, Purchase, Emily Crane Chadbourne Bequest, 1972 (1972.60.1)

York. He settled in San Francisco in 1890. It was there, while he was working in A. Page Brown's office before opening his own practice, that he met Willis Polk (1867–1924) and first adopted aesthetic and arts and crafts tenets.[161] The dining room in Maybeck's house for Laura Hall in Berkeley (1896) has a bold constructional simplicity that entirely absorbs the decorative. With such interiors we have shifted from the Aesthetic to the Arts and Crafts movement.

The change is even more apparent in the work of Charles Sumner Greene and Henry Mather Greene. In the mid-1880s the Greenes' father sent them to the manual-training school Calvin Milton Woodward (1837–1914) had established at Washington University in Saint Louis in 1879–80. Woodward had studied with Morris in London, and he based his school on the arts and crafts ideals Morris espoused. The Cultured Mind–The Skillful Hand was the school's motto. The Greenes considered their training under Woodward, not their later study at the Massachusetts Institute of Technology, the decisive factor in shaping their careers. Charles Sumner Greene once wrote, "Why is it we are taught that it is impossible to invent anything worthwhile while in architectural art? . . . Isn't invention the life of science? Don't men of science do it every day? And science has not had the last word yet. Why not art?"[162]

The dining room in the house the Greenes built for James A. Culbertson in Pasadena, California, in 1902, like Maybeck's in the Hall house, shows the constructional, rather than decorative, thrust of the Arts and Crafts movement. Yet the ornamental stylization of the "beams" in the ceiling and in the overmantel is derived from aesthetic interiors, such as White's dining room in Kingscote (see ILLS. 4.15, 4.16) and Burnham and Root's in the Ayer house (see ILL. 10.32). A comparison of the road facade of the Culbertson house (ILL. 10.41) with that of Richardson's W. Watts Sherman house of nearly thirty years before (see ILL. 10.9) affirms how deeply embedded were the principles of the Aesthetic movement. The Greenes' reliance on materials and construction

rather than on style and decoration, their emphasis on horizontal planes and lines, and their use of banks of casement windows all hark back to Richardson's design. The living room in the Culbertson house, with its built-in furniture, is yet another instance of total design concepts at work. The broad, flared roof is unquestionably Japanese inspired, recalling the "Japanese cottage" Price designed at Tuxedo Park a decade earlier.

The story of the impact of the Aesthetic movement on American architecture could end with no one better than Frank Lloyd Wright. Wright's first house for himself, the Studio in Oak Park, Illinois (1889), was based in part on Price's Chanler house at Tuxedo Park, as Scully has demonstrated.[163] In the house Mr. and Mrs. Francis W. Little commissioned Wright to design in 1912 on Lake Minnetonka in Wayzata, Minnesota, he created a superb arts and crafts living room (ILL. 10.42). In 1982 the living room, complete with the original textiles and the Japanese prints on the walls, was installed in The Metropolitan Museum of Art, New York. In the warm, low space, Wright deftly integrated the horizontal and vertical elements of posts and lintels, which give only a hint of their aesthetic origins in the houses of Shaw and Richardson. The built-in and movable furniture he designed for the room remains in place. With its simple lines and low, massive proportions, the furniture is an embodiment of Ruskin's ideas.[164]

The living room Wright crafted in 1914 for Taliesin, his home in Spring Green, Wisconsin, redeems the novelty of White's Kingscote dining room. Yet the Taliesin room is also entirely revealing of Wright's mature mode, a testimony to his strong perception of Japanese understatement and sense of proportion and to his unparalleled ability to fuse architecture, furniture, and artfully arranged objects and ornament in a unified design based on abstract principles as Godwin developed them. The room is not only one hundred percent Wright but also a hefty percent of what was to emerge as modernism after World War I. Like the Little room, the living room at Taliesin is an accurate measure of the Aesthetic movement's bequest to American architects.

NOTES

1. The terms used to classify the work of American architects of this period are at best stylisms, or secondary categories. The term Gothic revival is also a stylism, describing a number of phases that were not particularly evolutionary. The Gothic itself, on the other hand, was clearly a style. Some of H. H. Richardson's works, like the M. F. Stoughton house in Cambridge, Mass. (1882–83), are intelligibly Shingle style; others, like the Allegheny County Courthouse and Jail in Pittsburgh (1883–88), are not. Richardson's Trinity Church Rectory, Boston (see FIGS. 10.2–10.4, ILL. 10.11), and William Ralph Emerson's Art Club there (see ILL. 10.17), though stylistically compatible with the Stoughton house, cannot be considered Shingle style because of their stone construction. Moreover, these last buildings have great stylistic affinity with many works by Daniel H. Burnham and John Wellborn Root, Louis Sullivan, and Harvey Ellis in the Midwest that are usually classified as Chicago School. If Richardson's Rectory and Emerson's Art Club were in Chicago, they too might qualify. In Boston, they do not. I therefore differ with the way many architectural historians perceive style since the revolutions of the later eighteenth century. While it is useful to isolate buildings by function, by construction, and by locale, this cannot constitute a primary classification scheme as long as formal, stylistic methods remain the substance of art-historical research. See James D. Kornwolf, "High Victorian Gothic, or the Dilemma of Style in Modern Architecture," *Journal of the Society of Architectural Historians* 34 (Mar. 1975), pp. 37–47.

2. William Gaunt, *The Aesthetic Adventure* (New York, 1945), pp. 214–35, oversimplifies the explanation for the demise of the Aesthetic movement when he identifies it with Oscar Wilde's trial in 1895. By that time the movement had been eclipsed by the Arts and Crafts movement and Art Nouveau, and the aesthetic legacy was felt more strongly on the Continent than in Britain.

3. Key indications of Ruskin's socially oriented view of the arts are well seen in John Ruskin, *Unto This Last* (1862), vol. 17 of *The Works of John Ruskin,* ed. E. T. Cook and Alexander Wedderburn [library ed.], 39 vols. (London and New York, 1903–12); and his *Fors Clavigera* (1871–84), ninety-six essays written in the form of letters to workmen, vols. 27–29 of *Works of John Ruskin.* Morris increasingly turned to socialism in the period 1878–83, the height of the Aesthetic movement; see especially William Morris, *News from Nowhere* (1890), *A Dream of John Ball* (1888) . . . , vol. 16 of *The Collected Works of William Morris,* ed. May Morris, 24 vols. (London, 1910–15); idem, *Hopes and Fears for Art: Lectures on Art and Industry* (1882), vol. 22 of *Collected Works of William Morris;* and idem, *Signs of Change: Lectures on Socialism* (1888), vol. 23 of *Collected Works of William Morris.* In 1882 British architect-designer Arthur H. Mackmurdo (1851–1942) organized the Century Guild, the first of the many arts and crafts societies based on Ruskin's and Morris's efforts, and in 1884 he initiated the first "art" magazine, the *Hobby Horse,* which served as a model for publications such as the *Studio,* the main voice of the Arts and Crafts movement. The first issue of the *Studio* came out in London in 1893 with a cover designed by C. F. A. Voysey; the magazine carried architectural illustrations that breathed new life into the domestic, vernacular, and indigenous themes most architects of the Aesthetic movement had by that time abandoned, and it in turn became the prototype for *House Beautiful,* established in Chicago in 1896; the *Craftsman,* which Gustav Stickley (1858–1942) started in Rochester, N.Y., in 1901; and other similar magazines. Frank Lloyd Wright designed the first cover for *House Beautiful.*

4. Mark Girouard, *Sweetness and Light: The "Queen Anne" Movement, 1860–1900* (Oxford, 1977), p. 4, considers this disassociation of "art from mor-als" an important ramification of the Aesthetic movement. Excerpts from Pater's writings, which with Ruskin's form the theoretical core of the Aesthetic movement, are printed in Eric Warner and Graham Hough, *Strangeness and Beauty: An Anthology of Aesthetic Criticism, 1840–1910,* 2 vols. (Cambridge, Eng., 1983), vol. 2, pp. 1–71.

5. See, for example, Oscar Wilde, "The Soul of Man under Socialism," in *The Complete Works of Oscar Wilde,* intro. Vyvyan Holland (London and Glasgow, 1966), pp. 1079–1104.

6. John Ruskin, *Fors Clavigera* 79 (July 1877), quoted in Allen Staley, "Whistler and His World," in Wildenstein and Company, New York, *From Realism to Symbolism: Whistler and His World* (exhib. cat., 1971), p. 17. See also [James Abbott McNeill Whistler], *The Gentle Art of Making Enemies* (London, 1890).

7. Dudley Harbron, *The Conscious Stone: The Life of Edward William Godwin* (London, 1949), p. xvi. See also idem, "Queen Anne Taste and Aestheticism," *Architectural Review* 95 (July 1943), pp. 15–18. Elizabeth Aslin, *The Aesthetic Movement: Prelude to Art Nouveau* (New York and Washington, D.C., 1969), p. 14, maintains that the essence of the Aesthetic movement was "the union of persons of cultivated taste to define and decide upon what is to be admired."

8. Walter Kidney, *The Architecture of Choice: Eclecticism in America, 1880–1930* (New York, 1974), p. 11.

9. Girouard, *Sweetness and Light,* pp. 14–18.

10. Henry-Russell Hitchcock, *Architecture: Nineteenth and Twentieth Centuries* (1958; 4th ed. Harmondsworth, Eng., 1977), p. 296.

11. For a study of Shaw, see Andrew Saint, *Richard Norman Shaw* (New Haven and London, 1976).

12. Girouard, *Sweetness and Light,* p. 44, identifies Sparrowe's House as the source for the New Zealand Chambers.

13. The design for Shaw's own house appeared in *Builder,* Mar. 25, 1876, and *British Architect,* Nov. 19, 1880; Glen Andred in *Building News,* Mar. 6, 1881.

14. "Correspondence: Some Artists' Houses," *American Architect and Building News* [hereafter abbreviated as *American Architect*] 1 (Oct. 28, 1876), pp. 350–51.

15. Quoted in Harbron, *Conscious Stone,* p. xiii.

16. The independent and advanced character of Godwin's designs was noted by Hermann Muthesius, *Das Englische Haus,* 3 vols. (Berlin, 1904–5); see idem, *The English House,* ed. Dennis Sharp, abridged from 2d ed., 3 vols. in 1 (New York, 1979), pp. 31, 156–58. "Pioneering" on behalf of modernism is now distinctly unfashionable; today's historians are more interested in the nineteenth century for its own sake. And pioneering for modernism was hardly the main, let alone sole, intent of architects subscribing to the tenets of the Aesthetic and Arts and Crafts movements. Nikolaus Pevsner's basic thesis still holds, however, with regard to the importance of certain nineteenth-century developments for twentieth-century modernism; see his *Pioneers of Modern Design* (1936; rev. ed. New York, 1949; rev. ed. Harmondsworth, Eng., 1960), esp. pp. 62–64. See also Mark Girouard, "Chelsea's Bohemian Studio Houses," *Country Life* 152 (Nov. 23, 1972), pp. 1370–74, for a discussion of the White House and the Miles house. Mackmurdo is but one of the British architects usually identified with the Arts and Crafts movement who appears to have been influenced by the Aesthetic movement: his early architecture, such as his own house at 6 Private Road in Enfield, London (1886–87), probably owes much to Godwin.

17. "A Harmony in Yellow and Gold," *American Architect* 4 (July 27, 1878), p. 36, an article about the room Whistler and Godwin designed for London furniture maker William Watt's display at the Exposition Universelle in Paris in 1878.

18. Robin Spencer, *The Aesthetic Movement* (London and New York, 1972), p. 48.

19. R[obert] S[wain] P[eabody], "A Talk about 'Queen Anne,'" *American Architect* 2 (Apr. 28, 1877), pp. 133–34; "Correspondence: Architecture at the Royal Academy," pt. 2, *American Architect* 5 (June 21, 1879), p. 197; John D. Sedding, "The Modern Architect and His Art," pts. 1, 2, *American Architect* 17 (Jan. 24, 1885), pp. 41–43; (Jan. 31, 1885), pp. 55–57.

20. Girouard, *Sweetness and Light,* p. 1, points this out. On p. 15 Girouard cites two letters of 1862 from Warrington Taylor (about 1837–1870), who became manager of Morris and Company in 1865, to the British architect-designer E. R. Robson (1836–1917); in both letters Taylor referred to Queen Anne features in furniture. On p. 18 Girouard cites the Taylor–Robson correspondence again: Taylor, presumably talking about architecture, wrote, "You don't want any style, you want something English in character," and, on another occasion, "Style means copyism, the test of good work would be an absence of style." Girouard, *Sweetness and Light,* pp. 10–20, cites no references to Queen Anne with regard to architecture before the 1870s, nor does Aslin, *Aesthetic Movement.*

21. See John Summerson, *Architecture in Britain, 1530–1830* (Harmondsworth, Eng., 1953).

22. *American Architect* 15 (Feb. 16, 1884), p. 82.

23. "American Architecture: Present," *American Architect* 1 (Aug. 5, 1876), pp. 250–52.

24. Henry Van Brunt, cited in "American Institute of Architects, Boston Chapter," *American Architect* 2 (Feb. 17, 1877), pp. 53–54.

25. "In Search of a Style," *American Architect* 1 (Aug. 12, 1876), pp. 259–60.

26. [Review of J. H. Kirby, *The Portfolio of Cottages*], *American Architect* 18 (Aug. 29, 1885), p. 104.

27. John Moser, "Whither Are We Tending?" *American Architect* 4 (July 20, 1878), pp. 23–24; "Decorative Arts," *American Architect* 5 (Jan. 4, 1879), pp. 3–4.

28. William Rotch Ware, cited in "American Institute of Architects, Boston Chapter," *American Architect* 3 (Feb. 16, 1878), p. 57.

29. "Correspondence: The Union League Club-House Competition," *American Architect* 5 (Apr. 26, 1879), pp. 133–34. The remark was made with reference to "an out-and-out Queen Anne design" submitted by a Mr. Harney in the competition for the design of the Union League Club in New York.

30. [Summary of "Domestic Architectural Style in England"], *American Architect* 4 (Aug. 10, 1878), p. 46. The remark was made with regard to Shaw's work and the Queen Anne mode as described in an article that had appeared in *Architect,* July 6, 1878.

31. "Archaeology and the Vernacular Architecture" [letter to the editor], *American Architect* 4 (Oct. 26, 1878), p. 143, commenting on "Archaeology and American Architecture," *American Architect* 4 (Oct. 5, 1878), pp. 114–15.

32. [Letter to the editor], *American Architect* 4 (Nov. 2, 1878), p. 150, from a London reader commenting on "so-called Queen Anne work."

33. "English Furniture at the Exposition, Paris," *American Architect* 4 (Dec. 14, 1878), pp. 198–99. For a more recent debate on the Queen Anne, see Sadayoshi Omoto, "The Queen Anne Style and Architectural Criticism," *Journal of the Society of Architectural Historians* 23 (Mar. 1964), pp. 29–37; and Winslow Ames's letter to the editor, *Journal of the Society of Architectural Historians* 23 (Oct. 1964), p. 155.

34. Peabody, "A Talk about 'Queen Anne,'" *American Architect* 2 (Apr. 28, 1877), pp. 133–34. See also R[obert] S[wain] Peabody, "The Georgian Houses of New England," pts. 1, 2, *American Architect* 2 (Oct. 20, 1877), pp. 338–39; 3 (Feb. 16, 1878), pp. 54–55; and Arthur Little, *Early New England Interiors:*

Sketches in Salem, Marblehead, Portsmouth, and Kittery (Boston, 1878), preface.

35. [Letter to the editor], *American Architect* 4 (Aug. 10, 1878), p. 46.

36. Vincent J. Scully, Jr., *The Shingle Style and the Stick Style: Architectural Theory and Design from Downing to the Origins of Wright* (1955; rev. ed. New Haven and London, 1971). According to Scully, p. 64, this style came into being because "by then the passion for Queen Anne and colonial had become partially objectified and synthesized into a creative basis for architecture and design." The term Shingle style was used in *Tuxedo News* 2 (Nov. 1900), p. 7, in a discussion of Bruce Price's architecture at Tuxedo Park, N.Y.: "[To Price] is chiefly due the artistic success of the whole conception of the place. . . . [He] designed the Club House, and some fifteen or twenty most original and tasteful cottages, in a simple style, which, for lack of a better or more generic phrase, we of the profession have dubbed the Shingle Palace Style. This style is indigenous to this country, growing out of our abundance of timber of every kind, and the ease and cheapness with which the all-frame house can be produced." Scully later monumentalized his term by viewing much of American architecture since the late 1960s as the New Shingle style; see Vincent J. Scully, Jr., *The Shingle Style Today, or the Historian's Revenge* (New York, 1974).

Scully has since 1955 somewhat revised his view of what was important in the developments in late nineteenth-century architecture. In his appreciative introduction to Robert Venturi, *Complexity and Contradiction in Architecture* (New York, 1966), pp. 11–16, Scully criticizes modernism and writes, "Like all original architects, Venturi makes us see the past anew. He has made me, for example, who once focused upon the proto-Wrightian continuities of the Shingle Style, revalue their equally obvious opposite."

37. "Correspondence: Some Artists' Houses," *American Architect* 1 (Oct. 28, 1876), pp. 350–51.

38. Henry Hudson Holly, "The American Style," *American Architect* 2 (Aug. 18, 1877), p. 267.

39. "Red Brick in Architecture," *American Architect* 8 (Nov. 20, 1880), pp. 245–46. A note in *American Architect* 12 (Nov. 25, 1882), p. 258, called the new manner "The Red Brick Order," rather than Queen Anne.

40. [Review of Kirby, *Portfolio of Cottages*], *American Architect* 18 (Aug. 29, 1885), p. 104.

41. The first of many pieces the magazine published on Japanese architecture was "Japanese Houses," *American Architect* 1 (Jan. 22, 1876), pp. 26–27. See also "Japanese Work at the Centennial Grounds," *American Architect* 1 (Feb. 12, 1876), pp. 55–56; "Notes and Clippings: Japanese Architecture [at the Centennial]," *American Architect* 1 (Apr. 22, 1876), p. 136; and "Constructive Art in Japan," *American Architect* 1 (Apr. 15, 1876), pp. 124–25.

42. Though Voysey began working in a Tudor manner, by the late 1880s he appears to have discovered both Japanese architecture and the Shingle style as it was presented in the *American Architect*; see James D. Kornwolf, *M. H. Baillie Scott and the Arts and Crafts Movement: Pioneers of Modern Design* (Baltimore and London, 1972), esp. pp. 11–80. Wright's characteristic hipped roofs appeared only after Sullivan, under whom he worked from 1890 to 1893, set him to studying Voysey's drawings about 1890.

43. "Notes and Clippings: Japanese Fans," *American Architect* 16 (Oct. 18, 1884), p. 190.

44. [Review of Christopher Dresser, *Japan: Its Architecture, Art, and Art Manufactures*], pts. 1–3, *American Architect* 12 (Dec. 20, 1882), p. 310; 13 (Jan. 6, 1883), pp. 7–8; (Feb. 24, 1883), pp. 92–93.

45. For example, Sullivan's piers in the bar of the Auditorium Building in Chicago (1887–89) are grotesquely but wonderfully distorted from Doric and Byzantine models, with likely Japanese influence in the ornament.

46. H[enry] V[an] B[runt], "Japanese Homes and Their Surroundings," *American Architect* 19 (Jan. 2, 1886), pp. 3–4. The review continued in *American Architect* 19 (Jan. 16, 1886), pp. 31–33; (Jan. 23, 1886), pp. 41–42; (Feb. 6, 1886), pp. 65–66. See also "Domestic Architecture in Japan," *American Architect* 21 (Apr. 2, 1887), pp. 160–61; Clay Lancaster, "Japanese Buildings in the United States Before 1900: Their Influence upon American Domestic Architecture," *Art Bulletin* 35 (Sept. 1953), pp. 217–24; and idem, *The Japanese Influence in America* (New York, 1963). Josiah Conder, *Landscape Gardening in Japan* (Tokyo and London, 1893), appears to have been the earliest English-language publication to contain illustrations of Japanese gardens. Lancaster, *Japanese Influence in America*, pp. 189–215, mentions or alludes to a number of domestic Japanese gardens in the United States before 1900; the earliest he illustrates is an unidentified, undated garden in New England that appeared in *Country Life in America*, Mar. 1905. In addition to the Japanese buildings at the Centennial in 1876, a Japanese house was erected in San Francisco in 1886, the year Morse's book appeared, and Price established a Japanese tradition at Tuxedo Park from 1885 to 1890. The influential Japanese exhibition at the World's Columbian Exposition in Chicago occurred in 1893, and before 1900 S. Furukawa and A. Kimura had constructed a Japanese teahouse and garden in Atlantic City, N.J.

47. For further discussion, see Fine Art Society Limited, London, *The Aesthetic Movement and the Cult of Japan*, by Robin Spencer et al. (exhib. cat., 1972).

48. For a discussion of Robert Kerr, *The English Gentleman's House, or How to Plan English Residences* (1864; 2d ed. London, 1865), see Scully, *Shingle Style*, pp. 7–8.

49. [Review of Charles Wyllys Elliott, *The Book of American Interiors*], *American Architect* 1 (Feb. 5, 1876), p. 47; "American Interiors," *American Architect* 16 (Aug. 9, 1884), pp. 63–64. See also Charles Locke Eastlake, *Hints on Household Taste in Furniture, Upholstery, and Other Details* (1868; reprinted from 2d London ed., intro. and notes by Charles C. Perkins, Boston, 1872).

50. The "art in the household" articles and reviews in the *American Architect* have been treated by Gwendolyn Wright, "Making the Model Home: Domestic Architecture and Cultural Conflicts in Chicago, 1873–1913" (Ph.D. diss., University of California, Berkeley, 1978). See also David P. Handlin, *The American Home: Architecture and Society, 1815–1915* (Boston and Toronto, 1979); and Martha Crabill McClaugherty, "Household Art: Creating the Artistic Home, 1868–1893," *Winterthur Portfolio* 18 (Spring 1983), pp. 1–26.

51. "Mr. Talbert's Designs for Interior Decoration" [review of B. J. Talbert, *Examples of Ancient and Modern Furniture, Metal Work, Tapestries, Decorations, Etc.*], *American Architect* 2 (Mar. 24, 1877), p. 93; "American Vernacular Architecture," pt. 3 [review of Henry Hudson Holly, *Modern Dwellings in Town and Country Adapted to American Wants and Climate with a Treatise on Furniture and Decoration*], *American Architect* 3 (June 8, 1878), pp. 198–99. See also Clarence Cook, *The House Beautiful: Essays on Beds and Tables, Stools and Candlesticks* (1878; reprint New York, 1980); and the writings by and about Cook listed in the Dictionary of Architects, Artisans, Artists, and Manufacturers, this publication.

52. William Robinson, *The English Flower Garden* (1883; 9th ed. London, 1905), laid the foundations for what Derek Clifford, *A History of Garden Design* (New York, 1963), p. 211, calls the "new Picturesque."

53. *Artistic Houses, Being a Series of Interior Views of a Number of the Most Beautiful and Celebrated Homes in the United States*, 2 vols. in 4 pts. (1883–84; reprinted in 1 pt., New York, 1971); [George William Sheldon], *Artistic Country-Seats: Types of Recent American Villa and Cottage Architecture, with Instances of Country Club-Houses*, 2 vols. in 5 pts. (New York, 1886); John Calvin Stevens and Albert Winslow Cobb, *Examples of American Domestic Architecture* (New York, 1889); Montgomery Schuyler, *American Architecture* (New York, 1892); Russell Sturgis et al., *Homes in City and Country* (New York, 1893). Lewis Mumford was probably the first to recognize the singular importance of these achievements in *Sticks and Stones* (New York, 1924) and *The Brown Decades: A Study of Arts in America, 1865–1895* (New York, 1931). But Scully's *Shingle Style* (1955), as noted, was the first definitive study of the domestic architecture the Aesthetic movement helped to produce.

54. Leonard K. Eaton shows this convincingly in *American Architecture Comes of Age: European Reaction to H. H. Richardson and Louis Sullivan* (Cambridge, Mass., 1972).

55. The Whistler–Ruskin lawsuit was reported in [Mr. Whistler's pamphlet], *American Architect* 5 (Feb. 1, 1879), p. 33.

56. "New Interest in Art and How to Direct It," *American Architect* 2 (Sept. 29, 1877), p. 310; "Artists' Opinions Held to Be Facts," *American Architect* 15 (Jan. 26, 1884), pp. 44–45.

57. "A Plea for Wren's Churches," *American Architect* 5 (Mar. 22, 1879), pp. 94–95.

58. [Art prospers in education], *American Architect* 5 (Apr. 26, 1879), p. 130. This was the period, for example, when new buildings were being planned for The Metropolitan Museum of Art, New York, the Museum of Fine Arts, Boston, and the Museum of Fine Arts, Saint Louis; see *American Architect* 5 (Apr. 26, 1879); 8 (Oct. 16, 1880); (Oct. 30, 1880); 10 (Sept. 3, 1881). The magazine also sought support for a museum in New York to be devoted only to architectural drawings; see *American Architect* 13 (Apr. 21, 1883).

59. "An Architectural Medley," *American Architect* 8 (Sept. 18, 1880). If the *American Architect* is an accurate gauge of enlightened opinion on the arts in this period, European and American architectural critics were keenly aware not only of the excesses of the picturesque Queen Anne but also of an even more rampant, exaggerated nonart "aesthetic" associated with utilitarianism, engineering, and the mechanical age's generally unquenchable thirst for bigness. *American Architect* 15 (Feb. 16, 1884), p. 82, reported a Berlin newspaper's parody of plans for a hotel that was to be built in Saint Augustine, Fla. The hotel, which was to be three miles wide by six miles long and 3,840 feet high, would contain tens of thousands of rooms and cost $680 million. Dinner was to be announced not with the usual bell but with cannons fired on each floor. In addition, the story continued, the tables in the dining rooms would "measure four miles each, attendance being performed by twelve waiters on horseback on either side of the tables." Music during *table d'hôte* would be played, "gratis, by eight bands of seventy-seven men each." The billiard room would contain "nine hundred American, ninety-nine French, and one English table" and would "be fitted out with a spittoon of one hundred feet in circumference."

60. Lloyd Lewis and Henry Justin Smith, *Oscar Wilde Discovers America [1882]* (1936; reprint New York, 1967), p. 114; Kenneth Clark, *Ruskin Today* (Harmondsworth, Eng., 1964), p. xi.

61. The Jonathan Fairbanks house in Dedham, Mass., published with a photograph and measured floor plan in *American Architect* 10 (Nov. 26, 1881), was only one of dozens of Colonial buildings illustrated in the magazine in the period 1876–86. Old South Church, Boston (begun 1729), was, appropriately, the first; see *American Architect* 1 (July 15, 1876) and (Aug. 5, 1876). Christchurch in Philadelphia (begun 1727) was called Queen Anne in *Ameri-*

can *Architect* 5 (Apr. 12, 1879). Most of these buildings are cited in William B. Rhoads, "The Colonial Revival," 2 vols. (Ph.D. diss., Princeton University, 1974).

62. "The Habitations of Man," *American Architect* 1 (Feb. 26, 1876), pp. 68–70. "We are allowed," the article begins, "to make some extracts from a forthcoming translation of a new work by M. Viollet-le-Duc, called 'The Habitations of Man in All Ages,' which will be published simultaneously during the coming spring [in London and Boston]. We give in this number the description of a Chinese house . . . the house of the fat Fau (the name given to him by his servants)."

63. "American Vernacular Architecture," pt. 3, *American Architect* 3 (June 8, 1878), p. 199.

64. Clarence Cook, "Beds and Tables, Stools and Candlesticks," pt. 1, *Scribner's Monthly* 10 (June 1875), p. 172. This was the first in a series of eleven articles Cook published in *Scribner's Monthly* from 1875 to 1877 that were included in his book *House Beautiful* in 1878.

65. Ralph Adams Cram, "The Decoration of City Houses," *Decorator and Furnisher* 7 (Dec. 1885), p. 90.

66. Morris, *A Dream of John Ball* (1888; first published in *Commonweal*, 1886–87), in vol. 16 of *Collected Works of William Morris*.

67. Kidney, *Architecture of Choice*, p. 11.

68. Scully, *Shingle Style*, p. 14.

69. The poll was published in *American Architect* 17 (Apr. 11, 1885), pp. 178–79; (June 13, 1885), p. 282. Unless otherwise indicated, the American architects discussed in this chapter are listed in *Macmillan Encyclopedia of Architects*, ed. Adolf K. Placzek, 4 vols. (New York, 1982), which also gives basic bibliographies for each entry.

70. The irregular plan of Charles D. Gambrill and Richardson's James Cheney house in South Manchester, Conn., published in *American Architect* 3 (May 25, 1878), also clearly influenced a number of important houses.

71. At least ten of Cabot and Chandler's buildings were illustrated in the *American Architect* from 1876 to 1882. Their design for the Babbitt house appeared in *American Architect* 2 (Mar. 17, 1877).

72. Peabody and Stearns's slightly earlier design for a house for J. W. Denny at Brush Hill, Mass (1878), although it also shows Queen Anne and Richardsonian influence, is more interesting as a foretaste of the Colonial revival.

73. The "No. 2" design appeared in *American Architect* 4 (Nov. 23, 1878).

74. Sarah Bradford Landau, who has written definitively on Potter and Robertson, recognizes their importance in the period 1876–80 but observes that Potter was much less innovative after 1880. See Sarah Bradford Landau, "Potter, William A.," and "Robertson, Robert H.," in *Macmillan Encyclopedia of Architects*, vol. 3, pp. 467–68, 591; and idem, "Edward T. and William A. Potter: American High Victorian Architects, 1855–1901" (Ph.D. diss., New York University, 1978). Nearly a dozen of Potter and Robertson's designs in the new vein were illustrated in the *American Architect* between 1878 and 1880.

75. Scully uses the term Stick style to describe a kind of wood house American architects designed between the 1840s and the appearance of the Shingle style in the 1870s. Stick-style houses featured bargeboards and flat, decorative wood trim on the exteriors to suggest half-timbered construction; see Scully, *Shingle Style*, pp. xxiii–lix, 2.

76. For the Denny house (see note 72 above) in 1878 Peabody and Stearns used a Georgian, rather than Tudor, variant of Queen Anne. The house has a certain vertical proportion, however, that prevents a truly Georgian effect. The same vertical proportion dominates the not so obviously Georgian and more innovative design for a country house illustrated in

American Architect 4 (Nov. 23, 1878). With its angled wing, the country house design may have been influenced by Gambrill and Richardson's Cheney house (see note 70 above). For further discussion of Peabody and Stearns, see Wheaton A. Holden, "The Peabody Touch: Peabody and Stearns of Boston, 1870–1917," *Journal of the Society of Architectural Historians* 32 (May 1973), pp. 114–31.

77. Emerson's early designs probably influenced younger British and American architects, but according to Cynthia Zaitzevsky his work lost its innovative character after 1887; see Fogg Art Museum, Harvard University, Cambridge, Mass., *The Architecture of William Ralph Emerson, 1833–1917*, by Cynthia Zaitzevsky (exhib. cat., 1969). See also the review of this catalogue by Eleanor Pearson, *Journal of the Society of Architectural Historians* 32 (Oct. 1973), pp. 250–53. More than fifteen designs by Emerson were illustrated in the *American Architect* from 1876 to 1885; the Morrill house was illustrated in *American Architect* 5 (Mar. 22, 1879), pp. 96–97.

78. For information on McKim, Mead and White, see Leland M. Roth, *The Architecture of McKim, Mead and White, 1870–1920: A Building List* (New York, 1978); and idem, *McKim, Mead and White, Architects* (New York, 1983). At least twenty-four of McKim, Mead and White's designs appeared in the *American Architect* from 1877 to 1890, which may be more than for any other firm in that period. Roth has computed they received more than 940 commissions; see Leland M. Roth, "McKim, Mead and White," in *Macmillan Encyclopedia of Architects*, vol. 3, pp. 140–51.

79. Girouard, *Sweetness and Light*, p. 168.

80. Scully, *Shingle Style*, p. 133.

81. Although at least eight of Bates's designs were illustrated in the *American Architect* from 1879 to 1884 and five houses designed by him were built at Tuxedo Park in the period (see note 149 below), no basic research appears to have been done on him and he is not listed in *Macmillan Encyclopedia of Architects*.

82. Carl Pfeiffer was also omitted from *Macmillan Encyclopedia of Architects* and should not have been. He had at least a dozen designs illustrated in the *American Architect* from 1877 to 1884, all of which, including a design for the Plaza Hotel in New York, are basically Queen Anne. See *American Architect* 16 (July 5, 1884), p. 445, a design "by Carl Pfeiffer for the Plaza Apartment-House on Fifth Avenue between Fifty-eighth and Fifty-ninth streets."

83. For studies of Burnham and Root, see Thomas S. Hines, *Burnham of Chicago: Architect and Planner* (New York, 1974); and Donald Hoffmann, *The Architecture of John Wellborn Root* (Baltimore, 1973). Burnham and Root, not Sullivan, are really the "fathers" of the Chicago School insofar as they formed their distinctive style before Sullivan formed his. Root is generally credited with the design portion of the practice. Burnham and Root published periodically in the *American Architect* from 1876 on.

84. Hoffmann, *Architecture of John Wellborn Root*, pp. 155–76, offers Burnham and Root's Monadnock Block in Chicago (1889–92) as an example of their modernist and eclectic tendencies. It is perhaps indicative of today's postmodernist taste that McKim, Mead and White are given almost as much space as Sullivan and Burnham and Root combined in *Macmillan Encyclopedia of Architects*.

85. Many articles in the *American Architect* in these years were directed at achieving closer relationships among the various arts; see, for instance, the article by a Professor Weir of Yale University, "Relations and Points of Contact Between the Arts," *American Architect* 2 (Mar. 10, 1877), pp. 76–78.

86. "Decorative Fine-Art Work at Philadelphia: American Furniture," pt. 3, *American Architect* 2 (Jan. 13, 1877), pp. 12–13.

87. "American Vernacular Architecture," pt. 3, *American Architect* 3 (June 8, 1878), p. 199. See also Harriet Prescott Spofford, *Art Decoration Applied to*

Furniture (New York, 1878); Christopher Dresser, *The Art of Decorative Design* (1862; reprint Watkins Glen, N.Y., 1977); idem, *Principles of Decorative Design* (1873; reprint London, 1973); B[ruce] J. Talbert, *Gothic Forms Applied to Furniture, Metal Work, and Decoration for Domestic Purposes* (1867; reprint Boston, 1873); idem, *Examples of Ancient and Modern Furniture, Metal Work, Tapestries, Decorations, Etc.* (1876; reprint Boston, 1877); and Eastlake, *Hints on Household Taste*.

88. "Bruce J. Talbert (1838–1881)," *American Architect* 10 (Aug. 20, 1881), pp. 85–87.

89. J[ohn] M[cKean] B[rydon], "A Few More Words about 'Queen Anne,'" *American Architect* 2 (Oct. 6, 1877), pp. 320–22.

90. [Editorial], *American Architect* 9 (Jan. 8, 1881), p. 14. Morris's articles on decoration and pattern appeared in *American Architect* 9 (Jan. 8, 1881), pp. 14, 16–28; (Jan. 15, 1881), pp. 29–30; (Jan. 22, 1881), pp. 40–43; 11 (Jan. 21, 1882), pp. 32–35; (Jan. 28, 1882), pp. 44–46; (Feb. 11, 1882), pp. 66–68; 12 (Dec. 9, 1882), pp. 281–82. See also William Morris, "The Essential Difference Between the Work of the Medieval and Modern Craftsman," *American Architect* 16 (Aug. 23, 1884), pp. 89–91; and "William Morris at Work," *American Architect* 17 (June 20, 1885), pp. 296–98. No wonder Wright, who must have consulted the *American Architect* for those years, could state in a lecture he gave at Hull-House in Chicago in 1901 that "all artists love and honor William Morris"; see Frank Lloyd Wright, "Art and Craft of the Machine," in Chicago Architectural Club, *Catalogue of Exhibits and Supplementary List of Patrons* (Chicago [1901]).

Richardson visited Morris in London in 1882 and appears to have supported the purchase of Morris wallpapers and fabrics for the John J. Glessner house in Chicago, which Richardson designed in 1885 (see ILL. 3.8).

91. William Morris, "Hints on House Decoration," pt. 3, *American Architect* 9 (Jan. 22, 1881), p. 42.

92. Henry Van Brunt et al., "Studies of Interior Decoration," pts. 1–13, *American Architect* 2 (Feb. 24, 1877), pp. 59–60; (Mar. 10, 1877), pp. 75–76; (Mar. 17, 1877), pp. 84–85; (Mar. 24, 1877), pp. 92–93; (Apr. 14, 1877), pp. 115–16; (Apr. 21, 1877), pp. 123–24; (Apr. 28, 1877), pp. 131–32; (May 5, 1877), pp. 139–40; (May 26, 1877), pp. 163–64; (June 9, 1877), pp. 179–80; (June 23, 1877), pp. 196–97; (June 30, 1877), pp. 204–5; (July 21, 1877), pp. 232–33. See also John Ruskin, *The Seven Lamps of Architecture* (1849), vol. 8 of *Works of John Ruskin*.

93. For example, Shaw came to dislike using wallpaper; see Saint, *Richard Norman Shaw*, pp. 258–59.

94. Quoted in Robert Koch, *Louis C. Tiffany: Rebel in Glass* (New York, 1964), p. 11. See also Hugh F. McKean, *The "Lost" Treasures of Louis Comfort Tiffany* (New York, 1980).

95. See Kornwolf, *M. H. Baillie Scott*, esp. pp. 216–38, for details on the Haus eines Kunstfreundes (House for a Lover of Art) competition sponsored by Alex Koch in Darmstadt in 1901. This competition marked the start of a concerted German effort to stimulate the creation of an architecture free from revival modes. The Aesthetic movement and its offshoots, the Arts and Crafts movement and Art Nouveau, contributed much to the development of abstraction in art through the vehicle of the decorative arts. Ornament, including stained glass, became abstract, even nonobjective, even before Matisse, Picasso, and others developed those qualities in painting. Pevsner, *Pioneers of Modern Design* (1949), pp. 55–67, acknowledges the abstract nature of much Art Nouveau design, especially that associated with Henri van de Velde (1863–1957).

96. "Red Brick in Architecture," *American Architect* 8 (Nov. 20, 1880), pp. 245–46.

97. Terracotta became a favored material for ornament in the period, and terracotta and its production

were the subject of a number of articles in the *American Architect;* see "The Manufacture of Terra-cotta in Chicago," *American Architect* 1 (Dec. 30, 1876), pp. 420–21; "Details in Terra-cotta," *American Architect* 5 (Feb. 15, 1879), ills. between pp. 56 and 57; [Review of James J. Talbot, *Terra-cotta in Architecture*], *American Architect* 6 (Nov. 8, 1879), pp. 150–51; "The Architectural Employment of Terra-cotta," *American Architect* 8 (Sept. 25, 1880), pp. 150–51; "Terra-cotta," *American Architect* 16 (July 5, 1884), pp. 3–4; and "Architectural Terracotta," pts. 1, 2, *American Architect* 17 (June 6, 1885), pp. 267–68; 18 (July 4, 1885), pp. 3–4.

98. Rectus, "Modern House Painting," *American Architect* 10 (Oct. 22, 1881), p. 195.

99. [George Palliser and Charles Palliser], *Palliser's New Cottage Homes and Details* (New York, 1887), pl. 2. The Palliser brothers, whose architectural practice was based in Bridgeport, Conn., republished their *Palliser's Model Homes . . .* (1878) and *Palliser's American Cottage Homes* (1878) under the title *Palliser's American Architecture, or Every Man a Complete Builder* in 1888; this and their *New Cottage Homes and Details* (1887) were reprinted in one volume, *The Palliser's Late Victorian Architecture,* intro. Michael A. Tomlan (Watkins Glen, N.Y., 1978).

100. For further discussion and illustrations of Sullivan's ornamental designs, see Paul E. Sprague, "The Architectural Ornament of Louis Sullivan and His Chief Draftsmen" (Ph.D. diss., Princeton University, 1968); and idem, *The Drawings of Louis Henry Sullivan: A Catalogue of the Frank Lloyd Wright Collection at the Avery Architectural Library* (Princeton, 1979).

101. The view of ornament as the "soul" of architecture endured after World War I in the studies of Claude Bragdon (1866–1946), who sought to discover a basis for ornament in modern architecture that could not be criticized. Wright, among others, was not convinced, and the 1930s saw Wright locking horns with Bragdon over the debatable subject. Nonetheless, ornament as it was developed and defined by the architects of the Aesthetic movement continued to be used, though much less extensively, by architects identified with the Arts and Crafts movement, and it came to the fore again with architecture associated with Art Deco. Bragdon's ornament might be characterized today as Art Deco, and most Art Deco ornament, often in terracotta, still bore the aesthetic stamp; see Allied Arts of Seattle, Wash., *Art Deco Seattle* (exhib. cat., 1979). Bragdon's ideas about ornament, which owed much to Ruskin, Morris, and Sullivan, appear in many of his articles and books, but see especially Claude Bragdon, *Projective Ornament* (Rochester, N.Y., 1915); and idem, *The Frozen Fountain* (New York, 1924).

102. Louis Sullivan, *The Autobiography of an Idea* (1924; reprint New York, 1956), pp. 273, 283–84. The critical response to the negative effect industrialization and urbanization were exacting on the environment began well before the Aesthetic era. The response can be traced in Britain through William Blake (1757–1827), Thomas Carlyle (1795–1881), Charles Dickens (1812–1870), Pugin, Ruskin, and Morris. Thomas Jefferson (1743–1826), Ralph Waldo Emerson (1803–1882), Horatio Greenough (1805–1852), Henry David Thoreau (1817–1862), Walt Whitman (1819–1892), and Sullivan represent a corollary tradition in the United States. In general, their combined writings on the environment, the arts, and society constitute an Anglo-American counterculture, the legacy of which is readily perceived in the Aesthetic and Arts and Crafts movements. I have considered this in an unpublished manuscript, James D. Kornwolf, "Architecture, Environment, and the Arts and Crafts Movement: Sources and Dimensions of the Anglo-American Counterculture"; see also James B. Gilbert, *Work Without Salvation: America's Intellectuals and Industrial Alienation, 1880–1910* (Baltimore, 1977).

103. The importance of domestic architecture as a catalyst in the period was recognized thirty years ago by Henry-Russell Hitchcock, who gave "The Development of the Detached House in England and America from 1800 to 1900" its own chapter in *Architecture: Nineteenth and Twentieth Centuries* and concentrated on the Queen Anne and Shingle styles as these combined to help produce Wright's architecture.

104. Morris, "Hints on House Decoration," pt. 3, *American Architect* 9 (Jan. 22, 1881), p. 43.

105. "American Vernacular Architecture," pt. 5 [review of S. B. Reed, *House-Plans for Everybody, for Village and Country Residences, Costing from $250 to $8,000 . . .*], *American Architect* 4 (Sept. 21, 1878), p. 101.

106. "American Vernacular Architecture," pt. 3, *American Architect* 3 (June 8, 1878), p. 199.

107. Peabody, "Georgian Houses of New England," pt. 2, *American Architect* 3 (Feb. 16, 1878), p. 54.

108. A complete list of the more than two hundred contributions on American Colonial architecture the *American Architect* published between 1876 and 1895 was compiled in 1984 by Peter Turner, a student in my course in American Colonial architecture at the College of William and Mary, Williamsburg, Va. Most of the contributions dealt with preservation, not revival.

109. John J. Stevenson, "Architectural Restoration: Its Principles," *American Architect* 2 (July 7, 1877), pp. 219–20.

110. William Morris, cited in [A question of restoration], *American Architect* 6 (Nov. 8, 1879), pp. 145–46; and "The 'Restoration' of St. Mark's" [letter to the editor], *American Architect* 6 (Nov. 29, 1879), p. 174. Mackmurdo, like many others in Britain and in America, was concerned over the dilapidated state of many of Wren's churches in London. In 1883 he published *Wren's City Churches* (Orpington, Eng., 1883). The aesthetic title page Mackmurdo designed for his book was an important early source of Art Nouveau; see Pevsner, *Pioneers of Modern Design* (1949), p. 30. See also John Ruskin, *The Stones of Venice* (1851–53), vols. 9–11 of *Works of John Ruskin*.

111. See note 61 above.

112. Rhoads, "Colonial Revival," vol. 1, p. 77. Peabody and Stearns, as well as William Appleton Potter and Edward T. Potter, were involved with preservation at an early date.

113. "Colonial Architecture," pt. 1 [report to the American Institute of Architects], *American Architect* 10 (Aug. 13, 1881), pp. 71–74; see also pt. 2 of this well-illustrated article, *American Architect* 10 (Aug. 20, 1881), pp. 83–85.

114. Brydon, "A Few More Words about 'Queen Anne,'" *American Architect* 2 (Oct. 6, 1877), pp. 320–22.

115. *American Architect* 16 (Jan. 5, 1884), p. 12, cited in Samuel H. Graybill, Jr., "Bruce Price: American Architect, 1845–1903," 2 vols. (Ph.D. diss., Yale University, 1957), vol. 1, p. 243 (n. 25). For the Pallisers' publications, see note 99 above.

116. Quoted in Graybill, "Bruce Price," vol. 1, p. 247 (n. 68). According to Graybill, Price originally made this statement in 1886 in [Sheldon], *Artistic Country-Seats,* p. 37.

117. Graybill, "Bruce Price," vol. 1, p. 84. At least twenty Price designs were illustrated in the *American Architect* from 1876 to 1890. As an architect who moved from Victorian Gothic to an Aesthetic manner, Price is interesting to compare to Frank Furness and George B. Post. Furness's Udine Barge Club in Philadelphia (1882–83) has rather aesthetic massing, not without visual similarity to Post's New York Produce Exchange (1881–85), though the latter is in a Renaissance mode. The hall and fireplaces in the Gricom house in Haverford, Pa. (about 1881–82), attributed to Furness, are striking instances of the ef-

fect of the Aesthetic movement on the architect; see Philadelphia Museum of Art, *The Architecture of Frank Furness,* by James F. O'Gorman (exhib. cat., 1973). See also Russell Sturgis, "A Critique of the Works of Bruce Price," *Architectural Record, Great American Architects Series* 5 (June 1899), pp. 1–64.

118. Edward Teitelman, "Eyre, Wilson," in *Macmillan Encyclopedia of Architects,* vol. 2, pp. 34–36. In addition, see Betsy Fahlman, "The Architecture of Wilson Eyre" (Ph.D. diss., University of Delaware, 1979); and Betsy Fahlman and Edward Teitelman, "Wilson Eyre: The Philadelphia Domestic Ideal," *Pennsylvania Heritage* 8 (Summer 1982), pp. 23–27.

119. For a more detailed study of Ellis's work, see Eileen P. Manning [Michels], "The Architectural Designs of Harvey Ellis" (M.A. thesis, University of Minnesota, 1953).

120. *Saint James Gazette,* Dec. 17, 1881, p. 11.

121. See Walter Creese, *The Search for Environment: The Garden City Before and After* (New Haven and London, 1966).

122. Robinson, *English Flower Garden,* pp. 21–23.

123. "Decorative Fine-Art Work at Philadelphia," pt. 3, *American Architect* 2 (Jan. 13, 1877), pp. 12–13.

124. Christopher Hussey, *The Life of Sir Edwin Lutyens* (London, 1950), pp. 28–35. See also Betty Massingham, *Miss Jekyll: Portrait of a Great Gardener* (London, 1966); Beatrix Jones Farrand, "The Garden as a Picture," *Scribner's Magazine* 42 (July 1907), pp. 2–11; and Mrs. Robert Woods Bliss, *Beatrix Jones Farrand, 1872–1959: An Appreciation of a Great Landscape Gardener* (Washington, D.C., n.d.). Suggestions that women might become architects or landscape gardeners appeared in *American Architect* 1 (Sept. 30, 1876), p. 313; and "Landscape Gardening: A Profession for Women," *American Architect* 14 (July 28, 1883), p. 37. See also "Women as Wood-Carvers: The Movement in Cincinnati," *American Architect* 2 (Mar. 31, 1877), pp. 100–101; *American Architect* 2 (Oct. 20, 1877), p. 334, where it was noted that the women of the newly formed Society of Decorative Art in New York had opened a salesroom and that an "association of like aim" had been established in Boston; Catherine Lynn, "Surface Ornament: Wallpapers, Textiles, Carpets, and Embroidery," this publication; and Marilynn Johnson, "Art Furniture: Wedding the Beautiful to the Useful," this publication.

125. Elizabeth Stevenson, *Park Maker: A Life of Frederick Law Olmsted* (New York, 1977), pp. 407–8.

126. Olmsted wrote at least one two-part article in the *American Architect* before 1887, justifying the acquisition of land for public use and as open space and urging its proper maintenance; see Frederick Law Olmsted, "On Points of View and Methods of Criticism of Public Works of Landscape Architecture," pts. 1, 2, *American Architect* 17 (June 20, 1885), pp. 295–96; (June 27, 1885), pp. 306–7.

127. Quoted in Julius G. Fabos, Gordon T. Milde, and V. Michael Weinmayr, *Frederick Law Olmsted, Sr.: Founder of Landscape Architecture in America* (Amherst, Mass., 1968), pp. 10ff.

128. John W. Reps, *The Making of Urban America: A History of City Planning in the United States* (Princeton, 1965), esp. pp. 339–48. According to Reps, efforts to create ideal communities and the idea of the Garden City trace back at least to the British architect J. B. Papworth's *Rural Residences* (London, 1818). Reps does not mention Tuxedo Park.

129. Stevenson, *Park Maker,* p. 48.

130. Olmsted, Norton, and Farrand were all instrumental in the founding of the American Society of Landscape Architects in New York City in 1899. The first issue of the society's journal, *Landscape Architect,* appeared in 1910.

131. M. G. Van Rensselaer, "Landscape Gardening," *American Architect* 23 (Jan. 7, 1888), pp. 3–5.

132. The Greenes' design for the Gamble house in

Pasadena (1908), which shows direct Japanese influence, exemplifies their integrated approach to landscape and architecture.

133. The first of many articles the *American Architect* carried on landscape gardening was A. J. Bloor, "Landscape Treatment of Rural and Suburban Property," pts. 1, 2, *American Architect* 1 (May 20, 1876), pp. 164–65; (May 27, 1876), p. 173.

134. [Bedford Park], *American Architect* 10 (Aug. 13, 1881), p. 70. Americans were as aware as the British of the need for aesthetic environments; see, for example, the report of plans to visually improve Williamstown, Mass., *American Architect* 2 (June 16, 1877), p. 186; (June 30, 1877), p. 211.

135. "Notes and Clippings: An Art City," *American Architect* 10 (Dec. 17, 1881), p. 294.

136. For example, Chautauqua, N.Y., Asbury Park, N.J., and Thousand Island Park, N.Y., all begun in 1874, were planned as religious, noncommercial summer resorts, and some of them, such as Chautauqua, soon acquired decidedly cultural orientations; see Graybill, "Bruce Price," vol. 1, pp. 72–73. In 1901, the same year he built a house (called Trayaddo) at Tuxedo Park, the New York financier Spencer Trask founded Yaddo, a 400-acre retreat for artists at Saratoga Springs, N.Y.; see Donald F. Clark, *National Register of Historic Places Inventory: Nomination Form, Division of Historic Preservation, for Tuxedo Park, New York* (Albany, N.Y., 1978).

137. "An American Park," *American Architect* 16 (July 12, 1884), pp. 15–16, and ills. At least ten designs by Lamb and Rich were illustrated in the *American Architect* from 1879 to 1884. They designed Sagamore Hill, Theodore Roosevelt's house in Oyster Bay, N.Y., in 1893.

138. Pierre Lorillard I (roman numerals mine), a Huguenot who was a tobacconist in France, had established a tobacco shop on Chatham Street in New York City by 1760. In 1763 he married Dorothy Moore, whose brother owned a tobacco factory. He later relocated to Hackensack, N.J., and he was killed during the American Revolution in 1778. His son, Peter II (1746–1843), returned to New York City about 1790 and greatly expanded the business, importing fine Virginia tobacco and acquiring the tract of 7,000 acres on which Tuxedo Park would be built. His son, Peter III (d. 1867), began the tradition of hunting on the lands. Pierre IV, who married Emily Taylor in 1858, had by 1884 bought the tracts of the land bequeathed to his brothers and sisters. Pierre IV retained a keen interest in the project at Tuxedo Park through 1893. In the late 1890s E. H. Harriman instigated much development, although Pierre IV and his son, Pierre V, maintained houses at Tuxedo.

139. Among the Tuxedo Club's original or very early members, apart from numerous Lorillards, were William Waldorf Astor, Theodore Frelinghuysen, Amos Tuck French, Robert Goelet, E. H. Harriman, Cooper Hewitt, A. D. Juilliard, Grenville Kane, Herbert C. Pell, Jr., Henry W. Poor, and A. Van Cortlandt.

140. *Tuxedo News* 2 (Nov. 1900), pp. 1–24. For fur-

ther studies of Tuxedo Park, see Edwin C. Kent, *The Story of Tuxedo Park* (Rhinebeck, N.Y., 1937); Scully, *Shingle Style,* esp. pp. 126–29; George M. Rushmore, *The World with a Fence Around It: Tuxedo Park—the Early Days* (New York, 1957); Herbert Claiborne Pell, "Life in Tuxedo," transcript, Mar. 12, 1973, Oral History Program, Columbia University, New York; and [Special issue on the Anglo-American suburb], *Architectural Design* 51 (1981), p. 68. I am especially grateful to Albert Winslow, historian for the Town of Tuxedo, for his generous assistance with my research on Tuxedo Park.

141. Samuel Swift, "Community Life in Tuxedo," *House and Garden* 8 (Aug. 8, 1905), pp. 60–71.

142. Emily Post, "Tuxedo Park: An American Rural Community," *Century Illustrated Monthly Magazine* 82 (Oct. 1911), pp. 795–805.

143. Graybill, "Bruce Price," vol. 1, pp. 74, 78.

144. Quoted in Wendy Insinger, "The Greening of Tuxedo Park," *Town and Country,* May 1984, pp. 187–97, 261–62, 264–65.

145. Rushmore, *World with a Fence Around It.*

146. Price's Tuxedo Club was torn down in 1928. The present club is a design by John Russell Pope in a Tudor manner.

147. Graybill, "Bruce Price," vol. 1, esp. pp. 66, 68, 70, 83, 91–92, 101, 106, 110, 111, discusses Precolumbian and other exotic influences on Lorillard and Price. See also Claude-Joseph-Désiré Charnay, *Les Anciennes Villes du nouveau monde* (Paris, 1885).

148. "Tuxedo Park," *Art Age* 4 (Sept. 1886), pp. 19–21.

149. Of the 286 buildings surveyed for the National Register in 1978, 122 date to before 1900, 100 to between 1900 and 1941. Included are at least sixteen by Price, five by Bates, two by Eyre, two by McKim, Mead and White, two by William Lescaze, and others by William Appleton Potter, Sturgis, Pope, Carrère and Hastings, and Walker and Gillette. Many have been extensively remodeled or enlarged. See Clark, *National Register.*

150. Quoted in Barr Ferree, "A Talk with Bruce Price," *Architectural Record, Great American Architects Series* 5 (June 1899), pp. 65–84.

151. Post, "Tuxedo Park."

152. *Tuxedo News* 2 (Nov. 1900), pp. 1–24.

153. *American Architect,* quoted in Graybill, "Bruce Price," vol. 1, p. 70.

154. Lancaster, *Japanese Influence in America,* pp. 95–96.

155. Clark, *National Register.*

156. Graybill, "Bruce Price," vol. 1, p. 106. Graybill also located illustrations of Price's Japanese houses in *Building* 6 (Mar. 19, 1887) and Architectural League of New York, *Catalogue of the Sixth Annual Exhibition* (exhib. cat., 1890), p. 33 (no. 174).

157. Lancaster, *Japanese Influence in America,* pp. 189–215, considers Shiota of considerable importance in the period before World War I.

158. Graybill, "Bruce Price," vol. 1, p. 102, feels

Price tried "to merge himself with a 'Oneness'—an 'Allness'—as D. H. Lawrence described Whitman's search for the ultimate." See also Scully, *Shingle Style,* pp. 125–29, 159–60.

159. David Gebhard and Harriette Von Breton, *Architecture in California, 1868–1898* (Santa Barbara, Calif., 1968), p. 7.

160. For a discussion of Coxhead's work, see Richard W. Longstreth, *On the Edge of the World: Four Architects in San Francisco at the Turn of the Century* (Cambridge, Mass., 1983).

161. See Kenneth H. Cardwell, *Bernard Maybeck: Artisan, Architect, Artist* (Santa Barbara, Calif., 1977). In 1886–88, while at Carrère and Hastings, Maybeck worked principally on the Ponce de Leon Hotel in Saint Augustine, Fla.

162. Quoted in Randell L. Makinson, *Greene and Greene: Architecture as a Fine Art* (Salt Lake City, Utah, and Santa Barbara, Calif., 1977), pp. 26–27. Woodward, who was a graduate of Harvard University and held a Ph.D. from Washington University, is credited with introducing crafts in American secondary education. In addition to normal high-school courses, his students worked ten hours weekly in woodworking, metalworking, or tool making. It is not clear whether Peabody and Stearns's design of about 1879 for Washington University School (see ILL. 10.14) was for Woodward's school. If so, it was not executed, for the school opened in 1879 in a building designed for the purpose by Edwin Harrison. The building was enlarged in 1882. Woodward wrote numerous books and articles on manual training, but see especially Calvin Milton Woodward, *The Manual Training School* (1887; reprint New York, 1969). See also Charles P. Coates, "The Veering Winds: A Semicentennial Soliloquy," *Industrial-Arts Magazine* 15 (Sept. 1926), pp. 304–5; C. A. B., "Fifty Years Ago," *Industrial Education Magazine* 30 (June 1929), pp. 445–46; and Irving Dilliard, "Woodward, Calvin Milton," in *Dictionary of American Biography,* vol. 10, pt. 2 (New York, 1959), pp. 507–8.

163. Scully, *Shingle Style,* p. 159.

164. In 1903 Wright had designed a house in Peoria, Ill., for the Littles, who were generous patrons of the arts and typical of the aesthetically and progressively inclined intellectuals of their generation who made Wright's work a reality; see Leonard K. Eaton, *Two Chicago Architects and Their Clients: Frank Lloyd Wright and Howard Van Doren Shaw* (Cambridge, Mass., 1969). In 1972 the Metropolitan Museum acquired, along with the Little room, a group of Wright's original drawings for the Little house and its furnishings, as well as three copies of the Wasmuth portfolio of his works, *Ausgeführte Bauten und Entwürfe von Frank Lloyd Wright* (Berlin, 1910). The Littles were among the contributors who helped defray the costs of publishing the portfolio; see Edgar Kaufmann, Jr., "Frank Lloyd Wright at the Metropolitan Museum of Art," *Metropolitan Museum of Art Bulletin,* n.s. 40 (Fall 1982), esp. pp. 27–28.

Overleaf: Detail of cover of Easter Number, *Lotus* (ILL. 11.7)

An Aestheticism of Our Own:

American Writers and the Aesthetic Movement

Jonathan Freedman

AT THE BEGINNING of his 1882–83 tour of America, so the apocryphal story goes, Oscar Wilde (1854–1900) startled a customs clerk with his announcement that he had nothing to declare but his genius (ILL. 11.1). This comment was only the first of many masterstrokes of self-promotion Wilde was to accomplish during his stay, but it may also be understood as emblematic of the complexity of the American literary experience of British aestheticism. When viewed from one perspective, the anecdote tells the story of a British writer who, like so many of his countrymen, toured nineteenth-century America preaching a gospel of culture to the benighted natives and reaping a hefty profit in return. Seen from another vantage point, the account lends itself to a different reading. Wilde was hardly the first traveler in the New World who arrived at his destination with nothing to declare but his sense of self-worth. More than two hundred years earlier, the Puritans had landed in Massachusetts proclaiming their sense of mission and divine inspiration, and in the early 1700s, according to a second apocryphal story spread by its self-serving protagonist, Benjamin Franklin arrived in Philadelphia from Boston bearing only his wit and invention. Wilde, then, placed himself firmly in the context of one of the most enduring myths in American cultural history: that of the self-made man with nothing to his name but a feel for the unlimited possibilities that America had to offer and an eagerness to make the most of them.

The story of the American literary encounter with British aestheticism may be construed analogously. From one perspective, the interest in the British Aesthetic movement evident in late nineteenth-century America—already well established before Wilde's tour and growing steadily in intensity following it—appears to be a textbook case of British cultural imperialism. Aestheticism, in this light, could be defined as a parasitic excrescence on the healthy body of American letters, an aberration with little or no effect on the organic growth of the American tradition in literature. This is how most standard literary histories tell the story, when they tell it at all.[1]

From another viewpoint, the American literary experience with the British Aesthetic movement may be seen as a cross-cultural dialogue of dizzying complexity. When Americans encountered the likes of Wilde, John Ruskin (1819–1900), Dante Gabriel Rossetti (1828–1882), Walter Pater (1839–1894), and WILLIAM MORRIS, they were confronted with variant forms of their own most basic patterns of imaginative response, revised and expressed in a thoroughly alien and alienating vocabulary. They reacted to this combination of the familiar and the strange with a complicated mixture of sympathy and judgment, enthusiasm and distrust. When the matter is examined from this angle, a cultural matrix emerges that is neither imperialistic nor one-sided. American writers played a significant role in the formation of British aestheticism and were fascinated by its crystallization into a self-conscious, if diffuse, movement; they made an important contribution to the British as well as the American reception of that movement; and they continued to be affected by it well into the twentieth century. It is this perspective I wish to explore here.

Americans and Literary Aestheticism: Foreshadowings

By every account except his own, Wilde's American audiences greeted him with a combination of curiosity and boredom. Both reactions are understandable. Prior to 1882 all that the majority of Americans knew of Wilde was what they read in the British satiric magazine *Punch* or in reports cribbed from it, so it is no surprise that they thronged to his lectures very much as they flocked to P. T. Barnum's American Museum, in New York: to view a spectacle, if not something of a freak show. Since what Wilde delivered was a sober dissertation entitled "The Renaissance of English Art"[2]—by which he meant the entire corpus of the Aesthetic movement and the handicrafts revival from Ruskin through the Pre-Raphaelite Brotherhood and Morris—it is no wonder that most of these audiences yawned vigorously and applauded politely. (The response improved when Wilde, as practical-minded as his listeners, switched his attention to home decoration.) But Americans yawned for reasons other than the fact that the freak had turned out to be so serious a pedagogue. The subject of "The Renaissance in English Art" was hardly novel to an American audience that had been kept informed by its periodical press of the more recent developments on the British cultural scene and that, moreover, could reflect on the contributions that Americans themselves had made to the Aesthetic movement about which Wilde professed to instruct them. The comic dimension of the situation was astutely observed by the New York *Daily Graphic,* which published a cartoon (ILL. 11.2) showing Wilde offering sunflowers and lilies to a bluestocking Bostonian. "No, Sir. Shoddy New York may receive you with open arms," sniffs the earnest Bostonian, "but we have an Aestheticism of our own."[3]

Indeed they did. Bostonians of the time prided themselves on their artistic and cultural sophistication. They possessed in Charles Eliot Norton (1827–1908) an intellectual lion who had become Ruskin's best friend, had commissioned a painting by Rossetti, and was to found an American branch of Morris's Arts and Crafts

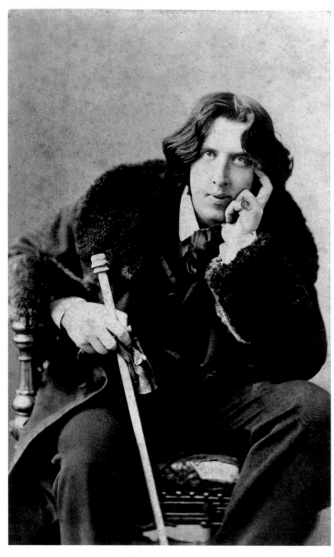

Above: ILL. 11.1 Oscar Wilde. Napoleon Sarony, ca. 1882. Albumin(?) print, 11¾ × 7¹/₁₆ in. (29.8 × 17.9 cm). The Metropolitan Museum of Art, The Elisha Whittelsey Collection, The Elisha Whittelsey Fund, 1969 (69.659)

Opposite: ILL. 11.2 "Boston Aestheticism Versus Oscar Wilde." New York *Daily Graphic* (Jan. 19, 1882). The New-York Historical Society

movement.[4] Such enthusiasm was not merely a Boston phenomenon; after the Civil War, Americans in general were increasingly preoccupied with high culture and particularly with the most elevated form of high culture available to them, that of Britain. Furthermore, Americans had long devoted themselves to their cultural improvement with an assiduousness that surpassed that of the British, and much of this enthusiasm was expressed through interest in the various manifestations of the British Aesthetic movement. "I have much to thank America for—heartier appreciation and a better understanding of what I am and mean, than I have ever met in England," wrote Ruskin, hailing a new American art periodical the *Crayon,* and even allowing for the hyperbole customary in such communications, his sense of his audience was acute. As Roger B. Stein has shown, Ruskin's authority was canonical to many American writers and artists as early as the middle of the nineteenth century, and his writings on art, science, nature, and society continued to influence American thought well into the twentieth.[5] But Ruskin was not the only figure of the Aesthetic movement whom Americans came to know and admire. The poetry of Pre-Raphaelites such as Rossetti and Morris was published in "genteel" journals, including the *Century* and *Harper's New Monthly Magazine,* and was praised by critics such as George Boker (1823–1890) and Edmund Clarence Stedman (1833–1908), although they drew the line at Algernon Charles Swinburne (1837–1909). While Americans laughed vigorously at satiric jabs at the aesthetes taken by George Du Maurier (1834–1896) in his *Punch* cartoons and by Gilbert and Sullivan in the comic opera *Patience* (1881), they constituted an eager market for the merchandisers of aestheticism. It was no less a figure than Richard D'Oyly Carte (1844–1901), Gilbert and Sullivan's canny producer, who had dispatched Wilde on his lecture tour of America in order to drum up publicity for *Patience,* and a score of pirate companies of the opera as well as popular songs and penny-dreadful novels on aestheticism followed in Wilde's wake.

It would be a mistake, however, to conclude that the cultural transactions involved in the American experience of aestheticism were one-sided. The finest poems of Swinburne, to cite one example, owe a heavy debt to the imagery and rhythms of Walt Whitman (1819–1892), and a number of the Pre-Raphaelites expressed admiration for Whitman's achievements. (During his visit to America, Wilde went to pains to visit the poet.) Indeed, Whitman's own predecessors exerted a strong, if relatively unacknowledged influence on the formation of the British Aesthetic movement itself. This fact should not surprise us. If aestheticism may be generally defined as the privileging of beauty and art in the face of the demands of morality and utility, then it was always present in American literature and criticism. Its force can be felt in the writings of Washington Irving (1783–1859), with his adoption of the narrative stance of the urbane flaneur, or detached aesthetic observer, as well as in Nathaniel Hawthorne's (1804–1864) tales of artists and artificers caught in the conflict between the claims of beauty and the imagination and those of human connection and moral action. It is also evident, spectacularly so, in the visionary fiction and sophisticated criticism of Edgar Allan Poe (1809–1849).

Fully to trace the delicate strands of influence and counterinfluence between American proto-aestheticism and the development of the British Aesthetic movement would demand more space than is available here. This is especially true of Poe, whose effect on Rossetti and Pre-Raphaelitism was great (ILL. 11.3); but because of the complications caused in the case of Poe by the mediating role of French culture, it will be more useful to turn to the equally important example of Ralph Waldo Emerson (1803–1882). Emerson (ILL. 11.4) was the most thoroughly exalted figure of late nineteenth-century American culture, even after he lapsed into embarrassing senility; when Swinburne or Matthew Arnold (1822–1888) dared to suggest his limitations, cries of outrage could practically be heard on the western shores of the Atlantic. Still, the acclaim

THE DAILY GRAPHIC

AN ILLUSTRATED EVENING NEWSPAPER

39 & 41 PARK PLACE

VOL. XXVII. | All the News. Four Editions Daily. | NEW YORK, THURSDAY, JANUARY 19, 1882. | $12 Per Year in Advance. Single Copies, Five Cents. | NO. 2744.

BOSTON ÆSTHETICISM VERSUS OSCAR WILDE.

The Old Lady of Beacon Hill—"NO, SIR. SHODDY NEW YORK MAY RECEIVE YOU WITH OPEN ARMS, BUT WE HAVE AN ÆSTHETICISM OF OUR OWN."

Emerson enjoyed in England was impressive. There was, the *English Review* complained in 1849, an "Emerson mania" abroad in the land, mainly among the young men at Oxford who found Emerson's reformulations of orthodox Protestantism stimulating in their flexibility of thought, their sense of the possibilities of human perfection, and their sympathy for the enlightening effects of human culture.[6] One such young man was Arnold, who personally thanked Emerson for the "refreshing and quickening effect your writings had on me at a critical time of my life," and who emphasized in a commemorative lecture the influence that the American had had on his early thinking.[7] It is a telling irony that when Wilde presumed to lecture Americans on the Arnoldian notion of culture as a redemptive category of thought, he ignored the fact that this very concept finds among its sources the American figure whom his audiences revered before all others.[8]

Ruskin (ILL. 11.5), too, testifies to the potency of influence exerted by Emerson, albeit in a less forthright way than Arnold. In an appendix to *Modern Painters, 3* (1856), Ruskin records that a student at the Working Men's College had asked him whether he noticed the similarities in ideas and expression between his own work and that of Emerson. Ruskin then sat down to read Emerson for the first time and discovered that the similarities were pronounced indeed.[9] Emerson, in the most famous passage of "Nature" (1836), writes, "Standing on the bare ground,—my head bathed by the blithe air and uplifted into infinite space,—all mean egotism vanishes. I become a transparent eyeball; I am nothing; I see all; the currents of the Universal Being circulate through me; I am part or parcel of God." In *Modern Painters, 3,* Ruskin argues, "The more I

think of it I find this conclusion more impressed upon me,—that the greatest thing a human soul ever does in this world is to *see* something, and tell what it *saw* in a plain way. Hundreds of people can talk for one who can think, but thousands can think for one who can see. To see clearly is poetry, prophecy, and religion,—all in one."[10] An obvious correlation between Ruskin and Emerson lies in their common privileging of the act of vision. As the above passages suggest (and they are hardly unique, in either case), Ruskin and Emerson redefine the self at its most successful, its most highly pitched, and its rarest as being fundamentally aesthetic in constitution—at least if "aesthetic" is understood in the root sense of the word, connoting the fulfillment or perfection of vision. "I am nothing; I see all" could be the credo for Emerson's transcendentalist and Ruskin's artist-hero alike, for each achieves a greater being than his fellow man by the surpassing perfection of his visual faculty.

What these figures gaze on is understood by Ruskin and Emerson in comparable ways. Both men describe the natural world in language that at once discovers and verifies moral and religious meaning in landscape. Emerson's claim that he would rather see a snow shower than hear a sermon would have appealed to Ruskin, for to each a snow shower *was* a sermon, an event pregnant with wonder that could be read as a series of signs, symbols, or types of moral meaning. Each man, further, had in consequence to bear a burden of contradiction, for each wanted, on the one hand, to value the visual experience of the natural world as an end in itself and, on the other, to privilege an all-powerful Vision that promised to transcend nature entirely. Although they locate in the artist—

ILL. 11.3 Third illustration for *The Raven* by Edgar Allan Poe. Dante Gabriel Rossetti, ca. 1846–47. Pen and ink and wash on paper, 9 × 8½ in. (22.9 × 21.6 cm). Trustees of the Victoria and Albert Museum, London

ILL. 11.4 Ralph Waldo Emerson. Rudolph Ruzicka, ca.
1915. Etching on Japan vellum, 5¹⁵⁄₁₆ × 3¹⁵⁄₁₆ in.
(15.1 × 10 cm). The Metropolitan Museum of Art, Gift
of Rudolph Ruzicka, 1920 (20.80.3)

ILL. 11.5 John Ruskin. Robert Bryden, *Some Wood Cuts of
Men of Letters of the Nineteenth Century* (London, 1899).
Woodcut on paper, 23 × 18 in. (58.4 × 45.7 cm). The
Metropolitan Museum of Art, Gift of David Silve, 1936
(36.23.47)

Ruskin's Turner or Emerson's poet-seer—a figure whose creative
imagination is potentially able to resolve the contradictions, both
writers confronted their stubborn refusal to be so reconciled.

While the similarities between Ruskin and Emerson are pro-
nounced, the differences are marked, too. Ruskin's splendid eye
for visual detail and his profound involvement with pictorial art
were not shared by Emerson, while Emerson's eagerness to make
the transcendental leap from the natural to the supernatural and his
uncanny optimism were by no means characteristic of Ruskin.
Taking note of these similarities and differences can help unravel
the complexity of the American response to Ruskin. When the
young Emersonian Charles Eliot Norton first encountered Rus-
kin's writings, in the 1850s, he found an example of a mode of
thought in keeping in its most crucial aspects with that of his com-
patriot, but purged of certain objectionable elements—a willful
ignorance of social realities, in particular—and invested with the
cultural authority and artistic sophistication that Emerson lacked.
The same was true of a number of other Americans, including
William James Stillman (1828–1901), a painter and transcendental-
ist turned Ruskinian, and the art critic James Jackson Jarves (1818–
1888), whose *Art-Idea* (1864) conflates an Emersonian theory of
culture with a Ruskinian belief in the power of an education in
visual art to ensure the progress of civilization.

The enthusiasm of Emersonians for Ruskin was not matched,
at least at first, by their reactions to those Englishmen Ruskin and
Arnold inspired, members of the self-conscious, self-styled Aes-
thetic movement of the 1870s, 1880s, and early 1890s. This relative
lack of zeal is striking, for many of Ruskin's British heirs have a
good deal in common with Emerson. Pater, for example, who was

perhaps Ruskin's most influential successor, shared fully the Emer-
sonian perception of the world as being in perpetual flux; expressed
a remarkably Emersonian vision of the self's essential solitude; and
articulated a philosophy, very much like Emersonian transcenden-
talism, locating in that self the capacity to achieve perfect moments
of intense experience and thereby transcend the flux. Pater's pop-
ularity in America was to grow during the 1880s and 1890s; but
the fact that Americans were initially able to perceive the conti-
nuity of thought between Ruskin and Emerson but not that be-
tween Pater and Emerson suggests how rigorously they differen-
tiated between the forms of aestheticism they deemed acceptable
and those they judged inadmissible. This habit of discriminating
among aestheticisms, of approving of some and remaining indif-
ferent or even hostile to others, continued to mark the American
response even as its content changed. As we shall see, it was pre-
cisely the American habit of cordoning off aestheticism into ac-
ceptable and unacceptable zones that, paradoxically enough, al-
lowed it to continue to exert cultural power.

Americans and Literary Aestheticism:
Fulfillment

Wilde's American tour did not end well, either for the host country
or for its guest. After having been feted in San Francisco and hav-
ing had a lode named for him in Nevada, Wilde arrived in New
York, where he was robbed by an acquaintance and, worse still,
neglected by the press. When he returned to England, he followed

Within the illustration:
"HE IS AN ÆSTHETIC SHAM. ECHO."

"NARCISSUS, — AS HE WAS HUNTING ONE DAY, HE BENT TO QUENCH HIS THIRST (£ "$) FROM A SPRING AS CLEAR AS CRYSTAL, AND A GODDESS CAUSED HIM TO FALL IN LOVE WITH HIS OWN SHADOW, WHICH WAS REFLECTED IN THE WATER, THE OBJECT OF HIS DESIRES BEING UNATTAINABLE, HE PINED AWAY FROM GRIEF AND THE FLOWER NAMED AFTER HIM HAS EVER SINCE CONTINUED AN EMBLEM OF HEARTLESS 'BEAUTY'. SEE CLASSICAL MYTHOLOGY."

ILL. 11.6 *Oscar Wilde as Narcissus*. After Thomas Nast, ca. 1882–84. Wood engraving (proof), 9⅜ × 11⅛ in. (23.8 × 28.3 cm). The Metropolitan Museum of Art, Gift of Thomas Nast, Jr., Mabel Nast Crawford and Cyril Nast, 1933 (33.35.91)

the example of many of his British predecessors who had played the American circuit and lectured the English on the foibles of their cousins across the seas—a series of lectures that, although extremely amusing, bore even less than the usual relation to his actual experiences.[11] Likewise, many Americans were critical of their British visitor (ILL. 11.6). Norton complained of Wilde's affections and "maudlin sensualisms"; Henry James (1843–1916), who had met Wilde in Washington, D.C., declared him an "unclean beast"; and the Reverend Washington Gladden (1836–1918), an eminent Christian Socialist, complained in the *Andover Review* of the new "Paganism" represented by Wilde and by the aestheticism he advocated.[12]

Neither these dismissals by guardians of America's own high culture nor those of the popular magazines that appealed to a lower-brow audience constituted the sole American response to British aestheticism. During the late 1880s and the early 1890s, Americans evinced an increasing sympathy with the literature of the British Aesthetic movement. To follow the critical response to Pater during these years, for example, is to witness an utter trans-

formation in American attitudes. When Pater's best-known work, *Studies in the History of the Renaissance,* was first published in 1873, it met an American reception ranging from indifference to amusement. The most positive review was provided by William Dean Howells (1837–1920) in the *Atlantic Monthly* (though even Howells expressed a good deal of skepticism about Pater's more purple passages),[13] whereas William Stillman criticized Pater severely for his "dilettantism," "subjectivism," and ignorance of the "pure beauty of Nature" in favor of the more suspect beauties of art.[14] Still, Pater's reputation rose steadily throughout the 1880s, and following its publication in 1885, his *Marius the Epicurean* was received far more favorably than *The Renaissance* had been. In the *Nation* the writer George Woodberry (1855–1930) expressed his surprise at discovering "in the evangel of aestheticism a morality of this height," although he, like most of the reviewers, remained dubious about the historical accuracy of the novel.[15] It was not until 1888 that Pater was accorded his first American rave, interestingly enough in the pages of the same journal that published Gladden's fulminations on Christianity and aestheticism, the *Andover Review.*

There the "infinite grace and indescribable charm" of Pater's writings were praised, even the more controversial among them.[16] Pater's death, in 1894, brought a number of respectful American obituaries and memorial tributes, and the posthumous reviews of *Plato and Platonism* (1893) and *Greek Studies* (1895) were universally well-disposed. By the mid-1890s the critical priorities of twenty years earlier had been fully reversed. In 1896 the *Outlook* ranked Pater alongside of Ruskin and Arnold as one of the "three great critics of our time," and in the same year the *Nation* suggested that, at least as an authority on art, Pater was "far safer and less whimsical." Indeed, by 1897 the *Nation* had come to look on Pater so highly that it suggested that his "counsel of perfection" was one from which a "gross and materialistic democracy like ours" could benefit.[17]

Americans' reactions to Pater reveal much about their general cultural attitudes in the late nineteenth century, including the decreasing moralism of American criticism and its increasing attunement to the latest trends in Britain. These changes occurred simultaneously with a great many social transformations, two of the more important being the growth in number and self-consciousness of a mobile, professional middle class eager to justify its new-found status by devoting itself to cultural self-improvement, and the concomitant decline of Calvinism and rise of interest among fashionable Episcopal and Congregational churchgoers in ritual and aesthetic experiences. These transformations were accompanied, in turn, by the development of universities and public art museums and the flourishing of less formal organizations, such as the Browning Society and the Ruskin Society, all of which helped spread the gospel of culture.[18] Pater and the Pre-Raphaelites were among the writers who moved from the cultural periphery to its center, and the American critical response to aestheticism changed from suspicion to wary respect.

The increasing legitimacy of aestheticism was not without its price, for it was attended by a continuing rejection of aestheticism's more eccentric forms. The seeming schizophrenia of the *Andover Review* is an excellent case in point. Its publication both of Woodberry's article in praise of Pater and of Gladden's attack on the new "Paganism" can be read as an indication of ambivalence among even the most liberal Christians on the question of aestheticism, but it can also be seen as a cultural horse trade: the acceptance of Pater—and even the most explicitly amoral aspects of Pater's thought—being permitted, but only in exchange for the rejection of Wilde. Similarly, even as Pater was admitted in the 1890s into the ranks of the great critics of the time, American journals and newspapers were filled with fervid condemnations of self-consciously "decadent" artists and writers, including Aubrey Beardsley (1872–1898), Arthur Symons (1865–1945), and Ernest Dowson (1867–1900), as well as with denunciations of Wilde, until his trial and imprisonment on charges of homosexuality in 1895, at which point the American press stopped mentioning him altogether.[19] The American cultural machinery, in other words, was calibrated to sift through the various types of the aestheticism it encountered to find a suitable variant, even when this year's gold was last year's dross.

As a direct result of this dual process of incorporation and expulsion, the modes of aestheticism that were rejected retained a healthy charge of the forbidden, and therefore a powerful appeal, for the generation of American writers who came to maturity in the late nineteenth century. While their parents were beginning to accept some of the more easily sanitized forms of aestheticism, many of these young men were throwing themselves eagerly into the imitation of its more disreputable aspects, particularly at the universities, which they attended in increasing numbers. The interest in aestheticism was particularly strong at Harvard College, then in the process of attracting a more heterogeneous student body. The memoirs of several Harvard students of the end of the nineteenth century and the beginning of the twentieth record the growth of a circle of self-proclaimed aesthetes and their formation of official societies and unofficial reading groups, as well as their widening control over college organizations such as the O.K. literary society and publications such as the *Harvard Advocate*. Malcolm Cowley's description of this phenomenon is perhaps the most eloquent, but the details he recounted of Harvard life before World War I had been true for a generation:

> Then, too, there was a type of aestheticism very popular during my own college years. The Harvard Aesthetes of 1916 were trying to create in Cambridge, Massachusetts, an after-image of Oxford in the 1890s. They read the *Yellow Book,* they read Casanova's memoirs and *Les Liaisons Dangereuses,* both in French, and Petronius in Latin; they gathered at teatime in one another's rooms, or at punches in the office of the *Harvard Monthly;* they drank, instead of weak punch, seidels of straight gin topped with a maraschino cherry; they discussed the harmonies of Pater, the rhythms of Aubrey Beardsley and, growing louder, the voluptuousness of the Church, the essential virtue of prostitution. They had crucifixes in their bedrooms, and ticket stubs from last Saturday's burlesque show at the Old Howard. They wrote, too; dozens of them were prematurely decayed poets, each with his invocation to Antinoüs, his mournful descriptions of Venetian lagoons, his sonnets to a chorus girl in which he addressed her as "little painted poem of God." In spite of these beginnings, a few of them became good writers.[20]

This fascination with the life of the aesthete was not exclusively an undergraduate experience. The *Yellow Book,* for instance, inspired two young Harvard alumni, Herbert Stuart Stone (1871–1915) and Hannibal Ingalls Kimball (1874–1933), to establish a firm that published much of the best American and foreign experimental writing between 1892 and 1905, a good deal of it in their own avant-garde literary magazine, the *Chap-Book,* founded in 1894. The *Chap-Book* was followed by a flood of similar efforts. In 1895 Elbert Hubbard (1856–1915), incensed at the refusal of either the women's magazines like the *Ladies' Home Journal* or the genteel periodicals like the *Century* to accept his work, issued the *Philistine* in his hometown of East Aurora, New York; Gelett Burgess (1866–1951) published the *Lark* in San Francisco; and in the East, James Huneker (1860–1921) and Vance Thompson (1863–1925) established *M'lle New York.* Between the years 1894 and 1897 hundreds of so-called dinkey magazines, dedicated to avant-garde work and necessarily directed at an elite audience, were founded, flourished, and folded, often in the most unexpected places (ILL. 11.7). Cincinnati, Omaha, Kansas City, and Fort Worth all had such publications, in which Beardsleyesque illustrations graced the verse of local writers or papers from the regional Browning Society.[21]

At the same time a number of poets and novelists took to calling themselves "aesthetic" or "decadent" writers. The minor novelist Edgar Saltus (1855–1921), who signed himself "Bourgeoisphobus," proclaimed his admiration not only for Wilde, but also for the French poets Charles Baudelaire (1821–1867) and Paul Verlaine (1844–1896). Saltus achieved notoriety with several novels, in the manner of Wilde's *Picture of Dorian Gray* (1891), that combined the frisson of exotic sense experience with plots so melodramatic as to approach the ludicrous. Similarly, the aforementioned James Huneker achieved fame as a name-dropper *extraordinaire* and a devotee of decadence, the latter with novels and memoirs that were as sensational as they were ineptly written. More important contributions were made by a group of poets deeply influenced by both British aestheticism and its French counterpart, the most estimable of whom were two Harvard men, George Cabot Lodge (1873–1909) and Trumbull Stickney (1874–1904). Stickney in par-

ILL. 11.7 Cover of Easter Number. *Lotus* (Apr. 1896). Art, Prints and Photographs Division, The New York Public Library, Astor, Lenox, Tilden Foundations

ticular is an overly neglected figure, a poet of remarkable technical skills, though resolutely minor vision, who deserves more consideration and recognition than he has hitherto received.

If the accomplishment of American aestheticist writers was less than compelling, their effect on the subsequent development of American literature was appreciable. The dinkey magazines, direct progenitors of the more significant "little" magazines of the early twentieth century, provided for the first time in American letters a successful means of matching struggling but dedicated authors with a sympathetic and sophisticated audience. Even more important was the way that aestheticism gave shape to the experience of the American writer. It is true, as the example of Poe suggests, that America was home to alienated artists who proclaimed their devotion to beauty and to art as an end in itself long before Pater, Wilde, or other fin-de-siècle authors gave voice to these notions. Indeed with Poe, America gave birth to perhaps the first, and certainly the most spectacular, alienated writer in the Anglo-American tradition. The same sense of alienation is evident in the works of many other nineteenth-century American literary figures, especially Hawthorne and Herman Melville (1819–1891). But these writers all lacked a means for expressing fully their sense of rootlessness, which enters their works through covert means alone. Hawthorne's "Custom House" (his introduction to *The Scarlet Letter,* 1850), for instance, traces with a wit born of despair the necessary gap between the writer as writer and as participant in society, and in *Pierre, or The Ambiguities* (1852) Melville sets out to offend virtually every member of his audience, denouncing them directly and ending the novel with a conclusion so ridiculous that it can only be described as an act of literary suicide. What the rhetoric of the British fin-de-siècle gave later American authors was a way of avoiding Hawthorne's or Melville's plight, for it endowed them with a model in which social disconnection could be expressed, a paradigm that allowed them to shape, and so escape, their feelings of insecurity and anonymity. It gave them, in other words, a form of rooted rootlessness, the security of a shared insecurity, a sense of alienation that was also a confirmation of community with those similarly alienated.

Aestheticism was responsible for formulating American letters in more specific ways as well. It has often been observed that a number of the great American modernists—notably Robert Frost (1874–1963), Wallace Stevens (1879–1955), and William Faulkner (1897–1962)—each underwent a period of infatuation with the works of British aestheticist writers, especially Pater and the Pre-Raphaelites, and certain of the fin-de-siècle poets, including Dowson and Lionel Johnson (1867–1902). The ramifications of this on their later development have rarely been discussed, but those ramifications are crucial indeed.[22] The poetry of Frost, the most unlikely of the modernists mentioned here, provides clear examples of such reverberations. Many critics cite Frost's publication of *North of Boston* in 1914 as marking a break with the traditions of expression of previous generations. Frost's economical verse and his unflinching response to nature, it is argued, overturn the influence of the rich, if not overripe, nature poetry of the nineteenth century with its too-abundant imagery, its appeal to a plenitude of sense experiences, its abstraction, and its languorous sentimentality.

The claim for the originality of Frost's achievement, however, ignores the fact that his college classmate, Trumbull Stickney, had been experimenting, though less successfully, with the same idiom a few years earlier, in poems such as "Mnemosyne" (1902), in which the landscape of the poet's memory is evoked in a series of spare stanzas punctuated by short declarative sentences, or in the equally restrained "In Summer" (1902). To note this resemblance is to be reminded that the origins of this spare poetic may be traced to, among other sources, a short lyric of Rossetti's, "The Woodspurge" (1870):

The wind flapped loose, the wind was still,
Shaken out dead from tree and hill:
I had walked on at the wind's will,—
I sat now, for the wind was still.

Between my knees my forehead was,—
My lips, drawn in, said not Alas!
My hair was over in the grass,
My naked ears heard the day pass.

My eyes, wide open, had the run
Of some ten weeds to fix upon;
Among those few, out of the sun,
The woodspurge flowered, three cups in one.

From perfect grief there need not be
Wisdom or even memory:
One thing then learnt remains to me,—
The woodspurge has a cup of three.[23]

Rossetti's poem anticipates a number of Frost's imaginative moves as well as what is most distinctive and innovative about them. Like so many of Frost's lyrics, "The Woodspurge" sets out on an interpretive quest into the natural world and attempts to discover value in it, something of "wisdom or even memory." Moreover, like Frost's poem "Design" (1922), it seeks its goal in nature at its most minimal, even trivial; Rossetti searches for meaning by limiting his vision to "some ten weeds to fix upon," Frost by limiting his to a spider. Finally, the most striking revelation of Rossetti's poem coincides with Frost's paradoxical conclusion in "Design" that the quest for meaning in nature can neither be abandoned nor fulfilled, for Rossetti ends his poem with a statement that is either richly resonant or utterly inconsequential: that "the woodspurge has a cup of three." Does the cup connote the chalice, the "three" the Trinity? Does the weed thereby imply the miracle of a divine presence in nature, even nature at its most reductive? Or is the pursuit of meaning in nature absurd or even tautological—ending in the discovery, perhaps, of certain facts, but also admitting ignorance of their significance? The poem will not instruct us as to which of these alternatives to accept, but rather licenses us to embark on a hermeneutical undertaking of our own—one that promises to be as barren of results as the poet's, but just as necessary.

Frost's "Design" confronts precisely the same issues:

I found a dimpled spider, fat and white,
On a white heal-all, holding up a moth
Like a white piece of rigid satin cloth—
Assorted characters of death and blight
Mixed ready to begin the morning right,
Like the ingredients of a witches' broth—
A snow-drop spider, a flower like a froth,
And dead wings carried like a paper kite.

What had that flower to do with being white,
The wayside blue and innocent heal-all?
What brought the kindred spider to that height,
Then steered the white moth thither in the night?
What but design of darkness to appall?—
If design govern in a thing so small.[24]

Rossetti's work flirts with the possibility that the natural sphere is suffused with a divine presence; Frost's "Design" also entertains the notion that a great power animates nature, and in its closing the poem suddenly sounds a note of enigma identical to that with which Rossetti concludes. Even though, as Richard Poirier has finely observed, Frost's penultimate line explicitly poses a ques-

tion—"What but design of darkness to appall?"—and the last merely suggests a tantalizing prospect—"If design govern in a thing so small"—it is the latter that actually probes more deeply.[25] Like Rossetti, Frost raises the questions: What if there is nothing beyond mere fact in the natural world? What if what we call beauty, intention, order, design are benign human projection at best, perverse human illusion at worst? Neither Frost nor Rossetti will confirm the truth or falsehood of the speculation that their poems engender. Still, by grounding the nature lyric gently but firmly in an epistemological quest the end of which remains compelling and mysterious, each has performed the act most characteristic of what has come to be viewed as modern poetry.

Bringing Rossetti and Frost together should serve to dispel the central myth of American modernism, the notion that a new and distinctive form of writing came spontaneously into being in the first decades of the twentieth century. As this pairing indicates, writers of the British Aesthetic movement laid the groundwork for modernism by establishing the themes, techniques, and modes of analysis that later generations were to make their own. Stressing the essential continuity between the imaginative enterprise of aestheticism and that of modernism not only demystifies the modernists' denials of their literary evolution, but also recovers a sense of the value of the Aesthetic movement to literary history. The experiments of aestheticism, successful or not, helped twentieth-century writers forge the idiom of modernism, even as the decline of aestheticism in the years after Wilde's trial provided a convenient excuse for them to ignore its importance.

The effect of British aestheticism on one of the most mandarin expounders of the myth of modernism, T. S. Eliot (1888–1965), was notable. Eliot's theory of poetry, to oversimplify, did not admit of much accomplishment between the seventeenth century and his own time, but he was especially hard on many of the aestheticists, particularly Pater. In "Arnold and Pater" (1930), for instance, Eliot complains of the latter's conflation of religion and art (a reductive reading of Pater's endeavor) and says, "I do not believe that Pater, in this book [The Renaissance] has influenced a single first-rate mind of a later generation."[26] Nevertheless, a number of Eliot's own essays are reminiscent of Pater. "The Perfect Critic" (1920), for example, explicitly rejects "aesthetic criticism," which Eliot traces from Pater to Symons; yet by its end the essay arrives at the perfectly Paterian assertion that good criticism is dependent on the quality of the reader's sensibility (as opposed to his historical or philosophical knowledge or interests) and hints at the bold Paterian concept that the best criticism of a work of art is another work of art.[27] It might be argued that "The Perfect Critic" is less than central to Eliot's canon, but a more significant treatise, "Tradition and the Individual Talent" (1919), also develops notions expressed by Pater in The Renaissance, including that of the artist's necessary self-limitation—what Eliot calls his "continual self-sacrifice . . . continual extinction of personality" and what Pater calls "ascesis . . . the austere and serious girding of loins in [artistic] youth."[28]

Several passages in Eliot's poetry, as well, are indebted to Pater, such as these lines from "East Coker" (1940): "Not the intense moment / Isolated, with no before and after, / But a lifetime burning in every moment / And not the lifetime of one man only / But of old stones that cannot be deciphered."[29] At first it would seem that this passage reiterates the criticism that Eliot offered in "Arnold and Pater." Pater's doctrines, Eliot wrote there, led to nothing more than "some untidy lives," and the quoted lines from "East Coker" suggest why: they imply that spending a lifetime seeking a single moment of intense experience leads only to isolation, if not solipsism. But a look at the affinities between Eliot's language here and that of Pater in the conclusion to The Renaissance shows that Eliot has become more generous than he was in his 1930 essay. To remember that Pater's definition of "success in life" is "to burn always with this hard, gemlike flame, to maintain this ecstasy" is

to recognize that he and Eliot are in fundamental accord.[30] For both, "a lifetime burning in every moment" was an ideal to be desired as deeply as it is known to be unachievable in a world of flux and loss. Eliot and Pater each deemed it necessary that "success in life" so defined be sought, but with the full knowledge that it is unattainable.[31]

The Case of James

The full complexity of the American literary encounter with aestheticism may be best appreciated by concentrating on a single figure, and no figure better serves this role than Henry James (ILL. 11.8). James was something of an Oscar Wilde in reverse, an American who arrived in England with nothing to declare but his genius and devoted himself to the task of becoming one of the British Empire's literary lions. In doing so, James came to know virtually all the manifestations of aestheticism in England—its Ruskinian and Pre-Raphaelite origins, its rise to prominence during the 1880s and early 1890s, its ambiguous consummation during the fin-de-siècle. James knew personally Ruskin, Morris, Rossetti, Pater, Wilde, John Everett Millais (1829–1896), and JAMES ABBOTT MCNEILL WHISTLER. Edward Burne-Jones (1833–1898) was a good friend, as was Henry Harland (1861–1905), editor of the Yellow Book, who solicited from James a story for the quarterly's first issue in 1894. James duly submitted "The Death of the Lion" for publication there, although not before receiving assurances that Beardsley would not be illustrating the story and that his work would not even appear in the same issue.[32]

As this anecdote suggests, James's response to aestheticism was multifaceted. His view of "decadent" aestheticism was always negative, and his early essays on Baudelaire and Swinburne condemn their lack of moderation with the same fervor evident in his attitude toward Beardsley. Still, it was not only the aestheticism of Baudelaire's Les Fleurs du mal (1857) or Swinburne's "Dolores" (1866) that he distrusted. James's reactions to Ruskin alternate between generous praise for his descriptive abilities and strenuous criticism of his moralistic excesses, and his comments on Pater are masterpieces of equivocation:

> Well, faint, pale, embarrassed, exquisite Pater! He reminds me, in the disturbed night of our actual literature, of one of those lucent matchboxes you place, on going to bed, near the candle, to show you, in the darkness, where you can strike a match—he shines in the uneasy gloom—vaguely, and he has a phosphorescence, not a flame. But I quite agree with you that he is not of the little day, but of the longer time.[33]

The judgment on Pater rendered in the 1894 letter to Edmund Gosse (1849–1928) quoted here is remarkably double-edged. James gives with one hand and takes away with the other, sometimes within a single sentence. The four adjectives that begin the passage depict Pater as a secondary, if not a second-rate, figure, as does the comparison of Pater to a phosphorescent matchbox, the source of a faint glow even in relation to a bedside candle. Mingled with these suggestions are moments of praise—though Pater's glow is pale, it illuminates the "disturbed night" of his contemporaries; he is "of the longer time." Ironically, James's ambivalence toward Pater is expressed in language that pays homage to the latter's own most famous image, that of the "hard, gemlike flame." The passage thus conveys an extraordinarily intricate sentiment. Pater's "pale" light may have fallen short of his own ideal flame, James implies, but such a failure does not diminish the importance of the ideal.

A similar complexity marks James's relations with Wilde. As has already been noted, James's personal dislike of Wilde was in-

ILL. 11.8 Henry James. After a drawing by John Singer Sargent, 1886. Engraving. Signed: *To my friend Henry / John S. Sargent*. Collection unknown

tense, and his displeasure was heightened when his own play *Guy Domville* (1895) was replaced at London's Saint James's Theatre by Wilde's *Importance of Being Earnest* (1895), which won the applause of the same audience that had hissed James off the stage. This personal dislike, however, is complicated by the frequent crossing of James's and Wilde's fictional paths. When, in *The Ambassadors* (1903), James's Lambert Strether advises Little Bilham, an expatriate American "artist-man," to "live all you can, it's a mistake not to," he repeats almost verbatim the counsel given by Wilde's Lord Henry Wotton to a similar, if more sinister, young man in *The Picture of Dorian Gray* of twelve years earlier, "Live! Live the wonderful life that is in you. Let nothing be lost upon you. Be always searching for new sensations." Moreover, Lord Henry's remarks to Dorian echo James's words to the aspiring novelist in "The Art of Fiction" (1884), "Try to be one of the people upon whom nothing is lost." They mimic, as well, the language of James's Gabriel Nash, the fictional aesthete in *The Tragic Muse* (1890), who anticipates both Lord Henry and Strether when he proclaims, "We must feel everything, everything we can. We are here for that." To confound matters further, certain aspects of Nash's character are transparently modeled on Wilde, notably his deployment of epigram and paradox, while his physical appearance is reminiscent of James's own.[34]

As these examples indicate, James's response to aestheticism was an exaggerated version of his fellow Americans' volatile mix-

ture of respect and hesitation, fascination and skepticism. In essence, James was attracted to the ideals of the aesthetes but disturbed by their failure to achieve them fully. Whatever his reservations, British aestheticism continually presented itself in his fiction as well as his criticism as a problem demanding careful consideration. Characters modeled directly on aesthetes or indirectly on satiric representations of them recur in James's novels. In addition to Gabriel Nash, James created Rowland Mallett, the indolent but conscience-stricken connoisseur of *Roderick Hudson* (1875), the ruthless Gilbert Osmond of *The Portrait of a Lady* (1881), and Adam Verver, the refined robber baron of *The Golden Bowl* (1904).

A look at the most familiar of these characters, Gilbert Osmond, reveals both the issues involved in James's reaction to aestheticism and the ways that, like so many Americans, his sensibility was shaped by and in turn helped shape the course of the British Aesthetic movement itself. Osmond is perhaps the most odious character in James's fiction. An idle but impecunious expatriate American connoisseur, he woos and wins the naïve American Isabel Archer, who has been endowed with a fortune through the intervention of her adoring and mortally ill cousin, Ralph Touchett. After marrying Osmond, Isabel discovers his coldness and calculation, particularly in his plans to marry off her stepdaughter, Pansy, to a rich nobleman (and former suitor of Isabel's) rather than to the man she loves. Isabel—informed by her best friend, Madame Merle, of Ralph's role as her benefactor, and discovering that

THE SIX-MARK TEA-POT.

Æsthetic Bridegroom. "IT IS QUITE CONSUMMATE, IS IT NOT?"
Intense Bride. "IT IS, INDEED! OH, ALGERNON, LET US LIVE UP TO IT!"

ILL. 11.9 "The Six-Mark Tea-Pot." George Du Maurier. *Punch, or the London Charivari* (Oct. 30, 1880). The New York Society Library

Madame Merle is Osmond's former lover and Pansy's mother—defies her husband by keeping vigil at Ralph's deathbed and then, in the book's unresolved conclusion, returns to the battle of wills that is her marriage.

What is most important to the present discussion about the portrayal of Osmond is that his aestheticism and his villainy are intimately linked. Indeed, his aestheticism *is* his villainy, for James shows through Isabel's increasingly bitter marital experience that Osmond treats everyone he meets as an object for his mental portrait gallery, to be collected or discarded at whim. Osmond resembles not only the leisured American expatriates in Italy who by 1881 were quite numerous, as James learned on his journeys there, but also the British aesthetes, the disciples of Wilde and Pater, whom James met as he began to make his way through British society. "What is life but an art? Pater said that so well, somewhere," remarks a fatuous young American named Lewis Leverett in James's 1879 story "A Bundle of Letters"; similarly, Osmond tells Isabel that one "must live one's life as a work of art."[35] Osmond's taste for Japanese china and his collection of bric-a-brac

place him in the context of the aesthetic craze of the late 1870s, as does the dismissive comment made by another character in *The Portrait of a Lady* that "there's a great rage for that sort of thing now" (vol. 4, p. 131).

Moreover, James's depiction of Osmond resembles Du Maurier's satiric cartoons of fashionable aesthetes that appeared in *Punch* during the time that *Portrait* was being serialized in *Macmillan's Magazine*.[36] Osmond's conflation of a rhetoric of aesthetic idealism with an actual pettiness of taste—he has, as the disillusioned Isabel observes, "a genius for upholstery" (vol. 4, p. 131)—repeats one of the main thrusts of Du Maurier's lampoon. The aesthetes were critiqued in a particularly well-known Du Maurier cartoon of 1880, "The Six-Mark Tea-Pot" (ILL. 11.9), which was based on a comment Wilde made while an undergraduate at Oxford. In the cartoon, an "aesthetic bridegroom" and an "intense bride" (not an insignificant combination in the context of *Portrait*) gaze reverently at a blue china teapot. "It is quite consummate, is it not?" asks the leering male (it is difficult to tell whether he is leering at the teapot or the woman), to which his bride replies, a look of rapt aesthetic devotion on her face, "It is, indeed! Oh, Algernon, let us live up to it!"[37] Living up to a teapot or to a piece of upholstery, James and Du Maurier agree, is what the aesthete's endeavor to conduct his life as a work of art ultimately reduces itself to: an exercise in triviality, inconsequentiality, and finally, poor taste.

Also in keeping with Du Maurier's satire is James's revelation of Osmond's social aspirations. The eloquent denunciation of him offered by Ralph Touchett, ". . . under the guise of caring only for intrinsic values, Osmond lived exclusively for the world. . . . Everything he did was *pose—pose* so subtly considered that if one were not on the lookout one mistook it for impulse" (vol. 4, pp. 144–45), parallels Du Maurier's assessment of the aesthetes as social climbers who adopted a stance of artistic cultivation as a means of entering a society that would otherwise have excluded them. The applications of aestheticism's valorization of the pose to the fine art of social climbing were equally obvious to Du Maurier and to James. In 1876, for example, Du Maurier's Swellington Spiff expressed the Osmondian hope that his china collection would help him meet a duke, and in 1880 his aesthete Postlethwaite averred that "the Lily carried me through my first season, the Primrose through my second . . . what Flower of Flowers will carry me through my next?"[38]

As a juxtaposition of James's and Du Maurier's treatment of the aesthete demonstrates, the terms in which Osmond is portrayed are more sophisticated but nevertheless recognizable variants of those in which the type was parodied in the popular press. Though dispatched by a number of flicks of authorial irony, Osmond is granted remarkable powers of malevolence. To Isabel, he seems a satanic figure who possesses an "evil eye" and the ability to make "everything wither that he touched" (vol. 4, p. 188). Here James's relation to British aestheticism becomes formative indeed. Before *Portrait,* aesthetes were depicted as benign characters; Du Maurier's Postlethwaite or W. S. Gilbert's poet Bunthorne are ridiculous but hardly evil figures. The same cannot be said for aesthetes who appear after Osmond, frequently in works that pay homage to James, be it implicit or explicit—aesthetes including Walter Hamlin of *Miss Brown* (1884), a novel by Vernon Lee (1856–1935), and Svengali, the notorious villain of Du Maurier's *Trilby* (1894).[39] Hamlin is an amalgam of Ralph Touchett and Gilbert Osmond; he endows Miss Brown with a fortune but horrifies her with his snobbish aestheticism. Svengali possesses literally what Osmond possesses only figuratively, an evil eye, and uses it to perform the eminently Osmondian task of forcing Trilby O'Ferrall, a beautiful young innocent, to testify to both his power and his taste: only when she is hypnotized by him can she sing (ILL. 11.10).

To view *The Portrait of a Lady* in the context of the work of Du Maurier and Lee is to note the relative complexity with which aestheticism is treated in James's novel. Du Maurier's and Lee's

aesthetes are morally isolated from the rest of the characters. It is true that Hamlin's designs on Miss Brown and Svengali's sexual domination of Trilby resemble the desires of other figures—Miss Brown is courted by a number of connoisseurs, and the artist Little Billee, who loves Trilby and loses her to the baleful Svengali, is as intent on idealizing his beloved as his rival is on corrupting her—but their excessively villainous behavior sets them apart from such harmless pseudo-aesthetes. Similarly, while the aesthetes in Du Maurier's cartoons may successfully enlist some of the particularly susceptible inhabitants of high society, they are always distinguished from other, sensible aristocrats.

Such a moral bifurcation does not obtain in *Portrait*. Paradoxically, while Osmond is far more malevolent than most of his counterparts, he shares a greater number of qualities with the benign characters than do other evil fictional aesthetes. Aestheticism is virtually pandemic in *Portrait,* and it is the unwitting aestheticist qualities of the admirable characters that, in fact, cause them to be defeated or trapped by Osmond. This point is intimated by numerous analogies in the novel between the aestheticism of Osmond and that of Isabel. Isabel is depicted by James in terms reminiscent of the most familiar catchphrases from the conclusion to *The Renaissance*. Pater wrote,

> Not the fruit of experience, but experience itself, is the end. . . . To burn always with this hard, gemlike flame, to maintain this ecstasy, is success in life. . . . Our one chance lies in expanding [our] interval, in getting as many pulsations as possible into the given time. . . . Only be sure it is passion—that it does yield you this fruit of a quickened, multiplied consciousness.[40]

The reader of *Portrait* learns that Isabel possesses a delicate, "flame-like spirit"; that she responds to Lord Warburton with a "quickened consciousness"; that she enjoys a number of aesthetic "pulsations" in Saint Peter's; and late in the novel, that she muses over the "infinite vista of a multiplied life" she glimpsed upon arriving in Europe (vol. 3, pp. 69, 91, 413; vol. 4, p. 190). To a certain extent James employs such language to describe the enthusiasm with which the young Isabel partakes of the Paterian endeavor of living life to its fullest and as an end in and of itself; but Isabel's naïve, eager form of aestheticism leads her to overvalue the connoisseurship and reserve of Osmond, to see him as a "specimen apart" (vol. 4, p. 377) from all the people who surround her, and thence to fall in love with him as if he were a beautiful art object. Her tendency to see Osmond as he sees himself—as a rare and fine work of art—leads to her unwitting Osmondian attempt to collect him. By marrying the "man with the best taste in the world" for what she sees as the quality of "indefinable beauty about him—in his situation, in his mind, in his face," however, Isabel finds herself transformed into a mere extension of that taste, an object for cultivated appreciation, with "nothing of her own but her own pretty appearance" (vol. 4, pp. 193, 192, 195). Seeking to collect a collector, she finds herself collected.

James's inculpation of Isabel brings into sharp focus the problems involved in the portrayal of aestheticism in *The Portrait of a Lady*. If so thoroughly laudable a character shares Osmond's reifying, manipulative aestheticism, then none can escape its taint. This becomes clear as character after character succumbs to a form of Osmondism. The suitor of Osmond's daughter, Ned Rosier, for example, thinks of his beloved "as he would have thought of a Dresden-china shepherdess" (vol. 4, p. 90), and the far more sinister Madame Merle asserts that the self is ultimately nothing but the sum total of its appurtenances. Through the better part of the novel it appears that society is just a collection of Osmonds, some more and some less ill intentioned but all participating in Osmond's aestheticizing vision of human beings as works of art.

However, in the later pages of the book a different view of the possibilities represented by aestheticism emerges. Perhaps the most significant vehicle for these possibilities is Isabel Archer herself. Isabel's disenchantment with Osmond takes her beyond her naïve aestheticism to a more exalted type, entailing, as it did for Ruskin and Pater, a heightening or perfection of the act of perception. An extended exercise in such heightened vision is provided in one of the culminating episodes in *Portrait* (the episode James claimed to have been most proud of), Isabel's silent revery in chapter 42. In that chapter, Isabel simply sits in front of a fire and muses over the intimacy she has observed (but does not yet understand) between her husband and Madame Merle. Isabel's mode of apprehension in the scene provides a compelling countermodel to both Osmond's vision and his value system. Unlike Osmond, who narcissistically attempts to force people and events to serve as objects of his own dispassionate contemplation, Isabel achieves a moment of vision experienced as an end in itself, a moment that, though fully removed from the world she inhabits, helps her to understand its nature. This achievement suggests the central point of contact between James's aestheticism and Pater's: a similar privileging of the sheer act of seeing. Both authors conceive of an instant during which the "quickened, multiplied consciousness," as Pater expressed it, comes into a powerful visionary being. It is quite true that for James the quickened consciousness is attached to high emotional drama, while for Pater it may be activated through many forms of intense sensation, including "the ecstasy and sorrow of love" and (first among equals) "the poetic passion, the de-

ILL. 11.10 "Au Clair de la Lune." George Du Maurier, *Trilby* (New York, 1894). Private collection

sire of beauty, the love of art for art's sake." For Pater as well as for James the moment at which consciousness exercises itself in heightened vision is valuable in and of itself as the ultimate "end . . . the perfect end."[41] Pater's aesthete and James's heroine each arrive at such an instant—perhaps the only consummation possible in a world shadowed by death and human failure.

This valorization of esthesis, which in the preface to *Portrait* James calls "the mere still lucidity" (vol. 3, p. xxi) of Isabel's mental vision, indicates the presence in the author's imaginative scheme of an aestheticism that has seemed either satirized or rejected elsewhere in the novel. The most successful deployment of aestheticism in *Portrait* occurs during the scene in which Isabel takes a lonely ride in the *campagna,* after she has learned of her husband's deceitfulness. Though Isabel may assume Osmond's position of the detached aesthetic observer gazing at the countryside—all motion arrested, the colors and gradations displayed in rich, muted tones—she does not seek to remove herself psychologically from her surroundings. On the contrary, the "profound sympathy" between Isabel and the objects she sees is illustrated repeatedly, often by a narrative voice that identifies qualities of the *campagna* with Isabel's life. In an example of what Ruskin called pathetic fallacy, the "sadness of the scene" reflects Isabel's "personal sadness," the "lonely attitudes" of the shepherds mirroring her own feelings of isolation and betrayal (vol. 4, p. 329). As she "rest[s] her weariness upon things that had crumbled for centuries," as she "drop[s] her secret sadness into the silence of lonely places," Isabel comes to recognize "the haunting sense of the continuity of the human lot" (vol. 4, p. 327). Having already learned in Rome of the mutuality of suffering, her experience in this episode will enable her to return to the city and enter into a community that understands shared pain, rather than rejoining the corrupt segment of Roman society that Osmond and Madame Merle inhabit. Instead of possessing a vision of landscape as irrevocably other, as a collection of mute objects unconnected to human emotions and events and coldly to be appreciated as such, Isabel achieves in the countryside a humanizing vision in which individual sadness and the sadness of the view before her unite to create an image of community rather than alienation. If in chapter 42 Isabel moves beyond her superficial Paterian aestheticism to the more highly valued mode of esthesis, so here she moves beyond a superficial type of aesthetic appreciation to one in which, to paraphrase Pater, she treats life in the spirit of art, as a generous, ennobling, and tragic spectacle.

Even in *Portrait,* then, James ultimately posits value in certain forms of aestheticism, thereby sharing and summarizing the sentiments of his fellow American writers. Like his contemporaries at, for example, the *Andover Review,* James sought to effect a discrimination of aestheticisms. Osmond performs for James the same role that Wilde played for the American critical establishment: he embodies the less attractive aspects of aestheticism and allows James to distinguish between those modes of which he approved and those he found less than compelling. Osmond helps James locate the facets of British aestheticism that most closely resembled the outlines of his own characteristic vision, free from the taint of sterile connoisseurship and epicene detachment (with which they were to his mind contaminated), and enables him to suggest that there might be an aestheticism of imaginative freedom as well as one of narcissistic self-cultivation and self-indulgent posing.

James's outlook on aestheticism was fully representative of that of his countrymen; his shifting reactions to the tenets and habits of thought he encountered in the British Aesthetic movement were part of the collective cultural labor in which American writers of the late nineteenth and early twentieth centuries were engaged. That labor was the long, difficult, and ultimately incomplete integration into a single entity of the American and British literary traditions, so intimately linked and yet so deeply wary of one another. The path toward integration concluded with the rise of a self-proclaimed Anglo-American literary modernism, with writers displaying greater concern about their modernness than their nationality. This imaginative process modified and was modified by both the British and the American traditions; the exchange of opinion between Ruskin and Norton or Emerson, between Pater and James, and the less sharply delineated but nevertheless significant interplay between Wilde and American authors served both traditions well. Such cultural dialogue challenged the British participants with the responses of those conversant with the basic terms of their discourse and yet sufficiently distanced from them to formulate and impart a critical perspective. It allowed the American participants the opportunity to elucidate their own notions of aesthetic merit, of the position of the writer in society, of the relationship between culture and society, and of that between aesthetic and moral experience. Through their dialogue, then, American and British writers alike came to define more clearly their experience and memorably to shape their art.

NOTES

1. See, for example, Alfred Kazin, "American *Fin-de-Siècle,*" in *On Native Grounds: An Interpretation of Modern American Prose Literature* (New York, 1942), pp. 51–72; and Harry Levin's otherwise excellent article, "The Discovery of Bohemia," in *A Literary History of the United States,* ed. Robert E. Spiller et al., 3 vols. (New York, 1948), vol. 2, pp. 1065–79, as representative examples.

2. Wilde's lecture was posthumously published in the collection *Miscellanies,* ed. Robert Ross (London, 1908), pp. 242–77.

3. New York *Daily Graphic,* Jan. 19, 1882, reprinted in *Oscar Wilde Discovers America [1882],* by Lloyd Lewis and Henry Justin Smith (New York, 1936), p. 105. This is the best single account of Wilde's American experience; see also E. H. Mikhail, ed., *Oscar Wilde: Interviews and Recollections,* 2 vols. (London, 1979), vol. 1, pp. 35–113.

4. Norton is a fascinating figure well repaying further study. A fine account of his public life is Kermit Vanderbilt, *Charles Eliot Norton: Apostle of Culture in a Democracy* (Cambridge, Mass., 1959). T. J.

Jackson Lears's speculative reading of Norton's inner conflicts is an exemplary fusion of psychoanalytic and cultural criticism; see his *No Place of Grace: Antimodernism and the Transformation of American Culture, 1880–1920* (New York, 1981), pp. 185–90.

5. Roger B. Stein, *John Ruskin and Aesthetic Thought in America, 1840–1900* (Cambridge, Mass., 1967). For Ruskin's letter to the *Crayon,* see that periodical's issue of May 2, 1855, p. 283.

6. *English Review* 12 (Sept. 1849), pp. 139–52.

7. Quoted in Clarence Gohdes, *American Literature in Nineteenth-Century England* (New York, 1944), p. 146.

8. Indeed Emerson's essay "Culture," while highly suggestive of his influence on Arnold, also seems in many ways to articulate the basic dogmas Wilde was preaching, as, for example: "A man is a beggar who only lives to the useful, and, however he may serve as a pin or rivet in the social machine, cannot be said to have arrived at self-possession. I suffer, every day, from the want of perception of beauty in people. They do not know the charm with which all moments and objects can be embellished." Ralph Waldo Emerson, *Essays and Lectures,* ed. Joel

Porte (New York, 1983), p. 1030.

9. John Ruskin, "Plagiarism," appendix 3 of *Modern Painters, 3,* in *The Works of John Ruskin,* ed. E. T. Cook and Alexander Wedderburn [library ed.], 39 vols. (London and New York, 1903–12), vol. 5, pp. 427–30. Ruskin's discussion of Emerson turns quickly to a fascinating consideration of the problem of literary influence itself, and particularly to a meditation on a figure who stands behind many of the continuities I will be describing between Ruskin and Emerson, Thomas Carlyle (1795–1881).

10. Emerson, "Nature," in *Essays and Lectures,* p. 10; Ruskin, *Modern Painters, 3,* in *Works,* vol. 5, p. 333.

11. See Oscar Wilde, "Impressions of America," in *The Artist as Critic: Critical Writings of Oscar Wilde,* ed. Richard Ellmann (New York, 1969), pp. 6–12.

12. Norton's comment may be found in an unpublished letter quoted in Lears, *No Place of Grace,* p. 246; for James's response, see Leon Edel, *Henry James: The Middle Years (1882–1895)* (Philadelphia, 1962), p. 31; and for Gladden's view, see the *Andover Review* 1 (Jan. 1884), p. 23. For further remarks on Wilde's American tour, see Charles Eliot Norton,

The Letters of Charles Eliot Norton, ed. Sara Norton and M. A. De Wolfe Howe, 2 vols. (Boston and New York, 1913), vol. 2, pp. 133–34.

13. *Atlantic Monthly* 32 (Oct. 1873), pp. 496–98.

14. *Nation* 17 (Oct. 9, 1873), pp. 243–44.

15. *Nation* 41 (Sept. 10, 1885), p. 220. The *Atlantic Monthly* review of August 1885 is also quite favorable but remains doubtful of Pater's descriptions of late Roman society and culture; see the *Atlantic Monthly* 56 (Aug. 1885), pp. 273–77.

16. Gamaliel Bradford, Jr., "Walter Pater," *Andover Review* 10 (Aug. 1888), p. 143; the reviewer quotes approvingly Pater's infamous description of Leonardo da Vinci's *La Giaconda,* or *Mona Lisa.*

17. *Outlook* 53 (Jan. 25, 1896), p. 160; *Nation* 62 (Apr. 9, 1896), p. 291; *Nation* 64 (Mar. 4, 1897), p. 167.

18. The complicated changes in late nineteenth-century American society and its culture have been described by Robert Wiebe, *The Search for Order, 1877–1920* (New York, 1967), esp. pp. 111–32; and Alan Trachtenberg, *The Incorporation of America: Culture and Society in the Gilded Age* (New York, 1982), esp. pp. 140–81. For religious developments, see Lears, *No Place of Grace,* pp. 183–216. For the rise of the university, see Lawrence Veysey, *The Emergence of the American University* (Chicago, 1965); and Burton Bledstein, *The Culture of Professionalism* (New York, 1976), esp. pp. 203–331.

19. But not American ministers, if Thomas Beer is to be believed. He estimates that Wilde was "mentioned" (unfavorably, one assumes) "in at least nine hundred known sermons" between 1895 and 1900; see Thomas Beer, *The Mauve Decade* (New York, 1926), p. 129, and take with a grain of salt.

20. Malcolm Cowley, *Exile's Return: A Narrative of Ideas,* rev. ed. (New York, 1951), p. 35. The Harvard aestheticism Cowley describes here was fueled in part by the continuing attunement to high culture and art in Boston and in part by the presence on the Harvard faculty of a number of diligent, sympathetic, and brilliant professors who helped inculcate it. George Santayana played an important role in this process, especially through his early work in aesthetics; see, for example, *The Sense of Beauty* (New York, 1896).

21. See Robert M. Limpus, *American Criticism of British Decadence, 1880–1900* (Chicago, 1939), pp. 117–34; and Larzer Ziff, *The American 1890s* (New York, 1966), pp. 120–45, for two accounts of what Gelett Burgess referred to as a "little riot of decadence" (Ziff, p. 139).

22. They have been studied most extensively in the case of Faulkner; see Hugh Kenner, *A Homemade World* (New York, 1975), pp. 194–221. For Pater's influence on Stevens, see Harold Bloom, *Wallace Stevens: The Poems of Our Climate* (Ithaca, N.Y., 1977), pp. 201–2.

23. Dante Gabriel Rossetti, *The Collected Works of Dante Gabriel Rossetti,* ed. William Michael Rossetti, 2 vols. (London, 1886), vol. 1, p. 298.

24. Robert Frost, *The Poetry of Robert Frost,* ed. Edward Connery Lathem (New York, 1969), p. 302. Copyright 1936 by Robert Frost. Copyright 1964 by Lesley Frost Ballantine. Copyright © 1969 by Holt, Rinehart and Winston. Reprinted by permission of Henry Holt and Company, Inc.

25. Richard Poirier, *Robert Frost: The Work of Knowing* (New York, 1977), p. 251.

26. T. S. Eliot, "Arnold and Pater," in *Selected Essays* [2d ed.] (New York, 1950), p. 392.

27. T. S. Eliot, "The Perfect Critic," in *The Sacred Wood: Essays on Poetry and Criticism,* 2d ed. (London, 1928), pp. 1–16.

28. T. S. Eliot, "Tradition and the Individual Talent" (1919), in *Selected Essays,* p. 7; Walter Pater, *The Renaissance: Studies in Art and Poetry,* vol. 1 of *The Works of Walter Pater* (London, 1900–1901), p. xiii, originally published as *Studies in the History of the Renaissance* (London, 1873).

29. T. S. Eliot, *The Complete Poems and Plays* (New York, 1952), p. 129.

30. Eliot, "Arnold and Pater," p. 392; Pater, *Renaissance,* p. 236.

31. For more on the relation between Pater and Eliot, see Gerald Monsman, *Walter Pater* (Boston, 1977), pp. 185–86; for a complete and extremely sophisticated account of Pater's influence on the entire generation of Anglo-American modernists, see pp. 160–86.

32. James recounts this story in his preface to *The Lesson of the Master . . . and Other Tales,* in Henry James, *The Novels and Tales of Henry James,* New York ed., 26 vols. (New York, 1907–17), vol. 15, pp. v–viii.

33. *Henry James: Letters,* ed. Leon Edel, 4 vols. (Cambridge, Mass., 1974–80), vol. 3, p. 492.

34. This last point is made by Edel, *Henry James: Middle Years,* p. 259. For quotations from the works mentioned, see Henry James, *The Ambassadors,* vols. 21 and 22 of James, *Novels and Tales* (New York, 1909), vol. 21, p. 217; Oscar Wilde, *The Picture of Dorian Gray* (London, 1891), p. 33; Henry James, "The Art of Fiction" (1884), in *Partial Portraits* (London, 1888), p. 390; and idem, *The Tragic Muse,* vols. 7 and 8 of *Novels and Tales* (New York, 1908), vol. 7, p. 30.

35. Henry James, "A Bundle of Letters," in *The Complete Tales of Henry James,* ed. Leon Edel, 12 vols. (Philadelphia, 1962–65), vol. 4, p. 441; Henry James, *The Portrait of a Lady,* vols. 3 and 4 of James, *Novels and Tales* (New York, 1908), vol. 3, p. 375. Further citations to *The Portrait of a Lady* will refer to this edition and will be incorporated in parentheses in the text.

36. The only account of this aspect of the novel with which I am familiar is Sara Stambaugh, "The Aesthetic Movement and *The Portrait of a Lady,*" *Nineteenth-Century Fiction* 30 (1976), pp. 495–510.

37. *Punch* 78 (Oct. 30, 1880), p. 445.

38. These examples were suggested to me by Leonée Ormond, *George Du Maurier* (Pittsburgh, 1969), p. 307.

39. Vernon Lee is a pseudonym for Violet Paget. According to James's notebooks, Du Maurier described the plot of *Trilby* to James and suggested he make it the subject of a novel. James briefly considered the idea before turning it back to Du Maurier; see Henry James, *The Notebooks of Henry James,* ed. F. O. Matthiessen and Kenneth Murdock (New York, 1947), pp. 97–98.

40. Pater, *Renaissance,* pp. 236, 238–39.

41. Ibid., pp. 238–39; for Pater's words, "Contemplation—impassioned contemplation—that, is with Wordsworth, the end-in-itself, the perfect end," see his "Wordsworth," in *Appreciations, with an Essay on Style,* vol. 5 of *The Works of Walter Pater* (London, 1901), p. 60.

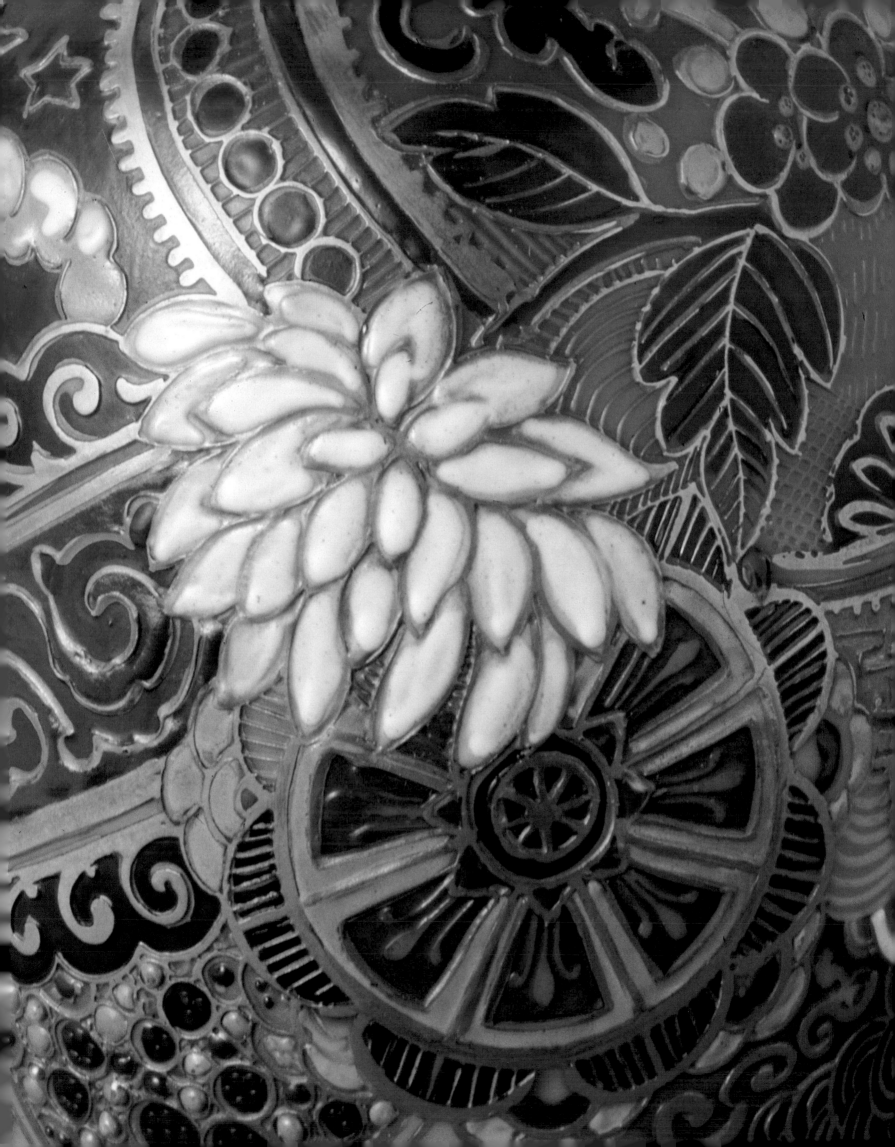

Dictionary of Architects, Artisans, Artists, and Manufacturers

Catherine Hoover Voorsanger

Author's note: The entries in this dictionary provide biographical sketches of, and selected bibliographic references for, the architects, artisans, artists, and manufacturers active in America and Britain who designed and/or made the works included in the exhibition that this book accompanies. Many other figures and firms active during the Aesthetic period but not represented in the exhibition are listed as well, with cross-references to the entry in which they are mentioned. The reference sections for better-known individuals and companies are more selective and direct the reader to sources in which comprehensive bibliographies may be found.

Thomas Allen, *see* **Josiah Wedgwood and Sons, Limited**

American Encaustic Tiling Company
1875–at least 1945
Zanesville, Ohio
Ceramics

In America during the late 1870s and 1880s, Ohio potteries were quick to take advantage of the varicolored local clays available to them. Of these firms, the American Encaustic Tiling Company, founded in 1875 by Benedict Fischer, was one of the first to anticipate the surge of interest in decorative tiles stimulated by the displays at the 1876 Philadelphia Centennial Exposition. Incorporated in 1878, and with a salesroom on West Twenty-third Street in New York City by the early 1880s, American Encaustic was in the forefront of tile manufacturing for more than half a century.

Initially the company produced encaustic tiles, which were formed by inlaying a design of light-colored clay in a darker ground, a medieval method of production that had been rediscovered in England during the Gothic revival of the 1830s and 1840s and that was most often used to produce flooring (FIG. 7.35, ILL. 7.13). The firm also produced glazed tiles from 1880, relief tiles from 1881, and white wall tiles from 1895. Large commissions for encaustic tiles for new buildings during the late 1870s, such as the New York state capitol in Albany, helped to establish both the reputation of the firm and the popularity of tiles as a decorative component of the interior.

Unlike art pottery, most art tiles made before 1900 were produced by machine, thereby exemplifying the belief that mechanical production need not be antithetical to artistic quality. The expansion of the Zanesville factory in 1890–92 included the acquisition of eight 8,000-pound presses, each capable of manufacturing some forty-eight thousand small tiles or twelve thousand large tiles per day. About 1891, in conjunction with the publisher Edmund Evans (1826–1906) and using the origi-

nal plates, American Encaustic made transfer-printed tiles with illustrations by WALTER CRANE from *The Baby's Own Aesop,* first published in London and New York in 1887 (FIG. 7.38); during the 1890s they also reproduced on tiles some of WILLIAM MORRIS's patterns.

Among the firm's most artistic creations were Herman Mueller's relief tiles, which often featured classically draped figures in pastoral settings. Mueller (1854–1941), a sculptor trained in Nuremberg and Munich, joined the firm about 1887 after working in Cincinnati. In 1890 Karl Langenbeck (1861–1938), a chemist also previously working in Cincinnati, came to the Zanesville firm, where he successfully experimented with new glazes and Parian wares. Both men resigned in 1894 to establish the Mosaic Tile Company in Zanesville; Mueller subsequently formed the Mueller Mosaic Company in Trenton, New Jersey, in 1908.

Until the Great Depression of the 1930s, American Encaustic Tiling Company remained one of the largest tile manufacturers in the world. Factories were acquired in Mauer, New Jersey, in 1912; Vernon, California, in 1919; and Hermosa Beach, California, in 1926. The company was reorganized as the American Encaustic Tiling Company, Inc., in February 1936, and continued at least until 1945.

REFERENCES
"The American Institute Awards," *Crockery and Glass Journal* 10 (Dec. 4, 1879), p. 17 // American Encaustic Tiling Company (Limited) and Mrs. Aaron F. Perry, correspondence, Feb. 20 and Aug. 7, 1882, Women's Art Museum Association of Cincinnati Collection, Box 2, Folder 9, Letters, 1882, Cincinnati Historical Society // [American Encaustic Tiling Company], *Decorator and Furnisher* 10 (Apr. 1887), p. 20 // Edwin AtLee Barber, *The Pottery and Porcelain of the United States* (New York, 1893; 3d ed., New York, 1909), pp. 353–60, 418–19 // [Karl Langenbeck to John F. Low, correspondence, Aug. 17, 1893], *Pottery Collectors' Newsletter* 3 (Aug. 1974), pp. 156–60 // American Encaustic Tiling Company, Limited, *Catalog A—Artistic Tiles*

and Ceramic Mosaic Tile Floor Designs (Zanesville [1900?]) // "H. C. Mueller," *Journal of the Ceramic Society* 6 (Jan. 1923), pp. 29–30 // American Encaustic Tiling Company, Limited, *Annual Report[s]* (Zanesville, 1927–30; 1936–37; 1944–45), Miscellaneous Pamphlet File, Yale University Library, New Haven // American Encaustic Tiling Company, Inc., to the Creditors and Stockholders of the American Encaustic Tiling Company (Limited), letter concerning the reorganization plan, Mar. 27, 1936, Financial History Pamphlet File, Yale University Library, New Haven // "Ceramic History—Herman Mueller: A Charter Member of the American Ceramic Society," *Bulletin of the American Ceramic Society* 21 (Jan. 1942), pp. 1–3 // Everett Townsend, "Development of the Tile Industry in the United States," *Bulletin of the American Ceramic Society* 22 (May 15, 1943), pp. 127–28 // E. Stanley Wires, "Decorative Tiles, Part 3: Their Contribution to Architecture and Ceramic Art," *New England Architect and Builder Illustrated* 2 (Mar. 1960), pp. 15–26 // Idem, "How Tiles Have Interpreted Aesop's Great Fables," *Antiques Journal* 25 (May 1970), pp. 10–12, 31 // Evan and Louise Purviance, *Zanesville Art Tile in Color* (Des Moines, Iowa, 1972) // E. Stanley Wires, Norris F. Schneider, and Moses Mesre, *Zanesville Decorative Tiles* (Zanesville, 1972), pp. 3–17, 32 // Chester Davis, "The AETCO Tiles of Walter Crane," *Spinning Wheel* 29 (June 1973), pp. 18–20 // Lisa Factor Taft, "Herman Carl Mueller (1854–1941): Innovator in the Field of Architectural Ceramics" (Ph.D. diss., Ohio State University, 1979) // William Benton Museum of Art, University of Connecticut, Storrs, *American Decorative Tiles, 1870–1930,* by Thomas P. Bruhn (exhib. cat., 1979), pp. 13 (ill.), 15–16, 20 (ills.) // Grant Muter, "Minton Secessionist Ware," *Connoisseur* 205 (Aug. 1980), pp. 256–63 // Detroit Institute of Arts, *The Quest for Unity: American Art Between World's Fairs, 1876–1893* (exhib. cat., 1983), p. 170 (ill.) // Norris F. Schneider, Zanesville, correspondence, June 2, 1984 // American Encaustic Tiling Company, *Designs for Tile Pavements, . . .* (New York, n.d.)

Frank Ames, see **Barnard, Bishop and Barnards**

Léon Arnoux, see **Minton and Company**

Associated Artists, see **Louis Comfort Tiffany** and **Candace Wheeler**

Francis H. Bacon, see **A. H. Davenport and Company**

Barnard, Bishop and Barnards
1826–1955
Norwich, Norfolk, England
Iron and brass

By the mid-nineteenth century the firm that later became Barnard, Bishop and Barnards was one of the major English industrial iron foundries responding to the design-reform movement that had begun in Britain in the early 1830s. Charles Barnard (1804–1871) started the foundry in Norwich's "Upper Walk" in 1826, taking his brother-in-law, M. B. Joy, as a partner a few years later. The partnership was dissolved in 1843, and Barnard was joined by one John Bishop in 1846; the firm's name was changed in 1859 to reflect the addition of Barnard's twin sons, Charles (1836–1912) and Godfrey (1836–1904), who entered the business that year.

Production consisted of a variety of innovative agricultural and domestic products, including a self-rolling mangle patented in 1838, a noiseless lawn mower, a coffee grinder, a series of kitchen ranges, hot-water heating systems, and the Country Parson, a slow-combustion stove that won a gold medal at the 1878 Exposition Universelle in Paris. By 1844 Charles Barnard had perfected the mechanical production of wire netting for agricultural use, the first of the various fencing materials still in production by the firm's present owners.

In 1851, having moved to a one-acre site formerly occupied by the Norfolk Ironworks, Barnards expanded production to include ornamental iron for domestic use: its prize-winning wrought-iron hinge and door knocker, exhibited at the Great Exhibition in London that year, ushered in a general revival of medieval craftsmanship, in which the firm was preeminent until the end of the century.

Barnards's most spectacular creations resulted from the collaboration of Frank Ames (1826–1912), the foundry's chief craftsman, and THOMAS JECKYLL, a Norwich architect associated with the firm from about 1859 to 1877. The Norwich Gates, the first of several pairs of gates Jeckyll designed for Barnards, were critically acclaimed at the 1862 International Exhibition in London and in 1863 were the wedding gift from the Gentlemen of Norfolk and Norwich to the Prince of Wales (later Edward VII) and his bride, Alexandra of Denmark. Installed at the royal residence at Sandringham that year, they remain in use today. Barnards's ornamental work reached its zenith in the two-story pagoda-like pavilion Jeckyll designed for presentation at the Philadelphia Centennial Exposition (ILLS. 8.19, 8.20). With its geometric balustrade of sunflowers, a motif typical of the aesthetic vocabulary, the struc-

ture was an exemplary demonstration of the firm's capabilities. Despite its formidable weight of forty tons, the pavilion was subsequently displayed at the Exposition Universelle in Paris in 1878 and in several other European cities until 1888, when it was purchased by the Norwich City Council; it was dismantled after sustaining damage beyond repair during the Second World War. Jeckyll also used the sunflower to form andirons (FIG. 8.29) usually made of either cast iron or gilt bronze; today these are extremely rare. Other designs by Jeckyll were for cast-iron furniture and, in both brass and cast iron, fireplace grates and surrounds. On many examples of the latter, the surface is ornamented with roundels, each featuring a different Japanese-style pattern (ILL. 8.22).

Aside from briefly concentrating its production on military equipment during the war years of 1939–45, in this century the firm has specialized in a variety of purely utilitarian metalwork products, such as grates and manhole covers. In 1955 Barnards was purchased by TWIL Ltd.

REFERENCES
The Illustrated Catalogue of the Universal Exhibition, published with the *Art Journal* (London and New York, 1868), pp. 104 (ill.), 294 (ill.) // "Modern Iron-Work," *Art Journal* (London), Oct. 1869, p. 320 (ill.) // "The Universal Exhibition at Vienna," *Art Journal* (London), June 1873, p. 183 (ill.) // "The Universal Exhibition at Vienna," *Art Journal* (London), July 1873, pp. 217 (ill.), 220 // James D. McCabe, *The Illustrated History of the Centennial Exhibition . . .* (Philadelphia, Chicago, and Saint Louis, 1876; reprint Philadelphia, 1975), p. 367 // "Art Reproductions in Metal," *Iron Age,* Sept. 7, 1876, p. 14 // [George Titus Ferris], *Gems of the Centennial Exhibition: Consisting of Illustrated Descriptions of Objects of an Artistic Character, in the Exhibits of the United States, Great Britain, France . . .* (New York, 1877), p. 73 (ill.) // "The Paris Universal Exhibition," pts. 6, 7, *Magazine of Art* 1 (1878), pp. 167 (ill.), 187 (ill.), 188, 189 (ill.) // J. Moyr Smith, *Ornamental Interiors, Ancient and Modern* (London, 1887), pp. 205, 206 (ill.), pl. 32 // Lewis F. Day, "Victorian Progress in Applied Design," *Art Journal* (London), June 1887, pp. 185–202 // Elizabeth Aslin, *The Aesthetic Movement: Prelude to Art Nouveau* (New York and Washington, D.C., 1969), pp. 94, 143–44, pl. 66 // "Barnards Have Led Way Since 1826," Norwich *Eastern Evening News,* Nov. 18, 1976, p. 13 // David Jones, Castle Museum, Norwich, correspondence, Dec. 28, 1984 // Roy Brigden and Michael Day, unpublished lecture notes, n.d., kindly provided by David Jones, Castle Museum, Norwich // Kenneth S. Lord, Department of Architecture, North East London Polytechnic, Eng., "Thomas Jeckyll, Architect and Designer, 1827–1881" (diss. presented to the Royal Institute of British Architects, n.d.)

A. J. Barrett, see **Gorham Manufacturing Company**

William Baumgarten, see **Herter Brothers**

John Bennett
1840–1907
New York City
Ceramist

Bennett, son and namesake of the proprietor of the Sneyd Pottery in Burslem, near Stoke-on-Trent, England, was trained in the Staffordshire potteries before moving to London about 1873. Later that year, while experimenting on his own with painted faience, Bennett had the good fortune to meet John Sparkes, then head of the Lambeth School of Art in London. Acting on Sparkes's recommendation, Henry Doulton (1820–1897), of Henry Doulton and Company, hired Bennett to establish a faience department in which to teach Doulton artisans the method of underglaze decoration Bennett had developed (ILL. 7.9). Little else is known about Bennett's early career in England.

Examples of his work were featured with the Doulton display at the 1876 Philadelphia Centennial Exposition, the contents of which the public eagerly purchased. Encouraged by this success, Bennett, already somewhat at odds with his Doulton colleagues—who described him as "imperious and touchy" (Gosse, 1970, p. 87)—emigrated to New York the following year and by 1878 had rented a studio at 101 Lexington Avenue. Soon after, according to his advertisements, he had a "lesson studio" on Fourth Avenue and a "works" at 412–418 East Twenty-fourth Street, where he resided with his wife and six of their eventual thirteen children.

The underglaze decoration that Bennett practiced came to be known as Bennett ware, and brought him to national attention in ceramics circles. Examples of his pottery were sold by such notable establishments as TIFFANY AND COMPANY and Davis Collamore in New York and Abram French and Company in Boston. Bennett's motifs evoke spring: field flowers and nodding grasses; apple, hawthorn, and dogwood blossoms; and peonies, roses, and asters (for example, FIGS. 7.20, 7.21, ILL. 7.11). Critics extolled his use of color—mustard yellow, lapis lazuli, Persian red, violet, olive green tinged with umber or gray—as well as his vitreous enamel glazes that one commentator found "as beautiful as a soap-bubble in the air" (*Crockery and Glass Journal,* Sept. 4, 1879, p. 12). In its fluid, somewhat stylized manner of painting, Bennett's work reveals not only the influence of such British designers as WILLIAM MORRIS but also that of Persian ceramics (FIGS. 7.18, 7.19, ILL. 7.10), an interest he shared with the English ceramist William De Morgan (1839–1917). Though Bennett first used bisqueware imported from England, he soon appreciated the range of available colors and the quality of American clays.

In February 1878 Bennett was engaged by the newly formed Society of Decorative Art in New York to take charge of its ceramics painting classes, a position he apparently filled for only one year. In the fall of 1878 the Women's Art Museum Association of Cincinnati entreated Bennett to come to their city to teach his under-the-glaze technique, but, perhaps not wishing to reveal his method, he declined.

Bennett's pottery wares were frequently exhibited, especially in Cincinnati and New

York, and amateur ceramists came from near and far to study his technique. After achieving this high degree of professional success, however, in 1883 Bennett retired to a farm in West Orange, New Jersey, where he was listed in city directories through 1889. He later spent time in London, between 1891 and 1892. He died in 1907 in West Orange.

Another ceramist named John Bennett, first listed in New York city directories in 1872, was active in New York during the 1870s and 1880s. His firm, Bennett and White, which specialized in china painting and firing, was located at 4 Great Jones Street by 1875. In 1879 that John Bennett severed his partnership with White and formed another with EDWARD LYCETT at the same address. When the firm of Bennett and Lycett was dissolved in January 1882, Bennett traveled to England to visit the Staffordshire potteries. After his return in June 1882, he resumed his connection with Lycett at their old address, until the latter left to join the FAIENCE MANUFACTURING COMPANY in 1884. Bennett then continued alone until 1889, when he took his son Albert into the business as his partner.

REFERENCES
"Bennett and White" [advertisement], *Crockery and Glass Journal* 2 (Oct. 14, 1875), p. 24 // "Notes: Art-Pottery," *Art Journal* (Appleton's) 4 (Jan. 1878), p. 31 // [John Bennett to teach classes at the Society of Decorative Art], *Crockery and Glass Journal* 7 (Jan. 31, 1878), p. 16 // "The Society of Decorative Art," *Crockery and Glass Journal* 7 (May 16, 1878), p. 20 // "Trade and Other Notes," *Crockery and Glass Journal* 7 (May 23, 1878), p. 16 // "New York Trade Notes," *Crockery and Glass Journal* 8 (July 11, 1878), p. 17 // John Bennett and Mrs. Aaron F. Perry, correspondence, Sept. 1878–Oct. 1882, Women's Art Museum Association of Cincinnati Collection, Boxes 1 and 2, Cincinnati Historical Society // "New York Letter: Bennett's Faience," *Cincinnati Enquirer,* Oct. 11, 1878, clipping from the Women's Art Museum Association of Cincinnati Collection Scrapbooks, Cincinnati Historical Society // "America Ahead of France" [excerpt from a letter], *Cincinnati Enquirer,* Oct. 12, 1878[?], clipping from the Women's Art Museum Association of Cincinnati Collection Scrapbooks, Cincinnati Historical Society // "Cincinnati Ceramics," *Cincinnati Enquirer,* Nov. 27, 1878, clipping from the Women's Art Museum Association of Cincinnati Collection Scrapbooks, Cincinnati Historical Society // Jennie J. Young, *The Ceramic Art: A Compendium of the History and Manufacture of Pottery and Porcelain* (New York, 1879), pp. 483–84 (ills.), 485 (ill.) // [Mr. J. Bennett, 4 Great Jones Street], *Crockery and Glass Journal* 9 (Jan. 9, 1879), p. 14 // "Trenton Potteries," *Crockery and Glass Journal* 9 (May 29, 1879), p. 20 // "American Faience," *Crockery and Glass Journal* 10 (Sept. 4, 1879), p. 12 // "New York Letter: Doulton Pottery Made in the United States— a Visit to John Bennett," *Cincinnati Commercial,* Sept. 13, 1879, clipping from the Women's Art Museum Association of Cincinnati Collection Scrapbooks, Cincinnati Historical Society // "Decorative Art: The Pottery Club," *Cincinnati Commercial,* Sept. 17, 1879, clipping from the Women's Art Museum Association of Cincinnati Collection Scrapbooks, Cincinnati Historical Society // Silex, "Trenton Potteries," *Crockery and Glass Journal* 10 (Oct. 16, 1879), p. 20 // "Bennett Faience" [advertisement], *Art Amateur* 2 (Dec. 1879), p. iii // Curio, "Artistic Decorative Pottery," *Art Amateur* 2 (Dec. 1879), pp. 16–17 // "Among the Dealers," *Art Amateur* 2 (Mar. 1880), p. 4 // Alice Donlevy, "Ceramic Clays in the United States," *Art Amateur* 2 (Mar. 1880), p. 78 // "Artistic Stone-ware," *Art Amateur* 3 (Sept. 1880), p. 75 // Constance Cary Harrison, *Woman's Handiwork in Modern Homes* (New York, 1881), pp. 98 (ill.), 106–7 // Montezuma [Montague Marks], "My Note Book," *Art Amateur* 4 (Feb. 1881), p. 47 // [Underglaze work of John Bennett], *Art Amateur* 6 (Jan. 1882), p. 36 // [Dissolution of Bennett and Lycett, china decorators] and [John Bennett returns permanently to Staffordshire, Eng.], *Crockery and Glass Journal* 15 (Jan. 5, 1882), p. 18 // Montezuma [Montague Marks], "My Note Book," *Art Amateur* 6 (Feb. 1882), pp. 148–49 // [John Bennett returns to New York from Staffordshire Potteries], *Crockery and Glass Journal* 15 (June 22, 1882), p. 20 // "Among the Dealers," *Art Amateur* 8 (Jan. 1883), p. 43 // [Laura B. Morton, former student of John Bennett], *Art Amateur* 9 (June 1883), pp. 19, 20 (ill.) // Isaac Edwards Clarke, *Art and Industry: Education in the Industrial and Fine Arts in the United States,* pt. 1, *Drawing in Public Schools* (Washington, D.C., 1885), pp. ccxlvi–ccxlvii // "Correspondence: 'Not a "Graduate" of Doulton's,'" *Art Amateur* 12 (Apr. 1885), p. 117 // "John Bennett and Son" [advertisement], *Art Amateur* 20 (Feb. 1889) // Edwin AtLee Barber, *The Pottery and Porcelain of the United States* (New York, 1893; 3d ed. New York, 1909), pp. 305–8 // John C. L. Sparkes and Walter Gandy, *Potters: Their Arts and Crafts* (London, 1897), pp. 255–56 // Edmund Gosse, *Sir Henry Doulton: The Man of Business as a Man of Imagination,* ed. Desmond Eyles (London, 1970), p. 87 // William Benton Museum of Art, University of Connecticut, Storrs, *American Decorative Tiles, 1870–1930,* by Thomas P. Bruhn (exhib. cat., 1979), pp. 18–19 (ill.) // Herman J. Nimitz, correspondence, Mar. 8, 1983 // John A. Cherol, The Preservation Society of Newport County, Newport, R.I., correspondence, Nov. 29, 1983, and Jan. 12, 1984 // Geoffrey Godden, Worthing, Sussex, Eng., correspondence, Feb. 13, 1984 // William and Eleanor Bennett, correspondence, Jan. 19 and Apr. 16, 1985 // Sarah Nichols, "John Bennett: From the Shadows to the Limelight," *Carnegie Magazine,* May–June 1986, pp. 22–25 // Thomas R. Roberts, *Arnold Bennett's Five Towns Origins* (City of Stoke-on-Trent Museum and Art Gallery, Eng., n.d.), pp. 1–6

Emma Bepler
1864–1947
Cincinnati, Ohio
Wood carver

A secondary figure in the Cincinnati art movement, Emma Bepler was the daughter of a prosperous German immigrant, Augustus Bepler, who made his fortune in the manufacture of paper bags and in lucrative real-estate investments. His Mount Tusculum estate in Cincinnati provided an idyllic environment for his ten children: gardens resplendent with zinnias, asters, peonies, roses, and pepper vines— as well as a collection of pet peacocks—were later transformed by Emma into carved ornamental motifs.

As a young girl Bepler essayed both china painting and wood carving, stimulated by the local interest in these arts generated by BENN PITMAN, HENRY LINDLEY FRY, and WILLIAM HENRY FRY in the early 1870s. Not until 1881, at the age of seventeen, did she enter the University of Cincinnati School of Design, later called the Art Academy of Cincinnati. She enrolled over the next four years in a number of drawing classes to study geometric solids and still lifes, figure drawing from casts and from life, and decorative design. The school regularly showed examples of her drawings and painted textiles in its annual exhibitions.

Bepler first studied wood carving with Benn Pitman at the Art Academy in 1886–87 and again during the 1891–92 academic year. Her round cherrywood fruit plate (FIG. 5.15), in which she combined natural floral ornament— wild roses—with abstract Saracenic arabesques, is an excellent example of her early work. Benn Pitman admired the piece enough to illustrate it in his book of 1895, *A Plea for American Decorative Art.*

In 1893 William Fry succeeded Pitman as the wood-carving instructor at the academy, and Bepler enrolled in Fry's class during the 1893–94 school year. The emphasis of both men on the application of artistic wood carving to the domestic interior is evident in the two black-walnut mantelpieces Bepler carved for her family home, one in 1893 and the other in 1897.

Most of Bepler's carved pieces (fewer than twenty-five in all) date from the 1890s, when she also began to teach china painting to her friends. A large wood settle in the Fry style of carving with peacocks, acanthus, and claw feet, executed while enrolled in William Fry's class for the second and final time during 1900–1901, was Bepler's last large-scale piece in that material. Although she reportedly won a prize for the examples of china painting she submitted to the Saint Louis World's Fair in 1904, embroidery, crocheting, and knitting occupied her in subsequent years, during which time she also managed her family's business affairs. Bepler was an active member of the Cincinnati Women's Art Club from 1906 until her death, in 1947, at the age of eighty-three.

REFERENCES
History of Cincinnati and Hamilton County (Cincinnati, 1894), pp. 506–7 // Benn Pitman, *A Plea for American Decorative Art,* Cincinnati Souvenir, Cotton States and International Exposition, Atlanta, Ga. (Cincinnati, 1895), unpaged, last ill. // "Woman Woodcarver, Artist, Dies at Eighty-three," *Cincinnati Times-Star,* Feb. 24, 1947, clipping from the Cincinnati Historical Society // Anita J. Ellis, "Cincinnati Art Furniture," *Antiques* 121 (Apr. 1982), pp. 930–41 // Adelaide Ottenjohn, Cincinnati, correspondence, Mar. 15, 1984 // Jana Kaye Martin, "'Private Pastimes': Develop-

ment of a Nineteenth-Century Cincinnati Woman Woodcarver, Emma Bepler" (M.A. thesis, University of Cincinnati, 1985)

Henry Berry, *see* Derby Silver Company

R. W. Binns, *see* Worcester Royal Porcelain Company

William Bloor, *see* Ott and Brewer

T. and R. Boote
1842–1962
Burslem, Staffordshire, England
Ceramics

The British firm of T. and R. Boote, founded in 1842, moved to the Waterloo Works, Burslem, in 1850. At first Boote manufactured encaustic tiles by the plastic-clay method, but in 1863, in collaboration with the firm of Boulton and Worthington, Boote obtained the patent for the pressed-dust method, which, because it was significantly cheaper, made encaustic tiles more widely available. The company also manufactured Parian ware, which it displayed at the Great Exhibition of 1851 in London; Boote's Parian copy of the Portland Vase was considered especially fine.

By the last quarter of the nineteenth century Boote, along with Maw and Company and MINTON AND COMPANY, had emerged as one of the largest English producers of decorative tiles. During the 1880s Boote manufactured a number of tiles with illustrations by WALTER CRANE (FIG. 7.37). In addition to encaustic and transfer-printed tiles, toward the end of the century the company made a great many majolica tiles in Art Nouveau designs. Boote also manufactured plain white, purely utilitarian tiles that were used in large construction projects, such as the Blackwall Tunnel under the Thames River, built between 1892 and 1897.

REFERENCES
The Illustrated Exhibitor: . . . The Principal Objects in the Great Exhibition of the Industry of All Nations, 1851 (London, 1851), pp. xxxvi, 435–36, 443 (ill.) // [Edward Boote's showrooms], *Art Amateur* 4 (May 1881), p. 129 // John Fleming and Hugh Honour, "Boote, T. and R.," in *Dictionary of the Decorative Arts* (New York, 1977), p. 103 // Michael Messenger, "Revival of a Medieval Technique: Encaustic Tiles in the Nineteenth Century," *Country Life* 163 (Jan. 26, 1978), pp. 214–15 // Jill and Brian Austwick, *The Decorated Tile: An Illustrated History of English Tile-making and Design* (London, 1980), pp. 67, 86, 100 (ill.), 130 (ills.), 154

Charles Booth
1844–1893
New York City and Orange, New Jersey
Stained-glass designer

Charles Booth, born in Liverpool, England, is first listed as a "stainer," that is, a stained-glass artist, in the New York city directories for 1875–76, located at 166 Fifth Avenue with a residence in New Jersey, later specified as the town of Orange. He next established a workshop at 47 Lafayette Place, which he kept throughout his time in New York. Although Booth returned to London in 1880, where he took over George Edward Cook's stained-glass studio at 98 Gower Street, moving to number 115 in 1886, he maintained a New York branch of his operations. Booth died in 1893 (Harrison, 1980, p. 57); the last listing for Booth's New York studio, however, appears in the New York city directories in 1905–1906. According to his will, made in 1884, Booth desired "that his business be carried on in England and America," and thus the workshop continued to operate under his name even after his death (Harrison, 1985).

Booth's activities as a decorative artist in New York and his artistic style are evident from three publications issued in America between 1876 and 1878: his own 1876 *Hints on Church and Domestic Windows, Plain and Decorated;* the 1877 *Modern Surface Ornament* (ILL. 6.2), which consisted of twenty-four Anglo-Japanesque designs by Booth and several other ornamentalists; and the *Art-Worker: A Journal of Design Devoted to Art-Industry* (ILL. 6.3), a short-lived, one-volume periodical published in 1878 by J. O'Kane, which included four plates by Booth. While his style incorporates some recognizably Modern Gothic motifs, it is for the most part a skillful interpretation of the geometricized plant forms popularized by CHRISTOPHER DRESSER and characteristic of the Anglo-Japanesque aesthetic of the 1870s. On the basis of these published designs, a number of stained-glass windows in Calvary Church in New York City (FIG. 6.2) and those in the Jefferson Market Courthouse (ILL. 6.4), also in New York, are now thought to be Booth's work.

REFERENCES
Charles Booth, *Hints on Church and Domestic Windows, Plain and Decorated* (Orange, N.J., 1876) // [Charles Booth et al.], *Modern Surface Ornament* (New York, 1877) // *Art-Worker: A Journal of Design Devoted to Art-Industry* 1 (Jan.–Dec. 1878), pls. 1, 8, 39, 55 // Martin Harrison, *Victorian Stained Glass* (London, 1980), p. 57 // James L. Sturm, *Stained Glass from Medieval Times to the Present: Treasures to Be Seen in New York* (New York, 1982), ills. 96, 97; p. 142 (n. 25) // Martin Harrison, London, correspondence, Feb. 19, 1984, and Oct. 13, 1985 // James L. Sturm, City University of New York, Saint George Campus, correspondence, Apr. 15, 1985

Boston and Sandwich Glass Company
1825–1888
Sandwich, Massachusetts
Glass

The Boston and Sandwich Glass Company is perhaps best remembered today for its lacy pressed wares dating from the late 1820s to the mid-1830s. Considering the great renown of its early production, however, there is surprisingly little knowledge of the firm's output after the Civil War. The wares made by the factory during the Aesthetic era, largely modeled on contemporary English and Venetian glass, deserve still the praise that they received in 1875 from an unknown chronicler who said, "The fragile, sparkling devices . . . are as marvelously artistic and lovely as the most fastidious person could desire" (*Crockery and Glass Journal,* Dec. 9, 1875, p. 19).

The Boston and Sandwich Glass Company's initial success is credited to Deming Jarves (1790–1863), who started the company in 1825 at Sandwich, on Cape Cod, after leaving his position as agent for the NEW ENGLAND GLASS COMPANY, of which he had been a founder in 1818. The factory prospered during Jarves's twenty-three-year leadership, and its prodigious production is evidenced by the large number of cup plates, salts, plates, and other surviving items attributed to his firm. When Jarves and his son John left the Boston and Sandwich Glass Company in 1858 to found the Cape Cod Glass Works, also in Sandwich, the Fessenden brothers, George and Sewall A., took over the business, with George as superintendent and Sewall as the company's Boston agent. Henry Francis Spurr, head salesman for the firm, who had worked for the factory since 1849, assumed control of the works in 1882, when George Fessenden retired; Sewall Fessenden retired the following year.

The Boston and Sandwich Glass Company began experiments with colored glass for pressed wares by the 1830s, although colorless flint glass constituted the major portion of the factory's output throughout its history. Interest in the artistic possibilities of colored glass, however, did not accelerate until the mid-1860s.

The firm's early art-glass production coincided with the arrival in 1869 of Nicholas Lutz, originally from Saint-Louis, France. His glassmaking career in America probably began before his arrival in Sandwich, at Christian Dorflinger's factory in White Mills, Pennsylvania. (After the 1888 closing of the Sandwich firm, he worked for a short time at the MOUNT WASHINGTON GLASS COMPANY in New Bedford, Massachusetts, and at the Union Glass Works in Somerville, Massachusetts.) It was probably Lutz who steered the company into the production of the Venetian-inspired glass then in vogue in England. He excelled in wares of the latticinio variety, in which filigreed glass rods were embedded. Notable examples of this type are the factory's machine-threaded vessels—pitchers, tumblers, and mugs (FIG. 7.43)—decorated with continuous concentric threads of glass, sometimes in blue or red.

Another Venetian technique the factory tried was a textured glass whose surface was covered with pulverized glass particles; it was variously called frosted, overshot, or ice-glass. Frosted objects were among the many kinds of glass that the Boston and Sandwich Glass Company featured in their 1878 exhibition at the Massachusetts Charitable Mechanics Association Fair. Particularly suited to one of the forms on display there, a champagne pitcher (FIG. 7.44), the frosted glass disguised the unsightly glass pocket, or bladder, that protruded into the body of the pitcher to contain ice, a device that kept the wine cool without diluting it. The firm's display also included chandeliers and lamps, epergnes and flower vases delicately engraved with ferns or flower sprays, and opal glass decorated with polychromed enamel by

staff artists. The opal glass closely resembled that produced by two New Bedford firms, the Mount Washington Glass Company and SMITH BROTHERS. Alfred and Harry Smith, as well as their father, William, had in fact previously worked for the Boston and Sandwich Glass Company under Deming Jarves.

The Boston and Sandwich Glass Company continued production of artistic, cut and engraved, pressed, and novelty glassware until its closing in 1888. Like the New England Glass Company, competition from cheaper glass made in the Midwest in conjunction with severe strikes by its workers forced the Sandwich firm out of business. A Boston retailer, Jones, McDuffee and Stratton, bought all the remaining stock and molds, and the following year the Electrical Glass Company of Sandwich purchased the factory complex for the manufacture of electrical glassware.

REFERENCES
Deming Jarves, *Reminiscences of Glass-making* (New York, 1865) // Boston and Sandwich Glass Company [trade cat.] (Boston [1874]; reprint Wellesley Hills, Mass., 1968) // "A Rare and Beautiful Exhibition," *Crockery and Glass Journal* 2 (Dec. 9, 1875), p. 19 // "Cobwebs and Dust: Some Unsuspected Sandwich," *Antiques* 1 (May 1922), pp. 198 (ills.), 200–202 // Priscilla C. Crane, "The Boston and Sandwich Glass Company," *Antiques* 7 (Apr. 1925), pp. 183–90 // Frederick T. Irwin, *The Story of Sandwich Glass* (Manchester, N.H., 1926) // Frank W. Chipman, *The Romance of Old Sandwich Glass* (Sandwich, 1932) // Dorothea Setzer, *The Sandwich Historical Society and Its Glass* (Sandwich, 1936) // Mabel M. Swan, "Deming Jarves and His Glass-Factory Village," *Antiques* 33 (Jan. 1938), pp. 24–27 // George E. Burbank, *A Bit of Sandwich History* (Sandwich, 1939) // Ruth Webb Lee, *Sandwich Glass: The History of the Boston and Sandwich Glass Company* (Framingham Center, Mass., 1939) // George S. McKearin and Helen McKearin, *American Glass* (New York, 1941) // Mabel M. Swan, "The Closing of the Boston and Sandwich Glass Factory," *Antiques* 40 (Dec. 1941), pp. 372–74 // Harriot Buxton Barbour, *Sandwich, the Town That Glass Built* (Boston, 1948) // Dorothea Setzer, *Personnel of the Boston and Sandwich Glass Factory*, introductory preface to the illustrated lecture "Styles in Sandwich Glass" given at the Third Sandwich Glass Forum, Sandwich, Aug. 14, 1963 (Sandwich, 1963) // Albert Christian Revi, *American Pressed Glass and Figure Bottles* (New York, 1964), pp. 72–75 // Idem, *Nineteenth Century Glass: Its Genesis and Development*, rev. ed. (Exton, Pa., 1967) // *The Sandwich Glass Museum Collection* (Sandwich, 1969) // Kenneth M. Wilson, *New England Glass and Glassmaking* (New York and Toronto, 1972) // Frank E. Robertson, "New Evidence from Sandwich Glass Fragments," *Antiques* 122 (Oct. 1982), pp. 818–23 // Raymond E. Barlow and Joan E. Kaiser, *The Glass Industry in Sandwich*, vol. 4 (Windham, N.H., 1983) // Barbara Bishop, "Deming Jarves as Glassmaker," *Glass Club Bulletin of the National Early American Glass Club* 139 (Winter 1983), pp. 5–8 // Idem, "Deming Jarves and His Glass Factories," *Glass Club Bulletin of the National Early American Glass Club* 140 (Spring 1983), pp. 3–5 // Barbara Bishop and Martha Hassell, eds., *Your Obdt. Srvt., Deming Jarves: Correspondence of the Boston and Sandwich Glass Company's Founder, 1825–1829* (Sandwich, 1984) // Jon H. Wetz, "Identifying Sandwich Glass: How Museums Do It," *Sandwich Collector: A Quarterly Journal for the Serious Glass Collector* 1 (Apr. 1984), pp. 3–15

Jane Bragg, *see* Benn Pitman

John Hart Brewer, *see* Ott and Brewer

Helen Tanner Brodt
1838–1908
Oakland and Berkeley, California
Art teacher, painter, ceramics decorator

Helen Tanner Brodt was born in Elmira, New York, and reportedly studied painting in New York City during the early 1860s. In 1863 she followed her husband of two years, Aurelius Webster Brodt, to Red Bluff, California, a mining town at the foot of the Sierra Nevada, near Sacramento, where he had accepted a job as a schoolteacher. By 1867 the Brodts moved to the San Francisco Bay Area, where Helen taught art in the Oakland public schools; in fact, from about 1872 to 1887 she managed the entire art program for the Oakland school system. Her most famous pupil was the painter Arthur F. Matthews (1860–1945), whose early interest in drawing, at age seven, was reputedly guided by Mrs. Brodt.

Brodt considered herself a professional artist—primarily a landscape, portrait, and miniature painter—and was active in the local art community. Her works were frequently shown in the exhibitions of the Mechanics' Institute in San Francisco, and the art section of the Chicago World's Columbian Exposition in 1893 included one of her portraits. In 1884 she opened a studio on Twelfth Street in Oakland.

Brodt's interest in china painting dates from about 1879 until at least 1884–85, when she received an award for her work at the World's Industrial and Cotton Centennial Exposition held in New Orleans. The brightly painted porcelain plate of 1881, which has been given the contemporary title *Oriental Fantasy*, is a delightful example of Brodt's accomplishment in this medium (FIG. 7.23). Against ground colors of pale blue, gray, and ivory, Brodt has carefully composed a broad selection of aesthetic motifs: to the left, two owls perch on a flowering branch; above, a picture-postcard sunset landscape overlaps the rim of the plate; and arranged clockwise from the top, butterflies in flight, violets and wild flowers, and six Japanese fans encircle an elfin child playing with a spider web atop a mushroom, framed by a peacock feather and a fiddlehead fern.

Unfortunately, further details of Brodt's career have not yet come to light. A great many of her paintings were lost in the San Francisco earthquake and fire of 1906, which occurred just two years before her death.

REFERENCES
Phil Kovinick, "Helen Tanner Brodt," in Muckenthaler Cultural Center, Fullerton, Calif., *The Woman Artist in the American West, 1860–1960* (exhib. cat., 1976), p. 13 // Chris Petteys, "Brodt, Helen Tanner," in *Dictionary of Women Artists: An International Dictionary of Women Artists Born Before 1900* (Boston, 1985), p. 97 // Kenneth R. Trapp, The Oakland Museum, conversation, Nov. 1985, correspondence, Jan. 7, 1986 // Archival material supplied by the Archives of California Art, The Oakland Museum, and the California Historical Society, San Francisco

William Bromley, Jr., *see* Ott and Brewer

William Bromley, Sr., *see* Ott and Brewer

Isaac Broome, *see* Ott and Brewer

William Burges
1827–1881
London
Architect

Despite the brevity of his career, William Burges was one of the most important Gothic-revival architects of the mid-nineteenth century. His career epitomizes the crucial dilemma faced by architects of this period, who searched the past for a style to express appropriately the aspirations of their era. Like the Pre-Raphaelite painters, his friends and contemporaries, Burges looked to the Middle Ages for example and inspiration. His own work was based on a scholarly knowledge of the French Gothic style of the thirteenth century. Yet Burges's approach was not merely antiquarian; he also studied the arts of exotic cultures and, with his opium-enhanced sense of humor, created an eclectic brand of medievalism closer to pure fantasy than historical truth, especially in his decorative projects.

The son of an important civil engineer, Burges enrolled at King's College, London, in 1839. At the age of sixteen he was articled to Edward Blore, special architect to Queen Victoria. It was under the influence of Matthew Digby Wyatt (1820–1877), whose office he joined in 1849, that reform of the industrial arts became for him a major interest. Burges believed that the solution to the problem of architectural style would evolve from the decorative arts: "We have no architecture to work from at all; indeed, we have not even settled the *point de départ*. . . . Our art . . . is domestic, and . . . the best way of advancing its progress is to do the best in our own houses. . . . If we once manage to obtain a large amount of art and colour in our sitting-rooms . . . the improvement may gradually extend to our costume, and perhaps eventually to the architecture of our houses" (Burges, 1865, pp. 91–92).

His winning designs for Lille Cathedral, 1855, and the Crimea Memorial Church in Constantinople, 1856 (both unexecuted), achieved for Burges an international reputation; at this time he opened his own architectural firm. At the 1862 London International Exhibition, whose Medieval Court Burges had designed, he became fascinated with Japanese objects, seeing in them a contemporary manifestation of the true medieval spirit; thereafter he became one of the first in England

to collect Japanese prints.

His earliest major commission, awarded in 1863, was the cathedral of Saint Finbar at Cork, Ireland. Burges is best remembered for Cardiff Castle, begun in 1865, and Castell Coch, commenced ten years later, both in Wales and both commissioned by his wealthy patron the third marquess of Bute, and each resplendent in every interior detail. His masterpiece, however, was his own residence at 9 Melbury Road in London, on which he worked from 1875 until his death. By the mid-seventies Burges was almost alone in England in his devotion to the Middle Ages; his friend E. W. GODWIN, for one, had already begun to explore the Queen Anne style in architecture and the Anglo-Japanesque in furniture design.

As early as 1858 Burges created painted furniture, architectural in form, with complex, often eccentric iconographic motifs—one wardrobe sported portraits of the architect's numerous pet dogs. He also excelled in the design of stained glass, metalwork, ceramics, textiles, and jewelry. Not as well documented are his wallpaper designs for JEFFREY AND COMPANY that he created between 1870 and 1874. Some of his wallpapers reached America, including the frieze of about 1875 (not known to be manufactured by Jeffrey) used in George Peabody Wetmore's Newport, Rhode Island, mansion in the late 1870s (FIG. 3.1), which resembles a stenciled motif Burges used in the entrance hall of his own house. A substantial contact with America was established in 1874, when Burges was commissioned to design Trinity College in Hartford, Connecticut. Only part of his quadruple-quadrangle scheme was ever built, and although his design was slightly altered during its construction, it was greatly admired by H. H. RICHARDSON and other American architects.

REFERENCES
William Burges, "The Various Systems of Coloured Decoration of the Middle Ages," *Building News* 8 (May 9, 1862), pp. 330–31 // Idem, "The International Exhibition," pts. 1, 2, *Gentleman's Magazine and Historical Review,* June 1862, pp. 663–76; July 1862, pp. 3–12 // Idem, "The Loan Museum at the South Kensington," *Gentleman's Magazine and Historical Review,* July 1862, pp. 32–41 // Idem, "The Japanese Court in the International Exhibition," *Gentleman's Magazine and Historical Review,* Sept. 1862, pp. 243–54 // Idem, *Art Applied to Industry* (Oxford and London, 1865) // "Designs for Furniture, 6: A Cabinet, by W. Burges, Esq., Architect," *Furniture Gazette* 1 (Sept. 6, 1873), p. 345 and ill. // G. H. J., "Correspondence: Architects' Furniture," *Furniture Gazette* 1 (Sept. 20, 1873), p. 374 // "Trinity College, Hartford, Connecticut," *American Builder* 10 (May 1874), pp. 122–23 // "An Ultra-artistic Home," *Art Amateur* 3 (Aug. 1880), p. 64 // "Foreign Art Chronicle—Necrology [William Burgess (sic), obituary], *American Art Review* (Boston) 2, pt. 2 (1881), p. 95 // "William Burges" [obituary], *Builder* 40 (Apr. 30, May 7, May 21, June 25, 1881), pp. 531–32, 534, 581, 648, 811 // Arthur Rotch, "William Burges, Architect" [obituary], *American Architect and Building News* 9 (May 14, 1881), pp. 236–37 // "Obituary," *Art Journal* (London), June 1881,

p. 192 // "Notes and Notices of Deceased Members: William Burges, A.R.A., Fellow," *Royal Institute of British Architects Journal,* session 1881–82 (Sept. 1882), pp. 17–30 // R. P. Pullan, ed., *The House of William Burges* (London, 1885) // E. W. Godwin, "The Home of an English Architect," pts. 1, 2, *Art Journal* (London), June 1886, pp. 170–73; Oct. 1886, pp. 301–5 // J. Moyr Smith, *Ornamental Interiors, Ancient and Modern* (London, 1887), pp. 52–54 // Lewis F. Day, "Victorian Progress in Applied Design," *Art Journal* (London), June 1887, pp. 185–202 // "Revival of the Crafts: The Influence of William Burges and Edward W. Godwin," *Royal Institute of British Architects Journal,* 3d ser. 8 (Dec. 22, 1900), pp. 82–84 // "Burges, William," in *Allgemeines Lexikon der Bildenden Künstler,* ed. Ulrich Thieme and Felix Becker, vol. 5 (Leipzig, 1911), p. 248 // R. A. Briggs, "The Art of William Burges, A.R.A.: An Appreciation," *Royal Institute of British Architects Journal,* 3d ser. 23 (Feb. 19, 1916), pp. 131–39 // Alan Victor Sugden and John Ludlam Edmondson, *A History of English Wallpaper, 1509–1914* (London and New York, 1926), pp. 209–12 // Mark Girouard, "Cardiff Castle, Glamorganshire," pts. 1–3, *Country Life* 129 (Apr. 6, 1961), pp. 760–63; (Apr. 13, 1961), pp. 822–25; (Apr. 20, 1961), pp. 886–89 // Idem, "Castell Coch, Glamorgan," pts. 1, 2, *Country Life* 131 (May 10, 1962), pp. 1092–95; (May 17, 1962), pp. 1174–77 // Charles Handley-Read, "Notes on William Burges's Painted Furniture," *Burlington Magazine* 105 (Nov. 1963), pp. 496–507 // Alison Kelly, *The Book of English Fireplaces* (Feltham, Eng., 1968), p. 78 (ill.) // Elizabeth Aslin, *The Aesthetic Movement: Prelude to Art Nouveau* (New York and Washington, D.C., 1969), pp. 79–83 // J. Mordaunt Crook, "Knightshayes, Devon: Burges Versus Crace," *National Trust Yearbook,* 1975–76, pp. 44–55 // Brenda Greysmith, *Wallpaper* (New York, 1976), p. 140 // N. Cromey-Hawke, "William Morris and Victorian Painted Furniture," *Connoisseur* 191 (Jan. 1976), pp. 32–43 // *Pictorial Dictionary of British Nineteenth Century Furniture Design,* intro. Edward Joy (Woodbridge, Eng., 1977), pp. xxxiv–xxxv // City Council, Cardiff, Wales, *William Burges, A.R.A., 1827–1881* (exhib. cat., 1978) // Anthony J. Coulson, *A Bibliography of Design in Britain, 1851–1970* (London, 1979), pp. 76, 179 // Catherine Lynn, *Wallpaper in America: From the Seventeenth Century to World War I* (New York, 1980), pp. 396, 413, pls. 87–88 // J. Mordaunt Crook, *William Burges and the High Victorian Dream* (Chicago and London, 1981) // Fine Art Society Limited, London, *Architect-Designers: Pugin to Mackintosh,* by Clive Wainwright and Charlotte Gere (exhib. cat., 1981), pp. 18–19 // National Museum of Wales, Cardiff, *The Strange Genius of William Burges, "Art-Architect," 1827–1881,* ed. J. Mordaunt Crook (exhib. cat., 1981) // J. Mordaunt Crook, "William Burges and the Dilemma of Style," *Architectural Review* 170 (July 1981), pp. 8–15 // Simon Jervis, "Burges, William," in *The Penguin Dictionary of Design and Designers* (Harmondsworth, Eng., and New York, 1984), pp. 91–93 // "Album of Photographs of Architectural Drawings by William Burges and Others," assembled by Alfred S. F. Kirby,

n.d., Rare Book Collection, Avery Architectural and Fine Arts Library, Columbia University, New York

Colin Minton Campbell, *see* Minton and Company

William Merritt Chase
1849–1916
New York City
Painter

William Merritt Chase played many roles in the American Aesthetic movement, but perhaps his most significant contribution, through his work as a teacher, his activities in art organizations, and his personal collection of art and art objects, was his dissemination of aesthetic principles. Born in Williamsburgh (now Nineveh), Indiana, Chase first studied art in 1867, with the portraitist Barton S. Hays (1826–1914) in Indianapolis. Two years later, at Hays's suggestion, he went to New York, where he enrolled in the school of the National Academy of Design, studying under Lemuel E. Wilmarth (1835–1918). In 1871 Chase rejoined his family, then in Saint Louis. There local art supporters raised the funds for him to go to Europe. The following year he entered the Royal Academy in Munich, where he studied with Karl Theodor von Piloty (1826–1886) and Alexander von Wagner (1838–1919). He was further influenced by the young realist Wilhelm Leibl (1844–1900) and by the contemporary taste for seventeenth-century Spanish and Dutch painting. He soon employed the dark palette, the bravura brushwork, and the broad handling of paint favored by the Munich school; these features remained hallmarks of his painting style for much of his career. In 1877—with the American painters Frank Duveneck (1848–1919), whom he had known well in Munich, and John H. Twachtman (1853–1902)—Chase traveled to Venice and worked there for nine months.

Chase returned to New York in 1878 and rented space in the Tenth Street Studio Building. About 1880 the contents of his studio, especially his extensive collection of paintings, curios, and art objects, became a subject for his paintings (FIG. 1.9). Representative of the new importance that the artist's studio came to hold during the 1880s, Chase's depictions showed not merely a workplace but an environment for display reflecting the inhabitant's taste and achievements. Chase's *Portrait of Miss Dora Wheeler* (1883, FIG. 9.15) addresses a similar theme. The sitter, daughter of CANDACE WHEELER, is shown amid such appurtenances as the Chinese taboret, the Elizabethan chair, and the golden embroidered textile that serves as a backdrop to the scene, presumably set in the studio in which she worked as a painter and textile designer.

Chase was a central figure on the New York art scene. In 1878 he contributed to the first exhibition of the Society of American Artists, for which he later served as president. Actively involved in the revival of various "secondary" media, including prints, tempera, and pastels, Chase was a founding member of the Society of Painters in Pastel and exhibited in their first exhibition in 1884. A member of the Tile Club

from 1877 to 1886, he joined in many of its sketching excursions. When *A Book of the Tile Club* was published in 1886 (ILL. 9.21), Chase's sobriquet "Briareus"—chosen because his remarkable virtuosity and productivity would seem to require the one hundred hands of the mythological monster—appeared in the design for the book's endpapers (ILL. 9.22). Elected an associate member of the National Academy of Design in 1888, Chase became an academician two years later. Throughout the 1880s he made several trips to Europe, visiting Spain, the Netherlands, France, and England, where he not only painted but also acquired additional objects for his collection.

It was during the decade of the eighties that Chase's painting style came under JAMES ABBOTT MCNEILL WHISTLER's sway. The two artists met in London in 1885 to paint one another's portraits. When Chase returned to New York, he brought with him his portrait of the Anglo-American painter, which strongly imitated Whistler's artistic approach. *At Her Ease* (about 1885, ILL. 9.29) and similar canvases were executed by Chase with the thinly applied pigments characteristic of Whistler's works; in *At Her Ease* Chase also borrowed the composition—a sitter in profile posed before a flat, unmodeled backdrop—that Whistler had made famous in his portraits of his mother and of Thomas Carlyle. Throughout his career, Chase produced portraits and still-life paintings, but by the late 1880s he was painting views of leisure-time activities in New York's Central Park and in Brooklyn's Prospect Park. In the 1890s he inaugurated a series of brilliantly lighted landscapes of Shinnecock, Long Island, which show the impact of Impressionism.

Chase was a popular and enthusiastic teacher. He taught not only at the Art Students League for many years (1878–85, 1886–96, 1907–12), but also at the Brooklyn Art School, the Chicago Art Institute (1897), the Pennsylvania Academy of the Fine Arts (1897–1909), and the Chase School (later the New York School of Art and then the Parsons School of Design), which he founded in 1896. He offered summer classes at Shinnecock between 1891 and 1902, and in the early 1900s he accompanied groups of students to Europe. Although his own painting style remained representational, Chase inculcated an appreciation of technique and the aesthetic properties of art in a whole generation of modernists, among them Arthur B. Carles (1882–1952) and Joseph Stella (1879–1946).

In 1902, after the death of his friend John Twachtman left an opening for a new member, Chase joined the Ten American Painters, a prestigious exhibition organization. In his later years he showed widely, won many awards, and was generally recognized for his achievements as both artist and teacher.

REFERENCES

John Moran, "Studio-Life in New York," *Art Journal* (Appleton's) 5 (Nov. 1879), pp. 343–45 // William C. Brownell, "The Younger Painters of America," *Scribner's Monthly* 20 (May 1880), pp. 1–15 // S[ylvester] R[osa] Koehler, "The Works of the American Etchers, 18: William M. Chase," *American Art Review* (Boston) 2, pt. 1 (1881), pp. 135 (ill.), 143 // M. G. Van Rensselaer, "William Merritt Chase," pts. 1, 2, *American Art Review* (Boston) 2, pt. 1 (1881), pp. 91–98, 135–42 // Idem, "American Etchers," *Century Illustrated Monthly Magazine* 25 (Feb. 1883), pp. 483–99 // "The Pedestal Fund Art Loan Exhibition," *Art Amateur* 10 (Jan. 1884), pp. 41–48 // "Mr. William M. Chase's Art," *Art Interchange* 12 (June 19, 1884), p. 148 // "A Boston Estimate of a New York Painter," *Art Interchange* 17 (Dec. 4, 1886), p. 179 // Clarence Cook, *Art and Artists of Our Time*, 3 vols. (New York, 1888), pp. 282–84 // Kenyon Cox, "William M. Chase, Painter," *Harper's New Monthly Magazine* 78 (Mar. 1889), pp. 549–57 // Ishmael, "Through the New York Studios: William Merritt Chase," *Illustrated American* 5 (Feb. 14, 1891), pp. 616–19 // Charles De Kay, "Mr. Chase and Central Park," *Harper's Weekly* 35 (May 2, 1891), pp. 324–28 // W. Lewis Fraser, "William Merritt Chase," *Century Illustrated Monthly Magazine* 45 (Nov. 1892), pp. 155–56 // William J. Baer, "Reformer and Iconoclast," *Quarterly Illustrator* 1 (1893), pp. 135–41 // Lillian Baynes, "Summer School at Shinnecock Hills," *Art Amateur* 31 (Oct. 1894), pp. 91–92 // W. A. Cooper, "Artists in Their Studios," *Godey's Magazine* 130 (Mar. 1895), pp. 291–98 // "William M. Chase's Studio Sale," *New York Times*, Jan. 5, 1896, p. 21 // "Chase Studio Auction Sale," *New York Times*, Jan. 11, 1896, p. 14 // William Merritt Chase, "Velasquez," *Quartier Latin* 1 (July 1896), pp. 4–5 // "The Chase School of Art and the Art Students League," *Art Amateur* 35 (Oct. 1896), pp. 91–92 // William Merritt Chase, "Talk on Art by William M. Chase," *Art Interchange* 39 (Dec. 1897), pp. 126–27 // Ernest Knaufft, "An American Painter: William M. Chase," *International Studio* 12 (Jan. 1901), pp. 151–58 // William Howe Downes, "William Merritt Chase: A Typical American Artist," *International Studio* 39 (Dec. 1909), pp. 29–36 // Katharine Metcalf Roof, "William Merritt Chase: An American Master," *Craftsman* 18 (Apr. 1910), pp. 33–45 // William Merritt Chase, "The Two Whistlers: Recollections of a Summer with the Great Etcher," *Century Illustrated Monthly Magazine* 80 (June 1910), pp. 218–26 // Idem, "The Import of Art" [interview with Walter Pach], *Outlook* 95 (June 25, 1910), pp. 441–45 // Arthur Hoeber, "American Artists and Their Art," pt. 2, *Woman's Home Companion* 37 (Sept. 1910), pp. 50–51 // Gustav Kobbé, "The Artist of Many Studios," *New York Herald Magazine*, Nov. 20, 1910, p. 11 // C. P. Townsley, "William M. Chase: A Leading Spirit in American Art," *Arts and Decoration* 2 (June 1912), pp. 285–87, 306 // William Merritt Chase, "Painting," *American Magazine of Art* 8 (Dec. 1916), pp. 50–53 // Metropolitan Museum of Art, *Loan Exhibition of Paintings by William Merritt Chase* (exhib. cat., 1917) // Katharine Metcalf Roof, *The Life and Art of William Merritt Chase* (New York, 1917) // Gifford Beal, "Chase, the Teacher," *Scribner's Magazine* 61 (Feb. 1917), pp. 257–58 // Katharine Metcalf Roof, "William Merritt Chase: His Art and His Influence," *International Studio* 60 (Feb. 1917), pp. 105–10 // Leo Stein, "William M. Chase," *New Republic* 10 (Mar. 3, 1917), pp. 133–34 // Katharine Metcalf Roof, "William M. Chase: The Man and the Artist," *Century Illustrated Monthly Magazine* 93 (Apr. 1917), pp. 833–41 // John C. Van Dyke, *American Painting and Its Tradition* (New York, 1919), pp. 187–215 // Arthur Edwin Bye, *Pots and Pans, or Studies in Still-Life Painting* (Princeton, 1921) // Royal Cortissoz, *American Artists* (New York, 1923), pp. 163–69 // Frederic Fairchild Sherman, "William M. Chase," *Art in America* 28 (July 1940), pp. 134–35 // John Herron Art Museum, Indianapolis, *Chase Centennial Exhibition*, by Wilbur D. Peat (exhib. cat., 1949) // Henry James, "Of Some Pictures Lately Exhibited, 1875," in *The Painter's Eye*, ed. John L. Sweeney (London, 1956) // Parrish Art Museum, Southampton, N.Y., *William Merritt Chase, 1849–1916: A Retrospective Exhibition*, by M. L. D'Otrange-Mastai (exhib. cat., 1957) // Art Gallery, University of California, Santa Barbara, *The First West Coast Retrospective Exhibition of Paintings by William Merritt Chase (1849–1916)*, by Ala Story (exhib. cat., 1964) // Brooklyn Museum, *Triumph of Realism: An Exhibition of European and American Realist Paintings, 1850–1910*, by Axel von Saldern (exhib. cat., 1967) // Chapellier Galleries, New York, *William Merritt Chase, 1849 to 1916* (exhib. cat., 1969) // Heckscher Museum, Huntington, N.Y., *The Students of William Merritt Chase*, by Ronald G. Pisano (exhib. cat., 1973) // Nicolai Cikovsky, Jr., "William Merritt Chase's Tenth Street Studio," *Archives of American Art Journal* 16, no. 2 (1976), pp. 2–14 // M. Knoedler and Company, New York, *William Merritt Chase (1849–1916)*, by Ronald G. Pisano (exhib. cat., 1976) // Ronald G. Pisano, "The Teaching Career of William Merritt Chase," *American Artist* 40 (Mar. 1976), pp. 26–33, 63–66 // E. B. Crocker Art Gallery, Sacramento, Calif., *Munich and American Realism in the Nineteenth Century*, by Michael Quick and Eberhard Ruhmer (exhib. cat., 1978) // Karal Ann Marling, "Portrait of the Artist as a Young Woman: Miss Dora Wheeler," *Bulletin of the Cleveland Museum of Art* 65 (Feb. 1978), pp. 46–57 // Parrish Art Museum, Southampton, N.Y., *William Merritt Chase in the Company of Friends*, by Ronald G. Pisano (exhib. cat., 1979) // Ronald G. Pisano, *William Merritt Chase* (New York, 1979) // Doreen Bolger Burke, *American Paintings in the Metropolitan Museum of Art*, vol. 3, *A Catalogue of Works by Artists Born Between 1846 and 1864* (New York, 1980), pp. 80–97 // Henry Art Gallery, University of Washington, Seattle, *American Impressionism*, by William H. Gerdts (exhib. cat., 1980) // Philbrook Art Center, Columbia, Mo., *Painters of the Humble Truth: Masterpieces of American Still Life, 1801–1939*, by William H. Gerdts (exhib. cat., 1981) // Henry Art Gallery, University of Washington, Seattle, *A Leading Spirit in American Art: William Merritt Chase, 1849–1916*, by Ronald G. Pisano (exhib. cat., 1983) // Ronald G. Pisano, "Prince of Pastels," *Portfolio* 5 (May–June, 1983), pp. 66–73

Chelsea Keramic Art Works

1872–1889
Chelsea, Massachusetts
Ceramics

The Robertson family, responsible for found-

ing the Chelsea Keramic Art Works in 1872, descended from more than five generations of potters. James Robertson (1810–1880), born in Edinburgh, Scotland, was the son of the head workman at the Fife Pottery in Dysart, Scotland, from whom he learned modeling and mold-making techniques. From the age of sixteen, when he was employed by the Watsons of Prestonpans, Scotland, leading fine-ware manufacturers, until he came to America, Robertson worked for a number of ceramic factories in Scotland and England and learned various methods of making red- and blackware. His son Hugh Cornwall Robertson (1845–1908), later to become the primary artist of the Chelsea Keramic Art Works, was born in Wolverton, England.

No doubt the increasing industrialization of British factories encouraged James Robertson's decision to emigrate to America. He embarked on the *Lord Mulgrave* with his wife, daughter, and three sons—Alexander, Hugh, and George—and arrived in Sayreville (then known as Roundabout), New Jersey, in 1853. For five years Robertson worked in New Jersey, first for James Carr, a ceramics manufacturer in South Amboy, and then for the firm of Speeler, Taylor and Bloor in Trenton.

Robertson and most of his family subsequently moved to Boston, where he was listed in the city directories for 1859 and 1860; Hugh Robertson, who apprenticed to the Jersey City Pottery about 1860, apparently stayed behind. Meanwhile, James Robertson formed a partnership with Nathaniel Plympton and manufactured crockery from yellow and white New Jersey clays. The firm of Plympton and Robertson received third prize for their wares at the ninth Massachusetts Charitable Mechanics Association Fair in 1860. Two years later, however, the partnership dissolved, and the factory reverted to its former owner, a Mr. Homer of Boston. James Robertson was retained as manager of this "East Boston Pottery" until 1872, when he and his sons formed the Chelsea Keramic Art Works.

In the meantime, a supply of fine, iron-rich, red clay in the vicinity of the Snake River had attracted Alexander W. Robertson (1840–1925) to Chelsea, Massachusetts, where in 1866 he established a firm to produce simple brownware. After brother Hugh joined Alexander as a partner about two years later, the company specialized in "plain and fancy flower-pots," ferneries, matchboxes, and the like. Some of these red terracotta pieces were colored with a green paint that in no way suggested the rich glazes Hugh Robertson was to perfect.

The firm's focus turned to art pottery after 1872, the year that James Robertson and his third son, George W. (1835–1914), joined forces with Alexander and Hugh. From this time until James Robertson's death, in 1880, the company was called James Robertson and Sons. The pottery itself was known as the Chelsea Keramic Art Works.

James Robertson's skill in mold making is no doubt evidenced by the variety of unglazed red and white bisqueware shapes, many of them based on ancient prototypes, which the company produced during its first six years. (James is also credited with inventing the first tile-pressing machine in America, a device later fully exploited by the designer JOHN GARDNER

LOW, a member of the Chelsea Keramic Art Works' staff from 1876 to 1877.) Terracotta artware in forms emulating ancient Greek examples was not officially offered for sale until 1875, although some unmarked pieces may have been made as early as 1873; one splendid piece painted by John Gardner Low was patterned on a published vase in the Englefield Collection (FIG. 7.1). Examples of painted red-figured vases, as well as undecorated redwares, were produced until 1878, when, for lack of public interest, the line was discontinued in favor of cream-colored bodies with a variety of colored glazes and surface treatments.

By the late 1870s some forty standard unglazed thrown and molded "metal" shapes were available, the latter being based on angular metalwork forms. Enraptured by oriental porcelains that he saw in Philadelphia in 1876, Hugh Robertson began to experiment with glazes. The Chelsea glazes he created included deep blue, a soft celadon green, mustard yellow, and a variety of rich brown shades (FIG. 7.17); a "dry glaze," produced by firing a high glaze at low heat, resulted in a matte gray brown similar in appearance to polished bronze. About 1876 the firm adapted another variation of faience, under-the-glaze painting with colored clays, called "Bourg-la-Reine" after the technique invented by E. Chaplet and then employed by the Haviland factory in Limoges, France. Hugh Robertson and other artists, including GEORGE W. FENETY (FIG. 7.13), created new ways of decorating ceramic surfaces. Some pieces were embellished with hammer-like marks to create a honeycomb pattern (FIG. 7.15) like that used in Japanese metalwork and in American silver by TIFFANY AND COMPANY; the buff-colored bodies of other pieces were incised with intaglio designs that were filled with white clay.

In 1884, four years after James Robertson's death, Alexander Robertson departed for San Francisco, where in 1899 he founded the Roblin Pottery. George Robertson had been employed by the J. AND J. G. LOW ART TILE WORKS in 1878 and later had his own firm, Robertson Art Tile Works (1890–95), in Morrisville, Pennsylvania. Hugh Robertson remained the sole proprietor of Chelsea Keramic Art Works. A five-year quest for the secret of the sang-de-boeuf, or oxblood, glaze that Hugh Robertson had admired on Ming vases at the Centennial Exposition consumed his energies during the late 1880s. At the expense of his health and the solvency of his firm, Robertson triumphed: some three hundred pieces bearing the ruby red glaze (FIG. 7.16) were produced before the Chelsea Keramic Art Works closed in 1889. Robertson considered the so-called *Twin Stars of Chelsea* (Museum of Fine Arts, Boston) his finest examples. These and other wares by Robertson later won awards at the World's Fairs of 1900, 1904, and 1915.

In 1891 a group of Boston businessmen opened another firm, the Chelsea Pottery, U.S.A., and installed Hugh Robertson as manager. In 1895 or 1896 the company moved to Dedham, Massachusetts, where it continued as the Dedham Pottery. Blue-and-white crackleware, which Robertson had developed in 1886, became the specialty of this firm. After Robertson's death (ostensibly from lead

poisoning) in 1908, his son and grandson directed the Dedham Pottery until 1943, when it ceased operations.

REFERENCES
"Boston," *Crockery and Glass Journal* 4 (Aug. 17, 1876), p. 18 // "Boston," *Crockery and Glass Journal* 4 (Nov. 2, 1876), p. 15 // "Chelsea Keramic Works: Etruscan Vases, Bowls, Tazzas, Lachrymatory" [advertisement], *Crockery and Glass Journal* 4 (Nov. 16, 1876), p. 11 // [Miss Ellen Robbins . . . decorating ceramics], *Crockery and Glass Journal* 5 (Apr. 5, 1877), p. 16 // "Massachusetts Art Potteries," *Crockery and Glass Journal* 7 (Apr. 18, 1878), p. 19 // "Some American Pottery," *Crockery and Glass Journal* 8 (Oct. 24, 1878), p. 19 // Jennie J. Young, "Chelsea Keramic Art Works," *Crockery and Glass Journal* 8 (Dec. 5, 1878), p. 24 // Idem, *The Ceramic Art: A Compendium of the History and Manufacture of Pottery and Porcelain* (New York, 1879), pp. 459, 468–70 // [James Robertson and Sons], *Crockery and Glass Journal* 10 (Aug. 28, 1879), p. 20 // [George W. Fenety], *Art Amateur* 4 (Dec. 1880), p. 2 // Edwin AtLee Barber, *The Pottery and Porcelain of the United States* (New York, 1893; 3d ed. New York, 1909), pp. 260–67, 381–82, 405 // Mabel M. Swan, "The Dedham Pottery," *Antiques* 10 (Aug. 1926), pp. 116–21 // "Gimbels Sells Entire Remaining Stock of the Dedham Pottery" [advertisement], *New York Times*, Sept. 19, 1943, p. 51 (ills.) // Lura Woodside Watkins, *Early New England Potters and Their Wares* (Cambridge, Mass., 1950), pp. 222–33 // Lloyd E. Hawes, "Hugh Cornwall Robertson and the Chelsea Period," *Antiques* 89 (Mar. 1966), pp. 409–13 // Dedham Historical Society, Mass., *The Dedham Pottery and the Earlier Robertson's Chelsea Potteries*, by Lloyd E. Hawes et al. (exhib. cat., 1968) // Paul Evans, "Chelsea Keramic Art Works," in *Art Pottery of the United States: An Encyclopedia of Producers and Their Marks* (New York, 1974), pp. 46–51 // Ralph and Terry Kovel, *The Kovels' Collector's Guide to American Art Pottery* (New York, 1974), pp. 14, 27–39 // Isabelle Anscombe and Charlotte Gere, *Arts and Crafts in Britain and America* (New York and London, 1978), p. 90 // Delaware Art Museum, Wilmington, *American Art Pottery, 1875–1930*, by Kirsten Hoving Keen (exhib. cat., 1978), pp. 22–23 // William Benton Museum of Art, University of Connecticut, Storrs, *American Decorative Tiles, 1870–1930*, by Thomas P. Bruhn (exhib. cat., 1979), pp. 21–22, 23 (ills.), 39 (ill.)

Cheney Brothers

1838–1955
Manchester and Hartford, Connecticut
Textiles

The history of the Cheney Brothers firm is paradigmatic of the growth of the textile industry in America in the nineteenth century. A family-owned and operated business from its beginning, by the turn of the century Cheney Brothers emerged as one of the leading silk manufacturers in the country. The success of the firm was directly related to the collaboration of family members, who combined busi-

ness acumen with extraordinary technological invention.

In the early 1830s, Ralph (1806–1897), Ward (1813–1876), Rush (1815–1882), and Frank Cheney (1817–1904), four of eight sons of a prosperous farmer in Manchester, Connecticut, participated in the speculative cultivation of the *Morus multicaulis,* an imported Chinese mulberry tree, and silkworms, both of which were in great demand by a developing silk industry. Additional acreage was acquired in Burlington, New Jersey, as well as in Georgia and Ohio, in the brothers' attempt to grow the tree successfully. Little more than ten years later, the mulberry market collapsed: the business depression of 1837, the high cost of the labor-intensive silkworm industry, and a blight fatal to mulberry trees in 1844 conspired to eradicate what had seemed a sure investment. Luckily, the Cheney brothers had founded the Mount Nebo Silk Mills in Manchester in 1838, and they now turned their attention to the manufacture of silk thread on a commercial scale, using raw silk imported from the Orient; theirs was the only mill in America to survive from this period into the late nineteenth century.

Improvement of manufacturing methods began in earnest. In 1844 Ward Cheney traveled to Northampton, Massachusetts, to learn the art of silk dyeing from a Mr. Valentine. Three years later Frank Cheney patented the first practical machine for making silk sewing thread, a device that soon became even more useful with the invention of the sewing machine. By the mid-fifties, after five years of experimentation, the firm developed a method of utilizing the "waste silk" previously thought too tangled for spinning, which increased the range of products and grades of silk that they could offer—to threads were added ribbons, handkerchiefs, and eventually broad goods.

In 1854 another Cheney brother, Charles (1803–1874), opened additional mills in nearby Hartford, chosen for its relatively larger labor force. At this time the company was reincorporated as the Cheney Brothers Silk Manufacturing Company (the name was shortened to Cheney Brothers in 1873), and Ward Cheney served as its first president until his death in 1876. He was succeeded by his brother Rush for six years and by his brother Frank from 1882 to 1893.

The Cheney Brothers product line was briefly enlarged during the Civil War to include 200,000 repeating carbine rifles (invented by a member of their staff, C. M. Spencer) for use by the Union army; this part of the business was later sold to the Winchester Arms Company. The war also affected the textile industry directly, and the imposition of strict tariffs on imported silk goods in 1861 and 1864 strengthened the domestic market. Under these conditions, Cheney Brothers continued to grow. By 1880 they were the leading producers of plush, velvet, printed, and jacquard silks. Textiles by CANDACE WHEELER and her Associated Artists (FIGS. 3.16, 3.17, 3.21, ILLS. 3.22, 3.31) illustrate Cheney Brothers' technical expertise coupled with aesthetic design and craftsmanship.

The Hartford holdings were enlarged with the construction of an office building for investment, known as the Cheney Block, which was commissioned from H. H. RICHARDSON in 1875, yet the home base of the business remained quite literally in Manchester, a model factory town. The Cheneys, unlike other such families, were not absentee employers but continued to live in Manchester as they had for fifty years before the mills were founded, and, for generations thereafter, many members of the Cheney family participated directly in the management of the firm. In the interests of maintaining a stable and efficient work force, the company provided attractive workers' housing in a variety of architectural styles, schools, recreational facilities, public utilities, and other benefits such as medical insurance.

In the twentieth century, although the firm was at the forefront of textile design, a combination of overproduction and competition from synthetic fabrics caused the company to decline in the 1920s. During the 1930s the Great Depression forced Cheney Brothers into bankruptcy. However, the demand for parachutes and other war goods in the 1940s revived the company's fortunes for another decade, until its sale to J. P. Stevens in 1955, which thereby brought the grand era of American silk manufacturing to a close.

REFERENCES
[E. Howland], "An Industrial Experiment at South Manchester," *Harper's New Monthly Magazine* 45 (Nov. 1872), pp. 836–44 // Linns P. Brockett, *The Silk Industry in America: A History Prepared for the Centennial Exposition* (New York, 1876), pp. 60–66 // "Cheney, Seth Wells," in *The National Cyclopaedia of American Biography,* vol. 9 (New York, 1899), p. 170 // "Cheney, Charles," in *Appleton's Cyclopaedia of American Biography,* vol. 1 (New York, 1900), pp. 597–98 // [Cheney Brothers], *Cheney Silks: A Glossary of Silk Terms Including a Short History of Silk . . .* (South Manchester, Conn., 1915) // H. H. Manchester, *The Story of Silk and Cheney Silks* (South Manchester, Conn., and New York, 1916) // Charles Cheney, *Silk, an Industry, an Art* (Chicago, 1925) // "Cheney, Charles," "Cheney, Ralph," "Cheney, Ward," "Cheney, Rush," and "Cheney, Frank," in *The National Cyclopaedia of American Biography,* vol. 19 (New York, 1926), pp. 71–74 // Garnet Warren and Horace B. Cheney, *The Romance of Design* (New York, 1926) // "A Century of Textile Pioneering," *American Fabrics* 28 (Spring 1954), pp. 102–5 // "Cheney, Seth Wells," and "Cheney, Ward," in *Dictionary of American Biography,* vol. 2, pt. 2 (New York, 1958), pp. 55–56 // "Cheney, Seth Wells," and "Cheney, Ward," in *Who Was Who in America, Historical Volume, 1607–1896* (Chicago, 1963), p. 103 // Margareta Swenson Cheney, *If All the Great Men: The Cheneys of Manchester* (privately printed, 1975) // "Cheney (Seth-Wells)," in *Dictionnaire critique et documentaire des peintres, sculpteurs, dessinateurs et graveurs,* ed. E. Bénézit, vol. 2 (Paris, 1976), p. 706 // John F. Sutherland, "Cheney Brothers Was the World: Migration and Settlement in Manchester, Connecticut, at the Turn of the Twentieth Century," *Proceedings [of the] New England–St. Lawrence Valley Geographical Society* 10 (Oct. 1980), pp. 10–14 // Idem, "Of Mills and Memories: Labor-Management Interdependence in the Cheney Silk Mills," *Oral History Review* 11 (1983), pp. 17–47

Chesapeake Pottery, *see* D. F. Haynes and Company

Cocheco Manufacturing Company

1812–ca. 1941
Dover, New Hampshire
Textiles

The Cocheco Manufacturing Company, which survived into the twentieth century as an important producer of printed cotton fabrics, began in the 1820s as a subsidiary of the Dover Manufacturing Company, situated along the Cocheco River in Dover, New Hampshire. It was to play an important role in the development of the American textile industry in the nineteenth century.

The Dover Cotton Factory, as the company was first called, was chartered by the New Hampshire legislature in December 1812. During the 1820s the company competed with other New England textile manufacturers to secure the technical expertise and equipment necessary to produce calico fabrics in the United States. A burgeoning demand for these products, coupled with an incapacity to produce them in America, had resulted in British domination of the market.

As the Dover Manufacturing Company, the firm expanded its operations enormously with the addition of two brick cotton mills in 1822–23 and a print works two years later. (Several architectural features of the latter structure were historically significant: its L-shaped plan, large scale—six stories in height—and skylight illumination of the attic story were unique in factory buildings at the time.) Lack of skilled workmen, high-quality machinery, consistent chemical dyes, and salable patterns, however, plagued the Dover Manufacturing Company as well as other American manufacturers. In an unsuccessful effort to protect the financial solvency of the firm, the company's directors isolated the printing operation under a separate act of incorporation, which became the Cocheco Manufacturing Company. Nevertheless, the Dover Manufacturing Company went under. Its debts and assets were subsequently acquired by Cocheco, which successfully produced popular cylinder-printed cotton cloth in quantity throughout the nineteenth century.

Cocheco's fabrics of the late nineteenth century were specifically directed to the working- and middle-class markets. During the 1880s the company produced more than ten thousand different patterns, and the Dover city directories record growth in production from twenty-four million yards of cloth in 1871 to fifty million in 1892. Lawrence and Company, the selling agent for Cocheco products, was responsible for all creative decisions regarding the selection of patterns, packaging, and pricing, as well as for sales, which extended throughout the United States, Canada, and Europe. The Mikado print (FIG. 3.19), style number 3286 in January 1886, and the salesmen's samples (ILLS. 3.24, 3.25) are typical of the company's output during the 1870s and 1880s. Despite the obvious volumetric success of the American printed-cloth industry, most of its managers and skilled workmen were British immigrants; John Bracewell and Wash-

ington Anderton, for example, Cocheco superintendents during the 1870s and 1880s respectively, were both trained in Lancashire, England, before coming to Cocheco.

Cocheco Manufacturing Company was absorbed by the Pacific Mills of Lawrence, Massachusetts, in 1909. Thereafter called the Cocheco Department, it continued to print cotton until about 1913 and to manufacture cotton cloth until 1940 or 1941.

REFERENCES

D. Hamilton Hurd, comp., *History of Rockingham and Strafford Counties, New Hampshire, with Biographical Sketches of Many of Its Pioneers and Prominent Men* (Philadelphia, 1882), pp. 818–19 // Theodore Z. Penn, "The Introduction of Calico Cylinder Printing in America: A Case Study in the Transmission of Technology," in *Technological Innovation and the Decorative Arts,* ed. Ian M. G. Quimby and Polly Anne Earl (Charlottesville, Va., 1974), pp. 235–55 // Caroline Sloat, "The Dover Manufacturing Company and the Integration of English and American Calico Printing Techniques, 1825–29," *Winterthur Portfolio* 10 (1975), pp. 51–68 // Richard Candee, "The 'Great Factory' at Dover, New Hampshire: The Dover Manufacturing Co. Print Works, 1825," *Old-Time New England* 66 (July–Dec. 1975), pp. 39–51 // Diane L. Fagan Affleck, Museum of American Textile History, North Andover, Mass., correspondence, Apr. 1, 1985 // *Catalogue of Cocheco Co. Satines* (n.p., n.d.), Department of Prints and Photographs, The Metropolitan Museum of Art, New York

William Christmas Codman, *see* Gorham Manufacturing Company

Caryl Coleman, *see* Charles Caryl Coleman

Charles Caryl Coleman
1840–1928
New York, Rome, Capri
Painter

Charles Caryl Coleman was born in Buffalo, New York, and received his earliest art training there from William H. Beard (1824–1900); in 1859 he went to Paris to study briefly with Thomas Couture (1815–1879) before settling in Florence. Coleman returned to the United States in 1862 and joined the Union army, from which he received an honorable discharge the following year after being wounded in South Carolina.

From 1863 to 1866 Coleman maintained a New York studio, first at 840 and then later at 896 Broadway, and began to show his work regularly in the exhibitions of the Boston Athenaeum, the Brooklyn Art Academy, and the National Academy of Design, New York, which elected him an associate in 1865. The following year he returned to Italy, where he was to spend the rest of his life.

From the late 1860s through the mid-1880s, Coleman lived in Rome, becoming part of a coterie of artist expatriates there. He traveled throughout Europe, often to Venice, and in

1875 he married Mary Edith Grey Alsager, an English musician. It is presumed that they separated about four years later, although in 1910 the *New York Times* described Coleman as a widower (*New York Times,* May 10, 1910, p. 1).

In 1886 Coleman purchased the former guest house of a convent on the island of Capri and converted it into his home and studio. His Villa Narcissus was an architectural palimpsest of Roman, Pompeian, Moorish, and Mediterranean details to which Coleman added mosaic tiles, stained glass, and wrought-iron grillework of his own design. He was an avid collector of decorative objects: period photographs depict the artist dressed in Arabian costume and his home filled with marble reliefs, ancient glass, ornamental Renaissance panels, terracotta vessels, and Turkish tapestries. A small collection of notable Roman objects given to the Metropolitan Museum by Henry G. Marquand (1819–1902) in 1892 was probably acquired from Coleman, who brought it to New York in 1890.

Coleman's interest in the decorative informed his paintings of the 1870s, such as *Still Life with Peach Blossoms* (1877, FIG. 9.13), in which a flowering branch in a glass vase is displayed with a Japanese fan against patterned silk brocades. The composition, pressed against the picture plane, is complemented by the gilded frame carved with Renaissance motifs, which helps to create the sense of a decorated surface without depth. The frame incorporates three roundels, one with the artist's initials—CCC—the others with ACD and WAD on the left and right, respectively. The existence of another painting with a similar frame (New York Art Market, 1985) suggests that Coleman made them as part of a decorative interior scheme. Commenting on such a commission for a different client, the *Art Amateur* reported in January 1880, "[Coleman's] decorative panels, peach and almond blossoms, for the house of Mrs. Tracy (Miss Agnes Ethel) at Buffalo are remarkably truthful and full of fancy" (*Art Amateur,* Jan. 1880, p. 15). *Quince Blossoms* (1878, FIG. 9.17), a related work from the same period, is similar to the painting Coleman exhibited at the Paris Salon of 1878, which was illustrated in the *Art Amateur* of February 1880, but which does not appear to have been part of a suite of decorative works.

Many of Coleman's paintings of the 1880s and 1890s transform the peasants, architecture, and landscape of Capri into a Hellenistic world of dappled sunlight, white columns, lush vines, and olive trees, peopled with beautiful women often in classical drapery. Later works with religious themes share a mysterious melancholy with those by ELIHU VEDDER, who was Coleman's close friend. Coleman often painted Mount Vesuvius and the Bay of Naples under changing conditions of light and atmosphere, as he witnessed them from his studio. His proximity to the volcano permitted him to document the great eruption of 1906 in a major oil as well as in a series of smaller works on paper entitled *Songs of Vesuvius.*

Lists of Coleman's professional memberships are numerous, but some of his honors should be noted. He was commissioned to paint a decorative frieze in the Horticulture Building at the 1893 World's Columbian Ex-

position in Chicago, and in 1901 he was awarded a silver medal at the Buffalo Pan-American Exposition. One-man exhibitions of his work were organized in 1906 at the New York galleries of Thomas C. Hoe; in 1907 at the Saint Botolph Club in Boston, the John Herron Art Institute in Indianapolis, the Detroit Museum of Art, and the Saint Louis City Art Museum; and in both 1907 and 1916 at the Buffalo Fine Arts Academy.

When Coleman died in 1928, he was survived by his brother, Caryl Coleman (about 1846–1930), who is often confused with Charles. Caryl was professionally involved with the decorative arts in New York City, and for several years he was the New York general agent for the J. AND J. G. LOW ART TILE WORKS. He subsequently started a journal called *Art and Decoration,* which he published in New York for just fifteen months in 1885–86. Caryl was a champion of American stained glass, particularly that of LOUIS COMFORT TIFFANY and JOHN LA FARGE, and a prolific author of articles on decoration—a series on tiles appeared in the *Decorator and Furnisher,* and other articles were published in the Boston magazine *American Art* between 1886 and 1887. In a 1906 essay in the *Craftsman,* Caryl lamented America's acceptance of machine-made products and pleaded for a revival of the handcraftmanship WILLIAM MORRIS advocated. This impassioned moralism was also manifested in his fascination with Christian art and symbolism, on which he wrote numerous articles for *Architectural Record* and *Catholic World* after the turn of the century. Caryl Coleman died in New Rochelle, New York, a little more than a year after his brother.

REFERENCES

"Studio Notes," *Art Amateur* 4 (Jan. 1880), p. 15 // "Charles C. Coleman," *Art Amateur* 2 (Feb. 1880), pp. 45 (ill.), 46 // B. W., "Correspondence: American Decorative Art and Artist Decorators," *American Architect and Building News* 7 (Feb. 14, 1880), pp. 58–59 // "Art in the Cities," *Art Journal* (Appleton's) 6 (May 1880), p. 159 // [Caryl Coleman, agent for Low's Art Tiles], *Art Amateur* 3 (July 1880), p. 44 // "Low's Art Tiles" [advertisement], *Art Amateur* 3 (July 1880), p. iii // "Studio Notes," *Art Interchange* 4 (July 1, 1880), p. 15 // Montezuma [Montague Marks], "My Note Book," *Art Amateur* 4 (Mar. 1881), p. 69 // "Notes and News: Mr. Caryl Coleman," *Art Interchange* 9 (Oct. 26, 1882), p. 91 // "Low's Art Tiles" [advertisement for Caryl Coleman, agent], *Art Interchange* 10 (Mar. 29, 1883), p. 86 // "A Roman Studio," *Decorator and Furnisher* 5 (Dec. 1884), pp. 86–87 // *Rand, McNally and Company's Handbook of the World's Columbian Exposition* (Chicago, 1893), pp. 141–42 // *Report of the Board of General Managers of the Exhibit of the State of New York at the World's Columbian Exposition* (Albany, 1894), pp. 97–98, ill. opp. p. 120 // "The Making of Church Windows: Mr. Coleman Tells the Church Club that America Excels in the Art," *New York Times,* Feb. 14, 1896, p. 7 // Caryl Coleman, *Symbolism in Religious Art: A Lecture Given Before the School of Applied Design for Women on the Seventeenth of February, 1898* (New York, 1899) // "Coleman, Charles Caryll [sic]," in *Appleton's Cyclopaedia*

of American Biography, ed. James Grant Wilson and John Fiske, vol. 1 (New York, 1900), p. 685 // Charles De Kay, "A Villa in Capri," Architectural Record 12 (May 1902), pp. 71–92 // Caryl Coleman, "Art in Industries and the Outlook for the Art Student," Craftsman 2 (July 1902), pp. 189–94 // Samuel Isham, The History of American Painting (New York and London, 1905), p. 304, fig. 67 // Walter Crane, An Artist's Reminiscences (London, 1907), p. 129 // John Herron Art Institute, Art Association of Indianapolis, Ind., Exhibition of Paintings by Charles Caryl Coleman (exhib. cat., 1907) // "C. C. Coleman, Artist, Ill, . . . Stricken in Italy," New York Times, May 10, 1910, p. 1 // "Coleman, Charles Caryll [sic]," in Allgemeines Lexikon der Bildenden Künstler, ed. Ulrich Thieme and Felix Becker, vol. 7 (Leipzig, 1912), pp. 197–98 // "Exhibition of Works by Charles Caryl Coleman at the Albright Art Gallery," Academy Notes [of the Buffalo Fine Arts Academy] 11 (Apr. 1916), pp. 57, 58–59 (ills.) // "Coleman, C(harles) C(aryl)," American Art Annual 14 (1917), p. 455 // "Charles Caryl Coleman," American Magazine of Art 15 (Sept. 1924), pp. 466, 467 (ill.) // "Coleman, Charles Caryll [sic]," in Cyclopedia of Painters and Paintings, ed. John Denison Champlin, Jr., and Charles C. Perkins, vol. 1 (New York, 1927), p. 313 // "C. C. Coleman Dies; American Painter," New York Times, Dec. 6, 1928, p. 31 // "Charles Coleman Memorial Exhibit," Art News 27 (Dec. 15, 1928), p. 2 // "Exhibition of Work of Charles Caryl Coleman," Brooklyn Museum Quarterly 16 (Jan. 1929), pp. 20 (ill.), 21 // "Of the Old School" [obituary], Art Digest 11 (Jan. 1, 1929), p. 9 // "C. C. Coleman Estate to Brother," New York Times, Feb. 2, 1929, p. 8 // [Obituary], Parnassus 1 (Apr. 1929), p. 9 // "Caryl Coleman" [obituary], New York Times, Apr. 18, 1930, p. 25 // "Coleman, Charles Caryl," in The National Cyclopaedia of American Biography, vol. 21 (New York, 1931), pp. 233–34 // George C. Groce and David H. Wallace, "Coleman, Charles Caryl," in The New-York Historical Society's Dictionary of Artists in America, 1564–1860 (New Haven and London, 1957), p. 139 // "Coleman, Charles Caryl," in Dictionary of American Biography, vol. 2, pt. 2 (New York, 1958), pp. 292–93 // Clark S. Marlor, ed., A History of the Brooklyn Art Association with an Index of Exhibitions (New York, 1970), p. 153 // Regina Soria, Elihu Vedder: American Visionary Artist in Rome (1836–1923) (Rutherford, N.J., 1970), pp. 25, 38–39, 48–49, 63, 103–4, 152–54, 159–60, 206–8, 233, 263–64 // "Maurice Sternberg Galleries" [advertisement], Antiques 99 (Jan. 1971), p. 33 (ill.) // Maria Naylor, ed., The National Academy of Design Exhibition Record, 1861–1900, 2 vols. (New York, 1973), vol. 1, pp. 174–75 // "Coleman (Charles Caryl)," in Dictionnaire critique et documentaire des peintres, sculpteurs, dessinateurs et graveurs, ed. E. Bénézit, vol. 3 (Paris, 1976), p. 104 // Dayton Art Institute, Ohio, American Expatriate Painters of the Late Nineteenth Century, by Michael Quick (exhib. cat., 1976), pp. 91, 148–49, pl. 5 // Bernard Karpel, ed., Arts in America: A Bibliography, vol. 3 (Washington, D.C., 1979), entries S5, S48 // Robert F. Perkins, Jr., and William J. Gavin III, eds., The Boston Athenaeum Art Exhibition Index, 1827–1874 (Boston, 1980), p. 38 // Regina Soria, "Coleman, Charles Caryl," in Dictionary of Nineteenth-Century American Artists in Italy, 1760–1914 (East Brunswick, N.J., 1982), pp. 91–93 // "Coleman, Charles Caryl," in Mantle Fielding's Dictionary of American Painters, Sculptors, and Engravers, ed. Glenn B. Opitz, rev. ed. (New York, 1983), p. 176 // "John H. Garzoli" [advertisement], Antiques 123 (May 1983), p. 963 (ill.) // Sotheby Parke Bernet Inc., New York, Important American Paintings, Drawings, and Sculpture (sale cat., May 30, 1984), lot 44 // William Doyle Galleries, New York, Important Nineteenth and Twentieth Century American Paintings and Sculpture (sale cat., Oct. 24, 1984), lot 53 (ill.) // Berry-Hill Galleries, New York, American Paintings, 3 (exhib. cat., 1985), pp. 54, 55 (ill.) // Regina Soria, Baltimore, Md., correspondence, Mar. 10, 1985 // Barbara White Morse, Springvale, Maine, correspondence, May 8, 1985 // Sotheby's, New York, Important American Eighteenth, Nineteenth and Twentieth Century Paintings, Drawings, and Sculpture (sale cat., May 30, 1985), lot 71 (ill.) // Vose Galleries of Boston, Inc. [untitled] (sale cat., Fall 1985), unpaged (ill.) // Susan Glover Godlewski, Art Institute of Chicago, correspondence, Sept. 25, 1985 // William H. Gerdts, City University of New York, Graduate School and University Center, conversation, Apr. 1986

William S. Coleman, see Minton and Company

Thomas Edward Collcutt

1840–1924
London
Architect

Thomas Edward Collcutt was one of a generation of English architects who reacted vigorously against the Gothic-revival styles practiced at mid-century by many architects, including George Edmund Street (1824–1881), George Gilbert Scott (1811–1879), and WILLIAM BURGES. Collcutt was born in Oxford, England. He apprenticed with R. E. Armstrong and worked in the offices of Miles and Murgatroyd before becoming an assistant to Street.

Richard Norman Shaw (1831–1912) and W. Eden Nesfield (1835–1888), Collcutt's contemporaries, became leading proponents of the so-called Queen Anne and Old English styles of the 1870s. In their eyes the Gothic had become a vulgarized modern vernacular: by 1860 it was used not only for ecclesiastical buildings but also for domestic, commercial, and institutional structures. If one of the main attractions of the Gothic was its preindustrial origins, then picturesque, native English architecture seemed to Collcutt and his colleagues an equally appropriate source of inspiration. Whereas the Gothic was considered "muscular," ecclesiastical, and to some degree French in derivation, the Queen Anne and Old English styles were secular, more domestic in scale, and undeniably English in character.

The Queen Anne style of the 1870s (which is not to be confused with the quite distinct Queen Anne style of the early eighteenth century) first appeared in urban houses; Shaw's New Zealand Chambers of 1872–73 in London was one of the first examples of its nondomestic application. By about 1873 the Queen Anne style, with its regrettably inaccurate name, was coherent enough to be recognizable: it could be characterized by the polychromatic use of exposed red brick detailed with light-colored stone; asymmetrical composition; and the eclectic combination of such varied elements as gables, round arches, tall chimneys, hipped roofs, wood cupolas, broken pediments, squat columns, wrought-iron railings, external shutters, pargeting (decorative plasterwork in raised figures), and bay, oriel, and small-paned sash windows. Most architects, including Shaw, Nesfield, and Collcutt, also practiced a contemporaneous Old English style for country houses, using local materials that were based on eighteenth-century examples and building traditions.

Like many architects of the period, Collcutt's interests extended to furniture and interior decoration. He became one of the chief designers for COLLINSON AND LOCK, the London cabinetmakers whose Fleet Street headquarters he revamped in 1870 and for whom he designed a house on the Street of Nations—plus much of its furniture—for the Paris Exposition Universelle in 1878. Several of Collcutt's pieces were displayed by Collinson and Lock at the 1876 Philadelphia Centennial Exposition, where they contributed to the popularity of ebonized art furniture in America during the following decade (FIG. 5.5, ILL. 5.4). Collcutt also designed furniture for the London firms of Jackson and Graham, Gillow and Company, and Maples. He was later responsible for the decoration of passenger ships owned by the P. and O. Steamship Company.

Collcutt's architectural career was extremely successful. In 1877 he won the Wakefield Town Hall competition with a design that recalled Shaw's New Zealand Chambers. (G. E. Street, who was the sole juror of the competition, passed over the submissions in the Gothic and classical styles in favor of Collcutt's Queen Anne.) The Imperial Institute of 1887–93 in London's South Kensington district, which Collcutt executed in a free interpretation of Renaissance style with Spanish and French detailing, is often cited as his most prestigious accomplishment. For his P. and O. Steamship building at the 1889 Paris Exposition Universelle, Collcutt won the Grand Prix for architecture.

In his influential book The English House, Hermann Muthesius (1861–1927) commended Collcutt for his domestic dwellings, noting especially his use of Elizabethan forms within "sharply outlined, fairly modern-looking buildings" as well as the spatial arrangement—organized around an open central hall—of Collcutt's 1898 house in Totteridge, near London (Muthesius, 1904–5, p. 36).

Collcutt was awarded a gold medal by the Royal Institute of British Architects in 1902 and served as the institute's president from 1906 to 1908. The buildings Collcutt created in his later years, while in partnership with Stanley Hamp, lack the vitality of his earlier works (Kinchin, 1982, p. 438).

REFERENCES

Paul Sédille, "L'Architecture moderne en Angleterre," pt. 3, *Gazette des Beaux-Arts,* 2d ser. 34 (1886), pp. 89–106 // Lewis F. Day, "Victorian Progress in Applied Design," *Art Journal* (London), June 1887, pp. 185–202 // Hermann Muthesius, *The English House,* ed. and intro. Dennis Sharp, pref. Julius Posener, trans. Janet Seligman, abridged from *Das Englische Haus,* 2d ed., 3 vols. in 1 (Berlin, 1904–5; 2d ed. Berlin, 1908–11; New York, 1979), pp. 35–36, 131 // Algernon Graves, comp., *The Royal Academy of Arts: A Complete Dictionary of Contributors and Their Work from Its Foundation in 1769 to 1904,* vol. 2 (London, 1905), pp. 103–4 // "Collcutt, Thomas Edward," in *Allgemeines Lexikon der Bildenden Künstler,* ed. Ulrich Thieme and Felix Becker, vol. 7 (Leipzig, 1912), p. 214 // "Collcutt, Thomas Edward," in *Who's Who, 1912* (London, 1912), p. 437 // Thomas E. Collcutt, "A Plea for a Broader Conception of Architectural Education," *Journal of the Royal Institute of British Architects* 29 (Jan. 14, 1922), pp. 133–46 // James S. Gibson, "Thomas Edward Collcutt, Past President, Royal Gold Medallist, R.I.B.A." [obituary], *Journal of the Royal Institute of British Architects* 31 (Oct. 18, 1924), pp. 666–68 // Victoria and Albert Museum, London, *English Cabinets* (1972), pl. 39 // Andrew Saint, *Richard Norman Shaw* (New Haven and London, 1976) // Mark Girouard, *Sweetness and Light: The "Queen Anne" Movement, 1860–1900* (Oxford, 1977) // Henry-Russell Hitchcock, *Architecture: Nineteenth and Twentieth Centuries,* 4th ed. (Harmondsworth, Eng., and New York, 1977), pp. 306–7 // Juliet Kinchin, "Collinson and Lock," *Connoisseur* 201 (May 1979), pp. 46–53 // Idem, "Collcutt, T. E.," in *Macmillan Encyclopedia of Architects,* ed. Adolf K. Placzek, 4 vols. (New York and London, 1982), vol. 1, pp. 437–38 // Simon Jervis, "Collcutt, Thomas Edward," in *The Penguin Dictionary of Design and Designers* (Harmondsworth, Eng., and New York, 1984), pp. 121–22 // Juliet Kinchin, Glasgow Museums and Art Galleries, correspondence, Mar. 7, 1985

Collinson and Lock

1870–1897
London
Furniture

Frank G. Collinson and George James Lock, two highly enterprising young men, formed a partnership in London in 1870 to manufacture and market "art furniture" on a commercial scale. By the time of the firm's dissolution nearly thirty years later, its operations included virtually every aspect of interior decoration.

Collinson and Lock's first published catalogue, *Sketches of Artistic Furniture* (1871), was illustrated by J. MOYR SMITH and included designs both by Smith and by the architect THOMAS EDWARD COLLCUTT, who in 1870 had transformed a staid building at 109 Fleet Street into appropriate headquarters for the up-and-coming young firm. The cabinets, sideboards, tables, chairs, wardrobes, and dressing tables pictured in Collinson and Lock's 1877 catalogue, notable for their rectilinear forms and stenciled or simple turned-and-incised decoration, represent a radical revamping of Victorian furniture along the lines suggested by CHARLES LOCKE EASTLAKE in his 1868 *Hints on Household Taste.*

Attribution of these furniture designs to specific individuals is difficult. During the firm's early years, Collcutt was certainly the most active of its designers, but E. W. GODWIN, an architect and friend of Collcutt's who worked in a similar style, was also under contract and designed the firm's "Lucretia" cabinet (FIG. 5.9) of 1873. Its panels were painted by Charles Fairfax Murray (1849–1919), a Pre-Raphaelite painter. The difficulty of assigning credit for an undocumented design is demonstrated by a Collinson and Lock rosewood side chair (FIG. 5.5), models of which were produced until at least 1887 (this example is marked with the company's name and an 1880s date). Similar to one displayed by the firm at the Philadelphia Centennial Exposition of 1876, the rosewood chair has been attributed to Collcutt on the basis of its stylistic affinity to pieces he designed for Collinson and Lock's Savoy Theatre commission in 1881; it has also been credited to Godwin based on similarities to chairs he sketched in his notebook of designs for the business.

During the 1870s Collinson and Lock was among the first to promote the ebonized furniture that simulated Japanese lacquerwork: Collcutt's design for a large sideboard, embellished with birds and female figures in classical drapery painted by Albert Moore (1841–1893) (ILL. 5.4), garnered attention at the World's Fairs of 1871, 1873, and 1876. The firm's display at the 1878 Paris Exposition Universelle included the most highly developed of its art-furniture designs. At that fair, Collinson and Lock also presented a country house in the style of William III as part of the Street of Nations and five fully furnished rooms in the British exhibition building. These contributions fetched two gold medals for the firm.

In the early 1880s Collinson and Lock's many important London commissions included not only the Savoy Theatre but also, with Gillow and Company and with Jackson and Graham (the latter absorbed by Collinson and Lock in 1885), G. E. Street's Law Courts (1874–82). Stephen Webb (1849–1933), a sculptor, joined the firm as chief designer about 1885. Webb, for whom craftsmanship took precedence over any other consideration, was inspired by French and Italian furniture forms, often enhancing his furniture with exquisite marquetry based on motifs from several historical periods.

The firm's increasingly conservative artistic stance was reflected both in its move to Oxford Street about 1885 and in its new focus on individual commissions for wealthy clients. In the 1890s Collinson and Lock decorated the interiors of several grandiose London houses, some of which are still intact. Early in 1897, however, Lock decided to establish an independent business on Conduit Street and withdrew his capital, undermining the company's financial stability. It was declared bankrupt that May, and what remained of its assets—accounts receivable, stock on hand, and raw materials—was absorbed by the Gillow firm.

REFERENCES

Collinson and Lock, *Sketches of Artistic Furniture Manufactured by Collinson and Lock, 109 Fleet Street, London* (London, 1871) // London International Exhibition of 1872, *Official Catalogue: Fine Arts Department* (London [1872]), nos. 2778–79* // "The Universal Exhibition at Vienna," *Art Journal* (London), June 1873, p. 185 (ill.) // Walter Smith, *Industrial Art,* vol. 2 of *The Masterpieces of the Centennial International Exhibition* (Philadelphia, copr. 1875 [1877?]), pp. 168, 240 (ills.) // [George Titus Ferris], *Gems of the Centennial Exhibition: Consisting of Illustrated Descriptions of Objects of an Artistic Character, in the Exhibits of the United States, Great Britain, France . . .* (New York, 1877), p. 96 (ill.) // "The Paris Universal Exhibition," pt. 2, *Magazine of Art* 1 (1878), pp. 30–31 // "The Paris Universal Exhibition," pt. 5, *Magazine of Art* 1 (1878), p. 113 // "The Fine Arts at the Paris Exposition," *Scribner's Monthly* 18 (May 1879), p. 182 // "Illustrated Catalogue of the Paris International Exhibition," pt. 15, *Art Journal* (Appleton's) 5 (July 1879), p. 210 (ill.) // G. T. Robinson, "Cabinet-makers' Art: Domestic Furniture," *Art Journal* (London), Dec. 1884, pp. 373–76 (ills.) // J. Moyr Smith, *Ornamental Interiors, Ancient and Modern* (London, 1887), pp. 71, 94 // Lewis F. Day, "Victorian Progress in Applied Design," *Art Journal* (London), June 1887, pp. 185–202 // Elizabeth Aslin, *The Aesthetic Movement: Prelude to Art Nouveau* (New York and Washington, D.C., 1969), p. 62, pls. 52, 54 // Metropolitan Museum of Art, New York, *Nineteenth-Century America: Furniture and Other Decorative Arts* (exhib. cat., 1970), fig. 224 // Victoria and Albert Museum, *English Cabinets* (London, 1972), pl. 39 // J. Johnson and A. Greutzner, *The Dictionary of British Artists, 1880–1940* (London, 1976), p. 116 // Juliet Kinchin, "Collinson and Lock," *Connoisseur* 201 (May 1979), pp. 46–53 // Idem, "T. E. Collcutt," in *Macmillan Encyclopedia of Architects,* ed. Adolf K. Placzek (New York, 1982), vol. 1, pp. 437–38 // Simon Jervis, "Collcutt, Thomas Edward," "Godwin, Edward William," and "Smith, J. Moyr," in *The Penguin Dictionary of Design and Designers* (Harmondsworth, Eng., and New York, 1984), pp. 121–22, 203–4, 454–55 // Juliet Kinchin, Glasgow Museums and Art Galleries, correspondence, Mar. 7, 1985 // Elizabeth Aslin, Hove, East Sussex, Eng., correspondence, May 16, 1985

Samuel Colman, *see* Louis Comfort Tiffany and Candace Wheeler

Clarence Cook

1828–1900
New York City
Writer and art critic

Clarence Chatham Cook is regarded as a brilliant pioneer in American art criticism. For a period of fifty years, his intelligent, frank, and frequently scathing commentary on art and architecture was a refreshing antidote to the colorless verbiage characteristic of most nineteenth-century journalism on the subjects. During the mid-1870s Cook turned his critical attention to furniture and decoration, and it is primarily for this that he is known as a con-

tributor to the Aesthetic movement.

Born in Dorchester, Massachusetts, Cook was raised in New York City and educated at Harvard University, from which he graduated in 1849. For a short time Cook studied architecture and landscape design with Andrew Jackson Downing (1815–1852) and his partner Calvert Vaux (1824–1895). Although not a practicing architect, throughout his career Cook was outspoken in his criticism of contemporary building. Downing's beliefs, many of which derived from the theories of Augustus Welby Northmore Pugin (1812–1852), had a profound and lasting effect on Cook's critical stance, which carried a moral imperative. Cook advocated honest construction, convenient spatial plans, building form reflective of purpose, integration of the building with the site, and judicious use of ornamentation. Cook was further influenced by the writings of John Ruskin (1819–1900) and by the work of such English architects as Jacob Wrey Mould (1825–1886), who practiced in New York in the 1850s. While Cook disparaged the revival of historical styles, he nonetheless admired the old Dutch and English farmhouses that still dotted the American countryside, and he praised American architecture of the Colonial and Federal periods, which he conjoined under the imprecise rubric of "Queen Anne."

Cook began his career in journalism in 1854, as art critic for the *Independent,* a weekly New York paper; he held the post for two years. Yet it was not until the early 1860s that he gained widespread recognition as a writer. In 1863 Cook helped found the Association for the Advancement of Truth in Art and served for one year as the first editor of its journal, *New Path.* The Ruskinian ideals espoused by the association and its journal dominated the New York artistic community until the end of the decade. Cook left the *New Path* in 1864 for a job at the *New York Daily Tribune,* the most prestigious American newspaper of the period.

In 1870 Cook was dispatched to Paris by the *Tribune.* His stay in France was disrupted by the outbreak of the Franco-Prussian War, however, and because of a relatively minor disagreement with Whitelaw Reid (1837–1912), the *Tribune*'s editor, about how best to cover such current events, Cook resigned from the paper. He and his wife traveled through France and Switzerland to Italy, where they met James Jackson Jarves (1818–1888), the American writer and art collector; they returned to the United States in 1871. Cook resumed his position with the *Tribune* almost immediately.

In June 1875 Cook commenced an important series of articles for *Scribner's Monthly* entitled "Beds and Tables, Stools and Candlesticks," which were collected into a book called *The House Beautiful: Essays on Beds and Tables, Stools and Candlesticks* (FIG. 5.6). Published in 1878, this volume was extremely popular in America, second only to CHARLES LOCKE EASTLAKE's 1868 *Hints on Household Taste* (FIG. 4.1); subsequent printings of *The House Beautiful* appeared in 1879, 1881, and 1895. Cook's household-art advice generally followed Eastlake's example but articulated a point of view Cook had held since the 1850s. "My purpose is not to recommend eccentricity, nor even a modified Bohemianism. I have no mission to preach a crusade against luxury

and bad taste . . . ," Cook declared in his introduction. "I can only say that . . . I have reached a point where simplicity seems to me a good part of beauty, and utility only beauty in a mask; and I have no prouder nor more pretending aim than to suggest how this truth may be expressed in the furniture and decoration of our homes" (Cook, 1878, p. 22). Cook's taste was eclectic and typically aesthetic; his purpose, to educate and edify. He promoted living rooms and open hearths; bookcases, étagères, and hanging shelves; oriental carpets and antiques; Modern Gothic and Anglo-Japanesque art furniture; and Japanese decorative arts and principles of design. *The House Beautiful* contained a colored frontispiece by WALTER CRANE (see frontispiece to Preface) and black-and-white illustrations of furniture and interior decor by Alexandre Sandier (FIG. 1.7) of HERTER BROTHERS (FIGS. 1.6, 5.7), COTTIER AND COMPANY (FIG. 5.8), and others. In his *House Beautiful* discussion, Cook also mentioned WILLIAM BURGES, COLLINSON AND LOCK, MORRIS AND COMPANY, and JOHN LA FARGE.

Cook's writings on related topics included a small book for WARREN, FULLER AND COMPANY, called *"What Shall We Do with Our Walls?"* in 1880 (FIG. 3.7, ILLS. 3.13, 3.14); a series on the modern home for the *Art Amateur* in 1884; and an essay on the history of house architecture and decoration for *Gately's World's Progress* in 1886. Cook also authored or edited a number of other books, among them Wilhelm Lübke's two-volume *Outlines of the History of Art* (1878), *Goethe's Mother: Correspondence of Catherine Elizabeth Goethe* (1880), and his own three-volume *Art and Artists of Our Time* (1888).

During the early 1880s Cook participated in a campaign of bitter accusations against Luigi Palma di Cesnola, the director of The Metropolitan Museum of Art whom Cook and others charged with fraudulently misrepresenting ancient statuary in the Museum's collection. This once again brought Cook into conflict with Whitelaw Reid at the *Tribune,* and as a result, Cook's affiliation with the newspaper was over by 1883. The next year Cook resuscitated the *Studio,* a short-lived art magazine begun in 1882. With a new cover by ELIHU VEDDER and plentiful illustrations, Cook's revival succeeded, and he remained as editor of the magazine until his retirement, about 1892.

REFERENCES

Clarence Cook, *A Description of the New York Central Park* (New York, 1869; reprint New York, 1972) // [Clarence Cook], "Beds and Tables, Stools and Candlesticks [1]: Some Chapters on House-Furnishing," *Scribner's Monthly* 10 (June 1875), pp. 169–82 // Idem, "Beds and Tables, Stools and Candlesticks, 2: More about the Living-Room," *Scribner's Monthly* 11 (Feb. 1876), pp. 488–503 // Idem, "Beds and Tables, Stools and Candlesticks, 4: Mantel-Pieces, Corner Cupboards, Hanging Shelves, Etc.," *Scribner's Monthly* 11 (Apr. 1876), pp. 809–22 // Idem, "Beds and Tables, Stools and Candlesticks, 5: En Route for the Dining-Room," *Scribner's Monthly* 12 (June 1876), pp. 168–75 // Idem, "Beds and Tables, Stools and Candlesticks, 6: En Route for the Dining-Room—a Halt in the Hall—the Din-

ing-Room," *Scribner's Monthly* 12 (Sept. 1876), pp. 796–807 // Idem, "Beds and Tables, Stools and Candlesticks, 7: Fire-Places, Book-Cases, Etc.," *Scribner's Monthly* 13 (Nov. 1876), pp. 86–95 // Idem, "Beds and Tables, Stools and Candlesticks, 8: Blue China Versus White—the Bedroom," *Scribner's Monthly* 13 (Jan. 1877), pp. 318–28 // Idem, "Beds and Tables, Stools and Candlesticks, 9: Still Harping on the Bedroom," *Scribner's Monthly* 13 (Mar. 1877), pp. 656–66 // Idem, "Beds and Tables, Stools and Candlesticks, 10: Talk Here and There," *Scribner's Monthly* 13 (Apr. 1877), pp. 816–20 // Idem, "Beds and Tables, Stools and Candlesticks, 11: Pleas and Remonstrances," *Scribner's Monthly* 14 (May 1877), pp. 1–8 // Clarence Cook, *The House Beautiful: Essays on Beds and Tables, Stools and Candlesticks* (New York, 1878; reprint New York, 1980) // Wilhelm Lübke, *Outlines of the History of Art,* trans. from 7th German ed., ed. Clarence Cook, 2 vols. (New York, 1878) // Clarence Cook, *"What Shall We Do with Our Walls?"* (New York, 1880) // Idem, *Transformations and Migrations of Certain Statues in the Cesnola Collection* (New York [1881?]) // "New Publications" [review of Cook, *"What Shall We Do with Our Walls?"*], *Art Amateur* 5 (June 1881), p. 22 // Clarence Cook, "Architecture in America," *North American Review* 135 (1882), pp. 243–52 // [Review of Cook, *Transformations and Migrations of Certain Statues in the Cesnola Collection*], *American Antiquarian and Oriental Journal* 4 (Apr.–July 1882), p. 256 // "Mr. Cook on American Architecture," *American Architect and Building News* 12 (Aug. 26, 1882), pp. 95–96 // [Colonial architecture as appreciated by Mr. Clarence Cook], *American Architect and Building News* 12 (Sept. 30, 1882), p. 153 // "Architectural Frenzy in the New World," *American Architect and Building News* 12 (Oct. 21, 1882), pp. 193–94 // C. Howard Walker, "Architecture in America," *American Architect and Building News* 12 (Oct. 28, 1882), pp. 205–6 // Clarence Cook, "A Doubtful Art Treasure: The 'Luca Della Robbia' at the Metropolitan Museum," *Art Amateur* 8 (Dec. 1882), pp. 21–22 // Idem, "The Vestibule and the Reception-Room," *Art Amateur* 10 (May 1884), pp. 139–40 // Idem, "The Modern Home: The Hall and Reception Room," *Art Amateur* 11 (June 1884), pp. 16–19 // Idem, [The drawing room], *Art Amateur* 11 (Aug. 1884), pp. 63–64 // Idem, [The boudoir], *Art Amateur* 11 (Sept. 1884), pp. 84–85 // Idem, [The library], *Art Amateur* 11 (Oct. 1884), pp. 108–9 // Idem, [The bedroom], *Art Amateur* 11 (Nov. 1884), pp. 129, 133 // Idem, "History of House Architecture and Decoration: Outline of the Life of the House," in *Gately's World's Progress: A General History of the Earth's Construction . . . ,* ed. Charles E. Beale (Boston, 1886), pp. 939–73 // Bangs and Company, New York, *Catalogue of . . . a Portion of the Library of C. Cook . . .* (sale cat., Mar. 1886) // Clarence Cook, *Art and Artists of Our Time,* 3 vols. (New York, 1888) // "Cook, Clarence" [obituary], *American Art Annual* 3 (1900–1901), p. 58 // "Cook, Clarence Chatham," in *Appletons' Cyclopaedia of American Biography,* ed. James Grant Wilson and John Fiske, vol. 1 (New York, 1900), p. 713 // "Cook, Clarence Chatham," in *The National Cyclopaedia of American Biography,* vol.

10 (New York, 1900), p. 167 // [Clarence Cook, obituary], *American Architect and Building News* 68 (June 9, 1900), pp. 73–74 // J. Anderson, Jr., New York, *Catalogue of the Library of the Late C. Cook . . .* (sale cat., Nov. 1900) // Clarence Cook, *Poems by Clarence Cook* (New York, 1902) // Anderson Auction Company, New York, *Painter-Etchings, Engravings, and Objects of Art, Including Those Belonging to the Estate of the Late C. Cook of Fishkill-on-the-Hudson, N.Y. . . .* (sale cat., Apr. 1909) // John Peter Simoni, "Art Critics and Criticism in Nineteenth-Century America" (Ph.D. diss., Ohio State University, 1952) // George C. Groce and David H. Wallace, "Cook, Clarence Chatham," in *The New-York Historical Society's Dictionary of Artists in America, 1564–1860* (New Haven and London, 1957), p. 144 // "Cook, Clarence Chatham," in *Dictionary of American Biography,* vol. 2, pt. 2 (New York, 1958), p. 371 // "Cook, Clarence Chatham," in *Who Was Who in America, Historical Volume, 1607–1896* (Chicago, 1963), p. 119 // Jo Ann W. Weiss, "Clarence Cook: His Critical Writings" (Ph.D. diss., Johns Hopkins University, 1976) // Mark Girouard, *Sweetness and Light: The "Queen Anne" Movement, 1860–1900* (Oxford, 1977), pp. 210–12, 241 // Martha Crabill McClaugherty, "Household Art: Creating the Artistic Home, 1868–1893," *Winterthur Portfolio* 18 (Spring 1983), pp. 1–26

Charles Allerton Coolidge

1858–1936
Boston
Architect

Although not as well remembered as his prodigious mentor, H. H. RICHARDSON, Charles Allerton Coolidge achieved a national reputation during an architectural career spanning fifty years. Born to a Boston family with a *Mayflower* lineage, Coolidge attended private school in Boston and then Harvard University (where he helped found the Harvard *Lampoon*). Following his graduation, in 1881, he received additional training in architecture at the Massachusetts Institute of Technology, in the office of Ware and Van Brunt, and in Europe, where he studied great monuments at firsthand.

In 1882 Coolidge joined Richardson and was, at the time of Richardson's death in 1886, a senior member of the firm. John J. Glessner, whose Chicago residence Richardson had been commissioned to design in 1885, credited Coolidge with the dining-room table and the handsome set of spindle-back dining-room chairs (FIG. 5.34), which were almost certainly manufactured by A. H. DAVENPORT AND COMPANY of Boston. After Richardson died, Coolidge formed a partnership with George Foster Shepley (1860–1903) and Charles Hercules Rutan (1857–1914) to complete several of Richardson's projects. In the fall of 1886, at age twenty-eight, he and Frederick Law Olmsted (1822–1903) were selected to design the Stanford University campus in California. Their plan, with its enclosed courtyards, represented one of the earliest uses of such a scheme in American university design. While Coolidge's single-story sandstone buildings with red tile roofs closely relate to Richardson's Romanesque style, the use of arcades to unify the complex was innovative and was probably inspired by the architecture of California's missions as much as by medieval cloisters.

Coolidge maintained his association with the Boston firm of Shepley, Rutan and Coolidge but freely pursued commissions on his own and formed partnerships in Saint Louis and Chicago. In 1889 he married his partner's sister, Julia Shepley of Saint Louis, with whom he had four children. Two years later he was elected a fellow of the American Institute of Architects. Coolidge left Boston in 1892 to practice in Chicago with Charles A. Hodgdon for eight years; he maintained his association with the Chicago office of Coolidge and Hodgdon until 1930. During this period he designed a number of impressive public buildings in both classical and Romanesque styles, including the Art Institute (1892–96) and the Public Library (begun 1893) in Chicago, the Ames Building (1900) in Boston, and, with Morin Goustiaux, the United States Pavilion at the Paris Exposition Universelle of 1900, for which he was appointed Chevalier of the Legion of Honor by the French government.

Collegiate buildings, medical schools, and hospitals constituted the majority of Shepley, Rutan and Coolidge's projects for the next thirty-six years. Coolidge maintained especially close ties with his alma mater; among the buildings designed for Harvard are Langdell Hall (1905–1906, 1928–29) for the law school, the Fogg Art Museum (1927), and Memorial Church (1933). Harvard awarded Coolidge an Honorary Doctor of Arts degree in 1906, a distinction that for some time thereafter was shared only by the painter John Singer Sargent (1856–1925).

His firm continued as Coolidge and Shattuck after 1914, and in 1924 Coolidge took Henry R. Shepley (George Shepley's son), Francis V. Bulfinch, and Lewis B. Abbott as partners. Coolidge died in 1936, but the firm, known since 1952 as Shepley, Bulfinch, Richardson and Abbott, continues to practice architecture in Boston.

REFERENCES
"The United States National Pavilion for the Paris Expo of 1900," *American Architect and Building News* 65 (Aug. 12, 1899), p. 55, pl. 1233 // "Applied Arts at the Paris Exposition," *American Art Annual* 3 (1900–1901), pp. 17, 21–22 // "Coolidge, Charles Allerton," in *The National Cyclopaedia of American Biography,* vol. 13 (New York, 1906), pp. 179–80 // Charles Allerton Coolidge, *A Monograph on the Gravestones in Boston and Vicinity* ([Boston], 1919) // "Coolidge, Charles Allerton," in *The National Cyclopaedia of American Biography,* Current Volume: C (New York, 1930), p. 521 and ill. // "Charles Allerton Coolidge" [obituary], *American Architect* 148 (Apr. 1936), p. 106 // "Charles Coolidge" [obituary], *New York Times,* Apr. 2, 1936, p. 25 // "Deaths: Charles A. Coolidge, FAIA," *Architectural Forum* 64 (May 1936), pp. 66, 68 // "Coolidge, Charles Allerton," in *Who Was Who in America,* vol. 1, 1897–1942 (Chicago, 1942), p. 256 // Charles A. Coolidge [Jr.], "Charles Allerton Coolidge," *American Society Legion of Honor Magazine* 22 (Summer 1951), pp. 105–17 // "Coolidge, Charles Allerton," in *Biographical Dictionary of American Architects (Deceased),* ed. Henry F. Withey and Elsie Rathburn Withey (Los Angeles, 1956), pp. 136–37 // J. D. Forbes, "Shepley, Bulfinch, Richardson and Abbott, Architects; an Introduction," *Journal of the Society of Architectural Historians* 17 (Fall 1958), pp. 19–31 // Paul V. Turner et al., *The Founders and the Architects: The Design of Stanford University* (Stanford, Calif., 1976) // Lawrence Wodehouse, "Shepley, Rutan and Coolidge," in *American Architects from the Civil War to the First World War* (Detroit, 1976), p. 178 // Peter C. Allen, "Stanford University: An Academic 'Inner City,'" *Historic Preservation* 30 (Apr.–June 1978), pp. 30–36 // Paul V. Turner, *Campus: An American Planning Tradition* (New York, Cambridge, Mass., and London, 1984), pp. 169–73, 191, 241–43, 304, 325 (n. 30), 326 (nn. 66–67) // Elaine Harrington, Chicago Architecture Foundation, correspondence, Mar. 4, 1985 // *Ames Building* (Boston, privately printed by Shepley, Rutan and Coolidge, n.d.), unpaged

Frederick W. Copeland, *see* Isaac Elwood Scott

Cottier and Company, *see* Daniel Cottier

Daniel Cottier

1838–1891
London, New York, Sydney, Melbourne
Stained-glass designer, decorator, and art
 dealer

Daniel Cottier, a Scotsman of French descent, was a pioneer of British decorative art, an accomplished stained-glass artist, and a consummate colorist. Along with WILLIAM MORRIS, Cottier was one of the first designers to formulate a style in stained glass divergent from the dominant Gothic-revival taste, and, beginning in the mid-1860s, he was largely responsible for encouraging the production of such stained glass in Scotland.

A disseminator of artistic ideas rather than an innovator per se, Cottier played an important and early role in introducing aesthetic taste to America, where in 1873 he opened a branch of his London decorating firm. In New York Cottier and his firm were known for high-quality work and exerted a considerable influence on taste in the fine as well as in the decorative arts. At Cottier's showrooms one could find fabrics, "faiencerie" (ILL. 7.8), Venetian glass, oriental carpets, lacquerwork, and bronzes as well as art furniture in the latest Old English, Japanese, and Queen Anne styles. In America as in England, Cottier supplied aesthetic stained-glass windows, a number of which are still extant in the United States (FIG. 6.1, ILL. 6.1); his activity in this medium preceded and no doubt encouraged that of JOHN LA FARGE and LOUIS COMFORT TIFFANY. He was also instrumental in bringing painters of the Barbizon and Dutch schools to the attention of the American public, while supporting American artists, including La Farge, Albert Pink-

ham Ryder (1847–1917; ILLS. 9.15, 9.16), HELENA DE KAY, MARIA OAKEY DEWING, and AUGUSTUS SAINT-GAUDENS, in their efforts to break with established artistic conventions.

Noteworthy in appearance with red hair and beard, Cottier was a generous and charming, good-humored and well-liked figure of the period. Given his importance to the Aesthetic movement in America, it is unfortunate that to date so little material evidence of his activities has been discovered. Virtually no business records have come to light; family papers and possessions have been dispersed. Although there are several documented stained-glass windows, very few authenticated pieces of furniture are known.

Born in Glasgow, Cottier apprenticed in the early 1850s to David Kier (1802–1864), a local manufacturer of stained glass. Before 1860 Cottier went to London, where he worked for a time and attended lectures by John Ruskin (1819–1900) and Ford Madox Brown (1821–1893) at the Working Men's College in Red Lion Square; Cottier must have known William Morris, who lived and worked nearby, and his circle. By 1862 Cottier was back in Scotland, working for the Edinburgh stained-glass makers Field and Allan. The firm submitted a Cottier-designed window to the 1864 Exhibition of Stained Glass and Mosaics at London's South Kensington Museum (now the Victoria and Albert Museum). In 1864 Cottier, with Andrew Wells, a former Field and Allan employee, established his own studio at 40 George Street, and in 1866 he married Field's daughter Marion. Several windows from this early period of 1864–68 can be seen in the Cathedral of Saint Machar in Aberdeen, Scotland.

In 1867 Cottier returned to Glasgow, where he worked on interior design as well as stained glass, specializing in painted and stenciled decoration. The colorfully painted decor in the Dowanhill Church and the United Presbyterian Church in Queen's Park, both in Glasgow, were products of Cottier's collaboration in this field with the architects William Leiper (1839–1916) and Alexander Thomson (1817–1875), respectively. The former building has recently been restored; the latter was destroyed in 1942.

In 1869 Cottier again left Glasgow for London, where he established Cottier and Company, Art Furniture Makers, Glass and Tile Painters. The Scottish architects John McKean Brydon (1840–1901)—who had previously worked in the office of RICHARD NORMAN SHAW and W. EDEN NESFIELD—William Wallace, and BRUCE J. TALBERT were briefly involved as partners in the firm. Colearn House in Auchterarder, Scotland, now a small hotel, is an early and substantially intact example of a Cottier and Company interior in a building designed by Leiper for the industrialist Alexander Mackintosh. Talbert designed the dining room and its furniture, including the fireplace and sideboard, which are still there; Cottier created the stained-glass windows throughout, some of which incorporate the allegorical female figures of Pomona, Ceres, Aphrodite, and the Four Seasons with painted glass tiles sporting sunflowers and small boats.

From London Cottier had easy access to Paris art galleries, among them Goupil and Durand-Ruel, where he acquired contemporary French and Dutch paintings to sell in England and America. He extended his firm in 1873 with the addition of a New York branch, located at 144 Fifth Avenue, the address at which it is first listed in the city directories of 1874–75. Cottier spent a good deal of his time in New York City, no doubt traveling frequently to and from England. He also relied heavily on his manager and eventual partner in the New York office, James Smith Inglis (1852–1907), a Scottish artist who had come to the United States with Cottier in 1873. Cottier further expanded his business in 1873 by establishing, with John Lamb Lyon (1835–1916), a fellow Scotsman he had known in Glasgow and London, a decorating and furniture business in Sydney, Australia, that included an additional branch in Melbourne. Although Cottier made at least three trips to Australia between 1873 and 1890, the operation of Lyon, Cottier and Company was largely his partner's concern.

In New York Cottier and Company's reputation for exciting interior decoration grew quickly. By 1874 the firm's impact was recognized in the press: "The great majority of people, who are bent on being in the fashion, and up to the times, and who have no weak sentiment about grandmothers, must be cared for—and the place for them is Cottier's. . . . Let a few years pass and we are sure the lesson that Messrs. Cottier are teaching us will have been so learned, that they will be put upon their mettle to keep up with us. For in America, there is a real love of comfort and beauty; we love our homes, and gladly welcome any news of how to make them more agreeable to our friends and to ourselves. We are all sick of tameness and copying, and only ask to be shown the better way, to walk in it with a will" (*Scribner's Monthly,* August 1874, pp. 500–501).

CLARENCE COOK openly acknowledged Cottier's assistance and advice in the preparation of his series of articles for *Scribner's Monthly* between 1875 and 1877, which in the following year were published as *The House Beautiful: Essays on Beds and Tables, Stools and Candlesticks.* Cottier designed the original cover of the book (FIG. 5.6), and many of the illustrations depict pieces of furniture available in the Cottier showrooms. Several of these are lightly scaled, ebonized versions of E. W. GODWIN's Anglo-Japanesque pieces (FIGS. 5.8, 5.10). Cook and Cottier also publicized Godwin's designs for Queen Anne chimneypieces as well as a version (FIG. 5.10) of MORRIS AND COMPANY's famous Sussex chair. Copies of some of Godwin's furniture were manufactured by Cottier's New York factory after Cottier experienced the difficulties involved in importing such delicate pieces from England. It is thought, however, that Cottier's stained glass was made in England and brought to America.

Cottier was one of the first to make aesthetic stained glass available in America, although windows by Morris and Company also made an early appearance and by 1876 CHARLES BOOTH, another British "stainer," was operating in New York as well. Cottier's earliest known commission was in 1878 for a large window in the Green Memorial Alcove of the New York Society Library, an interior decorated by Léon Marcotte (1824–1887). The window featured full-sized figures of Knowledge and Prudence surrounded by small floral quarries and by the heads of Homer, Dante, Virgil, and Petrarch (or Chaucer) in each of the four corners. Cottier and Company also supplied four (ILL. 6.1) of the memorial windows in H. H. RICHARDSON's Trinity Church in Boston. The firm was originally hired to execute the interior painting scheme under the direction of John La Farge, but because of a disagreement between the two artists Cottier did not complete the job. Other extant Cottier and Company windows in the United States include those in Calvary Church, on Gramercy Park, and the Church of the Incarnation, on Madison Avenue, both in New York City; the First Presbyterian and Grace churches of Brooklyn; Saint John's Church in Canandaigua, New York; as well as others at Yale and Harvard universities and in private collections (FIG. 6.1).

Cottier's stained-glass style was influenced by William Morris, the Pre-Raphaelites, and Japanism, but also by contemporaneous French and Dutch paintings and the iconography of his own Scottish heritage. Despite these many sources his windows display a sense of color and a figural type recognizably his own. From about 1872 until 1887, Cottier employed the Dutch painter Matthew Maris (1839–1917) in his London workshop; he apparently was responsible for restoring pictures as well as painting them. Figures in some Cottier and Company windows bear a strong resemblance to the sturdy peasants in Maris's paintings, and indeed Maris may have drawn some of the cartoons for windows executed by the firm.

In addition to stained-glass projects, Cottier and Company was commissioned to work on a number of important New York interiors, none of which still exist. The Union League Club, completed in 1881, showcased decorative schemes by La Farge, Tiffany, and Cottier, who was hired to do the library. A contemporary periodical described it as "a fine, high-ceilinged room, with light-colored glass in the upper windows, a carved-wood chimney-piece, . . . two other cozy fireplaces, . . . 'high-art' decorative curtains, and a general air of comfort and substance. The ceiling is dead-gilt, with brighter, flower-shaped ornaments distributed, and at either end olive-blue, with conventional giltstars and deep stenciled borders of dead-gilt, light yellows and light browns" (*Frank Leslie's Illustrated Newspaper,* May 7, 1881, p. 171). Other Cottier and Company decors ranged from interiors for the homes of F. W. Stevens and Joseph Decker, described in the 1883–84 publication *Artistic Houses,* to some of the furniture for Catharine Lorillard Wolfe's Newport, Rhode Island, "cottage."

Cottier, who had been weakened by rheumatism in his youth, died prematurely at the age of fifty-three while in Jacksonville, Florida. He was buried in Woodlawn Cemetery in New York City beneath a grave monument that reads "Art is Long, Life is Short." His collection of paintings, which he had assembled as a form of life insurance for his family, was sold at auction in 1892 through the Durand-Ruel gallery in Paris. His partner James Inglis managed the firm's operations in both America and England until his death in 1907, but Cottier and Company survived until 1915.

REFERENCES

"Culture and Progress: Cottier and Company," *Scribner's Monthly* 8 (Aug. 1874), pp. 500–501 // "Some Other Pictures," *Scribner's Monthly* 10 (June 1875), p. 253 // "Decorative Fine-Art Work at Philadelphia: American Furniture," pt. 3, *American Architect and Building News* 2 (Jan. 13, 1877), pp. 12–13 // Clarence Cook, *The House Beautiful: Essays on Beds and Tables, Stools and Candlesticks* (New York, 1878; reprint New York, 1980) // Mrs. H. R. [Mary Eliza] Haweis, *The Art of Beauty* (New York, 1878), pp. 210–11, 238–39 // Henry Hudson Holly, *Modern Dwellings in Town and Country . . .* (New York, 1878; reprinted in *Country Seats and Modern Dwellings*, Watkins Glen, N.Y., 1977), p. 155 // "Notes: Cottier's Art-Rooms," *Art Journal* (Appleton's) 4 (Mar. 1878), p. 94 // George A. Leavitt and Company, New York, *Fine Oil Paintings and Water-Color Drawings by the Great Modern Classic Painters* [imported by Cottier and Company] (sale cat., Apr. 23 and 24, 1878) // "Notes: The Cottier Sale of Pictures," *Art Journal* (Appleton's) 4 (June 1878), p. 192 // "Architecture: Green Memorial Alcove," *Art Interchange* 1 (Nov. 13, 1878), p. 39 // "Notes: New Pictures in New York Galleries," *Art Journal* (Appleton's) 5 (Jan. 1879), pp. 31–32 // [Monticelli paintings available at Cottier and Company], *Art Interchange* 2 (Apr. 30, 1879), p. 71 // "Notes: Art Alcove at the Society Library," *Art Journal* (Appleton's) 5 (July 1879), p. 191 // "Art Galleries," *Art Interchange* 3 (Sept. 17, 1879), p. 52 // Charles Cole, "Painted Glass in Household Decoration," *Harper's New Monthly Magazine* 59 (Oct. 1879), pp. 655–64, 663 (ill.) // Montezuma [Montague Marks], "My Note Book," *Art Amateur* 2 (Apr. 1880), p. 91 // "Architectural Progress of New York City: New Quarters of the Union League Club," *Frank Leslie's Illustrated Newspaper* 51 (Nov. 13, 1880), pp. 177–78 // Roger Riordan, "American Stained Glass," pt. 1, *American Art Review* (Boston) 2, pt. 1 (1881), pp. 229–34 // "The Union League Clubhouse," *Harper's Weekly* 25 (Feb. 19, 1881), pp. 116 (ill.), 118–19 // [Description of the Union League Club library], *Frank Leslie's Illustrated Newspaper* 52 (May 7, 1881), pp. 169 (ills.), 171 // "Some of the Union League Decorations," *Century Illustrated Monthly Magazine* 23 (Mar. 1882), pp. 745–52, 749 (ill.) // "Messrs. Cottier and Company, Interior Decorators . . . Corot's, Millet's, Diaz's, Troyon's . . . on View and Sale" [advertisement], *Critic* 2 (Apr. 8, 1882), p. ii // *Artistic Houses, Being a Series of Interior Views of a Number of the Most Beautiful and Celebrated Homes in the United States*, 2 vols. in 4 pts. (New York, 1883–84; reprinted in 1 pt., New York, 1971), vol. 1, pt. 2, pp. 100–109; vol. 2, pt. 2, pp. 145–48 // "The Architectural Progress of New York City," *Frank Leslie's Popular Monthly* 15 (Apr. 1883), p. 387 // Montezuma [Montague Marks], "My Note Book," *Art Amateur* 18 (Apr. 1888), p. 104 // [Daniel Cottier, obituary], *New York Sun*, Apr. 8, 1891, p. 7 // [Daniel Cottier, obituary], *New York Times*, Apr. 8, 1891, p. 5 // [Daniel Cottier, obituary], *New York Tribune*, Apr. 8, 1891, p. 7 // "Daniel Cottier's Death," *Collector* 2 (Apr. 15, 1891), p. 141 // "The Late Daniel Cottier," *Architect* 47 (May 13, 1892), pp. 323–24 //

W. E. H[enley], "Daniel Cottier," in Durand-Ruel, Paris, *Collection Cottier* (sale cat., May 27–28, 1892), pp. ix–xiii // "Gossip and Grumbles" [Ford Madox Brown's assessment of Cottier as a colorist], *Glasgow Evening Times*, Oct. 9, 1893, clipping from the Mitchell Library, Glasgow // W. C. Brownell, "The Sculpture of Olin Warner," *Scribner's Magazine* 20 (Oct. 1896), pp. 429, 434 (ill.) // "The Late Daniel Cottier," *Journal of Decorative Art and British Decorator* 22 (May 1902), p. 145 // American Art Galleries, New York, *Art Furniture Including Pianos, Cabinets, Chairs, Tables, Etc.* (sale cat., Mar. 12, 1909) // "Personal: Mr. John L. Lyon," *Australasian Decorator and Painter*, Aug. 1, 1909, pp. 263–64 // American Art Galleries, New York, *Illustrated Catalogue of the Artistic Property, Fine Antique and Modern Furniture, Important Flemish Tapestries, Stained Glass, Textiles and Other Objects of Household Utility and Embellishment of the Well-known House of Cottier and Company of New York* (sale cat., Nov. 19–26, 1913) // Christie, Manson and Woods Limited, London, *Catalogue of Decorative Furniture and Porcelain, the Property of Alexander Allan Webbe . . . Mrs. Cottier . . .* (sale cat., Apr. 23, 1914) // Idem, *Catalogue of Modern Pictures and Water Colour Drawings . . . the Property of Mrs. Cottier . . .* (sale cat., May 1, 1914) // Anderson Galleries, New York, *Catalogue of Paintings, Art Objects, Books, Fixtures, and Artistic Furniture Comprising the Entire Stock of . . . Cottier and Company . . .* (sale cat., Mar. 12, 1915) // John Robinson, "Personal Reminiscences of Albert Pinkham Ryder," *Art in America* 13 (June 1925), pp. 176, 179, 183–84 // Brian Gould, *Two Van Gogh Contacts: E. J. Van Wisselingh, Art Dealer; Daniel Cottier, Glass Painter and Decorator* (Bedford Park, Eng., 1969) // Geoffrey M. Down, "Nineteenth Century Stained Glass in Melbourne" (M.A. thesis, Melbourne University, 1975) // Martin Harrison, "Contemporary Art Glass One Hundred Years Ago," *Glass* 6 (Jan. 1975), pp. 36–39 // Sotheby's Belgravia, London, *English Furniture and Works of Art, European Bronzes and Arts and Crafts Furniture and Works of Art, 1830–1930* (sale cat., Feb. 5, 1975), fig. 84 // Idem, *Victorian and Arts and Crafts Furniture and Works of Art* (sale cat., Nov. 12, 1975), fig. 104 // Mark Girouard, *Sweetness and Light: The "Queen Anne" Movement, 1860–1900* (Oxford, 1977), pp. 210–12, 241 (n. 16) // George Gurney, "Olin Levi Warner (1844–1896): A Catalogue Raisonné of His Sculpture and Graphic Works" (Ph.D. diss., University of Delaware, 1978), pp. 359–67, 372 (n. 5), 373–75, 500–502 // Mason Hammond, "The Stained Glass Windows in Memorial Hall, Harvard University," typescript, 1978, pp. 108–36; and unpaged "Additions and Corrections" // Martin Harrison, *Victorian Stained Glass* (London, 1980), pp. 46–49, 56–62, 69–71 // Michael Donnelly, *Glasgow Stained Glass: A Preliminary Study* (Glasgow, 1981) // Suzanne Forge, *Victorian Splendour: Australian Interior Decoration, 1837–1901* (Melbourne, 1981), pp. 27 (ill.), 119 (ill.) // Joan Cottier Kennedy, correspondence, Oct. 22, 1981; Oct. 25, 1984; Feb. 15, 1985 // James L. Sturm, *Stained Glass from Medieval Times to the Present: Treasures to Be Seen in New York* (New York, 1982) // Jennifer A. Martin Bienenstock, "The Formation and Early Years of the Society of

American Artists, 1877–1884" (Ph.D. diss., City University of New York, 1983), pp. 18–22 // Danute Illuminata Giedraityte, "Stained and Painted Glass in the Sydney Area, ca. 1830–1920" (M.A. thesis, University of Sydney, 1983) // Beverley Sherry, "Secular Stained Glass in Australia," *Australian Antique Collector* 26 (June–Dec. 1983), pp. 44–49 // Simon Jervis, "Cottier, Daniel," in *The Penguin Dictionary of Design and Designers* (Harmondsworth, Eng., and New York, 1984), p. 127 // Lenore Nicklin, "Perils of Perfectionism: A Restoration Melodrama," *Connoisseur* 214 (Feb. 1984), pp. 56–61 // Martin Harrison, London, correspondence, Feb. 19, 1984 // ". . . Steinway and Son Grand Piano . . . Case Designed by Cottier and Company. Circa 1889. Serial Number 69376" [advertisement], *Antiques* 125 (May 1984), p. 1033 // Arthur L. Bolton, correspondence, Nov. 23 and Dec. 10, 1984 // Beverley Sherry, University of Sydney, correspondence, Dec. 3, 1984 // Ann Bomann, correspondence, Jan. 6, 1985 // Dorinda Evans, "Albert Pinkham Ryder's Use of Visual Sources," *Winterthur Portfolio* 21 (Spring 1986), pp. 21–40 // George Gurney, National Museum of American Art, Washington, D.C., correspondence, n.d. // "The Metropolis of To-day" [Cottier and Company], periodical page from unknown source, n.d., in the scholarship files, Department of American Decorative Arts, The Metropolitan Museum of Art, New York // Margaret H. Hobler, "In Search of Daniel Cottier, Artistic Entrepreneur, 1838–1891" (M.A. thesis, Hunter College, New York), in preparation

Walter Crane

1845–1915
London
Decorative artist

One of the most versatile decorative artists of the late nineteenth century, Walter Crane designed stained glass, mosaics, textiles and embroideries, tiles and ceramics, wallpapers, and decorative plasterwork. His greatest contribution to the period, however, was in the field of graphic arts. Crane pioneered a new awareness of book design, treating the printed or calligraphic word, illustration, and ornamental border as a unified decorative composition that frequently spanned the double-page spreads of a book. His illustrations—graceful, inventive images that stress linearity and pattern over three-dimensional representation—for fairy tales, nursery rhymes, and Old English songs were inspired not only by the Pre-Raphaelite painters, especially Edward Burne-Jones (1833–1898), but also by Sandro Botticelli, William Blake, and the arts of Japan.

Crane's father, Thomas (1808–1859), a talented but financially unsuccessful portrait painter from Liverpool, gave him his first lessons in art. In 1859 Crane commenced a three-year apprenticeship to William J. Linton, a London wood engraver of exceptional skill. By 1863 Crane had secured a position with the publisher and printer Edmund Evans (1826–1906), with whom he was to have a long collaborative affiliation: "I well remember certain murmurings or complaints reaching me from 'the trade' to the effect that my (and Mr. Ev-

ans') colours were not . . . bright enough," Crane later recalled. "It was a generation seeking magenta and emerald green, and finding none" (Weinstein, 1970, pp. 99–100).

Crane's books for children were enormously popular: *The Baby's Opera: A Book of Old Rhymes with New Dresses,* published in 1877, sold some forty thousand copies. His illustrations for these books created a new market in tiles and ceramics, to which they were easily adapted. Both *The Baby's Opera* and *The Baby's Bouquet: A Fresh Bunch of Old Rhymes and Tunes* (1878) inspired tiles produced by the British firms T. AND R. BOOTE and MINTON AND COMPANY (FIG. 7.37). Crane's publications were readily available in America, in original and pirated editions, and served as source books for American tile manufacturers as well, among them the AMERICAN ENCAUSTIC TILING COMPANY of Zanesville, Ohio, which made authorized transfer-printed tiles from the original printing plates for *The Baby's Own Aesop,* published in 1887 (FIG. 7.38). The linear quality of Crane's fairy-tale images made them perfect models for amateur china painters too; HELEN METCALF, for example, adapted an image from *Jack and the Beanstalk* (1874, FIG. 7.24), one of approximately fifty Sixpenny and Shilling Toybooks that Crane designed between 1865 and 1886.

In addition to tiles for Maw and Company and ceramic vases for JOSIAH WEDGWOOD AND SONS, LIMITED, from 1874 Crane designed wallpapers for JEFFREY AND COMPANY and embroideries for the Royal School of Art Needlework. During the 1880s he undertook textiles for Wardle and Company and Edmund Potter and Company, as well as carpets for Templeton's of Glasgow, Scotland; he also designed one tapestry for MORRIS AND COMPANY. While participating with THOMAS JECKYLL and WILLIAM MORRIS in the decoration of the London home of collector Alexander A. Ionides during the early 1870s, Crane revived the art of decorative plasterwork, and he designed mosaics for Frederick Leighton's Arab hall in his home near Holland Park, London, in 1877–79.

During his European travels of 1871–73, in Rome Crane encountered the American painters ELIHU VEDDER and CHARLES CARYL COLEMAN, who shared a decorative approach to classical and mythological subjects. While in Italy Crane received a commission for a frieze for the Newport, Rhode Island, home of Catharine Lorillard Wolfe. At the 1876 Philadelphia Centennial Exposition, Crane was represented by a set of prize-winning wallpapers displayed by Jeffrey and Company (ILL. 3.9), an embroidered screen with majestic peacocks (FIG. 3.20), and some opulent portieres executed by the Royal School of Art Needlework (ILL. 3.29), all of which inspired American artists, particularly CANDACE WHEELER. *The House Beautiful: Essays on Beds and Tables, Stools and Candlesticks* (1878) by CLARENCE COOK conveyed Crane's vignette of an artful environment to thousands of American readers (see frontispiece to the Preface).

During the 1880s Crane became an art activist. He helped found the Art Workers Guild in 1884 and served as its master from 1888 to 1889. From about 1885 Crane was a socialist and a leader in the formation of the Arts and Crafts Society, over which he presided until 1912, the years 1893–96 excluded. In 1891–92 Crane came to America for an extended visit. The Chace Act of 1891, protecting international copyright, had recently become law in America and may have prompted Crane's visit, since American publishers had issued many pirated and poor-quality copies of his books. While in America he created stained-glass designs for the library of a home in Newport and for a church in Newark, New Jersey; accepted a commission to provide illustrations for two books for Houghton, Mifflin Company; and painted two large murals for the Women's Christian Temperance Building in Chicago. The artists Crane met during his stay included JOHN LA FARGE and WILL H. LOW. During his visit to the United States, a major retrospective exhibition of his work, originally organized in 1891 by the Fine Art Society, London, was displayed in Boston, Chicago, Saint Louis, Philadelphia, and Brooklyn. The impact in America of this exposure to Crane's work throughout the 1890s is evident in the graphic appearance of magazines, such as *Knight Errant, Chap-Book,* and *St. Nicholas,* and in the work of illustrators, among them Will Bradley (1868–1962), Howard Pyle (1853–1911), and Edwin Austin Abbey (1852–1911).

From the 1890s Crane participated in an international avant-garde. He became director of design at the Manchester School of Art and was briefly associated with the art department at the College of Reading. In 1898 he served, for one year, as principal of the Royal College of Art, London. He wrote a number of important books that document his art theories and life experiences. These include *The Claims of Decorative Art* (1892), with Dutch and German editions in 1893 and 1896 respectively, *The Bases of Design* (1898), *Line and Form* (1900), *Ideals in Art* (1905), *An Artist's Reminiscences* (1907), and *William Morris to Whistler* (1911). His retrospective exhibition traveled from the United States back to Europe, where it toured until 1896. Articles praising his books and decorative work were published in *Art moderne,* and in 1895 his work was shown at S. Bing's L'Art Nouveau gallery in Paris. Crane was made an honorary member of the Vienna Secession in 1897 and the following year designed a cover for the magazine *Jugend.* His exhibition in Budapest in 1900 was shown in Vienna in 1901 and again at the international fair held in Turin in 1902. He received the Royal Society of Arts gold medal in 1905.

REFERENCES
Walter Crane, *Jack and the Beanstalk* (London [1874]) // Phillip T. Sandhurst et al., *The Great Centennial Exhibition Critically Described and Illustrated* (Philadelphia and Chicago, 1876), pp. 170–71 (ills.) // Walter Crane, *The Baby's Opera: A Book of Old Rhymes with New Dresses* (London and New York, 1877) // Idem, *The Baby's Bouquet: A Fresh Bunch of Old Rhymes and Tunes, Arranged and Decorated by Walter Crane . . .* (London [1878]) // "Nurseries and Servants' Rooms," *Art Interchange* 1 (Nov. 13, 1878), p. 39 // "Art Needlework," pt. 2, *Magazine of Art* 3 (1880), pp. 178–82 // "An English Fireplace," *Carpentry and Building* 6 (July 1884), pp. 125–26 // Walter Crane, *The Baby's Own Aesop, Being the Fables Condensed in Rhyme, with Portable Morals Pictorially Pointed [sic] by Walter Crane* (London and New York, 1887) // Lewis F. Day, "An Artist in Design," *Magazine of Art* 10 (1887), pp. 95–100 // Idem, "Our Copyright Law, an Example of Its Workings," *Studio,* n.s. 3 (June 1887), pp. 104–7 // Clara Erskine Clement and Laurence Hutton, "Crane, Walter," in *Artists of the Nineteenth Century and Their Works* (Boston and New York, 1889), pp. 169–70 // Fine Art Society Limited, London, *Catalogue of a Collection of Designs by Walter Crane . . . with Prefatory and Explanatory Notes by the Artist* (exhib. cat., 1891) // Museum of Fine Arts, Boston, *Catalogue of a Collection of Designs by Walter Crane . . .* (exhib. cat., 1891) // Art Institute of Chicago, *Catalogue of a Collection of Designs by Walter Crane . . .* (exhib. cat., 1892) // Brooklyn Art Association, *A Collection of Designs by Walter Crane* (exhib. cat., 1892) // Walter Crane, *The Claims of Decorative Art* (London and Boston, 1892) // Idem, *The Relation of Art to Education and Social Life, Being an Address Delivered at the Leek Town Hall on Thirty-first of October, 1892* (Leek, Eng., 1892) // Idem, "Design," pts. 1, 2, *Magazine of Art* 16 (1893), pp. 79–83, 131–36 // Lewis F. Day, "A Kensington Interior," *Art Journal* (London), 1893, pp. 139–44 // "Our Illustrated Note-book," *Magazine of Art* 16 (1893), pp. 70–72 (ills.), 249–52, 250 (ill.) // Walter Crane, *Of the Decorative Illustration of Books Old and New* (London and New York, 1896) // Idem, "Of the Influence of Architectural Style upon Design," pts. 1, 2, *Magazine of Art* 19 (1896), pp. 129–33, 191–96 // Idem, *The Bases of Design* (London, 1898; reprint New York, 1977) // Idem, "The Work of Walter Crane with Notes by the Artist," *Art Journal Easter Art Annual* (London, 1898) // Idem, *Line and Form* (London, 1900) // Idem, "Animals in Pattern Design: A Friendly Dispute Between Walter Crane and Lewis F. Day," *Art Journal* (London), July 1901, pp. 212–14 // P. G. Konody, *The Art of Walter Crane* (London, 1902) // Ralph E. Moreland, "The Art of Walter Crane," *Brush and Pencil* 10 (Aug. 1902), pp. 257–71 // Russell Sturgis, "English Decoration and Walter Crane," *Architectural Record* 12 (Dec. 1902), pp. 685–91 // Walter Crane, *Moot Points: Friendly Disputes on Art and Industry Between Walter Crane and Lewis F. Day* (London, 1903) // Idem, *Ideals in Art: Papers—Theoretical—Practical—Critical* (London, 1905; reprint New York, 1979) // Idem, *An Artist's Reminiscences* (London, 1907; reprint London, 1968) // Idem, *William Morris to Whistler: Papers and Addresses on Art and Craft and the Commonweal* (London, 1911; reprint London, 1978) // "Crane, Walter," in *Allgemeines Lexikon der Bildenden Künstler,* ed. Ulrich Thieme and Felix Becker, vol. 8 (Leipzig, 1913), pp. 61–62 // Gardner Teall, "Walter Crane, Master Decorator," *Cosmopolitan Magazine* 56 (May 1914), pp. 723–30 // [Walter Crane, obituary], *Royal Institute of British Architects Journal,* 3d ser. 22 (1914–15), pp. 240, 277, 280 // [Walter Crane, obituary], *New York Times,* Mar. 16, 1915, p. 11 // Gertrude C. E. Massé, *A Bibliography of First Editions of Books Illustrated by Walter Crane, . . . with a Frontispiece after G. F. Watts* (London, 1923) // Alan Victor Sugden and John Ludlam Edmondson, *A History of English Wallpaper, 1509–1914* (London and New

York, 1926), pp. 209–12 // Barbara L. Michaels, "English Children's Book Illustrations, ca. 1875–1890, as a Background to Post Impressionism and Art Nouveau: A Study of the Influences of Walter Crane, Kate Greenaway, and Randolph Caldecott" (M.A. thesis, New York University, 1962) // Frederic Daniel Weinstein, "Walter Crane and the American Book Arts, 1880–1915" (Ph.D. diss., Columbia University, 1970) // H. Allen Brooks, "Chicago Architecture: Its Debt to the Arts and Crafts," *Journal of the Society of Architectural Historians* 30 (Dec. 1971), pp. 312–17 // Chester Davis, "The AETCO Tiles of Walter Crane," *Spinning Wheel* 29 (June 1973), pp. 18–20 // Rodney K. Engen, *Walter Crane as a Book Illustrator* (London, 1975) // Isobel Spencer, *Walter Crane* (New York, 1975) // "Crane (Walter)," in *Dictionnaire critique et documentaire des peintres, sculpteurs, dessinateurs, et graveurs,* ed. E. Bénézit, vol. 3 (Paris, 1976), p. 260 // Delaware Art Museum, Wilmington, *The Pre-Raphaelite Era, 1848–1914,* by Rowland Elzea and Betty Elzea (exhib. cat., 1976), p. 134, figs. 6-1, 6-2, 6-3 // Gianna Piantoni, "Il Linguaggio della linea nella teoria di W. Crane," *Ricerche di storia dell'arte* 5 (1977), pp. 47–66 // Isabelle Anscombe and Charlotte Gere, "Walter Crane (1845–1915)," in *Arts and Crafts in Britain and America* (New York, 1978), pp. 113–14 // Anthony J. Coulson, *A Bibliography of Design in Britain, 1851–1970* (London, 1979), pp. 77, 127, 147, 207 // Terence A. Lockett, *Collecting Victorian Tiles* (Woodbridge, Eng., 1979) // Catherine Lynn, *Wallpaper in America: From the Seventeenth Century to World War I* (New York, 1980) // Simon Jervis, "Crane, Walter," in *The Penguin Dictionary of Design and Designers* (Harmondsworth, Eng., and New York, 1984), pp. 131–33

Alice H. Cunningham, *see* Alice Cunningham Ware

Matthew A. Daly, *see* Rookwood Pottery

A. H. Davenport and Company
1880–1908
Boston and East Cambridge, Massachusetts
Furniture and interior decoration

A. H. Davenport and Company was one of the most important commercial decorating firms in the United States between about 1875 and 1910. The company started in the facilities of the Ezra H. Brabrook Company, a "furniture and feathers" business first listed in the Boston city directory in 1842. By the time of Brabrook's death, in 1880, it was a thriving concern with substantial assets, which were purchased by Albert H. Davenport (1845–1906), the company's bookkeeper since 1866. An 1880 newspaper account waxed eloquent about Davenport's five-story buildings at 96–98 Washington Street, Boston, which housed a cabinet shop, woodworking department, and sumptuous displays of carpets, draperies, upholsteries, paper hangings, and furniture "almost too beautiful for earth" (Farnam, 1976, p. 1048).
 In 1883 the firm's operations were enlarged

by the acquisition of factory buildings at 108 Cambridge Street in East Cambridge, Massachusetts, and a branch office in New York City. A. H. Davenport was one of the few firms that could supply the quantity of luxury furniture and interior finishings—wallpaper, textiles, and woodwork—necessary to meet the needs of the period's sumptuous public and private buildings. Among the large commissions Davenport received, one was for 225 pieces of furniture and draperies for the Iolani Palace of the Hawaiian King Kalakaua about 1882–83 and another was for the 1902–1903 redecoration of several rooms of the White House during Theodore Roosevelt's presidency. Davenport was also closely associated with many prestigious architectural concerns, including Peabody and Stearns; McKim, Mead and White; H. H. RICHARDSON; and Richardson's successors, SHEPLEY, RUTAN AND COOLIDGE.
 The key figure in the firm, besides Davenport himself, was Francis H. Bacon (1856–1940), principal designer, then vice-president, from 1885 to 1908. A graduate of the Massachusetts Institute of Technology in 1877 (and brother of Henry Bacon, architect of the Lincoln Memorial in Washington, D.C.), Bacon traveled to Europe during 1878–79 and subsequently worked briefly in New York City as a draftsman for McKim, Mead and Bigelow and in Albany with Prentis Treadwell, an architect and decorator. For a short time Bacon was a designer for HERTER BROTHERS, the firm engaged on the William H. Vanderbilt house in New York (ILLS. 2.1, 4.7–4.9). European travels and two years with the Archaeological Institute of America on its excavations at the site of Assos, Turkey, between 1881 and 1883 sharpened Bacon's eye for classical detail.
 When he returned to the United States, Bacon worked in H. H. Richardson's office before joining Davenport and Company as a designer in 1885. At Davenport he was responsible for translating the handcraft ideals of the period into machine-made production, and it was probably he who interpreted the Colonial-revival style used in some of the furniture created for Richardson's buildings. In all likelihood Davenport and Company manufactured the set of chairs designed by CHARLES ALLERTON COOLIDGE in 1886 for the John J. Glessner House in Chicago, which was completed by the firm of Shepley, Rutan and Coolidge after Richardson's death in that year (FIG. 5.34). Davenport also provided the Glessners with a "car load" of other furniture, draperies, and hardware, as well as an artist who advised on paint colors—for which the total bill amounted to $10,139.83 (Docents, 1983, p. 28).
 A. H. Davenport died in 1906, and the firm was sold by his executors two years later. Bacon, who had tried unsuccessfully to purchase the company, in 1908 established his own business, which continued until 1944. Meanwhile, Irving and Casson, specialists in interior woodwork and furnishings since the 1860s, took over the Davenport firm in 1914 (although a relationship between the two companies may have existed prior to that). After the First World War the firm created interiors, many in the Gothic-revival style, in collaboration with such architectural firms as Cram,

Ferguson and Goodhue. Operations continued until about 1973, though the firm's most productive period ended with the advent of the Great Depression of the 1930s.

REFERENCES
Anne Farnam, "A. H. Davenport and Company, Boston Furniture Makers," *Antiques* 109 (May 1976), pp. 1048–55 // Idem, "H. H. Richardson and A. H. Davenport: Architecture and Furniture as Big Business in America's Gilded Age," in *Tools and Technologies: America's Wooden Age,* ed. Paul B. Kebabian and William C. Lipke (Burlington, Vt., 1979), pp. 80–92 // Docents of the Chicago Architecture Foundation, "Glessner House Interiors—The Artists and Their Arts," in "A Docent Resource and Training Manual for the John Jacob Glessner House, 1886," typescript, 1983, pp. 27–31

Lockwood de Forest, *see* Louis Comfort Tiffany and Candace Wheeler

Helena De Kay
1848–1916
New York City
Painter

Helena De Kay specialized in portraits, ideal figures, and flower paintings. A native and life-long resident of New York City, she studied painting privately with JOHN LA FARGE and WINSLOW HOMER and at the Cooper Union School of Design for Women, where she was enrolled as early as 1867–68. In 1871 she entered the first life-drawing class for women offered at the National Academy of Design; one of her fellow students at the academy was MARIA OAKEY DEWING, with whom De Kay shared a studio. The young women associated with a circle of forward-thinking artists and writers, among them Richard Watson Gilder (1844–1909), who was at the time assistant editor of *Scribner's Monthly* and whom De Kay met in 1872 and married in 1874. Gilder, a poet of distinction as well as an editor, published a series of love sonnets inspired by De Kay in *Scribner's Monthly* in 1873; these were published in a book entitled *The New Day: A Poem in Songs and Sonnets* in October 1875, despite its 1876 title-page date. De Kay illustrated this and several other books of her husband's poetry; she also designed its rich blue cover (FIG. 9.10), decorated with a gilt-stamped peacock feather, the "eye" symbolic of the rising sun in the poem from which the volume takes its name.
 De Kay exhibited her work at the National Academy of Design during the 1870s, but along with many of her contemporaries she was dissatisfied with the conservative taste of the academy's exhibition committees. "My sunflower [is] on the floor in the corridor," De Kay complained of the National Academy show in 1875; "they have determined that the 'new school' shall have no chance" (Bienenstock, 1983, p. 19). The "new school" included John La Farge, whose work had been rejected altogether, JAMES ABBOTT MCNEILL WHISTLER, whose work was poorly displayed, and many other artists who were influenced by

the work of the French Barbizon School painters. De Kay was one of the artists whose work was shown in an alternative exhibition held concurrently at the New York gallery of DANIEL COTTIER; CLARENCE COOK, Richard Watson Gilder, and De Kay's brother, Charles, were among the critics who championed the young artists in print. This rebellion led to the formation of the Art Students League in 1875, of which De Kay was a founding member, and of the Society of American Artists, which in 1877 was organized in the Gilders' home by De Kay, Walter Shirlaw (1838–1909), Wyatt Eaton (1849–1896), and AUGUSTUS SAINT-GAUDENS. In the first Society of American Artists exhibition the following year, De Kay displayed a figural piece entitled *The Last Arrow*. She traveled to Europe with her husband in 1879 and two years later translated Alfred Sensier's *Jean-François Millet, Peasant and Painter*.

The Gilders' home, for many years located at 103 East Fifteenth Street—a former stable remodeled by Stanford White—functioned as an informal artistic and literary salon. In 1881 Richard Watson Gilder became the editor in chief of *Century Illustrated Monthly Magazine,* the successor to *Scribner's Monthly,* a post he held for twenty-eight years. In addition to his prodigious literary career, Gilder was active in civic events, campaigning for civil-service reform, improved city government, and better housing for the city's poor. After 1886 De Kay's painting career was limited by domestic responsibilities, but she wrote occasionally and authored articles, such as an essay on women's suffrage for the *Critic* in 1894.

REFERENCES
Richard Watson Gilder and Helena De Kay Gilder, Journal and about forty letters, 1874–78, Manuscript Collection, Archives of American Art, New York // National Academy of Design, New York, *Catalogue of the Fiftieth Annual Exhibition of the National Academy of Design* (exhib. cat., 1875), p. 7 // Alfred Sensier, *Jean-François Millet, Peasant and Painter,* trans. Helena De Kay (Boston, 1881) // Clara Erskine Clement and Laurence Hutton, "De Kay, Helena (Mrs. R. Watson Gilder)," in *Artists of the Nineteenth Century and Their Works* (Boston and New York, 1889), p. 194 // "Gilder, Richard Watson," in *The National Cyclopaedia of American Biography,* vol. 1 (New York, 1892), pp. 312–13 // Helena De Kay Gilder, "Letter on Woman Suffrage," *Critic* 25 (Aug. 4, 1894), pp. 63–65 // Arthur Hoeber, "Famous American Women Painters," *Mentor* 2 (Mar. 16, 1914), p. 5 // "Gilder, Helena De Kay" [obituary], *American Art Annual* 13 (1916), p. 315 // Rosamond Gilder, ed., *The Letters of Richard Watson Gilder* (Boston and New York, 1916), pp. 58, 75 // "Helena De Kay Gilder" [obituary], *New York Times,* May 29, 1916, p. 6 // "Portrait by Wyatt Eaton" [of Helena De Kay Gilder], *Art World* 3 (Dec. 1917), p. 207 // "Gilder, Richard Watson," in *The Cyclopaedia of American Biography,* ed. James E. Homans, vol. 8 (New York, 1918), pp. 256–57 // R[osamond] Gilder, "La Nostalgilder: Letters of Eleonora Duse to Helena De Kay Gilder," *Theatre Arts Magazine* 10 (June 1926), pp. 368–82 // "Gilder, Helena De Kay," in *Cyclopedia of Painters and Paintings,* ed. John Denison Champlin, Jr., and Charles C. Perkins, vol. 2 (New York, 1927), p. 137 // L. M. Stark, "Gilder Poetry Collection," *New York Public Library Bulletin* 52 (July 1948), pp. 341–54 // Albert Ten Eyck Gardner, "A Century of Women," *Bulletin of the Metropolitan Museum of Art,* n.s. 7 (Dec. 1948), p. 114 // "Gilder, Richard Watson," in *Dictionary of American Biography,* vol. 4, pt. 1 (New York, 1960), pp. 275–78 // Whitney Museum of American Art, Downtown Branch, New York, *Nineteenth Century American Women Artists,* by Judith Bernstein et al. (exhib. cat., 1976) // Arthur John, *The Best Years of the Century: Richard Watson Gilder, Scribner's Monthly and the Century Magazine, 1870–1909* (Urbana, Ill., 1981) // Charlotte Streifer Rubinstein, *American Women Artists from Early Indian Times to the Present* (Boston and New York, 1982), pp. 74, 126, 140–41 // Jennifer A. Martin Bienenstock, "The Formation and Early Years of the Society of American Artists, 1877–1884" (Ph.D. diss., City University of New York, 1983) // Chris Petteys, "De Kay, Helena," in *Dictionary of Women Artists: An International Dictionary of Women Artists Born Before 1900* (Boston, 1985), p. 189

Derby Silver Company
1872–1898
Derby, Connecticut
Silver and silverplate

The Derby Silver Company was incorporated in 1872 and started production the following year. It was one of several companies formed after the Civil War to meet the growing demand for affordable silverplated hollow ware. With tools and equipment purchased from the Hartford Plate Company, the firm, under the presidency of Edwin N. Shelton, manufactured flatware until its reorganization, under the direction of Watson John Miller (b. 1845), at the end of the decade. Miller, who had operated his own silverplating factory in Middletown, Connecticut, before moving to Brooklyn in 1874 to work for a similar concern, returned to Connecticut to assume control of the Derby Silver Company in 1879 and was assisted in his endeavors by Thomas H. Newcomb, superintendent of the works, and by Henry Berry, valued designer and master mechanic. Patents received for various pieces after 1880 were issued jointly to Miller and Berry. In 1888 the two men registered the M & B trademark, which was to be stamped on the company's sterling silver well into the 1890s.

The Derby Silver Company became known for the high quality of its "German," or "nickel," silver, a silver-white alloy of copper, zinc, and nickel used as a base metal in the silverplating process. The company's catalogue of 1883 illustrates many pieces that, like the fan-shaped tray (FIG. 8.23), are hand engraved with such Japanese motifs as fans, cranes, butterflies, and cattails, all popular insignia of the Aesthetic movement.

The Derby Silver Company consolidated in 1933 with the International Silver Company (incorporated 1898), an amalgamation of numerous Connecticut, New York, and New Jersey manufacturers of silver and silverplated wares.

REFERENCES
Derby Silver Company, *Standard 1874 Price List of the Finest Grade of Silver Plated Ware . . .* (Philadelphia, 1874) // Samuel Orcutt, *The History of the Old Town of Derby, Connecticut, 1642–1880* (Springfield, Mass., 1880), pp. 256, 373, 408 // *Illustrated Review of the Naugatuck Valley* (New York, 1891), pp. 42–44 // Charles Bancroft Gillespie, *Souvenir History of Derby and Shelton, Connecticut . . .* (Derby, 1896), pp. 16–17 // "Miller, Watson John," in *The National Cyclopaedia of American Biography,* vol. 9 (New York, 1899), p. 101 // James B. McNamar, comp., *Official Souvenir and Program of Monument, First Connecticut Heavy Artillery and Dedicatory Exercises Held on State Capitol Grounds . . .* (Hartford, Conn. [1902?]), pp. 42–43 // Dorothy T. Rainwater and H. Ivan Rainwater, *American Silverplate* (Nashville, Tenn., and Hanover, Pa., 1968), pp. 13–27, 39–132 // *Victorian Silverplated Holloware* (Princeton, N.J., 1972), pp. 105–6, 109–56 (ills.) // Dorothy T. Rainwater, *Encyclopedia of American Silver Manufacturers* (New York, 1975), pp. 42, 77 // Mint Museum, Charlotte, N.C., *Mint Museum Antiques Show* (sale cat., Oct. 2–4, 1981), p. 20 (ill.)

Maria Oakey Dewing
1845–1927
New York City
Painter and decorative artist

Maria Richards Oakey was an accomplished painter in her own right before her marriage to the artist THOMAS WILMER DEWING in 1881. During the 1870s she was at the forefront of progressive art activity in New York, and the development of her artistic career, which included decorative as well as fine arts, suggests the impact of the Aesthetic movement on painters of her generation, particularly women.

Not much is known about the early years of Maria Richards Oakey, the fifth of ten children born to William Francis Oakey, an importer in New York, and his wife, Sally Sullivan Oakey, a cultivated Bostonian and a writer. Mrs. Oakey's book *From Attic to Cellar: A Book for Young Housekeepers* (1879) is a little-known volume of advice on home management and domestic etiquette that is related to the spate of books on household art and decoration published during this period, beginning in England with CHARLES LOCKE EASTLAKE's *Hints on Household Taste* (1868, FIG. 4.1) and followed in America by CLARENCE COOK's *House Beautiful* (1878, FIG. 5.6) and HARRIET PRESCOTT SPOFFORD's *Art Decoration Applied to Furniture* (1878, FIG. 2.3).

Maria Oakey began her art training in 1870 (or perhaps as early as 1866) under William Rimmer (1816–1879), George Butler (1838–1907), Edwin Forbes (1839–1895), and R. Swain Gifford (1840–1905) at the Cooper Union School of Design for Women in New York (where her friend HELENA DE KAY also studied) but apparently stayed only one year. Between 1871 and 1875 Oakey was enrolled in the Antique School of the National Academy of Design; she and De Kay shared a New York studio/apartment. During this period she also studied with JOHN LA FARGE. It was probably at La Farge's suggestion that Oakey went to

Boston to work with William Morris Hunt (1824–1879) and to Paris in 1876 to study with Thomas Couture (1815–1879). Even as a student her work was greatly respected, as one of her colleagues later recalled: "Maria Oakey . . . was looked upon as a distinguished student on account of her work being exhibited at the Academy, and attracting much attention for its broad, vigorous brush work, and rich, glowing color" (Bienenstock, 1977, pp. 52, 55).

In 1875 Oakey participated in the exhibition organized by John La Farge at DANIEL COTTIER's gallery in New York and the subsequent establishment of the Art Students League, both of which were reactions by a younger, European-influenced generation of artists against the conservative policies of the National Academy. The Cottier exhibition, which was well received by the press, was an important prelude to the formation of the Society of American Artists in 1877. Oakey was one of the society's early members and in 1878 displayed a work called *Violets* in its first annual exhibition. In a *Scribner's Monthly* article of 1880, the critic William C. Brownell singled her out: "It ought not to be forgotten that for a long time Miss Oakey was, in spirit and intention, one of the very few who can be termed the pioneers of the movement in painting which only yesterday everyone was calling 'the new movement' . . ." (Hobbs, 1981, p. 27, n. 67).

Oakey, whose art during the 1870s consisted predominantly of figural works and portraits, shifted in the 1880s to still lifes, specifically to flowers that were mostly painted out-of-doors. The work of her mentor, John La Farge, in this genre was enormously influential, as was the period's growing interest in oriental and decorative art, the latter of particular significance for women. For La Farge, Maria Oakey, and other painters like them, flowers were virtually arrangements of pure color and form: "Flowers offer a removed beauty that exists only for beauty," Maria wrote in 1915, "more abstract than it can be in a human being, even more exquisite" (Bienenstock, 1976, p. 27).

Her marriage to Thomas Wilmer Dewing in 1881 may also have been significant in changing Maria Oakey's artistic direction: because he was by then considered one of the major American figure painters, she may have wished to avoid being in direct competition. Thomas Dewing was an avid horticulturist as well, and during the couple's summers in Cornish, New Hampshire, between 1885 and 1905, Maria became a self-trained but proficient botanist who believed that the garden was the most important subject of study for the painter of nature. It has been suggested that Maria may have painted the abstracted floral backgrounds in some of her husband's paintings, such as *Portrait of Delancey Iselin Kane as a Boy* (ILL. 9.28) and *The Days* (FIGS. 9.18, 9.19).

During the early 1880s Maria Dewing created tapestry-like embroidered appliqué pieces, of which only a few are known to exist (FIGS. 9.2, 9.3). Her interest in this field was shared by her architect brother, Alexander F. Oakey (b. 1850), who wrote frequently on decorative-art subjects and illustrated two of Dewing's textiles in his 1884 book *The Art of Life and the Life of Art*. Dewing herself au-thored two books before the responsibilities of marriage, motherhood, and her painting career curtailed further writing until 1915, at which time she began a series of articles on painting for the *American Magazine of Art*. Although related to her interest in textiles, *Beauty in Dress* (1881), a study of color harmonies in costume and complexion, is essentially written from a painter's point of view. *Beauty in the Household* (1882) discusses the arrangements and accouterments of domestic rooms in addition to providing an unusual and revealing chapter on color.

For many years Dewing did not publicly acknowledge her interest in decorative arts. In 1921 she wrote to Royal Cortissoz, critic for the *New York Herald Tribune,* encouraging him to come and see the painted tapestries she had recently undertaken with her friend Mrs. Low. "Of course you do not know that for forty years past I have at moments broken out into decoration—all sorts of minor arts—sometimes never letting these passing attacks have the least publicity. Ages ago I did a theatre curtain & the famous & infamous Oscar Wilde praised it exorbitantly & said 'Why don't you go into decoration & wipe them all out?'—Because I must paint pictures or die said I" (Dewing to Cortissoz, Feb. 20, 1921).

Thus paintings of floral subjects were Dewing's major professional commitment throughout her career. She won bronze medals at the Chicago World's Columbian Exposition in 1893 and at the Buffalo Pan-American Exposition in 1901, and she had one-woman shows at the Pennsylvania Academy of the Fine Arts in 1907 and at the Knoedler and Company gallery in New York in 1914. Charles Lang Freer, John Gellatly, and Whitelaw Reid were among her distinguished patrons. Although in her own day she was compared to La Farge and to the French painters Henri Fantin-Latour (1836–1904) and Antoine Vollon (1833–1900), after her death, in 1927, Dewing's reputation faded into obscurity. Only recently have her works and career become the subject of scholarly and popular interest.

REFERENCES
Clarence Cook, *The House Beautiful: Essays on Beds and Tables, Stools and Candlesticks* (New York, 1878; reprint New York, 1980) // [Sally Sullivan] Oakey, *From Attic to Cellar: A Book for Young Housekeepers* (New York, 1879) // Alexander F. Oakey, *Building a Home* (New York, 1881) // [Maria Richards] Oakey, *Beauty in Dress* (New York, 1881) // "Colors Women Should Wear: Miss Oakey's Book on the Mysteries of Artistic Costumes," *Art Amateur* 5 (Nov. 1881), p. 130 // [Maria Oakey] Dewing, *Beauty in the Household* (New York, 1882) // [Alexander F. Oakey], "A Trial Balance of Decoration," *Harper's New Monthly Magazine* 64 (Apr. 1882), pp. 734–40 // [Maria Oakey] Dewing et al., "Walls and Ceilings from Well-Known Authors," *Decorator and Furnisher* 1 (Jan. 1883), p. 124 // Alexander F. Oakey, *The Art of Life and the Life of Art* (New York, 1884), pp. 33–34 // Maria Oakey Dewing, letter to Royal Cortissoz, Feb. 20, 1921, Royal Cortissoz Papers, Collection of American Literature, The Beinecke Rare Book and Manuscript Library, Yale University, New Haven // Jennifer A. Martin [Bienenstock], "The Rediscovery of Maria Oakey Dewing," *Feminist Art Journal* 5 (Summer 1976), pp. 24–27, 44 // Idem, "Portraits of Flowers: The Out-of-Door Still-Life Paintings of Maria Oakey Dewing," *American Art Review* (Los Angeles) 4 (Dec. 1977), pp. 48–55, 114–18 // Susan Hobbs, "Thomas Wilmer Dewing: The Early Years, 1851–1885," *American Art Journal* 13 (Spring 1981), pp. 26–27 (n. 67), 30–32 (n. 83) // Whitney Museum of American Art, New York, *Reflections of Nature: Flowers in American Art,* by Ella M. Foshay (exhib. cat., 1984), pp. 59–60, 62, 185 (nn. 91–95) // Jennifer A. Martin Bienenstock, Brussels, Belg., correspondence, July 24, 1984, and Jan. 24, 1986

Thomas Wilmer Dewing
1851–1938
New York City
Painter

Thomas Wilmer Dewing was born in Boston, Massachusetts; his father, who was in the paper-manufacturing business and owned a paper mill, died while he was still a child. Educated at home by his sister, Dewing first worked for a commercial lithographer, then trained under the prominent Belgian-born lithographer Dominique C. Fabronius. During the late 1860s and early 1870s he seems to have considered a variety of professions—he was listed variously in city directories as a taxidermist, a clerk, and finally, in 1872, as an artist. Dewing's opportunities for study in Boston were limited. In 1874–75 he may have attended William Rimmer's lectures at the Studio Building, where he was then in residence, and he may also have attended a life-drawing class arranged by students in a room at the Lowell Institute. To support himself, and in all likelihood to earn money for his European studies, in 1875 Dewing made a number of portrait drawings, which he executed in Albany, New York.

Dewing left for Paris in July 1876, and there he studied drawing at the popular Académie Julian with Jules-Joseph Lefebvre (1836–1911) and Gustave Boulanger (1824–1888). On his return to the United States in 1878, he took a studio in Boston, first in the Studio Building and later with Henry O. Walker (1843–1929) at 12 West Street. He taught at the newly founded art school of the Museum of Fine Arts and exhibited his work in both New York and Boston. In 1880 he moved to New York and set up his studio in the Rembrandt Building. The following year he married the noted flower painter MARIA RICHARDS OAKEY, whose publications on household art reveal the strong influence of the Aesthetic movement. Dewing soon joined with other young artists then returning from Europe to challenge established American artists and institutions; in 1882 he was elected a member of the Society of American Artists, and he began to teach at the Art Students League, where he served as an instructor for the next seven years.

Dewing's career has only recently been fully examined. His early works, those painted in Paris or shortly after his return, reflect the rigors of his academic training in their linearity, precision, and attention to detail. During the

1880s his works, such as *The Days* (1887, FIGS. 9.18, 9.19), present a new monumentality and an ornamental character that suggest Dewing's awareness of the paintings by the British aesthetes Dante Gabriel Rossetti (1828–1882) and Edward Burne-Jones (1838–1898), with whom he was frequently compared in the press. Like other artists of his generation, he undertook decorative projects, the appearance of which can be gleaned from period illustrations (ILL. 9.25). JAMES ABBOTT MCNEILL WHISTLER's influence on Dewing can be seen in his portrait of Delancey Iselin Kane (1887, ILL. 9.28), in which the artist emulates Whistler's cool, tonal palette and austere composition. Dewing's decorative paintings of women set in generalized landscapes and illuminated by a gentle half-light, seem to begin in the 1890s, shortly after Dewing started to visit the artists' colony at Cornish, New Hampshire. After the turn of the century, however, his figures appear in unadorned interiors, his creations inspired anew by Whistler's work. As the critic Sadakichi Hartmann (1867–1944) wrote, Dewing's sole aim was "to represent beautiful ladies, mostly mature women of thirty . . . [who] seem to possess large fortunes and no inclination for any professional work. They all seem to live in a Pre-Raphaelite atmosphere, in mysterious gardens, on wide, lonesome lawns, or in spacious empty interiors . . . there they sit and stand, and dream or play the lute or read legends . . . they all have a dream-like tendency, and, though absolutely modern, are something quite different from what we generally understand by modern women" (Hartmann, 1902, pp. 301–2). The term tonalist, or perhaps quietist, best describes Dewing, although he is often associated with the American Impressionists, with whom he displayed his works, beginning with the 1898 Ten American Painters exhibition.

Dewing produced an impressive oeuvre, not only in oil but also in pastel and silverpoint, two media that enjoyed a revival in America during the 1880s and 1890s. The well-known architect Stanford White, who often designed Dewing's frames, brought Dewing's work to the attention of a number of important patrons, among them Charles Lang Freer of Detroit and John Gellatly of New York. Their collections of Dewing's paintings are now preserved at the Smithsonian Institution's Freer Gallery of Art and National Museum of American Art, Washington, D.C.

REFERENCES
Greta [pseud.], "Boston Correspondence," *Art Amateur* 2 (Mar. 1880), pp. 74–75 // [Alexander F. Oakey], "A Trial Balance of Decoration," *Harper's New Monthly Magazine* 64 (Apr. 1882), pp. 734–40 // "Decoration Notes" [Mr. Charles J. Osborne's country house], *Art Age* 2 (Jan. 1885), p. 81 // Ripley Hitchcock, "Spring Exhibition, National Academy," *Art Review* 1, no. 6 (1887), pp. 1–6 // Sadakichi Hartmann, *A History of American Art,* 2 vols. (Boston, 1902), vol. 1, pp. 299–308 // Charles H. Caffin, "The Art of Thomas W. Dewing," *Harper's Monthly Magazine* 116 (Apr. 1908), pp. 714–24 // Royal Cortissoz, "An American Artist Canonized in the Freer Gallery—Thomas W. Dewing," *Scribner's Magazine* 74 (Nov. 1923), pp. 539–46 // Nelson C. White,

"The Art of Thomas W. Dewing," *Art and Archaeology* 29 (June 1929), pp. 253–61 // M. H. de Young Memorial Museum, San Francisco, *The Color of Mood: American Tonalism, 1880–1910,* by Wanda M. Corn (exhib. cat., 1972) // Sara Lea Burns, "The Poetic Mode in American Painting: George Fuller and Thomas Dewing" (Ph.D. diss., University of Illinois, Urbana-Champaign, 1979) // Susan Hobbs, "Thomas Wilmer Dewing: The Early Years, 1851–1885," *American Art Journal* 13 (Spring 1981), pp. 4–35 // Kathleen Pyne, "*Classical Figures,* a Folding Screen by Thomas Dewing," *Bulletin of the Detroit Institute of Arts* 59 (Spring 1981), pp. 5–15 // Susan Hobbs, "Thomas Dewing in Cornish, 1885–1905," *American Art Journal* 17 (Spring 1985), pp. 3–32

Dominick and Haff
1872–1928
New York City
Silver

The firm of Dominick and Haff has a long and complicated history. Though not established until 1872 or incorporated until 1889, Dominick and Haff can trace its beginnings to William Gale and Son, which started in New York in 1821, changed its name to Gale and North in 1860, and became Gale, North and Dominick in 1868, when Henry Blanchard Dominick (1847–1928) entered the business. (What relation, if any, he was to the James W. Dominick listed in New York city directories between 1865 and 1869 as a merchant of hardware and silver and in 1868–69 as a partner in Dominick and Corning, 447 Broome Street, is not known.) When Leroy B. Haff became a partner in 1870, after working for three years in the retail department, the firm changed its name to Gale, Dominick and Haff. The company was first listed as Dominick and Haff, at 451 Broome Street, in the New York city directories of 1873–74. It moved to Bond Street the following year and moved again, in 1893, to 860 Broadway, where it remained until 1904. Directory listings under various addresses continue into the 1920s.

About 1880 the company reportedly acquired the silverware tools and patterns of Adams and Shaw, a firm of silver and silver-plate manufacturers that had been absorbed by TIFFANY AND COMPANY. Dominick and Haff purchased the McChesney Company, in Newark, New Jersey, about 1926, and in 1928, the year of H. B. Dominick's death, was itself absorbed by Reed and Barton of Taunton, Massachusetts.

Relatively few details of Dominick and Haff's history are known at present. The firm sold its wares to such establishments as Bailey, Banks and Biddle, a venerable jewelry and silver company with a retail shop on Chestnut Street in Philadelphia. It was to that concern that Dominick and Haff sold the tea and coffee service (FIG. 8.18) embellished with repoussé floral ornament and butterflies, which stands as mute testimony to the company's standards of craftsmanship.

REFERENCES
American Art Association, New York, *Chinese Porcelains, Jades, and Other Semi-precious*

Stones from the Collections of Mr. H. B. Dominick and Mrs. Julius Chein (sale cat., Nov. 10–11, 1926) // "H. B. Dominick" [obituary], *New York Times,* Dec. 24, 1928, p. 13 // Reed and Barton, and Dominick and Haff, *The History of the Spoon, Knife, and Fork* ([Taunton?], Mass.], 1930) // Dorothy T. Rainwater, *Encyclopedia of American Silver Manufacturers* (New York, 1975), pp. 11–12, 43, 107, 132–34 // Charles H. Carpenter, Jr., and Mary Grace Carpenter, *Tiffany Silver* (New York, 1978), pp. 213–14 // Kathleen Stavec, New Jersey Historical Society, Newark, correspondence, Aug. 13, 1984 // Ulysses G. Dietz, The Newark Museum, N.J., and Dorothy T. Rainwater, correspondence, May 7, 16, and 21, 1985

Christopher Dresser
1834–1904
London
Industrial designer and ornamentalist

Christopher Dresser, following in the footsteps of his mentor, OWEN JONES, was the most influential ornamentalist of the Victorian period as well as an original and prolific industrial designer. Like Jones, Dresser sought to codify principles of design, and his publications on the subject included several folio volumes of ornamental designs in full color. Whereas Jones was sympathetic to the use of historical patterns, Dresser called for a new ornamental aesthetic free of past associations. Originally trained as a botanist, Dresser was fascinated by the geometry of plant structure, from which he developed a distinctive decorative vocabulary. Dresser shared with John Ruskin (1819–1900) the use of nature as the basis of ornament, but pushed the concept of ornamentation from naturalism toward ever-greater abstraction and flatness. In ideological opposition to Ruskin, Dresser condemned neither industrialism nor machine production.

Dresser was born in Glasgow, Scotland. His parents encouraged his artistic bent by allowing him to matriculate in the government-run School of Design at Somerset House, London, where he began his studies in 1847; about 1854 Dresser started to lecture on botany at the school, which had moved to Marlborough House several years earlier. In 1852 he had attended Jones's lectures "On the True and False in the Decorative Arts," in which Jones outlined the propositions that he was to articulate in his 1856 *The Grammar of Ornament.* Dresser assisted Jones with the last ten plates of the *Grammar,* which illustrated geometrized designs derived from nature, and drew plate 98 himself (FIG. 2.1).

In 1857 Dresser wrote the first of several articles for the *Art Journal* on "Botany, as Adapted to the Arts and Art-manufacture." Two years later he published two books on botany, called *The Rudiments of Botany* and *Unity in Variety;* soon afterward he was appointed professor of Botany Applied to the Fine Arts in the Department of Science and Art at the School of Design in South Kensington, London. Dresser was awarded an honorary doctorate from the University of Jena in 1860, but when he failed to be appointed to the chair in botany at University College, London, he became less involved with science and more

focused on the artistic potential of plant forms. *The Art of Decorative Design* (1862), his earliest book on the subject, was expanded from an 1857 article. Objects of Dresser's design were shown at the 1862 International Exhibition in London, where he was first exposed to Japanese art in the display of Rutherford Alcock's collection. Dresser's mature style, documented in one surviving sketchbook, was fully developed by the mid-1860s. In 1871–72 Dresser wrote articles on the principles of decorative design for Cassell's *Technical Educator,* which he intended as a practical guide for industrial manufacturers and which in 1873 he issued as a book in both London and New York. *Studies in Design,* an important compendium of Dresser's designs, appeared between 1874 and 1876 (ILLS. 2.5, 2.6).

With the help of his assistant J. MOYR SMITH and others, Dresser was extremely active as an industrial designer in England from the mid-1860s, when he became associated with MINTON AND COMPANY and with JOSIAH WEDGWOOD AND SONS, LIMITED. A relationship with the Watcombe Pottery Company in Devon began about 1871, and in 1879 Dresser became art director for the Linthorpe Pottery, for which he worked until 1882. The decoration on a two-handled earthenware Wedgwood vase of 1867 (FIG. 7.11) was later published as the "Design Exemplifying Power" in *Principles of Decorative Design* (1873). About 1871 Dresser began to design cast-iron furniture for the Coalbrookdale Ironworks in Shropshire. His association with Hukin and Heath (ILL. 8.5) and ELKINGTON AND COMPANY (ILL. 8.4) seems to date from about 1878 and 1884, respectively, although some of his silver and silverplate designs appear to date from the early 1870s. Dresser also created wallpapers for such firms as JEFFREY AND COMPANY, textiles for Warner and Sons, and carpets for Brinton. In 1879 Dresser, in partnership with Charles Holme of Bradford, established the short-lived concern of Dresser and Holme to import oriental goods. The following year he was appointed art editor of the *Furniture Gazette,* a post he held for one year. That same year he became art manager of the Art Furnishers' Alliance, an organization that attempted to produce goods based on the principles of Dresser and Jones; after only three years the alliance folded, despite backing from Arthur Lasenby Liberty and others.

Dresser's writings as well as his designs for two-dimensional ornament had a major influence on the Aesthetic movement in America, perhaps, one could venture to say, even greater impact than in England. One of the few important British designers actually to visit the United States, Dresser took an active interest in American manufactures. Several art periodicals, including the *Art Amateur,* published Dresser's comments on household decoration and design. Some trade journals, among them the *Carpet Trade Review,* bristled at Dresser's insinuation that American industry perpetrated bad taste—epitomized by carpet patterns that inappropriately featured full-blown, naturalistically rendered roses and fragments of Louis XVI ornaments, for example—and hastened to provide the public with Dresser's formula for remedy. Dresser's approach to ornament was especially appealing to American

neophytes in the field of decoration because it emphasized the flattened, stylized interpretation of easily accessible natural forms, such as flowers and birds, and required no previous artistic education or knowledge of history. LOUIS SULLIVAN's ornamental drawings of 1873–75 (ILL. 10.33, FIG. 10.6) demonstrate the immediate influence of Dresser's publications during those years: the frontal floral forms symmetrically flanked by wing-shaped leaves, for example, are recognizably derived from Dresser (ILL. 2.6). The publication in American periodicals as early as 1877 of Dresser-like patterns (ILLS. 2.7, 6.2, 6.3) by British artists working in the United States, such as CHARLES BOOTH, soon gave Dresser's ideas an even wider circulation, as materially reflected in wallpapers by American manufacturers (FIGS. 3.4, 3.5).

In 1876 Dresser traveled to America to visit the Philadelphia Centennial Exposition. While there he produced and patented a number of wallpaper designs (ILL. 3.10). The lectures he delivered at the newly formed Pennsylvania Museum and School of Industrial Art were published the following year. A comparison of one of Dresser's own wallpaper designs (ILL. 3.11) with a bronze doorplate and escutcheon made in Nashua, New Hampshire, about ten years later (FIG. 8.26) forcefully demonstrates how thoroughly the Anglo-aesthetic vocabulary was incorporated into the mainstream of American industrial arts.

From the United States Dresser continued on to Japan, where he acquired a large collection of objects for TIFFANY AND COMPANY during his stay of several months. He documented his trip in a book of 1882, *Japan: Its Architecture, Art, and Art Manufactures,* one of the most accurate accounts of life in the Far East to be published during this period. Another major publication, *Modern Ornamentation,* followed in 1886, and three years later Dresser opened a studio in Barnes, near London, that he ran with the help of ten assistants until the 1890s. During a business trip to Alsace in 1904, he died unexpectedly.

The stark look of some of Dresser's metalwork has been viewed as presaging the geometric character of much twentieth-century design, especially that of the Bauhaus, and his emphasis on the two-dimensionality of surface ornament can be seen as prefiguring related concerns in twentieth-century painting. However, despite Dresser's apparent position as a rare "pioneer of modern design," to use Nikolaus Pevsner's term, he shared with many other nineteenth-century theorists and designers a fascination with nature, an eclectic interest in various international and historical styles of ornament, and an insistence on the honest use of materials and decoration.

REFERENCES
Christopher Dresser, "Botany, as Adapted to the Arts and Art-manufacture," pts. 1–6, *Art Journal* (London), Jan. 1857, pp. 17–19; Feb. 1857, pp. 53–55; Mar. 1857, pp. 86–88; Apr. 1857, pp. 109–11; Aug. 1857, pp. 249–52; Nov. 1857, pp. 340–42 // Idem, *The Rudiments of Botany, Structural and Physiological, Being an Introduction to the Study of the Vegetable Kingdom . . .* (London, 1859) // Idem, *Unity in Variety, as Deduced from the Vegetable Kingdom, Being an Attempt at Developing That Oneness*

Which Is Discoverable in the Habits, Mode of Growth, and Principle of Construction of All Plants (London, 1859) // "Dr. Dresser's Process of Nature-printing," *Art Journal* (London), July 1861, p. 213 // Christopher Dresser, *The Art of Decorative Design, with an Appendix, Giving the Hours of the Day at Which Flowers Open . . . the Characteristic Flowers of the Month . . .* (London, 1862; reprint Watkins Glen, N.Y., 1977) // Idem, *Development of Ornamental Art in the International Exhibition* (London, 1862) // Idem, *Principles of Decorative Design* (London and New York, 1873) // Idem, *Studies in Design* (London, 1874–76) // Idem, "On Eastern Art and Its Influence on European Manufacturers and Taste," *Journal of the Society of Arts* 22 (Feb. 6, 1874), pp. 211–21 // Idem, "Carpets," in *British Manufacturing Industries,* vol. 5 (London, 1876), pp. 90–130 // Idem, "Art Industries," *Penn Monthly,* Jan. 1877, pp. 12–29 // Idem, "Art Museums," *Penn Monthly,* Feb. 1877, pp. 117–29 // Idem, "Art Schools," *Penn Monthly,* Mar. 1877, pp. 215–25 // George A. Leavitt and Company, New York, *The Dresser Collection of Japanese Curios and Articles Selected for Messrs. Tiffany and Co.* (sale cat., June 18, 1877) // Christopher Dresser, "The Art Manufactures of Japan, from Personal Observation," *Journal of the Society of Arts* 26 (Feb. 1, 1878), pp. 169–77 // Shirley Dare, "A Lady's Chat about Carpets," *Carpet Trade Review* 5 (Aug. 1878), pp. 92–93 // "A Japanese Room," *Art Journal* (Appleton's) 4 (Nov. 1878), pp. 324–25 // Christopher Dresser, "Notes on Four Japanese Ceilings, of Which Copies Were Presented to Dr. D. by the Japanese Minister of the Interior, Etc.," manuscript, 1879, Library of the Victoria and Albert Museum, London // "The Power to Design a Source of National Wealth and Prosperity," *Carpet Trade* 10 (Aug. 1879), pp. 13–14 // "Harmony of Colors," *Carpet Trade* 11 (Feb. 1880), p. 16 // "High Art in England: Jingoism among the Kidderminster Carpet Manufacturers," *Carpet Trade* 11 (June 1880), p. 19 // "Are We Progressive?" *Carpet Trade Review* 7 (Sept. 1880), p. 170 // "Ceiling and Wall Papers," *Art Amateur* 3 (Sept. 1880), pp. 84–85 // "A Few Words to Mr. Dresser," *Carpet Trade Review* 7 (Sept. 1880), p. 172 // "Parisian Fancies," *Carpet Trade Review* 7 (Nov. 1880), p. 223 // "What Subjects May Be Used for Carpet Designing," *Carpet Trade Review* 7 (Nov. 1880), p. 209 // "Anachronisms in Art," *Carpet Trade Review* 7 (Dec. 1880), pp. 231–32 // Christopher Dresser, *Principles of Art . . . Adopted by the Art Furnishers Alliance* (London, 1881) // "Wisdom from Here and There: Bad Taste in England," *Carpet Trade Review* 8 (Oct. 1881), pp. 184–85 // Christopher Dresser, *Japan: Its Architecture, Art, and Art Manufactures* (London and New York, 1882) // "Correct Principles in Furniture," *Art Amateur* 6 (Jan. 1882), pp. 37–38 // "Conventionalization of Flowers," *Carpet Trade Review* 9 (Mar. 1882), pp. 25–26 // "Corruption of Renaissance Ornament," *Art Amateur* 7 (Sept. 1882), p. 87 // [Furniture designs], *Art Amateur* 8 (Dec. 1882), pp. 14, 15 (ills.) // "Dr. Dresser on Furniture," *Art Amateur* 9 (July 1883), pp. 38–40 // "Sideboard: Designed in the Office of Christopher Dresser," *Art Amateur* 9 (Aug. 1883), p. 60 (ill.) // "Dr. Dresser on Carpet Designs," *Carpet Trade and Review*

16 (Jan. 15, 1885), pp. 33–34 // Christopher Dresser, "The Decoration of Our Homes," pts. 1–4, *Art Amateur* 12 (Mar. 1885), pp. 86–88; (Apr. 1885), pp. 109–10; 13 (June 1885), pp. 14–17; (July 1885), pp. 33–34 // Idem, *Modern Ornamentation, Being a Series of Original Designs for the Patterns of Textile Fabrics, for the Ornamentation of Manufactures in Wood, Metal, Pottery, . . . Also for the Decoration of Walls and Ceilings and Other Flat Surfaces* (London, 1886; reprint New York, 1978) // "Ceilings, Walls and Hangings: Some Modified Views by Dr. Dresser," *Decorator and Furnisher* 13 (Oct. 1888), pp. 26–27 // "The Work of Christopher Dresser," *International Studio* 6 (1899), pp. 104–14 // [Christopher Dresser, obituary], *Architect and Contract Reporter* 72 (Dec. 2, 1904), p. 360 // Nikolaus Pevsner, "Minor Masters of the Nineteenth Century, 9: Christopher Dresser, Industrial Designer," *Architectural Review* 81 (Mar. 1937), pp. 183–86 // Edgar Kaufmann, Jr., "Makers of Tradition, 30: Edward Godwin and Christopher Dresser, the 'Esthetic' Designers, Pioneers of the 1870's," *Interiors* 118 (Oct. 1958), pp. 162–65 // Shirley Bury, "The Silver Designs of Dr. Christopher Dresser," *Apollo* 76 (Dec. 1962), pp. 766–70 // Patricia Wardle, *Victorian Silver and Silver-plate* (New York, 1963), pp. 173–89 // C. Bracegirdle, "Linthorpe: The Forgotten Pottery," *Country Life* 149 (Apr. 29, 1971), pp. 1022–25 // Fine Art Society Limited, London, *Christopher Dresser, 1834–1904,* by Stuart Durant et al. (exhib. cat., 1972) // Birmingham Museums and Art Gallery, Eng., *Birmingham Gold and Silver, 1773–1973* (exhib. cat., 1973), "Functionalism," and figs. E1–E24 // Stuart Durant, "Aspects of the Work of Dr. Christopher Dresser (1834–1904), Botanist, Designer, and Writer" (thesis, Royal College of Art, 1973) // Malcolm Haslam, *English Art Pottery, 1865–1915* (Woodbridge, Eng., 1975), pp. 24–25, 26 (ill.), figs. 45, 104–9, 132–34, 136 // David [A.] Hanks, "Reform in Philadelphia: Frank Furness, Daniel Pabst, and 'Modern Gothic' Furniture," *Art News* 74 (Oct. 1975), pp. 52, 54 // Brenda Greysmith, *Wallpaper* (New York, 1976), pp. 144–46, 149 // Camden Arts Centre, London, *Christopher Dresser, 1834–1904,* by Michael Collins (exhib. cat., 1979) // Isabelle Anscombe, "'Knowledge Is Power': The Designs of Christopher Dresser," *Connoisseur* 201 (May 1979), pp. 54–59 // H. Suzuki, "Western Viewpoint/The Japanese Viewpoint—Christopher Dresser's Japanese Discoveries," *JA* 55 (June 1980), pp. 4–6 // Fine Art Society Limited, London, *Architect-Designers: Pugin to Mackintosh,* by Clive Wainwright and Charlotte Gere (exhib. cat., 1981), pp. 34, 35 (ill.) // Kunstgewerbe Museum, Cologne, *Christopher Dresser: Ein Viktorianischer Designer, 1834–1904* (exhib. cat., 1981) // John Kresten Jespersen, "Owen Jones's *The Grammar of Ornament* of 1856: Field Theory in Victorian Design at the Mid-Century" (Ph.D. diss., Brown University, 1984) // Christopher Dresser, *General Principles of Art, Decorative and Pictorial, . . .* (Philadelphia, n.d.)

Charles Locke Eastlake

1836–1906
London
Author and designer

Perhaps no name was heard more often in America during the Aesthetic movement than that of Charles Locke Eastlake, an Englishman who was the author of a book called *Hints on Household Taste in Furniture, Upholstery, and Other Details* (1868, FIG. 4.1). This volume was the earliest and most influential of the many household-art books published in England and America during the 1870s and 1880s. The first of at least four British editions was issued in London in 1868; the first American edition appeared in 1872, galvanizing public interest in interior design four years in advance of the Philadelphia Centennial Exposition. Subsequent American editions, of which there were seven by 1886 (with additional printings in between), had an impact on interior decoration that lasted for decades. Eastlake's writings were paraphrased, plagiarized, assimilated, and disseminated by American writers (see CLARENCE COOK and HARRIET PRESCOTT SPOFFORD) to an eager but self-conscious audience.

Born in Plymouth, England, Eastlake was the son of an admiralty law agent and the nephew of Sir Charles Lock Eastlake (1793–1865), president of the Royal Academy of Arts and keeper, then director, of the National Gallery in London, who took an active interest in his nephew's education. Young Eastlake displayed a talent for architecture and apprenticed to the architect Philip Hardwick (1792–1870); he later studied at the Royal Academy Schools. He won a prize for his architectural drawings at the Royal Academy in 1854 and exhibited others there in 1855–56. After his marriage, in 1856, Eastlake traveled extensively throughout Europe for three years. He never formally practiced architecture, but served as the assistant secretary of the Royal Institute of British Architects from 1866 until 1871, before becoming the institute's first permanent salaried secretary from 1871 to 1878. In 1872 he published *A History of the Gothic Revival,* concerning English architecture between 1820 and 1870, which is still regarded as an important study of the subject.

As a journalist during the 1860s, Eastlake published a number of articles on furniture and decoration, beginning in March 1864 with "The Fashion of Furniture" in *Cornhill Magazine.* A long series called "Hints on Household Taste" subsequently ran in *Queen;* other articles appeared in the *London Review.* When he reshaped the essays for publication as the book *Hints on Household Taste* in 1868, Eastlake inserted illustrations of furniture, wallpapers, tiles, and artifacts inspired by medieval and "Early English" sources. His furniture forms are solid and undecorated—J. MOYR SMITH described them as "in construction too much like that of a packing-case to suit those who desired something substantial" (Smith, 1887, p. 54). Eastlake's designs bear a marked though simplified resemblance to those of BRUCE J. TALBERT in *Gothic Forms Applied to Furniture, Metal Work, and Decoration for Domestic Purposes,* published the previous year, 1867.

Although he did design actual wallpapers for JEFFREY AND COMPANY (ILL. 3.3) and furniture for the London firm of Jackson and Graham, few examples of which survive, Eastlake had more impact as an arbiter of taste than as a designer. He sought to codify principles to guide the ordinary person in distinguishing

good and bad design in common articles of daily use. Clearly his training as an architect underlies the precepts he emphasized—"honest" construction, simple and functional design, the appropriate use of materials, and conventionalized ornament. Many of these ideas have roots in the work and writings of an older generation of British architects and theorists, such as Augustus Welby Northmore Pugin (1812–1852), John Ruskin (1819–1900), George Edmund Street (1824–1881), and OWEN JONES.

The French theorist and architect Eugène Emmanuel Viollet-le-Duc (1814–1879) was also a seminal influence on British and American architects who turned their attention to furniture and decoration—as WILLIAM BURGES once remarked, "We all cribbed from Viollet-le-Duc" (Jervis, 1984, p. 502). His major publications include a ten-volume analysis of Gothic architecture, the *Dictionnaire raisonné de l'architecture* (1858–68); a six-volume study of Gothic decorative arts, the *Dictionnaire du mobilier français* (1858–75); and a two-volume rationalist theory of architecture, *Entretiens sur l'architecture* (1863–72). A quotation from Viollet-le-Duc on the title page of the 1868 *Hints on Household Taste* suggests that his theories underscore Eastlake's point of view.

Despite his own predilection for the medieval, it was the period's spirit and principles of manufacture Eastlake admired rather than any one particular style—indeed, he found analogous qualities in contemporary Japanese culture. His concepts were broadly interpreted by American cabinetmakers, including A. KIMBEL AND J. CABUS, DANIEL PABST, and HERTER BROTHERS, in pieces ranging from Gothic to oriental in inspiration (FIGS. 5.3, 5.13, 5.27, 5.32).

Eastlake disdained those American manufacturers who literally interpreted his plea for good design at affordable prices as a license for the machine production of lesser-quality goods. These manufacturers popularized an "Eastlake" style (a generic term still in use) that is typically rectilinear in form; made of oak, walnut, or ebonized wood; with turned spindles, balusters, and finials, chamfered edges, and structural hardware; and often finished with gilt-incised geometric surface decoration. Although Eastlake was not philosophically opposed to the use of machines, which even some of the best cabinetmakers used as tools, the invocation of his name in connection with this mass-produced furniture was an unsolicited association that he felt compelled to renounce in print: "I find American tradesmen continually advertising what they are pleased to call 'Eastlake' furniture, with the production of which I have had nothing whatever to do, and for the taste of which I should be very sorry to be considered responsible" (Jervis, 1984, p. 169).

During his tenure at the Royal Institute of British Architects, Eastlake published *Lectures on Decorative Art and Art-Workmanship* (1876) and *The Present Condition of Industrial Art* (1877). Following his uncle's example, Eastlake accepted the post of keeper of the National Gallery in 1878 (a fact that, along with the different spelling of their respective middle names, has often led to confusion). Disappointed in his desire to become director, East-

lake nevertheless contributed a great deal to the organization and preservation of the art collections until he retired in 1898. He spent the last years of his life at his Terra Cottage in the Bayswater section of London.

In 1895, looking back on his career, Eastlake was satisfied with the changes in the decorative arts he had fostered: "Young housekeepers of the present age who sit in picturesque chimney corners, sipping tea out of Oriental china, or lounge on seventeenth century settles, in a parquetry-floored room filled with inlaid cabinets, Cromwell chairs, picturesque sideboards, hanging shelves and bookcases, can form no idea of the heavy and graceless objects with which an English house was filled some twenty years ago—the sprawling sofas, the gouty-legged dining tables, cut-glass chandeliers, lumbering ottomans, funereal buffets, horticultural carpets and zoological hearthrugs. Heaven save us from a return to that phase of ugly conventionalism, of life-less ornament, of dull propriety and inartistic gloom!" (Crook, 1970, p. ⟨20⟩).

REFERENCES

[Charles Locke Eastlake], "The Fashion of Furniture," *Cornhill Magazine* 9 (Mar. 1864), pp. 337–49 // B[ruce] J. Talbert, *Gothic Forms Applied to Furniture, Metal Work, and Decoration for Domestic Purposes* (Birmingham, Eng., 1867; reprint Boston, 1873) // Charles Locke Eastlake, *Hints on Household Taste in Furniture, Upholstery, and Other Details* (Eng. eds., London: 1st ed., 1868; 2d ed., 1869; 3d ed., 1872; 4th ed., 1878; Amer. eds. from the latest Eng. eds., with notes by Charles C. Perkins, Boston: 1st ed., 1872; 2d ed., 1874; 3d ed., 1875; 4th ed., 1876; 5th ed., 1877; 6th ed., 1877, 1878, 1881; 7th ed., 1883; 8th ed., 1886) // "Reviews: *Hints on Household Taste . . . ,*" *Art Journal* (London), Jan. 1, 1869, p. 31 // Charles L[ocke] Eastlake, *A History of the Gothic Revival* (London, 1872) // Idem, *Lectures on Decorative Art and Art-Workmanship* (London, 1876) // Idem, *The Present Condition of Industrial Art* (London, 1877) // "Eastlake and His Ideas," pts. 1, 2, *Art Amateur* 2 (May 1880), pp. 126–27; 3 (June 1880), pp. 14–15 // "High Art in England: Jingoism among the Kidderminster Carpet Manufacturers," *Carpet Trade* 11 (June 1880), p. 19 // J. Moyr Smith, *Ornamental Interiors, Ancient and Modern* (London, 1887), pp. 53–57, 60 // Lewis F. Day, "Victorian Progress in Applied Design," *Art Journal* (London), June 1887, pp. 185–202 // J. F. Boyes, "The Chiefs of Our National Museums, No. 2: The National Gallery, Mr. Charles Locke Eastlake," *Art Journal* (London), Apr. 1891, pp. 120–22 // Charles Locke Eastlake, *Our Square and Circle* (New York, 1895) // George W. Gay, "The Furniture Trade," in *One Hundred Years of American Commerce,* ed. Chauncey M. Depew, 2 vols. (New York, 1895; reprint New York, 1968), vol. 2, pp. 628–32 // Charles Locke Eastlake, "The National Competition of Art Schools, 1902: Decorative Art of the Near Future," pt. 1, *Magazine of Art* 27 (1902–3), pp. 36–39 // "Charles Locke Eastlake" [obituary], *Builder* 9 (1906), p. 607 // "The Late C. L. Eastlake," *Royal Institute of British Architects Journal,* 3d ser., 14 (1906–7), p. 59 // "Eastlake, Charles Locke," in *Dictionary of National Biography,*

vol. 1 (New York, 1912), p. 541 // "Eastlake, Charles Lock [*sic*]," in *Allgemeines Lexikon der Bildenden Künstler,* ed. Ulrich Thieme and Felix Becker, vol. 10 (Leipzig, 1914), pp. 288–89 // Alan Victor Sugden and John Ludlam Edmondson, *A History of English Wallpaper, 1509–1914* (London and New York, 1926), p. 210, pl. 115 // Nikolaus Pevsner, "Art Furniture of the Eighteen-Seventies," *Architectural Review* 111 (Jan. 1952), pp. 43–50 // Elizabeth Aslin, *Nineteenth Century English Furniture* (New York, 1962), p. 61 // J. Mordaunt Crook, Introduction to Charles Locke Eastlake, *A History of the Gothic Revival,* reprint ed. (Leicester, Eng., and New York, 1970) // Royal Academy of Arts, London, *Victorian and Edwardian Decorative Art: The Handley-Read Collection* (exhib. cat., 1972), p. 61 (ill.) // Hudson River Museum, Yonkers, N.Y., *Eastlake-Influenced American Furniture, 1870–1890,* by Mary Jean Smith Madigan (exhib. cat., 1973) // Alan Gowans, Introduction to Charles Locke Eastlake, *A History of the Gothic Revival,* reprint ed. (Watkins Glen, N.Y., 1975) // Mary Jean Smith Madigan, "The Influence of Charles Locke Eastlake on American Furniture Manufacture, 1870–90," *Winterthur Portfolio* 10 (1975), pp. 1–22 // Delaware Art Museum, Wilmington, *The Pre-Raphaelite Era, 1848–1914,* by Rowland Elzea and Betty Elzea (exhib. cat., 1976), p. 62 // Mary Jean [Smith] Madigan, "Eastlake-Influenced American Furniture, 1870–1890," *Connoisseur* 191 (Jan. 1976), pp. 58–63 // Susan Lasdun, "Keeping One's House in Order: Victorian Magazines and Furnishing Taste," *Country Life* 160 (Sept. 9, 1976), pp. 672–73 // Donald C. Peirce, "Mitchell and Rammelsberg, Cincinnati Furniture Manufacturers, 1847–1881," *Winterthur Portfolio* 13 (1978), pp. 222–29 // Fine Art Society Limited, London, *Architect-Designers: Pugin to Mackintosh,* by Clive Wainwright and Charlotte Gere (exhib. cat., 1981), pp. 38, 39 (ill.) // Martha Crabill McClaugherty, "Household Art: Creating the Artistic Home, 1868–1893," *Winterthur Portfolio* 18 (Spring 1983), pp. 1–26 // Barrymore Laurence Scherer, "The Gothicist: Shades of Charles Locke Eastlake," *Connoisseur* 213 (July 1983), pp. 74–79 // Simon Jervis, "Eastlake, Charles Locke," in *The Penguin Dictionary of Design and Designers* (Harmondsworth, Eng., and New York, 1984), pp. 168–69 // Christie, Manson and Woods Limited, London, *British Decorative Arts from 1880 to the Present Day* (sale cat., Jan. 28, 1986), p. 57 (ill.)

Elkington and Company
1824–1968
Birmingham, Warwickshire, England
Silver and silverplate

In the nineteenth century the reputation of Elkington and Company was predicated primarily on its perfection of the electromagnetic processes that revolutionized the art of silverplating and established the company's preeminence in that field.

In 1829 George Richards Elkington (1801–1865) assumed control of a family-owned firm that manufactured gilt articles, gold spectacle cases, and small appointments and accessories, such as silver-mounted scent bottles. During the 1830s, with his cousin Henry Elkington (1810–1852) as partner, he took out patents for improvements to the electrogilding process. Though not the first to experiment with electroplating of metals after the invention of the electric battery in 1800, he was able in 1840 to secure the patent for the first commercially viable process of electroplating silver and gold—that is, the electrical transfer of a coat of precious metal onto a base-metal object. A year later, under the direction of chief metallurgist Alexander Parkes, the company obtained a patent for electrotyping, a method by which multiple facsimiles could be obtained by the electrical transfer of metal into a mold made from an original object. For Elkington and Company, for the British economy, and for American manufacturers the ramifications of these processes were far-reaching. Elkington, having prudently bought up patents for other methods of electroplating, virtually controlled the industry in Britain until about 1875; other firms making electroplated objects were obliged to pay Elkington for the privilege. Electroplated goods were so relatively inexpensive to produce that within ten years the more labor-intensive Sheffield plate industry was all but wiped out. Moreover, luxury items were accessible for the first time to the middle-class consumer because silversmiths could manufacture the same design in both silver and silverplate, with a corresponding difference in price. By the 1860s the public esteem for silverplate was equal to that for sterling.

The electrotyping process spawned many new products, among which reproductions of existing works of art were the most notable. Elkington commissioned Dr. Benjamin Schlick (1796–1872), a Danish designer and amateur archaeologist, to make models of Greek and Roman plate, which the company reproduced as early as 1845. A few years later the South Kensington Museum (now the Victoria and Albert Museum) in London authorized the firm to reproduce objects in its collections. One undated Elkington and Company catalogue entitled *Art Metal Works* even offered full-size ancient statues, among them the *Apollo Belvedere* and the *Venus de' Medici,* "electrotyped in bronze metal if desired." Reproductions of art objects, applauded as educational, served also to make various historical decorative-arts styles popular.

Directed after 1865 by Frederick Elkington, one of George's two sons who had entered the family business in the 1850s, the company prospered from the sale of plated goods while continuing to produce the sterling silver and objects of cloisonné and champlevé enamelwork for which it was always highly respected. Because other British firms had ceased to make silver presentation pieces to exhibit at international fairs, only the Elkington company represented the art of British silversmithing in Philadelphia at the 1876 Centennial Exposition or in Paris at the 1878 Exposition Universelle. The choice of Renaissance and classical forms, often with repoussé embellishment, that dominated Elkington's silver production was to some extent dictated by the firm's French designers, including Emile Jeannest (1813–1857), who joined Elkington about 1849, Leonard Morel-Ladeuil (1820–1888), hired in 1859, and Albert Willms (active before 1848–about

1900), head of the design department from the 1860s until the end of the century.

Willms became interested in oriental art, and under his direction Elkington was among the first to experiment with Japanese forms and techniques during the 1870s; their earliest known work in this genre dates from 1865, just three years after Rutherford Alcock's collection of Japanese objects created excitement at the International Exhibition held in London in 1862. A parcel-gilt silver waiter of 1879 (FIG. 8.4) is one example of Elkington's Japanese-style decoration. This and similar items found American counterparts in silver and silver-plated objects manufactured in the 1880s by companies such as the DERBY SILVER COMPANY (FIG. 8.23).

CHRISTOPHER DRESSER, noted English botanist and ornamentalist, began about 1878 to create a number of designs for several firms to produce in both electroplate and silver; his association with Elkington seems to date from about 1884. A footed sugar bowl (ILL. 8.4; see also ILL. 8.3) of Elkington manufacture exemplifies Dresser's concern for economy of form and material. Almost clinical in its simplicity, the cup's shape suggests a source in Dresser's laboratory utensils, while the supports, amusingly anthropomorphic, bring to mind the Precolumbian pottery that had fascinated him at the Centennial in Philadelphia.

In the twentieth century, Elkington's production was largely confined to domestic plate but also included hot-brass stamping and copper refining. In 1954 the company moved to Goscote Lane, Walsall, near Birmingham, and two years later joined the Delta Group of Companies, in which it is now part of the Metal Products Division, and is known as Elkington Mansill Booth, Limited. Elkington produces high-quality stampings in nonferrous alloys used in the brewery, mining, fire-fighting, and security industries.

REFERENCES
George Richards Elkington, *Précis historique et analytique sur les divers procédés dorure sans mercure et par immersion . . .* (Paris [1841?]) // Charles Christofle, *Histoire de la dorure et de l'argenture électro-chimiques* (Paris, 1851), pp. 1–28, 75–82 // William C. Richards, *A Day in the New York Crystal Palace, and How to Make the Most of It . . .* (New York, 1853), p. 127 and ill. // H. Murray, "Recent Improvements in Minor British Art-Industry," *Art Journal* (London), Nov. 1864, pp. 335–36 // "Birmingham Arts and Manufactures and Their Progress," *Art Journal* (London), July 1866, pp. 223–24 // "Electro-metallurgy," *Art Journal* (London), Sept. 1866, pp. 286–87 // "Fine-Art Door and Bell Furniture," *Art Journal* (London), Dec. 1866, p. 361 // "The Universal Exhibition at Vienna," *Art Journal* (London), Aug. 1873, p. 245 (ill.) // "The Universal Exhibition at Vienna," *Art Journal* (London), Sept. 1873, pp. 278–79 (ills.) // George A. Sala, *Elkingtons and Electro: An Essay* [Philadelphia Centennial Exposition, 1876] (London, 1876) // "A Presentation Tazza," *Art Journal* (Appleton's) 2 (Jan. 1876), p. 8 (ill.) // "Jewelry and Silverware at the Centennial," *Jewelers' Circular and Horological Review* 7 (July 1876), pp. 93–95 // "Art Reproductions in Metal," *Iron Age*, Sept. 7, 1876, p. 14 // "The Paris Universal Exhibi-

tion," pt. 7, *Magazine of Art* 1 (1878), p. 187 (ill.) // J. Hungerford Pollen, "The Year's Advance in Art Manufactures, No. 1: Goldsmiths' and Silversmiths' Work," *Art Journal* (London), Jan. 1883, pp. 23 (ill.), 25 (ill.) // "The Pioneers of Electro-plating," *Art Journal* (London), Jan. 1889, Arts and Industries supplement, pp. 5–6 // W. J. Gawthorp, "Repoussé Metal Work," *Art Amateur* 23 (July 1890), p. 33 // American Art Galleries, New York, *Catalogue of Antique Chinese Porcelains . . . Elkington and Christofle Reproductions of Antiques and Armor . . .* (sale cat., May 8–9, 1919) // Shirley Bury, "The Silver Designs of Dr. Christopher Dresser," *Apollo* 76 (Dec. 1962), pp. 766–70 // Patricia Wardle, *Victorian Silver and Silver-plate* (New York, 1963) // "Metalwork," in Fine Art Society Limited, London, *The Aesthetic Movement and the Cult of Japan,* by Robin Spencer et al. (exhib. cat., 1972) // "Metalwork," in Fine Art Society Limited, London, *Christopher Dresser, 1834–1904,* by Stuart Durant et al. (exhib. cat., 1972), unpaged, nos. 140–43 // Royal Academy of Arts, London, *Victorian and Edwardian Decorative Art: The Handley-Read Collection* (exhib. cat., 1972), pp. 52, 53 (ill.), 75, 76 (ill.) // Birmingham Museums and Art Gallery, Eng., *Birmingham Gold and Silver, 1773–1973* (exhib. cat., 1973), secs. D and E // Judith Banister, "Silver of 1874," *Connoisseur* 185 (Jan. 1974), pp. 49–54 // Shirley Bury, "Elkington's and the Japanese Style," *Worshipful Company of Goldsmiths' Review,* 1974–75, pp. 27–28 // Dorothy T. Rainwater, *Encyclopedia of American Silver Manufacturers* (New York, 1975), pp. 47–48 // Margaret Holland, "Silver Made in Birmingham," *Antiques* 109 (Apr. 1976), pp. 760–65 // Idem, "George Roberts [sic] Elkington, Friend of the Apparently Rich," *Spinning Wheel* 33 (Sept. 1977), pp. 20–23 // Camden Arts Centre, London, *Christopher Dresser, 1834–1904,* by Michael Collins (exhib. cat., 1979), pp. 22–24 // Charles H. Carpenter, Jr., *Gorham Silver, 1831–1981* (New York, 1982), pp. 74, 86 // Margaret Holland, "Elkington's Aid to the Small Collector," *Silver* 18 (Jan.–Feb. 1985), pp. 13–15 // Mrs. Audrey Wall, Elkington Mansill Booth, Limited, Walsall, Eng., correspondence, Nov. 21 and Dec. 3, 1985 // Christie, Manson and Woods Limited, London, *British Decorative Arts from 1880 to the Present Day* (sale cat., Jan. 28, 1986), lots 5, 8, 18 // Elkington and Company, *Art Metal Works* (London, n.d.) // South Kensington Museum [now the Victoria and Albert Museum], *Illustrated Catalogue of Electrotype Reproductions of Works of Art from Originals in the South Kensington Museum Manufactured by Messrs. Elkington and Co. . . .* (London, n.d.) // Idem, *Inventory of Reproductions in Metal . . . for the Use of the South Kensington Museum, and Schools of Art . . . by Elkington and Company* (London, n.d.) // Idem, *Reproductions of Carved Ivories: A Priced Inventory of the Casts in "Fictile Ivory" in the South Kensington Museum . . . by Elkington and Company, Limited* (London, n.d.)

Ellin and Kitson
Active ca. 1867–?
New York City
Architectural sculptors

Published advertisements by the New York Architectural League during the 1880s and 1890s proclaim the firm of Ellin, Kitson and Company as "architectural sculptors," with expertise in carved wood and stone as well as modeled plaster and papier-mâché, and as specialists in church decoration. Between 1887 and 1889 the company was located at 513–519 West Twenty-first Street; number 511 was subsequently added to the row, after which the operation was moved to the "Foot [of] 25th Street, North River, New York," where it remained between 1891 and 1900.

Not much is known about Robert Ellin and John W. Kitson, the two Englishmen who comprised the partnership. In the late 1860s they were hired by the architect P. B. WIGHT to carve some of the column capitals in the National Academy of Design, a building on East Twenty-third Street that Wight had designed in an Italian Gothic style and whose construction was completed in 1865. A decade later Ellin and Kitson displayed a much-reproduced oak sideboard in the Jacobean style at the 1876 Philadelphia Centennial Exposition.

Ellin and Kitson have been credited with the carved satinwood panels incorporating bird motifs, perhaps representing an allegory of domestic life, for the dining room of Samuel J. Tilden's home on Gramercy Park in New York (FIG. 4.5, ILL. 4.11). This building, which became the headquarters of the National Arts Club in 1906, was remodeled under the direction of architect Calvert Vaux (1824–1895) in the early 1880s, the occasion for which these panels were created.

It should be noted that another English sculptor, Samuel J. Kitson (1848–1906), also participated in the redesign of Tilden's house. An article in the *New York Times* in 1882 describes the relief heads of Tilden's literary favorites—including Shakespeare, Milton, Goethe, and Dante—that Samuel Kitson carved on a panel between the entrance doors. Samuel Kitson also knew Tilden personally and modeled a bust of the former New York governor shortly after coming to New York in 1878. His relationship to the firm, however, if other than a coincidence of names, is at present unknown.

REFERENCES
"Culture and Progress: An Exhibition of Decorative Art," *Scribner's Monthly* 10 (Aug. 1875), pp. 518–19 // [George Titus Ferris], *Gems of the Centennial Exhibition: Consisting of Illustrated Descriptions of Objects of an Artistic Character, in the Exhibits of the United States, Great Britain, France . . .* (New York, 1877), pp. 136 (ill.), 137–39 // "Decorative Fine-Art at Philadelphia: American Furniture," pt. 3, *American Architect and Building News* 2 (Jan. 13, 1877), pp. 12–13 // "American Furniture," *Art Journal* (Appleton's) 3 (June 1877), p. 182 (ill.) // "Work on Mr. Tilden's House," *New York Daily Tribune,* Jan. 29, 1882, p. 12 // *Artistic Houses, Being a Series of Interior Views of a Number of the Most Beautiful and Celebrated Homes in the United States,* 2 vols. in 4 pts. (New York, 1883–84; reprinted in 1 pt., New York, 1971), vol. 2, pt. 1, pp. 61–65 // Architectural League of New York, *Catalogue of the . . . Annual Exhibition* (exhib. cat. [published annually]), 1887, p. 30; 1888, p. 8; 1889, p. 34;

1890, p. 38; 1891, p. 60; 1893, p. 86; 1896, p. 199a; 1897, p. 238; 1899, p. 63A // "Death List of the Day: Samuel J. Kitson," *New York Times,* Nov. 10, 1906, p. 9 // "Kitson, Samuel James," in *Allgemeines Lexikon der Bildenden Künstler,* ed. Ulrich Thieme and Felix Becker (Leipzig, 1927), vol. 20, p. 393 // Charles Rollinson Lamb, *The Tilden Mansion—Home of the National Arts Club* (New York, 1932), p. 9 // "Kitson, Samuel James," in *Who Was Who in America,* vol. 1, *1897–1942* (Chicago, 1942), p. 683 // Alan Burnham, ed., *New York Landmarks* (Middletown, Conn., 1963), pp. 136, 137 (ill.) // "Kitson, Samuel James," in *Who Was Who in American History—Arts and Letters* (Chicago, 1975), p. 274 // Dennis Steadman Francis, *Architects in Practice in New York City, 1840–1900* (New York, 1979–80), pp. 29, 47 // William C. Shopsin and Mosette Glaser Broderick, *The Villard Houses: Life Story of a Landmark* (New York, 1980), pp. 47, 64 // Burnham Library of Architecture, Art Institute of Chicago, *P. B. Wight: Architect, Contractor, and Critic, 1838–1925,* by Sarah Bradford Landau (exhib. cat., 1981), p. 20 (n. 30) // Russell E. Burke III, Kennedy Galleries, New York, conversation, 1985 // Ellin, Kitson and Company, "Book of Ornamentation," album of photographs of carving by the firm, n.d., Rare Book Collection, Avery Architectural and Fine Arts Library, Columbia University, New York // Idem, collection of mounted photographs of European architecture assembled by the firm, n.d., Rare Book Collection, Avery Architectural and Fine Arts Library, Columbia University, New York

Etruria Pottery, *see* Ott and Brewer

Eureka Pottery Company
1883–1887
Trenton, New Jersey
Ceramics

British pottery displays at the Philadelphia Centennial Exposition in 1876 brought brightly colored majolica to the attention of American manufacturers, who within a few years began to produce their own versions of these glazed earthenware products. The Eureka Pottery was probably established in Trenton, New Jersey, in 1883, the year it first appears in the city directory. The *Crockery and Glass Journal* soon reported steady progress in the quality of the firm's majolica wares, of which a plate with a Japanesque design is one example (FIG. 7.34). Although the firm did not always mark its majolica, it has been credited with the manufacture of two very popular lines known as the Bird and Fan and the Prunus and Fan.

Little of substance is known about the company's history. The business is listed in the 1883–85 Trenton city directory as being located on Mead Avenue and in 1886–87 at "Clinton opposite Mead." For the first year only Leon Weil and R. Weil are mentioned in connection with the firm. In 1885–86 Noah W. Boch is recorded as its proprietor, and Charles Boch, first noted as a potter in 1884, may also have been involved. The following year, 1886–87, the Bochs are listed again. This time

Charles is named proprietor of the pottery, now called the Eureka Porcelain Works, and Noah is recorded as "pottery superintendent." The Eureka Pottery Company is not mentioned again after 1887, although both of the Bochs appear in the directory for 1889.

REFERENCES
"The Potteries: Trenton," *Crockery and Glass Journal* 17 (May 10, 1883), p. 12 // "The Potteries: Trenton," *Crockery and Glass Journal* 17 (May 17, 1883), p. 21 // "The Potteries: Trenton," *Crockery and Glass Journal* 18 (Oct. 11, 1883), p. 16 // M. Charles Rebert, *American Majolica, 1850–1900* (Des Moines, Iowa, 1981), pp. 63 (ills.), 69, 82 // Ulysses G. Dietz, The Newark Museum, N.J., correspondence, Feb. 5, 1985 // Susan Finkel, New Jersey State Museum, Trenton, correspondence, Feb. 14, 1985

Faience Manufacturing Company
1880–1892
Brooklyn, New York
Ceramics

The Faience Manufacturing Company was established in the Greenpoint section of Brooklyn in 1880 and operated only until 1892. For the first few years, the company manufactured earthenware vases, baskets, and jardinieres enriched with hand-modeled flowers, painted barbotine (colored-slip) decoration, and majolica glazes. The company's initials, FMC°, were used to mark most of their pieces, although the Royal Crown mark was used briefly on their finer china. The zenith of the company's short-lived production coincided with Edward Lycett's tenure as its artistic director from 1884 to 1890.

Lycett (1833–1910) was an Englishman born in Newcastle-under-Lyme, near the Staffordshire potteries. He apprenticed at an early age to the firm of Copeland and Garrett at Stoke-on-Trent, where he worked under Thomas Battam; some examples of his early work were exhibited at the London Great Exhibition of 1851. In 1852 Lycett went to work for Thomas Battam, Sr., in whose London decorating shop he painted facsimiles of the British Museum's Greek vases.

In 1861 Lycett and his family emigrated to New York, where he opened a decorating workshop on Greene Street that eventually employed about forty people. At first Lycett decorated earthenware vases, made according to his designs by the Williamsburg Terra Cotta works on Long Island, and reproduced popular French patterns on imported Sèvres and Haviland china blanks. Lycett became renowned for his successful use of raised gold-work and brilliant over- and underglaze colors, especially a rich, dark blue that approximated the Royal Blue used by the Sèvres factory in France. He was indeed an accomplished painter: the fish, fowl, fruits, and vegetables on some of his early American pieces seem tangibly three-dimensional. He also excelled at monogrammed china services, and in 1865 he was commissioned by John Vogt and Company to reproduce a set of Abraham Lincoln's presidential china. Although the design itself was not his own, the high quality of his workmanship was widely reported. Soon after his

arrival in America, Lycett expanded his production to include items as diverse as painted wash basins and porcelain panels for use in furniture decoration. In 1874 the architect Richard Morris Hunt (1827–1895) hired Lycett to decorate large enameled-iron panels with designs from the Moorish Alhambra for the four-story facade of one of his New York buildings, possibly the Van Rensselaer building, one of his two in cast iron at 474–476 Broadway.

Following the Civil War, Lycett's Greene Street studio became a classroom as well as a professional workshop. He offered lessons in china painting to local ladies and fired the work of such amateur artists as MARIA LONGWORTH NICHOLS of Cincinnati, who sent some of her early pieces to Lycett. Her first husband, GEORGE WARD NICHOLS, is said to have written his book *Pottery: How It Is Made, Its Shape and Decoration* (1878, FIG. 7.30) after visiting Lycett's shop to study its operations. Invited to teach china painting for about a year at the newly organized Saint Louis School of Design, in 1877 Lycett accepted the offer and left William Lycett (1855–1909), the eldest of his three sons, in charge of the New York operations under the partnership name of Warrin and Lycett. Lycett subsequently taught china painting in Cincinnati for a few months; while there he displayed several of his pieces in the loan exhibition prepared by the Women's Art Museum Association in May 1878.

In March 1879 Lycett moved to East Liverpool, Ohio, where he intended to start a decorating business. He also planned to collaborate with Homer and Shakespeare Laughlin in the establishment of a ceramics factory in Philadelphia, but because of the latter's death the project was soon abandoned.

Instead, Lycett returned to New York later that same year, and with a decorator named John Bennett (see JOHN BENNETT) he opened a china-decorating workshop at 4 Great Jones Street. When the firm was dissolved by mutual consent in January 1882, Lycett continued for a short time at that address under his own name. Two years later, when Lycett joined the Faience Manufacturing Company, Bennett took over the Great Jones Street workshop and operated there until at least 1893.

While at the Faience Manufacturing Company, Lycett supervised a minimum of twenty-five decorators and continued to instruct students. He successfully experimented with the production of a fine grade of white porcelain (although most of his known pieces are earthenware) and succeeded in simulating the iridescent metallic glazes of Persian lusterware. Later, in 1895, he donated a number of his pieces, including several of those inspired by Near Eastern ceramics, to the Smithsonian Institution in Washington, D.C.

A bottle-shaped, cream-colored earthenware vase with a long neck and carved openwork cover (FIG. 7.8) recalls a Middle Eastern prototype and is typical of Lycett's work during his association with the Faience Manufacturing Company. Often his large decorative pieces combined an exotic form with Anglo-Japanesque decoration. This one, with its profusion of chrysanthemums in raised metallic gold and bands of deep blue with gold patterns, is similar to a vase once owned by Ed-

win AtLee Barber (1851–1916), as described in the 1917 sale catalogue of Barber's collection (lot 540). Barber, the dean of American ceramics, considered Lycett the "Pioneer of China Painting in America" and compared his work favorably with Sèvres and Minton china.

In 1890 the focus of the firm changed from the production of its own hand-decorated wares to the importation of French ceramics. Two years later it ceased operations altogether. Meanwhile, in 1890 Lycett resigned and retired to Atlanta, Georgia, to assist his son William, who in 1883 had founded a china-painting business and school there. Lycett remained in Atlanta until his death twenty years later. Two other sons, Joseph and Francis (Frank), both china painters, continued in their father's profession in Nashville, Tennessee, and Buffalo, New York, respectively. William Lycett died in 1909, predeceasing his father by one year; his business in Atlanta was carried on by his son, Edward Cordon Lycett, and by his son's heirs, until 1970.

REFERENCES
[Entries by Edward Lycett] in Women's Art Museum Association of Cincinnati, Ohio, *Loan Collection Exhibition* (exhib. cat., 1878), pp. 116–17, 119–21 // "Decorated Pottery," *Crockery and Glass Journal* [hereafter abbreviated as *CGJ*] 9 (Mar. 6, 1879), p. 14 // "Among the Dealers," *Art Amateur* 2 (Jan. 1880), p. 43 // [Bennett and Lycett expanding showroom], *CGJ* 11 (June 3, 1880), p. 16 // [A handsome vase, by Professor Lycett], *Art Amateur* 3 (Sept. 1880), p. 69 // "China Fired for Amateurs . . . Bennett and Lycett" [advertisement], *Art Amateur* 3 (Nov. 1880), p. iv // [Broadway showroom exhibition], *CGJ* 15 (Feb. 23, 1882), p. 22 // [Moving to 21 Warren Street], *CGJ* 15 (May 11, 1882), p. 20 // "China Fired for Amateurs . . . Edward Lycett" [advertisement], *Art Amateur* 7 (July 1882), p. iv // [Praise for showroom exhibit], *CGJ* 16 (July 13, 1882), p. 22 // [John Bennett rejoins Mr. Lycett], *CGJ* 16 (July 20, 1882), p. 22 // [Products improving and line expanding], *CGJ* 16 (Oct. 5, 1882), p. 30 // [Gold and silver relief pieces], *CGJ* 16 (Oct. 19, 1882), p. 26 // [Vase on exhibit in Washington, D.C.], *CGJ* 17 (Feb. 15, 1883), p. 16 // [Moving to Thirty-one Barclay Street], *CGJ* 17 (Apr. 19, 1883), p. 18 // [New styles of artistic pottery], *CGJ* 17 (June 7, 1883), p. 22 // "Lycett's Art Schools and China Decorating Works" [advertisement], *Art Amateur* 9 (Nov. 1883), p. iii // [Mantel sets and cabinet novelties], *CGJ* 17 (Nov. 1, 1883), p. 31 // [Praise for vase], *CGJ* 18 (Dec. 6, 1883), p. 24 // [Progress in artistic pottery], *CGJ* 19 (Mar. 6, 1884), p. 26 // [Description of jug], *CGJ* 20 (July 3, 1884), p. 24 // "Faience Mfg. Co." [advertisement], *Decorator and Furnisher* 7 (July 1886), supplement, p. 121 // Edwin AtLee Barber, "Recent Advances in the Pottery Industry," *Popular Science Monthly* 40 (Jan. 1892), pp. 297 (ill.), 298 // Idem, *The Pottery and Porcelain of the United States* (New York, 1893), pp. 313–19, 414 // Idem, "The Pioneer of China Painting in America," *Ceramic Monthly* 2 (Sept. 1895), pp. 5–20 // Idem, "The Pioneer of China Painting in America," *New England Magazine,* n.s. 13 (Sept. 1895), pp. 33–48 // Idem, "Interesting Work of a Noted China Painter," *Clay-Worker* 28 (Nov. 1897), pp. 362–64 // William P. Jervis, comp., "Faience Manufacturing Company," in *The Encyclopedia of Ceramics* (New York, 1902), p. 209 // Edwin AtLee Barber, *Marks of American Potters* (Philadelphia, 1904), pp. 83–85, 153–54 // Idem, "The Pioneer of China Painting in America," pts. 1, 2, *American Pottery Gazette* 2 (Dec. 5, 1905), pp. 19, 21–24; (Jan. 5, 1906), pp. 17–18, 22–24 // Samuel T. Freeman and Company, Philadelphia, [*The Collection of*] *the Late Edwin AtLee Barber, A.M., PH. D.: Illustrated Catalogue of China, Pottery, Porcelain, and Glass . . .* (sale cat., Dec. 10 and 11, 1917) // John Ramsay, *American Potters and Pottery* (Boston, 1939), pp. 198, 260 // Lydia Lycett, "China Painting by the Lycetts," *Atlanta Historical Society Bulletin* 6 (July 1941), pp. 201–14 // Paul Evans, *Art Pottery of the United States: An Encyclopedia of Producers and Their Marks* (New York, 1974), pp. 100–101 // Ralph Kovel and Terry Kovel, *The Kovels' Collector's Guide to American Art Pottery* (New York, 1974), pp. 85–87 // Delaware Art Museum, Wilmington, *American Art Pottery, 1875–1930,* by Kirsten Hoving Keen (exhib. cat., 1978), p. 23, fig. 40 // Carlyn G. Crannell [Romeyn], "In Pursuit of Culture: A History of Art Activity in Atlanta, 1847–1926" (Ph.D. diss., Emory University, 1981), pp. 275–87, 449–53 // Carlyn G. Crannell Romeyn, *The Lycetts* (n.p., 1983) // Idem, Atlanta, correspondence, Sept. 7, 1984 // Faience Manufacturing Company, *Catalogue of . . . Art Pottery, Barbotine Vases, Baskets, Jardinieres, Etc.* (New York, n.d.)

George W. Fenety
Active ca. 1876–ca. 1932
Chelsea and Boston, Massachusetts
Ceramics and textile artist

Jennie J. Young, author of *The Ceramic Art* (1879), could well have been admiring George W. Fenety's redware vase (FIG. 7.13) when she observed of the CHELSEA KERAMIC ART WORKS that "the best Chelsea works are in red and white unglazed earthenware. . . . The carving in relief belongs to a different order of work. Instead of being moulded, the ornamentation of leaves or flowers is carved out of clay laid upon the surface of the vase while still moist from the hands of the thrower. The effect is similar to that obtained by mouldings, but the work is finer, the details more highly finished, and the outlines sharper and clearer. . . . The absence of color allows the attention to rest solely upon the fidelity with which every detail is rendered" (Young, 1879, p. 470).

Only one ceramic object signed by George Fenety is presently known, and the dates of his employment at the Chelsea Keramic Art Works are uncertain. In a letter published by the *Art Amateur* in 1880, Fenety testified that the faience technique called "Bourg-la-Reine" was first used by the Chelsea pottery as early as 1876 (predating claims to the honor by both M. LOUISE MCLAUGHLIN and the Wheatley Pottery of Cincinnati), which suggests that Fenety was employed there at the time. He exhibited an earthenware plaque at the Boston Society of Decorative Art in 1879, and he later became a member of the Boston Society of Arts and Crafts. Interestingly, the Boston city directory lists Fenety's occupation as "Art Embroidery" between 1882 and 1932, when he appears for the last time. For many years Fenety worked in Boston's Studio Building; he then moved his workshop to 110 Tremont Street, where he is listed between 1915 and 1920, and finally down the street to 120 Tremont. As of 1915, Fenety is recorded as residing in Brookline.

Virtually nothing else is known about Fenety's life and career. However, an artist named Andrew C. Fenety, perhaps George's brother, is listed at the same addresses during the 1880s and may therefore provide a clue to further research.

REFERENCES
Jennie J. Young, *The Ceramic Art: A Compendium of the History and Manufacture of Pottery and Porcelain* (New York, 1879), p. 470 // "The Boston Society of Decorative Art," *Art Amateur* 1 (Sept. 1879), p. 86 // [George W. Fenety], *Art Amateur* 4 (Dec. 1880), p. 2 // Edwin AtLee Barber, *The Pottery and Porcelain of the United States* (New York, 1893; 3d ed. New York, 1909), p. 262 // *American Art Annual* 3 (1900–1901), pt. 2, p. 140 // Paul Evans, *Art Pottery of the United States: An Encyclopedia of Producers and Their Marks* (New York, 1974), pp. 49–51 // Karen E. Úlehla, ed., *Society of Arts and Crafts, Boston Exhibition Record, 1897–1927* (Boston, 1981), p. 81

I. P. Frink
1857–1974
New York City
Lighting systems and fixtures

Isaac P. Frink (d. 1891) of Newark, New Jersey, was the founder of a company that bore his name for more than one hundred years. The firm was established in 1857 and appeared in the New York city directories for the first time two years later. Frink was, by his own description, the "Original Inventor, Patentee, and Sole Manufacturer of the Silver-Plated and Crystal-Corrugated, Glass-Lined Reflectors." His reflector, a curious but useful invention, functioned somewhat like a mirror: flat and rectangular in shape, it was suspended from the exterior of a building below the window at an angle that would direct natural light through the window and onto the ceiling of the room within, thus creating greater ambient light than either gas or oil fixtures alone could provide—a real improvement for narrow and dark Victorian interiors. For those concerned about its appearance, the reflector could be backed with ebony or mahogany, or stenciled with gold lettering. By 1866 Frink had modified the reflector for interior use by attaching it to clusters of oil lamps, later to gaslights, and, by the 1880s, to electric light fixtures. By the turn of the century Frink reflectors were widely used in stores, churches, theaters, picture galleries, and offices, as well as in private homes.

In the late 1870s and 1880s the business expanded from purely utilitarian devices to include decorative light fixtures and chandeliers; Frink products became known nationwide. In the 1880s a prosperous meat-packer named William "Hog" Ryan installed one of Frink's

bronze chandeliers (FIG. 8.28) in the newly redecorated dining room of his Dubuque, Iowa, home. This large fixture, which is graced by six gaslights with etched-glass shades, glass pendants, and metalwork panels with floral ornament in the aesthetic taste, complemented the WILLIAM MORRIS wallpaper and cherrywood wainscoting in the room. Though unmarked, the chandelier is attributed to Frink on the basis of its similarity to special-order pieces pictured in the I. P. Frink catalogues of 1882 and 1883.

From 1863 until 1910 the company was located at 549–551 Pearl Street in Manhattan. It enlarged its operations with the purchase of the Sterling Bronze Company in 1928, a concern specializing in ornamental fixtures as well as marine and other custom lighting. I. P. Frink eventually moved across the East River to Long Island City and, sometime after 1950, to Brooklyn. Known by then as the Frink Corporation, it was reputed to be the largest specialty lighting company in the world. The Westinghouse Electric Corporation purchased Frink in 1960 and during the next decade undertook commercial projects unprecedented in size, such as the lighting for the entire World Trade Center in New York City. The Frink Corporation was liquidated by Westinghouse in 1974.

REFERENCES
I. P. Frink, *Patent Reflectors for Gas, Kerosene, Electric, or Day Light* (New York [1882 and 1883]), no. 720 (ill.) // Frink Corporation and Sterling Bronze Company, Inc., *Distinctive Architectural Effects with Custom Lighting* (New York [1961?]) // Metropolitan Museum of Art, New York, *Nineteenth-Century America: Furniture and Other Decorative Arts* (exhib. cat., 1970), fig. 226 // Denys Peter Myers, *Gaslighting in America: A Guide for Historic Preservation* (Washington, D.C., 1978), p. 205, pl. 98 // Jay Lewis, New York, conversation, 1986 // J. L. Kaswan, Westinghouse Electric Corporation, Parsippany, N.J., correspondence, Feb. 26, 1986 // I. P. Frink in R. G. Dun and Company [Credit ledgers], New Jersey, vol. 20, p. 293; New York City, vol. 190, pp. 388, 400, n.d., R. G. Dun and Company Collection, Baker Library, Harvard University, Graduate School of Business Administration, Cambridge, Mass. // "I. P. Frink . . . Suspended Double Cove Silver Plated Corrugated Glass Reflector with Brass Bands" [advertisement], and "Frink's Patent Daylight Reflectors" [advertisement], n.d., Landauer Collection, New-York Historical Society

Henry Lindley Fry
1807–1895
William Henry Fry
1830–1929
Cincinnati, Ohio
Wood carvers

Before coming to America about 1850, Henry Lindley Fry was a professional wood carver and engraver in Bath, England, where he probably met BENN PITMAN for the first time. Fry participated in several important Gothic-revival architectural projects prior to leaving England, including the carving of a screen designed by George Gilbert Scott (1811–1878) for Westminster Abbey and the decoration of the chambers of the houses of Parliament under Charles Barry (1795–1860) and Augustus Welby Northmore Pugin (1812–1852). Because of this experience, his carving style, as well as that of his son, William Henry Fry, recalls the English Gothic of the fourteenth and fifteenth centuries.

By most accounts, Henry Fry's residence in the United States began in New Orleans, where he was joined by his son William and his daughter-in-law. In 1851 he moved to Cincinnati, a rapidly growing city already bustling with furniture manufacturing. The Frys were recorded in the 1853 city directory as "carvers" at 150 West Third Street. (William Fry, however, reportedly lived in Texas as well as New Orleans during his early years in America. From about 1853 until about 1866, he lived on a farm near Monticello, Indiana, but apparently assisted his father from time to time on decorative projects before moving to Cincinnati permanently, probably about 1866 or 1867.) Because of their specialization in the decor of entire interiors as well as in the creation of individual pieces of furniture, the Frys were hired to decorate several Cincinnati churches, including the Church of New Jerusalem (of which they were members), the homes of several prominent Cincinnati citizens, such as John Shillito and Henry Probasco, and the State House in Columbus, Ohio. A sideboard and a dining-room table for President and Mrs. Rutherford B. Hayes were Henry and William's most noteworthy pieces of furniture.

Their most important patron was Joseph Longworth, who commissioned them on two occasions: first, to decorate his Cincinnati estate, Rookwood, during the late 1850s; and second, to design the interiors of a home, also in Cincinnati, built for his daughter MARIA LONGWORTH NICHOLS in honor of her marriage to GEORGE WARD NICHOLS in 1868. The Frys' work on the latter was open for viewing while under construction and no doubt served to foster the local interest in wood carving, which blossomed into an entire movement in the 1870s.

Like Benn Pitman, the Frys' attitudes toward decoration were influenced by John Ruskin (1819–1900) and WILLIAM MORRIS in that they viewed decoration as an integral part of utilitarian objects. Occasionally, however, they were criticized for too much "niggling ornament" covering every available surface. Their style included aesthetic motifs, such as the sunflower and lily on the mantel from their own Sunflower Cottage (FIG. 5.14), yet it also often incorporated medieval and Italianate elements, among them winged horses, lions' heads and paw feet, scrolls, and luxurious acanthus leaves as well as such exotic materials as imported miniature Italian mosaics.

The Frys championed wood carving as a woman's art. Their students, mostly upper-middle-class women, often assisted them in exchange for instruction. Examples of the Frys' work were prominently displayed at the Philadelphia Centennial Exposition in 1876, and several of their students participated in the decorative carving for the Cincinnati Music Hall organ, a project that commenced the following year. The Frys trained a small number of students privately beginning in the early 1870s, maintaining professional independence from the Art Academy of Cincinnati until William Fry replaced Benn Pitman as director of its wood-carving department in 1893. Their most accomplished protégé was William's daughter, LAURA FRY, who also studied wood carving with Benn Pitman.

William Fry continued in the family profession long after the death of his father in 1895. He received a prize for a carved Baldwin piano that was displayed at the Paris Exposition Universelle in 1900 and had a one-man show of his work at the City Art Museum of Saint Louis in 1910. By this time, however, his woodworking style—a contrast to the Arts and Crafts movement's emphasis on form rather than surface decoration—had begun to seem anachronistic. Nevertheless, Fry continued to teach at the Art Academy until 1926 and died three years later, just short of his one-hundredth birthday.

REFERENCES
"The Dining-Room of Geo. W. Nichols, Esq., Cincinnati, Ohio," in *The Book of American Interiors,* by Charles Wyllys Elliott (Boston, 1876), p. 87 (ill.) // "Women as Wood-Carvers," *American Architect and Building News* 2 (Mar. 31, 1877), pp. 100–101 // George Ward Nichols, ed., *The Cincinnati Organ: With a Brief Description of the Cincinnati Music Hall* (Cincinnati, 1878) // "Decorative Art Exhibition," *Crockery and Glass Journal* 10 (Nov. 6, 1879), p. 10 // Mrs. Aaron F. Perry, "Decorative Pottery of Cincinnati," *Harper's New Monthly Magazine* 62 (May 1881), pp. 834–45 // "The Fate of a Handsomely Carved Table," *Crockery and Glass Journal* 15 (Feb. 2, 1882), p. 24 // "Art Notes: Decorative Art," *Art Journal* (London), July 1882, pp. 221–22 // William H. Fry, *Wood-Carving: A Short Paper* (Cincinnati, 1897) // City Art Museum of Saint Louis [now the Saint Louis Art Museum], *A Collection of Wood Carvings by Mr. William H. Fry* (exhib. cat., 1910) // Erwin O. Christensen, *Early American Wood Carving* (Cleveland and New York, 1952), pp. 91–92 // Anita J. Ellis, "Cincinnati Art Furniture," *Antiques* 121 (Apr. 1982), pp. 930–41 // Columbus Museum of Art, Ohio, *Made in Ohio: Furniture, 1788–1888,* by E. Jane Connell and Charles R. Muller (exhib. cat., 1984), unpaged, ill. 88 // E. Jane Connell and Charles R. Muller, "Ohio Furniture, 1788–1888," *Antiques* 125 (Feb. 1984), p. 468 (fig. 7) // Mary Alice Heekin Burke, Cincinnati, conversation, Mar. 1985 // William Nagel, Cincinnati, conversation, Jan. 1986 // Kenneth R. Trapp, The Oakland Museum, Calif., correspondence, Jan. 7, 1986 // Bruce R. Kahler, Purdue University, West Lafayette, Ind., correspondence, Jan. 8, 1986 // Mr. and Mrs. W. Roger Fry, Cincinnati, miscellaneous newspaper clippings, family remembrances, and photographs, n.d.

Laura Fry
1857–1943
Cincinnati, Ohio
Wood carver and ceramics decorator

Like her contemporary AGNES PITMAN, Laura

Anne Fry was born to a family of English decorative artists and was one of the few women of the Cincinnati art movement to make wood carving and ceramics decorating a serious professional career. Born near Monticello, Indiana, but living in Cincinnati by about 1866, Fry enrolled at the University of Cincinnati School of Design (later the Art Academy of Cincinnati) in 1869 to study drawing and sculpture. She pursued wood carving under BENN PITMAN's direction between 1873 and 1876 and china painting under Maria Eggers's tutelage between 1874 and 1876. Like her father, WILLIAM HENRY FRY, and her grandfather, HENRY LINDLEY FRY, Laura Fry excelled in wood carving. She designed nine and carved one of the floral panels for the 1877–78 decoration of the Cincinnati Music Hall organ, the magnum opus of the wood-carving movement.

Fry is said to have learned the practical techniques of ceramics in Trenton, New Jersey, a center of commercial production, and in Europe, although the details of these excursions are not known. However, she did perfect the "scratch-blue" technique first developed by Hannah Barlow at Henry Doulton and Company in London, of which Fry's pitcher (FIG. 7.27) is an excellent early example.

In 1879 Fry became an honorary member of the Cincinnati Pottery Club, founded in that year by M. LOUISE MCLAUGHLIN. Two years later, in 1881, Fry joined the decorating team at Maria Longworth Nichols's ROOKWOOD POTTERY. At Rookwood for seven years, Fry designed some of the shapes that the pottery used and served as an instructor in the short-lived Rookwood School of Pottery Decoration. During the final two years of her employment at Rookwood, Fry returned to the Art Academy of Cincinnati to study life drawing under the instruction of Thomas Noble (1835–1907), a student of Thomas Couture's (1815–1879). In 1886 she also spent some time at the Art Students League in New York.

In 1884 Fry developed an ingenious method of spraying colored slips onto moist clay vessels by using a mouth atomizer. This technique, which through subtle shading and blending of colors allowed the creation of atmospheric effects, became the standard background for decoration on Rookwood wares. A patent for the "Fry method," using a commercial atomizer, was awarded in 1889.

For a short time after her departure from Rookwood, Fry did free-lance art work in Cincinnati. In 1891 she assumed the post of Professor of Industrial Art at Purdue University in West Lafayette, Indiana, where she founded the Lafayette Ceramic Club as well. But she left for Steubenville, Ohio, the next year to work for the Lonhuda Works, one of Rookwood's major competitors. The atomizer-spray method she had developed earlier was used extensively by both her new and old employers, so that in 1892 Fry initiated a suit against the Rookwood Pottery in an attempt to prove their infringement of her patent. The case, long delayed in court, was finally settled in Rookwood's favor six years later.

At the 1893 World's Columbian Exposition in Chicago, Fry received a prize for her wood carving. The following year she left the Lon-

huda pottery and worked on her own in Cincinnati, where she helped found the Porcelain League of Cincinnati. In 1896, her commissions from Cincinnati patrons diminishing, Fry returned to Purdue University, where she resumed teaching until her retirement in 1922.

REFERENCES

George Ward Nichols, ed., *The Cincinnati Organ: With a Brief Description of the Cincinnati Music Hall* (Cincinnati, 1878) // "Decorative Art for the Cincinnati Exposition," *Crockery and Glass Journal* 10 (Sept. 11, 1879), p. 28 // "Decorative Art," *Cincinnati Commercial Gazette,* Sept. 13, 1879, clipping from the Women's Art Museum Association of Cincinnati Collection Scrapbooks, Cincinnati Historical Society // "Decorative Art Exhibition," *Crockery and Glass Journal* 10 (Nov. 6, 1879), p. 10 // Cincinnati Pottery Club, *Eighth Cincinnati Industrial Exposition* (exhib. cat., 1880), pp. 4–8 // "Cincinnati Pottery Club," *Crockery and Glass Journal* 11 (Jan. 29, 1880), p. 14 // "Cincinnati Pottery Club," *Crockery and Glass Journal* 11 (May 13, 1880), p. 28 // "Cincinnati Art Pottery," *Harper's Weekly* 24 (May 29, 1880), pp. 341–42 // Lilian Whiting, "The Cincinnati Pottery Club," *Art Amateur* 3 (June 1880), pp. 10–11 // Mrs. Aaron F. Perry, "Decorative Pottery of Cincinnati," *Harper's New Monthly Magazine* 62 (May 1881), pp. 834–45 // "The Cincinnati Pottery Club Reception," *Crockery and Glass Journal* 13 (May 12, 1881), p. 24 // Clara Devereux, "Annual Exhibition of the Cincinnati Pottery Club," *Art Amateur* 5 (June 1881), p. 18 // "Ninth Cincinnati Exposition," *Crockery and Glass Journal* 14 (Sept. 22, 1881), p. 12 // "Cincinnati Reports" [Cincinnati Pottery Club], *Crockery and Glass Journal* 15 (May 18, 1882), p. 44 // "Pottery Exhibits," *Crockery and Glass Journal* 15 (May 25, 1882), p. 18 // Mary Gay Humphreys, "The Cincinnati Pottery Club," *Art Amateur* 8 (Dec. 1882), pp. 20–21 // "Pottery Club," *Cincinnati Commercial Gazette,* May 2, 1883, clipping from the Women's Art Museum Association of Cincinnati Collection Scrapbooks, Cincinnati Historical Society // Montezuma [Montague Marks], "My Note Book" [Exhibition of the Cincinnati Pottery Club at Howell and James], *Art Amateur* 9 (July 1883), p. 25 // Edwin AtLee Barber, *The Pottery and Porcelain of the United States* (New York, 1893; 3d ed., New York, 1909), pp. 275–78, 282–83 // Clara Chipman Newton, "The Cincinnati Pottery Club," *Bulletin of the American Ceramic Society* 19 (Sept. 1940), pp. 345–51 // "Porcelain League of Cincinnati," *Bulletin of the American Ceramic Society* 19 (Sept. 1940), pp. 351–53 // "Porcelain League Exhibit," *Bulletin of the American Ceramic Society* 19 (Oct. 1940), p. 409 // Herbert Peck, *The Book of Rookwood Pottery* (New York, 1968) // J. L. Collins, "Fry, Laura A.," in *Women Artists in America* (Chattanooga, Tenn., 1973), unpaged // Kenneth [R.] Trapp, "Japanese Influence in Early Rookwood Pottery," *Antiques* 103 (Jan. 1973), pp. 193–97, 195 (ill.) // Paul Evans, *Art Pottery of the United States: An Encyclopedia of Producers and Their Marks* (New York, 1974), pp. 141–44, 149, 256, 264, 328 // Cincinnati Art Museum, *The Ladies, God Bless 'Em: The Women's Art Movement in Cincinnati in the Nineteenth Century* (ex-

hib. cat., 1976), p. 63 // "Fry, Laura Anne," in *The International Dictionary of Women Workers in the Decorative Arts,* comp. Alice Irma Prather-Moses (Metuchen, N.J., and London, 1981), p. 60 // Kenneth R. Trapp, "'To Beautify the Useful': Benn Pitman and the Women's Wood-carving Movement in Cincinnati in the Late Nineteenth Century," in *Victorian Furniture: Essays from a Victorian Society Autumn Symposium,* ed. Kenneth L. Ames (Philadelphia, 1982), pp. 173–92 // Detroit Institute of Arts, *The Quest for Unity: American Art Between World's Fairs, 1876–1893* (exhib. cat., 1983), pp. 265 (ill.), 266 // Joan Siegfried, "American Women in Art Pottery," *Nineteenth Century* 9 (Spring 1984), pp. 12–18 // Chris Petteys, "Fry, Laura Ann," in *Dictionary of Women Artists: An International Dictionary of Women Artists Born Before 1900* (Boston, 1985), p. 265 // Kenneth R. Trapp, The Oakland Museum, Calif., correspondence, Jan. 7, 1986 // Bruce R. Kahler, Purdue University, West Lafayette, Ind., correspondence, Jan. 8, 1986 // Idem, *Professionalism in the Decorative Arts: Laura Anne Fry, 1857–1943* (Indianapolis: Indiana Historical Bureau), forthcoming // Kenneth R. Trapp, "Rookwood Pottery and the Application of Art to Industry: Design Reform in Cincinnati, 1875–1890" (Ph.D. diss. in preparation, University of Illinois, Urbana-Champaign)

Frank Furness
1839–1912
Philadelphia
Architect

During a career that spanned forty-five years and encompassed some four hundred buildings, Frank Furness played a major role in the development of late nineteenth-century architecture in Philadelphia. He forged a powerful and highly individual style in which ornament was integrated with structure. Although indebted to nineteenth-century English and French architecture and architectural theory, Furness's work transcends its sources in a manner without parallel in either Europe or America. A comparison of Furness's early urban buildings of the 1870s with his furniture of the same period also suggests that British industrial-design reformers and theorists, including BRUCE J. TALBERT and CHRISTOPHER DRESSER, were important influences on his work.

Furness was the youngest son of William Henry Furness (1802–1896), a Unitarian minister in Philadelphia known nationally not only for his abolitionist views but also for his interest in the arts. The latter was manifested in the careers of his four children: William Henry, Jr. (1828–1867), a portrait painter; Annis Lee Wistar (1830–1908), a student of German literature and a translator; Horace Howard (1833–1912), a Harvard-educated Shakespearean at the University of Pennsylvania; and Frank, an architect. Furness possessed a strong mind, domineering presence, colorful personality, and sharp tongue; LOUIS SULLIVAN recalled that Furness could "issue a string of oaths yards long" and draw simultaneously. His demeanor was apparently as vivid as his building facades: "He affected the English in fashion . . . wore loud plaids, and a scowl, and from his face depended fan-like a marvelous red beard" (Sulli-

van, in O'Gorman, 1973, p. 33).

Furness's education stopped short of the university level, and at the time there was no formal architectural training available in the United States. He learned draftsmanship in the Philadelphia architectural office of John Fraser (1825–1906), who became his partner after the Civil War, and in 1859 he entered Richard Morris Hunt's New York atelier for two years. There he encountered the major currents of contemporary French and English architectural thought. Hunt (1827–1895) exposed Furness to the classical system of the Ecole des Beaux-Arts, to French theorists such as Eugène Emmanuel Viollet-le-Duc (1814–1879), and to publications such as César Daly's *Revue générale de l'architecture,* while also encouraging the study and sketching of diverse architectural styles. The Ruskinian ideals that held sway in New York's artistic community in the 1850s were paralleled by the colorful Unitarian Church of All Souls (1853–55) by Jacob Wrey Mould (1825–1886), an Englishman who worked for OWEN JONES before coming to New York and who probably knew the young Furness through the Reverend Furness's Unitarian concerns. During the 1860s Ruskin's theories dominated New York architecture, of which P. B. WIGHT's National Academy of Design (1861–65) is an important early example and one that Furness must have studied closely.

During his New York apprenticeship, Furness spent the summer of 1860 in Newport, Rhode Island, where he saw the first of Hunt's picturesquely styled villas that were later to influence his domestic work. The Civil War forced a hiatus in Furness's training from 1861 to 1864; after his discharge from the Union cavalry (having earned the Congressional Medal of Honor), Furness returned briefly to Hunt's New York atelier. By 1866, however, he was again in Philadelphia, to be wed and to establish a partnership with John Fraser and George W. Hewitt (1841–1916), which he did the following year. In 1868 Furness became a charter member of the American Institute of Architects. The 1869 polychrome Moorish- and Gothic-inspired German synagogue, Rodef Shalom, in Philadelphia was Fraser, Furness and Hewitt's most important commission. Fraser departed for Washington, D.C., in 1871 to work as an architect for the Treasury Department; Furness and Hewitt maintained a practice together until 1875.

The Pennsylvania Academy of the Fine Arts in Philadelphia, executed by the firm between 1871 and 1876, is a masterpiece. Furness's Beaux-Arts training in Hunt's office is apparent in the exterior tripartite composition with mansard roof as well as in the pronounced decorative emphasis on structural elements inside. The building's rich exterior coloration, however—incorporating rusticated brownstone, dressed sandstone, polished granite and marbles, blue slate, and red brick—clearly derives from English Victorian Gothic examples. Incised, carved, cut, and stenciled geometric floral patterns used throughout the interior in wood, wrought iron, and stone also seem to reflect a firsthand familiarity with the English reform ideas transmitted through various books, such as Owen Jones's *The Grammar of Ornament* (1856) and Christopher Dresser's *Principles of Decorative Design* (1873).

This kind of surface ornament is most prevalent in the buildings conceived while Furness and Hewitt were partners, although Furness continued to use it in some of his buildings after 1875 and selectively in even later work. As we know from Louis Sullivan, who was employed by the firm in 1873, Hewitt was a dedicated Anglophile and may have been responsible for introducing Furness to contemporary English design: "It was he who did the Victorian Gothic in its pantalettes. . . . With precision . . . he worked out these decorous sublimities of inanity, as per the English current magazines and other English sources. He was a clean draftsman, and believed implicitly that all that was good was English" (Sullivan, in O'Gorman, 1973, p. 34).

The exaggerated crockets, hefty corbels, squat columns, chamfered corners, ponderous blocks, central salients, and oversize-shingle shapes that characterize Furness's bank facades of the 1870s are skillfully integrated with the structure of the buildings to create a symbolic image of power. The composition of these facades, among them the Provident Life and Trust Company of 1876–79 and the Kensington National Bank of 1877 (see O'Gorman, 1973, ills. 14–1, 15–1), while recalling contemporaneous English architecture, may also have been inspired by such British industrial designers as Bruce J. Talbert, whose book of Modern Gothic furniture designs had been reprinted in the United States in 1873 (FIGS. 5.1, 5.2).

Early in his career Furness began to design fixtures, fittings, and furnishings for the interiors of his buildings, although there are few remaining pieces documented or attributed to him. The earliest examples are chairs for the Rodef Shalom Synagogue (Congregation Rodeph Shalom, Philadelphia) and a carved desk and chair for his brother Horace (Philadelphia Museum of Art), all in a vigorous Modern Gothic style. An extraordinary Modern Gothic cabinet (FIG. 5.3) constructed of American woods that relates to Talbert's furniture style is attributed to Furness on the basis of unusual reverse-painted, ribbed-glass panels that are backed with gold foil and inset like tiles (FIG. 5.4). About 1876 Furness developed foil-backed painted glass to chromatically enhance his buildings, including the Pennsylvania Academy of the Fine Arts, the Brazilian Pavilion at the 1876 Philadelphia Centennial Exposition, and the Centennial National Bank of 1876, also in Philadelphia. The panels on the cabinet are closely related to those extant in the Pennsylvania Academy (see Johnson, 1979, pl. 77), which employ stylized, strictly symmetrical flowers with wing-shaped leaves that can be traced to designers such as Dresser, whom Furness probably met in 1876 when Dresser visited Philadelphia. Evidence strongly suggests that Furness's furniture designs were executed by DANIEL PABST, an exceptional Philadelphia wood carver.

The Furness and Hewitt partnership dissolved in 1875. Furness then practiced alone, developing his mature style until 1881, when he established a new firm with Allen Evans, whom he had hired as a draftsman in 1871. In 1885 Furness and Evans became Furness, Evans and Company, a name that continued well after Furness's death. Furness was the primary designer behind the firm's prolific output

during the period from 1881 to 1895, which included a great many railroad stations and suburban houses. The library for the University of Pennsylvania (1888–91; now called the Furness Building after Horace Howard Furness) was the masterwork of this phase. Picturesque massing and rich, idiosyncratic details place the exterior of this polychrome brick building squarely in the English Victorian Gothic tradition. However, the influence of Viollet-le-Duc and French rationalism inform the functional layout and the expandable stack system inside as well as certain interior details, including the exposed iron beams in the apsidal reading room.

Furness's university library was exactly contemporary with the classical public library McKim, Mead and White designed for Boston, a comparison that illustrates the dilemma of Furness's late career. Renaissance classicism executed in white stone was once again in vogue, having been given added impetus by the Chicago World's Columbian Exposition of 1893, and, in the minds of many, Furness's style had become anachronistic. Even so, there were a number of very fine large-scale commercial buildings and smaller works that he designed in the period after 1895. Furness's death, in 1912, was hardly noticed, however. His buildings were labeled aberrations and held in disrepute for decades; a great many of them were demolished. It is only in the last fifteen years that Furness has been rightfully recognized and widely appreciated as one of America's outstanding nineteenth-century architects.

REFERENCES

"Academy of the Fine Arts, Philadelphia," *Art Journal* (Appleton's) 2 (July 1876), p. 202 // [View of Furness's smoking room], in *Artistic Houses: Being a Series of Interior Views of a Number of the Most Beautiful and Celebrated Homes in the United States,* 2 vols. in 4 pts. (1883–84; reprinted in 1 pt., New York, 1971), vol. 2, pt. 2, p. 169 // William Campbell, "Frank Furness, an American Pioneer," *Architectural Review* 110 (Nov. 1951), pp. 310–15 // "Another Furness Building" [The Provident Life and Trust Company, Philadelphia], *Architectural Review* 112 (Sept. 1952), p. 196 // "Furness, Frank," in *Biographical Dictionary of American Architects (Deceased),* ed. Henry F. Withey and Elsie Rathburn Withey (Los Angeles, 1956), pp. 226–27 // James C. Massey, "The Provident Trust Buildings, 1879–1897," *Journal of the Society of Architectural Historians* 19 (May 1960), pp. 79–81 // Idem, "Frank Furness in the 1870's: Some Lesser Known Buildings," *Charette* 43 (Jan. 1963), pp. 13–16 // Idem, "Frank Furness in the 1880's," *Charette* 43 (Oct. 1963), pp. 25–29 // Idem, "Frank Furness: The Declining Years, 1890–1912," *Charette* 46 (Feb. 1966), pp. 8–13 // Philadelphia Museum of Art, *The Architecture of Frank Furness,* by James F. O'Gorman (exhib. cat., 1973) // David A. Hanks, "Reform in Philadelphia: Frank Furness, Daniel Pabst, and 'Modern Gothic' Furniture," *Art News* 74 (Oct. 1975), pp. 52, 54 // Philadelphia Museum of Art, *Philadelphia: Three Centuries of American Art,* by Darrel Sewell et al. (exhib. cat., 1976), pp. 388–91, 401–2 // David T. Van Zanten, "Second Empire Architecture in Phil-

adelphia," *Philadelphia Museum of Art Bulletin* 74 (Sept. 1978), pp. 9–24 // Diane Chalmers Johnson, *American Art Nouveau* (New York, 1979), pp. 73, 148, pl. 77 // Lamia Doumata, *Frank Furness, 1838–1912* (Monticello, Ill., 1980) // Marian Page, *Furniture Designed by Architects* (London and New York, 1980), pp. 70–75 // University Gallery, University of Delaware, Wilmington, *Architecture and Ornament in Late Nineteenth-Century America,* ed. Damie Stillman (exhib. cat., 1981), pp. 21–28 // Andrew Craig Morrison, "Furness, Frank," in *Macmillan Encyclopedia of Architects,* ed. Adolf K. Placzek, 4 vols. (New York, 1982), vol. 2, pp. 127–30 // Hyman Myers, "The Three Buildings of the Pennsylvania Academy," *Antiques* 121 (Mar. 1982), pp. 679–89 // Detroit Institute of Arts, *The Quest for Unity: American Art Between World's Fairs, 1876–1893* (exhib. cat., 1983), pp. 74–75 (ills.), 262–64 (ills.) // High Museum of Art, Atlanta, *The Virginia Carroll Crawford Collection: American Decorative Arts, 1825–1917,* by David A. Hanks and Donald C. Peirce (exhib. cat., 1983), pp. 78–79 // Simon Jervis, "Furness, Frank," in *The Penguin Dictionary of Design and Designers* (Harmondsworth, Eng., and New York, 1984), p. 192 // Sandra L. Tatman and Roger W. Moss, "Furness, Frank," in *Biographical Dictionary of Philadelphia Architects, 1700–1930* (Boston, 1985), pp. 287–96

Galloway and Graff

1868–1941?
Philadelphia
Terracotta

William Galloway (about 1838–1913) and John Graff formed a partnership in Philadelphia in 1868 to continue an older business established in 1810. Their firm, which was located at 1723–1725 Market Street near Eighteenth Street, specialized in utilitarian and ornamental terracottas—such as urns, pedestals, fountains, flower boxes, sundials, benches, and bird baths, as well as some architectural decorations—fashioned from Pennsylvania, Maryland, and New Jersey clays and predominantly for horticultural use.

Like other American manufacturers, Galloway and Graff perceived the 1876 Philadelphia Centennial Exposition as an opportunity to expand its reputation and its sales nationwide. The company's display, for which it received the only commendation awarded in the field of artistic terracotta, was a calculated appeal to the burgeoning public interest in "art manufactures." It included vases and urns copied from examples in the British Museum, London, and full-scale replicas of statuary. The firm's catalogue of 1876 illustrates, among others, the *Apollo Belvedere* from the Vatican Collections, *Dancing Girl* by Antonio Canova, and *Echo* by "Bailly," no doubt Joseph Alexis Bailly (1825–1883), a Parisian-born wood carver and sculptor working in Philadelphia who taught at the Pennsylvania Academy of the Fine Arts during the centennial year.

From 1875 to 1881 patents were issued to William Galloway for such practical earthenware products as the 1879 "porous refrigerator." In 1876, perhaps inspired by copies of ancient Greek vases displayed in the Danish Pa-

vilion (ILL. 7.5) at the Philadelphia Centennial Exposition, Galloway and Graff began to offer a full line of artistic vases and plaques based on antique models that, to judge from the regular notices published in the *Crockery and Glass Journal,* remained extremely popular at least through the mid-1880s. Some of these were decorated before being sold, but amateur artists could also obtain unpainted bisqueware. Examples of both kinds, some of them matching illustrations in the 1876 Galloway and Graff catalogue, were purchased in 1882 by the Women's Art Museum Association for the Cincinnati Art Museum collection (although they were catalogued by the museum as a gift in 1881; FIGS. 7.2, 7.3). Alfred Traber Goshorn (1833–1902), who in 1882 became the museum's first director, had previously served as the director general of the Centennial Exposition and obviously admired Galloway and Graff terracotta: a terracotta mask, the visage of a bearded old man in a cloth cap, is inset above the fireplace in the original director's office of the first Cincinnati Art Museum building designed by James McLaughlin and constructed between 1882 and 1886.

The firm's physical plant was moved to Walnut Street near Thirty-second Street in Philadelphia in 1889 and was destroyed by fire only five years later; when rebuilt on the same site, it reportedly included some 90,000 square feet of exhibition space in addition to the workrooms. Operating under the name of William Galloway by 1893, the firm's display of ornamental terracotta won a first prize at the Chicago World's Columbian Exposition that year and a grand prize at the Saint Louis World's Fair in 1904. The company was incorporated as the Galloway Terra-Cotta Company in 1911, with Galloway's son, William B., as president, and continued until at least 1941.

REFERENCES
Galloway and Graff, *Art and Horticultural Terra Cotta* (Philadelphia [1876]), unpaged, Collection of the Library Company of Philadelphia // James D. McCabe, *The Illustrated History of the Centennial Exhibition . . .* (Philadelphia, Chicago, and Saint Louis, 1876), pp. 356, 742 (ill.), 744 (ill.), 759 (ill.), 792 (ill.), 800, 803 (ill.) // "Ceramics at Philadelphia," pt. 11, *American Architect and Building News* 1 (Oct. 21, 1876), pp. 342–43 // "Patent Butter Cooler," *Crockery and Glass Journal* 8 (July 25, 1878), p. 21 // [Terracotta vases and plaques for decoration], *Crockery and Glass Journal* 8 (Dec. 12, 1878), p. 14 // Jennie J. Young, *The Ceramic Art: A Compendium of the History and Manufacture of Pottery and Porcelain* (New York, 1879), p. 455 // "Galloway, Graff and Company," *Crockery and Glass Journal* 10 (Aug. 28, 1879), p. 10 // "Philadelphia Trade Reports," *Crockery and Glass Journal* 12 (July 29, 1880), p. 24 // "The Potteries: Philadelphia," *Crockery and Glass Journal* 13 (Apr. 28, 1881), p. 18 // "The Potteries: Philadelphia," *Crockery and Glass Journal* 15 (June 1, 1882), p. 18 // "Women's Art Museum Association: The Articles Which Have Been Given the West Art Museum" [newspaper clipping, source unknown], 1884, from the Women's Art Museum Association of Cincinnati Collection Scrapbooks, Cincinnati Historical Society // Edwin AtLee Barber, *The Pottery and Porcelain*

of the United States (New York, 1893; 3d ed. New York, 1909), pp. 32, 272 // "William Galloway's Exhibit of Art Pottery," *Scientific American* 69 (Sept. 23, 1893), p. 200 // W. P. Lockington, "Terra Cotta Ornaments and Statuary," *Clay-Worker* 31 (Apr. 1899), pp. 342–43 // Samuel Swift, "American Garden Pottery," *House and Garden* 4 (July 1903), pp. 29–40 and ill. // Edwin AtLee Barber, *Marks of American Potters* (Philadelphia, 1904), p. 32 // "Terra-Cotta Garden Furniture (illustrations furnished by Galloway Terra-Cotta Company)," *Craftsman* 22 (Aug. 1912), pp. 567–68 // "Editorial Notes and Clippings—Continued" [William Galloway, obituary], *Clay-Worker* 60 (Dec. 1913), p. 688 // "Terra Cotta Garden Furnishings in Simple and Elegant Design (illustrations furnished by Galloway Terra-Cotta Company)," *Craftsman* 28 (May 1915), pp. 190–91, 235–36 // Helen E. Stiles, *Pottery in the United States* (New York, 1941), pp. 172–74 // Paul Evans, *Art Pottery of the United States: An Encyclopedia of Producers and Their Marks* (New York, 1974), pp. 52–53 // Marianne Promos, The Free Library of Philadelphia, correspondence, Aug. 28, 1984 // Anita J. Ellis, Cincinnati Art Museum, conversation, 1985; and correspondence, Oct. 21, 1985 // Kenneth R. Trapp, The Oakland Museum, Calif., conversation, 1985 // Galloway Terra-Cotta Company, *Price List No. 20* (Philadelphia, n.d.) // Idem, *Terra-Cotta and Pottery, Catalogue No. 14 for Garden and Interior* (Philadelphia, n.d.) // Idem, *Terra-Cotta and Pottery, Catalogue No. 15 for Garden and Interior* (Philadelphia, n.d.) // Idem, *Terra-Cotta and Pottery for Garden and Interior* (Philadelphia, n.d.) // Idem, *Terra Cotta and Pottery for Garden, Terrace, and Interior Decoration* (Philadelphia, n.d.)

Helena De Kay Gilder, *see* Helena De Kay

Richard Watson Gilder, *see* Helena De Kay

E. W. Godwin

1833–1886
Bristol, Gloucestershire, and London
Architect and designer

Max Beerbohm (1872–1956) called him "Godwin that superb architect . . . the greatest aesthete of them all" (Harbron, 1949, p. xiii). To be sure, E. W. Godwin's life, both personally and professionally, was rich and varied, if tragically short. He was a versatile architect and avid conservationist; theater critic and architectural journalist; art-furniture, stage, and costume designer; close friend of WILLIAM BURGES, JAMES ABBOTT MCNEILL WHISTLER, and Oscar Wilde (1854–1900); and paramour of Ellen Terry, the great Shakespearean actress.

Edward William Godwin was born in Bristol, England, the son of a currier. Following his formal education and at his father's insistence, he went to work for William Armstrong, the Bristol city surveyor, architect, and civil engineer. Because Armstrong knew very little about the artistic aspects of his profession, Godwin, educating himself, soon took charge of the architectural projects in the of-

fice. In 1854 he opened his own practice in Bristol, but, lacking any significant commissions, he went to Ireland in 1857, where he stayed for two years working with his brother, an engineer.

Godwin explored many versions of the Gothic revival in his buildings of the 1860s. A small church of 1857 in Saint Johnston, County Donegal, Ireland—his first project of consequence—emulated George Edmund Street's picturesque manner. In 1861 Godwin won his first nationally prestigious competition with an Italian Gothic design for the Northampton Town Hall, which revealed his close reading of John Ruskin's writings; the completed building was commended by CHARLES LOCKE EASTLAKE in his 1872 History of the Gothic Revival. By 1864 Godwin's interest had shifted to the French Gothic, as evidenced by his winning design for the Congleton Town Hall in East Cheshire. Two years later he collaborated with Burges, whom he met in 1858, on a design for the London Law Courts competition. Meanwhile, Godwin had established a partnership with Henry Crisp in 1864 (which lasted until 1871) and had opened a London office the following year.

Through Burges, Godwin was exposed at an early date to Japanese art, which was to influence his work profoundly. At the 1862 London International Exhibition, Gothic enthusiasts could compare medieval and Japanese art firsthand; Burges was struck by the medieval aspects of contemporary Japanese culture, while Godwin was fascinated by the beauty of Japanese craftsmanship, principles of construction, and asymmetrical design. Thus inspired, Godwin experimented with the interior of his Bristol home, creating an environment radically sparse in comparison to the standard Victorian decor of 1862: he arranged Japanese prints on plain-colored walls, scattered Persian rugs across bare floors, and selected eighteenth-century antiques. His London home of the 1870s was equally unconventional: "The floor [of the drawing room] was covered with straw-coloured matting, and there was a dado of the same material. Above the dado were white walls and the hangings were of cretonne, with a fine Japanese pattern in delicate grey-blue. The chairs were of wicker with cushions like the hangings, and in the centre of the room was a full-size cast of Venus de Milo, before which was a small pedestal, holding a censer from which was, curving round the Venus, ribbons of blue smoke" (Harbron, 1949, p. 95).

Godwin began to design wallpapers for JEFFREY AND COMPANY in 1866 (ILLS. 3.1, 3.2) and furniture about 1867, the year he commenced work on Dromore Castle, an important commission for his Irish patron, the earl of Limerick. The interior fittings and furnishings, which Godwin also designed, draw equally from oriental and Gothic sources. Lightweight and linear in conception, the furniture bears no relation to the solidity of the Modern Gothic works by Burges and BRUCE J. TALBERT. The Art Furniture Company, which Godwin started to manufacture his designs, was short-lived; his designs were later produced by several firms, including Gillow and Company, Green and King, and W. A. Smee.

The term "Anglo-Japanese" was coined to describe the slender, tapering lines and open, rectilinear forms of Godwin's art furniture. He favored black, ebonized wood and eschewed moldings, carving, or other ornamental additions that might hinder his attempt to create an effect by the "grouping of solid and void and by [a] more or less broken outline" (Fleming and Honour, 1977, p. 338). A sideboard that exemplifies Godwin's approach was designed for his own use as early as 1867, but it was not made commercially until about ten years later (ILL. 5.3). However, a related piece, the "Lucretia" cabinet—named after the female figure in the center panel painted by Charles Fairfax Murray (1849–1919)—is documented to the London firm of COLLINSON AND LOCK in 1873 (FIG. 5.9). A rosewood side chair (FIG. 5.5) also manufactured by Collinson and Lock may be Godwin's design (see THOMAS EDWARD COLLCUTT). It is similar to a chair exhibited by the firm at the 1876 Centennial Exposition, and certainly an awareness of such pieces is apparent in the work of some American cabinetmakers, such as HERTER BROTHERS (FIG. 5.26).

Godwin's original and elegant conceptions—Old English and Jacobean as well as Anglo-Japanesque in inspiration—became even more widely known (and frequently copied) through Art Furniture from Designs by E. W. Godwin . . . and Others, produced by the cabinetmaker William Watt of Grafton Street in 1877, though much of the furniture had been in production for some time. Americans had the chance to see some of Godwin's designs—for furniture, ceiling and wall decorations, and entire rooms—that were published in the Art-Worker in 1878. This one-volume publication, produced in New York, featured other British designers in addition to Godwin, among them F. E. Hulme (1841–1909) and CHARLES BOOTH. Godwin and his friend Whistler collaborated on an unusual suite of furniture that William Watt displayed at the 1878 Paris Exposition Universelle. Godwin designed the furniture in light-colored mahogany; Whistler added abstract, gold-painted panels. Described as a "harmony in yellow" by the designers and an "agony" by critics, the color of the accompanying walls, carpets, and upholstery ranged from yellow ocher to pale citron (Aslin, 1967, pp. 151–52).

Godwin produced some original architectural designs during the 1870s that were modified in their built form. In 1876 he designed corner houses and semidetached houses in a vernacular style for the Bedford Park estate in Chiswick, England's first garden suburb. Some of his homes, though changed, were eventually constructed, but RICHARD NORMAN SHAW soon replaced Godwin as the architectural consultant on the project (FIG. 10.1, ILL. 10.6). Godwin also designed a series of artists' houses on Tite Street in London's Chelsea district, including the White House for Whistler. A comparison of the proposed and actual elevations for the Frank Miles house of 1878 shows that Godwin conceived of the facade as a balanced but asymmetrical composition of solids and voids that was altered to conform to the less adventurous standards of the Metropolitan Board of Works (ILLS. 10.4, 10.5).

Godwin was a prolific writer throughout his career and addressed a wide variety of subjects, including floral decoration, historical architecture, conservatories, Shakespearean theater, and dress reform. As he concentrated on costume and set designs in the years preceding his death, in 1886, his innovative furniture designs became fewer. Nonetheless, Godwin's work of the 1870s significantly affected the look of industrial arts and interior decor and, as Hermann Muthesius (1861–1927) pointed out shortly after 1900, anticipated or perhaps even influenced modern design in Germany and France toward the end of the century.

REFERENCES

E. W. Godwin, A Handbook of Floral Decoration for Churches (London, 1865) // Idem, The Architecture and Costume of Shakespeare's Plays (London, 1874–75) // Idem, "Old English or Saxon Building," Architect 14 (1875), pp. 70–71, 84–85, 98–99, 112–14 // Art Furniture, from Designs by E. W. Godwin, F.S.A., and Others, with Hints and Suggestions on Domestic Furniture and Decoration, by William Watt (London, 1877; reprint New York and London, 1978) // "The Peacock Room," Carpet Trade Review 4 (May 1877), pp. 62–63, originally published in the Architect (London), Feb. 24, 1877, pp. 118–19 // Art-Worker: A Journal of Design Devoted to Art-Industry 1 (Jan.–Dec. 1878), pls. 13, 14, 22, 30, 37, 46, 53, 60, 69, 76 // Artistic Conservatories, and Other Horticultural Buildings . . . from Rough Sketches by E. W. Godwin, F.S.A., and from Designs and Drawings by Maurice B. Adams, A.R.I.B.A. (London, 1880; reprint New York and London, 1978) // E. W. Godwin, Dress, and Its Relation to Health and Climate (London, 1884) // Idem, "The Home of an English Architect," pts. 1, 2, Art Journal (London), June 1886, pp. 170–73; Oct. 1886, pp. 301–5 // "Art Notes and Reviews" [E. W. Godwin obituary], Art Journal (London), Nov. 1886, p. 352 // Lewis F. Day, "Victorian Progress in Applied Design," Art Journal (London), June 1887, pp. 185–202 // Hermann Muthesius, The English House, ed. and intro. Dennis Sharp, pref. Julius Posener, trans. Janet Seligman, abridged from Das Englische Haus, 2d ed., 3 vols. in 1 (Berlin, 1904–5; 2d ed. Berlin, 1908–11; New York, 1979), pp. 31, 156–58 // Dudley Harbron, "Edward Godwin," Architectural Review 98 (Aug. 1945), pp. 48–52 // Idem, The Conscious Stone: The Life of Edward William Godwin (London, 1949) // H. Montgomery Hyde, "Oscar Wilde and His Architect," Architectural Review 109 (Mar. 1951), pp. 175–76 // Nikolaus Pevsner, "Art Furniture of the Eighteen-Seventies," Architectural Review 111 (Jan. 1952), pp. 43–50 // Edgar Kaufmann, Jr., "Edward Godwin and Christopher Dresser: The 'Esthetic' Designers, Pioneers of the Eighteen-Seventies," Interiors 118 (Oct. 1958), pp. 162–65 // Elizabeth Aslin, Nineteenth Century English Furniture (New York, 1962), pp. 63–64 // Idem, "E. W. Godwin and the Japanese Taste," Apollo 76 (Dec. 1962), pp. 779–84 // Mark Bence-Jones, "An Aesthete's Irish Castle: Dromore Castle, Co. Limerick," Country Life 136 (Nov. 12, 1964), pp. 1274–77 // Elizabeth Aslin, "The Furniture Designs of E. W. Godwin," Victoria and Albert Bulletin 3 (Oct. 1967), pp. 145–54 // T. Affleck Greeves, "London's First Garden Suburb: Bedford Park, Chiswick," Country Life 142 (Dec. 7, 1967), pp. 1524–29 // Idem, "The

Making of a Community: Bedford Park, Chiswick," *Country Life* 142 (Dec. 14, 1967), pp. 1600–1602 // Mark Girouard, "Chelsea's Bohemian Studio Houses: The Victorian Artist at Home," pt. 2, *Country Life* 152 (Nov. 23, 1972), pp. 1370–74 // Alastair Service, "James MacLaren and the Godwin Legacy," *Architectural Review* 154 (Aug. 1973), pp. 111–18 // Bristol City Art Gallery, Eng., *Furniture by Godwin and Breuer,* by Cleo Witt and Karin Walton (exhib. cat., 1976) // Brenda Greysmith, *Wallpaper* (New York, 1976), pp. 140–41, 148 // John Fleming and Hugh Honour, "Godwin, Edward William," in *Dictionary of the Decorative Arts* (New York, 1977), pp. 338–39 // "William Watt: Art Furniture and E. W. Godwin," in *Pictorial Dictionary of British Nineteenth Century Furniture Design,* intro. Edward Joy (Woodbridge, Eng., 1977), pp. xxxvi–xxxvii // E. W. Godwin, *Art Furniture, and Artistic Conservatories* (New York and London, 1978) // Fine Art Society Limited, London, *Architect-Designers: Pugin to Mackintosh,* by Clive Wainright and Charlotte Gere (exhib. cat., 1981), p. 32 // Mary Belle Lawson Pendleton, "Bedford Park: An Introduction to Further Study" (Ph.D. diss., Northwestern University, 1981) // Françoise Teynac, Pierre Nolot, and Jean-Denis Vivien, *Wallpaper: A History* (New York, 1982), pp. 146, 153 // Simon Jervis, "Godwin, Edward William," in *The Penguin Dictionary of Design and Designers* (Harmondsworth, Eng., and New York, 1984), pp. 203–4 // Elizabeth M. Aslin, Hove, East Sussex, Eng., correspondence, May 16, 1985 // Idem, *E. W. Godwin: Furniture and Interior Decoration* (London, 1986) // Christie, Manson and Woods Limited, London, *British Decorative Arts from 1880 to the Present Day* (sale cat., Jan. 28, 1986), pp. 60–61 (lot 142)

Gorham Manufacturing Company
1863–present
Providence, Rhode Island
Silver and silverplate

One of the world's largest manufacturers of fine silver at the end of the nineteenth century was the Gorham Manufacturing Company, founded by Jabez Gorham (1792–1869), who after a seven-year apprenticeship with Nehemiah Dodge of Providence, Rhode Island, joined with four other men in 1813 to start a jewelry-making business. Although that partnership dissolved in 1818, Gorham continued in business and in 1831 took Henry L. Webster, a maker of coin-silver spoons, into his firm. William G. Price, another jeweler, joined them in 1837, but within a few years Gorham was again operating alone.

Gorham's son John (1820–1898) entered the business in 1841 and on his father's retirement in 1848 assumed control of J. Gorham and Son, as the firm was then called. It was probably in that year that the familiar trademark—lion, anchor, and the letter G—first appeared on Gorham silver. Though John was in partnership with his cousin Gorham Thurber for a short time during the 1850s, he remained for thirty years the driving force in the company's dramatic development.

With the ambition and the foresight to mechanize and increase production, during the 1850s John Gorham converted the plant to steam power, installed die presses purchased in England to facilitate the manufacture of flatware, initiated the production of silver hollowware, and instituted a company-managed sales program. The wisdom of his decisions was almost simultaneously reflected in the company's sales, which increased from $29,000 per year in 1850 to $397,000 in 1859.

On a visit to England in 1852, Gorham learned about the electroplating technology pioneered there by ELKINGTON AND COMPANY. (He did not immediately put his knowledge to use, however, for it was not until eleven years later that the Gorham company began to make silverplated wares.) Also on that first trip abroad, Gorham, although not a designer, apprenticed himself briefly to Charles Martin, a craftsman skilled in casting. In England again in 1860, Gorham recruited engravers, modelers, and chasers for his firm and began to assemble a reference library, still in use today, that includes a folio volume of OWEN JONES's *Grammar of Ornament* (1856), numerous publications on historical ornament, books on Japanese prints, and complete sets of the most important contemporary art journals.

In 1863 the firm became the Gorham Manufacturing Company—the title by which it was known for more than a hundred years—and it was incorporated two years later. In 1868 Gorham adopted the sterling standard and in the three decades that followed distinguished itself by producing an impressive array of fine silver in a variety of then-popular styles. In 1878, having suffered from the economic recession of the early 1870s, John Gorham declared personal bankruptcy and was forced out of the firm, a sad and abrupt end to his thirty-year tenure. William Crins (b. about 1819), a well respected Providence businessman, took over the reins until 1894, when he was succeeded by Edward Holbrook (1849–1919), who had been with the company since 1870.

Throughout the second half of the nineteenth century, England remained vitally important to American industries not only as a source of knowledge about advanced technology but also as a source of craftsmen and designers—the latter point well illustrated in the makeup of the Gorham Manufacturing Company. Between 1860 and 1915 many of the company's workmen and most of its known designers were British expatriates. George Wilkinson (1819–1894), born in Birmingham, England, came to Gorham in 1854 and was the company's chief designer from 1860 until his retirement in 1891. Thomas J. Pairpoint (1847–1902), formerly with the British firm of Lambert and Rawlings, was at Gorham from 1868 to 1877, during which time he was responsible for Renaissance-revival and classicized designs, most notably the famous Century Vase that he and George Wilkinson created for the Philadelphia Centennial Exposition. A. J. Barrett, who had worked for the eminent British firm of Hunt and Roskell, also came to Gorham in the late 1860s. Though their names have survived, few of the stylistically varied Gorham designs of the 1870s and 1880s can be clearly attributed to any of these designers. An unknown artist created the hot-water kettle dated 1875 (FIG. 8.21) on whose die-rolled gilt border sea horses and water nymphs gambol among seaweed. An anonymous hand also fashioned the gilt silver vase of 1877 (FIG. 8.5) on which the upright, stylized flowers in bright blue cloisonné enamel are quintessential Anglo-aesthetic ornament.

Gorham inaugurated a line of ecclesiastical wares in gold, bronze, wood, stone, and sterling in 1885, about the same time that it became the sole agent for the firm of Heaton, Butler and Bayne, London makers of stained-glass windows, mosaic decorations, and painted panels for churches. The company also produced many Japanesque pieces with cast ornament in varicolored metals applied to a hammered surface, a style similar to that of some TIFFANY AND COMPANY silver of the 1870s and 1880s (FIGS. 8.10, 8.11), but one splendid Gorham punch bowl of 1885 with ladle is especially unusual (FIG. 8.19). Its extraordinary repoussé chasing—a tumultuous sea enveloping fish, crustaceans, and a sinuous sea serpent—presages the fluid lines of the firm's Art Nouveau silver of the 1890s created by its best-known designer, William Christmas Codman (1839–1921), an Englishman.

In the twentieth century the Gorham Manufacturing Company continued to expand not only its silver operations but also its bronze casting. By the mid-1920s it had absorbed several other East Coast silver manufacturers, including the WHITING MANUFACTURING COMPANY. Today known as the Gorham Division of Textron Inc., the company still manufactures fine-quality silver and silverplated wares at their recently relocated plant in Smithfield, Rhode Island.

REFERENCES

J. Leander Bishop, *A History of American Manufactures from 1608 to 1860,* 3 vols. (Philadelphia and London, 1868), vol. 3, pp. 391–93 // "Silver and Silver Plate," *Harper's New Monthly Magazine* 37 (Sept. 1868), pp. 432–48 // "The Roach Testimonial," *Iron Age,* May 21, 1874, p. 1 // "The Silver Age," *Jewelers' Circular and Horological Review* 1–5 (May–Nov. 16, 1874), pp. 192–95 // "The Silver Age," *Scribner's Monthly* 9 (Dec. 1874), pp. 193–209 // "American Art-Work in Silver," *Art Journal* (Appleton's) 1 (Dec. 1875), pp. 371–74 // James D. McCabe, *The Illustrated History of the Centennial Exhibition . . .* (Philadelphia, Chicago, and Saint Louis, 1876; reprint Philadelphia, 1975), pp. 359–60, 828 (ill.), 833 (ill.), 837 (ill.) // Phillip T. Sandhurst et al., *The Great Centennial Exhibition Critically Described and Illustrated* (Philadelphia and Chicago, 1876), pp. 146–49 (ills.), 152–53, 155–56, 264–65 (ills.) // "The Century Vase," *Crockery and Glass Journal* 4 (Sept. 14, 1876), p. 16 // "Art Applied to Life Seen at the Centennial: The Story of the Century Vase," *Crockery and Glass Journal* 4 (Oct. 19, 1876), p. 18 // "Art in Industry," *Jewelers' Circular and Horological Review* 7 (Nov. 1876), p. 168 // "Centennial Notes," *Jewelers' Circular and Horological Review* 7 (Nov. 1876), p. 67 // "A Century Vase," *Jewelers' Circular and Horological Review* 7 (Nov. 1876), p. 149 // [George Titus Ferris], *Gems of the Centennial Exhibition: Consisting of Illustrated Descriptions of Objects of an Artistic Character, in the Exhibits of the United States, Great Britain, France . . .* (New York, 1877), pp. 10–15 // Frank H. Norton, ed., *Frank Les-*

lie's Historical Register of the United States Centennial Exposition, 1876 (New York, 1877), pp. 302–3, 310–11 // Walter Smith, Industrial Art, vol. 2 of The Masterpieces of the Centennial International Exhibition (Philadelphia, copr. 1875 [1877?]), pp. 52–56 // "General Report of the Judges of Group 11," in U.S. Centennial Commission, International Exhibition, 1876: Reports and Awards, 9 vols. (Washington, D.C., 1880), vol. 5, p. 413 // "Some American Silverware," Art Amateur 8 (Jan. 1883), p. 53 // "Enterprising: Mrs. Florence E. Cory's Management of the New York School of Industrial Art for Women—Taking a New Departure," Carpet Trade and Review 14 (Aug. 15, 1883), p. 34 // "Decorative Art Notes," Art Amateur 12 (Dec. 1884), p. 23 // A. St. Johnston, "American Silver-Work," Magazine of Art 9 (1886), pp. 13–18 // [Praise for Gorham Manufacturing Company], Jewelers' Circular and Horological Review 17 (Apr. 1886), p. 103 // "The Gorham M'F'G Co., Silversmiths, Broadway and Nineteenth Street, New York" [advertisement], in Architectural League of New York, Catalogue of the Fourth Annual Exhibition (exhib. cat., 1888) [advertising supplement], p. 54 // "Mackay Jardiniere," Jewelers' Circular and Horological Review 20 (Feb. 1889), p. 64 // "Gorham M'F'G Company" [advertisement], Jewelers' Circular and Horological Review 20 (Mar. 1889), p. 20 (ill.) // [Proposed Gorham factory], Jewelers' Circular and Horological Review 20 (Apr. 1889), p. 25 (ill.) // "Glimpses of the Exposition," Jewelers' Circular and Horological Review 20 (July 1889), pp. 28–29 // Hubert Howe Bancroft, The Book of the Fair: An Historical and Descriptive Presentation of the World's Science, Art, and Industry, as Viewed Through the Columbian Exposition at Chicago in 1893 (Chicago and San Francisco, 1893), pp. 145–47 // Georgiana Guild, The Gorham Family in Rhode Island: Notes on the Providence Line (Boston, 1900) // "Gorham, Jabez," in The National Cyclopaedia of American Biography, vol. 23 (New York, 1933), pp. 303–4 // "Gorham, Jabez," in Who Was Who in America, Historical Volume, 1607–1896, rev. ed. (Chicago, 1967), p. 281 // Larry Freeman, Early American Plated Silver (Watkins Glen, N.Y., 1973), pp. 46–48 // Dorothy T. Rainwater, Sterling Silver Holloware (Princeton, N.J., 1973), p. 7 // Idem, Encyclopedia of American Silver Manufacturers (New York, 1975), pp. 60–61 // Yale University Art Gallery, New Haven, Silver in American Life: Selections from the Mabel Brady Garvan and Other Collections at Yale University, ed. Barbara McLean Ward and Gerald W. R. Ward (exhib. cat., 1979), pp. 84 (ill.), 175 (ill.) // Charles H. Carpenter, Jr., Gorham Silver, 1831–1981 (New York, 1982) // Idem, "Gorham's Martelé Silver," Antiques 122 (Dec. 1982), pp. 1256–65 // Palácio Nacional da Ajuda, Lisbon, Port., A América na Ajuda: American Pieces in the Palácio Nacional da Ajuda (exhib. cat., 1985), pp. 6–10, 15–19, 21–33 // Sotheby's, New York, Important Twentieth-Century Decorative Arts (sale cat., Dec. 7, 1985), unpaged, lot 3 (ill.)

Greenwood Pottery

1861–1933
Trenton, New Jersey
Ceramics

James Tams (1845–1910), born in Staffordshire, England, came to America with his father, William, in 1861. William Tams (d. 1866), trained in England as a "dipper" and a kiln firer, worked briefly with the New Jersey pottery called Young's—as did James—before purchasing an old carriage shop in Trenton, which he converted into a pottery with a partner, William Barnard. In 1864 James traveled to England, where he married, and upon his return to the United States in 1865 he joined his father's pottery, in which Charles Brearly and James P. Stephens (d. 1901) had become partners. When William Tams died the following year, James purchased his father's share of the firm, which apparently continued as Brearly, Stephens and Tams until it was incorporated in 1868 as the Greenwood Pottery Company, with James Tams as its president and James Stephens as its secretary and treasurer.

The mainstay of the company's production before 1875 was durable white-granite and cream-colored tableware, sold nationally for use in hotels and restaurants and on railways and steamships. The company also manufactured ceramic hardware trimmings, such as doorknobs, and insulating supplies.

About the time of the 1876 Philadelphia Centennial Exposition, the Greenwood Pottery began to experiment with a pure white vitrified body that it marketed in 1878 as "American China." From Greenwood's display the next year at the American Institute fair in New York City, where this high-grade, semi-translucent porcelain garnered praise from the judges, the pottery received large orders for its new product. Soon the demand required building new kilns; in addition, Greenwood acquired the premises of both the old Eagle Pottery and the former Burroughs and Mountford Pottery.

Some of the company's utilitarian wares were hand decorated during the 1870s, according to the Crockery and Glass Journal, which in 1875 began to report frequently on the company's progress. "China" plates bearing portraits of New Jersey dignitaries and a dinner service graced with pink bands and apple blossoms were among the pieces displayed at the American Institute fair in 1879. Yet having developed the ability to produce a thin, translucent white porcelain, the pottery now focused on production of purely decorative ceramics. No doubt Tams, who was Greenwood's superintendent during the 1870s and 1880s, guided the company's artistic direction.

Fire and flood damage suffered by the Greenwood factory in 1882 proved to be a blessing in disguise. In the process of rebuilding, a capacious decorating department and showrooms were added, along with new kilns to accommodate the ever-increasing trade. A decorator named Jones, formerly of the WORCESTER ROYAL PORCELAIN COMPANY, joined the Greenwood staff in 1883, and by August of that year examples of his artistry were on view—appreciably similar to objects in the elegant oriental style of ornamentation favored by his former employer. Other English artisans from Worcester were hired by the pottery, with the result that Greenwood's limited production of art porcelain, dating mostly from the period 1883–86, could easily have been mistaken for its English counterparts.

Ne Plus Ultra was the aptly chosen trademark distinguishing most of these pieces. Many Greenwood vases of this period are covered with a deep blue glaze, akin to the coveted King's Blue used by the Sèvres factory in France, which many American ceramics decorators sought to imitate. Virtually all are embellished with raised gold, silver, or bronze-colored designs—such as birds in flight and sprays of flowers—in the Japanese mode. One unusual, and unmarked, pair of carnelian red rectangular vases, sparsely decorated with golden blades of grass, a sprig of foliage, and gilded butterflies (FIG. 7.7), was presented to the New Jersey State Museum by James Tams's descendants as a fitting memorial to the superb quality of design and craftsmanship achieved by the Greenwood Pottery during the 1880s.

The company's foray into artistic ceramics was short-lived. After 1891 the Greenwood Pottery continued to manufacture sturdy whiteware for commercial use. James Tams died in 1910, leaving his six sons to run the firm; his eldest son, William H., was already vice-president of the company. Production apparently continued until 1933, when the firm is listed for the last time in the Trenton city directories.

REFERENCES

"New Shapes," Crockery and Glass Journal [hereafter abbreviated as CGJ] 1 (May 20, 1875), p. 4 // "The Greenwood Pottery Company," CGJ 2 (Dec. 23, 1875), p. 22 // "American China," CGJ 7 (June 6, 1878), p. 19 // Jennie J. Young, The Ceramic Art: A Compendium of the History and Manufacture of Pottery and Porcelain (New York, 1879), pp. 462–63 // Silex, "Trenton Potteries," CGJ 9 (June 26, 1879), p. 20 // Idem, "Trenton Potteries," CGJ 10 (July 24, 1879), p. 21 // Idem, "Trenton Potteries," CGJ 10 (Sept. 18, 1879), p. 20 // "Native Ceramics at the American Institute," CGJ 10 (Oct. 9, 1879), p. 24 // Silex, "Trenton Potteries," CGJ 10 (Oct. 9, 1879), p. 20 // Idem, "Trenton Potteries," CGJ 10 (Oct. 30, 1879), p. 20 // "Pottery at the American Institute Fair: The Greenwood Pottery, Trenton," Art Amateur 1 (Nov. 1879), pp. 126–27 // Silex, "Trenton Potteries," CGJ 10 (Nov. 20, 1879), p. 20 // "American Institute Awards," CGJ 10 (Dec. 4, 1879), p. 17 // "General Report of the Judges of Group 2," in U.S. Centennial Commission, International Exhibition, 1876: Reports and Awards, 9 vols. (Washington, D.C., 1880), vol. 3, p. 590 // Silex, "Trenton Potteries," CGJ 11 (Jan. 15, 1880), p. 18 // Idem, "Trenton Potteries," CGJ 11 (Apr. 22, 1880), p. 20 // Idem, "Trenton Potteries," CGJ 11 (June 10, 1880), p. 20 // "The Potteries: Trenton, N.J.," CGJ 13 (Apr. 7, 1881), p. 24 // "The Potteries: Trenton, N.J.," CGJ 14 (Aug. 4, 1881), p. 16 // "The Potteries: Trenton, N.J.," CGJ 15 (Jan. 19, 1882), p. 16 // "The Potteries: Trenton," CGJ 17 (May 10, 1883), p. 12 // "The Potteries: Trenton," CGJ 18 (July 19, 1883), p. 38 // "The Potteries: Trenton," CGJ 18 (Aug. 2, 1883), p. 20 // "The Potteries: Trenton," CGJ 18 (Aug. 9, 1883), p. 8 // "The Potteries: Trenton," CGJ 18 (Aug. 16, 1883), p. 26 // "The Potteries: Trenton," CGJ 18 (Aug. 23, 1883), p. 16 // "The Potteries: Trenton," CGJ

18 (Oct. 11, 1883), p. 16 // "The Potteries: Trenton," *CGJ* 18 (Nov. 15, 1883), p. 16 // "The Potteries: Trenton," *CGJ* 18 (Dec. 20, 1883), p. 78 // "The Potteries: Trenton," *CGJ* 20 (Aug. 28, 1884), p. 12 // Isaac Edwards Clarke, *Art and Industry: Education in the Industrial and Fine Arts in the United States,* pt. 1, *Drawing in Public Schools* (Washington, D.C., 1885), p. ccxlvi // Edwin AtLee Barber, "Recent Advances in the Pottery Industry," *Popular Science Monthly* 40 (Jan. 1892), p. 296 // Idem, *The Pottery and Porcelain of the United States* (New York, 1893), pp. 226–28 // William P. Jervis, "Greenwood Pottery Company," in *Encyclopedia of Ceramics* (New York, 1902), p. 260 // Greenwood Pottery Company, *Illustrated Catalogue . . . of Vitrified Hotel and Thin China Ware* (Trenton, N.J., 1903) // Edwin AtLee Barber, *Marks of American Potters* (Philadelphia, 1904), pp. 46–47 // "James Tams Has Had Interesting Career," *Trenton Sunday Times Advertiser,* June 2, 1907, p. 13 // "Jas. Tams Dies after Notable Life as Potter," *Trenton Evening Times,* Nov. 12, 1910, pp. 1–2 // Newark Museum Association, N.J., *The Work of the Potteries of New Jersey from 1865 to 1876* (Newark, 1914), p. 22 and ill. // Idem, *The Pottery and Porcelain of New Jersey Prior to 1876* (exhib. cat., 1915), p. 25 // "James Tams, Dean among Potters," *Bulletin of the American Ceramic Society* 17 (Jan. 1938), pp. 35–36 // John Ramsay, *American Potters and Pottery* (Boston, 1939), pp. 182, 280 // New Jersey State Museum, Trenton, *Early Arts of New Jersey: The Potter's Art, c. 1680–c. 1900* (exhib. cat., 1956), p. 37 // Detroit Institute of Arts, *The Quest for Unity: American Art Between World's Fairs, 1876–1893* (exhib. cat., 1983), p. 181 (ill.) // Suzanne Corlette Crilley, New Jersey State Museum, Trenton, conversation, Sept. 1985, and correspondence, Jan. 29, 1986

Griffen, Smith and Company
1880–1889
Phoenixville, Pennsylvania
Ceramics

Majolica, or *maiolica* as it is also known, is a type of earthenware pottery that was extremely popular during the Italian Renaissance and that dates back at least to the fourteenth century in Spain. The revival of this technique during the nineteenth century was first initiated by the MINTON AND COMPANY pottery, whose displays at the international exhibitions in 1851, 1855, and 1862 brought majolica to public attention; JOSIAH WEDGWOOD AND SONS, LIMITED, and other English firms followed in the 1860s with the production of majolica for domestic use, and the Philadelphia Centennial Exposition of 1876 popularized such wares in America.

Described simply, majolica is a usually porous earthenware often covered with multicolored glazes or an opaque white tin or lead glaze upon which other glazes are applied before firing; the outcome is a brightly colored vitreous surface. The technical description of majolica does little to conjure up its imaginative nineteenth-century forms: dolphins, lions, and hummingbirds, seashells, leaves, lettuce, corn, and cauliflowers colored with glazes ranging from creamy tan or yellow to rich brown and from pale pink to lavender, turquoise blue, and many shades of green. Much of the majolica made in England and America in the nineteenth century was modeled or executed in thick relief. Although there was nothing new in the technique, majolica was adapted to contemporaneous tastes in ways more original than its history would at first suggest, and by the 1880s, the height of the Aesthetic movement in both England and America, festively colored, inexpensive majolica was manufactured on a large scale and could be found in most homes.

Griffen, Smith and Company of Phoenixville, Pennsylvania, was the most successful American manufacturer of majolica during the 1880s. Located at the corner of Starr and Church streets, the firm succeeded several others in that location, beginning with the Phoenix Pottery, Kaolin and Fire Brick Company, founded in 1867. The Phoenix Pottery manufactured simple utilitarian wares and bricks for the furnaces of the adjacent Phoenix Iron Company, owned by John Griffen. By 1872 the pottery operated under the auspices of W. A. H. Schreiber and J. F. Betz, manufacturers of yellow, white, and Rockingham wares (the latter term refers to a manganese brown glaze), as well as terracotta heads of hounds, stags, eagles, and dogs in various sizes for the decoration of public taverns. Five years later, in 1877, Schreiber and Company leased the works to Levi B. Beerbower and Henry Ramsay Griffen, the son of the nearby ironmonger. This firm manufactured simple white ironstone china, also known as graniteware, for two years before it was bought out and reorganized as Griffen, Smith and Hill, who presumably acquired the pottery works at that time. The partners in the new firm included Henry R. Griffen (1857–1907) and his brother, George S. Griffen (1854–1893), both of whom were trained as civil engineers at the Rensselaer Polytechnic Institute in Troy, New York; David Smith (1839–1895), an Englishman with experience in the potteries of Stoke-on-Trent, England, and Trenton, New Jersey; and William Hill, a potter about whom nothing is known. When Hill left shortly after the firm was established in 1880, the name became Griffen, Smith and Company, although the original *G.S.H.* mark was retained.

Perhaps as early as 1879, Griffen, Smith and Company was manufacturing its "Etruscan Majolica" from local Pennsylvania, New Jersey, and Delaware clays, some of which came from John Griffen's iron mines. No information about the company's English designer, a Mr. Bourne, survives except his name. David Smith, who acted as the factory's superintendent, may have been responsible for soliciting Bourne's participation or may have been responsible himself for some of the designs, many of which were based on eighteenth-century English prototypes. While many American potters strove to match British technology and to adapt it to machine production, sometimes less emphasis was placed on the originality of the designs themselves, and the English craftsmen who infiltrated American industries during this period often drew on sources familiar to them.

The begonia-leaf tableware, for which the Griffen, Smith firm is well known, originated in Phoenixville, although it too recalls leafy eighteenth-century European models. The sunflower, a popular aesthetic motif in England from about 1870, probably made its appearance in Griffen, Smith majolica in the early 1880s (FIG. 7.33), when Oscar Wilde (1854–1900; ILLS. 11.1, 11.2, 11.6), the consummate aesthete, toured the United States with a sunflower in one hand and a lily in the other. Other Griffen, Smith and Company majolica approximated Irish Belleek porcelain in appearance, with an extremely thin body, pearly glazes, and marine-form decoration. During the early 1880s the firm experimented with soft- and hard-paste porcelain and, according to Edwin AtLee Barber (1851–1916), also produced jetware—characterized by a brilliant black glaze and gold decorations—as well as Parian ware and lithopanes—window or lampshade transparencies with intaglio scenes illustrating Shakespeare or biblical history. The firm's display of majolica at the New Orleans World's Industrial and Cotton Centennial Exposition in 1884–85, accompanied by a souvenir catalogue with fourteen colored plates, resulted in the pottery's busiest period; by 1886 fifty decorators were employed.

Women, such as Susan Argue O'Neill and Susan Kelley Coyne, made between five and ten dollars a week for the painstaking work of decorating Etruscan majolica. Mrs. O'Neill remembered, "We each had our camel's hair brush and the little pots of majolica paint sitting before us. We painted the ware blue in order to get a pink; deep rose changed to blue; black would turn out a deep brown. . . . I was only eleven years old when I first started working for 'Jerry' Smith. . . . The whole idea seemed like play; what little girl wouldn't like to dab away making brilliantly colored jugs, vases, platters, plates, pitchers, and other bits of majolica" (Stern, 1947, p. 11).

By the end of the 1880s the majolica craze had abated. When David Smith left the firm in 1889 to erect levigating mills near the kaolin beds at Toughkenamon, Pennsylvania, he was replaced by J. Stewart Love, Henry Griffen's father-in-law, and the firm became Griffen, Love and Company. Majolica production was discontinued after a fire destroyed most of the factory in 1890, though it was rebuilt the following year, and the business was newly incorporated as the Griffen China Company. An English decorator named Thomas Scott Callowhill (b. 1840), formerly of the WORCESTER ROYAL PORCELAIN COMPANY and the Henry Doulton and Company works, was briefly employed there. Although Griffen China Company went out of business in 1892, the pottery works continued to operate under a succession of firms from 1894 until about 1902, first as the Chester Pottery Company of Pennsylvania, subsequently as the Penn China Company, and finally as the Tuxedo Pottery Company. Little artistic pottery was attempted during this period.

REFERENCES
[Griffen, Smith and Hill buy out business of Beerbower and Griffen], *Crockery and Glass Journal* 9 (Jan. 9, 1879), p. 14 // [Publication of illustrated catalogue by Griffen, Smith and Company], *Crockery and Glass Journal* 14 (Oct.

6, 1881), p. 31 // "The Potteries: Philadelphia," *Crockery and Glass Journal* 17 (Feb. 1, 1883), p. 30 // Edwin AtLee Barber, *The Pottery and Porcelain of the United States* (New York, 1893; 3d ed. New York, 1909), pp. 267–70 // Henry R. Griffen, *Clay Glazes and Enamels, with a Supplement on Crazing, Its Cause and Prevention* (Indianapolis, 1896) // Edwin AtLee Barber, "Historical Sketch of the Phoenixville (Pa.) Pottery: Second Paper," *Clay-Worker* 28 (Oct. 1897), pp. 266–67, 268 (ill.) // E[dwin] A[tLee] B[arber], "American 'Majolica,'" *Bulletin of the Pennsylvania Museum* 5 (July 1907), pp. 46–49 // Frederick H. Rhead, "The Italian Majolica Process and Painting Over Tin Enamels," *Bulletin of the American Ceramic Society* 1 (Sept. 1922), pp. 177–80 // Lois L. Phillips, "Majolica Ware," *American Home* 15 (May 1936), pp. 94–96 // Anna M. P. Stern, "Phoenixville Majolica," *American Antiques Journal* 2 (Aug. 1947), pp. 10–12 // Clarissa Smith, "Etruscan Majolica," *Antiques Journal* 12 (June 1957), pp. 8–11 // G[eorge] M[ichael], "Etruscan Majolica," *National Antiques Review* 3 (Oct. 1971), pp. 16–19 and cover (ill.) // Ruth Irwin Weidner, "The Majolica Wares of Griffen, Smith and Company" (M.A. thesis, University of Delaware, Wilmington, 1980) // Idem, "Majolica Wares of Griffen, Smith, and Company, Part 1: History and Manufacture," *Spinning Wheel* 36 (Jan.–Feb. 1980), pp. 13–17 // Idem, "American Majolica, Part 2 (Conclusion): The Designs and Their Sources," *Spinning Wheel* 36 (Mar.–Apr. 1980), pp. 14–19 // M. Charles Rebert, *American Majolica, 1850–1900* (Des Moines, Iowa, 1981).

Frederick Hackney, *see* D. F. Haynes and Company

D. F. Haynes and Company
1835–1908
Baltimore, Maryland
Ceramics

The Chesapeake Pottery was established at the corner of Nicholsen and Decatur Streets in Baltimore by Henry and Isaac Brougham and John Tunstall in 1880. Two years later, David Francis Haynes, a crockery jobber in Baltimore, purchased the company and transformed it from a single-kiln enterprise into one of the most commercially successful art potteries on the eastern seaboard.

Haynes, who was born in Brookfield, Massachusetts, was first involved in the merchandising of ceramics at the age of sixteen, when he worked for a crockery store in Lowell, Massachusetts. In 1856 Haynes was dispatched to England on business for several months; while there he visited the Staffordshire potteries and was presumably exposed to the design-reform ideas then under discussion, such as those found in OWEN JONES's influential volume *The Grammar of Ornament,* which was published in England that year.

Edwin AtLee Barber (1851–1916), chronicler of ceramics history in the United States, reported that upon Haynes's return to America in the fall of 1856, he was employed by the Abbott Rolling Iron Works in Baltimore, a firm that later produced armor plate for ironclad warships during the Civil War. In 1858 Haynes went to work for Ammidon and Company, a newly founded purveyor of oil and lamps at 347 West Baltimore Street, which enlarged its product line to include crockery and hardware. Haynes became a partner in the firm in 1872, and when he became the sole proprietor in 1877 the name was changed to D. F. Haynes and Company.

Until he purchased the Chesapeake Pottery in January 1882, Haynes was closely associated with the Maryland Queensware Company, which, starting in 1879, sold its entire production through his firm. This company was listed in the Baltimore city directories at 247 West Lexington Street—not far from Haynes's store—from 1878 until 1883, at which time it may also have been absorbed by him. In 1883 Haynes renamed his entire enterprise the Chesapeake Pottery.

Although Haynes designed and patented some of the ceramic forms produced by the Chesapeake Pottery, his true genius was in sales and marketing. Six months after acquiring the pottery, he hired two accomplished English ceramists to direct the production of the firm: Lewis Taft, originally of the Brownfield factory in Staffordshire and subsequently associated with OTT AND BREWER in Trenton, New Jersey, was made responsible for the bodies, glazes, and kilns; Frederick Hackney of Stoke-on-Trent, England, who had previously worked for JOSIAH WEDGWOOD AND SONS, LIMITED, and specialized in majolica, was put in charge of artistic affairs, especially the creation of molds. Thus it was probably Hackney who developed the majolica-like Clifton ware and the ivory-bodied Avalon ware that were among the first lines realized under Haynes's stewardship.

Except for such pieces as the Calvert-ware pitcher and the Japanesque pilgrim bottle in this exhibition (FIGS. 7.9, 7.10), most of the Chesapeake output could not aptly be described as aesthetic. Nevertheless, Haynes was dedicated to providing artistic quality, and on a commercial scale. In addition to several acclaimed lines of ceramic ware, the firm's most popular products—such as fully modeled Parian tea roses (mounted on velvet), portrait medallions of two prize shorthorns from a Massachusetts herd, and a rococo-style porcelain clock case—were sold in great numbers for two decades after 1890. As an active member of the United States Potters' Association, Haynes lobbied, if unsuccessfully, for a professional training school for ceramists and established close ties between his own firm and the Maryland Institute of Design, also in Baltimore; by 1884, some sixty women graduates of the institute were employed in the decorating department of the Chesapeake Pottery. Haynes's daughter Fannie, who studied at the Maryland Institute and at New York's Metropolitan Museum Art School, became a prize-winning ceramist and later a textile designer.

The enlargement of the Chesapeake Pottery factory in 1882 and the introduction of approximately nine new lines within the following five years created a financial strain that necessitated the sale of the works to Edwin Bennett of Baltimore in 1887. Three years later, however, Haynes was again the proprietor, this time in partnership with Bennett's son, E. Huston Bennett. The firm continued as Haynes, Bennett and Company until 1895, when Bennett retired. At that time Frank R. Haynes became a partner, and in 1896 the name was changed accordingly to D. F. Haynes and Son. In the years preceding D. F. Haynes's death, the firm received prizes at the 1901 Buffalo Pan-American Exposition and at the 1904 Saint Louis World's Fair. Sales began to decline about 1910. Four years later the business was liquidated and the property sold to the American Sugar Refining Company.

REFERENCES
[Messrs. D. F. Haynes and Co., Baltimore, have gone into the business of the Maryland Queensware Factory], *Crockery and Glass Journal* [hereafter abbreviated as *CGJ*] 10 (Aug. 7, 1879), p. 16 // [Maryland Queensware Factory and D. F. Haynes and Company], *CGJ* 10 (Aug. 21, 1879), p. 16 // "Baltimore Trade Reports," *CGJ* 11 (Apr. 1, 1880), p. 10 // "Baltimore Reports," *CGJ* 11 (May 20, 1880), p. 19 // "D. F. Haynes and Co.," *CGJ* 12 (Oct. 21, 1880), p. 32 // "Baltimore Reports," *CGJ* 13 (Apr. 14, 1881), p. 32 // "Baltimore Reports," *CGJ* 14 (Sept. 15, 1881), p. 42 // "Baltimore Reports," *CGJ* 14 (Nov. 24, 1881), p. 14 // "Baltimore Reports," *CGJ* 15 (Jan. 5, 1882), p. 16 // "Baltimore Reports," *CGJ* 15 (Jan. 19, 1882), p. 26 // "Baltimore Reports," *CGJ* 15 (Feb. 9, 1882), p. 36 // "Baltimore Reports," *CGJ* 15 (Apr. 13, 1882), p. 24 // "Baltimore Reports," *CGJ* 16 (July 20, 1882), p. 14 // "Baltimore Reports," *CGJ* 16 (Aug. 3, 1882), p. 16 // "The Potteries: Baltimore," *CGJ* 16 (Aug. 31, 1882), p. 30 // "Baltimore Reports," *CGJ* 16 (Sept. 14, 1882), p. 18 // "A Beautiful Display," *CGJ* 16 (Sept. 21, 1882), pp. 29–30 // "Artists and Artisans," *Baltimore Sun,* Dec. 5, 1882 // "Baltimore Reports," *CGJ* 16 (Dec. 21, 1882), p. 40; [Clifton ware], p. 42 // "Baltimore Reports," *CGJ* 17 (Jan. 11, 1883), p. 6 // Montezuma [Montague Marks], "My Note Book," *Art Amateur* 8 (Feb. 1883), p. 57 // [Salesmen for Chesapeake Pottery], *CGJ* 17 (Feb. 1, 1883), p. 20 // "Correspondence: The Nomenclature of the 'Chesapeake Pottery,'" *Art Amateur* 8 (Mar. 1883), p. 97 // "Baltimore Reports," *CGJ* 17 (Apr. 19, 1883), p. 21 // "Baltimore Reports," *CGJ* 17 (May 31, 1883), p. 8 // "Baltimore Reports," *CGJ* 17 (June 21, 1883), p. 10; [New designs], p. 22 // "Baltimore Reports," *CGJ* 18 (Aug. 16, 1883), p. 38 // "Baltimore Reports," *CGJ* 18 (Aug. 30, 1883), p. 34 // "Correspondence: Chesapeake Pottery Again," *Art Amateur* 9 (Nov. 1883), p. 131 // "Baltimore Reports," *CGJ* 18 (Nov. 15, 1883), p. 14 // "Baltimore Reports," *CGJ* 18 (Dec. 6, 1883), p. 28 // "Baltimore Reports," *CGJ* 19 (May 22, 1884), p. 32 // "Baltimore Reports," *CGJ* 19 (May 29, 1884), p. 25 // "Baltimore Reports," *CGJ* 19 (June 19, 1884), p. 14 // Isaac Edwards Clarke, *Art and Industry: Education in the Industrial and Fine Arts in the United States,* pt. 1, *Drawing in Public Schools* (Washington, D.C., 1885), p. ccxlvi // [Criticism of D. F. Haynes and Company's ceramic ware], *Art Amateur* 12 (Mar. 1885), p. 91 // Montezuma [Montague Marks], "My Note Book," *Art Amateur* 12 (May 1885), p. 121 // Pennsylvania Museum and School of Industrial Art, Philadelphia, *Exhibition of American Art Industry of*

1889, Including a Competition for American Workmen (exhib. cat., 1889), pp. 4, 7, 10, 12, 22–23 // Montezuma [Montague Marks], "My Note Book," *Art Amateur* 20 (May 1889), p. 122 // L. W. Miller, "Industrial Art: The Exhibition of Art Industry at Philadelphia," *Art Amateur* 21 (Nov. 1889), p. 134 // D. F. Haynes, "American Pottery," pts. 1, 2, *Home Magazine,* Aug. 1891, p. 10; Sept. 1891, p. 9 // Edwin AtLee Barber, "Recent Advances in the Pottery Industry," *Popular Science Monthly* 40 (Jan. 1892), pp. 304–6 // Idem, *The Pottery and Porcelain of the United States* (New York, 1893; 3d ed. New York, 1909), pp. 320–32 // *A History of the City of Baltimore: Its Men and Institutions* (Baltimore, 1902), pp. 208–11 // William P. Jervis, "Haynes, D. F., and Son," in *Encyclopedia of Ceramics* (New York, 1902), pp. 280–81 // Maryland Geological Survey [report], vol. 4 (Baltimore, 1902), pls. xxxvi, xxxvii // "David F. Haynes" [obituary], *Baltimore American,* Aug. 28, 1908, p. 14 // "Mr. D. F. Haynes Buried," Baltimore *Sun,* Aug. 28, 1908, p. 12 // Clayton Hall, *Baltimore: Its History and Its People,* 3 vols. (New York and Chicago, 1912), vol. 3, p. 858 // "Haynes, David Francis," in *Allgemeines Lexikon der Bildenden Künstler,* ed. Ulrich Thieme and Felix Becker, vol. 16 (Leipzig, 1923), p. 182 // John Ramsay, *American Potters and Pottery* (Boston, 1939), pp. 164, 263 // Maryland Historical Society, Baltimore, *The Potter's Craft in Maryland: An Exhibition of Nearly Two Hundred Examples of Pottery Manufactured 1793 to 1890* (exhib. cat., 1955), unpaged // Nancy Fitz-Patrick, "The Chesapeake Pottery Company," *Maryland Historical Magazine* 52 (Mar. 1957), pp. 65–71 // Paul J. FitzPatrick, "Chesapeake Pottery," *Antiques Journal* 33 (Dec. 1978), pp. 16–19, 48 // Laurie A. Baty, Museum and Library of Maryland History, Maryland Historical Society, Baltimore, correspondence, Aug. 22, 1984 // Claire R. Smalley, correspondence, Oct. 15, 1984 // Francis P. O'Neill, Museum and Library of Maryland History, Maryland Historical Society, Baltimore, correspondence, Feb. 15, 1985 // Wesley L. Wilson, Enoch Pratt Free Library, Baltimore, correspondence, Mar. 18, 1985 // Robert M. Bartram, George Peabody Library, The Johns Hopkins University, Baltimore, correspondence, June 28, 1985

David Francis Haynes, *see*
D. F. Haynes and Company

Hazelhurst and Huckel
Ca. 1881–1900
Philadelphia
Architects

Edward P. Hazelhurst (1853–1915) and Samuel William Huckel, Jr. (1858–1917), formed their architectural partnership about 1881 and quickly established themselves as a successful young firm specializing in residential architecture, primarily in Philadelphia and New Jersey. Prior to their association, Hazelhurst, born in Meade County, Kentucky, attended the University of Pennsylvania but left before graduating to work in the offices of T. P. Chandler (1845–1928) and FRANK FURNESS, two of Phil-

adelphia's then-leading architects. Huckel, a native of Philadelphia and a graduate of Central High School, worked in the local office of Benjamin D. Price (active 1867–1907), a church architect.

About 1885 Harrison Brothers and Company of Philadelphia hired the team of Hazelhurst and Huckel to prepare drawings of residential architecture (and a few train stations) in the contemporary Queen Anne style. These were reproduced and published about 1885 as a portfolio of unbound lithographs illustrating a variety of exterior paint schemes in such fashionable color combinations as ocher, umber, terracotta, and moss green (FIG. 10.5). The rather luxurious publication exceeded the boundaries of mere advertising: clearly the selection of house paint required a serious and educated artistic decision. The back of each lithograph bears the company's assertion that "this illustration has been made with due regard to the effect of light and shade on the colors and is a true representation of the appearance of such a building when painted with Harrisons' 'Town and Country' Ready Mixed Paints." The reader is then referred to the full selection of paint swatches mounted in the rear of the portfolio.

Both the style of rendering and the loose-leaf, art-print format of the paint catalogue are reminiscent of a series of lithographs published about 1882 (FIG. 10.1, ILL. 10.6) illustrating Bedford Park, a garden suburb in Turnham Green, near London, with houses designed by RICHARD NORMAN SHAW and E. W. GODWIN, two of the foremost British architects of the period. The cropped compositions and elevated points of view used in some of the English prints (each by a different artist), as well as the inclusion of Kate Greenaway–like figures in picturesque landscaped settings, are pictorial devices also used by the American architects, who may have modeled their Harrison paint work on the well-known Bedford Park prints.

The chronology of the firm's architectural commissions suggests that the Harrison catalogue effectively advertised their skills. Hazelhurst and Huckel is recorded as having only three relatively small projects prior to 1886: alterations and additions to the Philadelphia Art Club in 1884 plus a residence and the entrance lodge for the Greenmount Cemetery in Philadelphia (now demolished) in 1885. The following year the firm was considerably busier: they undertook the design of some fourteen residences, two banks, one courthouse, one hotel, an office building, and a parish house and Sunday school, as well as miscellaneous alterations.

Hazelhurst and Huckel continued their successful practice until Huckel received the commission to remodel New York City's Grand Central Station in 1899. The partnership was dissolved, and when Huckel returned to Philadelphia about 1902 he formed a new alliance, with Frank R. Watson (1859–1940); together they acquired a reputation for church architecture. In Philadelphia Hazelhurst independently pursued his career, which included many buildings for academic institutions.

REFERENCES
Harrison Brothers and Company, *Practical Illustrations of Various Combinations of Harrisons' "Town and Country" Ready Mixed Paints,* designed by Hazelhurst and Huckel (Philadelphia [1885/86]), Avery Architectural and Fine Arts Library, Columbia University, New York // "Hazelhurst, Edward P.," in *Biographical Dictionary of Philadelphia Architects, 1700–1930,* by Sandra L. Tatman and Roger W. Moss (Boston, 1985), pp. 350–56 // "Huckel, Samuel William, Jr.," in *Biographical Dictionary of Philadelphia Architects, 1700–1930,* by Sandra L. Tatman and Roger W. Moss (Boston, 1985), pp. 397–98

Edward Lamson Henry
1841–1919
New York City
Painter

From the 1870s until his death, Edward Lamson Henry was active as a genre painter, collector, and preservationist who treasured the buildings, interiors, costumes, and decorative arts of America's eighteenth-century past. His meticulous, documentary-style paintings express a nostalgia for the Colonial era that was stimulated by the Philadelphia Centennial Exposition in 1876 and that has continued unabated, in various forms, ever since.

Born in Charleston, South Carolina, Henry was orphaned as a young child. In 1848, at the age of seven, he was brought to New York to live with relatives, and by the age of fourteen he had commenced his art studies with Walter M. Oddie (1808–1865). In 1858 he went to Philadelphia, where he enrolled at the Pennsylvania Academy of the Fine Arts and where he may also have studied with Paul Weber (1823–1916), a German landscape painter. The following year Henry exhibited for the first time at the academy; observers thought his farmyard scene showed great promise.

In 1860 Henry made his first of several trips to Europe. He studied painting in Paris with Charles Alexandre Suisse, Charles Gleyre (1808–1874), and Gustave Courbet (1819–1877) and made a sketching tour through Italy, Germany, England, Ireland, and the Low Countries; his paintings, mostly small in scale and highly detailed, reveal little of this European training, however. Upon his return to the United States two years later, Henry began to concentrate on the purely American subject matter for which he is best known, and in 1864 he exhibited the first of his famous railroad subjects, *Station on Morris and Essex Railroad* (whereabouts unknown). A short stint in the Union army that year became a sketching opportunity. Some of his paintings are based on this experience, but typically they portray the pictorial aspects of the war, as in *A Presentation of Colors to the First Colored Regiment of New York by the Ladies of the City in Front of the Old Union League Club, Union Square, New York City in 1864* (1868; Union League Club, New York). Henry was one of few American genre painters to paint blacks, and as the title of this painting suggests, he treated them sympathetically in his work.

From the beginning Henry's work was popular with collectors; paintings were said to have been sold while hanging on the walls of the National Academy of Design, New York,

where he exhibited annually after 1861. Henry also showed his work regularly at the Brooklyn Art Association from 1863 until 1884 and occasionally at the Boston Athenaeum; he exhibited paintings at the 1878 and 1889 Paris Expositions Universelles. In 1867, at a relatively young age, he was elected an associate of the National Academy and became an academician two years later. With the exception of European travels in 1871, 1875 (after his marriage to Frances Livingston Wells, an amateur flower painter), and 1881–82, Henry pursued his career in New York, where he worked for many years in the Tenth Street Studio Building and, after 1885, at 3 Washington Square North. About 1872 he began to spend his summers at Cragsmoor, near Ellenville, New York, a bucolic little community in the Shawangunk Mountains that in the 1870s became an artists' colony. A few years after building a house there in 1883, Henry gave up his permanent residence in New York, although he returned to the city each year for the winter months.

An antiquarian of some note, Henry was an avid collector of paintings, prints, Colonial furniture, antique carriages, ceramics, glass, costumes, and textiles—objects that for him were imbued with age, beautiful workmanship, and symbolic meaning; his wife recalled an old tall clock that particularly inspired his reflection on the passage of time and human existence. His paintings, many of them interiors similar to *A Lover of Old China*, 1880, and *Old Clock on the Stairs*, 1868 (FIG. 1.8), evoke through their objects and historically accurate details an idealized, homogeneous period in American history, while other works record the ways of a rural life fast disappearing. Henry was also intensely devoted to preserving old buildings and landmarks, which he frequently painted and photographed; he was actively involved in the restoration of Independence Hall in Philadelphia. His summer house and New York studios were always full of architectural elements, including windows, mantelpieces, columns, and balusters, that Henry acquired from historic structures doomed to demolition.

His painting style and subject matter remained constant throughout his career, impervious to new artistic developments in Europe or America. His work continued to be popular through the end of the century, and many of his paintings were reproduced in prints. Henry received medals at the international exhibitions held in Chicago (1893), Buffalo (1901), Charleston (1902), and Saint Louis (1904). In 1902 Sadakichi Hartmann (1867–1944), describing "the old school," wrote, "Men like [J. G.] Brown and Henry in a way represent American art better than any one else; not its aspirations, but its stern cruel facts, those the large multitude can appreciate and understand. Even the best of the picture-loving public still prefer story-telling to any other style in painting. . . . As long as the public wants such pictures . . . they have their place" (Hartmann, 1902, pp. 156–57). Writing for the New York *Evening Post* on the occasion of Henry's death, however, WILL H. LOW hinted at the xenophobia that also informs Henry's work: "Without claiming for Mr Henry a dominant place, there are few American artists who have better

served their country in preserving for the future the quaint and provincial aspects of a life which has all but disappeared since we have become the melting pot for other races than our own" (Low, in McCausland, 1945, p. 65).

REFERENCES
Clarence Cook, *The House Beautiful: Essays on Beds and Tables, Stools and Candlesticks* (New York, 1878) // Clara Erskine Clement and Laurence Hutton, "Henry, Edward L.," in *Artists of the Nineteenth Century and Their Works,* vol. 1 (Boston, 1880), pp. 346–47 // Ortgies and Company, New York, *Catalogue of the Collection of Mr. E. L. Henry . . . Paintings, Rare Old Engravings, Colonial Furniture, Bric-a-Brac, to Be Sold at Auction* (sale cat., Mar. 2, 1887) // "Henry, Edward Lamson," in *The National Cyclopaedia of American Biography,* vol. 5 (New York, 1894), pp. 315–16 // "Henry, Edward Lamson," in *Appletons' Cyclopaedia of American Biography,* ed. James Grant Wilson and John Fiske, vol. 3 (New York, 1900), p. 171 // Sadakichi Hartmann, *A History of American Art,* 2 vols. (Boston, 1902), vol. 1, pp. 156–57 // *Reproductions of the Works of E. L. Henry, N.A., Etchings, Photogravures, Facsimiles, Platinotypes* (New York and London [1906]) // "Henry, E(dward) L(amson)," *American Art Annual* 10 (1913), p. 278, ill. opp. p. 257 // Lucia Fairchild Fuller, "The Field of Art: E. L. Henry, N.A., an Appreciation," *Scribner's Magazine* 68 (Aug. 1920), pp. 250–56 // "Henry, Eduard [*sic*] Lamson," in *Allgemeines Lexikon der Bildenden Künstler,* ed. Ulrich Thieme and Felix Becker, vol. 16 (Leipzig, 1923), p. 422 // "Henry, Edward L.," in *Cyclopedia of Painters and Paintings,* ed. John Denison Champlin, Jr., and Charles C. Perkins, vol. 2 (New York, 1927), p. 238 // Elizabeth McCausland, "The Life and Work of Edward Lamson Henry, N.A., 1841–1919," *New York State Museum Bulletin* 339 (Sept. 1945), pp. 1–381 // Frank Jewett Mather, Jr., "The Century and American Art," in *The Century, 1847–1946* (New York, 1947), pp. 154–83 // George C. Groce and David H. Wallace, "Henry, Edward Lamson," in *The New-York Historical Society's Dictionary of Artists in America, 1564–1860* (New Haven and London, 1957), p. 309 // "Henry, Edward Lamson," in *Dictionary of American Biography,* vol. 4, pt. 2 (New York, 1960), pp. 547–48 // Mary Sayre Haverstock, "The Tenth Street Studio," *Art in America* 54 (Sept.–Oct. 1966), pp. 48–57 // Albany Institute of History and Art, N.Y., *Paintings, Drawings, and Sketches of Edward Lamson Henry, N.A.* (exhib. cat., 1972) // "Henry (Edward Lamson)," in *Dictionnaire critique et documentaire des peintres, sculpteurs, dessinateurs, et graveurs,* ed. E. Bénézit, vol. 5 (Paris, 1976), p. 493 // A. Hyatt Mayor and Mark Davis, *American Art at the Century* (New York, 1977), pp. 56–57 (ill.), 128 // Barbara [Ball] Buff, "Cragsmoor, an Early American Art Colony," *Antiques* 114 (Nov. 1978), pp. 1056–67 // Elizabeth Stillinger, *The Antiquers* (New York, 1980), pp. 35–41 // Barbara Ball Buff, "Mr. Henry of Cragsmoor," *Archives of American Art Journal* 21, no. 3 (1981), pp. 2–7 // Celia Betsky, "Inside the Past: The Interior and the Colonial Revival in American Art and Literature, 1860–1914," in *The Colonial Revival in America,* ed. Alan Axelrod (New

York and London, 1985), pp. 241–77 // Natalie Spassky et al., *American Paintings in the Metropolitan Museum of Art,* vol. 2, *A Catalogue of Works by Artists Born Between 1816 and 1845* (New York, 1985), pp. 558–63

Herter Brothers
1865–1905
New York City
Furniture and interior decoration

For four decades following the Civil War, Herter Brothers set the standards for high quality in craftsmanship and luxury in interior decoration in the United States. Furniture and indeed entire rooms (and sometimes buildings) complete with woodwork, fixtures, and fittings were designed by Herter Brothers for some of the grandest private homes (as well as banks, office buildings, and churches) ever built in the United States—from New York to California—for clients who included Jay Gould, Mark Hopkins, Collis Potter Huntington, Pierre Lorillard, Darius Ogden Mills, J. Pierpont Morgan, and William H. Vanderbilt. Though the firm created furniture and decoration derived from a variety of historical periods, among them the Gothic, Renaissance, Queen Anne, and Rococo, during the 1870s and early 1880s the Herter Brothers' name became synonymous with the Anglo-Japanesque style. Despite the importance of this company to the Aesthetic movement in America, however, Herter Brothers has yet to be the subject of a serious scholarly study.

Gustave Herter (1830–1898) and his half brother Christian Herter (1840–1883) were born in Stuttgart, Germany. Their father, Christian, who had adopted Gustave (his wife's son by a previous marriage), was an accomplished cabinetmaker. No doubt exposure to the father's craft influenced the sons' choice of career. Before coming to the United States, Gustave worked under an eminent German architect named Leins and designed the interior woodwork for the royal palace at Berg. He emigrated in 1848, perhaps to escape the revolutions rocking Europe at the time, and for about three years after his arrival worked for Tiffany, Young and Ellis, predecessor of TIFFANY AND COMPANY; by 1851 Herter is listed as "cabinetmaker" in the New York city directories, at 48 Mercer Street. During this period he was also associated with Edward W. Hutchings, a leading New York cabinetmaker. It was probably in Hutchings's workshop that Herter met Auguste Pottier (1823–1896), later of Pottier and Stymus Manufacturing Company, with whom he was briefly in partnership in 1853 under the firm name of Herter, Pottier and Company.

At the Crystal Palace exhibition in New York in 1853–54, Herter was mentioned in conjunction with three pieces of elaborately carved furniture, which, it would appear, he designed. "Messrs. Bulkley and Herter" displayed a large Renaissance buffet carved by E. Plassman, which can only be described as exuberant, and a stately Gothic-style bookcase. (Between 1852 and 1854 Herter's shop was located at 56 Beekman Street, which accounts for his collaboration with Erastus Bulkley, who worked at the same address.) A rosewood

étagère designed by Herter for Mr. T. Brooks of Brooklyn was also on view at the fair (Silliman and Goodrich, 1854, pp. 67, 93, 168).

About 1856 Herter moved his workshop to 547 Broadway, its location until his retirement in 1870. His brother Christian emigrated to New York in 1860, following several years of art study in Stuttgart and in Paris at the Ecole des Beaux-Arts. After working briefly for Tiffany and Company, Christian joined Gustave's firm, the name of which became Herter Brothers in 1865.

Because Christian Herter displayed great artistic talent, his brother encouraged him to return to Paris for further study. Christian probably spent two years there, from 1868 until 1870, under the tutelage of Pierre Victor Galland (1822–1892), whose murals Herter was later to import for use in the homes of wealthy clients, such as William H. Vanderbilt. When Christian returned to the United States, he purchased Gustave's interest in Herter Brothers. Gustave retired to Stuttgart, where he lived until 1892, but he died in New York in 1898. Apparently none of his four sons were connected with the firm.

During his thirteen-year tenure, from 1870 until his death in 1883, Christian Herter put Herter Brothers at the forefront of progressive furniture design in America. While studying in Paris in the late 1860s, he would have been exposed to avant-garde interest in oriental art and design. A few years later, during the early 1870s, Herter visited England, where he must have been exposed firsthand to British reform ideals and to the art furniture of E. W. GODWIN and others. These influences were reinforced by the displays at the 1876 Centennial Exposition in Philadelphia. About this time Herter Brothers developed their unique version of the Anglo-Japanesque style in furniture: typically rectilinear in outline and constructed in ebony-colored wood with contrasting light-toned marquetry in stylized, often asymmetrical patterns, their work was exquisitely crafted, with shallow carving and incised details (FIGS. 5.26, 5.27, 5.32, ILL. 5.9). To complement the furniture and to complete the oriental motifs that he employed in interior decoration, after 1876 Christian Herter imported embroideries, Chinese porcelain, Persian pottery, and Japanese art objects.

Herter, by all accounts an engaging man of forceful intellect and refined artistic judgment, was no doubt responsible for overseeing his firm's development, but there were others whose contributions have not yet been fully assessed. William Baumgarten (1845–1906) was hired as a designer in 1870 and served as director of the company from 1881 until 1891. He was succeeded by William Gilman Nichols from 1891 to 1906. Alexandre Sandier (1843–1916), a Frenchman who later took charge of the art department at the Sèvres porcelain factory, worked for Herter Brothers in the 1870s. His furniture designs (FIGS. 1.6, 5.7), some of which were illustrated by CLARENCE COOK in *The House Beautiful* (1878, FIG. 5.6), are stylistically related to Godwin's. William B. Bigelow was a designer with the firm, as was FRANCIS H. BACON, who left in 1881 and later joined A. H. DAVENPORT AND COMPANY. Wilhelm Kimbel (see A. KIMBEL AND J. CABUS), an architect and interior designer, worked for the company about 1890. John Getz, once associated with Herter Brothers, reportedly opened a New York branch of S. Bing's operations in 1887, presumably to purvey Japanese goods as did Bing in Paris.

Throughout the 1870s Herter Brothers also created impressive pieces of furniture in the Renaissance- and classical-revival styles; Clarence Cook refers to Herter Brothers' pieces in the "Eastlake" (or Modern Gothic) style, but to date virtually none of these works have come to light. Some gilded pieces of about 1880 are delicate reinterpretations of eighteenth- and early nineteenth-century English styles modified by late nineteenth-century reform attitudes (FIGS. 5.30, 5.31). To be sure, although no one designer can be identified with the carved and gilded fire screen inset with one silk and one pressed-leather panel (FIG. 5.29) or the small ebonized cabinet with its extraordinary central panel arrayed with aesthetic marquetry (FIG. 5.28), both of about 1880, these works epitomize high-style aestheticism in America, not only because they exhibit the superb craftsmanship generally associated with Herter Brothers furniture, but also because they demonstrate the ability of the firm's designers to compose brilliantly unified pieces from eclectic stylistic sources. In addition to individual pieces of furniture, Herter Brothers provided its clients with textiles (FIG. 3.18), mosaics, stained glass, decorative plasterwork, carpets, and lighting fixtures of their own design, as well as imported wallpapers, brocades, and decorative objects.

The William H. Vanderbilt house, situated on the northwest corner of Fifth Avenue at Fifty-first Street in New York, was perhaps the firm's most prestigious project and certainly its most thoroughly documented; an illustrated two-volume "description" of it by Edward Strahan (Earl Shinn) was published in 1883–84 (ILLS. 2.1, 4.7, 4.8, 4.9). The building itself was designed by John B. Snook assisted by Charles B. Atwood (1849–1895), then with the Herter Brothers firm. Atwood joined Herter in 1875 and remained with the firm until 1884, when he established his own architectural office. Two pieces of furniture from the house suggest the astonishing extravagance invested in every interior detail: one is a gilded, goat-hoofed drawing-room chair with mother-of-pearl inlay and golden snakes coiling around the back rail (FIG. 4.2, ILL. 4.7); the other is a massive rosewood library table, unique in its arrangement of classical details and mother-of-pearl and brass inlay, whose surface is studded with stars and embellished with one side of the terrestrial globe at either end (FIGS. 4.3, 4.4, ILL. 4.8).

Christian Herter accepted the Vanderbilt commission in 1879 with the understanding that it would be his last. Sadly, it was. About 1880 Herter retired from the firm with the intention of studying painting in Paris with Jean-Paul Laurens (1838–1921). The Vanderbilt project continued until 1882, and just a year later Herter died in New York at the young age of forty-three from tuberculosis contracted in Europe.

Directed by William Baumgarten until 1891 and then by William Nichols until 1906, Herter Brothers continued to create lavish interiors for its elite clientele, the Oliver Ames, Jr., home in Boston of about 1883 being but one example (ILL. 3.23). Such luxury was not inexpensive: the Honorable W. D. Washburn of Minneapolis received one bill for almost $93,000 in 1884, while contracts for work on Saint Elizabeth's Roman Catholic Church in Philadelphia were reported at $180,000 in 1889, before the project was even near completion.

During the late 1880s Herter Brothers supplied paintings as well as decorative arts, particularly those by French artists of the Barbizon School. "The newest gallery of importance in the city, for the exhibition of pictures for sale," Montague Marks proclaimed in 1888, "is a fine apartment fitted up by Herter Brothers in their Fifth Avenue building, indicating that their business in paintings has grown considerably from the occasional sale to a client of the house, which about marked its limit a few years ago. It is evident from its interesting display, that the firm intends to rank among the important picture importers in the country" (Montezuma, 1888, p. 104).

In Chicago at the World's Columbian Exposition of 1893 the firm decorated the vestibule of the New York State Building. The niched fountains suggested the Villa Madama, the general managers of the New York display reported, and a highly elaborate mosaic, Pompeian in composition and color, that recalled designs of the sixteenth-century Mannerist painter and architect Giulio Romano was the work of Herter Brothers, "carried out by them with great skill and artistic feeling" (*Report*, 1894, p. 96). CHARLES CARYL COLEMAN was responsible for the murals on the nearby grand stairway, which shared the Pompeian theme.

The history of Herter Brothers after 1893 has not yet been studied. Christian Herter's sons were not affiliated with the company. Christian Archibald Herter (1865–1910) became a respected physician; Albert Herter (1871–1950) became a painter and later founded the famous Herter Looms, in 1911. A large sale of the contents of the Herter Brothers showroom and gallery in March 1905 probably marked, for all intents and purposes, the end of the firm's activities, although operations did not formally conclude until the following year.

REFERENCES

B. Silliman, Jr., and C. R. Goodrich, eds., *The World of Science, Art, and Industry Illustrated from Examples in the New-York Exhibition, 1853–54* (New York, 1854), pp. 67 (ill.), 93 (ill.), 168 (ill.) // "American Art-Manufactures," *Art Journal* (Appleton's) 1 (Feb. 1875), p. 53 (ill.) // "Concerning Furniture," *Scribner's Monthly* 11 (Nov. 1875–Apr. 1876), Scribner's Miscellany [bound in at back], pp. 9–10 // "Decorative Fine-Art Work at Philadelphia: American Furniture," pts. 1–3, *American Architect and Building News* 1 (Dec. 23, 1876), p. 412; 2 (Jan. 6, 1877), p. 3; (Jan. 13, 1877), pp. 12–13 // "A Frenchman's Ideas upon American Cabinet-Work [Frédéric-Auguste Bartholdi]," *American Architect and Building News* 2 (Sept. 1, 1877), p. 278 // Clarence Cook, *The House Beautiful: Essays on Beds and Tables, Stools and Candlesticks* (New York, 1878) // Harriet Prescott Spofford, *Art Decoration Applied to Furniture* (New York, 1878),

preface // "Carpet Designing in America," *Art Amateur* 5 (June 1881), pp. 11–12 // M. G. Van Rensselaer, "The Competition in Wall-Paper Designs," *American Architect and Building News* 10 (Nov. 26, 1881), pp. 251–53 // [Alexander F. Oakey], "A Trial Balance of Decoration, *Harper's New Monthly Magazine* 64 (Apr. 1882), pp. 734–40 // "Upholstery Personals," *Carpet Trade Review* 9 (Apr. 1882), p. 46 // *Artistic Houses, Being a Series of Interior Views of a Number of the Most Beautiful and Celebrated Homes in the United States,* 2 vols. in 4 pts. (New York, 1883–84; reprinted in 1 pt., New York, 1971), vol. 1, pt. 1, pp. 74–80; vol. 1, pt. 2, pp. 111–27; vol. 2, pp. 86–89, 101–3 // [Christian Herter, obituary], *New York Daily Tribune,* Nov. 3, 1883, p. 3 // "Character of Christian Herter," *New York Times,* Nov. 11, 1883, p. 14 // "Death of Christian Herter," *Carpet Trade and Review* 14 (Nov. 15, 1883), p. 43 // Edward Strahan [Earl Shinn], *Mr. Vanderbilt's House and Collection,* 2 vols. (Boston, New York, and Philadelphia, 1883–84), vol. 1, p. 7; vol. 2, pp. 78 (ill.), 105–6 // "Dining Room, West Hotel, Minneapolis," *Decorator and Furnisher* 7 (Jan. 1886), p. 116 (ill.) // Montezuma [Montague Marks], "My Note Book," *Art Amateur* 16 (Mar. 1887), p. 75 // Idem, "My Note Book," *Art Amateur* 18 (Apr. 1888), p. 104 // "Architectural Gossip," *Art Age* 9 (Jan. 1889), p. 10 // Montezuma [Montague Marks], "My Note Book," *Art Amateur* 20 (Mar. 1889), p. 74 // Idem, "My Note Book," *Art Amateur* 20 (May 1889), p. 122 // Idem, "My Note Book," *Art Amateur* 21 (Nov. 1889), p. 115 // "Herter, Christian," in *The National Cyclopaedia of American Biography,* vol. 5 (New York, 1894), p. 320 // *Report of the Board of General Managers of the Exhibit of the State of New York at the World's Columbian Exposition* (Albany, 1894), pp. 96–97 // William Baumgarten, "Christian Herter's Verdienste um das deutsch-amerikanische Kunstgewerbe," *Sonntagsblatt der New-Yorker Staats-zeitung,* Feb. 20, 1898, p. 27 // [Gustave Herter, obituary], *New York Tribune,* Dec. 1, 1898, p. 7 // "Baumgarten, William," in *The National Cyclopaedia of American Biography,* vol. 11 (New York, 1901), p. 466 // James P. Silo, Fifth Avenue Art Galleries, New York, *The Superb Collection of Furniture, Hangings, Embroideries, Paintings, and Museum Pieces of Herter Brothers . . .* (sale cat., Mar. 16–18, 1905) // *Fiftieth Anniversary of the New-York Wood-Carvers and Modellers Association* (New York, 1913) // "Herter, Christian," in *Allgemeines Lexikon der Bildenden Künstler,* ed. Ulrich Thieme and Felix Becker, vol. 16 (Leipzig, 1923), p. 554 // "Kimbel, Wilhelm," in *Allgemeines Lexikon der Bildenden Künstler,* ed. Ulrich Thieme and Felix Becker, vol. 20 (Leipzig, 1927), pp. 309–10 // "Herter, Gustave," in *The National Cyclopaedia of American Biography,* vol. 6 (New York, 1929), p. 297 // "Atwood, Charles Bowler," in *The National Cyclopaedia of American Biography,* vol. 22 (New York, 1932), pp. 110–11 // M[arguerite] B[artlett] H[amer], "Herter, Christian," in *Dictionary of American Biography,* vol. 8 (New York, 1932), pp. 596–97 // Martin Eidelberg, "American Arts and Crafts at the Turn of the Century," *Connoisseur* 181 (Nov. 1972), pp. 189–95 // Hudson River Museum, Yonkers, N.Y., *Eastlake-Influenced American Furniture,*

1870–1890, by Mary Jean Smith Madigan (exhib. cat., 1973) // Marilynn Johnson Bordes, "Christian Herter and the Cult of Japan," in "Aspects of the Arts and Crafts Movement in America," ed. Robert Judson Clark, *Record of the Art Museum, Princeton University* 34, no. 2 (1975), pp. 20–27 // William Seale, *The Tasteful Interlude* (New York, 1975), pp. 74–75 (ills.) // United States Antiques, Inc. [advertisement], *Nineteenth Century* 1 (Apr. 1975), p. 4 (ill.) // Mary Jean [Smith] Madigan, "Eastlake-Influenced American Furniture, 1870–1890," *Connoisseur* 191 (Jan. 1976), pp. 58–63 // Charles H. Carpenter, Jr., and Mary Grace Carpenter, *Tiffany Silver* (New York, 1978), p. 8 // Museum of Fine Arts, Houston, *Houston Collects Nineteenth-Century American Decorative Arts,* by David B. Warren and Katherine S. Howe (exhib. cat., 1978), fig. 16 // Washburn Gallery, New York, *Christian Herter and the Aesthetic Movement in America,* by David [A.] Hanks (exhib. cat., 1980) // [Advertisement], *Antiques and the Arts Weekly,* Feb. 22, 1980, p. 95 (ill.) // David [A.] Hanks, "Christian Herter and the Aesthetic Movement in America," *Arts Magazine* 54 (May 1980), pp. 138–39 // Lynn E. Springer, "The Cabinetmaker's Art: Selections of American Furniture to the Early Twentieth Century," in "American Furniture," *Saint Louis Art Museum Bulletin,* n.s. 15 (Summer 1980), pp. 36 (ill.), 39 (ill.), 40–44 (ills.) // Idem, "American Furniture in the Saint Louis Art Museum," *Antiques* 121 (May 1982), p. 1194 (ill.) // David A. Hanks, "Pottier and Stymus Manufacturing Company: Artistic Furniture and Decorations," *Art and Antiques* 7 (Sept.–Oct. 1982), pp. 84–91 // Henry [H.] Hawley, "Four Pieces of American Furniture: An 'Aesthetic' Sidechair," *Bulletin of the Cleveland Museum of Art* 69 (Dec. 1982), pp. 330–32, 338–39 (nn. 20–42) // Detroit Institute of Arts, *The Quest for Unity: American Art Between World's Fairs, 1876–1893* (exhib. cat., 1983), pp. 181–85 // High Museum of Art, Atlanta, *The Virginia Carroll Crawford Collection: American Decorative Arts, 1825–1917,* by David A. Hanks and Donald C. Peirce (exhib. cat., 1983), pp. 48–49 (ills.), 52 (ill.), 54 (ill.), 85 (ill.), 88 (ill.) // [Advertisement], *Antiques* 123 (Jan. 1983), p. 80 (ill.) // Arlene Palmer Schwind, Yarmouth, Maine, correspondence, Jan. 27, 1985 // Derek Ostergard, "Collecting Notes: Herter Brothers Revival," *Art and Auction* 7 (Feb. 1985), pp. 36, 40, 42, 44, 46 // Elaine Harrington, Chicago Architecture Foundation, correspondence, Mar. 4, 1985 // Marilynn Johnson, "The Herter Brothers," *House and Garden* 157 (May 1985), pp. 17, 20, 24, 28

Christian Herter, *see* **Herter Brothers**

Gustave Herter, *see* **Herter Brothers**

George W. Hewitt, *see* **Frank Furness**

Hobbs, Brockunier and Company
1863–1887
Wheeling, West Virginia
Glass

The Aesthetic period proved to be the apogee

of the almost twenty-five-year history of Hobbs, Brockunier and Company (sometimes known as the South Wheeling Glass Works) in both successful production and marketing of its wares. From the mid-1870s through the mid-1880s, the firm created a dazzling array of decorative art glass in a wide variety of alluring colors, patterns, and textures.

The history of the company can be traced to 1845, when two dissatisfied workers from the NEW ENGLAND GLASS COMPANY, John L. Hobbs (1804–1881), formerly superintendent of the cutting department and salesman, and James B. Barnes (d. 1849), a skilled engineer who had designed and managed the construction of the first furnace there, bought the inactive Plunkett and Miller Glasshouse in Wheeling, West Virginia, and formed Barnes, Hobbs and Company. According to advertisements, the company began manufacturing flint- (or lead-) glass "solar chimneys, jars, vials, tumblers, . . . and cologne bottles." In 1849 Barnes died and was succeeded by his son James F. Barnes (d. 1863), who, along with Hobbs's son, John H. Hobbs, had been involved in the firm since its inception; the business was then renamed Hobbs, Barnes and Company. When James F. Barnes died, the company was reorganized again, this time as Hobbs, Brockunier and Company, the partnership comprising the two Hobbses, Charles W. Brockunier, who had been the company bookkeeper and office manager, and one silent partner, William Leighton, Sr. (1808–1891), the son of New England Glass Company's Thomas Leighton. Leighton had also previously worked for the New England Glass Company, as the superintendent of its works. He provided much-needed technical skill to Hobbs, Brockunier and Company in his role as the factory's scientist and superintendent. His son William Leighton, Jr. (1833–1911), succeeded him in that position upon his retirement in 1867.

The first major development of Hobbs, Brockunier and Company occurred in 1864, when William Leighton perfected a formula for lime glass, which could compare favorably in appearance with flint glass but which would cost a fraction thereof to make. This discovery resulted in dramatic changes that affected the entire glass industry, especially in the Midwest. The Hobbs, Brockunier production soon consisted of cut and engraved flint ware and pressed ware in a variety of different patterns in colorless lime and opal glass. By 1879 Hobbs, Brockunier and Company was considered one of the largest glass factories in the United States.

It was the company's artistic glassware, or "fancy glass," dating from the early 1880s, that truly ensured the factory's lasting reputation. The first of these was a crackle or frosted glass that the company dubbed "Craquelle"—a type of glass that was being made at the BOSTON AND SANDWICH GLASS COMPANY and elsewhere. Other new patterns included Polka Dot and Optic, both of which were made in new colors, "aurora" and "rubina" to name just two. In 1883 the firm added spangled glass to its expanding line of novelty wares (FIG. 7.46). According to the *Crockery and Glass Journal,* it was "produced by flecking gold or silver foil on a ground of dark blue or green and then covering the spangles with a thin coating of

crystal glass" (*Crockery and Glass Journal*, Aug. 30, 1883, p. 40). The result was a unique effect akin to malachite or lapis lazuli.

Peachblow glass, begun in 1886, became the company's most famous art glass. Made of a white opal glass coated with a layer of amber glass shading to ruby, the final result resembled porcelain. Production was stimulated in large part by the March 1886 auction sale of a Chinese peach-bloom porcelain vase, similar to that in figure 7.48, from the collection of Mrs. Mary J. Morgan that was purchased by William T. Walters of Baltimore for the near-scandalous price of $18,000. Hobbs, Brockunier marketed a facsimile of the Morgan Vase (FIG. 7.49) as well as other forms in the same material, some of which were also based on oriental-vase shapes and were available with either shiny (FIG. 7.50) or matte (ILL. 7.14) surfaces. Still other peachblow vessels took the form of such utilitarian tablewares as tumblers and pitchers.

In 1886 Hobbs, Brockunier made an agreement with the New England Glass Company to become the exclusive producer of pressed amberina glass. The New England firm made only a small number of examples in pressed amberina, including the stork vase designed by JOSEPH LOCKE (FIG. 7.47). The West Virginia company, however, produced it in large quantity, often in patterns imitating cut glass, and increased the color range to include an entire rainbow of hues—amber, pink, yellow, and blue.

The success that Hobbs, Brockunier and Company achieved with their colorful art glass was short-lived, for in 1887 William Leighton, Jr., and Charles Brockunier retired from the company. Hobbs remained as president of the works under its new name, J. H. Hobbs Glass Company. In 1891 the glassworks closed, and it, along with seventeen other glass factories in the area, was taken over by the United States Glass Company.

REFERENCES
"Trade in the West," *Crockery and Glass Journal* [hereafter abbreviated as *CGJ*] 2 (July 29, 1875), p. 12 // "Notes of Travel: Wheeling, W. Va.," *CGJ* 8 (July 25, 1878), p. 16 // H., "The Manufacture of Glass at Wheeling, West Virginia," *CGJ* 10 (Sept. 4, 1879), p. 19 // "Miscellaneous Glass Notes," *CGJ* 10 (Sept. 4, 1879), p. 20 // "The Glass Factories of Wheeling and Vicinity," *CGJ* 10 (Sept. 25, 1879), p. 6 // "General Report of the Judges of Group 2," in U.S. Centennial Commission, *International Exhibition, 1876: Reports and Awards,* 9 vols. (Washington, D.C., 1880), vol. 3, pp. 597, 746 // Sand, "Wheeling Reports: Wheeling Glass-Houses," *CGJ* 12 (Sept. 30, 1880), p. 6 // Idem, "Wheeling Reports," *CGJ* 13 (Feb. 3, 1881), p. 6 // "The Glass Factories: Wheeling," *CGJ* 13 (June 16, 1881), p. 22 // "Death of a Prominent Glass Manufacturer," *CGJ* 14 (Nov. 10, 1881), pp. 31–32 // "The Glass Factories: Wheeling," *CGJ* 14 (Dec. 8, 1881), p. 34 // "The Glass Factories: Wheeling," *CGJ* 15 (Mar. 2, 1882), p. 28 // "The Glass Factories: Wheeling," *CGJ* 15 (Apr. 27, 1882), p. 28 // "The Glass Factories: Wheeling," *CGJ* 15 (May 11, 1882), p. 34 // "The Glass Factories: Wheeling," *CGJ* 16 (Sept. 21, 1882), p. 20 // "The Potteries: Exporting

Glass," *CGJ* 16 (Nov. 23, 1882), pp. 27–28 // "The Glass Factories: Wheeling," *CGJ* 17 (May 3, 1883), p. 14 // [The glass factories], *CGJ* 18 (Aug. 30, 1883), p. 40 // "The Glass Factories: Wheeling," *CGJ* 18 (Nov. 1, 1883), p. 20 // "The Glass Factories: Wheeling," *CGJ* 18 (Nov. 22, 1883), p. 12 // "The Glass Factories: Wheeling," *CGJ* 19 (Jan. 17, 1884), p. 12 // "The Glass Factories: Wheeling," *CGJ* 19 (Apr. 17, 1884), p. 14 // "Philadelphia Reports," *CGJ* 19 (May 29, 1884), p. 18 // "Philadelphia Trade Notes," *CGJ* 20 (Aug. 28, 1884), p. 12 // "The Glass Factories: Wheeling," *CGJ* 20 (Oct. 9, 1884), p. 16 // "The Glass Factories: Wheeling," *CGJ* 20 (Nov. 20, 1884), p. 12 // Ruth Webb Lee, "Peachblow Glass," *Antiques* 24 (Aug. 1933), pp. 48–50 // J. Stanley Brothers, Jr., "American Ornamental Glass," pt. 2, *Antiques* 29 (Mar. 1936), pp. 111–13 // George S. McKearin and Helen McKearin, *American Glass* (New York, 1941), pp. 141, 395, 419, 421, 601–2 // Josephine Jefferson, *Wheeling Glass* (Mount Vernon, Ohio, 1947) // Albert Christian Revi, *American Pressed Glass and Figure Bottles* (New York, 1964), pp. 182–92 // Idem, *Nineteenth Century Glass: Its Genesis and Development,* rev. ed. (Exton, Pa., 1967), pp. 23, 25, 26 (ill.), 30, 32, 45, 47 (ill.), 52, 62, 200, 201 (ill.), 212, 251–52 // Robert E. Di Bartolomeo, "On Hobbs, Brockunier and Company Glass," *Glass Club Bulletin of the National Early American Glass Club* 103 (Nov. 1972), pp. 3–12 // Idem, "Hobbs, Brockunier's Fancy Glass," *Antiques* 107 (Mar. 1975), pp. 494–501 // Huntington Galleries, W.Va., *A Century of Glassmaking in West Virginia,* by Eason Eige (exhib. cat., 1980), pp. 4–15 // Detroit Institute of Arts, *The Quest for Unity: American Art Between World's Fairs, 1876–1893* (exhib. cat., 1983), pp. 185–86 (ill.) // Oglebay Institute, Mansion Museum, Wheeling, W.Va., *The Wheeling Glasshouses,* by T. Patrick Brennan (exhib. cat., n.d.)

Winslow Homer
1836–1910
Boston
Painter

Winslow Homer was born in Boston and attended school across the Charles River in nearby Cambridge. An early interest in art led at the age of nineteen to a two-year apprenticeship with the Boston lithographic firm of J. H. Bufford. As a free-lance illustrator Homer drew scenes of everyday life in Boston and rural New England for *Ballou's Pictorial Drawing-Room Companion* (Boston) and *Harper's Weekly* (New York). *Harper's* offered Homer a full-time position as an illustrator when he moved to New York in 1859, but he preferred, until 1875, to work for the paper on a free-lance basis. Homer's drawings during the Civil War conveyed the daily routine of camp life to *Harper's* readers, and the war became the subject of his early oil paintings as well. In 1866 he completed *Prisoners from the Front* (The Metropolitan Museum of Art, New York), which established his reputation when it was exhibited that year at the National Academy of Design in New York and at the 1867 Exposition Universelle in Paris.

Homer's formal training was limited to drawing classes in Brooklyn, night school at the National Academy of Design about 1861, and a month of study in New York with the French genre and landscape painter Frederick Rondel (1826–1892). He exhibited regularly at the National Academy of Design starting in 1863, and in 1865, at the unusually young age of twenty-nine, he was elected an academician. Late in 1866 he traveled to France, where he stayed for ten months, returning to the United States in the fall of 1867. Little is known of his activities abroad. In Paris he shared a studio in Montmartre with Albert W. Kelsey, a friend from Belmont, Massachusetts, and probably met with his former colleague from Bufford's, J. Foxcroft Cole (1837–1892). *Prisoners from the Front* was on display at the current Exposition Universelle, and there Homer could easily have seen the works of the realists Gustave Courbet (1819–1877) and Edouard Manet (1832–1883). It is uncertain whether he saw any of the Impressionists' works while he was in Paris, since they did not formally exhibit as a group until 1874; similarities between his paintings and those of Monet and Degas are most likely the result of their common appreciation of the direct study of nature.

In 1872 Homer took a studio in the Tenth Street Studio Building, then a center of artistic activity in New York. He was a founding member of the Tile Club in 1877, and he served as host at the club's first annual dinner, which was held in his studio. Members of the club met regularly to paint on eight-by-eight-inch tiles like those by Tilers Charles S. Reinhart (1844–1896) (about 1879, ILL. 9.1) and Walter Paris (1842–1906) (1879, ILL. 9.2) on MINTON AND COMPANY blanks. Most of Homer's ceramic paintings—six single tiles, one round plaque, and tiles for two fireplace surrounds—date from 1878 to 1880, his period of greatest involvement with the group. *Pastoral* (1878, FIG. 9.8) is his most ambitious effort in this medium. Closely related to the illustrations of WALTER CRANE, it represents two figures, a shepherd and a shepherdess in quaint costumes, who stand on either side of the fireplace.

The Aesthetic movement briefly exerted an influence on Homer's oil paintings. In the simplification of form, in the decorative treatment of the clouds, and in the choice of a uniform blue palette to depict a nocturnal scene, works like *Promenade on the Beach* of 1880 (FIG. 1.10) suggest that Homer was aware of the work of JAMES ABBOTT MCNEILL WHISTLER. This decorative phase in his work passed quickly, however, and Homer soon returned to the unsentimentalized realism that had consistently lent vitality to his work. Henry James (1843–1916), in a review of his paintings exhibited at the National Academy of Design in 1875, gave this perceptive account of Homer's approach: "He has chosen the least pictorial features of the least pictorial range of scenery and civilization; he has resolutely treated them as if they *were* pictorial, as if they were every inch as good as Capri or Tangier; and, to reward his audacity, he has incontestably succeeded. . . . Mr. Homer has the great merit, moreover, that he naturally sees everything at one with its envelope of light and air. He sees not in lines, but in masses, in gross, broad

masses. Things come already modelled to his eye" (James, 1875, pp. 93–94).

Homer loved the country life and recorded scenes at fashionable resorts located in the White Mountains of New Hampshire, at Lake George or Saratoga in New York, and at Long Branch, New Jersey. The Adirondack Mountains, which he first visited about 1870, and later the Canadian province of Quebec, were the subjects of many oils, watercolors, and illustrations. During the mid-1870s Homer traveled to rural Virginia to make studies of blacks; these works inspired a group of paintings produced chiefly in 1876 and 1877.

During the summer of 1873, which he spent in Gloucester, Massachusetts, Homer began to work extensively in watercolor. He first exhibited at the American Watercolor Society in 1874, becoming a member three years later. In 1881 Homer moved to England and established himself in Cullercoats, a village on the North Sea not far from Tynemouth. For two years he devoted himself almost entirely to watercolor painting, making studies of the perilous lives of the North Sea fishermen and their families.

By 1884 Homer had returned to America and settled permanently in Prouts Neck, a rocky peninsula on the coast of Maine, several miles south of Portland. An independent man who jealously guarded his privacy, Homer sought and apparently found solitude in Prouts Neck, where he painted powerful marine subjects. He often went far south to escape the harsh northern winters, however, and on these journeys he visited Cuba, Nassau, Bermuda, and Florida, where he created oil paintings and watercolors that he considered his best work.

REFERENCES

Henry James, "On Some Pictures Lately Exhibited," *Galaxy* 20 (July 1875), pp. 93–94 // William Howe Downes, *The Life and Works of Winslow Homer* (Boston and New York, 1911) // Whitney Museum of American Art, New York, *Winslow Homer: Centenary Exhibition* (exhib. cat., 1937) // Lloyd Goodrich, *Winslow Homer* (New York, 1944) // Adirondack Museum, Blue Mountain Lake, N.Y., *Winslow Homer in the Adirondacks* (exhib. cat., 1959) // Lloyd Goodrich, *Winslow Homer* (New York, 1959) // Museum of Fine Arts, Boston, *Winslow Homer: A Retrospective Exhibition* (exhib. cat., 1959) // W[illiam] H[owe] D[ownes], "Homer, Winslow," in *Dictionary of American Biography*, vol. 5, pt. 1 (New York, 1960), pp. 186–91 // Albert Ten Eyck Gardner, *Winslow Homer, American Artist: His World and His Work* (New York, 1961) // E. P. Richardson, "Winslow Homer in Harper's Weekly," *Art in America* 51, no. 4 (1963), pp. 89–92 // Philip C. Beam, *Winslow Homer at Prouts Neck* (Boston and Toronto, 1966) // Museum of Art, Bowdoin College, Brunswick, Maine, *Winslow Homer at Prouts Neck* (exhib. cat., 1966) // Museum of Graphic Art, New York, *The Graphic Art of Winslow Homer*, by Lloyd Goodrich (exhib. cat., 1968) // Barbara Gelman, *The Wood Engravings of Winslow Homer* (New York, 1969) // Lloyd Goodrich, *Winslow Homer's America* (New York, 1969) // Donelson F. Hoopes, *Winslow Homer Watercolors* (New York, 1969) // Cooper-Hewitt Museum, New York, *Winslow Homer, 1836–1910*

(exhib. cat., 1972) // John Wilmerding, *Winslow Homer* (New York, 1972) // Whitney Museum of American Art, New York, *Winslow Homer*, by Lloyd Goodrich (exhib. cat., 1973) // Eric Rudd, "Winslow Homer and 'Mr. Hardy Lee,' His Yacht," *Antiques* 106 (Nov. 1974), pp. 844–51 // Melinda Dempster Davis, *Winslow Homer: An Annotated Bibliography of Periodical Literature* (Metuchen, N.J., 1975) // John Wilmerding, "Winslow Homer's Creative Process," *Antiques* 108 (Nov. 1975), pp. 965–71 // Idem, "Winslow Homer's English Period," *American Art Journal* 7 (Nov. 1975), pp. 60–69 // H. Barbara Weinberg, "Thomas B. Clarke: Foremost Patron of American Art from 1872 to 1899," *American Art Journal* 8 (May 1976), pp. 52–83 // William H. Gerdts, "Square Format and Proto-modernism in American Painting," *Arts Magazine* 50 (June 1976), pp. 70–75 // David Tatham, "Some Newly Discovered Book Illustrations by Winslow Homer," *Antiques* 110 (Dec. 1976), pp. 1262–66 // Nicolai Cikovsky, Jr., "Homer's Prisoners from the Front," *Metropolitan Museum Journal* 12 (1977), pp. 155–72 // Museum of Fine Arts, Houston, *Winslow Homer Graphics,* by Mavis Parrott Kelsey (Houston, 1977) // William H. Gerdts, "Winslow Homer in Cullercoats," *Yale University Art Gallery Bulletin* 36 (Spring 1977), pp. 18–35 // David Tatham, "Homer's Library," *American Art Journal* 9 (May 1977), pp. 92–98 // Michael Quick, "Homer in Virginia," *Los Angeles Museum of Art Bulletin* 24 (1978), pp. 60–81 // Philip C. Beam, *Winslow Homer's Magazine Engravings* (New York, 1979) // Gordon Hendricks, *The Life and Work of Winslow Homer* (New York, 1979) // Edgar Munhall, "Winslow Homer (1836–1910)," *Du* 9 (1980), pp. 72–80 // John Wilmerding, "Winslow Homer's *Right and Left*," *Studies in the History of Art* 9 (1980), pp. 59–85 // Mary Ann Calo, "Homer's Visits to Virginia During Reconstruction," *American Art Journal* 12 (Winter 1980), pp. 4–27 // Natalie Spassky, *Winslow Homer* (New York, 1981) // Henry Adams, "Mortal Themes: Winslow Homer," *Art in America* 71 (Feb. 1983), pp. 112–26 // Yale University Art Gallery, New Haven, *Winslow Homer: The Croquet Game,* by David Park Curry (exhib. cat., 1984) // David Park Curry, "Winslow Homer and Croquet," *Antiques* 126 (July 1984), pp. 154–62 // Carol Troyen, "Innocents Abroad: American Painters at the 1867 Exposition Universelle, Paris," *American Art Journal* 16 (Autumn 1984), pp. 2–29 // National Gallery of Art, Washington, D.C., *Winslow Homer Watercolors*, by Helen A. Cooper (exhib. cat., 1986)

James S. Inglis, *see* **Daniel Cottier**

International Tile and Trim Company
1882–1888
Brooklyn, New York
Ceramics

The history of the International Tile and Trim Company of Brooklyn, New York, illustrates the close ties between America and England in the field of industrial arts during the 1880s.

Organized in 1882 by John Ivory, the firm

does not appear in the Brooklyn city directory until 1884, at 92 Third Street. British investors provided all the necessary financial backing, and the machinery for making tiles came from Great Britain as well. Fred H. Wilde, an English ceramics decorator whose published recollections of the company constitute most of what is known about its history, noted that many of its craftsmen, including a printer and an engraver, were English. Wilde himself had worked for Maw and Company, one of the largest British tile manufacturers, before coming to the United States in 1885; upon his arrival he worked for International Tile and Trim until the following year.

Another branch of the company was reportedly established in England in 1884. The *Crockery and Glass Journal* published the following brief mention in August of that year: "The International Tile Co. of Brooklyn has become international in fact as well as in name, a new organization having been effected in England with English capital to the extent of £30,000."

In 1886 the British stockholders of the Brooklyn firm liquidated their interests, and Ivory persuaded John Arbuckle, a successful coffee merchant from Brooklyn, to buy their stock. Only two years later, International Tile and Trim was absorbed by the New York Vitrified Tile Company.

Not surprisingly, the transfer-printed tile *Industry* (FIG. 7.36), just one sample of the firm's production, is strikingly similar to many English tiles of the period 1875–85, such as the *Classical Muses* series Maw and Company issued about 1876, each of which featured the allegorical figure of a classically draped woman with her attributes. The International Tile and Trim piece not only alludes to Penelope, the virtuous, perpetually spinning wife of the Greek hero Odysseus, but would also have reminded Americans of their much-longed-for Colonial past.

REFERENCES

[A new organization effected in England], *Crockery and Glass Journal* 20 (Aug. 21, 1884), p. 22 // Fred H. Wilde, in Everett Townsend, "Development of the Tile Industry in the United States," *Bulletin of the American Ceramic Society* 22 (May 15, 1943), p. 130 // Julian Barnard, *Victorian Ceramic Tiles* (Greenwich, Conn., 1972), pp. 109–10, 166 // William Benton Museum of Art, University of Connecticut, Storrs, *American Decorative Tiles, 1870–1930,* by Thomas P. Bruhn (exhib. cat., 1979), pp. 19 (ill.), 30 // Jill Austwick and Brian Austwick, *The Decorated Tile: An Illustrated History of English Tile-Making and Design* (London, 1980), pp. 43–45, 59–63

Irving and Casson, *see*
A. H. Davenport and Company

Thomas Jeckyll
1827–1881
Norwich, Norfolk, and London
Architect and designer

Thomas Jeckyll, or Jeckell as his name was also spelled, was the son of a Norwich clergyman;

he became an architect and designer active in both Norwich and London. A member of JAMES ABBOTT MCNEILL WHISTLER's artistic circle, Jeckyll was among the first to design architecture in the Queen Anne style and to articulate the Anglo-Japanesque aesthetic in the decorative arts.

Like his friend and colleague E. W. GODWIN, Jeckyll began his architectural career as a Gothic revivalist; he was elected a fellow of the Royal Institute of British Architects in 1858. Many of his early projects were ecclesiastical ones: between 1858 and 1871 he designed or restored numerous parish churches, but none of these achieved a lasting reputation for him. In 1870 Jeckyll designed a five-story brick house (demolished 1957) for Henry Rance, mayor of Cambridge. An early example of the Queen Anne style, the building was noteworthy for the pattern of alternating wide and narrow windows on its facade. Inside, the dining-room ceiling was patterned with huge concentric circles and scattered ornamental medallions adapted from Japanese decorative arts.

In 1859 Jeckyll began his eighteen-year affiliation with BARNARD, BISHOP AND BARNARDS, the Norwich iron and brass foundry, an association for which both Jeckyll and the firm are best remembered today. The first of several pairs of monumental wrought-iron gates that Jeckyll designed for Barnards was displayed at the London International Exhibition of 1862. Neither specifically Gothic nor classical in style, the gates, which were conceived as a screen of symmetrically arranged leaves and flowers, were superbly executed by Barnards craftsmen and earned for the designer the sobriquet "Jeckyll of the Gates." Another prize-winning pair of gates by Jeckyll was on view at the Vienna fair of 1873, and he was responsible as well for those displayed at the Paris international exhibitions of 1867 and 1878.

Jeckyll also designed a series of enormously popular grates and fireplace surrounds in both iron and brass, typically studded with circular motifs, which were exquisitely detailed in low relief and sometimes set against a diaper pattern or reeding. The large roundels encapsulate Japanese-style flowers, birds, insects, and abstract designs; the smaller interstitial whorls bring to mind the calligraphic energy of Celtic manuscript pages (ILL. 8.22).

His greatest achievement for Barnards was the design of the firm's pavilion for the Philadelphia Centennial Exposition in 1876; it was a tour-de-force in cast- and wrought-iron that clearly showed Jeckyll's talent as a decorative designer (ILL. 8.19). Many of the details unfortunately are not visible in published drawings of the two-story structure. Supported by twenty-eight square and patterned columns, the brackets above the columns were embellished with delicate bas-reliefs—"'Apple blossom, with flying birds,' 'Whitethorn with pheasants,' 'Scotch fir with jays,' . . . 'Chrysanthemum, narcissus, daisy and grass, with a crane and rising lark'"—while a row of fans along the first-floor veranda roof was patterned with rose, honeysuckle, and hydrangea. Elsewhere there were the characteristic roundels—butterflies, bees, birds, and fish—set in a key pattern, and an elaborate cresting along the roof ridge (Ferriday, 1959, p. 411). The

four-foot six-inch wrought-iron sunflowers that formed the railing surrounding the building were later manufactured as gilt-bronze andirons (FIG. 8.29, ILL. 8.20).

In 1870 Jeckyll designed a new wing for 1 Holland Park, London, home of the collector Alexander A. Ionides, whose residence was a showcase for the work of several Aesthetic-period architects and artists, including PHILIP WEBB, WILLIAM MORRIS, and WALTER CRANE. In 1875 Jeckyll designed a suite of subtly asymmetrical furniture for Ionides in both padauk-wood and walnut with ebony moldings, brass mounts, and Chinese-style brackets.

The brilliant coloration and patterning of *Harmony in Blue and Gold,* popularly known as Whistler's Peacock Room (now installed in the Freer Gallery of Art, Washington, D.C.), has long obscured the fact that Jeckyll was its architect. It proved to be his last commission, part of the restoration of 49 Prince's Gate, the London home of shipping magnate Frederick Richards Leyland, that commenced in 1876. Jeckyll conceived of the dining room as a foil for the display of Whistler's *La Princesse du Pays de la Porcelaine* and Leyland's collection of blue-and-white porcelain in the tradition of the seventeenth-century *Porzellanzimmer.* He created a "somber and sumptuous" Anglo-Dutch ambience using a Tudor-style pendant ceiling and bracketed walnut shelves set against walls covered in antique Spanish leather tinted with bright red, yellow, and blue flowers (Curry, 1984, pp. 58–63). After Jeckyll was finished, Whistler preempted the room, gilding the incised oriental patterns on the woodwork and overpainting the leather and the ceiling in shades of dark turquoise blue and green emblazoned with gold peacocks and semicircular fish-scale or feather motifs (ILL. 4.10). Whistler's additions resulted in one of the greatest Aesthetic-period interiors, but an altercation between Whistler and Leyland over finances after the room's completion in 1877 completely overshadowed Jeckyll's contribution. The unfortunate architect was incapable of protesting; he had that year gone mad, and died insane in the Norwich Asylum four years later.

REFERENCES
E. W. Godwin, quoted in "The Peacock Room," *Carpet Trade Review* 4 (May 1877), pp. 62–63, originally published in the *Architect* (London), Feb. 24, 1877, pp. 118–19 // "English Decorative Art in Paris, No. 12: Exhibit by Messrs. Barnard, Bishop, and Barnards, Norwich and London," *British Architect and Northern Engineer* 10 (Nov. 1, 1878), p. 172 and two ills. // "Our Office Table" [obituary], *Building News* 41 (Sept. 16, 1881), p. 378 // "Notes on Current Events" [obituary], *British Architect and Northern Engineer* 16 (Sept. 23, 1881), pp. 471–72 // Lewis F. Day, "Victorian Progress in Applied Design," *Art Journal* (London), June 1887, pp. 185–202 // Peter Ferriday, "Peacock Room," *Architectural Review* 125 (June 1959), pp. 407–14 // Elizabeth Aslin, *The Aesthetic Movement: Prelude to Art Nouveau* (New York and Washington, D.C., 1969), pp. 93–95 // Royal Academy of Arts, London, *Victorian and Edwardian Decorative Art: The Handley-Read Collection* (exhib. cat., 1972), sec. D, nos. 9–10 (ills.), 11–12, 124–25, 137 //

Simon Jervis, "Victorian Decorative Art at the Royal Academy: Charles Handley-Read's Collecting Achievements," *Connoisseur* 179 (Feb. 1972), pp. 89–98 // Christopher Neve, "The Cult of Japan," *Country Life* 152 (Oct. 5, 1972), pp. 804–5 // Mark Girouard, *The Victorian Country House* (New Haven and London, 1979), pp. 366–70 // Ira M. Horowitz, "Whistler's Frames," *Art Journal* (New York) 39 (Winter 1979–80), pp. 124–31 // Freer Gallery of Art, Washington, D.C., *James McNeill Whistler at the Freer Gallery of Art,* by David Park Curry (exhib. cat., 1984), pp. 52–69, 92–94 // Simon Jervis, "Jeckyll, Thomas," in *The Penguin Dictionary of Design and Designers* (Harmondsworth, Eng., and New York, 1984), p. 253 // David Park Curry, "Whistler and Decoration," *Antiques* 126 (Nov. 1984), pp. 1186–99 // Jean D. Hamilton, Victoria and Albert Museum, London, correspondence, Nov. 28, 1984 // James Bettley, British Architectural Library, Royal Institute of British Architects, London, correspondence, Dec. 11, 1985 // Kenneth S. Lord, Department of Architecture, North East London Polytechnic, Eng., "Thomas Jeckyll, Architect and Designer, 1827–1881" (diss. presented to the Royal Institute of British Architects, n.d.)

Jeffrey and Company
1836–1930
London
Wallpaper

An advertisement for the London wallpaper manufacturer Jeffrey and Company published about 1890 announced that the reader could avail himself of a full range of wall coverings: hand or machine printed; flock, real silk flock; or raised flock; embossed or stamped paper and leather, some in high relief; and ceiling and staircase papers—all in a variety of designs by eminent artists. The telegraphic address given for the firm, "Wallpaper, London," intimated that Jeffrey and Company was unrivaled in its field.

The firm started about 1836 as Jeffrey, Wise and Company in Saint Helen's Place, London; two years later it moved to Kent and Essex Yard in Whitechapel, London. By 1840 the firm succeeded in using cylinders to print some of its papers, which suggests that the partners had some familiarity with the printing of calico fabric for which cylinders were first employed. During its early years the firm achieved recognition for its new and enterprising products: Pigot's *London Directory* of 1840 mentions the firm as the sole manufacturers of a washable wallpaper invented by a paper stainer named Crease.

When Robert Horne became a partner in 1842, the name of the company changed to Jeffrey, Wise and Horne; it changed again to Horne and Allen the following year. In 1851 the exhibitors at the Great Exhibition in London included Jeffrey, Allen and Company of Whitechapel and Robert Horne of Gracechurch Street. One of the wallpapers that Jeffrey and Allen exhibited was praised for the flatness of its design, a forerunner of the compositions of the 1870s and 1880s, yet others, including a twenty-four-foot frieze of the Elgin Marbles and a reproduction of a painting

by Bartolomé-Esteban Murillo (1618–1682), still created the illusion of three-dimensional space, a characteristic later viewed by English design reformers as typically French.

By 1862 the firm was operating under the name Jeffrey and Company of Whitechapel, and the partners included William Allen, Alfred Brown, and Edward Hamilton. Two years later they merged with Holmes and Aubert, a company known for hand-printed papers, flocks, and leaf-metal printing, whose factory and showrooms at 64 Essex Street in the Islington section of London became Jeffrey and Company's main headquarters. As a result of this union Jeffrey and Company was capable of producing hand-printed papers of the highest quality. One of the firm's customers in 1864 was WILLIAM MORRIS, who, dissatisfied with his own efforts to print his wallpaper designs, commissioned Jeffrey to produce his Daisy pattern of 1862 (FIG. 3.3). Although it was not the first wallpaper that Morris designed, it became the first Morris pattern available to the public. Thereafter Morris entrusted the printing of his wallpapers to Jeffrey and Company (ILLS. 3.4–3.7). (The firm continued to reprint Morris wallpapers from the original pearwood blocks until 1930.) In 1865 the London decorating firm of Jackson and Graham commissioned Jeffrey and Company to print an entire series of elaborate papers designed by OWEN JONES for the Viceroy's Palace in Cairo, for which one pattern alone required fifty-eight separate blocks.

Metford Warner (1843–1930) joined the firm as a junior partner in 1866, following the retirement of William Allen. When the other partners died a few years later (Edward Hamilton in 1869 and Alfred Brown in 1871), Warner became the company's sole proprietor. Warner was intent on elevating the status of wallpapers from an industrial to a fine art, and under his direction Jeffrey and Company established its preeminence in the field of wallpaper design and production. In 1873, at his insistence, wallpapers were displayed as fine art for the first time at the London Annual Exhibition of All Fine Arts, held at the Royal Albert Hall.

In 1869 the firm printed a popular design, called Solanum, by CHARLES LOCKE EASTLAKE; this was the first of a series of wallpapers Warner commissioned from leading British architects and designers, including Lewis F. Day, J. D. Sedding, C. F. A. Voysey, WILLIAM BURGES, WALTER CRANE, E. W. GODWIN, and BRUCE J. TALBERT. Godwin's design for a paper with bamboo and stylized flowers in red and black on a yellow ground (ILLS. 3.1, 3.2) was first printed in 1872 and was popular in America into the 1880s.

In 1875, using designs by Brightwen Binyon (1845/6–1905), an architect from Ipswich, Jeffrey introduced the idea of articulating the wall with a combination of dado, filling, and frieze papers—ornamentation comprised of three separate but harmonious patterns. One of the best-known examples of such tripartite wall treatments (an important feature of interior decoration until about 1890) was a set of wallpapers by Walter Crane (ILL. 3.9), which was displayed at the 1876 Centennial Exposition in Philadelphia, where it was awarded two gold medals. The theme is wifely virtue, based on a

passage from Chaucer's *Legend of Good Women.*

Jeffrey and Company gathered gold medals at subsequent international fairs—for example, in Paris in 1878, 1889, and 1900, and in Chicago in 1893—as well as prizes at other exhibitions throughout the nineteenth century; the Grand Prix was awarded to the firm at the Franco-British Exhibition in London in 1908.

Metford Warner directed his company until the 1920s, assisted by his sons Albert, Horace, and Marcus. In 1930 Jeffrey and Company was absorbed by Arthur Sanderson and Sons Ltd. (currently located in Uxbridge, England, with an office in New York City), and ten years later Sanderson acquired all of the printing blocks for Morris and Company wallpapers, which they hand print to this day.

REFERENCES

"Wall Decorations," *Building News* 26 (May 8, 1874), pp. 492–93 // Phillip T. Sandhurst et al., *The Great Centennial Exhibition Critically Described and Illustrated* (Philadelphia and Chicago, 1876), pp. 164–66, 170–71 // Walter Smith, *Industrial Art,* vol. 2 of *The Masterpieces of the Centennial International Exhibition* (Philadelphia, copr. 1875 [1877?]), pp. 5, 7 // "The Paris Universal Exhibition," pt. 7, *Magazine of Art* 1 (1878), pp. 188 (ill.), 190 (ill.) // "General Report of the Judges of Group 13," and ". . . Group 27," in U.S. Centennial Commission, *International Exhibition, 1876: Reports and Awards,* 9 vols. (Washington, D.C., 1880), vol. 5, p. 600; vol. 7, p. 655 // "Trade Intelligence, Paper-Hangings for 1881," *Journal of Decorative Art* 1 (Jan. 1881), p. 17 // G. T. Robinson, "The Year's Advance in Art Manufactures, No. 8: Household Decoration—Wall Papers," *Art Journal* (London), Nov. 1883, pp. 353–56 // J. Moyr Smith, *Ornamental Interiors, Ancient and Modern* (London, 1887), pp. 59–62 // Lewis F. Day, "Victorian Progress in Applied Design," *Art Journal* (London), June 1887, pp. 185–202 // Arts and Crafts Exhibition Society, London, *Catalogue of the First Exhibition* (exhib. cat., 1888), pp. 108–12, 121 // Idem, *Catalogue of the Second Exhibition* (exhib. cat., 1889), pp. [107], 121–23, 140–42 // Idem, *Catalogue of the Third Exhibition* (exhib. cat., 1890), pp. 193, 198–99, 201–6 // Idem, *Catalogue of the Fourth Exhibition* (exhib. cat., 1893), pp. 26, 28, 41–42 // Alan Victor Sugden and John Ludlam Edmondson, *A History of English Wallpaper, 1509–1914* (London and New York, 1926), pp. 209–12 // E. A. Entwisle, "Historians of Wallpaper," *Connoisseur* 115 (Mar. 1945), pp. 23–29 // Idem, *A Literary History of Wallpaper* (London, 1960), p. 145 // Peter Floud, "The Wallpaper Designs of William Morris," *Penrose Annual* 54 (1960), pp. 41–45 // E. A. Entwisle, *Wallpapers of the Victorian Era* (Leigh-on-Sea, Eng., 1964), pp. 37–40 // Ray Watkinson, *William Morris as Designer* (New York, 1967), p. 52, figs. 67–69 // Whitworth Art Gallery, Manchester, Eng., *Historical Wallpapers in the Whitworth Art Gallery* (exhib. cat., 1972), pp. 12–13, 54–56, pls. 22–25 // Catherine Lynn, *Wallpaper in America: From the Seventeenth Century to World War I* (New York, 1980), pp. 345–46 (ills.), 386 (ill.), 395, 424, 457, 458 (ill.), 460–61 (ills.) // Charles C. Oman and Jean [D.] Hamilton, *Wallpapers: A History and Illustrated Catalogue of the Collection of the Victoria and Albert Museum* (London, 1982) // Jean [D.] Hamilton, Department of Prints, Drawings, and Photographs, Victoria and Albert Museum, London, correspondence, Sept. 18, 1984 // Carolyn Aram, Arthur Sanderson and Sons Ltd., Uxbridge, Middlesex, Eng., correspondence, Oct. 16, 1984 // Jeffrey and Company, *Illustrations of the Victorian Series and Other Wallpapers Manufactured by Jeffrey and Company* (London, n.d.)

Owen Jones
1809–1874
London
Architect and ornamentalist

Although an architect by training, it was as an ornamentalist that Owen Jones exerted his greatest influence on the nineteenth-century arts of design. His *Grammar of Ornament* (1856) was seminally important to the British reform movement and to the Aesthetic movement in America. The book is a compendium of almost twenty-four hundred conventionalized designs from many historical periods and cultures as well as from nature, from which Jones extrapolated thirty-seven "General Principles in the Arrangement of Form and Colour in Architecture and the Decorative Arts." The *Grammar* was a chromolithographic printing feat: the original edition, an imperial folio, had one hundred lithographed colorplates, displaying up to sixty examples of ornament on each page. A second, smaller folio volume was issued in 1864, and an American edition was reportedly published in 1880. Significantly, the book, which introduced Western artists to non-Western, especially Islamic and Hispano-Moresque patterns (FIG. 2.2), presented an alternative to naturalistic decoration by demonstrating the beauty of flat, abstract, and geometric surface ornament.

Jones was the son of a London furrier of Welsh descent. He was educated in private schools and from 1825 spent six years training in the architectural office of Lewis Vulliamy (1791–1871), some of whose studies of Greek ornament from the 1820s Jones would later incorporate in the *Grammar.* In 1830 Jones traveled to Paris, Milan, Venice, and Rome. Two years later he began to explore more exotic regions, including Alexandria, Cairo, Constantinople, and Thebes, becoming fascinated by Arabic form and ornament and by the richness of polychrome architecture, which he first encountered in Greece and Egypt.

With Jules Goury (d. 1834), a French architect he met in Athens, Jones journeyed to Granada, Spain, in 1833. Together they commenced a detailed pictorial study of the Alhambra that resulted in a two-volume publication, *Plans, Elevations, Sections, and Details of the Alhambra* (1836–45), which Jones completed after Goury's death from cholera. Unable to find a commercial publisher willing to undertake such a complex color-printing task—the book was to include more than one hundred chromolithographed plates—Jones printed it himself, sparing no expense; on subsequent projects, however, he collaborated with the London firm of Day and Son.

Jones was first known primarily as a designer of tiles and mosaics, largely through his

involvement with John Marriott Blashfield, a terracotta manufacturer who had subscribed to the *Alhambra*. Jones produced two books for this patron, *Designs for Mosaic and Tessellated Pavements* (1842), comprised of his geometric designs, and *Examples of Encaustic Tiles* (1844), whose illustrations were based on his drawings of ancient examples. Other works illustrated by Jones that are particularly relevant to the history of ornament include *The Polychrome Ornament of Italy* by E. Adams (1846); *The Illuminated Books of the Middle Ages,* with Henry Noel Humphreys (1849); *One Thousand and One Initial Letters Designed and Illuminated by Owen Jones* (1864); *Seven Hundred and Two Monograms* (1864); and *Examples of Chinese Ornament* (1867).

By the mid-1840s Jones was associated with artists and designers at the forefront of the industrial-reform movement in England, and in 1850 he was appointed superintendent of the works for the London Great Exhibition of 1851. His attraction to architectural polychromy and to the color theories of Michel-Eugène Chevreul (1786–1889) and George Field (1777?–1854) inspired the painted decoration—pale blue touched with crimson and yellow—with which Jones brilliantly transformed the iron-and-wood structure of Joseph Paxton's Crystal Palace. Afterward, with Henry Cole (1808–1882), Richard Redgrave (1804–1888), and Augustus Welby Northmore Pugin (1812–1852), Jones acquired objects from the exhibition, including a great many from India and the Near East, for display in Marlborough House, a precursor of the Victoria and Albert Museum that housed one of Cole's Schools of Design.

In lectures that Jones delivered at Marlborough House during 1852, he outlined the philosophy of design that evolved into his declaration of thirty-seven propositions in *The Grammar of Ornament* four years later. The most important of these to subsequent design theory, number eight, posited that "all ornament should be based upon a geometrical construction." This idea was not articulated by Jones in 1852, however, and its inclusion in *Grammar* may be the result of Jones's collaboration with CHRISTOPHER DRESSER (Jespersen, 1984, pp. 24–26). Dresser, a botanist and student of design at the time of Jones's 1852 lectures, later assisted with the last ten plates of the *Grammar,* even drawing one of them himself. This plate, number ninety-eight, "Leaves and Flowers from Nature No. 8" (FIG. 2.1), only hints at the stylized organic forms that Dresser developed in his later work. Dresser, who succeeded Jones as the leading ornamentalist in England, ultimately advanced the theory of surface ornament toward pure abstraction.

Jones advocated the use of cast iron in architecture, which he endorsed as early as 1835 in a lecture entitled "On the Influence of Religion in Art." Although he was a member of the Royal Institute of British Architects, and received a gold medal for architecture in 1857, he actually executed relatively few buildings. He was instead an extremely productive commercial designer of tiles, carpets, silks, silver, wallpapers, and furniture and enjoyed important patrons, among them the South Kensington Museum (now the Victoria and Albert Museum) in London, for which he designed the Indian, Chinese, and Japanese courts (1863–64); the author George Eliot; and Alfred Morrison, a wealthy connoisseur and collector of Chinese porcelains and enamels, for whom Jones designed interiors at Fonthill and 16 Carleton House Terrace, London. The furniture Jones created for Morrison included a suite of ebony display cabinets, inlaid with elaborate ivory marquetry in the cinquecento style and manufactured by Jackson and Graham, for which gold medals were awarded at the Paris and Vienna international exhibitions of 1867 and 1873, respectively.

Jones the commercial designer, however, made less of a lasting impact on nineteenth-century decorative arts than Jones the theorist. Though his commercial designs were "eminently graceful," Jones elicited no particular following. The 1887 assessment of Jones's role by Lewis F. Day (1845–1910), a contemporary designer and prolific writer, seems accurate even after one hundred years: "Indeed it was as a theorist rather than as an artist that he made his mark upon the first years of the latter half of this century. His influence was immense. His 'Grammar of Ornament' marks a point, and a turning-point, in the history of English ornament. The 'principles' he enunciated were not such as one can endorse *en masse* . . . they were many of them not principles at all. . . . It would be nearer the mark (however irreverent) to call them 'tips;' and as such they were of immense value to manufacturers, decorators, and designers, who were floundering. . . . The influence of Ruskin, and of Pugin before him, counts also for something, but I attribute even more weight to the teaching of Owen Jones, because he appealed to and touched the manufacturers, . . . much to the improvement in the taste of their productions" (Day, 1887, pp. 187–88).

REFERENCES

Jules Goury and Owen Jones, *Plans, Elevations, Sections, and Details of the Alhambra* . . . (London, 1836–45) // Owen Jones, *Designs for Mosaic and Tessellated Pavements* (London, 1842) // Owen Jones et al., *Views on the Nile: From Cairo to the Second Cataract . . . from Sketches Taken in 1832 and 1833 by Owen Jones* . . . (London, 1843) // Owen Jones, *Examples of Encaustic Tiles, Drawn on Stone* (London, 1844) // E. Adams, *The Polychrome Ornament of Italy* (London, 1846) // Henry Noel Humphreys, *The Illuminated Books of the Middle Ages: An Account of the Development and Progress of the Art of Illumination from the Fourth to the Seventeenth Centuries* (London, 1849) // Owen Jones, *An Attempt to Define the Principles Which Should Regulate the Employment of Colour in the Decorative Arts . . . , Read Before the Society of Arts, April 28, 1852* (London, 1852) // Idem, *The Alhambra Court in the Crystal Palace* (London, 1854) // Idem, *An Apology for the Colouring of the Greek Court in the Crystal Palace* (London, 1854) // Owen Jones and Joseph Bonomi, *Description of the Egyptian Court Erected in the Crystal Palace* (London, 1854) // George Scharf, *The Roman Court Including the Antique Sculptures in the Nave Erected in the Crystal Palace by Owen Jones* (London, 1854) // Owen Jones, *The Grammar of Ornament . . . Illustrated by Examples from Various Styles of Ornament* (London, 1856) // John Burley Waring, *Art Treasures of the United Kingdom from the Art Treasures Exhibition, Manchester, with Essays by O. Jones* (London, 1858) // John Burley Waring, ed., *Examples of Weaving and Embroidery . . . with Essays by Owen Jones and M. Digby Wyatt* . . . (London [1858?]) // Owen Jones, *Gleanings from the Great Exhibition of 1851* (London, 1863) // Idem, *Lectures on Architecture and the Decorative Arts* (London, 1863) // Idem, *On the True and the False in the Decorative Arts; Lectures Delivered at Marlborough House, June 1852* (London, 1863) // Idem, *One Thousand and One Initial Letters Designed and Illuminated by Owen Jones* (London, 1864) // Idem, *Seven Hundred and Two Monograms* (London, 1864) // George Eliot, "Notices of New Books: *The Grammar of Ornament* by Owen Jones," *Fortnightly Review* 1 (May 15–Aug. 1, 1865), pp. 124–25 // Owen Jones, *Examples of Chinese Ornament Selected from Objects in the South Kensington Museum and Other Collections* (London, 1867) // "First Principles of Decoration," *Furniture Gazette* 1 (Apr. 19, 1873), pp. 20–21 // "Owen Jones" [obituary], *Practical Magazine* 3 (1874), p. 400 // "Owen Jones" [obituary], *New York Times*, May 4, 1874, p. 1 // "The Late Mr. Owen Jones," *Builder* 32 (May 9, 1874), pp. 383–85 // "Owen Jones" [obituary], *Art Journal* (London), July 1874, p. 211 // George Wallis, "The Exhibition of the Works of the Late Owen Jones," *Art Journal* (London), Sept. 1874, p. 285 // W. S. C., "Owen Jones, F.R.S., F.S.A.," *Practical Magazine,* n.s. 7 (1877), pp. 257–60 // "Treasure-Houses of Art," pt. 1, *Magazine of Art* 2 (1879), pp. 140–44 // Lewis F. Day, "Obsolete Teachings of Owen Jones," *Decorator and Furnisher* 1 (Oct. 1882), p. 10 // Idem, "Victorian Progress in Applied Design," *Art Journal* (London), June 1887, pp. 185–202 // Algernon Graves, comp., *Dictionary of Artists Who Have Exhibited Works in the Principal London Exhibitions from 1760 to 1893*, 3d ed. (New York, 1901; reprint New York, 1970), pp. x, 155 // Idem, *The Royal Academy of Arts: A Complete Dictionary of Contributors and Their Work from Its Foundation in 1769 to 1904*, vol. 4 (London, 1906), p. 278 // "Jones, Owen," in *Allgemeines Lexikon der Bildenden Künstler*, ed. Ulrich Thieme and Felix Becker, vol. 19 (Leipzig, 1926), pp. 124–25 // Alan Victor Sugden and John Ludlam Edmondson, *A History of English Wallpaper, 1509–1914* (London and New York, 1926), pp. 209–12 // Michael Darby, "Owen Jones and the Eastern Ideal" (Ph.D. diss., University of Reading, Eng., 1974) // Michael Darby and David T. Van Zanten, "Owen Jones's Iron Buildings of the 1850's," *Architectura* 1 (1974), pp. 53–75 // David T. Van Zanten, *The Architectural Polychromy of the 1930s* (New York, 1977) // Yale Center for British Art, New Haven, *Color Printing in England, 1486–1870,* by Joan M. Friedman (exhib. cat., 1978), pp. 51–54, pls. 19, 20 // Fine Art Society Limited, London, *Architect-Designers: Pugin to Mackintosh,* by Clive Wainwright and Charlotte Gere (exhib. cat., 1981), pp. 12–13 (ills.) // Michael Darby, *The Islamic Perspective* (London, 1983) // Simon Jervis, "Jones, Owen," in *The Penguin Dictionary of Design and Designers* (Harmondsworth, Eng., and New York, 1984), pp. 256–60 // John Kresten Jespersen, "Owen Jones's *The Grammar of Ornament* of 1856: Field

Theory in Victorian Design at the Mid-Century" (Ph.D. diss., Brown University, 1984) // Ellen A. Christensen, "The Significance of Owen Jones's *The Grammar of Ornament* to the Development of Architectural Ornament in Twentieth-Century Europe and America" (M.A. thesis, University of Cincinnati, 1986) // Owen Jones, *Chinese Ornament* (Philadelphia, n.d.)

A. Kimbel and J. Cabus
1863–1882
New York City
Furniture and decoration

Anthony Kimbel (d. 1895) was born into a family of cabinetmakers from Mainz, Germany. He came to the United States in the 1840s and was associated with Charles A. Baudouine, a local cabinetmaker of French descent, during his early years in America. Kimbel is first listed in the New York city directories in 1854 as a partner in the firm Bembé and Kimbel at 56 Walker Street, an association that lasted until about 1862. This may have been the New York branch of an established European firm. An article in *Gleason's Pictorial Drawing-Room Companion* mistakenly describes the firm as French, with a factory in Mayence [Mainz]: "Mr. Bembe, the senior partner, has furnished many of the noblest palatial residences in Western Europe" (*Gleason's*, 1854, p. 300). Kimbel's partner was probably a German relative, however. His maternal grandfather was a Mainz tapestry maker named A. Bembé, whose family business appears to have continued in that city, with expanded operations encompassing interior decoration, under the name of Anton Bembé until at least 1889.

Other members of the Kimbel family were involved in related artistic pursuits: Anthony Kimbel's brother Martin (1835–1921) was an architect who came to the United States in 1856, established the office of Laun and Kimbel in New York, and fought in the Union army during the early 1860s; he returned to Europe in 1864 and settled in Breslau two years later. Martin's son Wilhelm (b. 1868) became an interior designer and draftsman in Germany, working briefly for the Bembé firm in Mainz in 1889, the year he emigrated to the United States. Living in New York until his return to Germany in 1894, Wilhelm Kimbel worked for HERTER BROTHERS under WILLIAM BAUMGARTEN's direction.

About 1862 Kimbel joined Joseph Cabus in the latter's shop at 924 Broadway, where they are recorded together in 1863. Not much is known about Cabus's previous history, except that he worked with Alexander Roux (active New York 1837–1881), an eminent New York cabinetmaker, before establishing his own firm. In 1865 additional work space was acquired at 111 East Eighteenth Street, and from 1867 until 1874 the firm was at 928 Broadway and 136 East Eighteenth Street, subsequently moving to 7 and 9 East Twentieth Street with a factory at 458 Tenth Avenue. An interior view of the Twentieth Street showroom (ILL. 5.6) illustrates the Modern Gothic furniture made by Kimbel and Cabus during the 1870s. On the rear wall is a hanging key cabinet, an example of which—in carved golden oak with a silver-colored nickel hinge—is now in the collection of The Metropolitan Museum of Art, New York (FIG. 5.12).

The earliest Modern Gothic designs by Kimbel and Cabus predate the display of English furniture at the 1876 Philadelphia Centennial Exposition and thus owe their inspiration, at least in part, to such seminal British publications as BRUCE J. TALBERT's plentifully illustrated *Gothic Forms Applied to Furniture, Metal Work, and Decoration for Domestic Purposes* of 1867, republished in America in 1873 (FIGS. 5.1, 5.2), and CHARLES LOCKE EASTLAKE's *Hints on Household Taste in Furniture, Upholstery, and Other Details* of 1868, available in no less than eight American editions, the first appearing in 1872 (FIG. 4.1). A Kimbel and Cabus trade card (ILL. 8.3) from the 1870s shows a Modern Gothic cabinet similar to those published by Talbert and Eastlake; on the cabinet's shelves, a footed sugar bowl by CHRISTOPHER DRESSER confirms familiarity with another English design source (ILL. 8.4).

Kimbel and Cabus favored ebonized furniture, usually made of cherry (a close-grained hardwood) blackened, perhaps to resemble lacquer, and ornamented with linear, incised, and gilt decorations (FIG. 5.13). This furniture is informed by the principles of design—simplicity of form, revealed construction, and the appropriate use of materials—espoused by Eastlake in his book. While Eastlake did not recommend one specific style over another, some of his advice could be taken literally. In discussing mirror frames, for example, he wrote, "Why are we to tolerate in one class of decorative art the vulgarities which we despise in another? . . . If executed in oak, they may be left of their natural color: if in the commoner kinds of wood, they can be ebonised (i.e. stained black), and further decorated with narrow gold stripes. . . . This ought to be a less expensive, as it certainly would be a more effective, process than that of gilding the entire surface" (Eastlake, 1868, p. 164).

Unlike the custom-made ebonized furniture by Herter Brothers (which was typically Anglo-Japanesque in style and decorated with dexterous carving or marquetry of different colored woods in a unique and carefully integrated design), Kimbel and Cabus, following Talbert's example, inset imported British tiles—or printed papers—featuring stylized medieval figures or patterns into their standard forms (FIG. 5.13); a pair of photograph albums illustrating Kimbel and Cabus furniture, now in the Cooper-Hewitt Museum in New York, probably served as catalogues of available designs that customers could select. Although not sharing the carriage trade that supported Herter Brothers and DANIEL PABST, Kimbel and Cabus produced handsome, fashionably styled furniture and interior decoration for a prosperous and artistically aware clientele.

Kimbel and Cabus was one of the few cabinetmaking firms to exhibit Modern Gothic furnishings at the Philadelphia Centennial Exposition. Their display (FIG. 5.11) was arranged to look like a drawing room—with a fireplace and mantel, a doorway draped with portieres, a figured frieze, and a painted ceiling above a wallpaper fill—thereby providing a Modern Gothic environment for their furniture. This approach met with the approval of critics, who appreciated the "harmonious" effect of the whole, which they found "merited imitation by some of their [Kimbel and Cabus] rivals, who surpassed them in beauty of individual pieces" (Ferris, 1877, p. 140). The stylistic coordination of an entire room, which came to be considered a basic principle of good interior design, encouraged the development of professional decorators in the 1870s; city directories indicate that Kimbel and Cabus categorized themselves as such from 1872. The firm soon became one of the leading interpreters of the Modern Gothic in furniture, architectural woodwork, and decoration, even as it continued to manufacture Renaissance-style furniture throughout the 1870s.

By the time the Modern Gothic style waned in popularity, the Kimbel and Cabus partnership also came to an end, in 1882. Cabus moved uptown to 506 West Forty-first Street, where he worked as a cabinetmaker until 1897. Kimbel and two of his sons, Anthony, Jr., and Henry, reorganized as A. Kimbel and Sons (city directories between 1882 and 1893 also list a third son named Richard). Their firm remained at the East Twentieth Street and Tenth Avenue locations until about 1895, the year Anthony Kimbel, Sr., died. Kimbel and Sons continued to operate as interior decorators until 1941.

REFERENCES
[Engraving and description of parlor designed by Bembé and Kimbel], *Gleason's Pictorial Drawing-Room Companion* 7 (July–Dec. 1854), p. 300 (ill.) // B[ruce] J. Talbert, *Gothic Forms Applied to Furniture, Metal Work, and Decoration for Domestic Purposes* (Birmingham, Eng., 1867; reprint Boston, 1873) // Charles Locke Eastlake, *Hints on Household Taste in Furniture, Upholstery, and Other Details* (London, 1868; reprinted from the 2d London ed., intro. and notes by Charles C. Perkins, Boston, 1872) // "The Illustrations: Interior Perspective of a Room," *American Architect and Building News* 1 (July 22, 1876), p. 237 and ill. // "The Illustrations: Interior Designed by Messrs. Kimbel and Cabus, New York," *American Architect and Building News* 1 (Sept. 23, 1876), p. 308 and ill. // "The Illustrations: Decorative Interior," *American Architect and Building News* 1 (Nov. 25, 1876), p. 381 and ill. // [George Titus Ferris], *Gems of the Centennial Exhibition: Consisting of Illustrated Descriptions of Objects of an Artistic Character, in the Exhibits of the United States, Great Britain, France . . .* (New York, 1877), pp. 138 (ill.), 139–40 // "The Illustrations: Interior," *American Architect and Building News* 2 (Feb. 24, 1877), p. 60 and ill. // Clarence Cook, *The House Beautiful: Essays on Beds and Tables, Stools and Candlesticks* (New York, 1878; reprint New York, 1980), p. 255 // Harriet Prescott Spofford, *Art Decoration Applied to Furniture* (New York, 1878), p. 84 // "General Report of the Judges of Group 7," in U.S. Centennial Commission, *International Exhibition, 1876: Reports and Awards*, 9 vols. (Washington, D.C., 1880), vol. 4, p. 737; "General Report of the Judges of Group 27," vol. 7, p. 653 // Edwards and Critten, eds., *New York's Great Industries* (New York, 1885), p. 132 // "A. Kimbel" [notice of his will], *New York Times*, Oct. 20, 1895, p. 20 // "Kimbel, Mainzer Kunsttischlerfamilie" and "Kimbel, Wil-

helm," in *Allgemeines Lexikon der Bildenden Künstler*, ed. Ulrich Thieme and Felix Becker, vol. 20 (Leipzig, 1927), pp. 309–10 // Parke-Bernet Galleries, Inc., New York, *The Stock of the Well-Known Firm of Decorators, A. Kimbel and Son, Inc., New York* . . . (sale cat., Mar. 14 and 15, 1941) // "Anthony F. Kimbel," *Art News* 68 (Mar. 1969), p. 21 // Metropolitan Museum of Art, New York, *Nineteenth-Century America: Furniture and Other Decorative Arts* (exhib. cat., 1970), pp. xx, xxv–xxvi // Robert Bishop, *Centuries and Styles of the American Chair, 1640–1970* (New York, 1972), pp. 381 (ill.), 388–89 (ill.), 394–95 (ills.), 408 (ill.) // Hudson River Museum, Yonkers, N.Y., *Eastlake-Influenced American Furniture, 1870–1890*, by Mary Jean Smith Madigan (exhib. cat., 1973) // Mary Jean [Smith] Madigan, "Eastlake-Influenced American Furniture, 1870–1890," *Connoisseur* 191 (Jan. 1976), p. 59 (ill.) // David [A.] Hanks, "Kimbel and Cabus: Nineteenth-Century New York Cabinetmakers," *Art and Antiques* 3 (Sept.–Oct. 1980), pp. 44–53 // Detroit Institute of Arts, *The Quest for Unity: American Art Between World's Fairs, 1876–1893* (exhib. cat., 1983), pp. 75, 76 (ill.) // High Museum of Art, Atlanta, *The Virginia Carroll Crawford Collection: American Decorative Arts, 1825–1917*, by David A. Hanks and Donald C. Peirce (exhib. cat., 1983), p. 85 (ill.) // Phillips, Son and Neale, Inc., New York, *American Documents and Books; American Furniture, Decorations, and Silver; American Paintings and Sculpture* (sale cat., Jan. 24, 1984), pp. 53, 56 (ills.) // A. Kimbel and Sons, "Albums of Furniture, New York," 2 vols. of mounted photographs, n.d., Rare Book Collection, Cooper-Hewitt Museum, New York

Samuel J. Kitson, *see* Ellin and Kitson

John La Farge
1835–1910
New York City
Painter, stained-glass designer, decorator

Among the most innovative and articulate American artists of the nineteenth century, John Frederick Lewis Joseph La Farge was a leader in plein-air landscape painting, mural decoration, and stained glass, achieving recognition in these fields both at home and abroad. His influence was enhanced by his activities as a writer, a lecturer, and a tastemaker. Born in New York City, the son of wealthy French emigrés from Santo Domingo, he received his earliest instruction in drawing and watercolor painting from his maternal grandfather, Louis Binsse de Saint-Victor (1778–1844), a painter of miniatures. When La Farge entered Columbia Grammar School in 1845, his more formal art training began, and throughout the course of his classical education and law studies, his interest in art grew. In the 1850s he collected prints by the Barbizon School painters and met several American disciples of French art, among them Homer Dodge Martin (1836–1897) and George Inness (1825–1894).

In 1856, tired of his work in a New York law office, La Farge left for France. He immediately gained entrance to artistic and literary circles through his cousin, journalist and critic Paul de Saint-Victor, who introduced La Farge to the most influential people of the day, including Théophile Gautier and Charles-Pierre Baudelaire. Although La Farge worked in the Louvre in Paris copying and examining the works of the old masters, contemporary paintings also interested him, particularly those of Eugène Delacroix (1798–1863), Théodore Chassériau (1819–1856), and Thomas Couture (1815–1879), in whose studio La Farge studied for a few weeks. During this period La Farge made several trips, visiting Brittany, Germany, Denmark, Switzerland, and Russia. Called home in 1857 because of his father's illness, en route La Farge made a brief but important stop in England, where he visited the Manchester Art Treasures Exhibition and saw the work of the Pre-Raphaelites, whom he later asserted strongly influenced him as a painter.

After his return to New York, La Farge practiced law but maintained his interest in art. In 1858 he took a studio in the Tenth Street Studio Building, where he met the architect Richard Morris Hunt (1827–1895), who encouraged him to give up law and study painting under his brother William Morris Hunt (1824–1879). In the spring of 1859 La Farge joined an informal atelier in the latter's Newport, Rhode Island, studio, and was inspired by Hunt's knowledge of Barbizon painting. In 1862 La Farge exhibited his first still lifes and figure compositions at the National Academy of Design in New York, and by the late 1860s he was producing a series of highly innovative plein-air landscapes that reveal his interest in color theory. Some of these, especially his *Paradise Valley* of 1866–68 (Private collection, Boston; ill. Cortissoz, 1911, opp. p. 24), parallel the work of Claude Monet and other Impressionists in the use of light and color.

As early as 1865 La Farge began a series of decorative paintings commissioned by the architect Henry Van Brunt (1832–1903) for the dining room (ILL. 9.9) of Charles Freeland, a well-to-do Boston builder, but illness prevented him from completing the scheme. (He was replaced by another painter, Albion Bicknell [1837–1915].) Three surviving panels—*Fish* (1865, ILL. 9.10), *Hollyhocks and Corn* (1865, ILL. 9.11), and *Still Life with Eggplant and Flowers* (1865, FIG. 9.7)—suggest that La Farge carefully considered the intended placement of each composition in relationship to the other works in the room. La Farge's early assimilation of the principles of Japanese art, which he had been collecting since the late 1850s, is evident in these decorative paintings. A similar use of oriental compositional devices can be found in La Farge's illustrations, such as *Shipwrecked* (1864, FIG. 9.9), created for Alfred, Lord Tennyson's poem *Enoch Arden* (Boston, 1865).

La Farge had studied examples of European achievements in mural decoration and stained glass while abroad and, through his association with several architects, he played a central role in the development of these media in the United States. In fact, his methods revolutionized American stained-glass manufacture. La Farge began to experiment with stained glass in 1875, influenced by the work of the Pre-Raphaelite painters, some of whom—Edward Burne-Jones (1838–1898), Ford Madox Brown (1821–1893), and Dante Gabriel Rossetti (1828–1882)—he visited during a trip to Britain in 1873. He shortly thereafter introduced the use of opalescent glass to give tonality to colored glass and to eliminate traditional painted detail. His window (about 1877, FIG. 6.5) for the Newport residence of William Watts Sherman (ILLS. 4.5, 10.9, 10.10) was the first use of this innovation. *Peonies Blown in the Wind* (about 1880, FIG. 6.6), created for the home of Henry G. Marquand, also in Newport, is a more fully realized example of his stained-glass style, in which opalescent and streaked glass as well as glass wrinkled, cast, and blown into forms were combined to create surfaces rich in texture and vibrant in color. By his own reckoning, La Farge produced several thousand windows in the course of his career, of which nearly one thousand are well documented.

His work as a muralist was equally important. As early as 1873 the noted architect H. H. RICHARDSON discussed with La Farge the decoration of Trinity Church in Boston, a project La Farge actually began in 1876. To achieve unity in the building's decorative scheme, La Farge directed almost every phase of work on the church's interior. Working in an eclectic style inspired by his close study of European art, especially churches in the French region of Auvergne, he produced an impressive series of murals and architectural motifs. George P. Lathrop, a writer for *Scribner's Monthly*, applauded La Farge's accomplishment: "For the first time in the United States, the painting of a church came into the hands of artists instead of artisans. . . . The result, accordingly, was . . . a great advance upon any decoration heretofore achieved in this country" (Lathrop, 1881, p. 514). Other religious commissions were offered to La Farge, who subsequently executed murals for Saint Thomas Church (1877), the Church of the Incarnation (1885), and the Church of the Ascension (1886–88), all in New York City.

In 1880 he established his own firm of interior decorators, the La Farge Decorative Art Company, which he directed for five years before aesthetic disputes and financial mismanagement resulted in its demise. During the early 1880s he contributed decorations to several important interiors, among them the "Japanese" parlor in the New York residence of William H. Vanderbilt (ILL. 4.9) and the dining room and Water-Color Room in the home of William's son, Cornelius Vanderbilt II, also in New York. Although these buildings no longer stand, the appearance of Cornelius Vanderbilt's dining room can be discerned from period photographs (ILL. 9.13) and from surviving fragments of ornamental sculpture, especially *Apollo* (ILL. 9.5) and *Ceres* (FIG. 9.6). These were both completed with the assistance of AUGUSTUS SAINT-GAUDENS, but the *Ceres* in particular demonstrates La Farge's working procedure. Here La Farge borrowed his figure from a wall painting in the House of Castor and Pollux in Pompeii (ILL. 9.8), although he is original in his choice of materials, combining wood, ivory, marble, and bronze so that the panel harmonized with his decorative treatment in the rest of the room. He used a similar approach in Vanderbilt's Water-Color Room:

the palette of his murals, as exemplified by his oil study for *The Sense of Smell* (about 1881–82, ILL. 9.14), was chosen to coordinate with the golden tones he used in the ceiling.

Toward the end of his career, in the 1880s and 1890s, La Farge traveled to Japan and the South Seas, where he painted many richly colored and picturesque watercolors that he later used to illustrate accounts of these journeys. He also authored a number of books and theoretical treatises, including *Considerations on Painting* (1895), *Great Masters* (1903), and *The Higher Life in Art* (1908). By 1910, the year of his death, La Farge was a preeminent artist and an acknowledged leader in the field of stained glass, who was recognized as both a master of the great traditions of art and as an advocate of avant-garde principles of painting.

REFERENCES
John La Farge, "An Essay on Japanese Art," in *Across America and Asia: Notes of a Five Years' Journey Around the World and of a Residence in Arizona, Japan, and China*, by Raphael Pumpelly (New York, 1870), pp. 195–202 // "La Farge's Decorations of Trinity Church, Boston," *Art Journal* (Appleton's) 3 (Sept. 1877), pp. 285–86 // Roger Riordan, "American Stained Glass," pts. 1–3, *American Art Review* (Boston) 2, pt. 1 (1881), pp. 229–34; 2, pt. 2 (1881), pp. 7–11, pp. 59–64 // George Parsons Lathrop, "John La Farge," *Scribner's Monthly* 21 (Feb. 1881), pp. 503–16 // Mary Gay Humphreys, "Novelties in Interior Decoration: The Union League Club House and the Veterans' Room of the Seventh Regiment Armory," *Art Amateur* 4 (Apr. 1881), pp. 102–3 // Idem, "Colored Glass for Home Decoration," *Art Amateur* 5 (June 1881), pp. 14–15 // W. J. Linton, *The History of Wood-engraving in America* (Boston, 1882), pp. 31, 36, 55 // "Artistic Needlework in New York," *Art Amateur* 6 (Feb. 1882), p. 61 // "Some of the Union League Decorations," *Century Illustrated Monthly Magazine* 23 (Mar. 1882), pp. 745–52 // [Alexander F. Oakey], "A Trial Balance of Decoration," *Harper's New Monthly Magazine* 64 (Apr. 1882), pp. 734–40, esp. pp. 736, 738 // "New Houses—Indoors and Out," *Art Amateur* 8 (Feb. 1883), pp. 66–68 // "Some Notable Windows," *Art Amateur* 8 (Feb. 1883), p. 70 // Mary Gay Humphreys, "The Cornelius Vanderbilt House," *Art Amateur* 8 (May 1883), pp. 135–36 // Idem, "John La Farge, Artist and Decorator," *Art Amateur* 9 (June 1883), pp. 12–14 // "The Vanderbilt Tapestries," *Carpet Trade and Review* 14 (July 1, 1883), p. 57 // Mary Gay Humphreys, "The Progress of American Decorative Art," *Art Journal* (London), Jan. 1884, pp. 25–28; Mar. 1884, pp. 69–73; Nov. 1884, pp. 345–48 // Robert Jarvis, "Pictures by La Farge and Inness," *Art Amateur* 11 (June 1884), pp. 12–13 // "Decoration Notes: Mrs. Charles J. Osborne's Country House," *Art Age* 2 (Jan. 1885), p. 81 // Architect [pseud.], "Notes on Decoration," *Art Amateur* 12 (Jan. 1885), p. 44 // A. Bowman Dodd, "John La Farge," *Art Journal* (London), Sept. 1885, pp. 261–64 // M[ary] G[ay] H[umphreys], "Talks with Decorators: John La Farge on the Re-decoration of the American 'Meeting House,'" pts. 1, 2, *Art Amateur* 17 (June 1887), pp. 16, 18; (July 1887), p. 40 // "An Important Decorative Painting," *Art Amateur* 20 (Feb. 1889), pp. 65–66 // John La Farge, *The American Art of Glass, to Be Read in Connection with Mr. Louis C. Tiffany's Paper in the July Number of the "Forum," 1893* [New York, 1893] // Idem, "An Artist of Japan: Lecture Delivered Before the Architectural League of New York," typescript, June 1893, La Farge Papers, Collection of American Literature, The Beinecke Rare Book and Manuscript Library [hereafter abbreviated as YCAL], Yale University, New Haven // Idem, "Art," a lecture delivered in Buffalo, N.Y., typescript, 1894, La Farge Papers, YCAL // Idem, "Bing," a response to "the questions asked by Mr. [S.] Bing regarding my work and my ideas so as to include a notice of the same in his report to the French Government," typescript [Jan. 1894?], La Farge Papers, YCAL // Idem, *Considerations on Painting: Lectures Given in the Year 1893 at the Metropolitan Museum of New York* (New York, 1895; reprint New York, 1969) // Cecilia Waern, *John La Farge, Artist and Writer* (New York and London, 1896) // John La Farge, *An Artist's Letters from Japan* (New York, 1897; reprint New York, 1970) // Idem, *Hokusai: A Talk about Hokusai, the Japanese Painter, at the Century Club, March 28, 1896* (New York, 1897) // Idem, *Great Masters* (New York, 1903) // Samuel Isham, *The History of American Painting* (New York and London, 1905), pp. 316–28 // John La Farge, "Lecture on the Art of Painting," delivered in Boston, typescript [1906?], La Farge Papers, YCAL // Idem, "'Minor Arts' Lecture," typescript [1906?], La Farge Papers, YCAL // Idem, *The Higher Life in Art: A Series of Lectures on the Barbizon School of France Inaugurating the Scammon Course at the Art Institute of Chicago* (New York, 1908) // Idem, *The Ideal Collection of the World's Great Art* (New York, 1909) // John La Farge and August F. Jaccaci, eds., *Concerning Noteworthy Paintings in American Private Collections* (New York, 1909) // John La Farge, "The Minor Arts," *New England Magazine* 40 (May 1909), pp. 330–38 // American Art Galleries, New York, *Catalogue of the Art Property and Other Objects Belonging to the Estate of the Late John La Farge, N.A.* (sale cat., 1911), La Farge Papers, YCAL // Royal Cortissoz, *John La Farge: A Memoir and a Study* (Boston and New York, 1911) // Will H. Low, "John La Farge: The Mural Painter," *Craftsman* 19 (Jan. 1911), pp. 337–39 // John La Farge, *One Hundred Masterpieces of Painting* (New York, 1912) // Idem, *Reminiscences of the South Seas* (Garden City, N.Y., 1912) // Maria Oakey Dewing, "Flower Painters, and What the Flower Offers to Art," *Art and Progress* 6 (June 1915), pp. 255–62 // Frank Weitenkampf, "John La Farge, Illustrator," *Print Collector's Quarterly* 5 (Dec. 1915), pp. 472–94 // Charles Rollinson Lamb, "The Romance of American Glass," *Brooklyn Museum Quarterly* 16 (Oct. 1929), pp. 109–16 // Viola Roseboro, "Conversations with John La Farge," *Catholic World* 143 (June 1936), pp. 287–91 // M. Jeanne File, "An Evaluation of the Aesthetic Principles of John La Farge as Expressed in His Work in Glass" (M.A. thesis, Catholic University of America, 1946) // Ruth Berenson Katz, "John La Farge as Painter and Critic" (Ph.D. diss., Harvard University, 1951) // Mahonri Sharp Young, "John La Farge: A Revaluation," *Apollo* 81 (Jan. 1965), pp. 40–45 // "John La Farge," in *The Index of Twentieth Century Artists*, reprint with cumulative index (New York, 1970), pp. 527–43 // H. Barbara Weinberg, "The Decorative Work of John La Farge" (Ph.D. diss., Columbia University, 1972) // Idem, "The Early Stained Glass Work of John La Farge (1835–1910)," *Stained Glass* 67 (Summer 1972), pp. 4–16 // Idem, "John La Farge and the Invention of American Opalescent Windows," *Stained Glass* 67 (Autumn 1972), pp. 4–11 // Idem, "A Note on the Chronology of La Farge's Early Windows," *Stained Glass* 67 (Winter 1972–73), pp. 12–15 // Idem, "John La Farge: The Relation of His Illustrations to His Ideal Art," *American Art Journal* 5 (May 1973), pp. 54–73 // Idem, "John La Farge's Peacock Window," *Worcester Art Museum Bulletin*, n.s. 3 (Nov. 1973), pp. 1–12 // Idem, "The Work of John La Farge in the Church of St. Paul the Apostle," *American Art Journal* 6 (May 1974), pp. 18–34 // Idem, "The Decoration of the United Congregational Church," *Newport History* 47 (Winter 1974), pp. 109–20 // Idem, "John La Farge and the Decoration of Trinity Church, Boston," *Journal of the Society of Architectural Historians* 33 (Dec. 1974), pp. 323–53 // Idem, "La Farge's Eclectic Idealism in Three New York City Churches," *Winterthur Portfolio* 10 (1975), pp. 199–228 // Idem, "John La Farge's *Peonies Blown in the Wind*," *Pharos* (Journal of the Saint Petersburg, Fla., Museum of Fine Arts) 13 (July 1975), pp. 2–11 // Henry Adams, "The Stained Glass of John La Farge," *American Art Review* (Los Angeles) 2 (July–Aug. 1975), pp. 41–63 // Patricia Joan Lefor, "John La Farge and Japan: An Instance of Oriental Influence in American Art" (Ph.D. diss., Northwestern University, 1978) // William J. Dane, "La Farge Stained Glass Study Identified," *American Art Journal* 10 (May 1978), pp. 114–15 // Kathleen Adair Foster, "The Still-Life Painting of John La Farge," *American Art Journal* 11 (July 1979), pp. 4–37 // Henry Adams, "John La Farge, 1830–1870: From Amateur to Artist," 2 vols. (Ph.D. diss., Yale University, 1980) // Idem, "A Fish by John La Farge," *Art Bulletin* 62 (June 1980), pp. 269–80 // James L. Yarnall, "The Role of Landscape in the Art of John La Farge" (Ph.D. diss., University of Chicago, 1981) // James L. Sturm, *Stained Glass from Medieval Times to the Present: Treasures to Be Seen in New York* (New York, 1982), pp. 34–46 // Henry A. La Farge, "John La Farge and the 1878 Auction of His Works," *American Art Journal* 15 (Summer 1983), pp. 4–34 // Henry Adams, "John La Farge and Japan," *Apollo* 119 (Feb. 1984), pp. 120–29 // Henry A. La Farge, "The Early Drawings of John La Farge," *American Art Journal* 16 (Spring 1984), pp. 4–37 // Henry Adams, "Picture Windows," *Art and Antiques* 7 (Apr. 1984), pp. 94–103 // Henry A. La Farge, "John La Farge's Work in the Vanderbilt Houses," *American Art Journal* 16 (Autumn 1984), pp. 30–70 // Henry Adams, "John La Farge's Discovery of Japanese Art: A New Perspective on the Origins of *Japonisme*," *Art Bulletin* 67 (Sept. 1985), pp. 449–85 // James L. Yarnall, "La Farge's Baker Memorial Window," *Newport History* 58 (Fall 1985), pp. 93–105 // Henry Adams, "William James, Henry James, John La Farge, and the Foundations of Radical Empiricism," *American Art Journal* 17

(Winter 1985), pp. 60–67 // Idem, "Regaining Paradise," *Art and Antiques,* Mar. 1985, pp. 60–65 // James L. Yarnall, "John La Farge's *Portrait of the Painter* and the Use of Photography in His Work," *American Art Journal* 18, no. 1 (1986), pp. 4–20 // Idem, Washington, D.C., and New York, conversation, Apr. 1986 // National Museum of American Art, Washington, D.C., *The Art of John La Farge,* by Henry Adams et al. (exhib. cat., 1987), forthcoming

Karl Langenbeck, *see* American Encaustic Tiling Company

William Leighton, Jr., *see* Hobbs, Brockunier and Company

William Leighton, Sr., *see* Hobbs, Brockunier and Company

A. and H. Lejambre
1865–ca. 1907
Philadelphia
Furniture

This cabinetmaking firm was the outgrowth of an older company established in Philadelphia about 1825 by Jean Pierre Alphonse Lejambre (1786–1843), a French craftsman who emigrated to America during the second decade of the nineteenth century, after serving as a soldier in the Napoleonic Wars. Lejambre spent a brief period of time near Bordentown, New Jersey, where in 1820 he married Anna Rainier (1799–1878), then settled in Philadelphia and set up his shop, styled simply as "A. Lejambre, Upholsterer." There is no evidence that Lejambre himself was a cabinetmaker, although he provided furniture to his clients, he may have employed cabinetmakers in his workshop for this purpose. His inventory at the time of his death, in 1843, included some two hundred chairs, tables, étagères, and screens, which his wife inherited along with the other assets of the firm.

Anna Lejambre continued to operate as an "upholstress" under the name of A. Lejambre, taking her son Alexis as a partner about 1853. Alexis, who was related by marriage to Benjamin Randolph, the esteemed eighteenth-century Philadelphia cabinetmaker, seems to have been responsible for expanding production to include furniture. An 1853 billhead described the Lejambre concern as importing and manufacturing French furniture as well as curtains, trimmings, and cornices. By 1858 the billhead read "French Cabinet Maker and Upholsterer," a designation that remained unaltered for the next twenty-five years.

In 1865, three years after her son's untimely death, Anna Lejambre entered into a partnership with her son-in-law and cousin, Henri Lejambre, who had been employed by the firm since the 1850s; the name of the business was officially changed to A. and H. Lejambre in 1867. The company's financial success during the 1860s and 1870s resulted from the popularity of its furniture in the French taste, which was greatly in vogue in Philadelphia during this period. Most of the known examples of Lejambre furniture, massive and solid in

appearance, are adaptations of eighteenth-century French forms decorated with French Renaissance details.

There are some documented pieces of Lejambre furniture in the English reform style, however, such as the chest of drawers with étagère now in the collection of the Museum of Fine Arts, Houston, which features the rectilinear silhouette, stylized carved sunflowers, and incised details typical of objects inspired by CHARLES LOCKE EASTLAKE and BRUCE J. TALBERT. A delicate three-tiered mahogany occasional table of about 1880, its surface inlaid with a sparse composition in copper and mother-of-pearl, shows the influence of English art furniture by E. W. GODWIN, with elements—such as its scalloped arch—derived from more than one non-Western source (FIGS. 5.16, 5.17).

Anna Lejambre died in 1878, leaving her share of the partnership to her daughters Cora—Henri's wife—and Elizabeth. In 1887, five years after Elizabeth's death, her heirs relinquished their interests in the Lejambre concern, making Henri and Cora Lejambre its sole owners, presumably as a result of diminished profits: an 1888 report of R. G. Dun and Company stated that Lejambre "is doing a small business under light expense, and is probably making a living. Is manufacturing in a small way a fine grade of goods" (Strickland, 1978, p. 602). Henri Lejambre ran the company until about 1907, assisted by his son Eugène and various nephews. Numerous changes of address in its last years hint at the firm's financial decline.

REFERENCE
Peter L. L. Strickland, "Furniture by the Lejambre Family of Philadelphia," *Antiques* 113 (Mar. 1978), pp. 600–613

Walter Scott Lenox, *see* Ott and Brewer

Joseph Locke, *see* New England Glass Company

J. and J. G. Low Art Tile Works
1877–1907
Chelsea, Massachusetts
Ceramic tiles

The J. and J. G. Low Art Tile Works of Chelsea, Massachusetts, was without question one of the outstanding American tile manufacturers of the 1880s. Within a few years of the company's founding in 1877, the firm of J. and J. G. Low attained international acclaim to match that of the most renowned British firms, such as MINTON AND COMPANY and Maw and Company.

John Gardner Low (1835–1907) was born in Chelsea. His father, John Low (1808–1894), later his partner in the tile works, was a civil engineer. In 1858 the younger Low commenced a three-year study of painting in the Paris studios of Thomas Couture (1815–1879) and Constant Troyon (1810–1865); a one-man show and sale of his work was held in Boston in 1861. That year Low returned to the United States and married Charlotte Jane Farnsworth; their only son, John Farnsworth Low (1862–

1939), was born the following year. In 1869, after the death of his wife, Low was married a second time, to Cordelia Ann Lothrop.

Low worked as a scene and decorative painter in fresco for several years; the painted backdrop for the Chelsea Academy of Music was one such commission. By the early 1870s, however, Low was employed by James Robertson and his sons at the CHELSEA KERAMIC ART WORKS as an accomplished painter of vases in the ancient Greek manner (FIG. 7.1).

The 1876 Philadelphia Centennial Exposition inspired Low to capitalize on a growing popular interest in ceramics and tiles. In 1877 Low and his father started their business, located at 948 Broadway in Chelsea. Known by the name of J. and J. G. Low until 1883, and J. G. and J. F. Low thereafter—when John F. Low replaced his grandfather in the firm—the company was among the first to combine artistic designs with mass production, specializing in decorative tiles, although vessels were also manufactured by 1883. Low soon perfected the so-called natural process, for which he received a patent in 1879, even though the technology he employed had been used in England since 1840. Low's version of the technique involved creating impressions of leaves, grasses, flowers, and fabrics on clay tiles (FIG. 7.39). Soon he discovered that the same design could be made in relief by pressing a second clay tile against the intaglio one.

While Low continued to design tiles during the 1880s, much of the firm's production is attributable to other talented artists, among them Arthur Osborne. Osborne, a British sculptor and graduate of the design school at South Kensington, London, who joined Low's firm at its inception, had previously worked for the Chelsea Keramic Art Works. Not all of Osborne's designs are marked with his AO signature, but it is generally agreed that he was responsible for most of the modeled tiles (FIGS. 7.40, 7.41). Osborne created motifs based on historical styles and nature. "Plastic sketches" of mythological and historical figures, including several American presidents, were also very popular. With the help of George W. Robertson (1835–1914), whom Low hired away from the Chelsea Keramic Art Works in 1878, Low tiles appeared in a rich spectrum of colored glazes that included creamy white, chocolate brown, olive greens and earth tones, amber, orange, turquoise blue, and rose. Unlike other tile manufacturers in the United States, such as the AMERICAN ENCAUSTIC TILING COMPANY, the Low Art Tile Works did not issue hand-painted, printed, or encaustic tiles.

Low's first successful firing of tiles took place in 1879. A silver medal received later that year at the Cincinnati Industrial Exposition and a gold medal awarded by a prestigious British competition in 1880 were harbingers of Low's international reputation. More than thirty distributors marketed Low tiles from coast to coast, and even the British paid homage: Frederick Leighton and members of the royal family were among the visitors to an 1882 exhibition of Low tiles at the Fine Art Society in London.

In addition to fireplace surrounds and wall decorations, Low tiles were adapted to a variety of ornamental uses. The works of Low art-tile clocks (FIG. 8.30) were probably con-

tracted from other manufacturers, such as the New Haven Clock Company, which advertised a similar timepiece—identified as the "Albatross"—in its 1888 catalogue. The clock case itself may have been produced under the auspices of J. and J. G. Low, who applied in 1884 for a patent on a similar design, which they received two years later. The firm often contracted with other manufacturers, such as the Magee Art Castings Company of Chelsea, Massachusetts, to produce brass and metalwork objects—umbrella stands and picture frames, for example—which were retailed under the Low name. Low tiles also adorn the Art Westminster cast-iron stove (ILL. 8.23) made by Rathbone, Sard and Company of Albany, New York, itself symbolic of the marriage of utility and beauty sought by design reformers. Throughout the 1880s and 1890s, Low manufactured elaborate ceramic soda fountains, which were patented in 1889.

During his last ten years, John Gardner Low resumed his interest in painting (he held memberships in both the Allston Club and the Paint and Clay Club of Boston), leaving the management of the firm to his son, a chemist educated at the Massachusetts Institute of Technology. Production of Low ceramics stopped in 1902, and the Worcester Art Museum commemorated the firm's achievement with an exhibition in 1903. The company's assets were liquidated upon J. G. Low's death four years later.

REFERENCES
"American Tiles," *Crockery and Glass Journal* 10 (July 31, 1879), p. 30 // "Relief Tiles," *Crockery and Glass Journal* 10 (Oct. 2, 1879), p. 5 // [Household art rooms—Boston], *Art Amateur* 2 (Feb. 1880), p. iii // [Description of Low's art-tiles showroom], *Art Amateur* 3 (July 1880), p. 44; and [advertisement], p. iii // "Menu and Guest Cards," *Art Amateur* 3 (Oct. 1880), pp. 106–7 // "Miscellaneous: American Tiles in England," pt. 2, *American Art Review* (Boston) 1, pt. 2 (1881), p. 552 // J. and J. G. Low, *Art Tiles* (Chelsea, 1881) // Idem, *Illustrated Catalogue of Art Tiles* (Chelsea, 1881–82) // [Praise for Low art tiles], *Crockery and Glass Journal* 13 (Jan. 20, 1881), p. 14 // [Critique of an article in *Harper's Magazine* of Feb. 1881], *Art Amateur* 4 (Feb. 1881), p. 47 // [Various showrooms], *Art Amateur* 4 (May 1881), p. 129 // [Expansion of Low Art Tile Company], *Crockery and Glass Journal* 13 (May 5, 1881), p. 20 // "Is Our Art Only a Fashion?" *Art Amateur* 5 (June 1881), p. 2 // "New Decorative Metal Castings," *Art Amateur* 5 (June 1881), p. 12 // J. and J. G. Low, *Plastic Sketches* (Boston, 1882) // Frank D. Millet, "Some American Tiles," *Century Illustrated Monthly Magazine* 23 (Apr. 1882), pp. 896–904 // [An enthusiastic believer in pottery], *Art Amateur* 6 (May 1882), p. 127 // "Low's Art Tiles" [advertisement], *Art Amateur* 7 (Nov. 1882), p. vi // "Low's Art Tiles" [advertisement for Caryl Coleman, agent], *Art Interchange* 10 (Mar. 29, 1883), p. 86 // "Tiles," *Crockery and Glass Journal* 18 (Dec. 13, 1883), p. 23 // J. G. Low and J. F. Low, *Illustrated Catalogue of Art Tiles* [Chelsea, 1884?] // Isaac Edwards Clarke, *Art and Industry: Education in the Industrial and Fine Arts in the United States,* pt. 1, *Drawing in Public Schools* (Washington, D.C.,

1885), p. ccxlv // S[ylvester] R[osa] Koehler, "American Art Industries, 1: Heating Apparatus," *Magazine of Art* 8 (1885), pp. 37–40 // "Trade Catalogues," *Clay-Worker* 3 (Jan. 1885), pp. 117–18 // [Amanda B. Harris], "Fire-place Stories," *Wide Awake* 22 (Dec. 1885), pp. 42–50 // "Lee and Shepard's New Books: 'Plastic Sketches of J. G. and J. F. Low,'" *Critic* 9 (Nov. 27, 1886), p. xiii // Architectural League, New York, *Catalogue of the Third Annual Exhibition . . .* (exhib. cat., 1887) [advertisements], p. 57 // J. G. and J. F. Low, *Plastic Sketches* (Boston, 1887) // *Illustrated Catalogue of Clocks Manufactured by the New Haven Clock Company* (New Haven, 1888), "Albatross" // Clarence Cook, "The Exhibition of American Pottery and Porcelain," *Art Amateur* 20 (Dec. 1888), pp. 5–6 // Pennsylvania Museum and School of Industrial Art, Philadelphia, *Exhibition of American Art Industry of 1889, Including a Competition for American Workmen* (exhib. cat., 1889), pp. 26–29 // L. W. Miller, "Industrial Art: The Exhibition of Art Industry at Philadelphia," *Art Amateur* 21 (Nov. 1889), p. 134 // Emile Molinier, "Un Décorateur américain: J. G. Low," *L'Art* 49 (1890), pp. 138–40 // Edwin AtLee Barber, "Recent Advances in the Pottery Industry," *Popular Science Monthly* 40 (Jan. 1892), pp. 308–9 // Idem, *The Pottery and Porcelain of the United States* (New York, 1893), pp. 346–53 // [Karl Langenbeck to John F. Low, correspondence, Aug. 17, 1893], *Pottery Collectors' Newsletter* 3 (Aug. 1974), pp. 156–60 // Karl Langenbeck, Mosaic Tile Company, to J. F. Lowe [sic], correspondence, Jan. 5, 1897, collection of Barbara White Morse, Springvale, Maine // William P. Jervis, "Low Art Tile Company, Boston," in *Encyclopedia of Ceramics* (New York, 1902), pp. 356–57 // R. S., "The Field of Art—American Pottery," *Scribner's Magazine* 32 (Nov. 1902), pp. 637–40 // "J. G. Low, Chelsea, Dead," *Boston Herald,* Nov. 11, 1907, p. 12 // "John Gardner Low" [obituary], *Boston Daily Globe,* Nov. 11, 1907, p. 8 // "Death of John G. Lowe [sic]," *Chelsea Catholic Citizen,* Nov. 16, 1907, p. 4 // "Low, John Gardner," in *The National Cyclopaedia of American Biography,* vol. 14 (New York, 1917), p. 239 // "Low, John Gardner," in *Dictionary of American Biography,* vol. 11 (New York, 1933), p. 447 // Everett Townsend, "Development of the Tile Industry in the United States," *Bulletin of the American Ceramic Society* 22 (May 15, 1943), p. 129 // Lura Woodside Watkins, "Low's Art Tiles," *Antiques* 45 (May 1944), pp. 250–52 // Idem, *Early New England Potters and Their Wares* (Cambridge, Mass., 1950), pp. 227–30 // Barbara White Morse, "Tiles to Treasure: Low Art Tiles," *Spinning Wheel* 25 (Mar. 1969), pp. 18–22 // Regina Soria, *Elihu Vedder: American Visionary Artist in Rome (1836–1923)* (Rutherford, N.J., 1970), pp. 151–63 // Barbara White Morse, "Letters from Our Mailbag: 'Esmeralda' Low Tiles" [correction to Mar. 1969 article], *Spinning Wheel* 26 (July–Aug. 1970), p. 50 // Idem, "Buying a Low Art Tile Stove," pts. 1, 2, *Spinning Wheel* 26 (Nov. 1970), pp. 28–31; (Dec. 1970), pp. 12–15 // Idem, "John Gardner Low and His Original Art Tile Soda Fountain," pts. 1, 2, *Spinning Wheel* 27 (July–Aug. 1971), pp. 26–28; (Sept. 1971), pp. 16–19 // Julian Barnard, *Victorian Ceramic Tiles* (Greenwich, Conn.,

1972), pp. 36, 86–88, 109, 166, figs. 31, 70–71, 77, 79, 81, 95, 97 // Barbara White Morse, "Chelsea Ceramic Charm and Comfort," *Antiques Journal* 27 (Oct. 1972), pp. 13–15, 40 // Idem, "Low 'Art Tiles' Today: A Primer for the Novice Collector," *National Antiques Review* 5 (Oct. 1973), pp. 26–29 // Idem, "Low Art Tiles Illustrating the Victorian Japanesque Vogue," *Antiques Journal* 28 (Nov. 1973), pp. 20–22, 49 // Paul Evans, *Art Pottery of the United States: An Encyclopedia of Producers and Their Marks* (New York, 1974), pp. 151–53 // Ralph and Terry Kovel, *The Kovels' Collector's Guide to American Art Pottery* (New York, 1974), pp. 76–85 // Barbara White Morse, "John G. Low and Elihu Vedder, As Artist Dreamers," *Spinning Wheel* 32 (May 1976), pp. 24–27 // Idem, "The Low Family of Chelsea, Massachusetts, and Their Pottery," *Spinning Wheel* 33 (Sept. 1977), pp. 28–33 // Idem, "Art Tiles," *American Antiques* 5 (Nov. 1977), pp. 24–29 // Delaware Art Museum, Wilmington, *American Art Pottery, 1875–1930,* by Kirsten Hoving Keen (exhib. cat., 1978), p. 23 (fig. 39) // William Benton Museum of Art, University of Connecticut, Storrs, *American Decorative Tiles, 1870–1930,* by Thomas P. Bruhn (exhib. cat., 1979), pp. 8–9, 30–35 // David A. Hanks and Donald C. Peirce, "The Virginia Carroll Crawford Collection of American Decorative Arts," *Antiques* 124 (Oct. 1983), p. 746 (ill.) // Barbara White Morse, Springvale, Maine, correspondence, Mar. 23, Apr. 6 and 15, May 8, 10, and 23, 1985

John Low, see **J. and J. G. Low Art Tile Works**

John Farnsworth Low, see **J. and J. G. Low Art Tile Works**

John Gardner Low, see **J. and J. G. Low Art Tile Works**

Will H. Low
1853–1932
New York City
Painter

The American figure painter Will Hicok Low is best known for his mural paintings dating from the 1890s and the first two decades of the twentieth century; his most important commission comprised thirty-two murals of allegorical subjects created for the New York State Education Building in Albany, New York, between 1913 and 1918. As a student in France during the mid-1870s, Low witnessed the revival of monumental decorative painting in that country. Intent on establishing himself as a decorative painter, he returned to the United States in 1877, but nearly two decades passed before an equivalent demand for large-scale mural painting developed in this country. Throughout the intervening years Low participated in many other kinds of decorative projects, which included the design of stained-glass windows and book illustrations.

Born in Albany, New York, Low was first exposed to art in the studio of the sculptor Erastus Dow Palmer (1817–1904), the father of one of Low's boyhood friends. For a short time

he apprenticed to an English artist (identity unknown) in Albany who painted ornamental floral and landscape panels for the decoration of railroad cars; many years later Low would again paint similar panels to enhance furniture. By 1871 Low was living permanently in New York City, supporting himself as an illustrator for such magazines as Appleton's *Art Journal*. Through James E. Freeman (1808–1884), a portrait painter, he was introduced to the inhabitants of the Tenth Street Studio Building, thus gaining entry to the New York art world. Low was also a journalist and art critic, initially a correspondent for the *Albany Weekly Times* during the early 1870s under the pseudonyms Ned Sketchly and Neutral Tint. Later in his career Low wrote many articles for periodicals, including *Scribner's Magazine, Century Illustrated Monthly Magazine,* and *McClure's Magazine.*

Low first exhibited a painting at the National Academy of Design, New York, in 1872, but due to a misunderstanding about the entrance requirements he was unable to enroll in the academy's art classes. The following year, with the encouragement of Erastus Dow Palmer and the financial assistance of an Albany patron, Low went to Paris instead. His friends Wyatt Eaton (1849–1896) and J. Alden Weir (1852–1919) helped him enter the atelier of Jean-Léon Gérôme (1824–1904). After the summer recess, however, Low switched his allegiance to Emile-Auguste Carolus-Duran (1837–1917), whose spontaneous technique he found more attractive than Gérôme's academic method.

In 1873 Low spent the first of four summers in and around Barbizon, France, as part of a community of French and American artists. There he met and became friendly with Jean-François Millet (1814–1875), whose cogent figure paintings had an immediate impact on Low's work. Millet, who had recently been commissioned to decorate the Chapel of Saint Genevieve at the Panthéon in Paris, impressed upon Low his strong belief that there should be no distinction between history and genre paintings and that decorative pictures should communicate directly with the viewer, requiring no prior knowledge of literary sources. Low later brought this point of view to his own murals.

During his four years in France, Low exhibited one work at the 1876 Salon and studied at both the Académie Suisse and the Ecole Gratuite de Dessin, known as the Petite Ecole, which in its curriculum stressed the interrelationship between the fine and the decorative arts. Low resolved to become a decorative painter. He paid close attention to the mural paintings of contemporary artists, especially to those of Paul Baudry (1828–1886), Pierre-Victor Galland (1822–1892), and Pierre Puvis de Chavannes (1824–1898), and he studied the work of Il Rosso (1494–1541) and Primaticcio (1504–1570) at the royal palace of Fontainebleau. His first opportunity to participate in a major project came from the sculptor AUGUSTUS SAINT-GAUDENS, who in 1877 met Low and invited him to assist in the completion of fourteen bas-relief angels for the reredos that Saint-Gaudens, in collaboration with JOHN LA FARGE, had created for Saint Thomas Church in New York. Low shared Saint-Gaudens's Paris studio

for three months while the work was done; the two became lifelong friends in the process.

When Low returned to the United States late in 1877, the market for American artists was weak; many dealers were pushing European art. Meanwhile, European-trained American artists such as Low were also out of favor at the National Academy of Design, where a conservative generation of nativist painters still held control. Through RICHARD WATSON GILDER, Low once again found work as an illustrator. In 1878 he joined the newly formed Society of American Artists, established the previous year by his friends Eaton, Saint-Gaudens, and Gilder's wife, HELENA DE KAY. Also in 1878 he received a commission from John Boyd Thatcher of Albany for a large painting with an American subject, *Skipper Ireson's Ride,* based on a poem by John Greenleaf Whittier. The French-trained Low generally disdained American themes, but for this project his patron was insistent. Nevertheless, the painting, which was completed in 1881, greatly enhanced his artistic reputation, and he was hired to teach at the Cooper Union for the Advancement of Science and Art in New York.

Low kept his hand in the decorative arts by working as an assistant to John La Farge for about two years, starting in 1880. Under La Farge he contributed to the decoration of the Union League Club, the Water-Color Room and the dining room of the Cornelius Vanderbilt II house (ILL. 9.13), and the William H. Vanderbilt home, for which La Farge had designed a program of stained glass.

In 1882, in collaboration with an unknown cabinetmaker, Low painted small panels for use as ornamentation in furniture. Low used an ebonized cherrywood cabinet to frame four brightly colored figural panels that are unified by a common horizon line and are to be read as a single scene (FIG. 1.11). These, along with four small floral panels that are naturalistically rendered with light and shade, reveal Low's academic French training rather than the influence of contemporary British ideas about flat surface decoration. Although Low's cabinet may be viewed as part of a painted-furniture tradition revived in England by WILLIAM MORRIS and others (ILLS. 5.1, 5.4, FIG. 5.9), relatively few pieces of furniture were embellished by such American artists as Low and Albert Pinkham Ryder (ILLS. 9.15, 9.16).

An 1885 edition of John Keats's *Lamia,* with forty drawings by Low of subjects concerning life, love, and death, was considered a landmark in book illustration, matched only by ELIHU VEDDER's treatment of the *Rubáiyát of Omar Khayyám* (FIG. 9.11). The then-new heliotype process developed in America permitted exact reproduction of the artists' original drawings without the previous necessity of translating them into line engravings before printing.

By 1890 Low's reputation was established, and he joined the ranks of academicians at the National Academy of Design, having entered the academy's faculty the preceding year. He received his first major mural-painting commission from the Waldorf-Astoria Hotel in 1892, a project he executed in France during the next four years.

The 1893 World's Columbian Exposition in

Chicago sparked a widespread revival of large-scale decorative painting in America, to which Low devoted the rest of his career. Within little more than a decade, however, the academic style and idealized subject matter that Low's work represented began to be eclipsed by American realist painters and by the new developments in modern art that reached America with the Armory Show of 1913.

REFERENCES
Will H. Low, "Old Glass in New Windows," *Scribner's Magazine* 4 (Dec. 1888), pp. 675–86 // Idem, *A Chronicle of Friendships, 1873–1900* (New York, 1908) // Idem, *A Painter's Progress* (New York, 1910) // Idem, "The Primrose Way," typescript, 1930, Albany Institute of History and Art, N.Y. // Douglas S. Dreishpoon, "Will H. Low: American Muralist (1853–1932), with a Catalogue Listing of His Known Work" (M.A. thesis, Tufts University, 1979) // Richard N. Murray, "Painting and Sculpture," in Brooklyn Museum, *The American Renaissance, 1876–1917* (exhib. cat., 1979), pp. 153–89 // Doreen Bolger Burke, *American Paintings in the Metropolitan Museum of Art,* vol. 3, *A Catalogue of Works by Artists Born Between 1846 and 1864* (New York, 1980), pp. 167–68 // John H. Dryfhout, *The Work of Augustus Saint-Gaudens* (Hanover, N.H., and London, 1982), pp. 86–87 (ills.) // High Museum of Art, Atlanta, *The Virginia Carroll Crawford Collection: American Decorative Arts, 1825–1917,* by David A. Hanks and Donald C. Peirce (Atlanta, 1983), pp. 60–61 (ills.) // Mary Smart, "Sunshine and Shade: Mary Fairchild MacMonnies Low," *Woman's Art Journal* 4 (Fall/Winter 1983–84), pp. 20–25 // Laura L. Meixner, "Will Hicok Low (1853–1932): His Early Career and Barbizon Experience," *American Art Journal* 17 (Autumn 1985), pp. 51–70

Nicholas Lutz, *see* **Boston and Sandwich Glass Company**

Edward Lycett, *see* **Faience Manufacturing Company**

William P. McDonald, *see* **Rookwood Pottery**

M. Louise McLaughlin

1847–1939
Cincinnati, Ohio
Ceramist

Mary Louise McLaughlin could rightfully be called the pioneer of china painting in America. Her dedication to her craft, her painted ceramics, her later experiments in porcelain, and her writings all had a profound influence on other ceramics artists not only during the Aesthetic period but well beyond it.

A woman of some means, McLaughlin's artistic career began at a private art academy in Cincinnati for young ladies of her social and economic standing, which provided training she later described as "decidedly early Victorian" (McLaughlin, 1938, p. 217). Her education became more professionally oriented when, in 1873, she enrolled in the University

of Cincinnati School of Design and attended BENN PITMAN's first wood-carving class. It was also under his tutelage that McLaughlin was initially exposed to china painting. Pitman secured the necessary colors and equipment and hired Maria Eggers, a German instructor who had learned the skill in Dresden, to teach his students—all women—the art of overglaze painting on china. Among their first products were decorated teacups that were sold to raise funds to send an exhibition of wood carving, ceramics, and paintings to the 1876 Centennial Exposition in Philadelphia. One of the objects in the Cincinnati display in the Women's Pavilion at the Centennial was a desk (ILL. 5.7) carved by McLaughlin, under the direction of HENRY LINDLEY FRY and WILLIAM HENRY FRY, that was clearly inspired by a design for a hanging cupboard published in BRUCE J. TALBERT's important book *Gothic Forms Applied to Furniture, Metal Work, and Decoration for Domestic Purposes* (1867), which in 1873 had appeared in America. McLaughlin's piece was originally conceived as a wall cupboard; the legs converting it to a desk were later added by the Frys. The carved spear-plumed thistles, Scottish motto, and ivy panel that embellish the work not only recall McLaughlin's heritage, but can also be traced to specific plates in the publication *Art Studies Applied to Nature* (1872) by the British ornamentalist Frederick Edward Hulme (1841–1909), one of the many pattern books that American artists utilized during the Aesthetic movement.

The Philadelphia exhibition was a major event for young artists, and particularly for McLaughlin, who was fascinated by the Haviland faience from Limoges never before on public view in America. The faience was decorated under the glaze with colored slips, a technique discovered by the Laurin Factory in Bourg-la-Reine, France. McLaughlin soon began a series of experiments in an effort to duplicate the effect. It was about the same time that she wrote the first of her four books on china painting, *China Painting: A Practical Manual for the Use of Amateurs in the Decoration of Hard Porcelain* (1877).

By late 1877 McLaughlin announced that she had sucessfully replicated the look of the underglaze slip decoration that she had admired in the Limoges faience. At the time McLaughlin's wares were fired at the P. L. Coultry pottery in Cincinnati and were exhibited in Cincinnati and New York, as well as at the 1878 Exposition Universelle in Paris, where she received an honorable mention. In 1879 McLaughlin, along with eleven other women, including LAURA FRY, AGNES PITMAN, and ELIZABETH NOURSE, founded the Cincinnati Pottery Club, of which she was named president. The club members were concerned with mastering pottery decoration of all kinds—overglaze, incised, relief, and underglaze—and originally fired their pieces at the Frederick Dallas Pottery but later did so at Maria Longworth Nichols's ROOKWOOD POTTERY, until 1883. Some of the early examples of their underglaze painting, notably the work of Henrietta D. Leonard, showed the influence of JOHN BENNETT, whose work the Cincinnati women highly esteemed. The club, which grew to have twenty-five members, disbanded by 1890, when McLaughlin formed the Associated Artists of Cincinnati, a group of ceramics decorators and metalworkers for which she also served as president.

During the Pottery Club years, McLaughlin continued to perfect her underglaze slip technique, which she popularized through her book of 1880, *Pottery Decoration under the Glaze* (FIG. 7.28). She received great acclaim for her monumental "Ali Baba" vase, nearly forty inches high, that was said to be the largest ever made in America. According to Edwin AtLee Barber, three vases were made from the same mold. One, given to the Women's Art Museum Association and later to the Cincinnati Art Museum, was decorated with hibiscus blossoms on a sage green background; another version (FIG. 7.29) featured bold white calla lilies set off against a rich blue ground highlighted with a network of thin gold lines; the third is not known to survive. By the mid-1880s, largely as a result of McLaughlin's activities, underglaze slip decoration was widely practiced and became synonymous with pottery decoration in Cincinnati.

From the mid-1880s McLaughlin turned increasingly to writing and to work in metal, applying to her metalwork some of the same decorative techniques and motifs she had used in wood carving. One example, an acid-etched covered copper bowl (FIG. 8.31) that she decorated in 1884, has simple incised blossoms as its decoration and is related to her work as a printmaker and engraver. McLaughlin again concentrated on ceramics in 1895, initially pottery with the appearance of inlaid decoration (achieved by painting the molds in which the pieces were cast), and by 1898, single-fired white porcelain. The carved ware she produced in the latter medium was called Losanti, which she continued to make until 1906, when she all but abandoned ceramics to pursue a literary career, writing articles and books on historical and political subjects.

REFERENCES

M. Louise McLaughlin, *China Painting: A Practical Manual for the Use of Amateurs in the Decoration of Hard Porcelain* (Cincinnati, 1877) // Women's Art Museum Association of Cincinnati, *Loan Collection Exhibition* (exhib. cat., 1878), nos. 19–21½, 25½, 39, 53–54, 61–64, 85, 117, 120, 134, 138, 144, 148, 162, 181, 183, 185 // "The Faience Discovery," *Crockery and Glass Journal* 7 (Apr. 18, 1878), pp. 16, 19 // M. Louise McLaughlin, *Pottery Decoration under the Glaze* (Cincinnati, 1880) // "The Ali Baba Vase," *Art Amateur* 2 (Mar. 1880), p. 79 // "Cincinnati Art Pottery," *Harper's Weekly* 24 (May 29, 1880), pp. 341–42 // Lilian Whiting, "The Cincinnati Pottery Club," *Art Amateur* 3 (June 1880), pp. 10–11 // Constance Cary Harrison, *Woman's Handiwork in Modern Homes* (New York, 1881), pp. 108–10 // Mrs. Aaron F. Perry, "Decorative Pottery of Cincinnati," *Harper's New Monthly Magazine* 62 (May 1881), pp. 834–45 // Mary Gay Humphreys, "The Cincinnati Pottery Club," *Art Amateur* 8 (Dec. 1882), pp. 20–21 // M. Louise McLaughlin, "Hints to China Painters," pts. 1–20, *Art Amateur* 8 (Dec. 1882), p. 19; (Jan. 1883), p. 41; (Feb. 1883), pp. 71–72; (Mar. 1883), p. 88; (Apr. 1883), p. 111; (May 1883), p. 139; 9 (June 1883), pp. 18–19; (July 1883), p. 37; (Aug. 1883), p. 64; (Sept. 1883), p. 83; (Oct. 1883), pp. 105–6; (Nov. 1883), p. 123 // Idem, *Suggestions to China Painters* (Cincinnati, 1884) // Isaac Edwards Clarke, *Art and Industry: Education in the Industrial and Fine Arts in the United States* (Washington, D.C., 1885), pp. ccxlvii–ccxlviii // M. Louise McLaughlin, *Painting in Oil: A Manual for the Use of Students* (Cincinnati, 1888) // Pennsylvania Museum and School of Industrial Art, *Exhibition of American Art Industry of 1889, Including a Competition for American Workmen* (exhib. cat., 1889), pp. 4, 10, 13, 21 // Edwin AtLee Barber, "Recent Advances in the Pottery Industry," *Popular Science Monthly* 40 (Jan. 1892), pp. 289–322 // Idem, *The Pottery and Porcelain of the United States* (New York, 1893), pp. 275–84 // M. Louise McLaughlin, *The Second Madame: A Memoir of Elizabeth Charlotte, Duchesse d'Orléans* (New York [1895]) // Irene Sargent, "Some Potters and Their Products," *Craftsman* 4 (Aug. 1903), pp. 328–37 // "Personalities" [M. Louise McLaughlin], *Hampton-Columbian Magazine* 27 (Jan. 1912), pp. 835–36 // M. Louise McLaughlin, "The Beginnings of the War: A Review of the Antecedent Causes and the Thirteen Critical Days," *Current History* 7 (Dec. 1917), pp. 481–93 // Idem, *An Epitome of History from Pre-historic Times to the End of the Great War* (Boston, 1923) // Idem, "Miss McLaughlin Tells Her Own Story," *Bulletin of the American Ceramic Society* 17 (May 1938), pp. 217–25 // "Necrology: Another Honorary Member Has Passed Away, Mary Louise McLaughlin," *Bulletin of the American Ceramic Society* 18 (Feb. 1939), pp. 66–67 // Herbert Peck, *The Book of Rookwood Pottery* (New York, 1968) // Paul Evans, "Cincinnati Faience: An Overall Perspective," *Spinning Wheel* 28 (Sept. 1972), pp. 16–18 // Sue Brunsman, "The European Origins of Early Cincinnati Art Pottery, 1870–1900" (M.A. thesis, University of Cincinnati, 1973) // Paul Evans, *Art Pottery of the United States: An Encyclopedia of Producers and Their Marks* (New York, 1974), pp. 145–50, 255–56 // Martin Eidelberg, "American Ceramics and International Styles, 1876–1916," in "Aspects of the Arts and Crafts Movement in America," ed. Robert Judson Clark, *Record of the Art Museum, Princeton University* 34, no. 2 (1975), pp. 13–19 // Cincinnati Art Museum, *The Ladies, God Bless 'Em: The Women's Art Movement in Cincinnati in the Nineteenth Century* (exhib. cat., 1976) // Delaware Art Museum, Wilmington, *American Art Pottery, 1875–1930*, by Kirsten Hoving Keen (exhib. cat., 1978), pp. 8–10 // "McLaughlin, Mary Louise," in *The International Dictionary of Women Workers in the Decorative Arts*, comp. Alice Irma Prather-Moses (Metuchen, N.J., and London, 1981), pp. 105–6 // Kenneth R. Trapp, "Toward a Correct Taste: Women and the Rise of the Design Reform Movement in Cincinnati, 1874–1880," in Cincinnati Art Museum, *Celebrate Cincinnati Art* (exhib. cat., 1982), pp. 49–70 // Kimberly A. Dunn, "The Losanti Ware of Mary Louise McLaughlin" (M.A. thesis, Indiana University of Pennsylvania, 1983) // Joan Siegfried, "American Women in Art Pottery," *Nineteenth Century* 9 (Spring 1984), pp. 12–18 // "The History of Porcelain Making: The Losanti Ware," typescript, n.d., Cincinnati Historical Society // Kenneth R. Trapp, "Rookwood Pottery and the Application of

Art to Industry: Design Reform in Cincinnati, 1875–1900" (Ph.D. diss., University of Illinois, Urbana-Champaign), in preparation

Meriden Britannia Company
1852–1898
West Meriden, Connecticut
Silverplate

In 1852 a group of men engaged in the manufacture and marketing of britannia ware in Meriden, Connecticut, consolidated their resources in a single enterprise named the Meriden Britannia Company. The partners, ultimately seven in number, included Isaac Chauncey Lewis (1812–1893), the company's first president; Horace Cornwall Wilcox (1824–1890); and Samuel Simpson (1814–1894), founder of Simpson, Hall, Miller and Company (ILL. 8.13) in Wallingford, Connecticut.

Using first britannia and then nickel silver, two silver-colored alloys, as the base metal, Meriden Britannia was immediately able to organize the large-scale production of plated-silver objects. In 1862 the firm acquired tools, dies, and the 1847 trademark from the Rogers Brothers company, along with one of the Rogerses to work on silver production, and by 1870 was offering in illustrated catalogues an extensive selection of teapots, candlesticks, epergnes, punch bowls, goblets, and plated flatware. Certainly by 1870 Meriden Britannia was acknowledged to be the largest manufacturer of silverplated wares in the world, with sales offices in New York, San Francisco, Chicago, and London and with distribution said to extend as far as South America and the Far East. A serious fire in the Meriden plant in 1872 slowed production only temporarily, and by 1881 a second factory was operating in Hamilton, Ontario.

Three factors contributed to the company's rapid growth: the partners eliminated competition among themselves by uniting to form a single company; perfection of the electroplating process in England by ELKINGTON AND COMPANY in the 1840s simplified production; and the discovery of silver in the Comstock Lode in Nevada in 1859 and subsequent finds in other western states provided an abundance of that metal.

Meriden Britannia exhibited in the international fairs held in America in 1876 and 1893. The company's most acclaimed object at the 1876 Philadelphia Centennial Exposition was a silverplated centerpiece, after *The Buffalo Hunt* by the sculptor Theodore Bauer (1832–active 1925), featuring an Indian on horseback spearing a buffalo. The decoration of another epergne, this one three tiered and heavily chased and engraved, included water nymphs, a pair of walrus, and a figure of Neptune. In contrast to those conventional Victorian designs, a cardholder shaped like a painter's palette mounted on an easel (FIG. 8.24) is a literal interpretation of the "art craze" of the 1880s.

The company's purchase of the New York silversmithing shop of Wilcox and Evertson in 1895 enabled it to begin production of fine silver flatware within the next two years. Soon afterward, in 1898, Meriden Britannia joined with numerous other firms to form the International Silver Company.

REFERENCES
Charles H. S. Davis, *History of Wallingford, Connecticut, from Its Settlement in 1670 to the Present Time* (Meriden, 1870), pp. 475–84 // Meriden Britannia Company, *Appendix to Price List of July 1, 1871, of Heavily Plated Goods, July 1873* (West Meriden, 1873) // Idem, *Illustrated Catalogue and Price List of Heavily Plated Goods, Including Old Price List of 1867, Patterns of Porcelain-lined Ice Pitchers, Ice Urns, Etc., for 1874* (West Meriden, 1874) // "American Art-Work in Silver," *Art Journal* (Appleton's) 1 (Dec. 1875), pp. 371–74 // Meriden Britannia Company, *Illustrated Catalogue and Price List of Patent Perfection Granite Ironwork, Nickel Plated Britannia, and Planished Goods, ca. 1876* (West Meriden [1876?]) // Phillip T. Sandhurst et al., *The Great Centennial Exhibition Critically Described and Illustrated* (Philadelphia and Chicago, 1876), pp. 270–74 (ills.) // "Our Centennial Report," *Jewelers' Circular and Horological Review* 7 (Aug. 1876), p. 99 // Meriden Britannia Company, *Illustrated Price List, Electro Silver Plate, 1877* (West Meriden, 1877) // Frank H. Norton, ed., *Frank Leslie's Historical Register of the United States Centennial Exposition, 1876* (New York, 1877), pp. 285 (ill.), 305 // Walter Smith, *Industrial Art,* vol. 2 of *The Masterpieces of the Centennial International Exhibition* (Philadelphia, copr. 1875 [1877?]), pp. 21, 22 (ill.), 45 (ill.), 46–48, 59, 60 (ill.), 187, 193–94 // "Notes: Art-Work in Silver," *Art Journal* (Appleton's) 3 (Dec. 1877), p. 384 // Meriden Britannia Company, *Illustrated Catalogue and Price List of Electro Silver Plate on Nickel Silver and White Metal* (Meriden, 1878) // "General Report of the Judges of Group 9," in U.S. Centennial Commission, *International Exhibition, 1876: Reports and Awards,* 9 vols. (Washington, D.C., 1880), vol. 5, p. 409 // Meriden Britannia Company, *Illustrated Catalog and Price List of Electro Gold and Silver Plate on Nickel Silver and White Metal* (Meriden, 1882) // Idem [advertisement], *Decorator and Furnisher* 8 (Aug. 1886), p. 151 // "Among the Trades," *Decorator and Furnisher* 8 (Sept. 1886), supplement, p. 181 (ill.) // Hubert Howe Bancroft, *The Book of the Fair: An Historical and Descriptive Presentation of the World's Science, Art, and Industry, as Viewed Through the Columbian Exposition at Chicago in 1893* (Chicago and San Francisco, 1893), pp. 150–52 (ills.) // Charles Bancroft Gillespie, comp., *Art Souvenir Edition of the Meriden Daily Journal Illustrating the City of Meriden, Connecticut, in the Year 1895* (Meriden, 1895), pp. 30, 54 // [Meriden General Centennial Committee], *Centennial of Meriden, June 10–16, 1906: Report on Proceedings* (Meriden, 1906), pp. 331–32 // Idem, *An Historical Record and Pictorial Description of the Town of Meriden, Connecticut, and Men Who Have Made It* (Meriden, 1906), pp. 35–47, 386 // "Wilcox, Horace Cornwall," in *The National Cyclopaedia of American Biography,* vol. 9 (New York, 1907), p. 207 // "Lewis, Isaac Chauncey," in *The National Cyclopaedia of American Biography,* vol. 10 (New York, 1909), p. 26 // Earl Chapin May, *Century of Silver, 1847–1947: Connecticut Yankees and a Noble Metal* (New York, 1947) // Katherine Morrison McClinton, *Collecting American Nineteenth Century Silver* (New York, 1968), pp. 89, 91, 121, 124–26 // Dorothy T. Rainwater and H. Ivan Rainwater, *American Silverplate* (Nashville, Tenn., and Hanover, Pa., 1968), pp. 13–27, 39–132, 138–40 // *Victorian Silverplated Holloware* (Princeton, N.J., 1972), pp. 2–7, 11–12, 14 // Dorothy T. Rainwater, *Encyclopedia of American Silver Manufacturers* (New York, 1975), pp. 77, 80–81, 108–9, 139, 189 // Richard L. Bowen, Jr., "The Lamps and Candlesticks of the Meriden Britannia Company," *Antiques* 111 (Feb. 1977), pp. 332–37 // Mint Museum, Charlotte, N.C., *Mint Museum Antiques Show* (sale cat., Oct. 2–4, 1981), pp. 21 (ill.), 42 (ill.), 44–45 (ills.) // Palácio Nacional da Ajuda, Lisbon, Port., *A América na Ajuda: American Pieces in the Palácio Nacional da Ajuda* (exhib. cat., 1985), pp. 6, 11, 30–31 // Meriden Britannia Company, *1847 Rogers Bros. Spoons, Forks, Knives, Etc.: Catalogue No. 36* (Meriden, n.d.)

Helen Metcalf
1831–1895
Providence, Rhode Island
Founder, the Rhode Island School of Design, and ceramics decorator

The desire to establish industrial-arts training in the state of Rhode Island was formally expressed in 1854, when the state General Assembly chartered the Rhode Island Art Association to create "a permanent Art Museum and Gallery of the Arts of Design . . . and to use all other appropriate means for cultivating and promoting the Ornamental and Useful Arts," a mandate that even at that early date clearly implies the perceived value of applied arts as well as of painting and sculpture (Woodward, 1985, p. 11). The program was to include a yearly exhibition and a school, but unfortunately the requisite endowment never materialized.

By the 1870s the cultural climate in America was more conducive to art education of all kinds. Not only were many of the nation's major museums, such as The Metropolitan Museum of Art, New York, founded in this decade, but various kinds of industrial-arts training were instituted in schools throughout the country. In Cincinnati BENN PITMAN started wood-carving and china-painting classes at the University of Cincinnati School of Design during the early 1870s. In Lowell, Massachusetts, the School of Practical Design, with its emphasis on textile arts, was established in 1872 in response to state legislation enacted two years before. The growth of local industries, including silver making (see GORHAM MANUFACTURING COMPANY) and textiles, in Rhode Island after the Civil War was cause for renewed interest in founding a similar art-training program for industrial designers. In his annual report of 1873, the president of Brown University recognized that "a large number of the intelligent citizens of our State are now desirous that a Scientific School of high order—a school which, in addition to its more immediate aims shall not fail to provide also for sub-schools of Design, of Drawing, of Civil Engineering, of Architecture, of the Fine Arts,—may speedily be established in Rhode Island" (Woodward, 1985, p. 13). As was the case elsewhere, the Philadelphia Centennial

Exposition of 1876 served as a catalyst for this endeavor.

The Rhode Island School of Design was the ambitious dream of Helen Adelia Rowe Metcalf, the wife of a prosperous manufacturer of woolen goods. Mrs. Metcalf, who headed the Women's Centennial Commission of the Rhode Island delegation to Philadelphia, secured the surplus proceeds raised for the fair— $1,675 — as seed money for the school. Largely as a result of her individual dedication, the school was incorporated in 1877 and opened the following year in room 34 of the Hoppin Homestead Building at 283 Westminster Street in Providence. The school's objectives as stated in its bylaws manifest the period's optimistic ambition to elevate the status and quality of applied arts and to increase public awareness of good design:

1. The instruction of artisans in drawing, painting, modeling and designing so that they may successfully apply the principles of art to the requirements of trade and manufacture.
2. The systematic training of students in the practice of art in order that they may understand its principles, give instruction to others and become artists.
3. The general advancement of public art education by the collection and exhibition of works of art and by lectures and by other means of instruction in the fine arts (Woodward, 1985, p. 11).

The school was managed on a daily basis by Mrs. Metcalf, a role eventually assumed by her daughter, Eliza Radeke. In fact, the entire Metcalf family strongly supported the school. Mrs. Metcalf's husband, Jesse Metcalf (1827–1899), generously absorbed the school's operating deficits for many years and donated not only a building at 11 Waterman Street for its expansion in 1893 but also three new exhibition galleries in memory of Helen Metcalf (who died in 1895) that were completed in 1897. Steven O. Metcalf, another of the Metcalf's five children, became the school's treasurer in 1884. In 1885 Dr. Gustav Radeke, their son-in-law, donated his collection of casts, models, and industrial materials that he had assembled in Europe. The Metcalf family continued to support the school and museum for decades to come, with acquisition funds, additional real estate, and administrative expertise.

Exhibitions were considered an important vehicle for public education. Starting in 1879 the Rhode Island School of Design held annual exhibitions of student work. In 1880 the industrial museum of the school was inaugurated with a display of technical drawings. By 1884 there were enough graduates of the design school to hold an exhibition of works by alumni. Mrs. Metcalf's own efforts at china painting cannot be more precisely dated than about 1885; perhaps she attended the classes available at her school. Some of her decorations are based on WALTER CRANE's illustrations for *The Baby's Opera,* published in London in 1877, and for the fairy tale *Jack and the Beanstalk* (FIG. 7.24), published with Crane's illustrations in 1874.

The need for more space by the end of its first decade was a measure of both the school's

success and the museum's burgeoning collection. In 1892 the state General Assembly granted the corporation the right to hold possessions valued up to $500,000, plus works of art, and exempted school property from taxation. The new building given by the Metcalfs opened in 1893 with a large exhibition of paintings, casts, bronzes, pottery, metalwork, and embroidery. A permanent display selected from the collection, including a room full of autotype reproductions of famous works of art, opened to the public in 1894.

Helen Metcalf's death in 1895 and her husband's four years later brought the school's first era to a close. The emphasis on industrial arts prevalent during the 1880s waned in favor of traditional fine-arts training during the 1890s, and a more formal administrative structure was required. The Rhode Island School of Design, now internationally respected for its art school and museum, continues to operate in Providence.

REFERENCES
Augustus M. Lord, "An Address Commemorative of Jesse Metcalf and Helen Adelia Rowe Metcalf Delivered under the Auspices of . . . the Rhode Island School of Design ([Providence], May 17, 1900) // Carla Mathes Woodward, "Acquisition, Preservation, and Education: A History of the Museum," in *A Handbook of the Museum of Art, Rhode Island School of Design* (Providence, 1985), pp. 10–60 // Thomas S. Michie, Museum of Art, Rhode Island School of Design, Providence, correspondence, Nov. 26 and Dec. 19, 1985

Watson John Miller, *see* Derby Silver Company

Minton and Company
1793–present
Stoke-on-Trent, Staffordshire, England
Ceramics

In 1793 Thomas Minton (1765–1836) bought a small pottery in Stoke-on-Trent, England, at which he commenced production three years later. Minton first manufactured simple blue transfer-printed earthenware for everyday use, but by the mid-nineteenth century his firm had an established reputation for its "art-manufactures."

Major changes in the company's direction occurred after 1836, when Thomas Minton died and his son Herbert Minton (1793–1858) took over the leadership of the firm. Herbert's nephew and successor in 1858, Colin Minton Campbell (d. 1885), ably maintained the firm's preeminent position. Herbert Minton explored new production methods, increased the range of products, and attracted artists to the firm. His friendships with Henry Cole (1808–1882) and Augustus Welby Northmore Pugin (1812–1852), for example, resulted, during the 1840s and 1850s, in the production of tablewares with shapes designed by Cole and printed decoration by Pugin.

Also at mid-century, Léon Arnoux (1816–1902), a Frenchman who in 1849 had joined Minton and Company as art director, introduced an entirely new line of ceramics called

majolica, whose brightly colored glazes, naturalistically relief-molded shapes, and whimsical figural forms had great appeal for the Victorian public. These innovative products, which recalled Italian sixteenth- and seventeenth-century examples of *maiolica,* were highly praised at the 1851 Crystal Palace Exhibition in London and enjoyed a vogue lasting well into the 1880s. Other English and some American firms, including JOSIAH WEDGWOOD AND SONS, LIMITED; GRIFFEN, SMITH AND COMPANY (FIG. 7.33); and the EUREKA POTTERY COMPANY (FIG. 7.34), also shared in majolica's popularity.

Minton's fame was predicated as well on its prolific production of decorative tiles, which started as early as 1840 and continued until the beginning of the twentieth century. The firm's first tiles were encaustic (that is, tiles inlaid with different-colored clays), the type recommended for floors by CHARLES LOCKE EASTLAKE in his *Hints on Household Taste* (1868). Minton encaustic tiles were widely used in America; those in the stairhall of FRANK FURNESS's Pennsylvania Academy of the Fine Arts (1871–76) in Philadelphia, for example, are still in use today. Prompted by Minton's success, American competitors, especially the AMERICAN ENCAUSTIC TILING COMPANY of Zanesville, Ohio, began by the mid-1870s to make encaustic tiles (FIG. 7.35, ILL. 7.13).

Printed tiles with diverse patterns were also produced by Minton and Company in great numbers and featured designs by such artists as J. MOYR SMITH and CHRISTOPHER DRESSER. WALTER CRANE's book illustrations were popular images for tiles; other English factories, among them T. AND R. BOOTE, produced tiles so similar that they could effectively be intermingled (FIG. 7.37), and American firms eventually followed suit (FIG. 7.38). Minton tiles were used not only for interior decoration but also to ornament furniture, a practice that originated with British designer BRUCE J. TALBERT and that was employed by such American firms as A. KIMBEL AND J. CABUS. An unusual and unmarked brass plant stand thought to be of American manufacture, and probably retailed by the Meriden Flint Glass Company in Connecticut, incorporates an imported Minton tile into its aesthetic design (FIG. 8.27).

Minton and Company, like many of its counterparts, relied on skilled decorators whose ornamental work became a hallmark of that factory's production. By the 1860s there was a new generation of china painters, artists who had been trained at the Normal School of Design, London. In 1871 Minton opened its own Art Pottery Studio in South Kensington, London, where some of its staff decorators offered instruction in the decoration of earthenwares. The artist William S. Coleman (1829–1904), who began work at Minton in 1869, directed the studio. It employed some of England's leading designers, Christopher Dresser and J. Moyr Smith among them. "The Rose," a plate by Smith that postdates Coleman's tenure and the demise of the studio, features a seated Grecian female figure from Smith's *Anacreon* series, with a Japanesque border in gold (FIG. 7.12). Coleman's resignation from the studio in 1873 hastened its closing, which occurred when the studio buildings burned in 1875. Although short-lived, the Minton Art

Pottery Studio greatly contributed to an ever-growing interest in china painting during the Aesthetic period.

From the early 1860s, many of the firm's highest quality products in both earthenware and bone china were based on Chinese and Japanese porcelains, lacquerwork, enamels, and bronzes; the exoticism of the Near East appealed to Minton designers as well. An influx of French artists during the 1870s, most notably Sèvres artist Marc-Louis Solon (1835–1913), had a profound influence on the look of Minton ceramics, which included some *pâte-sur-pâte* ornamental pieces with decoration inspired by classical art. Minton and Company also purveyed biscuit-fired earthenware blanks for artists, professional or amateur, working independently; DANIEL COTTIER's firm was among those using Minton plaques for some of their decorative work (ILL. 7.8).

By the end of the nineteenth century, Minton and Company ceramics manifested the influences of the Art Nouveau and German Secessionist movements. Production has continued throughout the twentieth century, and in 1968 Minton became a member of the Royal Doulton Tableware Group.

REFERENCES

The Illustrated Exhibitor: . . . The Principal Objects in the Great Exhibition of the Industry of All Nations, 1851 (London, 1851), pp. xxxvi, 436 // Minton and Company, *Encaustic and Other Tiles for Floors and Walls of Churches, Public Buildings, . . . Etc.; as Shown in the New-York Exhibition of the Industry of All Nations* (New York, 1853) // M[atthew] Digby Wyatt, "On the Influence Exercised on Ceramic Manufactures by the Late Mr. Herbert Minton," *Journal of the Society of Arts* 6 (May 28, 1858), pp. 441–52 // Professor Archer, "On the Progress of Our Art-Industries, Part 1: Pottery and Porcelain," *Art Journal* (London), June 1874, pp. 174–75 // "Industrial Notes" [Minton tiles in New York buildings], *Crockery and Glass Journal* 7 (Mar. 14, 1878), p. 6 // Minton and Company, *Tiles* (Stoke-on-Trent [1879?]) // "General Report of the Judges of Group 2," in U.S. Centennial Commission, *International Exhibition, 1876: Reports and Awards,* 9 vols. (Washington, D.C., 1880), vol. 3, pp. 535–37 // [Various showrooms], *Art Amateur* 4 (May 1881), p. 129 // "Minton Art Pottery," *Art Amateur* 6 (Feb. 1882), pp. 54–55 // Lewis F. Day, "Victorian Progress in Applied Design," *Art Journal* (London), June 1887, pp. 185–202 // G. W. Rhead and F. A. Rhead, *Staffordshire Pots and Potters* (London, 1906) // Edward Wenham, "The Collector Considers Minton," *House and Garden* 53 (Jan. 1928), pp. 78–79, 116, 118, 134, 138 // Geoffrey A. Godden, "Costliest Way of Decorating Porcelain," *Country Life* 127 (June 9, 1960), pp. 1308–9 // Idem, *Victorian Porcelain* (London, 1961) // Idem, "Mintons' Nineteenth-Century Artists," *Country Life* 129 (May 18, 1961), pp. 1154–56 // Hugh Wakefield, *Victorian Pottery* (New York, 1962) // Geoffrey A. Godden, "Artists at Mintons," *Apollo* 76 (Dec. 1962), pp. 797–98 // Idem, *An Illustrated Encyclopedia of British Pottery and Porcelain* (New York, 1966), pp. 225–40, pl. 8 // Shirley Bury, "Felix Summerly's Art Manufactures," *Apollo* 85 (Jan. 1967), pp. 28–33 // Geoffrey A. Godden, *Minton Pottery and Porcelain of the First Period, 1793–1850* (New York and Washington, D.C., 1968) // Malcolm Haslam, *English Art Pottery, 1865–1915* (Woodbridge, Eng., 1975), pp. 11–14, 24–25, 28, 56–60, figs. 28–31 // Idem, "Bernard Palissy," *Connoisseur* 190 (Sept. 1975), pp. 12–17 // Victoria and Albert Museum, London, *Minton, 1798–1910,* by Elizabeth Aslin and Paul Atterbury (exhib. cat., 1976) // Paul Atterbury, "Minton Maiolica: The Revival of Sixteenth- and Seventeenth-Century Italian Earthenwares," *Connoisseur* 192 (Aug. 1976), pp. 304–8 // Michael Messenger, "Revival of a Medieval Technique: Encaustic Tiles in the Nineteenth Century," *Country Life* 163 (Jan. 26, 1978), pp. 214–15 // Camden Arts Centre, London, *Christopher Dresser, 1834–1904,* by Michael Collins (exhib. cat., 1979), pp. 12, 31–34 // Grant Muter, "Minton Secessionist Ware," *Connoisseur* 205 (Aug. 1980), pp. 256–63 // Paul Atterbury, ed., *The History of Porcelain* (New York, 1982), pp. 155–77 // Hyman Myers, "The Three Buildings of the Pennsylvania Academy," *Antiques* 121 (Mar. 1982), p. 680 (ill.) // Antoinette Faÿ-Hallé and Barbara Mundt, *Porcelain of the Nineteenth Century* (New York, 1983), pp. 206–15, 267 // Geoffrey A. Godden, *Staffordshire Porcelain* (London, 1983), pp. 130–47.

Edward C. Moore, *see* **Tiffany and Company**

Morris and Company, *see* **William Morris**

William Morris
1834–1896
London
Designer

A man of contradictions, William Morris was a bourgeois socialist, a poet who is known today primarily for his talents as a designer, and a revolutionary whose work could be afforded only by the upper class. He considered British aesthetes effete, yet in the United States his own wallpapers and textiles were the accepted norm for the aesthetic home.

Born on March 24, 1834, William Morris was the third of nine children. His father, William Morris, Sr., was a partner in a discount brokerage firm. When Morris was six years old, the growing success of his father's business enabled the family to move to a grand Palladian mansion, Woodford Hall, in Essex, England. There, in its fifty-acre park, Morris tended his own garden and, during his strolls through nearby Epping Forest, became fascinated with the forms of nature. Morris's father, an enthusiastic medievalist, encouraged young William in his explorations of local churches and cathedrals and even provided him with a small suit of armor.

In 1844 Morris's father became involved in setting up Devon Great Consols, a copper-mining company in Cornwall. The income from the shares of stock assured the family of prosperity, and, when he reached the age of twenty-one, provided Morris with a trust fund of £900 a year, thus helping him to feel secure in his decision to become an artist and a poet.

After a less than spectacular career at Marl-borough College, a Victorian public school, Morris set off for Exeter College, Oxford, with every intention of becoming a clergyman. At Oxford he developed a circle of friends with whom he would maintain ties for the rest of his life. These included Edward Burne-Jones (1838–1898), Richard Dixon, Charles James Faulkner, and William Fulford. Burne-Jones, the son of a Birmingham picture framer, had also gone up to Oxford with the hope of becoming a priest, but once he and Morris discovered art, architecture, and poetry, in addition to the publications of John Ruskin (1819–1900) and Thomas Carlyle, their professional goals began to waver. In 1855, on their second trip to France together, they both decided against joining the clergy. In 1856 they left school, Burne-Jones to learn painting under the tutelage of Dante Gabriel Rossetti (1828–1882), leader of the Pre-Raphaelite Brotherhood, and Morris to apprentice with George Edmund Street (1824–1881), a well-known Gothic Revival architect who later designed the Law Courts (1874–82) on the Strand in London. Morris did not stay at Street's office for long, but benefited by establishing a close friendship with Philip Webb (1831–1915), Street's senior assistant.

After visiting Burne-Jones every weekend in London from the spring to the fall of 1856, Morris too fell under the spell of the Pre-Raphaelites and was convinced by Rossetti to give up his work as an architect in favor of becoming a painter. In November 1856 Morris and Burne-Jones moved in together at 17 Red Lion Square. Shortly thereafter Morris tried his hand at furniture design for the first time. Rossetti described the large, heavy pieces as "intensively medieval" in form, and Rossetti, Burne-Jones, and Morris painted the surfaces with appropriately medieval figures and inscriptions.

In the summer of 1857 Morris joined with other Pre-Raphaelites in painting the ill-fated Oxford Union murals. After Morris completed his assigned scene from Sir Thomas Malory's *Morte d'Arthur,* a work of the late fifteenth century, he decorated the roof with heraldic beasts and birds. But the most important event of that summer was an evening at the theater, during which Morris and Burne-Jones noticed a "stunner" (their word for a beautiful girl) sitting in the row behind them. She was Jane Burden, the daughter of an Oxford groom, who was to become the epitome of the Pre-Raphaelite ideal woman and who would later be glorified in the drawings and paintings of Rossetti. In March 1858 Morris published his first volume of poetry, *The Defence of Guenevere and Other Poems,* directing some of his writing to her. They married in April 1859, and in 1860 they moved to Red House (ILL. 10.1), a landmark in the development of domestic architecture, which was designed for them by Philip Webb. Morris, Webb, and Burne-Jones collaborated on much of the furniture for Red House, which led Morris to follow Ford Madox Brown's (1821–1893) suggestion that he form a cooperative firm to produce well-designed and properly executed decorative work. In 1861 Morris, Marshall, Faulkner and Company opened for business, with Burne-Jones, Webb, Rossetti, and Brown included as partners.

The company planned to produce mural decorations, carvings, stained-glass windows, metalwork, furniture, and embroidery. Most of the early commissions were for stained-glass windows, which were designed by Marshall, Burne-Jones, Rossetti, Brown, Webb, and Morris. Faulkner's sisters, Lucy and Kate, helped to paint pottery and tiles, many of which were designed by William De Morgan (1839–1917), who, although he worked closely with the firm, never actually joined it. Morris taught himself how to embroider, and then trained his wife, her sister Elizabeth Burden, and Burne-Jones's wife, Georgiana, to take charge of the embroidery workshop. "Woman with a Sword" (ILL. 3.27) is one example of their work. *The Backgammon Players* (ILL. 5.1), a sample of the firm's artistic furniture, was designed by Webb and painted by Burne-Jones.

In 1862 the firm had two stalls at the London International Exhibition. Small decorative objects, such as candlesticks and jewelry made by Webb and tiles painted by Rossetti, were shown alongside some of their better-known products. That same year Morris designed the first of his ever-popular wallpapers. These included the patterns Daisy (FIG. 3.3), Fruit, and Trellis. Although created in 1862, Daisy was not issued until 1864, when Morris turned the design over to JEFFREY AND COMPANY for printing. In the following decades Morris designed many papers, some of which were later produced as fabric patterns. Daisy and other early designs, among them Queen Anne (about 1868–70, ILL. 3.4) and Sunflower (1879, ILL. 3.6), are quite flat and stylized. The development of Morris's work can be seen in the contrast between his two-dimensional patterning of the 1874 Willow (ILL. 3.5) and his comparative naturalism and use of shading in the 1887 Willow Bough (ILL. 3.7).

By 1870 Morris wallpapers were available for sale in Boston, and they remained a popular decoration in American homes for several decades (ILLS. 3.8, 4.4). Also successful in both England and the United States were the needlework kits that Morris designed, which could be completed by any woman in her home (ILL. 3.28). The chair seat in figure 5.33 illustrates just one way in which Americans updated their Colonial furniture with Morris-like patterns.

By the mid-1860s Morris, Marshall, Faulkner and Company were receiving major commissions. These included the Refreshment Room (1867, ILL. 10.2) in the South Kensington Museum (now the Victoria and Albert Museum), London, and two rooms in Saint James's Palace, London (1866–67).

The late 1860s and early 1870s saw the rise of Morris's fame as a poet. In 1867 he published *The Life and Death of Jason,* and in 1868 the first volume of *The Earthly Paradise* appeared, to great acclaim. In the eyes of his contemporaries, Morris was a leading poet. As a romantic medievalist, Morris turned for inspiration to the Norse culture of Iceland and made pilgrimages to Iceland in 1871 and 1873. He also collaborated on translations of Icelandic sagas, which were published in 1869.

By the mid-1870s, the original firm of Morris, Marshall, Faulkner and Company was in financial trouble. Rossetti, Brown, Marshall,

and Faulkner had ceased to contribute to the work, so Morris proposed that they retire, leaving only the productive partners—Morris, Burne-Jones, and Webb. This led to some ill feelings on the part of those to be retired, but after settling on £1,000 each as compensation for interest lost, the firm was reestablished in March 1875 under the name of Morris and Company.

The reorganization sparked a time of intense activity for Morris. Between 1876 and 1883 he designed eleven wallpapers and twenty-two chintzes. During this period Morris also learned how to use natural dyes and explored the art of weaving. In 1875 he produced his first design for a machine-woven fabric and for a machine-woven carpet, which he created for the Royal Wilton Carpet Works. A jacquard loom was installed in the firm's workshop in 1877, after which most of the Morris brocades and furnishing silks were produced on the premises.

Morris and his family moved to Kelmscott House, Hammersmith, London, in October 1878. Morris soon started work on two more textile experiments. He set up a tapestry loom in his bedroom and installed a carpet loom in the large coach house adjoining his property. Local women were hired to be the weavers of the famous hand-knotted Hammersmith carpets (ILL. 3.21), which Morris hoped would free England from its dependence on the East for beautifully designed rugs.

During the 1870s Morris regained the political awareness he had acquired as an undergraduate after reading Ruskin and Carlyle. He came to reject the philosophy of art for art's sake and concluded that it was impossible to have good art in the debased social and economic conditions of Victorian England. This led him to commit himself to change through socialist revolution, and in 1883 he joined the Democratic Federation, the first English Marxist socialist party. For the rest of his life he lectured, wrote, and worked for his political cause, which included editing and financing *Commonweal,* the Socialist League paper.

Morris's last artistic endeavor commenced in 1890 with the founding of the Kelmscott Press, which issued its first book in 1891. It operated for eight years and published fifty-three titles, each exquisitely illustrated, printed, and bound. Almost all were designed by Morris himself, in a style that emulated medieval manuscripts or early printed volumes. He also designed three typefaces, based on these models. All Kelmscott Press books were printed on handmade paper in limited editions.

By the mid-1890s Morris was becoming increasingly ill. He continued his constant schedule of work, writing, and lecturing until 1896, when, at the age of sixty-two, he collapsed and died. A doctor, speaking of Morris at his death, remarked that it had been caused by "simply being William Morris and having done more work than most ten men" (Bradley, 1978, p. 108).

REFERENCES

"Household Art: Objects Lent by Morris and Co., London," in *Exhibition of Painting, Engravings, Drawings, Aquarelles and Works of Household Art, in the Cincinnati Industrial Ex-*

position (exhib. cat., 1873) // "Culture and Progress: The 'William Morris Window,'" *Scribner's Monthly* 6 (June 1873), pp. 245–46 // "Notes: The Decoration of Houses" [review of Trades' Guild of Learning lecture series by William Morris], *Art Journal* (Appleton's) 4 (Apr. 1878), p. 127 // "Correspondence: Carpet Decoration," *Carpet Trade* 10 (Apr. 1879), pp. 17–19 // "A New Manufacture," *Carpet Trade Review* 7 (Aug. 1880), p. 149 // "Mr. Morris Makes a New Move," *Carpet Trade* 11 (Aug. 18, 1880), p. 22 // [William Morris], "Hints on House Decoration" [a paper read before the Birmingham Society of Artists], pts. 1–3, *American Architect and Building News* 9 (Jan. 8, 1881), pp. 16–18; (Jan. 15, 1881), pp. 28–30; (Jan. 22, 1881), pp. 40–43 // [Review of Mr. W. Morris's address on house decoration], *American Architect and Building News* 9 (Jan. 8, 1881), p. 14 // "Hints on House Decoration," *Brick, Tile, and Metal Review* 1 (Mar. 1881), p. 13 // "The Morris goods . . . ," *Art Amateur* 5 (Nov. 1881), p. 120 // [William Morris], "Some Hints on Pattern Designing" [a lecture at the Working Men's College], pts. 1–3, *American Architect and Building News* 11 (Jan. 21, 1882), pp. 32–35; (Jan. 28, 1882), pp. 44–46; (Feb. 11, 1882), pp. 66–68 // Idem, "The Progress of Decorative Art" [a lecture at the opening of the Fine-Art and Industrial Exhibition, Manchester, Eng.], *American Architect and Building News* 12 (Dec. 9, 1882), pp. 281–82 // "Arraigning Mr. William Morris," *Carpet Trade and Review* 15 (Nov. 1, 1884), p. 47 // "Decorative Art Notes," *Art Amateur* 12 (Dec. 1884), p. 23 // Lewis F. Day, "Victorian Progress in Applied Design," *Art Journal* (London), June 1887, pp. 185–202 // [H. Kuenemann], "Nature in Industrial Design: A Practical Designer's Advice to Young Artists—the Test of Fitness in Designs for Carpets, Upholstery Goods, Etc.," *Carpet Trade and Review* 18 (Aug. 15, 1887), pp. 36–37 // J. W. Mackail, *Life of William Morris,* 2 vols. (London, 1899) // May Morris, ed., *The Collected Works of William Morris,* 24 vols. (London, 1910–15) // G. D. H. Cole, ed., *William Morris: Selected Writings* (London, 1934) // Victoria and Albert Museum, London, *Catalogue of an Exhibition in Celebration of the Centenary of William Morris* (exhib. cat., 1934) // Walter Rendell Storey, "The Influence of William Morris," *New York Times,* Mar. 18, 1934 // May Morris, ed., *William Morris: Artist, Writer, Socialist,* 2 vols. (London, 1936) // Philip Henderson, ed., *Letters of William Morris to His Family and Friends* (London, 1950) // E. P. Thompson, *William Morris: Romantic to Revolutionary* (London, 1955) // Nikolaus Pevsner, *Pioneers of the Modern Movement: From William Morris to Walter Gropius* (London, 1956) // Peter Floud, "Dating Morris Patterns," *Architectural Review* 126 (July 1959), pp. 14–20 // Idem, "The Wallpaper Designs of William Morris," in *Penrose Annual* 54 (1960), pp. 41–45, figs. 1–20 // Asa Briggs and Graeme Shankland, eds., *William Morris: Selected Writings and Designs* (Baltimore, 1962) // William E. Fredeman, *Pre-Raphaelitism: A Bibliocritical Study* (Cambridge, Mass., 1965) // [Special William Morris issue], *DU: Atlantis* 25 (Sept. 1965) // Philip Henderson, *William Morris: His Life Work and Friends* (London, 1967) // Ray Watkinson, *William Morris as De-*

signer (New York, 1967) // Catherine Hall Lipke, "The Stained Glass Windows of Morris and Co. in the United States of America" (M.A. thesis, State University of New York, Binghamton, 1973) // A. Charles Sewter, *The Stained Glass of William Morris and His Circle*, 2 vols. (New Haven, 1974) // Jack Lindsay, *William Morris: His Life and Work* (London, 1975) // N. Cromey-Hawke, "William Morris and Victorian Painted Furniture," *Connoisseur* 191 (Jan. 1976), pp. 32–43 // Ian Bradley, *William Morris and His World* (New York, 1978) // Fine Art Society Limited, London, *Morris and Company* (exhib. cat., 1979) // Birmingham Museums and Art Gallery, Eng., *Textiles by William Morris and Morris and Co., 1861–1940*, by Oliver Fairclough and Emmeline Leary (exhib. cat., 1981) // Eileen Cynthia Boris, "Art and Labor: John Ruskin, William Morris, and the Craftsman Ideal in America, 1876–1915" (Ph.D. diss., Brown University, 1981) // Leonard Stoppani et al., *William Morris and Kelmscott* (Farnham, Eng., 1981) // Denise McColgan, "Naturalism in the Wallpaper Designs of William Morris," *Arts* 56 (Sept. 1981), pp. 142–49 // Marilyn Ibach, *William Morris and Company Stained Glass in North America* (New York, 1983) // Linda Parry, *William Morris Textiles* (New York, 1983) // G. L. Aho, *William Morris, a Reference Guide* (Boston, 1985) // Peter Stansky, *Redesigning the World* (Princeton, 1985)

Mount Washington Glass Company
1837–1958
South Boston and New Bedford,
 Massachusetts
Glass

Frederick S. Shirley's creative tenure as the manager of the Mount Washington Glass Company between 1874 and 1894 corresponded closely to the Aesthetic movement in America. During this twenty-year period the firm produced a wide range of artistic glass of exceptionally high quality, and by 1890 it justifiably proclaimed itself "The Headquarters of Art Glassware in America." At that time few other New England glass factories were still operating on a comparable scale.

The genealogy of the company dates to 1837, the year Deming Jarves (1790–1863), renowned founder of the BOSTON AND SANDWICH GLASS COMPANY, started a factory in South Boston, which he intended for his son George. By 1846, and until his death in 1850, George Jarves was indeed directly involved in the business, first with John D. Labree and then with Henry Comerais. The firm of Jarves and Comerais, commonly called the Mount Washington Glass Works, continued until 1861, when William L. Libbey (d. 1883), who began as the company bookkeeper in 1851, and Timothy Howe, its clerk since 1856, took over. When Howe died, in 1866, Libbey became the sole proprietor. The products of these early years included kerosene lamps as well as blown, cut, and pressed glass.

The South Boston plant and furnaces were in such poor condition by 1869 that Libbey shrewdly purchased the recently completed modern factory complex of the failed New Bedford Glass Company. Its state-of-the-art

equipment gave the Mount Washington Glass Works a head start on experiments in art-glass production, which it undertook during the 1870s and 1880s. For a short time after its move, the firm was known as W. L. Libbey and Company.

In 1871 Libbey inaugurated a decoration department headed by the Smith Brothers, but the next year he resigned to become the agent for the NEW ENGLAND GLASS COMPANY and left the business in the hands of his brother, Captain Henry Libbey. A severe depression forced its closure in 1873.

However, the company fortunes reversed one year later, when Frederick Stacey Shirley, an Englishman, became its manager. The company was enlarged and reorganized as the Mount Washington Glass Company in time for the 1876 Centennial Exposition in Philadelphia, where its scintillating display of cut-glass chandeliers and opal glass won official commendation.

About Shirley's personal history little is known, but an impressive list of patents and a corresponding array of beautiful glassware attest to his artistry and invention. Shirley obtained the first of numerous patents in 1878 and 1879 for the manufacture and decoration of black lava glass (named for one of its ingredients), also called Sicilian ware (FIG. 7.45). The elegantly simple vases made of this material were at once inspired by the ancient pottery and glass being unearthed in contemporary excavations and by the oriental forms in vogue after the 1876 exhibition.

Rose amber, produced from 1884 onward, was Shirley's version of the amberina ware, a transparent golden glass that turned ruby red when reheated, invented in 1883 by JOSEPH LOCKE of the New England Glass Company. When this method was applied to opal glass it resulted in a flush of subtly shaded color ranging from pale yellow to rose pink. Burmese glass, as the latter was called, was patented by Shirley in 1885 and was produced in more than two hundred and fifty different forms (FIG. 7.51). It became very popular in England after Shirley presented several pieces to Queen Victoria; Thomas Webb and Sons, a British glass manufacturer, was licensed to make "the Queen's Burmese" in 1886. Peachblow, or peachskin, was also a translucent shaded glass, ranging from blue white to deep rose. The Royal Flemish line (FIG. 7.55), one of several opulent gilded and enameled opal wares, was produced by 1889 and patented by Albert Steffin, foreman of the decorating department, in 1894. Napoli wares, patented the same year, consisted of clear glass decorated with a network of gold or silver on the exterior, while the interior was adorned with extraordinary painted decorations (FIG. 7.56). Throughout its existence, the Mount Washington Glass Company manufactured brilliant-cut and engraved crystal as well as an acid-etched cameo glass, but it never adopted the Art Nouveau style of the 1890s.

Meanwhile, the Pairpoint Manufacturing Company, named for its first superintendent, Thomas J. Pairpoint (1847–1902) (formerly with the GORHAM MANUFACTURING COMPANY), in 1880 constructed its factory adjacent to the Mount Washington Glass Company, which facilitated the production of silverplated mounts

for its neighbor's glassware. From this point onward the histories of the two firms are linked. Although the Mount Washington Glass Company continued to be known by its own name, it was absorbed by Pairpoint in 1894. That same year Frederick Shirley was listed for the last time in the New Bedford city directory. He and a partner, John P. Gregory, attempted to reopen the former Boston and Sandwich Glass Company in 1895, but the corporation lasted little more than one year.

Reorganized as the Pairpoint Corporation in 1900, a designation held until 1938, the successors of the Mount Washington Glass Company survived under several versions of the Pairpoint name until 1958, when operations were suspended for more than a decade.

REFERENCES

"Boston: Mount Washington Glass Works," *Crockery and Glass Journal* 2 (Sept. 16, 1875), p. 17 // "Trade at New Bedford," *Crockery and Glass Journal* 7 (May 9, 1878), p. 19 // "Inventions and Improvements," *Crockery and Glass Journal* 10 (Oct. 16, 1879), p. 22 // "General Report of the Judges of Group 2," in U.S. Centennial Commission, *International Exhibition, 1876: Reports and Awards*, 9 vols. (Washington, D.C., 1880), vol. 3, pp. 598, 746 // Mount Washington Glass Company [trade cat.] (New Bedford [1885?]) // Leonard Bolles Ellis, *History of New Bedford and Its Vicinity, 1602–1892* (Syracuse, N.Y., 1892), pp. 472–74 // J. Stanley Brothers, Jr., "American Ornamental Glass," pts. 1, 2, *Antiques* 26 (Aug. 1934), pp. 57–59; 29 (Mar. 1936), pp. 111–13 // "The Editor's Attic," *Antiques* 27 (Apr. 1935), pp. 129–30 // George S. McKearin and Helen McKearin, *American Glass* (New York, 1941), pp. 207, 411–12, 420, 602 // Kenneth M. Wilson, "The Mount Washington Glass Works and Its Successors, 1837–1958," *Antiques* 74 (July 1958), pp. 46–48 // Idem, "The Mount Washington Glass Company and Its English Relationships," in *Septième Congrès International du Verre, Comptes rendus* (Charleroi, Belg., 1965), pp. 253.1–253.10 // Albert Christian Revi, *Nineteenth Century Glass: Its Genesis and Development*, rev. ed. (Exton, Pa., 1967) // Kenneth M. Wilson, "Documenting Some Mount Washington Art Glass," *Antiques* 92 (Sept. 1967), pp. 367–71 // George C. Avila, *The Pairpoint Glass Story* (New Bedford, 1968), pp. 6–15 // Kenneth M. Wilson, *New England Glass and Glassmaking* (New York and Toronto, 1972), pp. 261–68, 282–83, 297–99, 339–65, 370–74 // Paul Hollister, "The Kahila Dig at Mount Washington," *Antiques* 102 (Sept. 1972), pp. 455–59 // Denys Peter Myers, *Gaslighting in America: A Guide for Historic Preservation* (Washington, D.C., 1978), pp. 152–53, pl. 72 // Nancy O. Merrill, "Glittering Cases: From Ancient Egypt to the Modern Age," *Apollo* 107 (Apr. 1978), pp. 264–71 // Leonard E. Padgett, *Pairpoint Glass* (Des Moines, Iowa, 1979) // Detroit Institute of Arts, *The Quest for Unity: American Art Between World's Fairs, 1876–1893* (exhib. cat., 1983), pp. 189–90 (ills.) // Mary Jean Blasdale, Old Dartmouth Historical Society Whaling Museum, New Bedford, correspondence, Jan. 14, 1985 // Albert Christian Revi, Hobby House Press, Inc., Cumberland, Md., correspondence, May 8, 1985

Herman Mueller, *see* **American Encaustic Tiling Company**

Karl Mueller, *see* **Union Porcelain Works**

Nashua Lock Company
1834–1892
Nashua, New Hampshire
Hardware

The Nashua Lock Company was founded in 1834 as a result of Samuel Shepard's invention of the mortise lock. Shepard (1801–?), originally from Dedham, Massachusetts, trained as an architect with Asher Benjamin (1773–1845) of Boston but achieved his reputation as a mechanical engineer and inventor. Moving to Nashua, New Hampshire, in 1834, he and a partner, David Baldwin (d. 1854), established a factory for the manufacture of prefabricated doors, window sashes, and blinds. As a related undertaking, Shepard began to manufacture mortise locks, an improvement over the less-secure British hardware then in common use in the United States. He and Baldwin sold their shop and established the Nashua Lock Company. In 1835, already tired of the business and eager to move on to other inventions, Shepard sold his interest in the company to Leonard White Noyes (1779–1867), who, with Baldwin, created an entire line of cast-iron and brass "house trimmings." These included both mortise and rim locks as well as latches, doorknobs, keys, escutcheons, and bell pulls. The company was expanded by Robert G. Livingstone, who became a partner in 1853, and salesrooms were opened in Boston.

By the end of the decade the company boasted eighty thousand dollars in annual sales and claimed to be processing thirty-five thousand pounds of brass castings a year. Noyes withdrew from the firm about 1857, and two years later it was bought out by Franklin Otis Munroe (1805–1873), who superintended its operations until his death.

Under Munroe's stewardship a new lock factory at 52 Spring Street was completed in 1860; by 1864, the year following the firm's incorporation, Nashua Lock employed 160 people and had outlets in Boston, New York, Baltimore, and Chicago. The company faltered in 1872, when a fire wiped out its Boston stockroom; Munroe's death a year later was an added blow, and a group of Boston competitors took control of the business. It continued operations until 1892, then ceased activity altogether.

Though the bronze door handle and escutcheon of about 1886 (FIG. 8.26) are marked with the company's name and are pictured in that year's sale catalogue (ILL. 8.15), the designer's name is unknown. The hardware, embellished with a potted sunflower, a hunched and glowering owl, and a cheeky little bird with outspread wings in a composition organized by Japanesque diagonals, displays the decorative vocabulary of the Aesthetic movement codified and distilled for industrial use.

REFERENCES
J. Leander Bishop, *A History of American Manufactures from 1608 to 1860*, 3 vols. (Philadelphia and London, 1868), vol. 3, p. 452 // Nashua

Lock Company, *Illustrated and Descriptive Catalogue* (Boston, 1882) // Idem, *Illustrated and Descriptive Catalogue and Price List of Hardware, Tools, Etc.* (Boston, 1886), p. 26 (ill.) // Edward E. Parker, ed., *History of the City of Nashua, New Hampshire* (Nashua, 1897), pp. 86, 441, 474, 551 // Ernest A. Levesque, Nashua Historical Society, correspondence, July 21 and Sept. 11, 1984

W. Eden Nesfield, *see* **Thomas Edward Collcutt**

New England Glass Company
1818–1888
East Cambridge, Massachusetts
Glass

The New England Glass Company, which specialized in high-quality glass tablewares, was one of America's longest-running and most successful glass factories, its history spanning seventy years. The firm was incorporated in 1818 by Amos Binney, Edmund Munroe, Daniel Hastings, Deming Jarves (1790–1868), and their associates; however, only Jarves was to have a direct hand in the firm's operations. That same year, 1818, the company purchased the existing glassmaking facilities of the defunct Boston Porcelain and Glass Company located at Craigie's Point, also known as Lechmere's Point, in East Cambridge, Massachusetts. Jarves played a crucial role in setting up the glassworks, but only seven years later, in 1825, he left the company to open another glass factory nearby, the BOSTON AND SANDWICH GLASS COMPANY, where he remained until 1858.

The early success of the New England Glass Company after Jarves's departure can be credited to Thomas Leighton (1786–1849), the factory's superintendent. Leighton worked as a glassmaker in Great Britain before starting his tenure at the New England Glass Company in 1826. From its inception the New England Glass Company specialized in fine blown tablewares made of flint (or lead) glass. Using the recently invented pressing machine that revolutionized glass production, by about 1827 the firm increased its output to include pressed wares, which were offered for sale in a wide variety of forms. The creation of expensive cut and engraved flint glass occupied hundreds of skilled workers throughout the company's history; these wares were especially featured at the company's glittering display at the 1876 Philadelphia Centennial Exposition. In the 1880s the New England Glass Company continued to produce cut glass under the artistic direction of a highly skilled cutter named Joseph Locke (1846–1936), who had been an established cameo-glass engraver in England before emigrating to America in 1853.

Born in Worcester, England, Locke was the son of a potter. Following his parents' untimely deaths, he was raised by an uncle, Edward Locke, a designer and decorator at the WORCESTER ROYAL PORCELAIN COMPANY, where Joseph was apprenticed at age twelve. His career in glassmaking, however, began at age nineteen, when he entered and won a competition sponsored by Guest Brothers, glass

etchers and decorators in Stourbridge, for a fireplace design for the czar of Russia. He later joined Hodgetts and Richardson, a leading firm in etched and engraved glass. Locke's career in England also included stints at the glass works of Pargeter and Company and, later, Thomas Webb and Corbett.

Locke is best known for his cameo-glass Portland Vase replica, executed in the late 1870s and reportedly the result of twelve months of labor. It was cameo cut and engraved, which entailed cutting and engraving a form made of glass of two or more different-colored layers to create a detailed design in relief. The Portland Vase attracted numerous copyists in both glass and ceramics, among them artists at T. AND R. BOOTE and at JOSIAH WEDGWOOD AND SONS, LIMITED, whose first reproductions were made in 1790 and were issued in several editions thereafter, including a special edition in 1877. Locke's version of the vase received praise at the Paris Exposition Universelle of 1878.

After several invitations from the Boston and Sandwich Glass Company to work for them in America, in 1883 Locke arrived in Boston, only to sign on with the New England Glass Company instead. His impact on that firm's production of artistic glassware was immediate. Locke's most important contribution was his patented amberina glass, a specially prepared amber glass, which when reheated turned partially ruby in color. A reporter for the *Crockery and Glass Journal* described the ingenious results shortly after amberina was introduced, saying that the new glass appeared in "every conceivable graduation of tint from a bright amber to a dark ruby, the two effects melting one into the other in the same piece" (*Crockery and Glass Journal,* July 5, 1883, p. 24). Amberina glass became so popular that the New England Glass Company made it into almost every imaginable shape, including a flower stand fashioned as a water pump with a glass bucket hanging on the spout. One of Locke's own designs was a small pressed amberina vase, square in section, with a Japanesque stork standing among marsh grasses in low relief on two sides (FIG. 7.47). Locke's amberina was copied by HOBBS, BROCKUNIER AND COMPANY, which later secured exclusive rights to the use of amberina in pressed glass, and by the MOUNT WASHINGTON GLASS COMPANY, for which FREDERICK S. SHIRLEY patented his version, called rose amber, in 1884.

Locke was responsible for most of the New England Glass Company's lavishly colored innovative fancy glass, known as Pomona, Agata, Maize, and Wild Rose (or Peachblow, as the Mount Washington Glass Company's version was called). Both Wild Rose and Peachblow were attempts to emulate in glass the subtle glazes on some oriental porcelains. The end product was a type of glass in which both the inner and outer surfaces were shaded from white to rose (in contrast to the peachblow glass made by Hobbs, Brockunier, in which the color remained only on the exterior surface, fused to an opaque inner lining). Wild Rose pieces were sometimes treated to give them a matte finish that was receptive to additional decoration, such as the fern frond painted in gold on one example (FIG. 7.52). Locke was responsible for creating other ex-

quisite objects as well, including the small vase he made and signed in 1887 (FIG. 7.54), whose surfaces were virtually bejeweled with applied polychrome enamels, gold, and etched details.

Despite the company's efforts to introduce ever-novel art glasses during the 1880s, since the centennial it had been plagued by labor and other problems, especially by competition from less-costly glass wares being produced in the Midwest. In 1878 William L. Libbey purchased a lease for the firm, and he, along with his son Edward Drummond Libbey, made valiant efforts to keep the factory running smoothly. Massive strikes among the workers crippled the New England Glass Company and other factories, and in 1888 Edward Libbey, having taken charge following his father's death in 1883, was forced to shut down the works. Libbey moved to Toledo, Ohio, where he continued in business with his Libbey Glass Company, a concern still in operation today. Joseph Locke accompanied Libbey to Toledo for a short time before moving to Pittsburgh, where he remained until he died, working independently and continuing to etch, engrave, paint, and enamel glass.

REFERENCES
William C. Richards, *A Day in the New York Crystal Palace, and How to Make the Most of It* (New York, 1853), p. 158 // "New England Glass Company's Works," *Ballou's Pictorial Drawing-Room Companion*, Jan. 20, 1855, pp. 40–41 // Deming Jarves, *Reminiscences of Glass-making* (New York, 1865) // "Boston," *Crockery and Glass Journal* 2 (Nov. 2, 1876), p. 15 // "Illustrated Catalogue of the Paris International Exhibition," pt. 6, *Art Journal* (Appleton's) 4 (Oct. 1878), pp. 301–12 // "Philadelphia Trade Reports," *Crockery and Glass Journal* 11 (May 6, 1880), p. 6 // [New England Glass Works], *Crockery and Glass Journal* 18 (July 5, 1883), p. 24 // "New Inventions," *Crockery and Glass Journal* 18 (Aug. 16, 1883), p. 44 // "The Boston Exhibitions," *Crockery and Glass Journal* 18 (Sept. 20, 1883), p. 29 // Lura Woodside Watkins, *Cambridge Glass, 1818–1888: The Story of the New England Glass Company* (Boston, 1930) // Alexander Silverman, "Joseph Locke, Artist," *Glass Industry* 17 (Aug. 1936), pp. 272–75 // "The Editors' Attic: Cambridge Glass," *Antiques* 35 (Jan. 1939), pp. 11–12 // Marguerite D. Toussaint, "Joseph Locke et la décoration du verre," *Clarté, art, art décoratif, architecture* 12 (Apr. 1939), pp. 8–11 // J. Stanley Brothers, Jr., "Locke's Maize Glass," *Antiques* 58 (Oct. 1950), pp. 303–4 // Geoffrey W. Beard, "English Makers of Cameo Glass," *Antiques* 65 (June 1954), pp. 472–74 // Idem, *Nineteenth Century Cameo Glass* (Newport, Eng., 1956), pp. 55–62, figs. 88–89 // Toledo Museum of Art, Ohio, *The New England Glass Company, 1818–1888* (exhib. cat., 1963) // Millard F. Rogers, Jr., "The New England Glass Company: Some Discoveries," *Antiques* 86 (July 1964), pp. 77–81 // "Economic Development of Cambridge," in Cambridge Historical Commission, *Survey of Architectural History in Cambridge, Report One: East Cambridge* (Cambridge, Mass., 1965), pp. 13–15, 59–60 // Millard F. Rogers, Jr., "A Glass Recipe Book of the New England Glass Company," *Journal of Glass Studies* 7 (1965), pp. 107–13 // Idem, "New England Glass Company Marks," *Antiques* 89 (May 1966), pp. 724–29 // Nell Jaffe Baer, "Joseph Locke and His Art Glass," *Auction* 2 (Apr. 1968), pp. 10–12 // Kenneth M. Wilson, *New England Glass and Glassmaking* (New York and Toronto, 1972), pp. 229–61, 381 // Ray and Lee Grover, *English Cameo Glass* (New York, 1980), pp. 2–4, 71–72 // Nancy O. Merrill, "Engraved New England Glass at the Chrysler," *Glass Club Bulletin of the National Early American Glass Club* 131 (Fall 1980), pp. 3–4 // Leonard S. Rakow and Juliette K. Rakow, "The Glass Replicas of the Portland Vase," *Journal of Glass Studies* 24 (1982), pp. 49–56 // Alice Cooney Frelinghuysen, "A Masterpiece of the New England Glass Company at the Metropolitan Museum of Art," *Journal of Glass Studies* 25 (1983), pp. 225–30

George Ward Nichols, *see* **Rookwood Pottery**

Maria Longworth Nichols, *see* **Rookwood Pottery**

Adelaide Nourse, *see* **Benn Pitman**

Elizabeth Nourse, *see* **Benn Pitman**

Alexander F. Oakey, *see* **Maria Oakey Dewing**

Maria Richards Oakey, *see* **Maria Oakey Dewing**

Arthur Osborne, *see* **J. and J. G. Low Art Tile Works**

Charles Osborne, *see* **Whiting Manufacturing Company**

Ott and Brewer
1871–1892
Trenton, New Jersey
Ceramics

In 1863 William Bloor, Joseph Ott (b. 1827), and Thomas Booth established the Etruria Pottery in Trenton, New Jersey. The name, which ambitiously recalled the renowned JOSIAH WEDGWOOD AND SONS, LIMITED, Etruria factory in England, was used throughout the history of the pottery (although it was not incorporated as such until 1878), but it was many years before the works was able to produce anything approximating the high-quality ceramics that the name implied.

Production commenced with cream-colored earthenware and white graniteware, typical of other New Jersey firms. Bloor, an experienced potter from East Liverpool, Ohio, with a knowledge of porcelain, had worked in Trenton during the 1850s before returning there in 1863. Ott, who owned a livery stable with William P. Brewer, and Booth, who was listed as a "paper carrier" in Trenton city directories, provided the financial backing. In 1864 Booth sold his interest to Garret Schenck Burroughs, who in turn sold it to John Hart Brewer (1844–1900) the following year. Brewer was the nephew of Joseph Ott and the son of Ott's livery-business partner. Thus in 1865 the firm became Bloor, Ott and Brewer.

Brewer not only contributed to the steady upgrading of the Etruria Pottery's production and to the ceramics chemistry in use there, but also eventually became a lobbyist for the American ceramics industry. In 1875 he was elected a member of the New Jersey State Assembly and subsequently a United States congressman, in which capacity he worked to set up protective tariffs. He was instrumental in organizing the United States Potters' Association and was active in the Trenton Potters' Association.

Shortly after Brewer joined the firm in 1864, Herman Roleder was hired to decorate Etruria graniteware; he was the only decorator in Trenton at the time, according to a Brewer manuscript note at the New Jersey State Museum. With Bloor's expertise, the pottery began to produce Parian ware long before it was popularized by the Philadelphia Centennial displays in 1876; a bust of Ulysses S. Grant in Civil War uniform, with the Bloor, Ott and Brewer mark, is believed to predate Grant's election to the presidency in 1868.

In 1871 (or 1873) Bloor left the partnership, and Ott and Brewer continued to run the Etruria Pottery. In preparation for the forthcoming Centennial, in 1873 the firm hired Isaac Broome (1835–1922) as designer and ceramist. Broome, a sculptor and academician of the Pennsylvania Academy of the Fine Arts, had briefly been involved in the manufacture of terracotta vases, fountains, and architectural elements in Pittsburgh about 1866 and in Brooklyn in 1871. He created several well-known porcelain sculptures displayed by Ott and Brewer in Philadelphia, the most famous being a *Baseball Vase* and a life-size *Bust of Cleopatra* (examples of both are now in the New Jersey State Museum, Trenton), the latter executed in several colored bodies, including deep blue with gold and silver decoration, chocolate brown, and Parian white. About this time Broome developed a method for applying lithographic designs to ceramics, some of which also were displayed at the Centennial Exposition. Broome left Ott and Brewer when he became the United States Commissioner of Ceramics for the Exposition Universelle in Paris in 1878, but he continued occasionally to design pieces for the firm after this time.

During Broome's tenure the pottery experimented with the production of porcelain in an attempt to duplicate Irish Belleek, an ivory-colored, eggshell-thin body with nacreous glaze that was much admired in America. By 1876 a fine-quality, ivory-bodied porcelain made entirely of American materials had been perfected, and Broome had designed an unusual rectangular kiln for firing porcelain and Parian wares. Between 1876 and 1882, the year the factory burned, Ott and Brewer began to make purely ornamental porcelain, which can best be described as "Belleek decorated ivory porcelain" (Mitchell, 1972, p. 225).

Despite these artistic successes, it was not until after 1882 that Ott and Brewer produced a true facsimile of Irish Belleek porcelain. As part of the restructuring of their operations following a factory fire, in 1882 Ott and Brewer hired William Bromley, Jr., an Irishman from the village of Belleek; the following

year, Bromley's father, William, Sr., and his brother, John, also joined the firm. With the expertise of these Irish ceramists, an "American Belleek" was produced, such as the pitcher (FIG. 7.6) decorated with pastel blue and pink glazes and encrustations of gilt that would have required several firings to achieve. Another piece, a porcelain vase (FIG. 7.5) with rectangular neck, bears a moss green glaze and soaring gilded crane in a Japanesque style similar to that favored by the WORCESTER ROYAL PORCELAIN COMPANY in England and the GREENWOOD POTTERY in Trenton, New Jersey, during this period. The firm displayed ornamental wares such as these as well as others in the form of porcelain picture frames with delicately modeled flowers at the 1884 World's Industrial and Cotton Centennial in New Orleans. Walter Scott Lenox (1859–1920), who was later to found a company that would become Lenox China, also worked for Ott and Brewer, from about 1875 until 1889, starting out as a clerk and becoming a decorator. While the exact nature of his involvement needs clarification, Lenox no doubt designed and decorated some of the firm's Belleek porcelain.

The extraordinary craftsmanship of Ott and Brewer ceramics found favor in the press—an 1886 article in the *Decorator and Furnisher* described the company's carved porcelain jewel cases with "open work . . . bars . . . scarcely larger than a large sewing needle" (*Decorator and Furnisher*, 1886, p. 150). But another critic lamented that the design and execution of the firm's Belleek porcelain "continually reminded [us] of our dependence upon transplanted traditions and imported skill" (Miller, 1889, p. 134).

By 1887 Ott and Brewer employed two hundred fifty workers and kept at least twelve kilns in operation at all times. Joseph Ott retired in 1887 (although he is listed as the company's president in the Trenton city directories between 1890 and 1892), and the firm was incorporated a second time, the first corporation having been dissolved in 1881. Despite the success of Ott and Brewer during the 1880s, an economic depression and a potters' strike in 1892 halted production and resulted in the sale of the company to Charles H. Cook, its former bookkeeper. Brewer founded the Hart Brewer Pottery Company in 1894 but withdrew from the financially troubled ceramics industry a year later to become an insurance executive.

REFERENCES

"Pottery and Potteries, No. 11," Trenton *Evening Argus*, Jan. 10, 1873 // "Trenton: The Etruria Pottery Works," *Crockery and Glass Journal* [hereafter abbreviated as *CGJ*] 2 (Dec. 2, 1875), p. 19 // "American Parian," *CGJ* 5 (Mar. 22, 1877), p. 15 // "Trenton Earthenware Manufactories," *CGJ* 6 (Oct. 25, 1877), pp. 25–26 // "Enterprise Rewarded," Trenton *Gazette*, cited in *CGJ* 6 (Dec. 20, 1877), p. 24 // Charles Wyllys Elliott, *Pottery and Porcelain, from Early Times down to the Philadelphia Exhibition of 1876* (New York, 1878), pp. 340–41 // "A Change in a Pottery," *CGJ* 7 (Jan. 31, 1878), p. 16 // "Trenton Potteries, Past and Present," *CGJ* 8 (Nov. 7, 1878), p. 5 // Jennie J. Young, *The Ceramic Art: A Compendium of the History and Manufacture of Pottery and Porcelain* (New York, 1879), pp. 462–67 // Silex, "Trenton Potteries," *CGJ* 9 (June 5, 1879), p. 20 // "Trenton's Great Industry," *CGJ* 10 (July 24, 1879), p. 21 // Silex, "Trenton Potteries," *CGJ* 10 (Aug. 21, 1879), p. 20 // "Native Ceramics at the American Institute," *CGJ* 10 (Oct. 9, 1879), p. 24 // Silex, "Trenton Potteries," *CGJ* 10 (Oct. 23, 1879), p. 20 // "Pottery at the American Institute Fair," *Art Amateur* 1 (Nov. 1879), pp. 126–27 // "American Institute Awards," *CGJ* 10 (Dec. 4, 1879), p. 17 // Silex, "Trenton Potteries," *CGJ* 11 (Jan. 22, 1880), p. 18 // Idem, "Trenton Potteries," *CGJ* 11 (Feb. 5, 1880), p. 18 // Idem, "Trenton Potteries," *CGJ* 11 (Mar. 11, 1880), p. 20 // Idem, "Trenton Potteries," *CGJ* 11 (Apr. 15, 1880), p. 20 // Idem, "Trenton Potteries," *CGJ* 12 (Aug. 5, 1880), p. 20 // "The Potteries: Trenton, N.J.," *CGJ* 14 (July 7, 1881), p. 21 // "The Potteries: Trenton, N.J.," *CGJ* 14 (Sept. 29, 1881), p. 36 // "The Potteries: Trenton, N.J.," *CGJ* 14 (Oct. 27, 1881), p. 22 // "The Potteries: Trenton, N.J.," *CGJ* 14 (Nov. 17, 1881), p. 36 // "The Potteries: Trenton, N.J.," *CGJ* 16 (July 13, 1882), p. 28 // "Fire in a Pottery," *CGJ* 16 (July 27, 1882), p. 7 // "The Potteries: Trenton," *CGJ* 18 (July 26, 1883), p. 22 // "The Potteries: Trenton," *CGJ* 18 (Sept. 20, 1883), p. 14 // "The Potteries: Trenton," *CGJ* 18 (Oct. 11, 1883), p. 14 // "The Potteries: Trenton," *CGJ* 18 (Dec. 20, 1883), p. 74 // "The Potteries: Trenton," *CGJ* 19 (Jan. 17, 1884), p. 16 // Isaac Edwards Clarke, *Art in Industry: Education in the Industrial and Fine Arts in the United States*, pt. 1, *Drawing in Public Schools* (Washington, D.C., 1885), pp. ccxlvi, cclvii // [Exhibit of Belleek ware], *Decorator and Furnisher* 8 (Aug. 1886), p. 150 // L. W. Miller, "Industrial Art: The Exhibition of Art Industry at Philadelphia," *Art Amateur* 21 (Nov. 1889), p. 134 // Edwin AtLee Barber, *The Pottery and Porcelain of the United States* (New York, 1893; 3d ed. New York, 1909), pp. 214–23, 233, 236, 242, 362, 372, 413, 430–31, 484–86 // Francis B. Lee, *History of Trenton, New Jersey . . .* (Trenton, 1895), p. 321 // Edwin AtLee Barber, *Marks of American Potters* (Philadelphia, 1904), pp. 52, 54, 56 // "Belleek China," *Pottery and Glass* 5 (July 1910), pp. 21–22 // Samuel T. Freeman and Company, Philadelphia, [*The Collection of*] *the Late Edwin AtLee Barber, A.M., PH. D.: Illustrated Catalogue of China, Pottery, Porcelains, and Glass* (sale cat., Dec. 10 and 11, 1917), pp. 60, 81 // Harry J. Podmore, "Old Pottery Landmark Passes at Trenton," *Ceramic Age* 19 (June 1932), p. 271 // Harriet E. Brewer, "American Belleek," *New Jersey Historical Society Proceedings* 52 (Apr. 1934), pp. 96–108 // John Ramsay, *American Potters and Pottery* (Boston, 1939), pp. 110, 113, 123, 183, 275 // New Jersey State Museum, Trenton, *Early Arts of New Jersey: The Potter's Art, c. 1680–c. 1900* (exhib. cat., 1956), pp. 40–41 // Marvin D. Schwartz and Richard Wolfe, *A History of American Art Porcelain* (New York, 1967), p. 44, pls. 35, 39–47, 49, 52, 57 // Marvin D. Schwartz, *Collectors' Guide to Antique American Ceramics* (Garden City, N.Y., 1969), pp. 114–17 // James [R.] Mitchell, "Ott and Brewer: Etruria in America," *Winterthur Portfolio* 7 (1972), pp. 217–28 // Idem, "The American Porcelain Tradition," *Connoisseur* 179 (Feb. 1972), pp. 123–31 // J. G. Stradling, "American Ceramics and the Philadelphia Centennial," *Antiques* 110 (July 1976), pp. 146–58 // Kathleen Stavec, New Jersey Historical Society, Newark, correspondence, Aug. 13, 1984 // East Brunswick Museum, N.J., *Golden Periods of New Jersey Ceramics* (exhib. cat., 1985), p. 14 // Suzanne Corlette Crilley, New Jersey State Museum, Trenton, conversation, Sept. 1985, and correspondence, Jan. 29, 1986

Daniel Pabst
1826–1910
Philadelphia
Cabinetmaker

In 1850, a year after his arrival in the United States, Daniel Pabst was but one of more than seven hundred German craftsmen and over fifteen hundred furniture workers living and working in Philadelphia, a number that would more than double during the next three decades. Throughout this period, in which machine production threatened handcraftmanship, Daniel Pabst's virtuoso carving and beautiful workmanship ensured his success among a select group of Philadelphia patrons. The history of Pabst's career is predicated on relatively scant physical or archival evidence: only a few pieces of furniture are labeled or attributed to his workshop on the basis of provenance or style, and few pieces are actually signed. Virtually no drawings or business records exist, but the recollections of Pabst's granddaughter were recorded by the late Calvin S. Hathaway, curator of decorative arts at the Philadelphia Museum of Art, who also obtained a copy of an incomplete list of clients dictated by Pabst to his daughter.

Born in Langenstein, Hesse-Darmstadt, Germany, Pabst attended the local technical high school, founded in 1836, which offered modeling as well as freehand and mechanical drawing in its curriculum. Pabst may have subsequently apprenticed himself to a local cabinetmaker. In 1849, at the age of twenty-three, he emigrated to the United States.

After a brief period as a journeyman furniture maker, in 1854 Pabst opened a shop at 222 South Fourth Street, Philadelphia, but he was not listed in the city directory until 1856. Between 1860 and 1870 his partner was Francis Krauss, a confectioner whose role was probably to provide financial support. In 1870 Pabst relocated his workshop to 269 South Fifth Street, where it remained until his retirement in 1896. It is estimated that during the course of his career he employed up to fifty workmen at any one time.

During the 1860s Pabst manufactured beautifully crafted furniture in the fashionable Renaissance-revival style, which attracted many important Philadelphia families as clients: their names included Bullitt, Disston, Furness, Ingersoll, Newbold, McKean, Parry, Wistar, and Wyeth, to cite just a few. A suite of walnut furniture made for the noted historian Henry Charles Lea (1825–1909) about 1868, now in the collection of the Philadelphia Museum of Art, comprises a fine example of the robust carving of Pabst's early production.

Pabst's work of the 1870s shifted markedly from Renaissance forms and ornamentation to

the Modern Gothic style. A walnut-and-maple cabinet of about 1874–77 (FIGS. 5.3, 5.4) is surely one of the finest examples of Modern Gothic furniture made in America. The manufacture of the cabinet is attributed to Pabst on the basis of its similarity in details—small engaged columns, chamfered edges, maple veneer, and reverse-painted, ribbed glass—to a documented Pabst cabinet (Wurts House, Philadelphia; Hanks, 1980, p. 101 [ill.]).

The influence of British designers of the 1870s, especially BRUCE J. TALBERT and CHRISTOPHER DRESSER, is readily apparent in this piece. The structure of the cabinet's upper section closely resembles a wall cupboard by Talbert that was reproduced as plate 12 in his influential book *Gothic Forms Applied to Furniture, Metal Work, and Decoration for Domestic Purposes*, published in Boston in 1873 after first appearing in Birmingham, England, in 1867 (FIGS. 5.1, 5.2); the use of glass panels in the Pabst cabinet corresponds to the use of tiles in Talbert's cupboard. Similarly, the conventionalized ornament on Pabst's cabinet doors (see frontispiece to chap. 5)—achieved by "cameo cutting," that is, by cutting through the maple veneer to the darker walnut base—compares favorably with cabinet doors pictured in plate 20 of Talbert's book.

Christopher Dresser's designs may have provided the inspiration for the stylized floral ornament on the Pabst cabinet's reverse-painted glass inserts; certainly Dresser's publications were well known in America. Dresser actually visited Philadelphia in 1876, both to view the Centennial Exposition and to lecture at the newly formed Pennsylvania Museum and School of Industrial Art.

The architectonic design of the cabinet's upper section also recalls the work of Philadelphia architect FRANK FURNESS, who in fact may have been the cabinet's designer (compare, for example, the facade of Furness's Provident Life and Trust Company building of 1876–79, or the projecting corner bay of his Kensington National Bank of about the same time; see Philadelphia Museum of Art, 1973, ills. 14–1, 15–1). Pabst and Furness often worked closely together (the Furness name appears on Pabst's client list), and Pabst probably executed Furness's furniture designs; this collaboration probably accounts for Pabst's change in style in the 1870s, from Renaissance revival to Modern Gothic. Besides the stylistic similarities in their respective works, Pabst and Furness shared many patrons, including Henry Pratt McKean and his son Thomas, and almost certainly collaborated on furniture and interior woodwork for the Long Island home of Theodore Roosevelt, some of which is now in the collection of the Sagamore Hill National Historic Site in Oyster Bay, New York. At the Centennial Exposition Pabst exhibited an award-winning walnut sideboard, which received the following critique: "The amount of rich carving far surpassed that on any other Gothic piece in the Exhibition; but in the main it was without purpose or distinctive meaning. Still it was free from conventionalisms. . . . His Gothic work reflected the prevalent defects of the revival in the tendency to introduce *too many architectural forms pertaining to stonework only*" (*American Architect and Building News*, 1877, p. 4; italics added).

According to the Philadelphia city directory, Pabst's son joined his business in 1894, but the workshop continued only another two years. After his retirement in 1896, Pabst made furniture for his family and friends; one such desk is reported to have been exhibited at the Saint Louis World's Fair of 1904. In 1910, on the occasion of his eighty-fourth birthday, Pabst was honored by the University of Pennsylvania, for whom he had carved ceremonial wood spoons every year since 1860. When the venerable Philadelphia cabinetmaker died little more than a month after this tribute, an era in the craftsman's tradition he represented also came to a close.

REFERENCES

B[ruce] J. Talbert, *Gothic Forms Applied to Furniture, Metal Work, and Decoration for Domestic Purposes* (Birmingham, Eng., 1867; reprint Boston, 1873), pls. 12, 20 // "Decorative Fine-Art Work at Philadelphia: American Furniture," pt. 2, *American Architect and Building News* 2 (Jan. 6, 1877), pp. 3–4 // "General Report of the Judges of Group 7," in U.S. Centennial Commission, *International Exhibition, 1876: Reports and Awards,* 9 vols. (Washington, D.C., 1880), vol. 4, p. 731 // Hudson River Museum, Yonkers, N.Y., *Eastlake-Influenced American Furniture, 1870–1890,* by Mary Jean Smith Madigan (exhib. cat., 1973) // Philadelphia Museum of Art, *The Architecture of Frank Furness,* by James F. O'Gorman (exhib. cat., 1973), figs. 14–1, 15–1 // David [A.] Hanks, "Reform in Philadelphia: Frank Furness, Daniel Pabst, and Modern Gothic Furniture," *Art News* 74 (Oct. 1975), pp. 52, 54 // Philadelphia Museum of Art, *Philadelphia: Three Centuries of American Art,* by Darrel Sewell et al. (exhib. cat., 1976), pp. 378–79 (ills.), 401–3 (ills.) // David A. Hanks and Page Talbott, "Daniel Pabst, Philadelphia Cabinetmaker," *Philadelphia Museum of Art Bulletin* 73 (Apr. 1977), pp. 4–24 // Isabelle Anscombe and Charlotte Gere, *Arts and Crafts in Britain and America* (New York and London, 1978), pp. 20–21, 24, 55, 89 // David [A.] Hanks, "Daniel Pabst, Philadelphia Cabinetmaker," *Art and Antiques* 3 (Jan.–Feb. 1980), pp. 94–101 // Detroit Institute of Arts, *The Quest for Unity: American Art Between World's Fairs, 1876–1893* (exhib. cat., 1983), pp. 192–93 (ill.) // Robert L. Edwards, The Artsman, an Association to Advance Arts and Crafts Ideals in America, Bryn Mawr, Pa., correspondence, Mar. 30, 1985

Thomas J. Pairpoint, *see* Gorham Manufacturing Company and Mount Washington Glass Company

Adelaide Nourse Pitman, *see* Benn Pitman

Agnes Pitman
1850–1946
Cincinnati, Ohio
Wood carver and ceramics decorator

Agnes Pitman's career as a decorative artist paralleled the development of the art movement in Cincinnati. The eldest child of BENN PITMAN, Agnes was born in Sheffield, England, in 1850. At age three, she emigrated with her parents to Cincinnati, where she spent the rest of her ninety-six years.

Agnes may have been the first of the Pitman family to become interested in wood carving; her younger half sister, Melrose, later recalled that Agnes took some carving lessons with WILLIAM HENRY FRY early in her career. While still in her twenties, Agnes, along with her mother, Jane Bragg Pitman (d. 1878), carved several pieces of furniture, doors, and other architectural woodwork that her father had designed, which they submitted to the Third Annual Cincinnati Industrial Exhibition of 1872.

One year later, Benn Pitman initiated wood-carving classes at the University of Cincinnati School of Design, with Agnes as his assistant. During the 1870s she purportedly taught wood-carving classes at the Mercantile Library Building and instructed students at Woodward High School. In 1874 she enrolled in the china-painting class first offered that year by Maria Eggers, while continuing her design studies at the university through 1877.

By the mid-1870s, however, Pitman's work was already quite developed. A beautiful chest of drawers embellished with carved floral motifs representing the months of April through September was one of the outstanding pieces shown in the Cincinnati Room of the Women's Pavilion at the 1876 Philadelphia Centennial Exposition. Her carved work was also shown in the Cincinnati industrial exhibitions of the 1870s and at the Cincinnati Loan Exhibition of 1878, organized by the Women's Art Museum Association, of which she was a member. She apparently did not contribute to the decoration of the great organ of the Cincinnati Music Hall during 1877–78, however, as did other students of her father. Pitman joined the Cincinnati Pottery Club in 1879, its founding year, but participated in its activities only until the mid-1880s. A ceramic vase of 1885 (FIG. 7.26) illustrates the strong relationship between her artistic wood carving and her work in ceramics.

Throughout her career, Pitman was engaged to create painted wall decorations for interiors. The Cincinnati Room in the Women's Pavilion at the Chicago Columbian Exposition of 1893 was probably her most important public commission. Her design for the walls and ceiling featured a border of buckeye flowers, from Ohio's state tree, surrounding clusters of tea roses in colors graduating from pale cream to rich crimson on a deep terracotta background with highlights of azure blue.

REFERENCES
Exhibition of Paintings, Engravings, Drawings, Aquarelles, and Works of Household Art in the Cincinnati Industrial Exposition (exhib. cat., 1874), nos. 136, 138, 141, 144, 377 // George Ward Nichols, ed., *The Cincinnati Organ: With a Brief Description of the Cincinnati Music Hall* (Cincinnati, 1878) // "Cincinnati Potteries," *Crockery and Glass Journal* 10 (Nov. 20, 1879), p. 28 // "Cincinnati Art Pottery," *Harper's Weekly* 24 (May 29, 1880), pp. 341–42 // "Miss Agnes Pitman's Christmas Festival," *Cincinnati Commercial,* Dec. 27, 1880, clipping from the art and artists file A–784, Cincinnati Historical

Society // Mrs. Aaron F. Perry, "Decorative Pottery of Cincinnati," *Harper's New Monthly Magazine* 62 (May 1881), pp. 834–45 // Hubert Howe Bancroft, *The Book of the Fair: An Historical and Descriptive Presentation of the World's Science, Art, and Industry, as Viewed Through the Columbian Exposition at Chicago in 1893* (Chicago and San Francisco, 1893), pp. 263, 285 (ill.) // "Miss Pitman's Design for the Walls of the Cincinnati Room in the Woman's Pavilion at the World's Fair . . . ," clipping [source unknown, 1893?], from the art and artists file A–784, Cincinnati Historical Society // *Report of the Woman's Columbian Exposition Association of Cincinnati and Suburbs, 1892–93* (Cincinnati [1893?]), p. 18 // "Last Rites . . . for Miss Agnes Pitman . . . ," *Cincinnati Enquirer*, Jan. 26, 1946, clipping from the Cincinnati Historical Society // "Noted Woodcarver, Ninety-five, Dies; Introduced Shorthand Plan," *Cincinnati Times Star*, Jan. 26, 1946, clipping from the Cincinnati Historical Society // Cincinnati Art Museum, *The Ladies, God Bless 'Em: The Women's Art Movement in Cincinnati in the Nineteenth Century* (exhib. cat., 1976), p. 68 // Anthea Callen, *Women Artists of the Arts and Crafts Movement, 1870–1914* (New York, 1979), pp. 164 (ill.), 165, 169–70, 225 // "Pitman, Agnes," in *The International Dictionary of Women Workers in the Decorative Arts,* comp. Alice Irma Prather-Moses (Metuchen, N.J., and London, 1981), pp. 133–34 // Anita J. Ellis, "Cincinnati Art Furniture," *Antiques* 121 (Apr. 1982), pp. 930–41

Benn Pitman

1822–1910
Cincinnati, Ohio
Educator and wood carver

There was no stronger catalytic force in the Cincinnati art movement of the 1870s and 1880s than Benn Pitman. Yet when he emigrated to America at mid-century, it was not with the intention of fostering the decorative arts.

Born in Trowbridge, England, Pitman was one of eleven children of a successful cloth manufacturer; he planned to become an architect in Australia, joining two of his brothers who had settled there. In the early 1830s, however, he went to Bath and apprenticed for a few years with a Mr. Lewis, the city architect. Pitman may have initially chosen that city because another of his brothers, Isaac Pitman, had already established a school there, but it is of equal interest that he probably met HENRY LINDLEY FRY and WILLIAM HENRY FRY, ornamental wood carvers, while he was living in Bath. Within a short time Pitman was actively involved in promoting phonography, the phonetic shorthand method that his brother Isaac had invented. He taught and lectured throughout England for ten years, when, at Isaac's urging, he decided to introduce phonography to America. He embarked from England in 1852, accompanied by Jane Bragg (d. 1878), his wife of three years, and two of their three children, Arnold (1851–1853) and AGNES PITMAN (1850–1946). (A third child, Ellis, was born and died in 1853.)

After a brief stay in Philadelphia, in 1853 the family settled in Cincinnati, where Pitman established the Phonography Institute. He produced a great many textbooks on the shorthand method, all of which he designed and illustrated himself. In conjunction with his publishing efforts, in 1856 Pitman invented the electrochemical process of relief engraving. During the 1860s he served briefly as a soldier in the Civil War, but later became the principal reporter for a number of important government prosecutions, including the 1865–67 trial of President Lincoln's assassins and the Ku Klux Klan trials of 1871–72.

Throughout the late 1860s and early 1870s, interest in decorative wood carving was growing in Cincinnati with the encouragement of the Frys, who by this time had emigrated from England and settled in Cincinnati. It is not known exactly when Pitman began to carve in wood, although it was probably a natural transition from his engraved work. Several examples of carving by Pitman, his wife, Jane, and his daughter Agnes were displayed at the Third Annual Cincinnati Industrial Exhibition of 1872.

In 1873 Pitman instituted the wood-carving department at the University of Cincinnati School of Design. His courses in carving, which he taught for twenty years, were exceedingly popular with the young women of Cincinnati, most of whom were members of the wealthy middle class despite the school's stated ambition to train the industrious poor. Pitman recommended modeling designs in clay before translating them into wood, and it was he who engendered interest in ceramics in Cincinnati by initiating classes in china painting at the School of Design in 1874. Several of his talented student carvers, among them LAURA FRY and M. LOUISE MCLAUGHLIN, became leaders in the Cincinnati art-pottery movement during the 1880s; some of the ceramics made by Pitman's daughter Agnes clearly reflect her experience in both clay and wood (FIG. 7.26). Another of Pitman's students, Adelaide Nourse (1854–1893), became his second wife in 1882. They also had three children: two sons, Ruskin and Emerson, who died as young children, and a daughter, Melrose, who was born in 1889 and was named after the Gothic abbey in Melrose, Scotland.

The wood-carving movement was given further momentum by the 1876 Philadelphia Centennial Exposition, at which the city of Cincinnati had its own display room. The following year, Pitman, the Frys, and their students embarked on an ambitious program of carved decoration for the organ of the Cincinnati Music Hall.

Deeply influenced by John Ruskin (1819–1900) and WILLIAM MORRIS, Pitman saw decorative art as a vital component of utilitarian objects and surroundings. Moreover, the art of decoration was potentially accessible to everyone. Pitman's style was predicated on the Ruskinian notion that nature provides an endless source of ornamental motifs, and he advocated the study of indigenous plant life—buckeye, hawthorn, sassafras, succory, wisteria, and wild parsnip—as well as the use of native American woods, such as black walnut and wild cherry. Pitman's house in Cincinnati, extensively embellished with carved floral decoration, still exists (ILL. 1.3). The motifs on the extravagantly carved bedstead (FIG. 1.4) Pitman designed and displayed in the Cincinnati Industrial Exhibition of 1883 (his wife, Adelaide, did the actual carving) include a flight of swallows, a crescent moon, hydrangeas, water lilies, asters, geraniums, and leaves of maple and oak; the painted panels of Night and Morning on either side of the headboard (FIG. 1.5) are by Elizabeth Nourse (1859–1938), Pitman's sister-in-law.

During the 1880s Pitman wrote numerous articles on decoration and wood carving for the *Art Amateur*. In 1889 he was appointed lecturer in the principles of decorative design at the Art Academy of Cincinnati; his philosophy of decoration was subsequently published in *American Art—Its Future Dependent on Improved Social Conditions* (1891, ILL. 1.4) and in *A Plea for Decorative Art* (1895). Pitman relinquished his post to William Fry in 1893 in order to continue his work in phonography, a subject on which he published several more books before his death, in 1910, at the age of eighty-eight.

REFERENCES

Benn Pitman, ed. and engraver, *History of Short Hand* (Cincinnati, 1856) // Idem, *Second Phonetic Reader* (Cincinnati, 1859) // *Exhibition of Paintings, Engravings, Drawings, Aquarelles, and Works of Household Art, in the Cincinnati Industrial Exposition* (exhib. cat., 1873), nos. 108, 114, 116, 190–93 // "The Decorative Art in Cincinnati," *Crockery and Glass Journal* 9 (Jan. 30, 1879), p. 10 // "Wood Carving in Cincinnati," *Crockery and Glass Journal* 9 (Apr. 10, 1879), pp. 5–6 // "Morning Room: . . . Clock of Mr. Pitman," *Art Interchange* 2 (June 25, 1879), p. 106 // "Decorative Art Exhibition," *Crockery and Glass Journal* 10 (Nov. 6, 1879), p. 10 // A. L. Vago, *Instructions in the Art of Modeling in Clay,* published with *An Appendix on Modeling Foliage, Etc.,* by Benn Pitman (Cincinnati, 1880) // "Art in the Cities: Cincinnati," *Art Journal* (Appleton's) 6 (Feb. 1880), pp. 62–63 // T. H. Bartlett, [Review of A. L. Vago, *Instructions in the Art of Modeling in Clay*], *American Art Review* (Boston) 2, pt. 1 (1881), pp. 34–35 // Mrs. Aaron F. Perry, "Decorative Pottery of Cincinnati," *Harper's New Monthly Magazine* 62 (May 1881), pp. 834–45 // "Carved Door of Cherry, with Lower Panels of Oak: Work of the Cincinnati School of Design," *Art Amateur* 6 (Dec. 1881), supplement, unpaged ill. // [Recent wood carving from the University of Cincinnati School of Design], *Art Amateur* 6 (Jan. 1882), p. 40 // "Suggestions for Art Workers," *Art Amateur* 6 (Apr. 1882), pp. 101 (ill.), 103 // "Art Notes: Cincinnati," *Art Journal* (London), July 1882, pp. 221–23 // Mary Gay Humphreys, "A Wood Carver's Home," *Art Amateur* 8 (Apr. 1883), pp. 114–15 // "Rosettes in Wood-carving," *Art Amateur* 9 (Sept. 1883), pp. 80, 81 (ill.) // "Mrs. Hayes' Portrait Frame," *Decorator and Furnisher* 3 (Oct. 1883), pp. 7 (ill.), 8 // "Panel Design for Wood-carving: 'Hawthorn,' from the Cincinnati School of Design," *Art Amateur* 9 (Oct. 1883), p. 103 (ill.) // "Hanging Cabinet: Designed by Benn Pitman," and "Wood-carving Designs for Vertical Borders: From the Cincinnati School of Design," *Art Amateur* 9 (Nov. 1883), pp. 126–27 (ills.) // "Design for Brass Plaque: Etched Centre and Repoussé Border," *Art*

Amateur 10 (May 1884), supplement, pl. 348 //
"Design for Wood Carving: 'Maple Leaves,'
by Benn Pitman of the Cincinnati School of
Design," Art Amateur 11 (July 1884), p. 45
(ill.) // [Combined cabinet and bookcase], Art
Amateur 11 (Oct. 1884), pp. 110, 111 (ill.) //
"Hanging Cabinet: Designed by Benn Pit-
man, Carved by the Pupils of the Cincinnati
Art School," Art Amateur 11 (Nov. 1884),
p. 130 (ill.) // Mary Gay Humphreys, "The
Progress of American Decorative Art," Art
Journal (London), Nov. 1884, pp. 345–48 //
"Panel Design for Wood-carving: 'White
Oleander,' the Seventh of a Series, by Benn
Pitman, of the Cincinnati Art School," Art
Amateur 12 (May 1885), p. 134 (ill.) // Benn
Pitman, "Practical Wood-carving and Design-
ing, Part 1," Art Amateur 18 (Jan. 1888), pp. 42
(ill.), 43 // Idem, "Practical Wood-carving and
Designing, Part 2," Art Amateur 18 (Feb.
1888), pp. 66–67, 69, 77 (ill.) // Idem, "Prac-
tical Wood-carving and Designing, Part 3: Pic-
ture-Frames," Art Amateur 18 (Mar. 1888), pp.
94–95 // Idem, "Practical Wood-carving and
Designing, Part 4: Elementary Carving," Art
Amateur 18 (Apr. 1888), pp. 112–13 // Idem,
"Practical Wood-carving and Designing, Part
5: Evolution of Modern Furniture from the
Primitive Stool, Chest, and Shelf," Art Ama-
teur 18 (May 1888), pp. 140–41 // Idem,
"Practical Wood-carving and Designing, Part
6," Art Amateur 19 (July 1888), pp. 42, 43
(ills.) // Idem, "Practical Wood-carving and
Designing, Part 7," Art Amateur 19 (Aug.
1888), p. 63 // Idem, "Practical Wood-carving
and Designing, Part 8," Art Amateur 19 (Sept.
1888), pp. 90–91, 93 (ills.) // Idem, "Decora-
tive Art," New England Magazine 6 (Oct.
1888), pp. 468–73 // Idem, "Practical Carving
and Designing, Part 8 [sic]," Art Amateur 19
(Oct. 1888), pp. 112, 113 (ill.) // Idem, "Prac-
tical Wood-carving and Designing, Part 9,"
Art Amateur 20 (Dec. 1888), pp. 17–18 //
Idem, "Gothic Bands for Wood-carving," Art
Amateur 20 (Jan. 1889), pp. 41, 42 (ills.) //
Idem, "Practical Carving and Designing, Part
10: Artistic Lettering," Art Amateur 20 (Mar.
1889), pp. 92, 93 (ill.) // Idem, "Practical
Wood-carving and Designing, Part 11: Metal
Work and Etching," Art Amateur 20 (Apr.
1889), pp. 112, 113 (ill.), 114 // Idem, "Prac-
tical Carving and Designing, Part 12: Diaper
Designs," Art Amateur 20 (May 1889), pp.
138–39 (ills.), 140–41 // Idem, "Practical
Carving and Designing, Part 13: Treatment of
Constructive Lines," Art Amateur 21 (Nov.
1889), pp. 128, 129 (ills.) // Idem, "Artistic
Lettering for Monograms," Art Amateur 22
(Dec. 1889), pp. 20, 21 (ills.) // Idem, "Etched
Metal Facings for Mantels," Art Amateur 22
(Jan. 1890), pp. 41–42, 43 (ills.) // Idem,
American Art—Its Future Dependent on Improved
Social Conditions (Cincinnati [1891]) // Idem,
A Plea for American Decorative Art, Cincinnati
Souvenir, Cotton States and International Ex-
position, Atlanta, Ga. (Cincinnati [1895]) //
"Pitman, Benn," in The National Cyclopaedia of
American Biography, vol. 4 (New York, 1895),
p. 87 // "Pitman, Benn," in Appletons' Cyclo-
paedia of American Biography, ed. James Grant
Wilson and John Fiske, vol. 5 (New York,
1900), p. 33 // Benn Pitman, A Plea for Alpha-
betic Reform (Cincinnati, 1905) // "Pitman,
Benn," in Who's Who in America, vol. 6 (1910),
p. 1524 // "Benn Pitman, Noted Stenogra-
pher, Dead," New York Times, Dec. 29, 1910,
p. 9 // "Pitman, Benn," in Who Was Who in
America, vol. 1, 1897–1942 (Chicago, 1943), p.
976 // Erwin O. Christensen, Early American
Wood Carving (Cleveland and New York,
1952), p. 92 // "Pitman, Benn," in Dictionary
of American Biography, vol. 7, pt. 2 (New York,
1962), pp. 641–42 // Cincinnati Art Museum,
The Ladies, God Bless 'Em: The Women's Art
Movement in Cincinnati in the Nineteenth Cen-
tury (exhib. cat., 1976), pp. 65–66 // Idem,
Celebrate Cincinnati Art, ed. Kenneth R. Trapp
(exhib. cat., 1982), pp. 48–55, 67–70 // Ken-
neth R. Trapp, "'To Beautify the Useful':
Benn Pitman and the Women's Woodcarving
Movement in Cincinnati in the Late Nine-
teenth Century," in Victorian Furniture: Essays
from a Victorian Society Autumn Symposium,
ed. Kenneth L. Ames (Philadelphia, 1982),
pp. 173–92 // Anita J. Ellis, "Cincinnati Art
Furniture," Antiques 121 (Apr. 1982), pp. 930–
41 // National Museum of American Art,
Washington, D.C., Elizabeth Nourse, 1859–
1938: A Salon Career, by Mary Alice Heekin
Burke (exhib. cat., 1983) // Mrs. A. Chap-
man, University of Bath Library, Eng., to
Mary Alice Heekin Burke, correspondence,
Aug. 16, 1985 // Mary Alice Heekin Burke,
Cincinnati, correspondence, Sept. 24, 1985 //
Kenneth R. Trapp, The Oakland Museum,
Calif., conversation, Jan. 1986

H. H. Richardson

1838–1886
New York City and Brookline,
 Massachusetts
Architect

During the two decades following the Civil
War, Henry Hobson Richardson emerged as
the first American architect of international
stature and influence. He developed a uniquely
personal style of masonry building singularly
well suited to the New England landscape.
This widely copied style, the so-called Rich-
ardsonian Romanesque, was instrumental in
freeing American architects from the cycle of
European revivals that dominated architectural
thinking in the nineteenth century.

Richardson was born at Priestley Plantation
along the Mississippi River in Louisiana. His
father was a New Orleans cotton merchant, his
mother the granddaughter of the British
chemist Joseph Priestley. Richardson was ed-
ucated in New Orleans before entering Har-
vard University in 1856. After graduation in
1859, he left immediately to study in Paris. He
entered the atelier of Jules-Louis André (1804–
1869), and in November of 1859 he gained ad-
mission to the Ecole des Beaux-Arts, preceded
among American architects only by Richard
Morris Hunt (1827–1895). In 1862, with the
fall of New Orleans to northern troops, Rich-
ardson's funds were cut off, and he had to
forgo his studies in order to seek work. He first
found employment with the architects Théo-
dore Labrouste (1799–1885), brother of Henri
Labrouste (1801–1875), and later with Jacques-
Ignace Hittorff (1792–1867). During these
years in Paris, Richardson had little chance to
travel; he stayed solely to learn enough so that
he could return to America to establish his
own architectural practice.

Late in 1865 Richardson did return, settling
in New York City. In 1867 he entered into
partnership with Charles D. Gambrill (1834–
1880); their relationship, which entailed little
more than a shared office, lasted until 1878. As
a result of the friendships he had made in col-
lege, almost all of Richardson's commissions
came from New England clients. Thus in
1874, when his practice was gathering mo-
mentum, he moved his office and family to
Brookline, Massachusetts.

Richardson's career can be divided into three
general periods. The first, from 1865 until
about 1872, was a time of experimentation in
which he searched for an individual style. His
earliest commission, in 1866, was for the
Unity Church in Springfield, Massachusetts.
There he employed the English Gothic style,
demonstrating that he did not find French
Beaux-Arts classical design suitable for New
England. During this time he built a number
of other churches in a variety of manners. In
the second period of his development, during
the mid-1870s, Richardson established his ar-
chitectural point of view, which combined the
forms of Romanesque architecture of southern
France and Spain with the granite of the New
England landscape and the indigenous ma-
sonry construction of the Boston area. Rich-
ardson's third and mature phase began with
Trinity Church in Copley Square, Boston, for
which he won the competition in 1872. When
the building, his first masterpiece, was finished
five years later, Richardson was perhaps the
best-known figure in his profession. The
tower of Trinity Church, inspired by the ca-
thedral at Salamanca, Spain, on the basis of
photographs sent to Richardson by JOHN LA
FARGE, was transformed into the apex of a
monumental pyramidal mass formed by the
nave, apse, and transepts of the cruciform
church. Its walls were constructed of the rock-
faced masonry that was to become Richard-
son's trademark; different sizes, shapes, and
colors of local granite were carefully arranged
in surface patterns. Richardson hired La Farge
to design and oversee the complex program of
interior decoration in the church.

In the succeeding decade, from 1876 until
his death in 1886, Richardson created masonry
buildings free of historical detail and exhibit-
ing extraordinary sensitivity to mass and sur-
face texture. These include a series of railroad
stations and public libraries in the suburbs of
Boston that, despite their small size, are of un-
usual monumentality, as well as the two works
of which Richardson was proudest: the Alle-
gheny County Courthouse and Jail (Pitts-
burgh, 1883–88) and the Marshall Field
Wholesale Store (Chicago, 1885–87). The
Norcross Brothers, master builders of Worces-
ter, Massachusetts, worked with Richardson
to achieve the remarkable quality of masonry
he required. The Trinity Church Rectory of
1879–80 (FIGS. 10.2, 10.3), which Richardson
built mostly of brick to blend with the adjacent
houses in Boston's Back Bay, nonetheless
demonstrates his compelling interest in the
texture and quality of stone, with his passion
for surface treatment manifested by the large
cut-brick floral panels (FIG. 10.4) that punc-
tuate the flat walls.

Richardson's dedication to unity of design

and quality of materials extended to his interior spaces. Natural-finish wood surfaces predominated, and particularly in his libraries and public buildings, all the furniture was conceived by him to harmonize with the building. Some of his designs, such as the benches for the Winn Memorial Public Library in Woburn, Massachusetts (1871–79), reflect the influence of the British architect E. W. GODWIN, whose work Richardson could have known through contemporary periodicals and publications. At the time of his death, Richardson was engaged in the creation of a private home for Mr. and Mrs. John J. Glessner in Chicago. CHARLES ALLERTON COOLIDGE, a member first of Richardson's office and then of the firm of Shepley, Rutan and Coolidge, Richardson's successors, assumed the completion of the interior spaces of the Glessner house.

REFERENCES

"Death of Henry H. Richardson, Architect," *American Architect and Building News* 19 (May 1, 1886), pp. 205–6 // H. Gillette Clark, "Richardson as an Interior Designer," *Art Amateur* 17 (Aug. 1887), pp. 62–63, 64 (ills.) // Arthur H. Chester, *Trinity Church in the City of Boston: An Historical and Descriptive Account* (Cambridge, Mass., 1888) // C. D. Gambrill and H. H. Richardson, *Trinity Church, Boston, Mass.* (Boston, 1888) // M. G. Van Rensselaer, *Henry Hobson Richardson and His Works* (New York, 1888; reprint New York, 1969) // Montgomery Schuyler, "The Romanesque Revival in New York," *Architectural Record* 1 (July–Sept. 1891), pp. 7–38 // Idem, "The Romanesque Revival in America," *Architectural Record* 1 (Oct.–Dec. 1891), pp. 151–98 // Horace Townsend, "H. H. Richardson, Architect," *Magazine of Art* 17 (1894), pp. 133–36 // John B. Gass, "American Architecture and Architects, with Special Reference to the Works of the Late Richard Morris Hunt and Henry Hobson Richardson," *Royal Institute of British Architects Journal* 3 (Feb. 6, 1896), pp. 229–32 // Museum of Modern Art, New York, *The Architecture of H. H. Richardson and His Times,* by Henry-Russell Hitchcock (exhib. cat., 1936) // Lewis Mumford, "The Regionalism of H. H. Richardson," in *The South in Architecture* (New York, 1941), pp. 79–110 // Henry-Russell Hitchcock, *The Architecture of H. H. Richardson and His Times,* rev. ed. (Hamden, Conn., 1961; reprint Cambridge, Mass., 1966) // Museum of Fine Arts, Boston, *The Furniture of H. H. Richardson,* by Richard H. Randall (exhib. cat., 1962) // "Richardson, Henry Hobson," in *Dictionary of American Biography,* vol. 8, pt. 1 (New York, 1963), pp. 566–70 // David T. Van Zanten, "H. H. Richardson's Glessner House, Chicago, 1886–87," *Journal of the Society of Architectural Historians* 23 (May 1964), pp. 106–11 // Henry-Russell Hitchcock, *Richardson as a Victorian Architect* (Baltimore, 1966) // Theodore E. Stebbins, Jr., "Richardson and Trinity Church: The Evolution of a Building," *Journal of the Society of Architectural Historians* 27 (Dec. 1968), pp. 281–98 // Leonard K. Eaton, *American Architecture Comes of Age: European Reaction to H. H. Richardson and Louis Sullivan* (Cambridge, Mass., 1972) // Leland B. Grant, "Richardsonian Architecture in America, 1886–1893" (M.A. thesis, New York University, 1974) //

Department of Printing and Graphic Arts, Harvard College Library, Cambridge, Mass., *H. H. Richardson and His Office: Selected Drawings,* by James F. O'Gorman (exhib. cat., 1974) // Henry-Russell Hitchcock, "An Inventory of the Architectural Library of H. H. Richardson," pts. 1, 2, *Nineteenth Century* 1 (Jan. 1975), pp. 27, 31; (Apr. 1975), pp. 18–19 // Lawrence Wodehouse, *American Architects from the Civil War to the First World War* (Detroit, 1976), pp. 162–70 // Robert F. Brown, "The Aesthetic Transformation of an Industrial Community," *Winterthur Portfolio* 12 (1977), pp. 35–64 // Cynthia D. Kinnard, "The Life and Works of Mariana Griswold Van Rensselaer, American Art Critic" (Ph.D. diss., Johns Hopkins University, 1977) // James F. O'Gorman, "Richardson, Henry Hobson," in *Who's Who in Architecture from 1400 to the Present,* ed. J. M. Richards (New York, 1977), pp. 268–72 // Lois Dinnerstein, "Opulence and Ocular Delight, Splendor and Squalor: Critical Writings in Art and Architecture by Mariana Griswold Van Rensselaer," 2 vols. (Ph.D. diss., City University of New York, 1979) // Anne Farnam, "H. H. Richardson and A. H. Davenport: Architecture and Furniture as Big Business in America's Gilded Age," in *Tools and Technologies: America's Wooden Age,* ed. Paul B. Kebabian and William C. Lipke (Burlington, Vt., 1979), pp. 80–92 // James F. O'Gorman, ed., "On Vacation with H. H. Richardson: Ten Letters from Europe, 1882," *Archives of American Art Journal* 19, no. 1 (1979), pp. 2–14 // Edgar de Noailles Mayhew and Minor Myers, Jr., *A Documentary History of American Interiors: From the Colonial Era to 1915* (New York, 1980), p. 288 (ill.) // Marian Page, *Furniture Designed by Architects* (London and New York, 1980), pp. 62–69 // Ann Jensen Adams, "The Birth of a Style: Henry Hobson Richardson and the Competition Drawings for Trinity Church, Boston," *Art Bulletin* 62 (Sept. 1980), pp. 409–33 // John Russell, "Henry Hobson Richardson," in *Three Centuries of Notable American Architects,* ed. Joseph J. Thorndike, Jr. (New York, 1981), pp. 110–29 // Jeffrey K. Ochsner, *H. H. Richardson: Complete Architectural Works* (Cambridge, Mass., and London, 1982) // William H. Pierson, Jr., "Richardson, H. H.," in *Macmillan Encyclopedia of Architects,* ed. Adolf K. Placzek, 4 vols. (New York, 1982), vol. 3, pp. 558–75 // James F. O'Gorman, "Documentation: An 1886 Inventory of H. H. Richardson's Library, and Other Gleanings from Probate," *Journal of the Society of Architectural Historians* 41 (May 1982), pp. 150–55 // David T. Van Zanten, "H. H. Richardson's Glessner House," *Journal of the Society of Architectural Historians* 41 (May 1982), pp. 105–11

Hugh C. Robertson, *see* **Chelsea Keramic Art Works**

James Robertson and Sons, *see* **Chelsea Keramic Art Works**

Rookwood Pottery

1880–1960
Cincinnati, Ohio
Ceramics

Maria Longworth (1849–1932) was an industrious woman with ambitions surpassing her social and family obligations. The Rookwood Pottery was her dream, brought to fruition with the financial backing of her father, Joseph Longworth, a devoted Cincinnati patron of the arts. Founded in 1880, Rookwood was among the nation's earliest art potteries and before long one of its most preeminent. By the time it closed in 1960 the pottery had enjoyed nearly a century of success.

In 1868, at the age of nineteen, Longworth married George Ward Nichols (1837–1885), a Civil War veteran who, like Maria's father, was active in the cultural life of Cincinnati. (In honor of her marriage, her father commissioned the English-born and trained wood carvers HENRY LINDLEY FRY and WILLIAM HENRY FRY to decorate the interior of her new home.) Music was George Nichols's main interest (though he had also been an art dealer in New York in the 1850s), but he also shared with his wife an involvement in the applied arts, on which he published two important books. The first, issued in 1877 and entitled *Art Education Applied to Industry,* dwelt upon the need for art education in the United States, the relation of education to industry, and methods for instruction in the applied arts. In 1878 he wrote *Pottery: How It Is Made, Its Shape and Decoration* (FIG. 7.30), which he reportedly based on his familiarity with the operations of EDWARD LYCETT'S New York studio. In this book Nichols enumerated principles to guide decoration and form, and provided practical instructions in china painting, his ultimate goal being to show that "the manufacture of pottery may become one of the great art industries of the United States." He illustrated the volume with six signed drawings by his wife based on Japanese prints.

Maria Longworth Nichols was first introduced to china painting in 1873 by a young artist named KARL LANGENBECK. She joined other Cincinnati women, among them M. LOUISE MCLAUGHLIN, LAURA FRY, and AGNES PITMAN, who embraced china painting with equal enthusiasm, and studied with Maria Eggers in the first china-painting classes offered, in 1874, at the University of Cincinnati School of Design. In 1879 M. Louise McLaughlin founded the Cincinnati Pottery Club to encourage china decoration. Nichols's invitation to the club's inaugural meeting reportedly never reached her, and taking this as a personal insult, she refused ever to join the organization. This was the start of a long rivalry between Nichols and McLaughlin. The two women concurrently experimented in ceramics decoration, and both worked at the commercial pottery of Frederick Dallas in Cincinnati, but in separate rooms.

In 1880 Nichols established her own pottery, which she called Rookwood, after her father's country estate. With her father's monetary support, Nichols was able to put the manufacture of art pottery above commercial concerns. Late in 1880 she hired Joseph Bailey, Jr. (and in 1881 his father, Joseph Bailey, Sr.), formerly of the Dallas Pottery, to superintend the works while she directed the artistic side of the business. Nichols's initial creations at Rookwood manifest her serious interest in the arts of Japan, which she and her husband collected

avidly. Japanese prints, notably those in the fifteen-volume *Manga* (or *Ten Thousand Sketches,* 1814–78) by Katsushika Hokusai, inspired the decoration on many of her vases of the early 1880s (FIGS. 7.31, 7.32). In October 1881 Nichols started a practical-art school, the Rookwood School for Pottery Decoration, with Laura Fry and Clara Chipman Newton (1848–1936) as two of its instructors. This venture was short-lived, however, and ended in the spring of 1883.

Many decorators were employed at Rookwood over the course of its history. Some of the most important during the Aesthetic period, in addition to Nichols, Fry, and Newton, were Albert R. Valentien (born Valentine, 1862–1925), hired in 1881, Matthew A. Daly (1860–1937) and William P. McDonald (1865–1931), both of whom joined in 1884, having previously worked for the Matt Morgan Pottery, and the Japanese artist Kataro Shirayamadani (1865–1948), who came to Rookwood in 1887. With the hiring of William Watts Taylor (1847–1913) in mid-1883 as manager of the pottery, Rookwood soon gained firm financial footing and became commercially successful. In 1889 a display of Rookwood wares decorated by Valentien and Shirayamadani received a gold medal at the Paris Exposition Universelle, signifying the achievement of an international reputation. Not long thereafter Nichols gave the pottery to Taylor as a present, naming him president in 1890, the year of its incorporation, and turning over its management to him entirely the following year.

In September 1885 George W. Nichols died, and in March 1886 Maria married Bellamy Storer, Jr., a prominent Cincinnati lawyer and politician active in the public life of the city. Due to her new responsibilities as his wife, she became less and less involved with Rookwood. In 1894, while living in Brussels, she began to work in bronze, and at the 1900 Exposition Universelle she won a gold medal for her work. But by the early years of the twentieth century her activities in the arts seem to have tapered off altogether. The pottery, meanwhile, continued to prosper under Taylor's direction, which lasted until 1913, and it produced artistic ceramics along with its production pieces in both high-glaze and matte finishes until the 1930s. Barely surviving the Great Depression and World War II, in 1960, following several reorganizations, the company closed its business in Cincinnati and moved to Starkville, Missouri. In 1967 it ceased operations completely.

REFERENCES
George Ward Nichols, *Art Education Applied to Industry* (New York, 1877) // Idem, *Pottery: How It Is Made, Its Shape and Decoration* (New York, 1878) // "Cincinnati Art Pottery," *Harper's Weekly* 24 (May 29, 1880), pp. 341–42 // Constance Cary Harrison, *Woman's Handiwork in Modern Homes* (New York, 1881), pp. 110–11 // Mrs. Aaron F. Perry, "Decorative Pottery of Cincinnati," *Harper's New Monthly Magazine* 62 (May 1881), pp. 834–45 // "The Potteries: Cincinnati," *Crockery and Glass Journal* 13 (Apr. 14, 1881), p. 23 // "Cincinnati Reports," *Crockery and Glass Journal* 14 (Nov. 3, 1881), p. 16 // "Cincinnati Reports," *Crockery and Glass Journal* 16 (Sept. 21, 1882), p. 16 //

Mary Gay Humphreys, "Cincinnati Pottery at the Bartholdi Exhibition," *Art Amateur* 10 (Feb. 1884), pp. 69–70 // "Colonel George Ward Nichols," *Harper's Weekly* 29 (Sept. 26, 1885), p. 631 // Clarence Cook, "The Exhibition of American Pottery and Porcelain," *Art Amateur* 20 (Dec. 1888), pp. 5–6 // Elizabeth W. [Mrs. Aaron F.] Perry, "The Work of Cincinnati Women in Decorated Pottery," in *Art and Handicraft in the Woman's Building of the World's Columbian Exposition, Chicago, 1893,* ed. Maud Howe Elliott (Paris and New York, 1893), pp. 80–86 // [Karl Langenbeck to John F. Low, correspondence, Aug. 17, 1893], *Pottery Collectors' Newsletter* 3 (Aug. 1974), pp. 156–60 // Maria Longworth Storer, *The History of Cincinnati Music Festivals and of Rookwood Pottery* [1895] (Paris, privately printed, 1919) // John Valentine, "Rookwood Pottery," *House Beautiful* 4 (Sept. 1898), pp. 120–29 // Lawrence Mendenhall, "Cincinnati's Contribution to American Ceramic Art," *Brush and Pencil* 17 (Feb. 1906), pp. 47–61 // Clara Ruge, "American Ceramics: A Brief Review of Progress," *International Studio* 28 (Mar.–June 1906), pp. xxi–xxviii // "Activities of the Society: Necrology, Mrs. Bellamy Storer," *Bulletin of the American Ceramic Society* 11 (June 1932), pp. 157–59 // "Rookwood Living Proof of Profit in Nonprofiteering Industry," *Bulletin of the American Ceramic Society* 13 (Jan. 1934), pp. 7–8 // H. F. Bopp, "Art and Science in the Development of Rookwood Pottery," *Bulletin of the American Ceramic Society* 15 (Dec. 1936), pp. 443–45 // Kenneth E. Smith, "Laura Anne Fry: Originator of Atomizing Process for Application of Underglaze Color," *Bulletin of the American Ceramic Society* 17 (Sept. 1938), pp. 368–72 // Ross C. Purdy, "Rookwood Pottery," *Bulletin of the American Ceramic Society* 19 (Jan. 1940), pp. 43–44 // Marion John Nelson, "Art Nouveau in American Ceramics," *Art Quarterly* 26 (Winter 1963), pp. 441–59 // Herbert Peck, *The Book of Rookwood Pottery* (New York, 1968) // Kenneth R. Trapp, "Maria Longworth Storer: A Study of Her Bronze Objets d'Art in the Cincinnati Art Museum" (M.A. thesis, Tulane University, 1972) // Paul Evans, "Cincinnati Faience: An Overall Perspective," *Spinning Wheel* 28 (Sept. 1972), pp. 16–18 // Kenneth R. Trapp, "The Bronze Work of Maria Longworth Storer," *Spinning Wheel* 28 (Sept. 1972), pp. 14–15 // Sue Brunsman, "The European Origins of Early Cincinnati Art Pottery, 1870–1900" (M.A. thesis, University of Cincinnati, 1973) // Kenneth R. Trapp, "Japanese Influence in Early Rookwood Pottery," *Antiques* 103 (Jan. 1973), pp. 193–97 // Paul Evans, *Art Pottery of the United States: An Encyclopedia of Producers and Their Marks* (New York, 1974), pp. 255–60 // Cincinnati Art Museum, *The Ladies, God Bless 'Em: The Women's Art Movement in Cincinnati in the Nineteenth Century* (exhib. cat., 1976) // Anthea Callen, *Women Artists of the Arts and Crafts Movement, 1870–1914* (New York, 1979), pp. 79–85, 226 // Garth Clark, *A Century of Ceramics in the United States, 1878–1978* (New York, 1979), pp. 6–10, 43–44, 260–61, 313–14, figs. 6, 9, 10, 15–17 // William Benton Museum of Art, University of Connecticut, Storrs, *American Decorative Tiles, 1870–1930,* by Thomas P. Bruhn (exhib. cat., 1979), pp.

27–28 (ills.), 43 // Jordan-Volpe Gallery, New York, *Ode to Nature: Flowers and Landscapes of the Rookwood Pottery, 1880–1940,* by Kenneth R. Trapp (exhib. cat., 1980) // Todd M. Volpe, "Rookwood Landscape Vases and Plaques," *Antiques* 117 (Apr. 1980), pp. 838–46 // Ruth Amdur Tanenhaus, "Rookwood: A Cincinnati Art Pottery," *Art and Antiques* 3 (July/Aug. 1980), pp. 75–81 // Kenneth R. Trapp, "Rookwood and the Japanese Mania in Cincinnati," *Cincinnati Historical Society Bulletin* 39 (Spring 1981), pp. 51–75 // Idem, "Toward a Correct Taste: Women and the Rise of the Design Reform Movement in Cincinnati, 1874–1880," in Cincinnati Art Museum, *Celebrate Cincinnati Art* (exhib. cat., 1982), pp. 49–70 // Denny Carter Young, "The Longworths: Three Generations of Art Patronage in Cincinnati," in Cincinnati Art Museum, *Celebrate Cincinnati Art* (exhib. cat., 1982), pp. 29–48 // Detroit Institute of Arts, *The Quest for Unity: American Art Between World's Fairs, 1876–1893* (exhib. cat., 1983), pp. 196–98 (ills.), 265–66 (ill.) // Jordan-Volpe Gallery, New York, *Toward the Modern Style: Rookwood Pottery, the Later Years, 1915–1950,* by Kenneth R. Trapp (exhib. cat., 1983) // Joan Siegfried, "American Women in Art Pottery," *Nineteenth Century* 9 (Spring 1984), pp. 12–18 // Kenneth R. Trapp, "Rookwood Pottery and the Application of Art to Industry: Design Reform in Cincinnati, 1875–1900" (Ph.D. diss., University of Illinois, Urbana-Champaign), in preparation // *Rookwood Pottery* (Cincinnati, n.d.) // *Rookwood Pottery, Founded in 1880: Its History and Its Aims* (Cincinnati, n.d.).

Augustus Saint-Gaudens
1848–1907
New York City and
 Cornish, New Hampshire
Sculptor

Augustus Saint-Gaudens was one of the giants of nineteenth-century American art. Born in Dublin, Ireland, he was the son of a French father and an Irish mother, who brought him to the United States while he was still an infant. His desire to become an artist led to an apprenticeship with two cameo cutters working in New York City. He attended some classes in New York, at the Cooper Union for the Advancement of Science and Art and at the National Academy of Design, but his formal training in sculpture did not begin until 1867, when he moved to Paris to study. Saint-Gaudens was the first American sculptor to choose that city instead of Rome or Florence. After briefly attending classes at the Ecole Gratuite de Dessin (called the Petite Ecole), he entered the atelier of François Jouffroy (1806–1882) until March 1868, when he was admitted to the Ecole des Beaux-Arts. In 1870, at the outbreak of the Franco-Prussian War, Saint-Gaudens moved to Rome, which, with the exception of a hiatus of about one year in New York, was his home for the next five years.

In 1875 Saint-Gaudens returned to New York. He set up a studio and joined a circle of friends that included the artist JOHN LA FARGE and the architects Stanford White and Charles Follen McKim. He supported himself primarily by carving cameos and copies of antique

busts and executing decorative motifs for silver presentation pieces, among them the Bryant Vase (FIG. 8.1) designed by James Horton Whitehouse of TIFFANY AND COMPANY. In 1877 he joined the Tile Club and, with La Farge, Olin Levy Warner (1844–1896), HELENA DE KAY, WILL H. LOW, and several other artists, founded the Society of American Artists, largely because the National Academy of Design had refused to accept one of his works for its annual exhibition.

The collaborative relationship of La Farge, White, and McKim exerted a profound influence on Saint-Gaudens, who produced, with La Farge, some of the crowning successes of the American Aesthetic movement, including the interior decoration of New York's Saint Thomas Church and the Cornelius Vanderbilt II mansion (designed in 1880 by George B. Post, 1837–1913) at Fifth Avenue and Fifty-seventh Street in New York. The sumptuously embellished entrance hall of the Vanderbilt house contained a monumental Numidian-marble mantelpiece, now in the Metropolitan Museum, which incorporated a mosaic overmantel by La Farge and two great caryatids by Saint-Gaudens representing Love and Peace. For the dining room (ILL. 9.13), forty-five feet in length, the two men created an opulent environment featuring figural panels carved from precious woods (mahogany and holly) and adorned with inlays of marble, repoussé bronze, ivory, mother-of-pearl, and coral (FIG. 9.6, ILL. 9.5).

Each of these experiences helped shape the sculptor's future art. His disciplined training as a cameo cutter is evident in his later mastery of relief sculpture. His studies in Paris taught him to work with bronze, and the French Beaux-Arts style inspired him with its richly textured surfaces and dramatically posed sculpture. In Italy, he was deeply influenced by the sculpture of the early Renaissance and especially by the fifteenth-century masters Ghiberti, Verrocchio, Della Robbia, and Donatello. Through his friendships with La Farge, White, and McKim, he acquired the sensibility of the Aesthetic movement. By 1881, when the *Farragut Memorial* was unveiled in Madison Square Park in New York, Saint-Gaudens was able to synthesize these formative experiences into a dramatic personal style. During the following thirty years he remained the most influential sculptor in America. A prolific artist, he modeled more than one hundred portraits and medals. His public statuary includes the standing and seated Lincolns (1884–87 and 1897–1906) in Chicago, the *Adams Memorial* (1890–91) in Washington, D.C., the *Memorial to Robert Gould Shaw* (1897) in Boston, and the equestrian statue of General Sherman (1903) in New York.

REFERENCES
"New Houses—Indoors and Out," *Art Amateur* 8 (Feb. 1883), pp. 66–68 // Mary Gay Humphreys, "The Cornelius Vanderbilt House," *Art Amateur* 8 (May 1883), pp. 135–36 // Idem, "The Progress of American Decorative Art," *Art Journal* (London), Jan. 1884, pp. 25–28; Nov. 1884, pp. 345–48 // Kenyon Cox, "Augustus Saint-Gaudens," *Century Illustrated Monthly Magazine* 35 (Nov. 1887), pp. 28–37 // William Walton, "The Decorations of the Chancel of Saint Thomas' Church, New York City: Work of John La Farge and Augustus Saint-Gaudens," *Craftsman* 9 (Dec. 1905), pp. 369–73 // Royal Cortissoz, *Augustus Saint-Gaudens* (Boston and New York, 1907) // C. Lewis Hind, *Augustus Saint-Gaudens* (New York, 1908) // Metropolitan Museum of Art, New York, *Catalogue of a Memorial Exhibition of the Works of Augustus Saint-Gaudens*, 2d ed. (New York, 1908) // Homer Saint-Gaudens, ed., *The Reminiscences of Augustus Saint-Gaudens,* 2 vols. (New York, 1913) // "Augustus Saint-Gaudens," in *Index of Twentieth Century Artists,* vol. 1 (New York, 1934), pp. 113–23 // Margaret I. Bouton, "The Early Works of Augustus Saint-Gaudens" (Ph.D. diss., Radcliffe College, 1946) // John W. Bond, "Augustus Saint-Gaudens: The Man and His Art," typescript, 1968, Office of Archaeology and Historic Preservation, National Park Service, Washington, D.C. // National Portrait Gallery, Washington, D.C., *Augustus Saint-Gaudens: The Portrait Reliefs,* by John H. Dryfhout and Beverly Cox (exhib. cat., 1969) // Louise H. Tharp, *Saint-Gaudens and the Gilded Era* (Boston, 1969) // John H. Dryfhout, "Augustus Saint-Gaudens: The Portraits in Bas-relief," *American Art Journal* 4 (Nov. 1972), pp. 84–95 // Lincoln Kirstein and Richard Benson, *Lay This Laurel: An Album on the Saint-Gaudens Memorial on Boston Common Honoring Black and White Men Together Who Served the Union Cause with Robert Gould Shaw and Died with Him July 18, 1863* (New York, 1973) // John H. Dryfhout, "Augustus Saint-Gaudens' *Actaeon* and the Cornelius Vanderbilt II Mansion," *J. B. Speed Art Museum Bulletin* 31 (Sept. 1976), pp. 2–13 // Lois Goldreich Marcus, "Studies in Nineteenth-Century American Sculpture: Augustus Saint-Gaudens (1848–1907)" (Ph.D. diss., City University of New York, 1979) // John H. Dryfhout, *The Work of Augustus Saint-Gaudens* (Hanover, N.H., and London, 1982) // Henry A. La Farge, "John La Farge's Work in the Vanderbilt Houses," *American Art Journal* 16 (Autumn 1984), pp. 30–70 // Kathryn Greenthal, *Augustus Saint-Gaudens: Master Sculptor* (New York, 1985) // Burke Wilkinson, *Uncommon Clay: The Life and Works of Augustus Saint-Gaudens* (San Diego, 1985)

Alexandre Sandier, *see* Herter Brothers

Isaac Elwood Scott
1845–1920
Philadelphia, Chicago, New York, Boston
Furniture, wood carving, and ceramics

In America as well as in England, the Modern Gothic style constituted an early phase of the design-reform movement. Once associated solely with the ecclesiastical arts, medieval concepts of design and methods of construction now sanctified the domestic interior and its furnishings. Nowhere, perhaps, was the Modern Gothic more ardently promoted in the years preceding the Philadelphia Centennial Exposition of 1876 than in Chicago, where the devastation following the fire of 1871 required extensive rebuilding of the city and thus created special opportunities for architects, designers, and craftsmen.

Isaac Elwood Scott, an accomplished but largely self-taught wood carver from the Manayunk section of Philadelphia, moved to Chicago within two years of the fire. He quickly became known for fine woodworking and was also associated with the Chicago Terra Cotta Company as a modeler of architectural ornament.

Chicago city directories reflect Scott as peripatetic; a different address each year between 1873 and 1883 suggests that he did not establish a studio or workshop of any size. For about two years after his arrival, Scott was a partner of architect Frederick W. Copeland in a firm recorded in the directories as "Scott and Copeland, Designers, Carvers, and Art Wood Workers."

A display of "artistic" household furnishings organized by the architects William Le Baron Jenney (1832–1907) and P. B. WIGHT for the 1875 Inter-State Industrial Exposition in Chicago did much to enhance Scott's reputation: of the five pieces (two armchairs, two sideboards, and a bookcase) illustrated in an Appleton's *Art Journal* account of the presentation, all but one had been carved by Scott. It must have been at this exhibition that Mr. and Mrs. John J. Glessner, Scott's generous patrons and lifelong friends, first saw his work. In December 1875 they commissioned from Scott the first of many pieces for their Chicago home, at 261 West Washington Boulevard. The tall, rectilinear bookcase with flying-buttress supports that he made for them is exemplary of the Modern Gothic style (ILL. 4.6). It is important to note that the great similarity between Scott's piece and a bookcase designed by Copeland (albeit carved by Scott), which had been displayed at the exposition, suggests that the design of the Glessners' bookcase was not Scott's conception alone. Nevertheless, for the rest of the decade, while he executed furniture designed by the architects Burnham and Root as well as Jenney, Scott also created for the Glessners distinctive bedroom and library pieces and at least four pilgrim vases with relief decoration (FIG. 7.14), which in 1879 he made at the CHELSEA KERAMIC ART WORKS in Massachusetts. In 1878 Scott designed a coach house for the Glessner home in association with the architect and furniture designer Asa Lyon.

During the early 1880s Scott began designing textiles and embroidery patterns, and between 1882 and 1884 he taught wood carving at the Chicago Society of Decorative Art. Primarily, however, he practiced architecture. His summer home for the Glessners at The Rocks, near Littleton, New Hampshire, was built in 1883. In 1882–84 a short-lived partnership with Henry S. Jaffray, in which Scott specialized in interiors, produced a new Chicago headquarters for John Glessner's firm, Warder, Bushnell and Glessner (part of International Harvester after 1902), at least one substantial residence, and a six-story downtown office building. The Glessner building, although somewhat altered, still stands at the corner of Jefferson and Adams streets in Chicago. By the end of 1884 Scott had split with Jaffray and left Chicago to settle in New York City, where, according to existing drawings, he again concentrated on designing interiors; one drawing dated 1887 gives his address as 1129 Broadway.

Scott changed cities for the last time in 1888, when he moved to Boston. There he returned to his original occupation of wood carver and later taught crafts at the Eliot School.

Meanwhile, in 1885 the Glessners commissioned H. H. RICHARDSON to design their new home at 1800 Prairie Avenue in Chicago, and although Scott's furniture from the 1870s was proudly installed there in 1887, he was given no role in the design of the interiors. Scott remained a personal friend of the Glessners and often summered at the New Hampshire home he had designed. He died in Melrose, Massachusetts, at the age of seventy-five.

REFERENCES

Mrs. John J. Glessner, unpublished journals [1870]–1921, Chicago Historical Society // "Household Art in Chicago," *Art Journal* (Appleton's) 2 (Jan. 1876), pp. 18–19; and correction (Feb. 1876), p. 64 // David A. Hanks, *Isaac E. Scott: Reform Furniture in Chicago: John Jacob Glessner House* (Chicago, 1974) // Idem, "Isaac E. Scott, Craftsman and Designer," *Antiques* 105 (June 1974), pp. 1307–13 // Detroit Institute of Arts, *The Quest for Unity: American Art Between World's Fairs, 1876–1893* (exhib. cat., 1983), pp. 266–67 // Docents of the Chicago Architecture Foundation, "Glessner House Interiors—the Artists and Their Arts," in "A Docent Resource and Training Manual for the John Jacob Glessner House, 1886," typescript, 1983, pp. 11–14 // Sharon Darling, *Chicago Furniture: Art, Craft, and Industry, 1833–1983* (New York, 1984), pp. 159, 163–69, 186, ill. opp. p. 194, 223, 391 // Elaine Harrington, Chicago Architecture Foundation, correspondence, Mar. 4, 1985 // Mary Alice Molloy, Chicago Architecture Foundation, notes and correspondence, Jan. 18, 19, 1986

Richard Norman Shaw, *see* Thomas Edward Collcutt

Shepley, Rutan and Coolidge, *see* Charles Allerton Coolidge

Kataro Shirayamadani, *see* Rookwood Pottery

Frederick S. Shirley, *see* Mount Washington Glass Company

Smith Brothers
1877–1899
New Bedford, Massachusetts
Glass decorators

For many, the name of Smith Brothers was synonymous with the finest hand-painted art glass produced during the last quarter of the nineteenth century in America. Alfred E. (1836–1926) and Harry A. Smith (about 1840–1916), the two proprietors, were born in Birmingham, England, before mid-century and were schooled in their craft by their father, William L. Smith (b. 1789), a glass painter and decorator. William began a seven-year apprenticeship to the glassmaking firm of Biddle, Lloyd and Summerfield in Birmingham about 1839. He had his own glass-decorating company for a number of years before 1851, when he was recruited by Deming Jarves (1790–1863) to head the decorating department of the BOSTON AND SANDWICH GLASS COMPANY in Massachusetts. Three of William's children joined him in the business of glass decoration: Alfred and Harry are known to have worked for Jarves's firm, and all three Smiths plus another brother, Samuel, were listed as "glass decorators" in the 1860 Sandwich census.

Eventually their father started his own firm, the Boston China Decorating Works, and in 1871 both Alfred and Harry relocated to New Bedford to head the decoration department at the MOUNT WASHINGTON GLASS COMPANY. After three years, the Smiths leased space from the glassworks and established themselves as an independent entity known simply as Smith Brothers. They continued throughout the history of their firm to concentrate exclusively on the decoration of glass objects (rather than on production) and perfected the delicate art of fusing colors onto glass surfaces. The blanks they used, which were very often made of opaque white opal glass, were purchased from a number of American and English manufacturers. Because most of these blanks were unmarked by the producers, it is difficult to distinguish their origin or, therefore, to establish a chronology for Smith Brothers' work. One form in particular, a cylindrical vase with hollow rings at top and bottom, was made in Sandwich as well as New Bedford and was embellished by the Smith Brothers—among others—in such quantities that it acquired a generic name, the Smith vase, regardless of the individual decorator involved.

Smith Brothers' painted decoration ran the gamut of Aesthetic-movement taste, including birds in blossoming foliage, herons among reeds and rushes, small landscape vignettes, and flowers and butterflies of every description (FIG. 7.53). They were also noted for their giltwork; it is said that they preferred the rich, red gold hue of melted-down British sovereigns for this purpose. In addition, Smith Brothers marketed cut, engraved, and etched wares as well as plaques, tiles, salts, lampshades, and vases in great variety.

For the Smith Brothers as for many other decorative artists, the 1876 Centennial Exposition in Philadelphia had the beneficial effect of publicizing their skills. By 1877 they had their own address on Prospect Street in New Bedford, and by the mid-eighties they were operating at 28–30 William Street, with a branch office and showroom in New York City by about 1890. Despite their great success for nearly three decades, Smith Brothers filed for bankruptcy in 1899, apparently the result of management conflicts. Harry Smith went to work in Meriden, Connecticut, for a time before returning to New Bedford, where he died in 1916. Alfred Smith remained in New Bedford, where he had his own workshop, the A. E. Smith Company, for a few years, but he ultimately returned to the Mount Washington Glass Company, which by then had merged with the Pairpoint Corporation.

REFERENCES

[Photographs taken from a catalogue of photographs of glasswares decorated at the Smith Brothers Decorating Company], New Bedford, ca. 1880s, Corning Museum of Glass Library, N.Y. // Albert Christian Revi, *Nineteenth Century Glass: Its Genesis and Development,* rev. ed. (Exton, Pa., 1967), pp. 71, 73, 81–86 // George C. Avila, *The Pairpoint Glass Story* (New Bedford, 1968), pp. 43 (ill.), 61–63 // Kenneth M. Wilson, *New England Glass and Glassmaking* (New York and Toronto, 1972), pp. 344–48 // Leonard E. Padgett, *Pairpoint Glass* (Des Moines, Iowa, 1979), pp. 51–58 // Marilyn Myers Slade, "Smith Brothers Decorated Glass," *MassBay Antiques* 4 (Aug. 1983), pp. 1, 27 // Wesley E. Lake, New Bedford Glass Museum, New Bedford Glass Society, Inc., conversation, 1984 // Jon H. Wetz, "Ring Vases—Sandwich or New Bedford?" *Sandwich Collector: A Quarterly Journal for the Serious Glass Collector* 1 (July 1984), pp. 3–15, cover (ill.) // Martha Hassell, Glass Museum, Sandwich Historical Society, Mass., correspondence, July 23, 1984 // Janie Chester Young, New Bedford Glass Museum, New Bedford Glass Society, Inc., correspondence, Aug. 9, 1984

David Smith, *see* Griffen, Smith and Company

J. Moyr Smith
Active 1868–1894
London
Decorative artist

John Moyr Smith, known as Moyr Smith, is perhaps best understood as an industrious secondary figure of the Aesthetic movement in England. He was an illustrator, a designer of decorative tiles, and the author of a history of interiors. Unfortunately, no information is readily available about Smith's education other than his architectural training in the Glasgow office of William Salmon. His period of activity can be dated from the publication of his first book until the last year he exhibited works at the Royal Academy of Arts in London.

Smith started his career in the 1860s as a designer in the studio of CHRISTOPHER DRESSER, to whom in 1868 he dedicated his book *Studies for Pictures*. About twenty years later, however, in his 1887 *Ornamental Interiors, Ancient and Modern,* a history of decoration from Egypt to modern times, Smith not only minimized Dresser's contribution to the period, but also intimated that he himself deserved recognition for many of Dresser's famed designs: "Here we may claim a small share in the art movement. . . . The author made some thousands of designs for furniture, decorations, wallpapers, carpets, tapestries, metal work, and pottery, which were executed by firms of high standing. Many of these designs, however, were done in the studio of a well-known ornamentist, and were given to the world as his work" (Smith, 1887, pp. 62–63).

During the early 1870s Smith was associated with the London furniture makers COLLINSON AND LOCK. He contributed some of the designs and lithographed the plates for the firm's 1871 catalogue, *Sketches of Artistic Furniture.* Lewis F. Day (1845–1910) somewhat facetiously later described Smith as "a vigorous disciple" of the Modern Gothic designer BRUCE J. TALBERT who "out-Talberted" his mentor in furniture

design (Day, 1887, p. 194). Indeed Smith, a great admirer of Talbert's work, in his *Ornamental Interiors* traced public interest in art furniture to the 1867 publication of Talbert's *Gothic Forms Applied to Furniture, Metal Work, and Decoration for Domestic Purposes* (FIG. 5.1).

The many books Smith illustrated ranged in subject from fairy tales to Shakespeare and from Plutarch to Robert Burns. He specialized in allegorical and literary figures, usually clothed in classical drapery, medieval garb, or Elizabethan dress. His avid, almost scholarly interest in classical costume and the decorative treatment of the figure is evident in his *Ancient Greek Female Costume,* published in 1882, an update of Thomas Hope's *Costume of the Ancients* (1809), to which Smith added drawings that he had copied from Greek pottery in the British Museum and the Louvre.

Smith's illustrations found a broader application in designs for tiles. He worked as a freelance artist for MINTON AND COMPANY, starting about 1875, as well as for Minton, Hollins and Company and for W. B. Simpson and Sons. Smith's *Album of Decorative Figures,* published in 1882, depicts several of his ideas for Minton tiles, many of which were exhibited at the 1878 Paris Exposition Universelle and illustrated in *Decoration,* a journal that Smith edited from 1881. One such example is "The Rose," which also appeared on Minton china with the addition of a decorative border (FIG. 7.12); it was one of six designs Smith based on the lyric verse of Anacreon, an ancient Greek poet of the sixth century B.C., who celebrated wine and love. American firms, many of them staffed by Englishmen, produced tiles with similar pictorial subjects (FIG. 7.36). Minton products were imported in great numbers to the United States, and some of Smith's tiles no doubt found their way into American homes. There is some evidence that Smith may even have had American clients of his own: two of the designs contained in the *Album of Decorative Figures* were executed for a Mr. Joy of Boston.

REFERENCES
James Boshwell [J. Moyr Smith], *The Book of Daubiton . . . Illustrated* (London, 1878) // J. Moyr Smith, *Album of Decorative Figures* (London, 1882) // Idem, *Ancient Greek Female Costume* (London, 1882) // Idem, *Ornamental Interiors, Ancient and Modern* (London, 1887) // Lewis F. Day, "Victorian Progress in Applied Design," *Art Journal* (London), June 1887, pp. 185–202 // J. Moyr Smith, *Legendary Studies and Other Sketches for Decorative Figure Panels* (London [1889]) // Julian Barnard, *Victorian Ceramic Tiles* (Greenwich, Conn., 1972), pp. 44, 83, figs. 16, 74, 86 // Jill Austwick and Brian Austwick, *The Decorated Tile: An Illustrated History of English Tile-making and Design* (London, 1980), pp. 55 (ill.), 91, 105–7 (ills.) // Simon Jervis, "Smith, J. Moyr," in *The Penguin Dictionary of Design and Designers* (Harmondsworth, Eng., and New York, 1984), pp. 454–55

Thomas Carll Smith, *see* Union Porcelain Works

Marc-Louis Solon, *see* Minton and Company

South Wheeling Glass Works, *see* Hobbs, Brockunier and Company

Harriet Prescott Spofford
1835–1921
Newburyport, Massachusetts
Author

Although relatively unknown now, during the last quarter of the nineteenth century Harriet Elizabeth Prescott Spofford was a prolific author of stories, articles, and poems that ensured her name as a household word for more than a generation. She was born in Calais, Maine, where she lived until the age of fourteen. Following the 1848 discovery of gold, in 1849 her father moved to the West Coast for several years to seek his fortune; his family, meanwhile, took up residence in Newburyport, Massachusetts. Harriet attended the Putnam Free School in Newburyport and the Pinkerton Academy in Derry, New Hampshire. Her natural talent for writing became a means of financial support for the Prescott family after her father's return from the West with his health broken, and her mother's subsequent illness. She achieved little recognition, however, until 1859, when "In a Cellar," a story of Parisian life, was published in the *Atlantic Monthly;* her romantic imagination and luxuriant writing style gained her immediate popularity. In 1865 she married Richard Smith Spofford, Jr., a Newburyport lawyer; the couple lived for several years in Washington, D.C. In 1874 the Spoffords purchased Deer Island, situated in the Merrimack River near Newburyport. It was in this quiet retreat that Harriet Spofford lived and worked for the rest of her life.

Art Decoration Applied to Furniture (FIG. 2.3), published in 1878, connects Spofford with the Aesthetic movement in America. Written as a history of furniture forms and styles coupled with decorating advice, the book, which had previously been issued as a series of articles in *Harper's Bazar* and *Harper's New Monthly Magazine,* became a vehicle for popular aesthetic ideas. Clearly Spofford was familiar with CHARLES LOCKE EASTLAKE's 1868 *Hints on Household Taste,* which had inspired several American publications similar to hers. She acknowledged a debt to CHRISTOPHER DRESSER and Eugène Emmanuel Viollet-le-Duc (1814–1879), among others, as well as to such publications as A. C. Racinet's *Polychromatic Ornament* (1873) and the handbooks of London's South Kensington schools. HERTER BROTHERS, A. KIMBEL AND J. CABUS, and COTTIER AND COMPANY were some of the American firms that provided her with information and designs; MORRIS AND COMPANY was one of the British names she mentioned.

English art furniture is very much in evidence in her book. The frontispiece is a three-part embroidered screen designed by WALTER CRANE (FIG. 3.20), executed by the students at the Royal School of Art Needlework in London, that was exhibited at the 1876 Philadelphia Centennial Exposition. Illustrations of furniture in the Modern Gothic style predominate in *Art Decoration Applied to Furniture.* Several Modern Gothic interiors that are pictured are reproduced from, though not credited to,

BRUCE J. TALBERT's influential *Gothic Forms Applied to Furniture, Metal Work, and Decoration for Domestic Purposes* (1867), published in America in 1873. Spofford devotes individual chapters to the evolution of forms ("The Seat," "The Table," "The Sideboard," and so on), the decoration of rooms in the house, and the history of styles, including the then-popular Moorish, oriental, Queen Anne, and Eastlake fashions.

Art Decoration Applied to Furniture contributed to the aesthetic mania that captivated a great many Americans in the 1870s and 1880s. It is unique in Spofford's oeuvre, however. She did not continue to write in this vein, although a few of her subsequent works, especially *The Servant Girl Question* (1881) and *Hearth and Home* (1891), dealt with the subject of domestic life and manners.

REFERENCES
Harriet Prescott Spofford, *Art Decoration Applied to Furniture* (New York, 1878) // Idem, *House and Hearth* (New York, 1891) // "Spofford, Harriet Elizabeth (Prescott)," in *The National Cyclopaedia of American Biography,* vol. 4 (New York, 1895), p. 308 // "Spofford, Harriet Prescott," in *Appletons' Cyclopaedia of American Biography,* ed. James Grant Wilson and John Fiske, vol. 5 (New York, 1900), pp. 633–34 // M. G. Morrison, "Memories of Mrs. Spofford," *Bookman* 62 (Nov. 1925), pp. 315–18 // Elizabeth K. Halbeisen, *Harriet Prescott Spofford: A Romantic Survival* (Philadelphia, 1935) // "Spofford, Harriet Elizabeth (Prescott)," in *American Authors, 1600–1900: A Biographical Dictionary of American Literature,* ed. Stanley J. Kunitz and Howard Haycraft (New York, 1938), pp. 707–8 // "Spofford, Harriet Elizabeth Prescott," in *Dictionary of American Biography,* vol. 9, pt. 1 (New York, 1964), pp. 464–65 // Martha Crabill McClaugherty, "Household Art: Creating the Artistic Home, 1868–1893," *Winterthur Portfolio* 18 (Spring 1983), pp. 1–26

Vincent Stiepevich
1841–at least 1910
New York City
Decorative painter

The formation of public museums and museum art schools was one significant result of the design-reform movement in both England and America. Following the example of London's South Kensington Museum (now the Victoria and Albert Museum), New York's Metropolitan Museum of Art was established in 1870, and a decade later its art school opened. The school's early emphasis was industrial-art education; classes in woodworking and metalwork were the first to be offered. By 1882 carriage drafting, ornamental design, and a women's class in the use of tempera on leather, silk, satin, and glass were also available.

Vincent G. Stiepevich, who had a decorating firm in New York, is first mentioned in conjunction with the Metropolitan Museum's school in 1882, as a member of the Museum's Committee on Art Schools and Industrial Art. In 1885, or possibly 1886, he began to teach a class advertised as "Water Color, Window and Wall Decoration" for anyone interested in "a

knowledge of Color and Drawing applicable to various art industries"; his course was offered regularly until 1892. After that, classes in ornamental and architectural design were dropped, and the Museum's art training consisted of traditional academic fine-arts classes, such as drawing and modeling from casts and live models.

A remarkable set of watercolor drawings probably from the 1880s documents Stiepevich's conceptions of window, wall, and ceiling treatments as well as some of his designs for painted furniture and provides a rare example of actual interior-decoration schemes from the period (FIGS. 4.6, 4.7). Stiepevich borrowed from a wide range of historical periods, as evidenced by his studies for a Louis XVI reception parlor, a Queen Anne drawing room, and a sitting room in the Anglo-Japanesque style.

Stiepevich's artistic career began in the 1860s in Italy, where, according to the U.S. Census of 1900, he had been born (either in Florence or Venice) in 1841. He studied with the Austrian history painter Karl von Blaas (1815–1894) at the Royal Academy of Venice, where he won a bronze medal in 1862 and a grand prize three years later for his efforts in watercolor. After studying decorative painting, he went to Milan as a muralist in 1868. The following year he exhibited some of his paintings in Vienna, where in all likelihood he met and married his Austrian wife.

Stiepevich was invited to decorate the Grand Hall of the Saint Louis Chamber of Commerce, and for this reason he emigrated to the United States with his family in 1872. Within six years he was in New York with a studio at 1193 Broadway, which he maintained until at least 1894; it was also the address of his firm, V. G. Stiepevich and Company, Mural Decorators, in which the Brooklyn artist Robert J. Pattison (1838–1903) was a partner. In addition to murals, Stiepevich executed genre paintings in both oil and watercolor, scenes of Venice, peasant life, and exotic harem women in Middle Eastern interiors, which he delighted in depicting under dramatic light and in rich detail—colorful earthenware tiles and oriental carpets, polished brass lanterns, furniture inlaid with mother-of-pearl, and glimmering jewels—all rendered with great fidelity. Like his contemporary EDWARD LAMSON HENRY, he occasionally portrayed the American interior, as in *Victorian Interior* of 1880 (New York Art Market, 1985), a fascinating record of a contemporaneous dining room in a wealthy New York home.

Starting in 1878, Stiepevich exhibited his works often at the National Academy of Design, New York, and at the Brooklyn Art Association. In fact, one of his 1878 exhibited paintings belonged to a "Mrs. de Cesnola," which suggests Stiepevich may have had an entrée to the Metropolitan Museum even before his association with its art school. (Luigi Palma di Cesnola was the Museum's secretary from 1877 until 1904 and its director from 1879 until 1904.) In 1880 Stiepevich submitted a study for a lunette mural to the Metropolitan Museum, but the proposed painting was not accepted.

Between 1885 and 1887 the city directories record the artist's residence in Elizabeth, New Jersey; thereafter, until at least 1910, he lived

in Brooklyn. He was a member of the Artists' Fund Society between 1900 and 1910, serving as its secretary in 1903–1904. No further records of the artist's life after 1910 have come to light.

REFERENCES
Alfred Trumble, "The School of Venice," with original illustrations by Vincent G. Stiepevich, *Monthly Illustrator* 5 (Sept. 1895), pp. 258–66 // Clark S. Marlor, ed., *A History of the Brooklyn Art Association, with an Index of Exhibitions* (New York, 1970), p. 343 // Sotheby Parke Bernet, Inc., Los Angeles, *Old Masters, Nineteenth and Twentieth Century European and American Paintings* (sale cat., May 27, 1974), lot 76 (ill.) // Hirschl and Adler Galleries, New York, *The Arts of the American Renaissance,* by Douglas Dreishpoon and Susan E. Menconi (exhib. cat., 1985), p. 109 (ill.) // Natalie Spassky et al., *American Paintings in the Metropolitan Museum of Art,* vol. 2, *A Catalogue of Works by Artists Born Between 1816 and 1845* (New York, 1985), pp. 556–57

Maria Longworth Storer, *see*
Rookwood Pottery

Louis Sullivan
1856–1924
Chicago
Architect

Louis Henry Sullivan was born in Boston to Patrick Sullivan, a dancing master, and Andrienne List, an accomplished musician and amateur artist. He grew up in Massachusetts and received his secondary education at the English High School in Boston. Summers were spent with his maternal grandparents on a farm outside the city. Thus cultivated, the appreciation of music and art and a love of nature remained with him throughout his life.

Boston was an ideal city for a young man who determined at an early age to become an architect. In the 1870s H. H. RICHARDSON was beginning his mature career there with the construction of Brattle Square Church and Trinity Church. In 1872, at the age of sixteen, Sullivan entered the Massachusetts Institute of Technology and studied for a year under William Robert Ware (1832–1915). In 1873 he moved to Philadelphia, where he was employed for a short time by FRANK FURNESS and George W. Hewitt (1841–1916). In the fall of that year Sullivan left for Chicago to work briefly for William Le Baron Jenney (1832–1907), an engineer/architect who helped to develop the skeleton construction for skyscrapers. It was a prophetic move for Sullivan, for his creations, perhaps more than those of any other architect, were to establish the international reputation of that city with the development of the tall building. In the summer of 1874 he left Chicago for Paris to study at the Ecole des Beaux-Arts in the atelier of Joseph-Auguste-Emile Vaudremer (b. 1829), a leading proponent of the Neo-Grec style in France. After his return to the United States in July 1875, Sullivan held a number of different jobs until 1879, when he was hired as a draftsman by the office of Dankmar Adler (1844–1900).

Three years later he became a partner in Adler's firm, and in 1883 the partnership name was changed from D. Adler and Company to Adler and Sullivan.

The first buildings by Adler and Sullivan were neither original nor distinguished. They showed an awareness of the early work of Richard Morris Hunt (1827–1895) in New York and of Frank Furness in Philadelphia, as well as the robust blend of English High Victorian Gothic and French Neo-Grec styles prevalent in American architecture of the late 1860s and the 1870s. Sullivan's early architectural embellishments (FIGS. 10.6, 10.7, ILLS. 10.33, 10.34) are indebted to the work of CHRISTOPHER DRESSER, OWEN JONES, and Victor Ruprich-Robert.

In 1886 Adler and Sullivan received the commission for the Auditorium Building in Chicago (1887–89), which was to secure their national fame. The arcaded masonry exterior was related to Richardson's 1885–87 Marshall Field Wholesale Store in Chicago, but the interiors, completed in 1890, clearly demonstrated Sullivan's mature ornamental style. The auditorium proper, in particular, showed Sullivan's struggle to create an architecture free from the many nineteenth-century historical revivals; as such, this interior stands as one of the masterworks of modern architecture.

The Getty Tomb (1890) in Chicago was perhaps the first synthesis of Sullivan's monumental geometric exterior forms and his new ornament, but the Wainwright Building (1890–91) in Saint Louis was a more compelling presentation. Here Sullivan achieved a fresh aesthetic that externally expressed the skeletal structure and the cellular interior arrangement of the modern office building. This project was followed in the 1890s by a number of important commissions, among them the Transportation Building at the Chicago World's Columbian Exposition (1893), the Guaranty Building in Buffalo, New York (1894–95), the Stock Exchange Building of Chicago (1893–94), and the Gage Building (1898–99), also in Chicago. Sullivan's last major commercial undertaking was for Schlesinger and Mayer (now Carson, Pirie and Scott) in Chicago (1898–1903). Here Sullivan treated the tall building as a horizontal structure and, on the lower two floors, designed some of his most exuberant naturalistic ornament. Sullivan's decoration during this period (FIG. 10.8) has often been called proto–Art Nouveau, but it was in fact highly original and personal in its complex interlocking geometric patterns and swirling tendrils.

Adler died in 1900; his partnership with Sullivan, however, had actually been dissolved in 1895. Sullivan's remaining years were difficult ones professionally and personally, in part because of the success of the academic revivals inspired by the 1893 World's Columbian Exposition in Chicago and in part because of his own uncompromising nature. Although he was no longer in the forefront of contemporary architecture, Sullivan did build a series of small banks in midwestern towns—notably the National Farmers' Bank in Owatonna, Minnesota (1907–1909)—which are among his best designs. In the early decades of the twentieth century Sullivan carried on his battle for a new architecture most effectively in his writ-

ings: "Kindergarten Chats," first published in 1901 (and issued posthumously as a book in 1934), was followed by *The Autobiography of an Idea* in 1924, the year of his death.

Louis Sullivan endures as one of the central figures of modern architectural history. Building on Richardson's remarkable achievements, Sullivan broke decisively with historical revivals to forge a new architecture for the next century, a vision that was continued and extended by Frank Lloyd Wright, his pupil.

REFERENCES
Louis Sullivan, "Essay on Inspiration," *Inland Architect* 8 (Dec. 1886), pp. 61–64 // Idem, "Ornament in Architecture," *Engineering Magazine* 3 (Aug. 1892), pp. 633–44 // Idem, "Emotional Architecture as Compared with Intellectual: A Study in Objective and Subjective," *Inland Architect* 24 (Nov. 1894), pp. 32–34 // Idem, "The Tall Office Building Artistically Considered," *Lippincott's Magazine* 57 (Mar. 1896), pp. 403–9 // Idem, "Kindergarten Chats," *Interstate Architect* 2–3 (Feb. 16, 1901–Feb. 8, 1902) // Idem, "What Is Architecture?: A Study of the American People," pts. 1–3, *Craftsman* 10 (May 1906), pp. 142–49; (June 1906), pp. 352–58; (July 1906), pp. 507–13 // Williams, Barker and Severn Company, Auctioneers, Chicago, *Household Effects, Library, Oriental Rugs, Paintings, Etc., of Mr. Louis Sullivan, the Well Known Chicago Architect, at Unreserved Sale* (sale cat., Nov. 29, 1909) // Louis Sullivan, *The Autobiography of an Idea* (New York, 1924) // Idem, *A System of Architectural Ornament According with a Philosophy of Man's Powers* (New York, 1924; reprint New York, 1967) // "Memorial Issue: Louis Henry Sullivan (1856–1924)," *Western Architect* 33 (June 1924) // Frank Lloyd Wright, "Louis H. Sullivan: His Work," *Architectural Record* 56 (July 1924), pp. 28–32 // Fiske Kimball, "Louis Sullivan: An Old Master," *Architectural Record* 57 (Apr. 1925), pp. 289–304 // Louis Sullivan, *Kindergarten Chats (Revised 1918) and Other Writings*, ed. Isabella Athey (New York, 1934; reprint 1980) // Hugh Morrison, *Louis Sullivan, Prophet of Modern Architecture* (New York, 1935; reprint New York, 1962) // George G. Elmslie, "Sullivan Ornamentation," *Monthly Bulletin* of the Illinois Society of Architects (June–July 1935); reprint *Journal of the American Institute of Architects* 6 (Oct. 1946), pp. 155–58 // Henry R. Hope, "Louis Sullivan's Architectural Ornament," *Magazine of Art* 40 (Mar. 1947), pp. 110–17 // Frank Lloyd Wright, "On Louis Sullivan," *Architectural Forum* 91 (Aug. 1949), pp. 94–97 // Willard Connely, "New Chapters in the Life of Louis Sullivan," *American Institute of Architects Journal* 20 (Sept. 1953), pp. 107–14 // Edgar Kaufmann, Jr., ed., *Louis Sullivan and the Architecture of Free Enterprise* (Chicago, 1956) // John Szarkowski, *The Idea of Louis Sullivan* (Minneapolis, 1956) // Vincent J. Scully, Jr., "Louis Sullivan's Architectural Ornament," *Perspecta* 5 (1959), pp. 73–80 // Albert Bush-Brown, *Louis Sullivan* (New York, 1960) // Willard Connely, *Louis Sullivan as He Lived* (New York, 1960) // Winston Weisman, "Philadelphia Functionalism and Sullivan," *Journal of the Society of Architectural Historians* 20 (Mar. 1961), pp. 3–19 // Paul Sherman, *Louis Sullivan: An Architect in American Thought* (Englewood Cliffs, N.J., 1962) // Suzanne Shulof, "An Interpretation of Louis Sullivan's Architectural Ornament Based on His Philosophy of Organic Expression" (M.A. thesis, Columbia University, 1962) // David Crook, "Louis Sullivan and the Golden Doorway," *Journal of the Society of Architectural Historians* 26 (Dec. 1967), pp. 250–58 // Paul E. Sprague, "The Architectural Ornament of Louis Sullivan and His Chief Draftsmen" (Ph.D. diss., Princeton University, 1968) // Narciso García-Menocal, "Louis Sullivan: His Theory, Mature Development, and Theme" (Ph.D. diss., University of Illinois, Urbana-Champaign, 1974) // Lawrence Wodehouse, *American Architects from the Civil War to the First World War* (Detroit, 1976), pp. 186–202 // David S. Andrew, "Louis Sullivan and the Problem of Meaning in Architecture" (Ph.D. diss., Washington University, 1977) // Paul E. Sprague, *The Drawings of Louis Sullivan: A Catalogue of the Frank Lloyd Wright Collection at the Avery Architectural Library* (Princeton, 1979) // Lauren S. Weingarden, "Louis H. Sullivan: Investigation of a Second French Connection," *Journal of the Society of Architectural Historians* 39 (Dec. 1980), pp. 297–303 // Wayne Andrews, "Louis Henri Sullivan," in *Three Centuries of Notable American Architects*, ed. Joseph J. Thorndike, Jr. (New York, 1981), pp. 182–203 // Narciso G[arcía]-Menocal, *Architecture as Nature: The Transcendentalist Idea of Louis Sullivan* (Madison, Wisc., 1981) // Southern Illinois University, Edwardsville, *Louis H. Sullivan Architectural Ornament Collection*, by Linda L. Chapman et al. (Edwardsville, 1981) // Paul E. Sprague, "Adler and Sullivan," in *Macmillan Encyclopedia of Architects*, ed. Adolf K. Placzek, 4 vols. (New York, 1982), vol. 4, pp. 34–35 // Idem, "Sullivan, Louis H.," in *Macmillan Encyclopedia of Architects*, ed. Adolf K. Placzek, 4 vols. (New York, 1982), vol. 4, pp. 152–64 // Lauren S. Weingarden, "The Colors of Nature: Louis Sullivan's Architectural Polychromy and Nineteenth-Century Color Theory," *Winterthur Portfolio* 20 (Winter 1985), pp. 243–60 // Robert Twombly, *Louis Sullivan: His Life and Work* (New York, 1986)

Lewis Taft, *see* **D. F. Haynes and Company**

Bruce J. Talbert

1838–1881
London
Architect and designer

During the 1860s Bruce James Talbert emerged as one of the most influential industrial designers of the Aesthetic movement in Great Britain, a leading interpreter of the reform Gothic style. Talbert's short-lived career lasted only slightly longer than the vogue for the style he popularized; by the time of his death, in 1881, the importance of the Modern Gothic had waned, although some of its underlying principles—such as revealed construction and the importance of a conceptually unified interior—continued to inform the work of progressive designers.

Talbert was a Scotsman, born in Dundee, who began his career as a cabinet carver under a Mr. Millar before apprenticing to Charles Edwards, a local architect then at work on the Corn Exchange Hall. In 1856 Talbert moved to the Glasgow architectural offices of W. N. Tait and Campbell Douglas. It was probably in Glasgow that he first met DANIEL COTTIER, a fellow Scotsman in whose London "Art furniture, Glass and Tile Painters" business Talbert participated for a short time about 1870. Talbert won a medal for architectural design in 1860 and another for drawing from the Edinburgh Architectural Association in 1862. From 1870 through 1876 he regularly exhibited his architectural drawings at the Royal Academy of Arts in London.

In the early 1860s, however, Talbert began to focus on the design of domestic furniture and decorative arts in a simplified Gothic style. About 1862 he entered the employ of the Manchester cabinetmakers Doveston, Bird and Hull, and within a year or two he was designing silver and wrought-iron metalwork for Francis Skidmore's Art Manufactures Company in Coventry (ILL. 8.1). In London by 1865 or 1866, Talbert began to create furniture designs for Holland and Sons. Several pieces, including a large breakfront cabinet (London Art Market, 1986) and the "Sleeping Beauty" cabinet, now in the Victoria and Albert Museum (ILL. 5.2), were featured by the firm in its award-winning display at the Paris Exposition Universelle of 1867.

In 1867 Talbert published *Gothic Forms Applied to Furniture, Metal Work, and Decoration for Domestic Purposes* (FIGS. 5.1, 5.2), a book that was, in essence, a practical demonstration of CHARLES LOCKE EASTLAKE's theories. It was to have far-reaching influence on cabinetmaking and interior decor in both England and America. The volume, which was dedicated to the Gothic-revival architect George Edmund Street (1824–1881), was issued in Birmingham; an American edition appeared in Boston six years later, in 1873.

Unlike earlier exponents of the Gothic revival, Talbert did not base his work on the literal reproduction of Gothic designs or on the application of architectural ornament to domestic furnishings; instead he scaled architectural forms such as gables, coves, turned columns, and trefoil arches to new decorative functions. Medieval joinery provided a new vocabulary of angular brackets, trestles, and spindles that stood for "honest" construction regardless of their actual service as structural supports. Talbert preferred the Gothic styles of the twelfth and thirteenth centuries, which he found "distinguished by great breadth and simplicity," though he acknowledged that precedents for domestic furniture from those periods were hard to find.

His furniture designs relied on framed construction, low-relief carving, geometric inlays, and pierced work. He abhorred the use of glue and veneers, glossy French polishes and staining, and he cautioned against "repetition of the tracery, buttresses, and crocketting used in stone work; . . . though this may not be so objectionable in church requirements, the use of these forms gives a monumental character quite undesirable for Cabinet Work" (Talbert, 1867, p. 1). Furthermore, as Talbert felt furniture must be harmoniously integrated with its architectural setting, his readers were ad-

vised about the correct decor for each major room in the house. His annotated illustrations of tables, cabinets, sideboards, writing desks, and chimneypieces provided specific visual information that cabinetmakers could follow or from which they could improvise. Many of his published illustrations depict entire rooms with fully detailed floors, wall and ceiling treatments, stained glass, and draperies (ILL. 10.8) that must have influenced the work of American firms, among them A. KIMBEL AND J. CABUS (FIG. 5.11).

During the 1870s Talbert continued to design furniture, stained glass, metalwork, textiles, carpets, and wallpapers. From the reform Gothic he pioneered in 1867, Talbert's work by 1876 had evolved into a skillful, if prosaic, Jacobean style that is illustrated in his second book, *Examples of Ancient and Modern Furniture, Metal Work, Tapestries, Decorations, Etc.,* also dedicated to Street and republished in America in 1877. Meanwhile, Talbert designed prize-winning ecclesiastical metalwork for Cox and Sons, his famous Sunflower wallpapers for JEFFREY AND COMPANY, carpets for Messrs. Brinton, ironwork for the Coalbrookdale Company, and textiles for firms such as Cowlishaw, Nicol and Company or Barbone and Miller. A drawing now in the Victoria and Albert Museum documents Talbert's Hatton pattern of about 1875, which was manufactured as a sumptuous gold-on-black silk portiere by Warner and Company (FIG. 3.14).

His furniture continued to garner acclaim at international exhibitions. The Pet Sideboard manufactured by Gillow and Company for the Vienna exhibition of 1873 was purchased for the South Kensington Museum, and the London firm of Jackson and Graham received the grand prize for Talbert's Juno cabinet, which was displayed at the Paris Exposition Universelle in 1878 and later sold to the viceroy of Egypt. The British journal *Building News* boasted that "Mr. Talbert made a name as a designer of furniture which has not been equalled in England since the days of Chippendale and Adams" (*American Architect and Building News,* Aug. 20, 1881, p. 87).

Remembered as a generous man with a sense of humor, Talbert died prematurely, in the midst of his active career. The *Cabinet-Maker and Art-Furnisher* posthumously published some of Talbert's furniture designs in a book entitled *Fashionable Furniture* and lamented his death in a lengthy obituary, all five columns of which were reprinted in the United States by the *American Architect and Building News.*

REFERENCES
B[ruce] J. Talbert, *Gothic Forms Applied to Furniture, Metal Work, and Decoration for Domestic Purposes* (Birmingham, Eng., 1867; reprint Boston, 1873, 1877) // London International Exhibition of 1872, *Official Catalogue: Fine Arts Department* (London [1872]), nos. 1053, 2705–6, 2732–33, 2769, 2780, 2782 // B[ruce] J. Talbert, *Examples of Ancient and Modern Furniture, Metal Work, Tapestries, Decorations, Etc.* (London, 1876; reprint Boston, 1877) // "Mr. Talbert's Designs for Interior Decoration," *American Architect and Building News* 2 (Mar. 24, 1877), p. 93 and two ills. // *Fashionable Furniture: A Collection of Three Hundred and Fifty Original Designs . . . Including One Hun-*

dred Sketches by the Late Bruce J. Talbert, Architect; also, a Series of Domestic Interiors, by Henry Shaw, Architect (London, 1881; New York, 188-) // "Trade Intelligence: Paper-Hangings for 1881," *Journal of Decorative Art* 1 (Jan. 1881), p. 17 // [Bruce J. Talbert, obituary], *Builder* 40 (Feb. 5, 1881), p. 152 // "Mr. J. B. [sic] Talbert" [obituary], *Art Journal* (London), May 1881, p. 95 // "Bruce J. Talbert, 1838–1881" [obituary], pts. 1, 2, *Cabinet-Maker and Art-Furnisher* 2 (July 1881), pp. 4–5; (Aug. 1881), pp. 24–25 // "Bruce J. Talbert (1838–1881)" [obituary], *American Architect and Building News* 10 (Aug. 20, 1881), pp. 85–87 // J. Moyr Smith, *Ornamental Interiors, Ancient and Modern* (London, 1887), pp. 54–55, 59–64, 72, 83, pl. 10 // Lewis F. Day, "Victorian Progress in Applied Design," *Art Journal* (London), June 1887, pp. 185–202 // George W. Gay, "The Furniture Trade," in *One Hundred Years of American Commerce,* ed. Chauncey M. Depew, 2 vols. (New York, 1895; reprint New York, 1968), vol. 2, pp. 628–32 // Algernon Graves, comp., *Dictionary of Artists Who Have Exhibited Works in the Principal London Exhibitions from 1760 to 1893,* 3d ed. (New York, 1901; reprint New York, 1970), p. 272 // Hermann Muthesius, *The English House,* ed. and intro. Dennis Sharp, pref. Julius Posener, trans. Janet Seligman, abridged from *Das Englische Haus,* 2d ed., 3 vols. in 1 (Berlin, 1904–5; 2d. ed. Berlin, 1908–11; New York, 1979), pp. 156–57 // Alan Victor Sugden and John Ludlam Edmondson, *A History of English Wallpaper, 1509–1914* (London and New York, 1926), p. 211 // "Talbert, Bruce James," in *Allgemeines Lexikon der Bildenden Künstler,* ed. Ulrich Thieme and Felix Becker, vol. 32 (Leipzig, 1938), p. 414 // Nikolaus Pevsner, "Art Furniture of the Eighteen-Seventies," *Architectural Review* 111 (Jan. 1952), pp. 43–50 // Elizabeth Aslin, *The Aesthetic Movement: Prelude to Art Nouveau* (New York and Washington, D.C., 1969), pp. 63, 66–67, pls. 7–9, 12–13, 70–71 // Victoria and Albert Museum, London, *English Cabinets* (London, 1972), no. 36 (ill.) // Birmingham Museums and Art Gallery, Eng., *Birmingham Gold and Silver, 1773–1973* (exhib. cat., 1973), sec. C, no. 66 (ill.) // Kenneth L. Ames, "The Battle of the Sideboards," *Winterthur Portfolio* 9 (1974), pp. 1–27 // *Pictorial Dictionary of British Nineteenth Century Furniture Design,* intro. Edward Joy (Woodbridge, Eng., 1977), pp. xi, xxxiv–xxxv // Martin Harrison, *Victorian Stained Glass* (London, 1980), p. 56 // Simon Jervis, "Talbert, Bruce J.," in *The Penguin Dictionary of Design and Designers* (Harmondsworth, Eng., and New York, 1984), pp. 475–76 // Linda Parry, Department of Textile Furnishings and Dress, Victoria and Albert Museum, London, correspondence, Jan. 8, 1986 // Christie, Manson and Woods Limited, London, *The Nineteenth Century: European Ceramics, Furniture, Sculpture, and Works of Art* (sale cat., Jan. 22, 1986), pp. 150–51 (lot 261)

James Tams, *see* **Greenwood Pottery**

Celia Thaxter
1835–1894
Appledore, Isles of Shoals, Maine
Poet and china painter

Celia Laighton Thaxter was a poet and essayist whose summer home on Appledore Island, one of the Isles of Shoals near the coasts of Maine and New Hampshire, functioned as an informal literary and artistic salon for three decades. Among her friends she was famous not only for her poetry, filled with images of her life by the ocean, but also for the magnificent garden she managed to cultivate successfully on the rocky granite island. The vibrant, sunlit poppies, peonies, hollyhocks, larkspurs, lavender, lupines, sunflowers, roses, and foxglove became popular subjects for the American painters who visited Appledore, including Childe Hassam (1859–1935), for whom this informal seaside garden symbolized nature in its freshest and most unfettered state.

Born in Portsmouth, New Hampshire, Thaxter was the daughter of Thomas Laighton, a prosperous dealer in lumber and West Indian goods as well as the editor of the *New Hampshire Gazette.* Frustrated in his bid for political office in the local Portsmouth government, Laighton purchased three of the Isles of Shoals—complete with lighthouse, of which he became the keeper—and removed his family to White Island in 1839, when Celia was four years old. Not quite ten years later, in 1848, Laighton opened a resort hotel, one of the first of its kind, on the island of Appledore. Over the years a variety of fascinating guests, among them the literary figures John Greenleaf Whittier, James Russell Lowell, Ralph Waldo Emerson, Nathaniel Hawthorne, Henry David Thoreau, and Sarah Orne Jewett, and the painters Ellen Robbins, William Morris Hunt, Arthur Quartley, John Appleton Brown, Ross Turner, and Childe Hassam, were attracted to the island.

In 1851 Celia Laighton was married on Appledore to Levi Lincoln Thaxter (d. 1884), a Robert Browning scholar and ornithologist (his collection is now housed in the Peabody Museum of Archaeology and Ethnology at Harvard University) who had been Celia's tutor. Three sons were born to them by 1858. The eldest, Karl, was mentally unsound and remained at his mother's side throughout her life. Thaxter's marriage was strained from the beginning by a demanding husband whose frail health prevented his development of a steady, income-producing career and whose interest in the Isles of Shoals did not match her own. In 1855 the family moved to Newtonville, Massachusetts, and in 1880 to Kittery, Maine, but after her father's death, in 1866, Celia Thaxter made increasingly frequent trips to Appledore Island, usually accompanied by one or more of her children, to assist her mother and her two brothers in managing the hotel.

Thaxter wrote her first poem in 1861, while in Newtonville. Without her knowledge, one of her brothers submitted the poem to James Russell Lowell, editor of the *Atlantic Monthly,* who published it under the title "Landlocked." Thereafter she was a frequent contributor to this and other magazines, and she became close friends with Lowell's successor, James T. Fields, and his wife, Annie. Three of Thaxter's books—*Poems, Among the Isles of Shoals,* and *Driftweed*—were published during the 1870s; *Poems for Children* and *Idylls and Pastorals* appeared in the following decade; and *An Island*

Garden, with illustrations by Childe Hassam, was published in 1894, shortly before her death. Her collected letters were issued in 1895.

About 1876 Thaxter began to paint china in addition to writing poetry; John Appleton Brown (1844–1902), a frequent guest on the island, gave her lessons in the medium in 1877. During the 1880s she and her son Karl spent their winters in Boston, where between 1883 and 1885 Thaxter studied painting with Ross Turner (1847–1915) and, for a short time during this period, with Childe Hassam. Apparently endowed with some talent, Thaxter was able to produce enough work to generate much-needed income from her china painting; in the winter of 1877, for example, she completed more than a hundred pieces. As with her poetry, she found most of her subjects readily at hand, from the island's geology and wildlife as well as from her own flower garden. Writing to her friend the poet Thomas Bailey Aldrich, she asked, "Which design would Lillian most enjoy—a bunch of violets or a branch of peach blossoms; a Roman anemone or an autumn cluster of crimson woodbine, a dried poppy head or a red rose haw, with a sad verse burned into the porcelain, or perhaps a green peacock feather?" (Thaxter, 1963, p. 185).

In 1880 Thaxter made her first and only trip to Europe, where she visited the artist ELIHU VEDDER in Rome and the poet Robert Browning in England. Several painted bowls that she completed after this voyage are decorated with purple olives on green branches accompanied by inscriptions in ancient Greek (FIG. 1.3). It is not known where these pieces were fired, but in a letter of November 1881 to her friend Annie Fields, Thaxter mentions a Mr. Ware in conjunction with her pottery (Fields and Lamb, 1895, pp. 125–26). The appearance of Ware's name suggests a connection with the Boston Society of Decorative Art, on whose Committee on Instruction WILLIAM ROTCH WARE served during the early 1880s; his wife, ALICE CUNNINGHAM WARE, briefly taught china painting for the society. It is conceivable, given that Thaxter spent several winters in Boston during the 1880s, that she had her china fired in the society's kilns.

While the restful atmosphere of Appledore House, the fresh sea air, and the view of the coastline from Maine to Massachusetts on a clear day were enough to make the island a pleasant summer retreat, it was Celia Thaxter who drew to Appledore the literary and artistic circle that gathered there from the 1860s until her death, in 1894. Writing of her in 1871, the author C. T. Young remarked upon the very qualities that Childe Hassam later immortalized in his brilliant Impressionist paintings, such as *Celia Thaxter in Her Garden* (1892; National Museum of American Art, Washington, D.C.) and *The Room of Flowers* (1894, ILL. 1.7): "Celia Thaxter was, I sometimes think, the most beautiful woman I ever saw, not the most splendid nor the most regular in feature, but the most graceful, the most easy, the most complete—with the suggestion of perfect physical adequacy and mental health in every look and motion. She abounded in life, it was like breathing a new life to look at her" (Thaxter, 1963, p. 88).

After Thaxter's death, the popularity of the Appledore resort began to wane. The buildings burned to the ground in 1914, and the garden was later abandoned. The current leaseholder of the island, the Shoals Marine Laboratory, recently restored Thaxter's garden at its original location.

REFERENCES
"Thaxter, Celia Laighton," in *The National Cyclopaedia of American Biography,* vol. 1 (New York, 1892), p. 445 // "Celia Thaxter" [obituary], *New York Times,* Aug. 28, 1894, p. 5 // A[nnie] F[ields] and R[ose] L[amb], eds., *Letters of Celia Thaxter* (Boston and New York, 1895) // Rosamond Thaxter, *Sandpiper: The Life and Letters of Celia Thaxter* (Francestown, N.H., 1963; reprint Hampton, N.H., 1982) // "Thaxter, Celia Laighton," in *Dictionary of American Biography,* vol. 9, pt. 2 (New York, 1964), pp. 397–98 // University Art Galleries, University of New Hampshire, Durham, *A Stern and Lovely Scene: A Visual History of the Isles of Shoals* (exhib. cat., 1978) // Henry Art Gallery, University of Washington, Seattle, *American Impressionism,* by William H. Gerdts (exhib. cat., 1980), pp. 42, 57–58 // Katharine L. Jacobs, "Celia Thaxter and Her Island Garden," *Landscape* 24, no. 3 (1980), pp. 12–17 // Jane E. Vallier, *Poet on Demand: The Life, Letters, and Works of Celia Thaxter* (Camden, Maine, 1982) // Montclair Art Museum, N.J., *Down Garden Paths: The Floral Environment in American Art,* by William H. Gerdts (exhib. cat., 1983) // Laura Fecych Sprague, Portland, Maine, correspondence, July 13, 1983 // Ella Foshay, *Reflections of Nature: Flowers in American Art* (New York, 1984), pp. 63–67, 185 // William H. Gerdts, *American Impressionism* (New York, 1984), pp. 92, 99–104, 311 // Deborah Nevins, "Poet's Garden, Painter's Eye," *House and Garden* 156 (Aug. 1984), pp. 93–96, 154–56

Tiffany and Company

1837–present
New York City
Silver

It took daring, acumen, and enterprise for Charles Louis Tiffany (1812–1902) and John B. Young to open a "fancy articles and curiosities" shop in 1837, the year a severe depression flattened the national economy. Their first site, at 259 Broadway, near City Hall in "uptown" New York, was considered unfashionable at the time, but with shrewd business decisions and a great sense of style the firm prospered. By the 1870s the silver and jewelry of the Tiffany company were among the finest in the world.

Anticipating, or perhaps stimulating, the public taste for exotic foreign goods that was to prevail by the 1870s, Tiffany and Young imported objects from Japan, China, and India as well as from Europe. The business flourished: in 1841 J. L. Ellis became the third partner; in 1850 a Paris branch opened under the direction of Gideon F. T. Reed; and in 1868 a London branch was established. Investing heavily in diamonds during the 1848 political and economic upheavals in Europe, the firm began that year to make jewelry and, at about the same time, to manufacture silver. Though it employed GUSTAVE HERTER as one of its first designers, the Tiffany company continued to commission most of its silver objects from independent New York artisans and in 1851 contracted with one of them, John Chandler Moore, to create hollow ware exclusively for the firm.

The company sold silverplate from 1868 on but was renowned for its handcrafted sterling objects. To attribute a specific design to any one individual is often impossible, but the extraordinary quality of the designs, especially those showing the influence of Japanese art, must be credited to Edward Chandler Moore (1827–1891), John's son, who took over his father's studio in 1851 and was associated with Tiffany and Company until his death forty years later. In 1852, at E. C. Moore's instigation, Tiffany became the first company in America to adopt the English sterling standard—925 of 1,000 parts pure silver. Later, he developed a method of spinning silver that is still used in making hollow ware. When the firm was formally incorporated as Tiffany and Company in 1868, Moore sold his workshop to the company and became one of its officers as well as director of its silver department.

A brilliant designer committed to craftsmanship, Moore studied the local technical schools during a visit to Paris in 1855 and probably again in 1867; he was undoubtedly familiar with England's similar institutions. Because no such resources existed in New York, he established an equivalent training program for silversmiths in the Tiffany workshops, then on Prince Street. His own reference library, comprising some 556 volumes on archaeology and the fine and industrial arts, included Japanese and Indian textile sample books; he also assembled an extensive collection of ancient, medieval, oriental, and Islamic decorative art objects, which he bequeathed along with his library to The Metropolitan Museum of Art (FIG. 7.4). These books and artifacts constitute a rich repository of design ideas. For example, the silver cylindrical vase of about 1873 (FIG. 8.6), probably one of Tiffany's earliest pieces in the Japanese style, is clearly based on a nineteenth-century brush holder in Moore's collection (FIG. 8.7). In 1876 Tiffany and Company contracted with the Englishman CHRISTOPHER DRESSER to collect a large number of Japanese objects, apparently for commercial purposes rather than for study, since the company auctioned off nearly two thousand of them in the Dresser collection sale the following year.

Silver in the Japanese style, while just one aspect of Tiffany's production during the 1870s and 1880s, was the one to which Moore was personally dedicated. He first became fascinated with oriental art in Paris at the 1867 Exposition Universelle; one of his sketchbooks of about 1865 to 1871 contains many drawings with Japanese-inspired details. Tiffany and Company accordingly produced flatware with Japanese patterns as early as 1871 and hollow ware by 1873 (FIG. 8.16). Moore was equally interested in Islamic art and developed a number of so-called Saracenic themes. His approach to design was far from literal replication, however; many of his pieces combine both Western and Eastern motifs and forms in unique and beautiful ways.

Tiffany's Japanesque silver of the post-centennial years typically combines organic forms, often with attenuated spouts and handles, and hand-hammered surfaces. Three-dimensional chromatic decorations—fruits, fish, insects, and plant forms exquisitely crafted in alloys of silver, copper, and gold—applied to the surface with other chased, inlaid, and engraved decorations (FIGS. 8.10–8.13, 8.15, ILLS. 8.8–8.10) emulate the Japanese metalwork exemplified by the sword guards from Moore's own collection (FIG. 8.8). Two rare pieces of Tiffany's Japanesque jewelry (FIG. 8.17), in austere contrast to the dazzling precious stones the company was designing for New York's social elite during that period, are a measure of the meticulous workmanship executed under Moore's supervision.

International exhibitions served as a major forum for display. Tiffany and Company, awarded a silver medal at the Paris Exposition Universelle of 1867, was the first American firm to be so honored at an international fair. At the Philadelphia Centennial Exposition of 1876 the company showed approximately 125 pieces, one of which was purchased for the Museum of Fine Arts, Boston (FIG. 8.3). In addition to numerous other citations, Tiffany received the highest awards for work in silver at exhibitions in the years 1876, 1878, and 1889. The French government invested Charles L. Tiffany in 1878 and E. C. Moore in 1889 as Chevaliers of the Legion of Honor. Not surprisingly, the firm was counting many of the crowned heads of Europe among its patrons by the early 1880s.

Fine silver was not all that Tiffany marketed; a public eager for decorative objects could find a large selection of fancy articles on the company's shelves. One advertisement of 1878 described goods imported from the Paris Exposition: "New Placques by Minton . . . Salviati's latest reproductions of the Venetian Glass of the Sixteenth century. Fac-similes of the Trojan iridescent bronze glass exhumed by Dr. Schliemann . . . Reproductions, by Doulton, of old Flemish stone ware . . . Specimens of Cape de Monti ware, Austrian iridescent and enameled Glass and Limoges Faience of new colors" (Art Interchange, 1878, p. ii).

The magnificent silver presentation pieces crafted in the Tiffany studios after the Civil War attest both to the great wealth accumulated in America during that period and to the enormous amount of silver being mined in the American West. The Bryant Vase (FIG. 8.1.), in its own time the most famous piece of presentation silver made in the United States, was designed in 1875 by James Horton Whitehouse (1833–1902), an Englishman in charge of Tiffany's engraving department. Though its decoration was then perceived only as symbolic of William Cullen Bryant's life and work, the amphora-like vase is a veritable compendium of aesthetic motifs skillfully composed on a classical form. The sculptor AUGUSTUS SAINT-GAUDENS is thought to have created the six relief medallions on the vase, one of which is a portrait of Bryant. Another amphora-shaped vase, commissioned in 1877 as a gift to Cincinnati philanthropist Reuben R. Springer, combines classical form and details with a hammered surface and stylized chrysanthemums that are oriental in origin (FIG. 8.22).

E. C. Moore's leadership lasted exactly four decades. Though several of his descendants have worked for Tiffany and Company, Moore's death in 1891 marked the end of an era in the firm's history. Tiffany's headquarters has been located on Fifth Avenue in New York City for almost fifty years, and the extensive company archives are currently housed at a secondary location in Parsippany, New Jersey.

REFERENCES

Official Catalogue of the New-York Exhibition of the Industry of All Nations, 1853 (New York, 1853), Class 23, no. 42 // J. Leander Bishop, A History of American Manufactures from 1608–1860, 3 vols. (Philadelphia and London, 1868), vol. 3, pp. 182–89 // Exhibition of Paintings, Engravings, Drawings, Aquarelles, and Works of Household Art in the Cincinnati Industrial Exposition (Cincinnati, 1873), pp. 18–20 // Exhibition of Paintings, Engravings, Drawings, Aquarelles, and Works of Household Art in the Cincinnati Industrial Exposition (exhib. cat., 1874), pp. 3–4, 21 // "Art in Industry," New York Times, July 13, 1874, reprinted in Marjorie Longley, Louis Silverstein, and Samuel A. Tower, 1851: America's Taste (New York, 1959), p. 86 // "The Bryant Testimonial Vase," Art Journal (Appleton's) 1 (May 1875), pp. 145–49 // "The 'Ocean Challenge Cup,'" Art Journal (Appleton's) 1 (Aug. 1875), p. 245 // "The Royal Albert Yacht Club Cup," Art Journal (Appleton's) 1 (Nov. 1875), pp. 342–43 // "American Art-Work in Silver," Art Journal (Appleton's) 1 (Dec. 1875), pp. 371–74 // James D. McCabe, The Illustrated History of the Centennial Exhibition Held in Commemoration of the American Independence (Philadelphia, Chicago, and Saint Louis, 1876; reprint Philadelphia, 1975), pp. 358, 808, 817 // Phillip T. Sandhurst et al., The Great Centennial Exhibition Critically Described and Illustrated (Philadelphia and Chicago, 1876), pp. 264–65, 266 (ill.) // Samuel Osgood, "The Bryant Vase," Harper's New Monthly Magazine 54 (July 1876), pp. 245–52 // "Jewelry and Silverware at the Centennial," Jewelers' Circular and Horological Review 7 (July 1876), pp. 93–94 // "The Adams and Shaw Company," Jewelers' Circular and Horological Review 7 (Aug. 1876), p. 99 // "Our Centennial Report," Jewelers' Circular and Horological Review 7 (Aug. 1876), p. 100 // "A New Challenge Cup," Crockery and Glass Journal 4 (Oct. 31, 1876), p. 16 // "Art in Industry," Jewelers' Circular and Horological Review 7 (Nov. 1876), p. 168 // [George Titus Ferris], Gems of the Centennial Exhibition: Consisting of Illustrated Descriptions of Objects of an Artistic Character, in the Exhibits of the United States, Great Britain, France . . . (New York, 1877), pp. 15 (ill.), 16–17 // Frank H. Norton, ed., Frank Leslie's Historical Register of the United States Centennial Exposition, 1876 (New York, 1877), pp. 260 (ill.), 303–4 // Walter Smith, Industrial Art, vol. 2 of The Masterpieces of the Centennial International Exhibition (Philadelphia, copr. 1875 [1877?]), pp. 6 (ill.), 9, 237 (ill.), 242, 256 (ill.), 259–60, 275–77 // George A. Leavitt and Company, New York, The Dresser Collection of Japanese Curios and Articles Selected for Messrs. Tiffany and Co. (sale cat., June 18, 1877) // Idem, Preemptory Sale: Messrs. Tiffany and Co.'s Large Stock of Japanese Miscellaneous Goods (sale cat., June 29, 1877) // Lucien Falize, "L'Orfèvrerie et la bijouterie au Champ-de-Mars," Gazette des Beaux-Arts 28 (1878), pp. 231–33, 250 // "Tiffany's Collection at the [Paris] Exposition," Trade Journal Treating of Furniture, Upholstery, Decoration, Kindred Industries 8 (June 29, 1878), p. 10 // "Tiffany and Company" [advertisement], Art Interchange 1 (Oct. 16, 1878), p. ii // [Edwin C. Taylor], "Metal Work of All Ages," National Repository 6 (1879), pp. 404–5 // "Cypriote Jewelry" [advertisement], Art Interchange 2 (Jan. 8, 1879), p. i // "Among the Dealers: American Silver in Europe," Art Amateur 1 (June 1879), p. 8 // "The Prang Competition," Art Amateur 3 (July 1880), p. 24 // "Japanese Decoration," Art Amateur 5 (Sept. 1881), pp. 79–80 // "Some Artistic Jewelry," Art Amateur 8 (May 1883), pp. 142–43 // "American Industrial Art Honored," Critic 3 (June 9, 1883), p. 275 // G. de Léris, "L'Habitation américaine," Revue des Arts Décoratifs, 4e ann. (1883–84), pp. 116–23 // "Mr. Charles T. Cook, Manager of the House of Tiffany and Company . . . ," Crockery and Glass Journal 19 (Mar. 20, 1884), pp. 20, 23 // [Tiffany and Company], Jewelers' Circular and Horological Review 18 (June 1887), p. 178 // "American Jewelers to the Fore," Jewelers' Circular and Horological Review 20 (Apr. 1889), p. 26 // "Glimpses of the Exposition," Jewelers' Circular and Horological Review 20 (July 1889), pp. 29–30, 31 (ill.) // W. C. Roberts-Austen, "The Use of Alloys in Art Metal-Work," pts. 1, 2, American Architect and Building News 29 (July 5, 1890), pp. 15 16; (July 12, 1890), pp. 27–29 // "Japanese Basket Work," Studio: A Weekly Journal of the Fine Arts, n.s. 5 (Sept. 6, 1890), pp. 390–91 // "Death of Edward C. Moore," Brooklyn Daily Eagle, Aug. 4, 1891, p. 4 // "E. C. Moore" [obituary], New York Daily Tribune, Aug. 4, 1891, p. 7 // "Edward C. Moore" [obituary], New York Times, Aug. 4, 1891, p. 5 // George Frederick Heydt, "A Prince of Silversmiths," Illustrated American 8 (Aug. 29, 1891), p. 70 // "The E. C. Moore Collection," Collector 2 (Sept. 1, 1891), p. 217 // "Mr. Edward C. Moore's Gift to the Metropolitan Museum of Art," Studio: A Weekly Journal of the Fine Arts, n.s. 7 (Dec. 5, 1891), pp. 5–6 // "The Moore Collection," New York Sun, Mar. 6, 1892, clipping from Tiffany and Company Archives, Parsippany, N.J. // Metropolitan Museum of Art, Twenty-second Annual Report of the Trustees of the Association (New York, 1892), pp. 14–15 // "The Edward C. Moore Collection," Collector 3 (May 1, 1892), pp. 199–201 // "Priceless Works of Art: The Moore Collection Opened at the Metropolitan Museum," New York World, May 3, 1892, clipping from Tiffany and Company Archives, Parsippany, N.J. // George Frederick Heydt, Charles L. Tiffany and the House of Tiffany and Company (New York, 1893) // Metropolitan Museum of Art, Twenty-third Annual Report of the Trustees of the Association (New York, 1893), pp. 24, 30, 202, 255 // "The Fine Arts: The Tiffany Exhibit for the Fair," Critic 25 (Apr. 15, 1893), p. 243 // "The Metropolitan Museum of Art: The Opening of the New North Wing," Harper's Weekly 38 (Nov. 10, 1894), pp. 1067–71 // "Tiffany, Charles L.," in The National Cyclopaedia of American Biography, vol. 2 (New York, 1895), p. 57 // "Whitehouse, James

Horton" [obituary], *American Art Annual* 4 (1903), p. 147 // C. H., "The Edward C. Moore Collection," *Bulletin of The Metropolitan Museum of Art* 2 (June 1907), pp. 105–6 // "Whitehouse, James Horton," in *Allgemeines Lexikon der Bildenden Künstler,* ed. Ulrich Thieme and Felix Becker, vol. 35 (Leipzig, 1942), p. 500 // Dorothy T. Rainwater and H. Ivan Rainwater, *American Silverplate* (Nashville, Tenn., and Hanover, Pa., 1968), p. 33 // Metropolitan Museum of Art, New York, *Nineteenth-Century America: Furniture and Other Decorative Arts* (exhib. cat., 1970), figs. 220–23, 229–31 (ills.) // Henry H. Hawley, "Tiffany's Silver in the Japanese Taste," *Bulletin of the Cleveland Museum of Art* 63 (Oct. 1976), pp. 236–45 // Charles H. Carpenter, Jr., "Nineteenth-Century Silver in the New York Yacht Club," *Antiques* 112 (Sept. 1977), pp. 496–505 // Bruce Kamerling, "Edward C. Moore: The Genius Behind Tiffany Silver," pts. 1, 2, *Silver* 10 (Sept.–Oct. 1977), pp. 16–20; (Nov.–Dec. 1977), pp. 8–12 // Shirley Bury, "Jewellery in an Age of Discovery, 1800–1900," in *Art at Auction: The Year at Sotheby Parke Bernet, 1977–78* (London, 1978), pp. 435–41 // Charles H. Carpenter, Jr., and Mary Grace Carpenter, *Tiffany Silver* (New York, 1978) // Hugh Tait and Charlotte Gere, *The Jeweller's Art: An Introduction to the Hull Grundy Gift to the British Museum* (London, 1978), pp. 14–21, 23 // Charles H. Carpenter, Jr., "The Mackay Service Made by Tiffany and Company," *Antiques* 114 (Oct. 1978), pp. 794–801 // Idem, "Tiffany Silver in the Japanese Style," *Connoisseur* 200 (Jan. 1979), pp. 42–47 // Idem, "American Art Nouveau Silver," *Art and Antiques* 3 (Mar.–Apr. 1980), pp. 102–9 // Idem, "President and Mrs. Lincoln's Silver," *Antiques* 121 (Feb. 1982), p. 491 (ill.) // Anita J. Ellis, "Cincinnati Music Hall Presentation Vase," *Silver* 18 (Mar.–Apr. 1985), pp. 8–11 // Kenneth Dinin, Annotated bibliography of E. C. Moore's library bequeathed to the Metropolitan Museum of Art in 1891, in preparation // "List of Two Hundred Sixteen Objects 'Bought for Patterns,'" n.d., Tiffany and Company Archives, Parsippany, N.J.

Louis Comfort Tiffany

1848–1933
New York City
Painter, stained-glass designer, decorator

Louis Comfort Tiffany was trained as a painter, but after 1880 he devoted himself primarily to decorative work and to the design and production of glass, becoming a leading exponent of the American Aesthetic movement. The son of Charles L. Tiffany (1812–1902), founder of the New York silver concern that still bears the family name (see TIFFANY AND COMPANY), Louis Comfort Tiffany was educated in boarding schools, among them the Eagleswood Military Academy near Perth Amboy, New Jersey, where he studied with George Inness (1825–1894). The young Tiffany was not interested in the family business, and in 1866 he decided to become an artist.

In 1867 Tiffany exhibited for the first time at the National Academy of Design in New York, and the following year he left for Paris. There he studied with Léon Belly (1827–1877), a painter of landscapes and Islamic genre scenes. In the spring of 1869 Tiffany accompanied the American landscape painter Samuel Colman (1832–1920) on a trip to North Africa, where, under Colman's influence, he made outdoor sketches in watercolors; on his return to New York he joined the American Watercolor Society. In 1871 he was elected an associate of the National Academy of Design. Tiffany went back to Europe in 1874 to spend the summer in Brittany. Throughout the 1870s he frequently produced paintings based on his travels in Europe and North Africa, which were exhibited at the 1876 Philadelphia Centennial Exposition and at the 1878 Paris Exposition Universelle. In 1880 he was made an academician at the National Academy.

At the age of thirty-one, Tiffany was encouraged by EDWARD C. MOORE, his father's chief designer, to choose a new career, that of interior decorator. "I have been thinking a great deal about decorative work, and I am going into it as a profession," he wrote to CANDACE WHEELER in 1879. "I believe there is more in it than in painting pictures" (Koch, 1964, p. 11). That same year he joined with Wheeler, his friend Colman, and Lockwood de Forest (1850–1932) to found ASSOCIATED ARTISTS. Strongly influenced by JAMES ABBOTT MCNEILL WHISTLER's interior designs, the firm incorporated exotic decorative motifs in its tiles, embroidered hangings, painted friezes, and colored glass. The decor devised for the interior of Tiffany's own residence (ILLS. 4.12, 9.12) in New York called for his dining-room walls to be covered with Japanese paper, the ceiling to be ornamented with blue circular plaques, and oriental porcelain to be displayed on the walls, shelves, and mantel. Tiffany's stained-glass window screen *Eggplants* (FIG. 6.3), with its rich surfaces and brilliant colors, was designed to complement the unusual flavor of the room. In 1879–80 Associated Artists decorated the public rooms of the city's Seventh Regiment Armory, combining exotic elements and military motifs to create an appropriate scheme (ILLS. 4.13, 4.14). Other prominent clients included Hamilton Fish, Henry de Forest, and John Taylor Johnston. The firm was dissolved in 1883, after which Candace Wheeler pursued her textile work under the name of Associated Artists, and Louis C. Tiffany and Company handled other decorative projects.

Tiffany spent much of the 1880s and 1890s working in glass. His earliest glass had been executed on a limited scale with Associated Artists, who, for example, had used glass to comprise the sides of a clock (FIG. 6.4). Now, however, Tiffany organized a studio of talented young artists and worked for architects, such as Stanford White (1853–1906) and Thomas Hastings (1860–1929), rather than for individual clients. In 1895 S. Bing, the Parisian promoter of the Art Nouveau style, described the purpose of Tiffany's enterprise: "Tiffany saw only one means of effecting this perfect union between the various branches of industry: the establishment of a large factory, a vast central workshop that would consolidate under one roof an army of craftsmen representing every relevant technique . . . all working to give shape to the carefully planned concepts of a group of directing artists, themselves united by a common current of ideas" (Bing, 1970, p. 146).

In 1892 Tiffany developed a new kind of blown glass, called Favrile, for bowls and vases, which were offered to the public the following year. Satiny in texture, Favrile glass is often iridescent with variegated colors; its forms suggest organic abstractions. Tiffany further expanded his activities and established a metalwork department, producing lamps, sconces, and chandeliers. He continued to design interiors, among them the residence of Mr. and Mrs. Henry Osborne Havemeyer, completed in 1890–91. The rich effects achieved in the glass mosaics that ornamented their entrance hall (ILLS. 6.6, 6.7, FIGS. 6.7, 6.8) are also evident in a bejeweled fire screen (FIG. 6.9) for the same room. The suite of furniture (FIGS. 5.24, 5.25) that Tiffany designed with Samuel Colman for the Havemeyers' music rooms shows the influence of Lockwood de Forest's Indian woodwork (ILL. 1.2) in the low-relief carved floral decoration and inlaid ornament. From the late 1880s until the turn of the century Tiffany decorated numerous churches throughout America, and in 1893 he featured a chapel, a "Light Room," and a "Dark Room" in his displays at the Chicago World's Columbian Exposition. Soon after the 1893 exposition, with Bing's assistance, he exhibited ten windows designed by such avant-garde artists as Pierre Bonnard (1867–1947) and Paul Sérusier (1863–1927).

The wide range of decorative objects made by the Tiffany Studios after 1900 encompassed enameled boxes, jewelry, tableware, and an assortment of household items, including clocks, desk sets, dishes, and trays. The expansion in the type and number of objects reflected changes in policy. Fewer unique objects were produced, and well-designed matched sets, made of the finest materials, were promoted. Tiffany, increasingly occupied with managing his business concerns, relied on other artists for designs. Among the large-scale commissions his firm undertook in the twentieth century were the curtain for the National Theater in Mexico City, completed by 1911; the windows for the Catholic Cathedral in Saint Louis; and a mosaic glass mural designed by Maxfield Parrish (1870–1966) for the Curtis Publishing Company building in Philadelphia. Tiffany Studios, an outgrowth of the Tiffany Glass and Decorating Company, continued under Louis Comfort Tiffany's guidance until 1928, when Arthur Nash assumed leadership, but by World War I it had significantly curtailed its operations and reduced its production.

In addition to his design work, Tiffany gave lectures, delivering his first in 1910, and financed several publications, including his biography, written by Charles De Kay. In 1918 Tiffany founded the Louis Comfort Tiffany Foundation, a retreat for young artists, designers, and craftsmen, which operated out of Laurelton Hall in Oyster Bay, New York, his home since 1904. When he died in 1933, however, Tiffany's accomplishments as a designer had been overshadowed by the functional aesthetic of the Bauhaus. Not until the 1950s was there a renewed interest in his work, with an important series of exhibitions held in Europe and America.

REFERENCES

Louis C. Tiffany, *Expression in Church Architecture* (New York, 1875) // John Moran, "New York Studios," pt. 3, *Art Journal* (Appleton's) 6 (Jan. 1880), pp. 1–4 // "A Model Theatre," *Art Journal* (Appleton's) 6 (May 1880), pp. 139–41 // Roger Riordan, "American Stained Glass," pts. 1–3, *American Art Review* (Boston) 2, pt. 1 (1881), pp. 229–34; 2, pt. 2 (1881), pp. 7–11, 59–64 // Mary Gay Humphreys, "Colored Glass for Home Decoration," *Art Amateur* 5 (June 1881), pp. 14–15 // "Is Our Art Only a Fashion?" *Art Amateur* 5 (June 1881), p. 2 // Donald G. Mitchell, "From Lobby to Peak: Round about—Again," *Our Continent,* Mar. 29, 1882, p. 101 // [Alexander F. Oakey], "A Trial Balance of Decoration," *Harper's New Monthly Magazine* 64 (Apr. 1882), pp. 734–40 // "High-toned House Decoration," *Carpet Trade and Review* 13 (Aug. 1882), p. 30 // "New Houses—Indoors and Out," *Art Amateur* 8 (Feb. 1883), pp. 66–68 // *Artistic Houses, Being a Series of Interior Views of a Number of the Most Beautiful and Celebrated Homes in the United States,* 2 vols. in 4 pts. (1883–84; reprinted in 1 pt., New York, 1971), vol. 1, pt. 1, pp. 1–6 // Mary G[ay] Humphreys, "The Progress of American Decorative Art," *Art Journal* (London), Jan. 1884, pp. 25–28; Mar. 1884, pp. 69–73 // "Some Work of the 'Associated Artists,'" *Harper's New Monthly Magazine* 69 (Aug. 1884), pp. 343–51 // Mary Gay Humphreys, "Bits in the Tiffany House," *Art Amateur* 16 (Jan. 1887), pp. 40, 42 // L. W. Miller, "Industrial Art: The Exhibition of Art Industry at Philadelphia," *Art Amateur* 21 (Nov. 1889), p. 134 // Louis C. Tiffany, "American Art Supreme in Colored Glass," *Forum* 15 (July 1893), pp. 621–28 // Cecilia Waern, "The Industrial Arts of America, 2: The Tiffany or 'Favrile' Glass," *International Studio* 5 (July 1898), pp. 16–21 // Gardner C. Teall, "The Art of Things," *Brush and Pencil* 4 (Sept. 1899), pp. 302–11 // "Louis C. Tiffany and His Work in Artistic Jewellery," *International Studio* 30 (Dec. 1906), pp. xxxii–xlii // Samuel Howe, "An American Country House," *International Studio* 33 (Feb. 1908), pp. 294–96 // Ethel Syford, "Examples of Recent Work from the Studio of Louis C. Tiffany," *New England Magazine,* n.s. 45 (Sept. 1911), pp. 97–108 // Charles De Kay, "A Western Setting for the Beauty of the Orient: Studio Home of L. C. Tiffany, Painter, Craftsman, and Collector," *Arts and Decoration* 1 (Oct. 1911), pp. 469–72 // Idem, *The Art Work of Louis C. Tiffany* (Garden City, N.Y., 1914) // "Louis C. Tiffany," *International Studio* 58 (Apr. 1916), p. lxiii // Louis C. Tiffany, "Color and Its Kinship to Sound," *Art World* 2 (May 1917), pp. 142–43 // René de Quélin, "A Many-Sided Creator of the Beautiful: The Work of Louis Comfort Tiffany as Viewed by an Associate," *Arts and Decoration* 17 (July 1922), pp. 176–77 // Edgar Kaufmann, Jr., "Tiffany Then and Now," *Interiors* 114 (Feb. 1955), pp. 82–85 // Gertrude Speenburgh, *The Arts of the Tiffanys* (Chicago, 1956) // Robert Koch, "The Stained Glass Decades: A Study of Louis Comfort Tiffany (1848–1933) and the Art Nouveau in America," 3 vols. (Ph.D. diss., Yale University, 1957) // Edgar Kaufmann, Jr., "At Home with Louis Comfort Tiffany," *Interiors* 117 (Dec. 1957), pp. 118–25, 183 (ill.) // Museum of Contemporary Crafts of the American Craftsmen's Council, New York, *Louis Comfort Tiffany, 1848–1933,* by Robert Koch (exhib. cat., 1958) // William B. O'Neal, "Three Art Nouveau Glass Makers," *Journal of Glass Studies* 11 (1960), pp. 125–37 // Stuart P. Feld, "'Nature in Her Most Seductive Aspects': Louis Comfort Tiffany's Favrile Glass," *Bulletin of the Metropolitan Museum of Art,* n.s. 21 (Nov. 1962), pp. 101–12 // Herwin Schaefer, "Tiffany's Fame in Europe," *Art Bulletin* 44 (Dec. 1962), pp. 309–28 // Robert Koch, *Louis C. Tiffany: Rebel in Glass* (New York, 1964; 2d ed. New York, 1966) // Mario Amaya, "Taste for Tiffany," *Apollo* 81 (Feb. 1965), pp. 102–9 // Idem, *Tiffany Glass* (New York, 1967) // Albert Christian Revi, *American Art Nouveau Glass* (Camden, N.J., 1968) // Martin Eidelberg, "Tiffany Favrile Pottery, a New Study of a Few Known Facts," *Connoisseur* 169 (Sept. 1968), pp. 57–61 // Elton Robinson, "Rediscovery: A Tiffany Room, New York's Seventh Regiment Armory," *Art in America* 57 (July–Aug. 1969), pp. 72–77 // S. Bing, *Artistic America, Tiffany Glass, and Art Nouveau,* intro. Robert Koch (Cambridge, Mass., and London, 1970) // Egon Neustadt, *The Lamps of Tiffany* (New York [1970]) // Robert Koch, *Louis C. Tiffany's Glass—Bronzes—Lamps: A Complete Collector's Guide* (New York, 1971) // Idem, "Tiffany's Abstractions in Glass," *Antiques* 105 (June 1974), pp. 1288–94 // Wilson H. Faude, "Associated Artists and the American Renaissance in the Decorative Arts," *Winterthur Portfolio* 10 (1975), pp. 101–30 // Robert Koch, "The Tiffany Exhibition Punch Bowl," *Arts in Virginia* 16 (Winter/Spring 1976), pp. 32–39 // Judith Saks, "Tiffany's Household Decoration: A Landscape Window," *Bulletin of the Cleveland Museum of Art* 63 (Oct. 1976), pp. 226–35 // Ian M. G. Quimby, "Oriental Influence on American Decorative Arts," *Journal of the Society of Architectural Historians* 35 (Dec. 1976), pp. 300–308, esp. pp. 304–6 for a discussion of Robert Koch, "Louis C. Tiffany's Collection of Japanese Art," read at the twenty-ninth annual meeting of the Society of Architectural Historians // Robert Koch, *Louis C. Tiffany's Art Glass* (New York, 1977) // Loch Haven Art Center, Orlando, Fla., *Tiffany's Chapel: A Treasure Rediscovered,* by Hugh [F.] McKean (exhib. cat., 1977) // Garth Clark, *A Century of Ceramics in the United States, 1878–1978: A Study of Its Development* (New York, 1979), pp. 333–34 // Grey Art Gallery and Study Center, New York, *Louis Comfort Tiffany: The Paintings,* by Gary A. Reynolds and Robert Littman (exhib. cat., 1979) // Gary Reynolds, "Louis Comfort Tiffany: Also a Painter," *American Art and Antiques* 2 (Mar.–Apr. 1979), pp. 36–45 // Alastair Duncan, *Tiffany Windows* (New York, 1980) // Hugh [F.] McKean, *The "Lost" Treasures of Louis Comfort Tiffany* (New York, 1980) // Charles H. Carpenter, Jr., "The Silver of Louis Comfort Tiffany," *Antiques* 117 (Feb. 1980), pp. 390–97 // Alastair Duncan, "Light and Landscape in Tiffany Windows," *Connaissance des Arts* 345 (Nov. 1980), pp. 105–12 // Idem, *Tiffany at Auction* (New York, 1981) // M. H. de Young Memorial Museum, San Francisco, *The Art of Louis Comfort Tiffany,* by Donald L. Stover (exhib. cat., 1981) // Barbara Gorely Teller, "Tiffany's Laurelton Hall, 1923," *Antiques* 119 (Jan. 1981), pp. 233–34 // Helene Weis, "Art Nouveau and Tiffany's Tiffany," *Stained Glass* 76 (Spring 1981), pp. 29–30 // Hugh [F.] McKean, "Tiffany Remembered," *Portfolio* 3 (May–June 1981), pp. 46–53 // James L. Sturm, *Stained Glass from Medieval Times to the Present: Treasures to Be Seen in New York* (New York, 1982) // Katherine Harlow, "A Pioneer Master of Art Nouveau: The Hand-wrought Jewelry of Louis C. Tiffany," *Apollo* 116 (July 1982), pp. 46–50 // Peter Johnson, "Long Island Long Ago," *Antique Collector* 56 (July 1985), pp. 56–59 // Tiffany Glass and Decorating Company, *Tiffany Favrile Glass* (New York, n.d.)

Union Porcelain Works

Ca. 1862– ca. 1922
Brooklyn, New York
Ceramics

Greenpoint, now part of Brooklyn, New York, became a center for ceramics production, especially porcelain, in the nineteenth century. Soft-paste porcelain had been attempted there by Charles Cartlidge in 1848 and by William Boch and Brothers, a German family that in 1850 established a similar enterprise, sometimes called the Empire, or Union, Porcelain Works and located on Eckford Street. Thomas Carll Smith (b. 1815) was first mentioned in connection with the Boch firm in 1859 and acquired a majority interest in it two years later. With the onset of the Civil War, Smith was forced to purchase the financially troubled company about 1862 to salvage his investment.

Smith, born and raised in Bridgehampton, New York, was a successful master builder and architect. Finding himself the owner of a porcelain factory, in 1863 he visited Sèvres and the Staffordshire potteries. He returned intent upon manufacturing porcelain with a kaolinic body (known as hard-paste or true porcelain), which can be made thinner than its soft-paste counterpart and which is more receptive to detailed surface modeling. At the time, true porcelain was not manufactured in the United States; Smith became the first to do so. As Susan Williams has pointed out, Smith's decision coincided with the imposition of stiff tariffs (up to fifty percent) on imported ceramics, which were to endure through the end of the century, thus creating propitious circumstances for American manufacturers. Smith refurbished his factory and tools and purchased a quarry in Branchfield, Connecticut, to supply his factory with quartz and feldspar, two key ingredients of porcelain. In 1864 he added kaolin from Pennsylvania (eventually the factory imported the material from England) and a year later succeeded in producing a plain white ware; hard porcelain was on the market by 1868. Smith is also credited with being the first in America to use underglaze decoration on a hard-porcelain body, although the overglaze method was actually used on most of his decorated products.

Between 1864 and 1869 the firm was formally known as Thomas C. Smith and Company at 300 Eckford Street, near the East River; John W. Mersereau was Smith's finan-

cial partner at this time. The factory continued to be known as the Union Porcelain Works, although it was not listed as such in the Brooklyn city directory until 1874. After 1869, when Charles H. L. Smith joined his father, the firm was known as Thomas C. Smith and Son; the company was not incorporated until 1888. Much of the Union Porcelain Works' production consisted of serviceable white china (advertised as "thick" and "half-thick") for hotels and domestic use. They also manufactured hardware trimmings, electrical insulators, and decorated tiles. Bawo and Dotter, at 30–32 Barclay Street, New York, was the agent for Union Porcelain Works' wares.

Signaling a change of direction, in anticipation of the nation's Centennial, in 1874 Smith hired the sculptor Karl L. H. Mueller (about 1820–before 1909) as the firm's chief designer. Mueller, the son of a goldsmith, was born in Coblenz, Germany, and studied at the Royal College of Coblenz and at the Royal Academy of Paris, where he was in the circle of François Rude (1784–1855). In Paris he completed a figural group entitled *The Minstrel's Curse,* for which he was awarded a gold medal by the academy. He brought the piece to New York when he emigrated in 1850 and reportedly displayed it to great acclaim at the National Academy of Design shortly after arriving, and again at New York's Crystal Palace in 1853 (although it is not mentioned in the published index of National Academy exhibitions). Nevertheless, Mueller contributed regularly to National Academy shows between 1856 and 1882 and displayed his work at the American Institute of the City of New York and at the Brooklyn Art Association as well.

His creations include genre-type figures, such as *School Boy, News Boy, Blacksmith,* and *Stonecutter,* as well as portrait medallions of eminent Americans, among them Washington, Webster, Clay, Calhoun, Franklin, and Morse. Some of these medallions were commissioned and distributed by the Cosmopolitan Art Association in 1857. Mueller worked in plaster, marble, bronze, silver, and terracotta, the last being especially noteworthy in light of his later association with the Union Porcelain Works. Not surprisingly, some of his sculpture subjects—*Bullfrog* (1869) and *Turtle* (1869), for example—also appear in porcelain designs. Mueller's patrons included artists, such as Asher B. Durand, John W. Casilear, A. F. Tait, and John M. Falconer—who later was a decorator for the Union Porcelain Works—as well as John Henry Matthews (1808–1870), the prolific inventor of soda-water machines who also became Mueller's father-in-law.

It was Thomas Smith's ambition to create an American style in ceramics, distinct from contemporary European models. The result, in his case, was an eclectic selection of symbols, usually from literature or everyday American life, applied to conventional forms. Under Smith's direction, Mueller created a number of decorative pieces during the 1870s. The Century Vase, made for the 1876 Philadelphia Centennial Exposition, was the most famous. Studded with bison heads that serve as handles and with smaller heads of other animals, the large urn-shaped vase is further embellished with a relief profile of George Washington, with relief panels commemorating events from the Colonial era, and with painted emblems of contemporary industry, including the seamstress and the potter, the steamboat, the reaper, and the telegraph.

One of Union Porcelain Works' painted plates, of about 1876 (FIG. 7.25), was probably decorated by Karl Mueller. Its circumference is ringed with a native American plant, the Indian cucumber root, and cruciform shapes. The central scene may relate to "a pair of curiously-shaped jugs . . . comically illustrated with 'the donkey and the thistle'" that are mentioned in a *Crockery and Glass Journal* review of the American Institute Fair of 1876.

Smith participated in local decorative-arts activities by displaying examples of Union Porcelain Works' ceramics in various exhibitions, including the loan show organized for the benefit of the New York Society of Decorative Art in 1878, and by making studio space available on his premises for amateur china painters.

The length of Mueller's association with Union Porcelain Works is unknown, as are the details of his personal life. Brooklyn city and telephone directories chronicle the factory, however, which appears to have ceased operations in 1922.

REFERENCES
"Carl Muller [*sic*] and His Works," *Cosmopolitan Art Journal* 1 (July 1856), p. 9 // "Masters of Art and Literature," *Cosmopolitan Art Journal* 1 (Mar. 1857), pp. 84–85 // "American Porcelain," *New York Times,* Oct. 27, 1872, p. 3 // "A Unique Bar Pitcher," *Crockery and Glass Journal* 2 (Nov. 11, 1875), p. 16 // "The American Institute Fair," *Crockery and Glass Journal* 4 (Sept. 28, 1876), p. 14 // "Trade Notes," *Crockery and Glass Journal* 5 (Apr. 5, 1877), p. 15 // National Academy of Design, New York, *Catalogue of the Loan Exhibition, 1878, in Aid of the Society of Decorative Art, Consisting of Gems of the Modern, Foreign, and American Schools of Painting and Rare Examples of Various Art Industries* (exhib. cat., 1878), p. 31 // [Wares of Union Porcelain Works available at Bawo and Dotter, agents, New York], *Crockery and Glass Journal* 7 (Feb. 14, 1878), p. 16 // "Industrial Notes," *Crockery and Glass Journal* 7 (Apr. 11, 1878), p. 20 // Jennie J. Young, *The Ceramic Art: A Compendium of the History and Manufacture of Pottery and Porcelain* (New York, 1879), pp. 443–44, 448–49, 451, 462–63, 473–87 // "Native Ceramics at the American Institute," *Crockery and Glass Journal* 10 (Oct. 9, 1879), p. 24 // "Pottery at the American Institute Fair," *Art Amateur* 1 (Nov. 1879), pp. 126–27 // "The American Institute Awards," *Crockery and Glass Journal* 10 (Dec. 4, 1879), p. 17 // "Chester County in China-Ware," *Crockery and Glass Journal* 10 (Dec. 4, 1879), p. 19 // Silex, "Trenton Potteries," *Crockery and Glass Journal* 11 (Feb. 19, 1880), p. 20 // [Workers threatening strike are discharged], *Crockery and Glass Journal* 11 (Mar. 11, 1880), p. 16 // [Letter to the editor from Thomas C. Smith], *Crockery and Glass Journal* 15 (Feb. 9, 1882), p. 25 // Thomas C. Smith to Mrs. Aaron F. Perry, correspondence, Aug. 21, 1882, Women's Art Museum Association of Cincinnati Collection, Box 2, Folder 9, item 233, Cincinnati Historical Society // G. de Léris, "L'Habitation américaine," pt. 1, *Revue des Arts Décoratifs,* 4e ann. (1883–84), pp. 33–38 // Henry R. Stiles, *The Civil, Political, Professional, and Ecclesiastical History, and Commercial and Industrial Record of the County of Kings and the City of Brooklyn, N.Y., from 1683 to 1884* (New York, 1884), pt. 2, pp. 761–67 // "Decorative Novelties," *Art Interchange* 19 (July 2, 1887), pp. 3–5 // Edwin AtLee Barber, *The Pottery and Porcelain of the United States* (New York, 1893; 3d ed. New York, 1909), pp. 162–64, 252–58, 276, 406 // Henry Hull, ed., *America's Successful Men of Affairs* (New York, 1895), vol. 1, p. 431 // C. Ruge, "Development of American Ceramics," *Pottery and Glass* 1 (Aug. 1908), pp. 3–8 // William L. Felter, *Historic Greenpoint . . . Issued in Connection with the Semicentennial of the Greenpoint Savings Bank and by That Institution* (New York [1919?]), p. 52 // "Müller, Charles," in *National Academy of Design Exhibition Record, 1826–1860,* comp. Bartlett Cowdrey, 2 vols. (New York, 1943), vol. 2, p. 46 // George C. Groce and David H. Wallace, "Müller or Miller, Charles [*sic*]," in *The New-York Historical Society's Dictionary of Artists in America, 1564–1860* (New Haven and London, 1957), p. 459 // Marvin D. Schwartz and Richard Wolfe, *A History of American Art Porcelain* (New York, 1967), p. 43, pls. 24–30, 32–34, 36 // Marvin D. Schwartz, *Collectors' Guide to Antique American Ceramics* (Garden City, N.Y., 1969), pp. 102–4, 108–14 // William C. Ketchum, Jr., *Early Potters and Potteries of New York State* (New York, 1970), pp. 46–48 // "Muller, Carl or Karl," in *A History of the Brooklyn Art Association with an Index of Exhibitions,* ed. Clark S. Marlor (New York, 1970), p. 283 // Metropolitan Museum of Art, New York, *Nineteenth-Century America: Furniture and Other Decorative Arts* (exhib. cat., 1970), nos. 196, 199–201, 203–4, 240 // James R. Mitchell, "The American Porcelain Tradition," *Connoisseur* 179 (Feb. 1972), pp. 123–31 // "Müller, Charles H. or Carl or Karl," in *National Academy of Design Exhibition Record, 1861–1900,* ed. Maria Naylor, 2 vols. (New York, 1973), vol. 2, pp. 668–69 // Cincinnati Art Museum, *The Ladies, God Bless 'Em: The Women's Art Movement in Cincinnati in the Nineteenth Century* (exhib. cat., 1976), pp. 37–38 // J. G. Stradling, "American Ceramics and the Philadelphia Centennial," *Antiques* 110 (July 1976), pp. 146–58 // Detroit Institute of Arts, *The Quest for Unity: American Art Between World's Fairs, 1876–1893* (exhib. cat., 1983), pp. 80–81 (ills.), 209 (ill.) // John Nally, New York, correspondence, Feb. 16, 1984 // Marvin D. Schwartz, "A Soda-Machine Door by a Prominent American Sculptor," typescript, n.d. // Susan R. Williams, The Strong Museum, Rochester, N.Y., "The Union Porcelain Works: Design in a Larger Context," typescript, n.d.

Albert Valentien, *see* Rookwood Pottery

Elihu Vedder
1836–1923
New York City and Rome
Painter

Elihu Vedder, best remembered for his visionary paintings, undertook many decorative efforts during the course of his career. Not only did he participate in the revival of mural painting in America, but he also worked as an illustrator and experimented with a number of ideas for more commercial projects, few of which achieved the success he had anticipated.

Born in New York City, Vedder, whose father worked in Cuba as a dentist, attended boarding schools in the city; he spent many summers on his grandfather's farm in Schenectady, New York. Tompkins Harrison Matteson (1813–1884), a historical, genre, and portrait painter in Sherburne, New York, provided Vedder's early instruction in art.

His significant development, however, really began in 1856, when he went abroad to study, beginning some sixty years of life as an expatriate. His first destination was Paris, where he enrolled in the atelier of François-Edouard Picot (1786–1868), with whom he studied for eight months. Disappointed in the French academic approach, Vedder decided to go to Italy, where he could see classical art firsthand as well as live more economically. In Florence, Vedder took drawing instruction from Raffaello Bonaiuti. There too he met a group of young, mainly Tuscan painters, called the Macchiaioli, who drew their inspiration from French plein-air painters and produced romantic landscapes using *macchie,* or splashes of color, and chiaroscuro. Also at this time Vedder joined a circle of expatriate English and American artists and writers. With one of them, James Jackson Jarves (1818–1888), an American writer and collector, Vedder discussed art theory and studied frescoes, particularly those of the primitive and Renaissance Florentine painters, whose work soon influenced him.

In 1860 Vedder went to Cuba, where he visited his father, who was reluctant to continue supporting his art career. Arriving in the United States at the outbreak of the Civil War, Vedder was exempted from military service by an arm injury. Back in New York, he supported himself by doing illustrations for *Vanity Fair* and *Frank Leslie's Illustrated Newspaper.* Vedder's association with such literary and artistic companions as Walt Whitman, Herman Melville, Fitz Hugh Ludlow, Fitz-James O'Brien, and Thomas Bailey Aldrich inspired him to begin a series of landscape paintings with literary symbolism, among them *The Questioner of the Sphinx* (1863) and *The Lair of the Sea Serpent* (1864), both now in the Museum of Fine Arts, Boston. He was made an associate of the National Academy of Design in New York in 1864, and a year later he became an academician. About this time Vedder left New York to join his friends William Morris Hunt (1824–1879) and JOHN LA FARGE in Boston.

Returning to Europe in 1866, Vedder spent several months in Paris and then summered in Brittany with Hunt. In 1867 he settled in Rome, where he remained, except for brief visits to the United States and England. During one trip home, in 1869, he married Caroline Rosekrans, whom he had met in Paris. The following year the couple traveled to London, where the artist took a studio and familiarized himself with the Pre-Raphaelite

painters and critics. During the early 1870s the Vedders spent their summers and autumns in the Perugian countryside, entertaining various English artists, including WALTER CRANE, Edwin Ellis (1841–1895), and William Davies (1826–1901), whose contact with the Pre-Raphaelite movement and interest in the visual symbolism of William Blake changed the course of Vedder's career. Vedder visited London again in 1876, and thereafter his work showed what Regina Soria has described as "a search for the beautiful effect where before there was a search for the tragic, the horrible, the awesome" (Soria, 1970, p. 112). This transformation can be attributed to his introduction to the paintings of Frederick Leighton (1830–1896), Lawrence Alma-Tadema (1836–1912), and George Watts (1817–1904), whose classical styles and idealized subjects encouraged Vedder to pursue a more decorative manner. In such mature works as *The Fates Gathering in the Stars* (1887, ILL. 9.26), the impact of Michelangelo's monumental figures in his ceiling for the Sistine Chapel in Rome can no doubt be discerned as well.

Vedder resided in New York in the winter of 1879–80, just as the American Aesthetic movement was reaching the height of its influence, and returned again for one and a half years in the autumn of 1881. It is hardly surprising that the American revival of decorative arts appealed to Vedder: rare and antique objects had long been featured in his paintings, as accessories and costumes in his figural works, and as models in such still-life paintings as *Japanese Still Life* (1879, FIG. 9.16). In New York he participated in the meetings and excursions of the Tile Club, whose members gathered regularly, beginning in 1877, to paint on ceramic tiles. Three of four firebacks modeled by Vedder, all of which treat themes of warmth appropriate for the hearth, were completed during the winter of 1881–82. In one of these, *The Soul of the Sunflower* (1882, FIG. 9.5), he returned to a motif of an earlier drawing (1868, ILL. 9.4) in which he had depicted a psychological state of mind. He also completed designs for at least five stained-glass windows, including an ambitious one that LOUIS COMFORT TIFFANY produced in 1882 for the New York residence of A. H. Barney. That same year Vedder attempted to patent a method of making a glass screen comprised of a system of rings that held pieces of glass; much to his dismay, Tiffany had patented a similar device the previous year. Vedder also designed a number of greeting cards, one of which, *Fortune* (1881, FIG. 9.4), was produced by L. Prang and Company in 1882, and drew covers for three magazines—*Harper's New Monthly Magazine* (1882), *Century Illustrated Monthly Magazine* (1882), and *Studio* (1883).

In 1883, while still in New York, Vedder began work on fifty-five illustrations for Edward Fitzgerald's 1859 translation of the *Rubáiyát of Omar Khayyám,* which Houghton, Mifflin and Company published in Boston on November 8, 1884. Vedder was responsible for every aspect of the publication: he drew the imaginative illustrations (FIG. 9.12), devised the lettering for the text, and designed the book's cover (FIG. 9.11). The *Rubáiyát* marked a new phase in Vedder's oeuvre; it not only provided him with thematic material for subsequent

large-scale projects, but also placed his work in great demand. His studio in Rome soon became a popular venue for wealthy Americans traveling abroad.

In the 1890s Vedder continued to do decorative works, the most important of which were mural paintings, in which he was able to use his knowledge of the frescoes of the Italian masters. The success of his murals for the Walker Art Gallery building at Bowdoin College, in Brunswick, Maine, won him other commissions, including the 1893 decorations for Collis Potter Huntington's New York dining room and a series of murals for the Library of Congress in Washington, D.C., two years later.

In spite of his American popularity, Vedder preferred to stay in Italy, and in 1900 he began to build a home on Capri, where his friend CHARLES CARYL COLEMAN had lived since 1886. Vedder spent his summers on the island and continued to live in Rome the rest of the year, painting and writing until his death, in 1923.

REFERENCES

James Jackson Jarves, *The Art-Idea* (New York, 1864), pp. 242–50 // [Charles De Kay], "Elihu Vedder," *Scribner's Monthly* 21 (Nov. 1880), pp. 111–24 // W. H. Bishop, "Elihu Vedder," pts. 1, 2, *American Art Review* (Boston) 1, pt. 2 (1881), pp. 325–29, 369–73 // "New Inventions" [tile by Elihu Vedder], *Crockery and Glass Journal* 15 (May 4, 1882), p. 36 // "New Inventions" [ornamental screen], *Crockery and Glass Journal* 16 (Aug. 17, 1882), p. 38 // *Rubáiyát of Omar Khayyám, the Astronomer-Poet of Persia,* rendered into English verse by Edward Fitzgerald, with an accompaniment of drawings by Elihu Vedder (Boston, 1884) // H. E. Scudder, "Vedder's Accompaniment to the Song of Omar Khayyám," *Century Illustrated Monthly Magazine* 29 (Nov. 1884), pp. 2–9 // "Reviews: Vedder's 'Rubáiyát' of Omar Khayyam," *Critic* 5 (Nov. 15, 1884), pp. 230–31 // A. Mary F. Robinson, "Elihu Vedder," *Magazine of Art* 8 (1885), pp. 120–25 // Architect [pseud.], "Notes on Decoration," *Art Amateur* 12 (Mar. 1885), pp. 88–89 // "Some Artistic Fire Places" [advertisement], *Critic* 8 (Jan. 16, 1886), p. iv // William Howe Downes, "Elihu Vedder's Pictures," *Atlantic Monthly* 59 (June 1887), pp. 842–46 // William C. Brownell, "Recent Work of Elihu Vedder," *Scribner's Magazine* 17 (Feb. 1895), pp. 157–64 // Ernest Radford, "Elihu Vedder, and His Exhibition," *Magazine of Art* 23 (1899), pp. 364–69 // Idem, "Elihu Vedder," *Art Journal* (London), Apr. 1899, pp. 97–103 // Lewis Lusk, "The Later Work of Elihu Vedder," *Art Journal* (London), May 1903, pp. 142–46 // Elihu Vedder, *The Digressions of V.* (Boston, 1910) // Idem, "Art Prattle," *Atlantic Monthly* 106 (Sept. 1910), pp. 403–15 // Ferris Greenslet, "Elihu Vedder in Rome," *Outlook,* Nov. 26, 1910, pp. 693–98 // Elihu Vedder, *Miscellaneous Moods in Verse* (Boston, 1914) // Idem, *Doubt and Other Things* (Boston, 1922) // Regina Soria, "Some Background Notes for Elihu Vedder's 'Cumean Sibyl' and 'Young Marsyas,'" *Art Quarterly* 23 (Spring 1960), pp. 71–87 // Idem, "Elihu Vedder's Mythical Creatures," *Art Quarterly* 26 (Summer 1963), pp. 180–93 // Idem, "Mark Twain and Vedder's Medusa," *American Quarterly* 16 (Winter 1964),

pp. 602–6 // "An American in Japan, 1863–1870," *Archives of American Art Journal* 6 (Jan. 1966), pp. 11–17 // Regina Soria, *Elihu Vedder: American Visionary Artist in Rome (1836–1923)* (Rutherford, N.J., 1970) // Idem, "Vedder's Happy Days in Bordighera," *Currier Gallery of Art Bulletin* (Jan.–Mar. 1970), unpaged // University Art Museum, University of California, Berkeley, *The Hand and the Spirit: Religious Art in America, 1700–1900,* essay by Joshua C. Taylor (exhib. cat., 1972), pp. 166–73 // Graham Gallery, New York, *Elihu Vedder: An American Visionary in Rome,* essay by Regina Soria (exhib. cat., 1974) // Marjorie Reich, "The Imagination of Elihu Vedder—as Revealed in His Book Illustrations," *American Art Journal* 6 (May 1974), pp. 39–53 // Dayton Art Institute, Ohio, *American Expatriate Painters of the Late Nineteenth Century,* by Michael Quick (exhib. cat., 1976), pp. 139–41, 157–58 // Regina Soria, "Elihu Vedder, American Old Master," *Georgia Museum of Art Bulletin* 2 (Spring 1976), pp. 24–31 // National Collection of Fine Arts, Washington, D.C., *Perceptions and Evocations: The Art of Elihu Vedder,* by Regina Soria et al. (exhib. cat., 1979)

Wakefield Rattan Company

1855–1897
Wakefield, Massachusetts
Wicker furniture

Wicker has been manufactured since ancient times. The term, which has its roots in the Scandinavian *vikker,* or willow, does not in fact denote a specific material but rather woven furniture in general. Closely related to the art of basketry, wicker furniture may be made from any of several materials, such as swamp reed, raffia, willow, young bamboo, rush, roots, wild grasses, split wood, and, since World War I, machine-twisted paper. Most wicker furniture, however, is manufactured from rattan, a palm vine native to Malaysia and the Far East that is flexible and water resistant. Cane, made from the rattan bark, is a by-product used for the seats and backs of chairs. Although England imported rattan from China for this purpose during the seventeenth century, the large-scale production of rattan furniture for the Western market did not begin until the nineteenth century—and then not in Europe or the Orient, but in America.

Cyrus Wakefield (1811–1873) was a farmer's son born in Roxbury, New Hampshire. As a young man he worked as a picker in a cotton mill in nearby Peterboro, and about 1826 he moved to Boston, where he worked for a retail grocery store. By trading in empty caskets and barrels on the side, the resourceful young Wakefield was able to save enough money to start his own grocery business in 1834. This was Foster and Wakefield, a short-lived enterprise of two years; by 1838 he had a similar partnership with his brother, Enoch, which dissolved after six years.

Down at the Boston docks one day in 1844, Wakefield became fascinated by the bundles of rattan that were being discarded after serving as dunnage on the cargo ships arriving from the Orient. He took some and experimented with wrapping a conventional chair in strips of cane. Meanwhile, finding that he could sell cane to furniture makers, Wakefield started a profitable jobbing trade just as the market was on the rise. Because he was able to import inexpensive "split rattan," as cane was also called, from China through his brother-in-law, who fortuitously was employed by Russell and Company in Canton, Wakefield was able to avoid the higher costs of American labor, and he quickly became one of the major suppliers to manufacturers across the country.

In the early 1850s, having decided to process cane locally, Wakefield moved to South Reading, near Boston, and acquired property that included a site on the Mill River, which in 1855 was where he built his factory and started the Wakefield Rattan Company. Although dependent at first on immigrant laborers, he eventually developed steam-powered machinery to separate cane from its pith, or reed. The following year, in 1856, when the start of the second Opium War curtailed the supply of rattan from the Orient, Wakefield was able to purchase the only remaining lots on the East Coast, which gave him complete control of the American market for the next few years. Concerned about using rattan efficiently, Wakefield resolved to salvage both the reed and the shavings that were considered waste products. The reeds soon became skirt hoops and baskets, while the shavings were transformed into a coarse yarn that was woven into carpets and matting. As he continued to experiment, Wakefield also developed methods of making woven furniture from the versatile rattan's pliable inner reed, which could be stained or painted, unlike natural rattan, which could only be varnished in its original state. Reed lent itself to the rococo curves, C-shaped scrolls, and arabesques that came into favor during the late nineteenth century. Early Wakefield wicker was a combination of rattan, cane (usually wrapped around a hardwood frame), and locally grown willow.

Lightweight and unharmed by wet weather, wicker furniture was manufactured as early as the 1850s but was most popular, for outdoor use, between 1865 and 1880. By 1880 reed furniture gained in fashion; painted, usually in white, green, brown, or gold, it moved indoors. In contrast to the array of curls, coils, and spirals that typify Wakefield's woven-reed wicker of this period, the rectilinearity of one 1880 rattan settee with a spider-web cane back recalls the oriental furniture forms favored by sophisticated Aesthetic-period designers (FIG. 5.18).

In 1865 Wakefield situated his nephew, Cyrus Wakefield, Jr., in Singapore to export rattan as well as tin, pepper, coffee, and spices. Back in South Reading, production increased with the 1870 invention (by William Houston, Wakefield's assistant) of a mechanical loom for weaving the large quantities of cane webbing required for railroad and streetcar seating; by the close of the early 1870s the factory covered no less than ten acres and employed one thousand people. The name Wakefield became synonymous with wicker, and in 1868 it was literally put on the map when South Reading changed its name to Wakefield in gratitude for its benefactor's gift of a town hall and war memorial.

Cyrus Wakefield died bankrupt during the depression of 1873, only two weeks after incorporating his firm, despite his extensive holdings of Boston real-estate and railroad stocks. He was succeeded by Cyrus, Jr., who about 1875 bought out a number of smaller competitors, including the American Rattan Company, and in 1883 opened a West Coast branch in San Francisco and a factory in Chicago. Although some authentic oriental wicker furniture was imported by merchants, among them A. A. Vantine of New York, most wicker to be found in America was of indigenous manufacture. Some examples of imported Chinese wicker "hourglass" chairs and Ceylonese cane chairs were displayed at the 1876 Philadelphia Centennial Exposition, but it was Wakefield's display at the fair that brought wicker to widespread public attention. There the company received an award "for original design and superior workmanship in furniture, chairs, and baskets, also for originality in the manufacture of mats and baskets of an otherwise waste material; also for a new form of car seats, durable, cool, clean, and economical" (Saunders, 1976, p. 23).

The Wakefield factory burned in 1881, but it was immediately replaced with an even more substantial and fireproof brick edifice. Cyrus Wakefield, Jr., died in 1888, after which the company was not well managed. In 1897 Wakefield Rattan consolidated with its greatest competitor, Heywood Brothers and Company of Gardner, Massachusetts. Established in 1826 by Levi Heywood (d. 1882), this was one of the largest American manufacturers of chairs, specializing in Windsor and bentwood types. During the early 1870s Heywood Brothers had also developed new methods of bending rattan, which led to further experiments with graceful frames wrapped in reed or cane. The president of the new company, called the Heywood Brothers and Wakefield Company, was Henry Heywood, the founder's nephew. Four factories in Wakefield, Gardner, Chicago, and San Francisco were soon supplying warehouses as far east as London and Liverpool and as far west as Portland, Oregon, and Los Angeles, California, with wicker chairs, cradles, cribs, tête-à-têtes, sofas, baby carriages, screens, umbrella stands, and window shades. The company continued its operations, centered in Gardner after the 1930s, and manufactured furniture of various kinds until 1979, although cane, reed, and rattan products were discontinued in the 1930s during the Great Depression.

REFERENCES
Lilley Eaton, *Genealogical History of the Town of Reading, Massachusetts, Including . . . Wakefield, Reading, and North Reading . . . from 1639 to 1874* (Boston, 1874), pp. 483–87, 677–83 // Wakefield Rattan Company [advertisement], *Carpet Trade Review* 5 (Dec. 1878), pp. ix–x (ills.) // Constance Cary Harrison, *Woman's Handiwork in Modern Homes* (New York, 1881), pp. 191, 193–94 // Esther Gilman Moore, *History of Gardner, Massachusetts, 1785–1967* (Gardner, Mass., 1967), pp. 222–28 // Ruth A. Woodbury, *Wakefield's Century of Progress* (Wakefield, 1968), pp. 3–7 // Katherine Boyd Menz, "Wicker in the American Home" (M.A. thesis, University of Delaware, 1976) // Richard Saunders, *Collecting and Restoring Wicker Furniture* (New York, 1976), pp.

13–15, 20–37, 57–58 // Ed Johnson, "An Era Ends: H-W Closes Shop," *Gardner News,* June 13, 1979, pp. 1–2 // Heywood Brothers and Wakefield Company, *Classic Wicker Furniture: The Complete 1898–1899 Illustrated Catalogue,* intro. Richard Saunders (New York, 1982) // Richard Saunders, *Collector's Guide to American Wicker Furniture* (New York, 1983) // Andrea Di Noto, "The Presence of Wicker," *Connoisseur* 214 (June 1984), pp. 78–84 // David Fournier, Levi Heywood Memorial Library, Gardner, Mass., conversation, 1985 // William E. Jones, Wakefield Historical Society, conversation, 1985

James E. Wall
Active 1881–died 1917
Boston
Bamboo furniture

The reopening of Japan to Western trade by Commodore Matthew Calbraith Perry in 1854 and the subsequent display of Japanese objects at the London International Exhibition of 1862 inaugurated in England and America a fascination with Japanese art and culture that had a significant impact on the decorative arts of both countries during the 1870s and 1880s. Sophisticated interpretations of Japanese designs, craftsmanship, and materials by furniture makers such as HERTER BROTHERS of New York were matched by more literal translations of oriental objects designed for the average householder, such as the bamboo chair of about 1886 by the Boston manufacturer James E. Wall (FIG. 5.19).

First introduced to the West by the China trade in the eighteenth century, bamboo again became fashionable, this time on a large scale, during the 1870s and 1880s. Recent research suggests that much of the bamboo furniture marketed as authentically Japanese was actually made by Western manufacturers eager to capitalize on the enthusiasm for exotica. Bamboo, recognizably Eastern in origin, was also inherently lightweight, decorative, and relatively inexpensive; in addition, the tubular bamboo reed was strong and well suited to the rectilinear furniture forms favored by architects and designers of the period.

Some furniture makers, among them George Hunzinger (1835–1898) of Brooklyn, New York, imitated bamboo's knobby surface in lathe-turned wood. James E. Wall actually used imported materials, bamboo and a lacquer panel. At first glance the chair in figure 5.19 looks like an import, but an article in the *Decorator and Furnisher* of December 1886 that illustrates an extremely similar chair (ILL. 5.8) virtually confirms Wall as its maker: "Mr. James E. Wall . . . sends out a catalogue with illustrations of articles in bamboo that deserve special attention. There are charming portfolio stands, tables that are unique . . . bamboo curtain poles that cannot fail to please . . . fire screens in various styles, bamboo chairs extremely odd and pretty, tables that are particularly suitable for magazines and papers."

Wall is first listed in the Boston city directory of 1881 as "bamboo worker" at 73 Cornhill Street, a business address he retains through 1895; in 1896 he is listed as a stockbroker. By 1901, however, he is back in the furniture business at 73 Cornhill Street, as a partner in the firm of Wall and Brackett, wallpaper hangers; in 1910 the company is listed at 43 Cornhill Street as "Importers of English, French, and German Wallpapers, Japanese Grass Cloth and Japanese Leathers." This business affiliation lasted until 1917, when the directory reports that James E. Wall died, on February 8.

REFERENCES
[Bamboo furniture], *Decorator and Furnisher* 9 (Dec. 1886), pp. 107–8 (ills.) // Carrie May Ashton, "Popular Whims in Furniture," *Interior Decorator* 4 (Aug. 1893), pp. 209–10 // Gillian Walkling, "Bamboo Furniture," *Connoisseur* 202 (Oct. 1979), pp. 126–31 // Christopher Monkhouse, Museum of Art, Rhode Island School of Design, Providence, conversation, 1985 // Museum of Art, Rhode Island School of Design, Providence, *American Furniture in Pendleton House,* by Christopher Monkhouse and Thomas S. Michie, with the assistance of John M. Carpenter, forthcoming

Alice Cunningham Ware
1851–1937
Boston and Milton, Massachusetts
Ceramist and wood carver

Alice Hathaway Cunningham, born in Cambridge, Massachusetts, in 1851, lived all of her long life in the Boston area. During the 1870s she achieved a local reputation as a ceramist; her first acclaim was for a piece displayed at the Women's Pavilion at the Philadelphia Centennial Exposition. The incised decoration on some of her ceramics, which was favorably remarked upon by critics, bears a resemblance to the "scratch-blue" technique of artists including Hannah Barlow of Henry Doulton and Company in England and LAURA FRY of Cincinnati. Cunningham's exposure to the Orient through her father, who was involved in the China trade, may have predisposed her to Japanesque motifs, such as the heron in a marsh featured on one of her plates (FIG. 7.22); this subject also appears on some of her painted tiles.

In 1877 Alice Cunningham married William Rotch Ware (1848–1917), a Boston architect who was editor of the *American Architect and Building News* from 1881 to 1907 and who was the nephew of William Robert Ware (1832–1915), head of the architecture department at the Massachusetts Institute of Technology. In 1880, while her husband was a member of the Committee on Instruction for the Boston Society of Decorative Art (founded in 1878), Mrs. Ware was put in charge of the School of Painting on Porcelain. Classes were held under her direction at the Museum of Fine Arts in Boston, and the 1880 annual report of the society stated that the students' work had decidedly improved in quality; the following year china painting was discontinued, however, apparently due to a lack of dedicated students.

Throughout her life Ware painted in oils, watercolors, and pastels and occasionally carved frames for her creations. She exhibited once at the Boston Society of Arts and Crafts, in 1899, as a woodworker.

It seems safe to surmise from the relatively few pieces of Ware's work that have come to light that her artistic avocations were never totally professional ones. The mother of seven sons born between 1879 and 1891, she created art primarily for personal pleasure and for the delight of her family. Grandchildren vividly recall "a tiny woman, with steel-blue eyes, long auburn hair, and a temper," who painted the nursery walls with Mother Goose rhymes and fairies, illustrated storybooks for her children, and decorated tiles that to this day adorn the fireplaces of some Milton, Massachusetts, homes (Sly, 1984). In 1905 Ware enrolled in a drawing class taught by Philip Hale at the Museum of Fine Arts, Boston. She may also have been the author of several poems as well as *A Book of Verses* published in 1910 under her maiden name, Alice Hathaway Cunningham. Ware outlived her husband by twenty years and died in East Milton in 1937.

REFERENCES
Arthur Beckwith, *Majolica and Faience . . .* (New York, 1877), p. 175 // "The Boston Society of Decorative Art," *Art Amateur* 1 (Sept. 1879), p. 86 // "How Miss McLaughlin's Discovery Has Revolutionized Faience . . . ," *Cincinnati Enquirer,* Nov. 27, 1879, clipping from the Women's Art Museum Association of Cincinnati Collection Scrapbooks, Box 4, Cincinnati Historical Society // "General Report of the Judges of Group 2," in U.S. Centennial Commission, *International Exhibition, 1876: Reports and Awards,* 9 vols. (Washington, D.C., 1880), vol. 3, p. 595 // *Second Annual Report of the Boston Society of Decorative Art* (Boston, 1880), p. 14 and "Instruction," p. [22] // "The School of Pottery and Painting on Porcelain," *American Architect and Building News* 8 (Oct. 30, 1880), p. 215 // *Third Annual Report of the Boston Society of Decorative Art* (Boston, 1881), p. 18 // Emma Forbes Ware, *Robert Ware of Dedham, Massachusetts (1642–1699), and His Lineal Descendants* (Boston, 1901), p. 286 // Alice Hathaway Cunningham, *A Book of Verses* (New York, 1910) // "Cunningham, Alice Hathaway," in *Reader's Guide to Periodical Literature* [Cumulated], vol. 3, *1910–14* (New York, 1915), p. 666 // "Cunningham, Alice Hathaway," in *Reader's Guide to Periodical Literature* [Cumulated], vol. 4, *1915–18* (New York, 1919), p. 452 // "Mrs. William R. Ware" [obituary], *New York Times,* Apr. 2, 1937, p. 23 // Karen E. Úlehla, ed., *Society of Arts and Crafts, Boston, Exhibition Record, 1897–1927* (Boston, 1981), p. 225 // Cary Cabot Wright, correspondence, 1984 // Richard B. Heath, Milton Historical Society, Mass., correspondence, Aug. 23, 1984 // Marian Ware Balch, correspondence, Oct. 7 and Nov. 11, 1984 // Betty Ware Sly, correspondence, Nov. 5, 1984 // Hilda Ware Sturges, correspondence, Nov. 8, 1984 // Cathie Zusy, Museum of Fine Arts, Boston, correspondence, Mar. 8, 1985 // Hugh Cabot Ware, correspondence, May 1985

William Rotch Ware, *see* Alice Cunningham Ware

Metford Warner, *see* Jeffrey and Company

Warren, Fuller and Company
1880–1901
New York City
Wallpaper

The Aesthetic movement, it has been said, was above all else a wallpaper craze. In America the wallpaper manufacturer most actively allied with the artistic goals of the period was the firm of Warren, Fuller and Company of New York. Like its English counterpart JEFFREY AND COMPANY, the firm hired prestigious artists to create new patterns and encouraged public interest in interior decoration through its publications and its international design competition in 1881. At the same time, developments in printing technology during the 1870s and early 1880s, including a method of applying bronze powders in a liquid state, permitted Warren, Fuller to realize its sophisticated designs as finished products, many of them multicolored papers with highlights in gold, silver, and bronze tints.

Located at 129 East Forty-second Street, near Grand Central Station, in New York City by 1880, Warren, Fuller and Company was the outgrowth of an older firm, J. S. Warren and Company, founded in 1855, which had operated at the same address during the 1870s. After John H. Lange joined James Warren and William H. Fuller as a third partner by 1882, the firm was known as Warren, Fuller and Lange for six years. Between 1888 and 1891 the New York city directories record the firm as Warren, Lange and Company, omitting Fuller, which suggests a reorganization at this time. However, Fuller was an active partner in the company, once again known as Warren, Fuller and Company, from 1891 until 1901.

In 1880 the firm commissioned CLARENCE COOK to write an essay describing the history and contemporary use of wallpapers, which was published as a small book entitled *What Shall We Do with Our Walls?* that same year (FIG. 3.7). (The popularity of the slim volume, which was reissued several times—the second edition appearing in 1883—is suggested by a book whose author was prompted to imitate its title: *What Shall We Do with Our Daughters?: Superfluous Women and Other Lectures,* by Mary A. Livermore [Boston and New York, 1883].) Cook observed that new approaches to design were possible in the 1880s: "Thanks to the revived freedom and naturalness of the so-called 'Queen Anne' style, and to the far more artistic art of the Japanese . . . the classic laws of symmetry and unity are no longer to be considered the absolute rulers of the field of decorative art" (Cook, 1880, p. 17).

Designs by LOUIS COMFORT TIFFANY and SAMUEL COLMAN (ILL. 3.13) illustrated Cook's essay and were actually manufactured as ceiling and wall papers by the company. Tiffany's snowcrystal ceiling decoration appeared in gold, silver, and blue; Colman's wallpaper with maple leaves and fruit, in gold on a plum-colored ground. One writer found Tiffany's wild clematis and cobweb design, printed in burnished metallic colors on a creamy yellow background, "wonderfully suggestive to any one who knows New England country roads, and has friendly memories of this 'gadding vine' with the dewy cobwebs glinting in the early morning sunshine between the downy clusters

of seeds"; for dining rooms this pattern was available on a more subdued wood-colored or crimson background (Ward, 1882, p. 283).

In 1881 Warren, Fuller and Company sponsored an international design competition and received about seventy submissions from England, France, and Germany as well as the United States. The judges, Christian Herter of HERTER BROTHERS, Edward C. Moore of TIFFANY AND COMPANY, and the painter Francis Lathrop (1849–1909), awarded the $2,200 in prize money to four Americans, all of them women. CANDACE WHEELER took first prize for her bee wallpaper (FIG. 3.8, ILL. 3.14), while her daughter, Dora Wheeler (FIG. 9.15), came in fourth. An enthusiastic commentator in the *Art Amateur* said the following about Mrs. Wheeler's entry: "The cleverest design of this group is a decorative treatment of the beehive. The 'filling' is a silver honeycomb with, at irregular but nicely calculated intervals, honey-cells of gold, and very lively and gorgeous bees are roaming at will in a charmingly natural way. The dado of metallic green is broken with a tangle of clover, gold disks, and more bees. The frieze is the only weak part of the design. The motive is the vertical section of a bee-hive, monotonously repeated." The same author also thought the pattern most appropriate for certain rooms: "Those wonderful insects buzzing . . . all day assuredly would not contribute to that sense of repose which, as a rule, a good wall-paper should afford. . . . But for a lounging room in a country house, or for a smoking room, or even a lady's boudoir in a town house, we believe the introduction of such a pretty fanciful paper as this would be not only permissible but absolutely delightful" (*Art Amateur,* Nov. 1881, p. 112).

By 1893, the year of the World's Columbian Exposition in Chicago, Warren, Fuller and Company had become part of the National Wallpaper Company, a consortium of manufacturers organized the previous year to stabilize prices and negate what it termed suicidal competition. At the fair, Warren, Fuller's display demonstrated the full range of its products: plain surface and embossed papers, made lustrous by pulverized mica; bronzed and iridescent papers; washable tile papers; fireproof asbestos papers; and high-relief flocked papers. The National Wallpaper Company survived only until 1900, its dissolution apparently coinciding with that of Warren, Fuller and Company. J. S. Warren appears for the last time in the city directories of 1899; the company he founded survived him by just a year or two and is not recorded by the directories after 1901.

REFERENCES
Clarence Cook, *"What Shall We Do with Our Walls?"* (New York, 1880) // [Samuel Colman and Louis C. Tiffany design wallpapers], *Art Amateur* 2 (Feb. 1880), p. 47 // Tom A. Kennett, "Art in Wall-Paper," *Art Amateur* 2 (May 1880), pp. 124–25 // "Decoration and Furniture: The Colman and Tiffany Wall-Papers," *Art Amateur* 3 (June 1880), pp. 12–13 // Warren, Fuller and Company [wallpaper advertisement with illustrated designs by Samuel Colman and Louis C. Tiffany, and reprint of an article from the New York *Evening Post,* Dec. 16, 1880], photocopy from the Department of Environmental Science Services Administration, Atmosphere Science Library, Silver Springs, Md. // Warren, Fuller and Company [advertisement], *Art Amateur* 4 (May 1881), p. iii // "New Publications," *Art Amateur* 5 (June 1881), p. 22 // "A Suggestive Exhibit of Designs," *Art Amateur* 5 (Nov. 1881), p. 112 // M. G. Van Rensselaer, "The Competition in Wall-Paper Designs," *American Architect and Building News* 10 (Nov. 26, 1881), pp. 251–53 // Hetta L. H. Ward, "Home Art and Home Comfort: Wall Papers," *Demorest's Monthly Magazine* 17 (Mar. 1882), pp. 282–83 // "Opinions of Representative Dealers: Paper Hangings," *Decorator and Furnisher* 1 (Dec. 1882), p. 98 // "Artistic Wall Paper," *Decorator and Furnisher* 4 (Feb. 1884), p. 180 // Warren, Fuller and Lange [advertisement], *Art Union* 1 (Feb. 1884), back cover (ill.) // Idem [advertisement], *Art Union* 1 (Mar. 1884), inside back cover (ill.) // Mary Gay Humphreys, "The Progress of American Decorative Art," *Art Journal* (London), June 1884, pp. 182–84 // "Fine Art in Wall Papers," *Art Union* 2 (Nov. 1885), p. 110 // "An Admirable Reform [The National Wall Paper Company]," *Interior Decorator* 4 (May 1893), p. 29 // The National Wall Paper Company [advertisement], *Interior Decorator* 4 (May 1893), pp. 26–27 // "Wall Papers at the Fair: Interesting Exhibits by American, English, and German Manufacturers," *Carpet and Upholstery Trade Review* 24 (June 15, 1893), p. 56a // Samuel How, "Wall Decorations: Suggestions by the Firm of Warren, Fuller and Company," *Interior Decorator* 5 (Jan. 1894), pp. 119–21 // Henry Burn, "American Wall-Papers," in *One Hundred Years of American Commerce,* ed. Chauncey M. Depew, 2 vols. (New York, 1895; reprint New York, 1968), vol. 2, pp. 505–8 // Victor S. Clark, *History of Manufactures in the United States,* 3 vols. (New York, 1929; reprint New York, 1949), vol. 3, p. 250 // Wilson H. Faude, "Associated Artists and the American Renaissance in the Decorative Arts," *Winterthur Portfolio* 10 (1975), pp. 126–27 // Catherine Lynn, *Wallpaper in America: From the Seventeenth Century to World War I* (New York, 1980), pp. 387, 389, 398, 402–3, 412–13, 420, 475, 513 (n. 83) // Charles C. Oman and Jean [D.] Hamilton, *Wallpapers: A History and Illustrated Catalogue of the Collection of the Victoria and Albert Museum* (London, 1982), pp. 73, 77

Philip Webb, *see* William Morris

Stephen Webb, *see* Collinson and Lock

Josiah Wedgwood and Sons, Limited
1759–present
Burslem, Staffordshire, England
Ceramics

Josiah Wedgwood and Sons, Limited, is probably England's best-known pottery today. Despite the plethora of material available on Wedgwood's history, however, most studies have focused solely on its development during the eighteenth and early nineteenth centuries. Until recently the factory's work from the second half of the nineteenth century until the present has been ignored, and its produc-

tion during the Aesthetic movement eclipsed.

Josiah Wedgwood (1730–1795) started a career in ceramics at a young age, working as an apprentice in various factories. By 1754 he began to experiment with clay bodies and glazes, and in 1759 he founded the now-famous pottery that still bears his name. In its first decades the firm concentrated on the creation of common tablewares. By 1769, however, Wedgwood began to make ornamental wares, such as portrait busts and classical vases, a tradition it has sustained. Wedgwood's fame during the 1860s and 1870s can be credited to the development of new ceramic bodies, in particular to an inexpensive, lightweight, cream-colored earthenware called creamware or queensware and to a fine-grained, matte earthenware in black, blue, and other colors, generally called jasperware or, when in black, basalt ware.

In the nineteenth century the factory produced a variety of artistic earthenware. The imitations of pottery from classical antiquity that Wedgwood had in production from the 1840s until at least 1860 were later emulated in the 1860s and 1870s by many other potters, among them the Watcombe Pottery in England, Madame Ipsen in Copenhagen, and the CHELSEA KERAMIC ART WORKS (FIG. 7.1) and GALLOWAY AND GRAFF (FIGS. 7.2, 7.3) in America. In 1860 Wedgwood began to make majolica, relief-molded wares with gaily colored glazes that MINTON AND COMPANY had revived some years earlier. Majolica was not only imported into the United States from England, but during the 1880s it was also made in American factories, including GRIFFEN, SMITH AND COMPANY (FIG. 7.33) and the EUREKA POTTERY COMPANY (FIG. 7.34). Wedgwood kept majolica in production until about 1910.

During the Aesthetic era the Wedgwood pottery was under the artistic direction of Josiah Wedgwood's grandson Godfrey Wedgwood (1833–1905), who had joined the firm in 1859. It was at about this time, in the late 1850s, that the company began to invite outside designers to work at Wedgwood. The first of these was Emile Lessore (1805–1876), a French painter who had been introduced to the ceramic medium at the Laurin Factory in Bourg-la-Reine and at Sèvres. Lessore, who arrived at Wedgwood in 1858, was the firm's top decorator, and he continued to paint Wedgwood ceramics after his return to France in 1863 and until his death. His work was primarily figural and was indebted to Renaissance designs.

Drawing from native British talent, Godfrey Wedgwood encouraged two of England's important late nineteenth-century designers, WALTER CRANE and CHRISTOPHER DRESSER, to provide patterns for his products. Crane's first commission came in 1867, when he was asked to paint some cream-colored tableware forms for the firm; he supplied designs until about 1888. Dresser's association with Wedgwood, as a designer rather than as a ceramics decorator per se, was for a considerably shorter time, lasting only from about 1866 until 1868. One of his most ambitious pieces, for which he invented the shape as well as the decoration, is a tall cylindrical vase (FIG. 7.11) whose sophisticated, monochromatic printed decoration was subsequently published in *Principles of Decorative Design* (1873).

In 1880 Thomas Allen (1831–1915) became art director at Wedgwood, after intermittently spending about twenty-seven years at Minton and Company. Following in Lessore's tradition, Allen relied mainly on figural subject matter for the vases and plaques he painted. Under his direction the pottery added a design department, which has been in existence ever since. Allen also initiated Wedgwood's production of pottery in the style of the WORCESTER ROYAL PORCELAIN COMPANY, characterized by an ivory body decorated with enamel and gilding and for the most part Japanesque in style. Oriental influence is also evident in Wedgwood's popular, less-expensive transfer-decorated earthenwares of the 1870s and 1880s, many of which have asymmetrical arrangements of such Japanesque motifs as birds and fans.

Allen retired from Wedgwood in 1905. His successors, located in Barlaston, Staffordshire, since 1940, have maintained Wedgwood's tradition of combining artistic wares with commercial production.

REFERENCES
Llewellynn Jewitt, "Wedgwood and Etruria: A History of the 'Etruria Works,' Their Founder and Productions," pts. 1–7, *Art Journal* (London), Apr. 1864, pp. 93–97; May 1864, pp. 125–30; June 1864, pp. 182–83; July 1864, pp. 193–97; Aug. 1864, pp. 225–31; Sept. 1864, pp. 253–59; Oct. 1864, pp. 285–90 // [Margaret Bertha Wright], "Wedgwood Ware and Its Creators," *Art Amateur* 7 (July 1882), pp. 31–33 // Lewis F. Day, "Victorian Progress in Applied Design," *Art Journal* (London), June 1887, pp. 185–202 // Harry Barnard, *Chats on Wedgwood Ware* (London, 1920) // William Burton, *Josiah Wedgwood and His Pottery* (London, 1922) // Kennard L. Wedgwood, "Wedgwood: Two Centuries in Retrospect," *Antiquarian* 14 (May 1930), pp. 38–40, 78 // Bernard G. Hughes, *Victorian Pottery and Porcelain* (London, 1959) // Harry M. Buten, *Wedgwood and Artists* (Philadelphia, 1960) // Geoffrey A. Godden, *Victorian Porcelain* (London, 1961) // Hugh Wakefield, *Victorian Pottery* (New York, 1962) // Alison Kelly, *Decorative Wedgwood in Architecture and Furniture* (London, 1965) // Geoffrey A. Godden, *An Illustrated Encyclopedia of British Pottery and Porcelain* (New York, 1966), pp. 337–55 // Julian Barnard, *Victorian Ceramic Tiles* (Greenwich, Conn., 1972) // Geoffrey [A.] Godden, *Illustrated Guide to British Porcelain* (London, 1974) // Alison Kelly, comp., *The Story of Wedgwood* (London, 1975) // David Buten and Patricia Pelehach, *Emile Lessore, 1805–1876: His Life and Work* (Philadelphia, 1979) // Camden Arts Centre, London, *Christopher Dresser, 1834–1904*, by Michael Collins (exhib. cat., 1979), p. 31 // Terence A. Lockett, *Collecting Victorian Tiles* (Woodbridge, Eng., 1979) // Robin Reilly and George Savage, *The Dictionary of Wedgwood* (Woodbridge, Eng., 1980) // Maureen Batkin, *Wedgwood Ceramics, 1846–1959: A New Appraisal* (London, 1982)

Candace Wheeler

1827–1923
New York City
Textile and wallpaper designer

Candace Wheeler was one of the most influential women of the American Aesthetic movement. An early feminist, Wheeler combined art with economics and encouraged women of all stations to become financially independent by producing needlework, painted china, or even pies to sell on the open market. At the age of fifty, she embarked on a career as a textile designer, which during the last three decades of the nineteenth century brought her to the forefront of the interior-decorating profession.

Candace Wheeler was born in 1827 in Delhi, a small town in central New York. Her father, Abner Thurber, ran a dairy farm, and there she learned all the tasks associated with farming and rural life. These included weaving, sewing, and embroidery. When she was seventeen, she married Thomas M. Wheeler and moved to Brooklyn, where she became acquainted with many of the leading painters of the Hudson River School. In 1854 the Wheelers built a house, Nestledown, in Hollis, Long Island, where they raised their four children. During the years that followed, Candace Wheeler traveled, visited various artists at home and abroad, and, as an amateur, painted, decorated china, and did needlework. However, her life changed abruptly after she visited the Philadelphia Centennial Exposition of 1876. A small exhibition of the much-admired embroideries of the Royal School of Art Needlework in London was an inspiration to her (FIG. 3.20, ILL. 3.29). Aesthetically, the needlework was artful and attractive, but more importantly, the school had discovered a genteel (or, perhaps, unthreatening) way to help women support themselves in a man's work world. As she later explained in *Yesterdays in a Busy Life*, "Women of all classes had always been dependent upon the wage-earning capacity of men, and although the strict observance of the custom had become inconvenient and did not fit the times, the sentiment of it remained. But the time was ripe for a change" (Wheeler, 1918, p. 210).

In February 1877 Wheeler, as vice-president and corresponding secretary, and New York society matron Mrs. David Lane, as president, founded the Society of Decorative Art of New York City. They enlisted the help of many wives of the New York elite and even engaged the widow of General George Armstrong Custer as their assistant secretary. Leading New York artists LOUIS COMFORT TIFFANY, JOHN LA FARGE, Samuel Colman (1832–1920), and Lockwood de Forest (1850–1932) took part in teaching classes and judging the materials submitted for sale through the society.

Although the Society of Decorative Art was a success, it did not wholly satisfy Wheeler's desire to address the needs of those women without artistic talent who had to support themselves and their families. In answer to this problem, in 1878 Wheeler founded the Women's Exchange, still an active organization today, which offered quality goods of all sorts made by women, including crafts and even foodstuffs. However, the ladies of the Society of Decorative Art felt that Wheeler had been disloyal in starting another group and demanded her resignation. This was actually to Wheeler's advantage, since it enabled her to submit her own needlework to the society's

decorative-arts competitions. Her "Consider the Lillies [sic] of the Field" curtain (ILL. 3.30) won first prize for portiere design in 1879.

In that same year, Louis C. Tiffany offered Wheeler the position of textile specialist in his newly formed interior-decorating firm, Associated Artists. The two other members were Samuel Colman, a Hudson River painter and specialist in color decoration, and Lockwood de Forest, an expert in carved and ornamental woodwork, especially that of oriental design (ILL. 1.2).

Associated Artists had many grand commissions during its four-year existence. These included the decoration of the Veterans' Room for the Seventh Regiment Armory (1879–80) in New York City (ILLS. 4.13, 4.14), Mark Twain's Hartford home (1881, ILL. 4.2), the re-decoration of four rooms in the White House (1882–83), and various other clubs and residences. One of the jobs of which Wheeler was proudest was the stage curtain she produced for the Madison Square Theater (1879) in New York. A realistic landscape appliquéd in velvet and silk, it unfortunately burned not long after it was made. An idea of its sumptuousness may be gained by viewing two portieres in the Metropolitan Museum's collection (FIG. 3.21, ILL. 3.31).

While still working with Associated Artists, Wheeler decided to try her hand at wallpaper design. WARREN, FULLER AND COMPANY, the wallpaper firm that in 1880 had commissioned art critic CLARENCE COOK to write a small book on the use of wallpaper, entitled *"What Shall We Do with Our Walls?"* (FIG. 3.7), in 1881 held an international wallpaper-design competition. Wheeler won first prize for her design of a silver honeycomb filled with gold honey cells and lively bees (ILL. 3.14, FIG. 3.8), which was published in the second edition of Cook's book and which relates to a later bee-patterned textile (FIG. 3.17). Her youngest daughter, Dora Wheeler (1856–1940, FIG. 9.15), won fourth prize with a peony motif. Women designers also won the second and third prizes, much to Wheeler's pleasure.

In 1883 the original Associated Artists partnership was dissolved, but Wheeler continued to produce textiles of all sorts under the name of Associated Artists. Assisted by her daughter Dora, a painter and designer of textiles (ILL. 3.32), and managed by her son, Wheeler kept the firm in business until 1907. During the course of her activities, she invented new techniques for needle-woven tapestries and entered into a relationship with CHENEY BROTHERS of Connecticut, a prominent silk mill; she considered her designs for Cheney Brothers to be among the first that were truly American, basing many of them on American flora and fauna (ILL. 3.22). Interestingly, she made sure her designs were printed on a variety of fabrics, both silk and cotton, so that every woman might afford them for her home. The famous Carp pattern (FIG. 3.16) was printed in a number of colors on denims of varying shades as well as in orange ink on blue silk.

The culmination of Wheeler's career was her election to the positions of director of the Bureau of Applied Arts for the display of the state of New York at the Chicago World's Columbian Exposition of 1893 and color director (that is, interior decorator) for the Women's

Building at the fair. Her primary task as color director was to decorate the enormous space given over to New York state for its women's library. Dora Wheeler painted murals for the ceiling, and Associated Artists provided a needle-woven tapestry of Raphael's *Miraculous Draught of Fishes*. In spite of time constraints and much infighting, when it opened the Woman's Building was considered a great success.

Under the auspices of the Board of Women Managers of the State of New York, Wheeler edited a book entitled *Household Art* (1893), to which she contributed an essay called "Decorative and Applied Art." This was the first of many books she wrote, most of them on the subject of textiles and decorative arts. Some of the better known include *Content in a Garden* (1901), *How to Make Rugs* (1902), *Principles of Home Decoration* (1903), and *The Development of Embroidery in America* (1921). In her 1918 autobiography, *Yesterdays in a Busy Life,* she reflected with pleasure upon a luncheon with her friends that included "a company of perhaps a dozen authors, editors, writers, artists and the like . . . all good friends and all busy and capable women. Mrs. Custer looked across the table. 'Why,' said she, 'we are all working-women; *not a lady among us!'"* (Wheeler, 1918, p. 422). Candace Wheeler died in 1923, at the age of ninety-six.

REFERENCES
[Portieres], *Art Interchange* 1 (Dec. 11, 1878), p. 49 // "The Supplement" [design from a drawing by Dora Wheeler], *Art Interchange* 3 (July 9, 1879), p. 2, pl. 15 // [Design competition], *Art Interchange* 3 (Nov. 26, 1879), p. 90 // "Sketch of First Prize Portiere by Mrs. T. M. Wheeler," *Art Interchange* 3 (Dec. 10, 1879), ill. following p. 99 // [Madison Square Theater drop curtain], *Art Interchange* 4 (Mar. 30, 1880), pp. 30, 38 // "The Colman and Tiffany Wall-Papers," *Art Amateur* 3 (June 1880), pp. 12, 13 (ills.) // "A Club Dining-Room" [Union League Club], *Art Amateur* 4 (May 1881), p. 125 // "Draperies of the Union League Club," *Art Amateur* 5 (June 1881), p. 17 // "Is Our Art Only a Fashion?" *Art Amateur* 5 (June 1881), p. 2 // M[ary] G[ay] H[umphreys], "Recent Church Decoration," *Art Amateur* 5 (Nov. 1881), p. 127 // "A Suggestive Exhibition of Designs," *Art Amateur* 5 (Nov. 1881), p. 112 // M. G. Van Rensselaer, "The Competition in Wall-Paper Designs," *American Architect and Building News* 10 (Nov. 26, 1881), pp. 251–53 // "The Associated Artists' Needlework," *Art Amateur* 6 (Dec. 1881), p. 13 // Montezuma [Montague Marks], ["Good Times," a holiday child's book of rhymes by Candace Wheeler], *Art Amateur* 6 (Jan. 1882), p. 25 // Clarence Cook, "What Shall We Do with Our Walls?" 2d ed. (New York, 1883) // "A French Critic on American Houses" [G. de Léris], *Art Amateur* 8 (Mar. 1883), p. 78 // Mary Gay Humphreys, "The Parlor," *Decorator and Furnisher* 2 (May 1883), p. 53 // "The Exhibition of Embroideries," *Art Amateur* 10 (Jan. 1884), p. 46 // Mary Gay Humphreys, "The Bartholdi Loan Association Exhibition," *Decorator and Furnisher* 3 (Jan. 1884), pp. 123–24 // Constance Cary Harrison, "Some Work of the 'Associated Artists,'" *Harper's New Monthly Magazine* 69 (Aug.

1884), pp. 343–51 // Mary Gay Humphreys, "The Progress of American Decorative Art," *Art Journal* (London), Nov. 1884, pp. 345–48 // "The Associated Artists," *Art Amateur* 12 (Jan. 1885), pp. 38–40 // "Industrial Designs and Decorative Art," *Carpet Trade and Review* 16 (May 15, 1885), p. 38 // S[ylvester] R[osa] Koehler, "American Embroideries," *Magazine of Art* 9 (1886), pp. 209–13 // "The Color Scheme of a Room: A Talk with Mrs. T. M. Wheeler, Who States Her Principles on the Subject," *Art Amateur* 16 (Feb. 1887), p. 62 // "Talks with Decorators, 3: Mrs. Wheeler on Fitting up a Seaside Cottage," *Art Amateur* 16 (May 1887), p. 136 // M[ary] G[ay] H[umphreys], "Exhibition of Embroideries," *Art Amateur* 18 (Dec. 1887), pp. 19–20 // Sarah Bolton, *Successful Women* (Boston, 1888), pp. 180–81 // Idem, "Embroidery in America, 1: Mrs. Wheeler's Views Concerning Conventional and Naturalistic Treatment," *Art Amateur* 18 (Jan. 1888), p. 46 // Idem, "Embroidery in America, 2: Mrs. Wheeler Tells How One May Become an Artist with the Needle," *Art Amateur* 18 (Feb. 1888), pp. 71–72 // Idem, "Embroidery in America, 3: Mrs. Wheeler's Views on Stuffs for Embroiderers' Use," *Art Amateur* 18 (Mar. 1888), pp. 99–100 // Idem, "Embroidery in America, 4: Mrs. Wheeler Talks about Appliqué Work," *Art Amateur* 18 (Apr. 1888), p. 123 // Idem, "Embroidery in America, 5: The Value of Buttonhole Stitch and the Use of Flax Threads," *Art Amateur* 18 (May 1888), p. 147 // Idem, "Embroidery in America, 6: New Uses for Cotton in Hangings and Artistic Needlework," *Art Amateur* 19 (June 1888), p. 21 // Idem, "Embroidery in America, 7: Mrs. Wheeler's Suggestions about the Decoration of Table Linen," *Art Amateur* 19 (July 1888), p. 46 // Idem, "Embroidery in America, 8: Some Suggestions by Mrs. Wheeler about Bed Linen and Coverlets," *Art Amateur* 19 (Sept. 1888), pp. 92–93 // Idem, "Embroidery in America, 9: Mrs. Wheeler Makes Some Suggestions for Needlework Decoration Applicable to the Street Costumes of Ladies," *Art Amateur* 19 (Nov. 1888), p. 141 // "Art Study Practically Applied," *Art Amateur* 21 (July 1889), pp. 42–43 // M[ary] G[ay] H[umphreys], "Embroidery in America, 10: Mrs. Wheeler Gives Hints about Darned Lace," *Art Amateur* 22 (Dec. 1889), p. 23 // Hubert Howe Bancroft, *The Book of the Fair: An Historical and Descriptive Presentation of the World's Science, Art, and Industry, as Viewed Through the Columbian Exposition at Chicago in 1893* (Chicago and San Francisco, 1893) // Candace Wheeler, "Applied Arts in the Woman's Building," in *Art and Handicraft in the Woman's Building of the World's Columbian Exposition Chicago, 1893,* ed. Maud Howe Elliott (Paris and New York, 1893), pp. 59–67 // Idem, *Columbia's Emblem, Indian Corn: A Garland of Tributes in Prose and Verse* (Boston and New York, 1893) // Idem, *Household Art* (New York, 1893) // Idem, "A Dream City," *Harper's New Monthly Magazine* 86 (May 1893), pp. 830–46 // Lucy Monroe, "Chicago Letter," *Critic* 23 (July 1, 1893), pp. 12–13 // [Review of Wheeler, *Household Art*], *Critic* 23 (Dec. 23, 1893), p. 409 // "Applied Arts Committee," in *Report of the Board of General Managers of the Exhibit of the State of New York at the*

World's Columbian Exposition (Albany, 1894), pp. 178–80 // Candace Wheeler, "The Fine Arts: Group Exhibitions," *Critic* 26 (Jan. 26, 1895), p. 70 // Idem, "Decorative Art," *Architectural Record* 4 (June 30, 1895), pp. 409–13 // Idem, "Art Education for Women," *Outlook* 55 (Jan. 2, 1897), pp. 81–87 // Candace Wheeler et al., eds., *Corticelli Home Needlework: A Manual of Art Needlework, Embroidery, and Crochet* (Florence, Mass., 1899) // Candace Wheeler, "Home Industries and Domestic Manufactures," *Outlook* 63 (Oct. 14, 1899), pp. 402–6 // Idem, *Content in a Garden* (Boston and New York, 1901) // Idem, *How to Make Rugs* (New York, 1902) // Idem, *Principles of Home Decoration with Practical Examples* (New York, 1903) // Idem, "Antiques," *Harper's Monthly Magazine* 106 (Apr. 1903), pp. 700–708 // Idem, *Doubledarling and the Dream Spinner* [pictures by Dora Wheeler Keith] (New York, 1905) // Idem, "The Decorative Use of Wild Flowers," *Atlantic Monthly* 95 (May 1905), pp. 630–34 // Idem, *The Annals of Onteora, 1887–1914* (New York, 1914) // Idem, *Yesterdays in a Busy Life* (New York and London, 1918) // [Review of Wheeler, *Yesterdays in a Busy Life*], *Dial* 65 (Oct. 19, 1918), p. 322 // Candace Wheeler, *The Development of Embroidery in America* (New York, 1921) // E. B. S., "A Gift of Textiles," *Bulletin of the Metropolitan Museum of Art* 23 (May 1928), pp. 137–38 // D. W. Keith, "The American Tapestry as Invented by Candace Wheeler: Woven Textile with Figure of Penelope," *Wellesley College Art Museum Bulletin* 2 (Jan. 1936), pp. 9a–9b // Georgiana Brown Harbeson, *American Needlework* (New York, 1938), pp. 161–63 // "Wheeler, (Mrs.) Candace Thurber," in *Allgemeines Lexikon der Bildenden Künstler,* ed. Ulrich Thieme and Felix Becker, vol. 35 (Leipzig, 1942), p. 489 // "Wheeler, Candace Thurber," in *Who Was Who In America,* vol. 2 (Chicago, 1950), p. 569 // Gertrude Speenburgh, *The Arts of the Tiffanys* (Chicago, 1956), pp. 83–85 // George C. Groce and David H. Wallace, "Wheeler, Candace Thurber," in *The New-York Historical Society's Dictionary of Artists in America, 1564–1860* (New Haven and London, 1957), p. 678 // Madeleine B. Stern, "An American Woman First in Textiles and Interior Decoration: Candace Wheeler, 1877," in *We the Women: Career Firsts of Nineteenth-Century America* (New York, 1963), pp. 273–303 // Elizabeth Aslin, *The Aesthetic Movement: Prelude to Art Nouveau* (New York and Washington, D.C., 1969), p. 179 // "Wheeler, Candace Thurber," in *Notable American Women, 1607–1950,* ed. Edward T. James et al. (Cambridge, Mass., and London, 1971), pp. 574–76 // "Wheeler, Candace," in *The National Academy of Design Exhibition Record, 1861–1900,* vol. 2 (New York, 1973), p. 1014 // Caroline Pullman, New York City, correspondence, Jan. 18, 1973 // Wilson H. Faude, "Associated Artists and the American Renaissance in the Decorative Arts," *Winterthur Portfolio* 10 (1975), pp. 101–30 // Idem, "Candace Wheeler, Textile Designer," *Antiques* 112 (Aug. 1977), pp. 258–61 // Isabelle Anscombe and Charlotte Gere, *Arts and Crafts in Britain and America* (New York, 1978), p. 104 (ill.) // Karal Ann Marling, "Portrait of the Artist as a Young Woman: Miss Dora Wheeler," *Bulletin of the Cleveland Museum of Art* 65 (Feb. 1978), pp.

47–57 // Brooklyn Museum, *The American Renaissance, 1876–1917* (exhib. cat., 1979), pp. 117, 127, fig. 96 // Anthea Callen, *Women Artists of the Arts and Crafts Movement, 1870–1914* (New York, 1979) // Catherine Lynn, *Wallpaper in America: From the Seventeenth Century to World War I* (New York, 1980), pp. 412–13, 456, fig. 16.24 // Virginia Williams, "Candace Wheeler, Textile Designer for Associated Artists," *Nineteenth Century* 6 (Summer 1980), pp. 60–61 // Jeanne Madeline Weimann, *The Fair Women* (Chicago, 1981), pp. 224–40 // "Wheeler, Candace Thurber," in *The International Dictionary of Women Workers in the Decorative Arts,* comp. Alice Irma Prather-Moses (Metuchen, N.J., and London, 1981), p. 172 // Charles C. Oman and Jean [D.] Hamilton, *Wallpapers: A History and Illustrated Catalogue of the Collection of the Victoria and Albert Museum* (London, 1982), pp. 73, 77 // Detroit Institute of Arts, *The Quest for Unity: American Art Between World's Fairs, 1876–1893* (exhib. cat., 1983), pp. 210–12 (ills.)

James Abbott McNeill Whistler

1834–1903
London
Painter

A proud man possessed of a brilliant and caustic wit, James Abbott McNeill Whistler was one of the most provocative and influential artists of his time. His innovative exploration of the abstract qualities of form and color during a period that celebrated narrative painting contributed to artistic developments only fully realized in the twentieth century.

Born in Lowell, Massachusetts, in 1834, Whistler was the third son of Major George Washington Whistler, a West Point graduate and civil engineer. After living in Stonington, Connecticut, and Springfield, Massachusetts, the nine-year-old Whistler was taken to Saint Petersburg, Russia, where his father served as a consulting engineer for the construction of the railroad to Moscow. There Whistler attended drawing classes at the Imperial Academy of Science and took private instruction from an officer named Karitzky. In 1848 Whistler was sent to school in England, where he lived with his half sister Deborah and her husband, the English doctor Seymour Haden (1818–1910), who later gained renown as an etcher. Following the death of Major Whistler in 1849, however, the family returned to the United States and settled in Pomfret, Connecticut. Whistler entered the United States Military Academy at West Point in 1851, but despite his success in Robert W. Weir's drawing class, his mischievous behavior and poor marks resulted in his dismissal. Whistler worked briefly in Baltimore and then in the drawings division of the United States Coast and Geodetic Survey, where he received his first training in etching. He proved, however, to be an apathetic and undependable employee.

He went to Europe in 1855, determined to become an artist, and settled in Paris to study for a short time at the Ecole Impériale et Spéciale de Dessin before entering the studio of the Swiss painter Charles Gleyre (1806–1874) in 1856. In 1858, having witnessed the revival of printmaking in France, Whistler published

his first set of etchings, *Douze eaux-fortes d'après nature,* the so-called *French Set,* printed by Auguste Delâtre. His prolific work in this medium was to stimulate further the printmaking revival in England, France, and the United States during the 1860s and 1870s.

At the Piano (1858–59; Taft Museum, Cincinnati), Whistler's first major painting, reflected his study of Dutch and Spanish art of the seventeenth century as well as the work of the contemporary French painter Gustave Courbet (1819–1877). The painting was not accepted for the Paris Salon of 1859, but when it was exhibited at the Royal Academy of Arts in London instead, it sold immediately. Whistler took up residence in Wapping, a section of London, and began the etchings published in 1871 as *A Series of Sixteen Etchings of Scenes on the Thames and Other Subjects,* or the *Thames Set.* He remained a frequent visitor to France, however, and painted at Trouville on the Normandy coast with Courbet, Charles-François Daubigny (1817–1878), and Claude Monet (1840–1926) in the autumn of 1865.

The influence of the English Pre-Raphaelites on Whistler's painting is readily apparent in *The White Girl,* subsequently called *Symphony in White, No. 1* (1862; National Gallery of Art, Washington, D.C.), a portrait of his mistress and principal model, Jo Hiffernan. As David Curry has recently pointed out, there is also a strong formal relationship between this painting and *Le Grand Gilles* (1717–19) by Jean-Antoine Watteau (1684–1721), in whom there was renewed critical interest from about 1830 until about 1860. Whistler's painting was rejected by both the Royal Academy in 1862 and the Paris Salon in 1863, but was shown along with Edouard Manet's *Déjeuner sur L'herbe* in the sensational 1863 Salon des Refusés.

Whistler initially used oriental costumes and accessories in works such as *Purple and Rose: The Lange Leizen of the Six Marks* (1864, FIG. 9.14), but he gradually adopted the formal elements of oriental composition and organization of space. In 1866 Whistler visited South America, where he painted the first of his night scenes. He was increasingly influenced by both Eastern aesthetics and classical sources, which preoccupied him throughout the 1860s. During this decade Whistler also conceived the first of his purely decorative schemes. Decor provided Whistler with a context in which he could combine aspects of oriental, classical, and French Rococo art. Inspired by the English painter Albert Moore (1841–1893), whom Whistler had met by 1865, he began a series of monumental figure compositions, which were unrealized except as a group of oil sketches, the so-called *Six Projects* (Freer Gallery of Art, Washington, D.C.). Depicting lithesome ladies swathed in classical drapery and carrying Japanese fans and parasols, the series was intended for an unknown architectural setting. Here again, as David Curry has remarked, Whistler's unusual palette, consisting of white, salmon, yellow, pink, turquoise green, and mauve, recalls those of Watteau and other eighteenth-century sources.

During the 1860s Whistler anguished over his inability to draw figures with the deftness of Ingres, but he found new resolve by 1870. The following year he began his celebrated series of Thames *Nocturnes,* first called *Moon-*

lights, with which he was occupied until 1885, of which *Nocturne: Blue and Gold—Southampton Water* (1871–72, FIG. 9.20) is an example. Independent of his contemporaries, Whistler developed his own theory of art, which in 1873 he described to his friend the Baltimore collector George Lucas as "the science of color and 'picture pattern' as I have worked it out for myself during these years" (Mahey, 1967, pp. 2–53). *Arrangements,* as he called his portraits, among them *Harmony in Grey and Green: Miss Cicely Alexander* (1872–73, ILL. 9.23), were, according to Whistler's credo, abstract compositions of color and form.

During the 1870s Whistler became increasingly involved with interior decoration, furniture, and the design of picture frames as well as exhibitions. The dining room he decorated for his patron Frederick Richards Leyland, which was designed by THOMAS JECKYLL and was known as the Peacock Room, or *Harmony in Blue and Gold* (1876–77, ILL. 4.10), demonstrates his major (and only surviving) achievement of this kind. Although it was a remarkable interior, Whistler's cavalier approach to the project alienated Leyland, and Jeckyll's contribution was all but obscured by the fanfare generated by the altercation that ensued.

Later that year the influential art critic John Ruskin (1819–1900) became outraged by the Grosvenor Gallery exhibition of Whistler's paintings, particularly by *Nocturne in Black and Gold: The Falling Rocket* (about 1875; Detroit Institute of Arts), and made the now-familiar incendiary remark that resulted in Whistler's suing him for libel in 1878: "I have seen and heard much of Cockney impudence before now; but never expected to hear a coxcomb ask two hundred guineas for flinging a pot of paint in the public's face" (Becker, 1959, p. 101). Whistler won the case but received small recompense for the damage to his reputation and pride, as well as to his finances; by the spring of 1879 he was bankrupt. Bailiffs took possession of his new home, the White House, which his friend E. W. GODWIN had recently designed.

In September of 1879 the Fine Art Society in London commissioned Whistler to make a set of twelve etchings of Venice (ILL. 9.19). While in Italy he concentrated on making prints and pastels that were greatly admired by a group of American artists working in Venice with Frank Duveneck (1848–1919), among them Joseph De Camp (1858–1923) and John White Alexander (1856–1915). After returning to England in the fall of 1880, Whistler began to paint small panels—marines, landscapes, portraits, and later such urban subjects as shop fronts and house facades inspired by his travels in England, France, and Holland. He also continued to make prints of various kinds. In 1886 his *Set of Twenty-six Etchings of Venice* was issued by Dowdeswells, and in 1887 *Notes,* a set of six lithographs, was published in London by Boussod, Valadon and Cie.

During the 1880s Whistler continued to publicize his artistic beliefs, his ideas always stimulating controversy. The catalogue for *Notes—Harmonies—Nocturnes,* an 1884 exhibition in London devoted to his work, articulated Whistler's "Proposition—No. 2," which began, "A Picture is finished when all trace of

the means used to bring about the end have disappeared." His famous "Ten O'Clock" lecture of 1885 elaborated upon his theories and attacked Ruskin's aesthetics; the lecture was published in England in 1888 and later translated into French by the poet Stéphane Mallarmé, to whom Whistler had been introduced by Monet. In 1890 a collection of Whistler's writings, *The Gentle Art of Making Enemies,* was published in London.

Whistler received international recognition in the late 1880s and the 1890s; American artists, such as WILLIAM MERRITT CHASE, THOMAS WILMER DEWING, and John H. Twachtman (1853–1902), began to adopt a Whistlerian approach to figure painting and landscape (ILLS. 9.27–9.29). The Wunderlich Gallery in New York held a large exhibition of Whistler's works in 1889, and the next year he met Charles Lang Freer of Detroit, already a collector of his prints, who became his major American patron. Whistler's paintings were by now also eagerly sought for public collections: the city of Glasgow was the first to purchase a Whistler painting in 1891, his portrait of Thomas Carlyle (1872–73; Glasgow Art Gallery and Museum, Glasgow). The Musée du Luxembourg followed suit with the acquisition of the portrait of his mother (1871; Musée du Louvre). The first Whistler painting to be acquired for a public American collection, *Arrangement in Black: La Dame au Brodequin Jaune— Portrait of Lady Archibald Campbell* (1882–84), was purchased for the Philadelphia Museum of Art in 1894.

The success of Whistler's later years was dampened by the death, in 1896, of his wife, Beatrix, the widow of E. W. Godwin whom Whistler had married in 1888. Her sister, Rosaland Birnie Philip, was soon adopted by Whistler as his ward and his executrix. In 1898 Whistler established the Company of the Butterfly to sell his work, though it operated only until 1901. In 1898 he also was elected president of the International Society of Sculptors, Painters, and Gravers and opened the Académie Carmen in Paris, named for his former model Carmen Rossi, but ultimately spent little time there. His death, in 1903, was memorialized the following year by a major exhibition in Boston, and in 1905 by others held by the International Society in London and at the Ecole des Beaux-Arts in Paris.

REFERENCES

James Abbott McNeill Whistler, *Whistler v. Ruskin: Art and Art Critics* (London [1878]) // William C. Brownell, "Whistler in Painting and Etching," *Scribner's Monthly* 18 (Aug. 1879), pp. 481–95 // "Whistler as an Etcher," *Art Amateur* 1 (Oct. 1879), pp. 89–90 // Messrs. Dowdeswell, London, *Notes—Harmonies—Nocturnes* (exhib. cat., 1884) // James Abbott McNeill Whistler, *Mr. Whistler's "Ten O'Clock"* (London, 1888) // Idem, *The Gentle Art of Making Enemies* (London, 1890) // Wynford Dewhurst, *Impressionist Painting* (London, 1904) // Léonce Bénédite, "Artistes contemporains: Whistler," pts. 1–4, *Gazette des Beaux-Arts,* 3d ser. 33 (1905), pp. 403–10, 496–511; 34 (1905), pp. 142–58, 231–46 // Mary Augusta Mullikin, "Reminiscences of a Whistler Academy by an American Student," *International Studio* 25 (May 1905), pp. 237–

41 // Elisabeth Luther Cary, *The Works of James McNeill Whistler: A Study, with a Tentative List of the Artist's Works* (New York, 1907) // Otto Bacher, *With Whistler in Venice* (New York, 1908) // E[lizabeth] R[obins] Pennell and J[oseph] Pennell, *The Life of James McNeill Whistler,* 2 vols. (London and Philadelphia, 1908) // Edward G. Kennedy, *The Etched Work of Whistler, Illustrated by Reproductions in Collotype of the Different States of the Plates* (New York, 1910; reprint San Francisco, 1978) // Don C. Seitz, *Writings by and about James Abbott McNeill Whistler: A Bibliography* (Edinburgh, 1910) // William Merritt Chase, "The Two Whistlers: Recollections of a Summer with the Great Etcher," *Century Illustrated Monthly Magazine* 80 (June 1910), pp. 218– 26 // E[lizabeth] R[obins] Pennell and J[oseph] Pennell, "Whistler as a Decorator," *Century Illustrated Monthly Magazine* 73 (Feb. 1912), pp. 500–513 // Idem, *The Whistler Journal* (Philadelphia, 1921) // Robert Schmutzler, "The English Origins of Art Nouveau," *Architectural Review* 117 (Feb. 1955), pp. 108–16 // Eugene Matthew Becker, "Whistler and the Aesthetic Movement" (Ph.D. diss., Princeton University, 1959) // Peter Ferriday, "The Peacock Room," *Architectural Review* 125 (June 1959), pp. 407–14 // Andrew McLaren Young, *James McNeill Whistler: An Exhibition of Paintings and Other Works Organized by the Arts Council of Great Britain and the English-speaking Union of the United States* (London and New York, 1960) // Horace Shipp, "Current Shows and Comments: Ruskin Versus Whistler," *Apollo* 72 (Sept. 1960), pp. 61–62 // Denys Sutton, *Nocturne: The Art of James McNeill Whistler* (Philadelphia and New York, 1964) // John Sandberg, "'Japonisme' and Whistler," *Burlington Magazine* 106 (Nov. 1964), pp. 500– 507 // Basil Gray, "'Japonisme' and Whistler," *Burlington Magazine* 107 (June 1965), p. 324 // John A. Mahey, "Documentation: The Letters of James McNeill Whistler to George A. Lucas," *Art Bulletin* 49 (Sept. 1967), pp. 247– 57 // Robert Harold Getscher, "Whistler and Venice" (Ph.D. diss., Case Western Reserve University, 1970) // "James Abbott McNeill Whistler: Painter and Graver," in *The Index of Twentieth Century Artists,* reprint with cumulative index (New York, 1970), pp. 175, 182– 209, 214–20 // Walter Muir Whitehill, "The Making of an Architectural Masterpiece: The Boston Public Library," *American Art Journal* 2 (Fall 1970), pp. 13–35 // Wildenstein and Company, New York, *From Realism to Symbolism: Whistler and His World,* by Allen Staley (exhib. cat., 1971) // Alastair Grieve, "Whistler and the Pre-Raphaelites," *Art Quarterly* 34 (Summer 1971), pp. 219–28 // Mark Girouard, "Chelsea's Bohemian Studio Houses: The Victorian Artist at Home," pt. 2, *Country Life* 152 (Nov. 23, 1972), pp. 1370– 74 // Judith Elaine Gorder, "James McNeill Whistler: A Study of the Oil Paintings, 1855– 1869" (Ph.D. diss., University of Iowa, 1973) // Margaret F. MacDonald, "Whistler: The Painting of the 'Mother,'" *Gazette des Beaux-Arts,* 6th ser. 85 (Feb. 1975), pp. 73– 88 // Allen Memorial Art Museum, Oberlin, Ohio, *The Stamp of Whistler,* by Robert H. Getscher and Allen Staley (exhib. cat., 1977) // D. Craven, "Ruskin vs. Whistler: The Case Against Capitalist Art," *Art Journal* (New

York) 37 (Winter 1977–78), pp. 139–43 // Margaret F. MacDonald, "Whistler's Designs for a Catalogue of Blue and White Nankin Porcelain," *Connoisseur* 198 (Aug. 1978), pp. 290–95 // Mary E. Hayward, "The Influence of the Classical Oriental Tradition on American Painting," *Winterthur Portfolio* 14 (Summer 1979), pp. 107–42 // Henry Nichols Clark, "Charles Lang Freer: An American Aesthetic in the Gilded Era," *American Art Journal* 11 (Oct. 1979), pp. 54–68 // Ira M. Horowitz, "Whistler's Frames," *Art Journal* (New York) 39 (Winter 1979–80), pp. 124–31 // Andrew McLaren Young et al., *The Paintings of James McNeill Whistler,* 2 vols. (New Haven, 1980) // Robin Spencer, "Whistler's Subject Matter: 'Wapping,' 1860–1864," *Gazette des Beaux-Arts,* 6th ser. 100 (Oct. 1982), pp. 131–42 // David Park Curry, "Charles Lang Freer and American Art," *Apollo* 118 (Aug. 1983), pp. 168–79 // Freer Gallery of Art, Washington, D.C., *James McNeill Whistler at the Freer Gallery of Art,* by David Park Curry (exhib. cat., 1984) // Katharine A. Lochnan, *The Etchings of James McNeill Whistler* (New Haven, 1984) // David Park Curry, "Whistler and Decoration," *Antiques* 126 (Nov. 1984), pp. 1186–99 // Katherine Pagan Shanno, "The Portraits of James McNeill Whistler: Some Old Master Sources" (M.A. thesis, University of California, Davis, 1985)

James Horton Whitehouse, *see* **Tiffany and Company**

Whiting Manufacturing Company
1866–1924
North Attleboro, Massachusetts,
 and New York City
Silver

The Whiting Manufacturing Company was among the most important producers of silver articles in the post–Civil War era. A few extraordinary examples of the company's production survive from the 1870s and 1880s, including several trophies commissioned by members of the New York Yacht Club, but details of the firm's history and principal designers remain largely obscure.

The company's founder, William Dean Whiting (1815–1891), of Attleboro, Massachusetts, first learned to work with precious metals during a seven-year apprenticeship in his uncle's local jewelry company, Draper and Tifft. He next worked in Attleboro for the firms R. and W. Robinson, Draper and Blackington, and H. M. Richards. Richards, a manufacturer of French-style enameled jewelry, later moved his business to Philadelphia, and for a brief time Whiting served as its superintendent there. In North Attleboro by 1840, Whiting and his partner Albert Tifft established a company that for the next thirteen years manufactured jewelry and, later, small silver toilet appointments. In 1847 the two men built a factory, which later housed the Whiting Manufacturing Company.

It seems likely that in an attempt to establish a successful retail outlet for his goods, Whiting opened a shop in New York City, listing himself in the 1853–54 directories as "W. Whiting Jeweler," while maintaining his residence in Massachusetts. Between 1865 and 1867 he appears as part of the firm of Whiting, Cowan and Bowen. The Whiting Manufacturing Company was formally established as a firm in 1866 and is recorded as "silversmiths" in the New York city directories of 1867–68. The company, at various addresses—including 694 Broadway from about 1876 until 1885 and 31 Union Square West until 1895—continues in the directories through 1923. The factory in North Attleboro burned to the ground in 1875 and was almost immediately rebuilt to more grandiose proportions.

During the 1870s the company's chief designer was Charles Osborne. Hoping to gain the Bryant Vase (FIG. 8.1) commission for Whiting Manufacturing, in 1875 Osborne submitted a design that was eventually rejected in favor of the one by JAMES HORTON WHITEHOUSE for TIFFANY AND COMPANY. He also executed for the firm a silver-and-enamel pitcher and tray, commissioned by Ogden Goelet, to be awarded by the New York Yacht Club to the winner of an 1882 schooner race. Another Whiting artist, a chaser who discreetly inscribed his name on the bottom, made a delicate little vase (FIG. 8.2) decorated with flowers that are stylized on the neck but on the body become progressively more naturalistic as the relief deepens. Other existing pieces from the period, with Japanese-style hammered surfaces and cast and applied decoration, are similar in manner to work being done at Tiffany and Company during the 1870s and 1880s (FIGS. 8.10, 8.11). Despite its Western form, the surface of a silver soup tureen dating from about 1880 (FIG. 8.20) is adorned with repoussé motifs that also demonstrate Japanese influence—a turtle on one side, a flying crane on the other.

Whiting's second son, Frank Mortimer (1848–1892), joined his father's business in 1868, working first in the office of the North Attleboro plant and later in various capacities in the New York City locations. Returning to North Attleboro after some years, he formed his own firm, the Holbrook, Whiting and Albee Company, and manufactured plated jewelry and novelties from his father's premises. In the late 1870s he dissolved his company and, with his father as partner, established the firm of F. M. Whiting and Company. When father and son died, within a year of one another, the business, under the name F. M. Whiting, was carried on by their wives and by Frank's two sisters from 1891 until 1895, when it operated as a stock company known as F. M. Whiting Company. The following year the women were forced to change the name of the firm to Frank M. Whiting and Company and to adopt an entirely new trademark, because the Whiting Manufacturing Company, now out of the family's hands, wished to prevent them from profiting by any supposed connection with it. The Frank M. Whiting Company continued under that name until 1940, when it was absorbed by the Ellmore Silver Company of Meriden, Connecticut.

As for the Whiting Manufacturing Company, in 1907 it came under the management of the Silversmiths Company, a holding operation controlled by the GORHAM MANUFACTURING COMPANY. The Whiting firm, by 1910 located in Bridgeport, Connecticut, nevertheless functioned as a separate entity until 1924. In that year it was acquired by Gorham, which transferred Whiting's operations to Gorham's location in Providence, Rhode Island, but continued to use the Whiting trademark on some of its flatware.

REFERENCES
"A Superb Work in Silver," *Jewelers' Circular and Horological Review* 1–5 (May–Nov. 16, 1874), p. 162 // "American Art-Work in Silver," *Art Journal* (Appleton's) 1 (Dec. 1875), pp. 371–74 // "The Uptown March," *Jewelers' Circular and Horological Review* 7 (June 1876), p. 66 // "The Goelet Schooner Yacht Prize," *Art Amateur* 8 (Apr. 1883), pp. 99 (ill.), 119 // William R. Cutler, *Genealogical and Personal Memoirs Relating to the Families of . . . Massachusetts* (New York, 1910), pp. 1877–79 // Katherine Morrison McClinton, *Collecting American Nineteenth Century Silver* (New York, 1968) // Dorothy T. Rainwater, *Encyclopedia of American Silver Manufacturers* (New York, 1975), pp. 51–52, 60–61, 169, 187 // Charles H. Carpenter, Jr., "Nineteenth-Century Silver in the New York Yacht Club," *Antiques* 112 (Sept. 1977), pp. 496–505 // Yale University Art Gallery, New Haven, *Silver in American Life: Selections from the Mabel Brady Garvan and Other Collections at Yale University,* ed. Barbara McLean Ward and Gerald W. R. Ward (exhib. cat., 1979), pp. 178–79 (ills.) // Charles H. Carpenter, Jr., *Gorham Silver, 1831–1981* (New York, 1982), pp. 91, 200, 254 // Detroit Institute of Arts, *The Quest for Unity: American Art Between World's Fairs, 1876–1893* (exhib. cat., 1983), pp. 212–13 (ills.) and pl. 4 // Kathleen Stavec, New Jersey Historical Society, Newark, correspondence, Aug. 13, 1984 // Ulysses G. Dietz, The Newark Museum, N.J., and Dorothy T. Rainwater, correspondence, May 7, 16, and 21, 1985 // Edward Money, Gorham Division of Textron Inc., Providence, R.I., correspondence, Oct. 2 and 22, 1985

P. B. Wight
1838–1925
New York and Chicago
Architect

The buildings, furniture, and interior decorations of Peter Bonnett Wight were important in establishing the Modern Gothic style in mid-nineteenth-century America. Wight's polychromatic work reveals an intensive study of seminal European theorists and designers, such as Eugène Emmanuel Viollet-le-Duc (1814–1879), Augustus Welby Northmore Pugin (1812–1852), John Ruskin (1819–1900), and OWEN JONES, whose ideas he knew through published books rather than through foreign travel. Wight was no mere copyist, however, but rather an original and inventive designer. During the latter half of his career, he became an important architectural critic and invented improved methods of construction and fireproofing.

With his friend Russell Sturgis (1836–1909), later an architect and influential critic in his own right, Wight attended the Free Academy (now City College, New York) shortly after its establishment in 1849. Although some engineering and drawing classes were offered, ar-

chitecture was not formally a part of the curriculum at that time. Ruskin's writings, which strongly endorsed the polychromatic Italian Gothic style in architecture, and the illustrated architectural books in the Astor Library that Wight avidly studied and traced constituted his early education in the field. It is not insignificant that Wight's graduation from the Free Academy in 1855 coincided with the founding of the *Crayon* by William James Stillman, the vociferous promulgator of Ruskinian ideals in America.

Wight remained at the Free Academy for an additional year to study drawing before entering the office of architect Thomas R. Jackson (1826–1901), an Englishman who had previously worked with Richard Upjohn (1802–1878), the American Gothic revivalist; for a brief period Wight also worked for the architect Isaac G. Perry (1822–1904). Between 1858 and 1859 Wight worked in Chicago under the architects Asher Carter (1805–1877), later his partner, and Augustus Bauer (1827–1894).

Wight's reputation was established when, following his return to New York in 1859, he won the National Academy of Design competition in 1861 with an Italian Gothic design that was Ruskinian in inspiration. The facades of the building—located on the northwest corner of Twenty-third Street and Fourth Avenue, completed in 1865, and demolished in 1901—were executed in gray and white Westchester marble bands, with buff and red brick in a diamond pattern at the third-story level, trimmed in North River bluestone, with red Vermont marble columns at the gabled entranceway. It was "such . . . as a Gothic artist of the thirteenth century might build, should he live now in New York, study our customs and needs, and become familiar with our materials and our workmen and their ways" (Sturgis, in Art Institute, 1981, p. 18). As advocated by Ruskin and the short-lived Association for the Advancement of Truth in Art, of which Wight and Sturgis were founding members in 1863, the carved-stone ornament throughout the building depicted native plants; the firm of ELLIN AND KITSON was responsible for those considered most beautiful, installed along the second-floor corridor overlooking the grand staircase.

From 1863 until 1868 Wight and Sturgis were partners. During this time Wight designed the Yale School of Fine Arts (1864–68), known as Street Hall, and the Brooklyn Mercantile Library (1867–69), a Gothic-derived building in red brick and two colors of sandstone. He also carefully orchestrated every aspect of the library's interior—furniture and fixtures as well as the richly colored wall and ceiling designs that recall medieval manuscript pages (FIG. 4.8). Wight's treatment of ceilings and walls as flat planes most appropriately served by stylized patterns was in keeping with the reform ideals of such English designers as Owen Jones and CHRISTOPHER DRESSER, whose influence can be seen in Wight's wallpaper designs of the 1870s (FIG. 3.2).

In Chicago once again after the disastrous fire of 1871, Wight was instrumental in rebuilding residences and commercial buildings with his partners at that time, Asher Carter and William H. Drake. Yet perhaps his most significant contribution was not the design of

specific buildings but rather his structural innovations. Wight specialized in fireproofing technology that involved the use of brick, terracotta, and concrete and claimed credit (which he may well deserve) for the first use of the so-called grill foundation, about 1880 in Burnham and Root's Montauk Building, an advancement that facilitated the construction of tall buildings. The Wight Fireproofing Company, founded in 1881, was a successful enterprise in Chicago for ten years until Wight dissolved it in 1891. He subsequently designed a number of buildings for the Chicago World's Columbian Exposition in 1893 and served as an architectural consultant to foreign and state governments exhibiting at the fair.

Throughout his career Wight was a prolific author and critic—writing for the *New Path* in 1863, translating lectures by Viollet-le-Duc as early as 1864, and contributing regularly not only to the *American Architect and Building News* after its inception in 1876 but also to many other periodicals and architectural journals of the era, such as the *Inland Architect*. For more than three years Wight edited the magazine *Fireproof* before its demise in 1907. When he retired, in 1918, Wight moved to southern California, where he became fascinated by local vernacular architecture. He died in Pasadena at the age of eighty-seven.

REFERENCES
"Wight, Peter Bonnett," in *Appletons' Cyclopaedia of American Biography,* ed. James Grant Wilson and John Fiske, vol. 6 (New York, 1900), pp. 501–2 // Irving K. Pond and Arthur Woltersdorf, "Obituary: Peter Bonnett Wight," *Journal of the American Institute of Architects* 13 (Oct. 1925), p. 386 // "Peter B. Wight," *American Architect* 128 (Nov. 5, 1925), pp. 389–90 // "Wight, Peter Bonnett," in *The National Cyclopaedia of American Biography,* vol. 21 (New York, 1931), pp. 369–70 // Michael T. Klare, "The Life and Architecture of Peter Bonnett Wight" (M.A. thesis, Columbia University, 1968) // "Wight, Peter Bonnett," in *Biographical Dictionary of American Architects (Deceased),* ed. Henry F. Withey and Elsie Rathburn Withey (Los Angeles, 1970), p. 657 // E. F. Jones and M. J. Kinsman, "Unknown Wight Designs in Louisville, Kentucky," *Nineteenth Century* 6 (Winter 1980), pp. 57–70 // Art Institute of Chicago, *P. B. Wight: Architect, Contractor, and Critic, 1838–1925,* by Sarah Bradford Landau (exhib. cat., 1981) // Sarah Bradford Landau, "Wight, Peter B.," in *Macmillan Encyclopedia of Architects,* ed. Adolf K. Placzek, 4 vols. (New York, 1982), vol. 4, pp. 397–98

George Wilkinson, see **Gorham Manufacturing Company**

Albert Willms, *see* **Elkington and Company**

Worcester Royal Porcelain Company
1862–present
Worcester, Worcestershire, England
Ceramics

Since at least 1751 porcelain has been manufac-

tured in Worcester, England. During the last decades of the nineteenth century, the Worcester Royal Porcelain Company emerged as the city's most important factory. Although not formally established until 1862, the company was a direct descendant of other factories with histories dating back to the eighteenth century. Its immediate predecessor was the firm of Kerr and Binns (1852–1862), owned by W. H. Kerr and R. W. Binns (d. 1900) and best known for its wares based on classical and Renaissance prototypes; a richly decorated dessert service made for Queen Victoria and shown at the 1862 London International Exhibition was a particularly famous example of their work. In 1862 Kerr left the factory, and Binns, who had been the artistic force in their firm, reorganized it as the Worcester Royal Porcelain Company.

The year 1862 also marked the introduction by the company of a new porcelain body, creamy in color, named Ivory porcelain. This was especially suited to applied-enamel ornament, which the firm's decorators used with great success. Ivory porcelains decorated in the Japanese style were among the most celebrated wares of their time and created the greatest impact on the American ceramics industry. Almost slavish in their reliance on Japanese art objects for inspiration, both in shape and decoration, these Worcester porcelains were the result of Binns's fascination with Japanese culture. He amassed a collection of Far Eastern porcelain that numbered no fewer than ten thousand pieces at his death. Many of the Japanese-style wares that the factory produced featured exquisite enamel, gold, and other metallic raised pastework, an effect, highly admired in America, that was copied in Trenton, New Jersey, by both OTT AND BREWER and the GREENWOOD POTTERY, and in Brooklyn, New York, by the FAIENCE MANUFACTURING COMPANY.

Although the Japanese style clearly dominated Worcester production from the late 1860s through the 1880s, during Binns's tenure, which lasted until 1897, the factory also made a number of pieces with painted and gilded decoration in Persian and Indian styles. Some of them assumed exotic shapes enlivened with intricately reticulated handles and covers, another feature that the Faience Manufacturing Company adopted (FIG. 7.8). Still other pieces bore depictions of children in the style of Kate Greenaway.

Perhaps the epitome of the Aesthetic movement as represented in the ceramic medium is the aesthetic teapot (FIG. 1.1) made by Worcester in 1882. This extremely small and delicately modeled piece assumes an aesthete's pose as its form: the figure's pale face and puce velvet hat serve as the teapot's cover; his arms, its handle and spout; his green jacket, silk tie, and the ubiquitous aesthetic sunflower pinned to his breast constitute the decoration of the pot itself. On the other side is a female figure wearing a calla lily as a corsage. Both the imagery and the satiric inscription on the bottom of the teapot—*FEARFUL CONSEQUENCES – / THROUGH THE LAWS OF NATURAL SELECTION / AND EVOLUTION – OF LIVING / UP TO ONE'S TEAPOT*—refer to Gilbert and Sullivan's operetta *Patience.*

Essentially a conservative pottery, the Worcester factory nonetheless experimented in

the 1880s and 1890s with novel techniques that included pierced work and new glaze effects. Despite those innovative pursuits, the firm's twentieth-century production has been dictated by prevailing popular and salable styles. Porcelain figures, for example, have been staples in the company's production since 1860, and many more of the firm's nineteenth-century lines were continued well into the twentieth century.

REFERENCES
"The Universal Exhibition at Vienna," *Art Journal* (London), June 1873, p. 181 (ills.) // "The Universal Exhibition at Vienna," *Art Journal* (London), Oct. 1873, p. 314 (ill.) // Worcester Royal Porcelain Works, *A Guide Through the Royal Porcelain Works, Worcester, with Illustrations of the Work-Rooms; also, an Epitome of the History of Pottery and Porcelain and the Marks on Worcester Porcelain* (Worcester, 1875) // R. W. Binns, *The Poetry of Pottery: Homer's Hymn, . . . Longfellow's Poem, . . . with Pottery Illustrations* [of a pair of vases man-ufactured at the Royal Porcelain Works, Worcester, for the Paris Exposition Universelle, 1878] (London and Chilworth [1878?]) // "General Report of the Judges of Group 2," in U.S. Centennial Commission, *International Exhibition, 1876: Reports and Awards,* 9 vols. (Washington, D.C., 1880), vol. 3, pp. 534–35 // "Japanesque Decoration," *Art Amateur* 5 (Sept. 1881), pp. 79–80 // R. W. Binns, *Catalogue of a Collection of Worcester Porcelain in the Museum at the Royal Porcelain Works* (Worcester, 1882) // Idem, *Catalogue of a Collection of Worcester Porcelain and Notes on Japanese Specimens in the Museum at the Royal Porcelain Works* (Worcester, 1884) // R. W. Binns and E. P. Evans, *A Guide Through the Royal Porcelain Works* (Worcester, 1885) // Lewis F. Day, "Victorian Progress in Applied Design," *Art Journal* (London), June 1887, pp. 185–202 // "China Making at Worcester," *Littell's Living Age* 209 (May 30, 1896), pp. 575–76 // R. W. Binns, *Worcester China: A Record of the Work of Forty-five Years, 1852–1897* (London, 1897) // "The Art Movement: Recent Royal Worcester," *Magazine of Art* 22 (1898), pp. 388–93 // Robert Lockhart Hobson, *Worcester Porcelain: A Description of the Ware from the Wall Period to the Present Day* (London, 1910) // Frederick Litchfield, "Worcester Porcelain, Later Period," *Connoisseur* 62 (Feb. 1922), pp. 67–77 // Franklin A. Barrett, *Worcester Porcelain* (London, 1953) // Geoffrey [A.] Godden, "Some Worcester Ceramic Artists of the Victorian Era," *Apollo* 72 (Nov. 1960), pp. 139–41 // Idem, *Victorian Porcelain* (London, 1961) // Idem, *An Illustrated Encyclopedia of British Pottery and Porcelain* (New York, 1966), pp. 365–81 // Stephen B. Jareckie, "British Pottery and Porcelain in the Museum Collection," *Worcester Art Museum Journal* 2 (1978–79), pp. 12–27 // Henry Sandon, *Royal Worcester Porcelain from 1862 to the Present Day* (London, 1973) // Paul Atterbury, ed., *The History of Porcelain* (New York, 1982), pp. 155–77 // Antoinette Faÿ-Hallé and Barbara Mundt, *Porcelain of the Nineteenth Century* (New York, 1983), pp. 216–21, 266–67

Selected Bibliography

Authors' note: This bibliography is a partial listing of the books and articles consulted during the preparation of the exhibition and publication *In Pursuit of Beauty: Americans and the Aesthetic Movement*. It is arranged chronologically by publishing date under headings that correspond to the subjects in the preceding essays. Sources are cited only once, under the most appropriate heading. More extensive references on individuals and firms represented in the exhibition can be found in the Dictionary of Architects, Artisans, Artists, and Manufacturers. Many periodicals were particularly useful; these are listed below with their city and first date of publication.

American Architect and Building News (Boston and New York, 1876)
American Art Review (Boston, 1879)
Art Age (New York, 1883)
Art Amateur (New York, 1879)
Art and Decoration (New York, 1885)
Art Interchange (New York, 1878)
Art Journal (London, 1839)
Art Journal (Appleton's) (New York, 1875)
Art Student (Boston, 1882)
Art-Union (New York, 1884)

Art-Worker (New York, 1878)
Brick, Tile, and Metal Review (Pittsburgh, 1881)
Carpentry and Building (New York, 1879)
Carpet Trade Review (New York, 1870)
Century Illustrated Monthly Magazine (New York, 1881)
Chromatic Art Magazine (New York, 1879)
Clayworker (Indianapolis, 1884)
Critic (New York, 1881)
Crockery and Glass Journal (New York, 1874)
Decorator and Furnisher (New York, 1882)

Demorest's Monthly Magazine (New York, 1865)
Furniture Gazette (London, 1873)
Furniture World and Furniture Buyer and Decorator (New York, 1870)
Harper's New Monthly Magazine (New York, 1850)
Iron Age (Middletown, N.Y., 1859)
Jewelers' Circular and Horological Review (New York, 1869)
Magazine of Art (London and New York, 1878)
Scribner's Monthly (New York, 1870)

GENERAL

1850–59

Seiss, J. A. *The Arts of Design, Especially as Related to Female Education. An Address Delivered in the Hall of the Maryland Institute, at the Commencement of the Female Dept. of the School of Design, Nov. 25th, 1856.* Baltimore, 1857.

1860–69

Bascom, John. *Aesthetics, or the Science of Beauty.* Boston, 1862.
Jarves, James Jackson. *The Art-Idea.* New York, 1864.
Burges, William. *Art Applied to Industry.* Oxford and London, 1865.

1870–79

Eastlake, Charles Locke. *A History of the Gothic Revival.* London, 1872.
Smith, Walter. *Art Education, Scholastic and Industrial.* Boston, 1872.
Lienard, Michel. *Specimens of the Decoration and Ornamentation of the Nineteenth Century.* Boston, 1875.
Massachusetts Normal Art School, Boston. *The Antefix Papers.* Boston, 1875.
Smith, Walter. "Industrial Art Education." An address delivered in Concert Hall, Philadelphia, Apr. 23, 1875. Manuscript, Thomas J. Watson Library, The Metropolitan Museum of Art, New York.
Alcock, Rutherford. *Art and Art Industries of Japan.* London, 1876.
[Ferris, George Titus]. *Gems of the Centennial Exhibition: Consisting of Illustrated Descriptions of Objects of an Artistic Character, in the Exhibits of the United States, Great Britain, France. . . .* New York, 1877.
The Masterpieces of the Centennial International Exhibition. 3 vols. Philadelphia, copr. 1875 [1877?]. Vol. 1, *Fine Art,* by Edward Strahan [Earl Shinn]; vol. 2, *Industrial Art,* by Walter Smith; vol. 3, *History, Mechanics, Science,* by Joseph M. Wilson.
Nichols, George Ward. *Art Education Applied to Industry.* New York, 1877.
Goadby, Edwin. "Art Manufactures." *Art Journal* (Appleton's) 3 (1877), pp. 111–12.
Haweis, Mary Eliza. *The Art of Beauty.* New York, 1878.
"Laboring Classes Abroad." *Crockery and Glass Journal* 10 (Aug. 28, 1879), p. 20.

1880–89

Benjamin, S. G. W. *Art in America: A Critical and Historical Sketch.* New York, 1880.
U.S. Centennial Commission. *International Exhibition, 1876: Reports and Awards.* 9 vols. Washington, D.C., 1880.
"Notes and Queries" [reading list for decorative art]. *Art Interchange* 4 (Jan. 21, 1880), p. 20.
Pollard, Josephine. *The Decorative Sisters.* New York, 1881.
Crane, Lucy. *Art and the Formation of Taste.* London, 1882.
Hamilton, Walter. *The Aesthetic Movement in England.* London, 1882.
Cole, Henry. *Fifty Years of Public Works.* London, 1884.

1890–99

Crane, Walter. *The Claims of Decorative Art.* London, 1892.
Wheeler, Candace, ed. *Household Art.* New York, 1893.
Kelly, A. Ashmun. "The True Function of Decorative Art." *Interior Decorator* 5 (Jan. 1894), p. 107.
Pitman, Benn. *A Plea for American Decorative Art.* Cincinnati, 1895.
Andrews, E. Benjamin. *The History of the Last Quarter-Century in the United States, 1870–1895.* 2 vols. New York, 1896.
Cobden-Sanderson, Thomas James, et al. *Art and Life and the Building and Decoration of Cities.* London, 1897.

1900–present

Arnold, Matthew. *Civilization in the United States.* Boston, 1900.

Wilde, Oscar. *Decorative Art in America: A Lecture by Oscar Wilde.* Ed. Richard Butler. New York, 1906.

Howe, Winifred E. *A History of the Metropolitan Museum of Art, with a Chapter on the Early Institutions of Art in New York.* New York, 1913.

Armstrong, D. Maitland. *Day Before Yesterday: Reminiscences of a Varied Life.* New York, 1920.

Gaunt, William. *The Aesthetic Adventure.* New York, 1945.

Ditter, Dorothy E. C. "The Cultural Climate of the Centennial City: Philadelphia, 1875–1876." Ph.D. diss., University of Pennsylvania, 1947.

Lynes, Russell. *The Taste Makers.* New York, 1949.

Commager, Henry Steele. *The American Mind: An Interpretation of American Thought Since the 1880s.* New Haven, 1950.

Lichten, Frances. *Decorative Art of Victoria's Era.* New York, 1950.

Mumford, Lewis. *The Brown Decades: A Study of the Arts in America, 1865–1895.* 2d ed. New York, 1955.

Schmutzler, Robert. "The English Origins of Art Nouveau." *Architectural Review* 117 (Feb. 1955), pp. 108–16.

Mann, Arthur. "British Social Thought and American Reformers of the Progressive Era." *Mississippi Valley Historical Review* 42 (Mar. 1956), pp. 672–92.

Bøe, Alf. *From Gothic Revival to Functional Form: A Study in Victorian Theories of Design.* Oslo and Oxford, 1957.

Brooklyn Museum. *Victoriana: An Exhibition of the Arts of the Victorian Era in America,* by Marvin D. Schwartz and Doris Creer. Exhib. cat., 1960.

Museum of Modern Art, New York. *Art Nouveau: Art Design at the Turn of the Century,* ed. Peter Selz and Mildred Constantine. Exhib. cat., 1960.

Lancaster, Clay. *The Japanese Influence in America.* New York, 1963.

McClinton, Katherine Morrison. *Collecting American Victorian Antiques.* New York, 1966.

Stein, Roger B. *John Ruskin and Aesthetic Thought in America, 1840–1900.* Cambridge, Mass., 1967.

Wiebe, Robert. *The Search for Order, 1877–1920.* New York, 1967.

Davis, Julia Finette, comp. "International Expositions, 1851–1900." *American Association of Architectural Bibliographers Papers* 4 (1967).

Garraty, John A. *The New Commonwealth, 1877–1890.* New York, 1968.

Handley-Read, Charles. "High Victorian Design: An Illustrated Commentary." In Victorian Society. *Design, 1860–1960. Sixth Conference Report by the Victorian Society.* London, 1968.

Pevsner, Nikolaus. *Studies in Art, Architecture, and Design.* 2 vols. New York, 1968.

Aslin, Elizabeth. *The Aesthetic Movement: Prelude to Art Nouveau.* New York and Washington, D.C., 1969.

Bing, S. *Artistic America, Tiffany Glass, and Art Nouveau.* Intro. Robert Koch. Cambridge, Mass., and London, 1970.

Harris, Neil, ed. *The Land of Contrasts, 1880–1901.* New York, 1970.

Metropolitan Museum of Art, New York. *Nineteenth-Century America: Furniture and Other Decorative Arts.* Exhib. cat., 1970.

Tomkins, Calvin. *Merchants and Masterpieces: The Story of the Metropolitan Museum of Art.* New York, 1970.

Jones, Howard Mumford. *The Age of Energy: Varieties of American Experience, 1865–1915.* New York, 1971.

Naylor, Gillian. *The Arts and Crafts Movement: A Study of Its Sources, Ideals, and Influences on Design Theory.* London, 1971.

Art Museum, Princeton University. *The Arts and Crafts Movement in America.* Exhib. cat., 1972.

Fine Art Society Limited, London. *The Aesthetic Movement and the Cult of Japan,* by Robin Spencer et al. Exhib. cat., 1972.

Royal Academy of Arts, London. *Victorian and Edwardian Decorative Art: The Handley-Read Collection.* Exhib. cat., 1972.

Spencer, Robin. *The Aesthetic Movement.* New York and London, 1972.

Camden Arts Centre, London. *The Aesthetic Movement, 1869–1890,* ed. Charles Spencer. Exhib. cat., 1973.

Fine Art Society Limited, London. *The Arts and Crafts Movement: Artists, Craftsmen, and Designers, 1890–1930.* Exhib. cat., 1973.

Morgan, Wayne H. *Victorian Culture in America, 1865–1914.* Itasca, Ill., 1973.

Barnard, Julian. *The Decorative Tradition: A Survey of Victorian Decorative Ornament.* Princeton, 1974.

National Gallery of Canada, Ottawa. *High Victorian Design,* by Simon Jervis. Exhib. cat., 1974.

Platt, Frederick. *America's Gilded Age: Its Architecture and Decoration.* New York, 1974.

Jervis, Simon. "High Victorian Design." *Canadian Antiques Collector* 9 (1974), pp. 6–10.

Maher, James T. *The Twilight of Splendor: Chronicles of the Age of American Palaces.* Boston, 1975.

"Aspects of the Arts and Crafts Movement in America." Ed. Robert Judson Clark. *Record of the Art Museum, Princeton University* 34, no. 2 (1975).

Cincinnati Art Museum. *The Ladies, God Bless 'Em: The Women's Art Movement in Cincinnati in the Nineteenth Century,* by Anita J. Ellis. Exhib. cat., 1976.

Delaware Art Museum, Wilmington. *The Pre-Raphaelite Era, 1848–1914,* by Rowland Elzea and Betty Elzea. Exhib. cat., 1976.

Gowans, Alan. *Images of American Living: Four Centuries of Architecture and Furniture as Cultural Expression.* New York, 1976.

Madsen, Stephan Tsudi. *Sources of Art Nouveau.* New York, 1976.

Gilbert, James B. *Work Without Salvation: America's Intellectuals and Industrial Alienation, 1880–1910.* Baltimore, 1977.

Girouard, Mark. *Sweetness and Light: The "Queen Anne" Movement, 1860–1900.* Oxford, 1977.

Knoepflmacher, U. C., and G. B. Tennyson, eds. *Nature and the Victorian Imagination.* Berkeley, 1977.

Anscombe, Isabelle, and Charlotte Gere. *Arts and Crafts in Britain and America.* New York, 1978.

Dan Klein Limited, London. *Aspects of the Aesthetic Movement.* Exhib. cat., 1978.

Minneapolis Institute of Arts. *Victorian High Renaissance.* Exhib. cat., 1978.

Morgan, Howard W. *New Muses: Art in American Culture, 1865–1920.* Norman, Okla., 1978.

Said, Edward W. *Orientalism.* New York, 1978.

Aleson, Alexandra, and John Voss, eds. *The Organization of Knowledge in America, 1860–1920.* Baltimore and London, 1979.

Brooklyn Museum. *The American Renaissance: 1876–1917.* Exhib. cat., 1979.

Callen, Anthea. *Women Artists of the Arts and Crafts Movement, 1870–1914.* New York, 1979.

Johnson, Diane Chalmers. *American Art Nouveau.* New York, 1979.

Gere, Charlotte, and Peyton Skipwith. "The Morris Movement." *Connoisseur* 201 (May 1979), pp. 32–39.

Barth, Gunther. *City People: The Rise of Modern American City Culture in Nineteenth Century America.* New York, 1980.

Jenkyns, Richard. *The Victorians and Ancient Greece.* Cambridge, Mass., 1980.

Leach, William [R.]. *True Love and Perfect Union: The Feminist Reform of Sex and Society.* New York, 1980.

Society for the Study of Japonisme. *Japonisme in Art: An International Symposium.* Tokyo, 1980.

Boris, Eileen Cynthia. "Art and Labor: John Ruskin, William Morris, and the Craftsman Ideal in America, 1876–1915." Ph.D. diss., Brown University, 1981.

Cincinnati Art Museum. *Art Palace of the West.* Exhib. cat., 1981.

Lears, T. J. Jackson. *No Place of Grace: Antimodernism and the Transformation of American Culture, 1880–1920.* New York, 1981.

Weimann, Jeanne M. *The Fair Women.* Chicago, 1981.

Wichmann, Siegfried. *Japonisme: The Japanese Influence on Western Art in the Nineteenth and Twentieth Centuries.* Trans. Mary Whitall. New York, 1981.

Cincinnati Art Museum. *Celebrate Cincinnati Art: In Honor of the One-Hundredth Anniversary of the Cincinnati Art Museum, 1881–1981,* ed. Kenneth R. Trapp. Exhib. cat., 1982.

Trachtenberg, Alan. *The Incorporation of America: Culture and Society in the Gilded Age.* New York, 1982.

Zimmerman, Enid, and Mary Ann Stankiewicz, eds. *Women Art Educators.* 2 vols. Bloomington, Ind., 1982–85.

Stankiewicz, Mary Ann. "The Creative Sister: An Historical Look at Women, the Arts, and Higher Education." *Studies in Art Education* 23 (1982), pp. 45–56.

Detroit Institute of Arts. *The Quest for Unity: American Art Between World's Fairs, 1876–1893.* Exhib. cat., 1983.

Floyd, Phyllis Anne. "Japonisme in Context: Documentation, Criticism, Aesthetic Reactions." Ph.D. diss., University of Michigan, 1983.

Gallery Association of New York State. *The Arts and Crafts Movement in New York State, 1890s–1920s,* by Coy L. Ludwig. Exhib. cat., 1983.

Green, Harvey. *The Light of the Home.* New York, 1983.

High Museum of Art, Atlanta. *The Virginia Carroll Crawford Collection: American Decorative Arts, 1825–1917,* by David A. Hanks and Donald C. Peirce. Exhib. cat., 1983.

Mintz, Steven. *A Prison of Expectations: The Family in Victorian Culture.* New York, 1983.

Warner, Eric, and Graham Hough, eds. *Strangeness and Beauty: An Anthology of Aesthetic Criticism, 1840–1910.* 2 vols. Cambridge, Eng., 1983.

Danforth Museum of Art, Framingham, Mass. *On the Threshold of Modern Design: The Arts and Crafts Movement in America.* Exhib. cat., 1984.

Jervis, Simon. *The Penguin Dictionary of Design and Designers.* Harmondsworth, Eng., and New York, 1984.

Saisselin, Rémy G. *The Bourgeois and the Bibelot.* New Brunswick, N.J., 1984.

Yale University Art Gallery, New Haven. *The Folding Image: Screens by Western Artists of the Nineteenth and Twentieth Centuries,* by Michael Komanecky and Virginia Butera. Exhib. cat., 1984.

Leach, William R. "Transformation in a Culture of Consumption: Women and Department Stores, 1890–1925." *Journal of American History* 71 (Sept. 1984), pp. 319–42.

Axelrod, Alan, ed. *The Colonial Revival in America.* New York and London, 1985.

Korzenik, Diana. *Drawn to Art: A Nineteenth-Century American Dream.* Hanover, N.H., 1985.

ARCHITECTURE

1840–49

Ruskin, John. *The Seven Lamps of Architecture.* 3 vols. London, 1849.

1860–69

Kerr, Robert. *The English Gentleman's House, or How to Plan English Residences.* London, 1864.

1870–79

Holly, Henry Hudson. *Modern Dwellings in Town and Country Adapted to American Wants and Climate with a Treatise on Furniture and Decoration.* New York, 1878.

[Palliser, George, and Charles Palliser]. *Palliser's American Cottage Homes.* Bridgeport, Conn., 1878.

———. *Palliser's Model Homes, Showing a Variety of Designs for Model Dwellings.* Bridgeport, Conn., 1878.

1880–89

Stevenson, John J. *House Architecture.* 2 vols. London, 1880.

Oakey, Alexander F. *Building a Home.* New York, 1881.

Dresser, Christopher. *Japan: Its Architecture, Art, and Art Manufactures.* London and New York, 1882.

Robinson, William. *The English Flower Garden.* London, 1883.

Jones, Mrs. C. S., and Henry T. Williams. *Beautiful Homes: How to Make Them.* Rockford, Ill., 1885.

Morse, Edward S. *Japanese Homes and Their Surroundings.* Boston, 1886.

[Sheldon, George William]. *Artistic Country-Seats: Types of Recent American Villa and Cottage Architecture, with Instances of Country Club-Houses.* 2 vols. in 5 pts. New York, 1886.

[Palliser, George, and Charles Palliser]. *Palliser's New Cottage Homes and Details.* New York, 1887.

Stevens, John Calvin, and Albert Winslow Cobb. *Examples of American Domestic Architecture.* New York, 1889.

1890–99

Morris, William. *News from Nowhere, or an Epoch of Rest, Being Some Chapters from a Utopian Romance.* London, 1890.

Schuyler, Montgomery. *American Architecture.* New York, 1892.

Sturgis, Russell, et al. *Homes in City and Country.* New York, 1893.

1900–present

Muthesius, Hermann. *Das Englische Haus.* 3 vols. Berlin, 1904–5.

Mumford, Lewis. *Sticks and Stones.* New York, 1924.

Gray, David. *Thomas Hastings, Architect.* Boston, 1933.

Morrison, Hugh. *Louis Sullivan, Prophet of Modern Architecture.* New York, 1935.

Harbron, Dudley. "Queen Anne Taste and Aestheticism." *Architectural Review* 95 (July 1943), pp. 15–18.

Hitchcock, Henry-Russell. *American Architectural Books: A List of Books, Portfolios, and Pamphlets on Architecture and Related Subjects Published in America Before 1895.* 3d ed. Minneapolis, 1946.

Sturgis, W. K. "The Long Shadow of Norman Shaw: The Queen Anne Revival." *Journal of the Society of Architectural Historians* 9 (1950), pp. 15–20.

Meeks, Carroll V. "Picturesque Eclecticism." *Art Bulletin* 32 (Sept. 1950), pp. 226–35.

Downing, Antoinette, and Vincent J. Scully, Jr. *The Architectural Heritage of Newport, Rhode Island, 1640–1915.* Cambridge, Mass., 1952.

[Michels], Eileen P. Manning. "The Architectural Designs of Harvey Ellis." M.A. thesis, University of Minnesota, 1953.

Scully, Vincent J., Jr. "Romantic Rationalism and the Expression of Structure in Wood: Downing, Wheeler, Gardner, and the 'Stick Style,' 1840–1876." *Art Bulletin* 35 (June 1953), pp. 121–42.

Lancaster, Clay. "Japanese Buildings in the United States Before 1900: Their Influence upon American Domestic Architecture." *Art Bulletin* 35 (Sept. 1953), pp. 217–94.

Meeks, Carroll V. "Creative Eclecticism." *Journal of the Society of Architectural Historians* 12 (Dec. 1953), pp. 15–18.

Omoto, Sadayoshi. "Some Aspects of the So-Called 'Queen Anne' Revival Style of Architecture." Ph.D. diss., Ohio State University, 1954.

Scully, Vincent J., Jr. *The Shingle Style: Architectural Theory and Design from Richardson to*

the Origins of Wright. New Haven, 1955.

Graybill, Samuel H., Jr. "Bruce Price: American Architect, 1845–1903." Ph.D. diss., Yale University, 1957.

Pevsner, Nikolaus. *Pioneers of Modern Design.* Rev. ed. Harmondsworth, Eng., 1960.

Burchard, John, and Albert Bush-Brown. *The Architecture of America.* Boston and Toronto, 1961.

Hitchcock, Henry-Russell. *The Architecture of H. H. Richardson and His Times.* Rev. ed. Hamden, Conn., 1961.

Mast, Alan. "American Architecture and Academic Reform, 1876–1893." M.A. thesis, University of Chicago, 1961.

Gloag, John. *Victorian Taste: Some Aspects of Architecture and Industrial Design from 1820–1900.* London, 1962.

Ferriday, Peter, ed. *Victorian Architecture.* London, 1963.

Peisch, Mark L. *The Chicago School of Architecture.* New York, 1964.

Omoto, Sadayoshi. "The Queen Anne Style and Architectural Criticism." *Journal of the Society of Architectural Historians* 23 (Mar. 1964), pp. 29–37; and [Comment on this article] (Oct. 1964), p. 155.

Collins, George. *Changing Ideals in Modern Architecture, 1750–1950.* London, 1965.

Creese, Walter. *The Search for Environment: The Garden City Before and After.* New Haven and London, 1966.

Bunting, Bainbridge. *Houses of Boston's Back Bay.* Cambridge, Mass., 1967.

Goudy, Marvin E., and Robert Walsh, eds. *The Boston Society of Architects: The First Hundred Years, 1867–1967.* Boston, 1967.

Bernstein, Gerald S. "In Pursuit of the Exotic: Islamic Forms in Nineteenth-Century American Architecture." Ph.D. diss., University of Pennsylvania, 1968.

Champney, Freeman. *Art and Glory: The Story of Elbert Hubbard.* New York, 1968.

Gebhard, David, and Harriette Von Breton. *Architecture in California, 1868–1898.* Santa Barbara, Calif., 1968.

Hitchcock, Henry-Russell. "Ruskin and American Architecture, or Regeneration Long Delayed." In John Summerson, ed. *Concerning Architecture.* London, 1968.

Pevsner, Nikolaus. *Studies in Art, Architecture, and Design.* 2 vols. New York, 1968.

Fogg Art Museum, Harvard University, Cambridge, Mass. *The Architecture of William Ralph Emerson, 1833–1917,* by Cynthia Zaitzevsky. Exhib. cat., 1969.

Lipscomb, Mary Elizabeth. "Harvey Ellis in Rochester." M.A. thesis, University of Rochester, 1969.

Feldman, Arthur M. "Architecture and Architectural Taste at the Philadelphia Centennial, 1876." M.A. thesis, University of Missouri, 1970.

Steegman, John. *Victorian Taste: A Study of the Arts and Architecture from 1830 to 1870.* Cambridge, Mass., 1970.

Michels, Eileen [P.] Manning. "A Developmental Study of the Drawings Published in *American Architect* and in *Inland Architect* Through 1895." Ph.D. diss., University of Minnesota, 1971.

Scully, Vincent J., Jr. *The Shingle Style and the Stick Style: Architectural Theory and Design from Downing to the Origins of Wright.* Rev.

ed. New Haven and London, 1971.

Teitelman, Edward. "Wilson Eyre and the Arts and Crafts in Philadelphia." *Journal of the Society of Architectural Historians* 30 (1971), pp. 245–46.

Brooks, H. Allen. *The Prairie School: Frank Lloyd Wright and His Midwest Contemporaries.* Toronto, 1972.

Eaton, Leonard K. *American Architecture Comes of Age: European Reaction to H. H. Richardson and Louis Sullivan.* Cambridge, Mass., 1972.

Kornwolf, James D. *M. H. Baillie Scott and the Arts and Crafts Movement: Pioneers of Modern Design.* Baltimore and London, 1972.

Goss, Peter L. "An Investigation of Olana, the Home of Frederic Edwin Church, Painter." Ph.D. diss., Ohio University, 1973.

Hoffmann, Donald. *The Architecture of John Wellborn Root.* Baltimore and London, 1973.

Philadelphia Museum of Art. *The Architecture of Frank Furness,* by James F. O'Gorman. Exhib. cat., 1973.

Pearson, Eleanor. [Review of Cynthia Zaitzevsky, *The Architecture of William Ralph Emerson, 1833–1917*]. *Journal of the Society of Architectural Historians* 32 (Oct. 1973), pp. 250–53.

Hines, Thomas S. *Burnham of Chicago: Architect and Planner.* New York, 1974.

Kidney, Walter. *The Architecture of Choice: Eclecticism in America, 1880–1930.* New York, 1974.

Pasadena Center, Calif. *California Design 1910.* Exhib. cat., 1974.

Rhoads, William B. "The Colonial Revival." Ph.D. diss., Princeton University, 1974.

Scully, Vincent J., Jr. *The Shingle Style Today, or the Historian's Revenge.* New York, 1974.

Bicknell, Amos J. *Victorian Architecture: Two Pattern Books by A. J. Bicknell and William Comstock.* Intro. John Maas. Watkins Glen, N.Y., 1975.

Lewis, Arnold, and Keith Morgan, eds. *American Victorian Architecture: A Survey of the Seventies and Eighties in Contemporary Photographs.* New York, 1975.

Bicknell, Amos J. *Bicknell's Village Builder: A Victorian Architectural Guidebook.* Ed. Paul Goeldner. Watkins Glen, N.Y., 1976.

Jordy, William H. *Progressive and Academic Ideals at the Turn of the Twentieth Century.* Vol. 3 of *American Buildings and Their Architects.* Ed. William H. Pierson. New York, 1976.

Saint, Andrew. *Richard Norman Shaw.* New Haven and London, 1976.

Cardwell, Kenneth. *Bernard Maybeck: Artisan, Architect, Artist.* Santa Barbara, Calif., 1977.

Hitchcock, Henry-Russell. *Architecture: Nineteenth and Twentieth Centuries.* 4th ed. Harmondsworth, Eng., 1977.

Makinson, Randell L. *Greene and Greene: Architecture as a Fine Art.* Salt Lake City, Utah, and Santa Barbara, Calif., 1977.

Andrews, Wayne. *Architecture, Ambition, and Americans.* Rev. ed. New York, 1978.

Dixon, Roger, and Stefan Muthesius. *Victorian Architecture.* New York and Toronto, 1978.

Landau, Sarah Bradford. "Edward T. and William A. Potter: American High Victorian Architects, 1855–1901." Ph.D. diss., New York University, 1978.

Roth, Leland M. *The Architecture of McKim, Mead and White, 1870–1920: A Building List.* New York, 1978.

Wright, Gwendolyn. "Making the Model Home: Domestic Architecture and Cultural Conflicts in Chicago, 1873–1913." Ph.D. diss., University of California, Berkeley, 1978.

Dinnerstein, Lois. "Opulence and Ocular Delight, Splendor and Squalor: Critical Writings in Art and Architecture by Mariana Griswold Van Rensselaer." Ph.D. diss., City University of New York, 1979.

Fahlman, Betsy. "The Architecture of Wilson Eyre." Ph.D. diss., University of Delaware, 1979.

Handlin, David P. *The American Home: Architecture and Society, 1815–1915.* Boston and Toronto, 1979.

Muthesius, Hermann. *The English House.* Ed. Dennis Sharp. Trans. Janet Seligman. New York, 1979. [Abridged from 2d ed., Berlin, 1908–11].

Benson, Susan Porter. "Palace of Consumption and Machine for Selling: The American Department Store, 1880–1940." *Radical History Review* 21 (Fall 1979).

Baker, Paul R. *Richard Morris Hunt.* Cambridge, Mass., 1980.

Davey, Peter. *Architecture of the Arts and Crafts Movement.* New York, 1980.

Keebler, Patricia. "The Life and Work of Frank Miles Day." Ph.D. diss., University of Delaware, 1980.

Wright, Gwendolyn. *Moralism and the Model Home: Domestic Architecture and Cultural Conflict in Chicago, 1873–1913.* Chicago, 1980.

Fahlman, Betsy. "Wilson Eyre in Detroit: The Charles Lang Freer House." *Winterthur Portfolio* 15 (Autumn 1980), pp. 257–69.

Teitelman, Edward. "Wilson Eyre in Camden: The Henry Genet Taylor House." *Winterthur Portfolio* 15 (Autumn 1980), pp. 229–55.

University Gallery, University of Delaware, Wilmington. *Architecture and Ornament in Late Nineteenth-Century America,* by Damie Stillman. Exhib. cat., 1981.

Bell Art Gallery, List Art Center, Brown University, Providence, R.I. *Buildings on Paper: Rhode Island Architectural Drawings, 1825–1945,* by William H. Jordy and Christopher Monkhouse. Exhib. cat., 1982.

Cromley, Elizabeth Collin. "The Development of the New York Apartment, 1860–1905." Ph.D. diss., City College of New York, 1982.

Frances, Ellen Elizabeth. "Progressivism and the American House: Architecture as an Agent of Social Reform." M.A. thesis, University of Oregon, 1982.

Macmillan Encyclopedia of Architects. Ed. Adolf K. Placzek. 4 vols. New York, 1982.

Ochsner, Jeffrey Karl. *H. H. Richardson: Complete Architectural Works.* Cambridge, Mass., and London, 1982.

Searing, Helen, ed. *In Search of Modern Architecture: A Tribute to Henry-Russell Hitchcock.* Cambridge, Mass., 1982.

O'Gorman, James F. "Documentation: An 1886 Inventory of H. H. Richardson's Library and Other Gleanings from Probate."

Journal of the Society of Architectural Historians 41 (May 1982), pp. 150–55.

Fahlman, Betsy, and Edward Teitelman. "Wilson Eyre: The Philadelphia Domestic Ideal." *Pennsylvania Heritage* 8 (Summer 1982), pp. 23–27.

Longstreth, Richard W. *On the Edge of the World: Four Architects in San Francisco at the Turn of the Century.* Cambridge, Mass., 1983.

Stamp, Gavin, and Andre Goulancourt. *The English House, 1860–1914: The Flowering of English Architecture.* Chicago, 1986.

Undated

Kornwolf, James D. "Architecture, Environment, and the Arts and Crafts Movement: Sources and Dimensions of the Anglo-American Counterculture." Manuscript, n.d.

CARPETS, EMBROIDERY, TEXTILES, AND WALLPAPERS

1860–69

Stewart, John. "French and English Paper-staining," pts. 1–3. *Art Journal* (London), Jan. 1861, pp. 6–7; Feb. 1861, pp. 55–56; Apr. 1861, pp. 105–6.

"Gothic Wall-Papers." *Art Journal* (London), Nov. 1863, p. 217.

1870–79

"Paperhangings." *Furniture Gazette* 1 (June 7, 1873), p. 166.

"Mirrors and Draperies in America." *Furniture Gazette* 1 (Aug. 11, 1873), pp. 293–94.

"The Royal School of Art Needlework, South Kensington." *Art Journal* (Appleton's) 1 (Oct. 1875), p. 300.

"American Paper-Hangings in England." *Carpet Trade Review* 4 (Feb. 1877), pp. 25–26.

Mason, George C. "Science and Mechanics: Wallpapers, Influence of Their Colors on Health." *Potter's American Monthly* 8 (Mar. 1877), p. 235.

"The New Styles in Wall Decoration." *Carpet Trade Review* 4 (May 1877), p. 68.

Dare, Shirley. "Carpets—and Carpets." *Carpet Trade Review* 4 (June 1877), pp. 76–77.

"Modern Wall-Papers." *Carpet Trade Review* 4 (July 1877), pp. 95–96.

"The Selection of Wall-Papers." *Carpet Trade Review* 4 (Aug. 1877), pp. 102–3.

Lockwood, M. S., and E[lizabeth] Glaister. *Art Embroidery, a Treatise on the Revived Practice of Decorative Needlework.* London, 1878.

"Spring Carpet Styles." *Carpet Trade* 9 (Jan. 1878), pp. 15–19.

"The Wakefield Rattan Company's Mattings." *Carpet Trade Review* 5 (Mar. 1878), p. 32.

Dare, Shirley. "A Lady's Chat about Carpets." *Carpet Trade Review* 5 (Aug. 1878), pp. 92–93.

"Carpet Designs." *Art Interchange* 1 (Dec. 11, 1878), p. 49.

Godon, Julien. *Painted Tapestry and Its Application to Interior Decoration.* London, 1879.

"Color Contrasts in Paper Hangings." *Carpet*

Trade Review 6 (Jan. 1879), p. 15.

"London Letter: Modern Carpets." *Art Interchange* 2 (Mar. 5, 1879), p. 37.

"Wall-Paper." *Carpet Trade Review* 6 (May 1879), pp. 93–94.

"Wall Decorations." *Art Interchange* 3 (July 9, 1879), p. 3.

"Modesty vs. Gaudiness: A Word or Two on Wall-Papers." *Carpet Trade Review* 6 (Aug. 1879), p. 190.

"Etching on Linen." *Art Interchange* 3 (Aug. 6, 1879), p. 37.

"Design in Carpets." *Art Amateur* 1 (Oct. 1879), p. 107.

"Fall Designs in Carpets." *Carpet Trade Review* 6 (Oct. 1879), pp. 225–26.

"Mr. Colman's Art Draperies." *Art Interchange* 3 (Nov. 12, 1879), p. 77.

1880–89

Cook, Clarence. *What Shall We Do with Our Walls?* New York, 1880.

"Art Needlework," pt. 2 [Royal School of Art Needlework]. *Magazine of Art* 3 (1880), pp. 178–82.

Carter, Susan N. "Principles of Decoration, 1: Wallpapers." *Art Journal* (Appleton's) 6 (Jan. 1880), pp. 4–11.

"Our Carpet Mills." *Carpet Trade* 11 (Jan. 1880), pp. 11–13.

"Stamped Wall Leather." *Art Amateur* 2 (Jan. 1880), pp. 36–37.

"The Colman and Tiffany Wallpapers." *Art Amateur* 3 (June 1880), pp. 12–13.

"High Art in England: Jingoism among the Kidderminster Carpet Manufacturers." *Carpet Trade* 11 (June 1880), p. 19.

"Carpets and Floor Coverings." *Carpet Trade Review* 7 (July 1880), pp. 132–33.

"The Principles of Design in Carpets." *Art Amateur* 3 (July 1880), pp. 40–41.

Bobbett, Betsey. "Color Treatment in Carpets." *Carpet Trade Review* 7 (Sept. 1880), p. 177.

"Ceiling and Wall Papers." *Art Amateur* 3 (Sept. 1880), pp. 84–85.

"What Carpets Will Sell." *Carpet Trade Review* 7 (Oct. 1880), pp. 188–89.

"Betsey Bobbett on the New Craze: Make Your Own Rugs." *Carpet Trade Review* 7 (Nov. 1880), pp. 212–13.

"Parisian Fancies." *Carpet Trade Review* 7 (Nov. 1880), p. 223.

"Needlework Screens." *Art Amateur* 4 (Dec. 1880), p. 9.

Harrison, Constance Cary. *Woman's Handiwork in Modern Homes.* New York, 1881.

"Natural Forms in Wall Paper Designs." *Carpentry and Building* 3 (Jan. 1881), p. 12.

"Carpet Designers and Their Obstacles." *Carpet Trade Review* 8 (Feb. 1881), p. 23.

"Covering the Floor." *Carpentry and Building* 3 (Apr. 1881), pp. 63–65.

Humphreys, Mary Gay. "Oriental Embroidery." *Art Amateur* 4 (Apr. 1881), pp. 100–101.

[Oakey, Alexander F.]. "Art Embroidery." *Harper's New Monthly Magazine* 62 (Apr. 1881), pp. 693–99.

Humphreys, Mary Gay. "Mrs. Holmes's Art-Embroideries." *Art Amateur* 4 (May 1881), p. 127.

"Two Useful Novelties." *Art Amateur* 4 (May 1881), p. 125.

"Carpet Designing in America." *Art Amateur* 5 (June 1881), pp. 11–12.

"Draperies of the Union League Club." *Art Amateur* 5 (June 1881), p. 17.

"Home Studies in Color." *Carpet Trade* 12 (June 1881), pp. 23–25.

"Domestic Designing: A Woman's Views on Native and Foreign Carpet Patterns." *Carpet Trade* 12 (July 1881), pp. 13–14.

"Art as Applied to Carpets." *Carpet Trade Review* 8 (Aug. 1881), p. 158.

"Carpet Designing in America." *Carpet Trade Review* 8 (Sept. 1881), p. 164.

Harrison, Constance Cary. "Needlework Novelties." *Art Amateur* 5 (Oct. 1881), p. 108.

Humphreys, Mary Gay. "Ceiling-Paper Designs." *Art Amateur* 5 (Oct. 1881), pp. 106–7.

———. "The Progress in Wallpapers." *Art Amateur* 5 (Oct. 1881), p. 107.

"A Suggestive Exhibition of Designs." *Art Amateur* 5 (Nov. 1881), p. 112.

"The Use of Paper for Ceiling Decorations." *Carpentry and Building* 3 (Nov. 1881), pp. 208–9.

"Wall Paper." *Carpet Trade Review* 8 (Nov. 1, 1881), pp. 202–7.

Church, Ella Rodman. *The Home Needle.* New York, 1882.

Humphreys, Mary Gay. "Novelties in Mantel Lambrequins." *Art Amateur* 6 (Jan. 1882), p. 41.

"Upholstery Department: Lincrusta-Walton." *Carpet Trade Review* 9 (Jan. 1882), p. 49.

"Art Embroidery Materials." *Art Amateur* 6 (Feb. 1882), pp. 66–67.

"Artistic Needlework in New York." *Art Amateur* 6 (Feb. 1882), p. 61.

Cory, Florence [E.]. "Applying Designs to Fabrics." *Art Amateur* 6 (Feb. 1882), p. 66.

"Embossed Wall Decorations." *Art Amateur* 6 (Feb. 1882), pp. 66–67.

Harrison, Constance Cary. "Embroidery for Bedrooms," pts. 1–3. *Art Amateur* 6 (Feb. 1882), pp. 60–61; (Mar. 1882), p. 88; (Apr. 1882), p. 110.

"A New Drapery and Carpet Fabric." *Art Amateur* 6 (Feb. 1882), p. 66.

"New Materials for Wall Decoration." *Century Illustrated Monthly Magazine* 1 (Feb. 1882), p. 646.

"The Rage for Portieres." *Carpet Trade Review* 9 (Feb. 1882), p. 57.

"Home Art and Home Comfort: Wallpapers." *Demorest's Monthly Magazine* 17 (Mar. 1882), pp. 282–83.

Cory, Florence E. "Practical Carpet Designing," pts. 1, 2. *Carpet Trade Review* 9 (Apr. 1882), pp. 57–59; (May 1882), pp. 57–60.

Humphreys, Mary Gay. "Instruction in Carpet Designing." *Art Amateur* 6 (Apr. 1882), p. 100.

"Aestheticism in Carpets." *Carpet Trade* 13 (May 1882), pp. 27–28.

Harrison, Constance Cary. "Needlework Suggestions." *Art Amateur* 6 (May 1882), p. 130.

Humphreys, Mary Gay. "Watering-Place Needlework." *Art Amateur* 7 (Aug. 1882), p. 62.

Harrison, Constance Cary. "Needlework Novelties." *Art Amateur* 7 (Sept. 1882), p. 86.

"'Crazy' Quilts." *Art Amateur* 7 (Oct. 1882), p. 108.

"Old South Kensington Designs." *Art Amateur* 7 (Nov. 1882), p. 129.

"Flowers in Embroidery." *Art Amateur* 8 (Dec. 1882), p. 23.

"La Farge Embroideries." *Art Amateur* 8 (Jan. 1883), p. 49.

Weaver, Jane. "Kensington-Stitch for Outline Embroidery." *Peterson's Magazine* 83 (Jan. 1883), p. 87.

Wright, Margaret Bertha. "Economy in Carpets, Screens, and Curtains." *Art Amateur* 8 (Jan. 1883), pp. 44–45.

———. "London Needlework Novelties." *Art Amateur* 8 (Jan. 1883), p. 49.

Harrison, Constance Cary. "Needlework Novelties." *Art Amateur* 8 (Feb. 1883), p. 73.

Humphreys, Mary Gay. "Portiere Embroideries." *Art Amateur* 8 (Apr. 1883), p. 117.

"Lincrusta Walton: The New Wall Decoration." *Art Amateur* 8 (May 1883), p. v.

"Wall-Paper Patterns." *Decorator and Furnisher* 2 (May 1883), p. 74.

"William Morris on Woman's Dress." *Art Amateur* 8 (May 1883), p. 143.

"Lincrusta Walton: The New Wall Decoration." *Art Amateur* 9 (June 1883), pp. 14–15.

"Art Needlework in England." *Art Amateur* 9 (July 1883), p. 43.

"The Vanderbilt Tapestries." *Carpet Trade and Review* 14 (July 1, 1883), p. 57.

"Carpets and Carpet Designing." *Carpet Trade Review* 14 (Aug. 1883), pp. 25–29.

Humphreys, Mary Gay. "Embroidery for Bedrooms." *Art Amateur* 9 (Sept. 1883), p. 87.

"Wallpaper Designed by Walter Crane." *Art Amateur* 9 (Nov. 1883), p. 125.

"The Crazy Quilt Mania." *Carpet Trade and Review* 14 (Nov. 15, 1883), p. 43.

"A Matter of Taste: Curiosities in Modern Carpet Design." *Carpet Trade and Review* 15 (Feb. 15, 1884), pp. 39–40.

Arachne [pseud.]. "Propriety in Needlework Decoration." *Art Amateur* 10 (Mar. 1884), pp. 90–91.

"The Decoration of Lincrusta." *Art Amateur* 10 (May 1884), pp. 140–41.

Humphreys, Mary Gay. "The Royal School of Art Needlework." *Art Amateur* 11 (Sept. 1884), pp. 88–89.

"American Taste in Upholstery." *Carpet Trade and Review* 15 (Dec. 1884), pp. 43–44.

"Dr. Dresser on Carpet Designs." *Carpet Trade and Review* 16 (Jan. 15, 1885), pp. 33–34.

"Exhibition of Crazy Quilts." *Carpet Trade and Review* 16 (Apr. 1885), p. 41.

"Design Patent Litigation." *Carpet Trade and Review* 16 (June 1, 1885), p. 39.

Higgin, L. "The Art of Embroidery." *Art Amateur* 13 (July 1885), p. 37.

"Suggestions for Portieres." *Carpet Trade and Review* 16 (July 15, 1885), pp. 37–38.

"A New Improved (Washable) Wall Paper." *Decorator and Furnisher* 6 (Aug. 1885), p. 142.

"Wall Paper Manufacturers and the Painting Trade." *Decorator and Furnisher* 6 (Aug. 1885), p. 134.

"Peculiar Carpet Patterns." *Carpet Trade and Review* 16 (Sept. 1, 1885), pp. 33–34.

"Curtain Hanging." *Decorator and Furnisher* 7

(Dec. 1885), p. 93.

"The Craziest Show on Earth." *Carpet Trade and Review* 16 (Dec. 15, 1885), p. 34.

Alford, M[arianne M.]. *Needlework as Art.* London, 1886.

Koehler, S[ylvester] R[osa]. "American Embroideries." *Magazine of Art* 9 (1886), pp. 209–13.

Higgin, L. "The Revival of Decorative Needlework," pts. 1, 2. *Art Journal* (London), Apr. 1886, pp. 121–25; May 1886, pp. 139–44.

"The Best Ideas in Other Papers: Wall Paper Should Be Tried Before Purchase." *Art Age* 4 (Oct. 1886), p. 33.

"Women as Carpet Buyers." *Carpet Trade Review* 17 (Nov. 15, 1886), p. 30.

"New Embroideries." *Art Amateur* 16 (Jan. 1887), p. 45.

"Decorative Panel Borrowed from Old Persian Tiles; also a Suitable Motive for Appliqué Embroidery." *Art Amateur* 16 (Feb. 1887), p. 64.

"Nature in Industrial Design: A Practical Designer's Advice to Young Artists—the Test of Fitness in Designs for Carpets, Upholstery Goods, Etc." *Carpet Trade and Review* 18 (Aug. 15, 1887), pp. 36–37.

"Household Ornaments and Minor Decoration: Less Expensive Curtains." *Art Age* 6 (Nov. 1887), p. 62.

Humphreys, Mary Gay. "Embroidery in America, 2: Mrs. Wheeler Tells How One May Become an Artist with the Needle." *Art Amateur* 18 (Feb. 1888), pp. 71–72.

——. "Embroidery in America, 5: The Value of Buttonhole Stitch and the Use of Flax Threads." *Art Amateur* 18 (May 1888), p. 147.

"Pa Crusta." *Carpentry and Building* 10 (May 1888), pp. 110–11.

"Decorative Treatment of Walls." *Carpentry and Building* 10 (Oct. 1888), p. 217.

"Best Effects in Wall Paper." *Carpentry and Building* 10 (Dec. 1888), p. 263.

"Embroidered Screens." *Art Amateur* 21 (June 1889), pp. 21–22.

Riordan, Roger. "The Arrangement of Curtains." *Art Amateur* 21 (Sept. 1889), pp. 82–83.

1890–99

Morrell, B. deM. "Art Needlework: Appliqué Work." *Art Amateur* 23 (July 1890), p. 35.

Bruce, Mrs. Barnes. "Art Needlework Fern Design for Table Linen." *Art Amateur* 23 (Nov. 1890), p. 125.

"New Wall Papers." *Carpet Trade and Upholstery Review* 24 (Feb. 15, 1893), pp. 59–60.

"Art in Wall Paper." *Interior Decorator* 4 (May 1893), p. 30.

"Lincrusta Walton." *Interior Decorator* 4 (May 1893), p. 29.

"Novelties in Wall Paper." *Interior Decorator* 4 (May 1893), p. 29.

"Wallpaper at the World's Fair." *Interior Decorator* 4 (May 1893), p. 30.

Parsons, Frederick. "Fine Modern Wall Papers." *Interior Decorator* 4 (Aug. 1893), pp. 205–7.

Holahan, C. M. "Styles in Wall Covering." *Interior Decorator* 4 (Sept. 1893), pp. 254–56.

Johnson, H. M. "Draperies, Rugs, and Car-

pets." *Interior Decorator* 4 (Oct. 1893), pp. 300–302.

"Ceiling, Side Wall, and Frieze," pts. 1–3. *Interior Decorator* 5 (Dec. 1893), p. 71; (Feb. 1894), pp. 173–74; (Apr. 1894), pp. 257–58.

"The Passing of the Carpet." *Interior Decorator* 5 (Feb. 1894), pp. 173–74.

"Japanese Wall Coverings." *Interior Decorator* 5 (Apr. 1894), p. 244.

History and Manufacture of Floor Coverings. New York, 1899.

1900–present

Day, Lewis F., and Mary Buckle. *Art in Needlework: A Book about Embroidery.* London, 1900.

Wheeler, Candace. *How to Make Rugs.* New York, 1902.

——. *The Development of Embroidery in America.* New York and London, 1921.

McClelland, Nancy. *Historic Wall-Papers: From Their Inception to the Introduction of Machinery.* Philadelphia and London, 1924.

Sugden, Alan Victor, and John Ludlam Edmondson. *A History of English Wallpaper, 1509–1914.* London and New York, 1926.

Harbeson, Georgiana Brown. *American Needlework.* New York, 1938.

Floud, Peter. "The Wallpaper Designs of William Morris." *Penrose Annual* 54 (1960), pp. 41–45.

Morris, Barbara. *Victorian Embroidery.* New York, 1962.

Melvin, Andrew. *William Morris: Wallpapers and Designs.* London, 1971.

Clark, Fiona. *William Morris: Wallpapers and Chintzes.* New York and London, 1973.

Greysmith, Brenda. *Wallpaper.* New York, 1976.

Rosenstiel, Helene von. *American Rugs and Carpets: From the Seventeenth Century to Modern Times.* New York, 1978.

Frangiamore, Catherine Lynn. *Wallpapers in Historic Preservation.* New York, 1979.

Geijer, Agnes. *A History of Textile Art.* London, 1979.

Wilson, Kax. *A History of Textiles.* Boulder, Colo., 1979.

Lynn, Catherine. *Wallpaper in America: From the Seventeenth Century to World War I.* New York, 1980.

Symondson, Anthony. "Wallpapers from Watts and Company." *Connoisseur* 204 (June 1980), pp. 114–21.

Birmingham Museums and Art Gallery, Eng. *Textiles by William Morris and Morris and Co., 1861–1940,* by Oliver Fairclough and Emmeline Leary. Exhib. cat., 1981.

McColgan, Denise. "Naturalism in the Wallpaper Designs of William Morris." *Arts Magazine* 56 (Sept. 1981), pp. 142–59.

Oman, Charles C., and Jean [D.] Hamilton. *Wallpapers: A History and Illustrated Catalogue of the Collection of the Victoria and Albert Museum.* London, 1982.

Teynac, Françoise, Pierre Nolot, and Jean-Denis Vivien. *Wallpaper: A History.* New York, 1982.

Nylander, Richard C. "Elegant Late Nineteenth Century Wallpapers." *Antiques* 122 (Aug. 1982), pp. 284–87.

——. "1870 to 1910: Stylized Designs for the Late Victorian Era." In *Wallpapers for*

Historic Buildings. Washington, D.C., 1983.

Parry, Linda. *William Morris Textiles.* New York, 1983.

McMorris, Penny. *Crazy Quilts.* New York, 1984.

Nylander, Richard C., Elizabeth Redmond, and Penny J. Sander. *Wallpaper in New England.* Boston, 1986.

CERAMICS AND GLASS

1840–49

Pellatt, Apsley. *Curiosities of Glass-Making.* London, 1849.

1860–69

W. C. "Modern Enamel Mosaics and the Reproduction of Venetian Glass in the Nineteenth Century." *Art Journal* (London), Aug. 1866, p. 257.

Marryat, Joseph. *A History of Pottery and Porcelain, Medieval and Modern.* London, 1868.

"The Slade Collection of Ancient Glass." *Art Journal* (London), Nov. 1868, p. 248.

1870–79

Hand Book for the Use of Visitors Examining Pottery and Porcelain in the Metropolitan Museum of Art. New York, 1875.

"Tileries." *Crockery Journal* 1 (Apr. 3, 1875), p. 3.

"Tiles for Mural Decoration." *Crockery Journal* 1 (May 6, 1875), p. 15.

"Some Examples of Ceramic Art." *Art Journal* (Appleton's) 1 (Sept. 1875), pp. 273–75.

"The China Mania." *Crockery and Glass Journal* 2 (Dec. 9, 1875), p. 29.

"Venetian Glass." *Art Journal* (London), Dec. 1876, pp. 376–77.

Beckwith, Arthur. *Majolica and Faience: Italian, Sicilian, Majorcan, Hispano-Moresque, and Persian.* New York, 1877.

Designs and Instructions for Decorating Pottery in Imitation of Greek, Roman, Egyptian, and Other Styles of Vases. Boston, 1877.

Jacquemart, Albert. *History of the Ceramic Art: A Descriptive and Philosophical Study of the Pottery of All Ages and All Nations.* Trans. Mrs. Bury Palliser. London, 1877.

Elliott, Charles Wyllys. "How to Decorate Pottery and Porcelain." *Art Journal* (Appleton's) 3 (Oct. 1877), pp. 305–9.

——. *Pottery and Porcelain, from Early Times down to the Philadelphia Exhibition of 1876.* New York, 1878.

Jewitt, Llewellynn. *Ceramic Art of Great Britain.* 2 vols. London, 1878.

Nichols, George Ward. *Pottery: How It Is Made, Its Shape and Decoration, Practical Instructions for Painting on Porcelain and All Kinds of Pottery with Vitrifiable and Common Oil Colors.* New York, 1878.

Piton, Camille. *A Practical Treatise on China Painting in America.* New York, 1878.

Prime, William C. *Pottery and Porcelain of All Times and Nations.* New York, 1878.

Sparkes, John C. L. *A Hand-Book to the Practice of Pottery Painting.* New York, 1878.

"Tiles and Tiling." *Crockery and Glass Journal* 7 (June 27, 1878), pp. 21–22.

"Tiles in Furnishings." *Crockery and Glass Jour-

nal 8 (July 18, 1878), p. 14.

"Tiles and Tiling: Their General History." *Art Interchange* 1 (Oct. 16, 1878), p. 21.

"Uses of Tiles." *Crockery and Glass Journal* 8 (Dec. 12, 1878), p. 5.

Young, Jennie J. *The Ceramic Art: A Compendium of the History and Manufacture of Pottery and Porcelain.* New York, 1879.

"Tile Manufacture." *Crockery and Glass Journal* 9 (Jan. 9, 1879), p. 12.

"The Blue China Rage." *Crockery and Glass Journal* 9 (June 26, 1879), p. 12.

"American Faience." *Crockery and Glass Journal* 10 (Sept. 4, 1879), p. 12.

"China Collecting." *Crockery and Glass Journal* 10 (Oct. 30, 1879), p. 19.

"Encaustic and Other Tiles." *Crockery and Glass Journal* 10 (Nov. 13, 1879), p. 12.

Carter, Susan [N.]. "Art Pottery Studios in London." *Art Journal* (Appleton's) 5 (Dec. 1879), pp. 378–79.

Curio. "Artistic Decorative Pottery." *Art Amateur* 2 (Dec. 1879), pp. 16–17.

"Modern Decorative Glassware." *Art Amateur* 2 (Dec. 1879), pp. 12–13.

1880–89

McLaughlin, M. Louise. *Pottery Decoration under the Glaze.* Cincinnati, 1880.

Tyndale, Hector. "Pottery, Porcelains, Bricks, Clays, Cements, and Their Materials, Etc." In "General Report of the Judges of Group 2." In U.S. Centennial Commission. *International Exhibition, 1876: Reports and Awards.* 9 vols. Washington, D.C., 1880, vol. 3, pp. 492–507.

Vago, A. L. *Instructions in the Art of Modeling in Clay,* published with *An Appendix on Modeling Foliage, Etc.,* by Benn Pitman. Cincinnati, 1880.

Piton, Camille. "Ceramic Clays in the United States." *Art Amateur* 2 (Mar. 1880), p. 78.

"Hints to China Collectors." *Art Amateur* 2 (May 1880), pp. 123–24.

"Original Designs for Art Manufactures." *Art Journal* (Appleton's) 6 (May 1880), pp. 177–80.

"Cincinnati Art Pottery." *Harper's Weekly* 24 (May 29, 1880), pp. 341–42.

"Artistic Stoneware." *Art Amateur* 3 (Sept. 1880), p. 75.

"American Tiles in England." *Crockery and Glass Journal* 12 (Sept. 23, 1880), p. 22.

"Decorative Pottery of Cincinnati." *Harper's New Monthly Magazine* 62 (May 1881), pp. 834–45.

"Tiles in Furniture." *Crockery and Glass Journal* 13 (June 9, 1881), p. 10.

"Tiles in Mural Decoration." *Crockery and Glass Journal* 14 (Sept. 29, 1881), p. 34.

"Tiles for Cabinets." *Art Amateur* 6 (Dec. 1881), p. 19.

Wheatley, Henry. *Art Work in Earthenware.* New York, 1882.

Jarves, James Jackson. "Ancient and Modern Venetian Glass of Murano." *Harper's New Monthly Magazine* 64 (Jan. 1882), pp. 177–90.

"Greek Painted Vases." *Art Amateur* 6 (Mar. 1882), pp. 82–83.

Millet, Frank D. "Some American Tiles." *Century Illustrated Monthly Magazine* 23 (Apr. 1882), pp. 896–904.

Armstrong, Walter. "The Year's Advance in

Art Manufactures, 6: Stoneware, Fayence, Etc. [and] 7: Porcelain." *Art Journal* (London), July 1883, pp. 221–23.

"Tiles." *Crockery and Glass Journal* 18 (Dec. 13, 1883), p. 23.

Humphreys, Mary Gay. "Cincinnati Pottery at the Bartholdi Exhibition." *Art Amateur* 10 (Feb. 1884), pp. 69–70.

"Tiles Historically Considered," pts. 1–4. *Decorator and Furnisher* 5 (Feb. 1885), p. 162; (Mar. 1885), pp. 213–14; 6 (Apr. 1885), p. 6; (May 1885), pp. 51–52.

Leland, Charles G. "Home Arts, 5: Modelling in Clay." *Art Journal* (London), May 1886, pp. 230–33.

N. S. S. "China and Porcelain." *Decorator and Furnisher* 8 (Aug. 1886), p. 136.

Gaskin, H. C. "Practical Lessons in China-Painting," pts. 1–8. *Art Amateur* 16 (Jan. 1887), p. 42; (Feb. 1887), p. 66; (Mar. 1887), p. 92; (Apr. 1887), pp. 116–17; (May 1887), p. 141; 17 (June 1887), pp. 19–20; (July 1887), pp. 44–45; (Aug. 1887), pp. 65–66.

Cook, Clarence. "The Exhibition of American Pottery and Porcelain." *Art Amateur* 20 (Dec. 1888), pp. 5–6.

"Painting on China." In John Q. Reed and Eliza Lavin. *Needle and Brush: Useful and Decorative.* New York, 1889.

1890–99

Earle, Alice Morse. *China Collecting in America.* New York, 1892.

Barber, Edwin AtLee. "Recent Advances in the Pottery Industry." *Popular Science Monthly* 40 (Jan. 1892), pp. 289–322.

———. *The Pottery and Porcelain of the United States: An Historical Review of American Ceramic Art from the Earliest Times to the Present Day.* New York, 1893.

"Glass and Ceramics at the Chicago Exhibition." *Art Journal* (London), 1893 supplement, pp. xxix–xxxii.

Smith, C. Philip. "The Art of China Decoration," pts. 1, 2. *Interior Decorator* 4 (May 1893), pp. 24–25; (June 1893), pp. 84–85.

1900–present

Jervis, William P., ed. *The Encyclopedia of Ceramics.* New York, 1902.

Barber, Edwin AtLee. *Marks of American Potters.* Philadelphia, 1904.

Jervis, William P. *A Pottery Primer.* Oyster Bay, N.Y., 1911.

Pennsylvania Museum, Philadelphia. *Exhibition of Tiles.* Exhib. cat., 1915.

Ramsey, John. *American Potters and Pottery.* Boston, 1939.

McKearin, George S., and Helen McKearin. *American Glass.* New York, 1941.

Townsend, Everett. "Development of the Tile Industry in the United States." *Bulletin of the American Ceramic Society* 22 (May 15, 1943), pp. 126–52.

Lee, Ruth Webb. *Victorian Glass: Specialities of the Nineteenth Century.* Northboro, Mass., 1944.

Watkins, Lura Woodside. *Early New England Potters and Their Wares.* Cambridge, Mass., 1950.

Perkins, Dorothy Wilson. "Education in Ceramic Art in the United States." Ph.D. diss., Ohio State University, 1956.

Wires, E. Stanley. "Decorative Tiles: Their Contribution to Architecture and Ceramic Art," pts. 1–4. *New England Architect and Builder, Illustrated* 2 (Jan. 1960), pp. 12–22; (Feb. 1960), pp. 9–18; (Mar. 1960), pp. 15–26; (Apr. 1960), pp. 21–31.

Godden, Geoffrey A. *Victorian Porcelain.* London, 1961.

Wakefield, Hugh. *Victorian Pottery.* New York, 1962.

Revi, Albert Christian. *American Pressed Glass and Figure Bottles.* New York, 1964.

———. *Nineteenth Century Glass: Its Genesis and Development.* Rev. ed. Exton, Pa., 1967.

Hillier, Bevis. *The Social History of the Decorative Arts: Pottery and Porcelain, 1700–1914.* New York, 1968.

Wires, E. Stanley. "How Tiles Have Interpreted Aesop's Great Fables." *Antiques Journal* 25 (May 1970), pp. 10–12, 31.

New Jersey State Museum, Trenton. *An Exhibition of Pottery and Porcelain Made by Ott and Brewer at Etruria Works in Trenton, New Jersey, 1871–1892.* Exhib. cat., 1971.

Barnard, Julian. *Victorian Ceramic Tiles.* Greenwich, Conn., 1972.

Purviance, Evan, and Louise Purviance. *Zanesville Art Tile in Color.* Des Moines, Iowa, 1972.

Trapp, Kenneth R. "The Women's Ceramic Movement in Cincinnati, 1873–1880: Prelude to Rookwood Pottery." In "Maria Longworth Storer: A Study of Her Bronze Objets d'Art in the Cincinnati Art Museum." M.A. thesis, Tulane University, 1972.

Wilson, Kenneth M. *New England Glass and Glassmaking.* New York and Toronto, 1972.

Wires, E. Stanley, Norris F. Schneider, and Moses Mesre. *Zanesville Decorative Tiles.* Zanesville, Ohio, 1972.

Wakefield, Hugh. "Venetian Influence on British Glass in the Nineteenth Century." In *Annales du Cinquième Congrès International d'Etude Historique du Verre.* Liege, 1972, pp. 293–97.

Evans, Paul. "Cincinnati Faience: An Overall Perspective." *Spinning Wheel* 28 (Sept. 1972), pp. 16–18.

Brunsman, Sue. "The European Origins of Cincinnati Art Pottery, 1870–1900." M.A. thesis, University of Cincinnati, 1973.

Evans, Paul. *Art Pottery of the United States: An Encyclopedia of Producers and Their Marks.* New York, 1974.

Haslam, Malcolm. *English Art Pottery, 1865–1915.* Woodbridge, Eng., 1975.

Polak, Ada. *Glass: Its Tradition and Its Makers.* New York, 1975.

Innes, Lowell. *Pittsburgh Glass, 1797–1891: A History and Guide for Collectors.* Boston, 1976.

Wills, Geoffrey. *Victorian Glass.* London, 1976.

Stradling, J. G. "American Ceramics and the Philadelphia Centennial." *Antiques* 110 (July 1976), pp. 146–58.

Morse, Barbara White. "Art Tiles." *American Antiques* 5 (Nov. 1977), pp. 24–29.

Morris, Barbara. *Victorian Table Glass and Ornaments.* London, 1978.

Messenger, Michael. "Revival of a Medieval Technique: Encaustic Tiles of the Nine-

teenth Century." *Country Life* 163 (Jan. 26, 1978), pp. 214–15.

Clark, Garth. *A Century of Ceramics in the United States, 1878–1978: A Study of Its Development*. New York, 1979.

Darling, Sharon S. *Chicago Ceramics and Glass*. Chicago, 1979.

Lockett, Terrence A. *Collecting Victorian Tiles*. Woodbridge, Eng., 1979.

Tait, Hugh. *The Golden Age of Venetian Glass*. London, 1979.

William Benton Museum of Art, University of Connecticut, Storrs. *American Decorative Tiles, 1870–1930*, by Thomas P. Bruhn. Exhib. cat., 1979.

Austwick, Jill, and Brian Austwick. *The Decorated Tile: An Illustrated History of English Tile-making and Design*. London, 1980.

Stillinger, Elizabeth. "Old China: History and Art, Hearth and Home." In *The Antiquers: The Lives and Careers, the Deals, the Finds, the Collections of the Men and Women Who Were Responsible for the Changing Taste in American Antiques, 1850–1930*. New York, 1980.

Manley, Cyril. *Decorative Victorian Glass*. New York, 1981.

Rebert, M. Charles. *American Majolica, 1850–1900*. Des Moines, Iowa, 1981.

Spillman, Jane Shadel. *American and European Pressed Glass in the Corning Museum of Glass*. Corning, N.Y., 1981.

Van Lemmen, Hans. *Victorian Tiles*. Aylesbury, Eng., 1981.

Trapp, Kenneth R. "Rookwood and the Japanese Mania in Cincinnati." *Cincinnati Historical Society Bulletin* 39 (Spring 1981), pp. 51–75.

Wakefield, Hugh. *Nineteenth Century British Glass*. Rev. ed. London, 1982.

Morse, Barbara White. "High Majolica Tiles of the United States Encaustic Tile Works." *Spinning Wheel* 38 (Mar.–Apr. 1982), pp. 40–45.

Barlow, Raymond E., and Joan E. Kaiser. *The Glass Industry in Sandwich*. Vol. 4. Windham, N.H., 1983.

Kimbell Art Museum, Fort Worth. *Wealth of the Ancient World: The Nelson Bunker Hunt and William Herbert Hunt Collections*, by Margaret Ellen Mayo. Exhib. cat., 1983.

Archer, Michael. "Pictures by Potters." *Album* 2 (1983), pp. 100–107.

Charleston, Robert J. *English Glass and the Glass Used in England, circa 400–1940*. London, 1984.

Undated

Whiteford, Sidney T. *A Guide to Porcelain Painting*. London, n.d.

FURNITURE

1860–69

"The Fashion of Furniture." *Cornhill Magazine* 9 (1864), pp. 337–49.

Talbert, B[ruce] J. *Gothic Forms Applied to Furniture, Metal Work, and Decoration for Domestic Purposes*. Birmingham, Eng., 1867.

1870–79

"English Furniture at International Exhibitions: A Retrospect, 1851–1873." *Furniture Gazette* 1 (Apr. 26, 1873), p. 40.

"The Furniture Trade of Cincinnati, U.S.A." *Furniture Gazette* 1 (June 14, 1873), p. 153.

"Art and Furniture." *Furniture Gazette* 1 (July 12, 1873), p. 211.

A Furniture Manufacturer Who Is His Own Designer. "Architects' Furniture." *Furniture Gazette* 1 (July 12, 1873), p. 218.

"Harmonizing Colour and Design in Furniture." *Furniture Gazette* 1 (Aug. 2, 1873), pp. 260–61.

Pocock, Edward. "Editorial: Cheap Artistic Furniture." *Furniture Gazette* 1 (Aug. 2, 1873), p. 263.

"Cheap Artistic Decoration for Deal and Pine Furniture," pts. 1–3. *Furniture Gazette* 1 (Aug. 23, 1873), p. 312; (Sept. 13, 1873), p. 360; (Oct. 4, 1873), p. 408.

"Decoration with Gold and Gild." *Furniture Gazette* 1 (Aug. 23, 1873), p. 312.

"Picture Panels and Decorations for Artistic Furniture." *Furniture Gazette* 1 (Aug. 23, 1873), pp. 307–8.

"Cabinets." *Furniture Gazette* 1 (Oct. 4, 1873), p. 408.

"Beauty in Household Furniture and Decoration." *Furniture Gazette* 1 (Oct. 18, 1873), pp. 437–38.

"Designs for Furniture, No. 9: A Toilet Table and Washstand." *Furniture Gazette* 1 (Oct. 18, 1873), p. 441.

"Furniture Exhibitions: The Cincinnati 'Fair.'" *Furniture Gazette* 1 (Oct. 25, 1873), p. 486.

One of the Public. "Correspondence: Curved Lines Versus Right Angles in the Construction of Furniture." *Furniture Gazette* 1 (Oct. 25, 1873), p. 458.

"Original Designs for Furniture, No. 1: Hall Tables." *Furniture Gazette* 1 (Dec. 6, 1873), p. 570.

"Concerning Furniture." *Scribner's Monthly* 11 (Nov. 1875–Apr. 1876), Scribner's Miscellany [bound in at back], pp. 9 10.

Pollen, John Hungerford. *Ancient and Modern Furniture and Woodwork*. New York, 1876.

Art Furniture, from Designs by E. W. Godwin, F.S.A., and Others, with Hints and Suggestions on Domestic Furniture and Decoration, by William Watt. . . . London, 1877.

"Women as Wood-Carvers: The Movement in Cincinnati." *American Architect and Building News* 2 (Mar. 31, 1877), pp. 100–101.

Spofford, Harriet Prescott. *Art Decoration Applied to Furniture*. New York, 1878.

Griesemer, F. A. "The Chair, Ancient and Modern." *Potter's American Monthly* 11 (Aug. 1878), pp. 142–47.

Wilson, James Grant. "About Bric-a-Brac." *Art Journal* (Appleton's) 4 (Oct. 1878), pp. 313–15.

"A Chapter on Screens." *Art Interchange* 1 (Nov. 27, 1878), p. 41.

"London Letter: Modern Furniture." *Art Interchange* 2 (Feb. 5, 1879), p. 21.

"Wood Carving: Women's Art Museum." *Art Interchange* 2 (Feb. 5, 1879), p. 19.

"Bed Furniture, Ancient and Modern." *Art Interchange* 2 (Mar. 19, 1879), p. 41.

[Patchin], Calista Halsey. "Woodcarving for Women." *Art Amateur* 1 (June 1879), p. 17.

"Cincinnati Schools of Design." *Art Interchange* 2 (June 25, 1879), pp. 102–3.

"Art in Piano Manufacture." *Art Amateur* 1 (Oct. 1879), p. 107.

1880–89

"Overmantels." *Art Amateur* 2 (Apr. 1880), pp. 104–5.

"Eastlake and His Ideas," pts. 1, 2. *Art Amateur* 2 (May 1880), pp. 126–27; 3 (June 1880), pp. 14–15.

"Reform in Grand Pianos." *Art Amateur* 3 (July 1880), p. 36.

"Reform in Piano Shapes." *Art Amateur* 3 (Aug. 1880), p. 62.

"A Superb Japanese Lacquer Screen." *Art Amateur* 3 (Sept. 1880), p. 81.

"Antique Sideboards, Sofas, and Tables." *Carpentry and Building* 3 (Mar. 1881), p. 53.

"Folding Screens." *Demorest's Monthly Magazine* 18 (Nov. 1881), p. 41.

"Decorative Painting for Furniture." *Art Amateur* 6 (Dec. 1881), p. 19.

Patchin, Calista Halsey. "Wood-carving by Women in the Cincinnati School of Design." *Art Amateur* 6 (Dec. 1881), p. 17.

"Tiles for Cabinets." *Art Amateur* 6 (Dec. 1881), p. 19.

"Correct Principles in Furniture." *Art Amateur* 6 (Jan. 1882), pp. 37–38.

"Carved Decoration." *Carpentry and Building* 4 (May 1882), pp. 81–83.

"Taste in Furniture." *Art Amateur* 7 (Aug. 1882), pp. 60–61.

Bond, A. Curtis. "American Art Furniture." In *Catalogue of the Art Department of the New England Manufacturers' and Mechanics' Institute*. Boston, 1883.

"Artistic Pianofortes." *Art Amateur* 8 (Jan. 1883), pp. 46–47.

Preston, R. B. "Modern Houses: Their Style and Decoration." *Decorator and Furnisher* 1 (Jan. 1883), pp. 111–12.

"Bric-a-Brac Mantle [*sic*] for Mr. Campbell, Ironton." *American Architect and Building News* 13 (Feb. 10, 1883), p. 372.

Penn, Arthur. "Concerning Bookcases." *Art Amateur* 8 (Apr. 1883), pp. 115–16.

"Dr. Dresser on Furniture." *Art Amateur* 9 (July 1883), pp. 38–40.

Thomson, James. "Ancient and Modern Furniture . . . , 2: The Design." *Decorator and Furnisher* 3 (Jan. 1884), p. 130.

Robinson, G. T. "Cabinet-Makers' Art: Domestic Furniture." *Art Journal* (London), Dec. 1884, pp. 373–76.

"Ornate Cabinet Work." *Art Amateur* 13 (July 1885), p. 34.

Church, Ella Rodman. "What to Do with a Country House." *Decorator and Furnisher* 7 (Dec. 1885), p. 73.

[Bamboo furniture]. *Decorator and Furnisher* 9 (Dec. 1886), pp. 107–8.

"The Bed." *Art Amateur* 18 (Feb. 1888), pp. 62–63.

"Decorative Devices: Sideboard and Cabinet." *Art Age* 7 (Mar. 1888), p. 46.

"Decorative Devices: Table." *Art Age* 7 (Mar. 1888), p. 46.

"Screens," pts. 1, 2. *Art Amateur* 20 (Mar. 1889), pp. 90–92; (Apr. 1889), pp. 114–15.

"Embroidered Screens." *Art Amateur* 21 (June 1889), pp. 21–22.

Riordan, Roger. "Chairs and Sofas," pts. 1, 2. *Art Amateur* 21 (June 1889), pp. 16–17; (July 1889), pp. 40–41.

1890–99

Ashton, Carrie May. "Popular Whims in Furniture." *Interior Decorator* 4 (Aug. 1893), pp. 209–10.

Johnson, C. A. "Fads and Fashions in Furniture." *Interior Decorator* 4 (Sept. 1893), pp. 285–86.

Holahan, C. M. "Novelties in Furniture." *Interior Decorator* 4 (Oct. 1893), pp. 302–3.

Crace, J. D. "Augustus Welby Pugin and Furniture." *Journal of the Royal Institute of British Architects* 1 (1894), pp. 517–19.

1900–present

Pevsner, Nikolaus. "Art Furniture of the Eighteen-Seventies." *Architectural Review* 111 (Jan. 1952), pp. 43–50.

Aslin, Elizabeth. *Nineteenth Century English Furniture*. New York, 1962.

———. "E. W. Godwin and the Japanese Taste." *Apollo* 76 (Dec. 1962), pp. 779–84.

Roth, Rodris. "American Art, the Colonial Revival, and Centennial Furniture." *Art Quarterly* 27 (1964), pp. 57–77.

Handley-Read, Charles. "England, 1830–1901." In *World Furniture*. Ed. Helena Hayward. New York and Toronto, 1965.

Crawford, Elizabeth McAshan. "Privacy in American Interiors." Ph.D. diss., University of North Carolina, 1967.

Aslin, Elizabeth. "The Furniture Designs of E. W. Godwin." *Victoria and Albert Bulletin* 3 (Oct. 1967), pp. 145–54.

Jervis, Simon. *Victorian Furniture*. Sydney and London, 1968.

Schaefer, Herwin. *Nineteenth Century Modern: The Functional Tradition in Victorian Design*. New York, 1970.

Ames, Kenneth L. "The Battle of the Sideboards." *Winterthur Portfolio* 9 (1974), pp. 1–27.

Madigan, Mary Jean Smith. "The Influence of Charles Locke Eastlake on American Furniture Manufacture, 1870–1890." *Winterthur Portfolio* 10 (1975), pp. 1–22.

Wilson, Michael I. "Burne-Jones and Piano Reform." *Apollo* 102 (Nov. 1975), pp. 342–47.

Menz, Katherine Boyd. "Wicker in the American Home." M.A. thesis, University of Delaware, 1976.

Saunders, Richard. *Collecting and Restoring Wicker Furniture*. New York, 1976.

Cromey-Hawke, N. "William Morris and Victorian Painted Furniture." *Connoisseur* 191 (Jan. 1976), pp. 32–43.

Wainwright, Clive. "A. W. N. Pugin's Early Furniture." *Connoisseur* 191 (Jan. 1976), pp. 3–11.

Pictorial Dictionary of British Nineteenth Century Furniture Design. Intro. Edward Joy. Woodbridge, Eng., 1977.

Aquis, Pauline. *British Furniture, 1880–1915*. Woodbridge, Eng., 1978.

Fine Art Society Limited, London. *Architect-Designers: Pugin to Mackintosh*, by Clive Wainwright and Charlotte Gere. Exhib. cat., 1981.

Ellis, Anita J. "Cincinnati Art Furniture." *Antiques* 121 (Apr. 1982), pp. 930–41.

Ames, Kenneth L., ed. *Victorian Furniture: Essays from a Victorian Society Autumn Symposium*. Philadelphia, 1983.

Columbus Museum of Art, Ohio. *Made in Ohio: Furniture, 1788–1888*, by E. Jane Connell and Charles R. Muller. Exhib. cat., 1984.

Darling, Sharon S. *Chicago Furniture: Art, Craft, and Industry, 1833–1983*. New York and London, 1984.

INTERIORS

1850–59

Downing, Andrew Jackson. *The Architecture of Country Houses*. New York, 1850.

1860–69

Eastlake, Charles Locke. *Hints on Household Taste in Furniture, Upholstery, and Other Details*. London, 1868.

Beecher, Catherine E., and Harriet Beecher Stowe. *The American Woman's Home, or Principles of Domestic Science, Being a Guide to the Formation and Maintenance of Economical, Healthful, Beautiful, and Christian Homes*. New York [1869].

1870–79

"Gossip and Notebook: Parlor Ornamentation." *Potter's American Monthly* 9 (Sept. 1872), p. 239.

"The Artistic Uses of Colour in Household Decoration." *Furniture Gazette* 1 (Apr. 12, 1873), pp. 5–6.

"Colour in Household Decoration." *Furniture Gazette* 1 (June 7, 1873), p. 139.

"A Lesson for Decorators." *Furniture Gazette* 1 (Oct. 25, 1873), p. 460.

"Decorative Treatment of the Fireplace." *Furniture Gazette* 1 (Dec. 6, 1873), pp. 565–66.

Cooper, H. J. *The Art of Furnishing on Rational and Aesthetic Principles*. London, 1876.

Elliott, Charles Wyllys. *The Book of American Interiors*. Boston, 1876.

Garrett, Rhoda, and Agnes Garrett. *Suggestions for House Decoration in Painting, Woodwork, and Furniture*. London, 1876.

Loftie, W. J. *A Plea for Art in the House*. London, 1876.

"Household Art in Chicago," pts. 1, 2. *Art Journal* (Appleton's) 2 (Jan. 1876), pp. 18–19; (Feb. 1876), p. 64.

Elliott, Charles Wyllys. "Household Art, 7: Fire and Mantelpiece." *Art Journal* (Appleton's) 2 (Aug. 1876), pp. 239–44.

Field, Margaret. "Making Home Beautiful." *Potter's American Monthly* 7 (Dec. 1876), pp. 432–34.

Orrinsmith, Mrs. [Lucy]. *The Drawing-Room: Its Decorations and Furniture*. London, 1877.

"Modern Dining-Room." *Art Journal* (Appleton's) 3 (Oct. 1877), p. 312.

Dare, Shirley. "One's Own House." *Carpet Trade Review* 4 (Nov. 1877), pp. 140–41.

M. E. W. S. "Some New York Interiors." *Art Journal* (Appleton's) 3 (Nov. 1877), pp. 329–34.

"Some New York Interiors." *Art Journal* (Appleton's) 3 (Dec. 1877), pp. 361–65.

Barker, Lady [Broome, Mary Anne (Stewart) Barker]. *The Bedroom and Boudoir*. London, 1878.

Cook, Clarence. *The House Beautiful: Essays on Beds and Tables, Stools and Candlesticks*. New York, 1878. (Originally published in *Scribner's Monthly*, June 1875–Apr. 1877.)

Gardner, Eugene C. *Home Interiors*. Boston, 1878.

Little, Arthur. *Early New England Interiors: Sketches in Salem, Marblehead, Portsmouth, and Kittery*. Boston, 1878.

Loftie, Mrs. W. J. [Martha Jane]. *The Dining-Room*. London, 1878.

"Notes: The Decoration of Houses" [review of Trades' Guild of Learning lecture series by William Morris]. *Art Journal* (Appleton's) 4 (Apr. 1878), p. 127.

"A Japanese Room." *Art Journal* (Appleton's) 4 (Nov. 1878), pp. 324–25.

"Decoration: A Refining Power." *Art Interchange* 1 (Nov. 2, 1878), p. 44.

"Nurseries and Servants' Rooms." *Art Interchange* 1 (Nov. 13, 1878), pp. 39–40.

Falke, Jacob von. *Art in the House: Historical, Critical, and Aesthetical Studies on the Decoration and Furnishing of the Dwelling*. Boston, 1879.

Oakey, Sally Sullivan. *From Attic to Cellar: A Book for Young Housekeepers*. New York, 1879.

"Treasure-Houses of Art," pt. 1 [Mr. Alfred Morrison's Carlton house terrace]. *Magazine of Art* 2 (1879), pp. 140–44.

Corson, W. R. "A Design for a Fire-place." *Scribner's Monthly* 18 (May 1879), pp. 143–44.

"Drawing-Room Decoration." *Carpet Trade Review* 6 (Oct. 1879), pp. 242–44.

"Mantelpiece Decoration." *Crockery and Glass Journal* 10 (Oct. 30, 1879), p. 8.

1880–89

Wright, Julia McNair. *The Complete Home: An Encyclopaedia of Domestic Life and Affairs*. Philadelphia, 1880.

Moran, John. "New York Studios," pt. 3. *Art Journal* (Appleton's) 6 (Jan. 1880), pp. 1–4.

Carter, Susan N. "Principles of Decoration, 2: Ceilings and Dados." *Art Journal* (Appleton's) 6 (Mar. 1880), pp. 68–74.

"The Art of Furnishing, 1: The Hall and the Staircase." *Art Amateur* 3 (June 1880), pp. 12–14.

Dare, Shirley. "Decoration and Furniture: A Beautiful Town Home." *Art Amateur* 3 (July 1880), pp. 35–36.

"An Ultra-artistic Home" [William Burges house]. *Art Amateur* 3 (Aug. 1880), p. 64.

"The Art of Furnishing." *Art Amateur* 3 (Oct. 1880), p. 104.

"Decoration in Excess." *Art Journal* (Appleton's) 6 (Nov. 1880), pp. 328–29.

Harrison, C[onstance] C[ary]. "Home Decorations: Screens and Portieres." *Scribner's Monthly* 21 (Nov. 1880), pp. 155–56.

Church, Ella Rodman. *How to Furnish a Home*. New York, 1881.

Edis, Robert W. *Decoration and Furniture of Town Houses*. New York and London, 1881.

Putnam, J. Pickering. *The Open Fire-place in All Ages*. Boston, 1881.

"Color Applied to House Decoration." *Carpentry and Building* 3 (Jan. 1881), pp. 7–8.

"Door Decoration." *Carpentry and Building* 3 (Jan. 1881), p. 7.

"Colors for Rooms." *Carpentry and Building* 3 (Feb. 1881), pp. 27–28.

"Competition in Dining Room Finish." *Carpentry and Building* 3 (Mar. 1881), p. 43.

"Hints of House Decoration." *Brick, Tile, and Metal Review* 1 (Mar. 1881), p. 13.

"House Decoration." *Carpentry and Building* 3 (Mar. 1881), pp. 47–50.

"Household Fancies." *Carpet Trade Review* 8 (Apr. 1, 1881), p. 70.

Bonnar, Thomas. "Colour in Interiors." *Architect* (London), Apr. 16, 1881, pp. 277–78.

"A Club Dining-Room" [Union League Club]. *Art Amateur* 4 (May 1881), p. 125.

"Draperies of the Union League Club." *Art Amateur* 5 (June 1881), p. 17.

"Home Studies in Color." *Carpet Trade* 12 (June 1881), pp. 23–25.

"Hints to Amateur House Decorators." *Carpet Trade Review* 8 (June 1, 1881), pp. 103–4.

"Decoration in the Seventh Regiment Armory." *Scribner's Monthly* 22 (July 1881), pp. 370–80.

"Drawing–Room Color and Decoration." *Art Amateur* 5 (July 1881), pp. 37–38.

Humphreys, Mary Gay. "Recent Church Decoration." *Art Amateur* 5 (Nov. 1881), p. 127.

[The direction of public taste]. *Carpentry and Building* 3 (Dec. 1881), p. 234.

"Practical Hints for Room Decoration." *Art Amateur* 6 (Dec. 1881), pp. 18–19.

Dewing, [Maria Oakey]. *Beauty in the Household*. New York, 1882.

Haweis, Mary Eliza. *Beautiful Houses, Being a Description of Certain Well-known Artistic Houses*. London, 1882.

Tuthill, William B. *Interiors and Interior Details*. New York, 1882.

Varney, Almon C. *Our Homes and Their Adornments, or How to Build, Finish, Furnish, and Adorn a Home: A Complete Household Cyclopedia, Designed to Make Happy Homes for Happy People*. Detroit, 1882.

"Carved Work for Interior Decoration." *Carpentry and Building* 4 (Jan. 1882), p. 2.

"Ceiling Decoration." *Art Amateur* 6 (Jan. 1882), pp. 39–40.

"Sketches for Suburban Residence by E. G. W. Dietrich." *American Architect and Building News* 11 (Jan. 21, 1882), p. 317.

"The Brunswick Hotel Decoration." *Carpet Trade Review* 9 (Feb. 1882), p. 47.

"Summer Fireplace Decoration." *Art Amateur* 6 (May 1882), p. 134.

"Art in New York: Gilded and Bronzed Leather." *Crockery and Glass Journal* 15 (May 4, 1882), p. 40.

Dare, Shirley. "Vexed Questions in Furnishings." *Art Amateur* 7 (July 1882), pp. 34–45.

"Suggestions for a Drawing–Room." *Art Amateur* 7 (Sept. 1882), p. 72.

"Ceiling and Wall Decoration." *Art Amateur* 7 (Oct. 1882), pp. 104–5.

Artistic Houses, Being a Series of Interior Views of a Number of the Most Beautiful and Celebrated Homes in the United States. 2 vols. in 4 pts. New York, 1883–84.

Batley, H. W. *A Series of Studies for Domestic Furniture and Decoration*. London, 1883.

Marshall, J. *Amateur House Decoration*. Edinburgh, 1883.

"Colorings." *Decorator and Furnisher* 1 (Jan. 1883), p. 118.

Cram, Ralph Adams. "The Reception Room." *Decorator and Furnisher* 1 (Jan. 1883), pp. 119–20.

Lander, E. T. "The Seasons Grates and Fireplaces." *Decorator and Furnisher* 1 (Jan. 1883), pp. 117–18.

"Inexpensive Home Decoration" [review of *Every-Day Art* by Lewis F. Day]. *Art Amateur* 8 (Feb. 1883), p. 66.

"New Houses—Indoors and Out." *Art Amateur* 8 (Feb. 1883), pp. 66–68.

"A French Critic on American Houses" [G. de Léris]. *Art Amateur* 8 (Mar. 1883), p. 78.

"Hints for the Dining Room." *Art Amateur* 8 (Apr. 1883), p. 113.

Humphreys, Mary Gay. "A Wood Carver's Home" [Benn Pitman house]. *Art Amateur* 8 (Apr. 1883), pp. 114–15.

Ward, Hetta L. H. "Home Art and Home Comfort: Bedrooms." *Demorest's Monthly Magazine* 19 (Apr. 1883), pp. 350–51.

Adams, Maurice R. "The Furnishing of Modern Houses." *Crockery and Glass Journal* 17 (Apr. 12, 1883), p. 20.

"Hints for the Drawing-Room." *Art Amateur* 8 (May 1883), p. 136.

"A New York Interior" [Ogden Goelet house]. *Art Amateur* 8 (May 1883), p. 143.

"A Tastefully and Economically Furnished Bedroom in a New York Residence." *Decorator and Furnisher* 2 (May 1883), p. 83.

"Hints for the Hall and Staircase." *Art Amateur* 9 (July 1883), p. 38.

"An Oriental Apartment." *Art Amateur* 9 (Aug. 1883), pp. 65–67.

"Suggestions for Bedrooms." *Art Amateur* 9 (Aug. 1883), p. 60.

"The Art of Furnishing, 3: The Drawing-Room." *Art Amateur* 3 (Sept. 1883), pp. 81–83.

"The Bedroom." *Art Amateur* 9 (Oct. 1883), p. 101.

Humphreys, Mary Gay. "The Progress of American Decorative Art," pts. 1–4. *Art Journal* (London), Jan. 1884, pp. 25–28; Mar. 1884, pp. 69–73; June 1884, pp. 181–84; Nov. 1884, pp. 335–48.

T. C. "The Color of Walls and Woodwork." *Art Amateur* 10 (Feb. 1884), pp. 73–74.

Zimmern, H. "The Home of Alma-Tadema." *Art Amateur* 10 (Feb. 1884), pp. 71–73.

"A Rich Reception Room." *Carpet Trade and Review* 15 (Apr. 1, 1884), p. 49.

Riordan, Roger. "The Modern Home," pts. 1–6. *Art Amateur* 10 (May 1884), pp. 137–39; 11 (July 1884), pp. 39–41; (Aug. 1884), pp. 60–63; (Sept. 1884), pp. 83–84; (Oct. 1884), pp. 104–8; (Nov. 1884), pp. 128–29.

Brooks, Noah. "The Typical American Home." *Art Amateur* 11 (Sept. 1884), pp. 85–86.

Seventh N.G.S.N.Y. Regiment Armory, Illustrated. New York [1885].

"Colors." *Decorator and Furnisher* 5 (Jan. 1885), p. 137.

"Decoration Notes: Mrs. Charles J. Osborne's Country House." *Art Age* 2 (Jan. 1885), p. 81.

"The Decorative Instinct." *Decorator and Furnisher* 5 (Feb. 1885), p. 178.

Humphreys, Mary Gay. "Three Rooms and a Hall" [Charles J. Osborne house, Mamaroneck, N.Y.]. *Decorator and Furnisher* 5 (Feb. 1885), p. 178.

"The Lighting and Decoration of Picture Galleries." *Art Amateur* 12 (Feb. 1885), pp. 70–72.

"Healthy Decoration." *Art Amateur* 12 (May 1885), p. 132.

"The Work of the Decorator." *Art Amateur* 13 (Oct. 1885), p. 99.

Decorator. "Interior Decoration, Good and Bad." *Art Union* 2 (Nov. 1885), pp. 97–98.

Myddleton, Hope. "The Decoration of Our Homes." *Art Amateur* 13 (Nov. 1885), pp. 120–21, 124.

"Artistic and Fashionable Mantels." *Decorator and Furnisher* 7 (Dec. 1885), p. 93.

"Wall and Ceiling Decoration in the House of Mr. E. C. Wallace." *Decorator and Furnisher* 7 (Dec. 1885), p. 70.

Armstrong, Katherine. "Suggestions: The Bed-Chamber." *Demorest's Monthly Magazine* 22 (Jan. 1886), pp. 183–87.

Godwin, E. W. "The Home of an English Architect" [William Burges house], pts. 1, 2. *Art Journal* (London), June 1886, pp. 170–73; Oct. 1886, pp. 301–5.

"The Decoration of Flats." *Decorator and Furnisher* 8 (Aug. 1886), p. 137.

"A Few Suggestions: Japanese Parasols." *Decorator and Furnisher* 8 (Sept. 1886), p. 166.

"House Alterations: A New Style of Entrance Hall." *Art Age* 4 (Sept. 1886), pp. 19–20.

"The Necessities of Life." *Decorator and Furnisher* 8 (Sept. 1886), p. 169.

"Decoration Notes and Suggestions: A Novel Use for the Japanese Parasol." *Art Age* 4 (Oct. 1886), p. 31.

Riordan, Roger. "Hints for Simple Decoration of Unadorned City Apartments," pts. 1–3. *Art Amateur* 16 (Dec. 1886), pp. 12–14; (Jan. 1887), pp. 38–39; (Feb. 1887), pp. 64–65.

Brunner, Arnold W., and Thomas Tryon. *Interior Decoration*. New York, 1887.

Goddard, Frederick Bartlett. *Furniture and the Art of Furnishing*. New York, 1887.

Smith, J. Moyr. *Ornamental Interiors, Ancient and Modern*. London, 1887.

"Cheap Splendor." *Art Amateur* 16 (Jan. 1887), p. 37.

"Decorative Panels for a Music-Room." *Art Amateur* 16 (Feb. 1887), p. 64.

"Sumptuous Bathrooms." *Art Amateur* 16 (Feb. 1887), p. 65.

[Wheeler, Candace]. "The Color Scheme of a Room." *Art Amateur* 16 (Feb. 1887), p. 62.

"Panelled Dados and Doors." *Decorator and Furnisher* 10 (Apr. 1887), p. 17.

"Talks with Decorators: Mr. E. J. N. Stent's Suggestions for the Drawing-Room Floor of a Remodelled City House." *Art Amateur* 16 (Apr. 1887), pp. 112–14.

Jarves, Robert. "Wall and Floor Decoration." *Art Amateur* 16 (May 1887), pp. 138–39.

"Household Ornaments and Minor Decorations: Observations of an Experienced Decorative Artist." *Art Age* 6 (Nov. 1887), pp. 62–63.

"Interior Decoration." *Art Amateur* 18 (Dec. 1887), pp. 14–15.

"Minor Household Decorations." *Art Age* 6 (Dec. 1887), pp. 81–83.

"An Apartment." *Art Age* 7 (Mar. 1888), pp. 44–46.

"The Furnishing of a Country House." *Art Age* 7 (July 1888), pp. 8–9.

"Various Furnishing Devices: A Firescreen."

Art Age 8 (Oct. 1888), p. 58.

"Interior Decorations." *Art Age* 8 (Nov. 1888), pp. 71–72.

"A Model New York Home." *Art Amateur* 20 (Dec. 1888), pp. 1, 14–15.

Haweis, Mary Eliza. *The Art of Decoration.* London, 1889.

"Hints from Japanese Homes." *Art Amateur* 20 (Feb. 1889), pp. 66–67.

"Decoration for Householders: A Very Pretty Bedroom." *Art Age* 9 (Apr. 1889), p. 78.

"Decoration for Householders: One of the Prettiest Drawing-Rooms of New York." *Art Age* 9 (Apr. 1889), p. 78.

Humphreys, Mary Gay. "Talks with Decorators: Mr. Bruce Price's View as to the Use of Gold and Color, with Some Hints about Lighting." *Art Amateur* 20 (Apr. 1889), pp. 110–11.

Jervis, Robert. "Notes on Bedrooms." *Art Amateur* 21 (July 1889), p. 41.

"A Modern Interior." *Art Amateur* 21 (July 1889), p. 39.

"Concerning Halls and Dining Rooms." *Art Amateur* 22 (Dec. 1889), pp. 17–19.

1890–99

Loftie, W. J. "Art at Home: Books." *Art Amateur* 23 (July 1890), pp. 36–37.

Spofford, Harriet Prescott. *House and Hearth.* New York, 1891.

Ormsbee, Agnes Bailey. *The House Comfortable.* New York, 1892.

Robinson, G. T. "Artistic Homes: The Decoration of Ceilings." *Magazine of Art* 15 (1892), pp. 235–40, 351–57.

Boughton and Terwilliger, Brooklyn. *Interior Decorations: Artistic Wood Floors.* Brooklyn, 1893.

"Artistic Interiors." *Interior Decorator* 4 (May 1893), p. 32.

Brown, Edward Hurst. "Decorative Items." *Interior Decorator* 4 (June 1893), p. 106.

"Renewing the Home." *Interior Decorator* 4 (June 1893), pp. 77–78.

Holahan, C. M. "Dens." *Interior Decorator* 4 (Aug. 1893), p. 203.

Smith, C. Philip. "Decorative Art: The Decoration of a Bed Room." *Interior Decorator* 4 (Aug. 1893), pp. 212–13.

"Hardwood Floors." *Interior Decorator* 4 (Oct. 1893), p. 330.

[A modern dining room, by Mr. Frederick Parsons]. *Interior Decorator* 4 (Oct. 1893), pp. 308–9.

"The Value of Accessories." *Interior Decorator* 5 (Feb. 1894), p. 163.

"Bric-a-Brac." *Interior Decorator* 6 (Apr. 1894), p. 249.

Holahan, C. M. "Some Good Effects in Furnishing and Decoration." *Interior Decorator* 5 (Nov. 1895), pp. 18–19.

Wharton, Edith, and Ogden Codman. *The Decoration of Houses.* New York, 1897.

1900–present

Dutton, Ralph. *The Victorian Home: Some Aspects of Nineteenth Century Taste and Manners.* London, 1954.

Memorial Art Gallery, University of Rochester, N.Y. *A Scene of Adornment: Decoration in the Victorian Home, from the Collections of the Margaret Woodbury Strong Museum.* Exhib. cat., 1975.

Seale, William. *The Tasteful Interlude: American Interiors Through the Camera's Eye, 1860–1917.* New York, 1975.

Faude, Wilson H. "Associated Artists and the American Renaissance in the Decorative Arts." *Winterthur Portfolio* 10 (1975), pp. 101–30.

Cooper, Nicholas. *The Opulent Eye: Late Victorian and Edwardian Taste in Interior Design.* New York, 1977.

Girouard, Mark. *The Victorian Country House.* Rev. ed. New Haven and London, 1979.

Seale, William. *Recreating the Historic House Interior.* Nashville, Tenn., 1979.

Mayhew, Edgar de Noailles, and Minor Myers, Jr. *A Documentary History of American Interiors: From the Colonial Era to 1915.* New York, 1980.

Cherol, John A. "Chateau-sur-Mer in Newport, Rhode Island." *Antiques* 118 (Dec. 1980), pp. 1220–25.

Forge, Suzanne. *Victorian Splendour: Australian Interior Decoration, 1837–1901.* Melbourne, 1981.

McClaugherty, Martha Crabill. "Household Art: Creating the Artistic Home, 1868–1893." M.A. thesis, University of Virginia, 1981.

Bradfield, Geoffrey N., and Connie LeGendre. *Great New York Interiors: Seventh Regiment Armory.* Intro. David [A.] Hanks. New York, 1983.

McClaugherty, Martha Crabill. "Household Art: Creating the Artistic Home, 1868–1893." *Winterthur Portfolio* 18 (Spring 1983), pp. 1–26.

Thornton, Peter. *Authentic Decor: The Domestic Interior, 1620–1920.* New York, 1984.

Schachter, Sophia Duckworth. "The Seventh Regiment Armory of New York City: A History of Its Construction and Decoration." M.A. thesis, Columbia University, 1985.

LITERATURE

1840–49

Ruskin, John. *Modern Painters.* 5 vols. London, 1843–60.

1850–59

Ruskin, John. *The Stones of Venice.* 3 vols. London, 1851–53.

1870–79

Pater, Walter. *Studies in the History of the Renaissance.* London, 1873.

1880–89

Hamilton, Walter. *The Aesthetic Movement in Literature.* London, 1881.

James, Henry. *The Portrait of a Lady.* London, 1881.

Pater, Walter. *Marius the Epicurean: His Sensations and Ideas.* London, 1885.

Rossetti, Dante Gabriel. *The Collected Works of Dante Gabriel Rossetti.* 2 vols. Ed. William Michael Rossetti. London, 1886.

1890–99

James, Henry. *The Tragic Muse.* London, 1890.

Wilde, Oscar. *Intentions.* London, 1891.

———. *The Picture of Dorian Gray.* London, 1891.

———. *The Importance of Being Earnest.* London, 1895.

Santayana, George. *The Sense of Beauty.* New York, 1896.

1900–present

Stickney, Trumbull. *Poems.* Boston, 1905.

Jackson, Holbrook. *The Eighteen Nineties.* New York, 1913.

Rosenblatt, Louise. *L'Idée de l'art pour l'art dans la littérature anglaise pendant le dix-neuvième siècle.* Paris, 1931.

Parry, Albert. *Garrets and Pretenders.* New York, 1933.

Praz, Mario. *The Romantic Agony.* London, 1933.

Lewis, Lloyd, and Henry Justin Smith. *Oscar Wilde Discovers America [1882].* New York, 1936.

Limpus, Robert. *American Criticism of British Decadence, 1880–1900.* Chicago, 1939.

James, Henry. *The Notebooks of Henry James.* Ed. F. O. Matthiessen and Kenneth Murdock. New York, 1947.

Buckley, Jerome. *The Victorian Temper.* Cambridge, Mass., 1951.

Cowley, Malcolm. *Exile's Return: A Narrative of Ideas.* New York, 1934. Rev. ed. New York, 1951.

Dickason, David. *The Daring Young Men: The Story of the American Pre-Raphaelites.* Bloomington, Ind., 1953.

Kermode, Frank. *The Romantic Image.* London, 1957.

Ziff, Larzer. *The American 1890s.* New York, 1966.

Hunt, John Dixon. *The Pre-Raphaelite Imagination.* Oxford, 1968.

Moers, Ellen. *The Dandy: Brummell to Beerbohm.* London, 1968.

deLaura, David. *Hebrew and Hellene in Victorian England.* Austin, Tex., 1969.

Ormond, Leonée. *George Du Maurier.* Pittsburgh, 1969.

Winner, Viola Hopkins. *Henry James and the Visual Arts.* Charlottesville, Va., 1970.

Bloom, Harold. "The Place of Pater: *Marius the Epicurean.*" In *The Ringers in the Tower.* Chicago, 1971.

Garner, Frances Adrien. "Henry James's Use of Architecture." Ph.D. diss., University of Tennessee, 1974.

Stein, Richard. *The Ritual of Interpretation. The Fine Arts as Literature: Ruskin, Rossetti, and Pater.* Cambridge, Mass., 1975.

Dowling, Linda. *Aestheticism and Decadence: A Selected Annotated Bibliography.* New York, 1977.

Edel, Leon. *Henry James: A Life.* New York, 1985.

METALWORK

1860–69

"Gothic Metal Work," pts. 1, 2. *Art Journal* (London), Sept. 1861, pp. 281–84; Nov. 1861, pp. 333–36.

"Minor Topics of the Month." *Art Journal*

(London), May 1863, pp. 102–3.

"Silver and Silver Plate." *Harper's New Monthly Magazine* 37 (Sept. 1868), pp. 432–48.

1870–79

"Discovery of Antique Silver." *Scribner's Monthly* 1 (Apr. 1871), pp. 618–20.

"Japanese Metalwork." *Furniture Gazette* 1 (Sept. 27, 1873), p. 391.

"British Manufactures: Jewellery by Mr. G. A. Godwin." *Art Journal* (London), Oct. 1874, p. 298.

"The Silver Age." *Scribner's Monthly* 9 (Dec. 1874), pp. 193–209.

"American Art-Work in Silver." *Art Journal* (Appleton's) 1 (Dec. 1875), pp. 371–74.

Farnum, Alexander. *The Century Vase.* Providence, R.I., 1876.

"Art Reproductions in Metal." *Iron Age,* Sept. 7, 1876, p. 14.

C[arter], S[usan] N. "Brass and Bronze Work at the Centennial Exhibition." *Art Journal* (Appleton's) 2 (Nov. 1876), p. 348.

"Silver in Art." *International Review* 5 (1878), pp. 241–46.

"Electroplating of Metals." *Trade Journal Treating of Furniture, Upholstery, Decoration, Kindred Industries* 8 (June 29, 1878), p. 8.

Taylor, Edwin C. "An American Wedge." *International Review* 6 (1879), pp. 170–75.

Maukis, Maurice. "The Iron-Smith," pts. 1, 2. *Art Journal* (Appleton's) 5 (July 1879), pp. 202–8; (Aug. 1879), pp. 228–35.

"Art Work in Wrought Iron." *Iron Age,* July 3, 1879, p. 1.

Taylor, Edwin C. "Metal Work of All Ages." *National Repository* 6 (Nov. 1879), pp. 404–5.

1880–89

"New Decorative Metal Castings." *Art Amateur* 5 (June 1881), p. 12.

J. L. Mott Iron Works. *1882 Illustrated Catalogue: Artistic Grates, Fenders, Andirons, Fire Irons, and Other Goods, for the Fitting and Decoration of the Fire Place.* New York, 1882.

"Design in Silverware." *Art Amateur* 7 (Sept. 1882), pp. 73–74.

"The Art Possibilities of Stoves." *Art Amateur* 7 (Nov. 1882), p. 125.

"Electro-Gold and Silver Plate." *Jewelers' Circular and Horological Review* 14 (May 1883), p. 104.

"Some Artistic Jewelry." *Art Amateur* 8 (May 1883), pp. 142–43.

"Ornamental Brass Work." *Art Amateur* 10 (Apr. 1884), pp. 112–14.

"Stove Architecture." *Brick, Tile, and Metal Review* 4 (Sept. 1884), p. 1.

Koehler, S[ylvester] R[osa]. "American Art Industries, 1: Heating Apparatus." *Magazine of Art* 8 (1885), pp. 38–39.

Robinson, Frank. "Decorative Iron Work: The Old and the New Smiths." *Decorator and Furnisher* 5 (Feb. 1885), pp. 177–78.

St. Johnson, A. "American Silver-Work." *Magazine of Art* 9 (1886), pp. 13–18.

Bee, Elsie. "Fashions in Jewelry." *Jewelers' Circular and Horological Review* 17 (Apr. 1886), p. 97.

Leland, Charles G. "Home Arts, 4: Repoussé or Sheet Metal-Work." *Art Journal* (London), June 1886, pp. 181–84.

"Among the Trades." *Decorator and Furnisher* 8 (Aug. 1886), p. 148.

Jarves, Robert. "American Silverware." *Art Amateur* 16 (Dec. 1886), pp. 18–19.

"Artistic Work in Silver and Bronze." *Jewelers' Circular and Horological Review* 18 (Nov. 1887), pp. 381–82.

"Twisted Sheet Metal Work." *Art Age* 6 (Nov. 1887), p. 65.

Urquhart, J. U. *Electro-plating: A Practical Handbook.* London, 1888.

"Sheet-Metal Center Pieces." *Carpentry and Building* 10 (Apr. 1888), p. 82.

"Kinnear's Metallic Ceilings." *Carpentry and Building* 10 (Nov. 1888), pp. 229–30.

1890–99

Pitman, Benn. "Etched Metal Facings for Mantels." *Art Amateur* 22 (Jan. 1890), pp. 41–42.

"Brasswork in Furnishing Decoration." *Interior Decorator* 5 (Nov. 1893), pp. 21–23.

1900–present

Leland, Charles G. *Elementary Metal Work: A Practical Manual for Amateurs and for Use in Schools.* London, 1914.

May, Earl Chapin. *Century of Silver, 1847–1947: Connecticut Yankees and a Noble Metal.* New York, 1947.

Wardle, Patricia. *Victorian Silver and Silverplate.* New York, 1963.

McClinton, Katherine Morrison. *Collecting American Nineteenth Century Silver.* New York, 1968.

Rainwater, Dorothy T., and H. Ivan Rainwater. *American Silverplate.* Nashville, Tenn., and Hanover, Pa., 1968.

Victorian Silverplated Holloware. Princeton, 1972.

Birmingham Museums and Art Gallery, Eng. *Birmingham Gold and Silver, 1773–1973.* Exhib. cat., 1973.

Gere, Charlotte. "Victorian Jewellery." *Connoisseur* 192 (June 1976), pp. 146–50.

Hawley, Henry H. "Tiffany's Silver in the Japanese Taste." *Bulletin of the Cleveland Museum of Art* 63 (Oct. 1976), pp. 236–45.

Darling, Sharon S. *Chicago Metalsmiths.* Chicago, 1977.

Bury, Shirley. "Jewellery in an Age of Discovery, 1800–1900." In *Art at Auction: The Year at Sotheby Parke Bernet, 1977–78.* London, 1978, pp. 435–41.

Carpenter, Charles H., Jr., and Mary Grace Carpenter. *Tiffany Silver.* New York, 1978.

Myers, Denys Peter. *Gaslighting in America: A Guide for Historic Preservation.* Washington, D.C., 1978.

Tait, Hugh, and Charlotte Gere. *The Jeweller's Art: An Introduction to the Hull Grundy Gift to the British Museum.* London, 1978.

Schiffer, Herbert, Peter Schiffer, and Nancy Schiffer. *Antique Iron: Survey of American and English Forms, Fifteenth Through Nineteenth Centuries.* Exton, Pa., 1979.

Yale University Art Gallery, New Haven. *Silver in American Life: Selections from the Mabel Brady Garvan and Other Collections at Yale University,* ed. Barbara McLean Ward and Gerald W. R. Ward. Exhib. cat., 1979.

Ellis, Myrtle. "Victorian Silver, 1837–1901." In Mint Museum, Charlotte, N.C. *Mint Museum Antiques Show.* Sale cat., Oct. 2–

4, 1981, pp. 17–43.

Carpenter, Charles H., Jr. *Gorham Silver, 1831–1981.* New York, 1982.

Albany Institute of History and Art, N.Y. *Cast with Style: Nineteenth-Century Cast Iron Stoves from the Albany Area,* by Tammis Kane Groft. Exhib. cat., rev. ed., 1984.

Tait, Hugh, ed. *The Art of the Jeweller. A Catalogue of the Hull Grundy Gift to the British Museum: Jewellery, Engraved Gems, and Goldsmiths' Work.* 2 vols. London, 1984.

Duman, Ann. "Victorian Modern: The Metalwork Designs of Christopher Dresser, C. R. Ashbee, and Archibald Knox, 1880–1910." *Antiques* 127 (June 1985), pp. 1342–51.

Undated

W. T. Mersereau and Company. *Catalogue of Brass Bedsteads and Furniture Manufactured by W. T. Mersereau and Co., No. 321 Broadway, N.Y.* [New York], n.d.

PAINTING AND SCULPTURE

1860–69

Jarves, James Jackson. *The Art-Idea.* New York, 1864.

———. *Art Thoughts.* New York, 1869.

1870–79

"Exhibition of Fans at the Draper's Hall, London." *Art Journal* (Appleton's) 4 (Oct. 1878), pp. 315–16.

Laffan, W[illiam] Mackay. "The Tile Club at Work." *Scribner's Monthly* 17 (Jan. 1879), pp. 401–9.

Laffan, W[illiam] Mackay, and Edward Strahan [Earl Shinn]. "The Tile Club at Play." *Scribner's Monthly* 17 (Feb. 1879), pp. 464–78.

1880–89

Laffan, W[illiam] Mackay, and Edward Strahan [Earl Shinn]. "The Tile Club Afloat." *Scribner's Monthly* 19 (Mar. 1880), pp. 641–71.

"A Painted Table." *Art Amateur* 3 (June 1880), pp. 4–8.

"Ruskin on Picture Galleries." *Art Amateur* 3 (Aug. 1880), p. 62.

Koehler, S[ylvester] R[osa]. "The Works of the American Etchers, 11: Samuel Colman." *American Art Review* (Boston) 1, pt. 2 (1881), pp. 387–88.

Linton, W. J. "The History of Wood-engraving in America," pts. 6–8. *American Art Review* (Boston) 1, pt. 2 (1881), pp. 431–38, 469–74, 515–23.

Harper's Christmas: Pictures and Papers Done by the Tile Club and Its Literary Friends. New York, 1882.

Koehler, S[ylvester] R[osa], comp. *The United States Art Directory and Year-Book.* 2 vols. New York, London, and Paris, 1882–84.

"Hanging and Framing." *Art Amateur* 6 (Jan. 1882), p. 39.

Laffan, W[illiam] Mackay. "The Tile Club Ashore." *Century Illustrated Monthly Magazine* 23 (Feb. 1882), pp. 481–98.

[Oakey, Alexander F.]. "A Trial Balance of

Decoration." *Harper's New Monthly Magazine* 64 (Apr. 1882), pp. 734–40.

"Hints about Picture Hanging." *Art Amateur* 7 (Aug. 1882), p. 61.

Humphreys, Mary Gay. "The Cornelius Vanderbilt House." *Art Amateur* 8 (May 1883), pp. 135–36.

Buel, C. C. "Log of an Ocean Studio." *Century Illustrated Monthly Magazine* 27 (Jan. 1884), pp. 356–71.

Champney, Lizzie W. "The Summer Haunts of American Artists." *Century Illustrated Monthly Magazine* 8 (Oct. 1885), pp. 845–60.

Strahan, Edward [Earl Shinn], and F. Hopkinson Smith. *A Book of the Tile Club.* Boston and New York, 1886.

Fitzgerald, Percy. "Picture Frames." *Art Journal* (London), Nov. 1886, pp. 324–28.

Moore, Evelyn M. "Fans and Their Makers." *Art Journal* (London), Apr. 1889, pp. 120–24.

1890–99

"A Talk about Picture-Frames." *Art Amateur* 22 (May 1890), pp. 125–26.

Eckford, Henry [Charles De Kay]. "A Modern Colorist: Albert Pinkham Ryder." *Century Illustrated Monthly Magazine* 40 (June 1890), pp. 250–59.

"Ten American Painters." *Collector* 9 (Apr. 15, 1899), p. 180.

1900–present

Hunt, William Holman. *Pre-Raphaelitism and the Pre-Raphaelites.* 2 vols. London, 1906.

Weitenkampf, F[rank]. *American Graphic Art.* New York, 1912.

Shelton, William Henry. *The Salmagundi Club.* Boston and New York, 1918.

White, Lawrence Grant. *Sketches and Designs by Stanford White.* New York, 1920.

Lucas, Edward V. *Edwin Austin Abbey.* 2 vols. New York, 1921.

Millet, J. B. "The Tile Club." In *Julian Alden Weir: An Appreciation of His Life and Works.* New York, 1921.

Shelton, William Henry. *The History of the Salmagundi Club as It Appeared in the* New York Herald Magazine *on Sunday, December Eighteenth, Nineteen Twenty Seven.* [New York], 1927.

Lyman Allyn Museum, New London, Conn. *A Catalogue of Work in Many Media by Men of the Tile Club,* by Dorothy Weir Young. Exhib. cat., 1945.

Becker, Eugene Matthew. "Whistler and the Aesthetic Movement." Ph.D. diss., Princeton University, 1959.

Ebersole, Barbara Warren. "An Investigation into the Nature and Problems of Decorative Painting." Ph.D. diss., Ohio State University, 1960.

Rubin, Ronnie. "The Tile Club, 1877–1887." M.A. thesis, New York University, 1967.

Museum of Fine Arts, Boston. *American Paintings in the Museum of Fine Arts.* 2 vols. Boston, 1969.

Young, Mahonri Sharp. "The Tile Club Revisited." *American Art Journal* 2 (Fall 1970), pp. 81–91.

Gerdts, William H., and Russell Burke. *Still-Life Painting in America.* New York and London, 1971.

Wildenstein and Company, New York. *From Realism to Symbolism: Whistler and His World,* by Theodore Reff and Allen Staley. Exhib. cat., 1971.

Gerdts, William H. "The Bric-a-Brac Still Life." *Antiques* 100 (Nov. 1971), pp. 744–48.

Harrison, Martin, and Bill Waters. *Burne-Jones.* London, 1973.

Yale University Art Gallery, New Haven. *Edwin Austin Abbey (1852–1911),* by Kathleen Adair Foster and Michael Quick. Exhib. cat., 1973.

Grieve, Alastair. "The Applied Art of D. G. Rossetti, 1: His Picture-Frames." *Burlington Magazine* 115 (Jan. 1973), pp. 16–24.

Hendricks, Gordon. *The Life and Work of Thomas Eakins.* New York, 1974.

[Burke], Doreen Bolger. "The Education of the American Artist." In Pennsylvania Academy of the Fine Arts, Philadelphia. *In This Academy: The Pennsylvania Academy of the Fine Arts, 1805–1976.* Exhib. cat., 1976, pp. 51–74.

Gerdts, William H. "The Square Format and Proto-modernism in American Painting." *Arts Magazine* 50 (June 1976), pp. 70–75.

Allen Memorial Art Museum, Oberlin, Ohio. *The Stamp of Whistler,* by Robert H. Getscher and Allen Staley. Exhib. cat., 1977.

Dayton Art Institute, Ohio. *Jean-Léon Gérôme (1824–1904),* by Gerald M. Ackerman and Richard Ettinghausen. Exhib. cat., 1977.

Hirshhorn Museum and Sculpture Garden, Washington, D.C. *The Thomas Eakins Collection of the Hirshhorn Museum and Sculpture Garden,* by Phyllis D. Rosenzweig. Exhib. cat., 1977.

Thompson, Susan Otis. *American Book Design and William Morris.* New York and London, 1977.

Hayward, Mary E. "The Influence of the Classical Oriental Tradition on American Painting." *Winterthur Portfolio* 14 (Summer 1979), pp. 107–42.

Boime, Albert. *Thomas Couture and the Eclectic Vision.* New Haven and London, 1980.

Foster, Kathleen Adair. "Makers of the American Watercolor Movement, 1860–1890." Ph.D. diss., Yale University, 1982.

Goodrich, Lloyd. *Thomas Eakins.* 2 vols. Cambridge, Mass., and London, 1982.

Betsky, Celia. "In the Artist's Studio." *Portfolio* 4 (Jan.–Feb. 1982), pp. 32–39.

Schneider, Rona. "The American Etching Revival: Its French Sources and Early Years." *American Art Journal* 14 (Autumn 1982), pp. 40–65.

Grand Central Art Galleries, Inc., New York. *La Femme: The Influence of Whistler and Japanese Print Masters on American Art, 1880–1917,* by Gary Levine, Robert R. Preato, and Francine Tyler. Exhib. cat., 1983.

Weinberg, H. Barbara. *The American Pupils of Jean-Léon Gérôme.* Fort Worth, Tex., 1984.

Brooklyn Museum. *The New Path: Ruskin and the American Pre-Raphaelites,* by Linda S. Ferber and William H. Gerdts. Exhib. cat., 1985.

Meixner, Laura L. "Will Hicok Low (1853–1932): His Early Career and Barbizon Experience." *American Art Journal* 17 (Autumn 1985), pp. 51–70.

Boime, Albert. "The Teaching of Fine Art and the Avant-Garde in France During the Second Half of the Nineteenth Century." *Arts Magazine* 60 (Dec. 1985), pp. 46–57.

PATTERN AND ORNAMENT

1850–59

Jones, Owen. *The Grammar of Ornament.* London, 1856.

Dresser, Christopher. *Unity in Variety, as Deduced from the Vegetable Kingdom, Being an Attempt at Developing That Oneness Which Is Discoverable in the Habits, Mode of Growth, and Principle of Construction of All Plants.* London, 1859.

1860–69

Dresser, Christopher. *The Art of Decorative Design, with an Appendix, Giving the Hours of the Day at Which Flowers Open . . . the Characteristic Flowers of the Month. . . .* London, 1862.

Jones, Owen. *Examples of Chinese Ornament Selected from Objects in the South Kensington Museum and Other Collections.* London, 1867.

Racinet, Albert Charles. *L'Ornement polychrome; cent planches en couleurs, or, et argent, contenant environ deux mille motifs de tous les styles, art ancien et asiatique, moyen âge, renaissance, dix-septième et dix-huitième siècle.* Paris, 1869–73.

1870–79

Hulme, F. Edward. "On the Adaptability of Our Native Plants to Purposes of Ornamental Art," pts. 1–6. *Art Journal* (London), Jan. 1870, pp. 14–15; Feb. 1870, pp. 54–55; Apr. 1870, pp. 110–11; June 1870, pp. 186–87; Aug. 1870, pp. 254–55; Oct. 1870, pp. 314–15.

Dresser, Christopher. *Principles of Decorative Design.* London and New York, 1873.

Hulme, F. Edward. "Chapters Towards a History of Ornamental Art," pts. 1–9. *Art Journal* (London), Jan. 1873, pp. 9–11; Feb. 1873, pp. 45–47; Mar. 1873, pp. 89–91; Apr. 1873, pp. 119–21; May 1873, pp. 133–35; July 1873, pp. 209–11; Sept. 1873, pp. 273–75; Nov. 1873, pp. 333–35; Dec. 1873, pp. 369–71.

"First Principles of Decoration." *Furniture Gazette* 1 (Apr. 19, 1873), pp. 20–21.

"The Study of Color." *Furniture Gazette* 1 (June 7, 1873), p. 131.

Pilsbury, Wilmot. "Principles of Decorative Design." *Furniture Gazette* 1 (Aug. 30, 1873), pp. 328–29.

Hulme, F. Edward. "Naturalistic Versus Non-Naturalistic." *Furniture Gazette* 1 (Sept. 13, 1873), pp. 356–57.

Dresser, Christopher. *Studies in Design.* London, 1874–76.

Jewitt, Llewellynn. "The Cross in Nature and in Art: Its History, Ramifications, and Various Aspects," pts. 1–7. *Art Journal* (London), Jan. 1874, pp. 23–26; May 1874, pp. 133–37; June 1874, pp. 185–88; Sept. 1874, pp. 281–84; Oct. 1874, pp. 309–12; Nov. 1874, pp. 337–40; Dec. 1874, pp. 365–66.

Redgrave, Gilbert R. *The Manual of Design, Compiled from the Writings and Addresses of Richard Redgrave.* London and New York, 1876.

"The Use of Plants in Decoration." *Jewelers' Circular and Horological Review* 7 (July 1876), p. 90.

[Booth, Charles, et al.]. *Modern Surface Ornament.* New York, 1877.

Hulme, F. Edward. "The Use of Animal Forms in Ornamental Art," pts. 1–5. *Art Journal* (Appleton's) 3 (Feb. 1877), pp. 46–48; (Apr. 1877), pp. 109–11; (June 1877), pp. 183–85; (Nov. 1877), pp. 334–36; (Dec. 1877), pp. 375–77.

Beckwith, Arthur. "Principles of Ornamentation." *Carpet Trade Review* 4 (July 1877), pp. 89–90.

"Decorative Designing." *Art Journal* (Appleton's) 3 (July 1877), pp. 209–14.

Jenney, William L. B. "The Principles of Ornament." *Carpet Trade Review* 5 (Feb. 1878), p. 22.

Day, Lewis F. "The Application of Color and Ornament." *Carpet Trade Review* 5 (Apr. 1878), pp. 43–45.

Colling, James K. "Analysis of Form," pts. 1, 2. *Carpet Trade* 5 (Oct. 1878), pp. 15–18; (Nov. 1878), pp. 16–19.

"Fitness in Decoration." *Art Interchange* 1 (Oct. 30, 1878), p. 29.

Rood, Ogden. *Modern Chromatics with Applications to Art and Industry.* New York, 1879.

"Ornamentation of Oriental Fabrics." *Carpet Trade Review* 6 (Jan. 1879), pp. 16–17.

Tyrwhitt, R. J. "The Study of Nature and Designing." *Carpet Trade Review* 6 (Jan. 1879), pp. 19–20.

Powers, C. E. "The Use of Plant Forms in Design." *Art Interchange* 2 (Apr. 10, 1879), p. 72.

Morris, William. "Historical Development of Pattern Designing." *Carpet Trade* 10 (June 1879), pp. 19–20.

"Conventional Art in Decoration." *Art Interchange* 2 (June 25, 1879), p. 101.

"Orator Fit, Poeta Nascitur." *Carpet Trade Review* 6 (July 1879), pp. 147–49.

"The Power to Design a Source of National Wealth and Prosperity." *Carpet Trade* 10 (Aug. 1879), pp. 13–14.

"Of the Multiplication of Patterns." *Carpet Trade Review* 6 (Sept. 1879), pp. 197–98.

Goodyear, William Henry. "Conventional Art in Decoration." *Art Interchange* 3 (Sept. 17, 1879), pp. 45–46.

1880–89

Cutler, Thomas W. *A Grammar of Japanese Ornament and Design.* London, 1880.

"Original Designs for Art-Manufacture." *Art Journal* (Appleton's) 6 (Feb. 1880), pp. 49–52.

"Decoration in Excess." *Art Journal* (Appleton's) 6 (Nov. 1880), pp. 328–29.

Audsley, W., and G. Audsley. *Outlines of Ornament in the Leading Style.* London, 1881.

"Marine Forms as Applicable to Decoration." *Scribner's Monthly* 21 (Apr. 1881), pp. 809–22.

"Japanesque Decoration." *Art Amateur* 5 (Sept. 1881), pp. 79–80.

"Decoration." *Carpet Trade Review* 8 (Oct. 1881), p. 196.

"What Ornament Should Be." *Art Amateur* 5 (Nov. 1881), pp. 128–29.

Audsley, W., and G. Audsley. *Polychromatic Decoration.* London, 1882.

Day, Lewis F. *Every-Day Art: Short Essays in the Arts Not Fine.* London, 1882.

Smith, J. Moyr. *Album of Decorative Figures.* London, 1882.

———. *Ancient Greek Female Costume.* London, 1882.

"Philosophy of Decorative Art." *Carpet Trade Review* 14 (Jan. 1882), p. 36.

"Principles of Decoration." *Carpet Trade* 9 (Feb. 1882), p. 21.

"Chinese and Japanese Decoration." *Art Amateur* 6 (Mar. 1882), p. 83.

"Conventionalization of Flowers." *Carpet Trade Review* 9 (Mar. 1882), pp. 25–26.

Wright, Mrs. George Curtis. "Theories and Harmony of Color." *Carpet Trade Review* 9 (June 1882), pp. 57–58.

"Conventional Treatment in Design." *Art Amateur* 7 (July 1882), p. 35.

"The Japanese Designer." *Art Amateur* 7 (Aug. 1882), p. 53.

"Corruption of Renaissance Ornament." *Art Amateur* 7 (Sept. 1882), p. 87.

Day, Lewis F. "The Obsolete Teachings of Owen Jones." *Decorator and Furnisher* 1 (Oct. 1882), p. 10.

"Anglo-Japanese." *Carpet Trade and Review* 13 (Oct. 1, 1882), p. 20.

"Principles Governing Color." *Art Amateur* 9 (Oct. 1883), p. 102.

"Points on Designing." *Carpet Trade and Review* 16 (Aug. 1, 1885), p. 28.

Dresser, Christopher. *Modern Ornamentation, Being a Series of Original Designs.* London, 1886.

Leland, Charles G. "Home Arts, 7: How to Design." *Art Journal* (London), Dec. 1886, pp. 365–69.

Day, Lewis F. "An Artist in Design." *Magazine of Art* 10 (1887), pp. 95–100.

———. "Victorian Progress in Applied Design." *Art Journal* (London), June 1887, pp. 185–202.

———. "Meaning in Ornament." *Art Journal* (London), July 1887, pp. 237–40.

Kuenemann, H. "Nature in Industrial Design." *Carpet Trade and Review* 18 (Aug. 15, 1887), p. 36.

"The Planning of Ornament." *Carpentry and Building* 10 (Apr. 1888), p. 73.

"Conventional Plant Forms." *Art Amateur* 19 (July 1888), p. 41.

"The Acanthus, the Lotus, and the Honeysuckle." *Art Journal* (London), Sept. 1889, pp. 269–72.

1890–99

Goodyear, William H. *The Grammar of the Lotus.* London, 1891.

Day, Lewis F. *Textbooks of Ornamental Design: The Planning of Ornament.* London, 1893.

Crane, Walter. "Design," pts. 1, 2. *Magazine of Art* 16 (1893), pp. 79–83, 131–36.

Batsford, Herbert. *Some Suggestions on the Formation of a Small Library of Reference Books on Ornament and the Decorative Arts.* London, 1897.

Crane, Walter. *The Bases of Design.* London, 1898.

Day, Lewis F. *Nature in Ornament.* London, 1898.

Morris, William. *Some Hints on Pattern Designing.* A Lecture Delivered at the Working Men's College, Dec. 10, 1881. London, 1899.

1900–present

Crane, Walter. *Line and Form.* London, 1900.

Day, Lewis F. *Ornament and Its Application.* London, 1904.

de Forest, Lockwood. *Illustrations of Design Based on Notes of Line Used by the Craftsmen of India.* Boston and New York, 1917.

Evans, Joan. *Pattern: A Study of Ornament in Western Europe from 1180–1900.* Oxford, 1931.

Stanton, Phoebe [B.]. "Pugin: Principles of Design vs. Revivalism." *Journal of the Society of Architectural Historians* 13 (Oct. 1954), pp. 20–25.

Bell, Quentin. *The Schools of Design.* London, 1963.

Watkinson, Ray. *William Morris as Designer.* New York, 1967.

Stanton, Phoebe [B.]. *Pugin.* London, 1971.

Durant, Stuart. *Victorian Ornamental Design.* London and New York, 1972.

———. "Ornament in an Industrial Civilization." *Architectural Review* 160 (Sept. 1972), pp. 139–43.

———. "Aspects of the Work of Dr. Christopher Dresser (1834–1904), Botanist, Designer, and Writer." Thesis, Royal College of Art, London, 1973.

Albarn, Keith, et al. *The Language of Pattern.* London, 1974.

Darby, Michael. "Owen Jones and the Eastern Ideal." Ph.D. diss., University of Reading, Eng., 1974.

Victoria and Albert Museum, London. *High Victorian Design,* by Simon Jervis. Exhib. cat., 1974.

Masheck, Joseph. "The Carpet Paradigm: Critical Prolegomena to a Theory of Flatness." *Arts Magazine* 51 (Sept. 1976), pp. 82–109.

Gombrich, E. H. *The Sense of Order: A Study in the Psychology of Decorative Art.* Ithaca, N.Y., 1979.

Johnson, Diana L. *Fantastic Illustration and Design in Britain, 1850–1930.* Providence, R.I., 1979.

Racinet, Albert Charles. *Handbook of Ornaments in Color.* 4 vols. Trans. J. A. Underwood. New York, 1979.

Dowling, Elizabeth M. "Ornament and the Machine in American Architecture in the Late Nineteenth and Early Twentieth Centuries." Ph.D. diss., University of Pennsylvania, 1981.

Darby, Michael. *The Islamic Perspective.* London, 1983.

Rhodes, John G. "Ornament and Ideology: A Study of Mid-Nineteenth-Century British Design Theory." Ph.D. diss., Harvard University, 1983.

Victoria and Albert Museum, London. *Pattern and Design: Designs for the Decorative Arts, 1480–1980,* ed. Susan Lambert. Exhib. cat., 1983.

Jespersen, John Kresten. "Owen Jones's *The Grammar of Ornament* of 1856: Field Theory in Victorian Design at the Mid-Century." Ph.D. diss., Brown University, 1984.

1860–69

Murray, H. "Recent Improvements in Minor Art-Industries: Glass Painting." *Art Journal* (London), Aug. 1869, pp. 231–32.

1870–79

Evans, Sebastian. "Glass Painting for Household Decoration." *Furniture Gazette* 1 (May 17, 1873), p. 86.

"Culture and Progress: The 'William Morris Window.'" *Scribner's Monthly* 6 (June 1873), pp. 245–46.

"Improvement in the Process of Ornamenting Glass." *Furniture Gazette* 1 (Nov. 22, 1873), p. 531.

Booth, Charles. *Hints on Church and Domestic Windows, Plain and Decorated.* Orange, N.J., 1876.

Wayne, Charles Stokes. "Stained Glass." *Potter's American Monthly* 8 (May 1877), pp. 331–33.

Cook, Clarence. "Recent Church Decoration." *Scribner's Monthly* 15 (Feb. 1878), pp. 569–77.

"New Jersey Pottery and Glass Interests." *Crockery and Glass Journal* 9 (Jan. 23, 1879), p. 18.

"A Cheap Substitute for Stained Glass." *Art Amateur* 1 (June 1879), p. 17.

"Painted Glass in Household Decoration." *Crockery and Glass Journal* 10 (Oct. 2, 1879), p. 19.

1880–89

Westlake, N. H. J. *A History of Design in Painted Glass.* 4 vols. London and Oxford, 1881–94.

Riordan, Roger. "American Stained Glass," pts. 1–3. *American Art Review* (Boston) 2, pt. 1 (1881), pp. 229–34; 2, pt. 2 (1881), pp. 7–11, 59–63.

"American Progress in the Manufacture of Stained Glass." *Scribner's Monthly* 21 (Jan. 1881), pp. 485–86.

"Glass Painting: Old and New." *Brick, Tile, and Metal Review* 1 (May 1881), p. 11.

Humphreys, Mary Gay. "Colored Glass for Home Decoration." *Art Amateur* 5 (June 1881), pp. 14–15.

"Stained Glass Windows Without Bars." *Art Amateur* 6 (Dec. 1881), p. 19.

"Stained Glass in Houses." *Crockery and Glass Journal* 16 (Nov. 23, 1882), p. 18.

Dewson, Edward. "American Stained Glass." In *Catalogue of the Art Department of the New England Manufacturers and Mechanics Institute.* Boston, 1883.

"Some Notable Windows." *Art Amateur* 8 (Feb. 1883), p. 70.

M. B. W. "Defensive Window Decoration." *Art Amateur* 8 (Mar. 1883), pp. 91–92.

"Stained Glass." *Demorest's Monthly Magazine* 19 (Apr. 1883), pp. 359–60.

Dewson, Edward. "Stained Glass as Applied to Transparencies." *Decorator and Furnisher* 3 (Oct. 1883), p. 9.

E. "America's Stained-Glass Interest." *American Architect and Building News* 15 (May 17, 1884), pp. 235–36.

Fenwick, R. "Modern French Stained Glass." *Art Journal* (London), Jan. 1885, pp. 20–23.

Riordan, Roger. "The Use of Stained Glass." *Art Amateur* 12 (May 1885), pp. 130–32.

Low, Will H. "Old Glass in New Windows." *Scribner's Magazine* 4 (Dec. 1888), pp. 675–86.

1890–99

La Farge, John. *The American Art of Glass, to Be Read in Connection with Mr. Louis C. Tiffany's Paper in the July Number of the "Forum," 1893.* [New York, 1893].

Coleman, Caryl. "A Sea of Glass." *Architectural Record* 2 (Jan.–Mar. 1893), pp. 264–85.

———. "The Second Spring." *Architectural Record* 2 (Apr.–June 1893), pp. 473–92.

Tiffany, Louis C. "American Art Supreme in Colored Glass." *Forum* 15 (July 1893), pp. 621–28.

Day, Lewis F. *Windows: A Book about Stained and Painted Glass.* London, 1894.

Holiday, Henry. *Stained Glass as an Art.* London, 1896.

Waern, Cecilia. *John La Farge, Artist and Writer.* New York and London, 1896.

———. "The Industrial Arts of America: The Tiffany Glass and Decorative Co." *International Studio* 2 (Sept. 1897), pp. 156–65.

Coleman, Caryl. "A Comparative Study of European and American Church Glass." *House Beautiful,* Apr. 1898, pp. 142–48.

1900–present

Cortissoz, Royal. *John La Farge: A Memoir and a Study.* Boston and New York, 1911.

Lamb, Charles Rollinson. "The Romance of American Glass." *Brooklyn Museum Quarterly* 16 (Oct. 1929), pp. 109–16.

Connick, Charles. *Adventures in Light and Color: An Introduction to the Stained Glass Craft.* New York, 1937.

Gough, Mary Rosalie. "A Study of Stained Glass in the District of Columbia and Its Environs." Ph.D. diss., Catholic University of America, 1943.

Koch, Robert. "The Stained Glass Decades: A Study of Louis Comfort Tiffany (1848–1933) and the Art Nouveau in America." Ph.D. diss., Yale University, 1957.

Armitage, E. Liddall. *Stained Glass: History, Technology, and Practice.* Newton Centre, Mass., 1959.

Sewter, A. Charles. "Victorian Stained Glass." *Apollo* 76 (Dec. 1962), pp. 760–65.

Lloyd, John Gilbert. *Stained Glass in America.* Jenkintown, Pa., 1963.

Koch, Robert. *Louis C. Tiffany: Rebel in Glass.* New York, 1964.

Stark, Carolyn C. "Stained Glass in the Denver Area." M.A. thesis, University of Denver, 1970.

Weinberg, H. Barbara. "The Decorative Work of John La Farge." Ph.D. diss., Columbia University, 1972.

———. "John La Farge and the Invention of American Opalescent Windows." *Stained Glass* 67 (Autumn 1972), pp. 4–11.

Lipke, Catherine Hall. "The Stained Glass Windows of Morris and Company in the United States of America." M.A. thesis, State University of New York, Binghamton, 1973.

Harrison, Martin. "Victorian Stained Glass." *Connoisseur* 182 (Apr. 1973), pp. 251–54.

Sewter, A. Charles. *The Stained Glass of William Morris and His Circle.* 2 vols. New Haven and London, 1974.

Allen, Francis. "American Ornamental Glass Windows: Forgotten Patterns in Crystal." *Glass Club Bulletin of the National Early American Glass Club,* June 1979, pp. 3–7.

Harrison, Martin. *Victorian Stained Glass.* London, 1980.

McKean, Hugh F. *The "Lost" Treasures of Louis Comfort Tiffany.* New York, 1980.

Donnelly, Michael. *Glasgow Stained Glass: A Preliminary Study.* Glasgow, 1981.

Sturm, James L. *Stained Glass from Medieval Times to the Present: Treasures to Be Seen in New York.* New York, 1982.

Ibach, Marilyn. *Morris and Company Stained Glass in North America.* New York, 1983.

Index

Photograph Credits

All photographs are by David Allison, with the exception of the following:

Henry Adams ILL. 9.9
Mr. and Mrs. Arthur G. Altschul ILL. 1.7
American Life Foundation, Watkins Glen, New York ILL. 10.35
Jaime Ardiles-Arce/Tiffany and Company, New York ILL. 4.13
Armen FIGS. 7.34, 8.5
The Art Institute of Chicago FIGS. 3.2, 4.8, 8.21, 9.20, ILLS. 3.21, 9.26
Art Resource/Scala Fine Arts ILL. 2.4
Avery Architectural and Fine Arts Library, Columbia University, New York FIGS. 10.1, 10.5, 10.6, 10.8, ILLS. 3.17, 10.6, 10.27, 10.33, 10.34, 10.40
Tom Barr FIG. 4.2, ILL. 7.11
Berry-Hill Galleries, Inc., New York FIG. 9.13
J. David Bohl FIGS. 3.4, 3.5, 3.10, ILL. 3.15
The Bostonian Society, Old State House ILL. 3.23
Bill Bowers ILL. 8.23
The British Museum, London FIG. 8.17, ILL. 8.5
The Brooklyn Museum, New York FIGS. 1.9, 3.18, 7.39, 8.6, ILLS. 1.6, 4.22
Bryn Mawr College Library, Maser Collection, Pennsylvania FIG. 9.10
Ken Burris FIG. 1.8
The Castle Howard Collection, York, England ILL. 3.27
Richard Cheek/ *The Magazine Antiques* ILLS. 4.3, 4.4, 4.15, 4.16, 4.19
The Chrysler Museum, Norfolk, Virginia FIGS. 7.51, 7.53, 7.55, 7.56, 7.57, 9.7, ILL. 7.14
Cincinnati Art Museum FIG. 8.22
Cincinnati Historical Society FIG. 7.26, ILL. 1.4
The Cleveland Museum of Art FIG. 9.15, ILLS. 3.32, 5.9
Cooper-Hewitt Museum, The Smithsonian Institution's National Museum of Design, New York FIGS. 3.1, 3.6, 3.11, 3.12, 3.13, 8.18, ILLS. 2.3, 3.11, 3.16, 3.26, 3.28
The Corning Museum of Glass, Corning, New York FIG. 7.44, ILL. 6.5
David A. Hanks and Associates, Inc., New York ILLS. 8.2, 8.15, 8.21, 10.38
Detroit Institute of Arts FIG. 5.9
Phil Dickenson ILL. 10.19
Documents Collection, College of Environmental Design, University of California, Berkeley ILL. 10.41
Rick Echelmeyer ILLS. 9.6, 9.7

Leon Edel ILL. 11.8
Bill Finney FIG. 8.20
Fogg Art Museum, Harvard University, Cambridge, Massachusetts ILL. 9.10
Ron Forth FIGS. 7.2, 7.3, 7.27, 7.28, 8.31, ILL. 5.7
Mr. and Mrs. W. Roger Fry FIG. 5.14
The Glessner House, Chicago Architecture Foundation FIG. 7.14, ILLS. 3.8, 4.6
Gorham Division of Textron Inc., Providence, Rhode Island ILL. 8.12
Guild Hall Museum, East Hampton, New York ILLS. 9.1, 9.2
Hallmark Historical Collection, Hallmark Cards, Inc., Kansas City, Missouri FIG. 9.4
Haslam and Whiteway Limited, London FIGS. 7.11, 8.29
Helga Studios, Montclair, New Jersey ILLS. 9.5, 9.17
High Museum of Art, Atlanta FIGS. 1.11, 5.28, 7.6, 7.20, 7.31, 7.49, 7.54
Historic American Buildings Survey, Washington, D.C. ILL. 10.32
Houghton Library, Harvard University, Cambridge, Massachusetts FIGS. 10.2, 10.3, 10.4
Johns Hopkins University Press, Baltimore ILLS. 10.27, 10.28
Los Angeles County Museum of Art ILL. 7.9
Louis H. Sullivan Architectural Ornament Collection, Southern Illinois University at Edwardsville FIG. 10.7
The Love Collection ILL. 9.4
Catherine Lynn ILL. 3.14
Richard and Gloria Manney FIG. 9.1
Mark Twain Memorial, Hartford, Connecticut FIG. 3.16, ILLS. 3.30, 4.2
Marshall Historical Society, Marshall, Michigan ILL. 3.19
Louis W. Meehan FIG. 5.1
The Metropolitan Museum of Art, New York, Photograph Studio FIGS. 3.17, 5.22, 7.18, 7.21, 7.52, 8.16, 8.28, ILLS. 1.5, 3.31, 4.7, 6.6, 6.7, 7.10, 9.18, 9.19, 9.27, 10.29, 10.42, 11.1
Myron Miller ILLS. 10.15, 10.16
Missouri Historical Society, Saint Louis ILL. 10.30
Mitchell Wolfson, Jr., Collection of Decorative and Propaganda Arts, Miami-Dade Community College FIG. 8.23, ILLS. 8.4, 8.22
Museum of Art, Rhode Island School of Design, Providence FIGS. 3.19, 3.22, 7.24
Museum of The City of New York ILL. 9.28
Museum of Fine Arts, Boston FIGS. 6.5, 7.1,

7.41, 8.3, 8.19, ILLS. 9.11, 9.14, 9.20, 9.30
The Museum of Fine Arts, Houston FIG. 8.30
Museum of Fine Arts, Springfield, Massachusetts FIG. 1.10
National Academy of Design, New York ILL. 9.29
National Monuments Record, London ILLS. 4.10, 10.1, 10.3
National Museum of American Art, Smithsonian Institution, Washington, D.C. FIGS. 9.11, 9.12, ILL. 9.16
National Museum of American History, Smithsonian Institution, Washington, D.C. ILL. 8.18
Neefus Studios/Friends of Olana, Inc. ILL. 1.1
The Newark Museum, New Jersey FIG. 8.27
The New-York Historical Society ILLS. 4.14, 8.3, 11.2
Jeffrey Nintzel FIG. 9.6
The Oakland Museum, California FIG. 7.23
Steven Oliver FIG. 9.16
Philadelphia Museum of Art FIGS. 5.26, 9.14, ILL. 8.11
Private archives ILL. 9.13
Michael Radtke ILL. 8.17
Andrew Ross FIGS. 6.7, 6.8, 6.9
The Saint Louis Art Museum FIGS. 5.16, 5.17
Shelburne Museum, Inc., Vermont FIGS. 5.24, 5.25
Spectrum Photography, Andover, Massachusetts ILLS. 3.24, 3.25
Spencer Museum of Art, The University of Kansas, Lawrence FIG. 9.5
Stowe-Day Foundation, Hartford, Connecticut FIG. 3.9, ILL. 3.1
The Strong Museum, Rochester, New York FIGS. 7.30, 8.24
Robert W. Thornton FIGS. 5.19, 7.43
Tiffany and Company, New York ILL. 8.10
Kenneth R. Trapp ILL. 1.3
United States Patents and Trademarks Office, Washington, D.C. ILL. 3.10
Victoria and Albert Museum, London FIGS. 3.3, 8.11, ILLS. 3.2, 3.5, 3.6, 3.7, 5.2, 5.3, 5.4, 8.1, 10.2, 10.4, 11.3
Wadsworth Atheneum, Hartford, Connecticut FIGS. 9.18, 9.19
Peter Warner FIG. 3.20
John Webb ILL. 9.23
Whitworth Art Gallery, University of Manchester, England ILL. 3.4
William Doyle Galleries, New York FIG. 9.17
Yale University Art Gallery, New Haven FIG. 8.10, ILLS. 8.13, 9.24